REF
N
5300
S923
2002
V.1

B+T 2-13-02 95.00 (2v. set)

Learni...
Carroll...
1601, Washington Rd.
Westminster, MD 21157

W9-BWN-904

WITHDRAWN

ART HISTORY

SECOND EDITION
VOLUME ONE

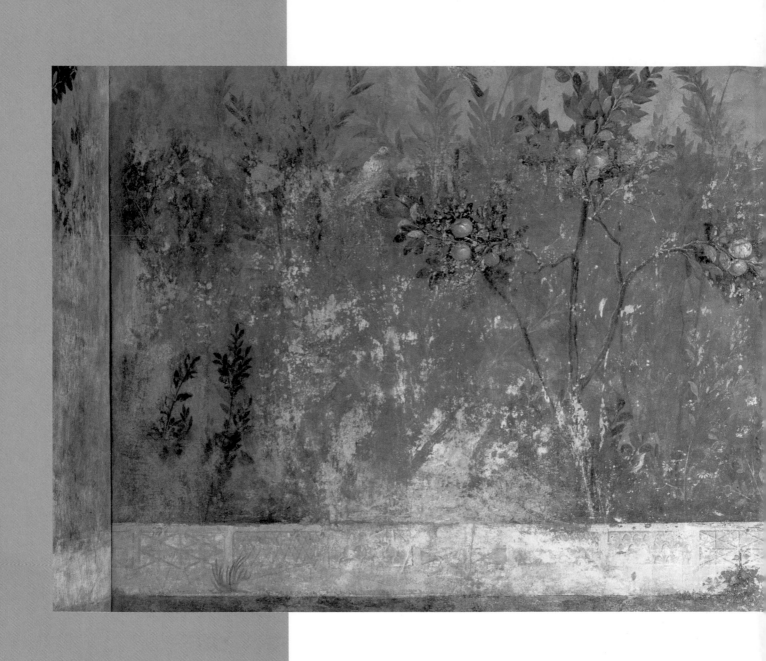

ART HISTORY

SECOND EDITION
VOLUME ONE

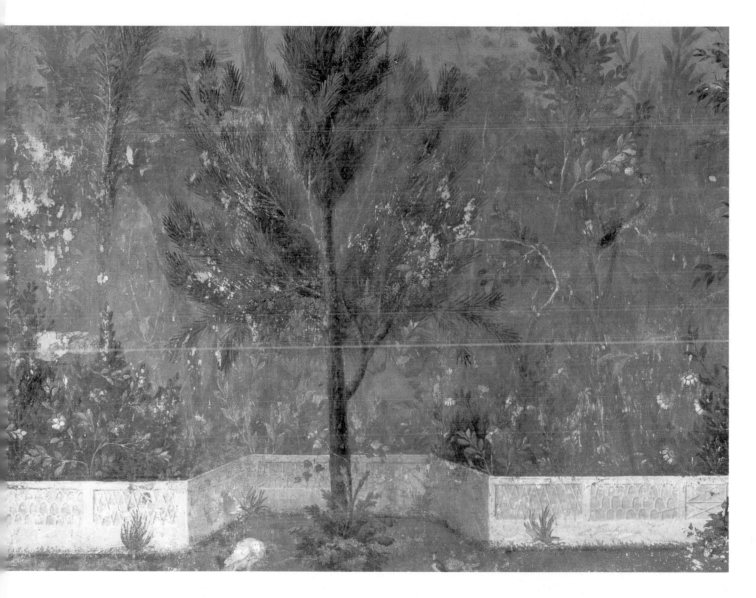

MARILYN STOKSTAD

in collaboration with DAVID CATEFORIS

with chapters by STEPHEN ADDISS, CHU-TSING LI,

MARYLIN M. RHIE, *and* CHRISTOPHER D. ROY

HARRY N. ABRAMS, INC., PUBLISHERS

DEDICATED TO MY SISTER, KAREN L. S. LEIDER, AND TO MY NIECE, ANNA J. LEIDER

Project manager and editorial director: *Julia Moore*
Project consultant: *Jean Smith*
Project editor: *Doris Chon*
Project assistant: *Holly Jennings*
Design and art direction: *Lydia Gershey/Vesica Aphia, Inc.*
Production: *Design 5 Creatives, Thomasina Webb, project manager*
Photo editing, rights and reproduction: *Photosearch, Inc.*
Illustrator: *John McKenna*
Indexers: *Peter and Erica Rooney*

Library of Congress has cataloged the Prentice Hall edition as follows:

Stokstad, Marilyn, 1929-
 Art history / Marilyn Stokstad in collaboration with David
 Cateforis with chapters by Stephen Addiss . . . [et al.].— 2nd ed.
 p. cm.
 Includes bibliographical references and index.
 ISBN 0-13-091868-7 (HC : combined) — ISBN 0-13-091852-0 (v. 1
 : PB) — ISBN 0-13-091850-4 (v. 2 : PB)
 1. Art–History. I. Cateforis, David. II. Addiss, Stephen,
 1935- III. Title.

 N5300 .S923 2001
 709–dc21

 2001000955

ISBN 0-8109-0610-4 (HC : 2 vol. boxed set ; Harry N. Abrams edition)

Copyright © 1995, 1999, 2002 Harry N. Abrams, Inc.

Published in 2002 by Harry N. Abrams, Incorporated, New York
All rights reserved. No part of the contents of this book may be reproduced
in any form or by any means without the written permission of the publisher.

Printed and bound in Japan
10 9 8 7 6 5 4 3 2 1

 Harry N. Abrams, Inc.
100 Fifth Avenue
New York, N.Y. 10011
www.abramsbooks.com

First Edition 1995
Revised Edition 1999
Second Edition 2002

Slipcase: Vincent van Gogh. *The Road Menders*. 1889. Oil on canvas, 29 x 36$\frac{1}{2}$" (73.4 x 91.8 cm).
The Phillips Collection, Washington, D.C.
Acquired 1949

Pages 2 and 3: Detail of figure 6-61, *Garden Scene*. Wall painting from the Villa of Livia at Primaporta, near Rome.
Late 1st century BCE. Museo Nazionale Romano, Rome

Brief Contents

Preface

In 1998 I wrote, "I want to thank my many friends and colleagues for welcoming *Art History* into their lives and their classrooms. I knew I wanted a new textbook for my students, but I had no idea how widespread that desire was. In the years since Abrams and Prentice Hall introduced *Art History*, it has exceeded all our hopes for its acceptance." With this new edition, I can only underline my original sentiments.

I believe more than ever that students ought to be able to enjoy their first course in art history. Only if they do will they want to experience and appreciate the visual arts—for the rest of their lives—as offering connection to the most tangible creations of the human imagination. To this end we continue to seek ways to make each edition of *Art History* a more sensitive, engaging, supportive, and accessible learning resource.

Art History **is contextual in its approach and object-based in its execution.** Throughout the text we treat the visual arts not in isolation but within the essential contexts of history, geography, politics, religion, and other humanistic studies, and we carefully define the parameters—social, religious, political, and cultural—that either have constrained or have liberated individual artists.

Art History **reflects the excitement and pleasures of art.** In writing about art's history, we try to express our affection for the subject. Each chapter of the narrative opens with a scene-setting vignette that concentrates on a work of art from that chapter. Set-off **text boxes**, many now illustrated, present interesting, often thought-provoking material. A number of them follow the theme of women in the arts—as artists and as patrons. Others give insights into discoveries and controversies. The discipline of art history is many-dimensional in its possibilities, and *Art History* invites a positive sampling of these possibilities.

We have maintained *Art History*'s comprehensiveness. We reach beyond the Western tradition to include an examination of the arts of other regions and cultures, from their beginnings to the twenty-first century. Acknowledging that the majority of survey courses concentrate on the Western tradition, we have organized the chapters on non-Western arts and cultures so that art can be studied from a global perspective within an integrated sequence of Western and non-Western art. Just as smoothly, non-Western material can be skipped over without losing the thread of the Western narrative.

WHAT'S NEW?

Art History's **view of art is even more inclusive.** We cover not only the world's most significant paintings and works of sculpture and architecture but also drawings and prints; photographs; works in metal, ceramic, and glass; textiles; jewelry; furniture and aspects of interior design (things that were once considered utilitarian arts). In covering the late twentieth century we include, as well, **new mediums** such as video art and installation art and such temporal arts as Happenings and performance art.

We pay due respect to the canon of great monuments of the history of art. In fact, this edition contains **more canonical works** than the original edition of 1995 and the Revised Edition of 1998, and now includes such works as the fifth-century BCE *Stele of Hegeso* and Dürer's *Self-Portrait* of 1500. Simultaneously, we continue to introduce artists and works not recognized in other surveys. An example is **an expanded representation of Canadian artists** in Chapters 28 and 29 and **the addition of two contemporary artists whose medium is glass.**

Art History **has been updated to include the most recent scholarship, scholarly opinion, technical analysis, archaeological discoveries, and controversies.** Chapter 29 devotes a whole page to recent debates over public funding for the arts, including a review of the events surrounding the 1999 exhibition "Sensation: Young British Artists from the Saatchi Collection." While the text's currency is not always conspicuous, revised opinion has been incorporated into discussions of artworks included in the two previous editions. Examples include the greater attention given to art and architecture of the Middle Byzantine period, especially that in Ukraine and Sicily, in Chapter 7 and the redisposition of figures on the west pediment of the Temple of Zeus at Olympia in Chapter 5.

To explore the role of a work of art within its context, we have added a new feature, The Object Speaks, which focuses in depth on some of the many things a work of art may have to say. At the same time that we stay grounded in the works of art that are, after all, what make art history distinctive among other humanistic disciplines, we emphasize the significance of the work of art.

Recently cleaned and/or restored works of art and architecture have been rephotographed and are now illustrated in their cleaned or restored states. Among the new images of buildings, fresco cycles, panel and easel paintings, and architectural and freestanding sculpture are the Archaic Greek *New York Kouros*, an interior view of the Dome of the Rock in Jerusalem, and Michelangelo's *Pietà*.

We responded to your suggestions for making Art History even more teachable. In this edition, we reorganized material on the Early Renaissance and integrated the graphic arts into the discussion of painting and sculpture. Chapter 18, on sixteenth-century art, draws a greater distinction than before on early- and late-sixteenth-century styles and gives greater attention to the impact of religious turmoil on the arts. In covering the seventeenth century, we resequenced material so that the colonial styles of New England are treated after English art and the art of colonial Mexico appears after the art of Spain. David Cateforis, my colleague at The University of Kansas and a specialist in twentieth-century art, has rewritten Chapters 26 through 29,

from Rococo through the dawn of the twenty-first century. He clarifies many issues and has added scores of illustrations and several text boxes, enriching and elucidating the discussion of art of the modern age.

Although the number of book pages is about the same as for the first two editions, **the text actually is shorter.** This means that more of the **illustrations are larger than ever.**

We have strengthened the pedagogical advantage of *Art History.* When first published, *Art History* was instantly embraced for its groundbreaking use of drawings and diagrams to aid readers in mastering the terminology of art history. The **Elements of Architecture** and **Technique boxes** visually explain how buildings are constructed and how artists use materials to do everything from creating cave paintings to decorating armor to making photographs. New to this edition, for example, are an Elements of Architecture box on timber construction and a Technique box that illustrates fresco painting.

Maps and **timelines** have been rethought and redesigned. Every chapter has at least one map and a timeline, and maps identify every site mentioned in the text. At the end of every chapter, you will now find a summary, called **Parallels**, that lists all major works in that chapter by country, time period, or stylistic category and reminds the reader of works of art from other cultures that are parallel in time. Terms specific to art history are printed in boldface type, which indicates their inclusion in the 900-word **Glossary**. The **Bibliography**, compiled by distinguished art librarian Susan Craig, is specific to this Second Edition.

As much as possible, without distorting the narrative of art history, we have chosen **works of art that are in North American museums, galleries, and collections** so that readers can most easily experience these works directly. This selection includes works from college and university galleries and museums.

More than three-quarters of the illustrations in this edition of Art History are now in color, and there are more drawings and diagrams than ever before. We have added labels to many drawings as well.

Art History **has a Companion Website™** that makes it possible to integrate the art history survey course with the vast power of the Internet. For students, the Stokstad Companion Website™ features Study Guide, Reference, Communication, and Personalization Modules. For instructors, the Companion Website™ has a special Faculty Module and Syllabus Manager.™

In addition, the textbook comes with a **complete ancillary package**, including an interactive CD-ROM with hundreds of images from the book, a student Study Guide, and an Instructors Resource Manual with Test Bank.

IN GRATITUDE

Art History **represents the cumulative efforts of a distinguished group of scholars and educators.** Single authorship of a work such as this is no longer viable, especially because of its global coverage. The work done by Stephen Addiss (Chapters 11 and 22), Chu-tsing Li (Chapters 10 and 21), Marylin M. Rhie (Chapters 9 and 20), and Christopher D. Roy (Chapters 13 and 25) for the original edition of *Art History* is still largely intact. David Cateforis incorporated material from the Revised Edition by Bradford R. Collins in reworking Chapters 26 through 29. As ever, this edition has benefited from the assistance and advice of scores of other teachers and scholars who have generously answered my questions, given recommendations on organization and priorities, and provided specialized critiques I hope you will enjoy the Second Edition of *Art History* and, as you have done so generously and graciously over the past six years, will continue to share your responses and suggestions with me.

Marilyn Stokstad
Lawrence, Kansas
Spring 2001

Acknowledgments

In the acknowledgments to the original edition, published in 1995, I wrote, "Writing and producing this book has been a far more challenging undertaking than any of us originally thought it would be. Were it not for the editorial and organizational expertise of Julia Moore, we never would have pulled it off. She inspired, orchestrated, and guided the team of editors, researchers, photo editors, designers, and illustrators who contributed their talents to the volume you now hold." In 1998 we revised the original edition in response to suggestions from readers and in order to add more and better illustrations. The success of Art History has made it possible to create a full-scale revision in 2001. I want to thank Julia again for her collaboration on this edition and acknowledge the team of editors who worked to refine this book. Special thanks are due to Jean Smith, Nancy Cohen, Doris Chon, Holly Jennings, and Erin Barnett. Reaching back, I want to cite Mark Getlein for his extraordinary care in developing the original chapters on Asian and African art, which are much as they have been in the first two versions of the book. In their work on the original edition, photo researchers Lauren Boucher, Jennifer Bright, Helen Lee, and Catherine Ruello performed miracles in finding the illustrations we needed; and in this edition the team at Photosearch, Inc., working under Abrams' John Crowley, took on this important work. John McKenna's drawings again bring exactly the right mix of information and clarity to the illustration program. Designer Lydia Gershey and Yonah Schurink broke new ground in their design and layout of the original edition and the team at Design 5 Creatives, led by project manager Thomasina Webb, continued the great work in this edition, creating a book that is a joy to use. Sheryl Adams and Alison Pendergast, Prentice Hall marketing managers, have contributed many inspired marketing initiatives. Phil Miller, Charlyce Jones Owen, and Bud Therien at Prentice Hall have been unfailingly supportive.

In these times, no one person should try to write a history of art. Consequently I gathered together a congenial group of scholar-teachers to write the first edition—Stephen Addiss, University of Richmond; Bradford R. Collins, University of South Carolina; Chu-tsing Li, The University of Kansas (ret.); Marylin M. Rhie, Smith College; and Christopher Roy, University of Iowa. In the second edition David Cateforis, The University of Kansas, who specializes in American and twentieth-century art, has joined the team. Art Librarian Susan Craig, head of the Murphy Library of Art and Architecture at The University of Kansas, prepared the bibliography.

Many people reviewed the original edition of Art History and have continued to assist with its revision. Every chapter has been read by one or more specialists. For work on the original book, and continuing assistance with the second edition, my thanks go to: Barbara Abou-El-Haj, State University of New York at Binghamton; Jane Aiken, Virginia Polytechnic; Vicki Artimovich, Bellevue Community College; Elizabeth Atherton, El Camino College; Ulkü Bates, Hunter College, City University of New York; Joseph P. Becherer, Grand Rapids Community College; Janet Catherine Berlo, University of Rochester; Roberta Bernstein, State University of New York at Albany; Edward Bleiberg, University of Memphis; Robert Bork, University of Iowa; Daniel Breslauer, The University of Kansas; Ronald Buksbaum, Capital Community Technical College; Petra Ten-Doesschate Chu, Seton Hall University; John Clarke, University of Texas at Austin; Kathleen Cohen, San Jose State University; Robert Cohon, The Nelson-Atkins Museum of Art; Frances Colpitt, University of Texas, San Antonio; Lorelei H. Corcoran, University of Memphis; Nancy Corwin (ret.); Ann G. Crowe, Virginia Commonwealth University; Pamela Decoteau, Southern Illinois University; Susan J. Delaney, Mira Costa College; Walter B. Denny, University of Massachusetts, Amherst; Richard DePuma, University of Iowa; Brian Dursam, University of Miami; Ross Edman, University of Illinois, Chicago; Gerald Eknoian, DeAnza State College; Mary S. Ellett, Randolph-Macon College; Deborah Ellington, North Harris College; James D. Farmer, Virginia Commonwealth University; Craig Felton, Smith College; Mary F. Francey, University of Utah; Joanna Frueh, University of Nevada, Reno; Mark Fullerton, Ohio State University; Jill Leslie Furst; Anna Gonosova, University of California, Irvine; Robert Grigg; Glenn Harcourt, University of Southern California; Sharon J. Hill, Virginia Commonwealth University; Mary Tavener Holmes, New York City; Jeffrey Hughes, Webster University; Paul E. Ivey, University of Arizona; Carol S. Ivory, Washington State University; Nina Kasanof, Sage Junior College of Albany; John F. Kenfield, Rutgers University; Ruth Kolarik, Colorado College; Jeffrey Lang, The University of Kansas; William A. Lozano, Johnson County Community College; Franklin Ludden, Ohio State University (ret.); Lisa F. Lynes, North Idaho College; J. Alexander MacGillivray, Columbia University; Janice Mann, Bucknell University; Michelle Marcus, The Metropolitan Museum of Art; Virginia Marquardt, University of Virginia; Peggy McDowell, University of New Orleans; Sheila McNally, University of Minnesota; Victor H. Miesel, University of Michigan (ret.); Vernon Minor, University of Colorado, Boulder; Anta Montet-White, The University of Kansas (ret.); Anne E. Morganstern, Ohio State University; Robert Munman, University of Illinois, Chicago; William J. Murnane, University of Memphis; Lawrence Nees, University of Delaware; Sara Orel, Truman State University; John G. Pedley, University of Michigan; Elizabeth Pilliod; Nancy H. Ramage, Ithaca College; Patricia Reilly, Santa Clara State University; Ida K. Rigby, San Diego State University; Howard Risatti, Virginia Commonwealth University; Ann M. Roberts, University of Iowa; Katherine Howard Rogers, Oakton Community College; Stanley T. Rolfe, University of Kansas; Wendy W. Roworth, University of Rhode Island; James H. Rubin, State University of New York at Stony Brook; John Russell, Columbia University; Leah Rutchick; Patricia Sands, Pratt Institute; Thomas Sarrantonio, State University of New York at New Paltz; Diane G. Scillia, Kent State University; Linda Seidel, University of Chicago; Nancy Sevcenko, Philadelphia; Tom Shaw, Kean University; Jan Sheridan, Erie Community College; William Sieger, Northeastern Illinois University; Jeffrey Chipps Smith, University of Texas at Austin; Anne Rudloff Stanton, University of Missouri, Columbia; Thomas Sullivan, OSB, Benedictine College (Conception Abbey); Janis Tomlinson, National Academy of Sciences, Washington, D.C.; the late Eleanor Tufts; Dorothy Verkerk, University of North Carolina, Chapel Hill; Roger Ward, The Nelson-Atkins Museum of Art; Mark Weil, Washington University, St. Louis; Alison West, New York City; Randall White, New York University; David Wilkins, University of Pittsburgh; and Linda Woodward, North Harris College.

Others who joined in on the revised edition and have tried to keep me from errors of fact and interpretation—who have shared ideas and course syllabi, read chapters or sections of chapters, and offered suggestions and criticism—include: Janetta Rebold Benton, Pace University; Elizabeth Broun, Smithsonian American Art Museum; Robert G. Calkins, Cornell University; William W. Clark, Queens College, City University of New York; Jaqueline Clipsham; Alessandra Comini, Southern Methodist University; Charles Cuttler, University of Iowa (ret.); Ralph T. Coe, Santa Fe; Patricia Darish; Yvonne R. Dixon, Trinity College; Lois Drewer, Index of Christian Art, Princeton; Charles Eldredge, The University of Kansas; James Enyeart, Santa Fe; Ann Friedman, Rochester; Mary D. Garrard, American University; Paula Gerson, Florida State University; Walter S. Gibson, Case Western Reserve University (ret.); Stephen Goddard, The University of Kansas; Dorothy Glass, State University of New York at Buffalo; the late Jane Hayward, The Cloisters, The Metropolitan Museum of Art; Robert Hoffmann, Smithsonian Institution (ret.); Luke Jordan, University of Kansas; Joseph Lamb, Ohio University; Charles Little, The Metropolitan Museum of Art; Karen Mack; Richard Mann, San Francisco State University; Bob Martin, Arizona State University; Amy McNair, The University of Kansas; Sara Jane Pearman, The Cleveland Museum of Art; Michael Plante, H. Sophie Newcomb Memorial College, Tulane University; John Pultz, The University of Kansas; Virginia Raguin, College of the Holy Cross; Irving Sandler, New York; Pamela Sheingorn, Baruch College, City University of New York; James Seaver, The University of Kansas (ret.); Caryl K. Smith, Muncie; Walter Smith, Ball State University; Lauren Soth, Carleton College; Linda Stone-Ferrier, The University of Kansas; Michael Stoughton, University of Minnesota; Elizabeth Valdez del Alamo, Montclair State College; and Ann S. Zielinski, State University of New York at Plattsburgh (ret.).

Several of the artists included in the book helped with information: Christo and Jeanne-Claude, Wenda Gu, Betye Saar, Miriam Schapiro, and Roger Shimomura.

University of Kansas graduate students taught with each new version and helped me in many ways. Among those who offered special suggestions are Elissa Anderson, Reed Anderson, Sean Barker, Erin Barnett, Heather Jensen, Beverly Joyce, Martha Mundis, Joni Murphy, Carla Tilghman. Graduate research assistants Ted Meadows, Don Sloan, and Jill Vessely provided invaluable help. All have earned my lasting gratitude.

The original book was class tested with students under the direction of these professors: Fred C. Albertson, University of Memphis; Betty J. Crouther, University of Mississippi; Linda M. Gigante, University of Louisville; Jennifer Haley, University of Nebraska, Lincoln; Cynthia Hahn, Florida State University; the late Lawrence R. Hoey, University of Wisconsin, Milwaukee; Delane O. Karalow, Virginia Commonwealth University; Charles R. Mack, University of South Carolina; Brian Madigan, Wayne State University; Meredith Palumbo, Kent State University; Sharon Pruitt, East Carolina State University; J. Michael Taylor, James Madison University; Marcilene K. Wittmer, University of Miami; and Marilyn Wyman, San Jose State University.

As David Cateforis and I reworked the chapters, specialists in many fields continued to answer our questions and share their ideas with us. Our thanks go to many of the people I have already mentioned and to James Adams, Manchester College; Roger Aikin, Creighton University; Anthony Alofsin, University of Texas, Austin; Christiane Andersson, Bucknell University; Kathryn Arnold; Julie Aronson, Cincinnati Art Museum; Larry Beck; Evelyn Bell, San Jose State University; David Binkley, The National Museum of African Art, Smithsonian Institution; Sara Blick, Kenyon College; Judith Bookbinder, University of Massachusetts, Boston; Marta Braun, Ryerson Polytechnic University; Claudia Brown, Arizona State University; Glen R. Brown, Kansas State University; April Clagget, Keene State College; James D'Emilio, University of South Florida; Susan Earle, The University of Kansas; Edmund Eglinski, The University of Kansas; Grace Flam, Salt Lake City Community College; Patrick Frank, The University of Kansas; Randall Griffey, The Nelson-Atkins Museum of Art; Marsha Haufler, The University of Kansas; John Hoopes, The University of Kansas; Marni Kessler, The University of Kansas; Alison Kettering, Carleton College; Wendy Kindred, University of Maine at Fort Kent; Allan T. Kohl, Minneapolis College of Art; Carol H. Krinski, New York University; Aileen Laing, Sweet Briar College; Janet Le Blanc, Clemson University; Laureen Reu Liu, McHenry Country College; Loretta Lorance; Suzaan Boettger, Elizabeth Parker McLachlan, Rutgers University; Judith Mann, St. Louis Art Museum; James Martin, The Nelson-Atkins Museum of Art; Gustav Medicus, Kent State University; Tamara Mikailova, St. Petersburg, Russia, and Macalester College; Winslow Myers, Bancroft School; Amy Ogata, Cleveland Institute of Art; Judith Oliver, Colgate University; Edward Olszewski, Case Western Reserve University; Paul Rehak, Duke University; Lisa Robertson, Cleveland Museum of Art; Barry Rubin, Talmudic College of Florida; Charles Sack, Parsons, Kansas; Jan Schall, The Nelson-Atkins Museum of Art; Raechell Smith, Kansas City Art Institute; Pamela Trimpe, University of Iowa; Richard Turnbull, Fashion Institute of Technology; Lisa Vergara, City University of New York. Special thanks go to Jean Middleton James, Iowa City, who found many a slip of the pen—or computer key—in both the first and the revised editions.

FINAL WORDS

Dean Sally Frost Mason, Associate Dean Carl Strikwerda, and Provost David Shulenburger kindly reduced my teaching duties at the University on two occasions, and the Judith Harris Murphy Funds in The University of Kansas Endowment Association supported my research and travel. My colleagues in the Department of the History of Art have been unfailingly supportive; I have mentioned many of them here. Special thanks are due our Department administrators, Carol Anderson and Maud Morris, for computer assistance. Many friends, as well as colleagues, have endured my enthusiasms and despairs, but I extend my special thanks to Katherine Giele, Nancy and David Dinneen, Charlie and Jane Eldredge, Anta Montet-White, and Katherine Stannard (without whose swimming pool the second edition would never have been finished), and, of course, my very special thanks go to my sister, Karen Leider, and my niece, Anna Leider.

Finally, Paul Gottlieb, who was for twenty years president of Harry N. Abrams, Inc., believed in *Art History* from its inception. With heartfelt thanks for his faith in the project, his unending zeal for the production of valuable and beautiful books, and perhaps especially for his good humor, I express my admiration and gratitude.

Marilyn Stokstad
Lawrence, Kansas
Spring 2001

Contents

CHAPTER 1 Prehistory and Prehistoric Art in Europe 42

CHAPTER 2 Art of the Ancient Near East 66

CHAPTER 3 **Art of Ancient Egypt** 92

CHAPTER 4 **Aegean Art** 128

CHAPTER 5 Art of Ancient Greece 152

CHAPTER 6 Etruscan Art and Roman Art 222

Use Notes

The various features of this book reinforce each other, helping the reader to become comfortable with terminology and concepts that are specific to art history.

Starter Kit and Introduction The Starter Kit is a highly concise primer of basic concepts and tools. The outer margins of the Starter Kit pages are tinted to make them easy to find. The Introduction is an invitation to the many pleasures of art history.

Captions There are two kinds of captions in this book: short and long. Short captions identify information specific to the work of art or architecture illustrated:

> artist (when known)
> title or descriptive name of work
> date
> original location (if moved to a museum or other site)
> material or materials a work is made of
> size (height before width) in feet and inches, with
> centimeters and meters in parentheses
> present location

The order of these elements varies, depending on the type of work illustrated. Dimensions are not given for architecture, for most wall paintings, or for architectural sculpture. Some captions have one or more lines of small print below the identification section of the caption that gives museum or collection information. This is rarely required reading.

Long captions contain information that complements the narrative of the main text.

Definitions of Terms You will encounter the basic terms of art history in three places:

> IN THE TEXT, where words appearing in **boldface** type are defined, or glossed, at their first use. Some terms are explained more than once, especially those that experience shows are hard to remember.

> IN BOXED FEATURES on technique and other subjects and in Elements of Architecture boxes, where labeled drawings and diagrams visually reinforce the use of terms.

> IN THE GLOSSARY at the end of the volume, which contains all the words in **boldface** type in the text and boxes. The Glossary begins on page Glossary 1, and the outer margins are tinted to make the Glossary easy to find.

Maps, Timelines, and Parallels At the beginning of each chapter you will find a map with all the places mentioned in the chapter. Above the map, a timeline runs from the earliest through the latest years covered in that chapter.

Parallels, a table at the end of every chapter, lists, in the left column, key artworks in that chapter in chronological order and, in the right column, major works from other cultures of about the same time. Parallels offer a selection of simultaneous art events for comparison without suggesting that there are direct connections between them.

Boxes Special material that complements, enhances, explains, or extends the text is set off in three types of tinted boxes. Elements of Architecture boxes clarify specifically architectural features, such as "Space-Spanning Construction Devices" in the Starter Kit (page 22). Technique boxes (see "Lost-Wax Casting," page 21) amplify the methodology by which a type of artwork is created. Other boxes treat special-interest material related to the text.

Bibliography The bibliography at the end of this book beginning on page Bibliography 1 contains books in English, organized by general works and by chapter, that are basic to the study of art history today, as well as works cited in the text.

Dates, Abbreviations, and Other Conventions This book uses the designations BCE and CE, abbreviations for "before the Common Era" and "Common Era," instead of BC ("before Christ") and AD ("Anno Domini," "the year of our Lord"). The first century BCE is the period from 99 BCE to 1 BCE; the first century CE is from the year 1 CE to 99 CE. Similarly, the second century BCE is the period from 199 BCE to 100 BCE; the second century CE extends from 100 CE to 199 CE.

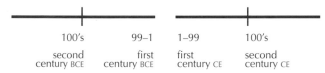

100's	99–1	1–99	100's
second century BCE	first century BCE	first century CE	second century CE

Circa ("about" or "approximately") is used with dates, spelled out in the text and abbreviated to "c." in the captions, when an exact date is not yet verified.

An illustration is called a "figure," or "fig." Thus, figure 6-70 is the seventieth numbered illustration in Chapter 6. Figures 1 through 28 are in the Introduction. There are two types of figures: photographs of artworks or of models, and line drawings. Drawings are used when a work cannot be photographed or when a diagram or simple drawing is the clearest way to illustrate an object or a place.

When introducing artists, we use the words *active* and *documented* with dates, in addition to "b." (for "born") and "d." (for "died"). "Active" means that an artist worked during the years given. "Documented" means that documents link the person to that date.

Accents are used for words in French, German, Italian, and Spanish only.

With few exceptions, names of museums and other cultural bodies in Western European countries are given in the form used in that country.

Titles of Works of Art Most paintings and works of sculpture created in Europe and North America in the past 500 years have been given formal titles, either by the artist or by critics and art historians. Such formal titles are printed in italics. In other traditions and cultures, a single title is not important or even recognized. In this book we use formal descriptive titles of artworks where titles are not established. If a work is best known by its non-English title, such as Manet's *Le Dejeuner sur l'Herbe (The Luncheon on the Grass)*, the original language precedes the translation.

Starter Kit

The Starter Kit contains basic information and concepts that underlie and support the study of art history, which concerns itself with the visual arts—traditionally painting and drawing, sculpture, prints, and architecture. It presents the vocabulary used to classify and describe art objects and is therefore indispensable to the student of art history. Use the Starter Kit as a quick reference guide to understanding terms you will encounter again and again in reading *Art History* and in experiencing art directly.

Let us begin with the basic properties of art. In concrete, nonphilosophical terms, a work of art has two components: FORM and CONTENT. It is also described and categorized according to STYLE and MEDIUM.

FORM

Referring to purely visual aspects of art and architecture, the term *form* encompasses qualities of LINE, COLOR, TEXTURE, SPATIAL ATTRIBUTES, and COMPOSITION. When art historians use the term *formal* they mean "relating to form." These qualities all are known as FORMAL ELEMENTS.

Line is an element—usually drawn or painted—that defines shape with a more-or-less continuous mark. In art historical writing, the word *linear* suggests an emphasis on line. Line can be real, as when the line is visible, or it may be imaginary, as when the movement of the eyes over the surface of the work of art follows a path that suggests a line or lines. The outline, edge, or silhouette of an object is perceived as line. Qualities of line range from angular to curvy (called curvilinear), from delicate to bold, from solid to sketchy.

Color has several attributes. These include HUE, VALUE, and SATURATION.

> HUE is what we think of when we hear the word *color*. Red, yellow, and blue are PRIMARY HUES (colors) because the SECONDARY COLORS of orange, green, and purple are made by combining red and yellow, yellow and blue, and red and blue, respectively. Red, orange, and yellow are regarded as warm colors, colors that advance toward us. Green, blue, and purple, which seem to recede, are called cool colors.

> VALUE is the relative degree of lightness or darkness of a given color and is created by the amount of light reflected from an object's surface. A dark green has a deeper value than a light green, for example. In black-and-white reproductions of colored objects, you see only value, and some artworks—for example, a drawing made with black ink—possesses only value, not hue or saturation.

> SATURATION, also referred to sometimes as INTENSITY, is a color's quality of brightness or dullness. A color described as highly saturated looks vivid and pure; a hue of low saturation may look a little muddy.

Texture, another attribute of form, is the tactile (or touch-perceived) quality of a surface. It is experienced and described with words such as *smooth, polished, rough, grainy, pitted, oily*, and the like. Texture relates to two aspects of an art object: the texture of the artwork's actual surface and the texture of the implied but imaginary surface of the object that the work represents.

Spatial attributes include SPACE, MASS, and VOLUME.

> SPACE is what contains objects. It may be actual and three-dimensional, as it is with sculpture and architecture, or it may be represented illusionistically in two dimensions, as when artists represent recession into the distance on walls, paper, or canvas.

> MASS and VOLUME are properties of three-dimensional things. Mass is matter—whether sculpture or architecture—that takes up space; it can be either solid or hollow. Volume is the space that mass organizes or defines by, for example, enclosing or partitioning it.

Composition is the organization, or disposition, of form in a work of art. PICTORIAL DEPTH (spatial recession) is a specialized aspect of composition in which the three-dimensional world is represented in two dimensions on a flat surface, or PICTURE PLANE. The area "behind" the picture plane is called the PICTURE SPACE and conventionally contains three "zones": FOREGROUND, MIDDLE GROUND, and BACKGROUND. Perpendicular to the picture plane is the GROUND PLANE.

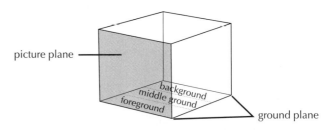

Diagram of picture space

Various techniques for conveying a sense of pictorial depth have been devised and preferred by artists in different cultures and at different times. A number of them are diagrammed here. In Western art, the use of various systems of PERSPECTIVE has created highly convincing illusions of recession into space. In other cultures, perspective is not the most favored way to treat objects in space.

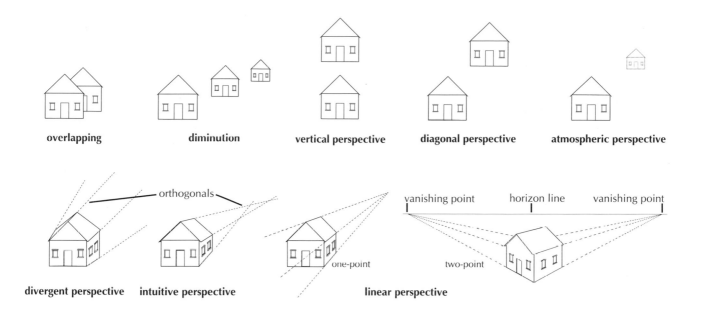

Pictorial devices for depicting recession in space

The top row shows several comparatively simple devices, including OVERLAPPING, in which partially covered elements are meant to be seen as located behind those covering them, and DIMINUTION, in which smaller elements are to be perceived as being farther away than larger ones. In VERTICAL and DIAGONAL PERSPECTIVE, elements are stacked vertically or diagonally, with the higher elements intended to be perceived as deeper in space. Another way of suggesting depth is through ATMOSPHERIC PERSPECTIVE, which depicts objects in the far distance, often in bluish gray hues, with less clarity than nearer objects and treats sky as paler near the horizon than higher up. In the lower row, DIVERGENT PERSPECTIVE, in which forms widen slightly and lines diverge as they recede in space, was used by East Asian artists. INTUITIVE PERSPECTIVE, used in some late medieval European art, takes the opposite approach: forms become narrower and converge the farther they are from the viewer, approximating the optical experience of spatial recession. LINEAR PERSPECTIVE, also called SCIENTIFIC, MATHEMATICAL, ONE-POINT, and RENAISSANCE PERSPECTIVE, is an elaboration and standardization of intuitive perspective and was developed in fifteenth-century Italy. It uses mathematical formulas to construct illusionistic images in which all elements are shaped by imaginary lines called ORTHOGONALS that converge in one or more VANISHING POINTS on a HORIZON LINE. Linear perspective is the system that most people living in Western cultures think of as perspective. Because it is the visual code they are accustomed to reading, they accept as "truth" the distortions it imposes. One of these distortions is FORESHORTENING, in which, for instance, the soles of the feet in the foreground are the largest elements of a figure lying on the ground.

CONTENT

Content is a term that embraces non-formal aspects of works of art, aspects that impart meaning. Content includes SUBJECT MATTER, which is, quite simply, what the artist is representing, even when what we see are strictly formal elements—lines and colors without recognizable imagery. REPRESENTATIONAL ART and NONREPRESENTATIONAL (or NONOBJECTIVE) ART are terms used to indicate whether subject matter is or is not recognizable. David Smith's *Cubi XIX*, seen in figure 5, is an example of nonrepresentational art.

Content also includes the ideas contained in a work. Content may comprise the social, political, and economic CONTEXTS in which a work was created, the INTENTION of the artist, the RECEPTION of the work by the beholder (the audience), and ultimately the MEANINGS of the work of art to both artist and audience.

The study of subject matter is ICONOGRAPHY (literally, "the writing of images"). The iconographer asks, What are we looking at? Because so many artists have used visual symbols to represent or identify concepts and ideas, iconography includes the fascinating study of SYMBOLS and SYMBOLISM.

STYLE

Expressed very broadly, style is the combination of form and content that makes a work distinctive. STYLISTIC ANALYSIS is one of art history's most developed practices, because it is how art historians identify works that are unsigned or whose history is unknown and how they group and classify artworks. This book will help make you sensitive to distinctions of style. For example, you can learn the ways in which French paintings in the Baroque style are distinguishable from Roman Baroque paintings, or how to

recognize the difference between Roman and Greek portrait heads. ARTISTIC STYLES fall in three major categories: PERIOD STYLE, REGIONAL STYLE, and FORMALIST STYLE.

Period style describes the common traits detectable in works of art and architecture from a certain time (and, usually, culture). For example, Roman portrait sculpture is distinguishable according to whether it was created during the Roman Republican era, at the height of the Empire, or in the time of the late Empire.

Regional style refers to stylistic traits that persist in a geographic region. An art historian whose specialty is medieval art can recognize French style through many successive medieval periods, even though individual objects may appear to the untrained eye to have been created in, say, Germany or the Low Countries.

Formalist style is not a common term in the literature of art, but it is a convenient way to present stylistic traits that are grounded in formal considerations. REALISM, NATURALISM, IDEALIZATION, and EXPRESSIONISM are often-found names for styles.

> **REALISM** is the attempt to depict objects as they are in actual, visible reality. Figure 2, *Flower Piece with Curtain*, is a good example of realism.

> **NATURALISM** is a style of depiction in which the physical appearance of the rendered image in nature is the primary inspiration. A work in a naturalistic style resembles the original, but not with the same exactitude and literalness as a work in a realistic style. The *Medici Venus* (fig. 7) is naturalistic in this sense.

> **IDEALIZATION** strives to realize in visual form a concept of perfection embedded in a culture's value system. The *Medici Venus* (fig. 7) just cited as naturalistic is also idealized.

> **EXPRESSIONISM** refers to styles in which the artist uses exaggeration of form and expression to appeal directly to the beholder's subjective emotional responses. The Hellenistic sculpture *Laocoön* (fig. 24) and van Gogh's *Large Plane Trees* (fig. 28) are both expressionistic.

Artists and artworks that are related by period, place, and style are linked by the term SCHOOL. In art history, the word *school* has several meanings. The designation *school of* is sometimes used for works that are not attributable but that show strong stylistic similarities to a known artist (for example, school of Rubens. A term such as *Sienese school* means that the work shows traits common in art from Siena, Italy, during the period being discussed. *Follower of* most often suggests a second-generation artist working in a variant style of the named artist. *Workshop of* implies that a work was created by an artist or artists trained in the workshop of an established artist. *Attributed to*, like a question mark next to an artist's name, means that there is some uncertainty as to whether the work is by that artist.

MEDIUM

What is meant by *medium* or *mediums* (the plural we use in this book to distinguish the word from print and electronic news media) is the material or materials from which an object is made. Broader even than medium is the distinction between art forms that are TWO-DIMENSIONAL and THREE-DIMENSIONAL.

Two-dimensional arts include PAINTING, DRAWING, THE GRAPHIC ARTS (also called PRINTS), and PHOTOGRAPHY. In short, these are arts that are made on a flat surface. Three-dimensional arts are SCULPTURE, ARCHITECTURE, and many ORNAMENTAL and FUNCTIONAL ARTS.

The visual arts' traditional mediums have been painting, drawing, graphic arts, sculpture, and architecture. As the study of art history has become more inclusive, other mediums have come within its sphere: photography and the ephemeral arts, furniture, works of ceramic and glass, metalwork, fiber arts, folk and vernacular art, as well as works that mix mediums. More recently, the study of popular arts, often referred to as visual culture, is emerging as a dimension of art history.

Painting includes WALL PAINTING and FRESCO, ILLUMINATION (the decoration of books with paintings), PANEL PAINTING (painting on wood panels) and painting on canvas, miniature painting (small-scale painting), and HANDSCROLL and HANGING SCROLL painting. Paint is pigment mixed with a liquid vehicle, or binder. Various kinds of paint and painting are explained throughout this book in Technique boxes.

Drawing encompasses SKETCHES (quick visual notes for larger drawings or paintings), STUDIES (more carefully drawn analyses of details or entire compositions), drawings as complete artworks in themselves, and CARTOONS (full-scale drawings made in preparation for work in another medium, such as fresco). Drawings are essentially linear in nature and are made with such materials as ink, charcoal, crayon, and lead pencil.

Graphic arts are the printed arts—images that are reproducible. They are usually works of art on paper. The graphic arts traditionally include WOODCUT, WOOD ENGRAVING, ETCHING, DRYPOINT, METAL ENGRAVING, and LITHOGRAPHY.

Sculpture is three-dimensional art that is CARVED, MODELED, CAST, or ASSEMBLED. Carved sculpture is reductive in the sense that the image is created by taking away material. In fact, wood, stone, and ivory can be carved into sculpture only because they are not pliant, malleable materials. Modeled sculpture is considered additive, meaning that the object is built up from a material, such as clay, that is soft enough to be molded and shaped. Metal sculpture is usually cast (see "Lost-Wax Casting," page 21) or is assembled by welding or a similar means of permanent joining.

TECHNIQUE
LOST-WAX CASTING

The lost-wax casting process (also called *cire perdue*, the French term) has been used for many centuries. It probably started in Egypt. By 200 BCE the technique was known in China and ancient Mesopotamia and was soon after used by the Benin peoples in Africa. It spread to ancient Greece sometime in the sixth century BCE and was widespread in Europe until the eighteenth century, when a piece-mold process came to predominate. The usual metal is bronze, an alloy of copper and tin, or sometimes brass, an alloy of copper and zinc.

The progression of drawings here shows the steps used by Benin sculptors. A heat-resistant "core" of clay (approximating the shape of the sculpture-to-be (and eventually becoming the hollow inside the sculpture) was covered by a layer of wax about the thickness of the final sculpture. The sculptor carved the details in the wax. Rods and a pouring cup made of wax were attached to the model. A thin layer of fine, damp sand was pressed very firmly into the surface of the wax model, and then model, rods, and cup were encased in thick layers of clay. When the clay was completely dry, the mold was heated to melt out the wax. The mold was then turned upside down to receive the molten metal, which for the Benin was brass, heated to the point of liquification. The cast was placed in the ground. When the metal was completely cool, the outside clay cast and the inside core were broken up and removed, leaving the cast brass sculpture. Details were polished to finish the piece of sculpture, which could not be duplicated because the mold had been destroyed in the process.

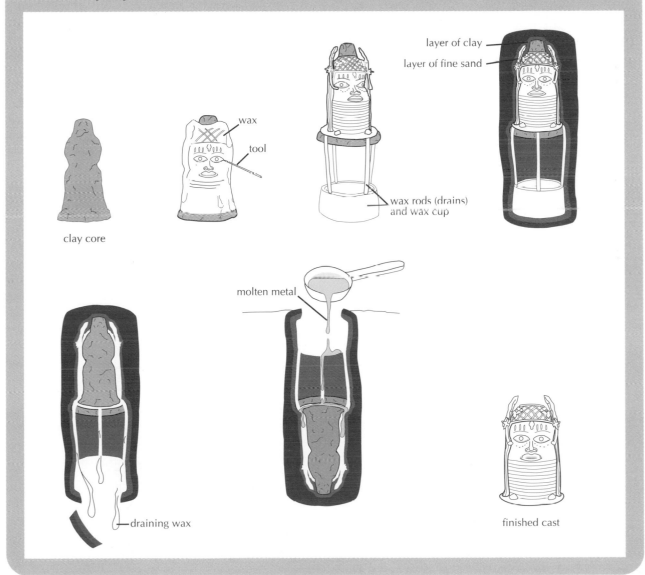

clay core

wax

tool

wax rods (drains) and wax cup

layer of clay

layer of fine sand

molten metal

draining wax

finished cast

ELEMENTS OF ARCHITECTURE

Space-Spanning Construction Devices

Gravity pulls on everything, presenting great challenges to the need to cover spaces. The purpose of the spanning element is to transfer weight to the ground. The simplest space-spanning device is post-and-lintel construction, in which uprights are spanned by a horizontal element. However, if not flexible, a horizontal element over a wide span breaks under the pressure of its own weight and the weight it carries.

Corbeling, the building up of overlapping stones, is another simple method for transferring weight to the ground. Arches, round or pointed, span space. Vaults, which are essentially extended arches, move weight out from the center of the covered space and down through the corners. The cantilever is a variant of post-and-lintel construction. When concrete is reinforced with steel or iron rods, the inherent brittleness of cement and stone is overcome because of metal's flexible qualities. The concrete can then span much more space and bear heavier loads. Suspension works to counter the effect of gravity by lifting the spanning element upward. Trusses of wood or metal are relatively lightweight spanners but cannot bear heavy loads. Large-scale modern construction is chiefly steel frame and relies on steel's properties of strength and flexibility to bear great loads. The balloon frame, an American innovation, is based in post-and-lintel principles and exploits the lightweight, flexible properties of wood.

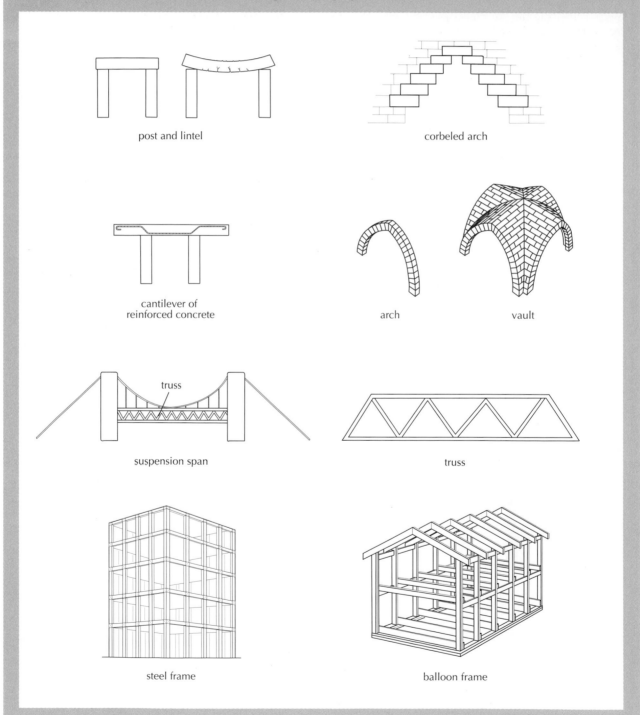

post and lintel

corbeled arch

cantilever of reinforced concrete

arch

vault

suspension span

truss

truss

steel frame

balloon frame

Sculpture is either FREESTANDING (that is, not attached) or in RELIEF. Relief sculpture projects from the background surface of which it is a part. HIGH RELIEF sculpture projects far from its background; LOW RELIEF sculpture is only slightly raised; and SUNKEN RELIEF, found mainly in Egyptian art, is carved into the surface, with the highest part of the relief being the flat surface.

Mixed medium includes categories such as COLLAGE and ASSEMBLAGE, in which two or more mediums are combined to create the artwork. One of the mediums may be paint, but does not have to be.

Ephemeral arts include such chiefly modern categories as performance art, Happenings, earthworks, cinema, video art, and computer art. Common to all of them is the temporal aspect of the work: the art is viewable for a finite period of time, then disappears forever, is in a constant state of change, or must be replayed to be experienced again.

Architecture is three-dimensional, highly spatial, functional, and closely bound with technology and materials. An example of the relationship among technology, materials, and function is how space is spanned (see "Space-Spanning Construction Devices," page 22). Several types of two-dimensional graphic devices are commonly used to enable the visualization of a building. These architectural graphics include PLANS, ELEVATIONS, SECTIONS, and CUTAWAYS.

PLANS depict a structure's masses and voids, presenting a view from above—as if the building had been sliced horizontally at about waist height.

plan

ELEVATIONS show exterior sides of a building as if seen from a moderate distance without any perspective distortion.

elevation

SECTIONS reveal a building as if it had been cut by an imaginary slicer from top to bottom.

section

CUTAWAY DRAWINGS show both inside and outside elements from an oblique angle.

cutaway

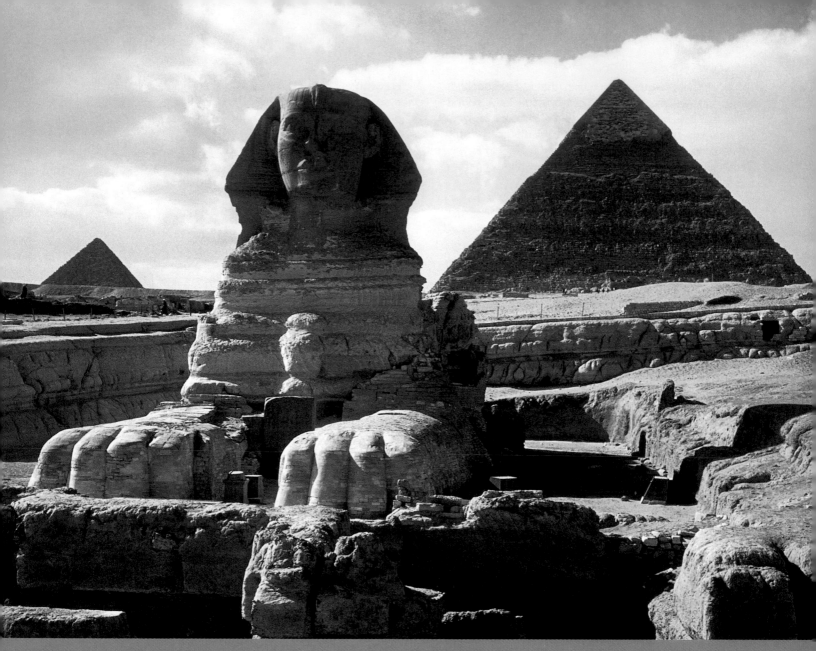

1. **The Great Sphinx, Giza**, Egypt. Dynasty 4, c. 2613–2494 BCE. Sandstone, height approx. 65' (19.8 m)

Introduction

Crouching in front of the pyramids of Egypt and carved from the living rock of the Giza plateau, the Great Sphinx is one of the best-known monuments in the world (fig. 1). By placing the head of the ancient Egyptian king Khafra on the body of a huge lion, the sculptors joined human intelligence and animal strength in a single image to evoke the superhuman power of the ruler. For some 4,600 years the Sphinx has defied encroaching desert sands and other assaults of nature; today it also must withstand the human-made sprawl of urban Cairo and the impact of air pollution. The Sphinx, in its majesty, symbolizes mysterious wisdom and dreams of permanence, of immortality. But is such a monument a work of art? Does it matter that the people who carved the Sphinx—unlike today's independent, individualistic artists—followed time-honored, formulaic conventions and the precise instructions of their priests? No matter how viewers of the time may have labeled it, today most people would answer, "Certainly it is art. Human imagination conceived this amazing creature, and human skill gave material form to the concept of man-lion. Using imagination and skill to create huge, simplified shapes, the creators have defined the idea of awesome grandeur and have created a work of art." *But what is art?*

WHAT IS ART?

The answer to the seemingly simple question is in fact multifaceted. Common definitions of art usually refer to the product of some combination of skill, training, and observation. But the definition of art also depends upon what is created, when it was created, how it was created, the intention of the creator and the anticipated "role" of the creation, perhaps who commissioned it, and certainly the response of the viewer—both at the historical time it was created and today. It is the role of art history, which we'll look at in more detail below, to help us with these complexities.

When we become captivated by the mysteriousness of a creation such as the Sphinx, art history can help us understand its striking imagery and meaning; the artwork's total cultural context—that is, the social, economic, and political situation of the historical period in which it was produced; the belief systems, rituals, and myths (the philosophy and religion) of the time; the relationships to other arts (music, drama, literature, dance); the technology making the art possible. Art history, unlike other humanistic studies, remains grounded in material objects that are the tangible expression of the ideas and ideals—of a culture. Thus, art history is distinctive because it puts the primary focus on the art object even as it explores the context of its culture, because art does not simply reflect history but also participates in it. Art historians know, for example, that someone had to learn to read Egyptian hieroglyphs to tell us that we are looking at the face of a king on the Sphinx. By studying the translations of these hieroglyphs, they could study the historical period in which it was made and learn about the king's earthly power, the culture's belief in an afterlife, and the overwhelming cultural importance of ceremony—all defined and expressed by the monumental Sphinx.

Works of exceptional physical beauty—however *beauty* may be defined—can speak to us over great expanses of time and space, but the study of art history can greatly enhance our experience of art by helping us to formulate the kinds of questions that enable us to appreciate for ourselves the material culture of our own and other times. But while grappling with the question of what art is, we are inevitably drawn into another question whose answer is almost always culturally specific: *What is beauty?*

WHAT IS BEAUTY?

Historically, beauty has quite literally been "in the eye of the beholder." Beauty has been expressed in a variety of **styles**, or manners of representation. Some times and places have valued as beautiful styles of art that are realistic, or **naturalistic**—art that has a surface reality because the artists appear to have recorded, with greater or lesser accuracy, exactly what they saw. Naturalism and **abstraction**—the transformation of visible forms into patterns that suggest the original—are opposite approaches to representing beauty. In abstraction through **idealization**, for example, artists represent beauty not as it is but as they think it *should* be. So what is beauty? Different cultures have defined it as something that brings pleasure to the senses or to the mind or to the spirit, and the way that

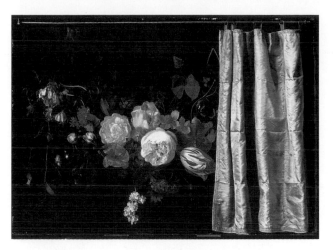

2. Adriaen van der Spelt and Frans van Mieris. *Flower Piece with Curtain*. 1658. Oil on panel, 18¼ x 25¼" (46.5 x 64 cm). The Art Institute of Chicago
Wirt D. Walker Fund

various peoples have represented beauty can tell us a great deal about their cultures and values.

NATURE OR ART?

Beauty can be expressed in many ways—in the natural beauty of huge old trees or in the created beauty of a painting of those trees (see fig. 28, "The Object Speaks: *Large Plane Trees*"). In the ancient world, the Greek philosopher Aristotle (384–322 BCE) evaluated works of art on the basis of *mimesis* ("imitation"), that is, how faithfully artists recorded what they saw in the natural world. But we need to be aware that when artists working in a naturalistic style make images that seem like untouched snapshots of actual objects, their skill can also render lifelike such fictions as a unicorn or the Wicked Witch of the West—or a being with the body of a lion and the head of a king.

Like many people today, ancient Greeks enjoyed the work of especially skillful naturalistic artists (the Greek word for art, *tckne*, is the source of the English word *technique*; the word *art* comes from the Latin word *ars*, or "skill"). Their admiration for naturalistic depiction is illustrated in a famous story about a competition between rival Greek painters named Zeuxis and Parrhasios in the late fifth century BCE. Zeuxis painted a picture of grapes so accurately that birds flew down to peck at them. Then Parrhasios took his turn, and when Zeuxis asked his rival to remove the curtain hanging over the picture, Parrhasios gleefully pointed out that the curtain was his painting. Zeuxis agreed that Parrhasios won the competition since he, Zeuxis, had fooled only birds but Parrhasios had tricked an intelligent fellow artist.

In the seventeenth century, painter Adriaen van der Spelt (1630–73) and his artist friend Frans van Mieris (1635–81), paid homage to the story of Parrhasios's curtain with their painting of blue satin drapery drawn aside to show a garland of flowers (fig. 2). More than a tour-de-force of eye-fooling naturalism, the work is an

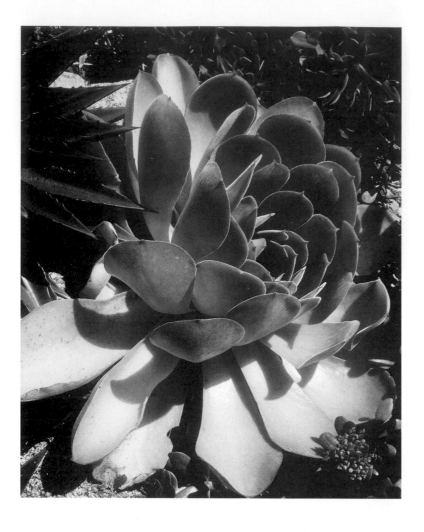

3. **Edward Weston.** *Succulent*. 1930. Gelatin silver print, 7¹/₂ x 9¹/₂" (19.1 x 24 cm). Collection Center for Creative Photography, The University of Arizona, Tucson
© 1981 Center for Creative Photography, Arizona Board of Regents

intellectual delight. The artists not only re-created Parrhasios's curtain illusion but also included a reference to another Greek legend, which was popular in the fourth century BCE, that told of Pausias, who painted the exquisite floral garlands made by a young woman, Glykera. This second story raises the troubling and possibly unanswerable question of who was the true artist—the painter who copied nature in his art or the garland maker who made works of art out of nature. The seventeenth-century patrons—the people who bought such paintings—knew those stories and appreciated the artists' classical references as well as their skill in drawing and manipulating colors on canvas.

The flower garland also symbolizes the passage of time and the fleeting quality of human riches. The brilliant red and white tulip, the most desirable and expensive flower of the time—symbolizes wealth and power. Yet insects creep out of it, and a butterfly—fragile and transitory—hovers above the flower. Today, after studying the painting in its cultural context, we, too, understand that it is much more than a simple flower piece, the type of still life with flowers popular in the Netherlands in van der Spelt's and Mieris's time.

Just as Dutch flower pieces were ideal expressions of naturalism then, so today modern photography seems like a perfect medium for expressing the natural beauty of plants, especially when they are selected and captured at perfect moments in their life cycles. In his photograph *Succulents*, Edward Weston (1886–1958) did just that by using straightforward camera work, without manipulating the film in the darkroom (fig. 3). Aristotle might have appreciated this example of *mimesis*, but Weston did more than accurately portray his subject; he made photography an **expressionistic** medium by perfecting the close-up view to evoke an emotional response. He argued that although the camera sees more than the human eye, the quality of the image depends not on the camera, but on the choices made by the photographer-artist.

Many people even today think that naturalism represents the highest accomplishment in art. But not everyone agrees. First to argue persuasively that observation alone produced "mere likeness" was the Italian master Leonardo da Vinci (1452–1519), who said that the painter who copied the external forms of nature was acting only as a mirror. He believed that the true artist should engage in intellectual activity of a higher order and attempt to capture the inner life—the energy and power—of a subject. In the twentieth century, Georgia

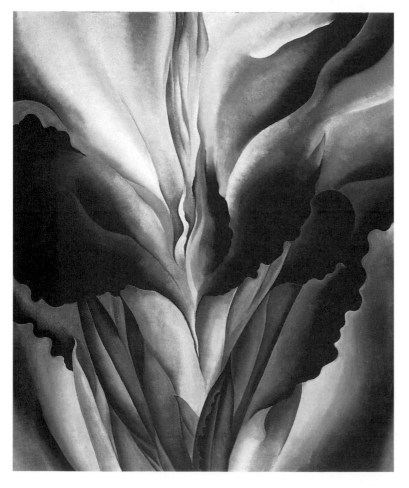

4. **Georgia O'Keeffe.** *Red Canna*. 1924. Oil on canvas mounted on Masonite, 36 x 29⁷/₈" (91.44 x 75.88 cm). The University of Arizona Museum of Art, Tucson

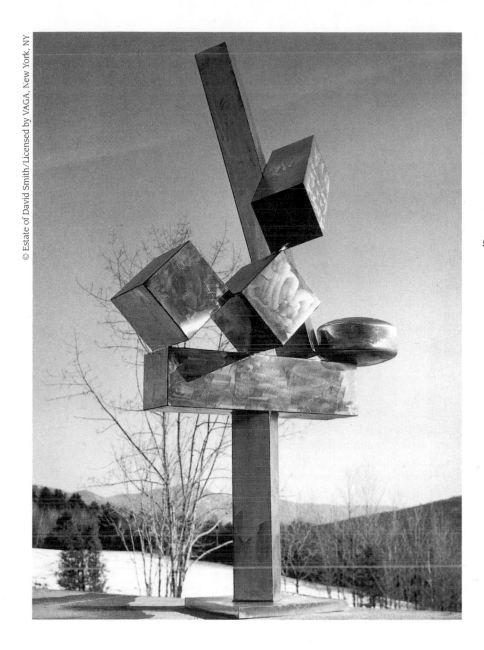

© Estate of David Smith/Licensed by VAGA, New York, NY

5. David Smith.
Cubi XIX.
1964. Stainless
steel, 9'5³⁄₈" x
1'9³⁄₄" x 1'8"
(2.88 x 0.55 x
0.51 m). Tate
Gallery, London

O'Keeffe (1887–1986), like van der Spelt and Weston, studied living plants; however, when she painted the canna lily she, like Leonardo, sought to capture the flower's essence (fig. 4). By painting the canna lily's organic energy, she created a new abstract beauty, conveying in paint the pure vigor of its life force.

Furthest of all from naturalism or the Greek concept of *mimesis* are the pure geometric creations of polished stainless steel made by David Smith (1906–65). His *Cubi* works, such as the sculpture in figure 5, are usually called **nonrepresentational** art—art so abstract that it does not represent the natural world. With works like *Cubis*, it is important to distinguish between subject matter and content, or meaning. Abstract art has both subject matter and meaning. Nonrepresentational art does not have subject matter but it does have meaning, which is a product of the interaction between the artist's intention and the viewer's interpretation. Some viewers may see *Cubis* as giant excrescences, for example, mechanistic plants sprung from the core of an unyielding earth, a reflection of today's mechanistic society that challenges the natural forms of trees and hills. Because meaning can change

over time, one goal of contextual art history, which this book exemplifies, is to identify the factors that produce a work, to determine what it probably meant for the artist and the original audience, and to acknowledge that no interpretation is definitive: Again, such visions are in the "eye of the beholder."

THE IDEA OF THE IDEAL

In contrast to Aristotle, an earlier Greek philosopher, Plato (428–348/7 BCE), had looked beyond nature for a definition of art. In his view even the greatest work of art was only a shadow of the material world, several times removed from reality. Physical beauty for Plato's followers depended on the harmony created by symmetry and proportion, on a rational, even mathematical, view of the world. The contemplation of such ideal physical beauty eventually leads the viewer to a new kind of artistic truth to be found in the realm of pure idea. Let us take a simple example from architecture: the carving at the top of a column called the capital. A popular type, known as Corinthian order, which first began to appear in ancient

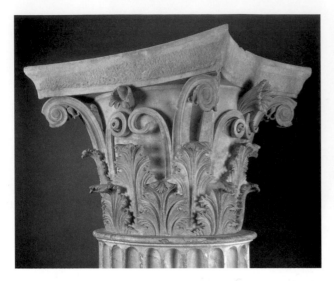

6. Corinthian capital from the *tholos* at Epidaurus.
c. 350 BCE. Archaeological Museum, Epidaurus, Greece

Greece about 450 BCE, has an inverted bell shape surrounded by acanthus leaves (fig. 6). Although inspired by the appearance of natural vegetation, the sculptors who carved the leaves have eliminated blemishes and arranged the leaves symmetrically. In short, they have created ideal leaves by first looking at nature and then carving the essence of the form, the Platonic ideal of foliage. No insect has ever nibbled at such a timelessly perfect, ideal leaf.

To achieve Plato's ideal images and represent things "as they ought to be" in a triumph of human reason over nature, the sculptors eliminated all irregularities and instead sought perfect balance and harmony. The term *classical*, which refers to both the period in ancient Greek history when this type of idealism emerged and to the art of ancient Greece and Rome in general, has come to be used broadly as a synonym for the peak of perfection in any period. Classical sculpture and painting established ideals that have inspired Western art ever since.

For all recorded times and in most places, one of the subjects artists have frequently chosen to express the sense of beauty is woman. We can see how the different concepts of art and beauty we have mentioned play out by comparing the way that three different arts, in three different ages and parts of the world, have depicted women.

BEAUTIFUL WOMEN

Classical idealism pervades the image of Venus, goddess of love, even in a Roman copy of a Greek statue like the *Medici Venus* (fig. 7). Clearly the artist had the skill to represent a woman as she actually appeared but instead chose to generalize her form and adhere to the classical canon (rule) of proportions. In so doing, the sculptor has created a universal image, an ideal woman rather than a specific woman.

Very different from the classical ideal is the abstract vision of woman seen in a woodblock print by Japanese artist Kitagawa Utamaro (1753–1806). His *Woman*

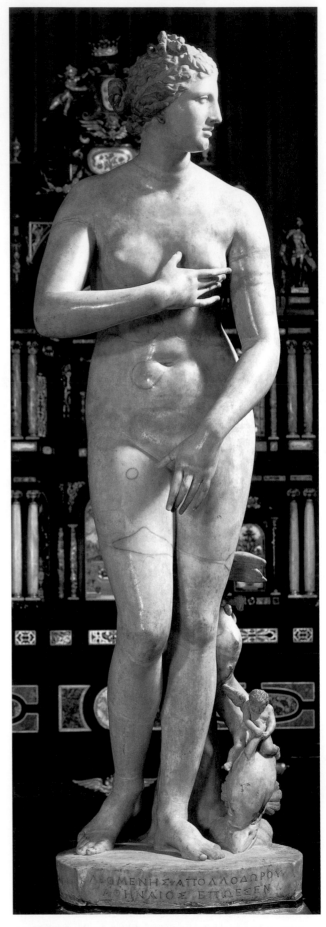

7. *Medici Venus*. Roman copy of a 1st century BCE Greek statue. Marble, height 5' (1.53 m) without base. Galleria degli Uffizi, Florence, Italy

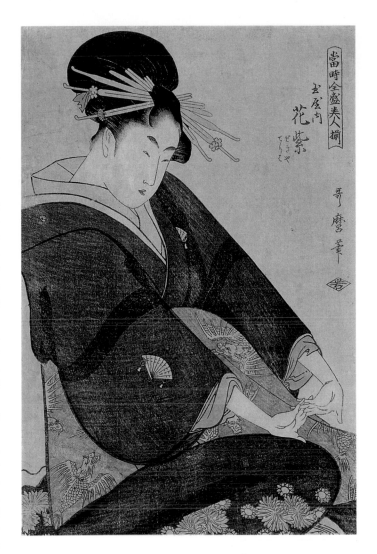

8. **Kitagawa Utamaro. *Woman at the Height of Her Beauty*.** Mid-1790s. Color woodblock print, 15 1/8 x 10" (38.5 x 25.5 cm). Spencer Museum of Art, The University of Kansas, Lawrence
William Bridges Thayer Memorial

at the Height of Her Beauty (fig. 8) reflects a complex society regulated by convention and ritual in its stylization. Simplified shapes suggest underlying human forms, although the woman's dress and hairstyle defy the laws of nature. Rich textiles turn her body into an abstract pattern, and pins hold her hair in elaborate shapes. Utamaro rendered the decorative silks and carved pins meticulously, but he depicted the woman's face with a few sweeping lines. The elaboration of surface detail combined with an effort to capture the essence of form is characteristic of abstract art of Utamaro's time and place.

How different from either of these ideas of physical beauty can be the perception and representation of spiritual beauty. A fifteenth-century bronze sculpture from India represents Punitavati, a beautiful and generous woman who was deeply devoted to the Hindu god Shiva. Abandoned by her miserly husband because she gave food to beggars, Punitavati offered her beauty to Shiva. Shiva accepted her offering and, in taking her loveliness, turned her into an emaciated, fanged hag (fig. 9). According to legend, Punitavati, with clanging cymbals, provides the music for Shiva as he keeps the universe in motion by dancing the cosmic dance of destruction and creation. The bronze sculpture, although it depicts Punitavati's hideous appearance realistically, is beautiful both in its formal qualities as a work of art and in its message of generosity and sacrifice.

BEAUTY IN ARCHITECTURE

The ways that artists depict beauty in their representations of nature and human beings may seem obvious. But how does an artist represent beauty in architecture?

For thousands of years, people have sought to build what they hoped would be magnificent and permanent structures—buildings such as the Cathedral of the Apostle James in Santiago de Compostela, Spain. In the twelfth century, the author of a guidebook for pilgrims going to the shrine of the saint described the perfection of the building: its fine construction, spaciousness, and proportions ("In the church there is indeed not a single crack, nor any damage to be found; it is wonderfully built, large, spacious, well-lighted; of fitting size, harmonious in width, length, and height; held to be admirable and beautiful in execution"); its form ("And furthermore

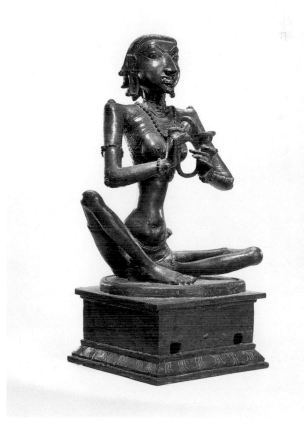

9. ***Punitavati (Karaikkalammaiyar)*,** Shiva saint, from Karaikka, India. 15th century. Bronze, height 16 1/4" (41.3 cm). The Nelson-Atkins Museum of Art, Kansas City, Missouri
Purchase: Nelson Trust (33-533)

it is built with two stories like a royal palace"); and its effect on visitors ("For he who visits the galleries, if sad when he ascends, once he has seen the preeminent beauty of this temple, rejoices and is filled with gladness"). After nearly a thousand years, the building continues to shelter and dignify the rituals of the Christian religion and to affirm the ancient guidebook's evaluation of its beauty—its ability to bring pleasure to the senses, mind, and spirit (fig. 10).

WHY DO WE NEED ART?

The person who wrote of a building bringing gladness to the viewer reminds us of the importance of beauty in human life. Biologists account for the human desire for art in other terms. They explain that human beings have very large brains that demand stimulation. Curious, active, and inventive, we humans constantly explore, and in so doing invent things that appeal to our senses—fine arts, fine food, fine scents, and fine music. So far, we have mostly considered art in terms of seeking beauty, but there are other reasons deeply rooted in the human experience that create needs for art. For one, humans also speculate on the nature of things and the meaning of life. Visually and verbally, we constantly communicate with each other; in our need to understand and our need to communicate, the arts serve a vital function.

ART AND THE SEARCH FOR MEANING

Throughout history, art has played an important part in our search for the meaning of the human experience. In an effort to understand the world and our place in it, people create rituals that they believe will provide links with unseen powers and also with the past and the future. Believers employ special apparatus in their rituals, such as candles, incense, statues, masks, and various containers. But these utensils are works of art in the eyes of outsiders who do not know—or care—about their intended use and original significance.

Rituals are part of all belief systems, including religions such as Christianity. For Catholic Christians, a complex rite enacted at a consecrated altar changes ordinary wine into the blood of Christ; for Protestants, the wine remains the symbol of that blood; but for both, communication between God and humans becomes possible through the ritual enactment of Jesus' Last Supper with his friends and disciples. The chalice, the vessel for the sacramental wine, plays a central role and today is usually seen as a ritual object. But if a chalice is taken from its place on the altar and set in a different context, it may just as well be viewed purely as a work of art.

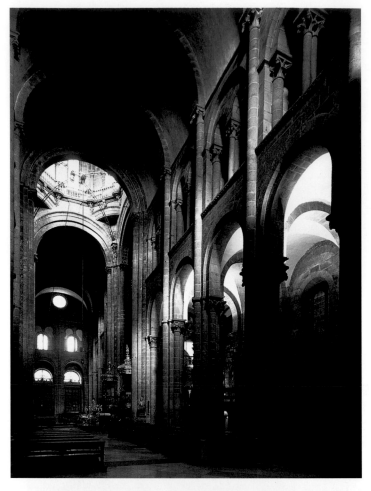

10. Cathedral of the Apostle James, Santiago de Compostela, Spain. 1078–1122. View toward the crossing.
Achim Bednorz, Cologne

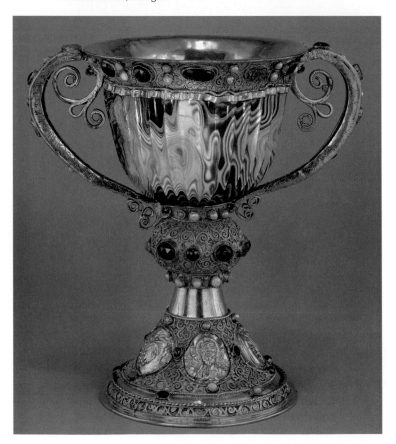

11. Chalice of Abbot Suger, from Abbey Church of Saint-Denis, France. Composite of elements from Ptolemaic Egypt (2nd–1st century BCE) and 12th-century France. 1137–40. Cup: sardonyx; mounts: silver gilt, adorned with filigree, semiprecious stones, pearls, glass insets, and opaque white glass. 7½ x 4¼" (19 x 10.8 cm). National Gallery of Art, Washington, D.C.

Much of the art that moves us most deeply today was originally created as an expression of spiritual experience and an object of devotion. Consider, for example, the so-called *Chalice of Abbot Suger* (fig. 11). In twelfth-century France, Abbot Suger, head of the monastery dedicated to Saint Denis near Paris, found an ancient vase in the storage chests of the abbey. He ordered his goldsmiths to add a foot, a rim, and handles as well as semiprecious stones and medallions to the vase, turning it into a chalice to be used at the altar of the church that was the birthplace of Gothic architecture. Today Suger's chalice no longer functions in the liturgy of the Mass. It has taken on a new secular life, enshrined as a precious work of art in a museum. Instead of linking the congregation with God, now it links the modern viewer with the past, the Middle Ages of some 850 years ago.

Profoundly stirring religious art continues to be made, however. James Hampton's *Throne of the Third Heaven of the Nations' Millennium General Assembly* (fig. 12) is such a work, called by the art critic Robert Hughes the "finest piece of visionary art produced by an American." Hampton (1909–64) worked as a janitor to support himself while, in a rented garage, he built this monument to his faith. In rising tiers, thrones and altars have been prepared for Jesus and Moses, with references to the New Testament on the right and to the Old Testament on the left. Hampton labeled and described everything, even inventing his own language to express his visions. On one of many placards he wrote his credo: "Where there is no vision, the people perish" (Proverbs 29:18). Yet he made this fabulous assemblage out of discarded furniture, flashbulbs, Kraft paper, and all sorts of refuse tacked together and wrapped in gold and silver aluminum foil and purple tissue paper. How can such worthless materials be turned into such an exalted work of art? Today we recognize that the genius of the artist transcends any material.

Works of art from many cultures may speak to us across the vastness of time and space. The Yoruba people of Africa, like people in other times and places, have used art objects to communicate with their gods (fig. 13). This sculpture, carved by the Yoruba master Olowe of Ise (d. 1938), may seem to be just a woman with a child on her back holding an ornate covered cup, but like Suger's chalice, this cup has an importance not immediately apparent to the outsider. It is a divination bowl, made to hold the objects used in ceremonies in which people call on the god Olodumare (or Olorun) to reveal their destiny. The child suggests the life-giving power of women and the idea that all creation rests on women's energy. Men and women help the woman support the bowl, and more women link arms in a ritual dance on the cover. The richly decorative and symbolic wood carving, even when isolated in a museum case, reminds us of those people seeking to learn from Olodumare, the god of destiny, certainty, and order.

Like the divination bowl, many of the expressions that we regard as art were originally meant for other purposes; some were intended to achieve social, political, and educational ends.

12. James Hampton. *Throne of the Third Heaven of the Nations' Millennium General Assembly.* c. 1950–64. Gold and silver aluminum foil, colored Kraft paper, and plastic sheets over wood, paperboard, and glass, 10'6" x 27' x 14'6" (3.2 x 8.23 x 4.42 m). National Museum of American Art, Smithsonian Institution, Washington, D.C.

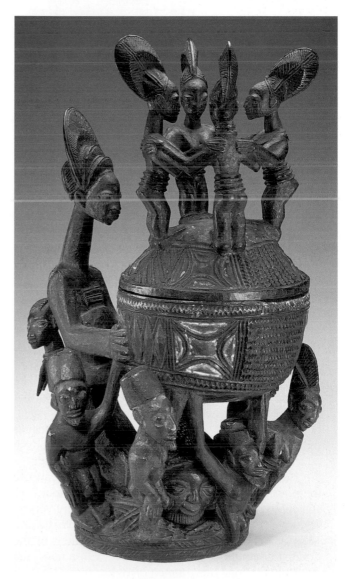

13. Olowe of Ise. Divination bowl. c. 1925. Wood and pigment, diameter 25 1/16" (63.7 cm). National Museum of African Art, Smithsonian Institution, Washington, D.C. Bequest of William A. McCarty-Cooper, 91-10-1

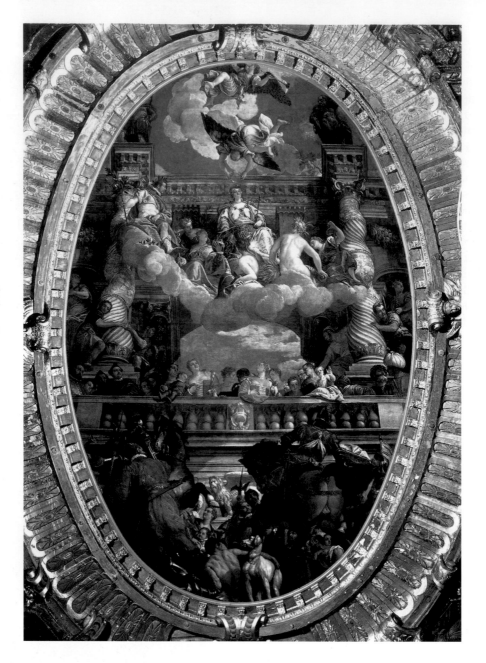

14. **Veronese. *The Triumph of Venice***, fresco in the Council Chamber, Palazzo Ducale, Venice, Italy

ART AND THE SOCIAL CONTEXT

The visual arts are among the most sophisticated forms of human communication, at once shaping and being shaped by their social context. Artists may unconsciously interpret their times, but they may also be enlisted to consciously serve social ends in ways that range from heavy-handed propaganda to subtle suggestion. From ancient Egyptian priests to elected officials today, religious and political leaders have understood the educational and motivational value of the visual arts.

How governments—that is, civic leaders—can use the power of art to strengthen the unity that nourishes society was well illustrated in sixteenth-century Venice. There, city officials ordered Veronese (Paolo Caliari, 1528–88) and his assistants to fill the ceiling of the Council Chamber in the ruler's palace with a huge and colorful painting, *The Triumph of Venice* (fig. 14). Their contract with the artist survives, proclaiming their intention. They wanted a painting that showed their beloved Venice surrounded by peace, abundance, fame, happiness, honor, security, and freedom—all in vivid colors

and idealized forms. Veronese complied by painting the city personified as a mature, beautiful, and splendidly robed woman enthroned between the towers of the arsenal, a building where ships were built for worldwide trade, the source of the city's wealth and power. Veronese painted enthusiastic crowds of cheering citizens, while personifications of Fame blow trumpets and Victory crowns Venice with a wreath. Supporting this happy throng, bound prisoners and piles of armor attest to Venetian military power. The Lion of Venice—the symbol of the city and its patron, Saint Mark—oversees the triumph. Veronese has created a splendid propaganda piece as well as a work of art. Although Veronese created his work to serve the purposes of his patron, his artistic vision was as individualistic as that of James Hampton, whose art was purely a form of self-expression.

WHO ARE ARTISTS?

We have focused so far on works of art. But what of the artists who make them? How artists have viewed themselves and been viewed by their contemporaries has changed dramatically over time. In Western art,

artists were first considered artisans or craftspeople. Ancient Greeks and Romans, for example, considered artists to rank among the skilled workers; they admired the creations, but not the creators. People in the Middle Ages went to the opposite extreme and attributed especially fine works of art to angels or to Saint Luke. Artists continued to be seen as craftspeople—admired, often prosperous, but not particularly special—until the Renaissance, when artists such as Leonardo da Vinci proclaimed themselves to be geniuses with singular God-given abilities.

A little after Leonardo's declaration, the Italian painter Il Guercino (Giovanni Francesco Barbieri, 1591–1666) synthesized the idea that saints and angels make art with the concept that human painters have unique gifts. In his painting *Saint Luke Displaying a Painting of the Virgin* (fig. 15), Guercino portrays the evangelist who was regarded as the patron saint of artists because, Christians widely believed, he himself had painted a portrait of the Virgin Mary holding the Christ Child. In Guercino's work, Luke, seated before just such a painting and assisted by an angel, holds his palette and brushes. A book, a quill pen, and an inkpot decorated with a statue of an ox (Saint Luke's symbol) rest on a table, reminders of his status as an evangelist. Guercino seems to say that if Saint Luke is a divinely endowed artist, then surely all other artists share in this special power and status. This image of the artist as an inspired genius has largely continued into the twenty-first century.

Because art is often a communal creation, we sometimes need to use the plural of the word: *artists*. Even after the idea of "specially endowed" creators emerged, numerous artists continued to see themselves, as they had in many historical periods, as craftspeople led by the head of a workshop, and oftentimes artwork continued to be a team effort. In the eighteenth century, for example, Utamaro's color woodblock prints (see fig. 8) were the product of a number of people working together. Utamaro painted pictures for his assistants to transfer to blocks of wood. They carved the lines and areas to be colored, covered the surface with ink or colors, and then transferred the image to paper; nevertheless, Utamaro—as the one who conceived the work—is the "creative center."

The same spirit is evident today in the complex glassworks of American artist Dale Chihuly (b. 1941). His team of artist-craftspeople is skilled in the ancient art of glassmaking, but Chihuly remains the controlling mind and imagination. Once created, many of his multipart pieces are transformed every time they are assembled; they take on a new life in accordance with the will of every owner. The viewer/owner thus becomes part of the creative team. Made in 1990, *Violet Persian Set with Red Lip Wraps* (fig. 16) has twenty separate pieces, and the person who assembles them determines the composition. Artist and patron thus unite in an ever-changing act of creation.

Whether artists work individually or communally, even the most brilliant ones typically spend years in study and apprenticeship. In his painting *The Drawing Lesson*, Dutch artist Jan Steen (1626–79) takes us into an artist's studio where two people—a boy apprentice and a young

15. Il Guercino. *Saint Luke Displaying a Painting of the Virgin*. 1652–53. Oil on canvas, 7'3" x 5'11" (2.21 x 1.81 m). The Nelson-Atkins Museum of Art, Kansas City, Missouri
Purchase (F83-55)

16. Dale Chihuly. *Violet Persian Set with Red Lip Wraps*. 1990. Glass, 26 x 30 x 25" (66 x 76.2 x 63.5 cm). Spencer Museum of Art, The University of Kansas, Lawrence
Peter T. Bohan Acquisition Fund

17. Jan Steen. *The Drawing Lesson*. 1665. Oil on wood, 19³⁄₈ x 16¹⁄₄" (49.3 x 41 cm). The J. Paul Getty Museum, Los Angeles, California

woman—are learning the rudiments of their art. The pupil has been drawing from sculpture and plaster casts because women were not permitted to work from nude models (fig. 17). *The Drawing Lesson* records contemporary educational practice and is a valuable record of an artist's workplace in the seventeenth century.

Even mature artists considered among history's greatest continued to learn from each other. Before Rembrandt van Rijn (1606–69), for example, painted *The Last Supper* (fig. 18), he carefully studied Leonardo da Vinci's late-fifteenth-century painting of the same subject (fig. 19). Since he never went to Italy, Rembrandt could only have known the Italian master's great mural painting from a print. Rembrandt copied the image in hard red chalk, and also made detailed studies. Later he reworked the drawing in a softer chalk, assimilating Leonardo's lessons but revising the composition and the mood of the original. With heavy overdrawing,

18. Rembrandt van Rijn. *The Last Supper*, after Leonardo da Vinci's fresco. Mid-1630s. Drawing in red chalks, 14³⁄₈ x 18³⁄₄" (36.5 x 47.5 cm). The Metropolitan Museum of Art, New York

Robert Lehman Collection, 1975 (1975.1.794)

Rembrandt re-created the scene, shifting Jesus' position and expression. With a few strokes and smudges of chalk, he created a composition that now reflected the Baroque style of his time: Classical symmetry has given way to asymmetry; shadows loom; highly expressive figures fill a compressed space. The drawing is more than an academic exercise; it is a sincere tribute from one great master to another. Rembrandt must have been pleased with his version of Leonardo's masterpiece because he signed his drawing boldly in the right-hand corner.

WHAT IS A PATRON?

As we have seen, the person or group who commissions or supports a work of art—the patron—can have significant impact on it. The Sphinx (see fig. 1) was "designed" by the conventions of priests in ancient Egypt; the content of Veronese's *Triumph of Venice* (see fig. 14) was determined by that city's government; Chihuly's glassworks (see fig. 16) are assembled according to the collector's specifications, desires, wishes, or whims. Although some artists work independently, hoping to sell their work on the open market, throughout art history both individuals and institutions have acted as patrons of the arts. Patrons very often have been essential factors in the development of arts, but all too often have been overlooked when we study the history of art. Today, not only individuals but also museums, other institutions, and national governments (for example, the United States, through the National Endowment for the Arts) provide support for the arts.

INDIVIDUAL PATRONS

People who are not artists often want to be involved with art, and patrons of art constitute a very special audience for artists. Many collectors truly love works of art, but some who collect art do so to enhance their own prestige, creating for themselves an aura of power and importance. Patrons vicariously participate in the creation of a work when they provide economic support to the artist. Such individual patronage can spring from a cordial relationship between a patron and an artist, as is evident in an early-fifteenth-century manuscript illustration in which the author, Christine de Pisan, presents her work to Isabeau, the Queen of France. Christine, a widow who supported her family by writing, hired painters and

19. Leonardo. *The Last Supper*, wall painting in the refectory, Monastery of Santa Maria delle Grazie, Milan, Italy 1495–98. Tempera and oil on plaster, 15'2" x 28'10" (4.6 x 8.8 m)

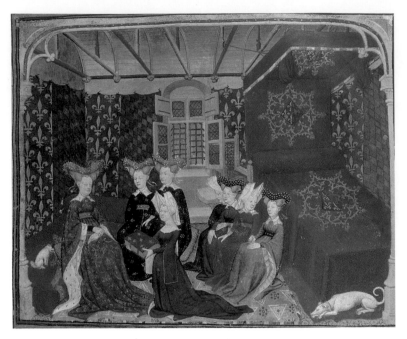

20. *Christine Presenting Her Book to the Queen of France*. 1410–15. Tempera and gold on vellum, image approx. 5½ x 6¾" (14 x 17 cm). The British Library, London.

MS. Hartley 4431, folio 3

21. James McNeill Whistler. *Harmony in Blue and Gold*. The Peacock Room, northeast corner, from a house owned by Frederick Leyland, London. 1876–77. Oil paint and metal leaf on canvas, leather, and wood, 13'11⅞" x 33'2" x 19'11½" (4.26 x 10.11 x 6.83 m). Freer Gallery of Art, Smithsonian Institution, Washington, D.C. (04.61)

scribes to copy, illustrate, and decorate her books. She especially admired the painting of a woman named Anastaise, whose work she considered unsurpassed in the city of Paris. Queen Isabeau was Christine's patron; Christine was Anastaise's patron; and all the women seen in the painting were patrons of the brilliant textile workers who supplied the brocades for their gowns, the tapestries for the wall, and the embroideries for the bed (fig. 20).

Relations between artists and patrons do not always prove to be as congenial as Christine portrayed them.

Patrons may change their minds and sometimes fail to pay their bills. Artists may ignore their patron's wishes, to the dismay of everyone. In the late nineteenth century, the Liverpool shipping magnate Frederick Leyland asked James McNeill Whistler (1834–1903), an American painter living in London, what color to paint the shutters in the dining room where he planned to hang Whistler's painting *The Princess from the Land of Porcelain*. The room had been decorated with expensive embossed and gilded leather and finely crafted shelves to show off Leyland's blue-and-white porcelain. Whistler, inspired by the Japanese theme of his own painting as well as by the Asian porcelain, painted the window shutters with splendid turquoise, blue, and gold peacocks. But he did not stop there: While Leland was away, Whistler painted the entire room, covering the gilded leather on the walls with turquoise peacock feathers (fig. 21). Leyland was shocked and angry at what seemed to him to be wanton destruction of the room. Luckily, he did not destroy Whistler's "Peacock Room" (which Whistler called simply *Harmony in Blue and Gold*), for it is an extraordinary example of total interior design.

INSTITUTIONAL PATRONAGE: MUSEUMS AND CIVIC BODIES

From the earliest times, people have gathered and preserved precious objects that conveyed the idea of power and prestige. Today both private and public museums are major patrons, collectors, and preservers of art. Curators of such collections acquire works of art for their museums and often assist patrons in obtaining especially fine pieces, although the idea of what is best and what is worth collecting and preserving changes from one generation to another. For example, the collection of abstract and nonrepresentational art formed by members of the Guggenheim family was once considered so radical that few people—and certainly no civic or governmental group—would have considered the art worth collecting at all. Today the collection fills more than one major museum.

Frank Lloyd Wright's Solomon R. Guggenheim Museum (fig. 22), with its snail-like, continuous spiral ramp, is a suitably avant-garde home for the collection in New York City. Sited on Fifth Avenue, beside the public green space of Central Park and surrounded on the other three sides by relentless quadrangles of the city buildings, the Guggenheim Museum challenges and relieves the inhumanity of the modern city. The Guggenheim Foundation recently opened another home for art, in Bilbao, Spain, designed by Frank Gehry, a leader of the twenty-first-century avant-garde in architecture. As both Guggenheim museums show, such structures can do more than house collections; they can be works of art themselves.

Civic sponsorship of art is epitomized by the citizens of fifth-century BCE Athens, a Greek city-state where the people practiced an early form of democracy. Led by the statesman and general Pericles, the Athenians defeated the Persians, then rebuilt Athens's civic and religious

22. **Frank Lloyd Wright. Solomon R. Guggenheim Museum, New York City**. 1956–59. Aerial view

23. **Lawrence Alma-Tadema. *Pheidias and the Frieze of the Parthenon, Athens***. 1868. Oil on canvas, 29³/₅ x 42¹/₃" (75.3 x 108 cm). Birmingham City Museum and Art Gallery, England
118-23

center, the Acropolis, as a tribute to the goddess Athena and a testament to the glory of Athens. In figure 23, a nineteenth-century British artist, Sir Lawrence Alma-Tadema, conveys the accomplishment of the Athenian architects, sculptors, and painters, who were led by the artist Pheidias. Alma-Tadema imagines the moment when Pheidias showed the sculpted and painted frieze at the top of the wall of the Temple of Athena (the Parthenon) to Pericles and a privileged group of Athenian citizens—his civic sponsors. We can also see civic sponsorship today in the architecture, including the museums, of most modern national capitals and in the wide variety of public monuments around the world.

WHAT IS ART HISTORY TODAY?

Compared to art itself, art history as a field of study is a relatively recent phenomenon; many art historians consider the first art history book to be the 1550 publication *Lives of the Most Excellent Italian Architects, Painters and Sculptors*, by the Italian artist and writer Giorgio Vasari. As the name implies, *art history* combines two very different special studies—the study of an individual work of art outside time and place (formal analysis and even art appreciation) and the study of art in its historical context (the primary approach taken in this book). The scope of art history is immense: It shows how people have represented

their world and how they have expressed their ideas and ideals. As a result, art history today draws on many other disciplines and diverse methodologies.

Art history as a humanistic discipline adds theoretical and contextual studies to the formal analysis of works of art. Art historians draw on biography to learn about artists' lives; social history to understand the economic and political forces shaping artists, their patrons, and their public, and the history of ideas to gain an understanding of the intellectual currents influencing artists' work (see "The Object Speaks: *Large Plane Trees*," page 41). They also study the history of other arts—including music, drama, and literature—to gain a richer sense of the context of the visual arts. Their work results in an understanding of the **iconography** (the narrative and allegorical significance) and the context (social history) of the artwork.

Today art historians study a wider range of artworks than ever before, and many reject the idea of a fixed canon of superior pieces. The distinction between elite fine arts and popular utilitarian arts has become blurred, and the notion that some mediums, techniques, or subjects are better than others has almost disappeared. This is one of the most telling characteristics of art history today, along with the breadth of studies it now encompasses and its changing attitude to challenges such as preservation and restoration.

At the most sophisticated level, the intense study of individual art objects is known as **connoisseurship**. Through years of close contact with and study of the formal qualities that make up various styles in art, the connoisseur learns to recognize authenticity and quality. The connoisseur places an unknown work with related pieces, attributing it to a period, a place, and even to an artist. Today such experts also make use of all the scientific tests available to them, but ultimately they depend on their visual memory and their skills in formal analysis.

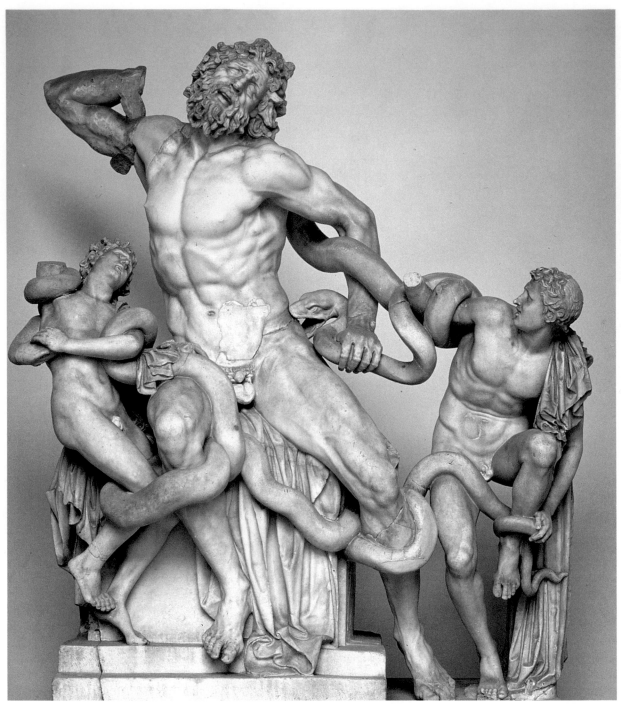

24. Hagesandros, Polydoros, and Athanadoros of Rhodes. *Laocoön and His Sons*, as restored today. Probably the original of 1st century CE or a Roman copy of the 1st century CE. Marble, height 8' (2.44 m). Musei Vaticani, Museo Pio Clementino, Cortile Ottagono, Rome, Italy

Such intense study of the history of art is also enhanced by the work of anthropologists and archaeologists, who study the wide range of material culture produced by a society. Archaeologists often have the excitement of finding new and wonderful objects as they reconstruct the social context of the works. They do not, however, single out individual works of perceived excellence, produced for an elite culture, for special attention.

Even as methodological sophistication and technological advances soar in art history today, art historians and other viewers are faced with some special challenges of interpretation, especially regarding works that have been damaged or restored. As we try to understand such works of art, we must remain quizzical and flexible; damaged artworks may have had large parts replaced—the legs of a marble figure or a section of wall in a mural painting, for example. Many of the works seen in this book have been restored, and many have recently been cleaned. Let's look more closely at some of the challenges those issues pose to art historians today.

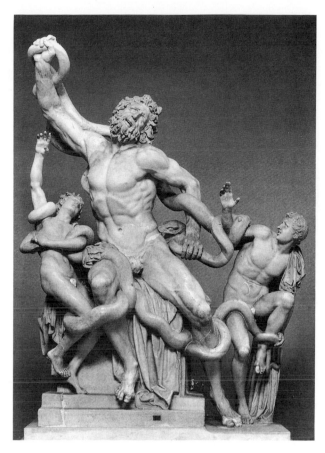

25. Hagesandros, Polydoros, and Athanadoros of Rhodes. *Laocoön and His Sons*, in an earlier restoration

DEFENDING ENDANGERED OBJECTS

Art historians must be concerned with natural and human-caused threats to works of art. In some cases, the threats result from well-meaning actions. The dangers inherent in restoration, for example, are blatantly illustrated by what happened during two restorations, hundreds of years apart, of the renowned sculpture *Laocoön and His Sons*.

Laocoön was a priest who warned the Trojans of an invasion by the Greeks in Homer's account of the Trojan War. Although he told the truth, the goddess Athena, who took the Greeks' side in the war, dispatched serpents to strangle him and his sons. A tragic hero, Laocoön represents a virtuous man destroyed by unjust forces. In the powerful ancient Greek sculpture, his features twist in agony, and the muscles of his and his sons' superhuman torsos and arms extend and knot as they struggle (figs. 24 and 25). When the sculpture was discovered in Rome in 1506, artists such as Michelangelo rushed to see it, and it inspired many artists to develop a heroic style. The pope acquired it for the papal collection, and it can still be seen in the Vatican Museums.

In piecing together the past of this one work, we know that mistakes were made during an early restoration. The broken pieces of the *Laocoön* group first were reassembled with figures flinging their arms out in the melodramatic fashion seen in figure 25—this was the sculpture the Renaissance and Baroque artists knew. Modern conservation methods, however, have produced a different image and with it a changed mood (fig. 24). Arms turn back upon the bodies, making a compact composition that internalizes the men's agony. This version speaks directly to a self-centered twenty-first century. We can only wonder if twenty-fifth-century art historians will re-create yet another *Laocoön*.

Restoration of works like *Laocoön* is intended to conserve precious art. But throughout the world, other human acts intentionally or mindlessly threaten works of art and architecture—and this is not a recent problem. Egyptian tombs were plundered and vandalized many hundreds of years ago—and such theft continues to this day. Objects of cultural and artistic value are being poached from official and unofficial excavation sites around the world, then sold illegally.

In industrialized regions of the world, emissions from cars, trucks, buses, and factories accrue in corrosive rain that damages and sometimes literally destroys the works of art and architecture on which it falls. For art, however, war is by far the most destructive of all human enterprises. History is filled with examples of plundered works of art that, as spoils of war, were taken elsewhere and paraded and protected. But countless numbers of churches, synagogues, mosques, temples, and shrines have been burned, bombed, and stripped of decoration in the name of winning a war or confirming an ideology. So much has been lost—especially in modern times, with weapons of mass destruction—that is absolutely irrecoverable.

Individuals are sometimes moved to deface works of art, but nature itself can be equally capricious: Floods, hurricanes, tornadoes, avalanches, mudslides, and earthquakes all damage and destroy priceless treasures. For example, an earthquake on the morning of September 27, 1997, convulsed the small Italian town of Assisi, where Saint Francis was born and where he founded the Franciscan order. It shook nearly to pieces the thirteenth-century Basilica of Saint Francis of Assisi—one of the richest repositories of Italian Gothic and Early Renaissance wall painting—causing great damage to architecture and paintings.

In all the examples mentioned, art historians have played a role in trying to protect the treasures that are the cultural heritage of us all. But they play another role that also affects our cultural heritage: helping to increase our understanding of the social and political factors that contribute to the artwork's context.

UNCOVERING SOCIOPOLITICAL INTENTIONS

Because art history considers the role and intention of artists, art historians have explored—but not always discovered—whether the sculpture of Laocoön, for example, had a political impact in its own time. As we have seen, artists throughout history have been used to promote the political and educational agendas of powerful patrons, but modern artists are often independent-minded, astute commentators in their own right. Art history needs to

26. **Honoré Daumier.** *Rue Transonain, Le 15 Avril 1834*. Lithograph, 11 x 17³/₈" (28 x 44 cm). Bibliothèque Nationale, Paris

27. **Roger Shimomura.** *Diary* **(Minidoka Series #3)**. 1978. Acrylic on canvas, 4'11⁷/₈" x 6'¹/₁₆" (1.52 x 1.83 m). Spencer Museum of Art, The University of Kansas, Lawrence

look at these motivations too. For example, among Honoré Daumier's most powerful critiques of the French government is his print *Rue Transonain, Le 15 Avril 1834* (fig. 26). During a period of urban unrest, the French National Guard fired on unarmed citizens, killing fourteen people. For his depiction of the massacre, Daumier used lithography—a cheap new means of illustration. He was not thinking in terms of an enduring historical record, but rather of a medium that would enable him to spread his message as widely as possible. Daumier's political commentary created such horror and revulsion that the government ordered all copies of the print to be gathered up and destroyed. As this example shows, art historians need to consider not just the historical context but also the political content and the medium of a work of art to have a complete understanding of it.

Another, more recent, work with a powerful sociopolitical message is a reminder to those of us in the twenty-first century who may not know or may have forgotten that American citizens of Japanese ancestry were removed from their homes and confined in internment camps during World War II. Roger Shimomura (b. 1939) in 1978 painted *Diary*, recalling his grandmother's record of the family's experience in one such camp in Idaho (fig. 27). Shimomura has painted his grandmother writing in her diary, while he (the toddler) and his mother stand by an open door—a door that does not signify freedom but opens on to a field bounded by barbed wire. In this painting—a commentary on twentieth-century discrimination and injustice—Shimomura combines two formal traditions—the Japanese art of color woodblock prints and American Pop art—to create a personal style that expresses his own dual culture.

Art historians must examine such sociopolitical factors as critical aspects of the historical context of works of art. But what is our responsibility as viewers?

WHAT IS THE VIEWER'S RESPONSIBILITY?

We as viewers enter into an agreement with artists, who in turn make special demands on us. We re-create the works of art for ourselves as we bring to them our own experiences, our intelligence, even our prejudices. Without our participation, artworks are only chunks of stone or painted canvas. But we must also remember that styles change with time and place. From extreme realism at one end of the spectrum to entirely nonrepresentational art at the other—from van der Spelt and van Mieris's *Flower Piece with Curtain* (see fig. 2) to Smith's *Cubi* (see fig. 5)—artists have worked with varying degrees of naturalism, idealism, and abstraction. The challenge for the student of art history is to discover not only how but also why those styles evolved, and ultimately what of significance can be learned from that evolution.

Our involvement with art may be casual or intense, naive or sophisticated. At first we may simply react instinctively to a painting or building or photograph, but this level of "feeling" about art—"I know what I like"—can never be fully satisfying. Because as viewers we participate in the re-creation of a work of art, its meaning changes from individual to individual, from era to era. Once we welcome the arts into our lives, we have a ready source of sustenance and challenge that grows, changes, mellows, and enriches our daily experience. The Starter Kit, which begins on page 18, introduces us to many of the tools of art history, but no matter how much we study or read about art and artists, eventually we return to the contemplation of an original work itself, for art such as Vincent van Gogh's *Large Plane Trees* (fig. 28, "The Object Speaks") is the tangible evidence of the ever-questing human spirit.

THE OBJECT SPEAKS

LARGE PLANE TREES

In Vincent van Gogh's *Large Plane Trees*, huge trees writhe upward from an undulating earth as tiny men labor to repair a street in the southern French town of Saint-Rémy. The painting depicts an ordinary scene in an ordinary little town. Although the canvas is unsigned, stylistic and technical analysis confirms its attribution to the Post-Impressionist master Vincent van Gogh (1853–90). *Large Plane Trees* now hangs in The Cleveland Museum of Art. Museum curators, who study and care for works of art, have analyzed its physical condition and formed opinions about its quality. They have also traced its **provenance** (the history of its ownership) from the time the painting left the artist's studio until the day it entered their collection).

What *Large Plane Trees* says to us depends upon who we are. Art historians and art critics looking at this painting from the perspectives of their own specialties and approaches to the study of art's history can and do see many different meanings. Thus, this art object speaks in various ways.

Some art historians have looked at the work through the prism of the biographical facts of van Gogh's life. At the time he painted *Large Plane Trees*, he was suffering from depression and living in an asylum in Saint-Rémy. His brother, Theo, an art dealer in Paris, supported him and saved Vincent's letters, including two that mention this work. Archival research—study in libraries that have original documents, such as letters—is an essential part of art history.

Art historians steeped in the work of Sigmund Freud (1856–1939)—whose psychoanalytic theory addresses creativity, the unconscious mind, and art as expressions of repressed feelings—will find in this painting images infused with psychoanalytic meaning. The painting, despite its light, bright colors, might seem to suggest something ominous in the uneasy relationship between the looming trees and tiny people.

In contrast to Freud's search into the individual psyche, the political philosopher Karl Marx (1818–83) saw human beings as products of their economic environment. Marxist art critics might see in van Gogh's life and art a reflection of Marx's critique of humanity's over-concern with material values: van Gogh worked early in his life as a lay minister, identified with the underclass, and never achieved material success. This painting might also speak to such art critics of the economic structures that transform an unsalable nineteenth-century painting into a twentieth-century status symbol for the wealthy elite. Similarly, feminist art critics would challenge how the worth of a painting is determined and question the assumption that a painting by van Gogh should bring a higher price than a painting by Georgia O'Keeffe (see fig. 4).

Works of art can also be approached from a purely theoretical point of view. Early in the twentieth century, the Swiss linguist Ferdinand de Saussure (1857–1913) developed Structuralist theory, which defines language as a system of arbitrary signs. Painting, too, can be treated as a language in which the marks of the artist (the lines and colors) replace words. In the 1960s and 1970s, Structuralism evolved into other critical tools to determine what a painting may have to say, such as semiotics (the theory of signs and symbols) and deconstruction.

To the semiologist, *Large Plane Trees* is an arrangement of colored marks on canvas. To decode the message, the critic is not concerned with the artist's meaning or intention but rather with the "signs" van Gogh used. The "correct" interpretation is no longer of interest. Similarly, the deconstructionism of the French philosopher Jacques Derrida (b. 1930) questions all assumptions and frees the viewer from the search for a single, correct interpretation. So many interpretations emerge from the creative interaction between the viewer and the work of art that in the end the artwork is "deconstructed."

Today, critics and art historians have begun to reconsider artworks as tangible objects. Many have turned their attention from pure theory to a contextual or social history of art. Some have even taken up connoisseurship again.

The existence of so many approaches to a work of art may lead us to the conclusion that any idea or opinion is equally valid. But art historians, regardless of their theoretical stance, would argue that the informed mind and eye are absolutely necessary. The creation of works of art remains a uniquely human activity, and knowledge of the history of art is essential if art is to truly speak to us.

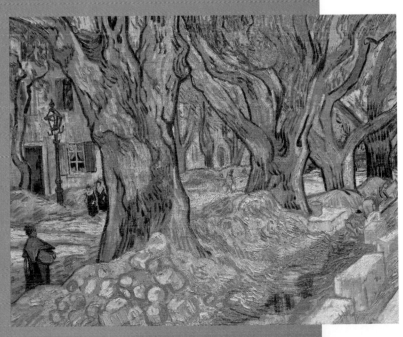

28. Vincent van Gogh. *Large Plane Trees*. 1889. Oil on canvas, 28 x 35 1/8" (73.4 x 91.8 cm). The Cleveland Museum of Art
Gift of the Hanna Fund, 1947.209

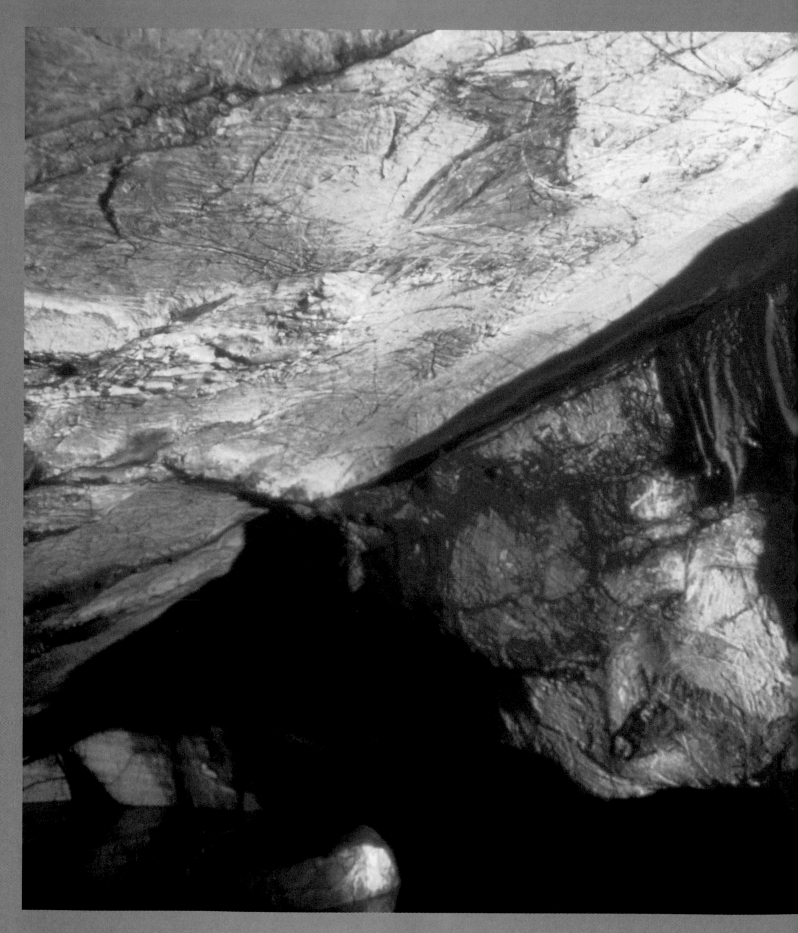

1-1. Wall with horses, Cosquer cave,
Cap Morgiou, France. c. 16,500 BCE.
Charcoal and manganese dioxide on limestone

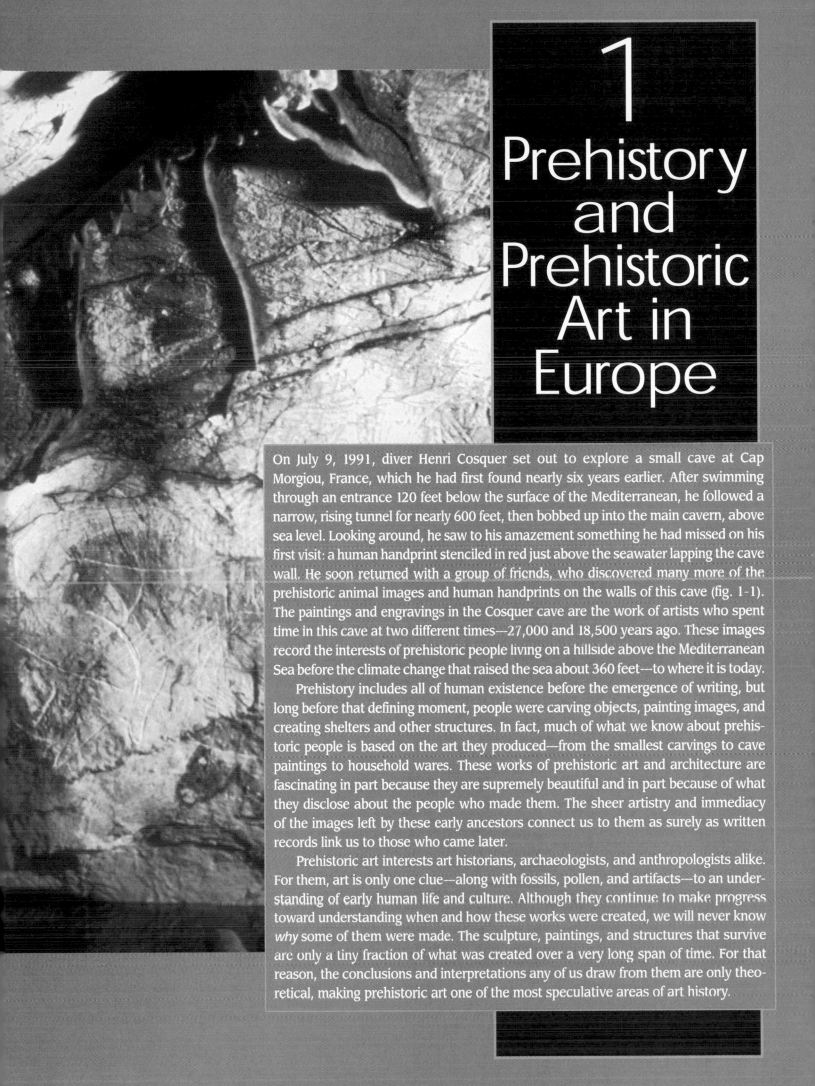

1 Prehistory and Prehistoric Art in Europe

On July 9, 1991, diver Henri Cosquer set out to explore a small cave at Cap Morgiou, France, which he had first found nearly six years earlier. After swimming through an entrance 120 feet below the surface of the Mediterranean, he followed a narrow, rising tunnel for nearly 600 feet, then bobbed up into the main cavern, above sea level. Looking around, he saw to his amazement something he had missed on his first visit: a human handprint stenciled in red just above the seawater lapping the cave wall. He soon returned with a group of friends, who discovered many more of the prehistoric animal images and human handprints on the walls of this cave (fig. 1-1). The paintings and engravings in the Cosquer cave are the work of artists who spent time in this cave at two different times—27,000 and 18,500 years ago. These images record the interests of prehistoric people living on a hillside above the Mediterranean Sea before the climate change that raised the sea about 360 feet—to where it is today.

Prehistory includes all of human existence before the emergence of writing, but long before that defining moment, people were carving objects, painting images, and creating shelters and other structures. In fact, much of what we know about prehistoric people is based on the art they produced—from the smallest carvings to cave paintings to household wares. These works of prehistoric art and architecture are fascinating in part because they are supremely beautiful and in part because of what they disclose about the people who made them. The sheer artistry and immediacy of the images left by these early ancestors connect us to them as surely as written records link us to those who came later.

Prehistoric art interests art historians, archaeologists, and anthropologists alike. For them, art is only one clue—along with fossils, pollen, and artifacts—to an understanding of early human life and culture. Although they continue to make progress toward understanding when and how these works were created, we will never know *why* some of them were made. The sculpture, paintings, and structures that survive are only a tiny fraction of what was created over a very long span of time. For that reason, the conclusions and interpretations any of us draw from them are only theoretical, making prehistoric art one of the most speculative areas of art history.

TIMELINE 1-1. **Prehistoric Periods in Europe.** The Upper Paleolithic lasted until about 8000 BCE and overlapped the Neolithic as the last Ice Age glaciers receded northward. Metals began to be used in southern Europe during the Neolithic; by about 2300 BCE, the Bronze Age had begun in northern Europe, followed in about 1000 BCE by the Iron Age.

MAP 1-1. **Prehistoric Europe.** As the Ice Age glaciers receded, Paleolithic, Neolithic, Bronze Age, and Iron Age settlements increased from south to north.

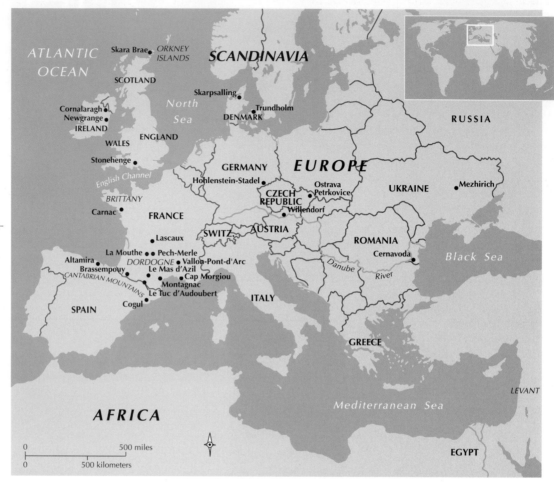

THE PALEOLITHIC PERIOD

Archaeological evidence indicates that the earliest upright human species came into being about 4.4 million years ago in Africa. How and when modern humans evolved is the subject of lively debate, but anthropologists now agree that the hominids called *Homo sapiens* ("wise humans") appeared about 200,000 years ago and that the species to which we belong, *Homo sapiens sapiens*, evolved about 120,000 to 100,000 years ago. Modern humans spread across Asia, into Europe, and finally to Australia and the Americas. The most recently developed dating techniques suggest that this vast movement of people took place between 100,000 and 20,000 years ago. Not only did these early modern humans have the ability to travel great distances, but, as curators in the National Museum of Natural History in Washington, D.C., note, they had "aesthetic spirit and questing intellect." This book presents the tangible record of that uniquely human "aesthetic spirit."

Systematic study of prehistory began only about 200 years ago. Struck by the many stone tools, weapons, and figurines found at ancient living sites, those first scholars named the whole period of early human development the "Stone Age." Today's researchers divide the Stone Age into three major periods: the Paleolithic (from the Greek *paleo-*, "old," and *lithos*, "stone"), the Mesolithic (Greek *meso-*, "middle"), and the Neolithic (Greek *neo-*, "new"). The Paleolithic period is itself divided into three phases, Lower, Middle, and Upper, reflecting their relative position in excavated strata, or layers, with Upper being the most recent.

This chapter presents the prehistoric art of Europe (Map 1-1); later chapters consider the prehistoric art of other continents and cultures. The Upper Paleolithic period in Europe began between 42,000 and 37,000 years ago and lasted until the end of the Ice Age, about 9000–8000 BCE (Timeline 1-1). Much of northern Europe was covered by glaciers in the transitional period between the Upper Paleolithic and Neolithic. This period corresponds to the Mesolithic in other parts of the world. The gradual retreat of the ice between about 11,000 and 8,000 years ago introduced a new stone age, that is, Neolithic culture. Although the precise dates for these periods vary from place to place, the divisions are useful as we examine developments in the arts.

In the Upper Paleolithic period, long before the development of writing, our early ancestors created another

form of communication: the visual arts. Many examples of sculpture, painting, architecture, and other arts have survived the long passage of time to move and challenge us. They may even provide us with insights into the lives and beliefs of their makers. Nevertheless, it is impossible to determine what "art" meant to the people who made it in such early times.

THE BEGINNING OF ARCHITECTURE

People have always found ingenious ways of providing themselves with shelter. Sometimes they occupied the mouth of a cave or fashioned a hut or tent next to a protective cliff. Traditionally, the term *architecture* has been applied to the enclosure of spaces with at least some aesthetic intent, so some people object to its use in connection with prehistoric improvisations. But building even a simple shelter requires a degree of imagination and planning deserving of the name "architecture."

In the Upper Paleolithic period, people in some regions built shelters that were far from simple. Circular or oval huts of light branches and hides might measure as much as 15 to 20 feet in diameter. (Modern tents to accommodate six people vary from 10-by-11-foot ovals to 14-by-7-foot rooms.) Most activities centered around the inside fire pit, or hearth, where food was prepared and tools were fashioned. Larger dwellings might have had more than one hearth and other spaces set aside for different uses—working stone, making clothing, sleeping, and dumping refuse. Some people colored their floors with powdered ocher, a naturally occurring iron ore ranging in color from yellow to red to brown, suggesting a deliberate aesthetic intent.

Remains of Upper Paleolithic dwellings in Russia and Ukraine reveal the ingenuity of people living in those inhospitable northern regions. In the treeless grasslands there, builders created settlements of up to ten houses using the bones of the woolly mammoth, a kind of elephant now extinct (fig. 1-2). One of the best-preserved mammoth-bone villages, discovered in Mezhirich, Ukraine, dates from 16,000–10,000 BCE. Most of its houses were from 13 to 26 feet in diameter, and the largest one, 24 by 33 feet, was cleverly constructed of dozens of mammoth skulls, shoulder blades, pelvic bones, jawbones, and tusks. The long, curving tusks made excellent roof supports and effective arched door openings. The bone framework was probably covered with animal hides and turf. Inside the largest dwelling, archaeologists found fifteen small hearths that still contained ashes and charred bones left by the last occupants.

SCULPTURE

The earliest known works of sculpture are small figures, or figurines, of people and animals and date from as early as 32,000 BCE. Thousands of such figures in bone, ivory, stone, and clay have been found across Europe and Asia. Such self-contained, three-dimensional pieces are examples of

1-2. Reconstruction drawing of mammoth-bone house, from Ukraine. c. 16,000–10,000 BCE

1-3. *Lion-Human*, from Hohlenstein-Stadel, Germany. c. 30,000–26,000 BCE. Mammoth ivory, height 11⅝" (29.6 cm). Ulmer Museum, Ulm, Germany

sculpture in the round. Prehistoric carvers also produced **relief sculpture** in stone, bone, and ivory. In relief sculpture, the surrounding material is carved away to a certain depth, forming a background that sets off the figure.

A human figure carved from mammoth ivory and nearly a foot tall—much larger than most early figurines—was found broken into many pieces at Hohlenstein-Stadel, Germany (fig. 1-3). Astonishingly, the head represents some

1-4. *Woman from Willendorf*, Austria. c. 22,000–21,000 BCE. Limestone, height 4 3/8" (11 cm). Naturhistorisches Museum, Vienna

1-5. *Woman from Ostrava Petrkovice*, Czech Republic. c. 23,000 BCE. Hematite, height 1 3/4" (4.6 cm). Archaeological Institute, Brno

species of cat. Was this lively, powerful figure intended to represent a person wearing a lion mask and taking part in some ritual? Or is this a portrayal of some imagined creature, half human and half beast? One of the few things that can be said with certainty about the *Lion-Human* is that a gifted artist from as long as 30,000 years ago displayed sophisticated thinking to create a creature never seen in nature and considerable technical skill to produce a work that still inspires wonder.

Animals and nude women are the subjects of most small sculpture from the Upper Paleolithic period. The most famous female figure, the *Woman from Willendorf*, Austria (fig. 1-4), dates from about 22,000–21,000 BCE and is only 4 3/8 inches tall. Carved from limestone and originally colored with red ocher, the figure is composed of rounded shapes that convey stability, dignity, and permanence—and incidentally make the work seem much larger than it is. The sculptor carved the stone in a way that conveys the body's fleshiness, exaggerating its female attributes by giving it pendulous breasts, a big belly with deep navel (a natural indentation in the stone), wide hips, and solid thighs. The gender-neutral parts of the body— the face, the arms, the legs—have been reduced to mere vestiges. A pattern signifying hair covers the head.

Another carved figure, found in what is now the Czech Republic, the *Woman from Ostrava Petrkovice*,

presents an entirely different conception of the female form (fig. 1-5). It is less than 2 inches tall and dates from about 23,000 BCE. Archaeologists excavating an oval house stockpiled with flint stone and rough chunks of hematite (the iron oxide ore powdered to make ocher pigment) discovered the figure next to the hearth. Someone at the house had apparently picked up a piece of hematite and shaped it into the figure of a youthful, athletic woman. She stands in an animated pose, with one hip slightly raised and a knee bent as if she were walking.

The hematite woman is so beautiful that one longs to be able to see her face. Perhaps it resembled the one preserved on a fragment from another female figure found in France. This tiny ivory head, known as the *Woman from Brassempouy* (fig. 1-6), dates from about 22,000 BCE. The person who carved it was concerned with those contours necessary to identify the piece as a human head—an egg shape atop a graceful neck, a wide nose, and a strongly defined browline suggesting deep-set eyes. The cap of shoulder-length hair is decorated with a grid pattern perhaps representing curls or braiding, or even a wig or headdress.

This head is an example of **abstraction**: the reduction of shapes and appearances to basic forms that do not faithfully reproduce those of the thing represented. Instead of copying a specific person's face detail by detail, the artist

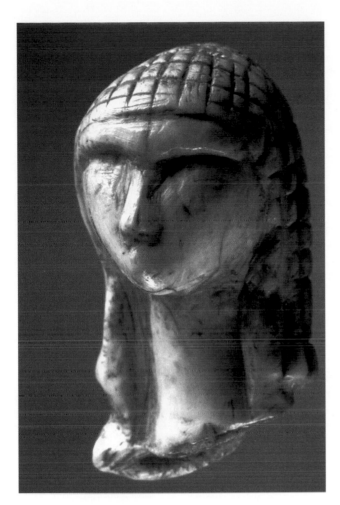

1-6. Woman from Brassempouy, Grotte du Pape, Brassempouy, Landes, France. c. 22,000 BCE. Ivory, height 1¼" (3 cm). Musée des Antiquités Nationales, St.-Germain-en-Laye

provided only those features common to all of us. This is what is known as a **memory image**, an image that relies on the generic shapes and relationships that readily spring to mind at the mention of an object—in this case, the human head. Although it is impossible to know what motivated the artist to carve them in just this way, the simplified planes of

the tiny face from Brassempouy appeal to our twentieth-century taste for abstraction. Intentionally or not, the artist communicates an essential humanity, even isolated from any cultural context, across the millennia.

Because so many of the surviving human figures from the period are female, some scholars have speculated that prehistoric societies were matriarchal, or dominated by women. Others believe that these female figures, many of them visibly pregnant, reflect concerns with perpetuating the cycles of nature and ensuring the continuing life of people, animals, and vegetation and that they could be fertility symbols. Quite likely, the *Woman from Willendorf*, the *Woman from Brassempouy*, and similar Upper Paleolithic figures did have such a function (see "The Power of Naming," below). But they can also be interpreted as representations of actual women, as expressions of ideal beauty, as erotic images, as ancestor figures, or even as dolls meant to help young girls learn women's roles. Given the diversity of ages and physical types represented in sculpture, the figures could have any or all of these meanings.

CAVE ART

Art in Europe entered a rich and sophisticated phase between about 28,000 and 10,000 BCE, when many images were painted on the walls of caves in southern France and northern Spain. The earliest known site of prehistoric cave paintings created during this period in Europe, discovered in December 1994, is the Chauvet cave near Vallon-Pont-d'Arc in southern France—a tantalizing trove of hundreds of animal and bird paintings. The most dramatic of the Chauvet cave images depict grazing, running, or resting animals. Among the animals represented are the wild horse, the bison, the mammoth, the bear, the panther, the owl, deer, aurochs (extinct ancestors of oxen), the woolly-haired rhino, and the wild goat, or ibex (see fig. 1, in the Introduction). Also included are occasional people, both male and female, many handprints, and hundreds of geometric markings such as

THE POWER OF NAMING Words are only symbols for ideas. But the very words we invent—or our ancestors invented—reveal a certain view of the world and can shape our thinking. Early people recognized clearly the power of words. In the Old Testament, God gave Adam dominion over the animals and allowed him to name them (Genesis 2:19–20). Today, we still exert the power of naming when we select a name for a baby, call a friend by a complimentary nickname, or use demeaning words to dehumanize those we dislike.

Our ideas about art can also be affected by names, even the ones used in captions in a book. Before the twentieth century, artists usually did not name, or title, their works. Names were eventually supplied by the works' owners or by scholars writing about them and thus may express the cultural prejudices of the labelers or of the times generally.

An excellent example of such distortion is provided by the names early scholars gave to the hundreds of small prehistoric statues of women they found. They dubbed the first of these to be discovered (see fig. 1-4) the "Venus of Willendorf" after the place where it had been found. Using the name of the Roman goddess of love and beauty sent a message that this figure was associated with religious belief, that it represented an ideal of womanhood,

and that it was one of a long line of images of "classical" feminine beauty. In a short time, most similar works of sculpture from the Upper Paleolithic period came to be known as Venus figures. The name was repeated so often that even scholars began to assume that these *had* to be fertility figures and mother goddesses although there is no absolute proof that people once thought these works had religious significance or supernatural powers.

Our ability to understand and interpret works of art creatively is easily compromised by distracting labels. Calling a prehistoric figure a "woman" instead of "Venus" encourages us to think about it in new and different ways.

THE MEANING OF PREHISTORIC CAVE PAINTINGS

What caused people 30,000 or even 15,000 years ago to paint images on the walls of caves? Anthropologists and art historians have devised several theories to explain prehistoric art, but they often tell us as much about the scholars and their times as they do about the art.

The idea that human beings have an inherent desire to decorate themselves and their surroundings—that an aesthetic sense is somehow innate to the human species—found ready acceptance in the nineteenth century. Some artists promoted the idea of "art for art's sake," and many believed that people created art for the sheer love of beauty. Scientists agree that human beings have an aesthetic impulse and take pleasure in pursuing impractical activities, but the effort required to accomplish the great paintings of Lascaux suggests that their creators were motivated by more than simple pleasure.

Early-twentieth-century scholars rejected the idea of art for art's sake. Led by Salomon Reinach, who believed that art fulfills a social function and that aesthetics are culturally relative, they proposed that prehistoric cave paintings might be products both of *totemistic rites* to strengthen clan bonds and of *increase ceremonies* to enhance the fertility of animals depended on for food. In 1903, Reinach suggested that cave paintings were expressions of "sympathetic magic." Still encountered in many societies, sympathetic magic relies on two assumptions: first, things that look the same can have a physical influence on each other; and second, things once in contact continue to act upon each other even at great distances. In the case of cave paintings, producing a picture of a bison lying down would ensure that hunters found their prey asleep. Ritual killing of the picture of a bison would guarantee the hunters' triumph over the beast itself.

In the early 1920s, Abbé Henri Breuil took these ideas somewhat further and concluded that cave paintings were early forms of religious expression. Convinced that caves were used as places of worship and the settings for initiation rites, he interpreted them as aids in rituals and in instruction.

In the second half of the twentieth century, scholars tended to base their interpretations on rigorous scientific methods and current social theory. French scholars such as André Leroi-Gourhan and Annette Laming-Emperaire dismissed the "hunting magic" theory because debris from human settlements revealed that the animals used most frequently for food were not the ones traditionally portrayed in caves. These scholars discovered that cave images were often systematically organized, with different animals predominating in different areas of a cave. Although they disagreed on details, Leroi-Gourhan and Laming-Emperaire concluded that cave images are meaningful pictures. As Laming-Emperaire put it, the paintings "might be mythical representations . . . they might be the concrete expression of a very ancient metaphysical system . . . they might be religious, depicting supernatural beings. They might be all these at one and the same time . . ." (Annette Laming-Emperaire, *La signification de l'art rupestre paléolithique*, 1962, pages 236–7). She felt certain that horses, bison, and women suggested "calm, peace, harmony," and were "concerned with love and life."

Researchers continue to discover new cave images and correct earlier errors of fact or interpretation. A restudy of the Altamira cave in the 1980s led Leslie G. Freeman to determine that these artists faithfully represented a herd of bison during the mating season. Instead of being dead, asleep, or disabled—as earlier observers had supposed—the bison on the ground were dust wallowing, common behavior hunters might have seen during the breeding season.

Today, rigorous dating techniques have enhanced our ability to place prehistoric artifacts in time (see "How Early Art Is Dated," page 54), and anthropological studies have extended our knowledge of the cultures out of which cave art emerged. But the discovery of paintings at Cap Morgiou reminds us how great a role chance plays in this rapidly changing field.

grids, circles, and dots. Footprints in the Chauvet cave, left in soft clay by a young boy going to a "room" containing bear skulls, are the oldest human footprints ever documented—charcoal found where he stopped to clean his torch has been dated to about 24,000 BCE.

These caves must have had a special meaning, because people returned to them time after time over many generations, in some cases over thousands of years (see "The Meaning of Prehistoric Cave Paintings," above). The prehistoric artists who worked there must have felt that their art would be of some specific benefit to their communities. Perhaps Upper Paleolithic cave art was the product of rituals intended to gain the favor of supernatural forces. If so, its significance may have had less to do with the finished painting than with the very act of creation. The subterranean galleries were not used as living quarters, but artifacts and footprints suggest that they were gathering places. People may have congregated there to celebrate initiation rites or the sealing of social alliances—just as we gather today for baptisms, bar mitzvahs and bat mitzvahs, weddings, funerals, or town meetings.

The paintings of animals in the Cosquer cave at Cap Morgiou (see fig. 1-1) were created about 16,500 BCE, but the earliest of the handprints found there date from long before, as early as 25,000 BCE. In other caves, painters worked not only in large caverns but also far back in the smallest chambers and recesses, many of which are almost inaccessible today. Small stone lamps found in such caves (see fig. 1-13) indicate that they worked in the dim flicker of light from burning animal fat. Occasional small holes have been found carved into a cave's rock walls. These may have been used to anchor the scaffolding needed for painting the cave's high ceilings and walls.

A cave site at Pech-Merle, in France, appears to have been used and abandoned several times over a period of 5,000 years. Images of animals, handprints, and nearly 600 geometric symbols have been found in thirty different parts of the underground complex. The earliest artists to work in the cave, some 18,000 years ago, specialized in painting horses (fig. 1-7). All of their horses have small, finely detailed heads, heavy bodies, massive extended necks, and legs tapering to almost nothing at

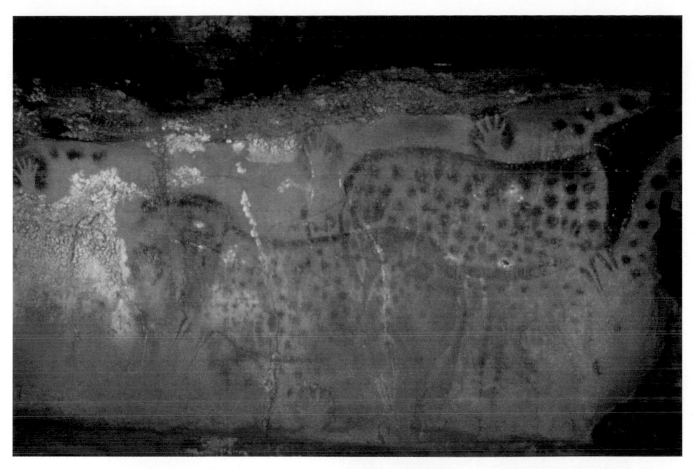

1-7. Spotted Horses and Human Hands, Pech-Merle cave, Dordogne, France. Horses c. 16,000 BCE; hands c. 15,000 BCE. Paint on limestone, length approx. 11'2" (3.4 m)

TECHNIQUE

PREHISTORIC WALL PAINTING

In a dark cave in France, working by the light of a flickering lamp fueled with animal fat, an artist places charcoal in his mouth, chews it, diluting it with saliva and water, then spits it out against the wall, using his hand as a stencil. The artist is Michel Lorblanchet, a cave archaeologist. He is showing us how the original artists at Pech-Merle created their magnificent paintings.

Having successfully reproduced a smaller cave painting of animals before, Lorblanchet turned to the best-known and most complex of the Pech Merle paintings, the one of the spotted horses (see fig. 1-7). He first made a light sketch in charcoal, then painted the horses' outlines using the spitting technique. By turning himself into a human spray can, he produced clear lines on the rough stone surface more easily than he could with a brush. To create the sharpest lines, such as those of the upper hind leg and tail, he simply blew pigment below his hand. He finger-painted the forelegs and the hair on the horses' bellies, and he punched a hole in a piece of leather to make a stencil for the dense, round spots. In some places, he blew a thick pigment through a reed, but in others he applied it with a brush he made by chewing the end of a twig.

Lorblanchet needed thirty-two hours to reproduce the spotted horses. The fact that he could execute such a work in a relatively short time tends to confirm that a single artist—perhaps with an assistant to mix pigments and tend the lamp—created the original. Jean Clottes, who has studied the composition of pigments to date cave painting in France, thinks that pigments used in a given region remained fairly consistent but that the recipe for the medium—the precise mix of saliva, water, and other liquids used to bind them—varied over time and from place to place.

Although we may never know just what these paintings meant to the artists who produced them, the *process* of creating them must have been rich with significance. Lorblanchet puts it quite eloquently: "Human breath, the most profound expression of a human being, literally breathes life onto a cave wall" (*Archaeology*, November–December 1991, page 30).

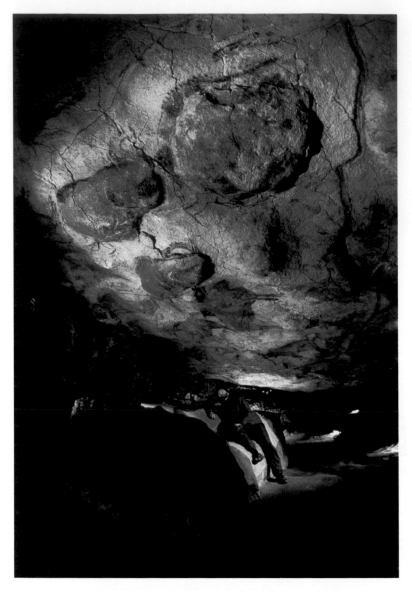

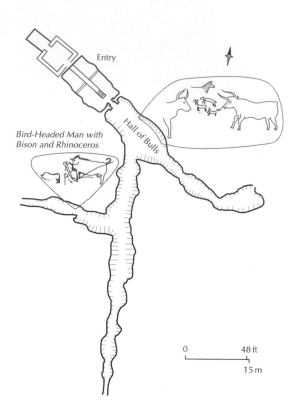

1-9. Plan of Lascaux caves, Dordogne, France

1-8. *Bison*, on the ceiling of a cave at Altamira, Spain.
c. 12,000 BCE. Paint on limestone, length approx.
8'3" (2.5 m)

No one knew of the existence of prehistoric cave painting until one day in 1879, when a young girl exploring with her father on the family estate in Altamira crawled through a small opening in the ground and found herself in a cave chamber whose ceiling was covered with painted animals. Her father searched the rest of the cave, then told authorities about the remarkable find. Few people believed that these amazing works could have been done by "primitive" people, and the scientific community declared the paintings a hoax. They were accepted as authentic only in 1902, after many other cave paintings, drawings, and engravings had been discovered at other spots in northern Spain and in France.

the hooves. The horses were then overlaid with bright red circles. Some interpreters see these circles as ordinary spots on the animals' coats, but others see them as representations of rock weapons hurled at the painted horses in a ritual meant to assure success in the hunt.

The handprints on the walls at Pech-Merle and other cave sites were almost certainly not idle graffiti or accidental smudges but were intended to communicate

something. Some are positive images made by simply coating the hand with color pigment and pressing it against the wall. Others are negative images: the surrounding space rather than the hand shape itself is painted. Negative images were made by placing the hand with fingers spread apart against the wall, then spitting or spraying paint around it with a reed blowpipe—an artist's tool found in such caves (see "Prehistoric Wall Painting," page 49). Most of the handprints are small enough to be those of women or even children, yet footprints preserved in the mud floors at other caves show that they were visited by people of all sizes. A series of giant aurochs at Pech-Merle, painted in simple outlines without color, has been dated to a later period, about 15,000 BCE. Sometime afterward, other figures were created near the mouth of the cave by **incising**, or scratching lines into the walls' surface. Thanks to rapid advances in laboratory analysis techniques, it is only a matter of time until all prehistoric wall paintings can be dated more precisely.

The first cave paintings to be discovered and attributed to the Upper Paleolithic period were those at Altamira, near Santander in the Cantabrian Mountains of northern Spain. Scholars recently dated them to about 12,000 BCE. The Altamira artists created sculptural effects by painting the bodies of their animals over and around natural irregularities in the cave's walls and ceilings. To produce the herd of bison on the ceiling of the main cavern (fig. 1-8), they used rich red and brown ochers to paint the large areas of the animals' shoulders, backs, and

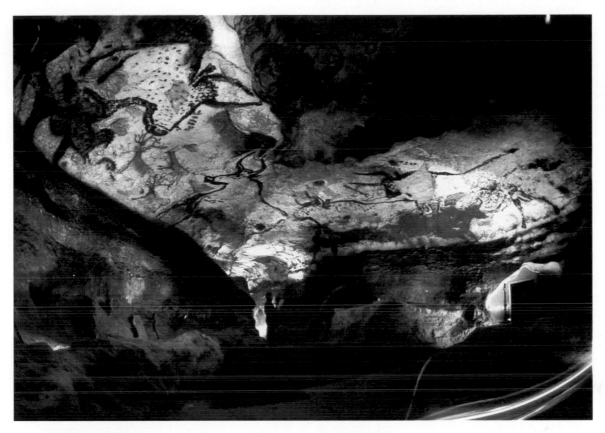

1-10. Hall of Bulls, Lascaux caves. c. 15,000–13,000 BCE. Paint on limestone

Discovered in 1940 and opened to the public after World War II, the prehistoric "museum" at Lascaux soon became one of the most popular tourist sites in France. Too popular, for the many visitors sowed the seeds of the paintings' destruction in the form of heat, humidity, exhaled carbon dioxide, and other insidious contaminants from the outside world. The cave was closed to the public in 1963, so that conservators might battle an aggressive fungus that had attacked the paintings. Eventually they won, but instead of reopening the site, the authorities created a facsimile of it. Visitors at what is called Lascaux II may now view copies of the painted scenes without harming the precious originals.

flanks, then added the details of the legs, tails, heads, and horns in black and brown. They must have observed the bison herd with great care in order to capture the distinctive appearance of the beasts.

The best-known cave paintings are those found in 1940 at Lascaux, in the Dordogne region of southern France, which have been dated to about 15,000–13,000 BCE (fig. 1-9). The Lascaux artists also used the contours of the rock as part of their compositions (fig. 1-10). They painted cows, bulls, horses, and deer along natural ledges, where the smooth, white limestone of the ceiling and upper wall meets a rougher surface below. The animals appear singly, in rows, face to face, tail to tail, and even painted on top of one another. As in other cave paintings, their most characteristic features have been emphasized. Horns, eyes, and hooves are shown as seen from the front, yet heads and bodies are rendered in profile. Even when their poses are exaggerated or distorted, the animals are full of life and energy, and the accuracy in the drawing of their silhouettes, or outlines, is remarkable.

One scene at Lascaux is unusual not only because it includes a human figure but also because it is the only painting in the cave complex that seems to tell a story (fig. 1-11). It was discovered on a wall at the bottom of a

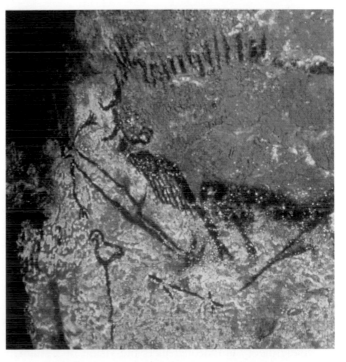

1-11. Bird-Headed Man with Bison and Rhinoceros, Lascaux caves. c. 15,000–13,000 BCE. Paint on limestone, length approx. 9' (2.75 m)

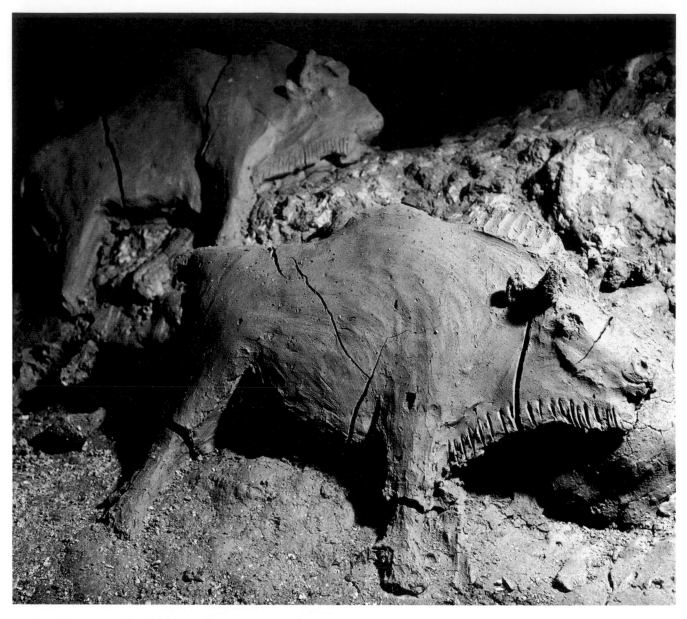

1-12. *Bison*, Le Tuc d'Audoubert, Ariège, France. c. 13,000 BCE. Unbaked clay, length 25" (63.5 cm) and 24" (60.9 cm)

16-foot shaft containing spears and a stone lamp. A figure who could be a hunter, highly stylized but recognizably male and wearing a bird's-head mask, appears to be lying on the ground. A great bison looms above him. Below him lie a staff, or baton, and a spear thrower—a device that allowed hunters to throw farther and with greater force—the outer end of which has been carved in the shape of a bird. The long, diagonal line slanting across the bison's hindquarters is a spear. The bison has been disemboweled and will soon die. To the left of the cleft in the wall is a woolly rhinoceros—possibly the bison's slayer.

What is this scene telling us? Why did the artist portray the man as only a sticklike figure when the bison was rendered with such accurate detail? It may be that the painting illustrates a myth regarding the death of a hero. Perhaps it illustrates an actual event. The most likely theory is that it depicts the vision of a shaman. Shamans were—and still are—people thought to have special powers, an ability to foretell events and assist their people through contact with spirits in the form of

animals or birds. Shamans typically make use of trance states, in which they believe they fly and receive communications from their spirit guides. The images they use to record their visions tend to be abstract, incorporating geometric figures and combinations of human and animal forms such as the bird-headed man in this scene from Lascaux or the lion-headed figure discussed earlier (see fig. 1-3). Some scholars have interpreted the horses with red dots at Pech-Merle as a shamanistic combination of natural and geometric forms.

Caves were sometimes adorned with relief sculpture as well as paintings. In some instances, such as Altamira, an artist simply heightened the resemblance of a natural projecting rock to a familiar animal form. Other reliefs were created by **modeling**, or shaping, the damp clay of the cave's floor. An excellent example of such work in clay from about 13,000 BCE is preserved at Le Tuc d'Audoubert, in the Dordogne region of France. Here the sculptor created two bison leaning against a ridge of rock (fig. 1-12). Although these beasts are modeled in very **high relief** (they extend

1-13. Lamp with ibex design, from La Mouthe cave, Dordogne, France. c. 15,000–13,000 BCE. Engraved stone, 6¾ x 4¾" (17.2 x 12 cm). Musée des Antiquités Nationales, St.-Germain-en-Laye

well forward from the background plane), they display the same conventions as earlier painted ones, with emphasis on the broad masses of the meat-bearing flanks and shoulders. To make the animals even more lifelike, their creator engraved short parallel lines below their necks to represent their shaggy coats. Numerous small footprints found in the clay floor of this cave must have been left by young people, suggesting that initiation rites may have been performed here.

An aesthetic sense and the ability to pose and solve problems are among the characteristics unique to human beings. That these characteristics were richly developed in very early times is evident from Paleolithic artifacts of all kinds. Lamps found in caves provide an example of objects that were both functional and aesthetically pleasing. Some are carved in simple abstract shapes admirably designed to hold oil and wicks and to be easily portable. Others were adorned with engraved images, like one found at La Mouthe, France (fig. 1-13). The creator decorated the underside of this lamp with the image of an ibex. The animal's distinctive head is shown in profile, its sweeping horns reflecting the curved outline of the lamp itself.

Objects such as the ibex lamp were made by people whose survival, up until about 10,000 years ago, depended upon their skill at hunting animals and gathering wild grains and other edible plants. But a change was already under way that would alter human existence forever.

THE NEOLITHIC PERIOD

Today, advances in technology, medicine, transportation, and electronic communication have changed the human experience in a generation. Many thousands of years ago, change came much more slowly. The warming of the climate that brought an end to the Ice Age was so gradual that the people of the time could not have known it was occurring, yet it altered life as dramatically as any changes that have come since. The retreating glaciers exposed large temperate regions, and rising ocean levels changed the shorelines of continents, in some places making islands.

About 6000 BCE, the land bridge connecting England with the rest of Europe disappeared beneath the waters of what are now known as the North Sea and the English Channel. Europe became covered with grassy plains supporting new edible plants and forests that lured great herds of animals, such as deer, farther and farther northward. At the same time, the people in these more hospitable regions were finding ways to enhance their chances of survival. Hunters invented the bow and arrow. Bows were easier to carry and much more accurate at longer range than spears and spear throwers. Dugout boats came into use, opening up new areas for fishing and hunting. With each such advance the standard of living improved.

The changing environment led to a new way of life. People began domesticating animals and cultivating plants. As they gained greater control over their food supply, they established settled communities. None of these changes occurred overnight. Between 10,000 and 5,000 years ago, people along the eastern shore of the Mediterranean began domesticating wild grasses, developing them into more-productive grains such as bread wheat. In this same period, the people of Southeast Asia learned to grow millet and rice and those in the Americas began to cultivate the bottle gourd and eventually corn. Dogs probably first joined with human hunters more than 11,000 years ago, and cattle, goats, and other animals were domesticated later. Large numbers of people became farmers, living in villages and producing more than enough food to support themselves—thus freeing some people in the village to attend to other communal needs. Over time these early societies became increasingly complex. Although most people were still farmers, some of them specialized in political and military affairs, still others in ceremonial practices. The new farming culture gradually spread across Europe, reaching Spain and France by 5000 BCE. Farmers in the Paris region were using plows by 4000 BCE.

These fundamental changes in the prehistoric way of life mark the Neolithic period and occurred in some regions earlier than others. To determine the onset of the Neolithic period in a specific region, archaeologists look for the evidence of three conditions: an organized system of agriculture; animal husbandry, or the maintenance of herds of domesticated animals; and permanent, year-round settlements. By the end of the period, villages were larger, trading had developed among distant regions, and advanced building technology had produced awe-inspiring architecture.

ROCK-SHELTER ART

The period of transition between Paleolithic and Neolithic culture saw the rise of a distinctive art combining geometric forms and schematic images—simplified, diagrammatic renderings—with depictions of people and animals engaged in everyday activities. Artists of the time preferred to paint and engrave such works on easily accessible, shallow rock shelters. In style, technique, and subject matter, these rock-shelter images are quite different from those

1-14. *People and Animals*, detail of rock-shelter painting, Cogul, Lérida, Spain. c. 4000–2000 BCE

found in Upper Paleolithic cave art. The style is abstract, and the technique is often simple line drawing, with no addition of color. Paintings from this period portray striking new themes: people are depicted in energetic poses, whether engaged in battle, hunting, or possibly dancing. They are found in many places near the Mediterranean coast but are especially numerous, beginning about

6000 BCE, in a region located in northeastern Spain.

At Cogul, in the province of Lérida in Catalonia, the broad surfaces of a rock shelter are decorated with elaborate narrative scenes involving dozens of small figures—men, women, children, animals, even insects (fig. 1-14). They date from between 4000 and 2000 BCE (see "How Early Art Is Dated," below). No specific landscape

HOW EARLY ART IS DATED When Upper Paleolithic cave paintings were first discovered at Altamira, Spain, in 1879, they were promptly rejected as forgeries by the Lisbon Congress on Prehistoric Archaeology. Seven years later, scientists proved that similar paintings discovered in France were indeed thousands of years old because a layer of mineral deposits had built up on top of them. Since those first discoveries, archaeologists have developed increasingly sophisticated ways of dating such finds.

During the twentieth century, archaeologists have primarily used two approaches to determine an artifact's age. **Relative dating** relies on the chronological relationships among objects in either a single excavation or several sites. If archaeologists have determined, for example, that pottery types A, B, and C follow each other chronologically at one site, they can apply that knowledge to another site; even if "type B" is the only pottery present, it can be assigned a relative date. **Absolute dating** aims to determine a precise span of calendar years

in which an artifact was created.

The most accurate method of absolute dating is **radiometric dating**, which measures the degree to which radioactive materials have disintegrated over time. Used for dating organic (plant or animal) materials—including some pigments used in cave paintings—one radiometric method measures a carbon isotope called radiocarbon, or carbon-14, which is constantly replenished in a living organism. When an organism dies, it stops absorbing carbon-14 and starts to lose its store of it at a predictable rate. Under the right circumstances, the amount of carbon-14 remaining in organic material can tell us how long ago an organism died. This method has serious drawbacks for dating works of art, however. Using carbon-14 dating on a carved antler or wood sculpture shows only when the animal died or the tree was cut down, not when the artist created the work, which could have been centuries later. Also, some part of the object must be destroyed to conduct this kind of test—something rarely desirable in a work of art. For this reason, researchers

frequently test organic materials found in the same context as the work of art rather than the work itself.

Radiocarbon dating is most accurate for materials no more than 30,000 to 40,000 years old. **Potassium-argon dating**, which measures the decay of a radioactive potassium isotope into a stable isotope of argon, an inert gas, is most reliable with materials more than a million years old. Two newer techniques have been used since the mid-1980s. **Thermoluminescence dating** measures the irradiation of the crystal structure of a material such as flint or pottery and the soil in which it is found, determined by the luminescence produced when a sample is heated. **Electron spin resonance techniques** involve a magnetic field and microwave irradiation to date a material such as tooth enamel and its surrounding soil.

Recent experiments have helped to date cave paintings with increasing precision. Twelve different radiocarbon-analysis series have determined, for example, that the animal images in the Cosquer cave are 18,500 years old, the handprints 27,000 years old.

ELEMENTS OF ARCHITECTURE
Post-and-Lintel and Corbel Construction

Of all the methods for spanning space, **post-and-lintel construction** is the simplest. At its most basic, two uprights (posts) support a horizontal element (**lintel**). There are countless variations, from the trilithons, wood structures, dolmens and other underground burial chambers of prehistory, to Egyptian and Greek stone construction, to medieval timber frame buildings, and even to cast iron and steel construction. Its limitation as a space spanner is the degree of tensile strength, or flexibility, of the lintel material: the more flexible, the greater the span possible. Another early method for creating openings in walls and covering space is **corbeling**, in which rows or layers of stone are laid with the end of each row projecting beyond the row beneath, until opposing layers almost meet and can be capped with a stone that rests across the tops of both layers.

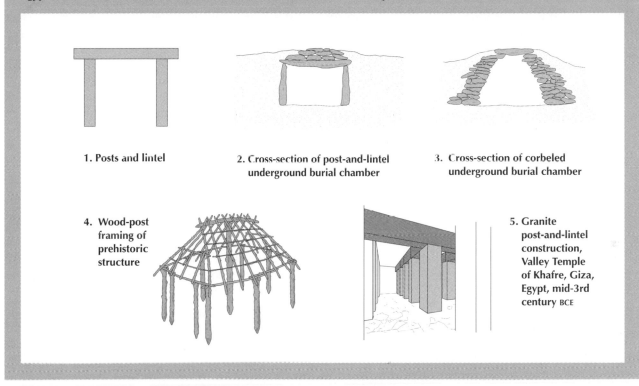

1. Posts and lintel

2. Cross-section of post-and-lintel underground burial chamber

3. Cross-section of corbeled underground burial chamber

4. Wood-post framing of prehistoric structure

5. Granite post-and-lintel construction, Valley Temple of Khafre, Giza, Egypt, mid-3rd century BCE

features are indicated, but occasional painted patterns of animal tracks give the sense of a rocky terrain, like that of the surrounding barren hillsides. In the detail shown here, a number of women are seen gracefully strolling or standing about, some in pairs holding hands. The women's small waists are emphasized by large, pendulous breasts. They wear skirts with scalloped hemlines revealing large calves and sturdy ankles, and all of them appear to have shoulder-length hair. The women stand near several large, long-horned cattle and are surrounded by smaller cattle, the Spanish ibex, red deer, and a pig. A pair of ibexes visible just above the cattle as well as a dog in the foreground are shown leaping forward with legs fully extended. This pose, called a flying gallop, has been used to indicate speed in a running animal from prehistory to the present.

In other paintings at the site, not shown here, some women seem to be looking after children while others carry baskets, gather food, and work the earth with digging sticks. These paintings are more than a record of daily life. They must have had some greater significance, for they were repainted many times over the centuries. Because rock shelters were so accessible, people continued to visit these sites long after their original purpose had been forgotten. At Cogul, in fact, inscriptions in Latin and an early form of Spanish scratched by Roman-era visitors—2,000-year-old graffiti—share the rock wall surfaces with the prehistoric paintings.

ARCHITECTURE

As people adopted a settled, agricultural way of life, they began to build large structures to serve as dwellings, storage spaces, and shelters for their animals. In Europe, timber became abundant after the disappearance of the glaciers, and Neolithic people, like their Paleolithic predecessors, continued to construct buildings out of wood and other plant materials. People clustered their dwellings in villages, and they built large tombs and ritual centers outside their settlements.

Dwellings and Villages. A northern European village probably consisted of three or four long timber buildings, each of them housing forty-five to fifty people. These houses were up to 150 feet long, and they included large granaries, or storage space for the harvest, a necessity in agricultural communities. The structures were rectangular, with a row of posts down the center supporting a ridgepole, a long horizontal beam against which the slanting roof poles were braced (see example 4 in "Post-and-Lintel and Corbel Construction," above). Their walls were probably made of what is known as **wattle and daub**, branches woven in a basketlike pattern, then covered with mud or clay. They were probably roofed with thatch, some plant material such as reeds or straw tied over a framework of poles. Similar structures can still be seen today in some

1-15. Plan, village of Skara Brae, Orkney Islands, Scotland. c. 3100–2600 BCE

1-16. House interior, Skara Brae (house 7 in fig. 1-15)

regions, serving as animal shelters or even dwellings.

Around 4000 BCE, Neolithic settlers began to locate their communities at sites most easily defended, near rivers, on plateaus, or in swamps. For additional protection, they also frequently surrounded them with wooden walls, earth embankments, and ditches.

A Neolithic settlement has been excellently preserved at Skara Brae, in the Orkney Islands off the northern coast of Scotland (fig. 1-15). This village was constructed of stone, an abundant building material in this austere, treeless region. A long-ago storm buried this seaside village under a layer of sand, and another storm brought it to light again in 1850. The village exposed to view presents a vivid picture of Neolithic life in the far north. In the houses, archaeologists found beds, shelves, stone cooking pots, basins, stone mortars for grinding, and pottery with incised decoration. Comparison of these artifacts with objects from sites farther south and laboratory analysis of the village's organic refuse date the settlement at Skara Brae to between 3100 and 2600 BCE.

The village consists of a compact cluster of dwellings linked together by covered passageways. Each of the houses has a square plan with rounded corners. The largest one measures 20 by 21 feet, the smallest, 13 by 14 feet. Layers of flat stones without mortar form walls, with each layer, or **course**, projecting slightly inward over

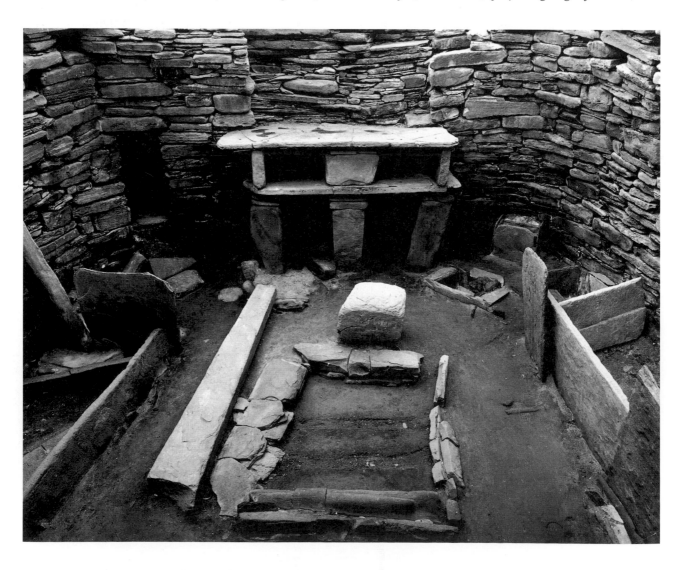

the one below. This type of construction is called **corbeling** (see example 3 in "Post-and-Lintel and Corbel Construction," page 55). In some structures, such inward-sloping walls come together at the top in what is known as a **corbel vault**, but at Skara Brae the walls stopped short of meeting, and the remaining open space was covered with hides or turf. There are smaller corbel-vaulted rooms within the main walls of some of the houses that may have been used for storage. One room, possibly a latrine, has a drain leading out under its wall.

The houses of Skara Brae were well equipped with space-saving built-in furniture. In the room shown (fig. 1-16), a large rectangular hearth with a stone seat at one end occupies the center of the space. Rectangular stone beds, some of them engraved with simple designs, stand against the walls on two sides of the hearth. These box-like beds would probably have been filled with heather "mattresses" and covered with warm furs. In the left corner, a sizable storage room is built into the thick outside wall. Smaller storage niches were provided over each of the beds. Stone tanks lined with clay to make them watertight are partly sunk into the floor. These containers were probably used for live bait, for it is clear that the people at Skara Brae were skilled fisherfolk.

On the back wall is a two-shelf cabinet that is a clear example of what is known as **post-and-lintel construction** (see "Post-and-Lintel and Corbel Construction," page 55). In this structural system, two or more vertical elements (posts) are used to support a bridging horizontal one (**lintel**). The principle has been used throughout history, not only for structures as simple as these shelves but also in huge stone monuments such as Stonehenge (see fig. 1-19) and the temples of Egypt (Chapter 3) and Greece (Chapter 5).

Ceremonial and Tomb Architecture. In western and northern Europe, Neolithic people commonly erected ceremonial structures and tombs using huge stones. In some cases, they had to transport these great stones over long distances. The monuments thus created are examples of what is known as megalithic architecture, the descriptive term derived from the Greek word roots for large (*mega-*) and stone (*lithos*). Architecture formed of such massive elements testifies to a more complex, stratified society than any encountered before. Only strong leaders could have assembled and maintained the required labor force. Skilled "engineers" were needed to devise methods for shaping, transporting, and aligning the stones. Finally, powerful religious figures must have been involved, identifying the society's need for such structures and dictating their design. The accomplishments of the builders of these monuments are all the more impressive considering the short life expectancy of the time—it was uncommon for anyone to survive past the age of thirty. As one anthropologist has noted, these imposing structures were the work of teenagers.

Elaborate megalithic tombs first appeared in the Neolithic period. Some were built for single burials; others consisted of multiple burial chambers. The simplest type of megalithic tomb was the **dolmen**, built on the

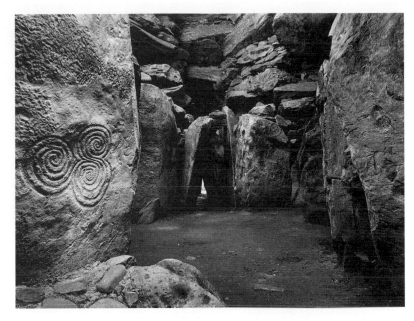

1-17. Tomb interior with corbeling and engraved stones, Newgrange, Ireland. c. 3000–2500 BCE

post-and-lintel principle. The tomb chamber was formed of huge upright stones supporting one or more tablelike rocks, or **capstones**. The structure was then mounded over with smaller rocks and dirt to form an artificial hill. A more imposing structure was the **passage grave**, which was entered by one or more narrow, stone-lined passageways into a large room at the center.

At Newgrange, in Ireland, the mound of an elaborate passage grave (fig. 1-17) originally stood 44 feet tall and measured about 280 feet in diameter. The mound was built of sod and river pebbles and was set off by a circle of decorated standing stones around its perimeter. Its passageway, 62 feet long and lined with standing stones, leads into a three-part chamber with a corbel vault rising to a height of 19 feet. The stones at the entrance and along the passageway are engraved with linear designs, mainly rings, spirals, and diamond shapes. These patterns must have been marked out using strings or compasses, then carved by pecking at the rock surface with tools made of antlers. Such large and richly decorated structures did more than honor the distinguished dead; they were truly public architecture that fostered communal pride and a group identity. As is the case with elaborate funerary monuments built today, their function was both practical and symbolic.

Many megalithic structures were ritual centers serving the people of an entire region. In the Carnac district on the south coast of Brittany, in France, thousands of **menhirs**, or single vertical megaliths, were set up sometime between 4250 and 3750 BCE. They were placed in either circular patterns known as **cromlechs** or straight rows known as **alignments**. More than 3,000 menhirs still stand in 2-mile lines near Ménec (fig. 1-18). Each of these squared-off stones weighs several tons. There are thirteen rows of alignments, their stones graduated in height from about 3 feet on the eastern end to upward of 13 feet toward the west. The east-west orientation of the

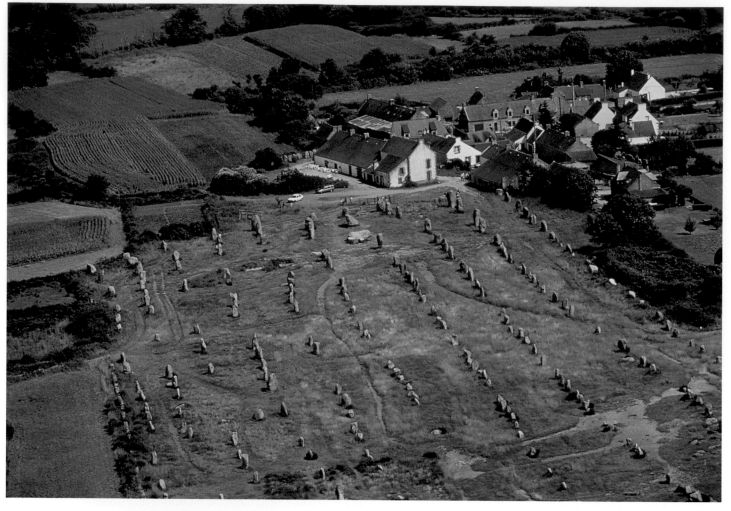

1-18. Menhir alignments at Ménec, Carnac, France. c. 4250–3750 BCE

One legend of Celtic Brittany explains the origin of the Carnac menhirs quite graphically. It relates that a defeated army retreating toward the sea found no ships waiting to carry it to safety. When the desperate warriors turned around and took up their battle stations in preparation for a fight to the death, they were miraculously transformed into stone. Another legend claims that the stones were invading Roman soldiers who were "petrified" in their tracks by a local saint named Cornely.

alignments suggests some connection to the movement of the sun. Neolithic farming people, whose well-being depended on a recurring cycle of sowing, growing, harvesting, and fallow seasons, would have had every reason to worship the sun and do all they could to assure its regular motion through the year. The menhirs at Carnac may well have marked an established procession route for large groups of people celebrating public rites. It is also possible that they were points of reference for careful observation of the sun, moon, and stars.

Of all the megalithic monuments in Europe, the one that has stirred the imagination of the public most strongly is Stonehenge, on Salisbury Plain in southern England (figs. 1-19, 1-20). A **henge** is a circle of stones or posts, often surrounded by a ditch with built-up embankments. Laying out such circles with accuracy would have posed no particular problem. Their architects likely relied on the human compass, a simple but effective surveying method that persisted well into modern times. All that is required is a length of cord either cut or knotted to mark the desired radius of the circle. A person holding one end of the cord is stationed in the

center; a co-worker, holding the other end and keeping the cord taut, steps off the circle's circumference. By the time of Stonehenge's construction, cords and ropes were readily available; people, probably women, began working with plant fibers very early. They made ropes, fishing lines, nets, baskets, and even garments using techniques resembling modern macramé and crochet (see "The Fiber Arts," page 86).

Stonehenge is not the largest such circle from the Neolithic period, but its importance to its region is reflected in the fact that it was repeatedly reworked to incorporate new elements, making it one of the most complicated megalithic sites. It is the product of at least four major building phases between about 2750 and 1500 BCE. In the earliest stage, its builders dug a deep, circular ditch, placing the excavated material on the inside rim to form an embankment more than 6 feet high. Digging through the turf, they exposed the chalk substratum characteristic of this part of England, thus creating a brilliant white circle about 330 feet in diameter. An "avenue" from the henge toward the northeast led well outside the embankment to a pointed sarsen megalith—sarsen is a

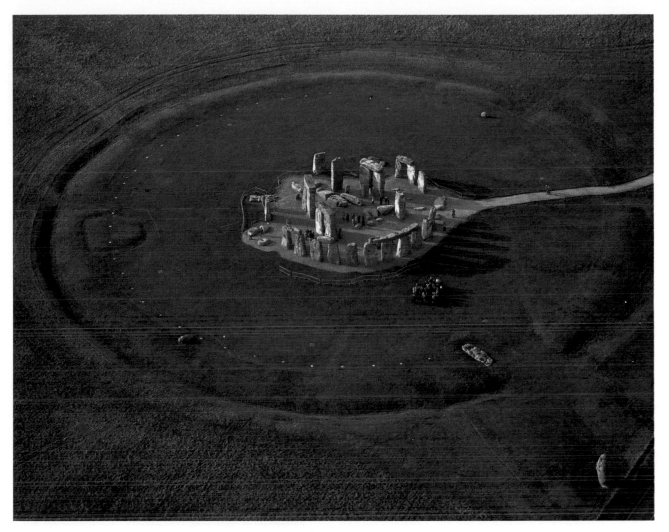

1-19. Stonehenge, Salisbury Plain, Wiltshire, England. c. 2750–1500 BCE

gray sandstone—brought from a quarry 23 miles away. Today, this so-called heel stone, tapered toward the top and weighing about 35 tons, stands about 16 feet high. The ditches and embankments bordering the approach avenue were constructed somewhat later.

By about 2100 BCE, Stonehenge included all of the internal elements reflected in the drawing shown here (see fig. 1-20). Dominating the center was a horseshoe-shaped arrangement of five sandstone trilithons, or pairs of upright stones topped by lintels. The one at the middle stood considerably taller than the rest, rising to a height of 24 feet, and its lintel was more than 15 feet long and 3 feet thick. This group was surrounded by the so-called sarsen circle, a ring of sandstone uprights weighing up to 50 tons each and standing 20 feet tall. This circle, 106 feet in diameter, was capped by a continuous lintel. The uprights were tapered slightly toward the top, and the gently curved lintel sections were secured by **mortise-and-tenon joints**, a conical projection from one piece fitting into a hole in the next. Just inside the sarsen circle was once a ring of bluestones—worked blocks of a bluish dolerite found only in the mountains of southern Wales,

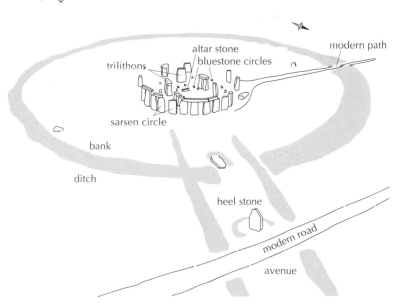

1-20. Diagram of Stonehenge, showing elements discussed here

150 miles away. Why the builders of Stonehenge used this type of stone is one of the many mysteries of Stonehenge. Clearly the stones were highly prized, for centuries later, about 1500 BCE, they were reused to form a smaller horseshoe (inside the trilithons) that encloses the so-called altar stone.

Whoever stood at the exact center of Stonehenge on the morning of the summer solstice 4,000 years ago would have seen the sun rise directly over the heel stone. The observer could then warn people that the sun's strength would shortly begin to wane, that the days would grow shorter and the nights cooler until the country was once more gripped by winter.

Through the ages, many theories have been advanced to explain Stonehenge. (Most of these explanations say more about the times when they were put forward than about Stonehenge.) In the Middle Ages, people thought that Merlin, the magician of the King Arthur legend, built Stonehenge. Later, the site was incorrectly associated with the rituals of the Druids, a Celtic priesthood. Its original function continues to challenge the ingenuity of scholars even today. Because its orientation is related to the movement of the sun, some think it may have been a kind of observatory. Anthropologists suspect that the structure was an important site for major public ceremonies, possibly planting or harvest rituals. Whatever its first role may have been, Stonehenge continues to fascinate the public. Crowds of people still gather there at midsummer to thrill to its mystery. Even if we never learn the original purpose of megalithic structures, the technology developed for building them was a major advance, one that made possible a new kind of architecture and sculpture.

SCULPTURE AND CERAMICS

Having learned how to cut and transport massive blocks of stone, Neolithic sculptors were capable of carving large, freestanding stone figures. Their menhir statues, dating from between 3500 and 2000 BCE, stood 3 to 4 feet high, and all were carved in a similar way. Elements of the human figure reduced to near-geometric forms were incised on all four sides of a single upright block. Faces were usually suggested by a vertical ridge for the nose and a horizontal one for the browline. Incised linear patterns on the sides and backs of such figures have been interpreted as ribs and backbones, but it is possible that they were meant to represent elements of ritual costume or body painting. A menhir statue of a woman found in Montagnac, in southern France (fig. 1-21), has a face composed of a straight nose, a heavy, continuous brow, and protruding eyes. Above the browline she wears a headband. What first appears to be a square jaw and wide, rectangular mouth is actually the outline of a necklace. The woman's hands are raised to cover her breasts, giving her arms a U shape. A belt encircles her waist. Some figures of women have no arms or hands—only breasts and a necklace. Those of men often carry weapons.

In southern France, solitary menhir statues have been discovered on wooded hills and sometimes near tombs or villages. Set on hilly sites, they may have served as "guardians" and signposts for travelers making their way to sacred places. Those in the vicinity of tombs may have served as guardians of the dead. Some female figures found near dwellings are thought to have been household protectors.

1-21. Menhir statue of a woman, from Montagnac, France. c. 2000 BCE. Limestone, height approx. 33" (85 cm). Musée d'Histoire Naturelle et Préhistoire, Nîmes

Besides working in stone, Neolithic artists also commonly used clay. Their **ceramics—wares** made of baked clay—whether figures of people and animals or vessels, display a high degree of technical skill and aesthetic imagination. This art required a different kind of conceptual leap. In the sculpture previously discussed, artists created their work out of an existing substance, such as stone, bone, or wood. To produce ceramic works, artists had to combine certain substances with clay—bone ash was a common addition—then subject the objects formed of that mixture to high heat for a period of time, thus hardening them and creating an entirely new material. Among the ceramic figures discovered at a pottery-production center in the Danube River valley at Cernavoda, Romania, are a seated man and woman who form a most engaging pair (fig. 1-22, "The Object Speaks"). The artist who made them shaped their bodies out of simple cylinders of clay but managed to pose them in ways that make them seem very true to life.

One of the unresolved puzzles of prehistory is why people in Europe did not produce pottery vessels much earlier. They understood how to harden clay figures by firing them in an oven at high temperatures as early as

THE OBJECT SPEAKS

PREHISTORIC WOMAN AND MAN

For all we know, the artist who created these figures almost 6,000 years ago had nothing particular in mind—people had been modeling clay figures in southeastern Europe for a long time. Perhaps a woman who was making cooking and storage pots out of clay amused herself by fashioning images of the people she saw around her. Perhaps not. That these figures were found in a grave suggests an otherworldly message today.

The Cernavoda woman, spread-hipped and big-bellied, sits directly on the ground, expressive of the mundane world. She exudes stability and fecundity. Her ample hips and thighs seem to ensure the continuity of her family. But in a lively, even elegant, gesture, she joins her hands coquettishly on one knee, raises the knee, curls up her toes, and tilts her head upward. Does she gaze at the skies—the sun or moon and stars? Though earthbound, is she a spiritual figure communing with heaven? In the workaday world, her upwardly tilted head could suggest that she is watching the smoke rising from her hearth, or worrying about holes in her roof, or admiring hanging containers of laboriously gathered drying berries, or gazing adoringly at her partner. We do not know. The Cernavoda man is rather slim, with massive legs and shoulders. He rests his head on his hands in a brooding, pensive pose, evoking for us thoughtfulness, even weariness or sorrow.

These very old figures speak to us in many different ways, not the least of which is the reminder, by their very presence, that men and women not essentially different from us lived and worked, wondered and worried, thousands of years ago. We can interpret the Cernavoda woman and man in many ways, but we cannot know what they meant to their makers or owners. Depending on how they are displayed, we spin out different stories about them. When set facing each other, side by side as they are below, we tend to see them as a couple—a woman and man in a relationship. In fact, we do not know whether the artist conceived them in this way, or even at the same time. For all their visual eloquence, their secrets remain hidden from us.

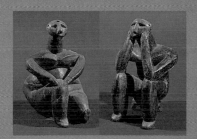

1-22. Figures of a woman and a man, from Cernavoda, Romania. c. 3500 BCE. Ceramic, height 4½" (11.5 cm). National Historical Museum, Bucharest

POTTERY AND CERAMICS

The terms *pottery* and *ceramics* may be used interchangeably—and the two often are. The word *ceramics* came into use only in the nineteenth century. Because it covers all baked-clay wares, *ceramics* is technically a more inclusive term than *pottery*.

Pottery includes all baked-clay wares except **porcelain**, which is the most refined product of ceramic technology. Pottery vessels can be formed in several ways. It is possible, though difficult, to raise up the sides from a ball of raw clay. Another method is to coil long rolls of soft, raw clay, stack them on top of each other to form a container, and then smooth them by hand. A third possibility is to simply press the clay over an existing form, a dried gourd for example. By about 4000 BCE, Egyptian potters had developed the potter's wheel, a round, spinning platform on which a lump of clay is placed and then formed with the fingers. Using a potter's wheel, it is relatively simple to produce a uniformly shaped vessel in a very short time. The potter's wheel appeared in the ancient Near East about 3250 BCE and in China about 3000 BCE.

After a pot is formed, it is allowed to dry completely before it is fired. Special ovens for firing ceramics, called **kilns**, have been discovered at prehistoric sites in Europe dating from as early as 32,000 BCE. For proper firing, the temperature must be maintained at a relatively uniform level. Raw clay becomes porous pottery when heated to at least 500° centigrade. It then holds its shape permanently and will not disintegrate in water. Fired at 800° centigrade, pottery is technically known as earthenware. When subjected to temperatures between 1200° and 1400° centigrade, certain stone elements in the clay vitrify, or become glassy, and the result is a stronger type of ceramics called stoneware.

Pottery is relatively fragile, and new vessels were constantly in demand to replace broken ones, so fragments of low-fired ceramics—fired at the hearth, rather than the hotter kiln—are the most common artifacts found in excavations of prehistoric settlements. Moreover, because pottery disintegrates very slowly, pottery fragments, or **potsherds**, serve as a major key in dating sites and reconstructing human living and trading patterns.

One of the first ways of decorating pottery was simple **incising**—scratching lines into the surface of the clay before it was left to dry. By the dawn of the Bronze Age, about 2300 BCE, vessels were produced in a wide variety of specialized forms and were decorated with great finesse.

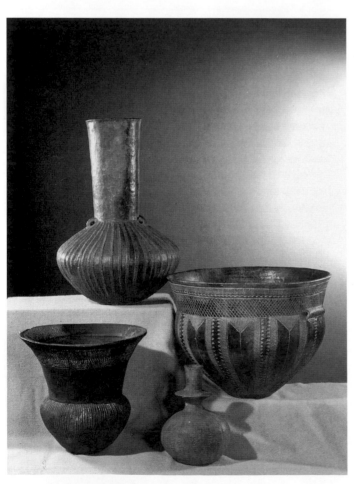

1-23. Vessels, from Denmark. c. 3000–2000 BCE. Ceramic, heights range from 5¾" to 12¼" (14.5 to 31 cm). National Museum, Copenhagen

32,000 BCE. But it was not until about 7000 BCE that they began making vessels using the same technique. Some anthropologists argue that clay is a medium of last resort for vessels. Compared to hollow gourds, wooden bowls, or woven baskets, clay vessels are heavy and quite fragile, and firing them requires considerable expertise.

Excellence in ceramics depends upon the degree to which a given vessel combines domestic utility, visual beauty, and fine execution (see "Pottery and Ceramics," above). A group of bowls from Denmark, made in the third millennium BCE, provides only a hint of the extraordinary achievements of Neolithic artists working in clay (fig. 1-23). Taking their forms from baskets and bags, the earliest pots were round and pouchlike and had built-in loops so that they could be suspended on cords. The earliest pieces in the illustration are the globular bottle with a collar around its neck (bottom center), a form perhaps inspired by eggs or gourd containers, and the flask with loops (top). Even when potters began making pots with flat bottoms that could stand without tipping, they often added hanging loops as part of the design. Some of the ornamentation of these pots, including hatched engraving and stitchlike patterns, seems to reproduce the texture of the baskets and bags that preceded ceramics as containers. It was also possible to decorate clay vessels by impressing stamps into their surface or scratching it with sticks, shells, or toothed implements. Many of these techniques appear to have been used to decorate the flat-bottomed vase with the wide, flaring top (bottom left), a popular type of container that came to be known as a funnel beaker.

The large engraved bowl (center right), found at Skarpsalling, is considered to be the finest piece of northern

Neolithic pottery yet discovered. The potter lightly incised its sides with delicate linear patterns, then rubbed white chalk into the engraved lines so that they would stand out against the dark body of the bowl. Much of the finest art to survive from the Neolithic period is the work of potters; it is an art of the oven and the hearth.

THE BRONZE AGE

Neolithic culture persisted in northern Europe until about 2000 BCE. Metals had made their appearance in the region about 2300 BCE. In southern Europe and the Aegean region, copper, gold, and tin had been mined, worked, and traded even earlier (Chapter 4). Exquisite objects made of **bronze**—an alloy, or mixture, of tin and copper—are frequently found in the settlements and graves of early northern farming communities. The period that follows the introduction of metalworking is commonly called the Bronze Age.

A remarkable sculpture from the Bronze Age in Scandinavia depicts a wheeled horse pulling a cart laden with a large, upright disk commonly thought to represent the sun (fig. 1-24). The work dates from between 1800 and 1600 BCE and was discovered at what is now Trundholm, in Denmark. Horses had been domesticated in Ukraine by about 4000 BCE, but the first evidence of wheeled chariots and wagons designed to exploit the animals' strength dates from about 2000 BCE. Rock engravings in northern Europe show the sun being drawn through the sky by either an animal or a bird—possibly an indication of a widespread sun cult in the region. The Trundholm horse and sun cart could have been rolled from place to place in a ritual reenactment of the sun's passage across the sky.

The valuable materials from which the sculpture was made and the great attention devoted to its details attest to its importance. The horse, cart, and sun were cast in bronze. After two faults in the casting had been repaired, the horse was given its surface finish, and its head and neck were incised with ornamentation. Its eyes were represented as tiny suns. Elaborate and very delicate designs were engraved on its body to suggest a collar and harness. The bronze sun was cast as two disks, both of which were engraved with concentric rings filled with zigzags, circles, spirals, and loops. A thin sheet of beaten gold was then applied to one of the bronze disks and pressed into the incised patterns. Finally, the two disks were joined together by an encircling metal band. The patterns on the horse tend to be geometric and rectilinear, but those of the sun disks are continuous and curvilinear, suggestive of the movement of the sun itself.

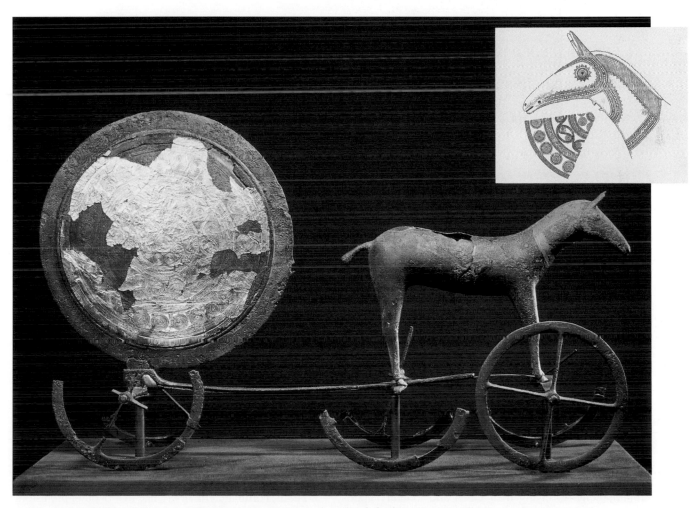

1-24. *Horse and Sun Chariot* and schematic drawing of incised design, from Trundholm, Zealand, Denmark.
c. 1800–1600 BCE. Bronze, length 23¼" (59.2 cm). National Museum, Copenhagen

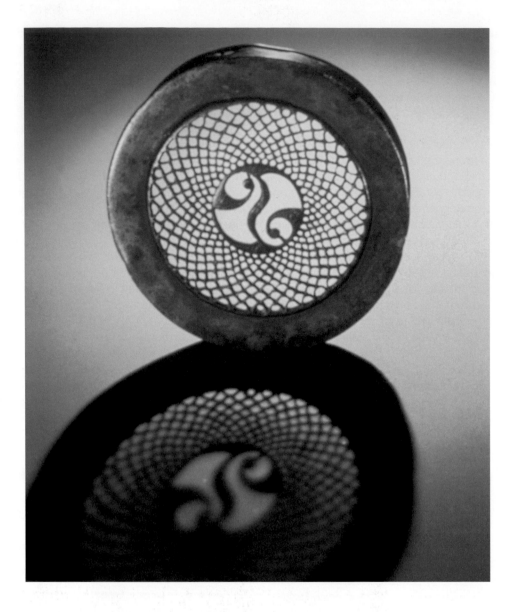

1-25. Openwork box lid, from Cornalaragh, County Monaghan, Ireland. La Tène period, c. 1st century BCE. Bronze, diameter 3" (7.5 cm). National Museum of Ireland, Dublin

THE IRON AGE

By 1000 BCE, iron technology had spread across Europe, although bronze remained the preferred material for luxury items. Cheaper and more readily available than other metals, iron was most commonly used for practical items. The blacksmiths who forged the warriors' swords and the farmers' plowshares held a privileged position among artisans, for they practiced a craft that seemed akin to magic as they transformed iron by heat and hammer work into tools. A hierarchy of metals emerged based on the materials' resistance to corrosion. Gold, as the most permanent and precious metal, ranked first, followed by silver, bronze, and finally practical but rusty iron.

During the Iron Age of the first millennium BCE, Celtic peoples inhabited most of central and western Europe. Celtic artists made a distinctive contribution to the art of the West through their skill in abstract design. Their wooden buildings and sculpture and their colorful woven textiles have disintegrated, but protective **earthworks** such as embankments fortifying their cities and funerary goods such as jewelry, weapons, and tableware have survived.

An **openwork** box lid, in which space is worked into the pattern, in the La Tène style, illustrates the characteristic Celtic style and the continuing use of bronze during this period (fig. 1-25). (*La Tène* refers to a site in Switzerland where discoveries were made of Iron Age artifacts, although this object was found at Cornalaragh, Ireland.) Solid metal and open space play equal roles in the pattern, which consists of a pair of expanding, diagonally symmetrical trumpet-shaped spirals surrounded by lattice. Shapes inspired by compass-drawn spirals, stylized vines, and serpentine dragons seem to change at the blink of an eye, for the artist has eliminated any distinction between figure and background. The openwork trumpets—the forms defined by the absence of material—catch the viewer's attention, yet at the same time the delicate tendrils of solid metal are equally compelling. In Celtic hands, pattern becomes an integral part of the object itself, not an applied decoration.

With the Celts, the prehistoric period in European art comes to an end. Some of what we know about them was recorded by their literate neighbors—the Greeks and Romans. Fortunately, their art, like that of other prehistoric people, survives as direct evidence of their culture.

PARALLELS

PERIOD	ART IN PREHISTORIC EUROPE	ART IN OTHER CULTURES
UPPER PALEOLITHIC c. 40,000–8000 BCE	**1.** Chauvet cave (c. 28,000) **1-3.** *Lion-Human* (c. 30,000–26,000) **1-1.** Cosquer cave horses (c. 16,500) **1-2.** Mammoth-bone house (c. 16,000–10,000) **1-4.** *Woman from Willendorf* (c. 22,000–21,000) **1-7.** *Spotted Horses and Human Hands* (c. 16,000) **1-11.** *Bird-Headed Man* (c. 15,000–13,000) **1-13.** Lamp with ibex (c. 15,000–13,000)	
PALEOLITHIC-NEOLITHIC c. 8000–7000 BCE		**2-3.** Ain Ghazal figure (c. 7000–6000 BCE), Jordan
NEOLITHIC c. 8000–2300 BCE	**1-18.** Menhirs, Carnac (c. 4250–3750) **1-14.** *People and Animals* (c. 4000–2000) **1-22.** Seated woman and man (c. 3500) **1-16.** Interior, Skara Brae (c. 3100–2600) **1-17.** Tomb, Newgrange (c. 3000–2500) **1-23.** Danish ceramic vessels (c. 3000–2000) **1-19.** Stonehenge (c. 2750–1500) **1-21.** Menhir woman (c. 2000)	**2-7.** Uruk woman (c. 3500–3000), Iraq **10-3.** *Cong* deity (before 3000), China **3-10.** Great Pyramids (c. 2601–2515), Egypt **4-3.** Cycladic figure (c. 2500–2200), Greece
BRONZE AGE c. 2300–1000 BCE	**1-24.** *Horse and Sun Chariot* (c. 1800–1600) 	**9-4.** Harappa torso (c. 2000), India **4-19.** Funerary mask (c. 1550–1500), Greece
IRON AGE c. 1000 BCE–	**1-25.** Openwork box lid (1st century) 	**10-4.** *Fang ding* (c. 12th century), China

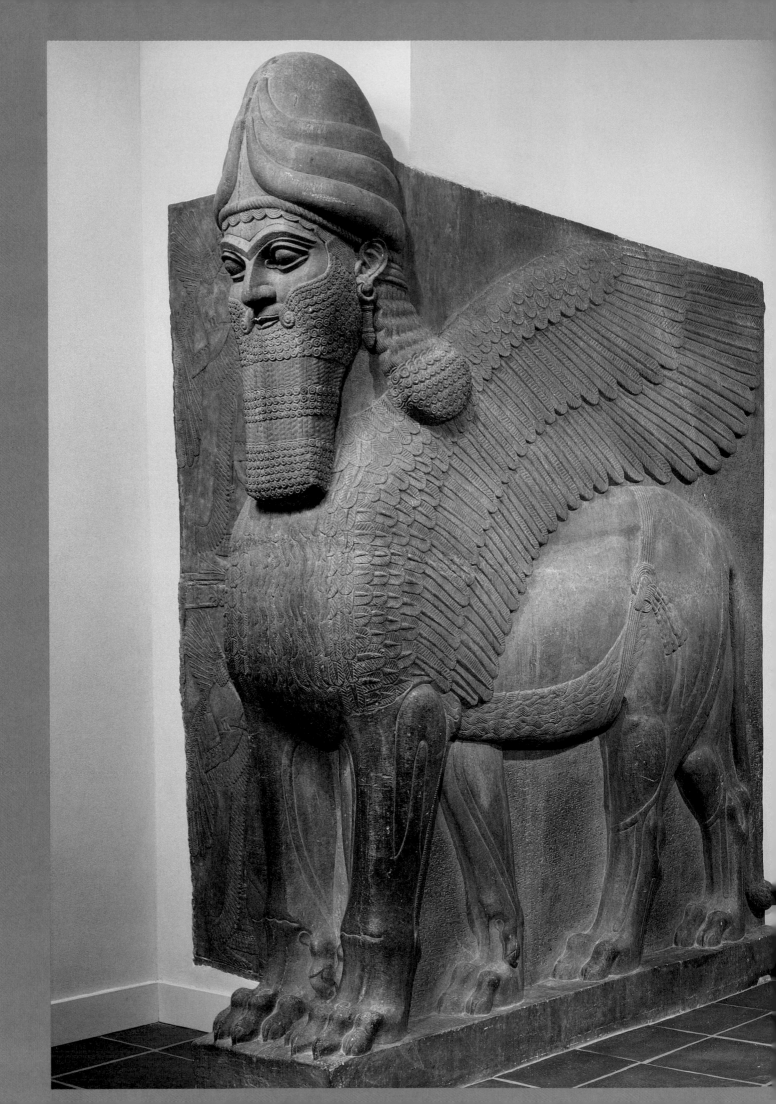

2
Art of the Ancient Near East

2-1. *Human-Headed Winged Lion (Lamassu),* from the palace of Assurnasirpal II, Nimrud. 883–859 BCE. Limestone, height 10'2" (3.11 m). The Metropolitan Museum of Art, New York
Gift of John D. Rockefeller, Jr., 1932, (32.143.2)

Visitors to capital cities like Washington, Paris, and Rome today stroll along broad avenues among huge buildings, dominating gateways, and imposing sculpture. They are experiencing "controlled space," a kind of civic design that rulers and governments—consciously or not—have used since the time of the Assyrian city-state to impress or even intimidate. Ninth-century BCE emissaries to Nimrud, for example, would have encountered breathtaking examples of this ceremonial urbanism, in which the city itself is a stage for the ritual dramas of rulership that reinforce and confirm absolute power. Even from a distance, as they approached the city, these strangers would have seen the vast fortifications and temple where the king acted as intermediary between citizen and god. Following a processional way, they would have passed sculpture extolling the power of the Assyrian armies and then come face-to-face with *lamassus,* extraordinary guardian-protectors of palaces and throne rooms. These creatures may combine the bearded head of a man, the powerful body of a lion or bull, the wings of an eagle, and the horned headdress of a god (fig. 2-1). Often *lamassus* have five legs, so that when seen from the front they appear immobile, but when viewed from the side they seem to be in motion, vigorously striding. *Lamassus'* sheer size—usually large and often twice a person's height— symbolizes the strength of the ruler they defend. Their forceful forms and prominent placement contribute to an architecture of domination. The exquisite detailing of their beards, feathers, and jewels testifies to boundless wealth, which is power. These fantastic composite beasts inspire civic pride and fear. They are works of art with an unmistakable political mission in just one of many cultures that rose and fell in the ancient Near East.

TIMELINE 2-1. **The Ancient Near East.** Beginning about 9000 BCE, early Neolithic civilization arose in the Fertile Crescent. After about 7000 BCE, many different peoples successively conquered and dominated Mesopotamia.

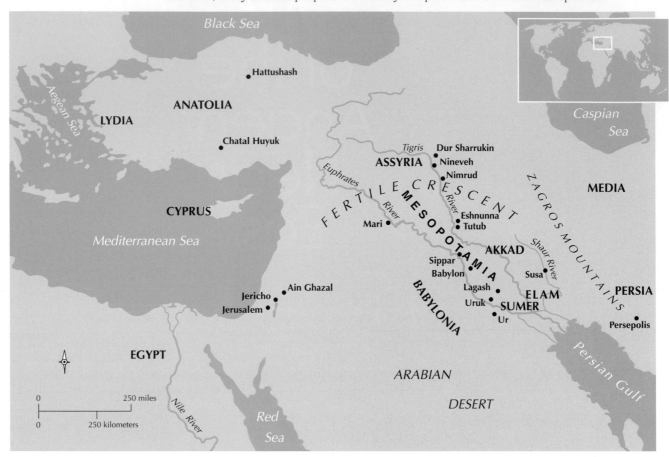

MAP 2-1. **The Ancient Near East.** Ancient Mesopotamia was the Fertile Crescent between the Tigris and Euphrates rivers.

THE FERTILE CRESCENT

Well before farming communities arose in Europe, agriculture emerged in the ancient Near East in an area known as the Fertile Crescent. The "crescent" stretched along the Mediterranean coast through modern Jordan, Israel, Lebanon, and Syria, arched into central Turkey, and descended along the fertile plains between the Tigris and Euphrates rivers (ancient Mesopotamia, the "land between the rivers"), sweeping through Iraq and a slice of western Iran to the Persian Gulf (Map 2-1).

The earliest settled farming communities arose about 9000 BCE, first in the hills above rivers and later in river valleys. In the Near East, agricultural villages gradually evolved into cities, where large populations were separated from outlying rural areas. Mesopotamia's relatively harsh climate, prone to both drought and flood, may have contributed to this change there, as early agriculturists cooperated to construct large-scale systems for controlling their water supply. Trade among distant communities also increased. Farming spread from the Fertile Crescent and reached the Atlantic coast of Europe by about 5000 BCE.

Between 4000 and 3000 BCE, a major cultural shift took place in the Near East. Archaeologists have long believed that this change happened first in southern Mesopotamia, then spread northward. Excavations beginning in 1999, however, strongly suggest that the evolution of agricultural villages and cities occurred simultaneously and independently in the northern and southern regions of the Near East. Prosperous cities and their surrounding territory developed into city-states, each with its own government; eventually, larger kingdoms absorbed these city-states. Urban life and population density gave rise to the development of specialized skills other than those for agricultural work, and social hierarchies evolved. Workshops for milling flour and making bricks, pottery, textiles, and metalware sprang up, and the construction of temples and palaces kept builders and artists busy.

Specialists also emerged to control rituals and the sacred sites. The people of the ancient Near East were polytheistic, worshiping numerous gods and goddesses, and they attributed to them power over human activities and the forces of nature. Each city had a special protective deity, and people believed the fate of the city depended

on the power of that deity. (The names of comparable deities varied over time and place—for example, Inanna, the Sumerian goddess of fertility, love, and war, was equivalent to the Babylonians' Ishtar, the Egyptians' Isis, the Greeks' Aphrodite, and the Romans' Venus.) Large **temple complexes**—clusters of religious, administrative, and service buildings—developed in each city as centers of worship and also as thriving businesses. Religious and political power were closely interrelated.

Mesopotamia's wealth and agricultural resources, as well as its few natural defenses, made it vulnerable to repeated invasions from hostile neighbors and to internal conflicts. Over the centuries, the balance of power shifted between north and south and between local powers and outside invaders (Timeline 2-1). First the Sumerians formed a state in the south. Then for a brief period they were eclipsed by the Akkadians, their neighbors to the north. When invaders from farther north in turn conquered the Akkadians, the Sumerians regained power locally. The Babylonians were next to dominate the south. Later, the center of power shifted to the Assyrians in the north, then back again to Babylonia, called Neo-Babylonia. Throughout this time, important cultural centers arose outside of Mesopotamia as well, such as the newly found excavations in the north, Elam on the plain between the Tigris River and the Zagros Mountains to the east, the Hittite kingdom in Anatolia, and Persia, east of Elam. Beginning in the sixth century BCE, the Achaemenid Persians, a nomadic people from the mountains of modern-day Iran, forged an empire that included not only Mesopotamia but the entire Near East.

EARLY NEOLITHIC CITIES

One of the earliest Near Eastern cities, Jericho, located in today's West Bank territory in Palestine, was home to about 2,000 people by around 7000 BCE. Its houses, made of mud bricks (shaped from clay and dried in the sun), covered 6 acres, an enormous size for that time. Ain Ghazal ("Spring of Gazelles"), just outside present-day Amman, Jordan, was even larger. That settlement, dating from about 7200 to 5000 BCE, occupied 30 acres on terraces stabilized by stone retaining walls. Its houses may have resembled the adobe pueblos that native peoples in the American Southwest began to build more than 7,000 years later (fig. 2-2). The concentration of people and resources in cities such as Jericho and Ain Ghazal was an early step toward the formation of the larger city-states that arose in Mesopotamia and later were common throughout the ancient Near East.

Among the objects recovered from Ain Ghazal are more than thirty painted plaster figures. Fragments suggest that some figures were nearly lifesize (fig. 2-3). Sculptors molded the figures by applying wet plaster to reed-and-cord frames in human shape. The eyes were inset cowrie shells, and small dots of the black, tarlike

2-2. Reconstruction drawing of houses at Ain Ghazal, Jordan. c. 7200–5000 BCE

2-3. Figure, from Ain Ghazal, Jordan. c. 7000–6000 BCE. Clay plaster with cowrie shell, bitumen, and paint, height approx. 35" (90 cm). National Museum, Amman, Jordan

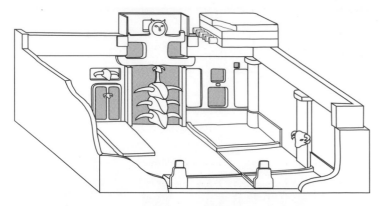

2-4. Composite reconstruction drawing of a shrine room at Chatal Huyuk, Turkey. c. 6500–5500 BCE

Many ancient Near Eastern cities still lie undiscovered. In most cases an archaeological site in a region is signaled by a large mound—known locally as a *tell*, *tepe*, or *huyuk*—that represents the accumulated debris of generations of human habitation. When properly excavated, such mounds yield evidence about the people who inhabited the site. But critical information is lost when treasure hunters, who have no interest in the context in which they find things, loot sites for artifacts to sell on the international art market. Even scientific excavation destroys context, and subsequent investigators are forced to rely on the excavators' detailed records. This is especially true at Chatal Huyuk, which was reburied after it was excavated in the 1950s.

2-5. Reconstruction drawing of the Anu Ziggurat and White Temple, Uruk (modern Warka, Iraq). c. 3100 BCE

substance bitumen—which Near Eastern artists used frequently—formed the pupils. The figures probably wore wigs and clothing and stood upright.

Although agriculture appears to have been the economic mainstay of these new permanent communities, other specialized activities, such as crafts and trade, were also important. Chatal Huyuk, a city in Anatolia with a population of about 5,000 from about 6500 to 5500 BCE, developed a thriving trade in obsidian, a rare, black volcanic glass that was used from Paleolithic into modern times for sharp blades. The inhabitants of Chatal Huyuk lived in single-story buildings densely clustered around shared courtyards, used as garbage dumps. Like other early Near Eastern cities, Chatal Huyuk was easy to defend because it had no streets or open plazas and was protected with continuous, unbroken exterior walls. People moved around by crossing from rooftop to rooftop, entering houses through openings in their roofs.

Many of the interior spaces were elaborately decorated and are assumed to have been shrines (fig. 2-4). Walls were adorned with bold geometric designs, painted

animal scenes, actual animal skulls and horns, and three-dimensional shapes resembling breasts and horned animals. On some walls were depictions of women giving birth to bulls. In one chamber, a leopard-headed woman—portrayed in a high-arched wall area above three large, projecting bulls' heads—braces herself as she gives birth to a ram. Although this dramatic image suggests worship of a fertility goddess, any such interpretation is risky because so little is known about the culture. Like other early Near Eastern settlements, Chatal Huyuk seems to have been abandoned suddenly, for unknown reasons, and never reoccupied.

SUMER

The cities and then city-states that developed along the rivers of southern Mesopotamia between about 3500 and 2340 BCE are known collectively as Sumer. The inhabitants, who had migrated from the north but whose origins are otherwise obscure, are credited with many firsts. Sumerians invented the wagon wheel and plow, cast objects in copper and bronze, and created a system of writing—perhaps their greatest contribution to later civilizations, though recent discoveries indicate that writing developed simultaneously in Egypt (Chapter 3). Sumerians pressed **cuneiform** ("wedge-shaped") **symbols** into clay tablets with a **stylus** (writing stick) to keep business records (see "Cuneiform Writing," page 71). Thousands of Sumerian tablets document the gradual evolution of writing and arithmetic, another tool of commerce, as well as an organized system of justice and the world's first epic literature (see "Gilgamesh," page 71).

The Sumerians' most impressive buildings were **ziggurats**, stepped pyramid structures with a temple or shrine on top. The first such structures may have resulted from repeated rebuilding at a sacred site, with rubble from one structure serving as the foundation for the next; elevating the buildings also protected the shrines from flooding. Whatever the origin of their design, ziggurats towering above the flat plain proclaimed the wealth, prestige, and stability of a city's rulers and glorified its protective gods. Ziggurats functioned symbolically, too, as lofty bridges between the earth and the heavens—a meeting place for humans and their gods. They were given names such as "House of the Mountain" and "Bond between Heaven and Earth," and their temples were known as "waiting rooms" because priests and priestesses waited there for deities to reveal themselves. Ziggurats had impressive exteriors, decorated with elaborate clay **mosaics**—images made by small colored pieces affixed to a hard surface—and reliefs. The gods would have been pleased with all this handiwork, it was said, because they disliked laziness in their people.

Uruk (modern Warka, Iraq), the first independent Sumerian city-state, had two large temple complexes in the 1,000-acre city. One complex was dedicated to Inanna, the goddess of love and war, and the other probably to the sky god Anu. The Anu Ziggurat, built up in stages over the centuries, ultimately rose to a height of about 40 feet. Around 3100 BCE, a whitewashed brick temple was erected on top that modern archaeologists refer to as the White Temple (fig. 2-5). This now-ruined

CUNEIFORM WRITING Sumerians developed a very early system of writing around 3100 BCE, apparently as an accounting system for goods traded at Uruk. The symbols were **pictographs**, simple pictures incised on moist clay slabs with a pointed tool. Between 2900 and 2400 BCE, the symbols evolved from pictures into phonograms—representations of syllable sounds—thus becoming a true writing system. During the same centuries, scribes adopted a **stylus**, or writing tool, with one triangular end and one pointed end. The stylus could be pressed rapidly into a wet clay tablet to create the increasingly abstract symbols, or characters, of **cuneiform** writing.

This illustration shows examples of the shift from pictograph to cuneiform writing. The drawing of a bowl, which means "bread" and "food" and dates from about 3100 BCE, was reduced by about 2400 BCE to a four-stroke sign, and by about 700 BCE to a highly abstract vertical arrangement. By combining the pictographs and, later, cuneiform signs, writers created composite signs; for example, a composite of the signs for "head" and "food" came to mean "to eat."

Cuneiform writing was a difficult

stylus

skill, and few people in ancient Mesopotamia mastered it. Some boys attended schools, where they learned to read and write by copying their teachers' lessons, but the small number of girls who learned to read and write probably were tutored at home.

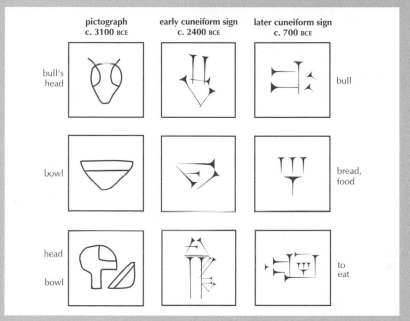

	pictograph c. 3100 BCE	early cuneiform sign c. 2400 BCE	later cuneiform sign c. 700 BCE	
bull's head				bull
bowl				bread, food
head bowl				to eat

GILGAMESH Among the many thousands of cuneiform tablets excavated thus far in Sumer, fewer than 6,000, containing about 30,000 lines of text, record religious myths, heroic tales, legendary histories, hymns, songs of mourning, and so called wisdom texts, consisting of essays, debates, proverbs, and fables. These make up the world's oldest written literature, and they tell us much about Sumerian beliefs. Most are written as poetry, and some may have been performed with music.

The best-known literary work of ancient Mesopotamia is the *Epic of Gilgamesh*. Its origins are Sumerian, but only fragments of the Sumerian version survive. The fullest version, written in Akkadian, was found in the library of the Assyrian king Assurbanipal (ruled 669–c. 627 BCE) in Nineveh (modern Kuyunjik, Iraq). It recounts the adventures of Gilgamesh, a legendary Sumerian king of Uruk, and his companion Enkidu. When Enkidu dies, a despondent Gilgamesh sets out to find the secret of eternal life from Utnapishtim and his wife, the only survivors of a great flood sent by the gods to destroy the world, and the only people to whom the gods had granted immortality.

In *Tablet XI*, the *"Flood Tablet,"* Utnapishtim tells this story—with its many striking similarities to the Hebrew Bible's tale of Noah and the Ark. He describes building a huge boat and loading it with "all the seeds of living things," wild and domesticated beasts, and people who knew all the crafts. When the flood strikes:

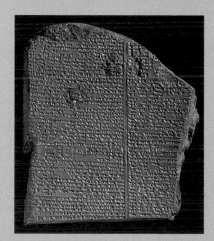

The so-called *Flood Tablet*, Tablet XI, The Epic of Gilgamesh, 2nd millennium BCE.
The British Museum, London

For six days and seven nights
The wind blew, flood and tempest overwhelmed the land;
When the seventh day arrived the tempest, flood and onslaught
Which had struggled like a woman in labour, blew themselves out.
The sea became calm, the *imhullu* wind grew quiet, the flood held back.
I looked at the weather; silence reigned,
For all mankind had returned to clay.
The flood-plain was flat as a roof.
I opened a porthole and light fell on my cheeks.
I bent down, then sat. I wept.

Henrietta McCall. *Mesopotamian Myths*, British Museum Publications in cooperation with University of Texas Press, Austin, 1990. p. 48.

Gilgamesh ultimately abandons his quest for eternal life and returns to Uruk, having accepted his mortality and recognized that the majestic city is his lasting accomplishment.

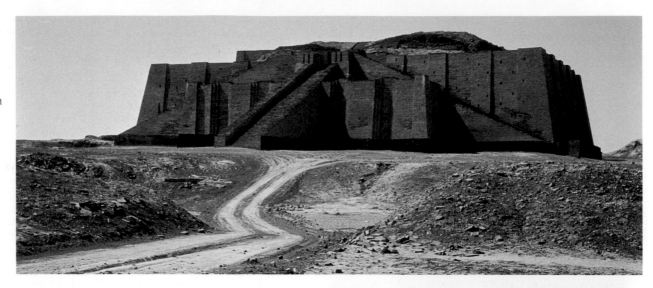

2-6. Nanna Ziggurat, Ur (modern Muqaiyir, Iraq). c. 2100–2050 BCE

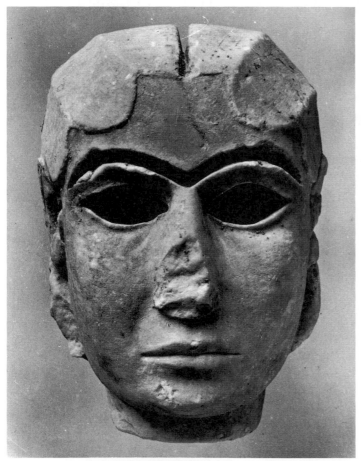

2-7. **Face of a woman**, from Uruk (modern Warka, Iraq). c. 3500–3000 BCE. Marble, height approx. 8" (20.3 cm). Iraq Museum, Baghdad

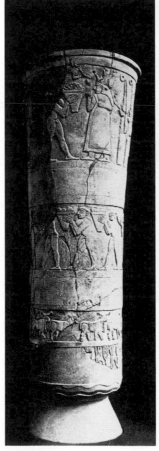

2-8. **Carved vase** (both sides), from Uruk (modern Warka, Iraq). c. 3500–3000 BCE. Alabaster, height 36" (91 cm). Iraq Museum, Baghdad

structure was a simple rectangle oriented to the points of the compass. An off-center doorway on one of the long sides led into a large chamber containing a raised platform and altar; smaller spaces opened off this main chamber. **Cone mosaic**, a technique apparently invented at Uruk, decorated many courtyards and interior walls in the Inanna and Anu compounds. Thousands of small cones, made of baked clay and brilliantly colored, were pressed like thumbtacks into wet plaster walls to create shimmering, multicolored designs.

South of Uruk lay the city of Ur (modern Muqaiyir, Iraq), the birthplace of the patriarch Abraham, who founded the Hebrew people. About a thousand years after the completion of the White Temple, the people of Ur built a ziggurat dedicated to the moon god Nanna, also called Sin (fig. 2-6). Although located on the site of an earlier temple, this imposing mud-brick structure was elevated by design, not as the result of successive rebuildings. Its base is a rectangle 190 by 130 feet, with three sets of stairs converging at an imposing entrance gate atop the first of what were

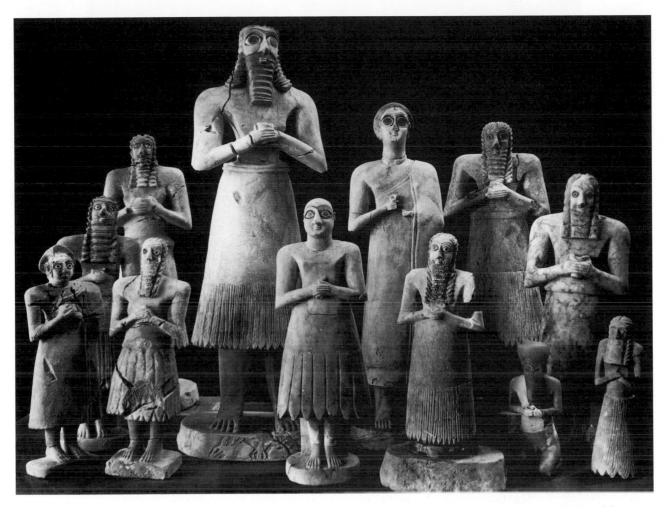

2-9. Votive statues, from the Square Temple, Eshnunna (modern Tell Asmar, Iraq). c. 2900–2600 BCE. Limestone, alabaster, and gypsum, height of largest figure approx. 30" (76.3 cm). The Oriental Institute of The University of Chicago; Iraq Museum, Baghdad

three platforms. Each platform's walls angle outward from top to base, probably to prevent rainwater from forming puddles and eroding the mud-brick pavement below. The first two levels of the ziggurat and their retaining walls have been reconstructed in recent times; little remains of the upper level and temple.

Sculpture of this period was associated with religion, and large statues were commonly placed in temples as objects of devotion. A striking lifesize marble face from Uruk may represent a goddess and once have been part of such an image (fig. 2-7). The face would have been attached to a wooden head on a full-size wooden body. Now stripped of its original facial paint, wig, and **inlaid** (set-in) brows and eyes—probably with shell used for the whites and lapis lazuli for the pupils—it is a stark, white mask. Nevertheless, its compelling stare and sensitively rendered features attest to the skill of Sumerian sculptors.

A tall, carved, alabaster vase found near the temple complex, a group of buildings dedicated to a religious purpose, of Inanna at Uruk (fig. 2-8) shows how Near Eastern sculptors of the time—and for the next 2,500 years—told their stories with great economy and clarity by organizing picture space into **registers**, or bands, and condensing the narrative, much as modern comic-strip artists do. Its lower registers show the natural world, including animals

and plants that medical historians have identified as the pomegranate and the now-extinct silphium, plants used by early people both to control fertility and as fertility symbols. Above them, on a solid **groundline**, rams and ewes alternate, facing right. In the top register, Inanna is accepting an offering from a naked priest.

Size was associated with importance in ancient art, a convention known as **hieratic scale**, and the goddess dominates the scene. The **stylized** figures, which do not conform to natural appearances, are shown simultaneously in side or profile view (heads and legs) and in three-quarter view (torsos), which makes both shoulders visible and increases each figure's breadth. Inanna stands in front of her shrine, indicated by two reed door poles hung with banners. Through the doorway her wealth is displayed, and behind the priest come others who bear offerings. The scene is usually interpreted as the ritual marriage between the goddess and a human during the fall New Year's festival, meant to ensure the fertility of crops, animals, and people, and thus the continued survival of Uruk.

Limestone statues dated to about 2900–2600 BCE from ruins of a temple at Eshnunna (modern Tell Asmar, Iraq) reveal another aspect of Mesopotamian religious art (fig. 2-9). These **votive figures**—images dedicated

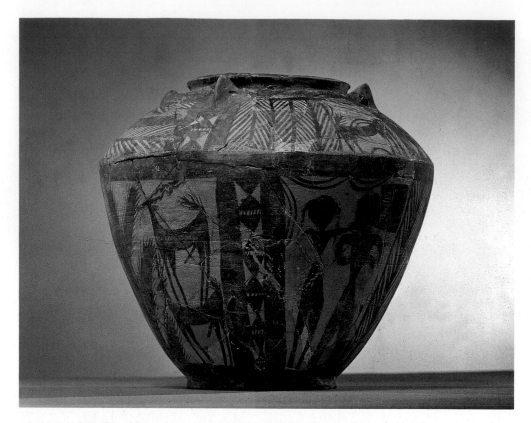

2-10. Scarlet Ware vase, from Tutub (modern Tell Khafajeh, Iraq). c. 3000–2350 BCE. Ceramic, height 11³/4" (30 cm). Iraq Museum, Baghdad

The archaeologist's best friend is the potsherd, or piece of broken pottery. Ceramic vessels are easily broken, but the fragments are almost indestructible. Their earliest appearance at a site marks the time when people in the region began producing ceramics. Pottery styles, like automobile designs and clothing fashions today, change over time. Archaeologists are able to determine the chronological order of such changes. By matching the potsherds excavated at a site with the types in this sequence, they can determine the relative date of the site (see "How Early Art Is Dated," page 54).

to the gods—represent an early example of an ancient Near Eastern religious practice: the placement in a shrine of simple, small statues of individual worshipers before a larger, more elaborate image of a god. Anyone who could afford to might commission a self-portrait and dedicate it to a shrine. A simple inscription might identify the figure as "One who offers prayers." Longer inscriptions might recount in detail all the things the donor had accomplished in the god's honor. Cuneiform texts reveal the importance of approaching a god with an attentive gaze, hence the wide-open eyes seen here. Each sculpture served as a stand-in, at perpetual attention, making eye contact, and chanting its donor's praises through eternity.

The sculptors of the Eshnunna statues followed the conventions of Sumerian art—that is, the traditional ways of representing forms with simplified faces and bodies and dress that emphasized the cylindrical shapes. The figures stand solemnly, hands clasped in respect. As with the face of the woman from Uruk, arched brows inlaid with dark shell, stone, or bitumen once emphasized their huge, staring eyes. The male figures, bare-chested and dressed in sheepskin skirts, are stocky and muscular, with heavy legs, large feet, big shoulders, and cylindrical bodies. The two female figures (the tall, regal woman near the center and the smaller woman at

the far left) have somewhat slighter figures but are just as square-shouldered as the men.

The earliest pottery in the Near East dates to about 7000 BCE. Decorated vessels excavated in large numbers from gravesites provide some sense of the development of pottery styles in various regions. One popular type of Sumerian painted ceramic was Scarlet Ware, produced from around 3000 to 2350 BCE (fig. 2-10). Designs on these vessels, predominantly in red with touches of black, were painted with colored mixtures of clay and water. Circles, herringbones, zigzags, diamonds, and other geometric patterns, as well as animal images, were common motifs. The vase pictured here is about a foot tall and includes human figures, which is unusual.

From about 3000 BCE on, Sumerian artisans worked in various metals, including bronze (see Chapter 1) and precious metals, often combining them with other materials. Many of their metal creations were decorated with—or were in the shape of—animals or composite animal-human-bird creatures. A superb example of their skill is a lyre—a kind of harp—from the tomb of King Abargi of Ur (c. 2685 BCE), which combines wood, gold, lapis lazuli imported from Afghanistan, and shell (fig. 2-11). From one end of the lyre projects the three-dimensional head of a bearded bull, intensely lifelike despite the decoratively patterned blue beard.

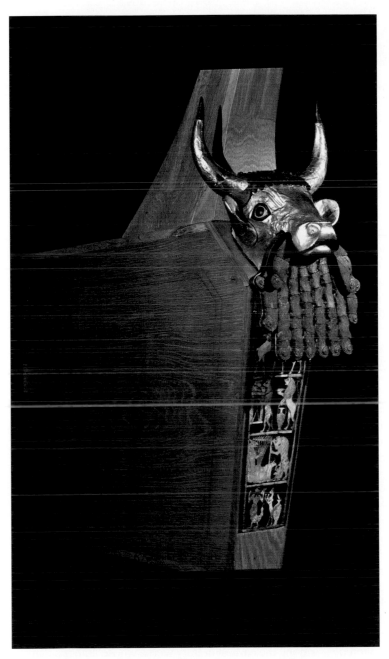

2-11. **Bull lyre**, from the tomb of King Abargi, Ur (modern Muqaiyir, Iraq). c. 2685 BCE. Wood with gold, lapis lazuli, bitumen, and shell, reassembled in modern wood support. University Museum, University of Pennsylvania, Philadelphia

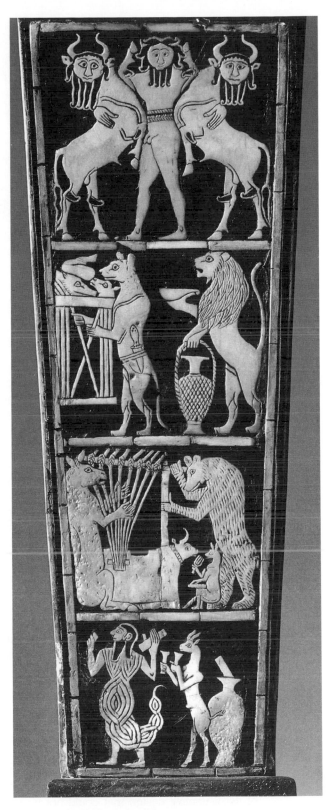

2-12. **Mythological figures**, detail of the sound box of the bull lyre from Ur (fig. 2-11). Wood with shell inlaid in bitumen, 12¼ x 4½" (31.1 x 11 cm)

On the panel below the head, four horizontal registers present scenes executed in shell inlaid in bitumen (fig. 2-12). In the bottom register a scorpion-man holds clappers in his upraised hands. He is attended by a gazelle standing on its hind legs and holding out two tall cups, perhaps filled from the large container from which a ladle protrudes. The scene above this one depicts a trio of animal musicians. A seated donkey plucks the strings of a bull lyre—showing how such instruments were played—while a standing bear braces the instrument's frame and a seated fox plays a small percussion instrument, perhaps a rattle. The next register shows animal

2-13. Cylinder seal from Sumer and its impression. C. 2500 BCE. Marble, height approx. 1¾" (4.5 cm). The Metropolitan Museum of Art, New York

Gift of Walter Hauser, 1955 (55.65.4)

The distinctive design on the stone cylinder seal on the left belonged to its owner, like a coat of arms in the European Middle Ages or a modern cattle-rancher's brand. When rolled across soft clay applied to the closure to be sealed—a jar lid, the knot securing a bundle, or the door to a room—the cylinder left a raised image, or band of repeated raised images, of the design. Sealing discouraged unauthorized people from secretly gaining access to goods or information.

attendants, also walking erect, bringing food and drink for a feast. On the left a hyena assuming the role of a butcher with a knife in its belt carries a table piled high with pork and mutton. A lion follows with a large wine jug and pouring vessel. In the top panel, facing forward, is an athletic man with long hair and a full beard, naked except for a wide belt, who is clasping two rearing human-headed bulls.

Because the lyre and others like it were found in graves and were used in funeral rites, their imagery probably depicts the fantastic realm of the dead, offerings to the goddess of the underworld, or a funeral banquet. The animals shown are the traditional guardians of the gateway through which the newly dead had to pass. Cuneiform tablets preserve songs of mourning from Sumer, which may have been chanted by priests to lyre music at funerals. One begins: "Oh, lady, the harp of mourning is placed on the ground"—and indeed this harp was so placed in a king's grave.

About the time written records appeared, Sumerians developed stamps and seals for identifying documents and establishing property ownership. At first, Sumerians used simple clay stamps with designs **incised** (cut) into one surface to sign documents and to mark the clay sealing container lids and doorways to storage rooms. Pressed against a damp clay surface, the stamp left a mirror image of its distinctive design that could not be easily altered once dry. Around 3400 BCE, temple record keepers redesigned the stamp seal in the form of a cylinder. Sumerian **cylinder seals**, usually less than 2 inches high, were made of a hard stone, such as marble, so that the tiny, elaborate scenes carved into them would not wear away. The scene in figure 2-13 includes rearing lions fighting with a human-headed bull and a stag on the left, and a hunter on the right—perhaps a spoils-of-the-hunt depiction or an example of the Near Eastern practice of showing leaders protecting their people from both human and animal enemies as well as exerting control over the natural world.

AKKAD During Sumerian domination, a people known as the Akkadians settled to the north of Uruk and adopted Sumerian culture. Unlike the Sumerians, the Akkadians spoke a Semitic language (a language in the same family as Arabic and Hebrew). Under the powerful military and political figure Sargon I (ruled c. 2332–2279 BCE), they conquered the Sumerian cities and most of Mesopotamia. For more than half a century, Sargon ruled this empire from his capital at Akkad, whose actual site is yet to be discovered. As "King of the Four Quarters of the World," Sargon assumed broad earthly powers and also elevated himself to the status of a god, a precedent followed by later Akkadian rulers.

Enheduanna, the daughter of Sargon I, was a major public figure who combined the roles of princess, priestess, politician, poet, and prophet and wielded exceptional power. During her lifetime, she was considered the embodiment of the goddess Ningal, wife of the moon god Nanna, and after her death she herself may have been elevated to the status of goddess. She was apparently the only person to hold the office of high priestess for the ziggurats of both Nanna and Anu, Sumer's two most prestigious gods. She began the tradition of princesses serving as high priestesses, and she complemented her father's political consolidation of his empire by uniting religious authority within it. Her hymns in praise of Sargon and Inanna are among the earliest literary works whose author's name is known. She is memorialized on several cylinder seals, as well as on an inscribed alabaster disk that bears her picture (fig. 2-14). The figures carved in **high relief** in a band across the middle of this disk are participating in a ritual at the base of a ziggurat, seen at the far left. A nude priest pours ceremonial liquid from a pitcher onto an offering stand. The tall figure behind him, wearing a flounced robe and priestess's headdress, is presumed to be Enheduanna. She and the two figures to her right, probably priests with shaven heads, each raise one hand in a gesture of reverent greeting. The disk shape of this work is unique and may have to do with its dedication to the moon god.

2-14. ***Disk of Enheduanna***, from Ur (modern Muqaiyir, Iraq). c. 2300 BCE. Alabaster, diameter approx. 10" (25.4 cm). University Museum, University of Pennsylvania, Philadelphia

An inscription on the back of the disk reads: "Enheduanna, priestess of the moon god, [wife] of the moon god, child of Sargon the king of the universe, in Ishtar's temple of Ur she built [an altar] and named it . . . Offering Table of Heaven" (adapted from William W. Hallo, "Enheduanna," *Harvard Magazine*, May–June 1994, page 48).

The concept of imperial authority was literally carved in stone in the *Stele of Naramsin* (fig. 2-15). This 6½-foot-high **stele**, or upright stone slab, commemorates a military victory of Naramsin, Sargon's grandson. It is an early example of a work of art created to celebrate the achievements of an individual ruler. The sculptors used the stele's pointed shape, accommodating the carved mountain, as a dynamic part of the **composition** (the arrangement of elements in the work), but in a sharp break with visual tradition, they replaced the horizontal registers with wavy groundlines. The images stand on their own, with no explanatory inscription, but the god-like king is immediately recognizable. Watched over by three solar deities, symbolized by the rayed suns in the sky, Naramsin ascends a mountain wearing the horned crown associated with deities. He stands at the dramatic center of the scene, closest to the mountaintop, silhouetted against the sky. His greater size is in hieratic relationship to his soldiers, who follow at regular intervals, passing conquered enemy forces sprawled in death or begging for mercy. Both the king and his warriors hold their weapons upright. Although this stele depicts Akkadians in triumph, they managed to dominate the region for only about another half century.

LAGASH About 2180 BCE, the Akkadian Empire fell under attack by the Guti, a mountain people from the northeast. The Guti controlled most of the Mesopotamian plain for a brief time, then the Sumerians regained control of their own region and Akkad. But one large Sumerian city-state remained independent during the period of Guti control: Lagash (modern Telloh, Iraq), on the Tigris River in the southeast, under the ruler Gudea. Gudea built and restored many temples, in which he placed votive statues representing himself as governor and as the embodiment of just rule. The statues are made of diorite, a very hard stone that was difficult to work, prompting sculptors to use compact, simplified forms for the portraits. Twenty of these figures survive, making

2-15. ***Stele of Naramsin***. c. 2254–2218 BCE. Limestone, height 6'6" (1.98 m). Musée du Louvre, Paris

This stele probably came originally from Sippar, an Akkadian city on the Euphrates River, in what is now Iraq. It was not discovered at Sippar, however, but at the Elamite city of Susa (modern Shush, Iran), some 300 miles to the southeast. Raiders from Elam presumably took it there as booty in the twelfth century BCE.

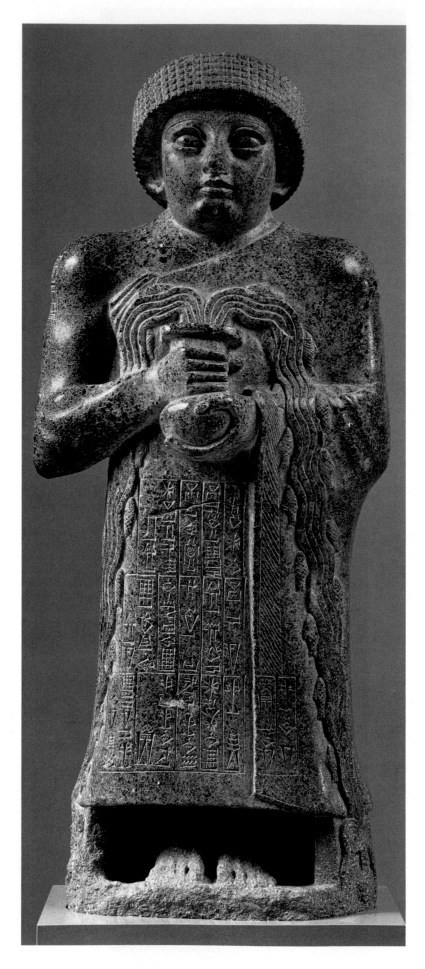

2-16. Votive statue of Gudea, from Lagash (modern Telloh, Iraq). c. 2120 BCE. Diorite, height 29" (73.7 cm). Musée du Louvre, Paris

Gudea's face a familiar one in ancient Near Eastern art.

Images of Gudea present him as a strong, peaceful, pious ruler worthy of divine favor. Whether he is shown sitting or standing, he wears a garment similar to that of the female votive figures from Eshnunna, which provides ample space for long cuneiform inscriptions (fig. 2-16). Here the text relates that Gudea, who holds a vessel from which life-giving water flows in two streams filled with leaping fish, dedicated himself, the statue, and its temple to the goddess Geshtinanna, the divine poet and interpreter of dreams. This imposing statue is **monumental**—that is, it gives an impression of grandeur—although it is only 2½ feet tall. The sculptor's treatment of the human body, as in other Mesopotamian figures, emphasizes its power centers: the eyes, head, and smoothly muscled chest and arms. Gudea's face, below the sheepskin hat, is youthful and serene, and the eyes—oversized and wide open, the better to return the gaze of the deity—express intense concentration.

BABYLON AND MARI

For more than 300 years, periods of political turmoil alternated with periods of stable government in Mesopotamia. The Amorites, a Semitic-speaking people from the Arabian Desert, to the west, eventually reunited Sumer under Hammurabi (ruled 1792–1750 BCE), whose capital city was Babylon and whose subjects were called Babylonians. Among Hammurabi's achievements was a written legal code that listed the laws of his realm and the penalties for breaking them (fig. 2-17, "The Object Speaks").

As kingship and empire became increasingly important, palace architecture overshadowed temple architecture. The great palace of another Amorite king, Hammurabi's contemporary Zimrilim (ruled 1779–1757 BCE), reflects this trend. Zimrilim's capital city, Mari, was strategically located on the Euphrates River about 250 miles northwest of Babylon. It prospered from commercial traffic on the river and was notable for its well-built houses, sophisticated sanitation system, and bronze-working industry. The palace boasted an enormous courtyard paved in alabaster, several temples and shrines, hundreds of other rooms and courtyards, and a notable art collection. Zimrilim and Hammurabi had once been allies, but in 1757 BCE Hammurabi marched against Mari and destroyed Zimrilim's palace. From the palace, a few **murals**—large paintings or decorations affixed directly to the wall—have survived, providing rare examples of a fragile ancient Near Eastern art form.

The subjects of the murals range from geometric patterns decorating the royal family's quarters to military and religious scenes in the administrative areas. One, in the palace's main courtyard, shows Zimrilim receiving his authority from Ishtar, the Babylonian goddess of war,

THE OBJECT SPEAKS

THE CODE OF HAMMURABI

Hammurabi made his capital, Babylon, the intellectual and cultural center of the ancient Near East. One of his greatest accomplishments was the first systematic codification of his people's rights, duties, and punishments for wrongdoing, which was engraved on the *Stele of Hammurabi* (fig. 2-17). This black basalt stele—in effect, a megalith—speaks to us both as a work of art that depicts a legendary event and as a historical document that records a conversation about justice between god and man.

At the top of the stele, we see Hammurabi on a mountaintop, indicated by three flat tiers on which Shamash, the sun god and god of justice, rests his feet. Hammurabi listens respectfully, standing in an attitude of prayer. Shamash sits on a backless throne, dressed in a long flounced robe and crowned by a conical horned cap. Flames rise from his shoulders, and he holds additional symbols of his power—the measuring rod and the rope circle—as he gives the law to the King Hammurabi, the intermediary between the god and the people. From there, the laws themselves flow forth in horizontal bands of exquisitely engraved cuneiform signs. The idea of god-given laws engraved on stone tables is a longstanding tradition in the ancient Near East: in another example, Moses, the Lawgiver of Israel, received the Ten Commandments on two stone tablets from God on Mount Sinai (Exodus 32:19).

A prologue on the front of the stele lists the temples Hammurabi has restored, and an epilogue on the back glorifies Hammurabi as a peacemaker, but most of the stele was clearly intended to ensure uniform treatment of people throughout his kingdom. In the introductory section of the stele's long cuneiform inscription, Hammurabi declared that with this code of law he intended "to cause justice to prevail in the land and to destroy the wicked and the evil, that the strong might not oppress the weak nor the weak the strong." Most of the 300 or so entries that follow deal with commercial and property matters. Only sixty-eight relate to domestic problems, and a mere twenty deal with physical assault.

Punishments are based on the wealth, class, and gender of the parties—the rights of the wealthy are favored over the poor, freemen over slaves, men over women. The death penalty is frequently decreed for crimes such as stealing from a temple or palace, helping a slave to escape, or insubordination in the army. Trial by water and fire could also be imposed, as when an adulterous woman and her lover were to be thrown into the water (those who did not drown were deemed innocent) or a woman who committed incest with her son was to be burned (an incestuous man was only banished). Although some of the punishments seem excessive to us today, we recognize that Hammurabi was breaking new ground in his attempt to create a society regulated by published laws rather than the whims of judges or rulers.

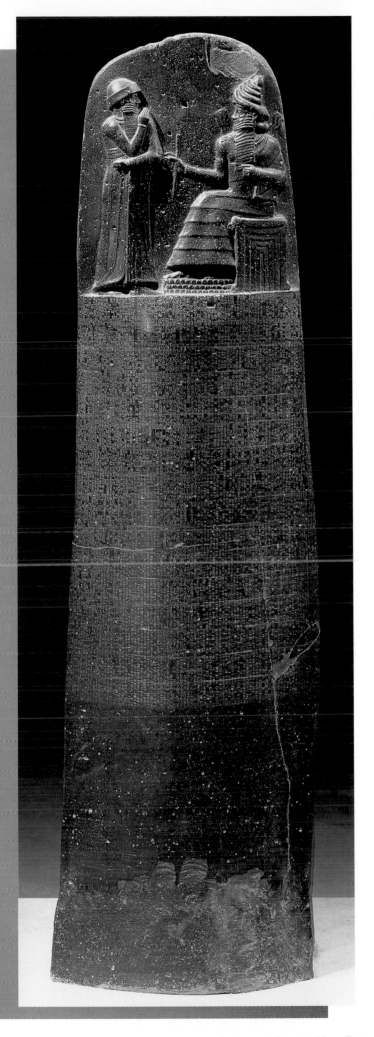

2-17. *Stele of Hammurabi*, from Susa (modern Shush, Iran). c. 1792–1750 BCE. Basalt, height of stele approx. 7' (2.13 m), height of relief 28" (71.1 cm). Musée du Louvre, Paris

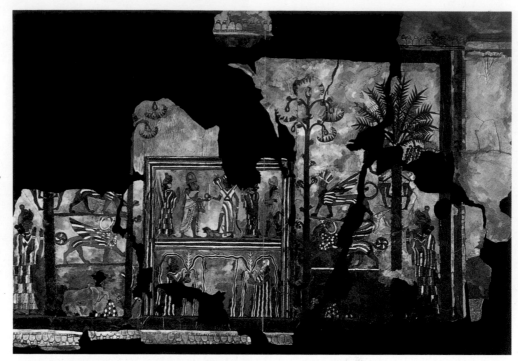

2-18. *Investiture of Zimrilim*, facsimile of a wall painting on mud plaster from the palace at Mari (modern Tell Hariri, Iraq), Court 106. Before c. 1750 BCE. Height 5'5" (1.7 m). Musée du Louvre, Paris

fertility, and love (fig. 2-18). The central panels, devoted to the investiture ceremony, are organized in the formal, symmetrical style familiar in earlier Sumerian art. In the framed upper register, the goddess, holding weapons and resting her foot on a lion—all emblems of power—extends the rod and the ring, symbols of rule, to the king. Below, two goddesses, holding tall plants in red vases, are surrounded by streams of water that flow from the vases—a theme familiar from the Gudea statue (see fig. 2-16). Flanking these two panels are towering aloelike plants with fan-shaped, stylized foliage; three tiers of animals, mythical and otherwise—bulls, winged lions, and crowned, human-headed winged creatures; date palms being climbed by two fruit pickers; and finally two gigantic goddesses, hands raised in approval. Eye-catching checked and striped patterning throughout the mural makes its surface sparkle. The colors have darkened considerably over time, but they probably included blue, orange, red, brown, and white.

ASSYRIA

After centuries of struggle among Sumer, Akkad, Lagash, and Mari in southern Mesopotamia, a people called the Assyrians rose to dominance in northern Mesopotamia. They were very powerful by about 1400 BCE, and after about 1000 BCE they began to conquer neighboring regions. By the end of the ninth century BCE, they controlled most of Mesopotamia, and by the early seventh century BCE they had extended their influence as far west as Egypt. Soon afterward they succumbed to internal weakness and external enemies, and by 600 BCE their empire had collapsed.

Assyrian rulers built huge palaces atop high platforms inside the different fortified cities that served at one time or another as the Assyrian capital. They decorated these palaces with scenes of victorious battles, presentations of tribute to the king, combat between men and beasts, and religious imagery.

During his reign (883–859 BCE), Assurnasirpal II established his capital at Nimrud, on the east bank of the Tigris River, and undertook an ambitious building program. His architects fortified the city with mud-brick walls 5 miles long and 42 feet high, and his engineers constructed a canal that irrigated fields and provided water for the expanded population of the city. According to an inscription commemorating the event, Assurnasirpal gave a banquet for 69,574 people to celebrate the dedication of the new capital in 879 BCE. Most of the buildings in Nimrud were made from mud bricks, but limestone and alabaster—more impressive and durable—were used for architectural decorations. *Lamassu* guardian figures flanked the major portals (see fig. 2-1), and panels covered the walls with scenes carved in low relief of the king participating in religious rituals, war campaigns, and hunting expeditions.

In a vivid lion-hunting scene (fig. 2-19), Assurnasirpal II stands in a chariot pulled by galloping horses and draws his bow against an attacking lion that already has four arrows protruding from its body. Another beast, pierced by arrows, lies on the ground. This was probably a ceremonial hunt, in which the king, protected by men with swords and shields, rode back and forth killing animals as they were released one by one into an enclosed area. The immediacy of this image marks a shift in Mesopotamian art away from a sense of timelessness and toward visual narrative. As in many earlier works, *Assurnasirpal II Killing Lions* shows a man confronting wild beasts. Unlike earlier works, however, the man is not part of nature, standing among animals as their equal, but has assumed dominion over nature. There is no question in this scene who will prevail.

Sargon II (ruled 721–706 BCE) built a new Assyrian capital (fig. 2-20) at Dur Sharrukin (modern Khorsabad, Iraq). At the northwest side, a walled **citadel**, or fortress, containing 200 rooms and thirty courtyards, straddled the

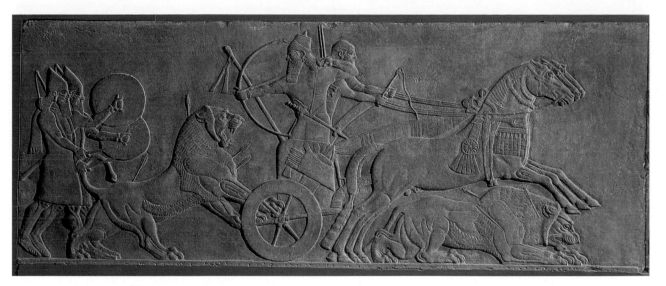

2-19. *Assurnasirpal II Killing Lions*, from the palace complex of Assurnasirpal II, Nimrud, Iraq. c. 850 BCE. Alabaster, height approx. 39" (99.1 cm). The British Museum, London

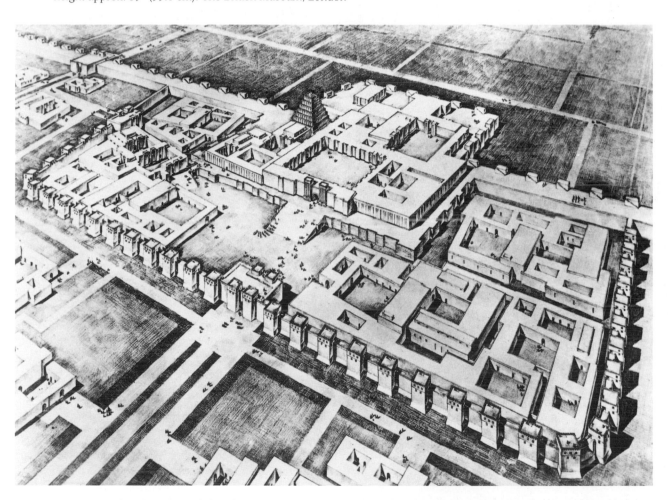

2-20. Reconstruction drawing of the citadel and palace complex of Sargon II, Dur Sharrukin (modern Khorsabad, Iraq). c. 721–706 BCE

city wall. The **palace complex** (the group of buildings where the ruler governed and resided), behind the citadel on a raised, fortified platform about 52 feet high, demonstrates the use of art as propaganda to support political power. Guarded by two towers, it was accessible only by a wide ramp leading up from an open square, around which the residences of important government and religious officials were clustered. Beyond the ramp was the main courtyard, with service buildings on the right and temples on the left. The heart of the palace, protected by a reinforced wall with only two small, off-center doors, lay past the main courtyard. Within the inner compound was a second courtyard, lined with narrative relief panels showing tribute bearers, that functioned as an audience hall. Visitors would have entered the king's throne room from this courtyard through a stone gate flanked by

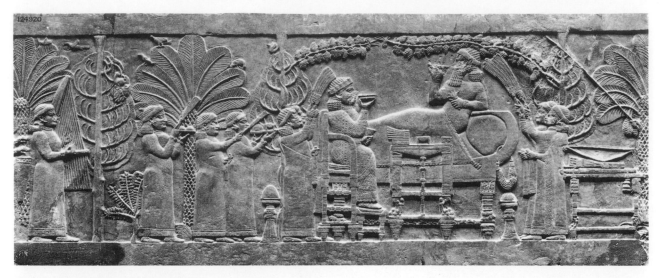

2-21. ***Assurbanipal and His Queen in the Garden***, from the palace at Nineveh (modern Kuyunjik, Iraq). c. 647 BCE. Alabaster, height approx. 21" (53.3 cm). The British Museum, London

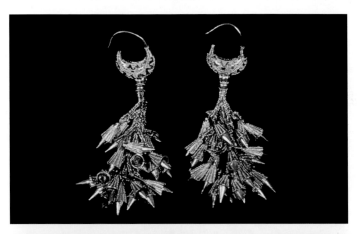

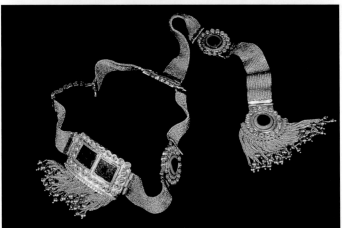

colossal guardian figures even larger than Assurnasirpal's (see fig. 2-1).

The ziggurat at Dur Sharrukin towered in an open space between the temple complex and the palace, declaring the might of Assyria's kings and symbolizing their claim to empire. It probably had seven levels, each about 18 feet high and painted a different color. The four levels still remaining were once white, black, blue, and red. Instead of separate flights of stairs between the levels, a single, squared-off spiral ramp rose continuously along the exterior from the base.

Assurbanipal (ruled 669–c. 627 BCE), king of the Assyrians three generations after Sargon II, established his capital at Nineveh (modern Kuyunjik, Iraq). His palace was decorated with alabaster panels carved with pictorial narratives in low relief. Most show the king and his subjects in battle and hunting, but there are occasional scenes of palace life. One panel shows the king and queen in a pleasure garden (fig. 2-21). The king reclines on a couch, and the queen sits in a chair at his feet. Some servants arrive with trays of food, while others wave whisks to protect the royal couple from insects. This apparently tranquil domestic scene is actually a victory celebration. The king's weapons (sword, bow, and quiver of arrows) are on the table behind him, and the severed head of his vanquished enemy hangs upside down from a tree at the far left. It was common during this period to display the heads and corpses of enemies as a form of psychological warfare, and Assurbanipal's generals would have sent him the head as a trophy.

Although much Assyrian art is relief carving, other arts were developing. One of the most spectacular archaeological finds in the Near East was the discovery, beginning in 1988, of more than a thousand pieces of gold jewelry weighing more than 125 pounds; they were found in three Assyrian royal tombs at Nimrud. The work dates from the ninth and eighth centuries BCE (fig. 2-22).

2-22. Earrings, crown, and rosettes, from the tomb of Queen Yabay, Nimrud, Iraq. Late 8th century BCE. Gold. Iraq Museum, Baghdad

2-23. Reconstruction drawing of Babylon in the 6th century BCE. The Oriental Institute of The University of Chicago

In this view, the palace of Nebuchadnezzar II, with its famous Hanging Gardens, can be seen just behind and to the right of the Ishtar Gate, to the west of the Processional Way. The Marduk Ziggurat looms up in the far distance on the east bank of the Euphrates River. This structure was at times believed to be the biblical Tower of Babel—Bab-il was an early form of the city's name.

The refinement and superb artistry of the crowns, necklaces, bracelets, armbands, ankle bracelets, and other ornaments recovered from these tombs accord with the richly carved surfaces of Assyrian stone sculpture.

NEO-BABYLONIA

At the end of the seventh century BCE, the Medes, a people from Media, now western Iran, and the Scythians (see page 209) from the frigid regions of modern Russia and Ukraine invaded the northern and eastern parts of Assyria. Meanwhile, under a new royal dynasty, the Babylonians reasserted themselves. This Neo-Babylonian kingdom began attacking Assyrian cities in 615 BCE and formed a treaty with the Medes. In 612 BCE, the allied army captured Nineveh. When the dust settled, Assyria was no more. The Medes controlled a swath of land below the Black and Caspian seas, and the Neo-Babylonians controlled a region that stretched from modern Turkey to northern Arabia and from Mesopotamia to the Mediterranean Sea.

The most famous Neo-Babylonian ruler was Nebuchadnezzar II (ruled 604–562 BCE), notorious today for his suppression of the Jews, as recorded in the Hebrew

Bible Book of Daniel. A great patron of architecture, he built temples dedicated to the Babylonian gods throughout his realm and transformed Babylon—the cultural, political, and economic hub of his empire—into one of the most splendid cities of its day. Babylon straddled the Euphrates River, its two sections joined by a bridge. The older, eastern sector was traversed by the Processional Way, the route taken by religious processions honoring the city's patron god, Marduk (fig. 2-23). This street of large stone slabs set in a bed of bitumen was up to 66 feet wide at some points. It ran from the Euphrates bridge past the temple district and palaces to end at the Ishtar Gate, the ceremonial entrance to the city. The walls on either side of the route were faced with dark blue bricks that were **glazed**—a film of glass placed over the bricks was fired in a process that had begun about 1600 BCE. Against that blue background, specially molded turquoise, blue, and gold-colored bricks formed images of striding lions, symbols of the goddess Ishtar. The walls and towers along the Processional Way were topped with notches, or **crenellation**.

The double-arched Ishtar Gate, a symbol of Babylonian power, was guarded by four crenellated towers. It is decorated with tiers of the dragons sacred to Marduk and the

2-24. Ishtar Gate and throne room wall, from Babylon (Iraq). c. 575 BCE. Glazed brick, height originally 40' (12.2 m) with towers rising 100' (30.5 m). Vorderasiatisches Museum, Staatliche Museen zu Berlin, Preussischer Kulturbesitz

bulls with blue horns and tails associated with other deities. Now reconstructed inside one of the Berlin State Museums, the Ishtar Gate is installed next to a panel from the throne room in Nebuchadnezzar's nearby palace (fig. 2-24). In this fragment, lions walk beneath stylized palm trees. Among Babylon's other marvels—none of which survives—were the city's walls, its fabled terraced and irrigated Hanging Gardens (see "The Seven Wonders of the World," page 104), and the Marduk Ziggurat. All that remains of this ziggurat, which ancient documents describe as painted white, black, crimson, blue, orange, silver, and gold, is the outline of its base and traces of the lower stairs.

Outside of Mesopotamia, other cultures—those in Elam, Anatolia, and Persia among them—developed and flourished. Each had an impact on Mesopotamia before one of them, Persia, eventually overwhelmed it.

ELAM

The strip of fertile plain known as Elam, between the Tigris River and the Zagros Mountains to the east (in present-day Iran), was a flourishing farming region by 7000 BCE. About this time, the city of Susa, later the capital of an Elamite kingdom, was established on the Shaur River. Elam had close cultural ties to Mesopotamia, but the two regions were often in conflict. In the twelfth century BCE, Elamite invaders looted art treasures from Mesopotamia and carried them back to Susa (see "Protection or Theft?," below).

About 4000 BCE, Susa was a center of pottery production. Twentieth-century excavations there uncovered nearly 8,000 finely formed and painted vessels (beakers, bowls, and jars), as well as coarse domestic **wares**. The fine wares have thin, fragile shells that suggest they were not meant for everyday use. Decorations painted in brown glaze on pale yellow clay are sometimes purely geometric but are more often a graceful combination of geometric designs and stylized natural forms, mainly from the animal world, expertly balanced between repetition and variation.

2-25. **Beaker**, from Susa (modern Shush, Iran). c. 4000 BCE. Ceramic, painted in brown glaze, height 11¼" (28.6 cm). Musée du Louvre, Paris

One handleless cup, or beaker, nearly a foot tall and weighing about 8 pounds, presents a pair of ibexes (only one of which is visible here) that has been reduced to pure geometric form (fig. 2-25). On each side, the great

PROTECTION OR THEFT?

Some of the most bitter resentments spawned by war—whether in Mesopotamia in the twelfth century BCE or in our own time—have involved the "liberation" by the victors of objects of great value to the people from whom they were taken. Museums around the world hold works either snatched by invading armies or acquired as a result of conquest. Two historically priceless objects unearthed in Elamite Susa, for example—the Akkadian *Stele of Naramsin* (see fig. 2-15) and the Babylonian *Stele of Hammurabi* (see fig. 2-17)—were not Elamite at all but were Mesopotamian. Both had been brought there as military trophies by an Elamite king, who added an inscription to the *Stele of Naramsin*

explaining that he had merely "protected" it.

The same rationale has been used in modern times to justify the removal of countless works from their cultural contexts. The Rosetta Stone, the key to the modern decipherment of Egyptian hieroglyphics, was discovered in Egypt by French troops in 1799, fell into British hands when they forced the French from Egypt, and ultimately ended up in the British Museum in London (see page 190). In the early nineteenth century, the British Lord Elgin removed renowned Classical Greek reliefs from the Parthenon in Athens with the blessing of the Ottoman authorities who governed Greece at the time (see fig. 5-42). Although his actions may indeed have protected the reliefs

from neglect and the ravages of the Greek war of independence, they have remained installed, like the Rosetta Stone, in the British Museum (see page 111), despite continuing protests from Greece. The Ishtar Gate from Babylon (see fig. 2-24) is now in a museum in Germany. Many German collections include works that were similarly "protected" at the end of World War II and are surfacing now. In the United States, Native Americans are increasingly vocal in their demands that artifacts and human remains collected by anthropologists and archaeologists be returned to them. "To the victor," it is said, "belong the spoils." It continues to be a matter of passionate debate whether this notion is appropriate in the case of revered cultural artifacts.

THE FIBER ARTS Fragments of fired clay impressed with cloth have been dated to 25,000 BCE, showing that fiber arts, including various weaving and knotting techniques, vie with ceramics as the earliest evidence of human creative and technical skill. Since prehistoric times, weaving appears to have been women's work—probably because women, with primary responsibility for child care, could spin and weave in the home no matter how frequently they were interrupted by the needs of their families. Men as shepherds and farmers produced the raw materials for spinning and as merchants distributed the fabrics not needed by the family. Early Assyrian cuneiform tablets preserve the correspondence between merchants traveling by caravan and their wives, who were running the production end of the business back home and complaining about late payments and changed orders. It is no coincidence that the *Woman Spinning* (see fig. 2-26) is a woman.

The production of textiles is complex. First, thread must be produced: fibers gathered from plants (such as flax for linen cloth or hemp for rope) or from animals (wool from sheep, goats, and camels or hair from humans and horses) are cleaned, combed, and sorted. Only then can they be twisted and drawn out under tension—that is, spun—into the long, strong, flexible fibers needed for textiles or cords. Spinning tools include a long, sticklike spindle to gather the spun fibers, a whorl (weight) to help rotate the spindle, and a distaff (a word still used to describe women and their work) to hold the raw materials. Because textiles are fragile and rapidly decompose, the indestructible stone or fired-clay spindle whorls are usually the only surviving evidence of thread making.

Weaving begins on a loom. Warp threads are laid out at right angles to weft threads, which are passed over and under the warp. In the earliest, vertical looms, warp threads hung from a beam, their tension created either by wrapping them around a lower beam (a tapestry loom) or by tying them to heavy stones (a warp-weighted loom, such as the woman from Susa would have used). Although weaving was usually a home industry, in palaces and temples slave women staffed large shops, specializing as spinners, warpers, weavers, and finishers.

The fiber arts also include various nonweaving techniques—cording for ropes and strings; netting for traps, fish nets, and hair nets; knotting for macramé and carpets; sprang (a looping technique like cat's cradle); and single-hook work or crocheting (knitting with two needles came relatively late).

Early fiber artists depended on the natural color of their materials and on natural dyes from the earth (ochers) and from plants (madder for red, woad, an herb, and indigo for blue, and safflower and saffron crocus for yellow). The ancients combined color and techniques to create a great variety of fiber arts: Egyptians seem to have preferred white linen for their garments, elaborately folded and pleated. Minoans created multicolored patterned fabrics with fancy edgings. Greeks perfected pictorial tapestries. The people of the ancient Near East used woven and dyed patterns and also developed knotted pile (the so-called Persian carpet) and felt (a cloth of fibers bound by heat and pressure, not spinning, weaving, or knitting).

sweep of the animals' horns encloses a small circular motif, or **roundel**, containing what might be a leaf pattern or a line of birds in flight. A narrow band above the ibexes shows short-haired, long-nosed dogs at rest. In the wide top band, stately wading birds stand motionless.

Susa's ingenious artisans produced a gray bitumen-based compound that could be molded while soft and carved when hard. From this compound, which still defies laboratory analysis, they made a variety of practical and decorative objects. An especially fine example shows an important-looking woman adorned with many ornaments (fig. 2-26). Her hair is elegantly styled, and her garment has a patterned border. She sits barefoot and cross-legged on a lion-footed stool covered with sheepskin, spinning thread with a large spindle (see "The Fiber Arts," above). A fish lies on an offering stand in front of her, together with six round objects (perhaps fruit). A young servant stands behind the woman, fanning her. At the lower right-hand corner of the fragment is what appears to be a portion of a long, flounced garment such as deities are frequently shown wearing, which might indicate the presence of a god or goddess to whom the offering is being made.

ANATOLIA

Anatolia, before the rise of the Assyrians, had been home to several independent cultures that resisted Mesopotamian domination. The most powerful of them was the Hittite civilization, whose founders had moved into the mountains and plateaus of central Anatolia from the east. They established their capital at Hattushash (near modern Boghazkeui, Turkey) about 1600 BCE. It was destroyed about 1200 BCE. Through trade and conquest, the Hittites created an empire that stretched along the coast of the Mediterranean Sea in the area of modern Syria and Lebanon, bringing them into conflict with the Egyptian Empire, which was expanding into the same region from the south (Chapter 3). They also made incursions into Mesopotamia.

The Hittites were apparently the first people to work in iron, which they used for war chariot fittings and weapons for soldiers, sickles and plowshares for farmers, and chisels and hammers for sculptors and masons. They are noted for the artistry of their fine metalwork and for their imposing palace citadels with double walls and fortified gateways.

The foundations and base walls of the Hittite stronghold at Hattushash, which date to about 1400–1300 BCE, were constructed of stone supplied from local quarries, but the upper walls, stairways, and walkways were finished in brick. The blocks of stone used to frame doorways were decorated in high relief with a variety of guardian figures—some of them 7-foot-tall, half-human-half-animal creatures, others naturalistically rendered animals like the lions shown here (fig. 2-27). These sculpted figures were part of the building, and the

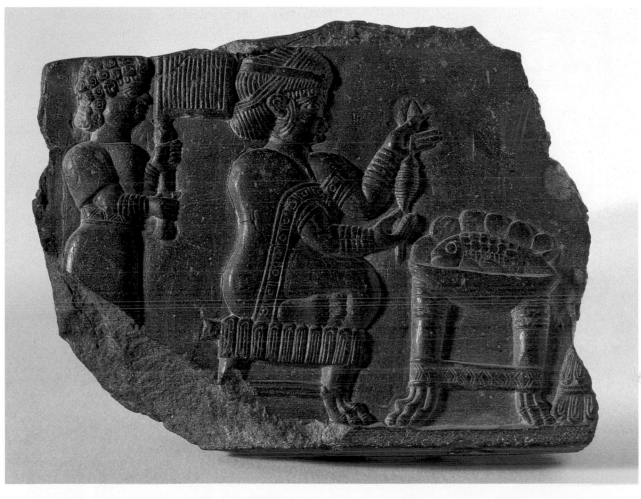

2-26. *Woman Spinning*, from Susa (modern Shush, Iran). c. 8th–7th century BCE. Bitumen compound, 3⅝ x 5⅛" (9.2 x 13 cm). Musée du Louvre, Paris

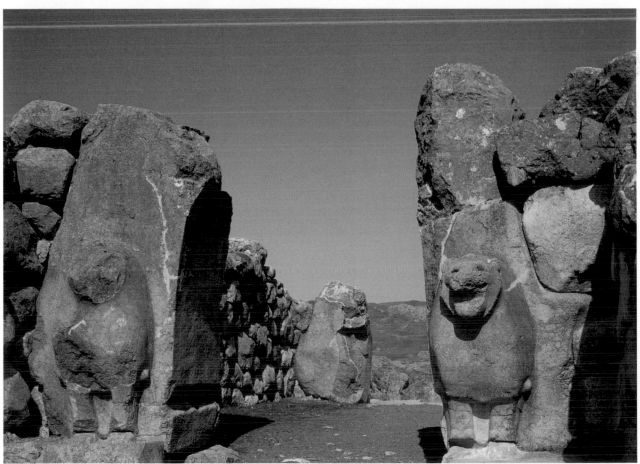

2-27. Lion Gate, Hattushash (near modern Boghazkeui, Turkey). c. 1400 BCE. Limestone

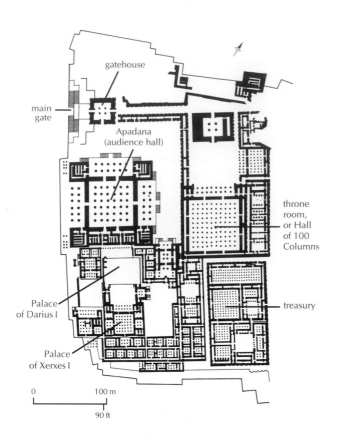

gatehouse

main gate

Apadana (audience hall)

throne room, or Hall of 100 Columns

Palace of Darius I

Palace of Xerxes I

treasury

0 100 m

90 ft

2-28. Plan of the ceremonial complex, Persepolis, Iran. 518–c. 460 BCE

boulders-becoming-creatures on the so-called Lion Gate harmonize with the colossal scale of this construction. Despite extreme weathering, the lions have endured over the millennia and still possess a sense of vigor and permanence.

PERSIA In the sixth century BCE, the Persians, a formerly nomadic, Indo-European–speaking people related to the Medes, began to seize power. From the region of Parsa, or Persis (modern Fars, Iran) southeast of Susa, they eventually overwhelmed Mesopotamia and the rest of the ancient Near East and established a vast empire. The rulers of this new empire traced their

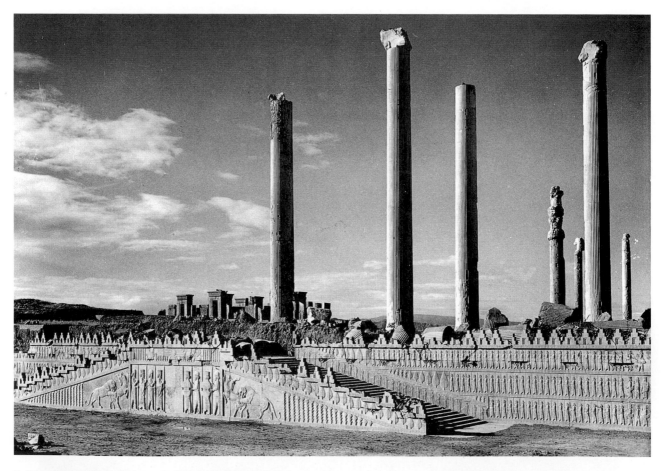

2-29. Apadana (audience hall) of Darius and Xerxes, ceremonial complex, Persepolis, Iran. 518–c. 460 BCE

The central stair displays reliefs of animal combat and tiered ranks of royal guards, the "10,000 Immortals," and delegations of tribute bearers. The figures cover the walls with repeated patterns. Unlike the bellicose Assyrian reliefs, however, Persian sculpture emphasizes the extent of the empire and the economic prosperity under Persian rule. The elegant drawing, calculated compositions, and sleek modeling of figures reflect the Persians' knowledge of Greek art and perhaps the use of Greek artists.

ancestry to a semilegendary Persian king named Achaemenes and consequently are known as the Achaemenids. Their dramatic expansion began in 559 BCE with the ascension of a remarkable leader, Cyrus II (called the Great, ruled 559–530 BCE). By the time of his death the Persian Empire included Babylonia; Media, which stretched across present-day northern Iran through Anatolia; and some of the Aegean islands far to the west. Conquests continued, and when Darius I (ruled 521–486 BCE), the son of a government official, took the throne, he could proclaim: "I am Darius, great King, King of Kings, King of countries, King of this earth."

Darius, like many powerful rulers, created monuments as visible symbols of his authority. He made Susa his first capital and commissioned a 32-acre administrative compound to be built there. In about 518 BCE, he began construction of Parsa, a new capital in the Persian homeland in the Zagros highlands. Today this city, known as Persepolis, the name the Greeks gave it, is one of the best-preserved ancient sites in the Near East (fig. 2-28). Darius imported materials, workers, and artists from all over his empire for his building projects. He even ordered work to be executed in Egypt and transported to his capital. The result was a new style of art that combined many different cultural traditions, including Persian, Mede, Mesopotamian, Egyptian, and Greek. This artistic integration reflects Darius's far-reaching political strategy.

In Assyrian fashion, the imperial complex at Persepolis was set on a raised platform and laid out on a rectangular **grid**, or system of crossed lines. The platform was 40 feet high and measured 1,500 by 900 feet. It was accessible only from a single ramp made of wide, shallow steps that allowed horsemen to ride up rather than dismount and climb on foot. Darius lived to see the erection of only a treasury, the Apadana (audience hall), and a very small palace for himself on the platform. The Apadana, set above the rest of the complex on a second terrace (fig. 2-29), had open porches on three sides and a square hall large enough to hold several thousand people. Darius's son Xerxes I (ruled 485–465 BCE) added a sprawling palace complex for himself, enlarged the treasury building, and began a vast new public reception space, the Hall of 100 Columns.

Sculpture at Persepolis displayed the unity and economic prosperity of the empire rather than the heroic exploits of its rulers. In a central relief, Darius holds an audience while his son and heir, Xerxes, listens from

TECHNIQUE
COINING MONEY

Long before the invention of coins, people used gold, silver, bronze, and copper as mediums of exchange, but each piece had to be weighed to establish its exact value. The Lydians of western Anatolia began to produce metal coins in standard weights in the seventh century BCE, adapting the seal—a Sumerian invention—to designate their value. Until about 525 BCE, coins bore an image on one side only. The beautiful early coin here, minted during the reign of the Lydian king Croesus (ruled 560–546 BCE), is stamped with the heads and forelegs of a bull and lion in low relief. The reverse has only a squarish depression left by the punch used to force the metal into the mold.

To make two-faced coins, the ancients used a punch and anvil, each of which held a die, or mold, incised with the design to be impressed in the coin. A metal blank weighing the exact amount of the denomination was placed over the anvil die, containing the design for the "head" (obverse) of the coin. The punch, with the die of the "tail" (reverse) design, was placed on top of the metal blank and struck with a mallet. Beginning in the reign of Darius I, kings' portraits appeared on coins, proclaiming the ruler's control of the coin of the realm—a custom that has continued throughout the world in coins such as the American Lincoln pennies and Roosevelt dimes. Because we often know approximately when ancient monarchs ruled, coins discovered in an archaeological excavation help to date the objects around them.

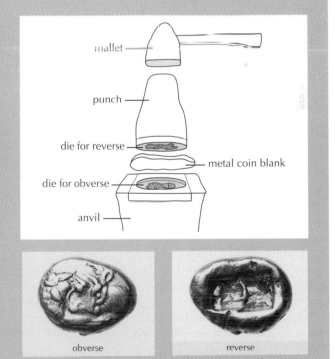

Front and back of a gold coin first minted under Croesus, king of Lydia. 560–546 BCE. Heberden Coin Room, Ashmolean Museum, Oxford

2-30. *Darius and Xerxes Receiving Tribute*, detail of a relief from the stairway leading to the Apadana, ceremonial complex, Persepolis, Iran. 491–486 BCE. Limestone, height 8'4" (2.54 m). Iranbastan Museum, Teheran

behind the throne (fig. 2-30). Such panels would have looked quite different when they were freshly painted in rich tones of deep blue, scarlet, green, purple, and turquoise, with metal objects such as Darius's crown and necklace covered in **gold leaf**, sheets of hammered gold.

The Persians' decorative arts—including ornamented weapons, domestic wares, horse trappings, and jewelry—demonstrate high levels of technical and artistic sophistication. The Persians also created a refined coinage, with miniature low-relief portraits of rulers, so that coins, in addition to their function as economic standards, served as propaganda, carrying the ruler's portrait throughout the empire. The Persians had learned to mint standard coinage from the Lydians of western Anatolia after Cyrus the Great defeated Lydia's fabulously wealthy King Croesus in 546 BCE (see "Coining Money," page 89). Croesus's wealth—the source of the lasting expression "rich as Croesus"—had made Lydia an attractive target for an aggressive empire builder like Cyrus. A Persian coin, the gold daric, named for Darius and first minted during his regime (fig. 2-31), is among the most valuable coins in the world today. Commonly called an "archer," it shows the well-armed emperor wearing his crown and carrying a lance in his right hand; he lunges forward as if he had just let fly an arrow from his bow.

At its height, the Persian Empire extended from Africa to India. From their spectacular capital, Darius in 490 BCE and Xerxes in 480 BCE sent their armies west to conquer Greece, but mainland Greeks successfully resisted the armies of the Achaemenids, preventing them from advancing into Europe (Chapter 5). And it was a Greek who ultimately put an end to their empire. In 334 BCE, Alexander the Great of Macedonia crossed into Anatolia

2-31. **Daric**, a coin first minted under Darius I of Persia. 4th century BCE. Gold. Heberden Coin Room, Ashmolean Museum, Oxford

and swept through Mesopotamia, defeating Darius III and nearly laying waste the magnificent Persepolis in 331 BCE. Although the Persian Empire was at an end, the art style unified there during the Achaemenid period clearly shows its links with Greece as well as with Egypt, which may have been heavily influenced by Mesopotamian culture.

PARALLELS

CULTURES	ART IN THE ANCIENT NEAR EAST	ART IN OTHER CULTURES
EARLY NEOLITHIC c. 9000 BCE–	**2-3. Ain Ghazal figure** (c. 7000–6000) **2-4. Chatal Huyuk shrine** (c. 6500–5500)	
ELAM c. 7000–600 BCE	**2-26. *Woman Spinning*** (c. 8th–7th century) **2-25. Susa beaker** (c. 4000)	**1-14. *Women and Animals*** (c. 4000–2000), Spain
SUMER c. 3500–2340 BCE	**2-7. Uruk woman** (c. 3500–3000) **2-8. Uruk vase** (c. 3500–3000) **2-5. Anu Ziggurat** (c. 3100) **2-10. Scarlet Ware** (c. 3000–2350) **2-9. Votive statues** (c. 2900–2600) **2-11. Bull lyre** (c. 2685) **2-13. Sumerian cylinder seal** (c. 2500)	**1-19. Stonehenge** (c. 2750–1500), England **3-10. Great Pyramids** (c. 2613–2494), Egypt **10-3. *Cong* deity** (before 3000), China
AKKAD c. 2340–2180 BCE	**2-14. *Disk of Enheduanna*** (c. 2300) **2-15. *Stele of Naramsin*** (c. 2254–2218)	**4-3. Cycladic figure** (c. 2500–2200), Greece
LAGASH c. 2150 BCE	**2-16. Gudea** (c. 2120)	
BABYLONIA, MARI c. 1792–1750 BCE	**2-17. *Stele of Hammurabi*** (c. 1792–1750) **2-18. *Investiture of Zimrilim*** (before c. 1750)	**13-1. *Cattle Gathered next to a Group of Huts*** (c. 2500–1500), Africa
HITTITE (ANATOLIA) c. 1600–1200 BCE	**2-27. Lion Gate** (c. 1400)	**4-19. Funerary mask** (c. 1600–1550), Greece **3-38. *Nefertiti*** (c. 1348–1335/6), Egypt
ASSYRIA c. 1000–612 BCE	**2-19. *Assurnasirpal II*** (c. 850) **2-1. *Lamassu*** (883–859) **2-20. Dur Sharrukin complex** (c. 721–706) **2-21. *Assurbanipal and Queen*** (c. 647)	**5-5. Dipylon vase** (c. 750), Greece
NEO-BABYLONIA c. 612–539 BCE	**2-24. Ishtar Gate** (c. 575)	**5-26. *Suicide of Ajax*** (c. 540), Greece
PERSIA c. 559–331 BCE	**2-29. Apadana of Darius and Xerxes** (518–c. 460) **2-30. *Darius and Xerxes Receiving Tribute*** (491–486) **2-31. Daric Persian coin** (4th century)	**5-18. *Anavysos Kouros*** (c. 525), Greece **5-39. Acropolis** (447–438), Greece

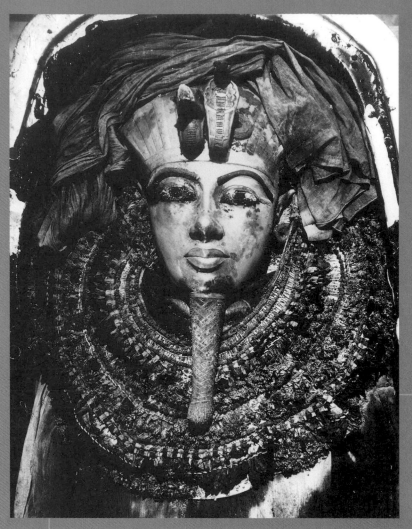

3-1. Funerary mask of Tutankhamun
(Dynasty 18, ruled c. 1336–1327 BCE), from the tomb of Tutankhamun, Valley of the Kings, Deir el-Bahri, photographed the day it was discovered—October 28, 1925

On February 16, 1923, *The Times* of London cabled *The New York Times* with intriguing archaeological news: "This has been, perhaps, the most extraordinary day in the whole history of Egyptian excavation. Whatever one may have guessed or imagined of the secret of Tut-ankh-Amen's tomb, they [sic] surely cannot have dreamed the truth as now revealed. The entrance today was made into the sealed chamber of the tomb of Tut-ankh-Amen, and yet another door opened beyond that. No eyes have seen the King, but to practical certainty we know that he lies there close at hand in all his original state, undisturbed." And indeed he did. A collar of dried flowers and beads covered the chest portion of the mask, and a linen scarf was draped around the head (figs 3-1, 3-2). The mask had been placed over the upper part of the young king's mummified body, which was enclosed in three coffins nested like a set of Russian dolls. These coffins were placed in a quartzite box that was itself encased within three gilt wooden shrines, each larger than the last. The innermost coffin, made of solid gold, is illustrated in figure 3-41. Tutankhamun's burial chamber was not the only royal tomb to survive unpillaged to the twentieth century, but it is by far the richest find.

Since ancient times, tombs have tempted looters, driven by simple greed; more recently, they also have attracted archaeologists and historians, motivated by scholarly interest. The first large-scale "archaeological" expedition in history landed in Egypt with the armies of Napoleon in 1798. The French commander, who went to investigate digging a canal between the Mediterranean and Red seas, clearly sensed that he might find great riches sheltered there, for he took with him some 200 French scholars to study ancient sites. Napoleon's military adventure ended in failure, but his scholars eventually published thirty-six richly illustrated volumes of their findings, unleashing a craze for all things Egyptian.

Popular fascination with this ancient African culture has not dimmed since Napoleon's time. Newspaper headlines around the world continue to herald major archaeological findings there, such as the 1995 discovery of a huge, unlooted burial complex near Thebes believed to hold the remains of many of Rameses II's fifty-two sons. In September 2000, Egyptian archaeologists again made the front pages of the world's newspapers when they announced the spectacular discovery of more than a hundred mummies—some from about 500 BCE and most from the time of the Roman occupation of Egypt—in a huge burial site about 230 miles southwest of Cairo. Called the Valley of the Golden Mummies, the cemetery was first published in 1999 when 105 mummies were discovered in the first four tombs to be opened. The director of excavations for the government of Egypt, Dr. Zahi Hawass, believes that as many as 10,000 mummies will eventually come to light from the Valley.

3
Art of Ancient Egypt

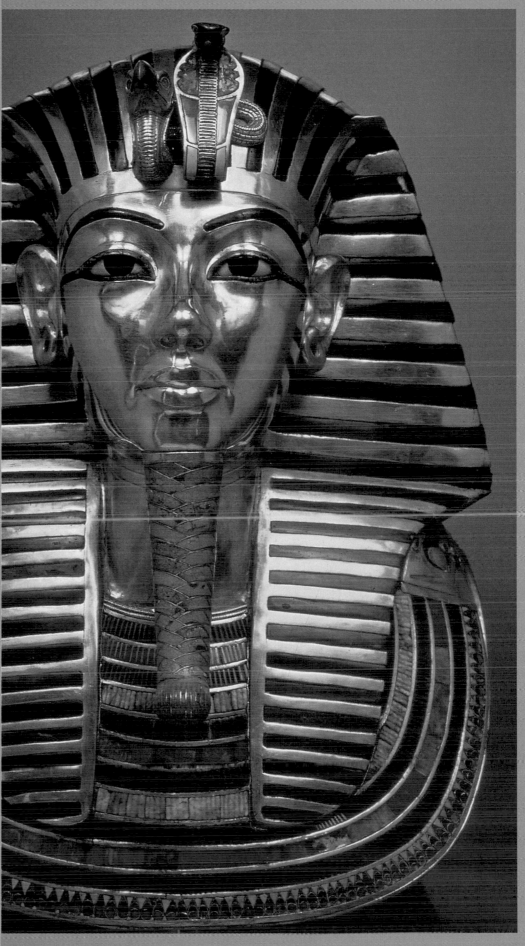

3-2. Funerary mask of Tutankhamun
Dynasty 18, c. 1327 BCE. Gold inlaid with glass and semiprecious
stones. Height 21¼" (54.5 cm). Egyptian Museum, Cairo

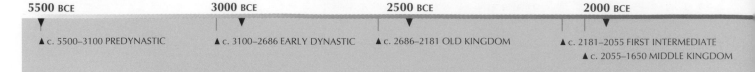

TIMELINE 3-1. **Ancient Egypt.** Neolithic culture began in ancient Egypt about 5500 BCE. The country was unified about 3100 BCE by the legendary King Narmer, who founded the first of the thirty dynasties established before the end of the Late Period, in 332 BCE, when Egypt was occupied by Ptolemaic Greek, then Roman rulers.

MAP 3-1. **Ancient Egypt.**
About 3150 BCE the legendary King Menes united Upper (southern) Egypt and Lower (northern) Egypt.

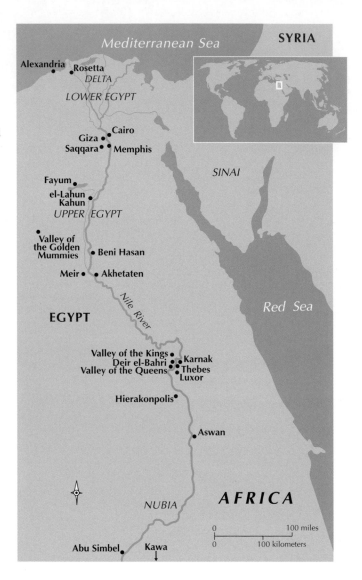

NEOLITHIC AND PREDYNASTIC EGYPT

The Greek traveler and historian Herodotus, writing in the fifth century BCE, remarked that "Egypt is the gift of the Nile." This great river, the longest in the world, winds northward from equatorial Africa and flows through Egypt in a relatively straight line to the Mediterranean (Map 3-1). There it forms a broad delta before emptying into the sea. Before it was dammed in the twentieth century CE at Aswan, the lower (northern) Nile, swollen with the runoff of heavy seasonal rains in the south, overflowed its banks for several months each year. Every time the floodwaters receded, they left behind a new layer of rich silt, making the valley and delta a fertile and attractive habitat for early people.

By about 8000 BCE, the valley's inhabitants had become relatively sedentary, living off the abundant fish, game, and wild plants. Not until about 5500 BCE did they adopt the agricultural, village life associated with Neolithic culture (Chapter 1). At that time, the climate of North Africa grew increasingly dry. To ensure an adequate supply of water, the early agriculturalists along the Nile cooperated to control the river's flow. As in Mesopotamia, this common challenge led riverside settlements to form alliances, and, over time, these rudimentary federations expanded by conquering and absorbing weaker communities. By about 3500 BCE, there were several larger states, or chiefdoms, in the lower Nile Valley.

The Predynastic period, roughly 5500 to 3100 BCE (Timeline 3-1), saw significant social and political transition

1500 BCE	1000 BCE	500 BCE	1 CE	500 CE

▲ c. 1650–1550 SECOND INTERMEDIATE ▲ c. 1069–747 THIRD INTERMEDIATE ▲ c. 332–30 PTOLEMAIC
 ▲ c. 1550–1069 NEW KINGDOM ▲ c. 747–332 LATE PERIOD ▲ c. 30 BCE–395 CE ROMAN

preceding the unification of Egypt under a single ruler and the formation of dynasties, in which members of the same family inherited Egypt's throne. During this period, a new dimension of leadership emerged, and political control was bolstered by the rulers' claims of divine powers. Their subjects, in turn, expected such leaders to protect them not only from outside aggression but also from natural catastrophes such as droughts and insect plagues. A royal ritual, the *heb sed* or *sed* festival, held in the thirtieth year of the living king's reign, was thought to renew and reaffirm his power. As part of the ceremony, the king ran a race on a specially built track to demonstrate his physical fitness. Then, enthroned and wearing the *sed* robe, he received his courtiers while the gods wished him "life, stability, dominion, and happiness."

The surviving art of the Predynastic period consists chiefly of ceramic figurines, decorated pottery, and reliefs carved on stone plaques and pieces of ivory. A few examples of Predynastic wall painting—lively scenes filled with small figures of people and animals—were found in what was either a temple or a tomb at Hierakonpolis, in Upper Egypt. This Predynastic town of mud-brick houses distributed over about 100 acres was once home to as many as 10,000 people.

A buff-colored pottery jar found at Hierakonpolis, dating from about 3500–3400 BCE, is decorated with a dark reddish brown river scene (fig. 3-3). Zigzags around the jar's mouth symbolize the waters of the Nile, upon which floats a boomerang-shaped boat with two deck cabins and palm fronds affixed to a pole on the prow. A row of vertical strokes along the bottom of the hull represents oars. These lines and strokes are a kind of **abstract** visual shorthand. We recognize what they stand for even though the forms they represent are simplified to their essence. Two figures of nearly equal size, a man and a woman, stand on the roof of the cabin on the left. The woman arches her long arms over her head in a gesture that may be an expression of mourning, while the man beside her and a smaller figure atop the other cabin reach out toward her. Perhaps this is a funeral barge.

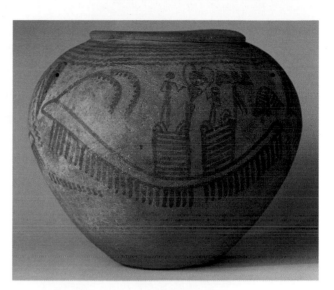

3-3. Jar with river scene, from Hierakonpolis. Predynastic, c. 3500–3400 BCE. Painted clay, 7 x 8¼" (17.5 x 20.9 cm). The Brooklyn Museum
Excavations of H. deMorgan 1907–8 (09.889.400)

chronological list of Egypt's rulers since the most ancient times. He grouped the kings into dynasties and included the length of each king's reign. Although scholars do not agree on all the dates, this dynastic chronology is still the accepted guide to ancient Egypt's long history. Manetho listed thirty dynasties that ruled the country between about 3100 and 332 BCE, when Egypt was conquered by the Greeks. Egyptologists have grouped these dynasties into larger periods reflecting broad historical developments from the Predynastic period through the New Kingdom (ending 1069 BCE). The dating system and the spelling of Egyptian names and places used in this book are those followed by the British Museum.

RELIGIOUS BELIEFS

Herodotus thought the Egyptians the most religious people he had ever encountered. Religious beliefs permeate Egyptian art of all periods, so we need some knowledge of them to understand the art.

Egypt's rulers were divine kings, sons of the sun god Ra (or Re). They rejoined their father at death and rode with him in the solar boat as it made its daily journey across the sky. Egyptians considered their kings to be their link to the invisible gods of the universe. To please the gods and ensure their continuing goodwill toward the state, Egypt's kings built them splendid temples and provided for priests to maintain them. The priests saw to it that statues of the gods, placed deep in the innermost rooms of their temples, were never without fresh food and clothing. The many gods and goddesses were depicted in various forms, some as human beings, others as animals, and still others as humans with animal

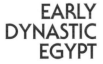

EARLY DYNASTIC EGYPT About 3100 BCE, Egypt became a consolidated state. According to legend, the country had previously evolved into two major kingdoms—the Two Lands—Upper Egypt in the south and Lower Egypt in the north. A powerful ruler from Upper Egypt, referred to in an ancient document as "Menes king–Menes god," finally conquered Lower Egypt and merged the Two Lands into a single kingdom. Modern Egyptologists, experts on the history and culture of ancient Egypt, suspect that the unification process was more gradual than the legend would have us believe.

In the third century BCE, an Egyptian priest and historian named Manetho used temple records to compile a

EGYPTIAN SYMBOLS

Symbolic of kingship, the crowned figure is everywhere in Egyptian art. Another pervasive image is the cobra, "she who rears up," which was equated with the sun, the king, and some deities and often included in headdress.

The god Horus, king of the earth and a force for good, is represented most characteristically as a falcon. Horus's eyes *(wedjat)* were regarded as symbolic of the sun and moon. The *wedjat* here is the solar eye. The *ankh* is symbolic of everlasting life. The scarab beetle was associated with the creator god Atum and the rising sun.

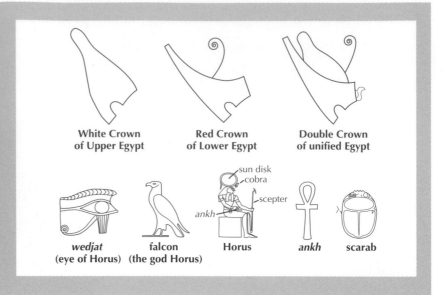

White Crown of Upper Egypt Red Crown of Lower Egypt Double Crown of unified Egypt

sun disk — cobra — scepter — *ankh*

wedjat (eye of Horus) falcon (the god Horus) Horus *ankh* scarab

EGYPTIAN MYTHS OF CREATION

Herodotus's contention that the Egyptians were obsessively religious is supported by the large number of gods in ancient Egyptian documents—even the River Nile was revered as a god. Early Egyptian creation myths introduce many of the earliest and most important deities in Egypt's pantheon.

One myth, focusing on the origins of the gods, relates that the sun god Ra—or Ra-Atum—shaped himself out of the waters of chaos, or unformed matter, and emerged seated atop a mound of sand hardened by his own rays. By spitting—or ejaculating—he then created the gods of wetness and dryness, Tefnut and Shu, who in turn begat the male Geb (earth) and the female Nut (sky). Geb and Nut produced two sons, Osiris and Seth—the gods of goodness and evil, respectively—and two daughters, the goddesses Isis and Nephthys (Isis can be seen in figure 3-42). Taking Isis as his wife, Osiris became king of Egypt. His envious brother, Seth, promptly killed Osiris, hacked his body to pieces, and snatched the throne for himself. Isis and her sister, Nephthys, gathered up the scattered remains and, with the help of the god Anubis (a jackal), patched Osiris back together. Despite her husband's mutilated condition, Isis somehow managed to conceive a son—Horus, another power for good capable of guarding the interests of Egypt. Horus defeated Seth and became king of the earth, while Osiris retired to the underworld as overseer of the realm of the dead (see fig. 3-43).

Several myths explain the creation of human beings. In one, Ra lost an eye but, unperturbed, replaced it with a new one. When the old eye was found, it began to cry, angered that it was no longer of any use. Ra created human beings from its tears. In another myth, favored by the people of Memphis, their local god Ptah created humankind on his potter's wheel.

By the Early Dynastic period, Egypt's kings were revered as gods in human form, a belief accounted for a thousand years later by a New Kingdom practice. As part of the annual *opet* festival, celebrating the flooding of the Nile, a procession carried statues of the god Amun and his wife, Mut, and son, Khons, from the temple at Karnak to their alternate temple at Luxor. Inscriptions in the processional colonnade record that, while at Luxor, the all-powerful god miraculously conceived a future ruler of Egypt.

heads. Osiris, for example, the god of the dead, regularly appears in human form wrapped in linen as a mummy. His wife, Isis, and their son the sky god Horus are human, but Horus was often depicted as having a human body and the head of a falcon. The sun god Ra appears at some times as a cobra, at other times as a scarab beetle (see "Egyptian Symbols," above).

Certain gods took on different forms over time and sometimes were worshiped in different regions under different names. In the New Kingdom at Thebes, for example, the creator god Amun and the sun god Ra were venerated as the single deity Amun-Ra. Everywhere else in Egypt in this period, the two continued to be thought of as separate gods. At the heart of Egyptian religion are stories that explain how the world, the gods, and human beings came into being (see "Egyptian Myths of Creation," above).

Egyptian religious beliefs reflect an ordered cosmos. The movements of heavenly bodies, the workings of gods, and the humblest of human activities were all thought to be part of a grand design of balance and harmony. Death was to be feared only by those who lived in such a way as to disrupt that harmony; upright souls could be confident that their spirits would live on eternally.

THE PALETTE OF NARMER

The first king, named Narmer (Dynasty 1, ruled c. 3100 BCE), is known from a slab of mudstone (a kind of shale), the *Palette of Narmer* (fig. 3-4), found at Hierakonpolis. It is carved in low relief on both sides with scenes and identifying inscriptions. The ruler's name appears on both sides in **pictographs**, or picture writing, in a small square at the top: a horizontal fish *(nar)* above a vertical chisel *(mer)*. The cow heads on each side of his name symbolize the protective goddess Hathor.

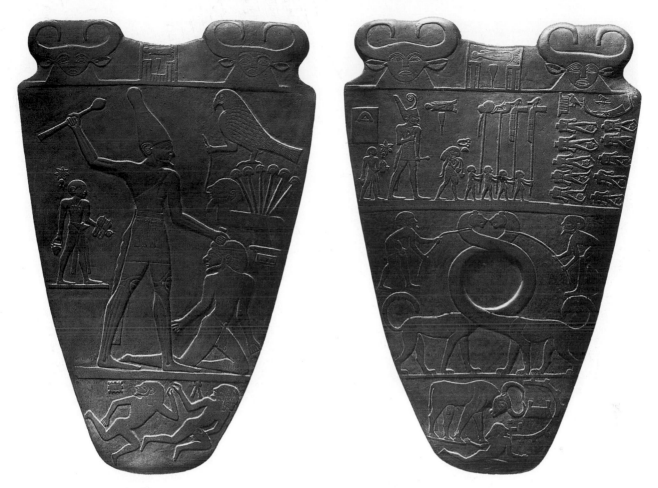

3-4. *Palette of Narmer*, from Hierakonpolis. Dynasty 1, c. 3000 BCE. Mudstone, height 25" (63.5 cm). Egyptian Museum, Cairo

Palettes, flat stones with a circular depression on one side, were common utensils of the time, used for grinding eye paint. Both men and women painted their eyelids to help prevent infections in the eyes and perhaps to reduce the glare of the sun, much as football players today blacken their cheekbones before a game. The *Palette of Narmer* has the same form as these common objects but is much larger. It and other large palettes decorated with animals, birds, and occasionally human figures probably had a ceremonial function.

King Narmer appears as the main character in the various scenes on the palette. Images of conquest proclaim him to be the great unifier, protector, and leader of the Egyptian people. **Hieratic scale** signals the status of individuals and groups in this highly stratified society, so, as in the *Stele of Naramsin* (see fig. 2-15), the ruler is larger than other human figures on the palette to indicate his importance and divine status. Narmer wears the White Crown of Upper Egypt, and from his waistband hangs a ceremonial bull's tail, signifying strength. He is barefoot, suggesting that this is a symbolic representation of a hero's preordained victory over evil. An attendant standing behind Narmer holds his sandals. Above Narmer's kneeling foe, the god Horus—a falcon with a human hand—holds a rope tied around the neck of a man whose head is beside stylized **papyrus**, a plant that grew in profusion along the lower Nile. This combination of symbols again makes clear that Lower Egypt has been tamed. In the bottom register (fig. 3-4, left), below Narmer's feet,

two of his enemies are sprawled on the ground, just as they fell when they were killed.

On the other side of the palette (fig. 3-4, right), Narmer is shown in the top register wearing the Red Crown of Lower Egypt, making clear that he now rules both lands. Here his name—the fish and chisel—appears not only in the rectangle at the top but also next to his head. With his sandal-bearer again in attendance, he marches behind his minister of state and four men carrying standards that may symbolize different regions of the country. Before them, under the watchful eye of Horus, lie the enemy dead. The decapitated bodies have been placed in two neat rows, their heads between their feet.

In the center register, the elongated necks of two feline creatures, each held on a leash by an attendant, curve gracefully around the rim of the cup of the palette. The intertwining of their necks is possibly another reference to the union of the Two Lands. In the bottom register, a bull menaces a fallen foe outside the walls of a fortress. The bull, an animal known for its strength and virility, may symbolize the king. The images affirm the absolute power of the ruler over the entire country of Egypt.

The images carved on the palette are strong and direct, and although scholars disagree about some of their specific meanings, their overall message is clear: a king named Narmer rules over the unified land of Egypt with a strong hand. Narmer's palette is particularly important because of the way it uses pictographs and symbols. Moreover, it provides very early examples of

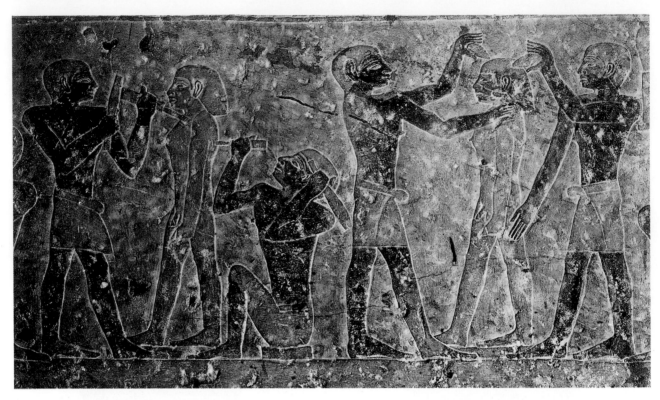

3-5. *Sculptors at Work*, relief from Saqqara. Dynasty 5, c. 2494–2345 BCE. Painted stone. Egyptian Museum, Cairo

3-6. An Egyptian canon of proportions for representing the human body

This canon sets the height of the male body from heel to hairline at 18 times the width of the fist, which is 1 unit wide. Thus, there are 18 squares between the heels and the hairline. As they must, according to the canon, the knees align with the fifth line up, the elbows with the twelfth, and the junction of the neck and shoulders with the sixteenth.

the unusual way Egyptian artists solved the problem of depicting the human form in the two-dimensional arts of relief sculpture and painting.

REPRESENTATION OF THE HUMAN FIGURE

Forceful and easy to comprehend, the images on the Narmer palette present a king's exploits as he wished them to be remembered. For the next several thousand years, much of Egyptian art was created to meet the demand of royal patrons for similarly graphic, indestructible testimonies to their glory.

Many of the figures on the palette are shown in poses that would be impossible to assume in real life. By Narmer's time, Egyptian artists, using the memory image, the generic form that suggests a specific object, had arrived at a unique way of drawing the human figure. The Egyptians' aim was to represent each part of the body from the most characteristic angle. Heads are shown in profile, to best capture the subject's identifying features. Eyes, however, are most expressive when seen from the front, so artists rendered the eyes in these profile heads in frontal view. Artists showed shoulders as though from the front, but at the waist they twisted the figure 90 degrees to show hips, legs, and feet in profile. If both hands were to be shown in front of a figure, artists routinely lengthened the farther arm so both arms would be visible. Unless the degree of action demanded otherwise, they placed one foot in front of the other on the **groundline**, showing both feet from the inside, each with a high-arched instep and a single, large toe. This artistic tradition, or convention, was followed especially in the depiction of royalty and other dignitaries, and it persisted until the fourth century BCE. Persons of lesser social rank engaged in active tasks tend to be represented more naturally (compare the figure of Narmer with those of his standard-bearers in figure 3-4, right). Similarly, long-standing conventions governed the depiction of animals, insects, inanimate objects, landscape, and architecture. Flies, for example, are always shown from above, bees from the side.

In three-dimensional sculpture, figures could be constructed as they are in life. A painted relief from the funerary complex at Saqqara shows that artists working in two dimensions were perfectly capable of drawing figures from the side (fig. 3-5). It shows a pair of sculptors putting the finishing touches on statues. The "living" sculptors are

portrayed in the conventional twisted pose, while the statues appear in full profile, as they would in reality.

Just as Egyptian artists adhered to artificial convention in posing figures, they also proportioned figures in accordance with an ideal image of the human form, following an established **canon of proportions**. The ratios between a figure's height and all of its component parts were clearly prescribed. They were calculated as multiples of a specific unit of measure, such as the width of the closed fist.

The specific measure employed and the proportions derived from it varied slightly over time, but the underlying concept and the means by which it was implemented did not. Having determined the size of a desired figure, the artist first covered the area the figure was to occupy with a grid made up of a fixed number of squares (fig. 3-6). If the width of the fist was the canon's basic unit of measure, the artist saw to it that each hand was one square wide. Knowing that the knee should fall a prescribed number of squares above the groundline, the waist x number of squares above the knee, and so on simplified the process of sizing the figure. The grid itself was covered up as the work progressed.

THE OLD KINGDOM

The Old Kingdom (c. 2686–2181 BCE) was a time of social cohesion and political stability despite the climate changes that made droughts and insect plagues increasingly common and the occasional military excursions to defend the country's borders. The expanding wealth of ruling families of the period is reflected in the size and complexity of the tomb structures they commissioned for themselves. Court sculptors were regularly called upon to create lifesize, even colossal royal portraits in stone. Kings were not the only patrons of the arts, however. Numerous government officials also could afford to have tombs decorated with elaborate carvings.

FUNERARY ARCHITECTURE

Ancient Egyptians believed that an essential part of every human personality is its life force, or spirit, called the **ka**, which lived on after the death of the body, forever engaged in the activities it had enjoyed in its former existence. The *ka* needed a body to live in, but in the absence of one of flesh and blood, a sculpted likeness was adequate. It was especially important to provide a comfortable home for the *ka* of a departed king, so that even in the afterlife it would continue to ensure the well-being of the Egyptian state.

To fulfill the requirements of the *ka*, Egyptians developed elaborate funerary practices. They preserved the bodies of the dead with care and placed them in burial chambers filled with all the supplies and furnishings the *ka* might require throughout eternity (see "Preserving the Dead," below). The quantity and value of these grave goods were so great that looters routinely plundered tombs, even in ancient times.

In Early Dynastic Egypt, the most common tomb structure was the **mastaba**, a flat-topped, one-story building with slanted walls erected above an underground burial chamber (see "Mastaba to Pyramid," page 100). Mastabas were customarily constructed of mud brick, but toward the end of Dynasty 3, more incorporated cut stone, at least as an exterior facing, or **veneer**. In its simplest form, the mastaba contained a **serdab**, a small, sealed room housing the *ka* statue of the deceased, and a chapel designed to receive mourning relatives with their offerings.

PRESERVING THE DEAD

Egyptians developed mummification techniques to ensure that the *ka*, or life force, could live on in the body in the afterlife. Whenever possible, a portrait statue was provided as an alternative, in case the mummy disintegrated (see fig. 3-12). The world's fascination with Egyptian mummies has a long history. In the Middle Ages and into the eighteenth century, Europeans prized pulverized mummy remains and swallowed them in various solutions, believing them to be of great medicinal value. One of the first concerns of the Egyptian National Antiquities Service after its founding in the second half of the nineteenth century was how to prevent people from stealing and destroying ancient human remains, as well as mummies of hundreds of thousands of cats and millions of ibises.

No ancient recipes for preserving the dead have been found, but the basic process seems clear enough from images found in tombs, the descriptions of later Greek writers such as Herodotus and Plutarch, scientific analysis of mummies, and modern experiments. By the time of the New Kingdom, the routine was roughly as follows. The dead body was taken to a mortuary, a special structure used exclusively for embalming. Under the supervision of a priest, workers removed the brains, generally through the nose, and emptied the body cavity through an incision in the left side. They then placed the body and major internal organs in a vat of natron, a naturally occurring salt, to steep for a month or more. This preservative caused the skin to blacken, so workers often dyed it later to restore some color, using red ocher for a man, yellow ocher for a woman. They then packed the body cavity with clean linen, provided by the family of the deceased and soaked in various herbs and ointments. They wrapped the major organs in separate packets, putting them either in special containers to be placed in the tomb chamber or into the body again.

Workers next wound the trunk and each of the limbs separately with cloth strips, then wrapped the whole body in a shroud. They then wound it in additional layers of cloth to produce the familiar mummy shape. The linen winders often inserted good luck charms and other smaller objects among the wrappings. If the family supplied a Book of the Dead (see fig. 3-43), a selection of magic spells meant to help the deceased survive a "last judgment" and win everlasting life, it was tucked between the mummy's legs.

ELEMENTS OF ARCHITECTURE

Mastaba to Pyramid

As the gateway to the afterlife for Egyptian kings and members of the royal court, the Egyptian burial structure began as a low rectangular mastaba with an internal *serdab* (the room where the *ka* statue was placed) and chapel, then a mastaba with attached chapel and *serdab* (not shown). Later, mastaba forms of decreasing size were stacked over an underground burial chamber to form the stepped pyramid. The culmination of the Egyptian burial chamber is the pyramid, in which the actual burial site may be within the pyramid—not below ground—with false chambers, false doors, and confusing passageways to foil potential tomb robbers.

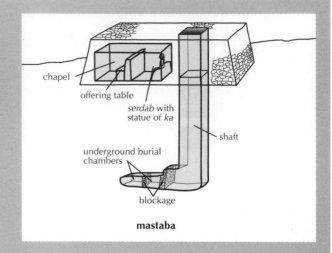

mastaba

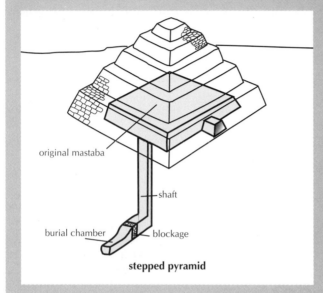

stepped pyramid

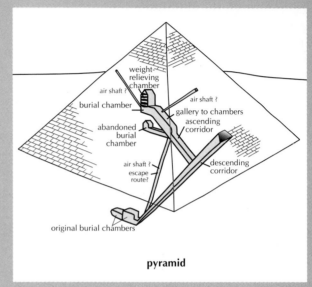

pyramid

A vertical shaft dropped from the top of the mastaba down to the actual burial chamber, where the remains of the deceased reposed in a **sarcophagus**, or stone coffin, surrounded by appropriate grave goods. This chamber was sealed off after interment. Many such structures had numerous underground burial chambers to accommodate whole families, and mastaba burial remained the standard for Egyptian royalty for centuries.

The kings of Dynasties 3 and 4 were the first to devote huge sums to the design, construction, and decoration of more extensive aboveground funerary complexes. These structures tended to be grouped together in a **necropolis**—literally, a "city of the dead"—at the edge of the desert on the west bank of the Nile, for the land of the dead was believed to be in the direction of the setting sun. Two of the most extensive of these early necropolises are at Saqqara and Giza, just outside modern Cairo.

Djoser's Funerary Complex at Saqqara. For his tomb complex at Saqqara, King Djoser (Dynasty 3, ruled c. 2667–2648 BCE) commissioned the earliest known monumental architecture in Egypt (fig. 3-7). The designer of the complex was the prime minister, Imhotep. His name, together with the king's, is inscribed on the base of Djoser's *ka* statue in the *serdab* of the funerary temple to

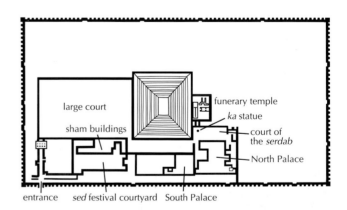

3-7. Plan of Djoser's funerary complex, Saqqara.
Dynasty 3, c. 2667–2648

Situated on a level terrace, this huge commemorative complex—some 1,800 feet (544 meters) long by 900 feet (277 meters) wide—was designed as a replica in stone of the wood, brick, and reed buildings of Djoser's actual palace compound. The enclosing wall had fifteen gates, only one of which was functional. Inside the wall, the stepped pyramid dominated the complex. Underground apartments copied the layout and appearance of rooms in the royal palace.

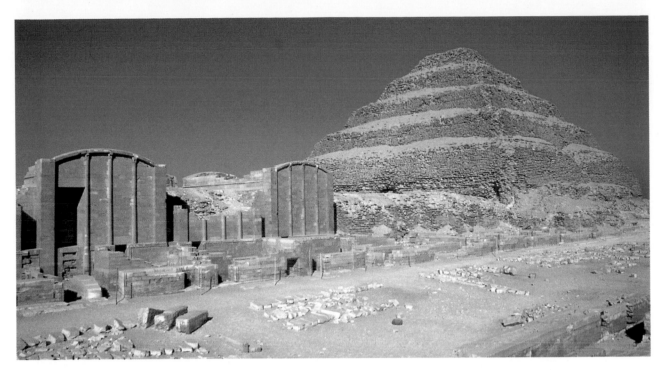

3-8. Stepped pyramid (six-stepped mastaba) of Djoser, Saqqara. Limestone, height 204' (62 m)

3-9. Wall of the North Palace, with engaged columns in the form of papyrus blossoms. Funerary complex of Djoser, Saqqara

the north of the tomb. He is thus the first architect in history known by name. Born into a prominent family, Imhotep was highly educated and served as one of Djoser's chief advisers on affairs of state. It appears that he first planned Djoser's tomb as a single-story mastaba, then later decided to enlarge upon the concept (figs. 3-8, 3-9). In the end, what he produced was a stepped pyramid with six mastabalike elements of decreasing size placed on top of each other (see "Mastaba to Pyramid," page 100). Although the final structure resembles the **ziggurats** of Mesopotamia, it differs in both its intention (as a stairway to the stars and to the sun god Ra) and its purpose of protecting a tomb. Djoser's imposing structure was originally faced with a veneer of limestone. A 92-foot shaft descended from the peak to a granite-lined burial vault.

The adjacent funerary temple, where priests performed their final rituals before placing the king's mummified body in its tomb, was also used for continuing worship of the dead king. In the form of his *ka* statue, Djoser intended to observe these devotions through two peepholes in the wall between the *serdab* and the funerary chapel. To the east of the pyramid were sham buildings—exquisitely carved masonry shells filled with debris—representing chapels, palaces with courtyards, and other structures. They were provided so that the dead king could continue to observe the *sed* rituals that had ensured his long reign. His spirit could await the start of the ceremonies in a pavilion near the entrance to the complex in its southeast corner. The running trials of the *sed* festival took place in a long outdoor

A **column** is a cylindrical, upright pillar that traditionally has three sections: a **base**, a **shaft**, and a top, called a **capital**. Most columns are freestanding and are used to support weight, usually a roof. When used decoratively and attached to a wall, a column is referred to as an **engaged column** or **attached column** (see fig. 3-9). A **colonnade** is a row of columns supporting a horizontal member.

Egyptians used columns, with and without bases, in their **temple complexes**, often in forms based on river plants, especially lotus and **papyrus**.

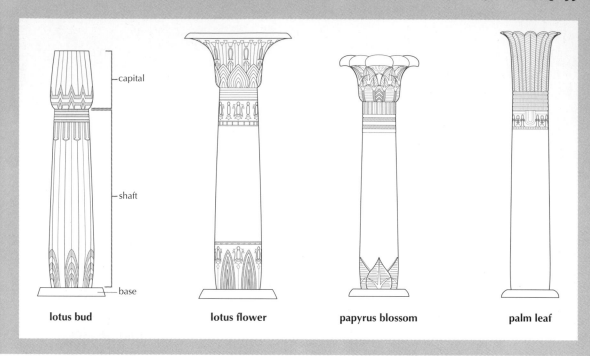

capital

shaft

base

lotus bud **lotus flower** **papyrus blossom** **palm leaf**

court-yard within the complex. After proving himself, the living king would proceed first to the South Palace then to the North Palace, to be symbolically crowned once again as king of Egypt's Two Lands.

Imhotep's architecture employs the most elemental structural techniques and the purest geometric forms. Although most of the stone wall surfaces were left plain, in some places he made effective use of **columns**. Some of these are plain except for **fluting**, but others take the form of stylized plants. The **engaged columns** spaced along and attached to the exterior walls of the North Palace, for example, resemble stalks of papyrus. Stylized papyrus blossoms serve as their **capitals**. These columns may have been patterned after the bundled papyrus stalks early Egyptian builders used to reinforce mud walls, and they symbolized Lower Egypt. By contrast, the architectural decorations of the South Palace featured the flowering sedge and the lotus—plants symbolic of Upper Egypt (see "Column," above).

The Pyramids at Giza. The architectural form most closely identified with Egypt is the true pyramid with a square base and four sloping triangular faces. The first such structures were erected in Dynasty 4. The angled sides of the pyramids may have been meant to represent the slanting rays of the sun, for inscriptions on the walls of pyramid tombs built in Dynasties 5 and 6 tell of deceased kings climbing up the rays to join the sun god Ra.

Egypt's most famous funerary structures are the three great pyramid tombs at Giza (fig. 3-10). These were built by the Dynasty 4 kings Khufu (ruled c. 2589–2566 BCE), Khafra (ruled c. 2558–2532 BCE), and Menkaura (ruled c. 2532–2503 BCE). The Greeks were so impressed by these huge, shining monuments—*pyramid* is a Greek term—that they numbered them among the world's architectural marvels (see "The Seven Wonders of the World," page 104). The early Egyptians referred to the pyramids as "Horizon of Khufu," "Great Is Khafra," and "Divine Is Menkaura," thus acknowledging the desire of these rulers to commemorate themselves as divine beings. The oldest and largest of the Giza pyramids is that of Khufu, which covers 13 acres at its base and rises to a height of about 450 feet in its deteriorated state. It was originally finished with a thick veneer of polished limestone that lifted its apex some 30 feet above the present summit, to almost 481 feet. The pyramid of Khafra, the only one of the three that still has a little of its veneer at the top, is slightly smaller than Khufu's. Menkaura's is considerably smaller than the other two and had a polished red granite base.

The site was carefully planned to follow the sun's east-west path. Next to each of the pyramids was a funerary temple connected by causeway, or elevated road, to a valley temple on the bank of the Nile (fig. 3-11). When a king died, his body was ferried across the Nile from the royal palace to his valley temple, where it

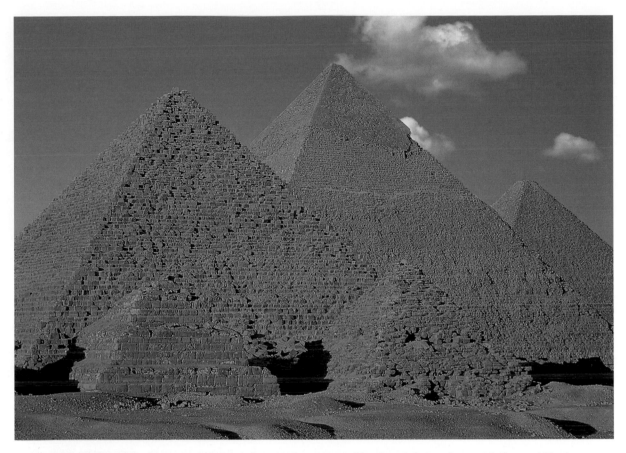

3-10. Great Pyramids, Giza. Dynasty 4, c. 2613–2494 BCE. Erected by (from left) Menkaura, Khafra, and Khufu (the three ruled 2589–2503 BCE). Granite and limestone, height of pyramid of Khufu 450' (137 m)

The designers of the pyramids tried to ensure that the king and his tomb "home" would never be disturbed. Khufu's builders placed his tomb chamber in the very heart of the mountain of masonry, at the end of a long, narrow, steeply rising passageway, sealed off after the king's burial by a 50-ton stone block. Three false passageways, either calculated to mislead or the result of changes in plans as construction progressed, obscured the location of the tomb. Despite such precautions, early looters managed to penetrate to the tomb chamber and make off with Khufu's funeral treasure. For many centuries, it was not known that the pyramids were the tombs of early Egyptian rulers. One theory was that they had been gigantic silos for storing grain during periods of drought and famine.

3-11. Model of the Giza plateau, showing from left to right the temples and pyramids of Menkaura, Khafra, and Khufu.

Prepared for the exhibition "The Sphinx and the Pyramids: One Hundred Years of American Archaeology at Giza," held in 1998 at the Harvard University Semitic Museum. Harvard University Semitic Museum, Cambridge, Massachusetts

THE SEVEN WONDERS OF THE WORLD

Just as guidebooks today publicize sights travelers must not miss, Greek writers in the second century BCE heralded the Seven Wonders of the World. The oldest of these "wonders"—and the only one reasonably intact today—is the trio of pyramids at Giza (see fig. 3-10), built during Dynasty 4 (c. 2613–2494 BCE). The next oldest, the so-called Hanging Gardens built for Nebuchadnezzar II in Babylon in the sixth century BCE (see fig. 2-23), had disappeared long before it made the list, although sections believed to be its foundations have been excavated. The other wonders can only be imagined from written descriptions, sculptural fragments, and archaeological reconstructions: the temple of the goddess Artemis at Ephesos, from the sixth century BCE; the statue of the god Zeus at Olympia by Pheidias, about 430 BCE; the Mausoleum at Halikarnassos, fourth century BCE (figure 5-57 shows a conjectural reconstruction); the Colossus of Rhodes, a bronze statue of the sun god Helios the height of a ten-story building, completed in 282 BCE (our own word *colossal* comes from this Greek term for an enormous human statue); and the lighthouse that guarded the port at Alexandria, in Egypt, built about 290 BCE, more than four times as tall as the Colossus. Today, underwater archaeologists working off the north coast of Egypt are raising the ancient port piece by piece and believe they have spotted large stones of the lighthouse.

was received with elaborate ceremonies. It was then carried up the causeway to his funerary temple and placed in its chapel. There family members presented it with offerings of food and drink, and priests performed the rite known as the "opening of the mouth," in which the deceased's spirit consumed a meal. Then the body was entombed in a vault deep inside the pyramid. Khafra's funerary complex is the best preserved today. His valley temple was constructed of massive blocks of red granite with a polished alabaster floor, which reflected the *ka* statue of the king.

Constructing a pyramid was a formidable undertaking. A huge labor force had to be assembled, housed, and fed. Most of the cut stone blocks—each weighing an average of 2.5 tons—used in building the Giza complex were quarried either on the site or nearby. Teams of workers transported them by sheer muscle power, at times employing small logs as rollers or pouring water on sand to create a slippery surface over which they could drag the blocks on sleds.

Scholars and engineers have put forward various theories about the method used to raise the pyramids. Some have been tested in computerized projections and a few in actual buildings attempted on a small but representative scale. The most efficient means of getting the stones into position might have been to build a temporary, gently sloping ramp around the body of the pyramid as it grew higher. The ramp might then be dismantled as the slabs of the stone veneer were laid from the top down. Clearly the architects who oversaw the building of such massive structures were capable of the most sophisticated mathematical calculations, for there was no room for trial and error. They had to make certain that the huge foundation layer was absolutely level and that the angle of each of the slanting sides remained constant so that the stones would meet precisely in the center at the top. They carefully oriented the pyramids to the points of the compass and may have incorporated other symbolic astronomical calculations as well. These immense monuments reflect not only the desire of a trio of kings to attain immortality but also the strength of the Egyptians' belief that a deceased ruler continued to affect the well-being of the state and his people from beyond the grave.

SCULPTURE

As was the custom, Khafra commissioned various stone portraits of himself to perpetuate his memory for all time. In his roughly lifesize *ka* statue, one of about twenty discovered inside his valley temple, he was portrayed as an enthroned king (fig. 3-12). His most famous portrait is the Great Sphinx, a colossal monument some 65 feet tall just behind the valley temple; it combines his head with the long body of a crouching lion.

In his *ka* statue, Khafra sits erect on a simple but elegant lion throne. Horus perches on the back of the throne, protectively enfolding the king's head with his wings. Lions—symbols of regal authority—form the throne's legs, and the intertwined lotus and papyrus plants beneath the seat symbolize the king's power over Upper and Lower Egypt. Khafra wears the traditional royal costume: a short, pleated kilt, a linen headdress with the cobra symbol of Ra, and a false beard symbolic of royalty. The figure conveys a strong sense of dignity, calm, and above all permanence; its compactness—the arms pressed tight to the body, the body firmly anchored in the block—ensured a lasting alternative home for the king's *ka*. The statue was carved in an unusual stone, northosite gneiss, imported from Nubia. This stone produces a rare optical effect: in sunlight, it glows a deep blue, the celestial color of Horus. Through skylights in the valley temple, the sun would have illuminated the alabaster floor and the figure, creating a blue radiance.

When carving such a statue, Egyptian sculptors approached each face of the block as though they were simply carving a relief. A master drew the image full face on the front of the block and in profile on the side. Sculptors cut straight back from each drawing, removing the superfluous stone and literally "blocking out" the figure. Then the three-dimensional shapes were refined, surface details were added, and finally the statue was polished and painted.

Dignity, calm, and permanence also characterize the beautiful double portrait of Khafra's son King Menkaura and a queen, probably Khamerernebty II (fig. 3-13). But the sculptor's handling of the composition of this work, discovered in Menkaura's valley temple, makes it far less austere than Khafra's *ka* statue. The couple's separate

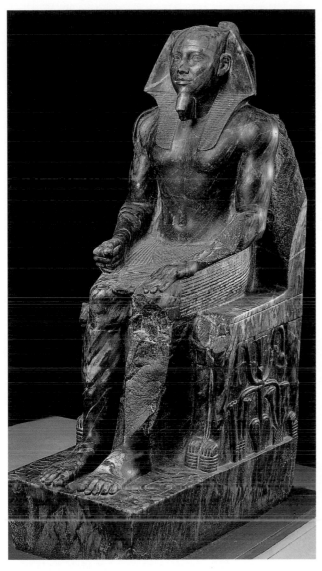

3-12. *Khafra*, from Giza. Dynasty 4, c. 2500 BCE. Northosite gneiss, height 5'6⅛" (1.68 m). Egyptian Museum, Cairo

figures, close in size, form a single unit, tied together by the stone out of which they emerge. They are further united by the queen's symbolic gesture of embrace. Her right hand emerges from behind to lie gently against his ribs, and her left hand rests on his upper arm. The king, depicted in accordance with the Egyptian ideal as an athletic, youthful figure nude to the waist and wearing the royal kilt and headcloth, stands in a typically Egyptian balanced pose with one foot in front of the other, his arms straight at his sides, and his fists tightly clenched. His equally youthful queen echoes his striding pose, but with a smaller step forward. The sculptor exercised remarkable skill in rendering her sheer, close-fitting garment, which clearly reveals the curves of her body. The time-consuming task of polishing this double statue was never completed, indicating that the work may have been undertaken only a few years before Menkaura's death in about 2503 BCE. However, traces of red paint remain on the king's face, ears, and neck (male figures were traditionally painted red), as do traces of black on the queen's hair.

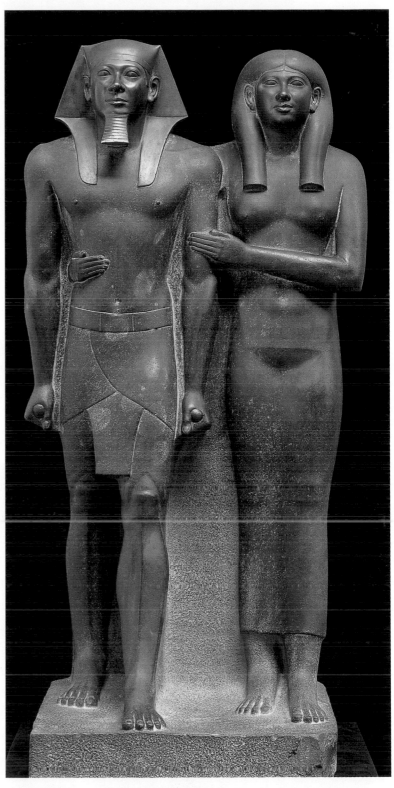

3-13. *Menkaura and a Queen*, perhaps his wife Khamerernebty, from Giza. Dynasty 4, c. 2500 BCE. Graywacke with traces of red and black paint, height 54½" (142.3 cm). Museum of Fine Arts, Boston
Harvard University–MFA Expedition

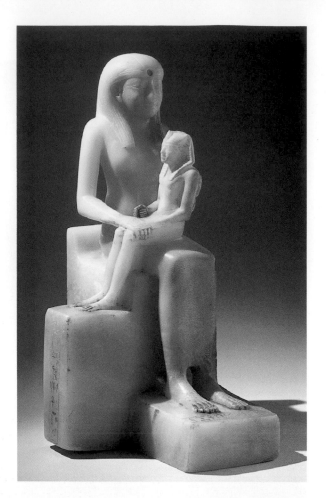

3-14. *Pepy II and His Mother, Queen Merye-ankhnes*. Dynasty 6, c. 2278–2184 BCE. Calcite, height 15¼" (39.2 cm). The Brooklyn Museum

Charles Edwin Wilbour Fund (39.119)

A type of royal portraiture that appeared in Dynasty 6 (c. 2345–2181 BCE) is seen in figure 3-14. In this statue, the figure of Pepy II (ruled c. 2278–2184 BCE), wearing the royal kilt and headdress but reduced to the size of a child, is seated on his mother's lap. The work thus pays homage to Queen Merye-ankhnes, who wears a vulture-skin headdress linking her to the goddess Nekhbet and proclaiming her of royal blood. The queen is inscribed "Mother of the King of Upper and Lower Egypt, the god's daughter, the revered one, beloved of Khum Ankhnes-merye." If Pepy II inherited the throne at the age of six, as Manetho claimed, then the queen may have acted as regent until he was old enough to rule alone. The sculptor placed the king at a right angle to his mother, thus providing two "frontal" views—the queen facing forward, the king to the side. In another break with convention, he freed the queen's arms and legs from the stone block of the throne, giving her figure greater independence.

Old Kingdom sculptors were commissioned to produce portraits not only of kings but also of less prominent people. Such works—for example, *Seated Scribe*, from early in Dynasty 5 (fig. 3-15)—are usually more lively and

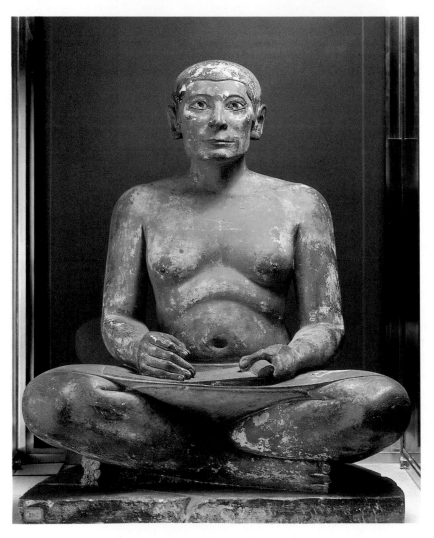

3-15. *Seated Scribe*, from the tomb of Kai, Saqqara. Dynasty 5, c. 2494–2345 BCE. Painted limestone with inlaid eyes of rock crystal, calcite, and magnesite mounted in copper, height 21" (53 cm). Musée du Louvre, Paris

Egyptian scribes began training in childhood. Theirs was a strenuously guarded profession, its skills generally passed down from father to son. Some girls learned to read and write, and although careers as scribes seem generally to have been closed to them, there is a Middle Kingdom word meaning "female scribe." Would-be scribes were required to learn not only reading and writing but also arithmetic, algebra, religion, and law. The studies were demanding, but the rewards were great. A comment found in an exercise tablet, probably copied from a book of instruction, offers encouragement: "Become a scribe so that your limbs remain smooth and your hands soft, and you can wear white and walk like a man of standing whom [even] courtiers will greet" (cited in Strouhal, page 216). A high-ranking scribe with a reputation as a great scholar could hope to be appointed to one of several "houses of life," where lay and priestly scribes copied, compiled, studied, and repaired valuable sacred and scientific texts. Completed texts were placed in related institutions called "houses of books," some of the earliest known libraries.

3-16. *Ti Watching a Hippopotamus Hunt*, from the tomb of Ti, Saqqara. Dynasty 5, c. 2494–2345 BCE. Painted limestone relief, height approx. 45" (114.3 cm)

This relief forms part of the decoration of a mastaba tomb discovered by the French archaeologist Auguste Mariette in 1865. Among Mariette's many other famous finds was the *ka* statue of Khafra (see fig. 3-12). A pioneer Egyptologist, Mariette was a man of great heart, intellect, and diverse talents. It was he who provided the composer Giuseppe Verdi with the scenario for the opera *Aida*, set in ancient Egypt. He pressed the Egyptians to establish the National Antiquities Service to protect, preserve, and study the country's art monuments. In gratitude, they later placed a statue of him in the new Egyptian Museum in Cairo. At his death, his remains were brought back to his beloved Egypt for burial.

less formal than royal portraits. This statue was found in the tomb of a vizier (comparable to a prime minister) named Kai, and there is some evidence that *Seated Scribe* may be a portrait of Kai himself. The scribe's sedentary vocation has made his body soft and a little flabby. He sits holding a papyrus scroll partially unrolled on his lap, his right hand clasping a now-lost reed pen, and his face reveals a lively intelligence. Because the pupils are slightly off-center in the irises, the eyes give the illusion of being in motion, almost to be seeking eye contact. Other early Dynasty 5 statues found at Saqqara have a similar round head and face, alert expression, and cap of close-cropped hair.

TOMB DECORATION

To provide the *ka* with the most pleasant possible living quarters for eternity, wealthy families often had the interior walls and ceilings of their tombs decorated with paintings and reliefs (see "Egyptian Painting and Relief Sculpture," page 108). Much of this decoration was symbolic or religious, especially in royal tombs, but it could also include a wide variety of everyday scenes recounting momentous events in the life of the deceased or showing the deceased engaged in routine activities. Tombs therefore provide a wealth of information about ancient Egyptian culture.

A scene in the large mastaba of a Dynasty 5 government official named Ti—a commoner who had achieved great power at court and amassed sufficient wealth to build an elaborate home for his immortal spirit—shows him watching a hippopotamus hunt (fig. 3-16). The artists who created this painted limestone relief employed a number of established conventions. They depicted the river as if seen from above, rendering it as a band of parallel wavy lines below the boats. The creatures in the river, however—fish, a crocodile, and hippopotamuses—are shown in profile for easy identification. The shallow boats carrying Ti and his men skim along the surface of the water unhampered by the papyrus stalks, shown as parallel

EGYPTIAN PAINTING AND RELIEF SCULPTURE

Painting usually relies for its effect on color and line, and relief sculpture usually depends on the play of light and shadow alone—but in Egypt, relief sculpture was also painted. The walls and closely spaced columns of Egyptian tombs and temples provided large surfaces for decoration, and nearly every inch was adorned with colorful figural scenes and hieroglyphic texts. Up until Dynasty 18 (c. 1550–1295 BCE), the only colors used were black, white, red, yellow, blue, and green. They were never mixed. Modeling might be indicated by overpainting lines in a contrasting color but never by shading the basic color pigment. In time, more colors were added, but the primacy of line was never challenged. Compositionally, with very few exceptions, figures, scenes, and texts were presented in bands, or registers. Usually the base line at the bottom of each register represented the ground, but determining the sequence of images can be problematic because it could run horizontally or vertically.

The preliminary steps in the creation of paintings and relief carvings were virtually identical. Surfaces to be painted had to be smooth, so in some cases a coat of plaster was applied. The next step was to lay out the registers with painted lines and draw the appropriate grid (see fig. 3-6). In this remarkable photograph of a wall in the unfinished Dynasty 18 tomb of Horemheb in the Valley of the Kings, the red base lines and horizontals of the grid are clearly visible. The general shapes of the hieroglyphs have also been sketched in red. The preparatory drawings from which carvers worked were black. Egyptian artists worked in

teams, and each member had a particular skill. The sculptor who executed the carving on the right was following someone else's drawing. Had there been time to finish the tomb, other hands would have smoothed the surface of this limestone relief, and still others would have made fresh drawings to guide the artists assigned to paint it.

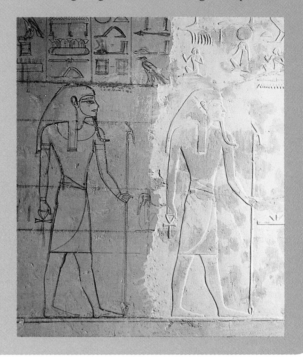

vertical lines, that choke the marshy edges of the river. At the top of the panel, where Egyptian convention often placed background scenes, several animals are seen stalking birds among the papyrus leaves and flowers. The erect figure of Ti, rendered in the traditional twisted pose, looms over this teeming Nile environment. The actual hunters, being of lesser rank and engaged in more strenuous activities, are rendered more realistically.

In Egyptian art, as in that of the ancient Near East, scenes showing a ruler hunting wild animals illustrated the power to maintain order and balance. By dynastic times, hunting had become primarily a showy pastime for the nobility. The hippopotamus hunt, however, was more than simple sport. Hippos tended to wander into fields, damaging crops, and killing them was an official duty of members of the court. Furthermore, it was believed that the companions of Seth, the god of darkness, disguised themselves as hippopotamuses. Tomb depictions of such hunts therefore illustrated not only the valor of the deceased but also the triumph of good over evil.

THE MIDDLE KINGDOM

The collapse of the Old Kingdom, with its long succession of kings ruling the whole of Egypt, was followed by roughly 150 years of political turmoil traditionally referred to as the First Intermediate period. About 2055 BCE, Mentuhotep II (Dynasty 11, ruled c. 2055–2004 BCE), from Thebes, finally reunited

the country. He and his successors reasserted royal power, but beginning with the next dynasty, about 1985 BCE, political authority became less centralized. Provincial governors claimed increasing powers for themselves, effectively limiting the king's responsibility to such national concerns as the defense of Egypt's frontiers. It was during the Middle Kingdom that Egypt's kings began maintaining standing armies to patrol the country's borders, especially its southern reaches in lower Nubia, south of modern Aswan.

Another royal responsibility was the planning and construction of large-scale water management projects, though regional administrators and the farmers themselves supervised irrigation locally. In this period, Egypt's farmers enjoyed relatively liberal rights, even though they were required to turn over most of what they produced to the nobles or priests who owned the land they worked. Those who failed to meet prescribed annual yields were subject to harsh punishments.

ARCHITECTURE AND TOWN PLANNING

Although Egyptians used durable materials in the construction of tombs, they built their own dwellings with simple mud bricks, which have either disintegrated over time or been carried away by farmers as fertilizer, leaving only the foundations. Archaeologists have developed a map of the remains of Kahun, a town built by Senusret II

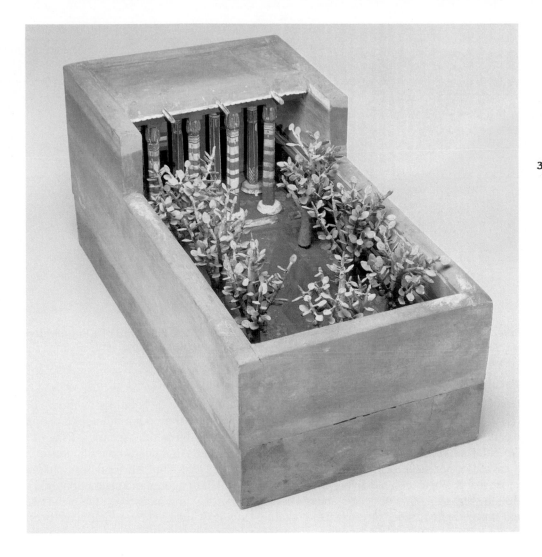

33-18. Model of a house and garden, from tomb of Meketra, Thebes. Dynasty 11, c. 2125–2055 BCE. Painted and plastered wood and copper, length 33" (87 cm). The Metropolitan Museum of Art, New York

Purchase, Rogers Fund and Edward S. Harkness Gift, 1920 (20.3.13)

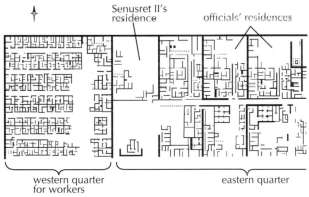

western quarter for workers

eastern quarter

Senusret II's residence

officials' residences

3-17. Plan of the northern section of Kahun, built during the reign of Senusret II near modern el-Lahun. Dynasty 12, c. 1880–1874 BCE

(Dynasty 12, ruled c. 1880–1874 BCE) for the many officials, priests, and workers in his court, that offers a unique view of the Middle Kingdom's social structure (fig. 3-17).

The town's design—streets laid out in a mainly east-west orientation, with rectangular blocks divided into lots for homes and other buildings—reflects three distinct economic and social levels. Appropriately, Senusret's own semifortified residence occupied the highest ground and fronted a large open square. The district to the east of his palace, connected to the square by a wide avenue, was occupied by priests, court officials, and their families. Their houses were large and comfortable, with private living quarters and public rooms grouped around central courtyards. The largest had as many as seventy rooms spread out over half an acre. Workers were housed in the western district, set off from the rest of the town by a solid wall. Their families made do with small, five-room row houses built back to back along narrow streets.

TOMB ART AND TOMB CONSTRUCTION

Tomb art reveals much about domestic life in the Middle Kingdom. Wall paintings, reliefs, and even small models of houses and farm buildings—complete with figurines of workers and animals—reproduce everyday scenes on the estates of the deceased. Many of these models survive because they were made of inexpensive materials of no interest to early grave robbers. One from Thebes, made of wood, plaster, and copper about 2125–2055 BCE, reproduces a portion of a house and garden (fig. 3-18). The flat-roofed structure opens into a walled garden through a **portico**, or columned porch, having columns with bound stems and stylized lotus flowers. The garden has a central pool flanked by sycamore trees. Although water was precious and only the wealthy could afford their own backyard source, some pools, lined with masonry and stocked with water lilies and fish, were so large that a small boat might be kept at the edge for fishing.

During Dynasties 11 and 12, members of the nobility and high-level officials frequently commissioned

3-19. Rock-cut tombs, Beni Hasan. Dynasty 12, c. 1985–1795 BCE. At the left is the entrance to the tomb of a provincial governor and commander-in-chief

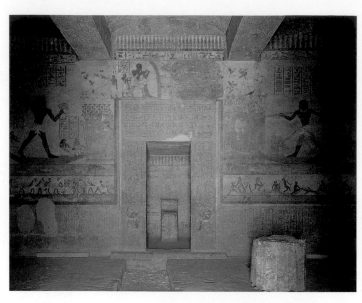

3-20. Interior of rock-cut tomb of Khnumhotep, Beni Hasan. Dynasty 12, c. 1985–1795 BCE

rock-cut tombs—burial places hollowed out of the faces of cliffs—such as those in the necropolis at Beni Hasan on the east bank of the Nile. The various chambers of such tombs and their ornamental columns, lintels, false doors, and niches were all carved out of solid rock (fig. 3-19). Each one was therefore like a single, complex piece of sculpture, attesting to the great skill of its designers and carvers. A typical Beni Hasan tomb included an entrance portico, a main hall, and a shrine with a burial chamber under the offering chapel. Rock-cut tombs at other spots along the Nile exhibit variations on this simple plan. The walls of rock-cut tombs were commonly painted.

In the Dynasty 12 tomb of the local lord Khnumhotep at Beni Hasan, a statue of the deceased once stood in the central niche of the shrine in the rear wall. Among the well-preserved paintings are some spirited depictions of

life on his farms (fig. 3-20). Paintings on the walls at each side of the opening show Khnumhotep, in a boat in the marshes, hunting birds and spearing fish. Above the door, he traps birds in a net. Smaller figures of his sons and his servants assist him. The composition is symmetrical, with panels of figures and inscriptions laid out on a horizontal-vertical grid focused on the niche with its *ka* statue. Originally, the opening would have been closed off by wooden doors. In the outer room, funeral rites and the ongoing cult rituals for Khnumhotep were performed. Representations of these activities on the tomb walls ensured their continuance for all time.

Likewise, funeral offerings represented in statues and paintings would be available for the deceased's use through eternity. On a funeral **stele** of Amenemhat I (fig. 3-21), a table heaped with food is watched over by a

3-21. Funerary Stele of Amenemhat I, from Assasif. Dynasty 11, 2055-1985 BCE. Painted limestone, 11 x 15" (30 x 50 cm). Egyptian Museum, Cairo. The Metropolitan Museum of Art, New York Excavation 1915-16

HIERO-GLYPHIC, HIERATIC, AND DEMOTIC WRITING

Ancient Egyptians developed three types of writing that are known today by the names the Greeks gave them.

The earliest system the Egyptians used for inscriptions employed a large number of symbols called hieroglyphs (from the Greek *hieros*, "sacred," and *glyphein*, "to carve"). As their name suggests, the Greeks believed they had religious significance. Some of these symbols were simple pictures of creatures or objects, or pictographs, similar to those used by the Sumerians (Chapter 2). Others were phonograms, or signs representing spoken sounds.

For record keeping, correspondence, and manuscripts of all sorts, the earliest scribes must also have used this system of signs. In time, however, they developed a simplified version of hieroglyphs that could be written more quickly in lines of script on papyrus scrolls. This type of writing is called hieratic, another term derived from the Greek word for "sacred." Even after this script was perfected, inscriptions in reliefs or paintings and on ceremonial objects continued to be written in hieroglyphics.

The third type of writing came into use only in the eighth century BCE, as written communication ceased to be restricted to priests and scribes. It was a simplified, cursive form of hieratic writing that was less formal and easier to master; the Greeks referred to it as demotic writing (from demos, "the people"). From this time on, all three systems were in use, each for its own specific purpose: religious documents were written in hieratic, inscriptions on monuments in hieroglyphics, and all other texts in demotic script.

The Egyptian language gradually died out after centuries of foreign rule, beginning with the arrival of the Greeks in 332 BCE. Modern scholars therefore had to decipher three types of writing in a long-forgotten language. The key was a fragment of a stone stele, dated 196 BCE, which was called the Rosetta Stone for the area of the delta where one of Napoleon's officers discovered it in 1799 CE. On it, a decree issued by the priests at Memphis honoring Ptolemy V (ruled c. 205–180 BCE) had been carved in hieroglyphics, demotic, and Greek. Even with the Greek translation, the two Egyptian texts were incomprehensible until 1818, when Thomas Young, an English physician interested in ancient Egypt, linked some of the hieroglyphs to specific names in the Greek version. A short time later, French scholar Jean-François Champollion located the names Ptolemy and Cleopatra in both of the Egyptian scripts. Having thereby determined the phonetic symbols for P, T, O, and L in demotic, he was able to slowly build up an "alphabet" of hieroglyphs, and by 1822 he had deciphered the two Egyptian texts. Thanks to him, Egyptologists are able to read ancient Egyptian documents and inscriptions as they come to light.

The Rosetta Stone with its three tiers of writing, from top to bottom: hieroglyphic, demotic, and Greek. The British Museum, London

Hieroglyphic signs for the letters P, T, O, and L, which were Champollion's clues to deciphering the Rosetta Stone, plus M, Y, and S: Ptolmys.

3-22. *Face of King Senusret III*. Dynasty 12, 1874–1855 BCE. Red quartzite, height 6¹⁄₂" (16.5 cm). The Metropolitan Museum of Art, New York

Purchase, Edward S. Harkness Gift, 1926 (26.7.1394)

young woman named Hapi. The family sits together on a lion-legged bench. Everyone wears green jewelry and white linen garments, produced by Amenemhat's wife Queen Iji and Hapi (see "The Fiber Arts," page 86). Amenemhat I (at the right) and his son Antel link arms and clasp hands while Iji holds her son's arm and shoulder with a firm but tender gesture. The **hieroglyphs**, or symbols, identify everyone and preserve their prayers to the god Osiris (see "Hieroglyphic, Hieratic, and Demotic Writing," page 111).

SCULPTURE

Royal portraits are less intimate than nonofficial portraits. Nevertheless, portraits from the Middle Kingdom do not always exhibit the idealized rigidity of earlier examples. Some express a special awareness of the hardship and fragility of human existence. A statue of Senusret III (Dynasty 12, ruled c. 1874–1855 BCE) reflects this new sensibility (fig. 3-22). Senusret was a dynamic king and successful general who led four military expeditions into Nubia, overhauled the central administration at home, and did much toward regaining control over the country's increasingly independent nobles. His portrait statue seems to reflect not only his achievements but also something of his personality and his inner thoughts.

He appears to be a man wise in the ways of the world but lonely, saddened, and burdened by the weight of his responsibilities.

Old Kingdom figures such as *Khafra* (see fig. 3-12) gaze into eternity confident and serene, whereas *Senusret III* shows a monarch preoccupied and emotionally drained. Deep creases line his sagging cheeks, his eyes are sunken, his eyelids droop, and his jaw is sternly set. Intended or not, this image betrays a pessimistic view of life, a degree of distrust similar to that reflected in the advice given by Amenemhat I, this Senusret's great-great-grandfather and the founder of his dynasty, to his son Senusret I (cited in Breasted, page 231):

> Fill not thy heart with a brother,
> Know not a friend,
> Nor make for thyself intimates, . . .
> When thou sleepest, guard for thyself thine own
> heart;
> For a man has no people [supporters],
> In the day of evil.

SMALL OBJECTS FOUND IN TOMBS

Middle Kingdom art of all kinds and in all mediums, from official portrait statues such as that of Senusret III to the least-imposing symbolic objects and delicate bits of jewelry, exhibits the desire of the period's artists for well-observed, accurate detail. A hippopotamus figurine discovered in the Dynasty 12 tomb of a governor named Senbi, for example, has all the characteristics of the beast itself: the rotund body on stubby legs, the massive head with protruding eyes, the tiny ears and distinctive nostrils (fig. 3-23). The figurine is an example of Egyptian **faience**, with its distinctive lustrous glaze (see "Glass-making and Egyptian Faience," page 122). The artist made the hippo the watery blue of its river habitat, then painted lotus blossoms on its flanks, jaws, and head, giving the impression that the creature is standing in a tangle of aquatic plants. Such figures were often placed in tombs so that the deceased might engage in an eternal hippopotamus hunt, enjoying the sense of moral triumph that entailed (see the discussion of *Ti Watching a Hippopotamus Hunt*, fig. 3-16).

The simple beauty of this faience hippopotamus contrasts sharply with the intricate splendor of a pectoral, or chest ornament, found at el-Lahun (fig. 3-24). Executed in gold and inlaid with semiprecious stones, it was discovered in the funerary complex of Senusret II, in the tomb of the king's daughter Sithathoryunet. The pectoral's design incorporates the name of Senusret II and a number of familiar symbols. Two Horus falcons perch on its base, and above their heads is a pair of coiled cobras, symbols of Ra, wearing the *ankh*, the symbol of life. Between the two cobras, a **cartouche**—an oval formed by a loop of rope—contains the hieroglyphs of the king's name. The sun disk of Ra appears at the top, and a scarab beetle, another symbol of Ra suggestive of rebirth, is at the bottom. Below the cartouche, a kneeling male figure helps the falcons support a double arch of notched palm ribs, a hieroglyphic

3-23. **Hippopotamus**, from the tomb of Senbi (Tomb B.3), Meir. Dynasty 12, c. 1985–1795 BCE. Faience, length 7⅞" (20 cm). The Metropolitan Museum of Art, New York

Gift of Edward S. Harkness, 1917 (17.9.1)

3-24. **Pectoral of Senusret II**, from the tomb of Princess Sithathoryunet, el-Lahun. Dynasty 12, c. 1880–1874 BCE. Gold and semiprecious stones, length 3¼" (8.2 cm). The Metropolitan Museum of Art, New York

Purchase, Rogers Fund and Henry Walters Gift, 1916 (16.1.3)

symbol meaning "millions of years." Decoded, the pectoral's combination of images yields the message: "May the sun god give eternal life to Senusret II."

THE NEW KINGDOM

During the Second Intermediate period—another turbulent interruption in the succession of dynasties ruling a unified country—an eastern Mediterranean people called the Hyksos invaded Egypt's northernmost regions. Finally, during Dynasty 18 (c. 1550–1295), the early rulers of the New Kingdom (c. 1550–1069 BCE) regained control of the entire Nile region from Nubia in the south to the Mediterranean in the north, restoring the country's political and economic strength. Roughly a century later, one of the same dynasty's most dynamic

kings, Thutmose III (ruled c. 1479–1425 BCE), extended Egypt's influence along the eastern Mediterranean coast as far as the region of modern Syria. His accomplishment was the result of fifteen or more military campaigns and his own skill at diplomacy. Thutmose III was the first ruler to refer to himself as "pharaoh," a term that simply meant "great house." Egyptians used it in the same way that people say "the White House" to mean the current United States president. The successors of Thutmose III continued to use the term, and it ultimately found its way into the Hebrew Bible—and modern usage—as the name for the kings of Egypt.

By the beginning of the fourteenth century BCE, the most powerful Near Eastern kings acknowledged the rulers of Egypt as their equals. Marriages contracted

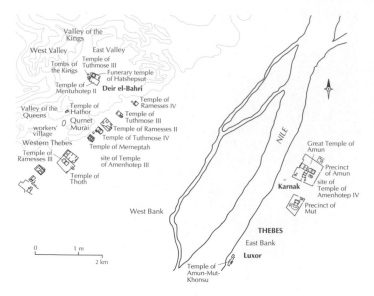

3-25. Map of the Thebes district

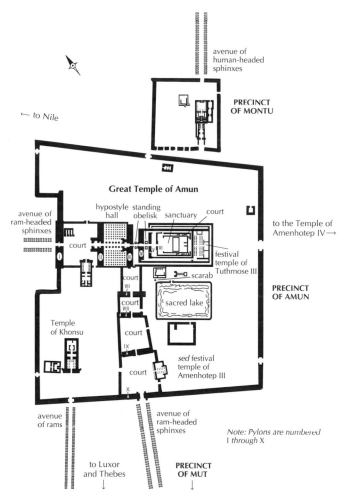

3-26. Plan of the Great Temple of Amun, Karnak. New Kingdom, c. 1295–1186 BCE

The Karnak site had been an active religious center for more than 2,000 years before these structures were erected on it. Over the nearly 500 years of the New Kingdom, successive kings busily renovated and expanded the Amun temple. Later rulers added pylons, courtyards, hypostyle halls, statues, and temples or shrines to other deities to the east, west, and south of the main temple until the complex covered about 60 acres, an area as large as a dozen football fields. In this ongoing process, it was common to demolish older structures and use their materials in new construction.

between Egypt's ruling families and Near Eastern royalty helped to forge a generally cooperative network of kingdoms in the region, stimulating trade and securing mutual aid at times of natural disaster and outside threats to established borders. Over time, however, Egyptian influence beyond the Nile diminished, and the power of Egypt's kings began to wane.

GREAT TEMPLE COMPLEXES

At the height of the New Kingdom, rulers undertook extensive building programs along the entire length of the Nile. Their palaces, forts, and administrative centers disappeared long ago, but remnants of temples and tombs of this great age have endured. Even as ruins, Egyptian architecture and sculpture attest to the expanded powers and political triumphs of the builders. Early in this period, the priests of the god Amun in Thebes, Egypt's capital city through most of the New Kingdom, had gained such dominance that worship of the Theban triad of deities—Amun, his wife Mut, and their son Khons—had spread throughout the country. Temples to these and other gods were a major focus of royal art patronage, as were tombs and temples erected to glorify the kings themselves.

Temples to the Gods at Karnak and Luxor. Two temple districts consecrated primarily to the worship of Amun, Mut, and Khons arose near Thebes—one at Karnak to the north and the other at Luxor to the south (fig. 3-25). Little of the earliest construction at Karnak survives, but the remains of New Kingdom additions to the Great Temple of Amun still dominate the landscape (fig. 3-26). Access to the heart of the temple, a sanctuary containing the statue of Amun, was through a principal courtyard, a **hypostyle hall**—a vast hall filled with columns—and a number of smaller halls and courts. Massive gateways, called **pylons**, set off each of these separate elements. The greater part of Pylons II through VI and the areas behind them were renovated or newly built and embellished with colorful wall reliefs between the reigns of Thutmose I (Dynasty 18, ruled c. 1504–1492 BCE) and Rameses II (Dynasty 19, ruled c. 1279–1213 BCE). A sacred lake to the south of the temple, where the king and priests might undergo ritual purification before entering the temple, was also added during this period. Behind the sanctuary of Amun, Thutmose III erected a court and festival temple to his own glory. Amenhotep III (Dynasty 18, ruled 1390–1352 BCE) later placed a large stone statue of Khepri, the scarab beetle symbolic of the rising sun and everlasting life, next to the sacred lake.

Only kings and priests were allowed to enter the sanctuary of Amun. The priests washed the god's statue every morning and clothed it in a new garment. Twice a day, they provided it with tempting meals. The god was thought to derive nourishment from the spirit of the food, which the priests then removed and ate themselves. Ordinary people entered only as far as the forecourts of the hypostyle halls, where they found themselves surrounded by inscriptions and images of kings and the god on columns and walls. During religious festivals, however,

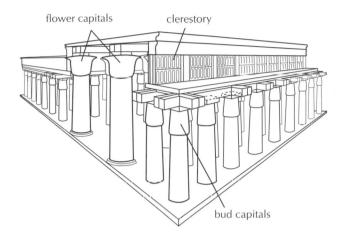

3-27. Reconstruction drawing of the hypostyle hall, Great Temple of Amun, Karnak. Dynasty 19, c. 1295–1186 BCE

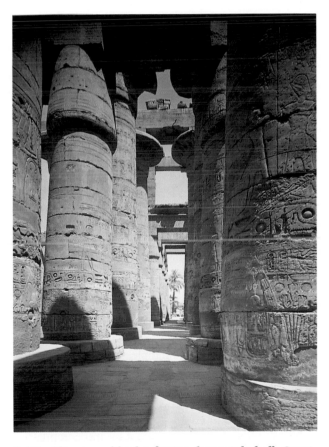

3-28. Flower and bud columns, hypostyle hall, Great Temple of Amun, Karnak

they lined the waterways along which statues of the gods were carried in ceremonial boats. At such times they were permitted to submit petitions to the priests for requests they wished the gods to grant.

Between Pylons II and III at Karnak stands the enormous hypostyle hall erected in the reigns of the Dynasty 19 rulers Sety I (ruled c. 1294–1279 BCE) and his son Rameses II (ruled c. 1279–1213 BCE). Called the "Temple of the Spirit of Sety, Beloved of Ptah in the House of Amun," it may have been used for royal coronation ceremonies. Rameses II referred to it in more mundane

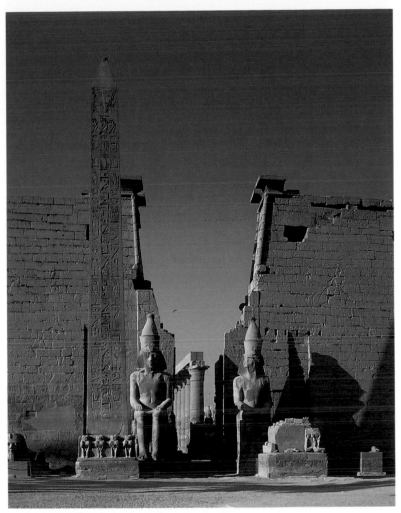

3-29. Pylon of Rameses II with obelisk in the foreground, Temple of Amun, Mut, and Khons, Luxor. Dynasty 19, c. 1279–1213 BCE

terms as "the place where the common people extol the name of his majesty." The hall was 340 feet wide and 170 feet long. Its 134 closely spaced columns supported a stepped roof of flat stones, the center section of which rose some 30 feet higher than the rest (figs. 3-27, 3-28). The columns supporting this higher part of the roof are 66 feet tall and 12 feet in diameter, with massive lotus flower capitals. The smaller columns on each side have lotus bud capitals that must have seemed to march off forever into the darkness.

In each of the side walls of the higher center section was a long row of window openings, creating what is known as a **clerestory**. These openings were filled with stone grillwork, so they cannot have provided much light, but they did permit a cooling flow of air through the hall. Despite the dimness of the interior, artists were required to cover nearly every inch of the columns, walls, and cross-beams with reliefs.

The sacred district at Luxor was already the site of a splendid temple complex by the thirteenth century BCE. Rameses II further enlarged the complex with the addition of a pylon and a **peristyle court**, or open courtyard ringed with columns and covered walkways (fig. 3-29). In front of his pylon stood two colossal statues of the king and a pair of **obelisks**—slender, slightly tapered square shafts of stone capped by a pyramid-

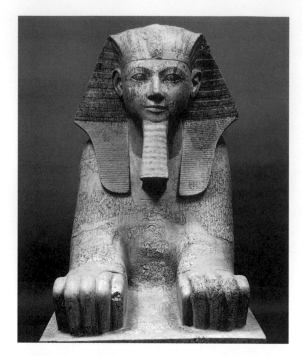

3-30. *Hatshepsut as Sphinx*, from Deir el-Bahri. Dynasty 18, c. 1473–1458 BCE. Red granite, height 5'4" (1.64 m). The Metropolitan Museum of Art, New York

Rogers Fund, 1931 (31.3.166)

Of the Egyptian queens who went down in history as "living gods" themselves and not merely "wives of gods," Hatshepsut may well have been the most commanding. Among the reliefs in her funerary temple at Deir el-Bahri (see fig. 3-31), she placed— just as a male king might have—a depiction of her divine birth. There she is portrayed as the daughter of her earthly mother, Queen Ahmose, and the god Amun. She also honored her real father, Thutmose I, by dedicating a chapel to him in her temple.

shaped block called a **pyramidion**. The faces of the pylon are ornamented with reliefs detailing the king's military exploits. The walls of the courtyard present additional reliefs of Rameses, shown together with various deities, his wife, seventeen of his sons, and other royal children, some hundred of whom he had by eight official wives and numerous concubines during his sixty-seven-year reign.

Temples for Rulers: Hatshepsut and Rameses II. The dynamic female ruler Hatshepsut (Dynasty 18, ruled c. 1473–1458 BCE) is a notable figure in a period otherwise dominated by male warrior-kings. Besides Hatshepsut, three other queens ruled Egypt—the little-known Sobekneferu and Tusret, and, much later, the notorious Cleopatra. The daughter of Thutmose I, Hatshepsut married her half brother, who then reigned for fourteen years as Thutmose II. When he died, she became regent for his underage son—Thutmose III—born to one of his concubines. Hatshepsut had herself declared king by the priests of Amun, a maneuver that prevented Thutmose III from assuming the throne for twenty years. In art, she

was represented in all the ways a male ruler would have been, even as a human-headed sphinx (fig. 3-30), and she was called "His Majesty." Sculpted portraits show her in the traditional royal trappings: kilt, linen head-cloth, broad beaded collar, false beard, and bull's tail hanging from her waist.

Hatshepsut's closest adviser, a courtier named Senenmut, was instrumental in carrying out her ambitious building program. Her most innovative undertaking was her own funerary temple at Deir el-Bahri (fig. 3-31). The structure was not intended to be her tomb; Hatshepsut was to be buried, like other New Kingdom rulers, in a necropolis known as the Valley of the Kings, about half a mile to the northwest (see fig. 3-25). Her funerary temple was magnificently positioned against high cliffs and oriented toward the Great Temple of Amun at Karnak, some miles away on the east bank of the Nile. The complex follows an **axial** plan—that is, all of its separate elements are symmetrically arranged along a dominant center line (fig. 3-32). A causeway lined with sphinxes once ran from a valley temple on the Nile, since destroyed, to the first level of the complex, a huge open space before a long row of columns, or **colonnade**. From there, visitors ascended a long, straight ramp flanked by pools of water to the second level. At the ends of the columned porticos on this level were shrines to Anubis and Hathor. Relief scenes and inscriptions in the south portico depict Hatshepsut's expedition to Punt, an exotic, half-legendary kingdom probably located on the Red Sea or the Gulf of Aden, to bring back rare myrrh trees for the temple's terraces. The uppermost level of the temple consisted of another colonnade fronted by colossal royal statues, and behind this a large hypostyle hall with chapels dedicated to Hatshepsut, her father, and the gods Amun and Ra-Horakhty—the power of the sun at dawn and dusk. Centered in the hall's back wall was the entrance to the temple's innermost sanctuary. This small chamber was cut deep into the cliff in the manner of Middle Kingdom rock-cut tombs.

Hatshepsut's funerary temple, with its lively alternating of open spaces and grandiose architectural forms, projects an imposing image of authority. In its day, its remarkable union of nature and architecture, with many different levels and contrasting textures—water, stone columns, trees, and cliffs—made it far more impressive than the bleak expanse of stone ruins and sand that confronts the visitor today.

Under Rameses II (Dynasty 19, ruled c. 1279–1213 BCE) Egypt became a mighty empire. Rameses was a bold military commander and an effective political strategist. In about 1259 BCE, he secured a peace agreement with the Hittites, a rival power centered in Anatolia (Chapter 2) that had tried to expand its borders to the west and south at the Egyptians' expense. He twice reaffirmed that agreement later in his reign by marrying Hittite princesses.

In the course of his long and prosperous reign, Rameses II initiated building projects on a scale rivaling the Old Kingdom pyramids at Giza (figs. 3-33, 3-34, 3-35, in "The Object Speaks"). The most awe-inspiring of his

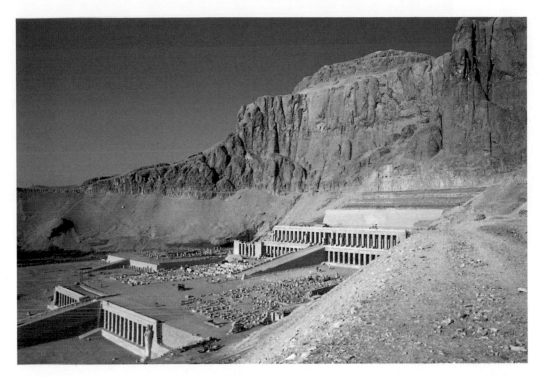

3-31. Funerary temple of Hatshepsut, Deir el-Bahri. Dynasty 18, c. 1473–1458 BCE.

At the far left, ramp and base of the funerary temple of Mentuhotep III. Dynasty 11, c. 2004–1992 BCE

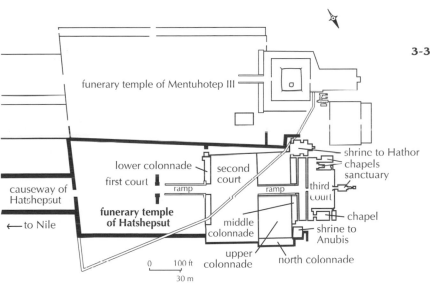

3-32. Plan of the funerary temple of Hatshepsut, Deir el-Bahri

funerary temple of Mentuhotep III

causeway of Hatshepsut

← to Nile

funerary temple of Hatshepsut

lower colonnade

first court

ramp

second court

ramp

third court

shrine to Hathor

chapels

sanctuary

chapel

shrine to Anubis

middle colonnade

upper colonnade

north colonnade

0 100 ft
30 m

many architectural monuments is found at Abu Simbel in Nubia, Egypt's southernmost region. There Rameses ordered the construction of two temples, a large one to himself and a smaller one to his chief wife, Nefertari. They were carved out of the face of a cliff in the manner of a rock-cut tomb but far surpass earlier temples created in this way. The dominant feature of Rameses' temple is a row of four colossal seated statues of the king himself, each more than 65 feet tall. Large figures of Nefertari and other family members stand next to his feet, but they do not even reach the height of the king's giant stone knees. The interior of the temple stretches back some 160 feet and was oriented in such a way that on the most important day of the Egyptian calendar the first rays of the rising sun shot through its entire depth to illuminate a row of four statues—the king and the gods Amun, Ptah, and Ra-Horakhty—placed against the back wall. The front of the smaller nearby temple to Nefertari is adorned with six statues 33 feet tall, two of the queen wearing the headdress of Hathor, and four of her husband, Rameses II.

AKHENATEN AND THE ART OF THE AMARNA PERIOD

The most unusual ruler in the history of ancient Egypt was Amenhotep IV, who came to the throne about 1352 BCE (Dynasty 18). In his seventeen-year reign, he radically transformed the political, spiritual, and cultural life of the

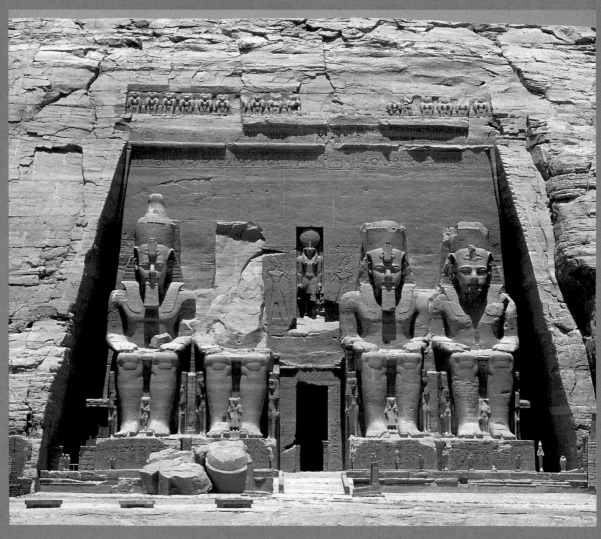

3-33. Temples of Rameses II (left) **and Nefertari** (right), **Abu Simbel**. Dynasty 19, c. 1279–1213 BCE

3-34. Temple of Rameses II, Abu Simbel. Dynasty 19, c. 1279–1213 BCE

THE TEMPLES OF RAMESES II

Many art objects speak to us subtly, fascinating us through their beauty or mystery. Rameses II (Dynasty 19, ruled c. 1279–1213 BCE) used art in a very big way to speak of his actions, legislation, and power. The enduring art he commissioned—youthful and vibrant, filled with power and energy—makes his message clear to any visitor dwarfed by his temples at Abu Simbel and, about 70 miles downriver, at Luxor.

Rameses built numerous monuments in Egypt, but his choice of sites for his funerary temple proclaims his military and diplomatic success: Abu Simbel is north of the second cataract of the Nile, in Nubia, the ancient land of Kush, which Rameses ruled and which was the source of his gold, ivory, and exotic animal skins. He asserted his divinity in two temples he had carved out of the sacred hills there. The larger temple (fig. 3-33, left side), carved out of the mountain Meha, is dedicated to Rameses and the Egyptian gods Amun, Ra, and Ptah. At its entrance, four awe-inspiring 65-foot statues of Rameses are flanked by relatively small statues of family members, including his wife Nefertari, affectionately caressing his shin, which reaches her eye level. Inside the temple, eight 33-foot (10-meter) statues of the god Osiris with the face of the god-king Rameses further proclaim his divinity (fig. 3-34).

About 500 feet away, Rameses ordered a smaller temple (fig. 3-33, right side) to be carved into the mountain Ibshek, sacred to Hathor, goddess of fertility, love, joy, and music, and to be dedicated to Hathor and to Nefertari. The two temples, together honoring the official gods of Egypt and his dynasty, were oriented so that their axes crossed in the middle of the Nile, suggesting that they may have been associated with the annual life-giving flood.

Monuments such as Rameses's colossal statue at his temple in Luxor (fig. 3-35; see also 3-29) also speak across the ages of the religious and political power of this complex ruler: the king-god of Egypt, the conqueror of the Hittites, the ruler of a vast empire, a virile man with nearly a hundred children, perhaps even the cruel pharaoh of the Hebrew Exodus. As an inscription he had carved into an obelisk now standing in the heart of Paris says: "Son of Ra: Rameses-Meryamun ['Beloved of Amun']. As long as the skies exist, your monuments shall exist, your name shall exist, firm as the skies."

Ironically, flooding nearly destroyed Rameses's temples at Abu Simbel. Buried in the sand over the ages, they were discovered and opened early in the nineteenth century. But in the 1960s, construction of the Aswan High Dam flooded the Abu Simbel site. Only an international effort and modern technology saved the complex, relocating it high above flood levels so that it could continue to speak to us.

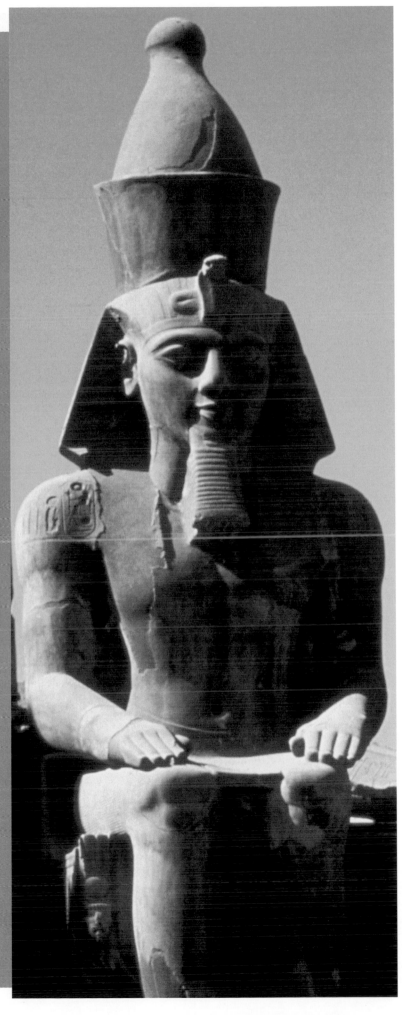

3-35. Colossal statue of Rameses II in his temple complex at Luxor. Dynasty 19, c. 1279–1213 BCE

3-36. *Akhenaten and His Family,* from Akhetaten (modern Tell el-Amarna). Dynasty 18, c. 1352–1336 BCE. Painted limestone relief, 12¼ x 15¼" (31.1 x 38.7 cm). Staatliche Museen zu Berlin, Preussischer Kulturbesitz, Ägyptisches Museum

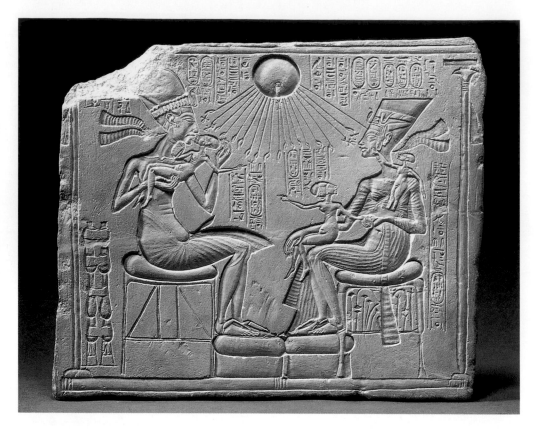

Egyptian relief sculptors often employed the technique seen here, called sunken relief. In ordinary reliefs, the background is carved away so that the figures project from the finished surface. In this technique, the original flat surface of the stone is the background, and the outlines of the figures are deeply incised, permitting the modeling of three-dimensional forms within them. If an ordinary relief became badly worn, a sculptor might restore it by recarving it as a sunken relief.

country. He founded a new religion honoring a single supreme god, the life-giving sun deity Aten (represented by a disk), and accordingly changed his own name about 1348 BCE to Akhenaten ("One Who Is Effective on Behalf of Aten"). Abandoning Thebes, the capital of Egypt since the beginning of his dynasty and a city firmly in the grip of the priests of Amun, Akhenaten built a new capital much farther north, calling it Akhetaten ("Horizon of the Aten"). Borrowing from the modern name for this site, Tell el-Amarna, historians refer to his reign as the Amarna period.

The king saw himself as Aten's son, and at his new capital he presided over the worship of Aten as a divine priest. His chief queen, Nefertiti, served as a divine priestess. Temples to Aten were open courtyards, where altars could be bathed in the direct rays of the sun. In art, Aten is depicted as a round sun sending down long thin rays ending in human hands, some of which hold the *ankh.*

Akhenaten emphasized the philosophical principle of *maat,* or divine truth, and one of his kingly titles was "Living in Maat." Such concern for truth found expression in new artistic conventions. In portraits of the king artists emphasized his unusual physical characteristics— long, thin arms and legs, a protruding stomach, swelling thighs, a thin neck supporting an elongated skull. Unlike his predecessors, and in keeping with his penchant for candor, Akhenaten urged his artists to portray the royal family in informal situations. Even private houses in the capital city were adorned with reliefs of the king and his family, an indication that he managed to substitute veneration of the royal household for the traditional worship of families of gods, such as Amun, Mut, and Khons.

A painted relief of Akhenaten, Queen Nefertiti, and three of their daughters exemplifies the new openness and a new figural style (fig. 3-36). In this **sunken relief**— where the outlines of the figures have been carved into

the surface of the stone, instead of being formed by cutting away the background—the king and queen sit on cushioned thrones playing with their children. The base of the queen's throne is adorned with the stylized plant symbol of a unified Egypt, which has led some historians to conclude that Nefertiti acted as co-ruler with her husband. The royal couple is receiving the blessings of Aten, whose rays ending in hands penetrate the open pavilion and hold *ankhs* to their nostrils, giving them the "breath of life." Other ray-hands caress the hieroglyphic inscriptions in the center. The king holds one child and lovingly pats her head. The youngest of the three perches on Nefertiti's arm and tries to attract her attention by stroking her cheek. The oldest sits on the queen's lap, tugging at her mother's hand and pointing to her father. The children are nude, and the younger two have shaved heads, a custom of the time. The oldest wears the sidelock of youth, a patch of hair left to grow and hang at one side of the head in a braid. The artist has conveyed the engaging behavior of the children and the loving concern of their parents in a way not even hinted at in earlier royal portraiture in Egypt.

Akhenaten's goals were actively supported not only by Nefertiti but also by his mother, Queen Tiy. She had been the chief wife of the king's father, Amenhotep III (Dynasty 18, ruled c. 1390–1352 BCE), and played a significant role in affairs of state during his reign. Queen Tiy's personality emerges from a miniature portrait head that reveals the exquisite bone structure of her dark-skinned face, with its arched brows, uptilted eyes, and slightly pouting lips (fig. 3-37).

This portrait of Tiy has existed in two versions. In the original, which may been made for the cult of her dead husband, Amenhotep III, the queen was identified with the funerary goddesses Isis and Nephthys. She wore a

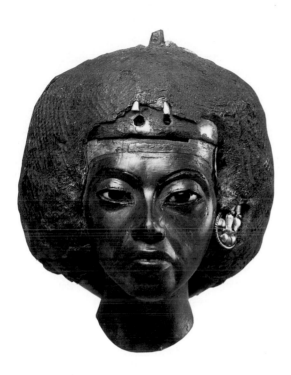

3-37. *Queen Tiy*, from Kom Medinet el-Ghurab (near el-Lahun). Dynasty 18, c. 1352 BCE. Yew, ebony, glass, silver, gold, lapis lazuli, cloth, clay, and wax, height 3³/₄" (9.4 cm). Staatliche Museen zu Berlin, Preussischer Kulturbesitz, Ägyptisches Museum

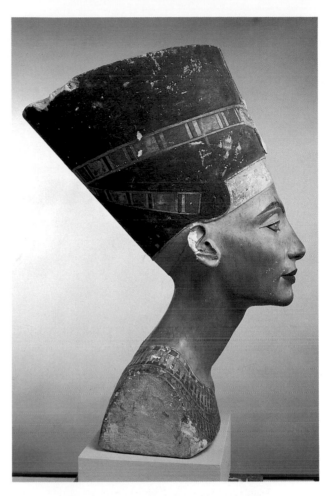

3-38. *Nefertiti*, from Akhetaten (modern Tell el-Amarna). Dynasty 18, c. 1352–1336 BCE. Painted limestone, height 20" (51 cm). Staatliche Museen zu Berlin, Preussischer Kulturbesitz, Ägyptisches Museum

This famous head was discovered, along with various drawings and other items relating to commissions for the royal family, in the studio of the sculptor Thutmose at Akhetaten, the capital city during the Amarna period. Bust portraits, consisting solely of the head and shoulders, were rare in New Kingdom art. Scholars believe that Thutmose may have made this one as a finished model to follow in sculpting or painting other images of his patron. From depictions of sculptors at work, we know that some statues were made in parts and then assembled, but there is no indication that this head was meant to be attached to a body.

silver headdress covered with gold cobras and gold jewelry. Later, when her son had come to power and established his new solar religion, the portrait was altered. A brown cap covered with glass beads was placed over the funeral headdress. A plumed crown, perhaps similar to the one worn by Nefertari (see fig. 3-42), rose above the cap (the attachment is still visible). The entire sculpture would have been about one-third lifesize.

Tiy's portrait contrasts sharply with a head of Nefertiti in which her refined, regular features, long neck, and heavy-lidded eyes appear almost too perfect to be real (fig. 3-38). Part of the beauty of this head is the result of the artist's dramatic use of color. The hues of the blue headdress and its colorful band are repeated in the rich red, blue, green, and gold of the jewelry. The queen's brows, eyelids, cheeks, and lips are heightened with color, as they no doubt were with cosmetics in real life. Whether or not Nefertiti's beauty is exaggerated, phrases used by her subjects when referring to her—"Fair of Face," "Mistress of Happiness," "Great of Love," or "Endowed with Favors"—tend to support the artist's vision.

Glassmaking also flourished in the Amarna period. The craft could only be practiced by artists working for the king, and Akhenaten's new capital had its own glass-making workshops. A fish-shaped bottle produced there was meant to hold scented oil (fig. 3-39). It is an example

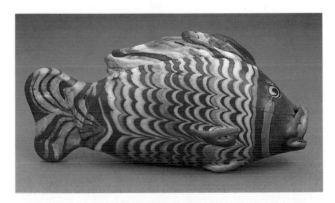

3-39. **Fish-shaped bottle**, from Akhetaten (modern Tell el-Amarna). Dynasty 18, c. 1352–1336 BCE. Core glass, length 5¹/₈" (13 cm). The British Museum, London

TECHNIQUE

GLASSMAKING AND EGYPTIAN FAIENCE

Heating a mixture of sand, lime, and sodium carbonate or sodium sulfate to a very high temperature produces glass. The addition of other substances can make it transparent, translucent, or opaque and create a vast range of colors. No one knows precisely when or where the technique of glassmaking was first developed.

By the Predynastic period, Egyptians were experimenting with faience, a technique in which glass paste, when fired, produces a smooth and shiny opaque finish. It was used first to form small objects—mainly beads, charms, and color inlays—but later as a colored glaze to ornament pottery wares and clay figurines (see fig. 3-23).

The first evidence of all-glass vessels and other hollow objects dates from the early New Kingdom. At that time, glassmaking was restricted to royal workshops, and only the aristocracy and priestly class could commission work from them. The first objects to be made entirely of glass in Egypt were produced by the technique known as core glass. A lump of sandy clay molded into the desired shape of the finished vessel was wrapped in strips of cloth, then skewered on a fireproof rod. It was then briefly dipped into a pot of molten glass. When the resulting coating of glass had cooled, the clay core was removed through the opening left by the skewer. To decorate the vessel thus created, glassmakers frequently heated thin rods of colored glass and fused them to the surface in elegant wavy patterns, zigzags, and swirls (see fig. 3-39).

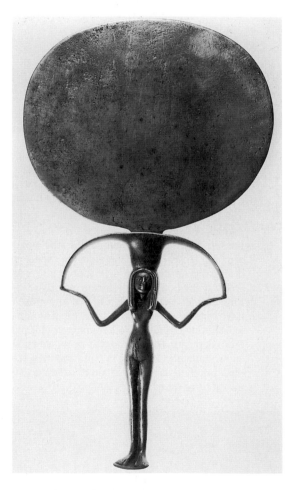

3-40. Hand mirror. Dynasty 18, c. 1550–1295 BCE. Bronze, height 9³/4" (24.6 cm). The Brooklyn Museum

Charles Edwin Wilbour Fund (37.365E)

scales, created by heating small rods of white and orange glass to the point that they fused to the body and could be manipulated with a pointed tool. The fish that lent its shape to the bottle has been identified as a bolti, a species that carries its eggs in its mouth and spits out its offspring when they hatch. It was therefore a common symbol for birth and regeneration, especially the sort of self-generation that Akhenaten attributed to the sun disk Aten.

Domestic objects routinely placed in tombs as grave goods often had similar symbolic significance. One such item is a hand mirror, less than 10 inches tall, discovered in a Dynasty 18 tomb (fig. 3-40). Its handle is formed by the figure of a slender young woman, probably a dancer, balancing a giant lotus blossom on her head. Her arms reach out to support the flower's elongated sepals, forming with them a highly decorative shape. The mirror itself is a metal disk polished to a high gloss to create a reflecting surface. On one level, the young woman can be thought of as an attendant obediently holding the mirror for the person wishing to gaze in it. But she might also be interpreted as a fertility goddess supporting the sun disk. This elegant luxury item could have been placed in the tomb to symbolize the blessings of Aten and the hope that the deceased would live eternally in peace.

THE RETURN TO TRADITION

Akhenaten's new religion and revolutionary ideas regarding the conduct appropriate for royalty outlived him by only a few years. His successors—it is not clear how they were related to him—had brief and troubled reigns, and the priesthood of Amun quickly regained its former power. The young king Tutankhaten (Dynasty 18, ruled c. 1336–1327 BCE) returned to traditional religious beliefs, changing his name to Tutankhamun. He also turned his back on Akhenaten's new city and moved his court to Thebes.

The Royal Tombs of Tutankhamun and Nefertari.
Tutankhamun died quite young and was buried in the Valley of the Kings. Remarkably, although early looters did rob

of what is known as core glass, which refers to the early technique used in its manufacture (see "Glassmaking and Egyptian Faience," above). Its body was created from glass tinted with cobalt, a dark blue metallic oxide. The surface was then decorated with swags resembling fish

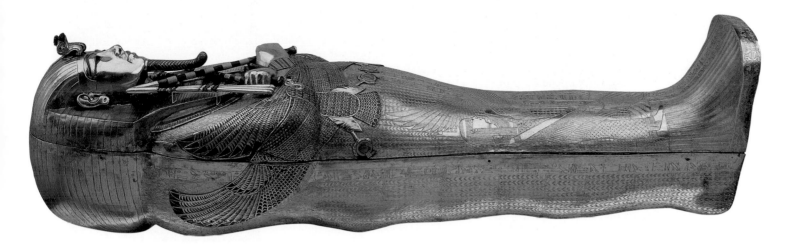

3-41. Inner coffin of Tutankhamun's sarcophagus, from the tomb of Tutankhamun, Valley of the Kings, near Deir el-Bahri. Dynasty 18, c. 1336–1327 BCE. Gold inlaid with glass and semiprecious stones, height 6' 7/8" (1.85 m). Egyptian Museum, Cairo

The English archaeologist Howard Carter had worked in Egypt for more than twenty years before he undertook a last expedition, sponsored by the wealthy British amateur Egyptologist Lord Carnarvon, after World War I. In November 1922 Carter discovered the entrance to the tomb of King Tutankhamun, the only Dynasty 18 royal burial place then still unidentified. His workers cleared their way down to its antechamber, which was found to contain unbelievable treasures: jewelry, textiles, gold-covered furniture, a carved and inlaid throne, four gold chariots, and other precious objects. In February 1923, they pierced through the wall separating the anteroom from the actual burial chamber, and in early January of the following year—having taken great care to catalog all the intervening riches and prepare for their safe removal—they finally reached the king's astonishing sarcophagus. Figure 3-1 shows Tutankhamun's funerary mask as it was first photographed in October 1925.

the tomb complex, his sealed inner tomb chamber was never plundered, and when it was opened in the 1920s its incredible riches were discovered just as they had been left. His body lay inside three nested coffins that identified him with Osiris, the god of the dead. The innermost coffin, in the shape of a mummy, is the richest of the three, for it is made of several hundred pounds of solid gold (fig. 3-41). Its surface is decorated with colored glass and semiprecious gemstones, as well as finely incised linear designs and hieroglyphic inscriptions. The king holds a crook and a flail—an implement used in threshing grain. Both symbols were closely associated with Osiris and were a traditional part of the royal regalia at the time. The king's features as reproduced on the coffin are those of a very young man. Even though they may not reflect Tutankhamun's actual appearance, the unusually full lips and thin-bridged nose hint at the continued influence of the Amarna period style and its dedication to actual appearances.

By royal standards, Tutankhamun's tomb was small and simply decorated. One of the most lavish tombs to be discovered so far is that of Nefertari, the principal wife of Rameses II. In one of the tomb's many beautiful, large-figured wall paintings, Nefertari offers jars of perfumed ointment to the goddess Isis (fig. 3-42). The queen wears the vulture-skin headdress of royalty, a royal collar, and a long, semitransparent white linen gown. Isis, seated on her throne behind a table heaped with offerings, holds a long scepter in her left hand, the

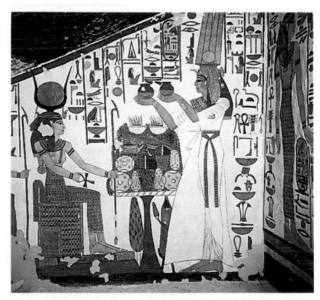

3-42. Queen Nefertari Making an Offering to Isis, wall painting in the tomb of Nefertari, Valley of the Queens, near Deir el-Bahri. Dynasty 19, c. 1279–1213 BCE

RESTORING THE TOMB OF NEFERTARI The tomb of Queen Nefertari, wife of Rameses II (Dynasty 19, ruled c. 1279–1213 BCE), was discovered in the Valley of the Queens, near Deir el-Bahri, in 1904 CE. Although it had been looted of everything that could be carried away, it still had splendid wall paintings of the deceased queen in the company of the gods (see fig. 3-42).

Egypt's dry climate and the care with which most tombs were sealed ensured that many such paintings remained in excellent condition for thousands of years, but the ones in Nefertari's tomb began to deteriorate soon after they were completed. Conservators have theorized that the walls were left damp when priests sealed the tomb, so that salts from the plaster leached to the surface, loosening the layer of pigment over time and causing it to flake. The dampness also allowed fungi to attack the paint. Disintegration accelerated dramatically when the tomb was opened to visitors. The crowds brought with them humidity, dirt, and bacteria, causing such damage by 1940 that the tomb was closed to the public.

In 1968, the Egyptian National Antiquities Service and the Getty Conservation Institute in Santa Monica, California, undertook a multimillion-dollar conservation project to save the tomb's decorations. Painting restorers Paolo and Laura Mora were commissioned to supervise a team of Italian and Egyptian conservators. Their first priority was to stop the paint from flaking and the plaster from crumbling any further. Over the course of a year, their crew applied more than 10,000 "bandages" made of Japanese mulberry-pulp paper to the tomb's interior surfaces.

Once the paint and plaster had been stabilized, the restorers could begin their real work. Their goal was to salvage every flake of paint they could from these 3,000-year-old works. They carefully cleaned the paintings with cotton swabs dipped in distilled water. Using hypodermic needles and a special resin glue, they were able to reattach small spots of loose plaster or pigment. Larger detached areas were removed whole, cleaned, then glued back in place. In the past, conservators commonly re-created and replaced lost sections with conjectural painting of their

Getty Conservation Institute conservator S. Rickerby at work in Chamber K, tomb of Nefertari, Valley of the Queens, near Deir el-Bahri

own, but restorers today prefer simply to make such gaps less obvious by shading them in tones matched to adjacent work. This was the procedure used in Nefertari's tomb.

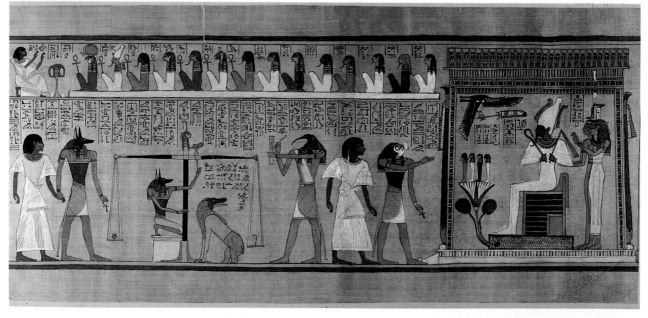

3-43. *Judgment before Osiris*, illustration from a Book of the Dead. Dynasty 19, c. 1285 BCE. Painted papyrus, height 15⅝" (39.8 cm). The British Museum, London

Osiris, the god of the underworld, appears on the right, enthroned in a richly ornamented pavilion, or chapel, in the "Hall of the Two Truths." Here the souls of the deceased were thought to be subjected to a "last judgment" to determine whether they were worthy of eternal life. Osiris was traditionally depicted as a mummified man wrapped in a white linen shroud. His other trappings are those of an Egyptian king. He wears the double crown, incorporating those of both Upper and Lower Egypt, a false beard, and a wide beaded collar, and he brandishes the symbolic crook and flail in front of his chest. The figure in the center combining a man's body with the head of an ibis, a wading bird related to the heron, is the god Thoth. He here functions as a sort of court stenographer—appropriately, for he was revered as the inventor of hieroglyphic writing.

ankh in her right. She too wears the vulture headdress, but hers is surmounted by the horns of Hathor framing a sun disk, clear indications of her divinity. The artists responsible for decorating the tomb, in the Valley of the Queens near Deir el-Bahri, worked in a new style diverging very subtly but distinctively from earlier conventions. The outline drawing and use of clear colors reflect traditional practices, but quite new is the slight modeling of the body forms by small changes of hue to increase their appearance of three-dimensionality. The skin color of these women is much darker than that conventionally used for females in earlier periods, and lightly brushed-in shading makes their eyes and lips stand out more than before (see "Restoring the Tomb of Nefertari," page 124). The tomb's artists used particular care in placing the hieroglyphic inscriptions around these figures, creating an unusually harmonious overall design.

BOOKS OF THE DEAD

By the time of the New Kingdom, the Egyptians had come to believe that only a person free from sin could enjoy an afterlife. The dead were thought to undergo a "last judgment" consisting of two tests presided over by Osiris and supervised by jackal-headed Anubis, the overseer of funerals and cemeteries. The deceased were first questioned by a delegation of deities about their behavior in life. Then their hearts, which the Egyptians believed to be the seat of the soul, were weighed on a scale against an ostrich feather, the symbol of Maat, goddess of truth.

These beliefs gave rise to a funerary practice especially popular among the nonroyal classes. Family members would commission papyrus scrolls containing magical texts or spells to help the dead survive the tests, and they had the embalmers place the scrolls among the wrappings of their loved ones' mummified bodies. Early collectors of Egyptian artifacts referred to such scrolls, often beautifully illustrated, as Books of the Dead. The books varied considerably in content. A scene created for a man named Hunefer (Dynasty 19) shows him at three successive stages in his induction into the afterlife (fig. 3-43). At the left, Anubis leads him by the hand to the spot where he will weigh his heart, contained in a tiny jar, against the "feather of Truth." Maat herself appears atop the balancing arm of the scales wearing the feather as a headdress. A monster—part crocodile, part lion, and part hippopotamus—watches eagerly for a sign from the ibis-headed god Thoth, who prepares to record the result of the weighing. That creature is Ammit, the dreaded "Eater of the Dead."

But the "Eater" is left to go hungry. Hunefer passes the test, and on the right Horus presents him to Osiris. The god of the underworld sits on a throne floating on a lake of natron, the substance used to preserve the flesh of the deceased from decay (see "Preserving the Dead," page 99). The four sons of Horus, each of whom was entrusted with the care of one of the deceased's vital organs, stand atop a huge lotus blossom rising up out of the lake. The goddesses Nephthys and Isis stand behind

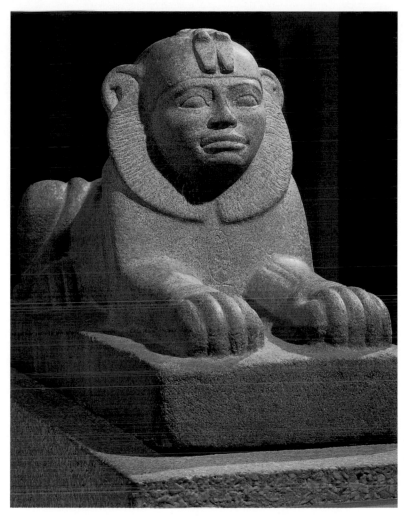

3-44. Sphinx of Taharqo, from Temple T, Kawa, Nubia. Dynasty 25, c. 690–664 BCE. Height 29 3/8" (74.7 cm). The British Museum, London

the throne, supporting the god's left arm with a tender gesture similar to the one seen in the Old Kingdom sculpture of Menkaura and his queen (see fig. 3-13). In the top register, Hunefer makes his appearance in the afterlife, kneeling before the nine gods of Heliopolis—the sacred city of the sun god Ra—and five personifications of life-sustaining principles.

THE CONTINUING INFLUENCE OF EGYPTIAN ART

The Late Period in Egypt (c. 747–332 BCE) saw the country and its art in the hands and service of foreigners. Nubians, Persians, Macedonians, Greeks, and Romans were all attracted to Egypt's riches and seduced by its art. In the seventh century BCE, the Nubians of Dynasty 25 controlled Egypt. Their art adopted the types and forms of earlier traditional Egyptian art. The royal sphinx of Taharqo (ruled c. 690–664 BCE), from Nubia (fig. 3-44), has a head with individualized Nubian features, an Egyptian king's headdress, and a lion's body, combining Egyptian formality with a realistic portrait of a Nubian ruler.

Three centuries later, in 332 BCE, Egypt was conquered by the Macedonian Greeks under Alexander the Great. After Alexander's death, his generals divided up the empire, with the Greek ruler Ptolemy eventually taking Egypt and initiating the Ptolemaic dynasty (c. 305–30 BCE). In 30 BCE, with the death of Cleopatra, the Romans succeeded the Ptolemies as Egypt's rulers. Fertile Egypt became Rome's breadbasket and thus the granary of Europe.

Not surprisingly, the style of painting of the time is **classical**—it reflects the conventions of Greek and Roman, not Egyptian, art. The most representative examples of this very late Egyptian art are the so-called Fayum portraits, painted faces on panels inserted into mummy wrappings. Well into Egypt's Roman period, the tradition of mummifying the dead continued; hundreds of mummies and mummy portraits from that time have been found in the Fayum region of Lower Egypt, The bodies were wrapped in linen strips, with a Roman-style portrait, painted on a wood panel in **encaustic** (hot colored wax), inserted over the face (fig. 3-45). Although great staring eyes invariably dominate the images, the artists recorded individual features and often captured something of the personality of the deceased. Though part of the essentially Egyptian mummy, the Fayum portraits belong more to the history of Roman and Western European art than to Egyptian art, and we shall meet them again in Chapter 6.

3-45. Mummy wrapping of a young boy, from Hawara. Roman period, c. 100–120 CE. Linen wrappings with gilded stucco buttons and inserted portrait in encaustic on wood, height of mummy 52 ³/₈" (133 cm); portrait 9¹/₂ x 6¹/₂" (24 x 16.5 cm). The British Museum, London

PARALLELS

PERIOD	ART IN ANCIENT EGYPT	ART IN OTHER CULTURES
PREDYNASTIC c. 5500–3100 BCE	**3-3.** Jar with river scene (c. 3500–3400)	**2-25.** Susa beaker (c. 4000), Elam
EARLY DYNASTIC c. 3100–2686 BCE	**3-4.** *Palette of Narmer* (c. 3000)	**2-5.** Anu Ziggurat (c. 3100), Sumer **1-16.** Skara Brae house interior (c. 3100–2600), Scotland
OLD KINGDOM c. 2686–2181 BCE	**3-8.** Djoser pyramid (c. 2667–2648) **3-10.** Giza pyramids (c. 2613–2494) **3-13.** *Menkaura and a Queen* (c. 2500) **3-15.** *Seated Scribe* (c. 2494–2345) **3-16.** *Ti Watching a Hippopotamus Hunt* (c. 2494–2345)	**2-9.** Votive statues (c. 2900–2600), Sumer **1-19.** Stonehenge (c. 2750–1500), England **2-11.** Bull lyre (c. 2685), Sumer **4-3.** *Cycladic figures* (c. 2500–2200), Greece **13-1.** *Cattle Gathered* (c. 2500–1500), Africa **2-15.** *Stele of Naramsin* (c. 2254–2218), Akkad
FIRST INTERMEDIATE c. 2181–2055 BCE		**2-16.** Votive Statue of Gudea (c. 2120), Lagash
MIDDLE KINGDOM c. 2055–1650 BCE	**3-19.** Rock-cut tombs, Beni Hasan (c. 1985–1795) **3-22.** *Face of King Senusret III* (c. 1860) **3-23.** Hippopotamus (c. 1985–1795)	**9-4.** Harappa torso (c. 2000), India **2-17.** *Stele of Hammurabi* (c. 1792–1750), Babylonia
SECOND INTERMEDIATE c. 1650–1550 BCE		
NEW KINGDOM c. 1550–1069 BCE	**3-30.** *Hatshepsut as Sphinx* (c. 1473–1458) **3-37.** *Queen Tiy* (c.1352) **3-36.** *Akhenaten and His Family* (1352–1336) **3-38.** *Nefertiti* (c. 1352–1336) **3-2.** Mask of Tutankhamun (c. 1336–1327) **3-26.** Karnak temples (c. 1295–1186) **3-43.** *Judgment before Osiris* (c. 1285) **3-33.** Abu Simbel temples (c. 1279–1213)	**4-19.** Funerary mask (c.1550–1500), Greece **2-28.** Lion gate (c. 1400), Anatolia **10-4.** *Fang ding* (c. 12th century), China
THIRD INTERMEDIATE c. 1069–747 BCE		
LATE PERIOD c. 747–332 BCE	**3-44.** Taharqo sphinx (c. 690–664)	**6-8.** Cerveteri sarcophagus (c. 520), Italy **2-29.** Apadana of Darius and Xerxes (518–c. 460), Iran **5-1.** *Discus Thrower* (c. 450), Greece **5-42.** Acropolis, Athens (447–438), Greece
PTOLEMAIC c. 332–30 BCE		**5-86.** *Aphrodite of Melos* (c. 150), Greece
ROMAN c. 30 BCE–395 CE	**3-45.** Mummy of boy (c. 100–120 CE)	**6-12.** Pont du Gard (late 1st century CE), France **6-31.** Colosseum (72–80 CE), Italy

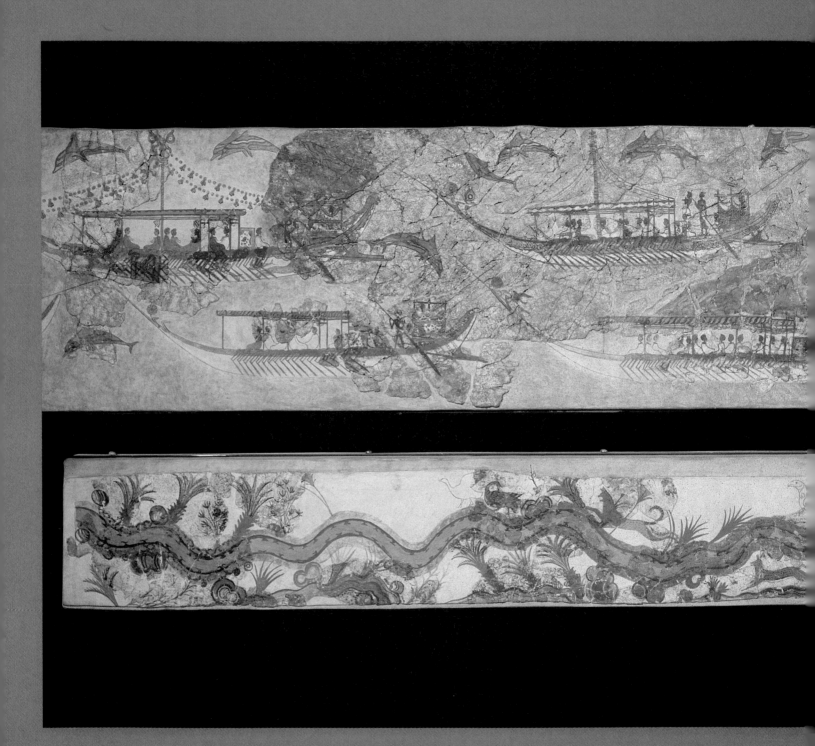

4-1. "Flotilla" fresco, from Room 5 of West House,
Akrotiri, Thera, Second Palace period,
c. 1650 BCE. National Archaeological Museum, Athens

4 Aegean Art

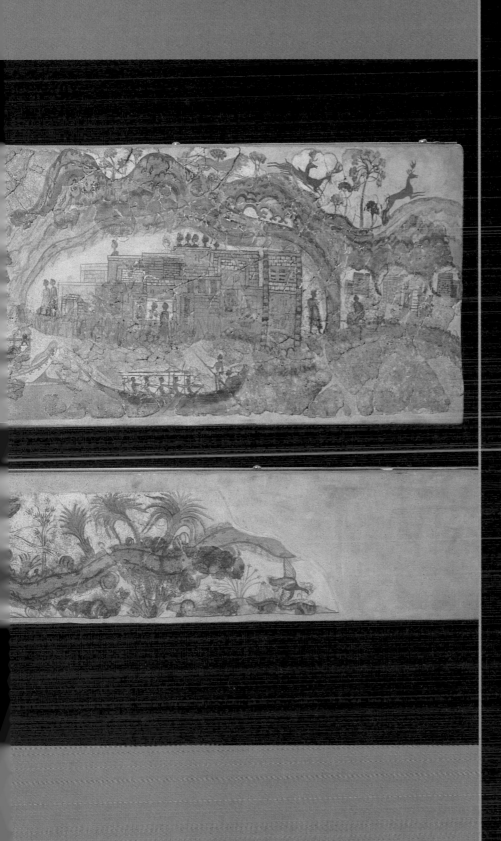

Glorious pink, blue, and gold mountains flicker in the brilliant sunlight. Graceful boats glide on calm seas past islands and leaping dolphins. Picturesquely tiered villages line the shore, with people lounging on terraces and rooftops. Is this description a travel agency's advertisement for the ideal vacation spot? No—but it could be. The words describe the very old painting you see here (fig. 4-1) from the port of Akrotiri on the island of Thera, one of the Cycladic Islands in the southern Aegean Sea. Today, Thera is called Santorini, a romantic and popular tourist destination. Akrotiri and the paradise depicted in this painting ended suddenly more than 3,500 years ago, when the volcano that formed the island Thera erupted and blew the top of the mountain off, spewing pumice that filled and sealed every crevice of Akrotiri—fortunately, after the residents had fled.

The discovery of Akrotiri in 1967 was among the most significant archaeological events of the second half of the twentieth century, and its excavation is still under way. We have much to learn about the cultures that took root on the Cycladic Islands and elsewhere in the Aegean, a region that is part of modern-day Greece. Every unearthed clue helps, because only one of the three written languages used there has been decoded. For now, we depend mainly on excavated works of art and architecture like this painting for our knowledge of life in the Aegean world.

TIMELINE 4-1. **The Aegean World.** During the Bronze Age in the Aegean, three cultures flourished: the Cycladic, the Minoan, and the Helladic, including the Mycenaean.

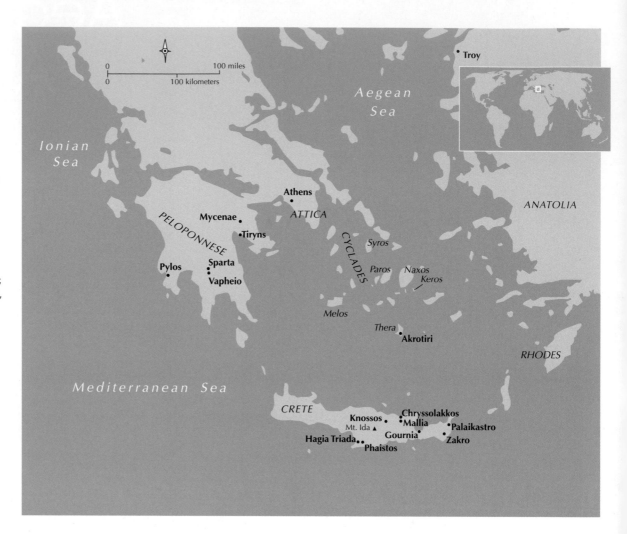

MAP 4-1. **The Aegean World.** The three main cultures in the ancient Aegean were the Cycladic, in the Cyclades; the Minoan, on Thera and Crete; and the Helladic, including the Mycenaean, on the mainland.

THE AEGEAN WORLD

Before 3000 BCE until about 1100 BCE, three early European cultures flourished simultaneously in the Aegean region: on a cluster of small islands called the Cyclades; on other islands in the Aegean Sea and Crete, which is in the eastern Mediterranean Sea; and on the mainland (Map 4-1). Scholars of these cultures have studied their grave sites, ruined architectural complexes, fortresses, and tombs. In recent years, archaeologists and art historians have also collaborated with researchers in such areas of study as the history of trade and climate change to provide an ever clearer picture of Aegean society.

Although the Aegean people were primarily farmers and herders, their lives were influenced by their proximity to the sea, and they were excellent seafarers. The sea provided an important link not only between the mainland and the islands but also to the world beyond. Egypt and the civilizations of the Near East were especially important trading partners (see "The Wreck at Ulu Burun," page 131).

One of the hallmarks of Aegean society from about 3000 to 1000 BCE was the use of bronze. Bronze, an alloy superior to pure copper for making weapons and tools, gave its name to the period, which is known as the Aegean Bronze Age. Using the metal ores they imported from Europe, Arabia, and Anatolia, the Aegean people created exquisite objects of bronze that became prized for export.

Probably the thorniest problem in Aegean archaeology is that of dating the finds (see "The Date Debate," page 131). Archaeologists have developed a relative dating system for the Aegean Bronze Age, but assigning absolute dates to specific sites and objects continues to be difficult and controversial. You may therefore encounter in other sources different dates than those given for objects shown here and should expect dating to change in the future. All dates are only approximations.

▲ c. 1900–1700 MINOAN OLD PALACE ▲ c. 1400–1100 MYCENAEAN CULTURE
 ▲ c. 1700–1450 MINOAN SECOND PALACE
 ▲ c. 1450–1375 LATE MINOAN

THE WRECK AT ULU BURUN

Shipwrecks offer vast amounts of information about the material culture—and the arts—of ancient societies whose contact with the rest of the world was by sea. The wreck of a trading vessel thought to have sunk between 1400 and 1350 BCE and discovered in the vicinity of Ulu Burun, off the southern coast of modern Turkey near the city of Kas demonstrates such ships' varied cargo: it carried metals, bronze weapons and tools, aromatic resin used in incense and perfume, fruits and spices, jewelry and beads, African ebony, ivory tusks, ostrich eggs, raw blocks of blue glass for use in faience and glassmaking, and ceramic wares made by potters from the Near East, mainland Greece, and Cyprus. Among the many gold objects was a scarab associated with Nefertiti, the wife of the Egyptian ruler Akhenaten (Chapter 3).

Its varied cargo suggests that this trading vessel cruised from port to port, loading and unloading goods as it went. It is tempting to see this vessel as evidence of Aegean entrepreneurship, but some scholars believe that Aegean foreign trade, like that in Egypt, was conducted exclusively as exchange between courts by palace officials.

Our study of Aegean art focuses on three Bronze Age cultures, beginning about 3000 BCE and ending about 1100 BCE (Timeline 4–1): Cycladic (on the islands of the Cyclades); Old Palace, Second Palace, and Late Minoan (on Crete and Thera); and Mycenaean, or Helladic (in mainland Greece).

THE CYCLADIC ISLANDS IN THE BRONZE AGE

A thriving late Neolithic and early Bronze Age culture existed on the Cycladic Islands, where people engaged in agriculture, herding, some crafts, and trade. They used local stone to build and fortify their towns and hillside burial chambers. Because they left no written records and their origins remain obscure, their art is a major source of information about them, as is the case with other Neolithic cultures. From about 6000 BCE on, Cycladic artists used a coarse, poor-quality local clay to make a variety of objects. Some 3,000 years later, they continued to produce relatively crude but often engaging ceramic figurines of humans and animals, as well as domestic and ceremonial wares.

Among the more unusual products of Cycladic potters were objects that reminded archaeologists of frying pans. These strange, unidentifiable pieces were made of **terra-cotta**, an orange-brown, low-fired clay, and were ornamented with **stylized** designs, either painted or

THE DATE DEBATE

Controversy has raged over the dating of Aegean objects almost since they were first excavated. New evidence is challenging established ideas of what happened when in the Aegean. The debate is far from over.

Because two of the three scripts used in the region still cannot be read, archaeologists have used changes in pottery styles to construct a chronology based on **relative dating** for the Aegean Bronze Age. A relative chronology indicates how old objects are in relation to each other but cannot assign them absolute dates. Influenced by the division of Egyptian history into Old, Middle, and New Kingdoms, Sir Arthur Evans, the British archaeologist who discovered and excavated the architectural complex at Knossos, used ceramic finds from different excavation levels to devise a similar chronological framework for Crete. He divided Minoan culture into three periods: Early Minoan, Middle Minoan, and Late Minoan, not terms used in this book. Today, Early Minoan and Middle Minoan are called the Palace Period. Later archaeologists extended this system to the Cyclades and the Helladic mainland.

Fortunately, historical records going back to the third millennium BCE have survived from the Near East and Egypt. By the careful cross-cultural referencing of lucky finds—datable foreign trade goods at undated Aegean sites or undated Aegean trade goods in datable foreign contexts—scholars are now able to assign dates to the relative chronology's periods, with a view toward **absolute date** chronology. **Radiometric**, or carbon-14, **dating** is increasingly useful as a method for dating Aegean organic material, though some dates can be determined only within a span of two or three centuries.

After decades of painstaking work establishing a chronology for the Aegean, archaeologists generally agreed that a huge volcanic explosion on the Cycladic island of Thera had thoroughly devastated Minoan civilization on Crete, only 60 miles to the south, around 1450 BCE. New evidence—namely, tree rings from Ireland and California and traces of volcanic ash in ice cores from Greenland—puts the date of the Thera eruption in the 1630s or 1620s BCE. This discovery leaves Minoan and Mycenaean dating in serious disarray—off by centuries. The chronologies for Aegean civilizations and their trading partners—particularly Egypt—must be revised.

How has this controversy affected the dating of Minoan and Mycenaean art works illustrated in this chapter? Sometimes you will find Evans's periods cited without attached dates. While experts ponder the evidence, the rest of us must rely on the conventional best-guess dates.

4-2. **"Frying pan,"** from Syros, Cyclades. c. 2500–2200 BCE. Terra-cotta, diameter 11" (28 cm), depth 2⅜" (6 cm). National Archaeological Museum, Athens

incised before firing. The elaborate decoration on one side of a piece from the island of Syros, dated about 2500–2200 BCE, consists of a wide, geometric border encircling a scene showing a boat on a sea of waves depicted as linked spirals (fig. 4-2). With its long hull and banks of oars, the boat resembles those seen in Neolithic Egyptian art from Hierakonpolis (see fig. 3-3). The large fish to the left might be a carved prow ornament. In the triangular area set off below the scene, the artist incised a symbol for the female pubic area. The function of these "frying pan" objects is unknown. Perhaps they had some magical association with pregnancy and childbirth, as well as death, for they are most often found at grave sites.

The Cyclades, especially the islands of Naxos and Paros, had ample supplies of a fine and durable white marble that became a popular medium for sculptors. Out of it they created a unique type of nude figure ranging from a few inches to about 5 feet tall. These figures are often found lying on graves. To shape the stone, sculptors used scrapers and chisels made of obsidian from the island of Melos and polishing stones of emery from Naxos. The introduction of metal tools may have made it possible for them to carve on a larger scale, but perhaps because the stone fractured easily, they continued to limit themselves to simplified sculptural forms.

A few male figurines have been found, including depictions of musicians and acrobats, but they are greatly outnumbered by representations of women. The earliest female figures had simple, violinlike shapes. From these, a more familiar type evolved, by 2500 BCE, that has become the best-known type of Cycladic art (fig. 4-3). Compared with Egyptian statues from the same time (see fig. 3-13), the Cycladic marbles appear to many modern eyes like pared-down, elegant renderings of the figure. With their

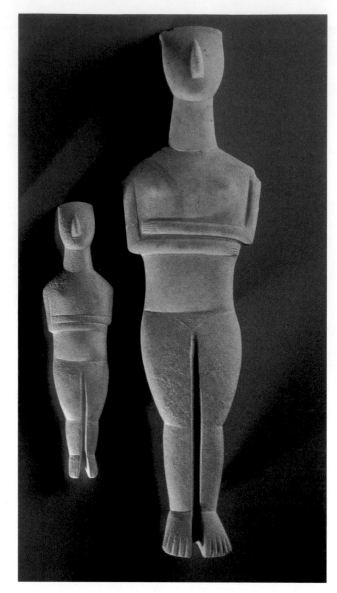

4-3. **Two figures of women**, from the Cyclades. c. 2500–2200 BCE. Marble, heights 13" (33 cm) and 25" (63.4 cm). Museum of Cycladic Art, Athens
Courtesy of the N. P. Goulandris Foundation

simple contours, the female statuettes shown here seem not far removed from the marble slabs out of which they were carved. Their tilted-back heads, folded arms, and down-pointed toes suggest that the figures were intended to lie on their backs, as if asleep or dead. Anatomical detail has been kept to a minimum; the body's natural articulations at the hips, knees, and ankles are indicated by lines, and the pubic area is marked with a lightly incised triangle. These statues originally had painted facial features, hair, and ornaments in black, red, and blue.

The *Seated Harp Player* of roughly the same period is fully developed **sculpture in the round** (fig. 4-4), yet its body shape is just as simplified as that of the female figurines. The figure has been reduced to its geometric essentials, yet with careful attention to those elements that best characterize an actual musician. The harpist sits on a high-backed chair with a splayed base, head tilted back as if singing, knees and feet apart for stability, and arms raised, bracing the instrument with one hand while plucking its strings with the other. So expressive is the pose that we can almost hear the song.

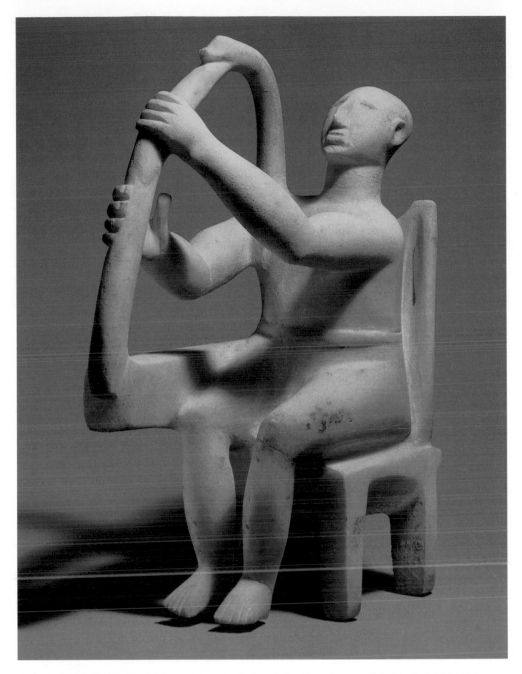

4-4. ***Seated Harp Player***, from Keros, Cyclades. 3rd millennium BCE. Marble, height 11 1/2" (29.2 cm). The Metropolitan Museum of Art, New York
Rogers Fund, 1947, (47.100.1)

Some Cycladic figures have been found in and around graves, but many have no archaeological context. Although their specific use and meaning are unclear, one interpretation is that they were used for worship in the home and then buried with their owners, often after having been symbolically broken as part of the funeral ritual. According to this theory, the larger statues were set up for communal worship, either as representations of the supernatural or as **votive figures**.

CRETE AND THE MINOAN CIVILIZATION

By 3000 BCE, Bronze Age people lived on the island of Crete. A distinctive culture flourished on Crete between about 1900 BCE and 1375 BCE, which Sir Arthur Evans (see "Pioneers of Aegean Archaeology," page 149) called Minoan. The name *Minoan* comes from the legend of Minos, a king who ruled from Knossos, the island's ancient capital (see "The Legend of the Minotaur," page 134).

Crete is the largest of the Aegean and eastern Mediterranean islands, 150 miles long and 36 miles wide. It was economically self-sufficient, producing its own grains, olives and other fruits, and cattle and sheep. But because it lacked the ores necessary for bronze production, it was forced to look outward. Crete took advantage of its many safe harbors and its location to become a wealthy sea power, trading with mainland Greece, Egypt, the Near East, and Anatolia.

Archaeological discoveries suggest that in Minoan belief three goddesses controlled various aspects of the natural world. These deities may also have been the

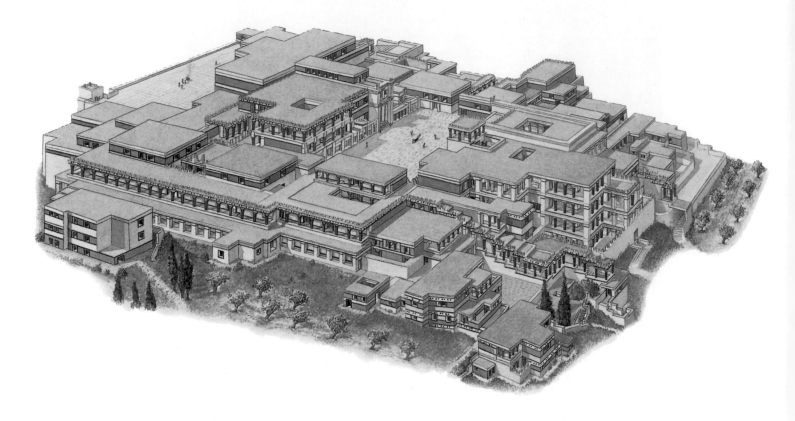

4-5. Plan and reconstruction of the palace complex, Knossos, Crete. Site occupied 2000–1375 BCE; complex begun in Old Palace period (C. 1900–1700 BCE); complex rebuilt after earthquakes and fires during Second Palace period (C. 1700–1450 BCE); final destruction C. 1375 BCE.

ancestors of the later Greek goddesses Demeter, Artemis, and Athena (Chapter 5). Female images found in graves and palace shrines may represent goddesses, priestesses, or female worshipers.

Although a number of written records from the period are preserved, the two earliest forms of Minoan writing, called hieroglyphic and Linear A, continue to

defy translation. The surviving documents in a later script, Linear B—a very early form of Greek imported from the mainland—have proven to be valuable administrative records and inventories that give an insight into Minoan material culture.

Beginning in the third millennium BCE, the Minoans built and maintained (rebuilding after earthquakes and

THE LEGEND OF THE MINOTAUR
According to Greek legend, the half-man-half-bull Minotaur was the son of the wife of King Minos of Crete and a bull belonging to the sea god Poseidon. The monster lived in the so-called Labyrinth, a maze. To satisfy the Minotaur's appetite for human flesh and to keep him tranquil, King Minos ordered the city of Athens, which he ruled, to pay him a yearly tribute tax of fourteen young men and women. Theseus, the son of King Aegeus of Athens, vowed to free his people from this grisly burden by slaying the monster.

He set out for Crete with the doomed young Athenians, promising his father that on his return voyage he would replace his ship's black sails with white ones as a signal of victory. In the manner of ancient heroes, Theseus won the heart of Crete's princess Ariadne, who gave him a sword with which to kill the Minotaur and a spindle of thread to mark the path he took into the Labyrinth. Theseus defeated the Minotaur, followed his trail of thread back out of the maze, and sailed off to Athens with Ariadne and the relieved Athenians. Along the way, his ship put into port on the island of Naxos, where Theseus had a change of heart and left Ariadne behind as she lay sleeping. In his haste to return home, he neglected to raise the white sails. When Aegeus

saw the black-sailed ship approaching, he drowned himself in the sea that now bears his name. Theseus thus became king of Athens.

Such psychologically complex myths have long inspired European artists. In William Shakespeare's *A Midsummer Night's Dream*, the play-within-the-play celebrates the marriage of Theseus to an Amazon queen. The plight of Theseus's abandoned lover Ariadne—who finds comfort in the arms of the Greek god Dionysos—is the plot of a 1912 opera by Richard Strauss. Also in the last century, Pablo Picasso used the Minotaur in his art as a symbol of the Spanish dictator Francisco Franco and the horrors of the Spanish Civil War.

fires) great architectural complexes. Excavators in the nineteenth century CE called these complexes "palaces," an inaccurate term because *palaces* imply *kings*, and we do not know the sociopolitical structure of the society. The term *palaces* is still commonly used, and we will use it in this chapter. A number of these sites have been excavated and provide a wealth of art and information.

The walls of early Minoan buildings were made of rubble and mud bricks faced with cut and finished local stone. This was the first use of **dressed stone** as a building material in the Aegean. Columns and other interior elements were made of wood. Both in palaces and in buildings in the surrounding towns, timber appears to have been used for framing and bracing walls; its strength and flexibility would have minimized damage from the earthquakes still common to the area. Nevertheless, a major earthquake about 1700 BCE damaged several building sites, including the important palaces at Knossos and Phaistos. The structures were then repaired and enlarged, and the two resulting new complexes shared a number of features. Multistoried, flat-roofed, and with many columns, they were designed to maximize light, air, and adaptability, as well as to define access and circulation patterns. Daylight and fresh air entered through staggered levels, open stairwells, and strategically placed air shafts and light wells.

Suites of rooms lay around a spacious rectangular courtyard from which corridors and staircases led to other courtyards, private rooms and apartments, administrative and ritual areas, storerooms, and baths. Walls generally were coated with plaster, and some were painted with murals. Floors were either plaster, plaster mixed with pebbles, stone, wood, or beaten earth. The residential quarters had many luxuries: sunlit courtyards, richly colored murals, and sophisticated plumbing systems (at Knossos, a network of terra-cotta pipes was laid below ground). Clusters of workshops in and around the palace complexes formed commercial centers. Storeroom walls were lined with enormous clay jars for oil and wine, and in their floors stone-lined pits from earlier structures had been designed for the storage of grain. The huge scale of the centralized management of foodstuffs became apparent when excavators at Knossos found in a single storeroom enough ceramic jars to hold 20,000 gallons of olive oil.

THE OLD PALACE PERIOD (c. 1900–1700 BCE)

Minoan civilization remained very much a mystery until British archaeologist Sir Arthur Evans discovered the buried ruins of the architectural complex at Knossos, on Crete's north coast, in 1900 CE (fig. 4-5). Evans spent the rest of his life excavating and reconstructing the buildings he had found (see "Pioneers of Aegean Archaeology," page 149). The site had been occupied in the Neolithic period, then built over with a succession of Bronze Age buildings.

Minoan builders seem sensitive to natural settings, for their structures often focus on special landscape features, such as the sacred Mount Ida. The palace complex

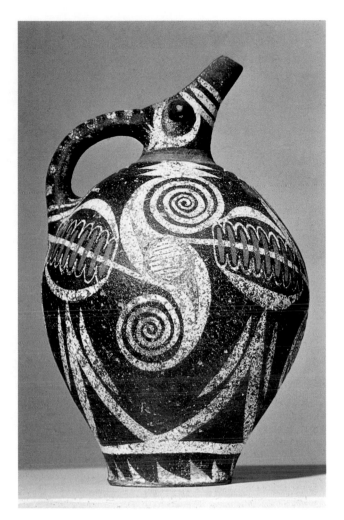

4-6. Kamares Ware jug, from Phaistos, Crete. Old Palace period, c. 2000–1900 BCE. Ceramic, height 10⅝" (27 cm). Archaeological Museum, Iraklion, Crete

itself had a squarish plan and a large central courtyard. Causeways and corridors led from outside to the central courtyard or to special areas such as granaries or storage pits. The complex often had a theater or performance area. Around the central court, independent units were made up of eight or nine suites of rooms. Each suite consisted of a forecourt with light well, a hall with a stepped lustral basin, a room with a hearth, and a series of service rooms. Such suites might belong to a family or serve a special business or government function.

The complex also included workshops that attest to the centralization there of large-scale manufacturing. During the Old Palace period, Minoans developed extraordinarily sophisticated metalwork and elegant new types of ceramics, spurred in part by the introduction of the potter's wheel early in the second millennium BCE. One type is called Kamares Ware, after the cave on Mount Ida overlooking the palace complex at Phaistos, in southern Crete, where it was first discovered. The hallmarks of this select ware—so sought-after that it was exported as far away as Egypt and Syria—were its extremely thin walls, its use of color, and its graceful, stylized, painted decoration. An example from about 2000–1900 BCE has a globular body and a "beaked" pouring spout (fig. 4-6). Decorated with

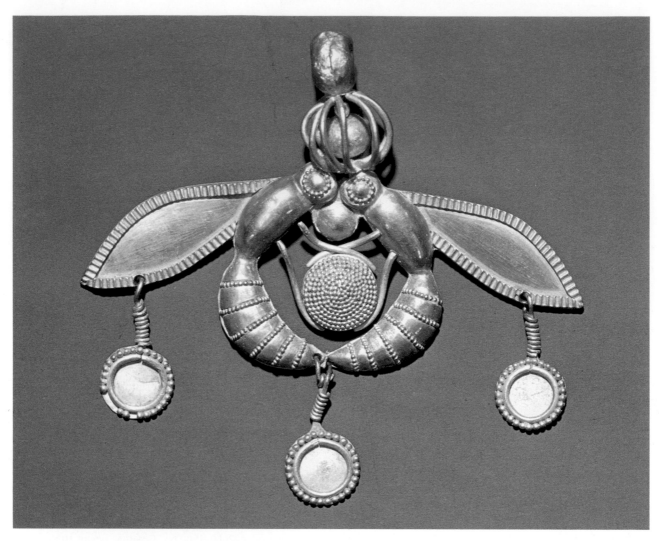

4-7. Pendant of gold bees, from Chryssolakkos, near Mallia, Crete. Old Palace period, c. 1700 BCE. Gold, height approx. 1¹³⁄₁₆" (4.6 cm). Archaeological Museum, Iraklion, Crete

TECHNIQUE

AEGEAN METALWORK

Aegean artists imported gold to create exquisite luxury goods. Their techniques included **lost-wax casting**, **inlay**, **filigree**, *repoussé* (embossing), **granulation**, **niello**, and **gilding**. The *Vapheio Cup* (see fig. 4-16) and the funerary mask (see fig. 4-19) are examples of *repoussé*, in which the artist gently hammered out relief forms from the back of a thin sheet of gold. Experienced goldsmiths may have done simple designs freehand or used standard wood forms or punches. For more elaborate decorations they would first have sculpted the entire relief design in wood or clay and then used this form as a mold for the gold sheet.

Minoan jewelers were especially skilled at decorating their goldwork with minute granules, or balls, of gold fused to the surfaces, as seen on the bees pendant above. They learned the technique of granulation from Syrian metalsmiths, demonstrating the extensive contact among artists of the time. The technique was only recently rediscovered after nearly a thousand years. The major mystery was how the granules were attached,

since all modern solders—heated metal alloys used as adhesives—melted and overwhelmed the tiny gold globules. The ancient smiths are now believed to have used a complex copper-based solder that fused strongly but nearly invisibly.

The artists who created the Mycenaean dagger blade (see fig. 4-26) not only inlaid one metal into another but also employed a special technique called niello, still a common method of metal decoration. Powdered nigellum—a black alloy of lead, silver, and copper with sulfur—was rubbed into very fine engraved lines in the object being decorated, then fused to the surrounding metal with heat. The lines appear to be black drawings.

Gilding, the application of gold to an object made of some other material, was a technically demanding process by which paper-thin sheets of hammered gold called **gold leaf** (or, if very thin, gold foil) were meticulously affixed to the surface to be gilded. This was done with amazing delicacy for the now-bare stone surface of the *Harvester Vase* (see fig. 4-10) and the wooden horns of the bull's-head rhyton (see fig. 4-11).

brown, red, and creamy white pigments on a black body, the jug has rounded contours complemented by bold, curving forms derived from plant life.

Matching Kamares Ware in sophistication is early Minoan goldwork (see "Aegean Metalwork," page 136). By about 1700 BCE, Aegean metalworkers were producing decorative objects rivaling those of Near Eastern jewelers, whose techniques they seem to have borrowed (see fig. 2-22). For a necklace pendant in gold found at Chryssolakkos (fig. 4-7), the artist arched a pair of bees (or perhaps wasps) around a honeycomb of gold granules, providing their sleek bodies with a single pair of outspread wings—a visual "two in one." The pendant hangs from a spiderlike form, with what appear to be long legs encircling a tiny gold ball. Small disks dangle from the ends of the wings and the point where the insects' bodies meet. The simplified geometric patterns and shapes well convey the insects' actual appearance.

THE SECOND PALACE PERIOD (c. 1700–1450 BCE)

The "old palace" at Knossos, erected about 1900 BCE, formed the core of an elaborate new one built after a terrible earthquake shook Crete about 1700 BCE and destroyed Knossos. The Minoans rebuilt at Knossos and elsewhere, inaugurating the Second Palace period and the flowering of Minoan art. In its heyday, the palace complex covered six acres (see fig. 4-5). Because double-ax motifs were used in its architectural decoration, the Knossos palace was referred to in later Greek legends as the Labyrinth, meaning the "House of the Double Axes" (Greek *labrys*, "double ax"). The layout of the complex seemed so dauntingly complicated that the word *labyrinth* came to mean "maze."

The layout provided the complex with its own internal security system: a baffling array of doors leading to unfamiliar rooms, stairs, and yet more corridors. Admittance could be denied by blocking corridors, and some rooms were accessible only from upper terraces. In short, the building was a warren of halls, stairs, dead ends, and suites—truly a labyrinth. Close analysis, however, shows that the builders had laid out the complex on a square grid following predetermined principles and that the apparently confusing layout was caused in part by earthquake destruction and rebuilding over the centuries.

In typical Minoan fashion, the rebuilt Knossos complex of religious, residential, manufacturing, and warehouse spaces was organized around a large central courtyard. A few steps led from the central courtyard down into the so-called Throne Room to the west, and a grand staircase on the east side descended to the Hall of the Double Axes, an unusually grand example of a Minoan hall (Evans gave the rooms their misleading but romantic names). This hall and others were supported by the uniquely Minoan-type wood columns that became standard in Aegean palace architecture. The tree trunks from which the columns were made were inverted so that they tapered toward the bottom. Thus, the top, supporting massive roof beams and a broad flattened capital, was wider than the bottom (fig. 4-8).

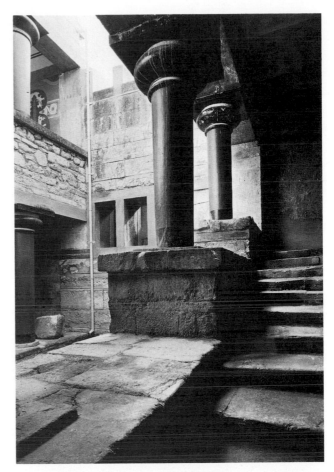

4-8. Court with staircase reconstructed by Sir Arthur Evans, leading to the southeast residential quarter, palace complex, Knossos, Crete

The hundreds of tapered, cushion-capitaled columns of the palace were made of wood and painted bright colors, especially red, yellow, and black. Evans's restorers installed concrete replicas of columns, capitals, and lintels based on ceramic house models and paintings from the Minoan Second Palace period. Today's archaeologists might not attempt such wholesale reconstruction without absolutely authentic documentation, and they would make certain that reconstructed elements could never be mistaken for the originals.

The suites, following Minoan Old Palace tradition, were arranged around a central space rather than along a long axis, as we have seen in Egypt and will see in Mycenae (page 147). During the Second Palace period, suites functioned as archives, business centers, and residences. Some must also have had a religious function, though the temples, shrines, and elaborate tombs seen in Egypt are not found in Minoan architecture.

Surviving Minoan sculpture consists mainly of small, finely executed religious works in wood, ivory, precious metals, stone, and faience. Female figurines holding serpents were fashioned on Crete as far back as 6000 BCE and may have been associated with water, regenerative power, and protection of the home. The *Woman or Goddess with Snakes* from the palace at Knossos is intriguing both as a ritual object and as a work of art.

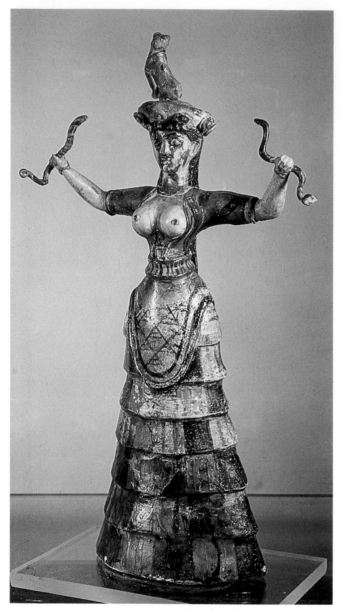

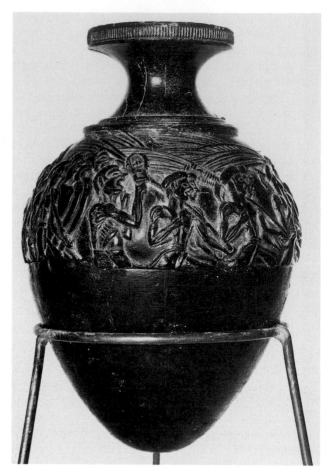

4-10. *Harvester Vase*, from Hagia Triada, Crete. Second Palace period, c. 1650–1450 BCE. Steatite, diameter 4¹/₂" (11.3 cm). Archaeological Museum, Iraklion, Crete

4-9. *Woman or Goddess with Snakes*, from the palace complex, Knossos, Crete. Second Palace period, c. 1600–1550 BCE. Faience, height 11⁵/₈" (29.5 cm). Archaeological Museum, Iraklion, Crete

This faience figurine was found with other ceremonial objects in a pit in one of Knossos's storerooms. Bare-breasted, arms extended, and brandishing a snake in each hand, the woman is a commanding presence (fig. 4-9). A leopard or a cat (perhaps a symbol of royalty, perhaps protective) is poised on her crown, which is ornamented with circles. This shapely figure is dressed in a fitted, open bodice with an apron over a typically Minoan flounced skirt. A wide belt cinches the waist. The red, blue, and green geometric patterning on her clothing reflects the Minoan weavers' preference for bright colors, patterns, and fancy edgings. Realistic elements and formal, stylized ones combine to create a figure that is both lively and dauntingly, almost hypnotically powerful—a combination that has led scholars to disagree whether statues such as this one represent deities or their human attendants.

Almost certainly of ritual significance are the stone vases and **rhytons**—vessels used for pouring liquids during sacred ceremonies—that Minoans carved from steatite (a greenish or brown soapstone). These pieces were all found in fragments, suggesting that they were ritually broken. One of the treasures of Minoan art is the *Harvester Vase*, an egg-shaped rhyton barely 4¹/₂ inches in diameter (fig. 4-10). It may have been covered with **gold leaf**, or sheets of hammered gold (see "Aegean Metalwork," page 136). A rowdy procession of twenty-seven men has been crowded onto its curving surface. The piece is exceptional for the freedom with which the figures occupy three-dimensional space, overlapping and jostling one another instead of marching in orderly single file across the surface in the manner of Near Eastern or Egyptian art. Also new is the exuberance of this scene, especially the emotions shown on the men's faces. They march and chant to the beat of a sistrum—a rattlelike percussion instrument—played by a man who seems to sing at the top of his lungs. The uneven arrangement of elements reinforces the boisterousness of the scene. The men have large, coarse features and sinewy bodies so thin that their ribs stick out. Archaeologists have interpreted the scene as a spring planting or fall harvest festival, a religious procession, a dance, a crowd of warriors, or a gang of forced laborers.

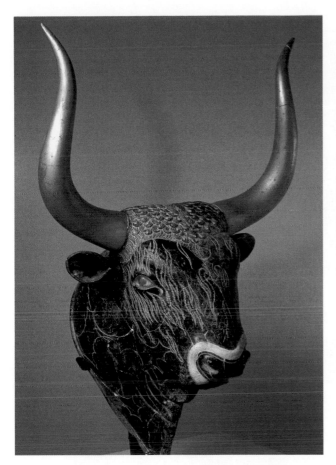

4-11. Bull's-head rhyton, from the palace complex, Knossos, Crete. Second Palace period, c. 1550–1450 BCE. Steatite with shell, rock crystal, and red jasper, the gilt-wood horns restored, height 12" (30.5 cm). Archaeological Museum, Iraklion, Crete

Depictions of bulls appear quite often in Minoan art, rendered with an intensity not seen since the prehistoric cave paintings at Altamira and Lascaux (Chapter 1), and rhytons were also made in the form of a bull's head. Although many early cultures associated their gods with powerful animals, neither their images nor later myths offer any proof that the Minoans worshiped a bull god. According to later Greek legend, for example, King Minos kept the bull-man called the Minotaur captive in his palace, but the creature was not an object of religious veneration (see "The Legend of the Minotaur," page 134). The sculptor of a bull's head rhyton found at Knossos used a block of greenish-black steatite to create an image that approaches animal portraiture in its decorative detailing (fig. 4-11). Lightly engraved lines, filled with white powder to make them visible, indicate the animal's coat: short, curly hair on top of the head, longer shaggy strands on the sides, and circular patterns along the neck to suggest its dappled coloring. White bands of shell outline the nostrils, and painted rock crystal and red jasper form the eyes. The horns, now restored, were made of wood covered with gold leaf. Bull's-head rhytons were used for pouring ritual fluids—water, wine, or perhaps even blood. Liquid was poured into a hole in the neck and flowed out from the mouth.

Minoan potters also created more modest vessels. The ceramic arts, so splendidly demonstrated in Old

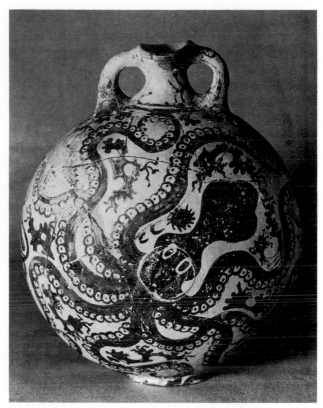

4-12. Octopus Flask, from Palaikastro, Crete. Second Palace period, c. 1500–1450 BCE. Marine Style ceramic, height 11" (28 cm). Archaeological Museum, Iraklion, Crete

Palace Kamares Ware, continued throughout the Second Palace period. In fact, archaeologists have established the chronology of Minoan art based on the ceramics found in excavations.

Some of the most striking ceramics were done in what is called the Marine Style because of the depiction of sea life painted on their surfaces. In a stoppered bottle of this style known as the *Octopus Flask*, made about 1500–1450 BCE (fig. 4-12), the painter celebrates Crete's sea power, then at its height. Like microscopic life teeming in a drop of pond water, sea creatures float around an octopus's tangled tentacles. The decoration on the Kamares Ware jug (see fig. 4-6) reinforces the solidity of its surface, but here the pottery skin seems to dissolve. The painter captured the grace and energy of natural forms while presenting them as a stylized design in harmony with the vessel's spherical shape.

Minoan painters also worked on a larger scale, covering the walls of palace rooms with geometric borders, views of nature, and scenes of human activity. Murals can be painted on either a still-wet plaster (**buon fresco**) surface or a dry one (**fresco secco**). The wet technique binds pigments well to the wall, but forces the painter to work very quickly. On a dry wall, the painter need not hurry, but the pigments tend to flake off in time. Minoans used both techniques. Their preferred colors were red, yellow, black, white, green, and blue. Like Egyptian painters, Minoan artists filled in the outlines of their figures and objects with unshaded areas of pure color. But after that, the resemblance stops.

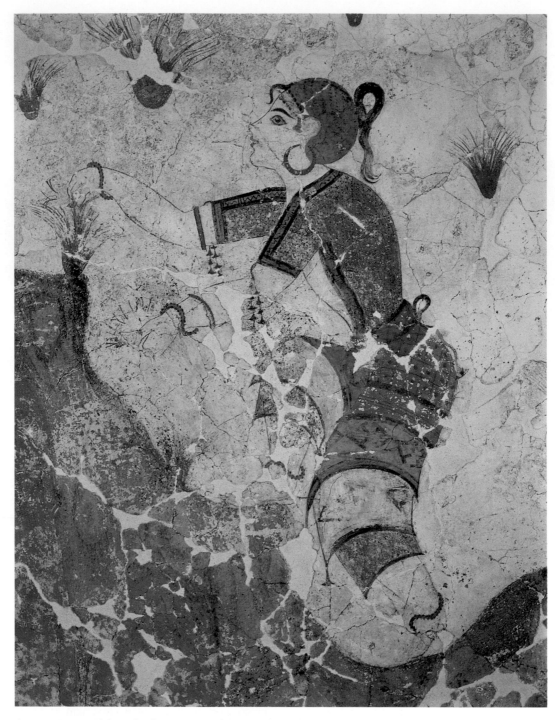

4-13. *Young Girl Gathering Crocus Flowers*, detail of wall painting, Room 3 of House Xeste 3, Akrotiri, Thera. Second Palace period, c. 1700–1450 BCE

Minoan wall painting displays elegant drawing, linear contours filled with bright colors, a preference for profile or full-faced views, and a stylization that turns natural forms into decorative patterns yet keenly observes the appearance of the human body in motion. Those conventions can be seen in the vivid murals at Akrotiri, on the island Thera (see fig. 4-1). Along with other Minoan cultural influences, the art of wall painting seems to have spread to both the Cyclades and mainland Greece. Thera was so heavily under Crete's influence at this time that it was virtually an outpost of Minoan culture.

The paintings in residences at Akrotiri demonstrate a highly decorative sense, both in color selection and in surface detail. Some of the subjects there also occur in the art of Crete, but others are new. One of the houses, for example, has rooms dedicated to young women's initiation ceremonies. In the detail shown here, a young woman picks purple fall saffron crocus, valuable for its use as a yellow dye, as a flavoring for food, and as a medicinal plant to alleviate menstrual cramps (fig. 4-13). The girl wears the typically colorful Minoan flounced skirt with a short-sleeved, open-breasted bodice, large earrings, and bracelets. She still has the shaved head, fringe of hair, and long ponytail of a child, but the light

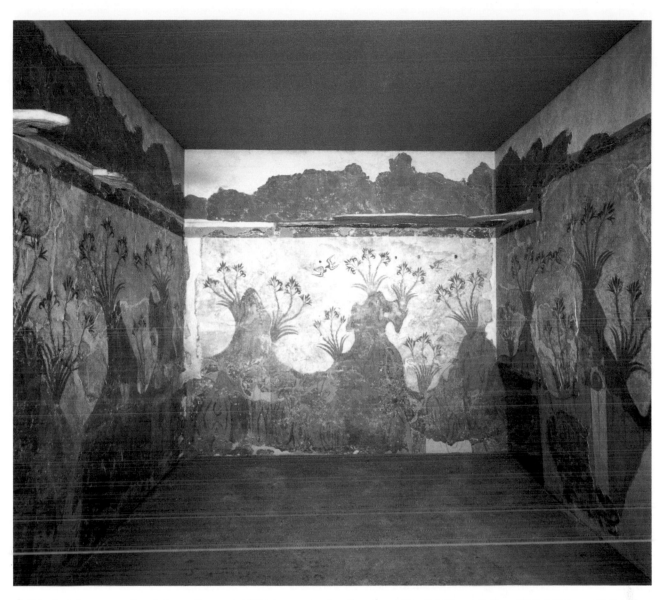

4-14. **Landscape**, wall painting with areas of modern reconstruction, from Akrotiri, Thera. Before 1630–1500 BCE. National Archaeological Museum, Athens

blue color of her scalp indicates that the hair is beginning to grow out. On another wall, not shown here, girls present their flowers to an older seated women who is flanked by a blue Nubian monkey and a griffin (half lion–half eagle). Surely the woman is a goddess receiving her devotees, and the room had a special ceremonial use.

In another house, an artist has created a pure landscape of hills, rocks, and flowers (fig. 4-14). This mural is unlike anything previously encountered in ancient art. A viewer standing in the center of the room is surrounded by orange, rose, and blue rocky hillocks sprouting oversized deep red lilies. Swallows, represented by a few deft lines, swoop above and around the flowers. The artist unifies the rhythmic flow of the undulating landscape, the stylized patterning imposed on the natural forms, and the decorative use of bright colors alternating with darker neutral tones, which were perhaps meant to represent areas of shadow. The colors—pinks, blues, yellows—may seem fanciful to us; however, sailors today who know the area well attest to

their accuracy: the artist recorded the actual colors of Thera's wet rocks in the sunshine. The impression is one of organic life and growth, a celebration of the natural world symbolized by the lilies. How different is this art—which captures a zesty joy of life—from the cool, static elegance of Egyptian painting.

LATE MINOAN PERIOD (c. 1450–1375 BCE)

About 1450 BCE, a conquering people from mainland Greece, known as Mycenaeans (see page 142), arrived in Crete. They occupied the buildings at Knossos and elsewhere until a final catastrophe and the destruction of Knossos about 1375 BCE caused them to abandon the site. While on Crete, they adopted Minoan art with such enthusiasm that sometimes experts disagree over the identity of the artists—were they Minoans working for Mycenaeans or Mycenaeans taught by, or copying, Minoans?

At Knossos, one of the most famous and best-preserved paintings depicts bull leaping. The restored

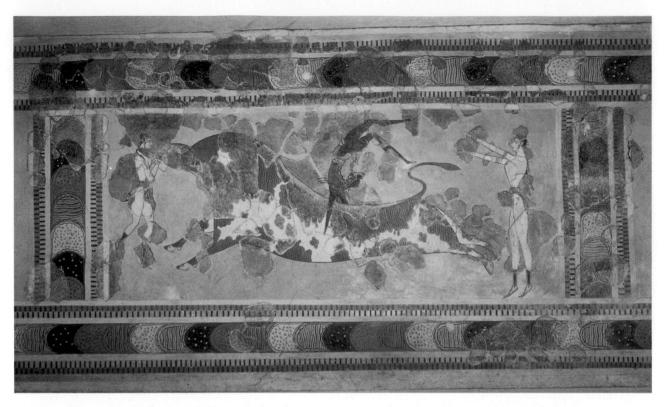

4-15. Bull Leaping, wall painting with areas of modern reconstruction, from the palace complex, Knossos, Crete. Late Minoan period, c. 1450–1375 BCE. Height approx. 24½" (62.3 cm). Archaeological Museum, Iraklion, Crete

Careful sifting during excavation preserved many fragments of the paintings that once covered the palace walls. The pieces were painstakingly sorted and cleaned by restorers and reassembled into puzzle pictures that often had more pieces missing than found. The next step was to fill in the gaps with colors similar to the original ones, but lighter and grayer in tone, to make obvious which portions were restored while enabling the eye to read and enjoy the image.

panel is one of a group of paintings with bulls as subjects from a room in the palace's east wing. The action may represent an initiation or fertility ritual (fig. 4-15). *Bull Leaping* shows three scantily clad, youthful figures around a gigantic dappled bull, charging in the flying-gallop pose. The pale-skinned person at the right—probably a woman—is prepared to catch the dark-skinned man in the midst of his leap, and the pale-skinned woman at the left grasps the bull by its horns, perhaps to begin her own vault. The bull's thundering power and sinuous grace are masterfully rendered although the flying-gallop pose is not true to life. Framing the action are variegated overlapping ovals (the so-called chariot-wheel motif) set within striped bands.

The skills of other Minoan artists, particularly metal-smiths, made them highly sought after in mainland Greece. Two magnificent gold cups found in a large tomb at Vapheio, on the Greek mainland south of Sparta, were made sometime between 1650 and 1450 BCE, either by Minoan artists or by local ones trained in Minoan style and techniques. One cup is shown here (fig. 4-16). The relief designs were executed in **repoussé**—the technique of hammering from the back of the sheet. The handles were attached with rivets, and the cups were then lined with sheet gold. In the scenes that circle the cups, men are depicted trying to capture bulls in various ways. On this one, a half-nude man has roped a bull's hind leg. The figures dominate the landscape, which literally bulges with a muscular vitality that belies the cups' small size—they are only 3½ inches tall. The depiction of olive trees could indicate that the scene is a sacred grove and that

these are illustrations of exploits in some long-lost heroic tale rather than commonplace herding scenes.

The Mycenaean invaders appear to have continued to use Crete as a base for many years. But by 1400 BCE the center of political and cultural power in the Aegean had shifted to mainland Greece, which at that time was home to wealthy warrior-kings.

MAINLAND GREECE AND THE MYCENAEAN CIVILIZATION

Archaeologists use the term *Helladic* (from *Hellas*, the Greek name for Greece) to designate the Aegean Bronze Age on mainland Greece. The Helladic period extends from about 3000 to 1000 BCE, concurrent with the Cycladic and Minoan periods. In the early part of the Aegean Bronze Age, Greek-speaking peoples moved into the mainland. They brought advanced metalworking, ceramic, and architectural techniques, and they displaced the indigenous Neolithic culture. When Minoan culture declined after about 1500 BCE, a late Helladic mainland culture known as Mycenaean, after the city of Mycenae, rose to dominance in the Aegean region.

ARCHITECTURE

The Citadel at Mycenae. Later Greek writers recalled the fortified city of Mycenae (fig. 4-17), located near the east coast of the Peloponnese peninsula in southern Greece, as the home of the leader of the Greek army that

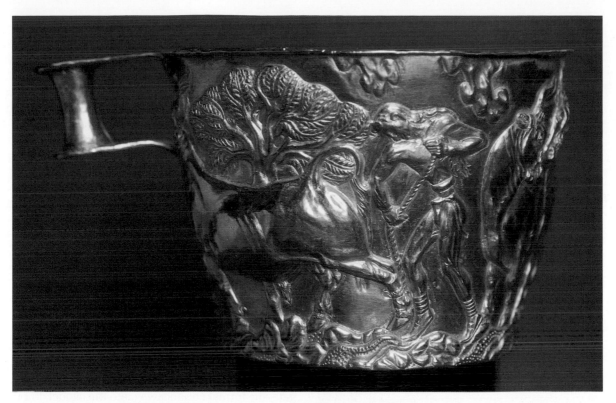

4-16. *Vapheio Cup*, found near Sparta, Greece. c. 1650–1450 BCE. Gold, height 3½" (8.9 cm). National Archaeological Museum, Athens

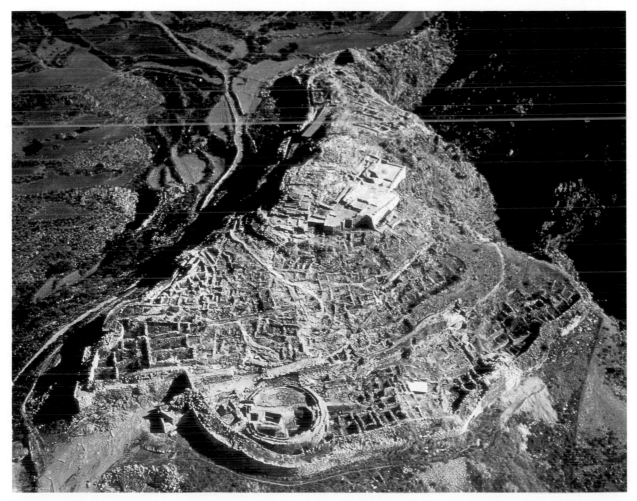

4-17. Citadel, Mycenae, Greece. Site occupied c. 1600–1200 BCE; walls built c. 1340, 1250, 1200 BCE

The citadel's hilltop position, the grave circle at the bottom center of the photograph, and the circuit walls are clearly visible. The Lion Gate (see fig. 4-18) is at the lower left. The megaron floor and bases of columns and walls are at the top of the hill, at the upper center of the photograph.

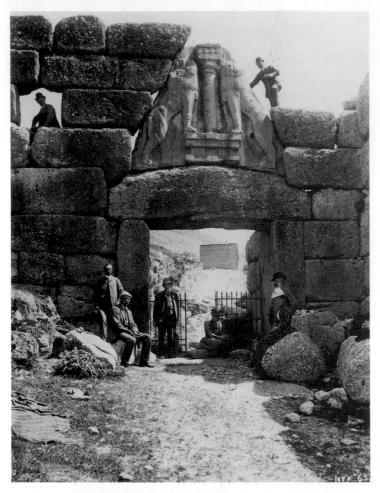

4-18. Lion Gate, Mycenae. c. 1250 BCE. Limestone relief, height of sculpture approx. 9'6" (2.9 m)

In this historic photograph, Heinrich Schliemann, director of the excavation, stands to the left of the gate and his second wife and partner in archaeology, Sophia, sits to the right.

conquered the great city of Troy (see "The Trojan War," below). Even today, the monumental gateway to the **citadel** at Mycenae (fig. 4-18) is an impressive reminder of the city's warlike past. The gate itself dates from about 1250 BCE, perhaps a century later than the first of the citadel's **ring walls**, or surrounding walls. Although formed of megaliths, this gate is very different in purpose and style from other megalithic structures of the time—Stonehenge, for example (see fig. 1-19). The basic architecture of this gate is post-and-lintel construction with a **relieving arch** above. The corbel arch "relieved" the lintel of the weight of the wall that rose above it to a height of about 50 feet. As in Near Eastern citadels, the gate was provided with guardian figures. The Mycenaean sculptors carved a pair of lions nearly 9½ feet tall on a triangular panel filling the opening above the lintel. Their now-missing heads were made separately—of stone, wood, bronze, or gold—then fastened into holes in the stone. The two animals, one on each side of a Minoan-style column, stand facing each other, their forepaws resting on Minoan-style stone altars. From this gate, the formal entranceway into the citadel, known as the Great Ramp, led up the hillside to the king's palace.

Tombs assumed much greater prominence for Helladic period culture of the mainland than for the Minoans, and ultimately they became the most architecturally sophisticated monuments of the entire Aegean period. The earliest burials were in shaft graves. The Mycenean ruling families laid out their dead in opulent costumes and jewelry and surrounded them with ceremonial weapons, gold and silver wares, and other articles indicative of their high status, wealth, and power (fig. 4-19, "The Object Speaks"). By about 1600 BCE, kings and princes on the mainland had

THE TROJAN WAR The legend of the Trojan War and its aftermath held a central place in the imagination of ancient people. It inspired, sometime before 700 BCE, the great epics of the Greek poet Homer—the *Iliad* and the *Odyssey*—and provided later poets and artists with rich subject matter.

According to the legend, a woman's infidelity caused the war. While on a visit to the city of Sparta in the Peloponnese, in southern Greece, young Paris, the son of King Priam of Troy, fell in love with Helen, a human daughter of Zeus who was the wife of the Spartan king Menelaus. With the help of Aphrodite, the goddess of love, Helen and Paris fled to Troy, a rich city in northwestern Asia Minor. The angry Greeks dispatched ships and a huge army to bring Helen back. Led by Agamemnon, king of Mycenae and the brother of Menelaus, the Greek forces laid siege to Troy. The two sides were deadlocked for ten years, until a ruse devised by the

Greek warrior Odysseus enabled the Greeks to win: the Greeks pretended to give up the siege and built a huge wooden horse to leave behind as a parting gift to the goddess Athena, or so they led the Trojans to believe. In fact, Greek warriors were hidden inside the wooden horse. After the Trojans pulled the horse inside the gates of Troy, the Greeks slipped out and opened the gates to their comrades, who slaughtered the Trojans and burned the city.

This legend probably originated with a real attack on a coastal city of Asia Minor by mainland Greeks during the late Bronze Age. Tales of the conflict, modified over the centuries, endured in a tradition of oral poetry until Homer wrote them down.

Like the Greeks, the Romans found inspiration in the legendary struggle at Troy. Seeking heroic origins for themselves, they claimed descent from Aeneas, a Trojan warrior. As recounted in the *Aeneid*, an epic by the Roman poet Virgil (70–19 BCE), Aeneas

and his followers escaped from Troy and found their way to Italy.

As early as the seventeenth century CE, adventurers began searching for Troy. In the early nineteenth century, the Englishman Charles MacLaren and the American Frank Calvert both concluded that the remains of the legendary city might be found at the Hissarlik Mound in northwestern Turkey. Excavated first by Heinrich Schliemann (see "Pioneers of Aegean Archaeology," page 149) in 1872–90 and by an American team under Carl Blegen in the 1930s, this relatively small mound—less than 700 feet across—contained the "stacked" remains of at least nine successive cities, the earliest of which dates to at least 3000 BCE. The most recent hypothesis is that so-called Troy 6 (the city six levels down), which flourished between about 1800 and 1300 BCE, was the Troy of Homeric legend; its substantially reinforced fortifications suggest that was threatened by a powerful enemy.

THE OBJECT SPEAKS

THE "MASK OF AGAMEMNON"

"I have gazed on the face of Agamemnon," archaeologist Heinrich Schliemann supposedly telegraphed a Greek newspaper in late 1876. His words to the king of Greece, while more enthusiastic, were also more guarded: Schliemann expressed his great joy at having found the tombs of Agamemnon and his family, the House of Atreus. Just as Schliemann had followed clues in Homer's epics to discover Troy (see "Pioneers of Aegean Archaeology," page 149), so had he tracked the words of the second-century BCE Greek geographer Pausanias to the citadel at Mycenae, which Schliemann believed to be the home of Agamemnon, the commander-in-chief of the Greek forces against Troy (see "The Trojan War," opposite). Among the 30 pounds of gold objects he found in the royal graves were five death masks, and one of these golden treasures (fig. 4-19) seemed to him to be the face of Homer's hero. Even today, the gold mask that so moved Schliemann exerts a nearly hypnotic power. But is the face Agamemnon's—if there was such a person—and does it say anything to us about him, and about Schliemann?

In fact, we now know this golden mask has nothing to do with the heroes of the Trojan War. Research shows that the Mycenae graves are about 300 years older than Schliemann believed and the burial practices were different from those described by Homer. Still, the image is so commanding that we sense it nevertheless is a hero's face. However, the characteristics that make it seem so gallant—such as the handlebar moustache and large ears—have caused some scholars to question its authenticity.

Controversies surrounding the mask surfaced about thirty years ago and were raised again in the July–August 1999 issue of *Archaeology*, which asked, "Is Schliemann Mask a Fake?" Some scholars today maintain that the mask is just what Schliemann claimed: a treasure he discovered in a royal tomb at Mycenae. Scholars at the opposite extreme disagree. Noting that this mask is significantly different from the others found at the site, they contend that Schliemann had some of the features added to make the mask appear more heroic to viewers of his day.

Regardless of what future researchers may learn about this mask, several facts are indisputable. First, for Schliemann it was a symbol of the Mycenaean culture he had hoped to find—and of the new world of archaeology he in fact opened up with his discoveries. Second, the image of this face—whoever's it may be—has the power to move us to this day.

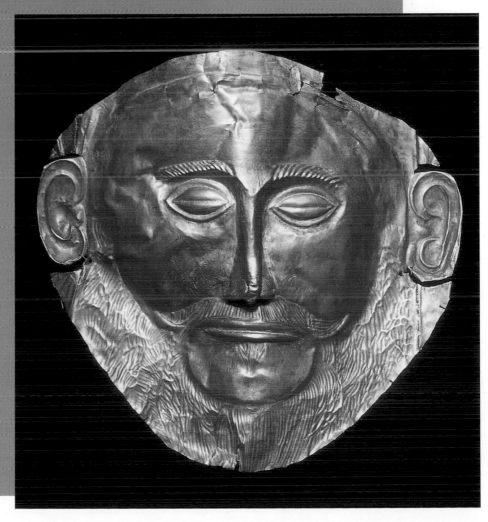

4-19. *"Mask of Agamemnon,"* funerary mask, from the royal tombs, Grave Circle A, at Mycenae, Greece. c. 1600–1550 BCE. Gold, height approx. 12" (35 cm). National Archaeological Museum, Athens

4-20. *Tholos,* **the so-called Treasury of Atreus,** Mycenae, Greece. c. 1300–1200 BCE

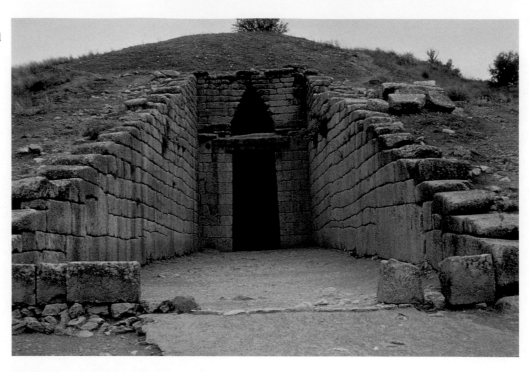

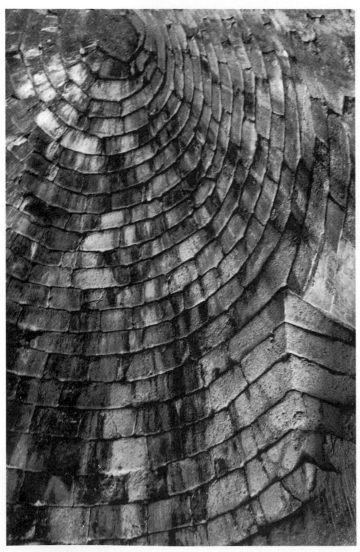

begun building large aboveground burial places commonly referred to as **beehive tombs** because of their rounded, conical shape. In their round plan, beehive tombs are somewhat similar to the prehistoric European megalithic tombs, such as the one at Newgrange, Ireland (see fig. 1-17).

4-21. **Corbeled vault, interior of the so-called Treasury of Atreus.** Limestone, height of vault approx. 43' (13 m), diameter 47'6" (14.48 m)

This great beehive tomb, which remained half buried until it was excavated by Christos Stamatakis in 1878, is neither a storage space for treasures nor likely to be connected to Atreus, the father of the kings Menelaus and Agamemnon, the king who led the campaign against Troy in Homer's *Iliad.* For more than a thousand years, this Mycenaean tomb remained the largest uninterrupted interior space built in Europe. The first European structure to exceed it in size was the Pantheon in Rome (Chapter 6), built in the first century BCE.

More than a hundred such tombs have been found on mainland Greece, nine of them in the vicinity of Mycenae. Most of the tombs have been robbed. Possibly the most impressive is the so-called Treasury of Atreus (fig. 4-20), which dates from about 1300 to 1200 BCE. The structure is an example of **cyclopean construction**, so called because it was believed that only the race of giants known as the Cyclopes could have moved its massive stones. A walled passageway through the earthen mound covering the tomb, about 120 feet long and 20 feet wide and open to the sky, led to the tomb's entrance facade. The original entrance was 34 feet high and the door was 18 feet high, faced with bronze plaques and flanked by engaged, upward-tapering columns of green Egyptian porphyry (a type of stone) incised with geometric bands and **chevrons**—inverted Vs—filled with **running spirals**, a favored Aegean motif seen in earlier Cycladic and Minoan art. The section above the lintel had smaller engaged columns on each side, and the relieving triangle was disguised behind a red-and-green engraved marble panel. The main tomb chamber (fig. 4-21) is a circular room 47½ feet in diameter and 43 feet high. It is roofed with a **corbel vault** built up in regular **courses**, or layers, of **ashlar**—squared stones—smoothly leaning inward and carefully calculated to meet in a single capstone at the peak, a remarkable engineering feat.

The Citadel at Tiryns. The builders of the citadel at Tiryns (fig. 4-22), about 10 miles from Mycenae and near the coast, made up for the site's lack of natural defenses by drawing heavily on their knowledge of military strategy. Homer referred to the resulting fortress as "Tiryns of the Great Walls." Its ring wall was about 20 feet thick, and the inner palace walls were similarly massive. The main entrance gate was approached along a narrow ramp that wound clockwise along the ring wall, forcing attacking soldiers to approach with their right sides exposed to the defenders on top of the wall (they carried their shields on their left arms). If the attackers reached the entrance, they still had to fight their way through a series of inner fortified gates. Corbel-vaulted casemates, or rooms and passages within the thickness of the ring walls, provided space for storing arms and sheltering soldiers or towns-people seeking safety within the citadel (fig. 4-23). In the unlikely event that the citadel gate was breached, the people inside could fight attackers from openings in the casemates.

As in all Mycenean citadels, the ruler's residence at Tiryns had a large audience hall called a **megaron**, or

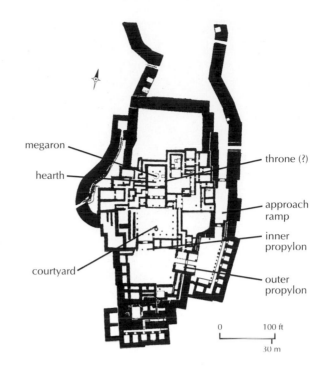

4-22. Plan of the citadel at Tiryns, Greece. Site occupied
c. 1600–1200 BCE; fortified c. 1365 BCE

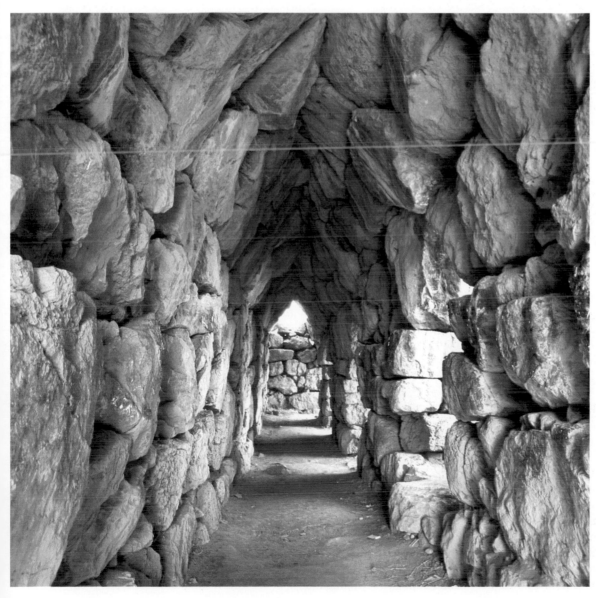

4-23. Corbel-vaulted casemate inside the ring wall of the citadel at Tiryns c. 1365 BCE

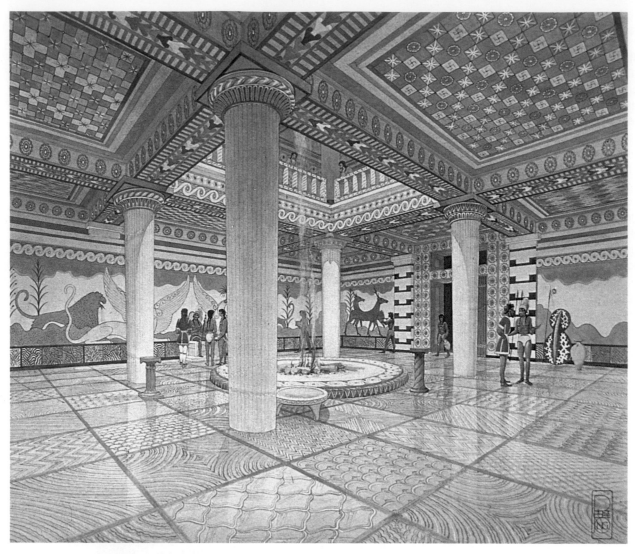

4-24. Reconstruction drawing of the megaron in the palace at Pylos, Greece. c. 1300–1200 BCE. Drawing in Antonopouleion Archaeological Museum, Pylos

"great room." The main courtyard led to a porch, a vestibule, and then to the great room—a much more direct approach than the complex corridors imposed on visitors in a Minoan palace. In the typical megaron plan, four large columns around a central hearth supported the ceiling. The roof section above the hearth was either raised or open to admit light and air and permit smoke to escape. Architectural historians surmise that the megaron eventually came to bc specifically associated with royalty. The later Greeks therefore adapted its form when building temples, which they saw as earthly palaces for their gods.

The Palace at Pylos. Tiryns required heavy defense works because of its proximity to the sea and its location on a flat plain. The people of Pylos, in the extreme southwest of the Peloponnese, perhaps felt that their more remote and defensible location made them less vulnerable to military attack. The palace at Pylos, built about 1300–1200 BCE, followed the megaron plan and was built on a raised site without fortifications. Set behind a porch and vestibule facing the courtyard, the Pylos megaron was a magnificent display of architectural and decorative prowess. The reconstructed view provided here (fig. 4-24) shows how the combined throne room and audience hall, with fluted, upward-swelling Minoan-type columns supporting heavy ceiling beams, might have looked when new. Every inch was painted—the floors, ceilings, beams, and door frames with brightly colored abstract designs, and the walls with large mythical animals and highly stylized plant and landscape forms.

Linear B clay tablets found in the ruins of the palace include an inventory of the palace furnishings that indicates they were as elegant as the architecture. The listing on one tablet reads: "One ebony chair with golden back decorated with birds; and a footstool decorated with ivory pomegranates. One ebony chair with ivory back carved with a pair of finials and with a man's figure and heifers; one footstool, ebony inlaid with ivory and pomegranates." It may be that the people of Pylos should have taken greater care to protect themselves. Within a century of its construction, the palace was destroyed by fires, apparently set during the violent upheavals that brought about the collapse of Mycenaean Greek dominance.

SCULPTURE

Mainland artists saw Minoan art acquired through trade. Perhaps they even worked side by side with Minoan artists brought back by the Greek conquerors of Crete. A carved

4-25. *Two Women with a Child*, found in the palace at Mycenae, Greece. c. 1400–1200 BCE. Ivory, height 2³⁄₄" (7.5 cm). National Archaeological Museum, Athens

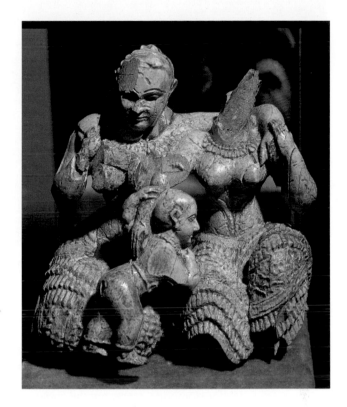

ivory group of two women and a child (fig. 4-25), less than 3 inches high and found in the palace shrine at Mycenae, appears to be a product of Minoan-Mycenaean artistic exchange. Dating from about 1400–1200 BCE, the miniature exhibits carefully observed natural forms, an intricately interlocked composition, and finely detailed rendering. The group is carved entirely in the round—top and bottom as well as back and front. It is an object to be held in the hand and manipulated. Because there are no clues to the identity or the significance of the group, we might easily interpret it as generational—with grandmother, mother, and child—but the figures could just as well represent two nymphs or devotees attending a child god. In either case, the mood of affection and tenderness among the three is unmistakable, and, tiny as it is, the sculpture counters the militaristic vein of so much Mycenaean art.

PIONEERS OF AEGEAN ARCHAEOLOGY

The pioneering figure in the modern study of Aegean civilization was Heinrich Schliemann (1822–90 CE), who was inspired by Homer's epic tales, the *Iliad* and the *Odyssey* (see page 144). Born in Germany but an American citizen after 1869, he was the son of an impoverished minister, from whom he inherited a love of literature and languages. Yet Schliemann was forced by economic circumstances to follow a commercial course of study and to enter the business world—as a grocer's apprentice—in 1836. Largely self-educated, he worked hard, grew rich, and retired in 1863 to pursue his lifelong dream of becoming an archaeologist. Between 1865 and 1868, he studied archaeology and Greek in Paris; in 1869, he began conducting fieldwork in Greece and Turkey.

Scholars of that time considered Homer's stories pure fiction, but by studying the descriptions of geography in the *Iliad*, Schliemann located a multilayered site at Hissarlik, in modern Turkey, whose sixth level down is now generally accepted as being Homer's Troy (see "The Trojan War," page 144).

After his success at Hissarlik, Schliemann pursued his hunch that the grave sites of Homer's Greek royal family would be found inside the citadel at Mycenae. He did find opulent burials in shaft graves uncovered near the Lion Gate (see figs. 4-18, 4-19), but later data proved the graves to be too early to contain the bodies of Atreus, Agamemnon, and their relatives—if these legendary figures ever existed. Nevertheless, scholars today accept the possibility that some Homeric legends are based on actual events.

In 1887, Schliemann tried unsuccessfully to buy a site on the island of Crete where he hoped to find the palace of the legendary King Minos. That discovery fell to a British archaeologist, Sir Arthur Evans (1851–1941), who led the excavation of the palace at Knossos between 1900 and 1905 (see fig. 4-5). It was Evans who gave the name *Minoan*—after King Minos—to Bronze Age culture on Crete. His chief focus was early Minoan writing. He also made a first attempt to establish an absolute chronology for Minoan art, basing his conjectures on datable Egyptian artifacts found in the ruins on Crete and on Minoan finds in Egypt. Later scholars have revised and refined his datings.

Men were not the only energetic researchers in the field in those days. Sophia Schliemann contributed much to her husband's work, and American archaeologist Harriet Boyd Hawes (1871–1945)—assisted by Edith Hall—was responsible for the discovery and excavation of Gournia, which is one of the best-preserved Bronze Age sites in Crete. She published her findings in 1908.

American archaeologist **Harriet Boyd Hawes**, photographed on Crete in 1902.

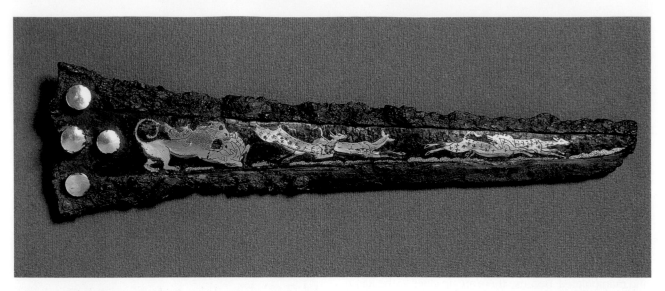

4-26. Dagger blade, from Shaft Grave IV, Grave Circle A, Mycenae, Greece. c. 1600–1550 BCE. Bronze inlaid with gold, silver, and copper, length 9⅜" (23.8 cm). National Archaeological Museum, Athens

METALWORK

The beehive tombs at Mycenae had been looted long before archaeologist Heinrich Schliemann arrived in the 1870s CE to search for Homeric Greece, but the contents of the shaft graves he excavated—constructed about 300 years before the beehive tombs—reflect even earlier mainland culture (see "Pioneers of Aegean Archaeology," page 149). Shaft graves were vertical pits 20 to 25 feet deep. In Mycenae, the royal graves were enclosed in a circle of standing stone slabs. Magnificent gold and bronze swords, daggers, masks, jewelry, and drinking cups were often buried with members of the elite. As in the tombs of Egyptian royalty, some of the men were found wearing masks of gold or a silver-gold alloy called electrum, as if to preserve their heroic features forever (see fig. 4-19, "The Object Speaks").

Also found in one of the shaft graves at Mycenae were three bronze dagger blades decorated with inlaid scenes.

The Mycenaean artist cut shapes out of different-colored metals—copper, silver, and gold—then inlaid them in the bronze blades, then added the fine details in niello (see "Aegean Metalwork," page 136). In the *Iliad*, Homer's epic poem about the Trojan War written sometime before 700 BCE, the poet describes similar decoration on Agamemnon's armor and Achilles' shield. The decoration on the blade shown here, depicting men with shields battling three lions, is typically Aegean in the animated and naturalistic treatment of the figures (fig. 4-26). Interestingly, the scene on another blade found at the site, showing a leopard attacking ducks in a papyrus swamp, reflects Egyptian influence.

CERAMICS

In the final phase of the Helladic period, Mycenaean potters created highly refined ceramics in uniform sizes and shapes. Although their vessels were superior to most earlier wares in terms of technique, the decorations applied to them were often highly stylized. A narrative scene ornaments the Mycenaean *Warrior Vase*, dating from about 1300–1100 BCE (fig. 4-27). On the side shown here, a woman at the far left bids farewell to a group of helmeted men marching off to the right with beribboned lances and large shields. The vibrant energy of the *Harvester Vase* or the *Vapheio Cup* has changed in this scene to the regular rhythm inspired by marching men. The only indication of the woman's emotions is the symbolic gesture of an arm raised to her head, and the figures of the men are seemingly interchangeable parts in a rigidly disciplined war machine.

Mycenaean civilization did not have a long history. By 1200 BCE, more aggressive invaders were crossing into mainland Greece, and within a century they had taken control of the major cities and citadels. The period between about 1100 and 900 BCE was a kind of "dark age" in the Aegean, marked by political, economic, and artistic instability and upheaval. But a new culture was forming, one that looked back to the exploits of the Helladic warrior-kings as the glories of a heroic age while setting the stage for a new Greek civilization.

4-27. *Warrior Vase*, from Mycenae, Greece. c. 1300–1100 BCE. Ceramic, height 16" (41 cm). National Archaeological Museum, Athens

PERIOD	ART IN THE AEGEAN	ART IN OTHER CULTURES
CYCLADIC c. 3000–1600 BCE	**4-2.** "Frying pan" (c. 2500–2200) **4-3.** Cycladic woman figure (c. 2500–2200) **4-4.** *Harp Player* (3rd millennium)	**1-19.** Stonehenge (c. 2750–1500), England **3-10.** Great Pyramids (c. 2613–2494), Egypt **3-13.** *Menkaura and a Queen* (c. 2500), Egypt **2-16.** Gudea (c. 2120), Lagash **2-6.** Nanna Ziggurat (c. 2100–2050), Iraq **11-2.** Jomon vessel (c. 2000), Japan **9-4.** Harappa torso (c. 2000), India
MINOAN OLD PALACE c. 1900–1700 BCE	**4-6.** Kamares Ware (c. 2000–1900) **4-7.** Bee pendant (c. 1700)	**1-24.** *Horse and Sun Chariot* (c. 1800–1600), Denmark **3-24.** Senusret II pectoral (c. 1880–1874), Egypt **3-22.** *Face of King Senusret III* (1874–1855), Egypt **2-17.** *Stele of Hammurabi* (c. 1792–1750), Susa
MINOAN SECOND PALACE c. 1700–1450 BCE	**4-5.** Knossos palace (c. 1700–1450) **4-9.** *Woman or Goddess with Snakes* (c. 1600–1550) **4-10.** *Harvester Vase* (c. 1650–1450) **4-14.** *Landscape* (before 1630–1500) **4-11.** Bull's head rhyton (c. 1550–1450) **4-12.** *Octopus Flask* (c. 1500–1450)	
LATE MINOAN c. 1450–1375 BCE	**4-15.** *Bull Leaping* (c. 1450–1375) 	
MYCENAEAN c. 1400–1100 BCE	**4-16.** *Vapheio Cup* (c. 1650–1450) **4-17.** *Mycenae citadel* (c. 1600–1200) **4-19.** Funerary mask (c.1600–1550) **4-25.** *Two Women* (c. 1400–1200) **4-23.** Tiryns citadel (c. 1365) **4-20.** *Tholos "Treasury"* (c. 1300–1200) **4-27.** *Warrior Vase* (c. 1300–1100) **4-18.** Lion Gate (c. 1250)	**2-27.** Lion Gate (c. 1400), Turkey **3-37.** *Queen Tiy* (c. 1352), Egypt **3-36.** *Akhenaten and His Family* (c. 1352–1336), Egypt **3-38.** *Nefertiti* (c. 1352–1336), Egypt **3-1.** Tutankhamun mask (c. 1336–1327), Egypt **3-29.** Pylon of Rameses II (c. 1279–1213), Egypt

5
Art of Ancient Greece

5-1. Myron. *Discus Thrower (Diskobolos),*
Roman copy after the original bronze of c. 450 BCE.
Marble, height 5'1" (1.54 m). Museo Nazionale
Romano, Rome

A sense of awe fills the stadium when the athletes recognized as the fastest runners in the world enter for the second day of competition. With the opening ceremonies behind them, each runner has only one goal: to win—to earn recognition as the best, to take home the award, the praise, the championship. The runners have come from near and far, as will the wrestlers and riders, the discus throwers and long jumpers, the boxers and javelin hurlers who will compete.

This competition took place more than 2,000 years ago, but the scene seems comfortably familiar. Every four years, then as now, the best athletes were to come together. Attention would shift from political confrontation to physical competition, to individual human beings who seemed able to surpass even their own abilities in the glorious pursuit of an ideal. Yet beyond those common elements lie striking differences between Olympics past and present. At those first Olympian Games, the athletes gathered on sacred ground near Olympia, in modern-day Greece, to pay tribute to the supreme god, Zeus, and his wife, Hera. The first day's ceremonies were religious rituals, and the awards were crowns of wild olives. The winners' deeds were celebrated by poets long after their victories, and the greatest of the athletes might well live the rest of their lives at public expense. They were idealized for centuries in extraordinary Greek sculpture, such as the *Discus Thrower*, originally created in bronze by Myron about 450 BCE (fig. 5-1). The Olympian Games were so significant that many Greeks date the beginning of their history as a nation to the first Games, traditionally said to have been held in 776 BCE. (The Roman emperor Theodosius banned the Games in 394 CE, and they were not resumed until 1896.) In recognition of the original Games, the modern Olympics begin with the lighting of a flame from a torch ignited by the sun at Olympia that is carried by relay to that year's site—an appropriate metaphor for the way the light of inspiration was carried from ancient Greece throughout the Western world.

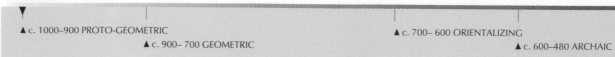

▲ c. 1000–900 PROTO-GEOMETRIC

▲ c. 900– 700 GEOMETRIC

▲ c. 700– 600 ORIENTALIZING

▲ c. 600–480 ARCHAIC

TIMELINE 5-1. Art Periods in Ancient Greece. After the waning of the Mycenaean culture, Greek styles between 900 and 480 BCE were dominated by the Geometric, Orientalizing, and Archaic. After the Transitional, or Early Classical, period, Greece entered the Fifth- and Fourth-Century Classical periods, until about 320 BCE, when the style known as Hellenistic spread throughout the Greek Empire.

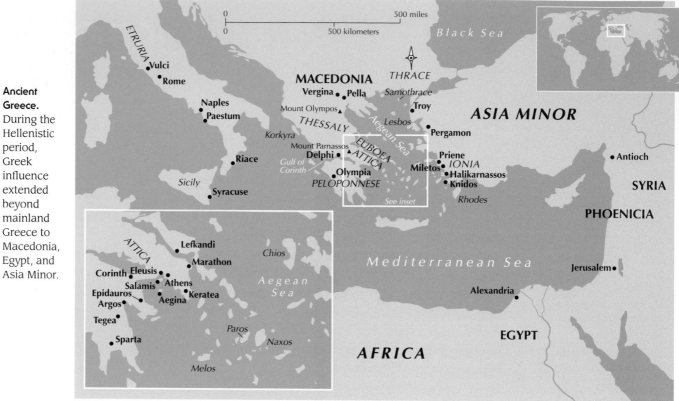

MAP 5-1. Ancient Greece. During the Hellenistic period, Greek influence extended beyond mainland Greece to Macedonia, Egypt, and Asia Minor.

THE EMERGENCE OF GREEK CIVILIZATION

"Man is the measure of all things," concluded Greek sages, and Greeks carved those words on a temple at one of their sacred sites, the Temple of Apollo at Delphi. Supremely self-aware and self-confident, the Greeks developed this concept of human supremacy and responsibility into a worldview that demanded a new visual expression in art. Artists studied human beings intensely, then distilled their newfound knowledge to capture in their art works the essence of *humanity*—a term that, by the Greeks' definition, applied only to those who spoke Greek; they considered those who could not speak Greek "barbarians."

Ancient Greece was a mountainous land of spectacular natural beauty. Olive trees and grapevines grew on the steep hillsides, producing oil and wine, but with little good farmland the Greeks turned to commerce to supply their needs. In towns, skilled artisans provided metal and ceramic wares to exchange abroad for grain and raw materials. Greek merchant ships carried pots, olive oil, and bronzes from Athens, Corinth, and Aegina around the

Mediterranean Sea. The Greek cultural orbit included mainland Greece with the Peloponnese in the south and Macedonia in the north, the Aegean islands, and the western coast of Asia Minor (Map 5-1). Greek colonies in Italy, Sicily, and Asia Minor rapidly became powerful independent commercial and cultural centers themselves, but they remained tied to the homeland by common language, traditions, religion, and history.

More than 2,000 years have passed since the artists and architects of ancient Greece worked, yet their achievements continue to have a profound influence. Their legacy is especially remarkable given their relatively small numbers, the almost constant warfare that beset them, and the often harsh economic conditions of the time. Greek artists sought a level of perfection that led them continually to improve upon their past accomplishments through changes in style and approach. For this reason, the history of Greek art contrasts dramatically with that of Egyptian art, where the desire for permanence and continuity induced artists to maintain artistic conventions for nearly 3,000 years. In the comparatively short time span from around 900 BCE to about 100 BCE,

Greek artists explored a succession of new ideas to produce a body of work in every medium—from pottery and painting to sculpture and architecture—that exhibits a clear stylistic and technical direction toward representing the visual world as we see it. The periods into which ancient Greek art is traditionally divided (see page 157) reflect the definable stages in this stylistic progression rather than political developments.

The Greeks contributed more to posterity than their art. Their customs, institutions, and ideas have had an enduring influence in many parts of the world. Countries that highly esteem athletic prowess reflect an ancient Greek ideal. Systems of higher education in the United States and Europe also owe much to ancient Greek models. Many important Western philosophies, especially regarding the individual human being, have conceptual roots in ancient Greece. Perhaps most significant, representative governments throughout the world today owe a debt to ancient Greek experiments in democracy.

A BRIEF HISTORY

Following the collapse of Mycenaean dominance about 1100 BCE, the Aegean region experienced a period of disorganization during which most prior cultural developments, including writing, were destroyed or forgotten. The mainland, the Aegean islands, and the coastal areas of Asia Minor were left open to new waves of migrating peoples. Although nothing is known for certain of their origins or the dates of their arrivals, some of these immigrants may have brought Iron Age technology to these regions.

The mountains and sea that divide the lands of the region also divided the people. By about 900 BCE, the inhabitants of the Aegean region established small, distinct groups in valleys, on coastal plains, and on islands, living in self-sufficient, close-knit communities but all speaking some form of the same language. It was these people, a fusion of new migrants and earlier inhabitants, who came to be called Greeks. From these independent communities, Greeks in the ninth and eighth centuries BCE developed the city-state (polis), an autonomous region having a city—Athens, Corinth, Sparta—as its political, economic, religious, and cultural center. Each was independent, deciding its own form of government, securing its own economic support, and managing its own domestic and foreign affairs. The power of these city-states initially depended at least as much on their manufacturing and commercial skills as on their military might. In the seventh century BCE, the Greeks adopted two sophisticated new tools from Asia Minor, coins and alphabetic writing, opening the way for success in commerce and literature.

Among the emerging city-states, Corinth, located on major land and sea trade routes, was one of the oldest and most powerful. By the sixth century BCE, Athens, located in Attica on the east coast of the mainland, began to assume both commercial and cultural preeminence. In 594 BCE, the poet and patriot Solon became the political leader of Athens. He developed a judiciary and a constitutional government with a popular assembly and a council. By the end of the sixth century BCE, Athens had a representative government in which every community (or deme, hence "democracy") had its own assembly and magistrates. All citizens participated in the assembly and all had an equal right to own private property, to exercise freedom of speech, to vote and hold public office, and to serve in the army or navy. Citizenship, however, remained an elite male prerogative. The census of 309 BCE in Athens listed 21,000 citizens, 10,000 foreign residents, and 400,000 others—that is, women, children, and slaves. In spite of the exclusive and intensely patriarchal nature of citizenship, the idea of citizens with rights and responsibilities was an important new concept in governance. Only in Sparta did a warrior aristocracy retain power. (The Greek cities of Asia Minor, controlled by the Persian Empire under Darius, did not fare well politically at this time; see Chapter 2.)

At the beginning of the fifth century BCE, the Greek cities of Asia Minor led by Miletos (page 199) revolted against Persia, initiating a period of warfare between Greeks and Persians. In 490 BCE, at the Greek mainland city of Marathon, the Athenians drove off Darius's Persian army (today's marathon races still recall the feat of the man who ran the 26 miles from Marathon to Athens with news of victory and dropped dead from exhaustion as he gasped out his words). Ten years later, the Persians again invaded Greece and even destroyed Athens. But the Athenians were skilled mariners, and they had a small but formidable navy. They destroyed the Persian fleet at Salamis in 479 BCE. Athens emerged from the Persian wars as the leader of the city-states.

The victorious Greeks turned to rebuilding their cities and self-confidently celebrating Greek culture. Pericles, who dominated Athenian politics from mid-century until his death in 429 BCE, rebuilt the city and the temples on the Acropolis. Athens's artistic achievements during that period have been unrivaled in the Western world. Not all Greeks applauded the Athenians, however. In 431 BCE, a war broke out that only ended in 404 with the collapse of Athens and the victory of Sparta. In the fourth century BCE, a new force appeared in the north—Macedonia.

In 359 BCE, a crafty and energetic warrior, Philip II, came to the throne of Macedonia. In 338, he defeated Athens and rapidly conquered the other cities. When he was assassinated two years later, he left his kingdom to his twenty-year-old son, Alexander. Alexander, whom history calls "the Great," rapidly consolidated his power and then led a united Greece in a war of revenge and conquest against the Persians. In 334 BCE, he crushed the Persian army and conquered Syria and Phoenicia. By 331, he had occupied Egypt and founded the seaport he named Alexandria; the astute Egyptian priests of Amun recognized him as the son of a god, an idea he readily adopted.

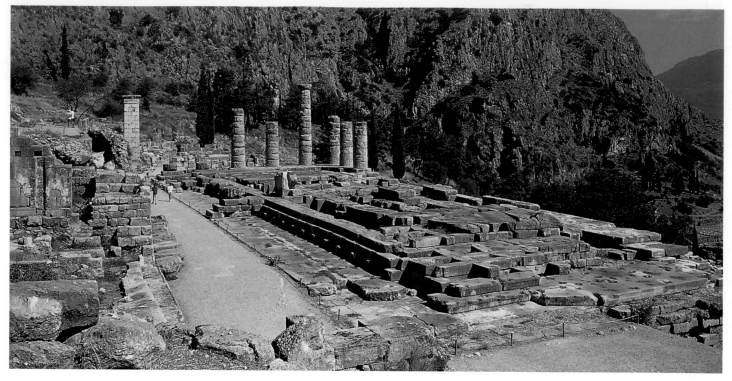

5-2. Sanctuary of Apollo, Delphi. 6th–3rd century BCE

This sacred home of the Greek god Apollo was built on the site of a sixth-century BCE temple destroyed in an earthquake; at a crevice here, the god was believed to communicate with humans through a woman medium called the Pythia. To prepare herself to receive his messages, she chewed sacred laurel leaves and drank water from the sacred Kassotis Spring, both of which are thought to have induced hallucinations. She then sat over the crevice on a three-legged stool. When she received the god's response to a petitioner's question, she conveyed it in often cryptic and ambiguous language. The Greeks attributed many twists of fate to misinterpretations of the Pythia's statements. When, for example, King Croesus of Lydia in Asia Minor (Chapter 2) came to Delphi in the mid-sixth century BCE to consult Apollo about his military plans, he received the message that he would cross a river and destroy a great kingdom. Ironically, the kingdom he destroyed was his own, when his troops crossed the Halys River and were wiped out by the Persians.

That same year, Alexander reached the Persian capital of Persepolis (Chapter 2), where his troops accidentally burned down the palace. He then continued east until he reached India in 326 BCE. Finally his troops refused to go any farther, and on the way home Alexander died of fever in 323. He was only thirty-three years old.

Alexander did not live long enough to consolidate his empire, and his generals divided the lands among themselves. Egypt, ruled by the Ptolemies, became especially rich and powerful (Chapter 3). These Hellenistic rulers in Egypt became patrons of arts and sciences, and their principal city, Alexandria, with its great library, became a center for the study of mathematics, geography, and medicine. Pergamon, Antioch, Jerusalem, and Athens all flourished under their own rulers in the fourth and third centuries BCE.

RELIGIOUS BELIEFS AND SACRED PLACES

Knowledge of Greek history is important to understanding its arts; knowledge of its religious beliefs is indispensable. The creation of the world, according to ancient Greek legend, involved a battle between the earth gods, called Titans or Giants, and the sky gods. The victors were the sky gods, whose home was believed to be atop Mount Olympos in the northeast corner of the Greek mainland. The Greeks saw their gods as immortal and endowed with supernatural powers, but, more than peoples of the ancient Near East and the Egyptians had, they visualized

them in human form and attributed to them human weaknesses and emotions. Among the most important Olympian deities were the ruling god and goddess, Zeus and Hera; Apollo, god of healing, arts, and the sun; Poseidon, god of the sea; Ares, god of war; Aphrodite, goddess of love; Artemis, goddess of hunting and the moon; and Athena, the powerful goddess of wisdom who governed several other important aspects of human life (see "Greek and Roman Deities and Heroes," page 158).

In addition to Mount Olympos, many sites throughout Greece, called **sanctuaries**, were thought to be sacred to one or more gods. Local people enclosed the sanctuaries with walls and designated them as sacred ground. The earliest sanctuaries had one or more outdoor altars or shrines and a sacred natural element such as a tree, a rock, or a spring. As additional buildings were added over time, a sanctuary might become a palatial home for the gods, called a **temenos**, with one or more temples, several **treasuries** for storing valuable offerings, various monuments and statues, housing for priests and visitors, an outdoor dance floor or permanent theater for ritual performances and literary competitions, and a **stadium** for athletic events. The Sanctuary of Hera and Zeus near Olympia, in the western Peloponnese, housed an extensive athletic facility with training rooms and arenas for track-and-field events. It was here that athletic competitions, prototypes of today's Olympic Games, were held.

The Sanctuary of Apollo at Delphi is located on a high plateau in the shadow of Mount Parnassos (fig. 5-2). In this

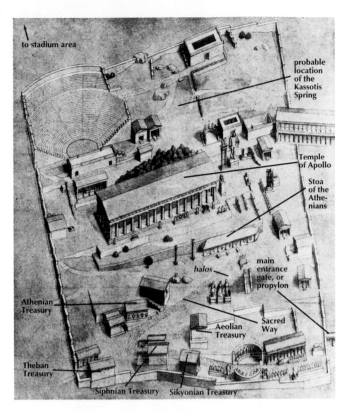

5-3. Reconstruction drawing of the Sanctuary of Apollo, Delphi. C. 400 BCE

long **colonnade** of the Temple of Apollo. This structure, built about 530 BCE on the ruins of an earlier temple, remained standing until it was destroyed by an earthquake in 373 BCE. Below the temple was a **stoa**, a columned pavilion open on three sides, built by the people of Athens. There visitors rested, talked, or watched ceremonial dancing on an outdoor pavement called a *halos*. At the top of the sanctuary hill was a stadium area for athletic games.

Greek sanctuaries are quite different from the religious complexes of the ancient Egyptians (see, for example, the funerary complex of Hatshepsut, figs. 3-31, 3-32). Egyptian builders dramatized the power of gods or god-rulers by placing their temples at the ends of long, straight, processional ways. The Greeks, in contrast, treated each building and monument within a *temenos* as an independent element to be integrated with the natural features of the site. It is tempting to draw a parallel between this manner of organizing space and the way Greeks organized themselves politically. Every structure, like every Greek citizen, was a unique entity meant to be encountered separately within its own environment while being closely allied with other entities in a larger scheme of common purpose.

HISTORICAL DIVISIONS OF GREEK ART

The names of major periods of Greek art (Timeline 5-1) have remained standard even though changing interpretations have led some art historians to question their appropriateness. The primary source of information about Greek art before the seventh century BCE is pottery, and the Geometric period (c. 900–700 BCE) owes its name to the geometric, or rectilinear, forms with which artists of the time decorated ceramic vessels. The Orientalizing period (c. 700–600 BCE) is named for the apparent influence of Egyptian and Near Eastern art on Greek pottery of that time, spread through trading contacts as well as the travels of artists themselves. The name of the third period, *Archaic*, meaning "old" or "old-fashioned," stresses a presumed contrast between the art of that time (c. 600–480 BCE) and the art of the following Classical period, which once was thought to be the most admirable and highly developed—a view that no longer prevails among art historians.

The Classical period has been subdivided into three phases: the Transitional, or Early Classical, from about 480 to 450 BCE, the Fifth-Century Classical, from about 450 to the end of the fifth century BCE; and the Fourth-Century Classical, from about 400 to about 320 BCE. Art historians still use these subdivisions as convenient chronological markers but no longer see them as chapters in a story detailing the "rise and decline" of the Classical style. For this reason, the neutral terms *Fifth-Century* and *Fourth-Century* have largely replaced the formerly conventional terms *High* and *Late Classical,* with their implication of a peak of achievement followed by a decline.

The name of the final period of Greek art, *Hellenistic,* means "Greek-like." Hellenistic art was produced throughout the eastern Mediterranean world as non-Greek people

rugged mountain site, according to Greek myth, the sky was attached to the *omphalos* (navel) of the earth by an umbilical cord. Here too, it was said, Apollo fought and killed the Python, the serpent son of the earth goddess Ge, who guarded his mother's nearby shrine. This myth may be a metaphorical account of the conquest of early Bronze Age people of Greece, whose religion centered on female earth deities, by a wave of new settlers who believed in a supreme male sky god. From very early times, the sanctuary at Delphi was renowned as an **oracle**, a place where a god (Apollo) was believed to communicate with humans by means of cryptic messages delivered through a human intermediary, or medium (the Pythia). The Greeks and their leaders routinely sought advice at oracles, and even foreign rulers requested help at Delphi.

Delphi was the site of the Pythian Games, named for the female medium there. This festival, like the Olympian Games, attracted participants from all over Greece. The principal events were both the athletic contests and the music, dance, and poetry competitions in honor of Apollo. As at Olympia, hundreds of statues dedicated to the victors of the competitions filled the sanctuary grounds, a kind of Pythian Games hall of fame (see fig. 5-34).

A reconstruction drawing of the Sanctuary of Apollo as it looked about 400 BCE (fig. 5-3) shows that the main temple, performance and athletic areas, and other buildings and monuments cleverly made full use of limited space on the hillside. After visitors climbed the steep path up the lower slopes of Parnassos, they entered the sanctuary by a ceremonial gate in the southeast corner. From there they zigzagged up the Sacred Way, so named because it was the route of religious processions during festivals. Moving past the numerous treasuries and memorials built by Greece's various city-states (see fig. 5-13), they soon arrived at the

GREEK AND ROMAN DEITIES AND HEROES The ancient Greeks had many deities, and myths about them varied over time. Many deities had several forms, or manifestations. Athena, for example, was revered as a goddess of wisdom, a warrior goddess, a goddess of victory, and a goddess of purity and maidenhood, among others. The Romans later adopted the Greek deities but sometimes attributed to them slightly different characteristics. What follows is a simplified list of the major Greek deities and heroes, with their Roman names in parentheses when they exist. The list includes some of the most important characteristics of each deity or hero, which often identify them in art.

According to the most widespread legend, twelve major sky gods and goddesses established themselves in palatial splendor on Mount Olympos in northeastern Greece after defeating the earth deities, called Giants or Titans, for control of the earth and sky.

THE FIVE CHILDREN OF EARTH AND SKY

Zeus (Jupiter), supreme deity. Mature, bearded man; holds scepter or lightning bolt; eagle and oak tree are sacred to him.

Hera (Juno), goddess of marriage. Sister/wife of Zeus. Mature woman; cow and peacock are sacred to her.

Hestia (Vesta), goddess of the hearth. Sister of Zeus. Her sacred flame burned in communal hearths.

Poseidon (Neptune), god of the sea. Holds a three-pronged spear; horse is sacred to him.

Hades (Pluto), god of the underworld, the dead, and wealth. His helmet makes the wearer invisible.

THE SEVEN SKY GODS, OFFSPRING OF THE FIRST FIVE

Ares (Mars), god of war. Son of Zeus and Hera. Wears armor; vulture and dog are sacred to him.

Hephaistos (Vulcan), god of the forge, fire, and metal handicrafts. Son of Hera (in some myths, also of Zeus); husband of Aphrodite. Lame, sometimes ugly; wears blacksmith's apron, carries hammer.

Apollo (Phoebus), god of the sun, light, truth, music, archery, and healing. Sometimes identified with Helios (the Sun), who rides a chariot across the daytime sky. Son of Zeus and Leto (a descendant of Earth); brother of Artemis. Carries bow and arrows or sometimes lyre; dolphin and laurel are sacred to him.

Artemis (Diana), goddess of the hunt, wild animals, and the moon. Sometimes identified with Selene (the Moon), who rides a chariot or oxcart across the night sky. Daughter of Zeus and Leto; sister of Apollo. Carries bow and arrows, is accompanied by hunting dogs; deer and cypress are sacred to her.

Athena (Minerva), goddess of wisdom, war, victory, the city, and civilization. Daughter of Zeus; sprang fully grown from his head. Wears helmet and carries shield and spear; owl and olive trees are sacred to her.

Aphrodite (Venus), goddess of love. Daughter of Zeus and the water nymph Dione; alternatively, daughter of Poseidon, born of his sperm mixed with sea foam; wife of Hephaistos. Myrtle, dove, sparrow, and swan are sacred to her.

Hermes (Mercury), messenger of the gods, god of fertility and luck, guide of the dead to the underworld, and god of thieves, commerce, and the marketplace. Son of Zeus and Maia, the daughter of Atlas, a Giant who supports the sky on his shoulders. Wears winged sandals and hat; carries caduceus, a wand with two snakes entwined around it.

OTHER IMPORTANT DEITIES

Demeter (Ceres), goddess of grain and agriculture.

Persephone (Proserpina), goddess of fertility and queen of the underworld. Wife of Hades; daughter of Demeter.

Dionysos (Bacchus), god of wine, the grape harvest, and inspiration. Shown surrounded by grapevines and grape clusters; carries a wine cup. His female followers are called maenads (Bacchantes).

Eros (Cupid), god of love. In some myths, the son of Aphrodite. Shown as an infant or young boy, sometimes winged; carries bow and arrows.

Eos (Aurora), goddess of dawn.

Ge, goddess of the earth; mother of the Titans.

Asklepios (Aesculapius), god of healing.

Amphitrite, goddess of the sea. Wife of Poseidon.

Pan, protector of shepherds, god of the wilderness and of music. Half man, half goat, he carries panpipes.

Nike, goddess of victory. Often shown winged and flying.

IMPORTANT HUMAN HEROES

Herakles (Hercules). A man of great and diverse strengths; granted immortality for his achievements, including the Twelve Labors.

Perseus. Killed Medusa, the snake-haired monster.

Theseus. Killed the Minotaur, a bull-monster that ate young men and maidens in a labyrinth in the palace of King Minos of Crete (see "The Legend of the Minotaur," page 134).

HEROES OF THE TROJAN WAR

Among the Greeks: Agamemnon (Greek commander-in-chief), Odysseus (Ulysses), Achilles, Patroclus, and Ajax.

Among the Trojans: Paris, Hector, Priam, Sarpedon, and Aeneas (progenitor of the Romans).

5-4. *Centaur*, from Lefkandi, Euboea. Late 10th century BCE. Terra-cotta, height 14⅛" (36 cm). Archaeological Museum, Eretria

5-5. *Funerary vase*, from the Dipylon Cemetery, Athens. c. 750 BCE. Terra-cotta, height 42⅝" (108 cm). The Metropolitan Museum of Art, New York

Rogers Fund, 1914 (14.130.14)

gradually became imbued with Greek culture under Alexander and his successors. The history and art of ancient Greece end with the fall of Egypt, the last bastion of Hellenistic rule, to the Romans in 31 BCE.

THE GEOMETRIC PERIOD

The first appearance of a specifically Greek style of vase painting, as opposed to Minoan or Mycenaean, dates to about 1050 BCE. This style—known as Proto-Geometric because it anticipated the Geometric style—was characterized by linear motifs, such as spirals, diamonds, and **cross-hatching**, rather than the stylized plants, birds, and sea creatures characteristic of Minoan vase painting. The Geometric style proper, an extremely complex form of decoration, became widespread after about 900 BCE in all types of art and endured until about 700 BCE.

CERAMIC DECORATION

A striking ceramic figure of a half-horse, half-human creature called a centaur dates to the end of the tenth century BCE (fig. 5-4). This figure exemplifies two aspects of the Proto-Geometric style: the use of geometric forms in painted decoration, and the reduction of human and animal body parts in sculptural works to simple geometric solids such as cubes, pyramids, cylinders, and spheres. The figure is unusual, however, because of its size (more than a foot tall) and because its hollow body was formed like a vase on a potter's wheel. The artist added solid legs, arms, and a tail (now missing) to this body and painted on the bold, abstract designs with **slip**, a mixture of water and clay. The slip fired to dark brown, standing out against the lighter color of the unslipped portions of the figure. Centaurs, prominent in Greek mythology, had both a good and a bad side and may have symbolized the similar dual nature of humans. This centaur, discovered in a cemetery, had been deliberately broken into two pieces that were buried in adjacent graves. Clearly, the object had special significance for the people buried in the graves or their mourners.

Large funerary vases discovered in the ancient cemetery of Athens just outside the Dipylon Gate, once the main western entrance into the city, exemplify the complex decoration typical of the Geometric style proper. For the first time, human beings are depicted as part of a narrative. The pot illustrated here, a grave marker dated about 750 BCE, provides a detailed record of the funerary rituals—including the relatively new Greek practice of cremation—for an important man (fig. 5-5). The body of the deceased is

5-6. *Man and Centaur*, perhaps from Olympia. c. 750 BCE. Bronze, height 4⁵/16" (11.1 cm). The Metropolitan Museum of Art, New York
Gift of J. Pierpont Morgan, 1917 (17.190.2072)

the rigidity, solemnity, and strong rhythmic accents of the carefully arranged elements.

Egyptian funerary art reflected the belief that the dead, in the afterworld, could continue to engage in activities they enjoyed while alive. Greek funerary art, in contrast, focused on the emotional reactions of the survivors, not the fate of the dead. The scene of human mourning on this pot contains no supernatural beings, nor any identifiable reference to an afterlife that might have provided solace for the bereaved. According to the Greeks, the deceased entered a place of mystery and obscurity that humans could not define precisely.

METAL SCULPTURE

Greek artists of the Geometric period produced many figurines of wood, ivory, clay, and especially cast bronze. These small statues of humans and animals are similar to those painted on pots. A tiny bronze of this type, *Man and Centaur*, dates to about 750 BCE (fig. 5-6). The two figures confront each other after the man has stabbed the centaur. The sculptor reduced the body parts of the figures to simple geometric shapes, arranging them in a composition of solid forms and open, or **negative, spaces** that makes the piece pleasing from every view. Most such works have been found in sanctuaries, suggesting that they may have been votive offerings to the gods.

THE FIRST GREEK TEMPLES

Greeks worshiped at outdoor altars within walled sanctuaries; their temples sheltered a statue of a god. Few ancient Greek temples remain standing today. Stone foundations define their rectangular shape, and their appearance has been pieced together largely from fallen columns, broken lintels, and fragments of sculpture lying where they fell centuries ago. Walls and roofs constructed of mud brick and wood have disappeared.

Small ceramic models, such as one from the eighth century BCE found in the Sanctuary of Hera near Argos, give some idea how these temples might have looked (fig. 5-7). The rectangular structure has a door at one end sheltered by a projecting **porch** supported on two sturdy posts. The steeply pitched roof forms a triangular area, or **gable**, in the **facade**, or front wall, that is pierced by an opening directly above the door. The abstract designs painted on the roof and side walls are similar to those used on other Geometric period ceramics; whether they reflect the way temples were actually decorated is not known.

Temple interiors followed an enduring basic plan adapted from the Mycenaean palace **megaron** (compare fig. 4-24 with plan [a] in "Greek Temple Plans," page 163). The large audience hall of the megaron became the main room of the temple, called the **cella**, or **naos**. In the center of this room, where the hearth would have been in the megaron, stood a statue of the god to whom the temple was dedicated. The small reception area that preceded the audience hall in the megaron became the temple's vestibule, called the **pronaos**.

placed on its side on a funeral bier, about to be cremated, at the center of the top **register** of the vase. Male and female figures stand on each side of the body, their arms raised and both hands placed on top of their heads in a gesture interpreted as expressing anguish—it suggests that the mourners are literally tearing their hair out with grief. In the bottom register, horse-drawn chariots and foot soldiers, who look like walking shields with tiny antlike heads and muscular legs, form a well-ordered procession.

The abstract forms used to represent human figures on this pot—triangles for torsos; more triangles for the heads in profile; round dots for eyes; long, thin rectangles for arms; tiny waists; and long legs with bulging thigh and calf muscles—are typical of the Geometric style. Figures are shown in either full-frontal or full-profile views that emphasize flat patterns and outline shapes. No attempt has been made to create the illusion of three-dimensional forms occupying real space. The artist has nevertheless communicated a deep sense of human loss by exploiting

THE ORIENTALIZING PERIOD

By the seventh century BCE, vase painters in major pottery centers in Greece had moved away from the dense linear decoration of the Geometric style. They now created more open compositions built around large motifs that included real and imaginary animals, abstract plant forms, and human figures. The source of these motifs can be traced to the arts of the Near East, Asia Minor, and Egypt. Greek painters did not simply copy the work of Eastern artists, however. Instead, they drew on work in a variety of mediums—including sculpture, metalwork, and textiles—to invent an entirely new approach to vase painting.

The Orientalizing style began in Corinth, a port city where luxury wares from Eastern cultures could be seen. The new style is evident in a Corinthian **olpe**, or wide-mouthed pitcher, dating to about 600 BCE, which has silhouetted creatures striding in horizontal bands against a light background with stylized flower forms called **rosettes** (fig. 5-8). An example of the **black-figure** pottery style, it is decorated with dark shapes of lions, a serpent, and composite creatures against a background of very pale buff, the natural color of the Corinthian clay (see "Greek Painted Vases," page 173). The artist incised fine details inside the silhouetted shapes with a sharp tool and added touches of white and reddish purple **gloss**, or clay slip mixed with metallic color pigments, to enhance the design.

THE ARCHAIC PERIOD

During the Archaic period, from about 600 to 480 BCE, the Greek city-states on the mainland, on the Aegean islands, and in the colonies grew and flourished. Athens, which had lagged behind the other city-states in population and economic development in the seventh century BCE, began moving artistically, commercially, and politically to the forefront.

The Greek arts developed rapidly during the Archaic period. In literature, the poet Sappho on the island of Lesbos was writing poetry that would inspire the geographer Strabo, near the end of the millennium, to write: "Never within human memory has there been a woman to compare with her as a poet." On another island, the semilegendary slave Aesop was relating animal fables that became lasting elements in Western culture. Artists shared in the growing prosperity of the city-states by competing for lucrative commissions from city councils and wealthy individuals, who sponsored the building of temples, shrines, government buildings, **monumental** (large-scale) sculpture, and fine ceramic wares. During this period, potters and vase painters began to sign their works.

5-7. Model of a temple, found in the Sanctuary of Hera, Argos. Mid-8th century BCE. Terra-cotta, length 14½" (36.8 cm). National Archaeological Museum, Athens

5-8. Pitcher (olpe), from Corinth. c. 600 BCE. Ceramic with black-figure decoration, height 11½" (30 cm). The British Museum, London

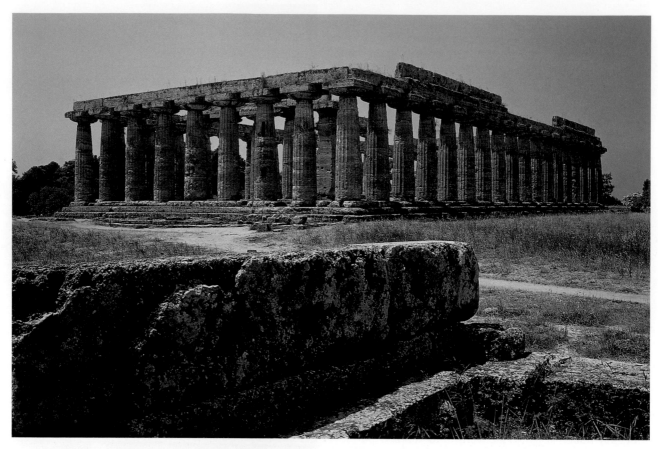

5-9. Temple of Hera I, Paestum, Italy. c. 550 BCE

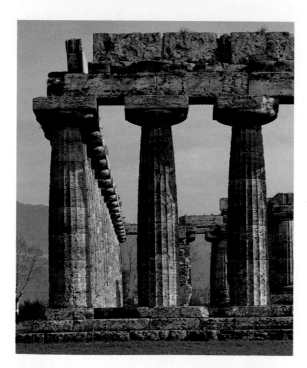

5-10. Corner view of the Temple of Hera I, Paestum

TEMPLE ARCHITECTURE

As Greek temples grew steadily in size and complexity over the centuries, stone and marble replaced the earlier mud-brick and wood construction. A number of standardized plans evolved, ranging from simple one-room structures with columned porches to buildings with double porches surrounded by columns (see "Greek Temple Plans," page 163). Builders also experimented with the design of temple **elevations**—the arrangement, proportions, and appearance of the columns and the entablatures. Two standardized elevation designs emerged during the Archaic period: the **Doric order** and the **Ionic order**. The **Corinthian order**, a variant of the Ionic order, developed later (see "The Greek Architectural Orders," page 164).

Paestum, the Greek colony of Poseidonica established in the seventh century BCE about 50 miles south of the modern city of Naples, Italy, contains some well-preserved early Greek temples. The earliest standing temple there, built about 550 BCE, was dedicated to Hera, the wife of Zeus (fig. 5-9). It is known today as Hera I to distinguish it from a second temple to Hera built adjacent to it about a century later.

Hera I is a large, rectangular, stone **post-and-lintel** structure with a stepped foundation supporting a **peristyle**, a row of columns that surrounds the cella on all four sides. This single peristyle plan is called a **peripteral** temple (see "Greek Temple Plans," page 163). Columns consist of **base**, **shaft**, and **capital** and stand on the **stylobate**. The peristyle of Hera I originally supported a tall lintel area called the **entablature**. The roof rested on the **cornice**, the slightly projecting topmost element of the entablature. At each end, the horizontal cornice of the entablature and the **raking** (slanted) **cornices** of the roof defined a triangular gable called the **pediment**.

ELEMENTS OF ARCHITECTURE

Greek Temple Plans

The simplest early temples consist of a single room, the **cella**, or **naos**. Side walls ending in attached **pillars** (**anta**) may project forward to frame two columns **in antis** (literally, "between the pillars"), as seen in plan (a). An **amphiprostyle** temple (b) has a row of columns (**colonnade**) at the front and back ends of the structure, not on the sides, forming **porticos**, or covered entrance porches, at the front and back. If the colonnade runs around all four sides of the building, forming a **peristyle**, the temple is **peripteral** (c and d). Plan (c), the Temple of Hera I at Paestum, Italy, shows a pronaos and an **adyton**, an unlit inner chamber. Plan (d), the Parthenon, has an adyton and an **opithodomos**, enclosed porch at the back. The **stylobate** is the top step of the **stereobate**, or layered foundation.

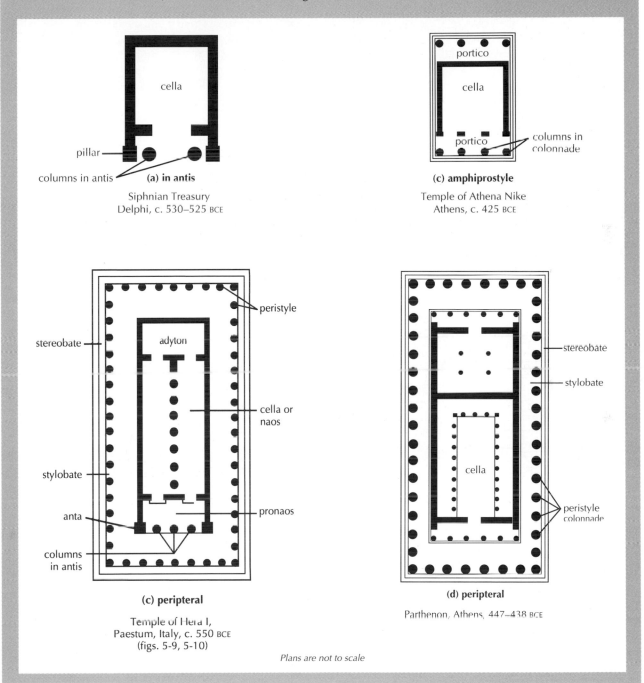

cella

pillar

columns in antis

(a) in antis

Siphnian Treasury
Delphi, c. 530–525 BCE

portico

cella

portico

columns in colonnade

(c) amphiprostyle

Temple of Athena Nike
Athens, c. 425 BCE

peristyle

stereobate

adyton

cella or naos

stylobate

anta

pronaos

columns in antis

(c) peripteral

Temple of Hera I,
Paestum, Italy, c. 550 BCE
(figs. 5-9, 5-10)

stereobate

stylobate

cella

peristyle colonnade

(d) peripteral

Parthenon, Athens, 447–438 BCE

Plans are not to scale

The elevation design of Hera I illustrates the early form of the Doric order, including columns with fluted shafts resting without bases directly on the stylobate (fig. 5-10). Capitals are made up of three distinct parts: the necking that makes the transition from the shaft, the round **echinus**, and the square **abacus**. A three-part entablature consists of a plain, flat band, called the **architrave**, topped by a decorated band, called the **frieze**, and capped with a cornice. In the Doric frieze, flat areas called **metopes** alternate with projecting blocks with three vertical grooves called **triglyphs**. The metopes were usually either painted or carved in relief and then painted. No sculpture has survived, but fragments of terra-cotta eave decorations painted in bright colors have been found in the rubble of Hera I.

ELEMENTS OF ARCHITECTURE

The Greek Architectural Orders

The three classical Greek architectural orders are the Doric, the Ionic, and the Corinthian. The Doric and Ionic orders were well developed by about 600 BCE. The Doric order is the oldest and plainest of the three orders. The Ionic order is named after Ionia, a region occupied by Greeks on the west coast of Asia Minor and the islands off the coast. The Corinthian order, a variation of the Ionic, began to appear around 450 BCE and was initially used by the Greeks in interiors. Later, the Romans appropriated the Corinthian order and elaborated it, as we shall see in Chapter 6. Greek orders—and later Roman orders—are known as classical orders. Each order is made up of a system of interdependent parts whose proportions are based on mathematical ratios. *No element of an order could be changed without producing a corresponding change in other elements.*

The basic components of the Greek orders are the **column** and the **entablature**, which function as post and lintel. All types of columns have a **shaft** and a **capital**; some also have a **base**. The shafts are formed of round sections, or **drums**, which are joined inside by metal pegs. In Greek temple architecture, columns stand on the **stylobate**, the "floor" of the temple; the levels below the stylobate form the **stereobate**.

The **Doric order** shaft rises directly from the stylobate, without a base. The shaft is **fluted**, or channeled, with sharp edges. At the top of the shaft and part of the capital is the **necking**, which provides a transition to the capital. The Doric capital itself has three parts: the necking, the rounded **echinus**, and the tabletlike **abacus**. The entablature includes the **architrave**, the distinctive **frieze** of **triglyphs** and **metopes**, and the **cornice**, the topmost, projecting horizontal element. The roofline may have decorative waterspouts and terminal decorative elements called **acroterion**.

The **Ionic order** has more elongated proportions than the Doric, its height being about nine times the diameter of the column at its base, as opposed to the Doric column's five-and-a-half– or seven-to-one ratio. The flutes on the columns are deeper and closer together and are separated by flat surfaces called **fillets**. The **capital** has a distinctive scrolled **volute**; the entablature has a three-panel architave, continuous frieze, and the addition of decorative moldings.

The **Corinthian order** was originally developed by the Greeks for use in interiors but came to be used on temple exteriors as well. Its elaborate capitals are sheathed with stylized **acanthus** leaves that rise from a convex band called the **astragal**.

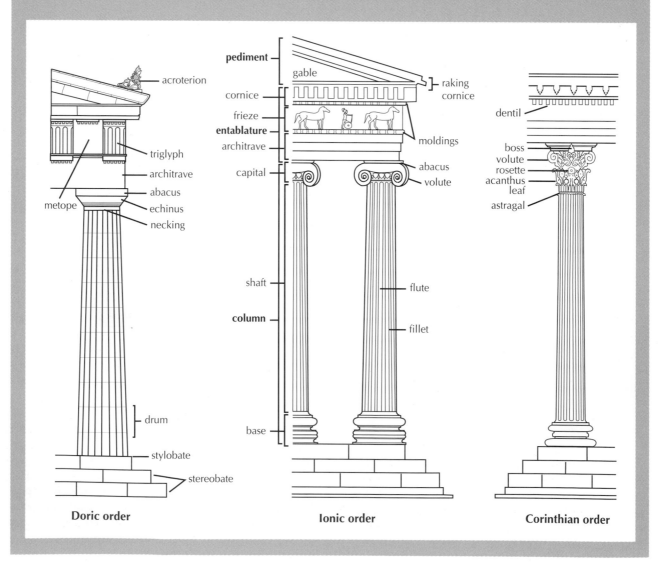

Doric order **Ionic order** **Corinthian order**

5-11. **Reconstruction of the west pediment of the Temple of Artemis,**
Korkyra (Corfu), after G. Rodenwaldt. c. 600–580 BCE

5-12. *Gorgon Medusa*, detail of sculpture from the west
pediment of the Temple of Artemis, Korkyra. c. 580
BCE. Limestone, height of pediment at the center 9'2"
(2.79 m). Archaeological Museum, Korkyra (Corfu)

Ancient Greeks would have seen the image of Medusa
at the center of this pediment as both menacing and
protective. According to legend, countless people
tried to kill this monster, only to die because they
looked at her face. The Greek hero Perseus, instructed
and armed by Athena, succeeded because he
beheaded her while looking only at her reflection
in his polished shield. Thus, the Medusa head
became a popular decoration for Greek armor. See,
for example, the shield of Ajax in figure 5-26.

The builders created an especially robust column,
only about four times as high as its maximum diameter,
topped with a widely flaring capital. This design creates
an impression of great stability and permanence but is
rather ponderous. As the column shafts rise, they swell
in the middle and contract again toward the top, a refine-
ment known as **entasis**. This subtle adjustment gives a
sense of energy and upward lift. In a local variation, Hera I
has an uneven number of columns—nine—across the
short ends of the peristyle, placing a column instead of a
space at the center of the ends. The entrance to the
pronaos also has a central column, and a row of columns
runs down the center of the wide cella to help support the
ceiling and roof. The unusual two-aisle, two-door
arrangement leading to the **adyton**, the small room at
the end of the cella proper, suggests that the temple may
have housed both a statue of Hera and that of a second
deity, possibly Zeus, her consort.

ARCHITECTURAL SCULPTURE

As Greek temples grew larger and more complex, sculp-
tural decoration took on increased importance. Among
the earliest surviving examples of Greek pedimental
sculpture are fragments of the ruined Doric order Temple
of Artemis on the island of Korkyra (Corfu) off the north-
west coast of the mainland, which date to about 580 BCE
(fig. 5-11). The figures in this sculpture were carved on
separate slabs, then installed in the pediment space.
They stand in such **high relief** from the background
plane that they actually break through the architectural
frame, which was more than 9 feet tall at the peak. At the
center is the rampaging snake-haired Medusa (fig. 5-12),
one of three winged female monsters called Gorgons.
Medusa had the power to turn humans to stone if they
should look upon her face, and in this sculpture she fixes
viewers with huge glaring eyes as if to work her dreadful

5-13. Reconstruction of the Treasury of the Siphnians, Delphi, using fragments found in the Sanctuary of Apollo. c. 530–525 BCE. Marble

This old reconstruction has been dismantled, and the fragments of the treasury's sculpture are exhibited separately at the Archaeological Museum, Delphi. There should have been a frontal four-horse chariot on the pediment and more chariots on the frieze. The photograph is useful, however, in providing an idea of how elegant and richly ornamented this small treasury building at Delphi was in its original state. The figure sculpture and decorative moldings were probably once painted in strong colors, mainly dark blue, bright red, and white, with touches of yellow to resemble gold. The people who commissioned this treasury were from Siphnos, an island in the Aegean Sea just southwest of the Cyclades.

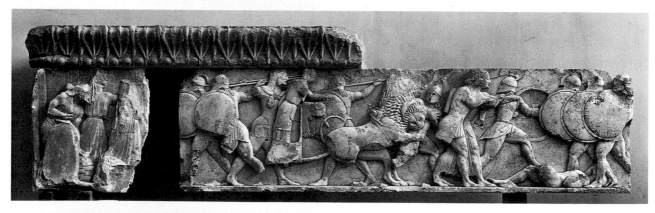

5-14. Battle between the Gods and the Giants, fragments of the north frieze of the Treasury of the Siphnians, from the Sanctuary of Apollo, Delphi. c. 530–525 BCE. Marble, height 26" (66 cm). Archaeological Museum, Delphi

magic on them. The much smaller figures flanking Medusa are the flying horse Pegasus on the left (only part of his rump and tail remain) and the giant Chrysaor on the right. These were Medusa's posthumous children (whose father was Poseidon), born from the blood that gushed from her neck after she was beheaded by the legendary hero Perseus. The felines crouching next to them literally bump their heads against the raking cornices of the roof. Dying human warriors lie on the ends of the pediment, their heads tucked into its corners and their knees rising with its sloping sides.

An especially noteworthy collaboration between builder and sculptor can still be seen in the small but luxurious Treasury of the Siphnians, built in the Sanctuary of Apollo at Delphi between about 530 and 525 BCE and housed today in the museum at Delphi. An old reconstruction of the facade of this building, now dismantled, shows a pronaos with two **caryatids**—columns carved in the form of draped women—set flush with the ends of the side walls, which were reinforced by square pillars, or **antae** (fig. 5-13). (This type of temple plan is called **in antis**, meaning "between the

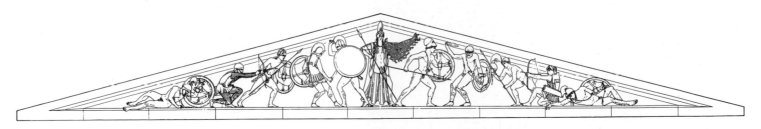

5-15. Reconstruction drawing of the east pediment of the Temple of Aphaia, Aegina. c. 480 BCE

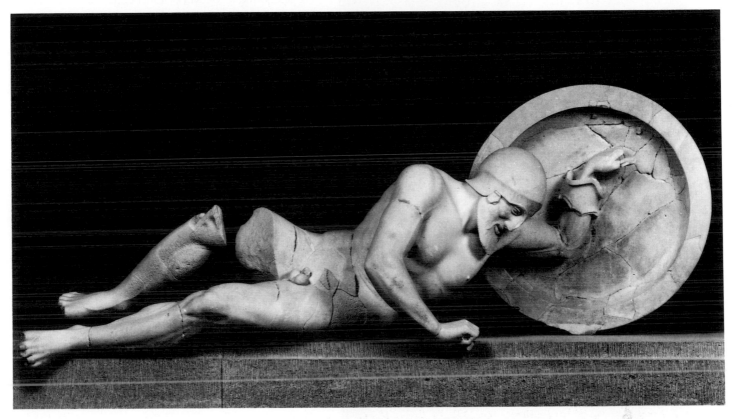

5-16. *Dying Warrior*, sculpture from the left corner of the east pediment of the Temple of Aphaia, Aegina. c. 480 BCE. Marble, length 6' (1.83 m). Staatliche Antikensammlungen und Glyptothek, Munich

pillars"; see "Greek Temple Plans," plan (a), page 163.) The stately caryatids, with their finely pleated, flowing garments, are raised on **pedestals** and balance elaborately carved capitals on their heads. The capitals support a tall entablature conforming to the Ionic order, which features a plain, or three-panel, architrave and a continuous carved frieze, set off by richly carved moldings (see "The Greek Architectural Orders," page 164).

Both the continuous frieze and the pediments of the Siphnian Treasury were originally filled with relief sculpture. A surviving section of the frieze from the building's north side, which shows a scene from the legendary battle between the Gods and the Giants, is one of the earliest known examples of a trend in Greek relief sculpture toward a more natural representation of space (fig. 5-14). To give a sense of three dimensions, the sculptor placed some figures behind others, overlapping as many as three of them and varying the depth of the relief. Countering any sense of deep recession, all the figures were made the same height with their feet on the same **groundline**.

The long pediments of Greek temples provided a perfect stage for storytelling, but the triangular pediment created a problem in composition. The sculptor of the east pediment of the Doric Temple of Aphaia at Aegina (fig. 5-15), dated about 480 BCE, provided a creative solution that became a design standard, appearing with variations throughout the fifth century BCE. The subject of the pediment, rendered in fully three-dimensional figures, is the sack of Troy. Fallen warriors fill the angles at both ends of the pediment base (fig. 5-16), while others crouch, lunge, and reel, rising in height toward an image of Athena as warrior goddess under the peak of the roof. The erect goddess, larger than the other figures and flanked by two defenders facing approaching opponents, dominates the center of the scene and stabilizes the entire composition.

Among the best-preserved fragments from this pedimental scene is the *Dying Warrior* from the far left corner, a tragic but noble figure struggling to rise while dying (fig. 5-16). This figure originally would have been painted and fitted with authentic bronze accessories, heightening the sense of reality it conveys. Fully exploiting the difficult framework of the pediment corner, the sculptor portrayed the soldier's uptilted, twisted form turning in space, capturing his agony and vulnerability. The subtle modeling of

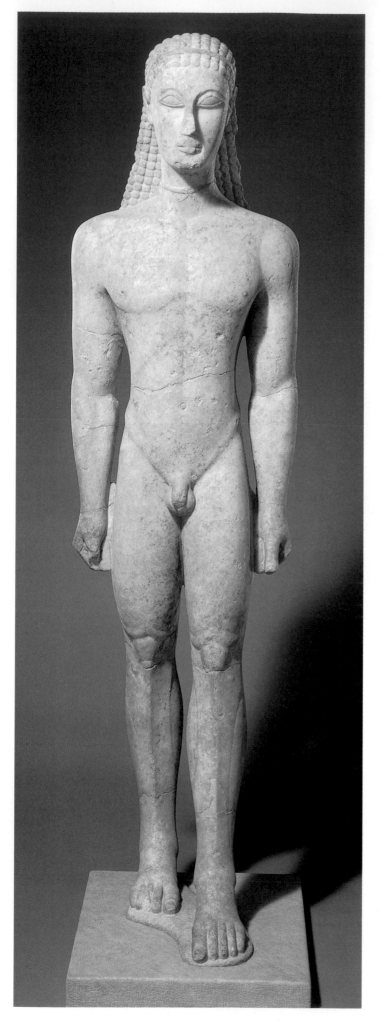

the body conveys the softness of human flesh, which is contrasted with the hard, metallic geometry of the shield and helmet.

FREESTANDING SCULPTURE

In addition to decorating temple architecture, sculptors of the Archaic period created a new type of large, freestanding statue made of wood, terra-cotta, or white marble from the islands of Paros and Naxos. Frequently lifesize or larger, these figures usually were standing or striding. They were brightly painted and sometimes bore inscriptions indicating that they had been commissioned by individual men or women for a commemorative purpose. They have been found marking graves and in sanctuaries, where they lined the sacred way from the entrance to the main temple.

A female statue of this type is called a **kore** (plural *korai*), Greek for "young woman," and a male statue is called a **kouros** (plural *kouroi*), Greek for "young man." Archaic *korai*, always clothed, probably represented deities, priestesses, and nymphs, young female immortals who served as attendants to gods. *Kouroi*, nearly always nude, have been variously identified as gods, warriors, and victorious athletes. Because the Greeks associated young, athletic males with fertility and family continuity, the figures may have been symbolic ancestor figures. Pliny the Elder, a Roman naturalist and historian of the first century CE, believed that some of them portrayed famous athletes. He wrote:

> It was not customary to make effigies [portraits] of men unless, through some illustrious cause, they were worthy of having their memory perpetuated; the first example was a victory in the sacred contest, especially at Olympia, where it was the custom to dedicate statues of all who had been victorious; and in the case of those who had been winners there three times they moulded [sculpted] a likeness from the actual features of the person, which they call "icons" (*Naturalis Historia* 34.16-17, cited in Pollitt, page 30).

A *kouros* dating about 580 BCE (fig. 5-17) recalls the pose and proportions of Egyptian sculpture, such as the statue of Menkaura (see fig. 3-13). Like Egyptian figures, this young Greek, shown frontally, has arms rigidly at his sides, fists clenched, and one leg slightly in front of the other. However, Greek artists of the Archaic period did not share the Egyptian obsession with permanence; they cut away all stone from around the body and introduced variations in appearance from figure to figure. Greek statues may be suggestive of the marble block from which they were carved, but they have a notable athletic quality quite unlike Egyptian statues. Here the artist delineated

5-17. *New York Kouros*, from Attica. c. 580 BCE. Marble, height 6'4" (1.93 m). The Metropolitan Museum of Art, New York
Fletcher Fund, 1932 (32.11.1)

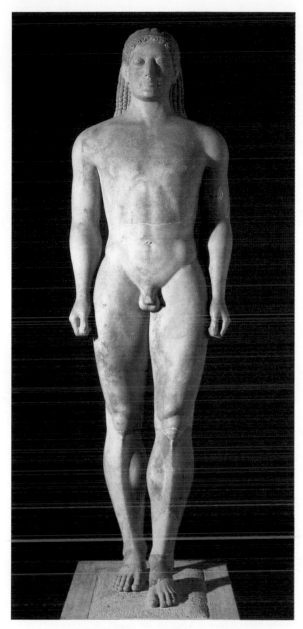

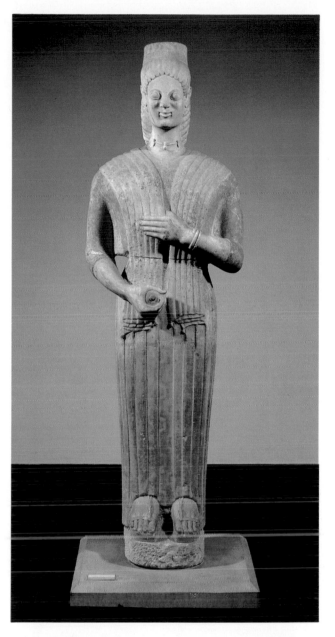

5-18. *Anavysos Kouros*, perhaps young Kroisos, from a cemetery at Anavysos, near Athens. c. 525 BCE. Marble with remnants of paint, height 6'4" (1.93 m). National Archaeological Museum, Athens

5-19. *Berlin Kore*, from a cemetery at Keratea, near Athens. 570–560 BCE. Marble with remnants of red paint, height 6'3" (1.9 m). Staatliche Museen zu Berlin, Antikensammlung, Altes Museum, Berlin-Mitte

the figure's anatomy with ridges and grooves that form geometric patterns. The head is ovoid, with heavy features and schematized hair evenly knotted into tufts and tied back with a narrow ribbon. The eyes are relatively large and wide open, and the mouth forms a characteristic closed-lip smile known as the **Archaic smile**, used to enliven the expressions of figures. In Egyptian sculpture, male figures were always at least partially clothed, wearing articles associated with their status, such as the headdresses, beaded pectorals, and kilts that identified kings. The total nudity of the Greek *kouroi*, in contrast, removes them from a specific time, place, or social class; the nude figure is like the gods but is a fully human shape.

The powerful, rounded body of a *kouros* known as the *Anavysos Kouros*, dated about 530 BCE clearly shows the

increasing interest of artists and their patrons in a more lifelike rendering of the human figure (fig. 5-18). The pose, wiglike hair, and Archaic smile echo the earlier style of *kouroi*, but the massive torso and limbs have greater anatomical accuracy suggesting heroic strength. The statue, a grave monument to a fallen war hero, has been associated with a base inscribed: "Stop and grieve at the tomb of the dead Kroisos, slain by wild Ares [god of war] in the front rank of battle." The viewer would have been inspired to emulate Kroisos's noble actions and heroic character.

The first Archaic *korai* are equally impressive. An early *kore* known as the *Berlin Kore*, found in a cemetery at Keratea and dated about 570–560 BCE, stands more than 6 feet tall (fig. 5-19). The erect, immobile pose and full-bodied figure—accentuated by a crown and thick-

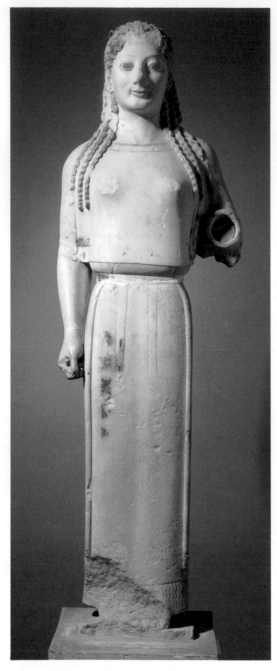

5-20. *Peplos Kore*, from the Acropolis, Athens. c. 530 BCE. Marble, height 48" (123 cm). Acropolis Museum, Athens

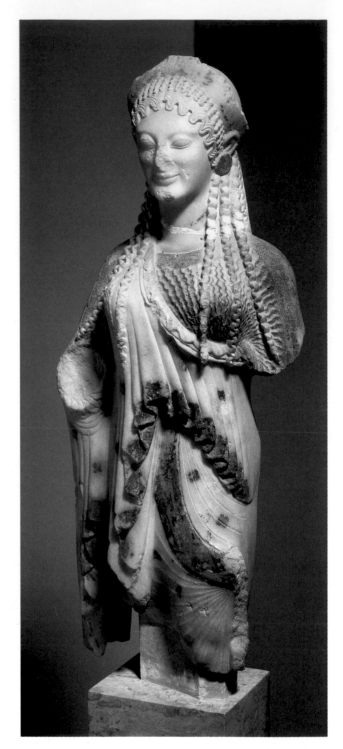

5-21. *Kore*, **from Chios (?)**. c. 520 BCE. Marble, height 21⅞" (56.6 cm). Acropolis Museum, Athens

soled clogs—seem appropriate to a goddess, although the statue may represent a priestess or an attendant. The thick robe and tassled cloak over her shoulders fall in regularly spaced, parallel folds like the fluting on a Greek column, further emphasizing the stately appearance. Traces of red—perhaps the red clay used to make thin sheets of gold adhere—indicate that the robe was once painted or gilded. The figure holds a pomegranate in her right hand, an **attribute** (identifying symbol) of Persephone, who was abducted by Hades, the god of the underworld (see fig. 5-66).

The *Peplos Kore* (fig. 5-20), which dates to about 530 BCE, is named for its distinctive and characteristic garment,

called a **peplos**—a draped rectangle of cloth, usually wool, folded over at the top, pinned at the shoulders, and belted to give a bloused effect. The *Peplos Kore* has the same motionless, vertical pose of the earlier *kore* but is a more rounded, feminine figure. Its bare arms and head convey a greater sense of soft flesh covering a real bone structure, and its smile and hair are somewhat more individualized and less conventionalized. The figure once wore a metal crown and earrings and has traces of **encaustic** painting, a mixture of pigments and hot wax that left a shiny, hard surface when it cooled.

The *Peplos Kore*, was recovered from debris on the Acropolis of Athens (see page 187), where many votive

5-22. *Calf Bearer (Moschophoros)*, from the Acropolis, Athens. c. 560 BCE. Marble, height 5'5" (1.65 m). Acropolis Museum, Athens

This photograph, made soon after the *Calf Bearer*'s excavation on the Acropolis, includes *Kritian Boy* (fig. 5-33) at the right.

and commemorative statues were placed in the sanctuary, but few have survived. When the Persians sacked the city in 480 BCE, they destroyed the sculpture there; the fragments were later used as fill in the reconstruction of the Acropolis after the Athenian victory the following year.

Another *kore* (fig. 5-21), dating to about 520 BCE, may have been made by a sculptor from Chios, an island off the coast of Asia Minor. Although the arms and legs of this figure have been lost and its face has been damaged, it is impressive for its rich drapery and the large amount of paint that still adheres to it. Like the *Anavysos Kouros* (see fig. 5-18) and the *Peplos Kore*, it reflects a trend toward increasingly lifelike anatomical depiction that would peak in the fifth century BCE. The *kore* wears a garment called a **chiton**; like the *peplos* but fuller, it was a relatively lightweight rectangle of cloth pinned along the shoulders. It originated in Ionia on the coast of Asia Minor but became popular throughout Greece. Over it, a cloak called a **himation** was draped diagonally and fastened

on one shoulder. The elaborate hairstyle and abundance of jewelry add to the opulent effect. A close look at what remains of the figure's legs reveals a rounded thigh showing clearly through the thin fabric of the *chiton*.

Not all Archaic statues followed the conventional *kouros* or *kore* models for standing figures. A different type is the *Calf Bearer* (*Moschophoros*) (fig. 5-22). This statue, from about 560 BCE, was also found in the rubble of the Acropolis, in the Sanctuary of Athena. It probably represents a priest or worshiper carrying an animal intended for sacrifice on the altar of a deity. The figure's smile, tufted hairdo, and wide-open eyes with large irises and semicircular eyebrows all reflect the Archaic style. Its short-cropped beard is similar to that of other statues of the period depicting men in active poses, but the gauze-thin robe is unusual. The sculptor has rendered the calf with perceptive detail, capturing its almost dazed look and the twisted position in which its captor holds its legs.

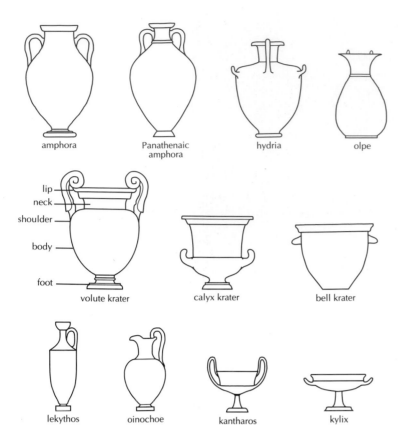

5-23. Standard shapes of Greek vessels

5-24. Ergotimos (potter) and Kleitias (painter). *François Vase.* c. 570 BCE. Black-figure decoration on a volute krater. Ceramic, height of volute krater 26" (66 cm). Museo Archeològico Nazionale, Florence

This large mixing bowl was made and decorated by Athenian artists but discovered in an Etruscan tomb. The Etruscans, who lived in central Italy, greatly admired and collected Greek pottery. Not only did they import vases, but they also may have brought in Greek artists to teach their local artists.

VASE PAINTING

Greek potters created only a few vessel forms, but each one combined beauty with a specific utilitarian function (fig. 5-23). The artists who painted the pots, which were often richly decorated, had to accommodate their work to these fixed shapes. During the Archaic period, Athens became the dominant center for pottery manufacture and trade in Greece. Athenian painters adopted the Corinthian black-figure techniques, which became the principal mode of decoration throughout Greece in the sixth century BCE. At first, Athenian painters retained the horizontal banded composition that was characteristic of the Geometric period. An important transitional work, the *François Vase*, illustrates the style (fig. 5-24). This vase, which dates about 570 BCE, is a **volute krater**—a large vessel with scroll-shaped, or volute, handles—which was used for mixing the traditional Greek drink of wine and water. The *François Vase* (discovered by an archaeologist named François) is one of the earliest known vessels signed by both the potter who made it (Ergotimos) and the painter who decorated it (Kleitias).

Kleitias was a great storyteller: this vessel, decorated with approximately 200 human and animal figures, identified with inscriptions, provides an important pictorial and literary record. The main narrative scene, which occupies the third band down from the top and encircles the whole vase, is the marriage of Peleus, the king of Thessaly, and Thetis, a sea nymph, who were the parents of Achilles. In the segment seen in figure 5-24, Peleus stands in front of his palace, greeting the Olympian gods, who are arriving at the marriage ceremony in a grand procession of chariots. The scenes on the neck of the vessel show, from the top down: the hunt for the dangerous Kalydonian Boar, led by the hero Meleager, and the funeral games in honor of Patroclus, Achilles' close friend who died in the Trojan War. On the body of the krater, below Peleus and Thetis, is a depiction of the ambush of the Trojan prince Troilus by Achilles. The Orientalizing style (see fig. 5-8) is still evident in the next band down, decorated with deer, griffins, and plant forms. On the foot of the vessel, very small warriors battle long-necked cranes, illustrating a story dating back to Homer. There are only three bands of pure geometric design—one of elongated triangles radiating up from the foot of the vessel and two narrow bands of looped decoration on the foot.

Over time, Athenian vase painters continued to decrease the number of bands and increase the size of figures until a single scene, usually one on a side, covered the vessel. A mid-sixth-century BCE **amphora**—a large, all-purpose storage jar—illustrates this development (fig. 5-25). The decoration on this vessel, a depiction of the wine god Dionysos with **maenads**, his female worshipers, has been attributed to an anonymous artist called the Amasis Painter, because work of this distinctive style was first recognized on vessels signed by a prolific potter named Amasis. Most of the Amasis Painter's work is found on small vessels, so this handsome amphora is an exception.

In the scene shown here, two maenads, arms around each other's shoulders, skip forward to present their

5-25. Amasis Painter. *Dionysos with Maenads.* C. 540 BCE. Black-figure decoration on an amphora. Ceramic, height of amphora 13" (33.3 cm). Bibliothèque Nationale, Paris

TECHNIQUE

GREEK PAINTED VASES

The three main types of Greek painted vase decoration are **black-figure**, **red-figure**, and **white-ground**. Sometimes tasks were divided between potters and painters. To create their works, painters used a complex procedure that involved preparing **slips** (mixtures of clay and water), applying slips to different areas of the vessel in varying thicknesses, and carefully manipulating the firing process in a **kiln**, or closed oven, to control the amount of oxygen reaching the vessel. If all went as planned (and sometimes it didn't), the designs painted in slip, which could barely be seen on the clay pot before firing, emerged afterward in the desired range of colors.

The firing process for both black-figure and red-figure painting involved three stages. In the first, a large amount of oxygen was allowed into the kiln, which "fixed" the whole vessel in one overall color that depended on the composition of the clay used. In the second, or "reduction," stage, the oxygen in the kiln was reduced to a minimum, turning the whole vessel black, and the temperature was raised to the point at which the slip partially vitrified (became glasslike). In the third phase, oxygen was allowed back into the kiln, turning the unslipped areas red. The partially vitrified slipped areas, sealed against the oxygen, remained black.

In black-figure painting, artists painted designs—figures, objects, or abstract motifs—in silhouette on the clay vessel. Then, using a sharp tool called a **stylus**, they cut through the slip to the body of the vessel to incise linear details within the silhouettes. In red-figure painting, the approach was reversed, and the background around the designs was painted with the slip. The linear details inside the shapes were also painted with the same slip, instead of being incised. In both techniques, artists often enhanced their work with touches of white and reddish purple **gloss**, metallic pigments mixed with slip.

White-ground vases became popular in the Fifth-Century Classical period. The white ground was created by painting the vessel with a highly refined, purified clay slip that turned white during the firing. The design elements were added to the white ground using either the black- or red-figure technique. After firing, the artists frequently painted on details and areas of bright and pastel hues using **tempera**, a paint made from egg yolks, water, and pigments. Because the tempera paints were fragile, these colors flaked off easily, and few perfect examples have survived.

5-26. Exekias. *The Suicide of Ajax*, c. 540 BCE. Black-figure decoration on an amphora. Ceramic, height of amphora 27" (69 cm). Château-Musée, Boulogne-sur-Mer, France

offerings—a long-eared rabbit and a small deer, signifying power over nature—to Dionysos. The maenad holding the deer wears the skin of a spotted panther (or leopard), its head still attached, draped over her shoulders and secured with a belt at her waist. The god, an imposing, richly dressed figure, clasps a large **kantharos** (wine cup). This encounter between humans and a god appears to be a joyful, celebratory occasion rather than one of reverence or fear. The Amasis Painter favored strong shapes and patterns, generally disregarding conventions for making figures appear to occupy real space, and emphasized fine details, such as the large, delicate

petal and spiral designs below each handle, the figures' meticulously arranged hair, and the bold patterns on their clothing.

The finest of all Athenian artists of the mid sixth century BCE, Exekias, signed many of his vessels as both potter and painter. Exekias took his subjects from Greek history, matching painted composition to vessel shape with great sensitivity. A scene on an amphora, *The Suicide of Ajax* (fig. 5-26), recounts an episode from the Trojan War (see "The Trojan War," page 144). Ajax was a fearless Greek warrior, second only to Achilles in bravery. After the death of Achilles, however, the Greeks bestowed his armor on Odysseus rather than Ajax. Distraught by this humiliation—compounded by his family ties to Achilles, who was his cousin—Ajax killed himself. Other artists showed the great warrior either dying or already dead, but Exekias has captured the story's most poignant moment, showing Ajax preparing to die. He has set aside his helmet, shield, and spear and crouches beneath a tree, planting his sword upright in a mound of dirt so that he can fall upon it. The painting exemplifies the quiet beauty and perfect equilibrium for which Exekias's works are so admired today. Two upright elements—the tree on the left and the shield on the right—frame and balance the figure of Ajax, their in-curving lines echoing the swelling shape of the amphora and the rounding of the hero's powerful back as he bends forward. The whole composition focuses the viewer's attention on the head of Ajax and his intense concentration as he pats down the earth to secure the sword. He will not fail in his suicide.

Not all subjects used for ceramics involved gods and heroes. A handsome example of black-figure decoration, painted about 510 BCE on an Athenian **hydria**, or water jug, by an artist who signed the work with the initials "A.D.," gives interesting insight into everyday Greek city life as well as a view of an important public building in use (fig. 5-27). Most women in ancient Greece were confined to their homes, so their daily trip to the communal well, or fountain house, would have been an important event. At a fountain house, in the shade of a Doric-columned porch, three women patiently fill hydriae like the one on which they are painted. A fourth balances her empty jug on her head as she waits, while a fifth woman, without a jug, appears to be waving a greeting to someone. The women's skin is painted white, a convention for female figures found also in Egyptian and Minoan art. Incising and touches of reddish purple paint create fine details in the architecture and in the figures' clothing and hair.

The composition of this vase painting is a fine balance of vertical, horizontal, rectangular, and rounded elements. The Doric columns, the decorative vertical borders, and even the streams of water flowing from the animal-head spigots echo the upright figures of the women. The wide black band forming the groundline, the architrave above the colonnade, and the left-to-right movement of the horse-drawn chariots across the shoulder area of the hydria emphasize the horizontal, friezelike arrangement of the women across the body of the pot. This geometric framework is softened by the

5-27. "A.D." Painter. *Women at a Fountain House.* 520–510 BCE. Black figure decoration on a hydria. Ceramic, height of hydria 20⅞" (53 cm). Museum of Fine Arts, Boston

William Francis Warden Fund

rounded contours of the female bodies, the globular water vessels, the circular **palmettes** (fan-shaped petal designs) framing the main scene, and the arching bodies of the galloping horses on the shoulder.

In the last third of the sixth century BCE, while "A.D." and others were still creating handsome black-figure wares, some pottery painters turned away from this meticulous process to a variation called **red-figure** decoration (see "Greek Painted Vases," page 173). This new method, as its name suggests, resulted in vessels with red figures against a black background, the opposite of black figure painting. In red-figure wares, the dark slip was painted on as background around the outlined figures, which were left unpainted. Details were drawn on the figures with a fine brush dipped in the slip. The result was a lustrous dark vessel with light-colored figures and dark details. The greater freedom and flexibility of painting rather than engraving the details led artists to adopt it widely in a relatively short time.

One of the best-known artists specializing in the red-figure technique was the Athenian Euphronios, who was praised especially for his study of human anatomy. His rendering of the *Death of Sarpedon*, about 515 BCE, is painted on a **calyx krater**, so called because its handles

5-28. Euphronios (painter) and Euxitheos (potter). *Death of Sarpedon.* c. 515 BCE. Red-figure decoration on a calyx krater. Ceramic, height of krater 18" (45.7 cm). The Metropolitan Museum of Art, New York

Purchase, Gift of Darius Ogden Mills, Gift of J. Pierpont Morgan, and Bequest of Joseph H. Durkee, by exchange, 1972 (1972.11.10)

curve up like a flower calyx (fig. 5-28). According to Homer's *Iliad*, Sarpedon, a son of Zeus and a mortal woman, was killed by the Greek warrior Patroclus while fighting for the Trojans. Euphronios shows the winged figures of Hypnos (Sleep) and Thanatos (Death) carrying the dead warrior from the battlefield. Watching over the scene is Hermes, the messenger of the gods, identified by his winged hat and caduceus, a staff with coiled snakes. Hermes is there in another important role, as the guide who leads the dead to the netherworld.

Euphronios, like the painter "A.D.," created a perfectly balanced composition of verticals and horizontals that take the shape of the vessel into account. The bands of decoration above and below the scene echo the long horizontal of the dead fighter's body, which seems to levitate in the gentle grasp of its bearers, and the inward-curving lines of the handles mirror the arching backs of Hypnos and Thanatos. The upright figures of the lance-bearers on each side and Hermes in the center counterbalance the horizontal elements of the composition. The painter,

while conveying a sense of the mass and energy of the subjects, also portrayed amazingly fine details of their clothing, musculature, and facial features with the fine tip of a brush. Euphronios created the impression of real space around the figures by **foreshortening** body forms and limbs—Sarpedon's left leg, for example—so that they appear to be coming toward or receding from the viewer. Euphronios understood anatomy and rendered bodies accurately and sympathetically.

Athens was as famous for its metalwork as it was for ceramics. A **kylix**, or drinking cup, illustrates the work in a foundry (fig. 5-29). The artist, called the Foundry Painter, presents all the workings of a contemporary foundry for casting lifesize and monumental bronze figures. The artist successfully organized this scene within the flaring space that extends upward from the foot of the vessel. The circle that marks the attachment of the foot to the vessel serves as the groundline for all the figures. The walls of the workshop are filled with hanging tools and other foundry paraphernalia: hammers, an ax and saw, molds of a human foot and hand, and several sketches. These sketches include one of a horse, some of human heads, and three of human figures in different poses.

On the section shown in figure 5-29, a worker wearing what looks like a modern-day construction helmet squats to tend the furnace on the left. The man in the center, perhaps the supervisor, leans on a staff, while a third worker assembles the already-cast parts of a leaping figure that is braced against a molded support. The unattached head lies between his feet. The scene continues past the handles, where more workers are shown putting the finishing touches on a larger-than-lifesize striding warrior figure. This painting provides clear evidence that the Greeks were creating large bronze statues in active poses—in marked contrast to the static pose of the Archaic *kouroi*—as early as the first decades of the fifth century BCE. Unfortunately, no examples of these early bronze figures have yet been found.

5-29. Foundry Painter. *A Bronze Foundry*, red-figure decoration on a kylix from Vulci, Italy. 490–480 BCE. Ceramic, diameter of kylix 12" (31 cm). Staatliche Museen zu Berlin, Preussischer Kulturbesitz, Antikensammlung

THE CLASSICAL PERIOD IN GREEK ART

Over the brief span of the next 160 years, the Greeks would establish an ideal of beauty that, remarkably, has endured in the Western world to this day. This period of Greek art, known as the Classical, is framed by two major events: the defeat of the Persians in 479 BCE and the death of Alexander the Great in 323 BCE. Art historians today divide the period into three phases, based on the formal qualities of the art: the Transitional, or Early, period (c. 480–450 BCE); the mature Fifth-Century Classical period (c. 450–400 BCE, formerly called the Golden Age or the High Classical period); and the late Fourth-Century Classical period (c. 400–323 BCE). The speed of change in this short span is among the most extraordinary characteristics of Greek art.

Scholars have characterized Greek Classical art as being based on three general concepts: humanism, rationalism, and idealism. The ancient Greeks believed the maxims they had carved on the Temple of Apollo and followed their injunctions in their art: "Man is the measure of all things," that is, seek an ideal based on the human form; "Know thyself," seek the inner significance of forms; and "Nothing in excess," reproduce only essential forms. In their full embrace of the first concept, humanism, the Greeks even imagined that their gods looked like perfect human beings. Apollo, for example, exemplified the Greek ideal: his body and mind in balance, he was athlete and musician, healer and sun god, leader of the Muses.

Yet in their judgment of humanity, and as reflected in their art, the Greeks valued reason over emotion. Practicing the faith in rationality expressed by their philosophers Sophocles, Plato, and Aristotle, and convinced that logic and reason underlie natural processes, the Greeks saw all aspects of life, including the arts, as having meaning and pattern; nothing happens by accident. Rationalism provided an intellectual structure for the arts, as can be seen in the creation of the orders in architecture and the canon of proportions in sculpture (see page 202). The great Greek artists and architects were not only practitioners but theoreticians as well. In the fifth century BCE, the sculptor Polykleitos and the architect Iktinos both wrote books on the theory underlying their practice.

Unlike artists in Egypt and the ancient Near East, Greek artists did not rely on memory images. And even more than the artists of Crete, they grounded their art in close observation of nature. Only after meticulous study of the particular did they begin to generalize, searching within each form for its universal ideal: rather than portray their models in their actual, individual detail, they sought to distill their essence. In so generalizing, they developed a system of perfect mathematical proportions.

In this way, humanism and rationalism produced the idealism that characterizes Classical Greek art, an idealism that for them encompassed the True, the Good, and the Beautiful. Greek artists of the fifth and fourth centuries BCE established a benchmark for art against which succeeding generations of artists and patrons in the Western world have since measured quality (see "*Classic* and *Classical*," page 179).

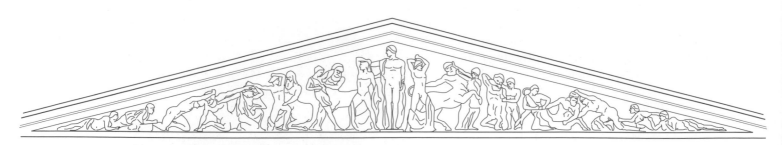

5-30. Reconstruction drawing of the west pediment of the Temple of Zeus, Olympia. C. 470–456 BCE

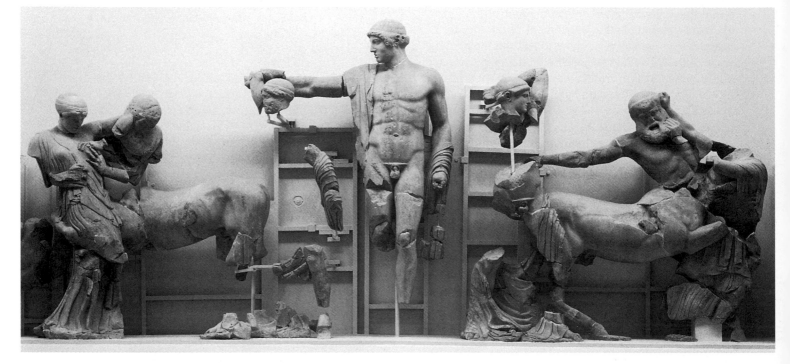

5-31. *Apollo with Battling Lapiths and Centaurs*, fragments of sculpture from the west pediment of the Temple of Zeus, Olympia. c. 460 BCE. Marble, height of Apollo 10'2" (3.1 m). Archaeological Museum, Olympia

THE TRANSITIONAL OR EARLY CLASSICAL PERIOD

In the early decades of the fifth century BCE, the Greek city-states, which for several centuries had developed relatively unimpeded by external powers, faced a formidable threat to their independence from the expanding Persian Empire. Cyrus the Great of Persia had incorporated the Greek cities of Ionia in Asia Minor into his empire in 546 BCE. After several failed invasions, in 480 BCE the Persians penetrated Greece with a large force and destroyed many cities, including Athens. In a series of encounters—at Thermopylae and Plataea on land and in the straits of Salamis at sea—an alliance of Greek city-states led by Athens and Sparta repulsed the invasion. By 479 BCE, the stalwart armies and formidable navies of the Greeks had triumphed over their enemies, and the victors turned to the task of rebuilding their devastated cities.

Some scholars have argued that the Greeks' success against the Persians imbued them with a self-confidence that accelerated the development of Greek art, inspiring artists to seek new and more effective ways to express their cities' accomplishments. In any case, the period that followed the Persian Wars, extending from about 480 to about 450 BCE, saw the emergence of a new art: Artists tried to portray the human figure in painting with greater accuracy and at the same time sought universal forms.

ARCHITECTURAL SCULPTURE

Just a few years after the Persians had been routed, the citizens of Olympia began a new Doric temple to Zeus in the Sanctuary of Hera and Zeus. The temple was

completed between 470 and 456 BCE. Today the massive temple base, fallen columns, and almost all the metope and pediment sculpture remains, monumental even in ruins. Although the temple was of local stone, it was decorated with sculpture of imported marble, and, appropriately for its Olympian setting, the themes demonstrated the power of the gods Zeus, Apollo, and Athena.

The freestanding sculpture that once adorned the west pediment (fig. 5-30) shows Apollo helping the Lapiths, a clan from Thessaly, in their battle with the centaurs. This legendary battle erupted after the centaurs drank too much wine at the wedding feast of the Lapith king and tried to carry off the Lapith women. Apollo stands calmly at the center of the scene, quelling the disturbance by simply raising his arm (fig. 5-31). The rising, falling, triangular composition fills the awkward pediment space. The contrast of angular forms with turning, twisting action poses dramatizes the physical struggle. In contrast, the majestic figure of Apollo celebrates the triumph of reason over passion and civilization over barbarism.

The metope reliefs of the temple illustrated the Twelve Labors imposed by King Eurystheus of Tiryns on Herakles. The hero, with the aid of the gods and his own phenomenal strength, accomplished these seemingly impossible tasks, thereby earning immortality. One of the labors was to steal gold apples from the garden of the Hesperides, the nymphs who guarded the apple trees. To do this, Herakles enlisted the aid of the giant Atlas, whose job was to hold up the heavens. Herakles offered to take on this job himself while Atlas fetched the apples for him. In the episode shown here (fig. 5-32), Herakles is at the center with the heavens on his shoulders. Atlas, on the right, holds out the gold apples to him. As we can see, and Atlas cannot, the human Herakles is backed, literally, by the goddess Athena, who effortlessly supports the sky with one hand. The artist has balanced the erect, frontal view of the heavily clothed Athena with profile views of the two nude male figures. Carved in high relief, the figures reflect a strong interest in realism. Even the rather severe columnlike figure of the goddess suggests the flesh of her body pressing through the graceful fall of heavy drapery.

FREESTANDING SCULPTURE

In the remarkably short time of only a few generations, Greek sculptors had moved far from the rigid, frontal presentation of the human figure embodied in the Archaic *kouroi*. One of the earliest and finest extant freestanding marble figures to exhibit more natural, lifelike

5-32. *Athena, Herakles, and Atlas*, metope relief from the frieze of the Temple of Zeus, Olympia. c. 460 BCE. Marble, height 5'3" (1.59 m). Archaeological Museum, Olympia

The Greeks believed Herakles was the founder of the Olympian Games, held every four years at Olympia beginning in 776 BCE. Supposedly, Herakles drew up the rules for the Games and decided that the stadium should be 600 feet long. The contests had a strong religious aspect, and the victors were rewarded with olive branches from the Sacred Grove of the gods instead of gold, silver, or bronze medals. The Olympian Games came to be so highly regarded that the city-states suspended all political activities while the Games were in progress. The Games ended in 394 CE, when they were banned by the Christian emperor Theodosius. The discovery and excavation of the site of the sanctuary at Olympia in the late nineteenth century stimulated great interest in the Games, inspiring the French baron Pierre de Coubertin to revive them on an international scale. The first modern Olympic Games were held in Athens in 1896.

CLASSIC AND CLASSICAL Our words *classic* and *classical* come from the Latin word *classis*, referring to the division of people into classes based on wealth. Consequently, *classic* has come to mean "first class," "the highest rank," "the finest quality," "the standard of excellence." In a more limited sense, the word *classical* refers to the culture of ancient Greece and Rome; by extension, the word may also mean the "in the style of ancient Greece and Rome," whenever or wherever that style is used. In the most general usage, a "classic" is something—perhaps a literary work, a car, or a film—of lasting quality and universal significance.

 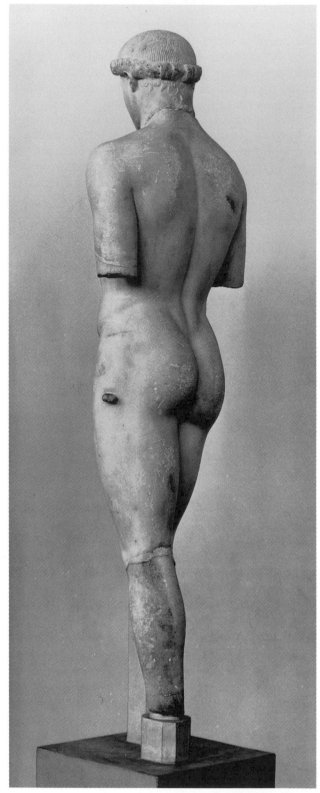

5-33. *Kritian Boy*, from Acropolis, Athens. c. 480 BCE. Marble, height 46" (116 cm). Acropolis Museum, Athens

qualities is the *Kritian Boy* of about 480 BCE (fig. 5-33). The damaged figure, excavated from the debris on the Athenian Acropolis, was thought by its finders to be by the Greek sculptor Kritios, whose work they knew only from Roman copies. A youthful athlete, the boy strikes an easy pose quite unlike the rigid, evenly balanced pose of Archaic

kouroi. The boy's weight rests on his left leg, and his right leg bends slightly at the knee. A noticeable curve in his spine counters the slight shifting of his hips and a subtle drop of one of his shoulders. The slight turn of the head invites the spectator to follow his gaze and move around the figure, admiring the small marble statue from every

angle. The boy's solemn expression lacks any trace of the "Archaic smile." The *Kritian Boy* is truly a transition between the Archaic *kouroi* and the ideal figures to come. Sometimes the art of the Transitional period is called the Severe Style.

A major problem for anyone trying to create a freestanding statue is to assure that it will not fall over. Solving this problem requires a familiarity with the ability of sculptural materials to maintain equilibrium under various conditions. At the end of the Archaic period, a new technique for **hollow-casting** bronze was developed. This technique created a far more flexible medium than solid marble or other stone and became the medium of choice for Greek sculptors. Although it is possible to create freestanding figures with outstretched arms and legs far apart in stone, hollow-cast bronze more easily permits vigorous and even off-balance action poses. After the introduction of the new technique, the figure in action became a popular subject among the ancient Greeks. Sculptors sought to craft poses that seemed to capture a natural feeling of continuing movement rather than an arbitrary moment frozen in time.

Unfortunately, foundries began almost immediately to recycle metal from old statues into new works, so few original Greek bronzes have survived. A spectacular lifesize bronze, the *Charioteer* (fig. 5-34), cast in the 470s BCE, was saved from the metal scavengers only because it was buried during a major earthquake in 373 BCE. Archaeologists found it in its original location in the Sanctuary of Apollo at Delphi, along with fragments of a bronze chariot and horses. According to its inscription, it commemorates a victory by a driver in the Pythian Games of 478 or 474 BCE. Pliny the Elder wrote that three-time winners in Greek competitions had their features memorialized in statues, and faces in the Transitional period often have a sullen look. If the *Kritian Boy* seems solemn, the *Charioteer* seems to pout. His head turns slightly to one side. His rather intimidating expression is enhanced by glittering, colored-glass eyes and fine silver eyelashes. His features suggest an idealized conception of youthful male appearance. The *Charioteer* stands erect; his long robe with its almost columnar fluting, is the epitome of elegance. The folds of the robe fall in a natural way, varying in width and depth, and the whole garment seems capable of swaying and rippling with the charioteer's movement. The feet, with their closely observed toes, toenails, and swelled veins over the instep, are so realistic that they seem to have been cast from molds made from the feet of a living person.

The sea as well as the earth has protected ancient bronzes. In 1972 CE, divers recovered a pair of larger-than-lifesize bronze figures from the seabed off the coast from Riace, Italy. Known as the Riace *Warriors* or *Warriors A* and *B*, they date about 460–450 BCE. Just what mishap sent them to the bottom is not known, but meticulous conservators have restored them to their original condition (see "The Discovery and Conservation of the Riace *Warriors*," page 183). *Warrior A* reveals a striking balance between idealized anatomical forms and naturalistic

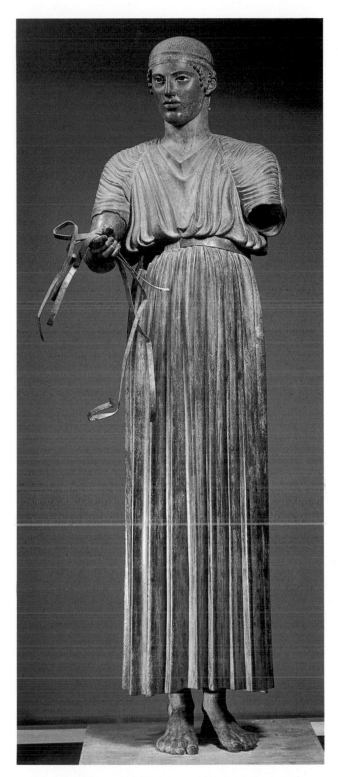

5-34. *Charioteer*, from the Sanctuary of Apollo, Delphi. c. 477 BCE. Bronze, height 5'11" (1.8 m). Archaeological Museum, Delphi

The setting of a work of art affects the impression it makes. Today, this stunning figure is exhibited on a low base in the peaceful surroundings of a museum, isolated from other works and spotlighted for close examination. Its effect would have been very different in its original outdoor location, standing in a horse-drawn chariot atop a tall monument. Viewers in ancient times, tired from the steep climb to the sanctuary and jostled by crowds of fellow pilgrims, could have absorbed only its overall effect, not the fine details of the face, robe, and body visible to today's viewers.

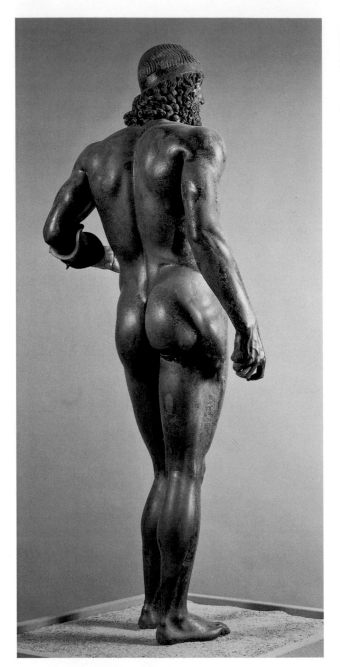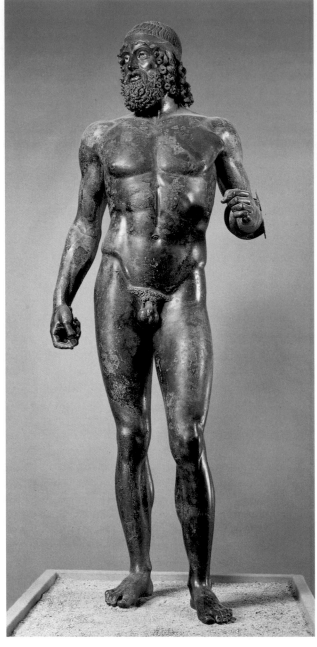

5-35. *Warrior A*, found in the sea off Riace, Italy. c. 460–450 BCE. Bronze with bone and glass eyes, silver teeth, and copper lips and nipples, height 6'8" (2.03 m). Museo Archeològico Nazionale, Reggio Calabria, Italy

details (fig. 5-35). The supple athletic musculature suggests a youthfulness belied by the maturity of the face. Minutely detailed touches—the navel, the swelling veins in the backs of the hands, and the strand-by-strand rendering of the hair—are also in marked contrast to the idealized, youthful smoothness of the rest of the body. The sculptor heightened these lifelike effects by inserting eyeballs of bone and colored glass, applying eyelashes and eyebrows of separately cast, fine strands of bronze, insetting the lips and nipples with pinkish copper, and

plating the teeth that show between the parted lips with silver. The man held a shield (parts are still visible) on his left arm and a spear in his right hand and was probably part of a monument commemorating a military victory, perhaps against the Persians.

At about the same time, the *Discus Thrower* (*Diskobolos*), reproduced at the beginning of this chapter, was created in bronze by the sculptor Myron (see fig. 5-1). It is known today only from Roman copies in marble, but in its original form it must have been as lifelike

THE DISCOVERY AND CONSERVATION OF THE RIACE WARRIORS

In 1972, a scuba diver in the Ionian Sea near the beach resort of Riace, Italy, found what appeared to be a human elbow and upper arm protruding from sand about 25 feet beneath the sea. Taking a closer look, he discovered that the arm was made of metal, not flesh, and was part of a large statue. He soon uncovered a second statue nearby.

Experienced underwater salvagers raised the statues: bronze warriors more than 6 feet tall, complete in every respect, except for swords, shields, and one helmet. But after centuries underwater, the *Warriors* were corroded and covered with accretions, as the illustration shows. The clay cores from the casting process were still inside the bronzes, adding to the deterioration by absorbing lime and sea salts. To restore the *Warriors*, conservators first removed all the exterior corrosion and lime encrustations using surgeon's scalpels, pneumatic drills with 3-millimeter heads, and high technology equipment such as sonar (sound-wave) probes and micro-sanders. Then they painstakingly removed the clay core through existing holes in the heads and feet using hooks, scoops, jets of distilled water, and concentrated solutions of peroxide. Finally, they cleaned the figures thoroughly by soaking them in solvents and sealed them with a fixa-tive specially designed for use on metals (see fig. 5-35).

Since the *Warriors* were put on view in 1980, conservators have taken additional steps to assure their preservation. In 1993, for example, a sonar probe mounted with two miniature video cameras found and blasted loose with sound waves the clay remaining inside the statues, which was then flushed out with water.

How did the *Warriors* end up at sea? They were probably on a ship bound from or to a Greek colony at the tip of Italy in ancient times and—as there was no evidence of a shipwreck in the vicinity of the find—must have accidentally slipped off the deck in rough seas or been deliberately jettisoned.

Back of *Warrior A* from Riace prior to conservation. Museo Archeològico Nazionale, Reggio Calabria, Italy

in its details as *Warrior A* from Riace. Like a sports photographer, Myron caught the athlete at a critical moment, the breathless instant before the concentrated energy of his body will unwind to propel the discus into space. His muscular torso is coiled tightly into a forward arch, and his powerful throwing arm is poised at the top of his backswing. Myron earned the adulation of his contemporaries, and it is interesting that he was as warmly admired for a sculpture that has not survived—a bronze cow—as for the *Discus Thrower*.

VASE PAINTING

Vase painters continued to work with the red-figure technique throughout the fifth century BCE, refining their styles and experimenting with new compositions. Among the outstanding vase painters of the Transitional period was the prolific Pan Painter, who was inspired by the less heroic myths of the gods to create an admirable body of red-figure works. The artist's name comes from a work involving the god Pan on one side of

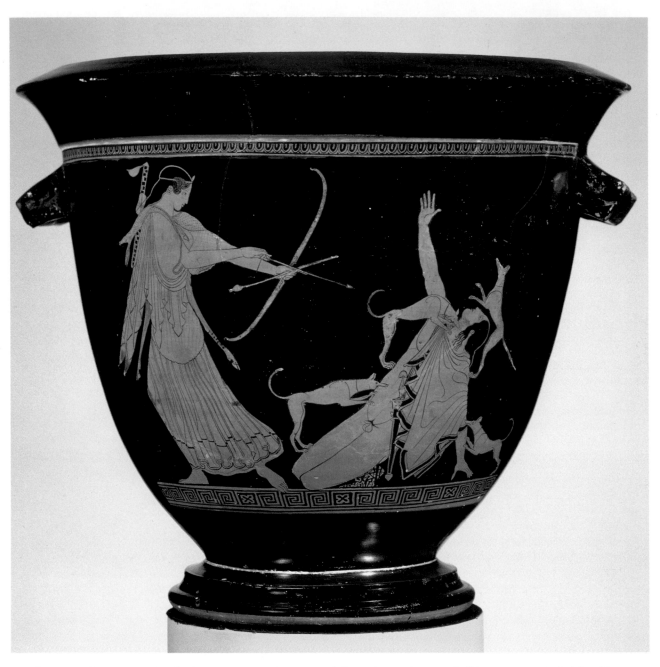

5-36. Pan Painter. *Artemis Slaying Actaeon*. c. 470 BCE. Red-figure decoration on a bell krater. Ceramic, height of krater 14⅝" (37 cm). Museum of Fine Arts, Boston

James Fund and by Special Contribution

a bell-shaped krater that dates to about 470 BCE. The other side of this krater shows *Artemis Slaying Actaeon* (fig. 5-36). Actaeon, while out hunting, happened upon Artemis, the goddess of the hunt, taking a bath. The enraged goddess caused Actaeon's own dogs to mistake him for a stag and attack him. The Pan Painter shows Artemis herself about to finish off the unlucky hunter with an arrow from her bow. The angry goddess and the fallen Actaeon each form roughly triangular shapes that conform to the flaring shape of the vessel. The scene is so dramatically rendered that one does not immediately notice the slender, graceful lines of the figures and the delicately detailed draperies that are the hallmarks of the Pan Painter's style.

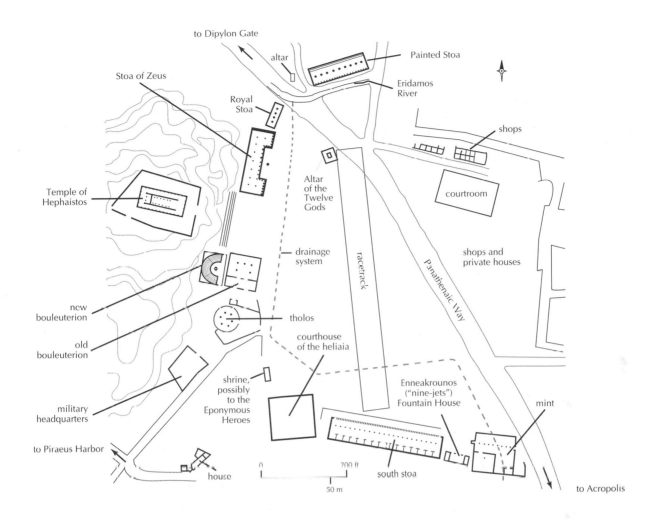

5-37. Plan of the Agora (marketplace), Athens. c. 400 BCE

THE FIFTH-CENTURY CLASSICAL PERIOD

The mature Classical period of Greek art, from about 450 to 400 BCE, corresponds roughly to an extended period of conflict between Sparta and Athens. The two had emerged as the leading city-states in the Greek world in the wake of the Persian Wars. Sparta dominated the Peloponnese and much of the rest of mainland Greece. Athens dominated the Aegean and became the wealthy and influential center of a maritime empire. The series of conflicts known as the Peloponnesian Wars (461–445 BCE and 431–404 BCE) ended with the defeat of Athens.

Except for a few brief interludes, Pericles, a dynamic, charismatic leader, dominated Athenian politics and culture from 462 BCE until his death in 429 BCE. Although comedy writers of the time sometimes mocked him, calling him "Zeus" and "the Olympian" because of his haughty personality, he led Athens to its greatest wealth and influence. He instituted political reforms that greatly increased the scope of Athenian democracy. And he was a great patron of the arts—supporting the use of Athenian wealth for the adornment of the city and encouraging artists to promote a public image of peace, prosperity,

and power. He brought new splendor to the sanctuaries of the gods who protected Athens and rebuilt much of the Acropolis, which had been laid waste by the Persians in 480 BCE. Pericles said of his city and its accomplishments that "future generations will marvel at us, as the present age marvels at us now." It was a prophecy he himself helped fulfill.

Athens originated as a Neolithic **acropolis**, or city on a hill (*akro* means "high" and *polis* means "city"). The flat-topped hill that was the original site of the city later served as a fortress and religious sanctuary. As the city grew, the Acropolis became the religious and ceremonial center devoted primarily to the goddess Athena, the city's patron and protector (see pages 188–189). The lower town, enclosed by a protective **ring wall**, became the residential and business center. In Athens, as in most cities of ancient Greece, commercial, civic, and social life revolved around the marketplace, or **agora**.

THE ATHENIAN AGORA

The Athenian Agora, at the foot of the Acropolis (fig. 5-37), began as an open space where farmers and

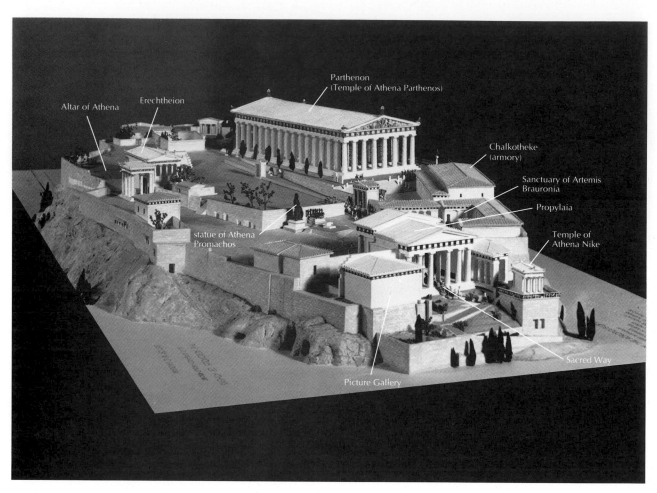

5-38. Model of the Acropolis, Athens, c. 400 BCE. Royal Ontario Museum, Toronto

Labels on image: Altar of Athena · Erechtheion · Parthenon (Temple of Athena Parthenos) · Chalkotheke (armory) · Sanctuary of Artemis Brauronia · Propylaia · Temple of Athena Nike · statue of Athena Promachos · Picture Gallery · Sacred Way

artisans displayed their wares. Over time, public and private structures were erected on both sides of the Panathenaic Way, a ceremonial road used during an important festival in honor of Athena. A stone drainage system was installed to prevent flooding, and a large fountain house (see fig. 5-27) was built to provide water for surrounding homes, administrative buildings, and shops. By 400 BCE, the Agora contained several religious and administrative structures and even a small race-track. The temple to Hephaistos, the god of the forge, so appropriate for an area where craftspeople gathered, was a fine Doric building. The Agora also had the city mint, its military headquarters, and two buildings devoted to court business.

Large stoas offered protection from the sun and rain, providing a place for strolling and talking business, politics, or philosophy. In design the stoa, a distinctively Greek structure found nearly everywhere people gathered, ranged from a simple roof held up by columns to a

substantial, sometimes architecturally impressive, building with two stories and shops along one side.

While city business could be, and often was, conducted in the stoas, agora districts also came to include buildings with specific administrative functions. In the Athenian Agora, the 500-member *boule*, or council, met in a building called the *bouleuterion*. This structure, built before 450 BCE, was laid out on a simple rectangular plan with a vestibule and large meeting room. Near the end of the fifth century BCE, a new *bouleuterion* was constructed to the west of the old one. This too had a rectangular plan. The interior, however, may have had permanent tiered seating arranged in an ascending semicircle around a ground-level **podium**, or raised platform, as in the outdoor theaters of the time. Nearby was a small, round building with six columns supporting a conical roof, a type of structure known as a ***tholos***. Built about 465 BCE, this *tholos* was the meeting place of the fifty-member executive committee of the *boule*. The committee

members dined there at the city's expense, and, rotating the responsibility among themselves, a few of them always spent the night there to be available for any pressing business that might arise.

Private houses surrounded the Agora. Compared with the often grand public buildings, houses of the fifth century BCE in Athens were rarely more than simple rectangular structures of **stucco**-faced mud brick with wooden posts and lintels supporting roofs of terra-cotta tiles. Rooms were small and included a dayroom in which women could sew, weave, and do other chores, a dining room with couches for reclining around a table, a kitchen, bedrooms, and occasionally an indoor bathroom. Where space was not at a premium, houses sometimes opened onto small courtyards or porches.

THE ACROPOLIS

After Persian troops destroyed the Acropolis in 480 BCE, the Athenians vowed to keep it in ruins as a memorial. Later Pericles convinced them to rebuild it to a new magnificence. He argued that this project honored the gods, especially Athena, who had helped the Greeks defeat the Persians. But Pericles also hoped to create a visual expression of Athenian values and civic pride that would glorify his city and bolster its status as the capital of the empire he was instrumental in building. He placed his close friend Pheidias, a renowned sculptor, in charge of the rebuilding and assembled under him the most talented artists and artisans in Athens and its surrounding countryside.

The cost and labor involved in this undertaking were staggering. Quantities of gold, ivory, and exotic woods had to be imported. Some 22,000 tons of marble had to be transported 10 miles from mountain quarries to city workshops. Pericles was severely criticized by his political opponents for this extravagance, but it never cost him popular support. In fact, many working-class Athenians—laborers, carpenters, masons, sculptors, and the carters and merchants who kept them supplied and fed—benefited from his expenditures.

Work on the Acropolis continued after Pericles' death and was completed by the end of the fifth century BCE (fig. 5-38). Visitors to the Acropolis in 400 BCE would have climbed a steep ramp on the west side of the hill to the sanctuary entrance, perhaps pausing to admire the small, marble temple dedicated to Athena Nike (Athena as the goddess of victory in war), poised on a projection of rock above the ramp. After passing through an impressive porticoed gatehouse called the Propylaia, they would have seen a huge bronze figure of Athena Promachos (the Defender). This statue, designed and executed by Pheidias between about 465 and 455 BCE, showed the goddess bearing a spear. Sailors entering Athens's port of Piraeus, about 10 miles away, could see the sun reflected off the helmet and spear tip. Behind this statue was a walled precinct that enclosed the Erechtheion, a temple dedicated to several deities.

Religious buildings and votive statues filled the hilltop. A large stoa with projecting wings was dedicated to Artemis Brauronia (the protector of wild animals).

Beyond this stoa on the right stood the largest building on the Acropolis, looming above the precinct wall that enclosed it. This was the Parthenon, a temple dedicated to Athena Parthenos (the Virgin Athena). Visitors approached the temple from its northwest corner. The cella of the Parthenon faced east, so visitors walked along the north side of the temple past an outdoor altar to Athena to reach the temple's entrance. With permission from the priests, they would have climbed the east steps of the Parthenon to look into the cella and see a colossal gold and ivory statue of Athena, created by Pheidias and installed in the temple in 432 BCE.

The Parthenon. Sometime around 490 BCE, Athenians began work on a temple to Athena Parthenos that was still unfinished when the Persians sacked the Acropolis a decade later. Kimon of Athens then hired the architect Kallikrates to begin rebuilding on the old site. Work was halted briefly then resumed in 447 BCE by Pericles, who commissioned the architect Iktinos to design a larger temple using the existing foundation and stone elements. No expense was spared on this elegant new home for Athena. The finest white marble was used throughout, even on the roof, in place of the more usual terra-cotta tiles.

The planning and execution of the Parthenon required extraordinary mathematical and mechanical skills and would have been impossible without a large contingent of distinguished architects and builders, as well as talented sculptors and painters. The result is thus as much a testament to the administrative skills as to the artistic vision of Pheidias, who supervised the entire project. The building was completed in 438 BCE, and its sculptural decoration, designed by Pheidias and executed by himself and other sculptors in his workshop, was completed in 432 BCE, when the pedimental sculpture was placed (figs. 5-39, 5-40, 5-41, "The Object Speaks").

The extensive decoration of the Parthenon strongly reflects Pheidias's unifying vision despite being the product of many individuals. A coherent, stylistic whole, the sculptural decoration conveys a number of political and ideological themes: the triumph of the democratic Greek city-states over Persia's imperial forces, the preeminence of Athens thanks to the favor of Athena, and the triumph of an enlightened Greek civilization over despotism and barbarism.

Like the pediments of most temples, including the Temple of Aphaia at Aegina (see fig. 5-15), those of the Parthenon were filled with sculpture in the round, set on the deep shelves of the cornice and secured to the wall with metal pins. Unfortunately, much of the Parthenon's pedimental sculpture has been damaged or lost over the centuries. Using the locations of the pinholes, scholars nevertheless have been able to determine the placement of surviving statues and infer the poses of missing ones. The west pediment sculpture, facing the entrance to the Acropolis, illustrated the contest that Athena won over the sea god Poseidon for rule over the Athenians. The east pediment figures, above the entrance to the cella, illustrated the birth of Athena, fully grown and clad in armor, from the brow of her father, Zeus.

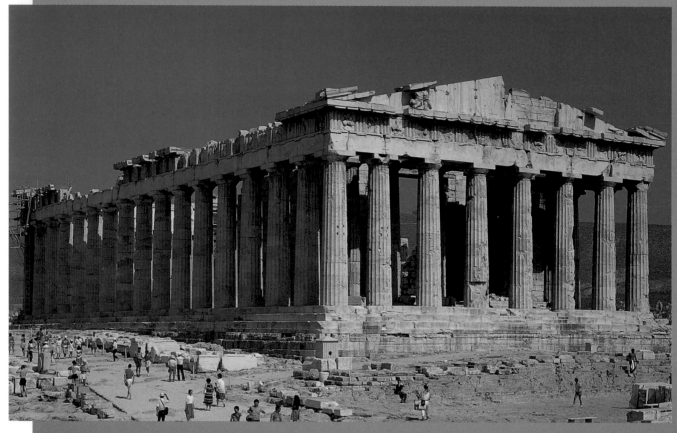

5-39. **Kallikrates and Iktinos. Parthenon, Acropolis,** Athens. 447–438 BCE. View from the northwest

What creates the Parthenon's sense of harmony and balance? One key is an aesthetics of number, which determines its perfect proportions—especially the ratio of 4:9 in breath to length and in the relationship of column diameter to space between columns. Just as important to the overall effect are subtle refinements of design, including the slightly arched base and entablature, the very subtle swelling of the soaring columns, and the narrowing of the space between the corner columns and the others in the colonnade. This aesthetic control of space is the essence of architecture, as opposed to mere building. The significance of their achievement was clear to its builders—Iktinos even wrote a book on the proportions of his masterpiece.

The Parthenon, a symbol of Athenian aspirations and creativity, rises triumphantly above the Acropolis (fig. 5-39). The sculptor Pheidias, the architects Iktinos and Kallikrates, teams of skillful stonecutters, and the political leader Pericles joined to create a building whose perfection has been recognized through the ages. This temple of the Goddess of Wisdom spoke eloquently to fifth-century BCE Greeks of independence, self-confidence, and justifiable pride—through the excellence of its materials and craftwork, the rationality of its simple and elegant post-and-lintel structure, and the subtle yet ennobling messages of its sculpture. Today, we continue to be captivated by the gleaming marble ruin of the Parthenon, the building that has shaped our ideas about Greek civilization, about the importance of architecture as a human endeavor, and also about the very notion of the possibility of perfectibility. Its form, even when regarded abstractly, is an icon for democratic values and independent thought.

When the Parthenon was built, Athens was the capital of a powerful, independent city-state. For Pericles, Athens was the model of all Greek cities; the Parthenon was the perfected, ideal Doric temple. Isolated like a work of sculpture, with the rock of the Acropolis as its base, the Parthenon is both an abstract form—a block of columns—and at the same time the essence of shelter: an earthly home for Athena, the patron goddess, who is represented in the temple by her cult statue. During the splendid Panathenaic procession held every four years, young women would climb the Acropolis, bringing with them a new *peplos* to present to Athena. In the Parthenon, Pheidias's ivory Athena was dressed in sheets of gold. It shone inside the Parthenon like an epiphany, while the procession wound around the building, both in reality and in a timeless marble frieze (see figs. 5-44–46).

5-40. **William Pars. The Parthenon when it contained a mosque.** Drawn in 1765 and published in James Stuart and Nicholas Reve, *The Antiquities of Athens* (London, 1789)

5-41. **William Strickland. The Second Bank of the United States, Philadelphia**. 1818–24. Watercolor by A. J. Davis. Avery Architecture and Fine Arts Library, Columbia University, New York

For the ancient Greeks the Parthenon symbolized Athens, its power and wealth, its glorious victory over foreign invaders, and its position of leadership at home. Over the centuries, very different people reacting to very different circumstances found that the temple could likewise express their ideals. They imbued it with meaning and messages that might have shocked the original builders. Over its long life, the Parthenon has been a Christian church dedicated to the Virgin Mary, an Islamic mosque (fig. 5-40), a Turkish munitions storage facility, an archaeological site, and a major tourist attraction. To many people through the ages, it remained silent, but in the eighteenth century CE, in the period known as the Enlightenment, the Parthenon found its voice again. British architects James Stuart and Nicholas Revett made the first careful drawings of the building in the mid-eighteenth century, which they published as *The Antiquities of Athens*, in 1789. People reacted to the Parthenon's harmonious proportions, subtle details, and rational relationship of part to part, even in drawings. The building came to exemplify, in architectural terms, human and humane values. In the nineteenth century, the Parthenon became a symbol of honesty, heroism, and civic virtue, of the highest ideals in art and politics, a model for national monuments, government buildings, and even homes.

Architectural messages, like any communications, may be subject to surprising interpretations. One of the most remarkable reincarnations of the Parthenon can still be seen in southern Germany. In 1821, Prince Ludwig of Bavaria, wishing to build a monument to German unity and heroism (and the defeat of Napoleon), commissioned Leo von Klenze to build a replica of the Parthenon on a bluff overlooking the Danube River near Regensburg. At the same time, the Scots began their Parthenon in Edinburgh, the "Athens

of the North," but ran out of funds in 1829, leaving only isolated Doric columns supporting the entablature.

Nineteenth-century Americans dignified their democratic, mercantile culture by adapting the Parthenon's form to government, business, and even domestic buildings. Not only was the simplicity of the Doric order considered appropriate but it also was the cheapest order to build. The first quotation of the Parthenon in the United States was William Strickland's Second Bank of the United States in Philadelphia (1818–24), whose porch is an exact copy of the Parthenon—but three-fifths the actual size (fig. 5-41). In the 1830s and 1840s, the Greek Revival style spread across the United States. In Washington, D.C., Robert Mills used the Parthenon's Doric colonnade for the porches of the U.S. Patent Office in 1835–40. At Berry Hill (1842–44), near Halifax, Virginia, a beautiful plantation was given a Doric, Parthenon-like veranda.

The Parthenon continued to speak into the twentieth century. Its columns and pediment became a universal image, like the Great Pyramids of Egypt, that was used and reused in popular culture. In Nashville, Tennessee, for example, the Parthenon became a temple of tourism, first as a state fair building, then as rebuilt in concrete in 1941. The Parthenon even has an intriguing half-life in postmodern buildings and decorative arts.

When the notable architect Le Corbusier sought to create an architecture for the twentieth century, he turned for inspiration to the still-vibrant temple of the goddess of wisdom's clean lines, simple forms, and mathematical ratios. Le Corbusier called the Parthenon "ruthless, flawless," and wrote, "There is nothing to equal it in the architecture of the entire world and all the ages . . ." (Le Corbusier, *Vers une architecture*, 1923).

The Parthenon still speaks to those in the twenty-first century who listen.

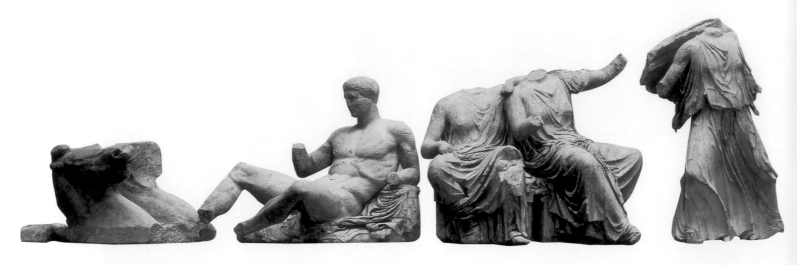

5-42. Photographic mock-up of the east pediment of the Parthenon (using photographs of the extant marble sculpture c. 438–432 BCE). The gap in the center represents the space that would have been occupied by the missing sculpture.

At the beginning of the nineteenth century, Thomas Bruce, the British earl of Elgin and ambassador to Constantinople, acquired much of the surviving sculpture from the Parthenon, which was being used for military purposes. He shipped it back to London in 1801 to decorate a lavish mansion for himself and his wife. By the time he returned to England a few years later, his wife had left him and the ancient treasures were at the center of a financial dispute. Finally, he sold the sculpture for a very low price. Referred to as the *Elgin Marbles*, most of the sculpture is now in the British Museum, including all the elements seen here except the torso of *Selene*, which is in the Acropolis Museum, Athens. The Greek government has tried unsuccessfully in recent times to have the *Elgin Marbles* returned.

The statues from the east pediment are the best preserved of the two groups (fig. 5-42). Flanking the missing central figures—probably Zeus seated on a throne with the just-born adult Athena standing at his side—were groups of three goddesses followed by single reclining male figures. In the left corner was the sun god Apollo in his chariot and in the right corner was the moon goddess Selene in hers. The reclining male nude on the left has been identified as both Herakles and Dionysos. His easy pose conforms to the slope of the pediment without a hint of awkwardness. The standing female figure just to the left of center is Iris, messenger of the gods, already spreading the news of Athena's birth. The three female figures on the right side, two sitting upright and one reclining, were once thought to be the Three Fates, whom the Greeks believed appeared at the birth of a child and determined its destiny. Most art historians now think that they are goddesses, perhaps Hestia (a sister of Zeus and the goddess of the hearth), Aphrodite, and her mother, Dione (one of Zeus's many consorts). These monumental interlocked figures seem to be awakening from a deep sleep, slowly rousing from languor to mental alertness. The sculptor, whether Pheidias or someone working in the Pheidian style, expertly rendered the female form beneath the fall of draperies. The clinging fabric both covers and reveals, creating circular patterns rippling with a life of their own over torsos, breasts, and knees and uniting the three figures into a single mass.

The Athenians intended their temple to surpass the Temple of Zeus at Olympia (see fig. 5-30), and they succeeded. The Parthenon was large in every dimension,

built entirely of fine marble. It held a spectacular gold and ivory cult statue of Athena about 40 feet high and had two sculptured friezes encircling it, one above the outer peristyle and another atop the cella wall inside (see fig. 5-44). The Doric frieze on the exterior was decorated with ninety-two metope reliefs, fourteen on each end and thirty-two along each side. These reliefs depicted legendary battles, symbolized by combat between two representative figures of each: a Lapith against a centaur; a god against a Giant; a Greek against a Trojan; a Greek against an Amazon, a member of the mythical tribe of female warriors sometimes said to be the daughters of the war god Ares.

Among the best-preserved metope reliefs are those from the south side, including several depicting the battle between the Lapiths and the centaurs. The panel shown here (fig. 5-43)—with its choice of a perfect moment of pause within a fluid action, its reduction of forms to their most characteristic essentials, and its choice of a single, timeless image to stand for an entire historical episode—captures the essence of Fifth-Century Classical art. So dramatic is the **X**-shaped composition that we easily accept its visual contradictions. Like the *Discus Thrower* (see fig. 5-1), the Lapith is caught at an instant of total equilibrium. What should be a grueling tug-of-war between a man and a man-beast appears instead as an athletic ballet choreographed to show off the Lapith warrior's muscles and graceful movements against the implausible backdrop of his carefully draped cloak. Like Greek sculptors of earlier periods, those of the Fifth-Century Classical style were masters of representing hard muscles but soft flesh. As noted earlier (see

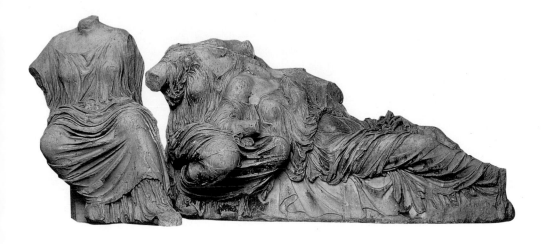

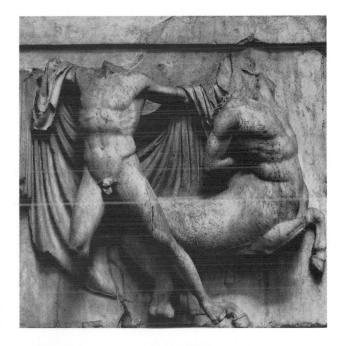

5-43. *Lapith Fighting a Centaur*, metope relief from the Doric frieze on the south side of the Parthenon. c. 440s BCE. Marble, height 56" (1.42 m). The British Museum, London

fig. 5-31), the legend of the Lapiths and centaurs may have symbolized the triumph of reason over animal passion.

Enclosed within the Parthenon's Doric order peristyle, the body of the temple consists of a cella, opening to the east, and an unconnected auxiliary space opening to the west. Short colonnades in front of each entrance support an entablature with an Ionic order frieze in relief that extends along both sides of the temple, for a total frieze length of 525 feet (fig. 5-44). The subject of this frieze is a procession celebrating the festival that took place in Athens every four years, when the women of the city wove a new wool *peplos* and carried it to the Acropolis to clothe an ancient wooden cult statue of Athena. The frieze culminated with the presentation of the new robe to Athena. A new interpretation suggested that the girl holding the *peplos* is to become a human sacrifice, a tribute to the role Athenian women played in saving the city. Current opinion favors the traditional interpretation, for the east facade presents a totally integrated program of images—the birth of the goddess in the pediment, her honoring by the citizens who present her with the newly woven *peplos*, and—seen through the doors—the glorious ivory and gold figure of Athena herself, the cult image. The Panathenaic procession began just outside the city walls in a cemetery, where people assembled among the grave monuments of their ancestors (see fig. 5-52). They then marched into the city through the Dipylon Gate, across the busy Agora along the Panathenaic Way, and up the ramp to the Acropolis. From the Propylaia, they moved onto the Sacred Way and completed their journey at Athena's altar.

In Pheidias's portrayal of this major ceremony, the figures—skilled riders managing powerful steeds, for

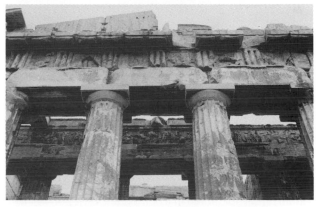

5-44. View of the outer Doric and inner Ionic friezes at the west end of the Parthenon. c. 440s–430s BCE

In the Doric metopes, Greeks, led by Theseus, battle Amazons. In the Ionic frieze at the top of the cella wall, horsemen are being organized by marshals.

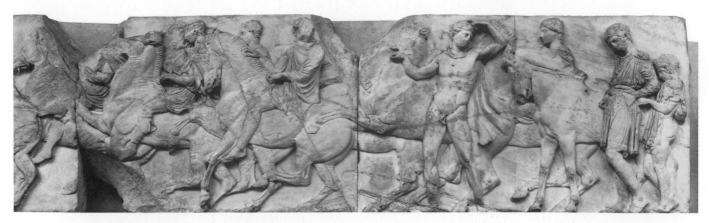

5-45. ***Horsemen***, detail of the Procession, from the Ionic frieze on the north side of the Parthenon. c. 438–432 BCE. Marble, height 41¾" (106 cm). The British Museum, London

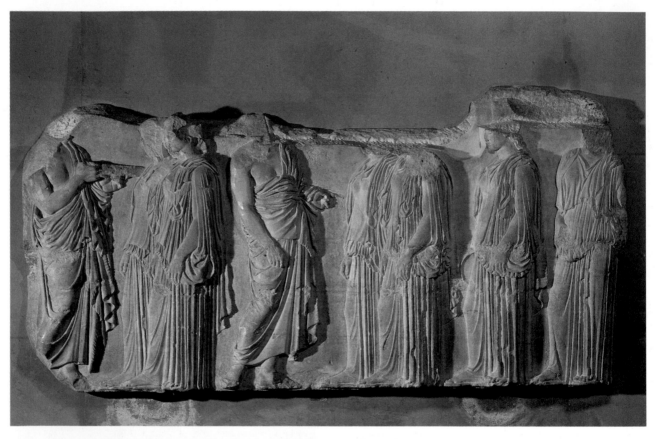

5-46. ***Marshals and Young Women***, detail of the Procession, from the Ionic frieze on the east side of the Parthenon. c. 438–432 BCE. Marble, height 43" (109 cm). Musée du Louvre, Paris

example (fig. 5-45), or graceful but physically sturdy young walkers (fig. 5-46)—seem to be representative types, ideal inhabitants of a successful city-state. The underlying message of the frieze as a whole is that the Athenians are a healthy, vigorous people, enjoying individual rights but united in a democratic civic body looked upon with favor by the gods. The people were inseparable from and symbolic of the city itself.

As with the metope relief of the *Lapith Fighting a Centaur* (see fig. 5-43), viewers of the processional frieze easily accept its disproportions, spatial incongruities, and such implausible compositional features as all the

animal and human figures standing on the same groundline, and upright men and women being as tall as rearing horses. Carefully planned rhythmic variations— changes in the speed of the participants in the procession as it winds around the walls—contribute to the effectiveness of the frieze: horses plunge ahead at full gallop; women proceed with a slow, stately step; parade marshals pause to look back at the progress of those behind them; and human-looking deities rest on conveniently placed benches as they await the arrival of the marchers. In executing the frieze, the sculptors took into account the spectators' low viewpoint and the

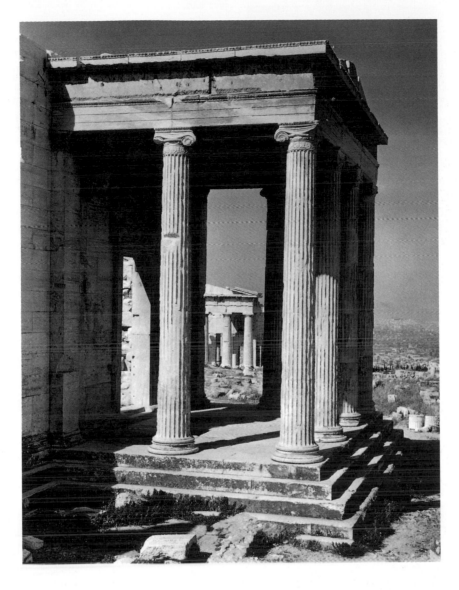

5-47. Mnesikles. Erechtheion, Acropolis, Athens. 430s–405 BCE. View of north porch

dim lighting inside the peristyle. They carved the top of the frieze band in higher relief than the lower part, thus tilting the figures out to catch the reflected light from the pavement and permit a clearer reading of the action. The subtleties in the sculpture may not have been as evident to Athenians in the fifth century BCE as they are now, because the frieze, seen at the top of a high wall and between columns, originally was completely painted. The background was dark blue and the figures were in contrasting red and ocher, accented with glittering gold and real metal details such as bronze bridles and bits on the horses.

The Erechtheion. Upon completion of the Parthenon, Pericles commissioned an architect named Mnesikles to design a monumental gatehouse, the Propylaia. Work began on it in 437 and stopped in 432 BCE, with the structure still incomplete. The Propylaia had no sculptural decoration, but its north wing was the earliest known *museum* (meaning "home of the Muses"), a gallery built specifically to house a collection of paintings for public view.

Mnesikles also designed the Erechtheion, the second-largest structure erected on the Acropolis under Pericles' building program (fig. 5-47). Work began on it in the 430s and ended in 405 BCE, just before the fall of Athens to Sparta. Its asymmetrical plan and several levels reflect its multiple functions in housing many different shrines, and also conform to the sharply sloping terrain on which it was located. The mythical contest between the sea god Poseidon and Athena for patronage over Athens was said to have occurred within the Erechtheion precinct. During this contest, Poseidon struck a rock with his trident (three-pronged harpoon), bringing forth a spout of water. Athena gave the olive tree and won. The Athenians enclosed what they believed to be this sacred rock, bearing the marks of the trident, in the Erechtheion's north porch. Another area housed a sacred spring dedicated to Erechtheus, a legendary king of Athens, during whose reign the goddess Demeter was said to have instructed the Athenians in the agricultural arts. The Erechtheion also contained a memorial to the legendary founder of Athens, Kekrops, half man and half serpent, who acted as judge in the contest between Athena and Poseidon. And it housed the wooden cult statue of Athena that was the center of the Panathenaic festival.

The Erechtheion had porches on the north, east, and south sides. Architects agree that the north porch has the most perfect interpretation of the Ionic order, and they have copied the columns and capitals, the carved moldings, and the proportions and details of the door ever since the eighteenth-century discovery of Greek art. The Porch of the

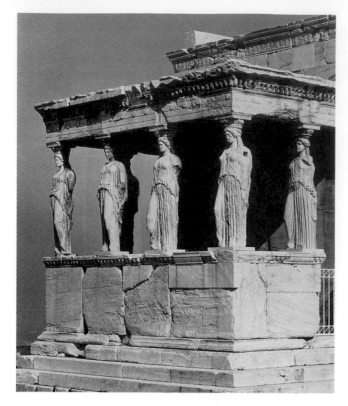

the knee, rests on the ball of the foot. The three caryatids on the left have their right legs engaged, and the three on the right have their left legs engaged, creating a sense of closure, symmetry, and rhythm. The vertical fall of the drapery on the engaged side resembles the fluting of a column shaft and provides a sense of stability, whereas the bent leg gives an impression of relaxed grace and effortless support. The hair of each caryatid falls in a loose but massive knot around its neck, a device that strengthens the weakest point in the sculpture while appearing entirely natural.

The Temple of Athena Nike. The Temple of Athena Nike (Athena as the goddess of victory in war), located on a bastion south of the Propylaia, was designed and built about 425 BCE, probably by Kallikrates (fig. 5-49). It is an Ionic order temple built on an **amphiprostyle** plan, that is, with a porch at each end (see "Greek Temple Plans," page 163). The porch facing out over the city is **blind**, with no entrance to the cella. Reduced to rubble during the Turkish occupation of Greece in the seventeenth century CE, the temple has since been rebuilt. Its diminutive size, about 27 by 19 feet, and refined Ionic decoration are in marked contrast to the massive Doric Propylaia adjacent to it. Between 410 and 407 BCE, the temple was surrounded by a **parapet**, or low wall, faced with sculptured panels depicting Athena presiding over her winged attendants, called Victories, as they prepared for a celebration. The parapet no longer exists, but some of the panels from it have survived. One of the most admired is of *Nike (Victory) Adjusting Her Sandal* (fig. 5-50).

Maidens (fig. 5-48), on the south side facing the Parthenon, is even more famous. Raised on a high base, its six stately caryatids with simple Doric capitals support an Ionic entablature made up of bands of carved molding. In a pose characteristic of Classical figures, each caryatid's weight is supported on one engaged leg, while the free leg, bent at

5-48. (above) **Porch of the Maidens (Caryatid Porch), Erechtheion,** Acropolis, Athens. 421–405 BCE

5-49. Kallikrates. Temple of Athena Nike, Acropolis, Athens. C. 425 BCE

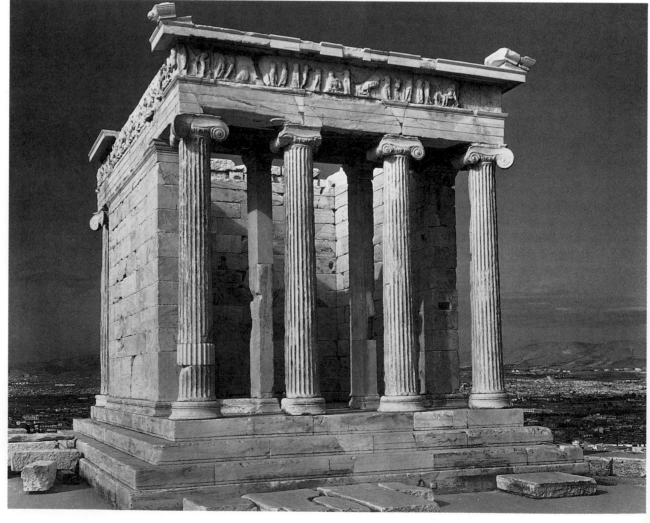

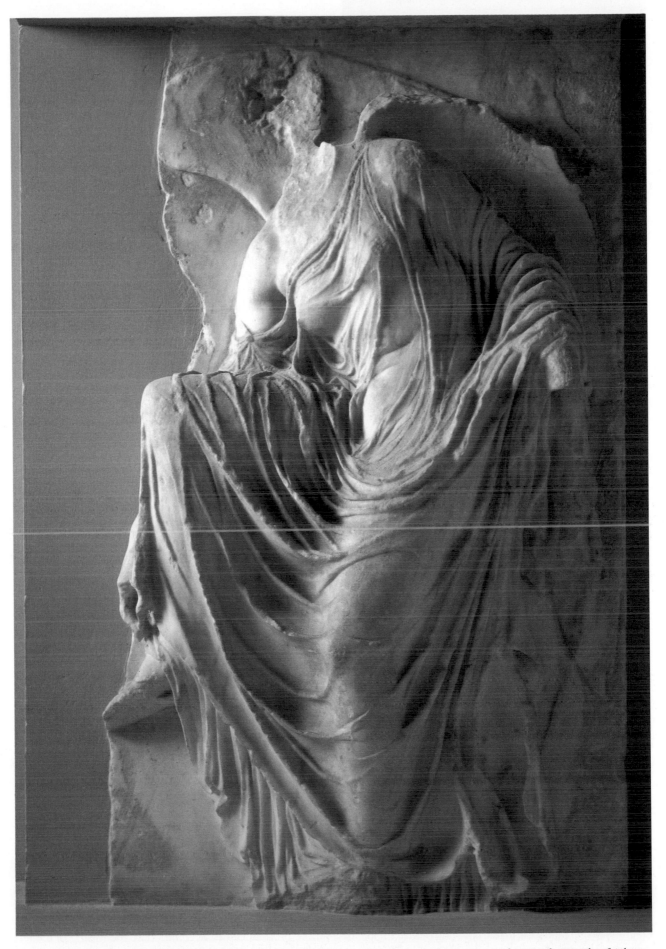

5-50. Nike (Victory) Adjusting Her Sandal, fragment of relief decoration from the parapet (now destroyed), Temple of Athena Nike, Acropolis, Athens. Last quarter of the 5th century BCE. Marble, height 42" (107 cm). Acropolis Museum, Athens

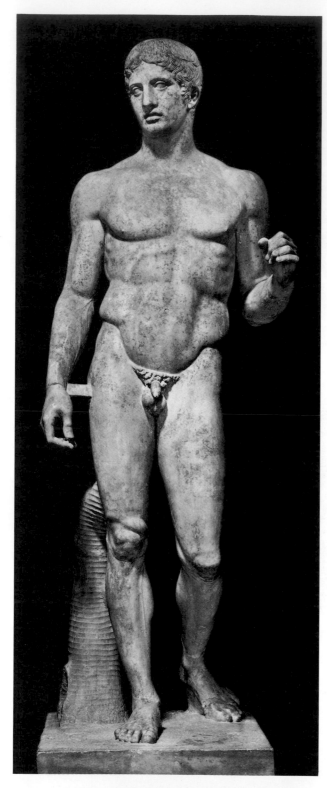

5-51. **Polykleitos.** *Spear Bearer (Doryphoros)*, Roman copy after the original bronze of c. 450–440 BCE. Marble, height 6'6" (2 m); tree trunk and brace strut are Roman additions. Museo Archeològico Nazionale, Naples

The figure bends forward gracefully, causing her ample *chiton* to slip off one shoulder. Her large wings, one open and one closed, effectively balance this unstable pose. Unlike the decorative swirls of heavy fabric covering the Parthenon goddesses or the weighty pleats of the robes of the Erechtheion caryatids, the textile covering this *Nike* appears delicate and light, clinging to her body like wet silk, one of the most discreetly erotic images in ancient art.

SCULPTURE AND THE CANON OF POLYKLEITOS

Just as Greek architects defined and followed a set of standards for ideal temple design, Greek sculptors sought an ideal of human beauty. Studying human appearances closely, the sculptors of the Fifth-Century Classical period selected those attributes they considered the most desirable, such as regular facial features, smooth skin, and particular body proportions, and combined them into a single ideal of physical perfection. The quest for the ideal, as we have noted, was seen also in fifth-century BCE rationalists' philosophy that all objects in the physical world were reflections of ideal forms that could be discovered through reason.

The best-known art theorist of the Classical period was the sculptor Polykleitos of Argos. About 450 BCE he developed a set of rules for constructing the ideal human figure, which he set down in a treatise called *The Canon* (*kanon* is Greek for "measure," "rule," or "law"). To illustrate his theory, Polykleitos created a larger-than-lifesize bronze statue, the *Spear Bearer* (*Doryphoros*). Neither the treatise nor the original statue has survived, but both were widely discussed in the writings of his contemporaries, and later Roman artists made copies in stone and marble of the *Spear Bearer* (fig. 5-51). By studying the most exact of these copies, or **replicas**, scholars have tried to determine the set of measurements that defined the ideal proportions in Polykleitos's canon. The canon included a system of ratios between a basic unit and the length of various body parts. Some studies suggest that his basic unit may have been the length of the figure's index finger or the width of its hand across the knuckles; others suggest that it was the height of the head from chin to hairline. The canon also included guidelines for *symmetria* ("commensurability"), by which Polykleitos meant the relationship of body parts to one another. In the statue he made to illustrate his book, he explored not only proportions but also the relationship of weight-bearing and relaxed legs and arms in a perfectly balanced figure. The cross-balancing of supporting and free elements in a figure is sometimes referred to as **contrapposto**. In true Classical fashion, Polykleitos also balanced careful observation and generalization to create an ideal figure.

The marble replica of the *Spear Bearer* illustrated here shows a male athlete, perfectly balanced with the whole weight of the upper body supported over the straight (engaged) right leg. The left leg is bent at the knee, with the left foot poised on the ball of the foot, suggesting preceding and succeeding movement. The pattern of tension and relaxation is reversed in the arrangement of the arms, with the right relaxed on the engaged side and the left bent to support the weight of the (missing) spear. This dynamically balanced body pose—characteristic of Fifth-Century Classical standing figure sculpture—differs somewhat from that of the *Kritian Boy* (see fig. 5-33) of a generation earlier. The tilt of the hipline in the *Spear Bearer* is a little more pronounced to accommodate the raising of the left foot onto its ball, and the head is turned toward the same side as the engaged leg.

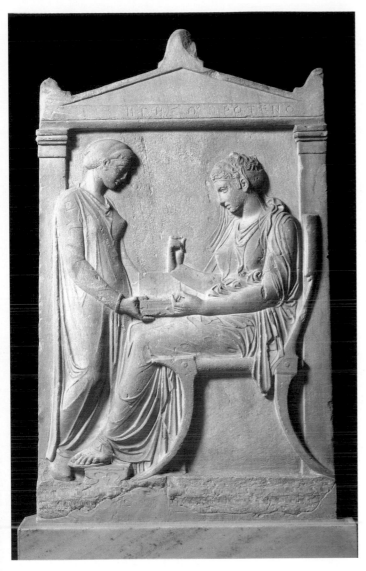

5-52. _Grave Stele of Hegeso_. c. 410–400 BCE. Marble, height 5'9" (1.5 m). National Archaeological Museum, Athens

stelai since the end of the sixth century BCE, when such personal monuments were banned. But during the third quarter of the fifth century they began to erect stelai in cemeteries again. Instead of images of warriors or athletes, however, the Classical stelai represent departures or domestic scenes that very often feature women. Although respectable women played no role in politics or civic life, the presence of many fine tombstones of women suggests that they held a respected position in the family.

The _Grave Stele of Hegeso_ depicts a beautifully dressed woman seated in an elegant chair, her feet on a footstool (fig. 5-52). She selects jewels (a necklace indicated in paint) from a box presented by her maid. The composition is entirely inward turning, not only in the gaze and gestures focused on the jewels but also in the way the vertical fall of the maid's drapery and the curve of Hegeso's chair seem to enclose and frame the figures. Although their faces and bodies are as idealized as the Parthenon maidens', the two women take on some individuality through accessory details of costume and hairstyle. The simplicity of the maid's tunic and hair contrasts with the luxurious dress and partially veiled, flowing hair of Hegeso. The sculptor has carved both women as part of the living spectators' space in front of a simple temple-fronted gravestone. The artist does not invade the private world of women, and Hegeso's stele and many others like it could be set up in the public cemetery with no loss of privacy or dignity to its subjects.

The imagery and mood of the stele were also found in painted ceramics, especially on the **lekythoi** (slim vessels; singular lekythos) used in graveside ceremonies, as markers and offerings. However, Athenians again banned private funeral monuments at the end of the fourth century (317 BCE).

PAINTING

Painted ceramics continued to be a major art form throughout the Classical period. A new style of **white-ground** decoration grew in popularity in the 460s BCE. White backgrounds had been applied on black-figure vases as early as the seventh century BCE, but the white-ground techniques of the fifth century BCE were far more complex than those earlier efforts (see "Greek Painted Vases," page 173). Characterized by dominantly white backgrounds and outlined or drawn imagery, white-ground painted pottery was a specialty of Athens' potters. Artists used both black-figure and red-figure techniques, and soon they began to enhance the fired vessel with a full range of colors using **tempera** paint, an opaque, water-based medium mixed with glue or egg white. This fragile decoration deteriorated easily and for that reason seems to have been favored for funerary, votive, and similarly non-utilitarian vessels.

The tall, slender, one-handled white-ground lekythos was used to pour liquids during religious rituals, and funerary lekythoi have been found both in and on tombs. Some convey grief and loss with a scene of a departing figure bidding farewell, while others depict a grave stele draped with garlands. Still others show scenes of the

A comparison of the _Spear Bearer_ to the _Warrior A_ from Riace (see fig. 5-35) is also informative. The treatment of the torso and groin is quite similar in both, and their poses are nearly identical, except for the slightly different positions of the unengaged left legs and the fact that the heel of the _Spear Bearer_ is raised. _Warrior A_ seems to stand still in alert relaxation. The _Spear Bearer_ appears to have paused before stepping forward.

To Polykleitos and others in the fifth century BCE, the Beautiful was synonymous with the Good. He sought a mathematical definition of the Beautiful as it applied to the human figure, aspiring to make it possible to replicate human perfection in the tangible form of sculpture.

STELE SCULPTURE

Another kind of freestanding monument was used in the Archaic and the Fifth-Century Classical periods in Greece—the upright stone slab, or **stele** (plural stelai), carved in low relief with the image of the person to be remembered. Athenians had not used private memorial

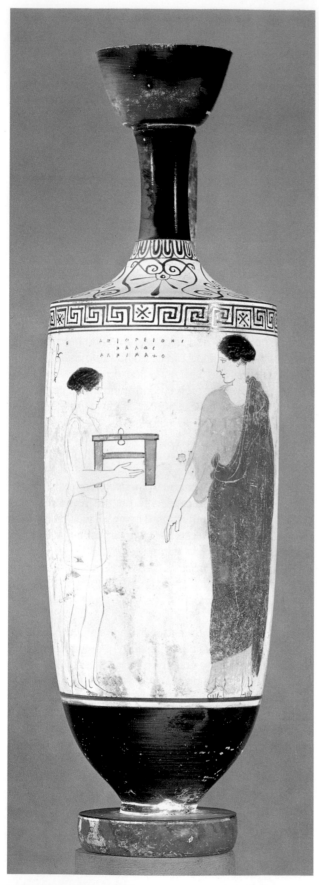

5-53. Style of Achilles Painter. *Woman and Maid*.
c. 450–440 BCE. White-ground and black-figure
decoration on a lekythos. Ceramic, with additional
painting in tempera, height of lekythos 15⅛"
(38.4 cm). Museum of Fine Arts, Boston
Francis Bartlett Fund

dead person once again in the prime of life and engaged in a seemingly everyday activity, but scrutiny reveals that the images are imbued with signs of separation and loss.

A white-ground lekythos, dated about 450–440 BCE and in the style of the Achilles Painter (an anonymous artist known from his painting of Achilles), shows a young servant girl carrying a stool for a small chest of valuables to a well-dressed woman of regal bearing, the dead person whom the vessel memorializes (fig. 5-53). Like the *Grave Stele of Hegeso*, the scene contains no overt signs of grief, but a quiet sadness pervades it. The two figures seem to inhabit different worlds, and their glances just fail to meet. White-figure painting must have echoed the style of contemporary paintings on walls and panels, but no examples of those have survived for comparison.

Other painting was found in settings such as the Painted Stoa (see fig. 5-37, top center). It was built on the north side of the Athenian Agora about 460 BCE, and was so called because it was decorated with paintings by the most famous artists of the time, including Polygnotos of Thasos (active c. 475–450 BCE). Nothing survives of Polygnotos's work, but his contemporaries praised his talents for creating the illusion of spatial recession in landscapes, rendering female figures clothed in transparent draperies, and conveying through facial expressions the full range of human emotions. Ancient writers describe his paintings enthusiastically, but nothing remains for us to see.

CLASSICAL ART OF THE FOURTH CENTURY After the Spartans defeated Athens in 404 BCE, they set up a pro-Spartan government led by Kritias. This government was so oppressive that within a year the Athenians rebelled against it, killed Kritias, and restored democracy. Athens recovered its independence and its economy revived, but it never regained its dominant political and military status. Sparta failed to establish a lasting preeminence over the rest of Greece, and the city-states again began to struggle among themselves. Although Athens had lost its empire, it retained its reputation as a center of artistic and intellectual accomplishment. In 387 BCE, the great philosopher-teacher Plato founded a school just outside Athens, as Plato's student Aristotle did later. Among Aristotle's students was young Alexander of Macedon, known to history as Alexander the Great.

The work of Greek artists during the fourth century BCE exhibits a high level of creativity and technical accomplishment. Changing political conditions never seriously dampened the Greek creative spirit. Indeed, the artists of the second half of the century in particular experimented widely with new subjects and styles. Although they observed the basic Classical approach to composition and form, they no longer adhered rigidly to its conventions. Their innovations were supported by a sophisticated and diverse new group of patrons, including the Macedonian courts of Philip and Alexander, wealthy aristocrats in Asia Minor, and foreign rulers anxious to import Greek wares and, sometimes, Greek artists.

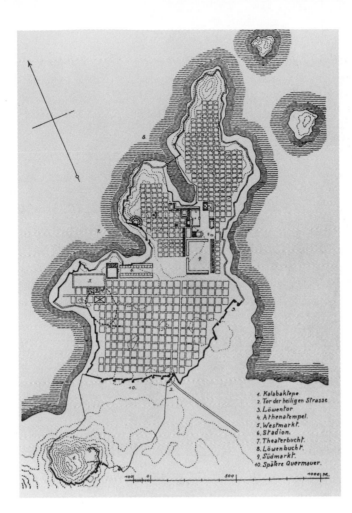

5-54. Plan of Miletos, with original coastline

1. Kalabaktepe
2. Tor der heiligen Strasse
3. Löwentor
4. Athenatempel
5. Westmarkt.
6. Stadion.
7. Theaterbucht.
8. Löwenbucht.
9. Südmarkt.
10. Spätere Quermauer.

ARCHITECTURE AND ARCHITECTURAL SCULPTURE

Despite the instability of the fourth century BCE, Greek cities undertook innovative architectural projects. Architects developed variations on the Classical ideal in urban planning, temple design, and the design of two increasingly popular structures, the *tholos* and the monumental tomb. In contrast to the previous century, much of this activity took place outside of Athens and even in areas beyond mainland Greece, notably in Asia Minor.

The Orthogonal City Plan. In older Greek cities such as Athens, which grew up on the site of an ancient **citadel**, buildings and streets developed irregularly according to the needs of their inhabitants and the requirements of the terrain. As early as the eighth century BCE, however, builders in some western Greek settlements began to implement a rigid, mathematical concept of urban development based on the **orthogonal** (right-angled) **plan**. New cities or rebuilt sections in old cities were laid out on straight, evenly spaced parallel streets that intersected at right angles to create rectangular blocks. These blocks, or plats, were then subdivided into identical building plots. The orthogonal plan probably originated in Egypt, where it was used early in the second millennium BCE at such sites as el Lahun (see fig. 3-17).

During the Classical period, Greek architects promoted the orthogonal system as an ideal for city planning. Hippodamos of Miletos, a major urban planner of the fifth century BCE, had views on the city philosophically akin to those of Socrates and aesthetically akin to those of Polykleitos. All three believed that humans could arrive at a model of perfection through reason. According to Hippodamos, who seems to have been more concerned with abstract principles of order than with the human individual, the ideal city should be divided into three zones—sacred, public, and private—and limited to 10,000 citizens divided into three classes—artists, farmers, and soldiers. The basic Hippodamian plat was a square 600 feet on each side, divided into quarters. Each quarter was subdivided into six rectangular building plots measuring 100 by 150 feet on a side, a scheme still widely used in Western cities and suburbs today.

Many Greek cities with orthogonal plans were laid out on relatively flat land that posed few obstacles to regularity. Miletos, in Asia Minor, for example, was redesigned by Hippodamos after its partial destruction by the Persians (fig. 5-54). Later the orthogonal plan was applied on less-hospitable terrain, such as that of Priene, which lies across the plain from Miletos on a rugged hillside. In this case, the city's planners made no attempt to accommodate their grid to the irregular mountainside, so some streets are in fact stairs.

The Tholos. Buildings with a circular plan had a long history in Greece going back to Mycenaean beehive tombs (see fig. 4-20). In later times various types of *tholoi*, or circular-plan buildings, were erected. Some were shrines or monuments and some, like the fifth-century BCE *tholos* in the Athens Agora (see fig. 5-37), were administrative buildings. However, the function of many, such as a *tholos* built

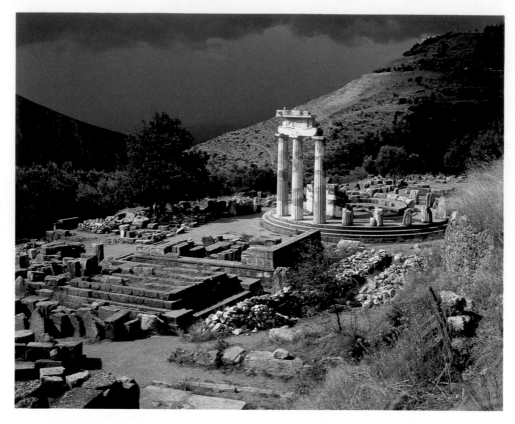

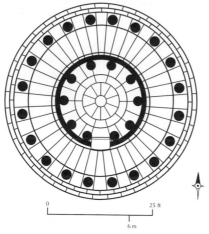

5-55. *Tholos*, **Sanctuary of Athena Pronaia, Delphi**. c. 400 BCE

Often the term following the name *Athena* is an epithet, or title, identifying one of the goddess's many roles in ancient Greek belief. For example, as patron of craftspeople, she was referred to as *Athena Ergane* ("Athena of the Worker"). As guardian of the city-states, she was *Athena Polias*. The term *Pronaia* in this sanctuary name simply means "in front of the temples," referring to the sanctuary's location preceding the Temple of Apollo higher up on the mountainside.

5-56. **Plan and section of the** *tholos*, **Sanctuary of Athena Pronaia, Delphi**

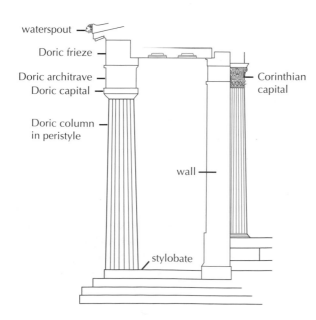

shortly after 400 BCE in the Sanctuary of Athena Pronaia at Delphi, is unknown (figs. 5-55, 5-56). Theodoros, the presumed architect, was from Phokaia in Asia Minor. The exterior was of the Doric order, as seen from the three columns and a piece of the entablature that have been restored. Other remnants suggest that the interior featured a ring of columns with capitals carved to resemble the curling leaves of the acanthus plant. This type of capital came to be called Corinthian in Roman times (see "The Greek Architectural Orders," page 164). It had been used on roof-supporting columns in temple interiors since the mid-fifth century BCE, but was not used on building exteriors until the Hellenistic period, more than a hundred years later.

The Monumental Tomb. Monumental tombs might be designed as large, showy memorials to their wealthy owners. One such tomb was built for Mausolos, prince of Karia, at Halikarnassos in Asia Minor. This monument

5-57. Reconstruction drawing of the Mausoleum (tomb of Mausolos), Halikarnassos (modern Bodrum, Turkey). c. 353 BCE

Later writers describe the building and its sculpture in frustratingly inexact detail. Consequently, many archaeologists have tried to reconstruct the appearance of the monument. This illustration shows the most likely possibilities.

5-58. Mausolos (?), from the Mausoleum (tomb of Mausolos), Halikarnassos. Marble, height 9'10" (3 m). The British Museum, London

(fig. 5-57) was so spectacular that later writers glorified it as one of the Seven Wonders of the World. Mausolos, whose name has given us the term **mausoleum** (a large burial structure), was the Persian governor of the region. He admired Greek culture and brought to his court from Greece writers, entertainers, and artists, as well as the greatest sculptors to decorate his tomb. The structure was completed after his death in 353 BCE under the direction of his wife, Artemisia, who was rumored to have drunk her dead husband's ashes mixed with wine.

A preserved male statue from the tomb was long believed to be of Mausolos himself (fig. 5-58). The man's broad face, long, thick hair, short beard and moustache, and stocky body could represent the features of a particular individual, but it is more likely that the statue represents a new heroic ideal—a glorification of experience, maturity, and intellect over youthful physical beauty and athletic vigor. The heavy swathing of drapery drawn into a thick mass around the waist reveals the underlying body forms while providing the necessary bulk to make the figure impressive to a viewer at the bottom of the monument.

The foundation, many scattered stones, and fragments of sculpture and moldings that are now in various museums are what remains of Mausolos's tomb, which was destroyed in the Middle Ages. Although early descriptions are often ambiguous, the structure probably stood about 150 feet high and rose from a base measuring 126 by 105 feet. The elevation consisted of three main sections: a plain-surfaced podium, a colonnaded section in

5-59. Panel from the Amazon frieze, south side of the Mausoleum at Halikarnassos. Mid-4th century BCE. The British Museum, London

the Ionic order, and a stepped roof. The roof section measured about 24 feet high and was topped with marble statues of a four-horse chariot and driver. The exterior decoration consisted of Ionic friezes and an estimated 250 freestanding statues, lifesize or larger, including more than 50 lions. The friezes were carved in relief with battle scenes of Lapiths against centaurs and Greeks against Amazons (fig. 5-59). According to the reconstruction of the monument in figure 5-57, statues of Mausolos's relatives and ancestors stood between the columns in the colonnade; statues of hunters killing lions, boars, and deer encircled the next level down; below them was a circle of unidentified standing figures; and around the base was depicted a battle between Greeks and Persians. Originally, all the sculptural elements of the tomb were painted.

SCULPTURE

Throughout the fifth century BCE, sculptors carefully maintained the equilibrium between simplicity and ornament that is fundamental to Greek Classical art. Standards established by Pheidias and Polykleitos in the mid-fifth century BCE for the ideal proportions and idealized forms of the human figure had generally been accepted by the next generation of artists. Fourth-century BCE artists, on the other hand, challenged and modified those standards. The artists of mainland Greece, in particular, developed a new canon of proportions for male figures—now 8 or more "heads" tall rather than the 6½- or 7-head height of earlier works. The calm, noble detachment characteristic of earlier figures gave way to more sensitively rendered images of men and women with expressions of wistful introspection, dreaminess, or even fleeting anxiety. Patrons lost some of their interest in images of mighty Olympian gods and legendary heroes and acquired a

taste for depictions of minor deities in lighthearted moments. This period also saw the earliest depictions of fully nude women in major works of art.

The fourth century BCE was dominated by three sculptors—Praxiteles, Skopas, and Lysippos. Praxiteles was active in Athens from about 370 to 335 BCE or later. According to the Greek traveler Pausanias, writing in the second century CE, Praxiteles' "Hermes of stone who carries the infant Dionysos" stood in the Temple of Hera at Olympia. Just such a sculpture in marble, depicting the messenger god Hermes teasing the baby Dionysos with a bunch of grapes, was discovered in the ruins of the ancient Temple of Hera in the Sanctuary of Hera and Zeus at Olympia (fig. 5-60). Archaeologists accepted *Hermes and the Infant Dionysos* as an authentic work by Praxiteles until recent studies indicated that it is probably a very good fourth-century BCE Roman or Hellenistic copy of an original made by Praxiteles or his followers.

The sculpture remains an excellent example that reflects a number of differences between Praxiteles' style and that of the late fifth century. His *Hermes* has a smaller head and a more youthful body than Polykleitos's *Spear Bearer*, and its off-balance, **S**-curve pose, requiring the figure to lean on a post, contrasts clearly with that of the earlier work (see fig. 5-51). This sculptor also created a sensuous play of light over the figure's surface. The gleam of the smoothly finished flesh contrasts with the textured quality of the crumpled draperies and the rough locks of hair, even on the baby's head. Surely owed to Praxiteles is the humanized treatment of the subject— two gods, one a loving adult and the other a playful child, caught in a moment of absorbed companionship. The interaction of the two across real space through gestures and glances creates an overall effect far different from

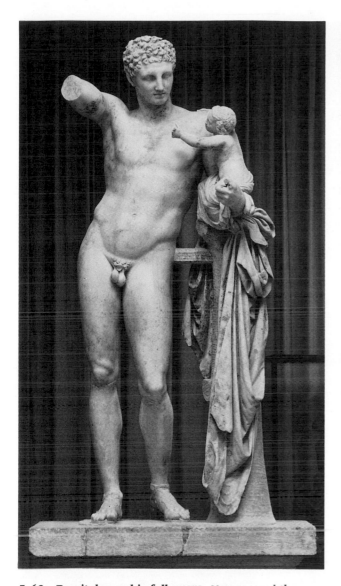

5-60. Praxiteles or his followers. *Hermes and the Infant Dionysos*, probably a Hellenistic or Roman copy after a 4th-century BCE original. Marble, with remnants of red paint on the lips and hair, height 7'1" (2.16 m). Archaeological Museum, Olympia

Discovered in the rubble of the ruined Temple of Hera at Olympia in 1875, this statue is now widely accepted as a very good Roman or Hellenistic copy. Support for this conclusion comes from certain elements typical of Roman sculpture: Hermes' sandals, which recent studies suggest are not accurate for a fourth-century BCE date; the supporting element of crumpled fabric covering a tree stump; and the use of a reinforcing strut, or brace, between Hermes' hip and the tree stump.

that of the austere Olympian deities of the fifth century BCE on the pediments and metopes of the Temple of Zeus (see figs. 5-31, 5-32), near where the work was found.

Around 350 BCE, Praxiteles created a statue of Aphrodite for the city of Knidos in Asia Minor. Although artists of the fifth century BCE had begun to hint boldly at the naked female body beneath tissue-thin drapery, as in *Nike Adjusting Her Sandal* (see fig. 5-50), this *Aphrodite* was apparently the first statue by a well-known Greek sculptor to depict a fully nude woman, and it set a new standard (fig. 5-61). Although nudity among athletic young men

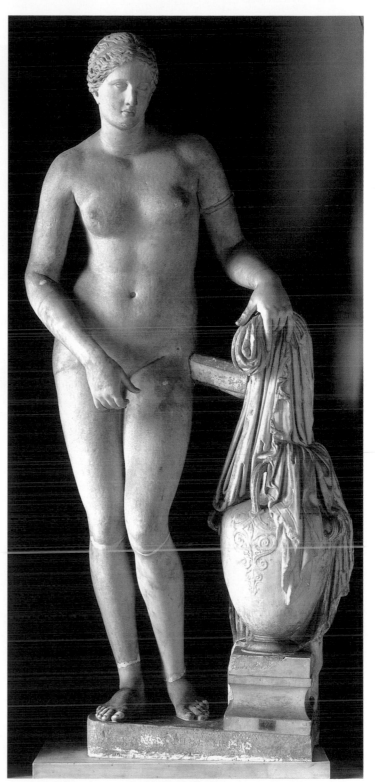

5-61. Praxiteles. *Aphrodite of Knidos*, composite of two similar Roman copies after the original marble of c. 350 BCE. Marble, height 6'8" (2.03 m). Musei Vaticani, Museo Pio Clementino, Gabinetto delle Maschere, Rome

The head of this figure is from one Roman copy, the body from another. Seventeenth- and eighteenth-century CE restorers added the nose, the neck, the right forearm and hand, most of the left arm, and the feet and parts of the legs. This kind of restoration would rarely be undertaken today, but it was frequently done and considered quite acceptable in the past, when archaeologists were trying to put together a body of work documenting the appearances of lost Greek statues. It was also done to create a piece suitable for sale to a private individual or for display in a museum.

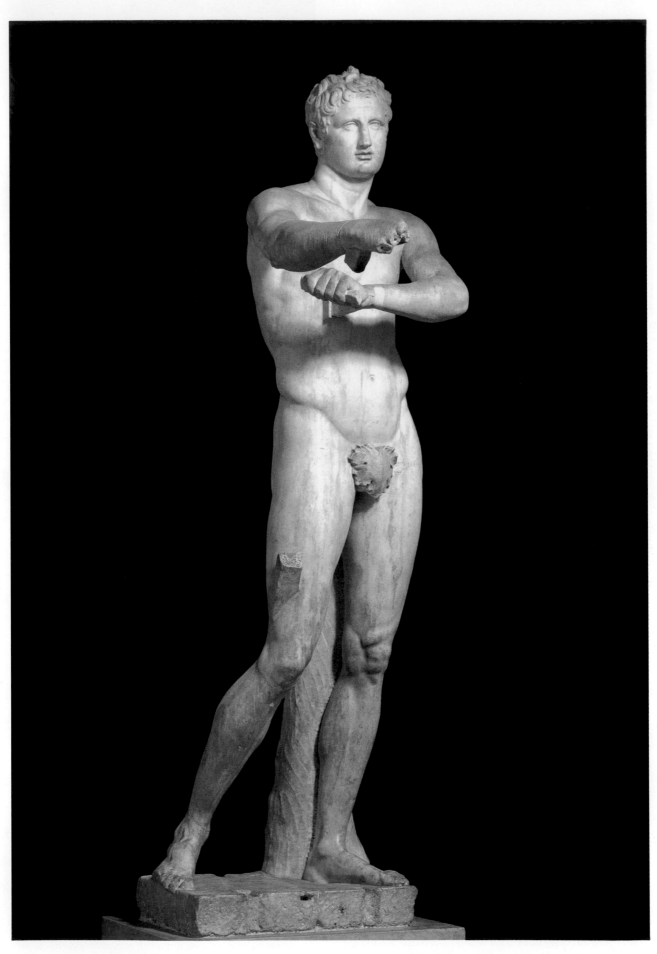

5-62. Lysippos. *The Scraper (Apoxyomenos)*, Roman copy after the original bronze of c. 330 BCE. Marble, height 6'9"
(2.06 m). Musei Vaticani, Museo Pio Clementino, Gabinetto dell'Apoxyomenos, Rome

was admired in Greek society, among women it had been considered a sign of low character. The eventual wide acceptance of female nudes in large statuary may be related to the gradual merging of the Greeks' concept of their goddess Aphrodite with some of the characteristics of the Phoenician goddess Astarte (the Babylonian Ishtar), who was nearly always shown nude in Near Eastern art.

In the version of the statue seen here, actually a composite of two Roman copies, the goddess is preparing to take a bath, with a water jug and her discarded clothing at her side. Her right arm and hand extend in what appears at first glance to be a gesture of modesty but in fact only emphasizes her nakedness. The bracelet on her left arm has a similar effect. Her well-toned body, with its square shoulders, thick waist, and slim hips, conveys a sense of athletic strength. She leans forward slightly with one knee in front of the other in a seductive pose that emphasizes the swelling forms of her thighs and abdomen.

Writers of the time relate that Praxiteles' original statue was of such enchanting beauty that it served as a public model of high moral value. According to an old legend, the sculpture was so realistic that Aphrodite herself made a journey to Knidos to see it and cried out in shock, "Where did Praxiteles see me naked?" The Knidians were so proud of their *Aphrodite* that they placed it in an open shrine where people could view it from every side. Hellenistic and Roman copies probably numbered in the hundreds, and nearly fifty survive in various collections today.

Skopas, another artist who was greatly admired in ancient times, had a brilliant career as both sculptor and architect that took him around the Greek world. Unfortunately, little survives, either originals or copies, that can be reliably attributed to him, even though early writers credited him with one whole side of the sculptural decoration of Mausolos's tomb. If the literary accounts are accurate, Skopas introduced a new style of sculpture admired in its time and influential in the following Hellenistic period. In relief compositions, he favored very active, dramatic poses over balanced, harmonious ones, and he was especially noted for the expression of emotion in the faces and gestures of his figures. The typical Skopas head conveys intensity with its deep-set eyes, heavy brow, slightly parted lips, and a gaze that seems to look far into the future.

The third of the fourth-century BCE masters, the sculptor Lysippos, is unique in that many details of his life are known. He claimed to be entirely self-taught and asserted that "nature" was his only model, but he must have received training in the technical aspects of his profession in the vicinity of his home, near Corinth. Although he expressed great admiration for Polykleitos, his own figures reflect a different set of proportions than those of the fifth-century BCE master, with small heads and slender bodies like those of Praxiteles. For his famous work *The Scraper* (*Apoxyomenos*), known today only from Roman copies, he chose a typical Classical subject, a nude male athlete, but treated it in an unusual way (fig. 5-62). Instead of a figure actively engaged in a sport or standing in the Classical shallow **S** curve, Lysippos depicted a young man methodically removing oil and dirt from his body with a scraping tool called a strigil.

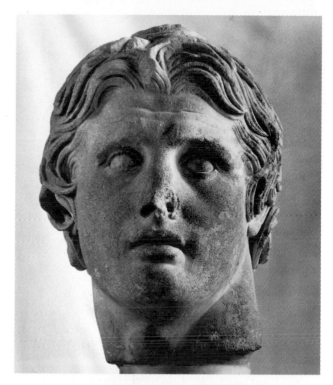

5-63. *Alexander the Great*, head from a Hellenistic copy (c. 200 BCE) of a statue, possibly after a 4th-century BCE original by Lysippos. Marble fragment, height 16⅛" (41 cm). Archaeological Museum, Istanbul, Turkey

Judging from the athlete's expression, his thoughts are far from his mundane task. His deep-set eyes, dreamy stare, heavy forehead, and tousled hair may reflect the influence of Skopas.

The Scraper, tall and slender with a relatively small head, makes a telling comparison with Polykleitos's *Spear Bearer* (see fig. 5-51). Not only does it reflect a different canon of proportions, but the figure's weight is also more evenly distributed between the engaged leg and the free one, with the free foot almost flat on the ground. The legs are also in a wider stance to counterbalance the outstretched arms. The *Spear Bearer* is contained within fairly simple, compact contours and oriented to a frontal view. In contrast, the arms of *The Scraper* break free into the surrounding space, requiring the viewer to move around the statue to absorb its full aspect. Roman authors, who may have been describing the bronze original rather than a copy, remarked on the subtle modeling of *The Scraper*'s elongated body and the spatial extension of its pose.

Lysippos was widely known and admired for his monumental statues of Zeus, which may be why he was summoned to do a portrait of Alexander the Great. Lysippos portrayed Alexander as a full-length standing figure with an upraised arm holding a scepter, just as he is believed to have posed Zeus, though none of these statues still exists.

A head found at Pergamon that was once part of a standing figure is believed to be from one of several copies of Lysippos's original of Alexander (fig. 5-63). It depicts a ruggedly handsome, heavy-featured young man with a large Adam's apple and short, tousled hair. The treatment of the hair may be a visual reference to the mythical hero Herakles, who killed the Nemean Lion as his First Labor and is often portrayed wearing its head and pelt as a hooded cloak. Alexander would have felt great kinship

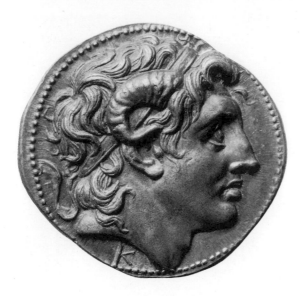

5-64. *Alexander the Great*, 4-drachma coin issued by Lysimachos of Thrace. 306–281 BCE. Silver, diameter 1 1/8" (30 mm). The British Museum, London

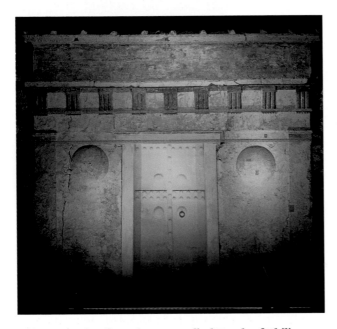

5-65. Facade of Tomb II, so-called Tomb of Philip, Vergina, Macedonia. Second half of the 4th century BCE. Fresco, height 18'2 1/2" x 3'9 5/8" (5.56 x 1.16 m)

The facade illustrates the Greeks' use of color to enhance architectural details.

5-66. *Abduction of Persephone*, detail of a wall painting in Tomb I (Small Tomb), Vergina, Macedonia. c. 366 BCE. Height approx. 39 1/2" (100.3 cm)

In the legend, Persephone was picking flowers in Eleusis, near Athens, when Hades, god of the underworld, kidnapped her. The king of Eleusis provided a home for Persephone's grieving mother, Demeter, the goddess of grain, as she searched for her lost daughter. In return for this kindness, Demeter taught the Eleusians to grow grain. Eventually Zeus interceded, and Hades allowed Persephone to divide her time between the earth and the underworld. Her comings and goings accounted for the change in seasons—fertile summer when she lived with her mother, the dead of winter when she lived with her husband. The Greeks built a sanctuary on the spot where they believed Persephone entered the underworld, and an extremely influential cult developed around Demeter and Persephone, a "mystery cult" comparable to that of Isis and Osiris in Egypt. Unlike most sanctuaries, the Sanctuary of Demeter and Persephone at Eleusis was under the private control of two aristocratic families and closed to all but initiated worshipers. Cult members were forbidden on pain of death to describe what happened inside the walls, and any outsider found trying to enter illegally would have been killed. None of the cult's activities—the Mysteries of Eleusis—was ever revealed, but they probably involved a ritual reenactment of Persephone's abduction and descent into the underworld and her return to earth.

with Herakles, whose acts of bravery and strength earned him immortality. The Pergamon head was not meant to be entirely true to life. The artist rendered certain features in an idealized manner to convey a specific message about the subject. The deep-set eyes are unfocused and meditative, and the low forehead is heavily lined, as though the figure were contemplating decisions of great consequence and waiting to receive divine advice.

According to the Roman-era historian Plutarch, Lysippos depicted Alexander in a characteristic meditative pose, "with his face turned upward toward the sky, just as Alexander himself was accustomed to gaze, turning his neck gently to one side" (cited in Pollitt, page 20). Because this description fits the marble head from Pergamon and others like it so well, they have been thought

to be copies of the Alexander statue. On the other hand, the heads could also be viewed as conventional, idealized "types" created by Lyssipos rather than identifiable portraits of Alexander. A reasonably reliable image of Alexander is found on a coin issued by Lysimachos, king of Thrace, in the late fourth and early third centuries BCE (fig. 5-64). It shows Alexander in profile wearing the curled ram's-horn headdress that identifies him as the

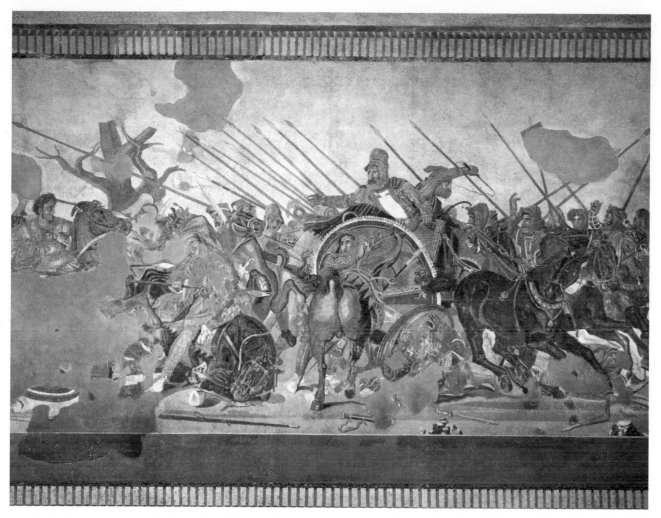

5-67. *Alexander the Great Confronts Darius III at the Battle of Issos*, from Pompeii. Roman mosaic copy after a Greek painting of c. 310 BCE, perhaps by Philoxenos or Helen of Egypt. Museo Archeològico Nazionale, Naples

Greek-Egyptian god Zeus-Amun. The portrait has the same low forehead, high-bridged nose, large lips, and thick neck as the Pergamon head.

WALL PAINTING AND MOSAICS

Greek painting has so far been discussed only in terms of pottery decoration because little remains of paintings in other mediums. Excavations in the 1970s CE have enriched our knowledge of fourth century BCE painting. At Vergina (modern-day Aigai), in Macedonia, two intact tombs were found in a large mound called the Great Tumulus. Dated from **potsherds** (broken ceramics) to around the middle of the fourth century BCE, both tombs were decorated with wall paintings. The larger of the tombs (Tomb II), which contained a rich casket, armor, and golden wreaths, may be that of Alexander's father, Philip II, although the identification has recently been questioned. Tomb II has a remarkable entrance wall, with well-preserved Doric architecture (fig. 5-65). The bright colors of the original paint remain. Such treatment in reds and blue must be imagined when looking at Greek buildings, beautiful as the marble, shed of its paint, may seem today.

A mural in the smaller of the tombs (Tomb I) depicts the kidnapping of Persephone by Hades (fig. 5-66). Even in its deteriorated state, the *Abduction of Persephone* is clearly the work of an outstanding artist. Hades has just

snatched Persephone and is carrying her off to the underworld to be his wife and queen. The convincing twists of the figures, the foreshortened view of the huge wheels of the chariot, and the swirl of draperies capture the story's action, conveying the intensity of the struggle and the violent emotions it has provoked. Hades, with his determined expression, contrasts strikingly with the young Persephone, who evokes pity with her helpless gestures. The subject, certainly appropriate for a tomb painting, may be a metaphor for rebirth, the changing seasons, the cycle of life and death. This mural, with its vigorous drawing style, complex foreshortening, and dynamic brushwork, proves claims by early observers such as Pliny the Elder that Greek painters were skilled in capturing the appearance of the real world. It also contradicts the view often held before its discovery that dramatic, dynamic figural representation in Greek art was confined to Hellenistic sculpture of the third to first century BCE.

Roman patrons in the second century BCE and later greatly admired Greek murals and commissioned copies, as either wall paintings or mosaics, to decorate their homes. These copies provide another source of evidence about fourth-century BCE Greek painting. Together with evidence from red-figure vase painting, they indicate a growing taste for dramatic narrative subjects. A second-century BCE mosaic, *Alexander the Great Confronts Darius III at the Battle of Issos* (fig. 5-67), was based on an original

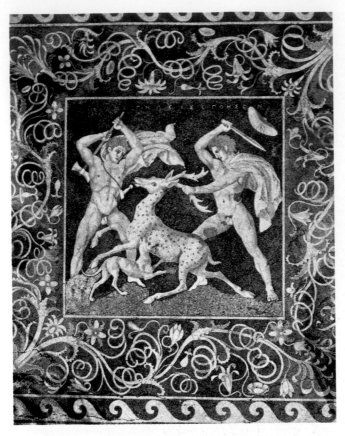

5-68. **Gnosis.** *Stag Hunt*, detail of mosaic floor decoration from Pella, Macedonia. 300 BCE. Pebbles, height 10'2" (3.1 m). Archaeological Museum, Pella. Signed at top: "Gnosis made it"

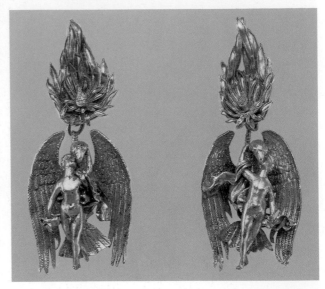

5-69. **Earrings**. C. 330–300 BCE. Hollow-cast gold, height 2³⁄₈" (6 cm). The Metropolitan Musem of Art, New York Harris Brisbane Dick Fund, 1937 (37.11.9–10)

wall painting of about 310 BCE. Pliny the Elder attributed the original to Philoxenos of Eretria; a recent theory claimed it was by a well-known woman painter, Helen of Egypt (see "Women Artists in Ancient Greece," page 209). Like the *Abduction of Persephone*, this scene is one of violent action, gestures, and radical foreshortening, all devised to elicit the viewer's response to a dramatic situation. Astride a horse at the left, his hair blowing free and his neck bare, Alexander challenges the helmeted and armored Persian leader, who stretches out his arm in a gesture of defeat and apprehension as his charioteer whisks him back toward safety in the Persian ranks. Presumably in close imitation of the original painting, the mosaicist created the illusion of solid figures through **modeling**, mimicking the play of light on three-dimensional surfaces by touching protrusions with highlights and shading undercut areas and areas in shadow. The same techniques were used in the *Abduction of Persephone*, but the mosaic's condition makes them difficult to see in a photographic reproduction.

The great interest of fourth-century BCE artists in creating a believable illusion of the real world was the subject of anecdotes repeated by later writers (see Introduction, page 000). One popular legend involved a floral designer, a woman named Glykera—widely praised for the artistry with which she wove blossoms and greenery into wreaths, swags, and garlands for religious processions and festivals—and Pausias, the foremost painter of the day. Pausias challenged Glykera to a contest, claiming that he could paint a picture of one

of her complex works that would appear as lifelike to the spectator as her real one. According to the legend, he succeeded. It is not surprising, although perhaps unfair, that the opulent floral borders so popular in later Greek painting and mosaics are described as "Pausian" rather than "Glykeran."

A mosaic floor from a palace at Pella in Macedonia provides an example of a Pausian design. Dated about 300 BCE, the floor features a series of framed hunting scenes, such as the *Stag Hunt* (fig. 5-68), prominently signed by an artist named Gnosis. Blossoms, leaves, spiraling tendrils, and twisting, undulating stems frame this scene, echoing the linear patterns formed by the hunters, the dog, and the struggling stag. The over-lifesize human and animal figures are accurately drawn and modeled in light and shade. The dog's front legs are expertly foreshortened to create the illusion that the animal is turning at a sharp angle into the picture. The work is all the more impressive because it was not made with uniformly cut marble in different colors but with a carefully selected assortment of natural pebbles. The background was formed of dark stones, and the figures and floral designs were made of light-colored stones. The smallest pebbles were used to create the delicate shading and subtle details.

THE ART OF THE GOLDSMITH

The work of Greek goldsmiths, which gained international popularity in the Classical period, followed the same stylistic trends and achieved the same high standards of technique and execution found in the other art mediums.

A specialty of Greek goldsmiths was the design of earrings in the form of tiny works of sculpture. They were often placed on the ears of marble statues of goddesses, but they adorned real ears as well. An earring designed as the youth Ganymede in the grasp of an

Although comparatively few artists in ancient Greece were women, there is evidence that women artists worked in many mediums. Ancient writers noted women painters—Pliny the Elder, for example, listed Aristarete, Eirene, Iaia, Kalypso, Olympias, and Timarete. Helen, a painter from Egypt who had been taught by her father, is known to have worked in the fourth century BCE and may have been responsible for the original wall painting of *Alexander the Great at the Battle of Issos* (see fig. 5-67).

Greek women excelled in creating narrative or pictorial tapestries. They also worked in pottery-making workshops. The hydria here, dating from about 450 BCE, shows a woman artist in such a workshop, but her status is ambiguous. The composition focuses on the male painters, who are being approached by Nikes bearing wreaths symbolizing victory in an artistic competition. A well-dressed woman sits on a raised dais, painting the largest vase in the workshop. She is isolated from the other artists and is not part of the awards ceremony. Perhaps women were excluded from public artistic competitions, as they were from athletics. Another interpretation, however, is that the woman is the head of this workshop. Secure in her own status, she may have encouraged her assistants to enter contests to further their careers and bring glory to the workshop as a whole.

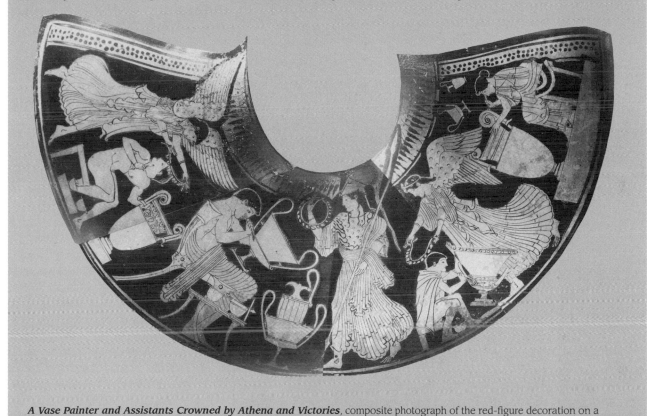

A Vase Painter and Assistants Crowned by Athena and Victories, composite photograph of the red-figure decoration on a hydria from Athens. c. 450 BCE. Private collection

eagle (Zeus) (fig. 5-69), dated about 330–300 BCE, is both a charming decoration and a technical tour de force. Slightly more than 2 inches high, it was hollow-cast using the **lost-wax** process, no doubt to make it light on the ear. Despite its small size, the earring conveys all the drama of its subject. Action subjects like this, with the depiction of swift movement through space, were to become a hallmark of Hellenistic art.

Greek goldsmiths' work was especially admired by the Scythians, a once-nomadic people from northern Asia who themselves had an ancient tradition of outstanding goldwork. An elaborate example of Greek artistry, a large, gold pectoral dating from the fourth century BCE, was found in a Scythian chief's tomb in the Caucasus Mountains of Russia (fig. 5-70). A series of four gold **torques**,

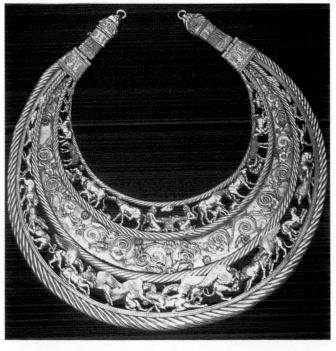

5-70. **Pectoral**, from the tomb of a Scythian at Ordzhonikidze, Russia. 4th century BCE. Gold, diameter 12" (30.6 cm). Historical Museum, Kiev

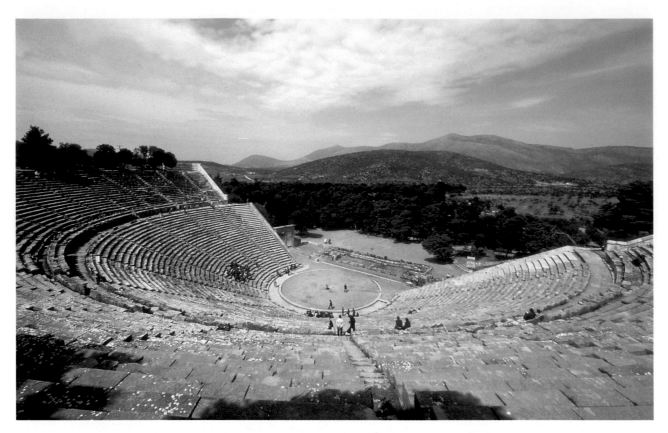

5-71. Theater, Epidauros. Early 3rd century BCE and later

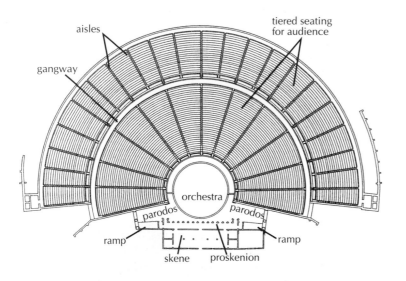

5-72. Plan of the theater at Epidauros

or neckpieces, of increasing diameter separates each of the sections. The upper and lower bands have figures, and the center one contains a stylized floral design that strongly resembles the floral border on the Pella floor (see fig. 5-68). In the pectoral's top band, the artist re-created a typical scene of Scythian daily life. At the center, two men are making a cloth shirt, while at the right another man milks a goat. Around them are cows and horses with their nursing calves and foals, all portrayed with great naturalistic detail. In contrast, the bottom band is devoted to a Near Eastern theme of animal combat, with griffinlike beasts attacking a group of horses. Is there a lesson here—that the domestication of animals is justified because it offers them protection from the dangers of the wild?

THE HELLENISTIC PERIOD

When Alexander died unexpectedly in 323 BCE, he left a vast empire with no administrative structure and no accepted successor. Almost at once his generals turned against one another, local leaders tried to regain their lost autonomy, and the empire began to break apart. The Greek city-states formed a new mutual-protection league but never again achieved significant power. Democracy survived in form but not substance in governments dominated by local rulers.

By the early third century BCE, three major powers had emerged out of the chaos, ruled by three of Alexander's generals and their heirs: Antigonus, Ptolemy, and Seleucus. The Antigonids controlled Macedonia and mainland Greece; the Ptolemies ruled Egypt; and the Seleucids controlled Asia Minor, Mesopotamia, and Persia. Over the course of the second and first centuries BCE, these kingdoms succumbed to the growing empire centered in Rome. Ptolemaic Egypt endured the longest, almost two and one-half centuries. The death in 30 BCE of its last ruler, the remarkable Cleopatra, marks the end of the Hellenistic period.

Alexander's lasting legacy was the spread of Greek culture far beyond its original borders. The Ptolemaic capital, Alexandria in Egypt, a prosperous seaport known for its lighthouse (another of the Seven Wonders of the World, according to ancient writers), emerged as a great Hellenistic center of learning and the arts. Its library is estimated to have contained 700,000 papyrus and parchment scrolls.

Artists of the Hellenistic period had a vision noticeably different from that of their predecessors. Where

earlier artists sought the ideal and the general, Hellenistic artists sought the individual and the specific. They turned increasingly away from the heroic to the everyday, from gods to mortals, from aloof serenity to individual emotion, and from drama to melodramatic pathos. A trend introduced in the fourth century BCE—the appeal to the senses through lustrous or glittering surface treatments and to the emotions with dramatic subjects and poses—became more pronounced. Even the architecture of the Hellenistic period largely reflected the contemporary taste for high drama.

THEATERS

In ancient Greece, the theater was more than mere entertainment; it was a vehicle for the communal expression of religious belief through music, poetry, and dance. In very early times, theater performances took place on the hard-packed dirt or stone-surfaced pavement of an outdoor threshing floor (*halos*)—the same type of floor later incorporated into religious sanctuaries (see fig. 5-3). Whenever feasible, dramas were also presented facing a steep hill that served as elevated seating for a kind of natural theater. Eventually such sites were made into permanent open-air auditoriums. At first, tiers of seats were simply cut into the side of the hill. Later, builders improved them with stone.

During the fifth century BCE, the plays usually were tragedies in verse based on popular myths and were performed at a festival dedicated to Dionysos. At this time, the three great Greek tragedians—Aeschylus, Sophocles, and Euripides—were creating the dramas that would define tragedy for centuries. Many theaters were built in the fourth century BCE, including those on the side of the Athenian Acropolis and in the sanctuary at Delphi, also for the performance of music and dance during the festival of Dionysos. Because theaters were used continuously and frequently modified over many centuries, no early theaters have survived in their original form.

The early third century BCE theater at Epidauros presents a good example of the characteristics of the fully realized theater (figs. 5-71, 5-72). A semicircle of tiered seats built into the hillside overlooked the circular performance area, called the orchestra, at the center of which was an altar to Dionysos. Rising behind the orchestra was a two-tiered stage structure made up of the vertical *skene* (scene)—an architectural backdrop for performances that also screened the backstage area from view—and the *proskenion* (**proscenium**), a raised platform in front of the *skene* that was increasingly used over time as an extension of the orchestra. Ramps connecting the *proskenion* with lateral passageways (*parodoi*; singular *parodos*) provided access to the stage for performers. Steps gave the audience access to the fifty-five rows of seats and divided the seating area into uniform wedge-shaped sections. The tiers of seats above the wide corridor, or gangway, were added at a much later date. This design provided uninterrupted sight lines and good acoustics and allowed for efficient entrance and exit of the 12,000 spectators. No better design has ever been created.

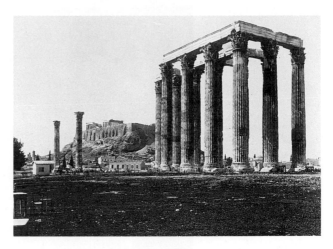

5-73. Temple of the Olympian Zeus, Athens. Building and rebuilding phases: foundation mid-6th century BCE; temple designed by Cossutius, begun 175 BCE, left unfinished 164 BCE, completed 132 CE using Cossutius's design

THE CORINTHIAN ORDER IN ARCHITECTURE

During the Hellenistic period there was increasing innovation in public architecture. A variant of the Ionic order featuring a tall, slender column with an elaborate foliate capital, for example, began to challenge the dominance of the Doric and Ionic orders on building exteriors. Invented in the late fifth century BCE and called Corinthian by later Romans, this highly decorative carved capital had previously been used only indoors, as in the *tholos* at Delphi (see fig. 5-55). Today, the Corinthian variant is routinely treated as a third Greek order (see "the Greek Architectural Orders," page 164). In the Corinthian column, the echinus becomes an unfluted extension of the column shaft set off by a collar molding called an **astragal**. From the astragal sprout curly acanthus leaves and coiled flower spikes. The molded abacus often has a central floral motif. Unlike the more standardized Doric and Ionic capitals, the Corinthian capital has many possible variations; only the foliage is required. The Corinthian entablature, like the Ionic, has a stepped-out architrave and a continuous frieze. It also has even more bands of carved moldings, often including a line of blocks called **dentils**. The Corinthian design became a lasting symbol of elegance and refinement that is still used on banks, churches, and office buildings.

The Corinthian order Temple of the Olympian Zeus, located in the lower city of Athens at the foot of the Acropolis, was commissioned by the Seleucid ruler Antiochus IV and was designed by the Roman architect Cossutius in the second century BCE (fig. 5-73). The temple's unusually large foundation, measuring 135 by 354 feet, is that of an earlier temple dating to the mid-sixth century BCE. Work on the Cossutius design halted in 164 BCE and was not completed until three centuries later under Roman rule, by Hadrian. The temple's great Corinthian columns may be the second-century BCE originals or Roman replicas of them. The peristyle soars 57 feet above the stylobate. Viewed through its columns, the Parthenon seems modest in comparison. But for all its height and luxurious decoration, the new

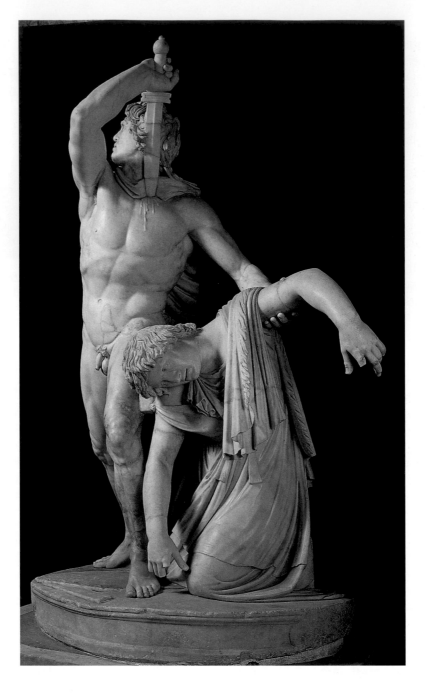

5-74. *Gallic Chieftain Killing His Wife and Himself*, Roman copy after the original bronze of c. 220 BCE. Marble, height 6'11" (2.1 m). Museo Nazionale Romano, Rome

temple followed long-established design norms. It stood on a three-stepped base, it had an enclosed room or series of rooms surrounded by a screen of columns, and its proportions and details followed traditional standards. Quite simply, it is a Greek temple grown very large.

SCULPTURE

Hellenistic sculptors produced an enormous variety of work in a wide range of materials, techniques, and styles. The period was marked by two broad and conflicting trends. One (sometimes called anti-Classical) led away from Classical models and toward experimentation with new forms and subjects; the other led back to Classical models, with artists selecting aspects of certain favored works by fourth-century BCE sculptors and incorporating them into new styles. The radical anti-Classical style was practiced in Pergamon and other eastern centers of Greek culture.

The Pergamene Style. The kingdom of Pergamon, a breakaway state within the Seleucid realm, established itself in the early third century BCE in western Asia Minor. The capital, Pergamon, quickly became a leading center of arts patronage and the hub of a new sculptural style that had far-reaching influence throughout the Hellenistic period. This new style is illustrated by sculpture from a monument commemorating the victory in 230 BCE of Attalos I (ruled 241–197 BCE) over the Gauls, a Celtic people. The monument extols the dignity and heroism of the defeated enemies. These figures of Gauls, originally in bronze but known today only from Roman copies in marble, were mounted on a large pedestal. One group depicts the murder-suicide of the Gallic chieftain and his wife (fig. 5-74) and the slow demise of a wounded soldier-trumpeter (fig. 5-75). Their wiry, unkempt hair and the trumpeter's twisted neck ring, or torque (the Celtic battle dress), identify them as "barbarians." The artist has sought to arouse the viewer's admiration and pity for his

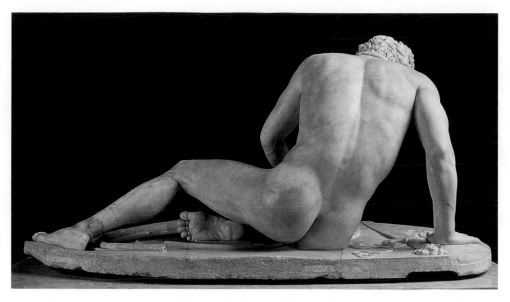

5-75. Epigonos (?). *Dying Gallic Trumpeter*, Roman copy after the original bronze of c. 220 BCE. Marble, lifesize. Museo Capitolino, Rome

The marble sculpture was found in Julius Caesar's garden in Rome. The bronze originals were made for the Sanctuary of Athena in Pergamon. Pliny wrote that Epigonos "surpassed others with his Trumpeter."

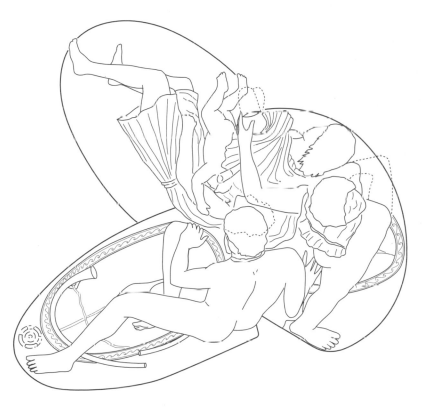

5-76. Reconstruction of monument of *Dying Gallic Trumpeter, Chieftain and Wife, and Mother and Child*, from Pergamon; from Eugenio Polito, *I Galati Vinti* (Milan: Electa, 1999)

subjects. The chieftain, for example, still supports his dead wife as he plunges the sword into his own breast. The trumpeter, fatally injured, struggles to rise, but the slight bowing of his supporting right arm and his unseeing downcast gaze indicate that he is on the point of death. This kind of deliberate attempt to elicit a specific emotional response in the viewer is known as **expressionism**, and it was to become a characteristic of Hellenistic art.

The marble copies of these works are now separated, but originally they formed part of an interlocked, multi-figured group on a raised base that could have been viewed and appreciated from every angle (fig. 5-76). Pliny the Elder described a work like the *Dying Gallic Trumpeter*, attributing it to an artist named Epigonos. Recent research indicates that Epigonos probably knew the early-fifth-century BCE sculpture of the Temple of Aphaia at Aegina, which included the *Dying Warrior* (see fig. 5-16), and could

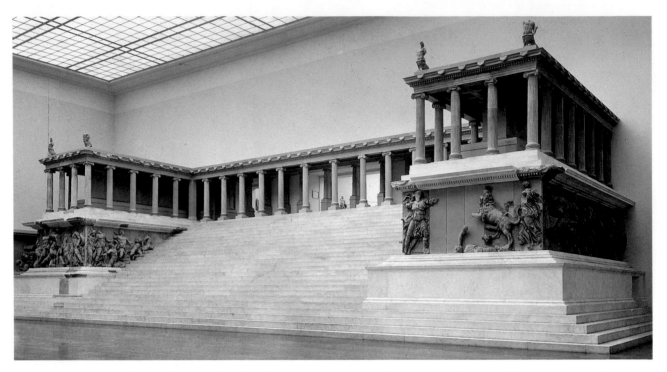

5-77. Reconstructed west front of the altar from Pergamon. c. 166–156 BCE. Marble. Staatliche Museen zu Berlin, Antikensammlung, Pergamonmuseum

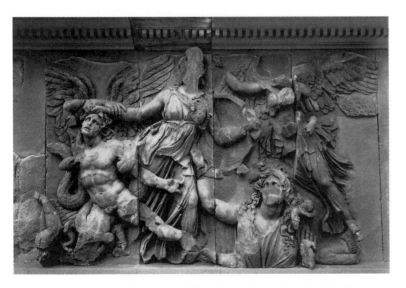

5-78. *Athena Attacking the Giants*, detail of the frieze from the east front of the altar from Pergamon. Marble, frieze height 7'6" (2.3 m). Staatliche Museen zu Berlin, Antikensammlung, Pergamonmuseum

have had it in mind when he created his own works.

The style and approach of the works in the monument to the defeated Gauls became more pronounced and dramatic in later works, culminating in the decorative frieze on the base of the great altar at Pergamon (fig. 5-77). The wings and staircase to the entrance of the courtyard in which the altar stood have been reconstructed inside a Berlin museum from fragments from the site. The original altar complex was a single-story structure with an Ionic colonnade raised on a high podium reached by a monumental staircase 68 feet wide and nearly 30 feet deep. The running frieze decoration, probably executed during the

reign of Eumenes II (197–159 BCE), depicts the battle between the Gods and the Giants, a mythical struggle that the Greeks are thought to have used as a metaphor for Pergamon's victory over the Gauls.

The frieze was about 7½ feet high, tapering along the steps to just a few inches. The Greek gods fight not only human-looking Giants, but also hybrids emerging from the bowels of the earth. In a detail of the frieze (fig. 5-78), the goddess Athena at the left has grabbed the hair of a winged male monster and forced him to his knees. Inscriptions along the base of the sculpture identify him as Alkyoneos, a son of the earth goddess Ge, who rises from the ground on the right in fear as she reaches toward Athena, pleading for her son's life. At the far right, a winged Nike rushes to Athena's assistance.

The figures in the Pergamon frieze not only fill the sculptural space, they break out of their architectural boundaries and invade the spectators' space. They crawl out of the frieze onto the steps, where visitors had to pass them on their way up to the shrine. Many consider this theatrical and complex interaction of space and form to be a benchmark of the Hellenistic style, just as they consider the balanced restraint of the Parthenon sculpture to be the epitome of the Fifth-Century Classical style. Where fifth-century BCE artists sought horizontal and vertical equilibrium and control, the Pergamene artists sought to balance opposing forces in three-dimensional space along diagonal lines. The Classical preference for smooth, sculpted surfaces reflecting a clear, even light has been replaced by a preference for dramatic contrasts of light and shade playing over complex forms carved in high relief with deep undercutting. The composure and stability

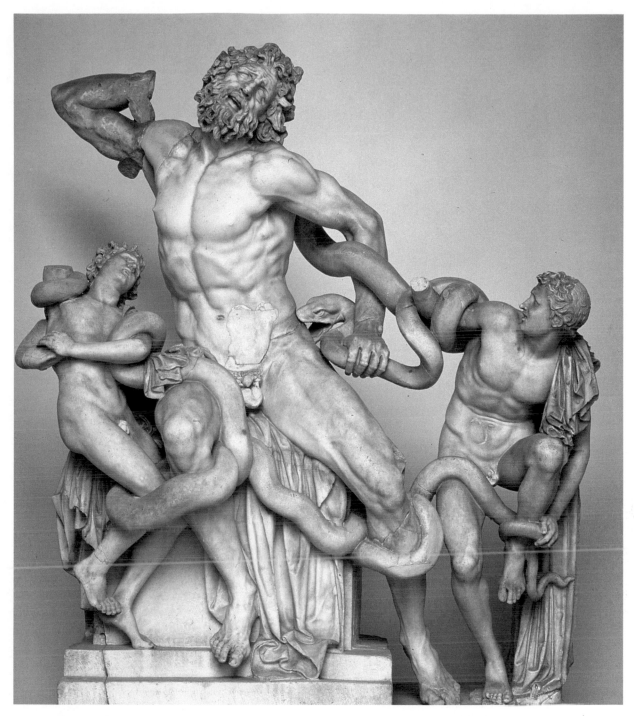

5-79. Hagesandros, Polydoros, and Athanadoros of Rhodes. *Laocoön and His Sons*, probably the original of the 1st century CE or a Roman copy of the 1st century CE. Marble, height 8' (2.44 m). Musei Vaticani, Museo Pio Clementino, Cortile Ottagono, Rome

admired in the Classical style have given way to extreme expressions of pain, stress, wild anger, fear, and despair. In the Fifth-Century Classical style, figures stood remote in their own space. In the fourth century BCE, they reached out into their immediate environment. In the Hellenistic period, they impose themselves, often forcefully, on the spectator. Whereas the Classical artist asked only for an intellectual commitment, the Hellenistic artist demanded that the viewer empathize with the depicted scene.

Pergamene artists may have inspired the work of Hagesandros, Polydoros, and Athanadoros, three sculptors on the island of Rhodes named by Pliny the Elder as the creators of the famed *Laocoön and His Sons* (fig. 5-79). This

work, in the collection of the Vatican since it was discovered in Rome in 1506, has been assumed by many art historians to be the original version from the second or first century BCE, although others argue that it is a brilliant copy commissioned by an admiring Roman patron. The complex sculptural composition illustrates an episode from the Trojan War. The Trojans' priest Laocoön warned them not to take the giant wooden horse (within which were concealed Greeks warriors) inside their walls. The gods who supported the Greeks in the war retaliated by sending serpents from the sea to destroy Laocoön and his sons as they walked along the shore. The struggling figures, anguished faces, intricate diagonal movements, and skillful unification

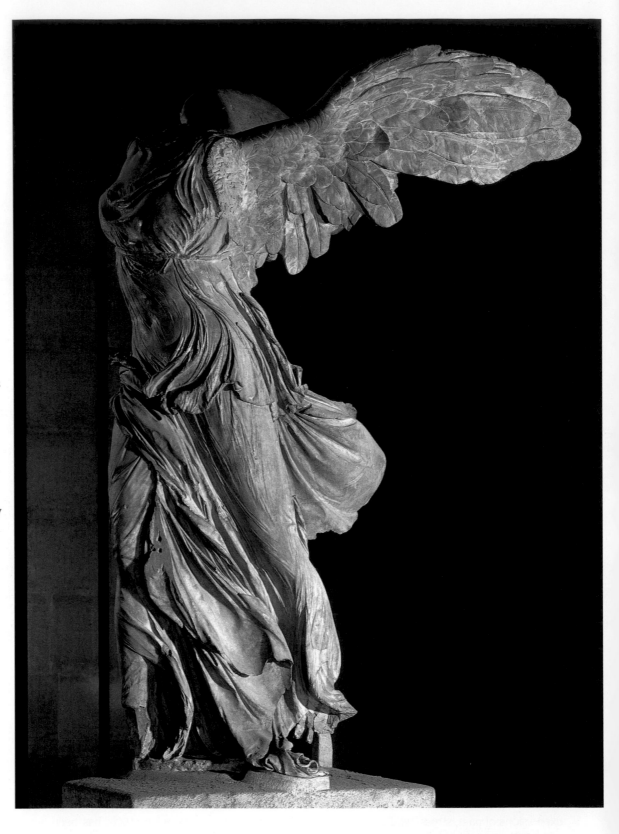

5-80. *Nike (Victory) of Samothrace*, from the Sanctuary of the Great Gods, Samothrace. c. 190 BCE (?). Marble, height 8' (2.44 m). Musée du Louvre, Paris

The wind-whipped costume and raised wings of this Victory indicate that she has just alighted on the prow of the stone ship that formed the original base of the statue. The work probably commemorated an important naval victory, perhaps the Rhodian triumph over the Seleucid king Antiochus III in 190 BCE. The Nike, lacking its head and arms, and a fragment of its ship base were discovered in the ruins of the Sanctuary of the Great Gods by a French explorer in 1863 (additional fragments were discovered later). Soon after, it entered the collection of the Louvre Museum in Paris. Poised high on the landing of the grand staircase, this famous Hellenistic sculpture continues to catch the eye and the imagination of thousands of museum visitors.

of diverse forces in a complex composition all suggest a strong relationship between Rhodian and Pergamene sculptors. Unlike the monument to the conquered Gauls, the *Laocoön* was composed to be seen from the front, within a short distance. As a result, although sculpted in the round, the three figures appear as very high relief and are more like the relief sculpture on the altar from Pergamon.

The *Nike (Victory) of Samothrace* (fig. 5-80) is more theatrical still. In its original setting—in a hillside niche high above the city of Samothrace and perhaps drenched with spray from a fountain—this huge goddess of victory must have reminded the Samothracians of the god in Greek plays who descends from heaven to determine the outcome of the drama. The fact that victory in real life does often seem miraculous makes this image of a goddess alighting suddenly on a ship breathtakingly appropriate for a war memorial. The forward momentum of the *Nike*'s heavy body is balanced by the powerful backward thrust of her enormous wings. The large, open movements of the figure, the strong contrasts of light and dark on the deeply

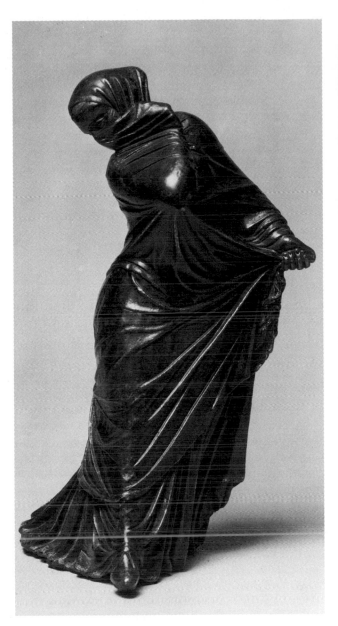

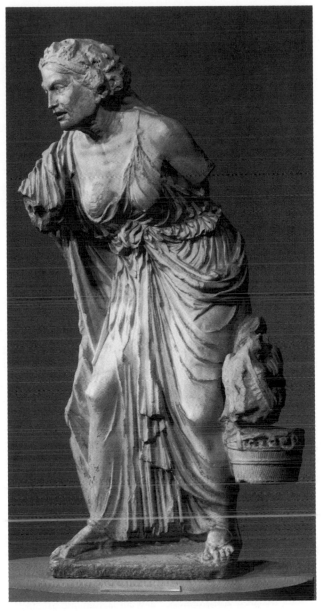

5-81. *Veiled and Masked Dancer*. Late 3rd or 2nd century BCE. Bronze, height 8¹/8" (20.7 cm). The Metropolitan Museum of Art, New York
Bequest of Walter C. Baker, 1971 (1972.118.95)

5-82. *Old Woman*. 2nd century BCE. Marble, height 49¹/2" (125.7 cm). The Metropolitan Museum of Art, New York
Rogers Fund, 1909 (09.39)

sculpted forms, and the contrasting textures of feathers, fabric, and skin typify the finest Hellenistic art.

Although "huge," "enormous," and "larger-than-life" are terms correctly applied to much Hellenistic sculpture, artists of the time also created fine works on a small scale. The grace, dignity, and energy of the 8-foot-tall *Nike of Samothrace* can also be found in a bronze about 8 inches tall (fig. 5-81). This figure of a heavily veiled and masked dancing woman twists sensually under the gauzy, layered fabric in a complex spiral movement. The dancer clearly represents an artful professional performer. Private patrons must have delighted in such intimate works, which were made in large numbers and featured a wide variety of subjects and treatments. This bronze would have been costly, but many such graceful figurines were produced in inexpensive terra-cotta from preshaped

molds and would have been accessible to almost anyone.

The appeal to the emotions in the sculpture signals a social change between the Classical and Hellenistic periods. In contrast to the Classical world, which was characterized by relative cultural unity and social homogeneity, the Hellenistic world was varied and multicultural. In this environment, artists turned from idealism, the quest for perfect form, to realism, the attempt to portray the world as they saw it (see "Realism and Naturalism," page 218). Portraiture, for example, became popular during the Hellenistic period, as did the representation of people from every level of society. Patrons were fascinated by depictions of unusual physical types as well as of ordinary individuals.

A marble statue a little over 4 feet tall of an old woman, once called *Market Woman* (fig. 5-82), may represent more

Is it redundant to say that artists "sought more realistic ways to portray the human figure in painting and sculpture and to place figures in more naturalistic settings"? Are *realistic* and *naturalistic* interchangeable here, or is there a subtle difference in the way the two words are used?

Both *realism* and *naturalism* are defined as the attempt to depict observable things accurately and objectively, even imitatively. Thus, in the passage quoted above, the two words may seem to mean exactly the same thing, but in fact have subtly shaded distinctions that may not be apparent in their dictionary definitions. (Many such words appear in the literature of art history. Those that are used in this book are explained in the text and are defined in the Glossary.)

In the visual arts, *realism* is most often used to describe the representation of people and other living creatures in an accurate, "warts and all" fashion. Detailed portraits of people, as well as pictures of animals or imaginary figures, are often described as "realistic." *Naturalism*, on the other hand, generally refers to the true-to-life depiction of the natural world, including landscape and background elements. Although both terms involve closely observed and accurately depicted representation, they can carry a slightly different meaning depending on their context.

than a peasant woman on her way to the agora with three chickens and a basket of vegetables. Despite the bunched and untidy way the figure's dress hangs, it appears to be of an elegant design and made of fine fabric. Her hair too bears some semblance of a once-careful arrangement. These characteristics, along with the woman's sagging lower jaw, unfocused stare, and lack of concern for her exposed breasts, have led some to speculate that she represents an aging, dissolute follower of the wine god Dionysos on her way to make an offering. Whether an aging peasant or a Dionysian celebrant, the subject of this work is the antithesis of the *Nike of Samothrace*. Yet, in formal terms, both sculpted figures are expressionistic. Both stretch out assertively into the space around them, both demand an emotional response from the viewer, and both display technical virtuosity in the rendering of forms and textures. They are closer to each other stylistically than either is to the *Nike Adjusting Her Sandal* or the *Aphrodite of Knidos* (see figs. 5-50, 5-61).

The Classical Alternative. Not all Hellenistic artists followed the trend toward realism and expressionism that characterized the artists of Pergamon and Rhodes. Some turned to the past, creating an eclectic style by reexamining and borrowing elements from earlier Classical styles and combining them with new elements. Certain popular sculptors, no doubt encouraged by patrons nostalgic for the past, looked back especially to Praxiteles and Lysippos for their models. This renewed interest in the style of the fourth century BCE is exemplified by the *Aphrodite of Melos* (fig. 5-83), found on the island of Melos by French excavators in the early nineteenth century CE. The sculpture was intended by its maker to recall the *Aphrodite* of Praxiteles

(see fig. 5-61), and indeed the head with its dreamy gaze is very Praxitelean. The figure has the heavier proportions of Fifth-Century Classical sculpture, but the twisting stance and the strong projection of the knee are typical of Hellenistic art. The drapery around the lower part of the body also has the rich, three-dimensional quality associated with the Hellenistic sculpture of Rhodes and Pergamon. The juxtaposition of flesh and drapery, which seems about to slip off the figure entirely, adds a note of erotic tension.

The standing male nude also continued to fascinate artists and patrons. The larger-than-lifesize *Hellenistic Ruler* (fig. 5-84, page 220) reflects the heroic figure types favored for official and religious sculpture. The figure recalls the descriptions of Lysippos's *Zeus* and *Alexander the Great.* Certainly the elongated body proportions and small head resemble Lysippos's *The Scraper* (see fig. 5-62). Yet the Hellenistic exaggeration overrides the lingering suggestions of Classical heroism and idealism. The overdeveloped musculature of this figure, the individualized features of the jowly face, and the arrogant pose suggest the unbridled power of an earthly ruler who saw himself as divine.

By the end of the first century BCE, the influence of Greek painting, sculpture, and architecture had spread to the artistic communities of the emerging Roman civilization. Roman patrons and artists maintained their enthusiasm for Greek art into Early Christian and Byzantine times. Indeed, so strong was the urge to emulate the great Greek artists that, as we have seen throughout this chapter, much of our knowledge of Greek achievements comes from Roman replicas of Greek art works and descriptions of Greek art by Roman-era writers.

The Greeks themselves, for all their admiration for works of art, never held artists in high regard. As Plutarch, a Greek commentator of the first century CE,

5-83. *Aphrodite of Melos* (also called *Venus de Milo*). c. 150 BCE. Marble, height 6'10" (2.1 m). Musée du Louvre, Paris

The original appearance of this famous statue's missing arms has been much debated. When it was dug up in a field in 1820, some broken pieces found with it (now lost) indicated that the figure was holding out an apple in its right hand. Many judged these fragments to be part of a later restoration, not part of the original statue. Another theory is that Aphrodite was admiring herself in the highly polished shield of the war god Ares, an image that was popular in the second century BCE. This theoretical "restoration" would explain the pronounced **S**-curve of the pose and the otherwise unnatural forward projection of the knee.

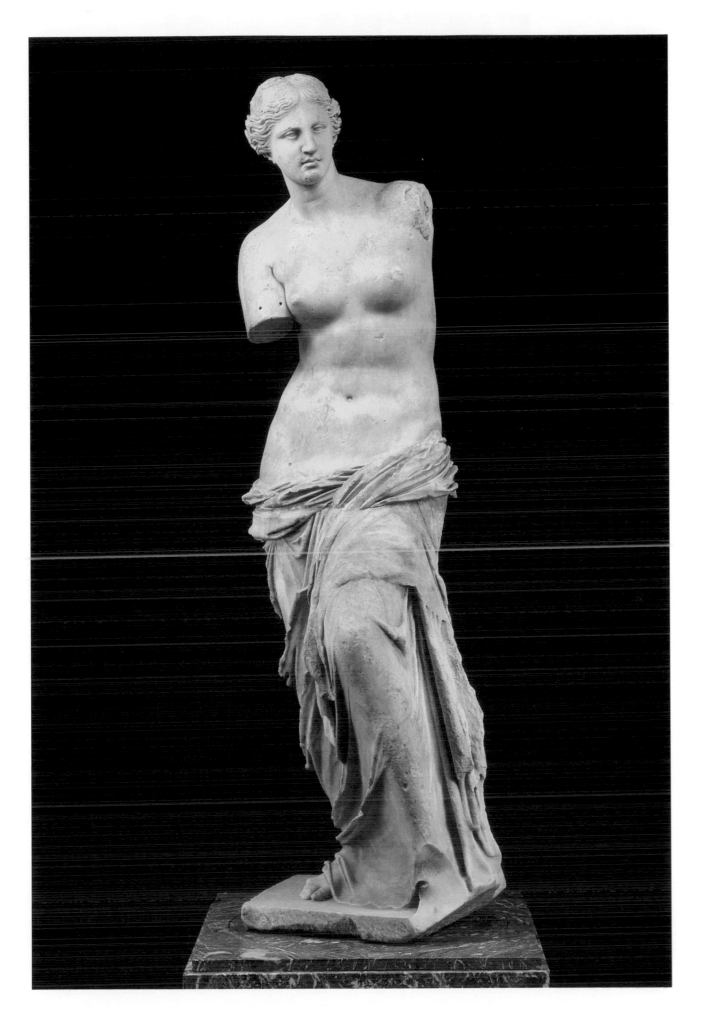

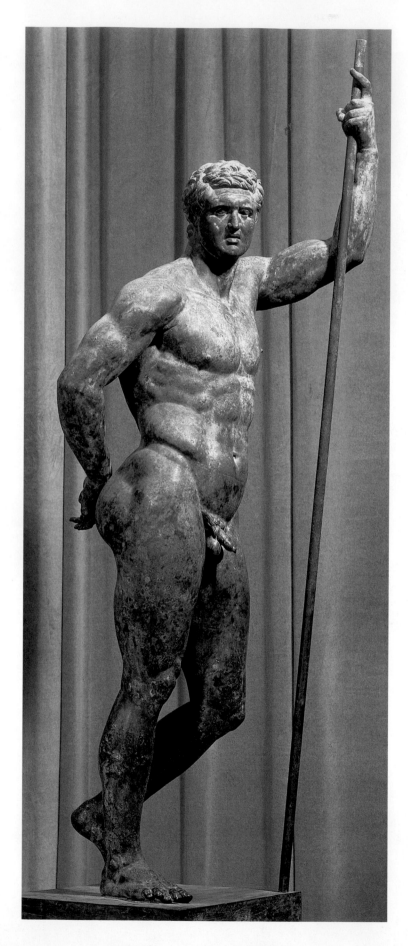

5-84. *Hellenistic Ruler*. c. 150–140 BCE. Bronze, height 7'9" (2.37 m). Museo Nazionale Romano, Rome

wrote: "No gifted young man, upon seeing the Zeus of Pheidias at Olympia, ever wanted to be Pheidias nor, upon seeing the Hera at Argos, ever wanted to be Polykleitos. . . . For it does not necessarily follow that, if a work is delightful because of its gracefulness, the man who made it is worthy of our serious regard" (quoted in Pollitt, page 227). Sculptors and painters, for all their genius, could not aspire to the status we accord them today.

PARALLELS

PERIOD	ART IN ANCIENT GREECE	ART IN OTHER CULTURES
GEOMETRIC c. 900–700 BCE	5-4. *Centaur* (10th cent.) 5-5. Dipylon vase (c. 750) 5-6. *Man and Centaur* (c. 750)	12-2. Olmec pyramids (900–600), Mesoamerica 12-3. Olmec head (900–500), Mesoamerica
ORIENTALIZING c. 700–600 BCE	5-8. Corinthian pitcher (c. 600)	
ARCHAIC c. 600–480 BCE	5-11. Temple of Artemis, Korkyra (c. 600–580) 5-9. Hera I, Paestum (c. 550) 5-13. Siphnian Treasury, Delphi (c. 530–525) 5-17. *New York Kouros* (c. 580) 5-24. *François Vase* (c. 570) 5-26. Exekias. *The Suicide of Ajax* (c. 540) 5-28. Euxitheos and Euphronius. *Death of Sarpedon* (c. 515) 5-16. *Dying Warrior* (c. 480)	6-5. *Apollo* from Veii (c. 500), Tuscany 6-1. *She-Wolf* (c. 500–480), Tuscany 2-29. Persepolis Apadana (518–460), Iran 13-3. Nok head (c. 500 BCE–200 CE), Africa
TRANSITIONAL, OR EARLY CLASSICAL c. 480–450 BCE	5-33. *Kritian Boy* (c. 480) 5-34. *Charioteer* (c. 477) 5-30. Temple of Zeus, Olympia (c. 470–456) 5-36. Pan Painter. *Artemis Slaying Actaeon* (c. 470) 5-31. *Apollo with Battling Lapiths and Centaurs* (c. 460) 5-35. *Warrior A* (c. 460–450)	
FIFTH-CENTURY CLASSICAL c. 450–400 BCE	5-1. Myron. *Discus Thrower* (c. 450) 5-51. Polykleitos. *Spear Bearer* (c. 450–440) 5-39. Kallikrates and Iktinos. Parthenon (447–438), friezes (c. 438–432) 5-47. Mnesikles. Erechtheion (430s–405) 5-50. *Nike Adjusting Her Sandal* (last quarter 5th cent.)	
FOURTH-CENTURY CLASSICAL c. 400–320 BCE	5-57. Mausoleum, Halikarnassos (c. 353) 5-61. Praxiteles. *Aphrodite of Knidos* (c. 350) 5-62. Lysippos. *The Scraper* (c. 330) 5-63. *Alexander the Great* (copy c. 200) 5-65. Tomb II facade (2nd half of 4th cent.) 5-67. *Alexander the Great Confronts Darius III at the Battle of Issos* (c. 310)	2-31. Daric coin (4th cent.), Persia
HELLENISTIC c. 320–30 BCE	5-71. Epidauros theater (early 3rd cent.) 5-75. *Dying Gallic Trumpeter* (c. 220) 5-80. *Nike of Samothrace* (c. 190?) 5-77. Pergamon altar (c. 166–156) 5-79. *Laocoön and His Sons* (2nd or 1st cent.) 5-83. *Aphrodite of Melos* (c. 150)	9-8. Sanchi stupa (3rd cent.), India 9-1. Ashokan pillar (c. 246), India 10-1. Qin soldiers (c. 210), China 12-16. Nazca earth drawing (200 BCE–200 CE), Peru 6-18. *Aulus Metellus* (late 2nd cent.), Rome 6-22. *Ara Pacis* (copy c. 1st cent.), Rome 6-62. *Initiation Rites of the Cult of Bacchus* (c. 50), Rome

6-1. *She-Wolf.* c. 500 BCE. Bronze, glass-paste eyes, height 33¹⁄₂" (85 cm). Museo Capitolino, Rome

6
Etruscan Art and Roman Art

A ferocious she-wolf turns toward us with a vicious snarl. Her tense body, thin flanks, and protruding ribs contrast with her heavy, milk-filled teats. Incongruously, she suckles two active, chubby little boys. We are looking at the most famous symbol of Rome, the legendary wolf who nourished and saved the city's founder, Romulus, and his twin brother, Remus (fig. 6-1). According to a Roman legend, the twin sons of the god Mars and a mortal woman were left to die on the banks of the Tiber River by their wicked uncle. A she-wolf discovered the infants and nursed them in place of her own pups; the twins were later raised by a shepherd. When they reached adulthood, the twins decided to build a city near the spot where the wolf had rescued them, according to tradition, in the year 753 BCE.

This composite sculptural group of wolf and boys suggests the complexities of art history on the Italian peninsula. An early people called Etruscans created the bronze wolf about 500 BCE, and Romans added the sculpture of children to it in the late fifteenth or early six-teenth century CE. This figure is thus a fitting image for the way that the themes and styles of the Etruscans and the later Romans combined.

We know that a statue of a wolf—and sometimes even a live wolf in a cage—stood on the Capitoline Hill, the governmental and religious center of ancient Rome. But whether the wolf in figure 6-1 is the same sculpture that Romans saw then is far from certain. According to tradition, the original bronze wolf was struck by light-ning and buried. The documented history of this *She-Wolf* begins in the tenth century CE, when it was rediscovered and placed outside the Lateran Palace, the home of the pope. At that time, statues of two small men stood under the wolf, personifying the alliance between the Romans and their former enemies from central Italy, the Sabines. But in the later Middle Ages, people mistook the figures for children and identified the sculpture with the founding of Rome. During the Renaissance, Romans wanted more specific imagery and added the twins we see here. Pope Sixtus IV (papacy after 1471 CE) had the sculpture moved from his palace to the Capitoline Hill; today, the *She-Wolf* maintains her wary pose in a museum there.

TIMELINE 6-1. **The Etruscan and Roman Worlds.** The Etruscans controlled the Italian peninsula until the Romans defeated them in 509 BCE. Roman kings unified Italy during their nearly 500-year reign. The emperors, beginning with Augustus in 27 BCE, first expanded the Roman Empire until it extended to Britain, then saw it contract until it weakened and was permanently split in 395 CE.

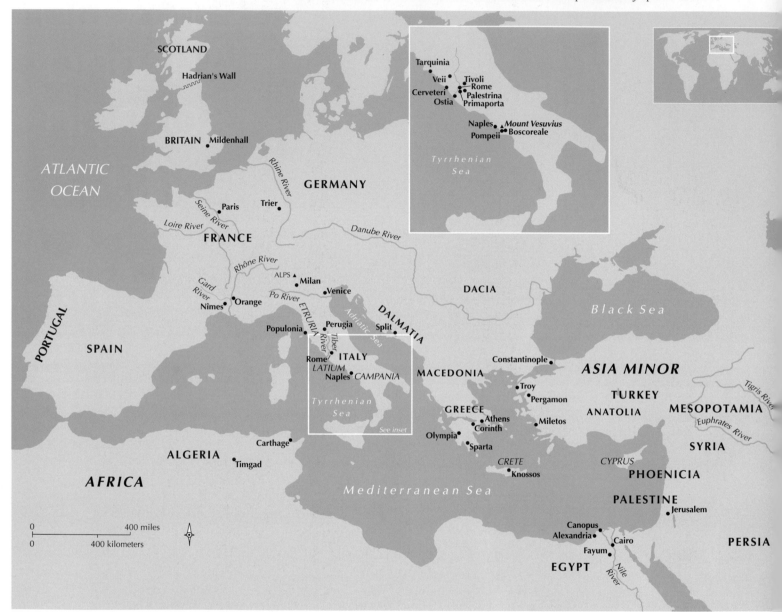

ETRUSCAN CIVILIZATION

The boot-shaped Italian peninsula, shielded to the north by the Alps, juts into the Mediterranean Sea. At the end of the Bronze Age (about 1000 BCE), a central European people known as the Villanovans occupied the northern and western regions of Italy, and central Italy was home to a variety of people who spoke a closely related group of Italic languages, Latin among them. Beginning about 750 BCE, Greeks too established colonies in Italy and in Sicily. Between the seventh and sixth century BCE, the people known as the Etruscans, probably related to the Villanovans, gained control of northern and much of central Italy, an area known as Etruria (modern Tuscany).

The Etruscans' wealth came from Etruria's fertile soil and abundance of metal ore. Noted as both farmers and metalworkers, the Etruscans were also sailors and merchants, and they exploited their resources in trade with the Greeks and with the people of Phoenicia (modern Lebanon). Although Etruscan artists knew and drew inspiration from Greek and Near Eastern sources, they never slavishly copied what they admired. Instead, they assimilated these influences and created a distinctive Etruscan style. Organized into a loose federation of a dozen cities, the Etruscans reached the height of their power in the sixth century BCE, when they expanded into the Po River valley to the north and the Campania region to the south.

▲ C. 27 BCE–395 CE ROMAN EMPIRE

MAP 6-1. (opposite)
The Roman Republic and Empire. After defeating the Etruscans in 509 BCE, Rome became a republic. It reached its greatest area by the time of Julius Caesar's death in 46 BCE. The Roman Empire began in 27 BCE, extended its borders from the Euphrates River to Scotland under Trajan in 106 CE, but was permanently split into the Eastern and Western Empires in 395 CE.

6-2. Porta Augusta, Perugia, Italy. 2nd century BCE

At the same time, the Latin-speaking inhabitants of Rome began to develop into a formidable power. For a time, kings of Etruscan lineage ruled them, but in 509 BCE the dynamic Romans overthrew the kings and formed a republic at Rome (Timeline 6-1). The Etruscans' power was in decline by the fifth century BCE, and they were absorbed by the Roman Republic at the end of the third century BCE, by which time the Romans had steadily expanded their realm in many directions. They had unified Italy and, after defeating Carthage, their rival in the western Mediterranean, had established an empire that encompassed the entire Mediterranean region (Map 6-1).

THE ETRUSCAN CITY

The Etruscan city was laid out on a grid plan, like cities in Egypt and Greece but with a difference. Two main streets—one usually running north-south and the other east-west—divided the city into quarters. The intersection of these streets was the town's business center. Because the Etruscans created house-shaped funerary urns and also decorated the interiors of tombs to resemble houses, we know that within these quadrants their houses were built around a central courtyard (or **atrium**) open to the sky with a shallow pool fed by rainwater.

Walls with protective gates and towers surrounded the cities. As a city's population grew, its boundaries expanded and building lots were added as needed outside the walls. The second-century BCE city gate of Perugia, called the Porta Augusta, is one of the few surviving examples of Etruscan monumental architecture (fig. 6-2). A tunnel-like passageway between two huge towers, this gate is significant for anticipating the Romans' use of the

round arch, which is here extended to create a semi-circular **barrel vault** over the passageway.

The round arch was not an Etruscan or Roman invention—ancient Near Eastern, Egyptian, and Greek builders had been familiar with it—but the Etruscans and Romans were the first to make widespread use of it (see "Arch, Vault, and Dome," page 228). Unlike the **corbel arch**, in which overhanging **courses** of masonry meet at the top, the round arch is formed by precisely cut, wedge-shaped stone blocks called *voussoirs*. In the Porta Augusta, a square frame surmounted by a horizontal decorative element resembling an **entablature** sets off the arch, which consists of a double row of *voussoirs*. The decorative section is lined with a row of circular panels, or **roundels**, alternating with rectangular, columnlike uprights called **pilasters**. The effect is reminiscent of the **triglyphs** and **metopes** of a Greek Doric frieze.

TEMPLES AND THEIR DECORATION

From early on, the Etruscans incorporated Greek deities and heroes into their pantheon. They also may have adapted from ancient Mesopotamians the use of divination to predict future events. Beyond this and their burial practices (revealed by the findings in their tombs, discussed below), we know little about their religious beliefs. Only a few foundations of Etruscan temples remain. Knowledge of the temples' appearance comes from ceramic **votive** models and from the writings of the Roman architect Vitruvius, who sometime between 46 and 39 BCE compiled descriptions of Etruscan and Roman architecture (see "Roman Writers on Art," page 229). His account indicates that Etruscan temples (fig. 6-3) were built on a platform called a **podium** and had a single flight of steps leading up to a front porch from a courtyard or open city square. Columns and an entablature supported the section of roof that projected over the porch. The ground plan was almost square and was divided equally between porch and interior space (fig. 6-4). Often, as in figure 6-4, the interior space was separated into three rooms that probably housed cult statues.

Etruscans built their temples with mud-brick walls. The columns and entablatures were made of wood or a quarried volcanic rock called tufa, which hardens upon exposure to the air. The columns' bases, shafts (which were sometimes fluted), and capitals could resemble those of either the Greek Doric or the Greek Ionic orders, and the entablature might have a frieze resembling that of the Doric order (not seen in the model). Vitruvius used the term *Tuscan order* for the variation that resembled the Doric order, with an unfluted shaft and a simplified base, capital, and entablature (see "Roman Architectural Orders," page 229). Although Etruscan temples were simple in form, they were embellished with dazzling displays of painting and terra-cotta sculpture. The temple roof, rather than the pediment, served as a base for large statue groups.

Etruscan artists excelled at making huge terra-cotta figures, a task of great technical difficulty. A splendid example is a lifesize figure of Apollo (fig. 6-5). Dating

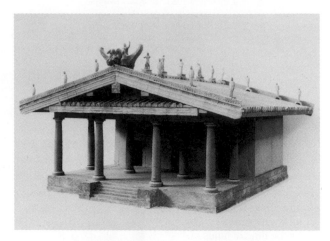

6-3. Reconstruction of an Etruscan temple, based on descriptions by Vitruvius. University of Rome, Istituto di Etruscologia e Antichità Italiche

0 40 ft

12 m

6-4. Plan of an Etruscan temple, based on descriptions by Vitruvius

from about 500 BCE and originally part of a four-figure scene depicting one of the labors of Hercules (Greek Herakles), the figure comes from the temple at Veii. The four figures depicted Apollo and Hercules fighting for possession of a deer sacred to Diana, while she and Mercury looked on (see "Greek and Roman Deities and Heroes," page 158). Apollo is shown striding as if he had just stepped over the decorative scrolled element that helps support the sculpture. The representation of the god chasing Hercules along the **ridgepole** of the temple roof defies the logical relationship of sculpture to architecture seen in Greek pedimental and frieze sculpture. The Etruscans seemed willing to sacrifice structural logic for lively action in their art.

The well-developed body and the **Archaic smile** of the *Apollo* from Veii clearly demonstrate that Etruscan sculptors were familiar with Greek Archaic *kouroi*. Despite those similarities, a comparison of the *Apollo* and

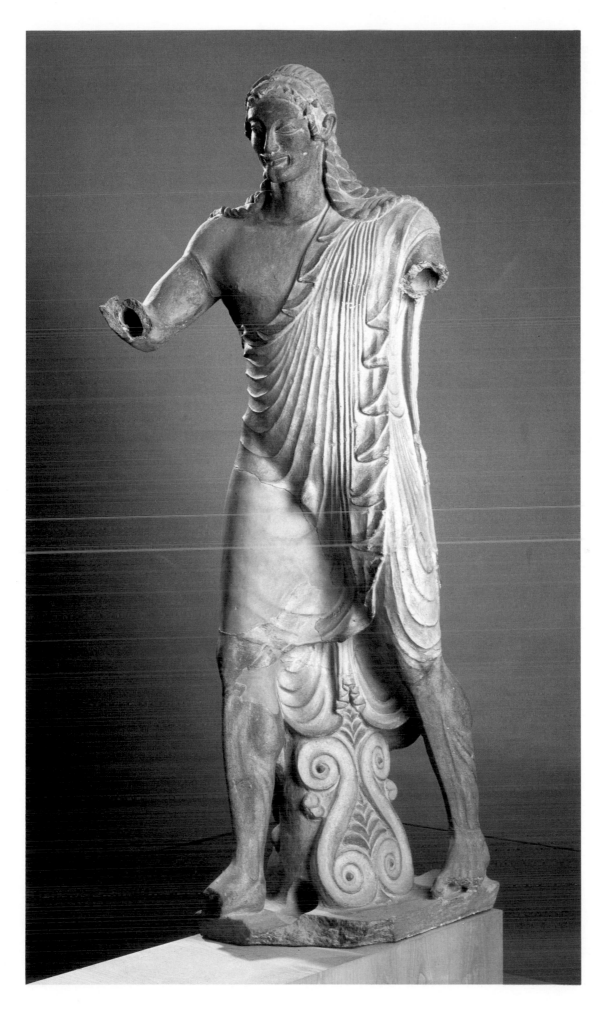

6-5. *Apollo*, from Veii. c. 500 BCE. Painted terra-cotta, height 5'10" (1.8 m). Museo Nazionale di Villa Giulia, Rome

This lifesize figure is made of terra-cotta ("baked clay"), the same material used for pottery containers. Making and firing a large clay sculpture such as this one requires great technical skill. The artist must know how to construct the figure so that it does not collapse under its own weight while the clay is still wet and must know how to precisely regulate the temperature in a large kiln for a long period of time. Etruscan terra-cotta artists must have been well known, for some of their names have come down to us, including that of a sculptor from Veii called Vulca, in whose workshop this *Apollo* may have been created.

ELEMENTS OF ARCHITECTURE

Arch, Vault, and Dome

The first true arch used in Western architecture is the round arch. When extended, the round arch becomes a barrel vault. The round arch and barrel vault were known and were put to limited use by Mesopotamians and Egyptians long before the Etruscans began their experiments. But it was the Romans who realized the potential strength and versatility of these architectural features and exploited them to the fullest degree.

The **round arch** displaces most of the weight, or downward thrust (see arrows on diagrams), of the masonry above it to its curving sides and transmits that weight to the supporting uprights (door or window **jambs**, **columns**, or **piers**), and from there to the ground. Arches may require added support, called **buttressing**, from adjacent masonry elements. Brick or cut-stone arches are formed by fitting together wedge-shaped pieces, called **voussoirs**, until they meet and are locked together at the top center by the final piece, called the **keystone**. Until the mortar between the bricks or stones dries, an arch is held in place by wooden scaffolding, called **centering**. The inside surface of the arch is called the *intrados*, the outside curve of the arch the *extrados*. The points from which the curves of the arch rise, called **springings**, are often reinforced by masonry **imposts**. The wall areas adjacent to the curves of the arch are **spandrels**. In a succession of arches, called an **arcade**, the space encompassed by each arch and its supports is called a **bay**.

The **barrel vault** is constructed in the same manner as the round arch. The outside pressure exerted by the curving sides of the barrel vault requires buttressing within or outside the supporting walls. When two barrel-vaulted spaces intersect each other at the same level, the result is a **groin vault**, or **cross vault**. The Romans used the groin vault to construct some of their grandest interior spaces, and they made the round arch the basis for their great freestanding **triumphal arches**.

A third type of vault brought to technical perfection by the Romans is the hemispheric **dome**. The rim of the dome is supported on a circular wall, as in the Pantheon (see figs. 6-35, 6-36). This wall is called a **drum** when it is raised on top of a main structure. Sometimes a circular opening, called an **oculus**, is left at the top.

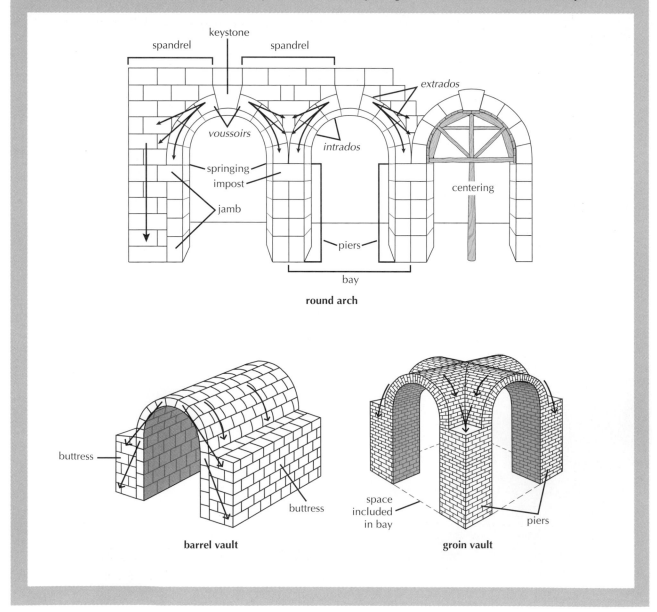

round arch

barrel vault

groin vault

ROMAN WRITERS ON ART

Only one book specifically on architecture and the arts survives from antiquity—all our other written sources consist of digressions and insertions in works on other subjects. That one book, Vitruvius's *Ten Books of Architecture*, written for Augustus in the first century CE, is a practical handbook for builders that discusses such things as laying out cities, siting buildings, and using the Greek architectural orders. Vitruvius argued for appropriateness and rationality in architecture, and his definition of Greek architectural terms is invaluable. Vitruvius also made significant contributions to art theory, including studies on proportion.

Pliny the Elder (c. 23–79 CE) wrote a vast encyclopedia of "facts, histories, and observations," known as *Naturalis Historia* (*The Natural History*). He often included discussions of art and architecture, and he used works of art to make his points—for example, sculpture to illustrate essays on stones and metals. Pliny's scientific turn of mind led to his death, for he was overcome while observing the eruption of Mount Vesuvius, the same eruption that buried Pompeii. His nephew Pliny the Younger (c. 61–113 CE), a voluminous letter writer, added to our knowledge of Roman domestic architecture with his meticulous description of villas and gardens.

Valuable bits of information can also be found in books by travelers and historians. Pausanias, a second-century CE Greek traveler, wrote descriptions of Greece that are basic sources on Greek art and artists. Flavius Josephus (c. 37–100 CE), a historian of the Flavians, wrote in his *Jewish Wars* a description of the triumph of Titus that includes a description of the treasures looted from the Temple of Solomon in Jerusalem (see fig. 6-38).

As an **iconographical** resource, *Metamorphoses* by the poet Ovid (43 BCE–17 CE) provided themes for artists in his own time and ever since. Ovid recorded Greek and Roman myths, stories of interactions between gods and mortals, and amazing transformations (metamorphoses)—for example, Daphne turning into a laurel tree to escape Apollo. Ovid is best known for his love poetry; his last book, *Ars Amatoria* (*The Art of Seduction*), may have caused his downfall. In any event, Augustus banished him from Rome in 8 CE.

For anyone interested in the theoretical basis of art, a knowledge of the philosopher Plotinus (c. 205–70 CE) is essential. In the *Enneads*, he discussed the relationship of *phantasia* (imagination and intuition) and *mimesis* (imitation of the natural world) in the creation of art. His emphasis on imagination and intuition and his theory of hierarchies leading from dull matter to the ultimate and immaterial, understood in aesthetic terms as pure light and color, had a profound influence on art theory.

Perhaps the best-known—and most pungent—comments on art and artists remain those of the Greek writer Plutarch (c. 46–after 119 CE), who opined that one may admire the art but not the artist, and the Roman poet Virgil (70–19 BCE), who in the *Aeneid* wrote that the Greeks practice the arts, but it is the role of Romans to rule, for their skill lies in government, not art.

ELEMENTS OF ARCHITECTURE

Roman Architectural Orders

The Etruscans and Romans adapted Greek architectural orders to their own tastes and uses (see "The Greek Architectural Orders," page 164).

The Etruscans modified the Greek Doric order by adding a base to the column. The Romans derived the sturdy, unfluted **Tuscan order** from the Greek Doric order by way of Etruscan models. They created the **Composite order** by incorporating the volute motif of the Greek Ionic capital with other forms from the Greek Corinthian. In this diagram, the two Roman orders are shown on **pedestals**, which consist of a **plinth**, a **dado**, and a **cornice**.

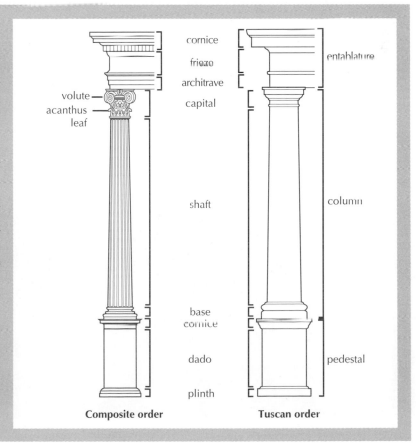

Composite order **Tuscan order**

6-6. Etruscan cemetery of La Banditaccia, Cerveteri.
7th–4th century BCE

the nearly contemporary Greek *Anavysos Kouros* (see fig. 5-18) reveals telling differences. Unlike the Greek figure, the body of the Etruscan *Apollo* is partially concealed by a robe that cascades in knife-edged pleats to his knees. The forward-moving pose of the Etruscan statue also has a vigor that is only hinted at in the balanced stance of the Greek figure. This implied energy expressed in purposeful movement is characteristic of both Etruscan sculpture and Etruscan tomb painting.

TOMBS

Etruscan beliefs about the afterlife may have been somewhat similar to those of the Egyptians. Unlike the Egyptians, however, the Etruscans favored cremation; nevertheless, they clearly thought of tombs as homes for the dead. The Etruscan cemetery of La Banditaccia at Cerveteri (fig. 6-6) was laid out like a small town, with "streets" running between the grave mounds. The tomb chambers were partially or entirely excavated below the ground, and some were hewn out of bedrock. They were roofed over, sometimes with corbel vaulting, and covered with dirt and stones.

Some tombs were carved out of the rock to resemble rooms in a house. The Tomb of the Reliefs, for example, has a flat ceiling supported by square, stone posts (fig. 6-7). Its walls were plastered and painted, and it was fully furnished. Couches were carved from stone, but most of the furnishings were simulated in **stucco**, a slow-drying type of plaster that can be easily molded and carved. Pots, jugs, robes, axes, and other items were carved into the posts to look like real objects hanging on hooks. Rendered in **low relief** at the bottom of the post just left of center is the family dog. As these details suggest, the Etruscans made every effort to provide earthly comforts for their dead, but tomb decorations also sometimes

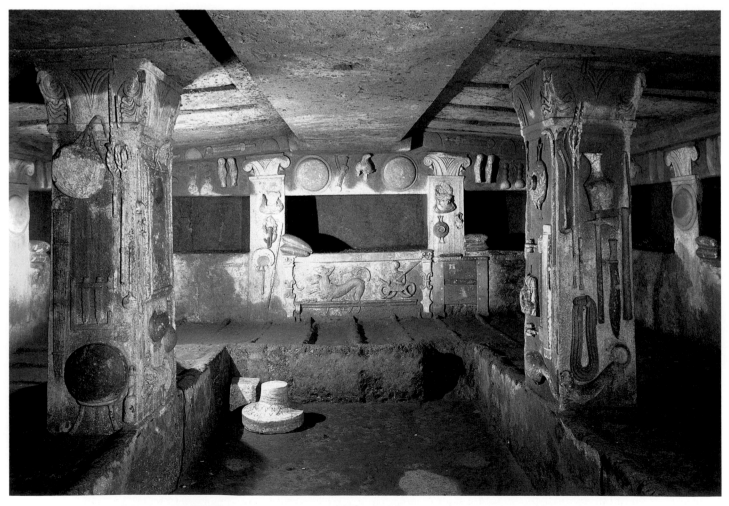

6-7. Burial chamber, Tomb of the Reliefs, Cerveteri. 3rd century BCE

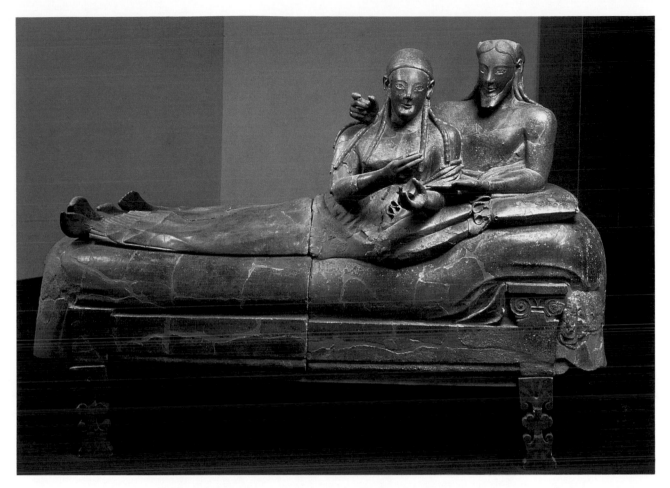

6-8. Sarcophagus, from Cerveteri. c. 520 BCE. Terra-cotta, length 6'7" (2.06 m). Museo Nazionale di Villa Giulia, Rome

included frightening creatures from Etruscan mythology. On the back wall of the Tomb of the Reliefs is another kind of dog—a beast with many heads—that probably represents Cerberus, the guardian of the gates of the underworld, an appropriate funerary image.

Sarcophagi, or coffins, often made entirely of terra-cotta, also might have provided a domestic touch. In an example from Cerveteri, about 520 BCE (fig. 6-8), a husband and wife are shown reclining comfortably on a couch. Rather than seeing a somber memorial to the dead, we find two lively, happy individuals rendered in sufficient detail to convey current hair and clothing styles. These genial hosts, with their smooth conventionalized body forms and faces, their uptilted, almond-shaped eyes, and their benign smiles, gesture as if to communicate something important to the living viewer—perhaps an invitation to dine with them for eternity. Portrait coffins like this one evolved from earlier terra-cotta cinerary jars with sculpted heads of the dead person whose ashes they held.

Brightly colored paintings of convivial scenes of feasting, dancing, musical performances, athletic contests, hunting, fishing, and other pleasures often decorated tomb walls. Many of these murals are faded and flaking, but those in the tombs at Tarquinia are well preserved. In a detail of a painted frieze in the Tomb of the Lionesses, from about 480–470 BCE, a young man and woman engage in an energetic dance to the music of a

double flute (fig. 6-9, page 232). These and other figures are grouped around the walls within a carefully arranged setting of stylized trees, birds, fish, animals, and architectural elements. Unlike Greek tomb paintings, women are portrayed as active participants. The Etruscan painters had a remarkable ability to suggest that their subjects inhabit a bright, tangible world just beyond the tomb walls. Rather than enacting the formal rituals of death, the dancers and musicians are performing exuberantly.

BRONZE WORK

The skill of Etruscan bronze workers was widely acknowledged in ancient times. Especially impressive are the few examples of large-scale **sculpture in the round** that survived the wholesale recycling of bronze objects over the centuries. One of these bronzes portrays a female wolf (see fig. 6-1). The animal is at the same time ferocious and an object of sympathy. The naturalistic rendering of her body contrasts with the decorative, stylized rendering of the tightly curled molded and incised ruff of fur around her neck and along her spine. The glass-paste eyes that add so much to the dynamism of the figure were inserted after the sculpture was finished.

After Etruria fell to Rome, the work of Etruscan artists continued to be held in high regard by Roman patrons. Etruscan bronze workers and other artists went to work for the Romans, often making the distinction

6-9. *Musicians and Dancers*, detail of a wall painting, Tomb of the Lionesses, Tarquinia. c. 480–470 BCE

between Etruscan and early Roman art moot. A head that was once part of a bronze statue of a man may be an example of an important Roman commission (fig. 6-10). Often alleged to be a portrait of Lucius Junius Brutus, the founder (in 509 BCE) and first consul of the Roman Republic, the head traditionally has been dated about 300 BCE, long after Brutus's death. Although it may represent an unknown Roman dignitary of the day, it could also be an imaginary portrait of the ancient hero. The rendering of the strong, broad face with its heavy brows, firmly set lips, and wide-open eyes (made of painted ivory) is scrupulously detailed. The sculptor seems also to have sought to convey the psychological complexity of the subject, showing him as a somewhat world-weary man who nevertheless projects strong character and great strength of purpose.

Etruscan bronze workers also created small items for either funerary or domestic use, such as a bronze

mirror from about 350 BCE (fig. 6-11). The subject of the decoration engraved on the back is a winged man, identified by the inscription as the Greek priest Calchas, who accompanied the Greek army under Agamemnon to Troy (see "The Trojan War," page 144). According to Homer, the Greeks consulted Calchas when they were uncertain about the gods' will or how to secure their favor in the war. Greeks, Etruscans, and Romans all believed that the appearance of animal entrails could reveal the future, and here Calchas is shown bending over a table, intently studying the liver of a sacrificed animal. The engraving may refer to an incident in which Calchas, called upon to determine why the Greek fleet had been left becalmed on its way to Troy, told Agamemnon that he had to sacrifice his daughter Iphigenia. According to another legend, Calchas retired after the war to his vineyards, where he died laughing,

6-10. Head of a man. C. 300 BCE. Bronze, eyes of painted ivory, height 12½" (31.8 cm). Palazzo dei Conservatori, Rome

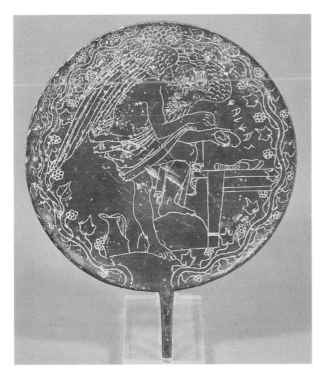

6-11. Mirror. C. 350 BCE. Engraved bronze, diameter 6" (15.3 cm). Musei Vaticani, Museo Gregoriano Etrusco, Rome

The back of this mirror depicts an Etruscan method of predicting the future from the appearance of the entrails and organs, especially the liver, of sacrificed animals. Diviners (prophets) not only would interpret what they saw in the entrails as good or bad omens but also would suggest a course of action.

and so fulfilled the prophecy that he would not live to drink his own wine. Perhaps alluding to this story, the artist has shown Calchas surrounded by grapevines and with a jug at his feet. The complex pose, the naturalistic suggestions of a rocky setting, and the pull and twist of drapery that emphasizes the figure's three-dimensionality convey a sense of realism.

ROMAN HISTORY

After the formation of the Roman Republic in 509 BCE, the Romans expanded the borders of their realm through near-continuous warfare. At its greatest extent, in the early second century CE, the Roman Empire reached from the Euphrates River in southwest Asia to Scotland. The vast territory ringed the Mediterranean Sea—*mare nostrum*, or "our sea," the Romans called it. As the Romans absorbed the peoples they conquered, they imposed on them a legal, administrative, and cultural structure that endured for some five centuries—in the eastern Mediterranean until the fifteenth century CE—and left a lasting mark on the civilizations that emerged in Europe.

These conquering peoples saw themselves, not surprisingly, in heroic terms and attributed heroic origins to their ancestors. According to one popular legend rendered in epic verse by the poet Virgil (70–19 BCE) in the *Aeneid*, the Roman people were the offspring of Aeneas, a Trojan who was the mortal son of the goddess Venus. Thanks to his mother's intervention with Jupiter, Aeneas and some companions escaped from burning Troy and made their way to Italy. There they settled at the mouth of the Tiber. Their sons were the Romans, the people who in fulfillment of a promise by Jupiter to Venus were destined to rule the world. Another popular legend told the story of Rome's founding by Romulus and Remus, the twin sons of Mars, the god of war (see fig. 6-1).

Archaeologists and historians have developed a more mundane picture of Rome's origins. In Neolithic times, groups of people who spoke a common language—Latin—settled in permanent villages on the plains of Latium, south of the Tiber River, as well as on the Palatine, one of the seven hills that would eventually become Rome. These first settlements were little more than clusters of small, round huts, but by the sixth century BCE Rome had developed into a major transportation hub and trading center.

Early Rome was governed by kings and an advisory body of leading citizens called the Senate. The population fell into two classes: a wealthy and powerful upper class, the patricians, and a lower class, the plebeians. The last kings of Rome were members of an Etruscan family, the Tarquins. In 509 BCE, Roman aristocrats overthrew the last Tarquin king and began the Roman Republic, which was to last about 450 years as an oligarchy, or government by the few. By the Republican period, nearly a million people lived in Rome.

During the fifth century BCE, through alliance and conquest, Rome began to incorporate neighboring territories in Italy, and by 275 BCE Rome controlled the entire Italian peninsula. Then, after more than a century of conflict

REIGNS OF SIGNIFICANT ROMAN EMPERORS

Dynasty	Emperor	Reign
	Augustus	27 BCE–14 CE
Julio-Claudian	Tiberius	14–37 CE
	Caligula	37–41
	Claudius	41–54
	Nero	54–68
Flavian	Vespasian	69–79
	Titus	79–81
	Domitian	81–96
The "Five Good Emperors"	Nerva	96–98
	Trajan	98–117
	Hadrian	117–138
Antonine	Antoninus Pius	138–161
	Marcus Aurelius	161–180
	Commodus	180–192
Severan	Septimius Severus	193–211
	Caracalla	211–217
	Severus Alexander	222–235
	Diocletian	284–305
	Constantine I	306–337

DISTINCTIVELY ROMAN GODS

Chapter 5 (page 158) gives a comprehensive list of Greek gods and their Roman counterparts. The Romans, however, honored some deities that were not found in Greece. They include:

Fortuna	goddess of fate (fortune)
Priapus	god of fertility
Saturn	god of harvests
Janus	god of beginnings and endings; has two faces, enabling him to look forward and backward
Pomona	goddess of gardens and orchards
Terminus	god of boundaries

known as the Punic Wars (264–146 BCE), the Romans defeated the Carthaginians, destroying Carthage, the Phoenician city on the north coast of Africa, and gaining control of the western Mediterranean. By the mid-second century BCE, they had taken Macedonia and Greece, and by 44 BCE they had conquered most of Gaul (modern France) as well as the eastern Mediterranean (see Map 6-1).

During this period of expansion, Rome changed from an essentially agricultural society to a commercial and political power. In 46 BCE, the Roman general Julius Caesar emerged victorious over his rivals, assumed autocratic powers, and ruled Rome until his assassination in 44 BCE. The conflicts that followed Caesar's death ended within a few years with the unquestioned control of his grandnephew and heir, Octavian, over Rome and all its possessions.

Although Octavian continued the forms of Republican government, he retained real authority for himself. In 27 BCE, he was granted the title "Augustus," which came to mean "supreme ruler" (and by which we will now call him); he is known to history as the first emperor of Rome (see "Reigns of Significant Roman Emperors," left). The Augustan era was firmly grounded in the Roman Republic and at the same time introduced a new style that established Roman imperial art. Assisted by his astute and pragmatic second wife, Livia, Augustus proved to be an incomparable administrator. He brought opposing factions under his control and established efficient rule throughout the empire. In 12 CE, he was given the title "Pontifex Maximus" ("High Priest") and so became the empire's highest religious official as well as political leader. During his lifetime, Augustus laid the foundation for an extended period of stability, internal peace, and economic prosperity known as the *Pax Romana* ("Roman Peace"), which lasted nearly 200 years. After his death in 14 CE, the Senate ordered Augustus to be venerated as a god.

Augustus's successor was his stepson Tiberius, and in acknowledgment of the lineage of both—Augustus from *Julius* Caesar and Tiberius from his father, Tiberius *Claudius* Nero, Livia's first husband—the dynasty is known as the Julio-Claudian (14–68 CE). Although the family produced some capable administrators, the times were marked by suspicion, intrigue, and terror in Rome. The dynasty ended with the reign of the despotic, capricious, and art-loving Nero. A brief period of civil war followed Nero's death in 68 CE, until an astute general, Vespasian, seized control of the government. This Flavian dynasty ruled from 69 to 96 CE. The Flavians restored the imperial finances and stabilized the empire's frontiers, but during the autocratic reign of the last Flavian, Domitian, intrigue and terror returned to the capital.

Five very competent rulers, known as the Five Good Emperors, succeeded the Flavians and oversaw a long period of stability and prosperity between 96 CE and 180 CE. Instead of depending on the vagaries of fate (or genetics) to produce intelligent heirs, each emperor selected an able administrator to follow him and "adopted" his successor. Italy and the provinces flourished equally, and official and private patronage of the arts increased. Under Trajan, the empire reached its greatest extent, when he conquered Dacia (roughly modern Romania) in 106 CE (see Map 6-1). Hadrian then consolidated the empire's borders and imposed far-reaching social, administrative, and military reforms. Hadrian was well educated and widely traveled, and his admiration for Greek culture spurred new building programs and art patronage throughout the empire.

Conquering and maintaining a vast empire required not only inspired leadership and tactics but also careful planning, massive logistical support, and great administrative skill. Some of Rome's most enduring contributions to Western civilization—its system of law, its governmental and administrative structures, and its sophisticated civil engineering and architecture—reflect these qualities.

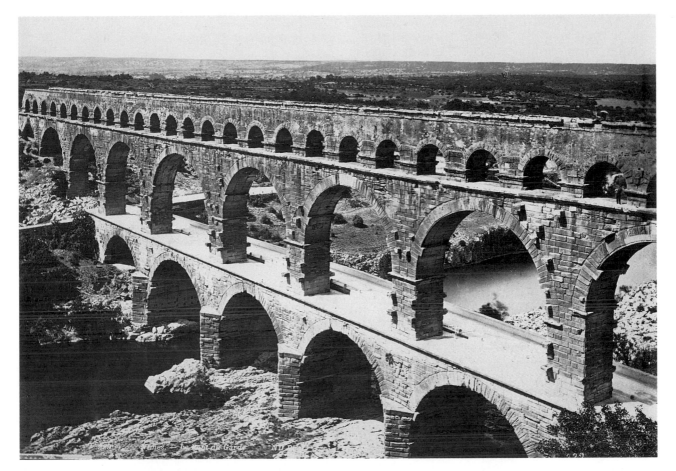

6-12. Pont du Gard, Nîmes, France. Late 1st century BCE

The 900-foot span rising 180 feet above the Gard River was originally an aqueduct that brought water from springs 30 miles to the north, providing 100 gallons of water a day for every person in Nîmes. Its three stacked walls with regularly spaced openings, or arcades, exemplify the simplest use of the arch as a structural element. The thick base arcade supports a roadbed approximately 20 feet wide. The arches of the second arcade are narrower than the first and are set at one side of the roadbed. The narrow third arcade supports the water trough, with three arches for every one below. The Pont du Gard is still in use as a bridge for pedestrians.

To facilitate the development and administration of the empire, as well as to make city life comfortable and attractive to its citizens, the Roman government undertook building programs of unprecedented scale and complexity, mandating the construction of central administrative and legal centers (**forums** and **basilicas**), recreational facilities (racetracks, **stadiums**), theaters, public baths, roads, bridges, **aqueducts**, middle-class housing, and even new towns. To accomplish these tasks without sacrificing beauty, efficiency, and human well-being, Roman builders and architects developed rational plans using easily worked but durable materials and highly sophisticated engineering methods (see "Roman Construction," page 236). The architect Vitruvius described these accomplishments in his *Ten Books of Architecture* (see "Roman Writers on Art," page 229).

To move their armies about efficiently, speed communications between Rome and the farthest reaches of the empire, and promote commerce, the Romans built a vast and sophisticated network of roads and bridges. Many modern European highways still follow the lines laid down by Roman engineers, and Roman-era foundations underlie the streets of many cities. Roman bridges are still in use, and remnants of Roman aqueducts need only repairs and connecting links to enable them to function again. The Pont du Gard, near Nîmes, in southern France, for example, is a powerful reminder of Rome's rapid spread and enduring impact (fig. 6-12). Entirely functional, the aqueduct conveys the balance, proportion, and rhythmic harmony of a great work of art and fits naturally into the landscape, a reflection of the Romans' attitude toward the land.

Despite their urbanity, Romans liked to portray themselves as simple country folk who had never lost their love of nature. The middle classes enjoyed their town-home gardens, wealthy city dwellers maintained rural estates, and Roman emperors had country villas that were both functioning farms and places of recreation. Wealthy Romans even brought nature indoors by commissioning artists to paint landscapes on the interior walls of their homes.

Like the Etruscans, the Romans admired Greek art. Historians have even suggested that although Rome conquered the Hellenistic world, Greek culture conquered

ELEMENTS OF ARCHITECTURE
Roman Construction

The Romans were pragmatic, and their practicality extended from recognizing and exploiting undeveloped potential in construction methods and physical materials to organizing large-scale building works. Their exploitation of the arch and the vault is typical of their adapt-and-improve approach. Their innovative use of **concrete**, beginning in the first century BCE, was a technological breakthrough of the greatest importance.

Roman concrete consisted of powdered lime, sand (in particular, a volcanic sand called *pozzolana* found in abundance near Pompeii), and various types of rubble, such as small rocks and broken pottery. Mixing in water caused a chemical reaction that blended the materials, which hardened as they dried into a strong, solid mass. At first, concrete was used mainly for poured foundations, but with technical advances it became indispensable

for the construction of walls, arches, and vaults for ever-larger buildings. In the earliest concrete wall construction, workers filled a framework of rough stones with concrete. Soon they developed a technique known as *opus reticulatum*, in which the framework is a diagonal web of smallish, pyramidal bricks set in a cross pattern.

Concrete-based construction freed the Romans from the limits of right-angle forms and comparatively short spans. With this freedom, Roman builders pushed the established limits of architecture, creating some very large and highly original spaces, many based on the curve.

Concrete's one weakness was that it absorbed moisture, so builders covered exposed concrete surfaces with a **veneer**, or facing, of finer materials, such as marble, stone, stucco, or painted plaster. Thus, an essential difference between Greek and Roman architecture is that Greek buildings reveal the building material itself, whereas Roman buildings show only the applied surface.

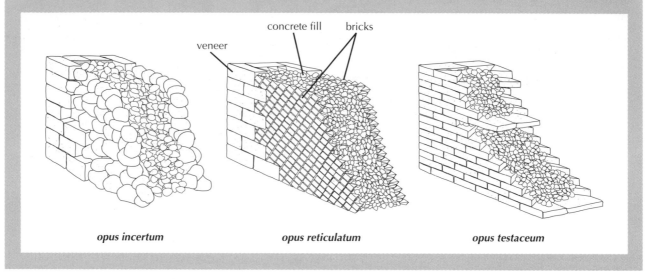

opus incertum opus reticulatum opus testaceum

Rome. The Romans used Greek designs and Greek orders in their architecture, imported Greek art, and employed Greek artists. In 146 BCE, for example, they stripped the Greek city of Corinth of its art treasures and shipped them back to Rome. Ironically, this love of Greek art was not accompanied by admiration for its artists. In Rome, as in Greece, professional artists were generally considered little more than skilled laborers.

Although the Romans had gods of their own (see "Distinctively Roman Gods," page 234), like the Etruscans they too adopted many Greek gods and myths (this chapter uses the Roman form of Greek names) and assimilated Greek religious beliefs and practices into a form of state religion. To the Greek pantheon they added their own deified emperors, in part to maintain the allegiance of the culturally diverse populations of the empire. Worship of ancient gods mingled with homage to past rulers, and oaths of allegiance to the living ruler made the official religion a political duty—increasingly ritualized, perfunctory, and distant from the everyday life of the average person. As a result, many Romans

adopted the more personal religious beliefs of the people they had conquered, the so-called mystery religions. Worship of Isis and Osiris from Egypt, Cybele (the Great Mother) from Anatolia, the hero-god Mithras from Persia, and the single, all-powerful God of Judaism and Christianity from Palestine challenged the Roman establishment. These unauthorized religions flourished alongside the state religion, with its Olympian deities and deified emperors, despite occasional government efforts to suppress them.

THE REPUBLICAN AND AUGUSTAN PERIODS

During the centuries of the Republic, Roman arts reflected Etruscan influences, but the expansion of the empire brought Romans wider exposure to the arts of other cultures. Under those diverse influences, Roman art became increasingly eclectic. It continued its transformation in tandem with the political transition represented by the reign of Augustus (27 BCE–14 CE), an emperor in fact who

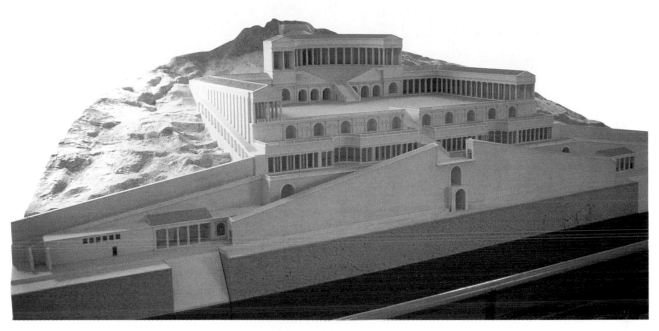

6-13. **Model of the Sanctuary of Fortuna Primigenia, Palestrina,** Italy. Begun c. 100 BCE. Museo Archeologico Nazionale, Italy

paid lip service to the Senate and always ruled with power voted to him by the Senate. During this period, some of the arts, such as architecture, evolved slowly while others, such as sculpture, underwent dramatic change.

ARCHITECTURE

Although Roman architects built temples, palaces, and tombs for the rich and powerful, they also had to satisfy the needs of ordinary people efficiently and inexpensively. To do so, they created new building types and construction techniques.

Roman architects relied heavily on the round arch and vault. Beginning in the second century BCE, they also created new forms using **concrete** (see "Roman Construction," opposite). In contrast to stone—which was expensive, time-consuming to quarry, and difficult to transport—the brick, rubble, and cement components of concrete were cheap, light, and easily transported. Building stone structures required highly skilled workers, but a large, semiskilled workforce directed by a few experienced supervisors could construct brick and concrete buildings, saving stone and marble for surfaces.

The remains of the Sanctuary of Fortuna Primigenia, an example of Roman Republican architectural planning and concrete construction at its most creative (fig. 6-13), were discovered after World War II by teams clearing the rubble from bombings of Palestrina (ancient Praeneste), about 16 miles southeast of Rome. The sanctuary, dedicated to the goddess of fate and chance, was begun

about 100 BCE and was grander than any building in Rome in its time. Its design and size show the clear influence of Hellenistic architecture, especially the colossal scale of buildings in cities such as Pergamon (see fig. 5-77). Built of concrete covered with a **veneer** (or thin coat) of stucco and finely cut limestone, the seven vaulted platforms or terraces of the Sanctuary of Fortuna covered a steep hillside. Worshipers ascended long ramps, then staircases to successively higher levels. Especially effective is the way enclosed ramps open onto the fourth terrace, which has a central stair with flanking colonnades and symmetrically placed **exedrae**, or semicircular niches. On the sixth level, **arcades** (series of arches) and colonnades form three sides of a large square, which is open on the fourth side to the distant view. Finally, from the seventh level, a huge, theaterlike, semicircular colonnaded pavilion is reached by a broad semicircular staircase. Behind this pavilion was a small **tholos**—the actual temple to Fortuna—hiding the ancient rock-cut cave where acts of divination took place. The overall **axial** plan—directing the movement of people from the terraces up the semicircular staircase, through the portico, to the tiny *tholos* temple, to the cave—brings to mind great Egyptian temples, such as that of Hatshepsut at Deir el-Bahri (see fig. 3-31).

More typical of Roman religious architecture than such a sanctuary were urban temples built in commercial centers. A small, rectangular temple in Rome, nearly contemporary with the Sanctuary of Fortuna Primigenia, stands on its raised platform, or podium, beside the Tiber

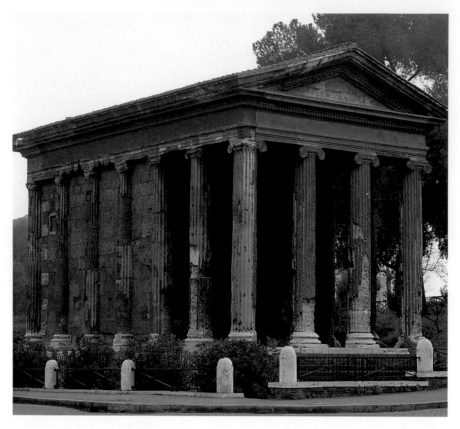

6-14. Temple perhaps dedicated to Portunus, Forum Boarium (Cattle Market), Rome. Late 2nd century BCE

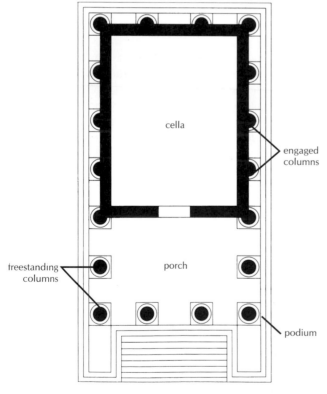

6-15. Plan of temple perhaps dedicated to Portunus

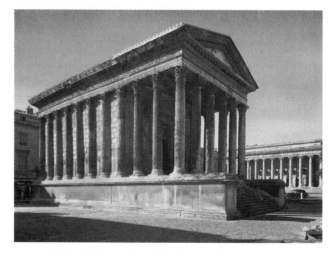

6-16. Maison Carrée, Nîmes, France. c. 20 BCE

River (figs. 6-14, 6-15). It may have been dedicated to Portunus, the god of harbors and ports. With a rectangular **cella** and a porch at one end reached by a single flight of steps, this late-second-century BCE temple echoes the Greek **prostyle** plan, with a colonnade across the entrance. The Ionic columns are freestanding on the porch and **engaged** (set into the wall) around the cella. The entablature above the columns on the porch continues around the cella as a decorative frieze. The plan of this structure resembles that of a **peripteral** temple, but because the columns around the cella are engaged it is called pseudo-peripteral. This design, with variations in the orders used with it, is typical of Roman temples.

Early imperial temples, such as the one known as the Maison Carrée ("Square House"), are simply larger and much more richly decorated versions of the so-called Temple of Portunus (fig. 6-16). Built in the forum at Nîmes, France, about 20 BCE and later dedicated to the grandsons of Augustus, the Maison Carrée differs from its prototype only in its size and its use of the opulent Corinthian order. This most elaborate order seems

ROMAN FUNERARY PRACTICES

Like the Etruscans, the early Romans generally cremated their dead, and they placed the ashes in special cinerary urns or vases. Unlike the Etruscans, however, they did not provide an earthly domestic setting for their deceased. Instead, they frequently kept the ash containers—along with family documents and busts and casts from death masks of their ancestors—on view in their homes, often in a room called the *tablinum* at one end of the atrium.

In Rome, related individuals or members of social clubs and other organizations established private group cemeteries. When a group had used up the cemetery's ground-level space, they tunneled underground to create a **catacomb**. The tunnels extended from one edge of the cemetery property to the other, like streets, and descended to another level as space filled up. The tunnels were lined with niches for urns and busts of the dead and opened into small side chambers called *cubicula*. Over time, a catacomb became a true **necropolis**, or city of the dead. Aboveground the Romans built funeral basilicas where they held banquets to honor the dead.

The Romans revered their ancestors and kept death masks as a way of remembering them. Pliny the Elder, writing in the first century CE, describes this practice: "Wax impressions of the face were set out on separate chests [at home], so that they might serve as the portraits which were carried in family funeral processions, and thus, when anyone died, the entire roll of his ancestors, all who ever existed, was present" (*Naturalis Historia* 35.6–7). The wax death masks were sometimes cast in plaster, and sculptors might be commissioned to create bust portraits of the dead. Sculptors might also be asked to create imaginary portraits of illustrious, long-dead ancestors to be displayed in the *tablinum* and carried in funeral processions.

appropriate for the city of Nîmes, which is located in what was one of the richest provinces of the empire. The temple summarizes the character of Roman religious architecture: technologically advanced but conservative in design, perfectly proportioned and elegant in sculptural detail. (These qualities appealed to the future American president and amateur architect Thomas Jefferson, who visited Nîmes and was said to have found inspiration in the Maison Carrée for his own designs for buildings in the new state of Virginia.)

The Romans also continued the Greek tradition of building large outdoor theaters against suitable hillsides. A well-preserved theater still stands in Orange, north of Nîmes (fig. 6-17). The seating resembles a Greek theater, but the orchestra, which in Greek theaters is circular and is part of the performance area, has here been reduced to a semicircle. A raised stage with an elaborate enclosing wall faces the audience. Built during the reign of Augustus in the first century BCE, the theater could hold 7,000 spectators. In its heyday, the plain masonry of the wall, 335 feet long and 123½ feet high, was disguised with columns and pediments and had a niche for a statue of the emperor. Unlike Greek theaters, in which the surrounding environment is part of the setting, this theater isolated audience and actors in an entirely architectural environment.

REPUBLICAN SCULPTURE

Sculptors of the Republican period sought to create believable images based on careful observations of their surroundings. The convention of rendering accurate and faithful portraits of individuals, called **verism**, may be derived from Roman ancestor veneration and the practice of making death masks of deceased relatives (see "Roman Funerary Practices," above). In any case, patrons in the Republican period clearly admired veristic portraits, and it is not surprising that they often turned to

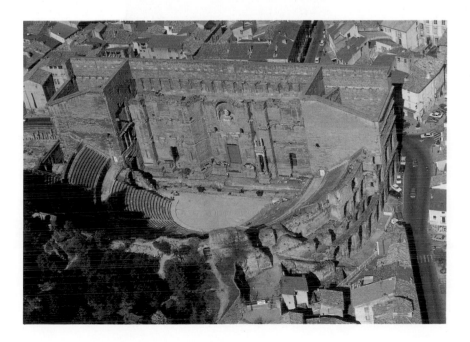

6-17. Roman theater, Orange, France. 1st century BCE

Plays are staged here today, so this Roman theater is still used for its original purpose.

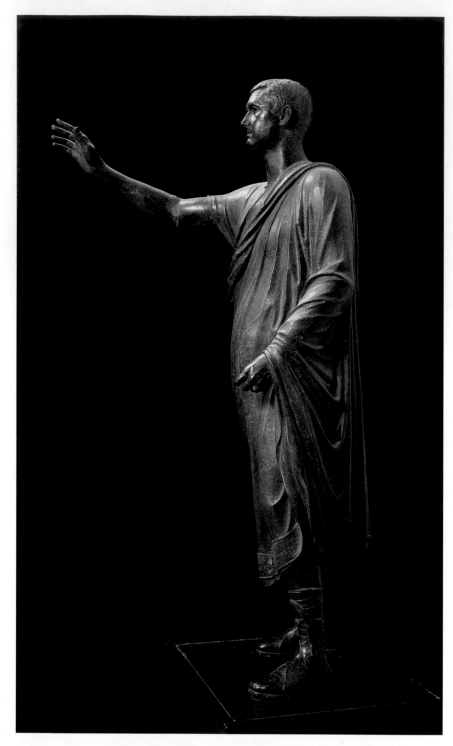

6-18. ***Aulus Metellus***, found near Perugia. Late 2nd or early 1st century BCE. Bronze, height 5'11" (1.8 m). Museo Archeològico Nazionale, Florence

6-19. ***Taking of the Roman Census***, frieze from a large base for statuary, possibly from the Temple of Neptune, Rome. c. 70 BCE. Marble, height 32" (81.3 cm). Musée du Louvre, Paris

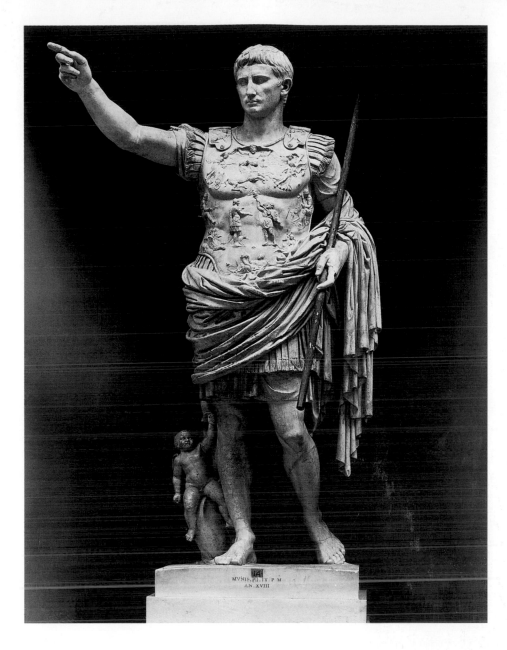

6-20. *Augustus of Primaporta*. Early 1st century CE (perhaps a copy of a bronze statue of c. 20 BCE). Marble, height 6'8" (2.03 m). Musei Vaticani, Braccio Nuovo, Rome

The popularity of the portrait type seen in the *Augustus of Primaporta* may be due to its sophisticated combination of Greek idealism and Roman individuality—in effect, a new Augustan ideal. This was the most popular image of the emperor. A catalogue of Augustan portraits published in 1993 listed 148 replicas in sculpture, including this one, plus six done as cameos—more than double the number of any other image. The original portrait sculpture may have marked the beginning of Octavian's rule as Augustus in 27 BCE, since the earliest known replica is securely dated before 25 BCE.

skilled Etruscan artists to execute them. The lifesize bronze portrait of *Aulus Metellus*—the Roman official's name is inscribed on the hem of his garment in Etruscan letters (fig. 6-18)—dates to the late second or early first century BCE. The statue, known from early times as *The Orator*, depicts the man addressing a gathering, his arm outstretched and slightly raised, a pose expressive of authority and persuasiveness. The orator wears sturdy laced leather boots and the folded and draped garment called a toga, both characteristic of a Roman official. According to Pliny the Elder, large statues like this were often placed atop columns as memorials to the individuals portrayed.

Historical events in ancient Rome were often recorded in relief sculpture. Among the earliest historical reliefs discovered in Rome is a long marble panel dating from the early first century BCE, the *Taking of the Roman Census* (fig. 6-19). This panel may have been part of a base for a statue in the Temple of Neptune. The left half of the panel shows the official registration of citizens; the right half shows a *lustrum*, a purification ceremony with the ritual sacrifice of animals. In this case, a bull, a sheep, and a large pig are being led in a procession to the altar

of Mars, at the center. The sculptor's desire to convey specific events and subjects in accurate detail overrode concerns for balanced composition.

AUGUSTAN SCULPTURE

Drawing inspiration from Etruscan and Greek art as well as Republican traditions, Roman artists of the Augustan age created a new style—a Roman form of idealism specifically grounded in the appearance of the everyday world. They enriched the art of portraiture in both official images and representations of private individuals; they recorded contemporary historical events on commemorative arches, columns, and mausoleums erected in public places; and they contributed unabashedly to Roman imperial propaganda.

The *Augustus of Primaporta* (fig. 6-20), discovered in the villa belonging to Augustus's wife, Livia, at Primaporta, demonstrates the creative assimilation of earlier sculptural traditions into a new context. In its idealization of a specific ruler and his prowess, the sculpture also illustrates the use of imperial portraiture for political propaganda. The sculptor of this larger-than-life marble statue eloquently

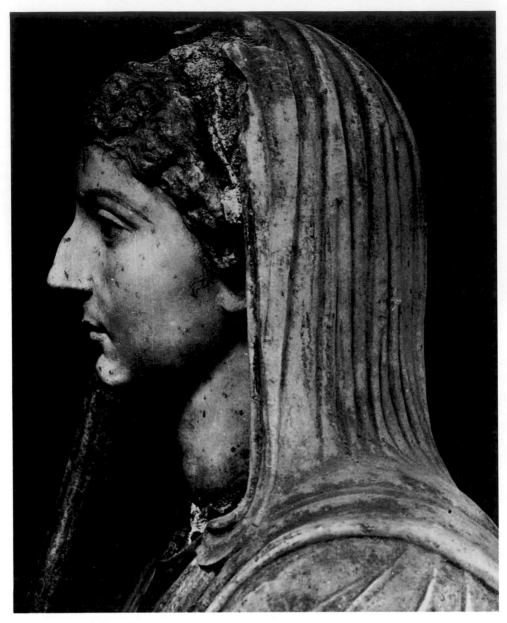

6-21. *Livia.* c. 20 BCE. Marble, height approx. 15" (38.5 cm). Antiquarium, Pompeii

adapted the orator's gesture of *Aulus Metellus* (see fig. 6-18) and combined it with the pose and ideal proportions developed by the Greek Polykleitos and exemplified in his *Spear Bearer* (see fig. 5-51). Mythological imagery exalts Augustus's position. Cupid, son of the goddess Venus, rides a dolphin next to the emperor's right leg, a reference to the claim of the emperor's family, the Julians, to descent from the goddess Venus through her human son Aeneas. Although Augustus wears a cuirass (torso armor) and holds a commander's baton, his feet are bare, suggesting to some scholars his elevation to divine status (**apotheosis**) after death.

This imposing statue creates a recognizable image of Augustus, yet it is far removed from the intensely individualized portrait that was popular during the Republican period. Augustus was in his late seventies when he died, but in his portrait sculpture he is always a vigorous young ruler. This statue was found in the atrium of Livia's

house, facing the door and, in effect, greeting the guests. Whether depicting Augustus as a general praising his troops or as a peacetime leader speaking words of encouragement to his people, the sculpture projects the image of a benign ruler, touched by the gods, who governs by reason and persuasion, not autocratic power.

Augustus's wife, Livia, was a strong and resourceful woman who remained by his side for more than fifty years. For both, this was a second marriage. Augustus had married his first wife for political reasons and divorced her after the birth of what would be his only child, Julia. By her first husband Livia had two children, Tiberius (who would become the second emperor of Rome) and Drusus. A portrait bust of Livia, dated about 20 BCE, reveals a woman with strong features in the realistic tradition of Roman portraits (fig. 6-21).

The combination of realism and idealism in Augustan sculpture is clear in the Ara Pacis, the Altar of

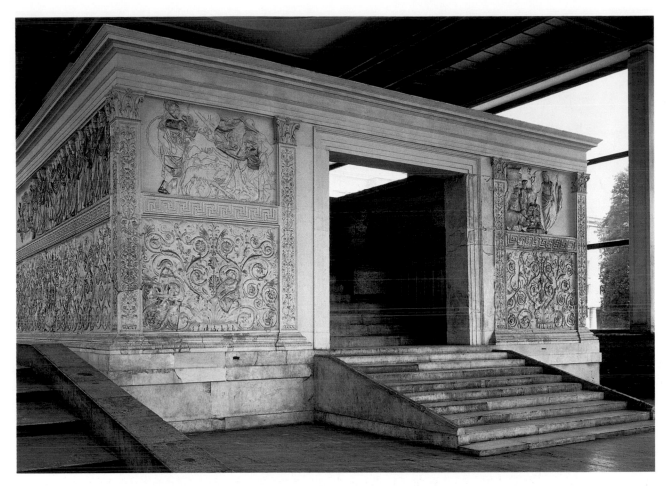

6-22. Ara Pacis, Rome. 13–9 BCE. Marble, approx. 34'5" (10.5 m) x 38' (11.6 m). View of west side.

In its original location, in the Campus Martius (Plain of Mars) beside the Tiber River, the Ara Pacis was aligned with a giant sundial that used an Egyptian obelisk as its pointer, suggesting that Augustus controlled not just Egypt but time itself. On the fall equinox (the time of Augustus's conception), the shadow of the obelisk pointed to the open door of the enclosure wall, on which sculptured panels depicted the first rulers of Rome—the warrior-king Romulus on the left and the second king, Numa Pompilius, who founded traditional religious practices and first sacrificed to Peace, on the right. The Ara Pacis thus celebrates Augustus as both a warrior and a peacemaker. The theme of time is almost as important as that of peace. The monument was begun when Augustus was fifty (13 BCE) and was dedicated on Livia's fiftieth birthday (9 BCE). In 1937–38 CE, the Italian premier Mussolini reconstructed the Ara Pacis in its present location, closer to the Tiber than originally.

Augustan Peace (fig. 6-22). The altar, begun in 13 BCE and dedicated in 9 BCE, commemorates Augustus's triumphal return to Rome after establishing Roman rule in Gaul. The walled rectangular enclosure with the altar inside is approached by a flight of steep stairs on the west. Its decoration is a thoughtful union of portraiture and allegory, religion and politics, the private and the public. On the inner walls, garlands of flowers suspended in **swags**, or loops, from *bucrania* (ox skulls) surround the altar. The ox skulls symbolize sacrificial offerings, and the garlands, which unrealistically include flowering plants from every season, signify continuous peace.

Decorative allegory gives way to Roman realism on the exterior side walls of the enclosure, where sculptors depicted the just-completed procession with its double lines of senators (on the north) and imperial family members (on the south). Here recognizable people wait

for other ceremonies to begin. At the head of the line on the south side of the altar is Augustus (not illustrated), with members of his family waiting behind him (fig. 6-23, page 244). Unlike the Greek sculptors who created an ideal procession for the Parthenon frieze (see fig. 5-46), the Roman sculptors of the Ara Pacis depicted actual individuals participating in a specific event at a known time. To suggest a double line of marchers in space, they varied the height of the relief, with the closest elements in high relief and those farther back in increasingly lower relief. They draw us, as spectators, into the event by making the feet of the nearest figures project from the architectural groundline into our space.

Moving from this procession, with its immediacy and naturalness, to the east and west ends of the enclosure wall, we find panels of quite a different character, an allegory of Peace and War in two complementary pairs of images. On the west front (see fig. 6-22), in the center of

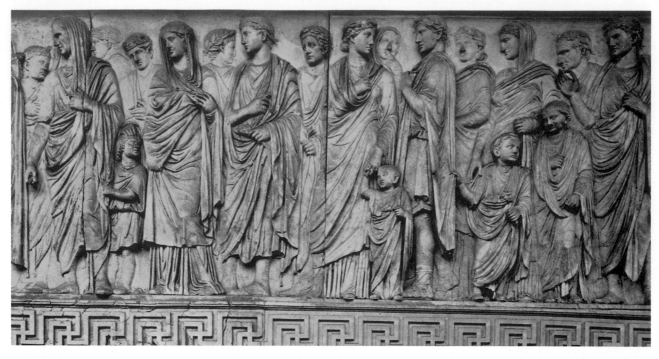

6-23. *Imperial Procession*, detail of a relief on the south side of the Ara Pacis. Height 5'2" (1.6 m)

The middle-aged man with the shrouded head at the far left is Marcus Agrippa, who would have been Augustus's successor had he not died in 12 CE. The bored but well-behaved youngster pulling at Agrippa's robe—and being restrained gently by the hand of the man behind him—is probably Agrippa's son Gaius Caesar. The heavily swathed woman next to Agrippa on the right may be Augustus's wife, Livia, followed by the elder of her two sons, Tiberius, who would become the next emperor. Behind Tiberius is Antonia, the niece of Augustus, looking back at her husband, Drusus, Livia's younger son. She grasps the hand of Germanicus, one of her younger children. Behind their uncle Drusus are Gnaeus and Domitia, children of Antonia's older sister, who can be seen standing quietly beside them. The depiction of children in an official relief was new to the Augustan period and reflects Augustus's desire to promote private family life.

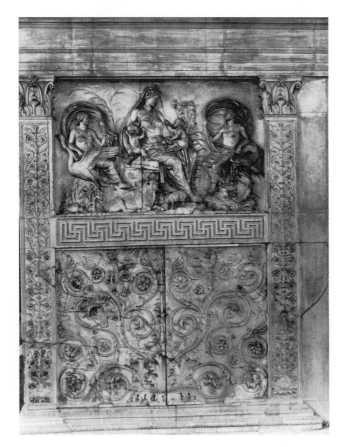

the top left-hand panel, is Romulus (the belligerent first king of Rome), and in the top right-hand panel is Numa Pompilius (the peacemaking second king). On the east side (fig. 6-24) are personifications (symbols in human form) of war and peace—Roma (the triumphant empire) and Pax (the goddess of peace), or Tellus. Augustus and Livia stood on the south side, between Numa and Pax, suggesting to the Roman citizens that they brought peace and prosperity to the empire.

In the best-preserved panel, figure 6-24, the goddess Pax, who is also understood to be *Tellus Mater*, or Mother Earth, nurtures the Roman people, represented by the two chubby babies in her arms. She is accompanied by two young women with billowing veils, one seated on the back of a flying swan, the other reclining on a sea monster. They are personifications of the sea wind and the land wind. The sea wind, symbolized by the sea monster and waves, would have reminded Augustus's contemporaries of Rome's dominion over the Mediterranean; the land wind, symbolized by the swan, the jug of fresh water, and the vegetation, would have suggested the fertility of Roman farms. The underlying theme of a peaceful, abundant Earth is reinforced by the flowers

6-24. *Allegory of Peace*, relief on the east side of the Ara Pacis. Height 5'2" (1.6 m)

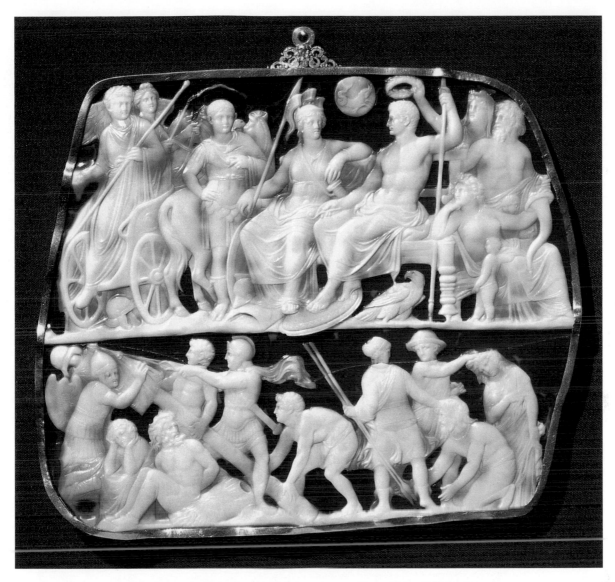

6-25. *Gemma Augustea*. Early 1st century CE. Onyx, 7½ x 9" (19 x 23 cm). Kunsthistorisches Museum, Vienna

and foliage in the background and the domesticated animals in the foreground.

Although the inclusion in this panel of features from the natural world—sky, water, rocks, and foliage—represents a Roman contribution to monumental sculpture, the idealized figures themselves are clearly drawn from Greek sources. The artists have conveyed a sense of three-dimensionality and volume by turning the figures in space and wrapping them in revealing draperies. The scene is framed by Corinthian pilasters supporting a simple entablature. A wide **molding** with a Greek key pattern (**meander**) joins the pilasters and divides the wall into two horizontal segments. Stylized vine and flower forms cover the lower panels. More foliage overlays the pilasters, culminating in the acanthus-covered capitals. The delicacy and minute detail with which these spiraling vegetal forms are rendered are characteristic of Roman decorative sculpture.

Exquisite skill characterizes all the arts of the Augustan period. A large onyx **cameo** (a gemstone carved in low relief) known as the *Gemma Augustea* carries the scene of the apotheosis of Augustus after his death in 14 CE (fig. 6-25). The emperor, crowned with a victor's wreath, sits at the center right of the upper register. He has assumed the identity of Jupiter, the king of the gods; an eagle, sacred to Jupiter, stands at his feet. Sitting next to him is a personification of Rome that has Livia's features. The sea goat in the roundel between them may represent Capricorn, the emperor's zodiac sign. Tiberius, the adopted son of Augustus, holds a lance and steps out of a chariot at the left. Returning victorious from the German front, he will assume the imperial throne as the designated heir of Augustus. Below this realm of godly rulers is the earth, where Roman soldiers are raising a trophy—a post or standard on which armor captured from the defeated enemy is displayed. The cowering, shackled barbarians on the bottom right wait to be tied to this trophy. The *Gemma Augustea* brilliantly combines idealized, heroic figures of a kind characteristic of Classical Greek art with recognizable portraits, the dramatic action of Hellenistic art, and a purely Roman realism in the depiction of historical events.

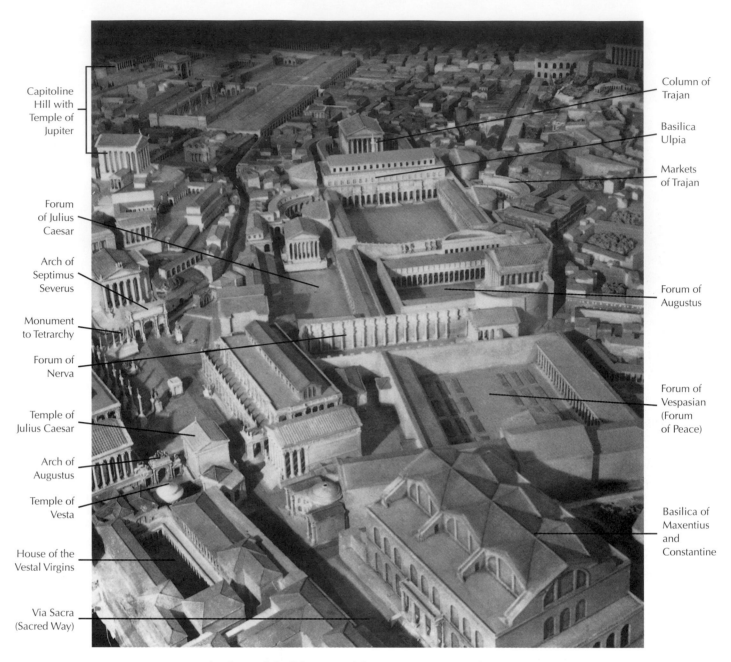

Capitoline
Hill with
Temple of
Jupiter

Forum
of Julius
Caesar

Arch of
Septimus
Severus

Monument
to Tetrarchy

Forum of
Nerva

Temple of
Julius Caesar

Arch of
Augustus

Temple of
Vesta

House of the
Vestal Virgins

Via Sacra
(Sacred Way)

Column of
Trajan

Basilica
Ulpia

Markets
of Trajan

Forum of
Augustus

Forum of
Vespasian
(Forum
of Peace)

Basilica of
Maxentius
and
Constantine

6-26. Model of the Imperial Forums, Rome. C. 46 BCE–325 CE

THE EMPIRE

As the scene on the *Gemma Augustea* illustrates, Tiberius stepped into the vacancy left by the death of Augustus. As we have noted, the Julio-Claudian dynasty ended with the forced suicide of Nero in 68 CE. The Flavians, practical military men, restored confidence and ruled for the rest of the first century CE. Then, from 96 to 180 CE, the "Five Good Emperors"—Nerva, Trajan, Hadrian, Antoninus Pius, and Marcus Aurelius—gave Rome an era of stability. Unfortunately, Marcus Aurelius broke the tradition of adoption and left his son, Commodus, to inherit the throne. Within twelve years, Commodus destroyed the government his predecessors had so carefully built.

IMPERIAL ARCHITECTURE

The Romans believed that their rule extended to the ends of the Western world, but the city of Rome remained the heart and nerve center of the empire. During his long and peaceful reign, Augustus paved the city's old Republican Forum, restored its temples and basilicas, and built the first Imperial Forum. These projects marked the beginning of a continuing effort to transform the capital itself into a magnificent monument to imperial rule. While Augustus's claim of having turned Rome into a city of marble is exaggerated, he certainly began the process of creating a monumental civic center. Such grand structures as the Imperial Forums, the Colosseum, the Circus Maximus (a track for chariot races), the Pantheon, and aqueducts rose amid the temples, baths, warehouses, and homes in the city center.

A twentieth-century model of the Imperial Forums makes apparent the city's dense building plan (fig. 6-26). The last and largest Imperial Forum was begun by Trajan in 110–13 CE and finished by Hadrian about 117 CE on a

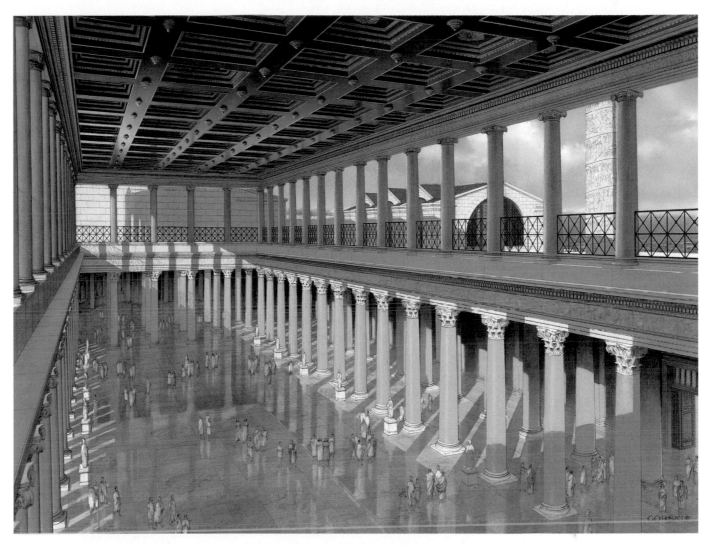

6-27. Restored perspective view of the central hall, Basilica Ulpia, Rome. 113 CE. Drawn by Gilbert Gorski

large piece of property next to the earlier forums of Augustus and Julius Caesar. For this major undertaking, Trajan chose a Greek architect, Apollodorus of Damascus. A straight, central axis leads from the Forum of Augustus through a triple-arched gate surmounted by a bronze chariot group into a large, colonnaded square with a statue of Trajan on horseback at its center. Closing off the courtyard at the north end was the Basilica Ulpia, dedicated in 113 CE and named for the family to which Trajan belonged.

A basilica was a large, rectangular building with a rounded extension, called an **apse**, at each end. A general-purpose administrative structure, it could be adapted to many uses. The Basilica Ulpia was a court of law, but other basilicas served as imperial audience chambers, army drill halls, and schools. The basilica design provided a large interior space with easy access in and out. The Basilica Ulpia was 385 feet long and 182 feet wide (not including the apses), with doors on the long sides. The interior space consisted of a large central area (the **nave**) flanked by two colonnaded aisles surmounted by open galleries (fig. 6-27). The central space

was taller than the surrounding galleries and was lit directly by an open gallery in the space normally occupied by a **clerestory** (upper nave wall with windows). The timber truss roof had a span of about 80 feet. The two apses, one at each end of the building, provided imposing settings for judges when the court was in session.

Behind the Basilica Ulpia stood twin libraries built to house the emperor's large collections of Latin and Greek manuscripts. These buildings flanked an open court and the great spiral column that became Trajan's tomb (Hadrian placed his predecessor's ashes in the base). The column commemorated Trajan's victory over the Dacians and was erected either with the Basilica Ulpia about 113 CE or by Hadrian after Trajan's death in 117 CE. The Temple of the Divine Trajan stands opposite the Basilica Ulpia, forming the fourth side of the court and closing off the end of the forum. Hadrian ordered the temple built after Trajan's death and apotheosis.

The relief decoration on the Column of Trajan spirals upward in a band that would stretch almost 656 feet if unfurled. Like a giant version of the scrolls housed in the libraries next to it, the column is a continuous pictorial

6-28. Column of Trajan, Rome. 113–16 or after 117 CE. Marble, overall height with base 125' (38 m), column alone 97'8" (29.77 m)

The height of the column, 100 Roman feet (97'8"), may have recorded the depth of the excavation required to build the Forum of Trajan. The column had been topped by a gilded bronze statue of Trajan, which was replaced in 1587 CE, by order of Pope Sixtus V, with the statue of Saint Peter seen today. Trajan's ashes were interred in the base in a golden urn.

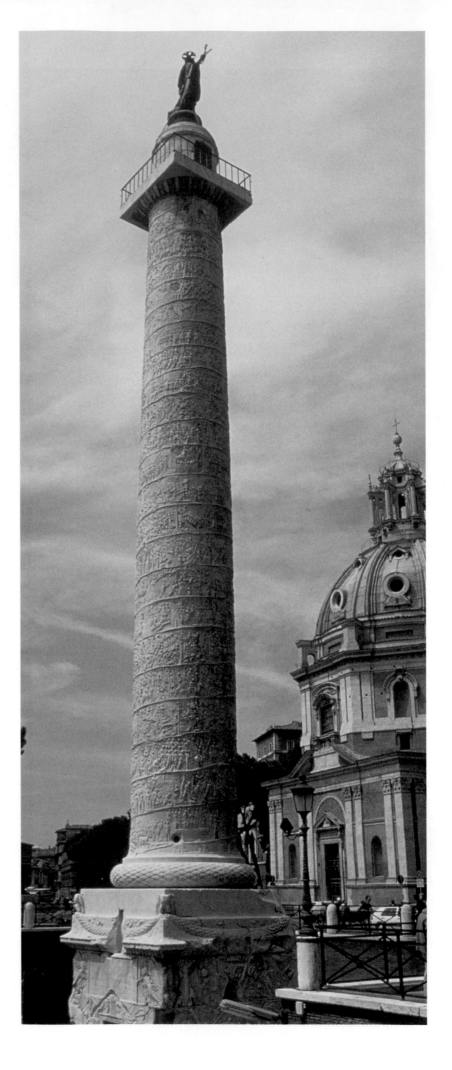

6-29. Main hall, Markets of Trajan, Rome. 100–12 CE

narrative of the Dacian campaign (fig. 6-28). This remarkable sculpture involved carving more than 2,500 individual figures linked by landscape, architecture, and the recurring figure of Trajan. The artist took care to make the scroll legible. The narrative band slowly expands from about 3 feet in height at the bottom, near the viewer, to 4 feet at the top of the column, where it is farther from view. The natural and architectural elements in the scenes have been kept small to emphasize the important figures.

During the site preparation for the forum, part of a commercial district had to be razed and excavated. To make up for the loss, Trajan ordered the construction of a handsome public market. The market, comparable in size to a large modern shopping mall, had more than 150 individual shops on several levels and included a large groin-vaulted main hall (fig. 6-29). In compliance with a building code that was put into effect after a disastrous fire in 64 CE, the market, like all Roman buildings of the time, had masonry construction—brick-faced concrete, with only some detailing in stone and wood.

An idea of the splendor of the forum and markets can be gained from another of Trajan's projects in the provinces, a market on the south side of Miletos (in modern Turkey). Markets were an essential part of city life, and improving them with splendid buildings was a way for wealthy families or rulers to gain popular favor. Only

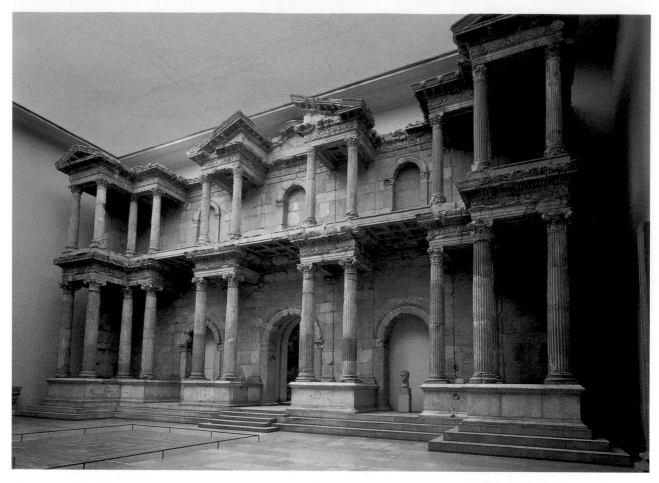

6-30. Market Gate, from Miletos (Turkey). C. 120 CE. Staatliche Museen zu Berlin, Preussischer Kulturbesitz, Antikensammlung

the core of Trajan's Miletos market survives. The gate (fig. 6-30) was added in about 120 CE during the reign of Hadrian. The gate has three arched openings screened by a series of paired columns. On the lower level, the columns are in the Composite order, with capitals formed by superimposing Ionic volutes on Corinthian capitals (see "Roman Architectural Orders," page 229). These Composite columns support short sections of entablature with carved friezes that in turn support the platformlike base of the second level. The shorter Corinthian columns and entablatures on the second level repeat the design of the lower level, except that the two center pairings support a **broken pediment**, which consists of the ends of a typical triangular pediment without a middle section. Such an elaborate building was not necessary for the market's operations—rather, it is symbolic architecture: architecture as propaganda for the power and glory of Rome. The intention of the patrons of structures like the gate at Miletos was to impress the populace.

Life in the city could be festive and exciting. In a way, Romans were as sports-mad as modern Americans, and the Flavian emperors catered to their taste by building the Colosseum, Rome's greatest arena (fig. 6-31). Construction on the arena began under Vespasian in 72 CE and was completed under Titus, who dedicated it in 80 CE as the Flavian Amphitheater. The name "Colosseum," by which it came to be known, was derived from a gigantic statue of Nero called the *Colossus* standing

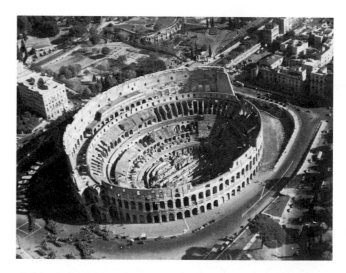

6-31. Colosseum, Rome. 72–80 CE

In July 2000, after a lapse of 1,500 years, audiences again paid to see performances at the Colosseum. A stage built to cover 4,300 square feet of the original 29,000-foot arena, part of a restoration and protection project, enabled an audience of 700 people to see adaptations of three ancient Greek tragedies by Sophocles where 70,000 once watched gladiators and beasts in mortal combat.

next to it. But *Colosseum* is a most appropriate description of this enormous entertainment center. It is an oval, measuring 615 by 510 feet, with a floor 280 by 175 feet, and it is 159 feet high. Roman audiences watched a variety of athletic events and spectacles, including animal hunts, fights to the death between gladiators or between gladiators and wild animals, performances of trained animals and acrobats, and even mock sea battles, for which the arena could be flooded. The opening performances in 80 CE lasted 100 days, during which time it was claimed that 9,000 wild animals and 2,000 gladiators died for the amusement of the spectators.

The floor of the Colosseum was laid over a foundation of service rooms and tunnels that provided an area for the athletes, performers, animals, and equipment. This floor was covered by sand, or *arena* in Latin, hence the English term "arena." Some 55,000 spectators could easily move through the seventy-six entrance doors to the three levels of seats and the standing area at the top. Each had an uninterrupted view of the spectacle below. Stadiums today are still based on this efficient plan. The Colosseum derived its oval shape—the amphitheater— from the idea of two theaters placed facing each other. Ascending tiers of seats were laid over barrel-vaulted access corridors and entrance tunnels connecting the ring corridors to the ramps and seats on each level (fig. 6-32). The intersection of the barrel-vaulted entrance tunnels and the ring corridors created what are called **groin vaults** (see "Arch, Vault, and Dome," page 226). The walls on the top level of the arena supported a huge

awning that could shade the seating areas. Sailors who had experience in handling ropes, pulleys, and large expanses of canvas worked the apparatus that extended the sun screen.

The curving, outer wall of the Colosseum consists of three levels of arcades surmounted by a wall-like **attic** (top) **story**. Each arch in the arcades is framed by engaged columns. Entablaturelike friezes mark the divisions between levels (fig. 6-33). Each level also uses a different architectural order, increasing in complexity from bottom to top: the plain Tuscan order on the ground level, the Ionic on the second level, the Corinthian on the third, and Corinthian pilasters on the fourth. The attic story is broken by small, square windows, which originally alternated with gilded bronze shield-shaped ornaments called **cartouches**. The cartouches were supported on brackets that are still in place and can be seen in the illustration. Engaged Corinthian pilasters above the Corinthian columns of the third level support another row of corbels beneath the projecting cornice. All of these elements are purely decorative and serve no structural function. As we saw in the Porta Augusta (see fig. 6-2), the addition of

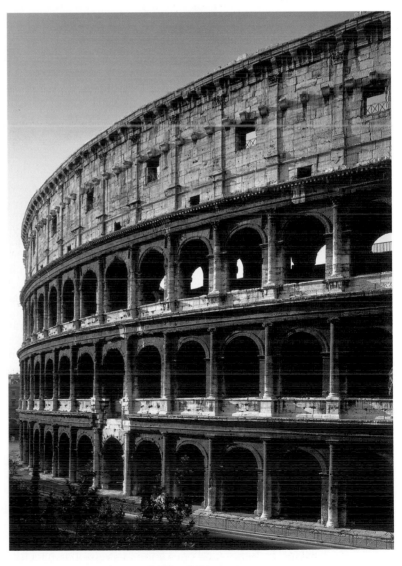

6-32. Colosseum. View of a radial passage with barrel and groin vaulting

6-33. Colosseum

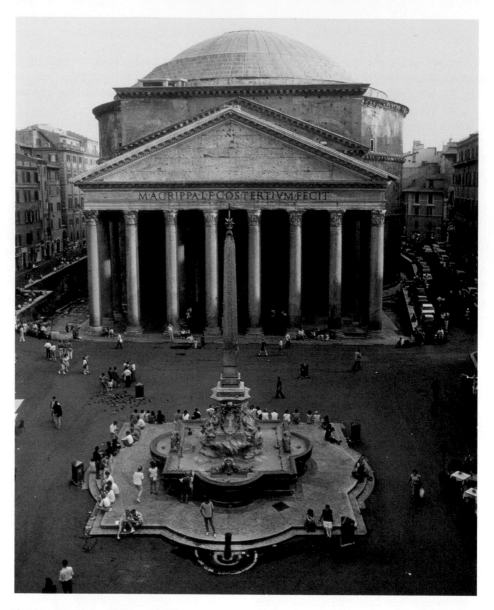

6-34. Pantheon, Rome. 125–28 CE

Originally the Pantheon stood on a podium and was approached by stairs from a colonnaded square. The difference in height of the street levels of ancient and modern Rome can be seen at the left side of the photograph. Although this magnificent monument was designed and constructed entirely during the reign of the emperor Hadrian, the long inscription on the architrave states that it was built by "Marcus Agrippa, son of Lucius, who was consul three times." Agrippa, the son-in-law and valued adviser of Augustus, was responsible for building on this site in 27–25 BCE a temple to all the gods, a pantheon, which later burned. Agrippa died in 12 BCE, but Hadrian, who had a strong sense of history, placed Agrippa's name on the facade in a grand gesture to the memory of the illustrious consul rather than using the new building to memorialize himself. Septimius Severus and Caracalla restored the Pantheon in 202 CE. Attachment holes in the pediment indicate the placement of sculpture, perhaps an eagle.

post-and-lintel decoration to arched structures was an Etruscan innovation. The systematic use of the orders in a logical succession from sturdy Tuscan to lighter Ionic to decorative Corinthian follows a tradition inherited from Hellenistic architecture. This orderly, dignified, and visually satisfying way of organizing the facades of large buildings is still popular. Unfortunately, much of the Colosseum was dismantled as a source of marble, metal fittings, and materials for later buildings.

Perhaps the most remarkable ancient building surviving in Rome—and one of the marvels of architecture in any age—is a temple to the Olympian gods called the Pantheon (literally "all the gods"). It was completed under the patronage of Hadrian between 125 and 128 CE on the site of an earlier temple that had been erected in 27 BCE to commemorate the defeat of Anthony and Cleopatra but had burned in 110 CE.

The approach to the temple gives little suggestion of its original appearance. Centuries of dirt and street construction hide its podium and stairs. Nor is there any hint of what lies beyond the entrance porch, which resembles the facade of a typical Roman temple (fig. 6-34). Behind this porch is a giant rotunda with 20-foot-thick walls that rise nearly 75 feet. The walls support a bowl-shaped

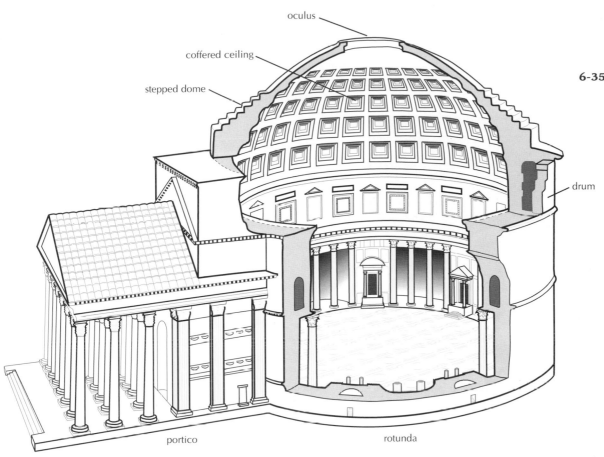

oculus

coffered ceiling

stepped dome

drum

portico rotunda

6-35. Reconstruction drawing of the Pantheon

Ammianus Marcellinus described the Pantheon in 357 CE as being "rounded like the boundary of the horizon, and vaulted with a beautiful loftiness." Although the Pantheon has inspired hundreds—perhaps thousands—of faithful copies, inventive variants, and eclectic borrowings over the centuries, only recently have the true complexity and the innovative engineering of its construction been fully understood.

dome that is 143 feet in diameter and 143 feet from the floor at its summit (fig. 6-35). Standing at the center of this nearly spherical temple, the visitor feels isolated from the outside world and intensely aware of the shape and tangibility of the space itself rather than the enclosing architectural surfaces. The eye is drawn upward over the circular patterns made by the sunken panels, or **coffers**, in the dome's ceiling to the light entering the 29-foot-wide *oculus*, or central opening (fig. 6-36). Through this opening, the sun pours on clear days; rain falls on wet ones, then drains off as planned by the original engineer; and the occasional bird flies in. The empty, luminous space imparts a sense of apotheosis, a feeling that one could rise buoyantly upward to escape the spherical hollow of the building and commune with the gods.

The simple shape of the Pantheon's dome belies its sophisticated design and engineering. Marble veneer disguises the internal brick arches and concrete structure. The interior walls, which form the **drum** that both supports and buttresses the dome, are disguised by two tiers of architectural detail and richly colored marble (more than half of the original decoration survives)—a wealth of columns, *exedrae*, pilasters, and entablatures. The wall is punctuated by seven niches—rectangular alternating

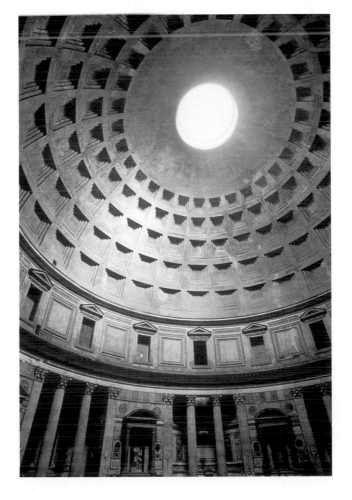

6-36. Dome of the Pantheon with light from the *oculus* on its coffered ceiling

with semicircular—that originally held statues of gods. This simple repetition of square against circle, which was established on a large scale by the juxtaposition of the rectilinear portico against the rotunda, is found throughout the building. The square, boxlike coffers inside the dome, which help lighten the weight of the masonry, may once have contained gilded bronze **rosettes** or stars suggesting the heavens. In 609 CE, Pope Boniface IV dedicated the Pantheon as the Christian church of Saint Mary and the Martyrs, thus ensuring its survival through the Middle Ages—which brought about the destruction of pagan temples—and to this day.

RELIEF SCULPTURE

Official commissions created the finest Roman art. Among the most admirable is a distinctive Roman structure, the **triumphal arch**. Part architecture, part sculpture, this freestanding arch commemorates a triumph, or formal victory celebration, during which a victorious general or emperor paraded with his troops, captives, and booty through the city after a significant campaign. When Domitian assumed the throne in 81 CE, for example, he immediately commissioned a triumphal arch to honor the capture of Jerusalem in 70 CE by his brother and deified predecessor, Titus (fig. 6-37). The Arch of Titus, constructed of concrete and faced with marble, is essentially a freestanding gateway whose passage is covered by a barrel vault. Originally the whole arch served as a giant base, 50 feet tall, for a statue of a four-horse chariot and driver, a typical triumphal symbol. Applied to the faces of the arch are columns in the Composite order supporting an entablature. The inscription on the attic story declares that the Senate and the Roman people erected the monument to honor Titus.

Titus's capture of Jerusalem ended a fierce campaign to crush a revolt of the Jews in Palestine. The Romans sacked and destroyed the Second Temple in Jerusalem, carried off its sacred treasures, then displayed them in a triumphal procession in Rome. An eyewitness, Jewish historian Josephus (*The Jewish War*), described Titus's triumphal procession:

> The most interesting of all were the spoils seized from the Temple of Jerusalem: a gold table weighing many talents, and a lampstand, also made of gold, which was made in a form different from that which we usually employ. For there was a central shaft fastened to the base; then spandrels [branches] extended from this in an arrangement which rather resembled the shape of a trident, and on the end of each of these spandrels a lamp was forged. There were seven of these, emphasizing the honor accorded the number seven among the Jews. The law of the Jews [Ark of the Covenant] was borne along after these as the last of the spoils . . . Vespasian drove along behind [it] . . . and Titus followed him; Domitian rode beside them, dressed in a dazzling fashion and riding a horse which was worth seeing.

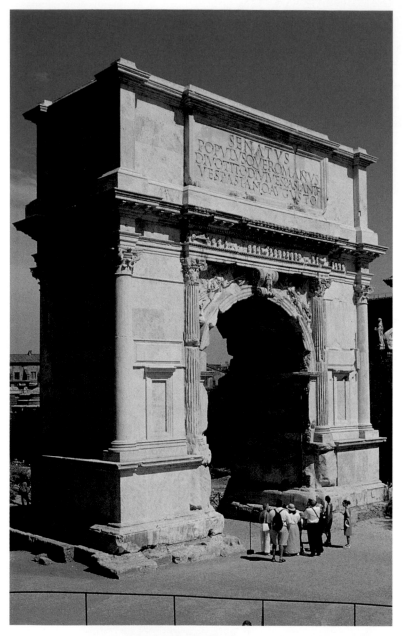

6-37. Arch of Titus, Rome. C. 81 CE. Concrete and white marble, height 50' (15 m)

The dedication inscribed across the tall attic story above the arch opening reads: "The Senate and the Roman People to the Deified Titus Flavius Vespasianus Augustus, son of the Deified Vespasian." The Romans typically recorded historic occasions and identified monuments with solemn prose and beautiful inscriptions in stone. The sculptors' use of elegant Roman capital letters—perfectly sized and spaced to be read from a distance and cut with sharp terminals (serifs) to catch the light—established a standard that calligraphers and alphabet designers still follow.

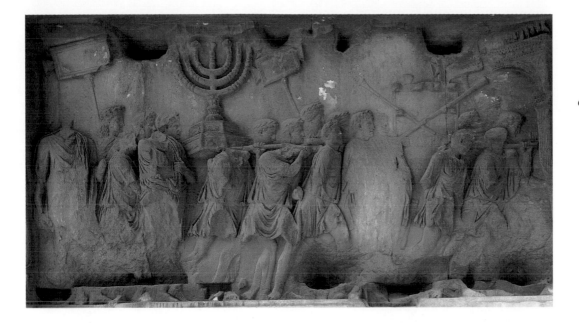

6-38. **Spoils from the Temple of Solomon, Jerusalem**, relief in the passageway of the Arch of Titus. Marble, height 6'8" (2.03 m)

The reliefs on the inside walls of the arch, capturing the drama of the occasion, depict Titus's soldiers flaunting this booty as they carry it through the streets of Rome (fig. 6-38). The viewer can sense the press of that boisterous, disorderly crowd and might expect at any moment to hear the soldiers and onlookers shouting and chanting.

The mood of the procession depicted in these reliefs contrasts with the relaxed but formal solemnity of the procession portrayed on the Ara Pacis (see fig. 6-23). Like the sculptors of the Ara Pacis, the sculptors of the Arch of Titus showed the spatial relationships among figures by rendering close elements in higher relief than those more distant. A **menorah**, or seven-branched lamp holder (the lampstand described by Josephus), from the Temple of Jerusalem dominates the scene. Reflecting their concern for representing objects as well as people in a believable manner, the sculptors rendered this menorah as if seen from the low point of view of a spectator at the event, and they have positioned the arch on the right through which the procession is about to pass on a diagonal. Using a technique also encountered on the Ara Pacis, the sculptors have undercut the foreground figures and have used low relief for the figures in the background. The panel on the other side of the arch interior shows Titus riding in his chariot as a participant in the ceremonies. On the vaulted ceiling, which shows his apotheosis, an eagle carries him skyward to join the gods.

Sculptors further refined the art of pictorial narrative in the next century, as we see when we revisit the Column of Trajan (see fig. 6-28). The scene at the beginning of the spiral (fig. 6-39), at the bottom of the column, shows Trajan's army crossing the Danube River on a pontoon bridge as the campaign gets under way. A giant river god, the personification of the Danube, supports the bridge of boats.

6-39. **Romans Crossing the Danube and Building a Fort**, detail of the lowest part of the Column of Trajan. 113–16 CE, or after 117. Marble, height of the spiral band approx. 36" (91 cm)

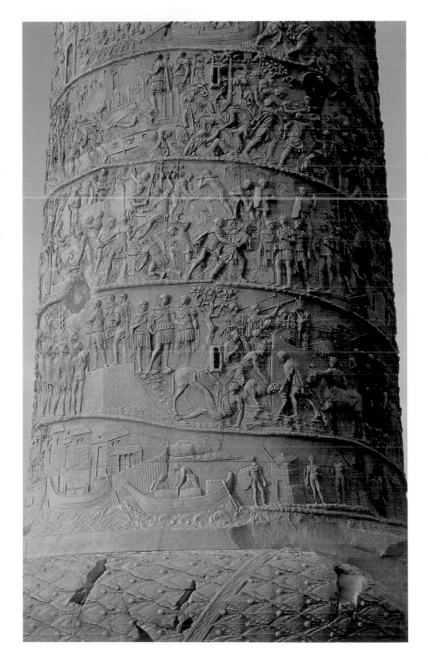

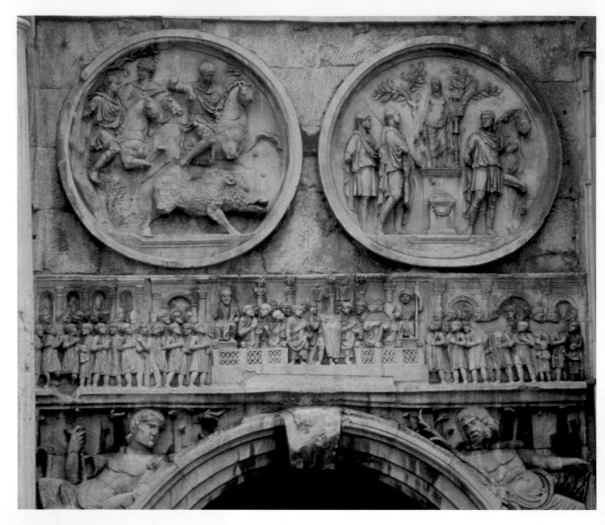

6-40. *Hadrian Hunting Boar and Sacrificing to Apollo*, roundels made for a monument to Hadrian and reused on the Arch of Constantine. Sculpture c.130–38 CE. Marble, roundel diameter 40" (102 cm)

In the fourth century CE, Emperor Constantine had the roundels removed from the Hadrian monument, had Hadrian's head recarved with his own or his father's features, and placed them on his own triumphal arch (see fig. 6-79).

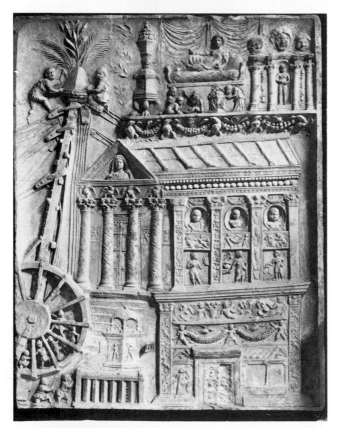

6-41. *Mausoleum under Construction*, relief from the tomb of the Haterius family, Via Labicana, Rome. Late 1st century CE. Marble, height 41" (104 cm). Musei Vaticani, Museo Gregoriano Profano, ex Lateranese, Rome

In the scene above, soldiers have begun constructing a battlefield headquarters in Dacia from which the men on the frontiers will receive orders, food, and weapons. Throughout the narrative—which is a spectacular piece of imperial propaganda—Trajan is portrayed as a strong, stable and efficient commander of a well-run army, but his barbarian enemies are shown as pathetically disorganized and desperate. The hardships of war—death, destruction, and the suffering of innocent people—are ignored, and, of course, the Romans never lose a battle.

Trajan's successor, Hadrian, also used monumental sculpture to vaunt his accomplishments. Several large, circular reliefs, or roundels—originally part of a monument that no longer exists—contain images designed to affirm his imperial stature and right to rule (fig. 6-40). In the scene on the left, he demonstrates his courage and physical prowess in a boar hunt. Other roundels, not included here, show him confronting a bear and a lion. At the right, in a show of piety and appreciation to the gods for their support of his endeavors, Hadrian makes a sacrificial offering to Apollo at an outdoor altar. As did the sculptors of the Column of Trajan, the sculptors of these roundels included elements of a natural landscape setting but kept them relatively small, using them to frame the proportionally larger figures. The idealized heads, form-enhancing drapery, and graceful yet energetic movement of the figures owe a distant debt to the works of Praxiteles and Lysippos (Chapter 5), but the well-observed details of the features and the bits of

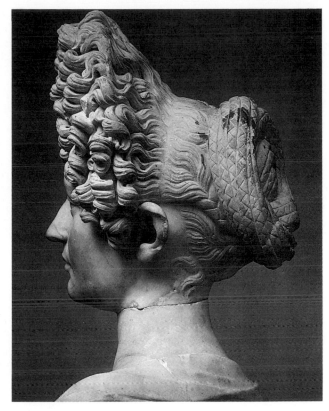

6-42. *Young Flavian Woman*. c. 90 CE. Marble, height 25" (65.5 cm). Museo Capitolino, Rome

The typical Flavian hairstyle seen on this woman and the older woman in figure 6-43 required a patient hairdresser handy with a curling iron and with a special knack for turning the back of the head into an intricate basketweave of braids. Male writers loved to scoff at the results. Martial described the style precisely as "a globe of hair." Statius spoke of "the glory of woman's lofty front, her storied hair." And Juvenal waxed comically poetic: "See her from the front; she is Andromache [an epic heroine]. From behind she looks half the size—a different woman you would think" (cited in Balsdon, page 256).

landscape are characteristically Roman. Much of the sculpture of the mid-second century CE shows the influence of Hadrian's love of Greek art, and for a time Roman artists achieved a level of idealized figural depiction close to that of Classical Greece.

Not all Roman sculpture was as sophisticated as the imperial reliefs. Lesser artists worked for less affluent patrons. A relief on the mausoleum of the plebeian Haterius family (fig. 6-41) shows a gigantic, human-powered crane at the left being maneuvered into place over the still-unfinished mausoleum. Funerary reliefs typically honor the dead with portraits, garlands, and narrative themes—sometimes of mythological figures, sometimes of biographical scenes associated with the deceased. Because this relief commemorates the construction of the mausoleum itself, some scholars believe that the deceased may have been an architect or a builder. The mausoleum under construction is an encyclopedia of decorative motifs—**egg-and-dart** moldings, garlands looped in swags, busts in shell-shaped niches, symmetrical vegetal reliefs, and robust Corinthian columns, heavily carved with spiraling garlands. The sculptor sacrificed clarity in order to convey as much information as possible.

The sculptors and patrons responsible for the reliefs on the Haterius family tomb were probably relatively unsophisticated, though quite clear about what they wanted. The sculptural style that emerged from such commissions was characterized by crowded compositions and deeply undercut forms, stocky figures, and detailed but visually unrealistic images.

PORTRAIT SCULPTURE

Roman patrons demanded likenesses in their portraits. However, sometimes they preferred some idealization of the sitter and at other times wanted an exact image. The portrait of a young Flavian woman, whose identity is not known (fig. 6-42), exemplifies the idealized portrait type, in the manner of the *Augustus of Primaporta* (see fig. 6-20). The well-observed, recognizable features—a strong nose and jaw, heavy brows, deep-set eyes, and a long neck contrast with the smoothly rendered flesh and soft, full lips. (The portrait suggests the retouched fashion photos of today.) The hair is piled high in an extraordinary mass of ringlets in the latest court fashion. Executing the head required skillful chiseling and drill-work, a technique for rapidly cutting deep grooves with straight sides, as was done here to render the holes in the center of the curls. The overall effect, from a distance, is very lifelike. The play of natural light over the more subtly sculpted surfaces gives the illusion of being reflected

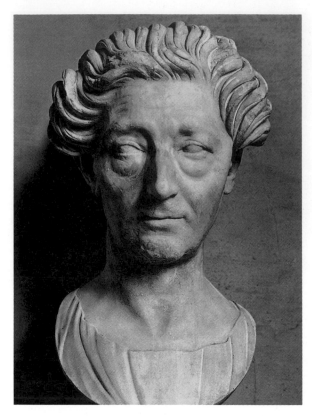

6-43. *Middle-Aged Flavian Woman*. Late 1st century CE.
Marble, height 9½" (24.1 cm). Musei Vaticani,
Museo Gregoriano Profano, ex Lateranese, Rome

off real skin and hair, yet closer inspection reveals a portrayal too perfect to be real.

A more realistic approach, exemplified by a bust of an older woman (fig. 6-43), reflects a revival of the verist style popular in the Republican period. Comic writers of the Flavian era liked to satirize older women who vainly sought to preserve their youthful looks, but the subject of this portrait, though she too wore her hair in the latest style, was apparently not preoccupied with her appearance. The work she commissioned shows her just as she appeared in her own mirror, with all the signs of age recorded on her face.

In contrast to the Roman taste for realism, Hadrian preferred and commissioned an idealized style. The widely traveled emperor admired Greek sculpture but had also seen the arts of other cultures. He liked to combine his favorite images in new works. A remarkable example of how styles could be merged is a portrait of his handsome young friend Antinous, who drowned in the Nile in 130 CE (fig. 6-44). Hadrian ordered that Antinous be deified and become the object of a cult. Represented in sculpture as an ideally beautiful youth, Antinous remains clearly recognizable with distinctive facial features and a slightly flabby body. He assumes the pose of an Egyptian king wearing the royal kilt and headdress. This **syncretic** image, with its combination of Greek, Roman, and Egyptian elements, is distinctly unsettling, for all its sleek perfection.

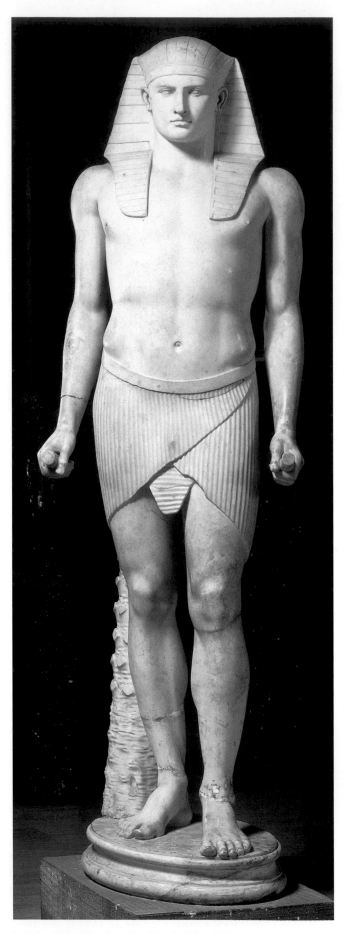

6-44. *Antinous*, from Hadrian's Villa at Tivoli. c. 130–38 CE.
Marble, height 8' (2.41m)
Museo Gregoriano Egizio, Rome

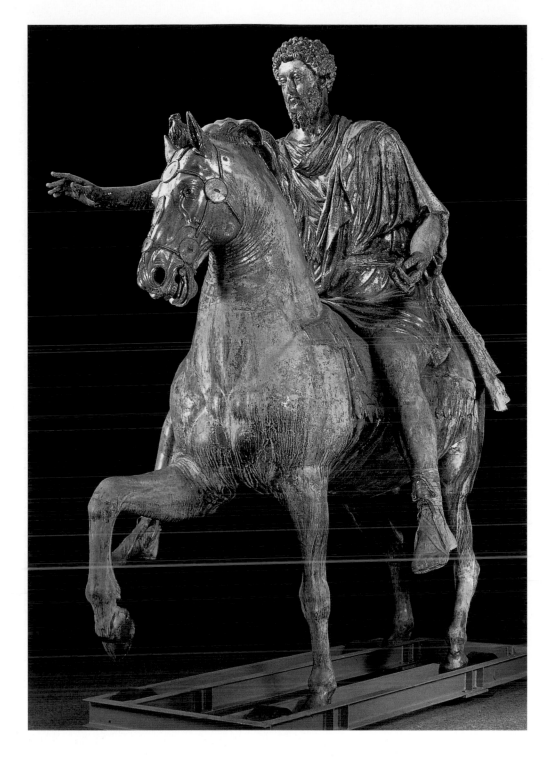

6-45. Equestrian statue of Marcus Aurelius (after restoration). c. 176 CE. Bronze, originally gilded, height of statue 11'6" (3.5 m). Museo Capitolino, Rome

Between 1187 and 1538, this statue stood in the piazza fronting the palace and church of Saint John Lateran in Rome. In January 1538, Pope Paul III had it moved to the Capitoline Hill. After being removed from its base for cleaning and restoration work some years ago, it was taken inside the Capitoline Museum to protect it from air pollution, and a copy replaced it in the piazza.

Imperial portraits—realistic or not—contain an element of propaganda. Marcus Aurelius, like Hadrian, was a successful military commander who was equally proud of his intellectual attainments. In a lucky error—or twist of fortune—a gilded bronze equestrian statue of the emperor (fig. 6-45) came early but mistakenly to be revered as a statue of Constantine, known in the Middle Ages as the first Christian emperor. Consequently the statue escaped being melted down, a fate that befell all other bronze equestrian statues from antiquity. The emperor is dressed as a military commander in a tunic and short, heavy cloak. The raised foreleg of his horse once trampled a crouching barbarian. Marcus Aurelius's head, with its thick, curly hair and full beard (a style that was begun by Hadrian to enhance his intellectual image), resembles the traditional "philosopher"

portraits of the Republican period. The emperor wears no armor and carries no weapons; like Egyptian kings, he conquers effortlessly by the will of the gods. And like his illustrious predecessor Augustus, he reaches out to the people in a persuasive, beneficent gesture.

It is difficult to create an equestrian portrait in which the rider stands out as the dominant figure without making the horse look too small. The sculptor of this statue found a balance acceptable to viewers of the time and, in doing so, created a model for later artists. The horse's high-arched neck, massive head, and short body suggest that it is from a Spanish breed of strong, compact, agile animals prized as war steeds.

Marcus Aurelius was succeeded as emperor by his son Commodus, a man lacking political skill, administrative

6-46. _Commodus as Hercules_, from Esquiline Hill, Rome. c. 191–2 CE. Marble, height 46½" (118 cm). Palazzo dei Conservatori, Rome

The emperor Commodus was not just decadent—he was probably insane. He claimed at various times to be the reincarnation of Hercules and the incarnation of the god Jupiter, and he even appeared in public as a gladiator. He ordered the months of the Roman year to be renamed after him and changed the name of Rome to Colonia Commodiana. When he proposed to assume the consulship dressed and armed as a gladiator, his associates, including his mistress, arranged to have him strangled in his bath by a wrestling partner. In this portrait, the emperor is shown in the guise of Hercules, adorned with references to the hero's legendary labors: his club, the skin and head of the Nemean Lion, and the golden apples from the garden of the Hesperides.

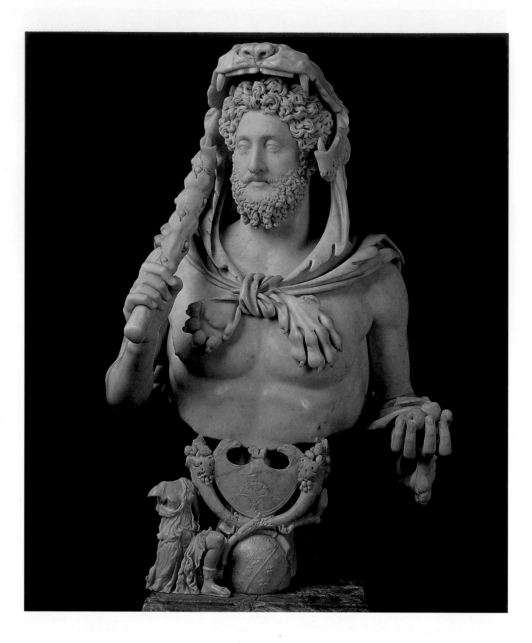

competence, and intellectual distinction. During his unfortunate reign (180–92 CE), he devoted himself to luxury and frivolous pursuits. He did, however, attract some of the finest artists of the day for his commissions. A marble bust of Commodus posing as Hercules reflects his character (fig. 6-46). The sculptor's sensitive modeling and expert drillwork exploit the play of light and shadow on the figure and bring out the textures of the hair, beard, facial features, and drapery. The portrait conveys the illusion of life and movement, but it also captures its subject's weakness. The foolishness of the man comes through in his pretentious assumption of the attributes of Hercules.

THE ROMAN CITY AND HOME

Through good times and bad, individual Romans—like people everywhere at any time—tried to live a decent or even comfortable life with adequate shelter, food, and clothing. Their poets and historians tell us that Romans were genuinely attached to the land, but they were essentially city dwellers. Today their cities and towns, houses, apartments, and country villas evoke the ancient Roman way of life with amazing clarity through the efforts of the modern archaeologists who have excavated them.

Such archaeological sites as Pompeii, Timgad, Ostia, and Tivoli, as well as those in Rome itself, illustrate different kinds of Roman cities and lifestyles. The affluent southern Italian city of Pompeii was a thriving center of about 20,000 inhabitants on the day in 79 CE that Mount Vesuvius erupted, burying it under more than 20 feet of volcanic ash. An ancient village that had grown and spread over many centuries, Pompeii lacked the gridlike regularity of newer, planned Roman cities (as we will see at Timgad), but its layout is typical of cities that grew over time. Temples and government buildings surrounded a main square, or forum; shops and houses lined straight paved streets; and a protective wall enclosed the heart of the city. The forum was the center of civic life in Roman towns and cities, as the agora was in Greek cities. Business was conducted in its basilicas and pavilions, religious duties performed in its temples,

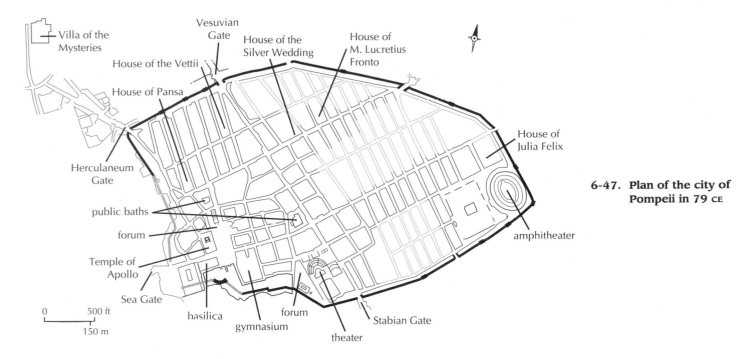

6-47. Plan of the city of Pompeii in 79 CE

Villa of the Mysteries
Vesuvian Gate
House of the Silver Wedding
House of the Vettii
House of M. Lucretius Fronto
House of Pansa
House of Julia Felix
Herculaneum Gate
public baths
forum
Temple of Apollo
Sea Gate
amphitheater
basilica
forum
gymnasium
theater
Stabian Gate

0 500 ft
150 m

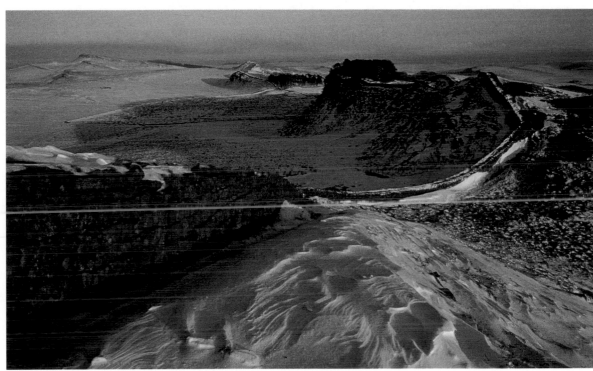

6-48. Hadrian's Wall, Great Britain. 2nd century CE. View from near Housesteads, England

and speeches presented in its open square. For recreation, people went to the nearby baths or to events in the theater or amphitheater (fig. 6-47).

The people of Pompeii lived in houses behind or above rows of shops. Even upper-class homes—gracious private residences with gardens—often had street-level shops. If there was no shop, the wall facing the street was usually broken only by a door, for the Romans emphasized the interior rather than the exterior in their domestic architecture.

In contrast to a city like Pompeii, which sprawled as it grew from its ancient, village origins, newer cities followed a design based on Roman army camps. The Roman army skillfully built sturdy walls and forts at outposts throughout the empire. Hadrian's Wall, in northern

Britain, is a singularly well preserved example of these structures (fig. 6-48). This stone barrier snakes from coast to coast across a narrow (80-mile-wide) part of Britain, creating a symbolic as well as a physical boundary between Roman territory and that of the "barbarian" Picts and Scots to the north. Seventeen large camps housed forces ready to respond to any trouble. These camps were laid out in a grid, with two main streets crossing at right angles dividing them into quarters; the commander's headquarters was located at their intersection.

Roman architects who designed frontier towns, new cities, and forts or who expanded and rebuilt existing ones based the urban plan on the layout of the army camp. Adopting the grid plan of the Etruscan and later

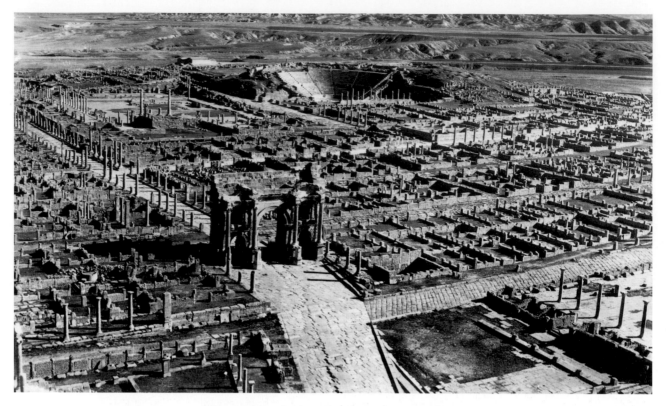

6-49. Ruins of Timgad, Algeria. Begun c. 100 CE

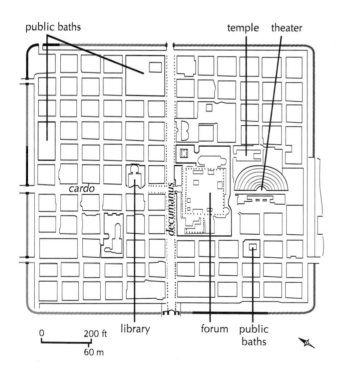

6-50. Plan of Timgad

Greek cities, they divided towns into four quarters defined by intersecting north-south and east-west avenues, called, respectively, the *decumanus* and the *cardo* by modern archaeologists. The forum and other public buildings were located at this intersection, just as the commander's headquarters had been in a camp. Terrain and climate had little effect on the symmetry of this simple, efficient plan. It remained much the same throughout the empire.

Some of the new towns designed along these lines in the outlying reaches of the empire were built by the imperial administration for the soldiers who had defended its borders. For example, in North Africa, Trajan founded a new town for retired soldiers and their families at Timgad (in modern Algeria). Timgad was once home to 15,000 people (fig. 6-49).

Timgad covered about 30 acres with two main streets dividing the grid into four equal districts with a central forum. Amenities included a theater, a library, and several public baths. An elaborate arch marked the main entrance to the town and the beginning of a colonnaded avenue. The streets were paved with precisely cut and fitted ashlar blocks (fig. 6-50).

Another city type can be seen in the remains of Ostia, the port of ancient Rome, a commercial city with a population of 100,000 at its height, during the empire. Laid out for the convenience of merchants and traders with a very long main street paralleling the Tiber River, Ostia had large public squares, shops, and a special square for the seventy large businesses that had their headquarters there. Mosaic floors, designed with appropriate traders' emblems, identified each office. A temple to the imperial

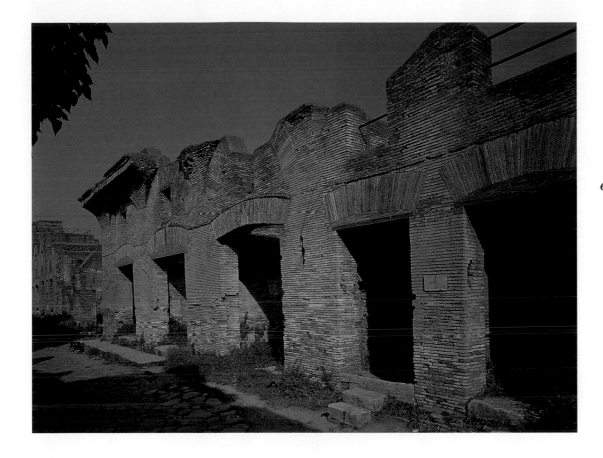

6-51. **Apartment block**
(insula), Ostia,
1st–2nd century CE

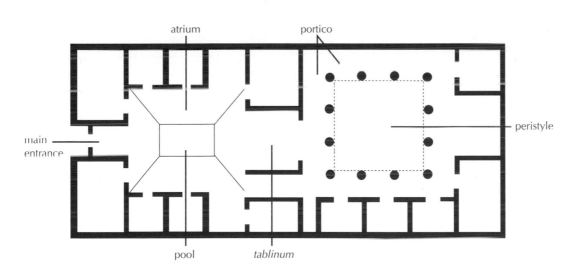

atrium portico

main ———
entrance

peristyle

pool _tablinum_

6-52. **Plan of a typical**
Roman house

grain supply (which was worshiped like a god) stood in the center of the square.

Much of the housing in a Roman city such as Ostia consisted of brick apartment blocks (fig. 6-51), referred to as _insulae_ ("islands"). These apartment buildings with their internal courtyards, multiple floors, narrow staircases, and occasional overhanging balconies give a better picture of typical Roman city life than the luxurious villas of Pompeii (see fig. 6-59), although Ostia had a garden-filled section too. Although most of the apartments might seem cramped to us, Roman city dwellers—then as now—were social creatures who lived much of their lives in public markets, squares, theaters, baths, and neighborhood bars. The city dweller returned to the _insulae_ to sleep, perhaps to eat. Even women enjoyed a public life outside the home—a marked contrast to the circumscribed lives of Greek women.

DOMESTIC ARCHITECTURE

A Roman house usually consisted of small rooms laid out symmetrically around one or two open courts (fig. 6-52). From the entrance, a corridor led to the atrium, a large space with a shallow pool or cistern for catching

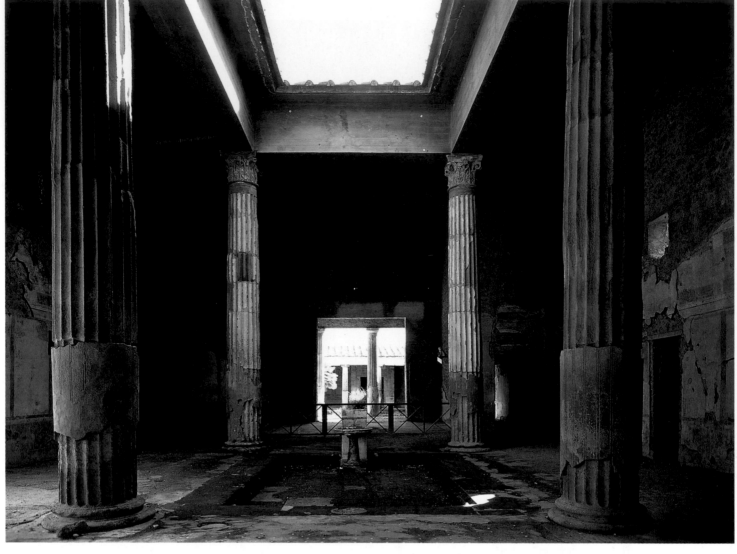

6-53. Atrium, House of the Silver Wedding, Pompeii. Early 1st century CE

Ancient Roman houses excavated at Pompeii and elsewhere are usually simply given numbers by archaeologists or (if known) named after the families or individuals who once lived in them. This house received its unusual name as a commemorative gesture. It was excavated in 1893, the year of the silver wedding anniversary of Italy's King Humbert and his wife, Margaret of Savoy, who had supported archaeological fieldwork at Pompeii.

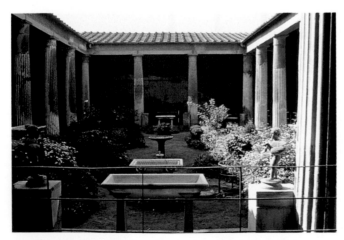

6-54. Peristyle garden, House of the Vettii, Pompeii. Mid-1st century CE

rainwater (fig. 6-53). This organization of the front part of the house—the centrally located atrium surrounded by small rooms—originated with the Etruscans. Beyond the atrium, in a reception room called the **tablinum**, where the head of the household conferred with clients, portrait busts of the family's ancestors might be displayed. In large houses, the *tablinum* opened onto a peristyle, a garden surrounded by a colonnaded walkway or portico. The most private areas—such as the dining room, the family sitting room, bedrooms, the kitchen, and servants' quarters—usually were entered from the peristyle.

The nature-loving Romans softened the regularity of their homes with beautifully planted gardens (see "The Urban Garden," page 266). Larger residences often had both fruit and vegetable gardens. In Pompeii, where the mild southern climate permitted gardens to flourish year-round, the peristyle was often turned into an outdoor living room with painted walls, fountains, and sculpture, as in the mid-first-century CE House of the Vettii (fig. 6-54).

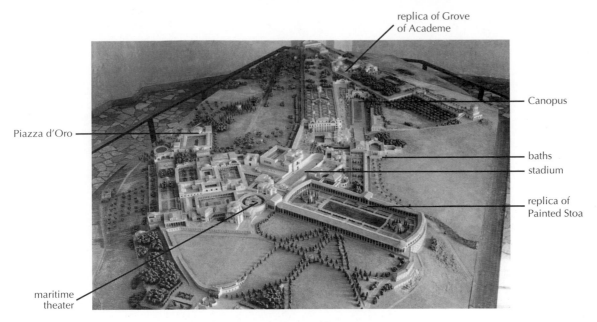

6-55. Model of Hadrian's Villa, Tivoli. C. 135 CE

Labels on image: replica of Grove of Academe; Canopus; baths; stadium; replica of Painted Stoa; Piazza d'Oro; maritime theater

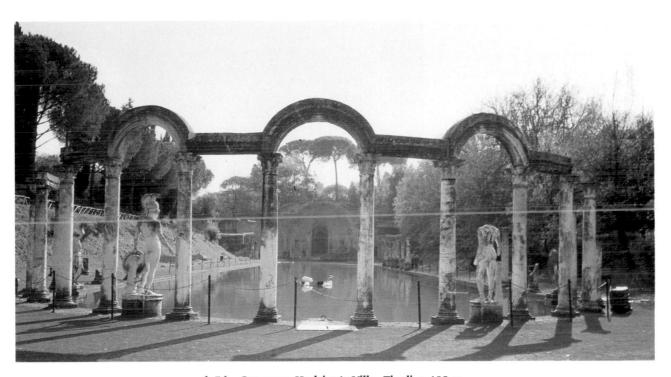

6-56. Canopus, Hadrian's Villa, Tivoli. C. 135 CE

To imagine Roman life at its most luxurious, however, one must go to Tivoli, a little more than 20 miles from Rome. Here, Hadrian, a great patron whose undertakings extended beyond public architecture, instructed his architects to re-create his favorite places throughout the empire in fantasy rather than actuality. In his splendid villa, he could pretend to enjoy the Athenian Grove of Academe where Plato had founded his academy, the Painted Stoa from the Athenian Agora, and buildings of the Ptolemaic capital of Alexandria, Egypt. Hadrian's Villa was not a single building but an architectural complex of many buildings, lakes, and gardens spread over half a square mile (fig. 6-55). Each section had its own inner logic, and each took advantage of natural land formations and attractive views. The individual buildings were not large, but they were extremely complex, challenging the ingenuity of Roman builders and engineers, who exploited to the fullest the flexibility offered by concrete and vaulted construction. Walls and floors had veneers of marble and travertine or exquisite mosaics and paintings. Landscapes with pools, fountains, and gardens turned the villa into a place of sensuous delight. An area with a long reflecting pool, called the Canopus after a site near Alexandria, was framed by a colonnade with alternating semicircular and straight entablatures (fig. 6-56). Copies of famous Greek statues, and sometimes even the originals, filled the spaces between the columns. So great was Hadrian's love of Greek sculpture that he even had the caryatids of the Erechtheion (see fig. 5-48) replicated for his pleasure palace.

THE URBAN GARDEN

The remains of urban gardens preserved in the volcanic fallout at Pompeii have been the focus of a decades-long study by archaeologist Wilhelmina Jashemski. Her work has revealed much about the layout of ancient Roman gardens and the plants cultivated in them. Early archaeologists, searching for more tangible remains, usually destroyed evidence of gardens, but in 1973 Jashemski and her colleagues had the opportunity to work on the previously undisturbed **peristyle** garden—a planted interior court enclosed by columns—of the House of G. Polybius in Pompeii. Workers first removed layers of debris and volcanic material to expose the level of the soil as it was before the eruption in 79 CE. They then collected samples of pollen, seeds, and other organic material and carefully injected plaster into underground root cavities to make casts for later study. These materials enabled botanists to identify the types of plants and trees cultivated in the garden, to estimate their size, and to determine where they had been planted.

The evidence from this and other excavations indicates that most urban gardens served a practical function. They were planted with fruit- and nut-bearing trees and occasionally with olive trees. Only the great luxury gardens were rigidly landscaped. Most gardens were randomly planted or, at best, arranged in irregular rows. Some houses had both peristyle gardens and separate vegetable gardens.

The garden in the house of Polybius was surrounded on three sides by a **portico**, which protected a large cistern on one side that supplied the house and garden with water. Young lemon trees in pots lined the fourth side of the garden, and nail holes in the wall above the pots indicated that the trees had been espaliered—pruned and trained to grow flat against a support—a practice still in use today. Fig, cherry, and pear trees filled the garden space, and traces of a fruit-picking ladder, wide at the bottom and narrow at the top to fit among the branches, was found on

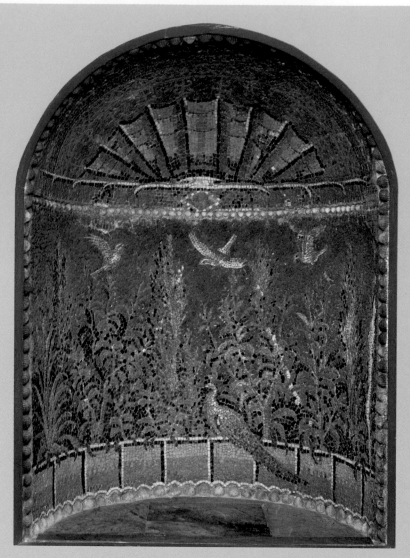

Wall niche, from a garden in Pompeii. Mid-1st century CE. Mosaic, 43³/₄ x 31¹/₂" (111 x 80 cm). Fitzwilliam Museum, University of Cambridge, England

the site. This evidence suggests that the garden was a densely planted orchard similar to the one painted on the dining-room walls of the villa of Empress Livia in Primaporta (see fig. 6-61).

An aqueduct built during the reign of Augustus had given Pompeii's residents access to a reliable and plentiful supply of water, eliminating their dependence on wells and rainwater basins and allowing them to add to their gardens pools, fountains, and flowering plants that needed heavy watering. In contrast to the earlier, unordered plantings, formal gardens with low, clipped borders and plantings of ivy, ornamental

boxwood, laurel, myrtle, acanthus, and rosemary—all mentioned by writers of the time—became fashionable. There is also evidence of topiary work, the clipping of shrubs and hedges into fanciful shapes. Sculpture and purely decorative fountains became popular. The peristyle garden of the House of the Vettii, for example, had more than a dozen fountain statues jetting water into marble basins (see fig. 6-54). In the most elegant peristyles, mosaic decorations covered the floors, walls, and even the fountains. Some of the earliest wall mosaics, such as the one illustrated here, were created as backdrops for fountains.

6-57. *Battle of Centaurs and Wild Beasts*, from Hadrian's Villa, Tivoli. c. 118–28 CE. Mosaic, 23 x 36" (58.4 x 91.4 cm). Staatliche Museen zu Berlin, Preussischer Kulturbesitz, Antikensammlung

This floor mosaic may be a copy of a much-admired painting of a fight between centaurs and wild animals done by the late-fifth-century BCE Greek artist Zeuxis.

Hadrian did more than copy his favorite cities; he also added to them. For example, he finished the Temple of the Olympian Zeus in Athens and dedicated it in 132 CE (see fig. 5-73). He also built a library, a stoa, and an aqueduct for the Athenians and according to Pausanias placed a statue of himself inside the Parthenon.

MOSAICS

Pictorial mosaics covered the floors of fine houses, villas, and public buildings throughout the empire. Working with very small *tesserae* (cubes of glass or stone) and a wide range of colors, mosaicists achieved remarkable illusionistic effects (see "Roman Mosaics," below). The *emblemata*, or panels, from a floor mosaic from Hadrian's Villa at Tivoli illustrate extraordinary artistry (fig. 6-57). In a rocky landscape with only a few bits of greenery, a desperate male centaur raises a large boulder over his head to crush a tiger that has attacked and severely wounded a female centaur. Two other felines apparently took part in the attack—the white leopard on the rocks to the left and the dead lion at the feet of the male centaur. The mosaicist rendered the figures with three-dimensional shading, **foreshortening**, and a great sensitivity to a range of figure types, including human torsos and powerful animals, living and dead, in a variety of poses.

TECHNIQUE

ROMAN MOSAICS

Mosaics were used widely in Hellenistic times and became enormously popular for decorating homes in the Roman period. **Mosaic** designs were created with pebbles or with small, regularly shaped pieces of colored stone and marble, called *tesserae*. The stones were pressed into a kind of soft cement called grout. When the stones were firmly set, the spaces between them were also filled with cement. After the surface dried, it was cleaned and polished. At first, mosaics were used mainly as durable, water-resistant coverings on floors and pavements. They were done in a narrow range of colors depending on the natural color of the stone— often earth tones or black or some other dark color on a light background. When mosaics began to appear on walls at outdoor fountains, a wide range of colors was used (see "The Urban Garden," page 266). So accomplished were some mosaicists that they could create works that looked like paintings. In fact, at the request of patrons, they often copied well-known paintings employing a technique in which very small *tesserae*, in all the needed colors, were laid down in irregular, curving lines that very effectively mimicked painted brushstrokes.

Mosaic production was made more efficient by the development of *emblemata* (the plural of *emblema*, "central design"). These small mosaic compositions were created in the artist's workshop in square or rectangular trays. They could be made in advance, carried to a work site, and inserted into a floor otherwise decorated with a simple background mosaic in a plain or geometric pattern.

THE UNSWEPT FLOOR

In his twenty-book work of comic genius, *Satyricon*, the first-century CE Roman satirist Petronius created one of the all-time fantastic dinner parties. *Trimalchio's Feast* (*Cena Trimalchionis*, Book 15) exposes the newly rich Trimalchio, who entertains his friends at a lavish banquet where he shows off his extraordinary wealth but also his boorish ignorance and bad manners. Unlike the Greeks, whose banquets were quite private affairs, reflecting their more spare material culture, Romans such as Trimalchio used such occasions to display their possessions. When dishes are broken, Trimalchio orders his servants to sweep them away with the rubbish on the floor.

In *The Unswept Floor* mosaic, the remains of fine food from a party such as Trimalchio's—from lobster claws to cherry pits—litter the floor (fig. 6-58). In the dining room where this segment was found, mosaics covered the floor along three walls. Because Romans arranged their dining rooms with three-person couches on three sides of a square table, the family and guests would have seen the fictive remains of past gourmet pleasures under their couches. Such a festive Roman dinner might have begun with appetizers of eggs, shellfish, dormice, and olives; continued with as many as seven courses, including a whole roasted pig (or ostrich, crane, or peacock), veal, and several kinds of fish; and ended with dessert of snails, nuts, shellfish, and fruit.

If art speaks to and of the ideals of a society, what does it mean that wealthy Romans commemorated their table scraps in mosaics of the greatest subtlety and skill? Is this a form of conspicuous consumption, proof positive that the owner of this house gave lavish banquets and hosted guests who had the kind of sophisticated humor that could appreciate *Trimalchio's Feast*? The Romans did in fact place a high value on displaying their wealth and taste in the semipublic rooms and gardens of their houses and villas, and they did so through their possessions, especially their art collections. *The Unswept Floor* is but one of a very large number of Roman copies of great Greek mosaics and paintings, such as *Alexander the Great Confronts Darius III* (see fig. 5-67), and sculptures such as Myron's *Discus Thrower* (see fig. 5-1). Julius Caesar owned a version of the *Dying Gallic Trumpeter* (see fig. 5-75); a *Laocöon* (see fig. 5-79) belonged to Nero; and a copy of Polykleitos's *Spear Bearer* (see fig. 5-51) was in the baths at Hadrian's Villa.

In the case of *The Unswept Floor*, Herakleitos, a second-century CE Greek mosaicist living in Rome, made this copy of an illusionistic painting by the renowned second-century BCE Pergamene artist Sosos. Consequently, the guests reclining on their banquet couches could have displayed their knowledge of the history of art—of the notable precedents for the trash on the floor.

6-58. Herakleitos. *The Unswept Floor,* **mosaic variant of a 2nd-century BCE painting by Sosos of Pergamon. 2nd century CE. Musei Vaticani, Museo Gregoriano Profano, ex Lateranese, Rome**

6-59. Reconstructed bedroom, from the House of Publius Fannius Synistor, Boscoreale, near Pompeii. Late 1st century CE, with later furnishings. The Metropolitan Museum of Art, New York
Rogers Fund, 1903 (03.14.13)

Although the elements in the room are from a variety of places and dates, they give a sense of how the original furnished room might have looked. The floor mosaic, found near Rome, dates to the second century CE. At its center is an image of a priest offering a basket with a snake to a cult image of Isis. The couch and footstool, which are inlaid with bone and glass, date from the first century CE. The wall paintings, original to the Boscoreale villa, may have been inspired by theater scene painting.

Artists created these fine mosaic image panels in their workshops. The *emblemata* were then set into a larger area already bordered by geometric patterns in mosaic. The mosaic floor in the reconstructed room in The Metropolitan Museum of Art in New York (see fig. 6-59) has a typical mosaic floor with a small image panel and many abstract designs in black and white. Image panels in floors usually reflected the purpose of the room. A dining room, for example, might have an *Unswept Floor* (fig. 6-58, "The Object Speaks"), with table scraps re-created in meticulous detail, even to the shadows they cast, and a mouse foraging among them.

WALL PAINTING

Many fine wall paintings have come to light through excavations, first in Pompeii and other communities surrounding Mount Vesuvius, near Naples, and more recently in and around Rome. The interior walls of Roman houses were plain, smooth plaster surfaces with few architectural features. On these invitingly empty spaces, artists painted decorations using pigment in a solution of lime and soap, sometimes with a little wax. After the painting was finished, they polished it with a special metal, glass, or stone burnisher and then buffed the surface with a cloth.

In the earliest paintings (200–80 BCE), artists attempted to produce the illusion of thin slabs of colored marble covering the walls, which were set off by actual architectural moldings and columns. By about 80 BCE, they began to extend the space of a room visually with painted scenes of figures on a shallow "stage" or with a landscape or cityscape. Architectural details such as columns were painted rather than made of molded plaster. As time passed, this painted architecture became increasingly fanciful. Solid-colored walls were decorated with slender, whimsical architectural and floral details and small, delicate vignettes.

The walls of a room from a villa at Boscoreale near Pompeii (reconstructed in The Metropolitan Museum, New York) open onto a fantastic urban panorama (fig. 6-59). The wall surfaces seem to dissolve behind columns and lintels, which frame a maze of floating architectural forms creating purely visual effects, like the backdrops of a stage. Indeed, the theater may have inspired this kind

6-60. *Cityscape*, detail of a wall painting from a bedroom in the House of Publius Fannius Synistor, Boscoreale. Late 1st century CE. The Metropolitan Museum of Art, New York
Rogers Fund, 1903 (03.14.13)

6-61. *Garden Scene*, detail of a wall painting from the Villa of Livia at Primaporta, near Rome. Late 1st century BCE. Museo Nazionale Romano, Rome

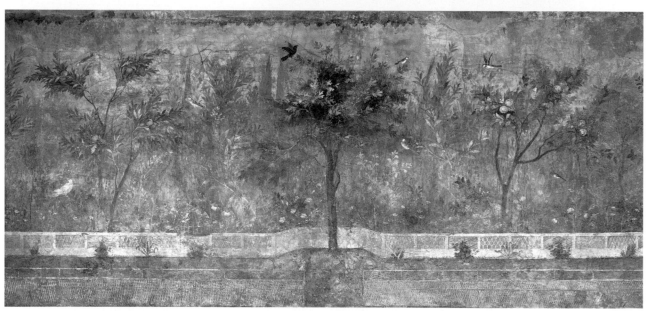

of decoration, as details in the room suggest. For example, on the rear wall, next to the window, is a painting of a grotto, the traditional setting for satyr plays, dramatic interludes about the half-man, half-goat followers of Bacchus. On the side walls, paintings of theatrical masks hang from the lintels.

One section shows a complex jumble of buildings with balconies, windows, arcades, and roofs at different levels, as well as a magnificent colonnade (fig. 6-60). The artist has used **intuitive perspective** admirably to create a general impression of real space. The architectural details follow diagonal lines that the eye interprets as parallel lines receding into the distance, and objects meant to be perceived as far away from the surface plane of the wall are shown slightly smaller than those intended to appear nearby.

The dining-room walls of the Villa of Livia at Primaporta exemplify yet another approach to creating a sense of expanded space (fig. 6-61). Instead of rendering a stage set or a cityscape, the artist "painted away" the wall surfaces to create the illusion of being on a porch or pavilion looking out over a low, paneled wall into an orchard of heavily laden fruit trees. These and the flowering shrubs are filled with a variety of wonderfully observed birds.

During the first century CE, landscape painters became especially accomplished. Pliny the Elder wrote in *Naturalis Historia* (35.116–17) of

6-62. *Seascape*, detail of a wall painting from Villa Farnesina, Rome. Late 1st century CE.

6-63. *Initiation Rites of the Cult of Bacchus (?)*, detail of a wall painting in the Villa of the Mysteries, Pompeii. c. 50 BCE

that most delightful technique of painting walls with representations of villas, porticoes and landscape gardens, woods, groves, hills, pools, channels, rivers, coastlines—in fact, every sort of thing which one might want, and also various representations of people within them walking or sailing . . . and also fishing, fowling, or hunting or even harvesting the wine-grapes.

In such paintings, the overall effect is one of wonder-invoking nature, an idealized view of the world, rendered with free, fluid brushwork and delicate color. A painting from the Villa Farnesina, in Rome (fig. 6-62), depicts the *locus amoenus*, the "lovely place" extolled by Roman poets, where people lived effortlessly in union with the land. Here two conventions create the illusion of space: distant objects are rendered proportionally smaller than near objects, and the colors become slightly grayer near the horizon, an effect called **atmospheric perspective**, which reproduces the tendency of distant objects to appear hazy, especially in seascapes.

In addition to landscapes and city views, other subjects that appeared in Roman art included historical and mythological scenes, exquisitely rendered **still lifes** (compositions of inanimate objects), and portraits. One of the most famous painted rooms in Roman art is in the so-called Villa of the Mysteries at Pompeii (fig. 6-63). The rites of mystery religions were often performed in private homes as well as in special buildings or temples, and this

6-64. ***Still Life***, detail of a wall painting from the House of Julia Felix, Pompeii. Late 1st century CE. Museo Archeològico Nazionale, Naples

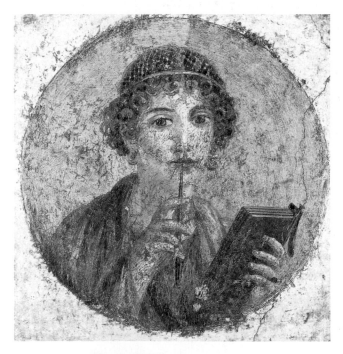

6-65. ***Young Woman Writing***, detail of a wall painting, from Pompeii. Late 1st century CE. Diameter 14⅝" (37 cm). Museo Archeològico Nazionale, Naples

The fashionable young woman seems to be pondering what she will write about with her stylus on the beribboned writing tablet that she holds in her other hand. Romans used pointed styluses to engrave letters on thin, wax-coated ivory or wood tablets in much the way we might use a hand-held computer; errors could be easily smoothed over. When a text or letter was considered ready, it was copied onto expensive papyrus or parchment. Tablets like these were also used by schoolchildren for their homework.

room, at the corner of a suburban villa, must have been a shrine or meeting place for such a cult. A reminder of the wide variety of religious practices tolerated by the Romans, the murals depict initiation rites—probably into the cult of Bacchus, who was the god of vegetation and fertility as well as wine and was one of the most important deities in Pompeii. The entirely painted architectural setting consists of a "marble" **dado** (the lower part of a wall) and, around the top of the wall, an elegant frieze supported by pilasters. The action takes place on a shallow "stage" along the top of the dado, with a background of brilliant, deep red (now known as Pompeian red) that was very popular with Roman painters. The scene unfolds around the entire room, depicting a succession of events that culminate in the acceptance of an initiate into the cult.

In the portion of the room seen here, a priestess (on the left) prepares to reveal draped cult objects, a winged figure whips a female initiate lying across the lap of another woman, and a devotee dances with cymbals, perhaps to drown out the initiate's cries. According to another interpretation, the dancing figure is the initiate herself, who has risen to dance with joy at the conclusion of her trials. The whole scene may show a purification ritual meant to bring enlightenment and blissful union with the god.

Wall painting also depicted more mundane subject matter. A still-life panel from the House of Julia Felix in Pompeii (fig. 6-64) depicts everyday domestic wares and the makings of a meal—eggs and recently caught game birds. Items have been carefully arranged to give the composition clarity and balance. The focus is on the round plate filled with eggs and the household containers that flank it. The towel on a hook on the right of the painting and the bottle tilted against the end of the shelf echo the pyramidal shape of the birds above the plate. A strong, clear light floods the picture from the left, casting shadows and enhancing the illusion of real objects in real space.

Portraits, sometimes imaginary ones, also became popular. A late-first-century CE **tondo** (circular panel) from Pompeii contains the portrait *Young Woman Writing* (fig. 6-65). The sitter has regular features and curly hair caught in a golden net. As in a modern studio portrait photograph with its careful lighting and retouching, the young woman may be somewhat idealized. Following a popular convention, she nibbles on the tip of her stylus. Her sweet mien and clear-eyed but unfocused and contemplative gaze suggest that she is in the throes of composition. The paintings in Pompeii reveal much about the lives of women during this period (see "The Position of Roman Women," page 274). Some, like Julia Felix, were the owners of houses where paintings were found. Others were the subjects of the paintings, shown as rich and poor, young and old, employed as business managers and domestic workers.

Just as architecture became increasingly grand, even grandiose, during the first 150 years of the Roman Empire, so, too, did the decorative wall painting in houses become ever more elaborate. In the House of M. Lucretius

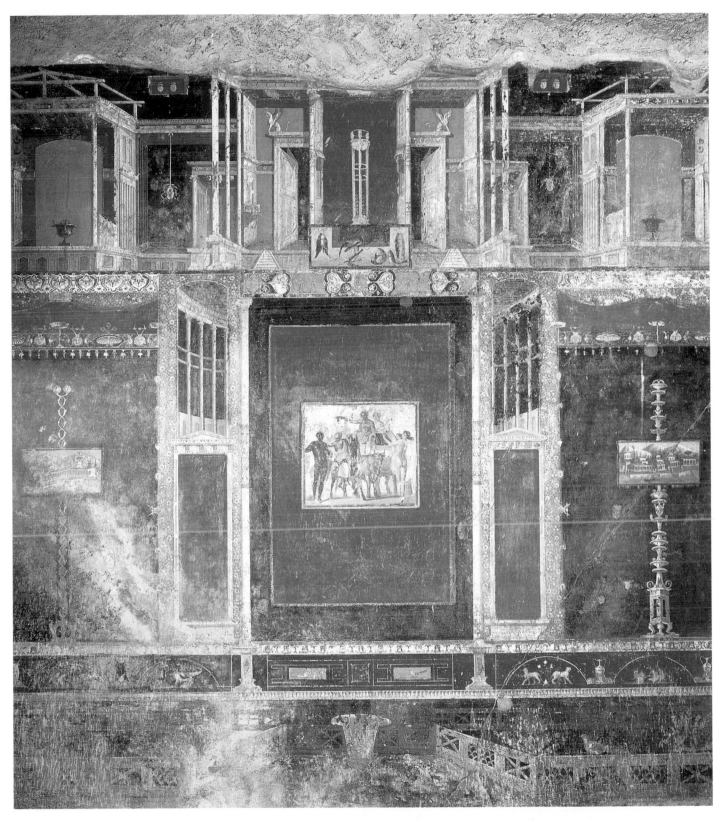

6-66. Detail of a wall painting in the House of M. Lucretius Fronto, Pompeii. Mid-1st century CE

Fronto in Pompeii, from the mid-first century CE (fig. 6-66), the artist painted a room with panels of black and red, bordered with architectural moldings. These architectural elements have no logic, and for all their playing with perspective, they fail to create any significant illusion of depth. Rectangular pictures seem to be mounted on the black and red panels. The scene with figures in the center is flanked by two small simulated window openings protected by grilles. The two pictures of villas in landscapes appear to float in front of intricate bronze easels.

6-67. *Septimius Severus, Julia Domna, and Their Children, Caracalla and Geta*, from Fayum, Egypt. c. 200 CE. Painted wood, diameter 14" (35.6 cm). Staatliche Museen zu Berlin, Preussischer Kulturbesitz, Antikensammlung

THE LATE EMPIRE

The comfortable life suggested by the wall paintings in Roman villas was, within a century, to be challenged by hard times. The reign of Commodus at the end of the second century CE marked the beginning of a period of political and economic decline. Barbarian groups pressed on Rome's frontiers, and many crossed the borders and settled within them, disrupting provincial governments. As strains spread throughout the empire, imperial rule became increasingly authoritarian. Eventually the army controlled the government, and the Imperial Guards set up and deposed rulers almost at will, often selecting candidates from among poorly educated, power-hungry provincial leaders in their own ranks.

THE SEVERAN DYNASTY

Despite the pressures of political and economic change, the arts continued to flourish under the Severan emperors (193–235 CE) who succeeded Commodus. Septimius Severus (ruled 193–211 CE) and his Syrian wife, Julia Domna, restored public buildings, commissioned official portraits, and made some splendid additions to the old Republican Forum, including the transformation of the House of the Vestal Virgins, who served the Temple of Vesta, into a large, luxurious residence. Their sons, Caracalla and Geta, succeeded Septimus Severus as co-emperors in 211 CE, but in 212 CE, Caracalla murdered Geta and ruled alone until he in turn was murdered by his successor in 217 CE.

THE POSITION OF ROMAN WOMEN

If we were to judge from the conflicting accounts of Roman writers, Roman women were either shockingly wicked and willful, totally preoccupied with clothes, hairstyles, and social events, or well-educated, talented, and active members of family and society. In ancient Rome, as in the contemporary world, sin sold better than saintliness, and for that reason written attacks on women by their male contemporaries must be viewed with some reservation. In fact, careful study has shown that Roman women were far freer and more engaged in society than their Greek counterparts.

Many women received a formal education, and a well-educated woman was as admired as a well-educated man. Although many educated women became physicians, shopkeepers, and even overseers in such male-dominated businesses as shipbuilding, education was valued primarily for the desirable status it imparted.

Ovid (43 BCE–17 CE) advised all young women to read both the Greek classics and contemporary Roman literature, including his own, of course. Women conversant with political and cultural affairs and with a reputation for good conversation enjoyed the praise and admiration of some male writers. A few women even took up literature themselves. A woman named Julia Balbilla was respected for her poetry. Another, Sulpicia, a writer of elegies, was accepted into male literary circles. Her works were recommended by the author Martial to men and women alike. The younger Agrippina, sister of the emperor Caligula and mother of Nero, wrote a history of her illustrious family.

Women were also encouraged to become accomplished singers, instrumentalists, and even dancers—as long as they did not perform publicly. Almost nothing appears in literature about women in the visual arts, no doubt because artists were not highly regarded.

6-68. *Caracalla*. Early 3rd century CE. Marble, height 14½" (36.2 cm). The Metropolitan Museum of Art, New York

Samuel D. Lee Fund, 1940 (40.11.1A)

The emperor Caracalla (ruled 211–17 CE) was consistently represented with a malignant, scowling expression, a convention meant to convey a particular message to the viewer: The emperor was a hard-as-nails, battle-toughened military man, a lethal opponent ready to defend himself and his empire.

A portrait of the family of Septimius Severus provides insight into both the history of the Severan dynasty and early-third-century CE painting (fig. 6-67). The work is in the highly formal style of the Fayum region in northwestern Egypt, and it may be a souvenir of an imperial visit to Egypt. The emperor, clearly identified by his distinctive divided beard and curled moustache, wears an enormous crown. Next to him is the empress Julia Domna, portrayed with similarly recognizable features—full face, large nose, and masses of waving hair. Their two sons, Geta (who has been scratched out) and Caracalla, stand in front of them. Perhaps because we know that he grew up to be a ruthless dictator, little Caracalla looks like a disagreeable child. After murdering his brother, perhaps with Julia Domna's help, Caracalla issued a decree to abolish every reference to Geta. Clearly the owners of this painting complied and scraped off Geta's face. The work emphasized the trappings of imperial wealth and power—crowns, jewels, and direct forceful expressions—rather than attempting any psychological study. The rather hard drawing style, with its broadly brushed-in colors, contrasts markedly with the illusionism of earlier portraits, such as the *Young Woman Writing*.

Emperor Caracalla emerges from his adult portraits as a man of chilling and calculating ruthlessness. In the example shown here (fig. 6-68), the sculptor has enhanced the intensity of the emperor's expression by producing strong contrasts of light and dark with careful chiseling and drillwork. Even the marble eyes have been drilled and engraved to catch the light in a way that makes them glitter. The contrast between this style and that of the portraits of Augustus is a telling reflection of the changing character of imperial rule. Augustus presented himself as the first among equals, ruling by persuasion; Caracalla revealed himself as a no-nonsense ruler of iron-fisted determination.

The year before his death in 211 CE, Septimius Severus had begun a popular public-works project, the construction of magnificent new public baths on the southeast side of Rome. His son and successor, Caracalla, completed and inaugurated the baths in 216–17 CE, and they are known by his name. For the Romans, baths were recreational and educational centers, not simply places to wash, and emperors built large bathing complexes to gain public favor. Baths were luxurious buildings whose brick and concrete structures were hidden under a sheath of colorful marble and mosaic.

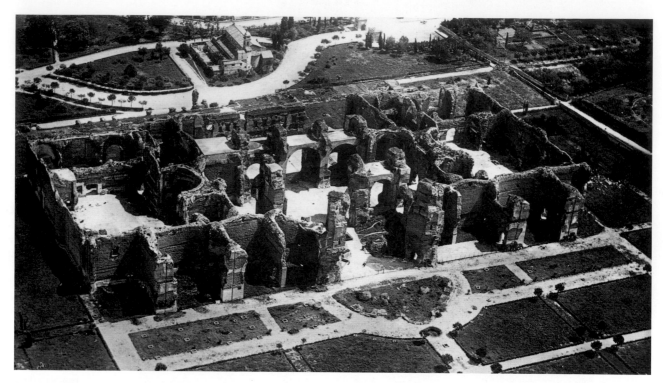

6-69. Baths of Caracalla, Rome. c. 211–17 CE

Although well-to-do people usually had private baths in their homes, women and men enjoyed the pleasures of socializing at public baths—but not together. In some cities, women and men had separate bathhouses, but it was also common for them to share one facility at different times of the day. Everyone—from nobles to working people—was allowed to use the public baths. Men had access to the full range of facilities, including hot, warm, and cold baths, moist- and dry-heat chambers (like saunas), pools for swimming, and outdoor areas for sunbathing or exercising in the nude. Women generally refrained from using very hot baths, dry-heat chambers, and the outdoor areas. Libraries provided study and reading facilities.

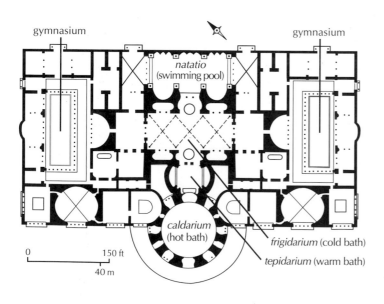

6-70. Plan of the Baths of Caracalla

The Baths of Caracalla (fig. 6-69) were laid out on a strictly symmetrical plan. The bathing facilities were grouped in the center of the main building to make efficient use of the below-ground furnaces that heated them and to allow bathers to move comfortably from hot to cold pools and finish with a swim (fig. 6-70). Many other facilities—exercise rooms, shops, latrines, and dressing rooms—were housed on each side of the bathing block. The baths alone covered 5 acres. The entire complex, which included gardens, a stadium, libraries, a painting gallery, auditoriums, and huge water reservoirs, covered an area of 50 acres and inspired later buildings when large crowds had to be accommodated (fig. 6-71).

THE THIRD CENTURY

The successors of the Severan emperors—the more than two dozen so-called soldier-emperors who attempted to rule the empire for the next seventy years—continued to favor the style of Caracalla's portraits. The sculptor of a bust of *Philip the Arab* (ruled 244–49 CE), for example, first modeled the broad structure of the emperor's head, then used both chisel and drill to deepen shadows and heighten the effects of light in the furrows of the face and the stiff folds of the drapery (fig. 6-72). Tiny flicks of the chisel suggest the texture of hair and beard. The overall

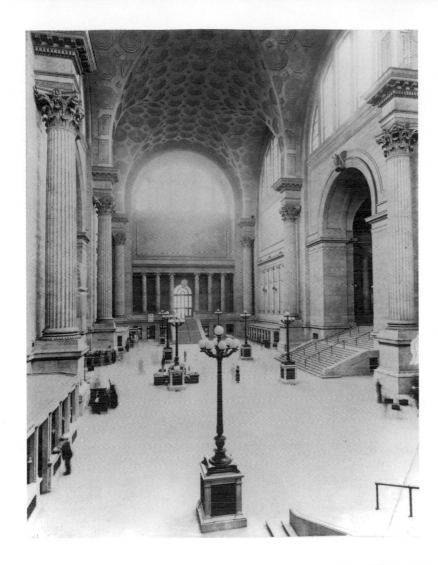

6-71. McKim, Mead, and White, architects. Waiting room, interior of New York City's Pennsylvania Railroad Station. 1906–10; demolished 1963

The design of this railroad terminal was based on the Baths of Caracalla.

impact of the work depends on the effects of light and the imagination of the spectator as much as on the carved stone itself. Nevertheless, this portrait does not convey the same malevolent energy as Caracalla's portraits. Philip seems tense and worried, suggesting that he was a troubled man in troubled times. What comes through from Philip's twisted brow, sidelong upward glance, quizzical lips, and tightened jaw muscles is a sense of guile, deceit, and fear. Philip had been the head of the Imperial Guard, but he murdered his predecessor and was murdered himself after only five years.

During the turmoil of the third century CE, Roman artists emphasized the symbolic or general qualities of their subjects and expressed them in increasingly simplified, geometric forms. Despite this trend toward abstraction, the earlier tradition of slightly idealized but realistic portraiture was slow to die out, probably because it showed patrons as they wanted to be remembered. In the engraved gold-glass of a woman with her son and daughter, the so-called *Family of Vunnerius Keramus* (fig. 6-73, page 278), the subjects are rendered as individuals, although the artist has emphasized their great almond-shaped eyes. The work seems to reflect

6-72. *Philip the Arab*. 244–49 CE. Marble, height 26" (71.1 cm). Musei Vaticani, Braccio Nuovo, Rome

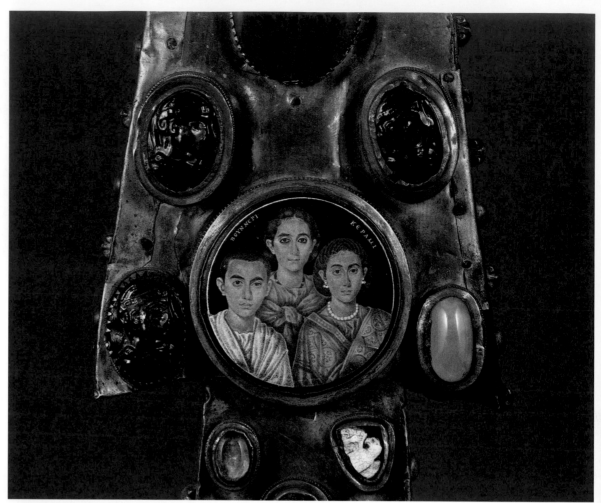

6-73. *Family of Vunnerius Keramus.* C. 250 CE. Engraved gold leaf sealed between glass, diameter 2³⁄₈" (6 cm). Museo Civico dell'Età Cristiana, Brescia

This gold-glass medallion of a mother, son, and daughter could have been made in Alexandria, Egypt, any time between the early third and the mid-fifth centuries CE. It is inscribed "Bounneri Kerami" in Alexandrian Greek—perhaps the signature of the artist. The medallion was later placed in the eighth-century Brescia cross (see fig. 14-9).

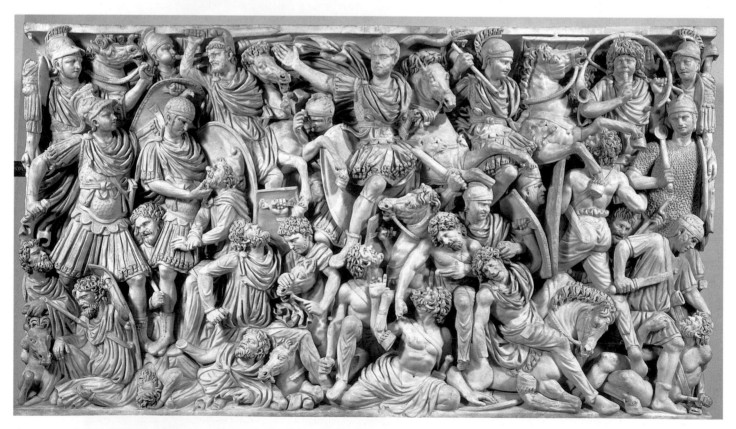

6-74. *Battle between the Romans and the Barbarians*, detail of the *Ludovisi Battle Sarcophagus*, found near Rome. c. 250 CE. Marble, height approx. 5' (1.52 m). Museo Nazionale Romano, Rome

the advice of Philostratus, who, writing in the late third century CE, commented:

> The person who would properly master this art [of painting] must also be a keen observer of human nature and must be capable of discerning the signs of people's characters even though they are silent; he should be able to discern what is revealed in the expression of the eyes, what is found in the character of the brows, and, to state the point briefly, whatever indicates the condition of the mind. (Quoted in Pollitt, pages 224–25)

The *Family of Vunnerius Keramus* portrait was engraved on a sheet of gold leaf and sealed between two layers of glass. This fragile, delicate medium, often used for the bottoms of glass bowls or cups, seems appropriate for an age of material insecurity and emotional intensity. This glowing portrait was inserted by a later Christian owner as the central jewel in an eighth-century cross (see fig. 14-9).

Although portraits and narrative reliefs were the major forms of public sculpture during the second and third centuries CE, changing funerary practices—a shift from cremation to burial—led to a growing demand for funerary sculpture. Wealthy Romans commissioned elegant marble sarcophagi to be placed in their tombs. Workshops throughout the empire produced thousands of these sarcophagi, which were carved with reliefs that ranged in complexity from simple geometric or floral ornament to scenes involving large numbers of figures. The subjects of the elaborate reliefs varied widely. Some included events from the life of the deceased; some showed dramatic scenes from Greek mythology and drama.

A sarcophagus known as the *Ludovisi Battle Sarcophagus* (after a seventeenth-century owner) dates about 250 CE (fig. 6-74). Romans triumph over barbarians in a style that has roots in the sculptural traditions of Hellenistic Pergamon. The artist has made no attempt to create a realistic spatial environment. The Romans at the top of the panel are efficiently dispatching the barbarians—clearly identifiable by their heavy, twisted locks and scraggly beards—who lie fallen, dying, or beaten at the bottom of the panel. The bareheaded young Roman commander, with his gesture of victory, recalls the equestrian statue of Marcus Aurelius (see fig. 6-45).

THE TETRARCHS

The half century of anarchy, power struggles, and inept rule by the soldier-emperors that had begun with the death of Alexander Severus (ruled 222–35 CE), the last in the Severan line, ended with the rise to power of Diocletian (ruled 284–305 CE). This brilliant politician and general reversed the empire's declining fortunes, but he also initiated an increasingly autocratic form of rule, and the social structure of the empire became increasingly rigid.

To distribute the task of defending and administering the empire and to assure an orderly succession, in 286 CE

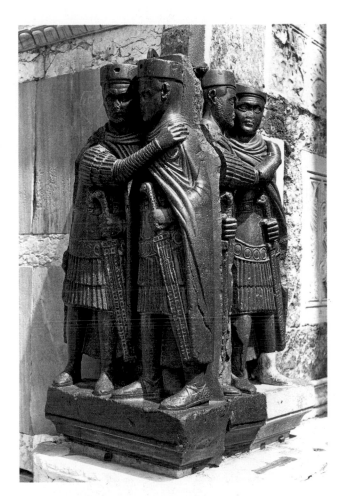

6-75. The Tetrarchs c. 300 CE. Porphyry, height of figures 51" (129 cm). From Constantinople; installed in the Middle Ages at the corner of the facade of the Cathedral of Saint Mark, Venice

Diocletian divided the empire in two. With the title of "Augustus" he would rule in the East, while another Augustus, Maximian, would rule in the West. Then, in 293 CE, he devised a form of government called a tetrarchy, or "rule of four," in which each Augustus designated a subordinate and heir, who held the title of "Caesar." Although Diocletian intended that on the death or retirement of an Augustus, his Caesar would replace him and name a new Caesar, the plan failed when Diocletian tried to implement it.

Sculpture depicting the tetrarchs, about 300 CE, documents a turn in art toward abstraction and symbolic representation (fig. 6-75). The four figures—two with beards, probably the senior Augusti, and two clean-shaven, probably the Caesars—are nearly identical. Dressed in military garb and clasping swords at their sides, they embrace each other in a show of imperial unity, proclaiming a kind of peace through concerted strength and vigilance. As a piece of propaganda and a summary of the state of affairs at the time, it is unsurpassed. The sculpture is made of porphyry, a purple stone from Egypt reserved for imperial use. The hardness of the stone, which makes it difficult to carve, and perhaps the sculptor's familiarity with Egyptian artistic conventions,

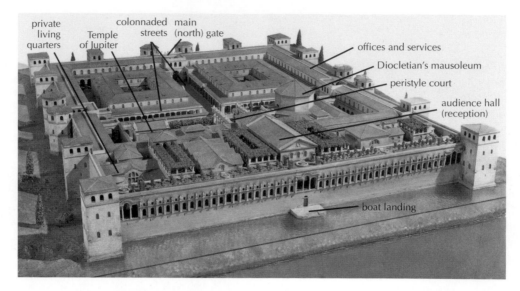

6-76. **Model of Palace of Diocletian, Split**, Croatia. c. 300 CE. Museo della Civiltà Romana, Rome

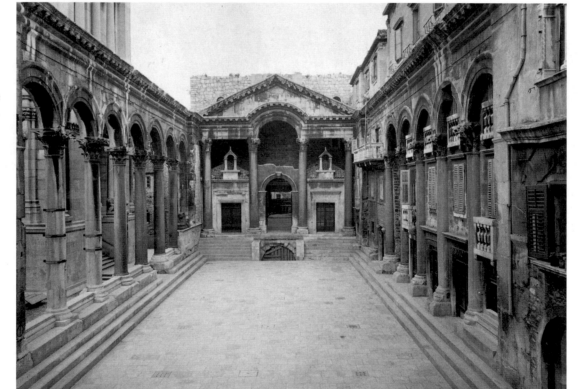

6-77. Peristyle court, Palace of Diocletian

may have contributed to the extremely abstract style of the work. The most striking features of *The Tetrarchs*—the simplification of natural forms to geometric shapes, the disregard for normal human proportions, and the emphasis on a message or idea—appear often in Roman art by the end of the third century. The sculpture may have been made in Egypt and moved to Constantinople after 330 CE. Christian Crusaders who looted Constantinople in 1204 CE took the statue to Venice, where they placed it on the Cathedral of Saint Mark.

Architecture also changed under Diocletian's patronage. Earlier great palaces such as Hadrian's Villa often had been as extensive and as semipublic as the Minoan palace at Knossos. Diocletian broke with this tradition by building a huge and well-fortified imperial residence at Split on the Dalmatian coast after he retired from active rule (fig. 6-76). Revolutionary in design, the structure recalls the compact, regular plan of a Roman army camp rather than the irregular, sprawling design of Hadrian's Villa. The palace consisted of a rectangular enclosure 650

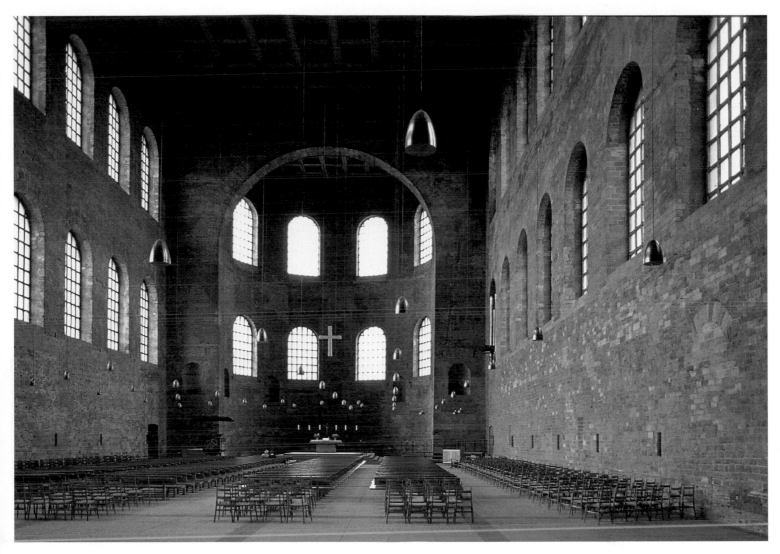

6-78. The Basilica, Trier, Germany. Early 4th century. View of the nave. Height of room 100' (30.5 m)

Only the left wall and apse survive from the original Roman building. The basilica became part of the bishop's palace during the medieval period.

by 550 feet, surrounded by a wall and crossed by two colonnaded streets that divided it into quarters, each with a specific function. The emperor's residential complex, which included the reception hall on the main, north-south axis of the palace, faced the sea. Ships bearing supplies or providing transport for the emperor tied up at the narrow landing stage. The support staff lived and worked in buildings near the main gate. A colonnaded avenue extended from this entrance to a peristyle court that ended in a grand facade with an enormous arched doorway where Diocletian made his ceremonial appearances (fig. 6-77). Like the Canopus at Hadrian's Villa, the columns of the peristyle court supported arches rather than entablatures (see fig. 6-56). On one side of the court, the arcade opened onto Diocletian's mausoleum; on the other side, it opened onto the Temple of Jupiter.

The tetrarchs ruled the empire from administrative headquarters in Milan, Italy; Trier, Germany; Thessaloniki, in Macedonia; and Nicomedia, in Asia Minor. In Trier, Constantius Chlorus (Augustus, 293–306 CE) and

his son Constantine fortified the city with walls and a monumental gate. They built public amenities such as baths and a palace with a huge audience hall, known as the Basilica (fig. 6-78). This early-fourth-century CE building's large size and simple plan and structure exemplify the architecture of the tetrarchs: imposing buildings that would impress their subjects.

The Basilica is a large rectangular building, 190 by 95 feet, with a single apse opposite the door. Brick walls, originally stuccoed on the outside and covered with marble veneer inside, are pierced by two rows of arched windows. The flat roof, 100 feet above the floor, covers both the nave and the apse. In a concession to the northern climate, the building was centrally heated with hot air flowing under the floor. The windows of the apse create an interesting optical effect. They are slightly smaller and set higher than the windows in the hall, so they create the illusion of greater distance and make the tetrarch enthroned in the apse appear larger than life. This simple interior with its focus on the apse inspired later Christian builders.

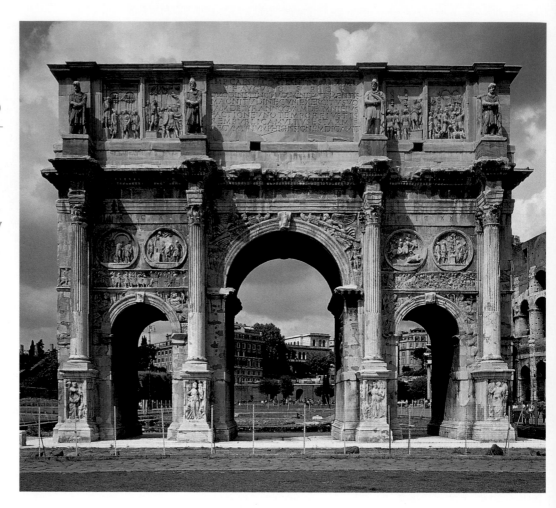

6-79. Arch of Constantine, Rome.
312–15 CE (dedicated July 25, 315)

This massive, triple-arched monument to Emperor Constantine's victory over Maxentius in 312 CE is a wonder of recycled sculpture. On the attic story, flanking the inscription over the central arch, are relief panels taken from a monument celebrating the victory of Marcus Aurelius over the Germans in 174 CE. On the attached piers framing these panels are large statues of prisoners made to celebrate Trajan's victory over the Dacians in the early second century CE. On the inner walls of the central arch (not seen here) are reliefs commemorating Trajan's conquest of Dacia. Over each of the side arches are pairs of giant roundels taken from a monument to Hadrian (see fig. 6-40). The rest of the decoration is contemporary with the arch.

CONSTANTINE THE GREAT AND HIS LEGACY

In 305 CE Diocletian abdicated and forced his fellow Augustus, Maximian, to do so too. The orderly succession he had hoped for failed to occur, and a struggle for position and advantage almost immediately ensued. Two main contenders emerged in the western empire: Maximian's son Maxentius and Constantine I, son of Tetrarch Constantius Chlorus. Constantine emerged victorious in 312 after defeating Maxentius at the Battle of the Milvian Bridge, at the entrance to Rome. According to tradition, Constantine had a vision the night before the battle in which he saw a flaming cross in the sky and heard these words: "In this sign you shall conquer." The next morning he ordered that his army's shields and standards be inscribed with the monogram *XP* (the Greek letters *chi* and *rho*, standing for *Christos*). The victorious Constantine then showed his gratitude by ending the persecution of Christians and recognizing Christianity as a lawful religion. (He may also have been influenced in that decision by his mother, Helen, a devout Christian—later canonized—who played an important part in his career.) In fact, *chi* and *rho* used together had long been an abbreviation of the Greek word *chrestos*, meaning "auspicious," which may have been the reason Constantine used the monogram. Whatever his motivation, in 313 CE, together with Licinius, who ruled the East, Constantine issued the Edict of Milan, a model of religious toleration:

With sound and most upright reasoning . . . we resolved that authority be refused to no one to follow and choose the observance or form of worship that Christians use, and that authority be granted to each one to give his mind to that form of worship which he deems suitable to himself, to the intent that the Divinity . . . may in all things afford us his wonted care and generosity. (Eusebius, *Ecclesiastical History* 10.5.5)

The Edict of Milan granted freedom to all religious groups, not just Christians. Constantine, however, remained the Pontifex Maximus of Rome's state religion and also reaffirmed his devotion during his reign to the military's favorite god, Mithras, and to the Invincible Sun, *Sol Invictus*, a manifestation of Helios Apollo, the sun god.

In 324 CE Constantine defeated Licinius, his last rival; he would rule as sole emperor until his death in 337. He made the port city of Byzantium the new Rome and renamed it Constantinople (modern Istanbul, in Turkey). After Constantinople was dedicated in 330, Rome, which had already ceased to be the seat of government in the West, further declined in importance.

The Arch of Constantine. In Rome, next to the Colosseum, the Senate erected a memorial to Constantine's victory over Maxentius (fig. 6-79), a huge, triple arch that

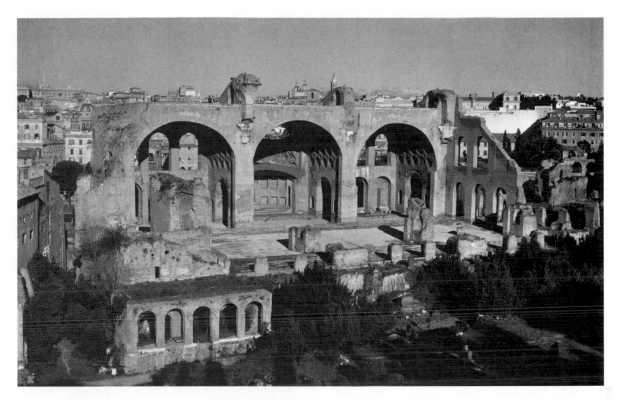

6-80. Plan and isometric projection of the Basilica of Maxentius and Constantine (Basilica Nova), Rome. 306–13 CE

The original plan for the basilica called for a single entrance on the southeast side, facing a single apse on the northwest. After building had begun, Constantine's architects added another entrance from the Via Sacra (Sacred Way) on the southwest and another apse opposite it across the nave. The effect was to dilute the focus on the original apse, which held the gigantic statue of the emperor (see fig. 6-82).

dwarfs the nearby Arch of Titus (see fig. 6-37). Its three barrel-vaulted passageways are flanked by columns on high pedestals and surmounted by a large attic story with elaborate sculptural decoration and a traditional laudatory inscription: "To the Emperor Constantine from the Senate and the Roman People. Since through divine inspiration and great wisdom he has delivered the state from the tyrant and his party by his army and noble arms, [we] dedicate this arch, decorated with triumphal insignia." The "triumphal insignia" were in part looted from earlier monuments made for Constantine's illustrious predecessors, the Good Emperors Trajan, Hadrian, and Marcus Aurelius. The reused items visually transferred the old Roman virtues of strength, courage, and piety associated with these earlier emperors to Constantine. New reliefs made for the arch recount the story of his victory and symbolize his power and generosity.

Although these new reliefs reflect the long-standing Roman affection for depicting important events with realistic detail, they nevertheless represent a significant change in style, approach, and subject matter that distinguishes them from the reused elements in the arch. The stocky, mostly frontal, look-alike figures are compressed by the buildings of the forum into the foreground plane. The arrangement and appearance of the uniform and undifferentiated participants below the enthroned Constantine clearly isolate the new emperor and connect him visually with his illustrious predeces-

sors on each side. This two-dimensional, hierarchical approach and abstract style are far removed from the realism of earlier imperial reliefs. This style, with its emphasis on authority, ritual, and symbolic meaning rather than outward form, was adopted by the emerging Christian Church. Constantinian art thus bridges the art of the Classical world and the art of the Middle Ages (roughly 476 to 1453 CE).

The Basilica of Maxentius and Constantine. Constantine's rival, Maxentius, who controlled Rome throughout his short reign (ruled 306–12), ordered the repair of many buildings there and had others built. His most impressive undertaking was a huge new basilica just southeast of the Imperial Forums called the Basilica Nova, or New Basilica. Now known as the Basilica of Maxentius and Constantine, this was the last important imperial government building erected in Rome. It functioned, like all basilicas, as an administrative center and provided a magnificent setting for the emperor when he appeared as supreme judge. Earlier basilicas, such as Trajan's Basilica Ulpia (see fig. 6-27), had been columnar halls, but Maxentius ordered his engineers to create the kind of large, unbroken, vaulted space found in public baths (fig. 6-80). The central hall was covered with groin vaults, and the side aisles were covered with lower barrel vaults. These vaults acted as buttresses, or projecting supports, for the central groin vault and allowed generous window openings in

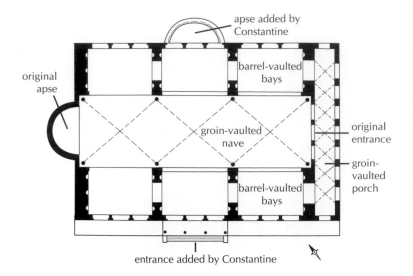

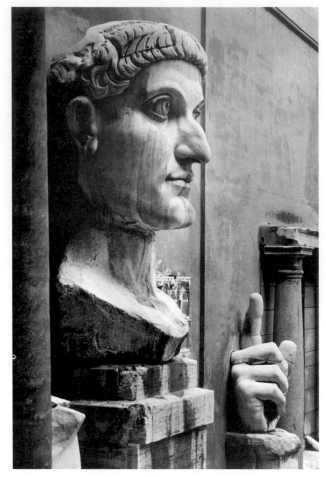

6-82. ***Constantine the Great***, from the Basilica of Maxentius and Constantine, Rome. 325–26 CE. Marble, height of head 8'6" (2.6 m). Palazzo dei Conservatori, Rome

These fragments came from a statue of the seated emperor. The original sculpture combined marble and probably bronze supported on a core of wood and bricks. Only a few marble fragments survive—the head, a hand, a knee, an elbow, and a foot. The body might have been made of either colored stone or of bronze on a scaffold of wood and bricks sheathed in bronze. This statue, although made of less expensive materials, must have been as awe-inspiring as the gigantic ivory and gold-clad statues of Zeus at Olympia and Athena on the Acropolis in Athens, made in the fifth century BCE. Constantine was a master at the use of portrait statues to spread imperial propaganda.

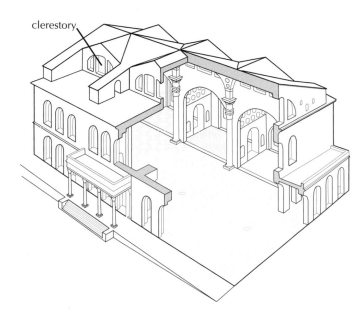

6-81. Basilica of Maxentius and Constantine (Basilica Nova)

the clerestory areas over the side walls. Three of these brick-and-concrete barrel vaults still loom over the streets of modern Rome (fig. 6-81). The basilica originally measured 300 by 215 feet and the vaults of the central nave rose to a height of 114 feet. A groin-vaulted porch extended across the short side and sheltered a triple entrance to the central hall. At the opposite end of the long axis of the hall was an apse of the same width, which acted as a focal point for the building. The directional focus along a central axis from entrance to apse was adopted by Christians for use in churches.

Constantine, seeking to impress the people of Rome with visible symbols of his authority, put his own stamp on projects Maxentius had started. He changed the orientation of the Basilica Nova by adding an imposing new entrance in the center of the long side facing the Via Sacra and a giant apse facing it across the three aisles. He finished the building in 306–13.

Constantine also commissioned a colossal, 30-foot portrait statue of himself and had it placed in the original apse (fig. 6-82). On a wooden frame, the sculptor combined the head, chest, arms, and legs carved of white marble with bronze drapery. This statue was a permanent stand-in for the emperor, representing him whenever the conduct of business legally required his presence. The sculpture combines features of traditional Roman portraiture with the abstract qualities evident in *The Tetrarchs* (see fig. 6-75). The defining characteristics of Constantine's face—his heavy jaw, hooked nose, and jutting chin—have been incorporated into a rigid, symmetrical pattern in which other features, such as his eyes, eyebrows, and hair, have

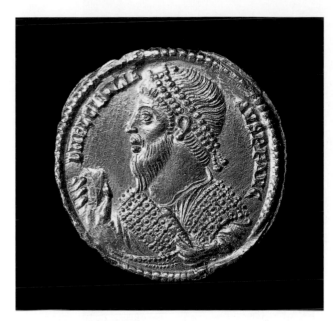

6-83. *Julian the Apostate*, coin issued 361–63 CE. Gold. The British Museum, London

been simplified into repeated geometric arcs. The result is a work that projects imperial power and dignity with no hint of human frailty or imperfection.

ROMAN TRADITIONALISM IN ART AFTER CONSTANTINE

Constantine was baptized formally into the Christian religion on his deathbed in 337 CE. All three of his sons were his heirs, and civil war broke out after his death. The old imperial religion revived during the reign of Constantius II's successor, Julian (361–63 CE), known by Christians as Julian the Apostate ("Religious Defector"). A follower of Mithras, Julian did not ban Christianity but tried to undermine it by adapting some of its liturgical devices and charitable practices into the worship of the traditional gods. He had himself portrayed on coins as a bearded scholar-philosopher (fig. 6-83), a portrait convention also favored by his illustrious predecessors Hadrian and Marcus Aurelius.

Christian emperors succeeded Julian. By the end of the fourth century CE, Christianity had become the official religion of the empire, and non-Christians had become targets of persecution. Many people resisted this shift and tried to revive classical culture. Among the champions of paganism were the Roman patricians Quintus Aurelius Symmachus and Virius Nicomachus Flavianus. A famous ivory **diptych**—a pair of panels attached with hinges—attests to the close relationship between their families, perhaps through marriage, as well as to their firmly held beliefs. One family's name is inscribed at the top of each panel. On the panel inscribed *Symmachorum* (fig. 6-84), a stately, elegantly attired priestess burns incense at a beautifully decorated altar. She is assisted by a small child, and the event takes place out of doors under an oak tree, sacred to Jupiter. The Roman ivory

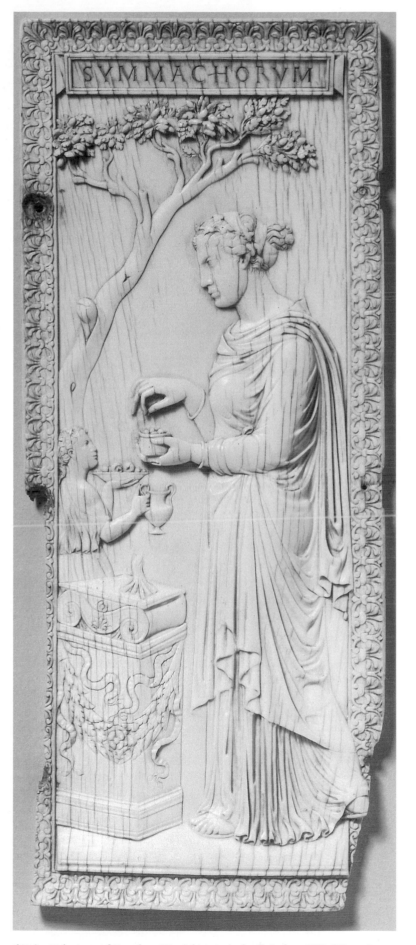

6-84. *Priestess of Bacchus* **(?)**, right panel of a diptych. c. 390–401 CE. Ivory, 11³/₄ x 5¹/₂" (29.9 x 14 cm). Victoria and Albert Museum, London

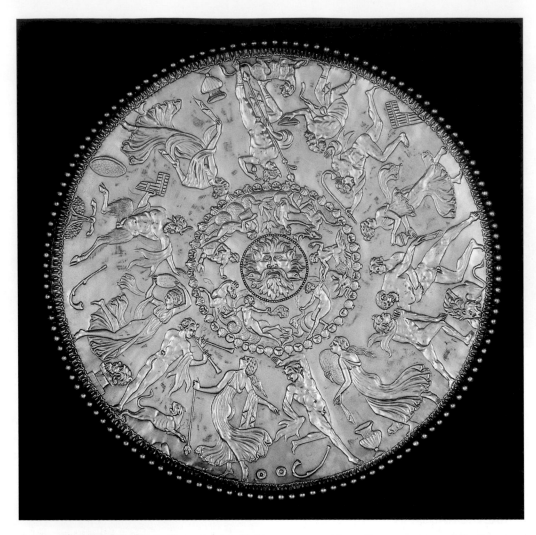

6-85. Dish, from Mildenhall, England. Mid-4th century CE. Silver, diameter approx. 24" (61 cm). The British Museum, London

carvers of the fourth century were extremely skillful, and their wares were widely admired and commissioned by pagans and Christians alike. For conservative patrons like the Nicomachus and Symmachus families, they imitated the Augustan style effortlessly. The exquisite rendering of the drapery and foliage recalls the reliefs of the Ara Pacis (see fig. 6-23).

Classical subject matter remained attractive to artists and patrons, and imperial repression could not immediately extinguish it. Even such great Christian thinkers as the fourth-century CE bishop and saint Gregory of Nazianzus spoke out in support of the right of the people to appreciate and enjoy their classical heritage, so long as they were not seduced by it to return to pagan practices. As a result, stories of the ancient gods and heroes entered the secular realm as lively, visually delightful, and even erotic decorative elements. The style and subject matter of the art reflect a society in transition.

A large silver platter dating from the mid-fourth century CE shows how themes involving Bacchus continued to provide artists with the opportunity to create elaborate figural compositions displaying the nude or lightly draped human body in complex, dynamic poses (fig. 6-85). The Bacchic revelers whirl, leap, and sway in a dance to the piping of satyrs around a circular central medallion. In

this centerpiece, the head of the sea god Oceanus is ringed by nude females frolicking in the waves with fantastic sea creatures. In the outer circle, Bacchus is the one stable element. Wine bottles on his shoulder and at his feet and one foot on the haunches of his panther, he listens to a male follower begging for another drink. Only a few figures away, the pitifully drunken hero Hercules has lost his lion-skin mantle and collapsed in a stupor into the supporting arms of two satyrs. The detail, clarity, and liveliness of this platter reflect the work of a skillful artist. Deeply engraved lines emphasize the contours of the subtly modeled bodies, echoing the technique of undercutting used to add depth to figures in stone and marble reliefs and suggesting a connection between silver working and relief sculpture.

The platter was found in a cache of silver near Mildenhall, England. Such opulent items were often hidden or buried to protect them from theft and looting, a sign of the breakdown of the long Roman peace. Even as Roman authority gave way to local rule by powerful barbarian tribes in much of the West, many people continued to appreciate classical learning and to treasure Greek and Roman art. In the East, classical traditions and styles endured to become an important element of Byzantine art.

PARALLELS

PERIOD	ETRUSCAN AND ROMAN ART	ART IN OTHER CULTURES
ETRUSCAN 700–509 BCE	6-8. **Cerveteri sarcophagus** (c. 520 BCE) 6-1. *She-Wolf* (c. 500 BCE) 6-5. **Veii** *Apollo* (c. 500 BCE) 6-2. **Porta Augusta** (2nd cent. BCE)	3-44. **Taharqo sphinx** (c. 690–664 BCE), Egypt 2-24. **Ishtar Gate** (c. 575 BCE), Neo-Babylonia 5-9. **Temple of Hera** (c. 550 BCE), Italy 5-26. **Exekias.** *Suicide of Ajax* (c. 540 BCE), Greece 5-20. *Peplos Kore* (c. 530 BCE), Greece 5-13. **Siphnian Treasury** (c. 530–525 BCE), Greece 5-18. *Anavysos Kouros* (c. 525 BCE), Greece
REPUBLICAN 509–27 BCE	6-11. **Bronze mirror** (c. 350 BCE) 6-10. **Head of a man** (c. 300 BCE)	2-29. **Apadana of Darius and Xerxes** (518–c. 460 BCE), Persia
AUGUSTAN 27 BCE–14 CE	6-18. *Aulus Metellus* (late 2nd/1st cent. BCE) 6-13. **Sanctuary of Fortuna Primigenia** (begun c. 100 BCE) 6-12. **Pont du Gard** (late 1st cent. BCE) 6-61. *Garden Scene* (late 1st cent. BCE) 6-63. *Initiation Rites of the Cult of Bacchus* (?) (c. 50 BCE) 6-16. **Maison Carrée** (c. 20 BCE) 6-20. *Augustus of Primaporta* (c. 20 BCE) 6-22. *Ara Pacis* (13–9 BCE)	2-30. *Darius and Xerxes Receiving Tribute* (491–486 BCE), Persia 5-33. *Kritian Boy* (c. 480 BCE), Greece 5-1. **Myron.** *Discus Thrower* (c. 450 BCE), Greece 5-39. **Kallikrates and Iktinos. Parthenon** (447–438 BCE), Greece 5-61. **Praxiteles.** *Aphrodite of Knidos* (c. 350 BCE), Greece 9-8. **Sanchi stupa** (3rd cent. BCE), India 10-1. **Qin soldiers** (c. 210 BCE), China 5-77. **Pergamon altar** (c. 166–156 BCE), Greece 5-83. *Aphrodite of Milos* (c. 150 BCE), Greece
IMPERIAL 14–180 CE	6-26. **Imperial Forums** (c. 46 BCE–325 CE) 6-54. **House of the Vettii** (mid-1st cent. CE) 6-31. **Colosseum** (72–80 CE) 6-37. **Arch of Titus** (c. 81 CE) 6-60. *Cityscape* (late 1st cent. CE) 6-65. *Young Woman Writing* (late 1st cent. CE) 6-49. **Timgad** (begun c. 100 CE) 6-28. **Column of Trajan** (113–16 or after 117 CE) 6-30. **Miletos gate** (c. 120 CE) 6-34. **Pantheon** (125–28 CE) 6-55. **Hadrian's Villa** (c. 135 CE) 6-45. *Marcus Aurelius* (c. 176 CE)	3-45. **Mummy of boy** (100–120 CE), Egypt
LATE EMPIRE 180 CE–395 CE	6-46. *Commodus as Hercules* (c. 191–2 CE) 6-67. **Fayum portrait** (c. 200 CE) 6-69. **Baths of Caracalla** (c. 211–17 CE) 6-74. *Ludovisi Battle Sarcophagus* (c. 250 CE) 6-78. **Trier Basilica** (early 4th cent. CE) 6-81. **Basilica of Maxentius and Constantine** (306–13 CE) 6-79. **Arch of Constantine** (312–15 CE) 6-84. *Priestess of Bacchus* (?) diptych (c. 390–401 CE)	7-3. *Menorahs and Ark of the Covenant* (3rd cent. CE), Rome 7-5. **Synagogue** (244–45 CE), Dura-Europos 7-6. *Good Shepherd, Orants, and Story of Jonah* (4th cent. CE), Rome

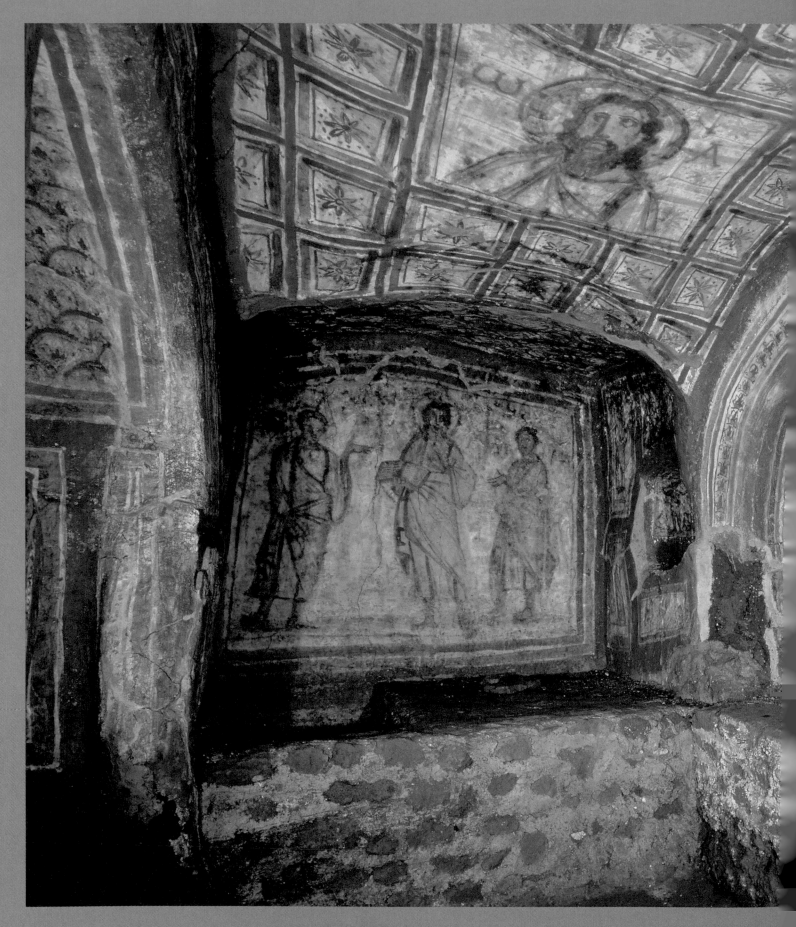

7-1. *Cubiculum* of Leonis,
Catacomb of Commodilla, near Rome.
Late 4th century

7 Early Christian, Jewish, and Byzantine Art

In ancient Rome, gravediggers were the architects of the underground. Where subsoil conditions were right—the tufa around Rome, for example—they tunneled out streets and houses in a city of the dead—a necropolis—with as many as five underground levels. Working in dark, narrow galleries as much as 70 feet below the surface, they dug out corridors, shelves, and small burial rooms to create catacombs. Aboveground, the gravediggers acted as the cemeteries' guards and gardeners. Some of them may have been painters, too, for even the earliest catacombs had some pictorial decoration—initially very simple inscriptions and symbols.

Cemeteries were always built outside the city walls, so that the dead would not defile the city, but they were not secret or ever used as hiding places—such stories are products of the nineteenth-century romantic imagination. Burial in catacombs became common in the early third century CE and ended by about 500. Although Rome's Christian catacombs are the most famous today, people of other faiths—Jews, devotees of Isis, followers of Bacchus and other mystery religions, pagan traditionalists—were interred in their own communal catacombs, which were decorated with symbols of their faiths.

In the third century CE, catacombs were painted with images of salvation based on prayers for the dead. By the fourth century, painting had become even more elaborate, as in this catacomb near the tomb of Saint Paul on the road to Ostia, which depicts New Testament saints with a particular connection to Rome (fig. 7-1). In the center of a small burial room's ceiling, between *alpha* and *omega*—the Greek letters signifying the beginning and end—the head of Christ appears in a circle (a halo). Facing the door is Christ with the Roman martyrs Felix (d. 274) and Adauctus (d. 303). At the right, a painting depicts Peter in the hours before the cock crowed, denying that he knew Jesus (Matthew 26:74–75). On the left, Peter miraculously brings forth water from a rock in Rome's Mamertine Prison to baptize his fellow prisoners and jailers. Here the painter has copied the traditional Jewish scene of Moses striking water from the rock (Exodus 17:1–7); were it not for the painting's Christian context, it would be indistinguishable from Jewish art.

TIMELINE 7-1. Early Christian and Byzantine Worlds. Early Christianity, first documented about 70–100 CE, took root and spread during the time of the Roman Empire. The Byzantine era is traditionally divided into Early, Middle, and Late periods.

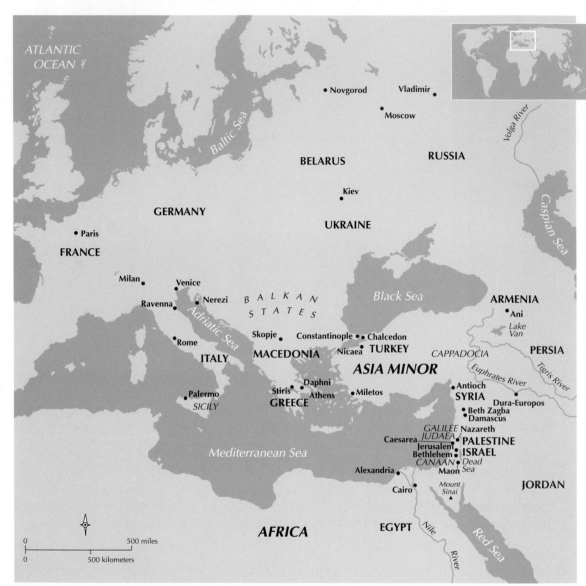

MAP 7-1. Early Christian, Jewish, and Byzantine Worlds. The eastern Mediterranean lands of Canaan and Judaea were centers of Jewish settlement. Rome was a major center of early Christianity. Byzantine culture took root in Constantinople and flourished throughout the Eastern Roman, or Byzantine, Empire and extended into northern areas such as Russia and Ukraine.

JEWS AND CHRISTIANS IN THE ROMAN EMPIRE

Three religions that arose in the Near East dominate the spiritual life of the Western world: Judaism, Christianity, and Islam. All three religions are monotheistic; followers hold that only one god created and rules the universe. Traditional Jews believe that God made a covenant, or pact, with their ancestors, the Hebrews, and that they are God's chosen people. They await the coming of a savior, the Messiah, "the anointed one." Traditional Christians believe that Jesus of Nazareth was that Messiah (the appellation "Christ" is derived from the Greek term meaning "Messiah"). They believe that God took human form, preached among men and women, and suffered execution, then rose from the dead and ascended to heaven

after establishing the Christian Church under the leadership of the apostles (his closest disciples). Muslims, while accepting the Hebrew prophets and Jesus as divinely inspired, believe Muhammad to be God's (Allah's) last and greatest prophet, the Messenger of God through whom Islam was revealed some six centuries after Jesus' lifetime. All three are "religions of the book," that is, they have written records of God's will and words: the Hebrew Scriptures; the Christian Bible, which includes the Hebrew Scriptures as its Old Testament as well as the Christian New Testament; and the Muslim Koran, believed to be the Word of God revealed in Arabic directly to Muhammad through the archangel Gabriel. Jewish and Early Christian art and Byzantine art, including some of the later art of the Eastern Orthodox Church, are considered in this chapter (Timeline 7-1). Islamic art is discussed in Chapter 8.

EARLY JUDAISM

The Jewish people trace their origin to the Semitic people called the Hebrews, who lived in the land of Canaan. Canaan, known from the second century CE by the Roman name "Palestine," was located along the Mediterranean Sea (Map 7-1). According to the Torah, the first five books of the Hebrew Scriptures, God promised the patriarch Abraham that Canaan would be a homeland for the Jewish people (Genesis 17:8), a belief that remains important among Jews to this day.

Jewish settlement of Canaan probably began sometime in the second millennium BCE. According to Exodus, the second book of the Torah, the prophet Moses led the Hebrews out of slavery in Egypt to the promised land of Canaan. At one crucial point during the journey, Moses climbed alone to the top of Mount Sinai, where God gave him the Ten Commandments, the cornerstone of Jewish law. The commandments, inscribed on tablets, were kept in a gold-covered wooden box, the Ark of the Covenant.

In the tenth century BCE, the Jewish king Solomon built a temple in Jerusalem to house the Ark of the Covenant. He sent to nearby Phoenicia for cedar, cypress, and sandalwood, and for a superb artisan to supervise construction of the Temple (later known as the First Temple) (Chronicles 2:2–15). The Temple consisted of courtyards, two bronze pillars, an entrance hall, a main hall, and the Holy of Holies, the innermost chamber that housed the Ark and its guardian **cherubim**, or attendant angels (perhaps resembling the winged guardians of Assyria, seen in figure 2-1). The Temple was the spiritual center of Jewish life.

In 586 BCE, the Babylonians, under King Nebuchadnezzar II, conquered Jerusalem. They destroyed the Temple, exiled the Jews, and carried off the Ark of the Covenant. When Cyrus the Great of Persia conquered Babylonia in 539 BCE, he permitted the Jews to return to their homeland and rebuild the Temple in Jerusalem (the Second Temple). But from that time forward, Canaan existed primarily under foreign rule; eventually, it became part of the Roman Empire. Herod the Great, the king of Judaea (ruled 37–4 BCE), restored the Temple, but in 70 CE, Roman forces led by the general and future emperor Titus destroyed the Herodian temple and all of Jerusalem (Chapter 6). The Jews dispersed and established communities throughout the Roman Empire. The site of the Temple is now occupied by a Muslim shrine (Chapter 8).

EARLY CHRISTIANITY

Christians believe in one God manifest in three persons: the Trinity of Father (God), Son (Jesus Christ), and Holy Spirit. According to Christian belief, Jesus was the son of God (the Incarnation) by a human mother, the Virgin Mary. His ministry on earth ended when he was executed by being nailed to a cross (the Crucifixion). He rose from the dead (the Resurrection) and ascended into heaven (the Ascension). Christian belief, especially about the Trinity, was formalized at the first ecumenical council of the Christian Church, called by Constantine I at Nicaea (modern Iznik, Turkey) in 325.

The life and teachings of Jesus of Nazareth, who was born sometime between 8 and 4 BCE and was crucified at the age of thirty-three, were recorded between about 70 and 100 CE in the New Testament books attributed to the Four Evangelists: Matthew, Mark, Luke, and John. These books are known as the Gospels (from an Old English translation of a Latin word derived from the Greek *euangelion*, "good news"). In addition to the Gospels, the New Testament includes an account of the Acts of the Apostles (one book) and the Epistles, twenty-one letters of advice and encouragement to Christian communities in cities and towns in Greece, Asia Minor, and other parts of the Roman Empire. Thirteen of these letters are attributed to a Jewish convert, Saul, who took the Christian name "Paul." The twenty-seventh and final book is the Apocalypse (the Revelation), a series of enigmatic visions and prophecies concerning the eventual triumph of God at the end of the world, written about 95 CE.

Jesus was born during the reign of Emperor Augustus (ruled 27 BCE–14 CE), when Herod the Great ruled the Jewish kingdom of Judaea as a Roman protectorate. Following Herod's death in 4 BCE, Judaea came under direct Roman rule, leading to widespread political and social unrest and religious dissent. Tiberius (ruled 14–37 CE) was emperor during the three-year period in which Jesus is thought to have preached. Jesus' arrest and crucifixion probably occurred not long after the Roman Pontius Pilate was appointed administrator of Judaea in 26 CE.

The Gospels' sometimes conflicting accounts relate that Jesus was a descendant of the Jewish royal house of King David and that he was born in Bethlehem in Judaea, where his mother, Mary, and her husband, Joseph, had gone to be registered in the Roman census. He grew up in Nazareth in Galilee (in what is now northern Israel), where Joseph was a carpenter. At the age of thirty, Jesus gathered a group of disciples, male and female, preaching love and charity, a personal relationship with God, the forgiveness of sins, and the promise of life after death.

Jesus limited his ministry primarily to Jews; the apostles, as well as later followers such as Paul, took Jesus' teachings to non-Jews. Despite sporadic persecutions, Christianity persisted and spread throughout the Roman Empire, although the government did not formally recognize the religion until 313. As well-educated, upper-class Romans joined the Church during its first century of rapid growth, they instituted an increasingly elaborate organizational structure and ever more sophisticated doctrine.

Christian communities were organized by geographical units, along the lines of Roman provincial governments. Senior Church officials called bishops served as

ROME, CONSTANTINOPLE, AND CHRISTIANITY The balance of power in the Roman-Byzantine world and the composition of the empire shifted continually. Constantine I (ruled 306–37) defeated his rivals and became sole emperor of the Roman Empire in 324. In 330, he moved the empire's capital from Rome to Byzantium, a city located at the intersection of Europe and Asia. The site offered great advantages in military defense and trade. The new capital, renamed Constantinople, was the seat of the Roman Empire until 395, when the empire split permanently in two, becoming the Western (Roman) Empire and the Eastern (Byzantine) Empire. Despite the cultural division between the Latin-speaking West, where urban society was the product of comparatively recent imperial conquest, and the Greek-speaking East, heir to much older civilizations, the Byzantines always called themselves Romans and their empire the Eastern Roman Empire.

What remained of the greatly weakened Roman Empire in the West ended in 476, crumbling under the continual onslaught of Germanic invaders. Constantinople succeeded Rome as the center of power and culture. At its greatest extent, in the sixth century, the Byzantine Empire included most of the area around the Mediterranean, including northern Africa, the Levant, Anatolia, all of Greece, much of Italy, and a small part of Spain. The Byzantine Empire lasted until 1453, when Constantinople became an Islamic capital under the Ottoman Turks.

The relationship of church and state in the Roman-Byzantine world was complex. When the empire divided in the late fourth century, the Christian Church developed two branches, Eastern and Western. Despite centuries of disagreement over doctrine and jurisdiction, the Church did not officially split until 1054, resulting in the Western, or Catholic, Church and the Eastern, or Orthodox, Church. The Western Church, led by the pope, has been centered throughout most of its history in Rome. The patriarch of Constantinople has headed the Eastern Church, which, over time, has developed along regional lines, with several national patriarchs as semi-autonomous leaders.

Constantine transfers capital from Rome to Constantinople
330

Diocletian divides Roman Empire **286 CE**

Roman Empire splits into Western and Eastern Empires **395**

Western Empire collapses **476**

Ottonian Empire (later called Holy Roman Empire) **962**

Roman Empire begins **27 BCE**

WESTERN EMPIRE

ROMAN EMPIRE

CHRISTIAN CHURCH

WESTERN (CATHOLIC) CHURCH

Christianity begins

EASTERN (BYZANTINE) EMPIRE

EASTERN (ORTHODOX) CHURCH

313 Christianity officially recognized

Growing rift between Western and Eastern Churches

1054 Christian Church officially splits into Western (Catholic) and Eastern (Orthodox) Churches

1453 Byzantine Empire ends

governors of dioceses made up of smaller units, parishes, headed by priests. Bishops' headquarters—known as sees, or seats—were often in Roman provincial capitals. (A bishop's church is a cathedral, a word derived from the Latin *cathedra*, which means "chair" but took on the meaning "bishop's throne.") Archbishops administered several sees. The archbishops of Jerusalem, Rome, Constantinople, Alexandria, and Antioch (in southern Turkey) were the most important. The bishop of Rome eventually became head of the Western Church, holding the title "pope." The bishop of Constantinople became the head, or patriarch, of the Eastern Church. In spite of tensions between East and West, the Church remained united until 1054, when the Western pope and Eastern patriarch declared one another to be in error, and the Church split in two. Since this schism, the pope has been the supreme authority in the Western, Catholic Church, and the patri-arch, with his metropolitans (equivalent to archbishops), has governed the Eastern, Orthodox Church. (See "Rome, Constantinople, and Christianity," above.)

JEWISH ART AND EARLY CHRISTIAN ART Jewish law forbade the making of images that might be worshiped as idols. In early Judaism this prohibition against representational art was applied primarily to sculpture in the round. Jewish art combined both Near Eastern and classical Greek and Roman elements to depict Jewish subject matter, both symbolic and narrative. Because Christianity claimed to have arisen out of Judaism, its art incorporated many symbols and narrative representations from the Hebrew Scriptures and other Jewish sources. Christian rites prompted the development of special buildings—churches

and baptistries—as well as specialized apparatus, and Christians began to use the visual arts to instruct the laity as well as to glorify God. Almost no examples of specifically Christian art exist before the early third century, and even then it drew its styles and imagery from Jewish and classical traditions. In this process, known as **syncretism**, artists assimilate images from other traditions, giving them new meanings; such borrowings can be unconscious or quite deliberate. For example, **orant** figures—worshipers with arms outstretched—can be pagan, Jewish, or Christian, depending on the context in which they occur.

Perhaps the most important of these syncretic images is the **Good Shepherd**. In pagan art, he was Hermes the shepherd or Orpheus among the animals, but Jews and Christians saw him as the Good Shepherd of the Twenty-third Psalm: "The Lord is my shepherd; there is nothing I lack" (Psalms 23:1).

PAINTING AND SCULPTURE

Jews lived in communities dispersed throughout the Roman Empire, and most of the earliest surviving examples of Jewish art date from the Hellenistic and Roman periods. Six Jewish catacombs (see "Roman Funerary Practices," page 239), discovered just outside the city of Rome and in use from the first to fourth century CE, display wall paintings with Jewish themes. In one example, from the third century CE, two **menorahs**, or seven-branched lamps, flank the long-lost Ark of the Covenant (fig. 7-2). The conspicuous representation on the Arch of Titus in Rome (see fig. 6-38) of the menorah looted from the Second Temple of Jerusalem kept the memory of these treasures alive.

Christians, too, used catacombs for burials and funeral services even before Constantine I (ruled 306–37) granted their religion official recognition. In the Christian Catacomb of Commodilla, dating from the fourth century, long rectangular niches in the walls, called *loculi*, each held two or three bodies (see fig. 7-1). Affluent families created small rooms, or **cubicula**, off the main passages to house *sarcophagi*. The *cubicula* were hewn out of the soft tufa, a volcanic rock, then plastered and painted with imagery related to their owners' religious beliefs. The finest Early Christian catacomb paintings resemble murals in houses such as those preserved at Rome and Pompeii (see figs. 6-61, 6-62); however, the aesthetic quality of the painting is secondary to the message it conveys.

Communal Christian worship focused on the central "mystery," or miracle, of the Incarnation and the promise of salvation. At its core was the ritual consumption of bread and wine, identified as the body and blood of Jesus, which Jesus had inaugurated at the Last Supper, a Passover meal with his disciples. Around these acts developed an elaborate religious ceremony, or liturgy, called the Eucharist (also known as Holy Communion or Mass). Christians adopted the grapevine and grape cluster of the Roman god Bacchus to symbolize the wine of the Eucharist and the blood of Christ (see "Christian Symbols," page 294).

One fourth-century Roman catacomb contained remains, or relics, of Saints Pietro and Marcellino, two third-century Christians martyred for their faith. Here, the

7-2. *Menorahs and Ark of the Covenant*, wall painting in a Jewish catacomb, Villa Torlonia, Rome. 3rd century

The menorah form probably derives from the ancient Near Eastern Tree of Life, symbolizing for the Jewish people both the end of exile and the paradise to come.

7-3 *Good Shepherd, Orants*, and *Story of Jonah*, painted ceiling of the Catacomb of Saints Pietro and Marcellino, Rome. 4th century

ceiling of a *cubiculum* is partitioned by a central **medallion**, or round ornament, and four **lunettes**, semicircular wall areas framed by an arch (fig. 7-3). At the center is a Good Shepherd, whose pose has roots in Greek sculpture. In its new context, the image was a reminder of Jesus' promise: "I am the good shepherd. A good shepherd lays down his life for the sheep" (John 10:11). The semicircular compartments at the ends of the arms of the cross tell the Old Testament story of Jonah and the sea monster (Jonah 1–2), in which God caused Jonah to be thrown overboard in a storm, swallowed by a monster, and released, repentant and unscathed, three days later. Christians reinterpreted this story as a parable of Christ's death and resurrection—and hence of the everlasting life awaiting true believers—and it was a popular subject in Christian catacombs. On the left, Jonah is thrown from the boat; on the right, the monster spews him up; and at the center, Jonah reclines in the shade of a gourd vine, a symbol of paradise. Orants, figures with upraised hands in the ancient gesture of prayer, stand between the lunettes.

CHRISTIAN SYMBOLS Symbols have always played an integral role in Christian art. Some were devised just for Christianity, but most were borrowed from pagan and Jewish traditions and were adapted for Christian use.

Dove

The Old Testament dove is a symbol of purity, representing peace when it is shown bearing an olive branch. In Christian art, a white dove is the symbolic embodiment of the Holy Spirit and is often shown descending from heaven, sometimes haloed and radiating celestial light.

Fish

The fish was one of the earliest symbols for Jesus Christ. Because of its association with baptism in water, it came to stand for all Christians. Fish are sometimes depicted with bread and wine to represent the Eucharist.

Lamb (Sheep)

The lamb, an ancient sacrificial animal, symbolizes Jesus' sacrifice on the cross as the Lamb of God, its pouring blood redeeming the sins of the world. The Lamb of God (*Agnus Dei* in Latin) may appear holding a cross-shaped scepter and/or a victory banner with a cross (signifying Christ's resurrection). The lamb sometimes stands on a cosmic rainbow or a mountaintop. A flock of sheep represents the apostles—or all Christians—cared for by their Good Shepherd, Jesus Christ.

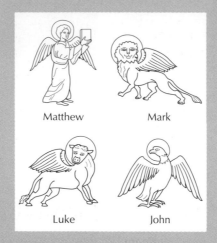

Matthew Mark

Luke John

Four Evangelists

The evangelists who wrote the New Testament Gospels are traditionally associated with the following creatures: Saint Matthew, a man (or angel); Saint Mark, a lion; Saint Luke, an ox; and Saint John, an eagle. These emblems derive from visionary biblical texts and may be depicted either as the saints' **attributes** (identifying accessories) or their embodiments (stand-ins for the saints themselves).

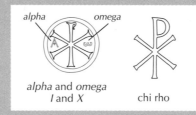

alpha and *omega*
I and *X* chi rho

Monograms

Alpha (the first letter of the Greek alphabet) and *omega* (the last) signify God as the beginning and end of all things. This symbolic device was popular from Early Christian times through the Middle Ages. *Alpha* and *omega* often flank the abbreviation IX or XP. The initials *I* and *X* are the first letters of Jesus and *Christ* in Greek. The initials *XP*, known as the *chi rho*, were the first two letters of the word *Christos*. These emblems are sometimes enclosed by a halo or wreath of victory.

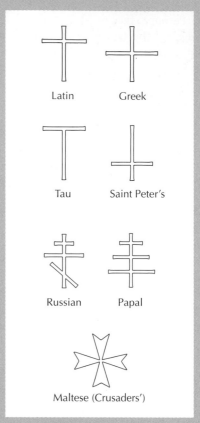

Latin Greek

Tau Saint Peter's

Russian Papal

Maltese (Crusaders')

Cross

The primary Christian emblem, the cross, symbolizes the suffering and triumph of Jesus' crucifixion and resurrection as Christ. It also stands for Jesus Christ himself, as well as the Christian religion as a whole. Crosses have taken various forms at different times and places, the two most common in Christian art being the Latin and Greek.

Sculpture that is clearly Christian is even rarer than painting from before the time of Constantine. What there is consists mainly of small statues and reliefs, many of them Good Shepherd images. A remarkable set of small marble figures, probably made in the third century in Asia Minor, also depicts the Jonah story (fig. 7-4); their function is unknown. Carved of a fine marble, they illustrate the biblical story with the same literalness and enthusiasm as the paintings on the catacomb ceiling.

ARCHITECTURE AND ITS DECORATION

The variety of religious buildings found in modern Syria at the abandoned Roman outpost of Dura-Europos, a Hellenistic fortress taken over by the Romans in 165 CE, illustrates the cosmopolitan character of frontier Roman society, as well as places of worship, in the second and third centuries. Although Dura-Europos was destroyed in 256 CE by Persian forces, important parts of the

7-4. *Jonah Swallowed* and *Jonah Cast Up*, two statuettes of a group from the eastern Mediterranean, probably Asia Minor. Probably 3rd century. Marble, heights 20⁵/₁₆" (51.6 cm) and 16" (40.6 cm). The Cleveland Museum of Art

John L. Severance Fund, 65.237, 65.238

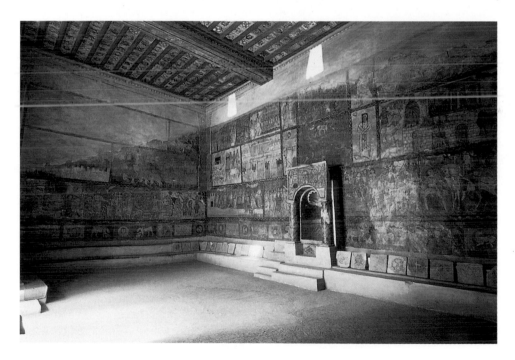

7-5. **Wall with Torah niche**, from a house-synagogue, Dura-Europos, Syria. 244–45. Tempera on plaster, section approx. 40' (12.19m) long. Reconstructed in the National Museum, Damascus, Syria

stronghold have been excavated, including a Jewish **house-synagogue**, a Christian **house-church**, shrines to the Persian gods Mithras and Zoroaster, and temples to Greek and Roman gods, including Zeus, Artemis, and Adonis. The Jewish and Christian structures were preserved because they had been built against the inside wall of the southwest rampart. When the desperate citizens attempted to strengthen this fortification in futile preparation for the final attack, they buried these buildings. The entire site was abandoned and was rediscovered only in 1920 by a French army officer.

Jewish Places of Worship. Some Jewish places of worship, or synagogues, were located in private homes, or in buildings originally constructed as homes. The first Dura-Europos synagogue, built like a house, consisted of an assembly hall with a niche for the Torah scrolls, a separate alcove for women, and a courtyard. After a remodeling of the building, completed in 244–45 CE, men and women shared the hall, and residential rooms were added. Two architectural features distinguished the assembly hall: a bench along its walls and a niche for the Torah scrolls (fig. 7-5).

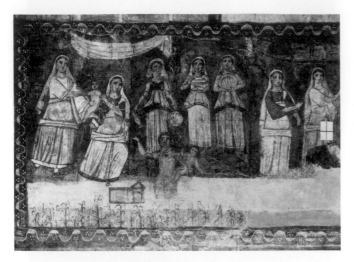

7-6. *Finding of the Baby Moses*, detail of a wall painting from a house-synagogue, Dura-Europos, Syria. Second half of 3rd century. Copy in tempera on plaster. Yale University Art Gallery, New Haven, Connecticut
Dura-Europus Collection

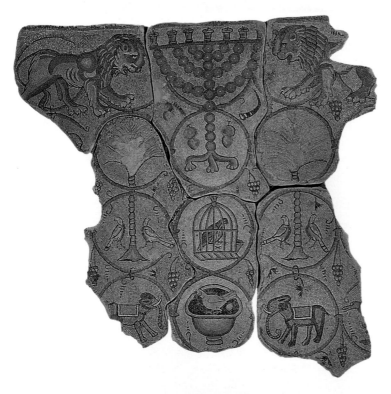

7-7. Mosaic synagogue floor, from Maon (Menois). c. 530. The Israel Museum, Jerusalem

In addition to house-synagogues, Jews built synagogues designed, as were Christian churches, on the model of the ancient Roman **basilica**. A typical basilica synagogue had a central **nave**; an **aisle** on both sides, separated from the nave by a line of columns; a mosaic floor; a semicircular **apse** in the wall facing Jerusalem; and perhaps an atrium and porch, or **narthex**. A Torah was kept in a shrine in the apse.

Synagogues contained little representational sculpture because of the prohibition against praying to images

or idols, but paintings and mosaics often decorated walls and floors. Jewish representational painting flourished in the third century, as seen in the murals that covered the Dura-Europos house-synagogue's interior. Narrative and symbolic scenes depicting events from Jewish history unfold in three registers of framed panels. The work of more than one artist, they are done in a style in which static, almost two-dimensional figures seem to float against a neutral background. *Finding of the Baby Moses* (fig. 7-6) illustrates what took place after Moses' mother set him afloat in a reed basket in the shallows of the Nile in an attempt to save him from the pharaoh's decree that all Jewish male infants be put to death (Exodus 1:8–2:10): The pharaoh's daughter finds him and claims him as her own child. The painting shows the story unfolding in a continuous narrative set in a narrow foreground space. At the right, the princess sees the child hidden in the bulrushes; at the center, she wades nude into the water to save him; and at the left, she hands him to a nurse (actually his own mother). The frontal poses, strong outlines, and flat colors are distinctive pictorial devices; they are, in fact, features of later Byzantine art, which perhaps derived from works such as this.

Among the mosaics that decorated early Jewish places of worship, a fragment of a mosaic floor from a sixth-century synagogue at Maon (Menois) features traditional Jewish symbols along with a variety of stylized plants, birds, and animals (fig. 7-7). Two lions of Judah flank a menorah. Beneath it is the ram's horn (*shofar*) blown on ceremonial occasions and three citrons (*etrogs*) used to celebrate the harvest festival of Sukkoth. Other Sukkoth emblems—including palm trees and the *lulov*, a sheaf of palm, myrtle, and willow branches and an *etrog*—symbolize the bounty of the earth and unity of all Jews. The variety of placid animals may represent the universal peace prophesied by Isaiah (11:6–9; 65:25). The pairing of images around a central element—as in the birds flanking the palm trees or the lions facing the menorah—is characteristic of Near Eastern art. The grapevine forming circular medallions as a frame for the images was popular in Roman mosaics.

Christian House-Churches. The Dura-Europos house-church, about 300 yards from the synagogue, reminds us that Christians first gathered in the homes of members of the community. The church was a typical Roman house, with rooms around a courtyard and a second-floor apartment for the owner. A small red cross painted above the main entrance alerted Christians that the building was a gathering place. Two of the five ground-floor rooms—a large assembly hall (made by eliminating a wall dividing two rooms) and a room with a water tank—were clearly for Christian use. The other rooms are undifferentiated from residential chambers.

Opening off the courtyard, the room with the water tank must have been the **baptistry**, a special place for the baptismal rite. One end of the room had a niche equipped with a water basin, above which were images of the Good Shepherd and of Adam and Eve (fig. 7-8). These murals reminded new Christians that humanity fell from grace when the first man and woman disobeyed God and ate

fruit from the tree of knowledge offered to them by an evil serpent. But the Good Shepherd (Jesus Christ) came to earth to carry his sheep (Christians) to salvation and eternal life. Baptism washed away sin, leaving the initiate reborn as a member of the community of the faithful.

IMPERIAL CHRISTIAN ARCHITECTURE AND ART

In 313, Constantine I issued the Edict of Milan, granting all people in the Roman Empire freedom to worship whatever god they wished. This religious toleration, combined with Constantine's active support of Christianity (though he himself did not convert until just before his death), allowed Christianity to enter a new phase, developing a sophisticated philosophical and ethical system that incorporated many ideas from Greek and Roman thought. Church scholars edited and commented on the Bible, and the papal secretary who would become Saint Jerome (c. 347–420) undertook a new translation from Hebrew, Greek, and Latin versions into Latin, the language of the Western Church. Completed about 404, this so-called Vulgate became the official version of the Bible. (The term *Vulgate* derives from the same Latin word as *vulgar*, meaning "common" or "popular.") Christians also gained political influence in this period. The Christian writer Lactantius (c. 240–320), for example, tutored Constantine I's son Crispus; and Eusebius (c. 260–c. 339), bishop of Caesarea, was a trusted imperial adviser from about 315 to 339. These transformations in the philosophical and political arenas coincided with a dramatic increase in size and splendor of Christian architecture.

ARCHITECTURE AND ITS DECORATION

Christian congregations needed large, well-lit spaces for their worship. The basilica suited perfectly. The nave with aisles on the two long sides created a space for processions (see "Basilica-Plan and Central-Plan Churches," page 296). If the clergy needed to partition space, they used screens or curtains—for example, around the **altar** or in aisles. The entrance was on a short end of the basilica, facing the apse and the place where the altar stood, the same place that in a pagan basilica was reserved for the judge or presiding official.

Basilica-Plan Churches. After Constantine consolidated imperial power, uniting the West and East around 324, he began a vast building program that included Christian churches. Among these was a residence, a church, and a baptistry for the bishop of Rome (the pope) on the site of the imperial Lateran palace. The church of Saint John Lateran remains the cathedral of Rome, although the pope's residence has since the thirteenth century been the Vatican. Perhaps as early as 320, the emperor also ordered the construction of a large new basilica to replace the second-century monument marking the place where Christians believed Saint Peter (c. 64 CE) was buried. The new basilica—now known as Old Saint Peter's because it was completely replaced by a new building in the sixteenth

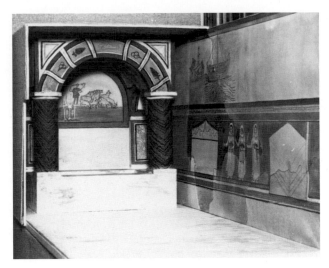

7-8. Small-scale model of walls and baptismal font, from the baptistry of a Christian house-church, Dura-Europos, Syria. c. 240. Yale University Art Gallery, New Haven, Connecticut

Dura-Europos Collection

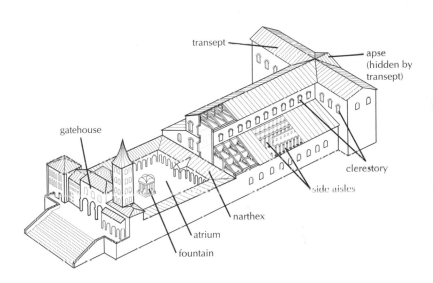

7-9. Reconstruction drawing of Old Saint Peter's basilica, Rome. c. 320–27; atrium added in later 4th century. Approx. 394' (120 m) long and 210' (64 m) wide

century—would protect the tomb of Peter, whom Christ had designated as the leader of the Church, and make the site accessible to the faithful. As the church of Saint Peter and his successors, it established a model for churches just as the bishop of Rome gained authority over all other bishops. Our knowledge of Old Saint Peter's is based on written descriptions, drawings made before and while it was being dismantled, the study of other churches inspired by it, and modern archaeological excavations at the site (fig. 7-9).

Old Saint Peter's was an unusual basilica church in having double side aisles instead of one aisle on each side of the nave. A narthex across the width of the building protected five doorways—a large, central portal into the nave and two portals on each side opening directly to each of the four side aisles. Open wood rafters roofed the nave and aisles. Columns supporting an entablature lined

ELEMENTS OF ARCHITECTURE

Basilica-Plan and Central-Plan Churches

The forms of early Christian buildings were based on two classical prototypes: rectangular Roman basilicas (see fig. 6-27) and round-domed structures—rotundas—such as the Pantheon (see figs. 6-34, 6-35). As in Old Saint Peter's in Rome (see fig. 7-9), **basilica-plan** churches are characterized by an **atrium**, or forecourt, which leads to the **narthex**, a porch spanning one of the building's short ends. Doorways—known collectively as the church's **portal**—lead from the narthex into a long central area called a **nave**. The high-ceilinged nave is separated from aisles on either side by rows of columns. The nave is lit by windows along its upper story—called a clerestory—that rises above the side aisles' roofs. At the opposite end of the nave from the narthex is a semicircular projection, the **apse**. The apse is the building's symbolic core, where the altar, raised on a platform, is located.

Sometimes there is also a **transept**, a horizontal wing that crosses the nave in front of the apse (see fig. 7-9). The transept was developed for early Christian churches that were pilgrimage sites to provide space for large numbers of people near the altar and its relics.

Central-plan structures were first used by Christians as tombs, baptism centers (**baptistries**), and shrines to martyrs (**martyria**). The **Greek-cross plan**, in which two similarly sized "arms" intersect at their centers, is a type of central plan. Instead of the longitudinal axis of basilica-plan churches, which draws worshipers forward toward the apse, central-plan churches such as Ravenna's San Vitale (see figs. 7-26, 7-27) have a more vertical axis. This makes the **dome**, which is a symbolic "vault of heaven," a natural focus over the main worship area. Like secular basilicas, central-plan churches generally have an atrium, a narthex, and an apse. The **naos** is the space containing the central dome, sanctuary, and apse.

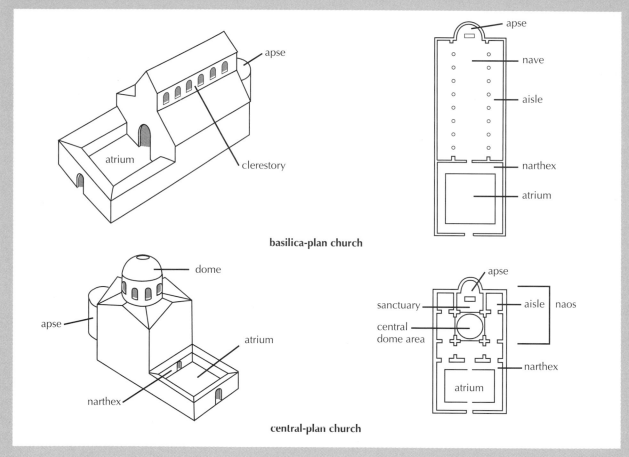

basilica-plan church

central-plan church

the nave, forming what is called a **nave colonnade**. The row of columns between the side aisles supported a series of round arches. Constantine's architects devised a new element for the basilica plan. At the **apsidal** end of the nave and aisles, they added a **transept**, which crossed in front of the apse, projecting a **T** form that anticipated the later **Latin-cross** church plan (see "Basilica-Plan and Central-Plan Churches," above). This area provided additional space near the tomb for pilgrims.

Saint Peter's bones supposedly lie below, marked in the nave by a permanent, pavilionlike structure supported on four columns called a *ciborium*. Catacombs lay beneath the church, and over time a large **crypt**, or underground vault, was used for the burial of popes. Sarcophagi and tombs eventually also lined the side aisles. Old Saint Peter's thus served a variety of functions. It was a congregational church, a pilgrimage shrine commemorating Peter's martyrdom and containing his relics, and a burial site. Old Saint Peter's could hold at least 14,000 worshipers, and it remained the largest Christian church until the eleventh century.

Most early Christian churches have been rebuilt, some many times, but the Church of Santa Sabina in Rome, constructed by Bishop Peter of Illyria between 422 and 432,

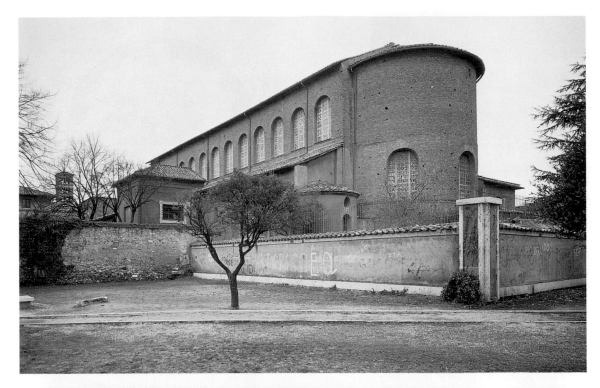

7-10. **Church of Santa Sabina, Rome**. 422–32

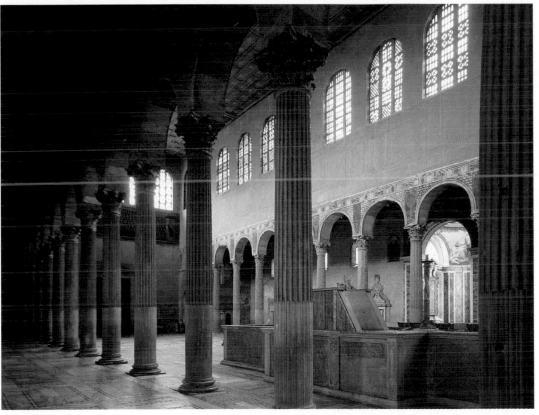

7-11. **Interior, Church of Santa Sabina**. View toward the east

appears much as it did in the fifth century (fig. 7-10). The basic elements of the basilica church are clearly visible inside and out: a nave with side aisles, lit by **clerestory** windows, ending in a rounded apse. (Compare Roman secular basilicas, such as the Basilica Ulpia [see fig. 6-27] and the Basilica at Trier [see fig. 6-78].) Santa Sabina's exterior, typical of the time, is severe brickwork. In contrast, the interior displays a wealth of marble veneer and twenty-four fluted marble columns with Corinthian capitals acquired from a second-century building (fig. 7-11). (Material reused from pagan buildings is known as *spolia*, Latin for "spoils.") The columns support round arches, creating a **nave arcade**, in contrast to a nave colonnade. The **spandrels** are inlaid with marble images of the chalice and paten (the plate that holds the bread)—the essential equipment for the Eucharistic rite that took place at the altar. The decoration of the upper walls is lost, and a paneled ceiling covers the rafter roof. The **triforium**, the blind wall between the arcade and the clerestory, typically had paintings or mosaics with scenes from the Old Testament or the Gospels.

Triforium mosaic panels still survive in the Church of Santa Maria Maggiore (Saint Mary the Great), which was built between 432 and 440. The church was the first to be dedicated to the Virgin Mary after the Council of Ephesus

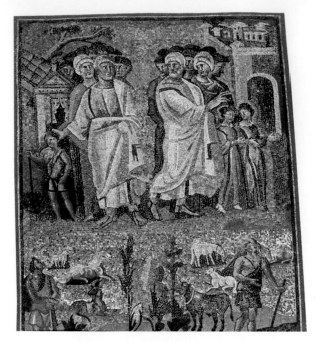

7-12. *Parting of Lot and Abraham*, mosaic in the nave arcade, Church of Santa Maria Maggiore, Rome. 432–40. Panel approx. 4'11" x 6'8" (1.2 x 2 m)

in 431 declared her to be *Theotokos*, Bearer of God. The mosaics of the Church of Santa Maria Maggiore reflect a renewed interest in the earlier classicizing style of Roman art that arose during the reign of Pope Sixtus III (432–40). The mosaics along the nave walls, in framed panels high above the worshipers, illustrate Old Testament stories of the Jewish patriarchs and heroes—Abraham, Jacob, Moses, and Joshua—whom Christians believe foretold the coming of Christ and his activities on earth. These panels were not merely didactic—that is, they were not simply intended to instruct the congregation. Instead, like most of the decorations in great Christian churches from this time forward, they were also meant to praise God through their splendor, to make churches symbolic embodiments of the Heavenly Jerusalem that awaits believers.

Some of the most effective, "legible" compositions are those in which a few large figures dominate the space, as in the *Parting of Lot and Abraham* (fig. 7-12), a story told in the first book of the Hebrew Scriptures (Genesis 13:1–12). The people of Abraham and his nephew Lot, dwelling together, had grown too numerous, so the two agreed to separate and lead their followers in different directions. On the right, Lot and his daughters turn toward the land of Jordan, while Abraham and his wife stay in the land of Canaan. This parting is significant to both Jews and Christians because Abraham was the founder of Israel and an ancestor of Jesus.

In this mosaic, the toga-clad men share a parting look as they gather their robes about them and turn decisively away from each other. The space between them in the center of the composition emphasizes their irreversible decision to part. Clusters of heads in the background represent Abraham's and Lot's followers, an artistic convention used effectively here. References to the earlier Roman illusionistic style can be seen in the solid three-dimensional rendering of foreground figures, the hint of perspective in the building, and the landscape setting, with its flocks

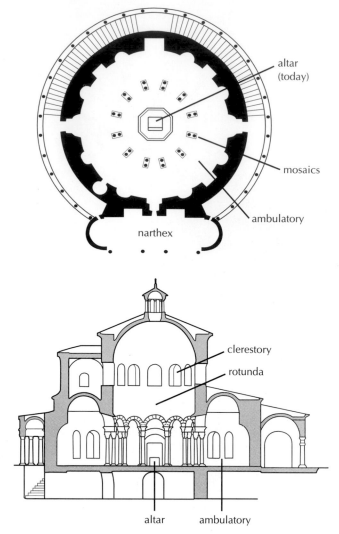

7-13. Plan and section of the Church of Santa Costanza, Rome. c. 338–50

of sheep, bit of foliage, and touches of blue sky. The mosaic was created with small cubes of marble and glass ***tesserae*** set closely together. The use of graduated colors creates shading from light to dark, producing three-dimensional effects that are offset by strong outlines. These outlines, coupled with the sheen of the gold *tesserae*, tend to flatten the forms.

CENTRAL-PLAN CHURCHES

A second type of ancient building—the ***tholos***, a round structure with a central plan and vertical axis—also served Christian builders for tombs, martyrs' churches, and baptistries (see "Basilica-Plan and Central-Plan Churches," page 298). One of the earliest surviving central-plan Christian buildings is the mausoleum of Constantina, the daughter of Constantine, which was built outside the walls of Rome just before 350 (fig. 7-13). The mausoleum was consecrated as a church in 1256 and is now dedicated to Santa Costanza (the Italian form of the Christian princess's name). The building consists of a tall **rotunda** with an encircling **barrel-vaulted** passageway called an **ambulatory** (fig. 7-14). A double ring of paired columns with Composite capitals and richly molded entablature blocks supports the arcade and dome. The building's interior was entirely sheathed in mosaics and fine marble.

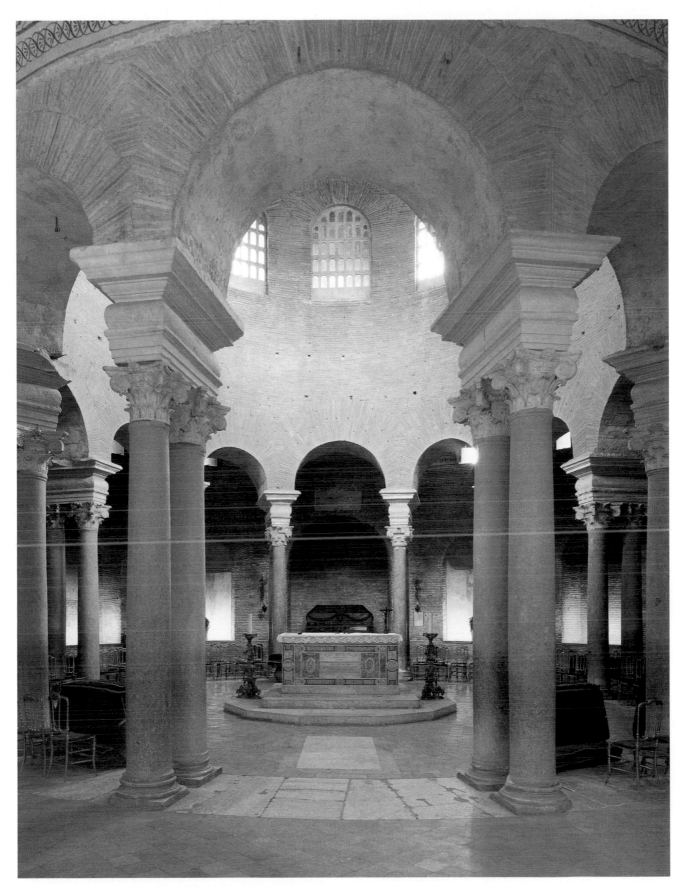

7-14. Church of Santa Costanza. View through ambulatory into central space

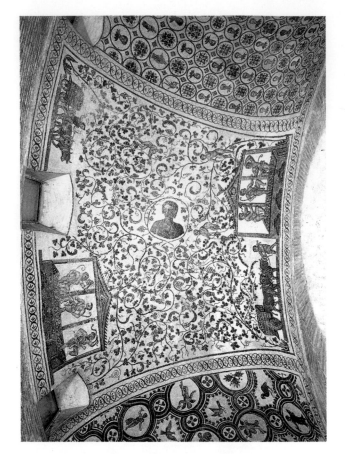

7-15. *Harvesting of Grapes*, mosaic in the ambulatory vault, Church of Santa Costanza

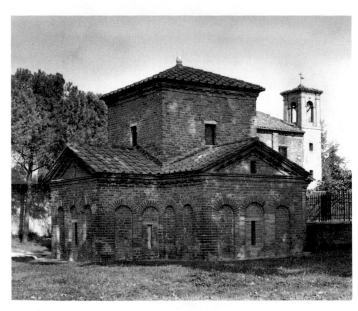

7-16. Mausoleum of Galla Placidia, Ravenna, Italy. c. 425–26

Mosaics in the ambulatory vault recall the catacombs' syncretic images. One section, for example, is covered with a tangle of grapevines filled with ***putti***—naked male child-angels, or cherubs, derived from classical art—who vie with the birds to harvest the grapes (fig. 7-15). Along the bottom edges on each side, *putti* drive wagonloads of grapes toward pavilions covering large vats in which more *putti* trample the grapes into juice. The technique, subject, and style are Roman, but the meaning has been altered. The scene would have been familiar to the pagan followers of Bacchus, but in a Christian context the wine became the wine of the Eucharist. For Constantina, the scene probably evoked only one—Christian—interpretation; her pagan husband, however, may have recognized the double allusion.

Constantine had planned to build his tomb in the cemetery of Saints Pietro and Marcellino in Rome, but after making Constantinople the center of government, he decided to build a funerary church there. The building, dedicated to the Holy Apostles, has not survived, but descriptions remain to tell us that it had the form of an equal-armed cross, a form known as the **Greek cross**, and it inspired a famous copy in the West, the Cathedral of Saint Mark in Venice (see fig. 7-39). Having dedicated the building to the apostles, Constantine provided **cenotaphs** (memorial tombs) for them. (Later, relics of the apostles were gathered in the church, making it a true ***martyrium***.) He placed his own tomb in the center, in effect elevating himself to the position of thirteenth apostle.

As Rome's political importance dwindled, that of the northern Italian cities of Milan and Ravenna grew. In 395, Emperor Theodosius I split the Roman Empire into eastern and western divisions, each ruled by one of his sons: Arcadius (ruled 383–408) assumed complete control of the Eastern Empire, based in Constantinople; heading the Western Roman Empire, Honorius (ruled 395–423) first established himself at the new capital of Milan. When Germanic settlers laid siege to Milan in 402, Honorius moved his capital to the east coast of Italy at Ravenna, whose naval base, Classis (modern Classe), had been important since the early days of the empire. In addition to military security, Ravenna offered direct access by sea to Constantinople. Ravenna flourished under Roman rule, and when Italy fell in 476 to the Ostrogoths from the East, the city became one of their headquarters. It still contains a remarkable group of well-preserved fifth- and sixth-century buildings.

One of the earliest surviving Christian structures in Ravenna is a funerary chapel attached to the church of the imperial palace (now Santa Croce, meaning "Holy Cross"). Built about 425–26, the chapel was constructed when Honorius's half sister, Galla Placidia, was regent (ruled 425–c. 440) in the West for her son. The chapel came to be called the Mausoleum of Galla Placidia because she and her family were once believed to be buried there (fig. 7-16). This small building is **cruciform**, or cross-shaped; a barrel vault covers of each of its arms, and a **pendentive dome**—a dome continuous with its **pendentives**—covers the space at the intersection of the arms (see "Pendentives and Squinches," page 311). **Blind arcading**—a series of decorative arches applied to a solid wall—tall slit windows, and

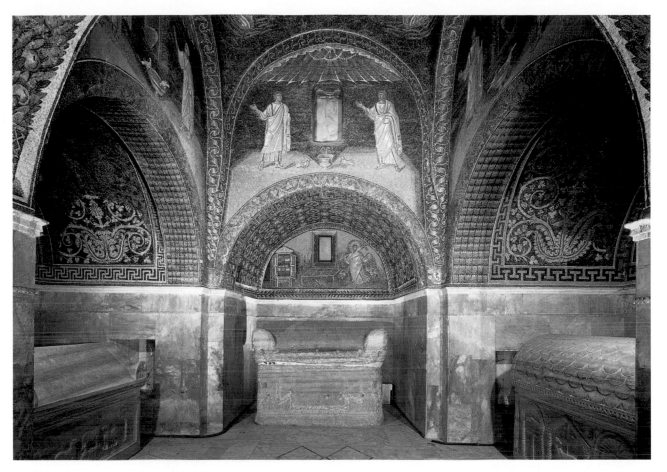

7-17. Mausoleum of Galla Placidia, eastern bays with sarcophagus niches in the arms and lunette mosaic of the *Martyrdom of Saint Lawrence*

a simple **cornice** are the only decorations on the exterior. The vaults covering the arms of the cross have been hidden from view on the outside by sloping, tile-covered roofs.

The interior of the chapel contrasts markedly with the exterior, a transition designed to simulate the passage from the real world into a supernatural one (fig. 7-17). The worshiper looking from the western entrance across to the eastern bay of the chapel sees a brilliant, abstract pattern of mosaic suggesting a starry sky filling the barrel vault. Panels of veined marble sheath the walls below. Bands of luxuriant foliage and floral designs derived from funerary garlands cover the four central arches, and the walls above them are filled with the figures of standing apostles, gesturing like orators. Doves flanking a small fountain between the apostles symbolize eternal life in heaven. In the lunette below, a mosaic depicts the third-century martyrdom of Saint Lawrence, to whom the building may have been dedicated. The saint holds a cross and gestures toward the fire and metal grill, on which he was literally roasted (so becoming the patron saint of bakers). At the left stands a tall cabinet containing the Gospels, signifying the faith for which he died (see a detail showing the contents of the cabinet in "Early Forms of the Book," page 304).

Opposite Saint Lawrence, in a lunette over the entrance portal, is a mosaic of the *Good Shepherd* (fig. 7-18). A comparison of this version with a fourth-century depiction of the same subject (see fig. 7-3) reveals significant changes in content and design. The Ravenna

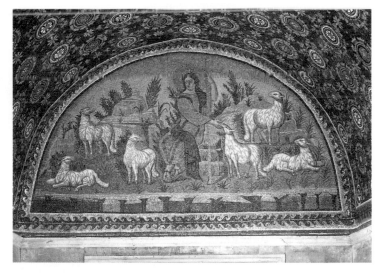

7-18. *Good Shepherd*, mosaic in the lunette over the west entrance, Mausoleum of Galla Placidia

EARLY FORMS OF THE BOOK

Since people began to write some 5,000 years ago, they have kept records on a variety of materials, including clay or wax tablets, pieces of broken pottery, papyrus, animal skins, and finally paper. Books have taken two forms: scroll and **codex**.

Scribes made scrolls from sheets of papyrus glued end to end or from thin sheets of cleaned, scraped, and trimmed sheep- or calfskin, a material known as **parchment** or, when softer and lighter, **vellum**. Each end of the scroll was attached to a rod; the reader slowly unfurled the scroll from one rod to the other. Scrolls could be written to be read either horizontally or vertically.

At the end of the first century CE, the more practical and manageable codex (plural codices)—sheets bound together like the modern book—replaced the scroll. The basic unit of the codex was the eight-leaf quire, made by folding a large sheet of parchment twice, cutting the edges free, then sewing the sheets together up the center.

Until the invention of printing in the fifteenth century, all books were **manuscripts**—that is, written by hand. Manuscripts often included illustrations, but techniques for combining pictures and text varied: Some illustrations were simply above or below the text, but others were within the text or set off with frames. Illustrations in books came to be called **miniatures**, from *minium*, the Latin word for a reddish lead pigment. Manuscripts decorated with gold and colors were said to be **illuminated**. Manuscript illumination became increasingly specialized during the European Middle Ages, with some experts doing only borders, others decorating initials, others painting pictures, and still others applying gold leaf.

Heavy covers in the form of wooden boards covered with leather kept the sheets of a codex flat. Very opulent manuscripts sometimes had covers decorated with precious metals, jewels, ivory, and enamels. The thickness and weight of parchment and vellum made it impractical to produce a very large manuscript, such as an entire Bible, in a single volume. As a result, individual sections were made into separate books. The Gospels, the Psalms, and the first five books of the Old Testament (the Pentateuch), for example, were often bound individually. These weighty tomes were stored flat on shelves in cabinets like the one holding the Gospels shown here and visible in the mosaic of Saint Lawrence in the Mausoleum of Galla Placidia (see fig. 7-17).

Bookstand with the Gospels in codex form, detail of a mosaic in the eastern lunette, Mausoleum of Galla Placidia, Ravenna, Italy. c. 425–26 (see fig. 7-17)

mosaic contains many familiar classical elements, such as illusionistic shading suggesting a single light source acting on solid forms, and an intimation of landscape in rocks and foliage. The conception of Jesus the shepherd, however, has changed. In the fourth-century painting, he was a simple shepherd boy carrying an animal on his shoulders; in this mosaic, he is a young adult with a golden halo, wearing imperial robes of gold and purple and holding a long, golden staff that ends in a cross instead of a shepherd's crook. The stylized elements of a natural landscape are arranged more rigidly than before. Individual plants at regular intervals fill the spaces between animals, and the rocks are stepped back into a shallow space that rises from the foreground plane and ends in foliage. The rocky band at the bottom of the lunette scene, resembling a cliff face riddled with clefts, separates the divine image from worshipers.

Just as the political role of Ravenna changed in the fourth and fifth centuries, so did the religious belief of its leaders. The early Christian Church faced many philosophical and doctrinal controversies, some of which resulted in serious splits, called schisms, within the Church. When this happened, its leaders gathered in church councils to decide on the orthodox, or official, position and denounce others as heretical. They rejected, for example, Arianism and Monophysitism, two early

forms of Christianity that questioned the doctrine of the Trinity. Arianism, named after Arius (c. 250–336), a church official in Alexandria, held that Jesus was coeternal with God but not fully divine, having been made by God. The first church council, called by Constantine at Nicaea in 325, declared the doctrine of the Trinity to be orthodox and denounced Arianism as heretical. Monophysites took the opposite viewpoint from Arians. They believed that Jesus was an entirely divine being even while on earth. Attempting to address this belief, the Council of Chalcedon, near Constantinople, in 451 declared Jesus to be of two natures—human and divine—united in one. This declaration did not put an end to Monophysitism, which remained strong in Egypt, Syria, Palestine, and Armenia in Asia Minor.

In Ravenna, two baptistries still stand as witness to these disputes: the Baptistry of the Orthodox and the Baptistry of the Arians. The Baptistry of the Orthodox was constructed next to the cathedral of Ravenna in the early fourth century. It was renovated and refurbished between 450 and 460, the wooden ceiling replaced with a dome and splendid interior decoration added in marble, stucco, and mosaic (fig. 7-19). On the clerestory level, an arcade springing from columns with large **impost** blocks repeats blind arcading below. Each main arch contains three arches framing a window.

Flanking the windows are figures of Old Testament prophets in stucco relief surmounted by pediments containing shell motifs. The pediment above the figure to the left of each window is round, whereas that on the right is pointed. The main arcading acts visually to turn the domed ceiling into a huge canopy tethered to the imposts of the columns.

In the dome itself, concentric rings of decoration draw the eye upward to a central image: the baptism of Jesus by John the Baptist, the forerunner of Jesus. The lowest ring depicts fantastic architecture, similar to Roman wall painting. Eight circular niches contain alternating altars holding gospel books and empty thrones under *ciboria*. The empty thrones symbolize the throne that awaits Christ's Second Coming (Matthew 25:31–36), his return to earth before Judgment Day. In the next ring, toga-clad apostles stand holding their crowns, the rewards of martyrdom; stylized golden plant forms divide the deep blue ground between them. Although the figures cast dark shadows on the pale green grass, their cloudlike robes, shot through with golden rays, give them an otherworldly presence. The landscape setting of the Baptism of Jesus in the central **tondo**—a circular image—exhibits classical roots, and the personification of the Jordan River recalls pagan imagery. The background, however, is not the blue of the earthly sky but the

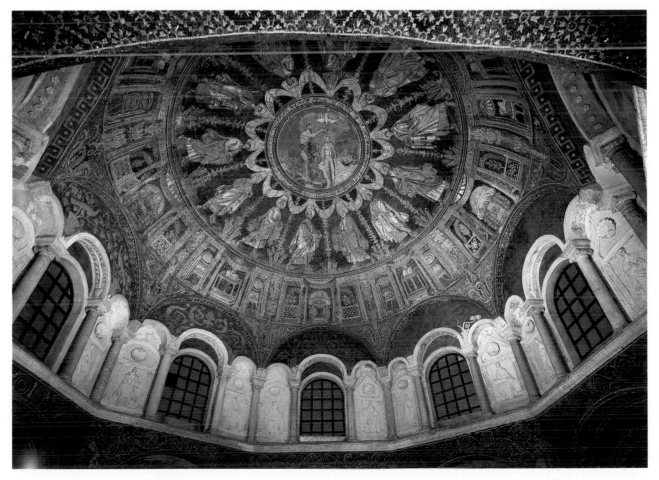

7-19. **Clerestory and dome, Baptistry of the Orthodox, Ravenna**, Italy. Early 5th century; dome remodeled c. 450–60

ICONOGRAPHY OF THE LIFE OF JESUS

Iconography is the study of subject matter in art. It involves identifying both what a work of art represents—its literal meaning—and the deeper significance of what is represented—its symbolic meaning. Events about the life of Jesus, grouped in "cycles," form the basis of Christian iconography. What follows is an outline of those cycles and the main events of each.

THE INCARNATION CYCLE AND THE CHILDHOOD OF JESUS

This cycle contains events surrounding the conception, birth, and youth of Jesus.

The Annunciation: The archangel Gabriel informs the Virgin Mary that God has chosen her to bear his son. A dove represents the Holy Spirit, Mary's miraculous conception of Jesus through the Holy Spirit.

The Visitation: Mary visits her older cousin Elizabeth, who is pregnant with the future Saint John the Baptist. Elizabeth is the first to acknowledge the divinity of the child Mary is carrying. The two women rejoice.

The Nativity: Jesus is born to Mary in Bethlehem. The Holy Family—Jesus, Mary, and her husband, Joseph—is shown in a stable, or, in Byzantine art, in a cave.

The Annunciation to the Shepherds and **The Adoration of the Shepherds**: An angel announces Jesus' birth to humble shepherds. They hasten to Bethlehem to honor him.

The Adoration of the Magi: The Magi—wise men from the East—follow a bright star to Bethlehem to honor Jesus as King of the Jews, presenting him with precious gifts: gold (symbolizing kingship), frankincense (a fragrant wood, symbolizing divinity), and myrrh (perfumed oil symbolizing death). In the European Middle Ages, the Magi were identified as three kings.

The Massacre of the Innocents and **The Flight into Egypt**: An angel warns Joseph that Herod, king of Judaea—to eliminate the threat of a newborn rival king—plans to murder all the male babies in Bethlehem. The Holy Family flees to Egypt.

The Presentation in the Temple: Mary and Joseph bring the infant Jesus to the Temple in Jerusalem, where he is presented to the high priest. It is prophesied that Jesus will redeem humankind but that Mary will suffer great sorrow.

Jesus among the Doctors: In Jerusalem for the celebration of Passover, Joseph and Mary find the twelve-year-old Jesus in serious discussion with Temple scholars. This is seen as a sign of his coming ministry.

THE PUBLIC MINISTRY CYCLE

In this cycle Jesus preaches his message.

The Baptism: At age thirty Jesus is baptized by John the Baptist in the Jordan River. He sees the Holy Spirit and hears a heavenly voice proclaiming him God's son. This marks the beginning of his ministry.

The Calling of Matthew: Passing by the customhouse, Jesus sees Matthew, a tax collector, to whom he says, "Follow me." Matthew complies, becoming one of the apostles.

Jesus and the Samaritan Woman at the Well: On his way from Judaea to Galilee, Jesus rests by a spring called Jacob's Well. Contrary to custom, he speaks directly to a woman, a Samaritan (a people despised by the Jews), asking her for a drink from the well. Jesus teaches that he alone can satisfy spiritual thirst.

Jesus Walking on the Water: The apostles, in a storm-tossed boat, see Jesus walking toward them on the water. Peter tries to go out to meet Jesus, but begins to sink. Jesus saves him and chides him for his lack of faith.

The Raising of Lazarus: Jesus brings his friend Lazarus back to life four days after his death. Lazarus emerges from the tomb wrapped in his shroud.

The Delivery of the Keys to Peter: Jesus designates Peter as his successor, symbolically turning over to him the keys to the kingdom of heaven.

The Transfiguration: Jesus reveals his divinity on Mount Tabor in Galilee as his closest disciples—Peter, James, and John the Evangelist—look on. A cloud overshadows them, and a heavenly voice proclaims Jesus to be God's son.

The Cleansing of the Temple: Jesus, in anger at the desecration, drives money changers and animal traders from the Temple.

THE PASSION CYCLE

This cycle contains events surrounding Jesus' death and resurrection. (*Passio* is Latin for "suffering.")

The Entry into Jerusalem: Jesus, riding a donkey, and his disciples enter Jerusalem in triumph. Crowds honor them, spreading clothes and palm fronds in their path.

The Last Supper: During the Passover seder, Jesus reveals his impending death to his disciples. Instructing them to drink wine (his blood) and eat bread (his body) in remembrance of him, he lays the foundation for the Christian Eucharist (Mass).

Jesus Washing the Apostles' Feet: After the Last Supper, Jesus humbly washes the apostles' feet to set an example of humility. Peter, embarrassed, protests.

The Agony in the Garden: In the Garden of Gethsemane on the Mount

of Olives, Jesus struggles between his human fear of pain and death and his divine strength to overcome them (*agon* is Greek for "contest"). An angelic messenger bolsters his courage. The apostles sleep nearby, oblivious.

The Betrayal (The Arrest): Judas Iscariot, one of the apostles, accepts a bribe to point Jesus out to his enemies. Judas brings an armed crowd to Gethsemane. He kisses Jesus, a prearranged signal. Peter makes a futile attempt to defend Jesus from the Roman soldiers who seize him.

The Denial of Peter: Jesus is brought to the palace of the Jewish high priest, Caiaphas, to be interrogated for claiming to be the Messiah. Peter follows, and there, three times before the cock crows, denies knowing Jesus, as Jesus predicted he would.

Jesus before Pilate: Condemned by the Jewish court for the blasphemy of calling himself the Messiah, Jesus is then sent to the Roman civil court to be tried for treason for calling himself the King of the Jews. Although both Roman governors, Herod and Pontius Pilate, find him innocent, the crowd demands his execution. Pilate washes his hands before the crowd to signify that Jesus' blood is on their hands, not his.

The Flagellation (The Scourging): Jesus is whipped by his Roman captors, an act traditional before crucifixions.

Jesus Crowned with Thorns (The Mocking of Jesus): Pilate's soldiers torment Jesus. They dress him in royal robes, crown him with thorns, and kneel before him, sarcastically hailing him as King of the Jews.

The Bearing of the Cross (The Road to Calvary): Jesus bears the cross of his crucifixion from Pilate's house to Golgotha, where he is executed. Medieval artists depicted this event and its accompanying incidents in fourteen images known today as the Stations of the Cross: (1) Jesus is condemned to death; (2) Jesus picks up the cross; (3) Jesus falls for the first time; (4) Jesus meets his grieving mother; (5) Simon of Cyrene is forced to help Jesus carry the cross; (6) Veronica wipes Jesus' face with her veil; (7) Jesus falls again; (8) Jesus admonishes the women of Jerusalem; (9) Jesus falls a third time; (10) Jesus is stripped; (11) Jesus is nailed to the cross; (12) Jesus dies on the cross; (13) Jesus is taken down from the cross; (14) Jesus is entombed.

The Crucifixion: The earliest representations of the Crucifixion are abstract, showing either a cross alone or a cross and a lamb. Later depictions include some or all of the following narrative details: two criminals (one penitent, the other not), are crucified on either side of Jesus; the Virgin Mary, John the Evangelist, Mary Magdalen, and other followers mourn at the foot of the cross; Roman soldiers torment Jesus—one extends a pole with a sponge soaked with vinegar instead of water for him to drink, another, required to prove the criminal is dead before sundown, stabs him in the side with a spear, and others gamble for his clothes; a skull identifies the execution ground as Golgotha, "the place of the skull," where Adam was buried. The association symbolizes the promise of redemption: the blood flowing from Jesus' wounds will wash away Adam's Original Sin.

The Descent from the Cross (The Deposition): Jesus' followers take his body down from the cross. Joseph of Arimathea and Nicodemus wrap it in linen with myrrh and aloe. Also present are the grief-stricken Virgin, John the Evangelist, and sometimes Mary Magdalen, other disciples, and angels.

The Lamentation (*Pietà* or *Vesperbild*): Jesus' sorrowful followers gather around his body in a group expressing grief. An image of the Virgin mourning alone with Jesus across her lap is known in Italian as a *pietà* (from the Latin *pietas*, "pity") or, in German, a *Vesperbild* (the image for evening prayer).

The Entombment: Jesus' mother and friends place his body in the tomb provided by Joseph of Arimathea. This is done hastily because of the approaching Jewish Sabbath.

The Descent into Limbo (The Anastasis): No longer in mortal form, Jesus, now called Christ, descends into limbo, on the borders of hell, to free deserving souls, among them Adam, Eve, and Moses.

The Resurrection: Three days after his death, Christ leaves his tomb while the soldiers guarding it sleep.

The Marys at the Tomb (The Holy Women at the Sepulcher): Christ's female followers—usually including Mary Magdalen and the mother of the apostle James, also named Mary—discover his empty tomb. An angel announces Christ's resurrection. The soldiers guarding the tomb sleep.

***Noli Me Tangere* ("Do Not Touch Me"), The Supper at Emmaus, and The Incredulity of Thomas**: Christ makes a series of appearances to his followers in the forty days after his resurrection. He first appears to Mary Magdalen, who thinks he is a gardener. She reaches out to him, but he warns her not to touch him. In the Supper at Emmaus, he shares a meal with his apostles. In the Incredulity of Thomas, Christ invites the doubting apostle to touch the wound in his side to convince Thomas of his resurrection.

The Ascension: Christ ascends to heaven from the Mount of Olives, disappearing in a cloud. His disciples, often accompanied by the Virgin, watch.

7-20. *Resurrection and Angel with Two Marys at the Tomb*, panel of a diptych, found in Rome. c. 400. Ivory, 14 1/2 x 5 3/8" (37 x 13.5 cm). Castello Sforzesco, Milan

gold of paradise. Already in the mid-fifth century, artists working for the Christian Church had begun to reinterpret and transform Roman naturalism into an abstract style better suited to their patrons' spiritual goals.

SCULPTURE

In sculpture, as in architecture, Christians adapted Roman forms for their own needs. Commemorative ivory **diptychs**—two carved panels hinged together—originated with Roman politicians elected to the post of consul, who sent to friends and colleagues notices of that event, and, later, other events, inscribed in wax on the inner sides of a pair of carved ivory panels (see fig. 6-84). Christians adapted the practice for religious use by at least the fifth century, inscribing a diptych with the

names of people to be remembered with prayers during Mass. An ivory panel found in Rome and dating to about 400 may have been an early example of this practice (fig. 7-20). The top register shows the moment of Christ's resurrection in both symbolic and narrative terms. While the soldiers guarding his tomb sleep, the evangelists Luke (represented by the ox in the upper left) and Matthew (represented by the man in the upper right) acknowledge the event from the clouds. The bottom register shows the moment when Mary, mother of the apostle James, and Mary Magdalen learn from a young man whose "appearance was like lightning and . . . clothing was white as snow" (Matthew 28:1–6) that the tomb is empty. The top panels of the carved doors of the tomb show the Raising of Lazarus, the Gospel story in which Jesus brings a man back to life to prove his divine power. In the top right door panel, the shrouded Lazarus emerges from his tomb, symbolizing the Christian promise of life after death. The varied natural poses of the figures, the solid modeling of the bodies beneath their drapery, the architectural details of the tomb, and the decorative framing patterns all indicate the classical roots of this work, which in its theme is completely Christian.

Monumental stone sculpture can be studied in sarcophagi such as the elaborately carved *Sarcophagus of Junius Bassus* (fig. 7-21). Junius Bassus was a Roman official who, as the inscription here tells us, was "newly baptized" and died on August 25, 359, at the age of forty-two. The front panel has two registers divided by columns into shallow spaces of equal width. On the top level, the columns are surmounted by an entablature incised with the inscription. On the bottom register, columns support alternating triangular and arched gables. Fragments of architecture, furniture, and foliage suggest the earthly setting for each scene. In the center of both registers, columns carved with *putti* producing wine frame the triumphal Christ. In the upper register, he appears as a teacher-philosopher flanked by Saints Peter and Paul. In a reference to the pagan past, Christ in this scene rests his feet on the head of Aeolus, the god of the winds in classical mythology, shown with a veil billowing behind him. To Christians, Aeolus personified the skies, so that Christ is meant to be seen as seated above, in heaven, where he is giving the Christian Law to his disciples, imitating the Hebrew Scriptures' account of God dispensing the Law to Moses. In the bottom register, Jesus makes his triumphal entry into Jerusalem.

The earliest Christian art, such as that in catacomb paintings and on the *Sarcophagus of Junius Bassus*, unites the imagery of Old and New Testaments in elaborate allegories, called **typological** exegesis. That is, Old Testament themes illuminate events in the New Testament. On the top left, Abraham, the first Hebrew patriarch, learns that he has passed the test of faith and need not sacrifice his son Isaac. Christians saw in this story a prophetic sign of God's sacrifice of his son, Jesus, on the cross. In the next frame to the right, the apostle Peter has just been arrested for preaching after the death of Jesus. On the upper right side are two scenes from Christ's Passion (see "Iconography of the Life of Jesus," pages 306-7),

his arrest and his appearance before Pontius Pilate, who is about to wash his hands, symbolizing that he denies responsibility for Jesus' death. In the lower left frame, God tests the faith of Job, who provides a model for the sufferings of Christian martyrs. Next, Adam and Eve have set in motion the entire Christian story. Lured by the serpent, they have eaten the forbidden fruit, have become conscious of their nakedness, and are trying to hide their genitals with leaves. This fall from grace will be redeemed by Christ. Two frames to the right, the story of Daniel saved by God from the lions prefigures Christ's resurrection. In the last frame, Paul is arrested. The images in the upper central frame of Paul and Peter, whose martyrdoms in Rome led to the power of the Roman Church, also represent the continuing power of Christ and his disciples.

7-21. *Sarcophagus of Junius Bassus*. c. 359. Marble, 4 x 8' (1.2 x 2.4 m). Grottoes of Saint Peter, Vatican, Rome

EARLY BYZANTINE ART

The Byzantine artistic tradition was, in the words of one scholar, "monumental, kaleidoscopic, constantly open to fashion, energizing and far-reaching" (Beckwith, page 344). Byzantine art can be thought of broadly as the art of Constantinople (whose ancient name, before Constantine renamed it after himself, was Byzantium) and the regions under its influence from the fifth through the fifteenth century, as well as the art centered in Ukraine and Russia in the fifteenth and sixteenth centuries. In this chapter, we focus on Byzantine art's three "golden ages." The Early Byzantine period, most closely associated with the reign of Emperor Justinian I (527–65), dates from the fifth century until 726, the onset of the iconoclastic controversy that led to the destruction of religious images (see "Iconoclasm," below). The Middle Byzantine period began in 843, when Empress Theodora (c. 810–62) reinstated the veneration of icons, and lasted until 1204, when Christian Crusaders from the West occupied Constantinople. The Late Byzantine period began with the restoration of Byzantine rule in 1261 and ended, in Constantinople and

ICONOCLASM Christianity, like Judaism and Islam, has always been uneasy with the power of religious images. The early Church feared that the faithful would worship the works of art themselves instead of what they represented. This discomfort grew into a major controversy in the Eastern Church as images increasingly replaced holy relics as objects of devotion from the late sixth century on. Many **icons** were believed to have been created miraculously, and all were thought to have magical protective and healing powers. Prayer rituals came to include prostration before images surrounded by candles, practices that seemed to some dangerously close to idol worship.

In 726 Emperor Leo III launched a campaign of **iconoclasm** ("image breaking"), decreeing that all religious images were idols and should be destroyed. In the decades that followed, Iconoclasts undertook widespread destruction of devotional pictures of Jesus Christ, the Virgin Mary, and the saints. Those who defended devotional images (Iconodules) were persecuted. The veneration of images was briefly restored under Empress Irene following the Second Council of Nicaea in 787, but the Iconoclasts regained power in 814. In 843 Empress Theodora, widow of Theophilus, the last of the iconoclastic emperors, reversed her husband's policy.

While the Iconoclasts held power, they enhanced imperial authority at the expense of the Church by undermining the untaxed wealth and prestige of monasteries, whose great collections of devotional art drew thousands of worshipers. They also increased tensions between the Eastern Church and the papacy, which defended the veneration of images and refused to acknowledge the emperor's authority to ban it. The Iconoclasts claimed that representations of Jesus Christ, because they portrayed him as human, promoted heresy by separating his divine from his human nature or by misrepresenting the two natures as one. Iconodules countered that upon assuming human form as Jesus, God took on all human characteristics, including visibility. According to this view, images of Christ, testifying to that visibility, demonstrate faith in his dual nature and not, as the Iconoclasts claimed, denial of it: "How, indeed, can the Son of God be acknowledged to have been a man like us . . . if he cannot, like us, be depicted?" (Saint Theodore the Studite, cited in Snyder, page 128).

Those who defended images made a distinction between veneration—a respect for icons as representations of sacred personages—and worship of icons as embodiments of divinity, or idols. Moreover, they saw image making not only as an effective teaching tool but also as a humble parallel to the divine act of creation, when "God created man in his image" (Genesis 1:27).

7-22. Anthemius of Tralles and Isidorus of Miletus. Church of Hagia Sophia, Istanbul, Turkey. 532–37. View from the southwest

The body of the original church is now surrounded by later additions, including the minarets built after 1453 under the Ottoman Turks. Today the structure houses a museum.

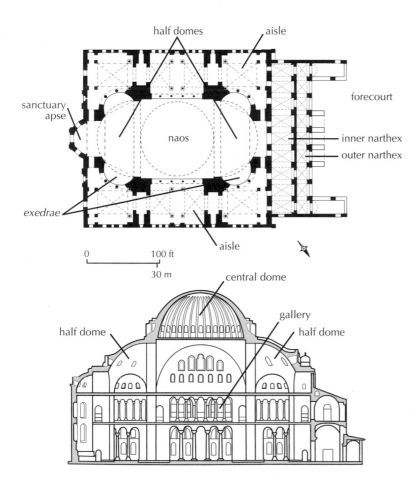

7-23. Plan and section of the Church of Hagia Sophia

its realm, with the empire's fall to Ottoman Turks in 1453. However, Late Byzantine art continued to flourish through the sixteenth century in Ukraine and Russia, which succeeded Constantinople as the center of the Eastern Orthodox Church after the empire's collapse.

During the fifth and sixth centuries, while invasions and religious controversy wracked the Italian peninsula,

the Eastern Empire prospered. Constantinople remained secure behind massive walls defended by the imperial army and navy. Its control of land and sea routes between Europe and Asia made many of its people wealthy. The patronage of the affluent citizenry, as well as that of the imperial family, made the city an artistic center. Greek literature, science, and philosophy continued to be taught in its schools. Influences from the regions under the empire's control—Syria, Palestine, Egypt, Persia, and Greece—gradually combined to create a distinctive Byzantine culture.

In the sixth century, Byzantine political power, wealth, and culture reached its height under Emperor Justinian, ably seconded by Empress Theodora (c. 500–48). Imperial forces held northern Africa, Sicily, much of Italy, and part of Spain. Ravenna became the empire's administrative capital in the West, and Rome's power declined, though Rome would remain under nominal Byzantine control until the eighth century. The pope remained head of the Western Church; however, the Byzantine policy of caesaropapism, whereby the emperor was head of both church and state, required that the pope pay homage to the powers in Constantinople (see "Rome, Constantinople, and Christianity," page 292). As Slavs and Bulgars moved into the Balkan peninsula in southeastern Europe, they, too, came under Constantinople's sway. Only on the frontier with the Persian Empire to the east did Byzantine armies falter, and there Justinian bought peace with tribute. To centralize his government and impose a uniform legal system throughout the empire, Justinian began a thorough compilation of Roman law known as the Justinian Code. Written in Latin, this code was the foundation for the later legal systems of Europe.

THE CHURCH AND ITS DECORATION

Constantinople. Justinian and Theodora embarked on a building and renovation campaign in Constantinople that overshadowed any in the city since the reign of Constantine two centuries earlier. Their massive undertaking would more than restore the city, half of which had been destroyed by rioters in 532, but little remains of their architectural projects or of the old imperial capital itself. A magnificent exception is the Church of Hagia Sophia ("Holy Wisdom," fig. 7-22). It replaced a fourth-century Hagia Sophia destroyed when crowds at the hippodrome, a racetrack beside the imperial palace, took to the streets and, spurred on by Justinian's foes, set fire to the church. The empress Theodora, a brilliant, politically shrewd woman, is said to have goaded Justinian to resist the rioters by saying, "Purple makes a fine shroud"—meaning that she would rather die an empress (purple was the royal color) than flee for her life. Taking up her words as a battle cry, imperial forces crushed the rebels and restored order.

Justinian chose two scholar-theoreticians, Anthemius of Tralles and Isidorus of Miletus (Miletos), to rebuild the church as an embodiment of imperial power and Christian glory. Anthemius was a specialist in geometry and optics,

ELEMENTS OF ARCHITECTURE

Pendentives and Squinches

Pendentives and **squinches** are two methods of supporting a round dome or its drum over a square opening. They convert the square formed by walls or arches into a circle. A squinch is formed by a wood or masonry beam that is itself supported by an arch or a series of corbeled arches that give it a nichelike or trumpet shape. The first set of squinches converts the square to an octagon, and additional squinches may be inserted as needed. In Islamic architecture, squinches are multiplied until they take on the stalactite form known as **muqarnas**. Pendentives are mathematically and structurally much more sophisticated. Spherical triangles of masonry are based on a dome (see fig. 7-24). Curving inward and around, they rise from the supporting pier to form the circular rim of a smaller dome whose diameter is the width of the bay to be covered. A drum (a wall) may be inserted between the pendentives and the dome.

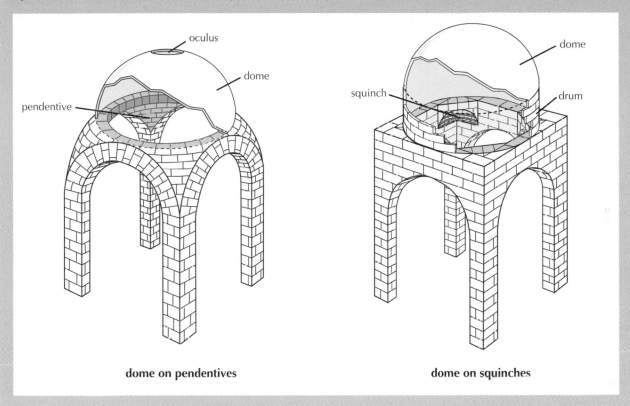

dome on pendentives **dome on squinches**

and Isidorus a specialist in physics who had also studied vaulting. They developed a daring and magnificent design. The dome of the church provided a vast, golden, light-filled canopy high above a processional space for the many priests and members of the imperial court who assembled there to celebrate the Eucharist.

The new Hagia Sophia was not constructed by the miraculous intervention of angels, as was rumored, but by mortal builders in only five years (532–37). The architects, engineers, and masons who built it benefited from the accumulated experience of a long tradition of great architecture. Procopius of Caesarea, who chronicled Justinian's reign, claimed poetically that Hagia Sophia's gigantic dome seemed to hang suspended on a "golden chain from Heaven." Legend has it that Justinian himself, aware that architecture can be a potent symbol of earthly power, compared his accomplishment with that of the legendary builder of the First Temple in Jerusalem, saying, "Solomon, I have outdone you."

Hagia Sophia is based on a central plan with a dome inscribed in a square (fig. 7-23). To form a longitudinal nave, half domes expand outward from the central dome to connect with the narthex on one end and the half dome of the sanctuary apse on the other. Side aisles flank this central core, called the **naos** in Byzantine architecture; **galleries**, or stories open to and overlooking the naos, are located above the aisles.

The main dome of Hagia Sophia is supported on pendentives, triangular curving vault sections built between the four huge arches that spring from piers at the corners of the dome's square base (see "Pendentives and Squinches," above). The origin of the dome on pendentives, which became the preferred method for supporting domes in Byzantine architecture, is obscure, but Hagia Sophia represents its earliest use in a major building. Here two half domes flanking the main dome rise above **exedrae** with their own smaller half domes at the four corners of the nave. Unlike the Pantheon's dome, which is solid with an **oculus** at the top (see fig 6-36), Hagia Sophia's dome has a band of forty windows around its base. This daring concept challenged architectural logic by weakening the integrity of the masonry but created the all-important circle of light that makes

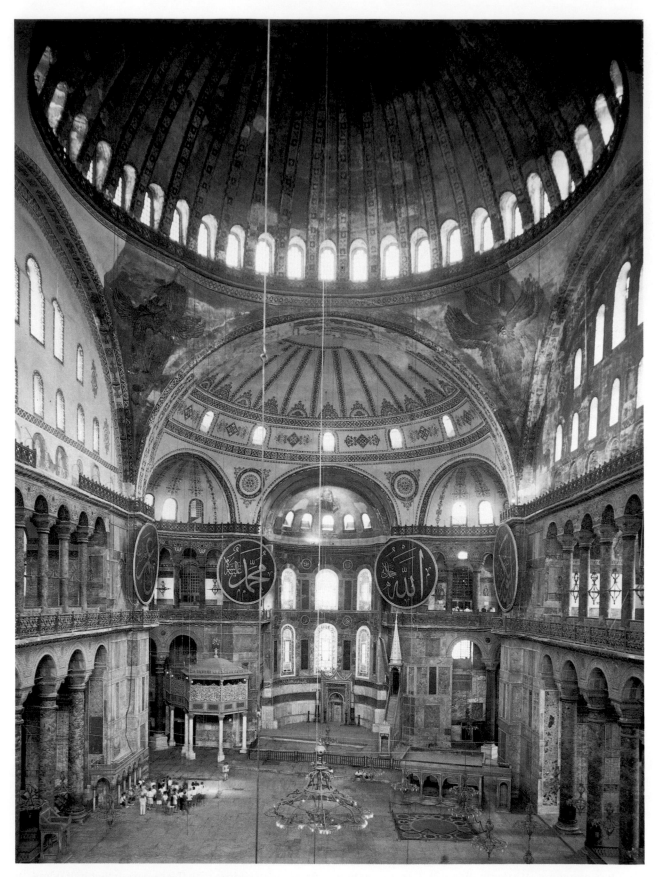

7-24. Church of Hagia Sophia

Hypatius of Ephesus, writing in the mid-sixth century, justified decorating churches in a luxurious manner as a means to inspire piety in the congregation. He wrote: "We, too, permit material adornment in the sanctuaries, not because God considers gold and silver, silken vestments and vessels encrusted with gems to be precious and holy, but because we allow every order of the faithful to be guided in a suitable manner and to be led up to the Godhead, inasmuch as some men are guided even by such things towards the intelligible beauty, and from the abundant light of the sanctuaries to the intelligible and immaterial light" (cited in Mango, page 117). The large medallions were added in the nineteenth century.

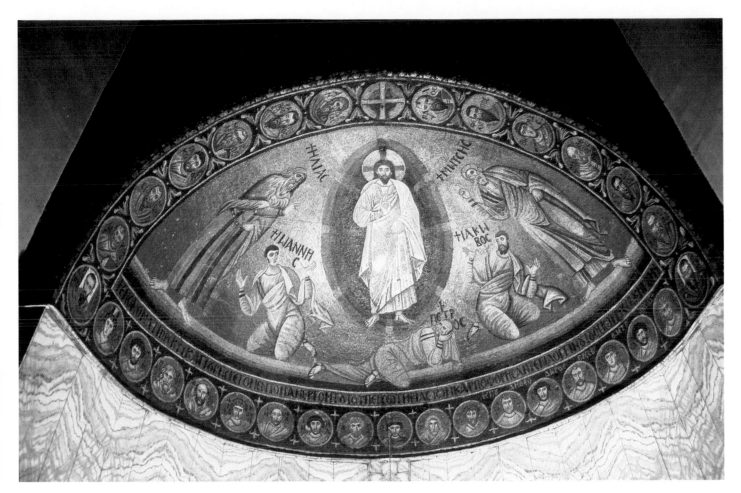

7-25. *Transfiguration of Christ*, mosaic in the apse, Church of the Virgin, Monastery of Saint Catherine, Mount Sinai, Egypt. c. 548–65

the dome appear to float (fig. 7-24). In fact, when the first dome fell in 558, it did so because a **pier** and pendentive shifted and because the dome was too shallow, not because of the windows. Confident of their revised technical methods, the architects designed a steeper dome that put the summit 20 feet higher above the floor. Exterior **buttressing** was added, and although repairs had to be made in 869, 989, and 1346, the church has since withstood the shock of earthquakes.

As in a basilica-plan church, worshipers entered Hagia Sophia through a forecourt and outer and inner narthexes on a central axis. Once through the portals, though, their gaze was drawn by the succession of curving spaces upward and then forward, to the central dome and on to the distant sanctuary. With this inspired design, Anthemius and Isidorus had reconciled an inherent conflict in church architecture between the desire for a symbolically soaring space and the need to focus attention on the altar and the liturgy. The domed design came to be favored by the Eastern Church.

The liturgy used in Hagia Sophia in the sixth century has been lost, but it presumably resembled the rites described in detail for the church in the Middle Byzantine period. Assuming that was the case, the celebration of the Mass took place behind a screen—at Hagia Sophia a crimson curtain embroidered in gold, in later churches

an **iconostasis**, or wall hung with devotional paintings called **icons** ("images" in Greek). The emperor was the only layperson permitted to enter the sanctuary; others stood in the aisles (men) or galleries (women). Processions of clergy moved in a circular path from the sanctuary into the nave and back five or six times during the ritual. The focus of the congregation was the screen and the dome rather than the altar and apse. This upward focus reflects the interest of Byzantine Neoplatonic philosophers, who viewed meditation as a way to rise from the material world to a spiritual state. Worshipers standing on the church floor must have felt just such a spiritual uplift as they gazed at the mosaics of saints, angels, and, in the golden central dome, heaven itself.

The churches of Constantinople were once filled with the products of Justinian's patronage: mosaics, rich furniture, and objects of gold, silver, and silk. Mosaics in the Monastery of Saint Catherine on Mount Sinai in Egypt were the result of such a donation and help us to imagine the splendors of the capital city. The apse mosaic of the monastery's church (fig. 7-25) depicts the Transfiguration on Mount Tabor (see "Iconography of the Life of Jesus," pages 306-7). Dated between 548 and 565, this imposing work shows the transfigured Christ in a triple blue **mandorla**, an almond-shaped halo that surrounds Christ's whole figure, against a golden sky that fills the

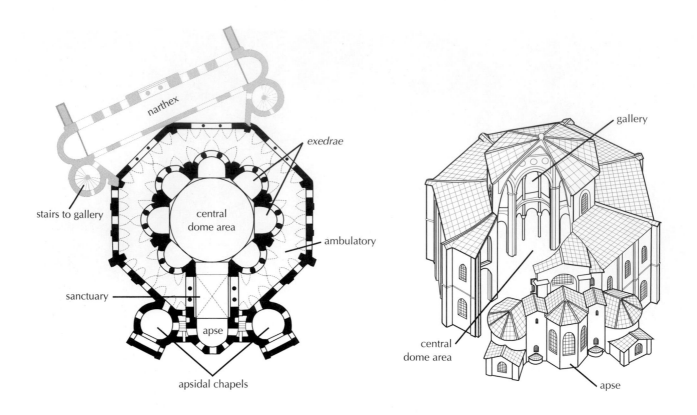

7-26. Plan and cutaway drawing of the Church of San Vitale, Ravenna, Italy. 526–47

half dome of the apse. The figure of Christ emits rays of light, and the standing Old Testament prophets Moses and Elijah affirm his divinity. The astonished apostles—who have fallen to the ground in fear and amazement, while Christ stands calmly in the relaxed pose of a classical orator—are identified as Peter below, John at the left, and James at the right. A supernatural wind seems to catch the ends of their robes, whipping them into curiously jagged shapes. Mount Tabor is suggested only by a narrow strip at the bottom, half green and half reflecting the golden light. This **abstract** rendering contrasts with the continuing classical influence seen in the figures' substantial bodies, revealed by their tightly wrapped drapery.

The formal character of the *Transfiguration of Christ* mosaic reflects an evolving approach to representation that began with imperial Roman art of the third century. As the character of imperial rule changed, the emperor became an increasingly remote figure surrounded by pomp and ceremony. Orators often used terms like *Sacred, Majestic*, or *Eternalness* to address him. In official art such as the Arch of Constantine (see fig. 6-79), abstraction displaced the naturalism and idealism of the Greeks. The Roman interest in capturing the visual appearance of the material world fully gave way in Christian art to a new **hieratic**—formally abstract or priestly—style that sought to express essential religious meaning rather than exact external appearance. Attempting to create tangible images that would stand for intangible Christian concepts, artists

rejected the physicality of the real world for a timeless supernatural world. Geometric simplification of forms, an expressionistic abstraction of figures, use of **reverse perspective**, and standardized conventions to portray individuals and events characterized the new style.

Ravenna. In 540, Byzantine forces captured Ravenna from the Arian Christian Ostrogoths who had taken it in 476, and the city became a base for the further conquest of Italy, completed by Justinian I in 553. Much of our knowledge of the art of this turbulent period—from the time of Honorius (emperor of the Western Roman Empire 395–423) through Arian Ostrogothic control to the triumphant victory of the Byzantine Empire—comes from the well-preserved monuments at Ravenna.

In 526, Ecclesius, bishop of Ravenna from 521 to 532, commissioned two new churches, one for the city and one for its port, Classis, as well as other churches and baptistries. With funding from a wealthy local banker, construction began on a central-plan church in Ravenna dedicated to the fourth-century Roman martyr Saint Vitalis and a basilica-plan church in the port dedicated to Saint Apollinaris, the first bishop of Ravenna. The churches were not completed until after Justinian had conquered Ravenna and established it as the administrative capital of Byzantine Italy. The Church of San Vitale was dedicated in 547, followed by the Church of Sant'Apollinare in Classe two years later.

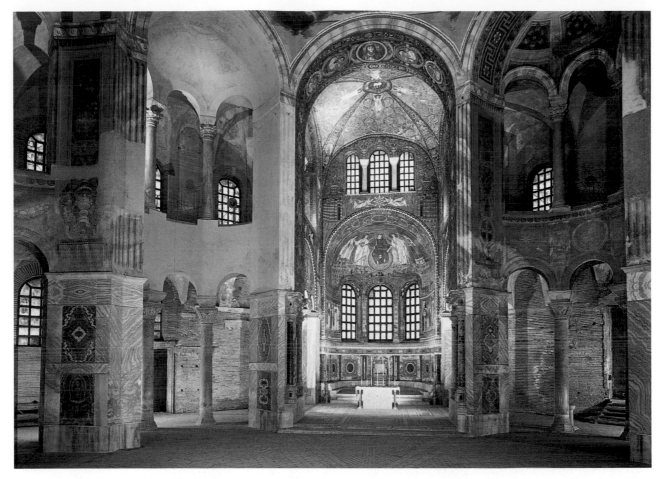

7-27. Church of San Vitale. View across the central space toward the sanctuary apse with mosaic showing Christ enthroned and flanked by Saint Vitalis and Bishop Ecclesius

The design of San Vitale is basically a central-domed octagon extended by **exedra**-like semicircular bays, surrounded by an ambulatory and gallery, all covered by vaults (fig. 7-26). A rectangular sanctuary and semicircular apse project from one of the sides of the octagon, and circular rooms in typical Byzantine fashion flank the apse. A separate oval narthex, set off-axis, joined church and palace and also led to cylindrical stair towers that gave access to the second-floor gallery. This sophisticated design has distant roots in Roman buildings such as Santa Costanza (see fig. 7-13).

The floor plan of San Vitale only hints at the effect of the complex, interpenetrating interior spaces of the church, an effect that was enhanced by the offset narthex, with its double sets of doors leading into the church. People entering from the right saw only arched openings, whereas those entering from the left approached on axis with the sanctuary, which they saw straight ahead of them. The round dome, hidden on the exterior by an octagonal shell and a tile-covered roof, is a light, strong structure ingeniously created out of interlocking ceramic tubes and mortar. The whole rests on eight squinches and large piers that frame the *exedrae* and the sanctuary. The two-story *exedrae* open through arches into the outer aisles on the ground floor and into galleries on the second floor. They expand the octagonal central space physically and also create an airy, floating sensation, reinforced by the liberal use of gold *tesserae* in

the mosaic surface decoration. The architecture dissolves into shimmering light and color.

In the half dome of the sanctuary apse, an image of Christ enthroned is flanked by Saint Vitalis and Bishop Ecclesius, who presents a model of the church to Christ (fig. 7-27). The other sanctuary images relate to its use for the celebration of the Eucharist. Pairs of lambs flanking a cross decorate impost blocks above the intricately interlaced carving of the marble column capitals (visible in figure 7-28, page 316). The lunette on the south wall shows an altar table set with a chalice for wine and two patens, to which the high priest Melchizedek on the right brings an offering of bread, and Abel, on the left, carries a sacrificial lamb (fig. 7-28). Their identities are known from the inscriptions above their heads.

The prophets Isaiah (right) and Moses (left) appear in the spandrels. Moses is shown twice: The lower image depicts the moment when, while tending his sheep, he heard the voice of an angel of God coming from a bush that was burning with a fire that did not destroy it. Just above, Moses is shown reaching down to remove his shoes, a symbolic gesture of respect in the presence of God or on holy ground. In the gallery zone of the sanctuary the Four Evangelists are depicted, two on each wall, and in the vault the Lamb of God supported by four angels appears in a field of vine scrolls.

Justinian and Theodora did not attend the dedication ceremonies for the Church of San Vitale conducted by

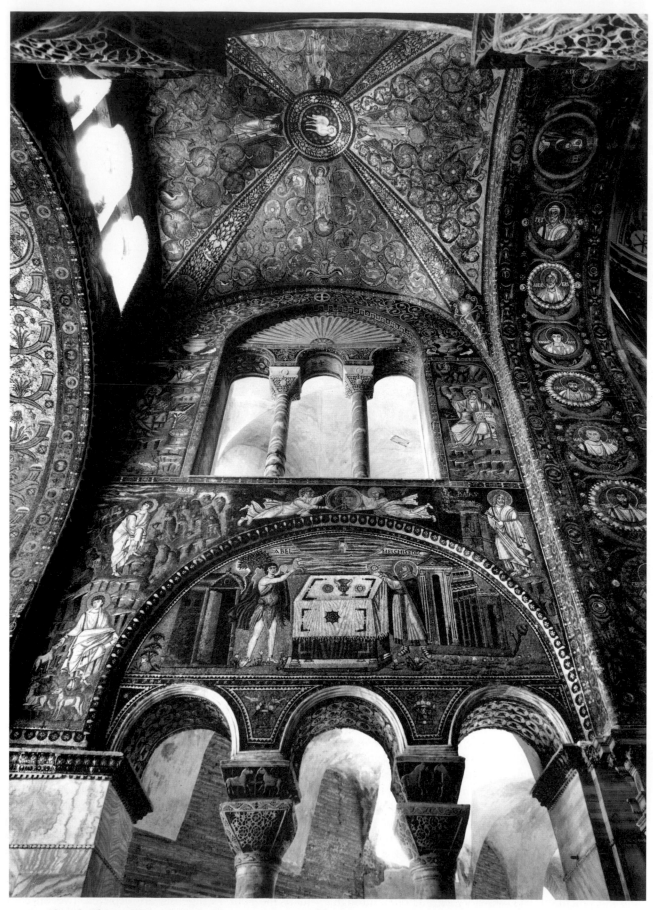

7-28. Church of San Vitale, south wall of the sanctuary, with Abel and Melchizedek in the lunette, Moses and Isaiah in the spandrels, portraits of the evangelists in the gallery zone, and the Lamb of God in the vault

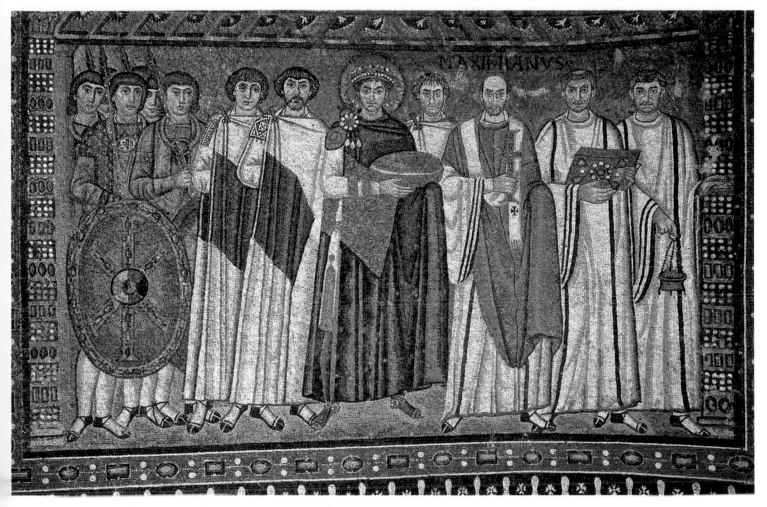

7-29. Emperor Justinian and His Attendants, mosaic on north wall of the apse, Church of San Vitale, Ravenna, Italy. c. 547. 8'8" x 12' (2.64 x 3.65 m)

As head of state, Justinian wears a huge jeweled crown and a purple cloak; as head of church, he carries a large golden paten to hold the Host, the symbolic body of Jesus Christ. The Church officials at his left hold a jeweled cross and a gospel book symbolizing Christ and his church. Justinian's soldiers stand behind a shield decorated with the *chi rho*, a monogram of Greek letters standing for "Christ." On the opposite wall, Empress Theodora, also dressed in royal purple, offers a golden chalice for the liturgical wine (see fig. 7-30).

Archbishop Maximianus in 547—they may never have set foot in Ravenna—but two large mosaic panels that face each other across its apse still stand in their stead. Justinian (fig. 7-29), on the north wall, carries a large golden paten for the Host and stands next to Maximianus, who holds a golden, jewel-encrusted cross. The priestly celebrants at the right carry the Gospels, encased in a golden, jeweled book cover, symbolizing the coming of the Word, and a censer containing burning incense to purify the altar prior to the Mass.

On the south wall, Theodora, standing beneath a fluted shell canopy and singled out by a gold halolike disk and elaborate crown, carries a huge golden chalice studded with jewels (fig. 7-30, page 318). She presents the chalice both as an offering for the Mass and as a gift of great value for Christ. With it she emulates the Magi (see "Iconography of the Life of Jesus," pages 306-7), depicted at the bottom of her purple robe, who brought valuable gifts to the infant Jesus. A courtyard fountain stands to the left of the panel and patterned draperies adorn the openings at left and right.

Theodora's huge jeweled and pearl-hung crown nearly dwarfs her delicate features, yet the empress dominates these worldly trappings by the intensity of her gaze.

The mosaic decoration in the Church of San Vitale combines imperial ritual, Old Testament narrative, and Christian liturgical symbolism. The setting around Theodora—the implied shell form, the fluted pedestal, the open door, and the swagged draperies—are classical illusionistic devices, yet the mosaicists deliberately avoid making them space-creating elements. Byzantine artists accepted the idea that objects exist in space, but they no longer conceived pictorial space the way Roman artists had, as a view of the natural world seen through a "window," the **picture plane**, and extending back from it toward a distant horizon. In Byzantine aesthetic theory, invisible rays of sight joined eye and image so that pictorial space extended forward from the picture plane to the eye of the beholder and included the real space between them. Parallel lines appear to diverge as they get farther away and objects seem to tip up in a

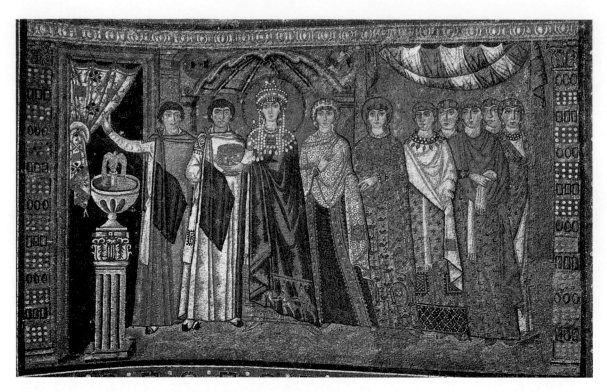

7-30. *Empress Theodora and Her Attendants*, mosaic on south wall of the apse, Church of San Vitale. c. 547. 8'8" x 12' (2.64 x 3.65 m)

The mosaic suggests the richness of Byzantine court costume. Both men and women dressed in layers beginning with a linen or silk tunic, over which men wore another tunic and a long cloak fastened on the right shoulder with a *fibula* (brooch) and decorated with a rectangular panel (*tablion*). Women wore a second, fuller long-sleeved garment over their tunics. Over all their layers, women wore a large rectangular shawl, usually draped over the head. Justinian and Theodora wear imperial purple cloaks with gold-embroidered *tablions* held by *fibulae*. Embroidered in gold at the hem of Theodora's cloak is the scene of the Magi bringing gifts to Jesus. Her elaborate jewelry includes a superhumeral (an item worn on the shoulders) of embroidered and jeweled cloth. A pearled crown, hung with long strands of pearls (thought to protect the wearer from diseases), frames the haunted face of Theodora, who died not long after this mosaic was completed.

representational system known as **reverse perspective**.

Bishop Maximianus consecrated the Church of Sant'Apollinare in Classe in 549. The atrium has disappeared, but the simple geometry of the brick exterior clearly reflects the basilica's interior spaces (fig. 7-31). A narthex entrance spans the full width of the ground floor; a long, tall nave with a clerestory ends in a semicircular apse; and side aisles flank the nave.

Inside, nothing interferes visually with the movement forward from the entrance to the raised sanctuary (fig. 7-32), which extends directly from a triumphal-arch opening into the semicircular apse. The apse mosaic depicts an array of men and sheep in a stylized landscape. In the center, a jeweled cross with the face of Christ at its center symbolizes the Transfiguration—Jesus' revelation of his divinity. The Hand of God and the Old Testament figures Moses and Elijah emerge, legitimizing the newer religion and attesting to the divinity of Christ. The apostles Peter, James, and John—represented here by the three sheep with raised heads—also witness the event. At the center below the cross, Bishop Apollinaris raises his hands in prayer and blessing, an orant. The twelve lambs flanking him represent the apostles. Stalks of blooming lilies, along with tiny trees and other plants, birds, and

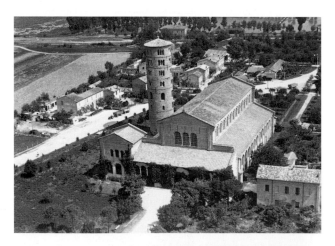

7-31. Church of Sant'Apollinare in Classe (Classis), the former port of Ravenna, Italy. Dedicated 549

oddly shaped rocks, fill the green mountain landscape. Unlike the landscape in the *Good Shepherd* lunette of the Mausoleum of Galla Placidia (see fig. 7-18), these highly stylized forms bear little resemblance to nature. The artists eliminated any suggestion of spatial recession by making the trees and lambs at the top of the golden sky larger than those at the bottom.

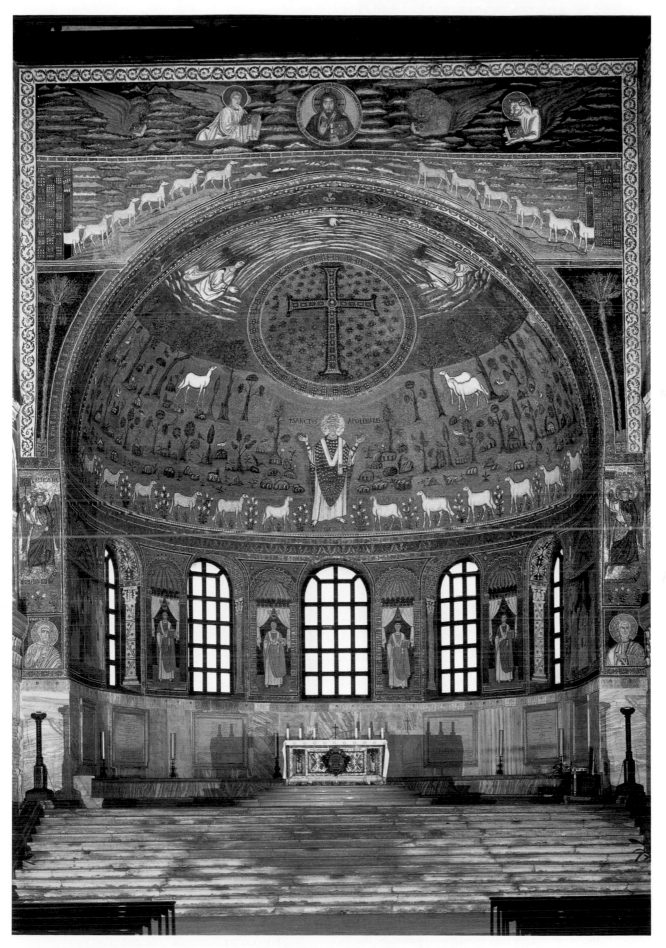

7-32. ***The Transfiguration of Christ with Saint Apollinaris, First Bishop of Ravenna***, mosaic in the apse,
Church of Sant'Apollinare in Classe. Apse, 6th century; mosaics above apse, 7th and 9th centuries

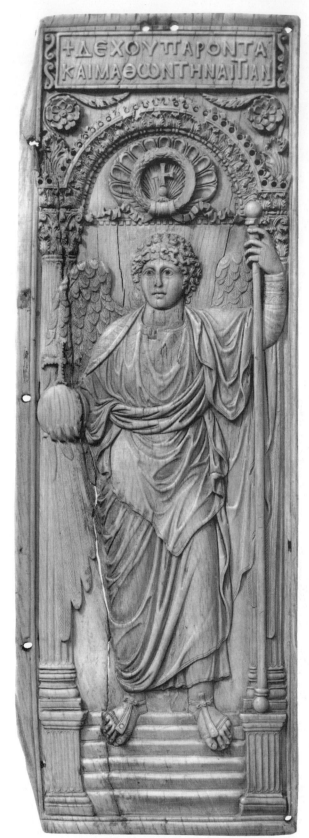

7-33. *Archangel Michael*, panel of a diptych, probably from the court workshop at Constantinople. Early 6th century. Ivory, 17 x 5½" (43.3 x 14 cm). The British Museum, London

The lost half of this diptych would have completed the Greek inscription across the top, which begins: "Receive these gifts, and having learned the cause . . ." Perhaps the other panel contained the portrait of the emperor or another high official who presented the panels as a gift to an important colleague, acquaintance, or family member.

7-34. **Page with *Wild Blackberry***, from De Materia Medica, by Pedanius Dioscorides (1st century), copy made and illustrated in Constantinople for Princess Anicia Juliana. c. 512. Tempera on vellum, 15 x 13" (38.1 x 33 cm). Österreichische Nationalbibliothek, Vienna

7-35. **Page with *Rebecca at the Well***, from Book of Genesis, probably made in Syria or Palestine. Early 6th century. Tempera, gold, and silver paint on purple-dyed vellum, 13½ x 9⅞" (33.7 x 25 cm). Österreichische Nationalbibliothek, Vienna

In the mosaics on the wall above the apse, which were added in the seventh and ninth centuries, Christ, now portrayed with a cross inscribed in his halo and flanked by symbols representing the evangelists, blesses and holds the Gospels. Sheep (the apostles) emerge from gateways and climb golden rocks toward their leader and teacher.

Ivories, Manuscripts, and Panel Paintings. The court workshops of Constantinople excelled in the production of carved ivory objects for liturgical use. The panel here depicts the archangel Michael in a classicizing style (fig. 7-33). In his beauty, physical presence, and elegant setting, the archangel is comparable to the priestess of Bacchus in the Symmachus panel (see fig. 6-84). His relation to the architectural space and the frame around him, however, has changed. His heels rest on the top step of a stair that clearly lies behind the columns and pedestals, but the rest of his body projects in front of them. The angel is shown here as a divine messenger, holding a staff of authority in his left hand and a sphere symbolizing worldly power in his right, a message reinforced by repetition: within the arch is a cross-topped orb, framed by a wreath, against the background of a scallop shell. This image floats in an indefinite space, unrelated to either the archangel or the message.

The Byzantine court also sponsored a major **scriptorium** (writing room for scribes—professional document writers) for the production of **manuscripts** (handwritten books). Among these works was a botanical encyclopedia known by its Latin title, *De Materia Medica*, listing the appearance, properties, and medicinal uses of plants. Compiled in the first century CE by a Greek physician named Pedanius Dioscorides (c. 40–90), who probably traveled as a physician with the Roman army, this work was the first systematic treatment of plants. Generations of scribes copied it. The earliest known surviving copy, a **codex** (see "Early Forms of the Book," page 304) from Constantinople dated about 512, was given to Princess Anicia Juliana, whose father had been emperor in the West for a few months in 472. The illustrators transformed a practical reference book in Greek into an exquisitely illustrated work suitable for the imperial library (fig. 7-34). Although Dioscorides' work is secular and pagan, Christians found religious as well as medical significance in the plants it catalogs. For example, the wild blackberry bramble illustrated here came by tradition to represent the burning bush of Moses and the purity of the Virgin Mary.

Byzantine manuscripts often used very costly materials. Although plain sheets of **vellum** (a fine writing surface made from calfskin) and natural pigments were used in this copy of *De Materia Medica*, purple-dyed vellum and gold and silver inks were used in a *Book of Genesis* (fig. 7-35). The book was probably made in Syria or Palestine, and the purple vellum indicates that it may have been done for an imperial patron (costly purple dye, made from the shells of murex mollusks, usually was restricted to imperial use). The Genesis book, like *De Materia Medica*, is in codex form and is written in Greek. Illustrations appear below the text at the bottom of the pages. The illustration of the story of Rebecca at the Well (Genesis 24) shown here appears to be a single scene, but it actually mimics the continuous narrative of a

7-36. Page with *The Crucifixion*, from the Rabbula Gospels, from Beth Zagba, Syria. 586. 13½ x 10½" (33.7 x 26.7 cm). Biblioteca Medicea Laurenziana, Florence

scroll. Events that take place at different times in the story follow in succession. Rebecca, the heroine of the story, appears at the left walking away from the walled city of Nahor with a large jug on her shoulder to fetch water. She walks along a miniature colonnaded road toward a spring personified by a reclining pagan water nymph who holds a flowing jar. In the foreground, Rebecca, her jug now full, encounters a thirsty camel driver and offers him water to drink. Unknown to her, he is Abraham's servant Eliezer in search of a bride for Abraham's son Isaac. Her generosity leads to her marriage with Isaac. Although the realistic poses and rounded, full-bodied figures in this painting reflect an earlier Roman painting tradition, the unnatural purple of the background and the glittering metallic letters of the text remove the scene from the mundane world.

An illustrated Gospels, signed by a monk named Rabbula and completed in February 586 at the Monastery of Saint John the Evangelist in Beth Zagba, Syria, provides a near-contemporary example of a quite different approach to religious art. Church murals and mosaics may have inspired its illustrations. They are intended not only to depict biblical events but also to present the Christian story through complex, multileveled symbolism. Besides full-page illustrations like those of the Crucifixion and the Ascension shown here, there are also lively smaller scenes, or **vignettes**, in the margins.

The Crucifixion in the *Rabbula Gospels* presents a detailed picture of Christ's death and resurrection (fig. 7-36).

7-37. Page with *The Ascension*, from the Rabbula Gospels

behind the crosses give way to the lush foliage of the garden around the tomb. This very complete representation of the orthodox view of the Crucifixion may have been intended to counter the claim of the Monophysites that Christ was entirely divine.

The ascension of Christ into heaven (fig. 7-37) is described in the New Testament: "[A]s they [his apostles] were looking on, he was lifted up, and a cloud took him from their sight" (Acts of the Apostles 1:9). The cloud has been transformed into a mandorla supported by two angels. Two other angels follow, holding victory crowns in fringed cloths. The image directly under the mandorla combines fiery wheels and the four beasts seen by the Hebrew prophet Ezekiel in a vision (Ezekiel 1). The four beasts also appear in the New Testament's Revelations and are associated with the Four Evangelists: Matthew, an angel; Mark, a lion; Luke, an ox; and John, an eagle. Christians interpreted this vision as a precursor of the vision of Judgment Day described in Revelations.

Below this imagery, the Virgin Mary stands calmly in the pose of an orant, while angels at her side confront the astonished apostles. One angel gestures at the departing Christ and the other appears to be offering an explanation of the event to attentive listeners (Acts of the Apostles 1:10–11). The prominence accorded Mary here can be interpreted as a result of her status of *Theotokos,* God-bearer. She may also represent the Christian community on earth, that is, the Church. As we noted earlier, the Christian world at this time was filled with debate over the exact natures of Christ, the Trinity, and the Virgin Mary. Taken as a whole, the *Rabbula Gospels* would provide evidence of the owner's adherence to orthodoxy.

Eastern Christians prayed to Christ, Mary, and the saints while looking at images of them on icons. The first such image was believed to have been a portrait of Jesus that appeared miraculously on the scarf with which his follower Veronica wiped his face along the road to the execution ground. Church doctrine toward the veneration of icons was ambivalent. Key figures of the Eastern Church, such as Basil the Great of Cappadocia (c. 329–79) and John of Damascus (c. 675–749), distinguished between idolatry—the worship of images—and the veneration of an idea or holy person depicted in a work of art. The Eastern Church thus prohibited the worship of icons but accepted them as aids to meditation and prayer. The images were thought to act as intermediaries between worshipers and the holy personages they depicted.

Most early icons were destroyed in the eighth century in a reaction to the veneration of images known as iconoclasm (see "Iconoclasm," page 309), making those that have survived especially precious. A few very beautiful examples were preserved in the Monastery of Saint Catherine on Mount Sinai, among them the *Virgin and Child with Saints and Angels* (fig. 7-38). As *Theotokos,* Mary was viewed as the powerful, ever-forgiving intercessor, or go-between, appealing to her Divine Son for mercy on behalf of repentant worshipers. She was also called the Seat of Wisdom, and many images of the Virgin and Child, like this one, show her holding Jesus on

He appears twice, on the cross in the center of the upper register and with the two Marys—the mother of James and Mary Magdalen—at the right in the lower register. The Byzantine Christ is a living king who triumphs over death. He is shown as a mature, bearded figure, not the youthful shepherd depicted in the catacombs (see fig. 7-3). Even on the cross he is dressed in a long, purple robe, called a *colobium,* that signifies his royal status. (In many Byzantine images he also wears a jeweled crown.) At his sides are the repentant and unrepentant thieves who were crucified with him. Beside the thief at the left stand the Virgin and John the Evangelist; beside the thief at the right are the holy women. Soldiers beneath the cross throw dice for Jesus' clothes. A centurion stands on either side of the cross. One of them, Longinus, pierces Jesus' side with a lance; the other, Stephaton, gives him vinegar instead of water to drink from a sponge. The small disks in the heavens represent the sun and moon. In the lower register, directly under Jesus on the cross, stands his tomb, with its open door and stunned or sleeping guards. This scene represents the Resurrection. The angel reassures the holy women at the left, and Christ himself appears to them at the right. All these events (described in Matthew 28) take place in an otherworldly setting indicated by the glowing bands of color in the sky. The austere mountains

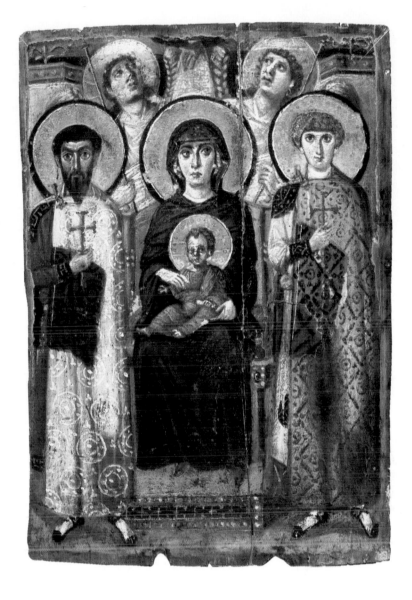

7-38. *Virgin and Child with Saints and Angels*, icon. Second half of 6th century. Encaustic on wood, 27 x 18⁷⁄8" (69 x 48 cm). Monastery of Saint Catherine, Mount Sinai, Egypt

her lap in a way that suggests that she represents the throne of Solomon. The Christian warrior-saints Theodore (left) and George (right)—both legendary figures said to have slain dragons, representing the triumph of the Church over the "evil serpent" of paganism—stand at each side, while angels behind them look heavenward. The Christ Child, the Virgin, and the angels were painted with a Roman-derived, illusionistic technique and are almost realistic. The male saints are much more stylized than the other figures; the richly patterned textiles of their cloaks barely hint at the bodies beneath.

MIDDLE BYZANTINE ART

The Iconoclasts, who had ruled for more than a century, lost power in 843, and under new leadership, the Eastern Empire revitalized. Early Byzantine civilization had been centered in lands along the rim of the Mediterranean Sea that had been within the Roman Empire. During the Middle Byzantine period, Constantinople's scope was reduced to what is present-day Turkey and other areas by the Black Sea, the Balkan peninsula including Greece, and southern Italy. The influence of Byzantine culture also extended into Russia,

Ukraine, and Venice, Constantinople's trading partner in northeastern Italy, at the head of the Adriatic Sea.

Under the Macedonian dynasty (867–1056) initiated by Basil I, the empire prospered and enjoyed a cultural rebirth. Middle Byzantine art and architecture, visually powerful and stylistically coherent, reflect the strongly spiritual focus of the period's autocratic—and wealthy—leadership. From the mid-eleventh century, however, incursions by other powers on Byzantine territory began to weaken the empire. It stabilized temporarily under the Comnenian dynasty (1081–1185), extending the Middle Byzantine period well into the Western Middle Ages—until 1204, when Christian Crusaders seized Constantinople.

ARCHITECTURE AND ITS DECORATION

Although comparatively few Middle Byzantine churches in Constantinople have survived intact, enough remain to suggest what the city's Christian architecture looked like then. Fortunately, many central-plan domed churches, favored by Byzantine architects, survive beyond the imperial capital, in Ukraine to the northeast and Sicily to

ELEMENTS OF ARCHITECTURE

Multiple-Dome Church Plans

The construction of a huge single dome, such as Hagia Sophia's (see figs. 7-23 and 7-24) presented almost insurmountable technical challenges. Byzantine architects found it more practical to cover large interior spaces with several domes. Justinian's architects devised the five-dome Greek-cross plan, which was copied in the West at Saint Mark's in Venice ([a], and see fig. 7-39). Middle Byzantine builders preferred smaller, more intricate spaces, and multiple-dome churches were very popular. The five domes of the Greek cross would often rise over a nine-bay square (b). The most favored plan was the quincunx, or cross-in-square, in which barrel vaults cover the arms of a Greek cross around a large central dome, with domes or groin vaults filling out the corners of a nine-bay space (c). Often the vaults and secondary domes are smaller than the central dome. Any of these arrangements can be made into an expanded quincunx (d) by additional domed aisles, as at the Cathedral of Saint Sophia in Kiev (see fig. 7-41), or by a second set of four domes, in the Cathedral of Saint Basil in Moscow (see fig. 7-54).

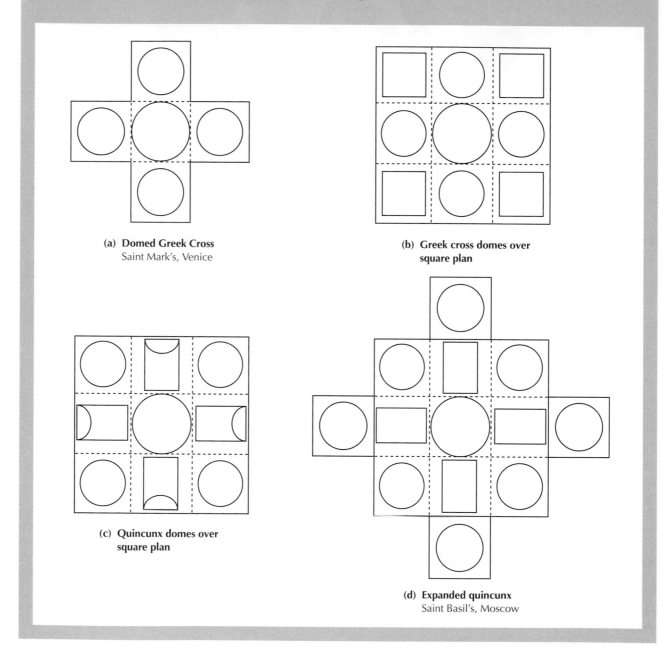

(a) Domed Greek Cross
Saint Mark's, Venice

(b) Greek cross domes over square plan

(c) Quincunx domes over square plan

(d) Expanded quincunx
Saint Basil's, Moscow

the southwest, for example. These structures reveal the builders' taste for a multiplicity of geometric forms, verticality, and rich decorative effects both inside and out.

The loss of buildings similarly makes the study of Byzantine domestic architecture almost impossible, but Byzantine palaces must have been spectacular. Descriptions of the imperial palace in Constantinople tell of extraordinarily rich marbles and mosaics, silk hangings, and golden furniture, including a throne surrounded by mechanical singing birds and roaring lions. Palaces and houses evidently followed the pattern established by the Romans of a series of rooms around open courts. The

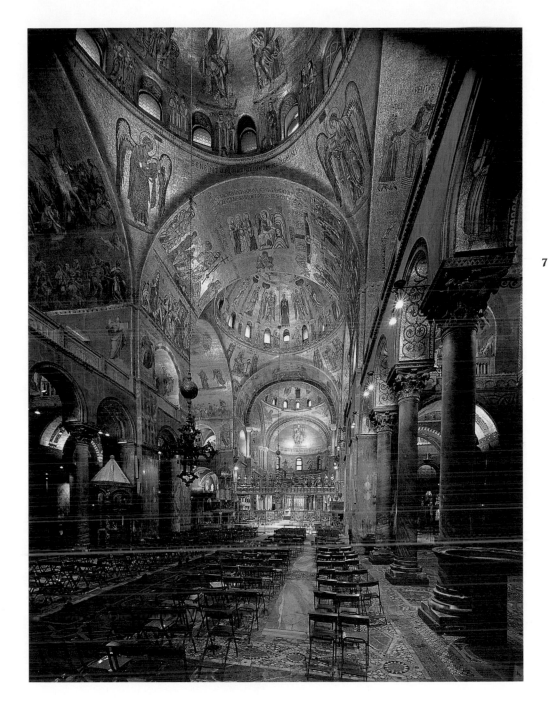

7-39. Cathedral of Saint Mark, Venice. Present building begun 1063. View looking toward apse

This church is the third one built on the site. It was both the palace chapel of the *doge* and the *martyrium* that stored the bones of the patron of Venice, Saint Mark. This great multi-domed structure, consecrated as a cathedral in 1807, has been reworked continually to the present day.

great palace of the Byzantine emperors may have resembled Hadrian's Villa, with different buildings for domestic and governmental functions set in gardens, which were walled off from the city.

Venice. The northeastern Italian city of Venice, set on the Adriatic at the crossroads of Europe and Asia Minor, had been subject to Byzantine rule in the sixth and seventh centuries and, until the tenth century, the city's ruler, the *doge*, had to be ratified by the emperor. At the end of the tenth century, Constantinople granted Venice a special trade status that allowed its merchants to control much of the commercial interchange between the East and the West, which brought the city great wealth and increased its exposure to Eastern cultures, clearly reflected in its art and architecture. One of Venice's great Byzantine monuments is the Cathedral of Saint Mark, which was modeled after the Church of the Holy Apostles in Constantinople.

Venetian architects looked to the Byzantine domed church for inspiration in 1063, when the *doge* commissioned a much larger church to replace the palace chapel. The chapel had served since the ninth century as a *martyrium*, holding the relics of Saint Mark the Apostle, which were brought to Venice from Alexandria in 828. On the chapel's site rose the massive Cathedral of Saint Mark, which has a Greek-cross plan, each square unit of which is covered by a dome (see "Multiple-Dome Church Plans," page 324). There are five great domes in all, separated by barrel vaults and supported by pendentives. Unlike Hagia Sophia, with its flow of space from the narthex through the nave to the apse (see fig. 7-23), Saint Mark's domed compartments produce a complex space with five separate vertical axes (fig. 7-39). Marble covers the lower walls and golden mosaics glimmer above, covering the vaults,

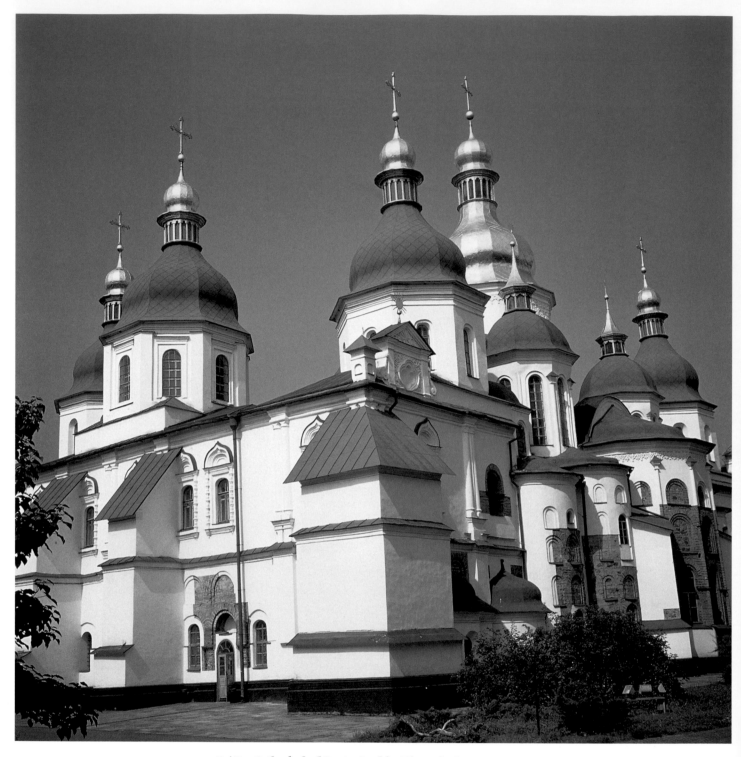

7-40. Cathedral of Santa Sophia, Kiev, Ukraine. c. 1017–37

pendentives, and domes. The dome seen in figure 7-39 depicts the Pentecost, the descent of the Holy Spirit on the apostles. The mosaics were continually reworked and were completed in the sixteenth and seventeenth centuries.

Kiev. As Constantinople turned its gaze to the east, Ukraine, Belarus, and Russia fell under its spell. These lands had been settled by Eastern Slavs in the fifth and sixth centuries, but later were ruled by Swedish Vikings. The Vikings had sailed down the rivers from the Baltic to the Black Sea, establishing forts and trading stations along the way. They traveled as far as Constantinople, where the Byzantine

emperor hired them as his personal bodyguards. In the ninth century, the Viking traders established headquarters in the upper Volga region and in the city of Kiev, which became the capital of the area under their control, known as Kievan Rus.

The first Christian member of the Kievan ruling family was Princess Olga (c. 890–969), who was baptized in Constantinople by the patriarch himself, with the Byzantine emperor as her godfather. Her grandson Grand Prince Vladimir (ruled 980–1015) established Byzantine Christianity as the state religion in 988. Vladimir sealed the pact with the Byzantines by accepting baptism and marrying Anna,

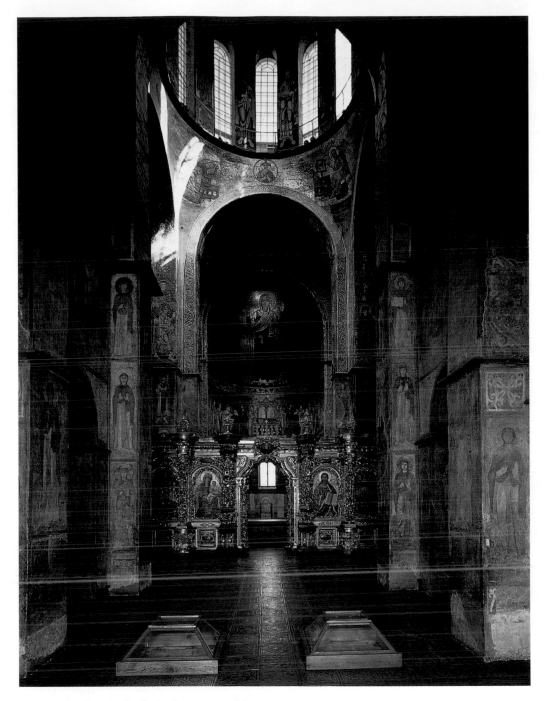

7-41. Interior, Cathedral of Santa Sophia

The view under the dome and into the apse does not convey the quality of the interior as an agglomeration of tall narrow spaces divided by piers whose architectural function is disguised or ignored by elaborate paintings.

the sister of the powerful Emperor Basil II (ruled 976–1025).

Vladimir's son Grand Prince Yaroslav (ruled 1019–54) founded the Cathedral of Santa Sophia in Kiev (fig. 7-40) after the city burned in 1017. The church originally had a typical nine-bay, cross-in-square, or **quincunx**, design (see "Multiple-Dome Church Plans," page 324), but it was expanded to have double side aisles, five apses (whose original brickwork was left free of plaster in the recent restoration), a large central dome, and twelve smaller domes. The small domes were said to represent the twelve apostles gathered around the central dome representing Christ the *Pantokrator*, Ruler of the Universe. The great cen-

tral dome, typical of Middle Byzantine churches, gives the complex silhouette a roughly pyramidal shape. Although the tall drums and pointed, bulbous onion domes on the exterior were added in the seventeenth and eighteenth centuries, they convey the sense of intricate, rising spaces typical of Kievan (and later Russian) architecture.

Inside the church, the central domed space of the **crossing** focuses attention on the nave and the main apse. The many individual bays, each of which is an almost independent vertical unit, create an often confusing and compartmentalized interior (fig. 7-41). The interior walls glow with lavish decoration: mosaics

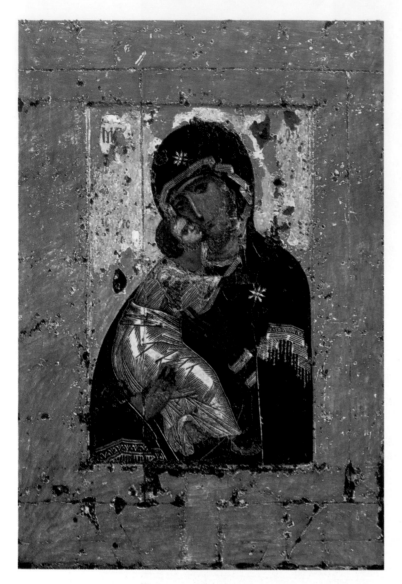

7-42. *Virgin of Vladimir*, icon, probably from Constantinople. Faces only, 12th century; the rest has been retouched. Tempera on panel, height approx. 31" (78 cm). Tretyakov Gallery, Moscow

powerful political declaration of his own—and the Kievan church's—importance and wealth.

The people of Kievan Rus learned their art by copying and recopying icons brought from Constantinople. One image transported to Kiev was the icon of Mary and Jesus known as the *Virgin of Vladimir* (fig. 7-42), which has been greatly revered since its creation. Its distinctively humanized approach suggests the growing desire, reflected in Byzantine art, for a more immediate and personal religion. (A similar trend began about the same time in the art of Western Europe.) Paintings of this type, known as the Virgin of Compassion, show Mary and the Christ Child pressing their cheeks together and gazing tenderly at each other. The source for this tender image was widely believed to be a portrait painted by the evangelist Luke following a vision he had of the Nativity. Almost from its creation (probably in Constantinople), the *Virgin of Vladimir* was thought to protect the people of the city where it resided. It arrived in Kiev sometime between 1131 and 1136 and was taken to the city of Suzdal and then to Vladimir in 1155. In 1480 it was moved to Moscow, where it graced the Cathedral of the Dormition in the Kremlin. Today, secularized, it is housed in a museum.

In 1169, Prince Andrew of Suzdal (c. 1111–74) sacked Kiev and made Vladimir the capital. Thus weakened, Kiev was unable to withstand the Mongol forces that laid waste to the city in 1240 and controlled Ukraine and much of Russia for more than a century thereafter.

Greece. Although an outpost, Greece lay within the Byzantine Empire in the tenth and eleventh centuries. The two churches of the Monastery of Hosios Loukas, built a few miles from the village of Stiris, Greece, in the tenth and eleventh centuries, are excellent examples of the architecture of the Middle Byzantine age (fig. 7-43). The Church of the Virgin Theotokos, on the right in the plan, is joined to the Katholikon, on the left. Both churches are essentially compact, central-plan structures. The dome of the Theotokos, supported by pendentives, rises over a cross-in-square core; that of the Katholikon, supported by **squinches**, rises over an octagonal core (see "Pendentives and Squinches," page 311). The high central space in the interior of the Katholikon carries the eye of the worshiper upward into the main dome, which soars above a ring of tall arched windows.

Unlike Hagia Sophia, with its clear, sweeping geometric forms, the two churches of Hosios Loukas have a complex variety of forms, including domes, groin vaults, barrel vaults, pendentives, and squinches (the squinches in the Katholikon are the fan shapes supporting the dome and converting the square bay into an octagon). The barrel vaults and tall sanctuary apses with flanking rooms further complicate the space. In the Katholikon, single, double, and triple windows create intricate and unusual patterns of light, illuminating a painting (originally a mosaic) of Christ *Pantokrator* in the center of the main dome. The secondary, sanctuary dome of the Katholikon is decorated with a mosaic of the Lamb of God surrounded by the Twelve Apostles, and the apse half dome has a mosaic of the Virgin and

glitter from the central dome, the apse, and the arches of the crossing, and the remaining surfaces are painted with scenes from the lives of Christ, the Virgin, the apostles Peter and Paul, and the archangels.

The mosaics established an iconographical system that came to be followed in Russian Orthodox churches. The *Pantokrator* fills the center of the dome (not visible above the window-pierced drum in figure 7-41). At a lower level, the apostles stand between the windows of the drum, with the Four Evangelists in the pendentives. The Virgin Mary, in the traditional pose of prayer (an orant figure), seems to float in a golden heaven, filling the half dome and upper wall of the apse. In the mosaic on the wall below the Virgin, Christ, appearing not once but twice, accompanied by angels who act as deacons, celebrates Mass at an altar under a canopy, a theme known as the Communion of the Apostles. He distributes communion to six apostles on each side of the altar. With this extravagant use of costly mosaic, Prince Yaroslav made a

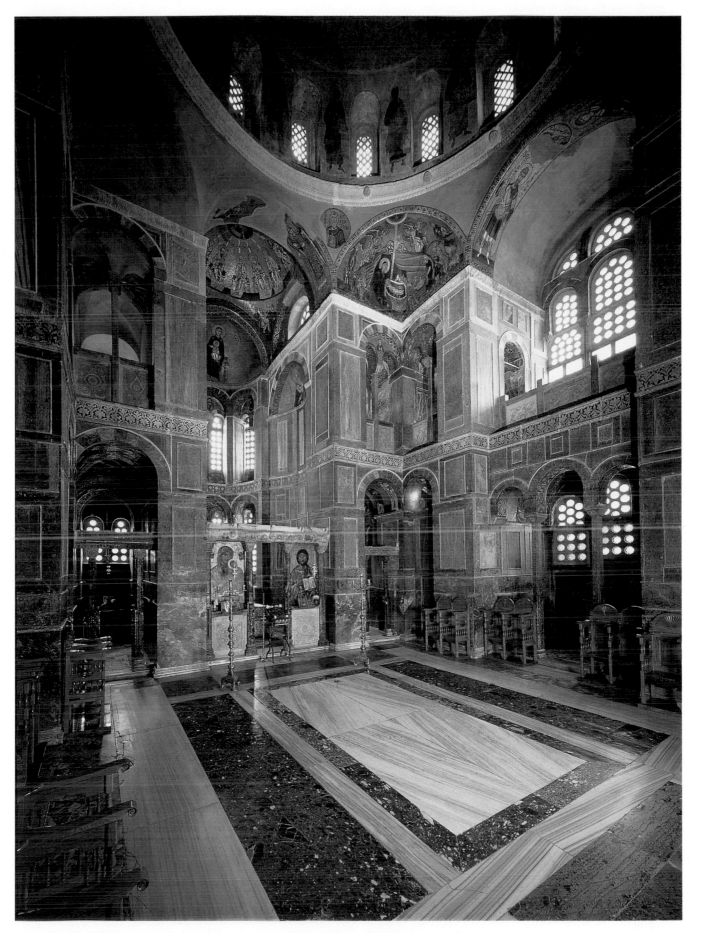

7-43. Central dome and apse, Katholikon, Monastery of Hosios Loukas, near Stiris, Greece. Early 11th century and later

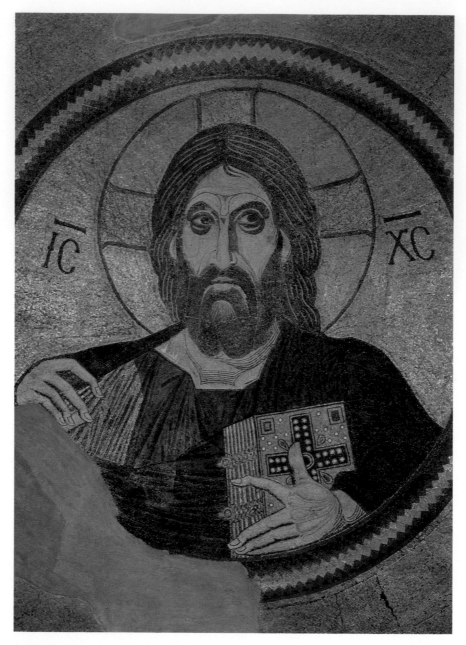

7-44. *Christ Pantokrator*, mosaic in the central dome, Church of the Dormition, Daphni, Greece. Central dome, c. 1080–1100

Child. Scenes from the Old and New Testaments and figures of saints fill the interior with brilliant color and dramatic images.

Eleventh-century mosaicists in Greece looked with renewed interest at models from the past, studying both classical art and the art of Justinian's era. They conceived their compositions in terms of an intellectual rather than a physical ideal. While continuing to represent the human figure and narrative subjects, some artists eliminated all unnecessary details, focusing on the essential elements of a scene to convey its mood and message.

The decoration of the Church of the Dormition at Daphni, near Athens, provides an excellent example of this moving but elegant style. (The term *dormition*—which comes from the Greek and Latin words for "sleep"—refers to the assumption into heaven of the Vir-

gin Mary at the moment of her death.) The *Christ Pantokrator*, a bust-length mosaic portrayal, fills the central dome of the church (fig. 7-44). This awe-inspiring image, hovering in golden glory, combines two persons of the Trinity—father and son, judge and savior. It is a powerful evocation of his promised judgment, with its reward for the faithful and punishment for sinners.

On a wall in the north arm of the church is an image of the Crucifixion (fig. 7-45). Jesus is shown with bowed head and sagging body, his eyes closed in death. Gone is the royal robe of the sixth-century *Rabbula Gospels* (see fig. 7-36); a nearly nude figure hangs on the cross. Also unlike the earlier Crucifixion scene, which depicts many people, some anguished and others indifferent or hostile, this image shows just two mourning figures, Mary and the young apostle John, to whom Jesus had entrusted the

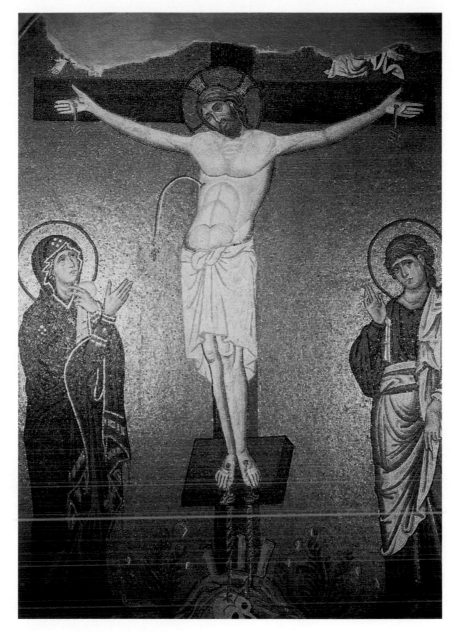

7-45. *Crucifixion*, mosaic in the north arm of the east wall, Church of the Dormition, Daphni, Greece. Late 11th century

care of his mother after his death. The arc of blood and water springing from Jesus' side refers to the Eucharist. The simplification of contours and the reduction of forms to essentials give the image great emotional power. This otherworldly space is a golden universe anchored to the material world by a few flowers, which suggest the promise of new life. The mound of rocks and the skull at the bottom of the cross represent Golgotha, the "place of the skull," a hill outside ancient Jerusalem where Adam was thought to be buried and the Crucifixion was said to have taken place. To the faithful, Jesus Christ was the new Adam sent by God to save humanity through his own sacrifice. As Paul wrote in his First Letter to the Corinthians: "For just as in Adam all die, so too in Christ shall all be brought to life" (1 Corinthians 15:22). The timelessness and simplicity of this image were meant to aid the Christian worshiper seeking to achieve a mystical union with the divine through prayer and meditation.

Sicily. Other notable mosaics were created during this period on the island of Sicily, a crossroads of Byzantine, Muslim, and European cultures. Muslims had ruled Sicily from 827 to the end of the eleventh century, when it fell to the Normans, descendants of the Viking settlers of northern France. The Norman Roger II, count of Sicily (ruled 1105–30), was crowned king of Sicily in Palermo in 1130 and ruled until 1154. The pope, who assumed ecclesiastical jurisdiction over Sicily for "God and Saint Peter," endorsed Norman rule. In the first half of the twelfth century, Sicily became one of the richest and most enlightened kingdoms in Europe. Roger extended religious toleration to the kingdom's diverse population, which

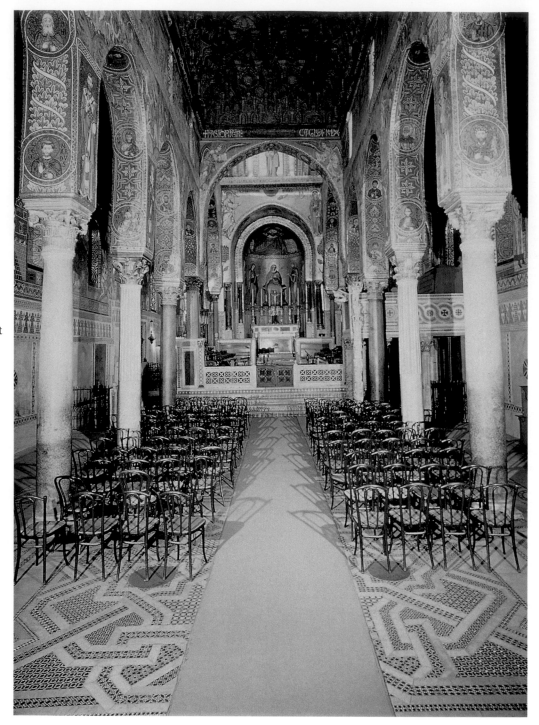

7-46. Palatine Chapel,
Palermo, Sicily.
Mid-12th century.
View toward the east

included western Europeans, Greeks, Arabs, and Jews. He involved all factions in his government, permitted everyone to participate equally in the kingdom's economy, and issued official documents in Latin, Greek, and Arabic.

Roger's court in his capital of Palermo was a brilliant mixture of Norman, Muslim, and Byzantine cultures, as reflected in the Palatine (palace) Chapel there. The Western-style basilica-plan church has a Byzantine dome on squinches over the crossing, an Islamic-style timber ceiling in the nave, lower walls and a floor of inlaid marble, and upper walls decorated with mosaic—the diverse elements dramatically combining into an exotic whole (fig. 7-46). A blessing Christ holding an open book fills the half dome of the apse; a Christ *Pantokrator* surrounded by

angels, the dome; the Annunciation, the arches of the crossing. The mosaics in the transept (seen at the right) have scenes from the Gospels, with the Nativity and shepherds on the end wall. In contrast to the focus on strictly essential forms seen in the mosaics at Daphni, the artists here seem to have been absorbed in depicting anecdotal details, so that well-proportioned figures clothed in form-defining garments might also have draperies with patterns of geometric folds and jagged, flying ends bearing no relation to gravity. Instead of modeling forms with subtle tonal gradations, the artists often relied on strong juxtapositions of light and dark areas. The style and some iconographical details are Byzantine, but the excited narrative energy is Western.

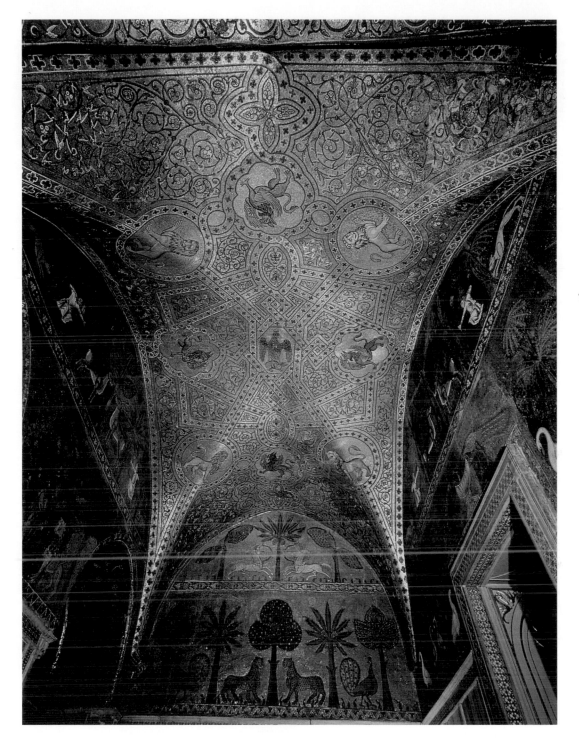

7-47. Chamber of King Roger, Norman Palace, Palermo, Sicily. Mid-12th century

A room in the Norman Palace in Palermo, made for William I (ruled 1154–66) although known as King Roger's chamber, gives an idea of domestic Byzantine interior decoration (fig. 7-47). The floor and lower walls have individual marble panels framed by strips inlaid with geometric patterns of colored stones. Columns with patterned marble shafts add to the decoration rather than form necessary supports. Mosaics cover the upper walls and vault. Against a continuous gold surface are two registers of highly stylized trees and paired lions, leopards, peacocks, centaurs, and hunters. The interior glistens with reflected light and color. The idea of a garden room, so popular in Roman houses, remains, but the artists have turned it into a stylized fantasy on nature—a world as formalized as the rituals that had come to dominate life in the imperial and royal courts.

IVORIES AND METALWORK

During the second Byzantine golden age, artists of impeccable ability and high aesthetic sensibility produced small luxury items of a personal nature for members of the court as well as for the Church. Many of these items were commissioned by rulers and high secular and church functionaries as official gifts for one another. As such, they had to be portable, sturdy, and exquisitely refined. In style these works tended to combine classical elements with iconic compositions,

7-48. *Harbaville Triptych*. Mid-11th century. Ivory, closed 11 x 9½" (28 x 24.1 cm); open 11 x 19" (28 x 48.2 cm). Musée du Louvre, Paris

successfully joining simple beauty and religious meaning. Such a piece is the *Harbaville Triptych*, dating from the mid-eleventh century (fig. 7-48). This small ivory devotional piece represents Christ in the upper center panel flanked by Mary and Saint John the Baptist acting as intercessors on behalf of worshipers; this group, known as Deesis, was an important new theme. The figures in the other panels (wings) are military saints and martyrs. All the figures exist in a neutral space given definition only by the small bases under the feet of the saints and by Christ's throne. Although conceived as essentially frontal and rigid, the figures have rounded shoulders, thighs, and knees that suggest physical substance beneath a linear, decorative drapery. Beautiful as the carved ivory seems to us, the triptych was likely to have been brightly painted and gilded, as microscopic examination of other Middle Byzantine ivories has revealed tiny grains of pigment in red, blue, green, black, white, and gold.

The refined taste and skillful work that characterize the arts of the tenth through twelfth centuries were also expressed in precious materials such as silver and gold. A silver-gilt and enamel icon of the archangel Michael was one of the prizes the Crusaders took back to Venice in 1204, after sacking Constantinople. The icon was presumably made in the late tenth or early eleventh century in an imperial workshop (fig. 7-49, "The Object Speaks"). The angel's head and hands, executed in relief, are surrounded by intricate relief and enamel decoration. Halo, wings, and garments are in jewels, colored glass, and delicate **cloisonné**, and the outer frame, added later, is inset with enamel **roundels**. The colorful brilliance of the patterned setting removes the image from the physical world, although the archangel appears here in essentially the same frontal pose and with the same idealized and timeless youthfulness with which he was portrayed in a

THE OBJECT SPEAKS
THE ARCHANGEL MICHAEL

Icons speak to us today from computer screens—tiny images leading us from function to function in increasingly sophisticated hierarchies. Allusive images formed of light and color, these icons—like the religious **icons** ("images" in Greek) that came before—speak to those who almost intuitively understand their suggestive form of communicating.

The earliest icons had a mostly religious purpose—they were holy images that mediated between people and their God. Icons in the early Church were thought to be miracle workers, capable even of defending their petitioners from evil. An icon made more than a thousand years ago, possibly from the front and back covers of a book, depicts the archangel Michael (fig. 7-49). The Protector of the Chosen, who defends his people from Satan and conducts their souls to God, Michael is mentioned in Jewish, Christian, and Islamic scriptures. On the front of this icon, Michael blesses petitioners with upraised hand; on the back is a relief in silver of the Cross, symbolizing Christ's victory over death.

When it was created, this icon would have spoken to believers of how archangels and angels mediate between God and humans—as when they announced Jesus' birth or mourned his death. Immaterial, they occupy no space; their presence is felt, not seen. They are known intuitively, not by human reason.

Intuitive understanding is the core of Christian mysticism, according to the sixth-century theologian Dionysus the Pseudo-Areopagite. As he explained, humans may, in stages, leave their sensory perception of the material world and rational thought and move to a mystical union with God. In icons, enamels, mosaics, and stained glass, artists tried to convey a sense of the divine with colored light, representing how matter becomes pure color and light as it becomes immaterial. Believers thus would have interpreted the ***Archangel Michael*** as an image formed by the golden light of heaven—his presence is felt; his body is immaterial. When believers then and now behold icons like the ***Archangel Michael***, they intuit the image of the Heavenly Jerusalem.

7-49. *Archangel Michael*, **icon.** Late 10th or early 11th century. Silver gilt with enamel, 19 x 14" (48 x 36 cm). Treasury of the Cathedral of Saint Mark, Venice

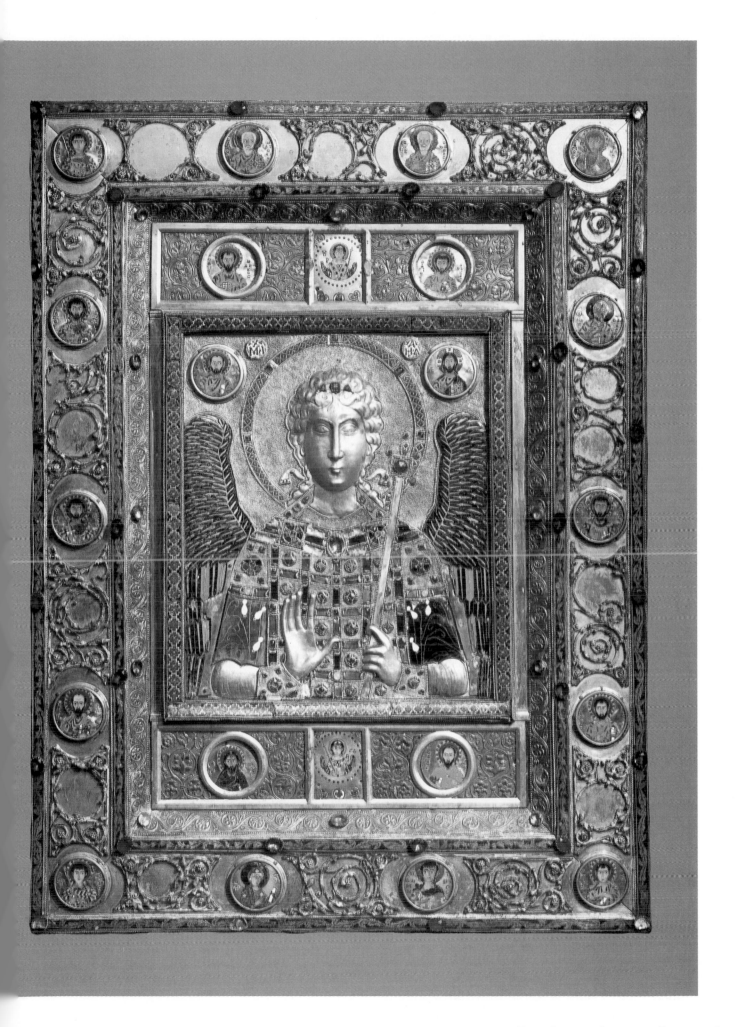

7-50. Page with *David the Psalmist*, from the *Paris Psalter*. Second half of the 10th century. Paint on vellum, sheet size 14 x 10 1/2" (35.6 x 26 cm). Bibliothèque Nationale, Paris

About a third of the Old Testament was written in poetry, and among its most famous poems are those in the Book of Psalms. According to ancient tradition, the author of the Psalms was Israel's King David, who, as a young shepherd and musician, saved the people by killing the Philistine giant Goliath. In Christian times, the Psalms were copied into a book called a psalter, used for private reading and meditation. *Psalm* and *psalter* come from a word referring to the sound or action of playing a stringed instrument called the psaltery.

sixth-century ivory panel (see fig. 7-33). The image exists on a lofty plane where light and color supplant form, and material substance becomes pure spirit.

MANUSCRIPTS

Several luxuriously illustrated manuscripts have survived from the second Byzantine golden age. As was true of the artists who decorated church interiors, the illustrators of these manuscripts combined intense religious expression, aristocratic elegance, and a heightened appreciation of rich decorative forms. The *Paris Psalter* from the second half of the tenth century is one example (fig. 7-50). Like the earlier *Rabbula Gospels* (see figs. 7-36, 7-37), the psalter (a version of the Psalms) includes scenes set off in frames on pages without text. Fourteen full-page paintings illustrate the *Paris Psalter*, the first of which depicts David, traditionally the author

7-51. **Page with *Joshua Leading the Israelites*,** from the *Joshua Roll*, made in Constantinople. c. 950. Vellum scroll with brown ink and colored washes, height 12½" (32.4 cm). Biblioteca Apostolica Vaticana, Rome

of the Old Testament's Book of Psalms. The illuminators turned to earlier classical illustrations as source material. The idealized, massive, three-dimensional figures reside in a receding space with lush foliage and a meandering stream that seem directly transported from ancient Rome. The architecture of the city and the ribbon-tied memorial column also derive from conventions in Greek and Roman funerary art, and in the ancient manner, the illustrator has personified abstract ideas and landscape features. Melody, a female figure, leans casually on David's shoulder, while another woman, perhaps the wood nymph Echo, peeks out from behind the column. The reclining youth in the lower foreground is a personification of Mount Bethlehem, as we learn from his inscription. The image of the dog watching over the sheep and goats while his master strums the harp suggests the classical subject of Orpheus charming wild animals with music. The subtle modeling of forms, the integration of the figures into a three-dimensional space, and the use of **atmospheric perspective** all enhance the classical flavor of the painting.

The *Joshua Roll* (fig. 7-51), a tenth-century manuscript in scroll form, reflects an approach different from that of the *Paris Psalter*, though both are believed to have been created in a Constantinople *scriptorium*. The illustrators worked on plain vellum, using colored inks—black, brown, blue, and red with white and gold—to convey the exploits of Moses' successor, Joshua, the Old Testament hero of the Battle of Jericho (Joshua 6:1–20), who conquered the promised land and whom the Byzantines thought foreshadowed their victories against the Muslims. In the section shown here, the events described in the text are depicted in a continuous landscape that recedes from the large foreground figures to distant cities and landforms. Strategically placed labels within the pictures identify the figures. The main character, Joshua, is at the far right. Crowned with a halo, unhelmeted but wearing upper-body armor, he leads his soldiers toward the Jordan River. The scroll in its original form would have rolled out in a continuous narrative like an ancient Roman victory column.

LATE BYZANTINE ART

The third great age of Byzantine art began in 1261, after the Byzantines expelled the Christian Crusaders who had occupied the capital and the empire for nearly sixty years. Although the empire had been weakened and its realm decreased to small areas of the Balkans and Greece, its arts underwent a resurgence. The patronage of emperors, wealthy courtiers, and the Church stimulated renewed church building. In this new work, the physical requirements of the clergy and the liturgy took precedence over costly interior decorations. The buildings, nevertheless, often reflect excellent construction skills and elegant and refined design.

New ambulatory aisles, narthexes, and side chapels were added to many small, existing churches. Among these is the former Church of the Monastery of Christ in Chora, Constantinople, now the Kariye Camii Museum. The expansion of this church was one of several projects that Theodore Metochites, the administrator of the Imperial Treasury at Constantinople, sponsored between 1315 and 1321. A humanist, poet, and scientist, Metochites became a monk in this monastery sometime after 1330. To its church he added a two-story annex on the north side, two narthexes on the west side, and a funerary chapel on the south side. These structures contain the most impressive interior decorations remaining in Constantinople from the Late Byzantine period. The

7-52. Funerary chapel, Church of the Monastery of Christ in Chora (now Kariye Camii Museum), Istanbul, Turkey. c. 1315–21

funerary chapel is entirely painted (fig. 7-52) with themes appropriate to such a setting—for example, the Last Judgment, painted on the vault of the nave, and the Anastasis, Christ's descent into limbo to rescue Adam, Eve, and other virtuous people from Satan, depicted in the half dome of the apse. Large figures of the church fathers (a group of especially revered early Christian writers of the history and teachings of the Church), saints, and martyrs line the walls below. Sarcophagi, surmounted by portraits of the deceased, once stood in side niches. *Trompe l'oeil* ("fool the eye") painting simulates marble paneling in the **dado**.

The *Anastasis* fills the funerary chapel's apse vault (fig. 7-53). Christ appears as a savior in white, moving with such force that even his star-studded mandorla has been set awry. He has trampled down the doors of hell; tied Satan into a helpless bundle; and shattered locks, chains, and bolts, which lie scattered over the ground. He drags the elderly Adam and Eve from their open sarcophagi with such force that their bodies seem airborne. Behind him are Old Testament prophets and kings, as well as his cousin John the Baptist.

Architecture of the Late Byzantine style flourished in the fifteenth and sixteenth centuries outside the borders of the empire in regions that had adopted Eastern Orthodox Christianity. After Constantinople's fall to the Ottoman Turks in 1453, leadership of the Orthodox Church shifted to Russia. Russian rulers declared Moscow to be the third Rome and themselves the heirs of Caesar (czars). Russian preference for complexity and verticality combined with Byzantine architecture in a spectacular style epitomized by the Cathedral of Saint Basil the Blessed in Moscow (fig. 7-54). The first Russian czar, Ivan IV, known as the Terrible (1530–84), commissioned the church, and the architects Barma and Postnik designed and built it between 1555 and 1561. Instead of a central dome, the architects employed a typical Russian form called a **shater** (a steeply pitched, tentlike roof form, designed to keep dangerously large accumulations of snow from forming). It is surrounded by eight chapels, each with its own dome seeming to grow budlike from the slender stalk of a very tall drum. The multiplications of shapes and sizes and the layering of the surfaces with geometric relief elements all distract visitors from the underlying plan—a nine-bay, cross-in-square, or quincunx, design surrounded by four more chapels, all on a podium approached by a covered stair (see "Multiple-Dome Church Plans," page 324). This spectacular church shows the evolution of Byzantine architecture into a distinct style that later typified Eastern Orthodox churches in Russia and elsewhere, including the United States.

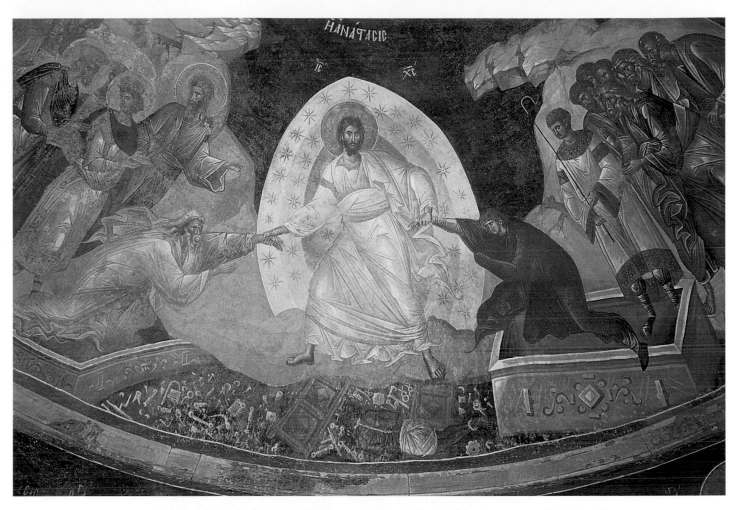

7-53. *Anastasis*, painting in the apse of the funerary chapel, Church of the Monastery of Christ in Chora

7-54. Barma and Postnik. Cathedral of Saint Basil the Blessed, Moscow
1555–61

Like most mid-sixteenth-century Russian churches, the entire exterior of Saint Basil's was originally painted white, and the domes were gilded. The bright colors we see today were added by later generations. The name of the church also changed over time. It was originally dedicated to the Intercession of the Virgin Mary, a reflection of the veneration of Mary in the Eastern Church.

7-55. Andrey Rublyov. *The Old Testament Trinity (Three Angels Visiting Abraham)*, icon. c. 1410–20. Tempera on panel, 55½ x 44½" (141 x 113 cm). Tretyakov Gallery, Moscow

Representing the dogma of the Trinity—one God in three beings—was a great challenge to artists. One solution was to depict God as three identical individuals. Rublyov used that convention to illustrate the Old Testament story of the Hebrew patriarch Abraham and his wife, Sarah, who entertained three strangers who were divine beings.

The practice of venerating icons continued in the Late Byzantine period. A remarkable icon from this time is *The Old Testament Trinity (Three Angels Visiting Abraham)*, a large panel created between 1410 and 1420 by the famed artist-monk Andrey Rublyov (fig. 7-55). It was commissioned in honor of the abbot Sergius of the Trinity-Sergius Monastery, near Moscow. This icon clearly illustrates how Late Byzantine artists relied on mathematical conventions to create ideal figures, as did the ancient Greeks, thus giving their work remarkable consistency. Unlike the Greeks, who based their formulas on close observation of nature, Byzantine artists invented an ideal geometry and depicted human forms and features according to it. Here, as is often the case, the circle forms the underlying geometric figure, emphasized by the form of the haloed heads. Despite the for-

mulaic, somewhat uniform approach, talented artists like Rublyov managed to create a personal expressive style. He relied on typical conventions—simple contours, elongation of the body, and a focus on a limited number of figures—to capture the sense of the spiritual in his work, yet distinguished his art by imbuing it with a sweet, poetic ambience. In this artist's hands, the Byzantine style took on new life. The Byzantine tradition would carry on in the art of the Eastern Orthodox Church and continues to this day in Russian icon painting. But in Constantinople, the three golden ages of Byzantine art—and the empire itself—came to a decisive end in 1453. When the forces of the Ottoman sultan Muhammad II overran the capital, the Eastern Empire became part of the Islamic world, with its own very rich aesthetic heritage.

PARALLELS

PERIOD	EARLY CHRISTIAN, JEWISH, BYZANTINE ART	ART IN OTHER CULTURES
EARLY JEWISH PERIOD	7-2. *Menorahs and Ark* (3rd cent.)	6-31. **Colosseum** (72–80), Italy
		3-45. **Mummy of boy** (c. 100–120), Egypt
		13-3. **Nok head** (500 BCE–200 CE), Nigeria
	7-5. **Dura-Europos synagogue** (244–45)	
	7-6. *Finding of the Baby Moses* (second half 3rd cent.)	
EARLY CHRISTIAN C. 100– 6TH CENTURY	7-1. **Leonis** *cubiculum* (late 4th cent.)	6-27. **Basilica Ulpia** (113), Italy
	7-3. *Good Shepherd* (4th cent.)	6-58. *Unswept Floor* (2nd cent.), Italy
		9-13. *Standing Buddha* (c. 2nd–3rd cent.), India
IMPERIAL CHRISTIAN 313–476	7-9. **Old Saint Peter's** (c. 320–27)	6-84. *Priestess* diptych (c. 390–401), Italy
		9-17. *Ajanta murals* (c. 475), India
		12-6. **Temple of the Feathered Serpent** (after 350), Mexico
	7-13. **Santa Costanza** (c. 338–50)	
	7-21. *Sarcophacus of Junius Bassus* (c. 359)	
	7-20. *Resurrection and Angel with Two Marys at the Tomb* (c. 400)	
	7-10. **Santa Sabina** (422–32)	
	7-17. **Mausoleum of Galla Placidia** (c. 425–26)	
	7-12. *Parting of Lot and Abraham* (432–40)	
EARLY BYZANTINE 5TH CENTURY–726	7-33. *Archangel Michael* (early 6th cent.)	11-4. *Haniwa* (6th cent.), Japan
	7-35. *Book of Genesis* (early 6th cent.)	8-2. **Dome of the Rock** (c. 687–91), Jerusalem
	7-26. **San Vitale** (526–47)	
	7-22. **Hagia Sophia** (532–37)	
	7-31. **Church of Sant'Apollinare** (dedicated 549)	
	7-25. *Transfiguration*, St. Catherine (c. 548–65)	
	7-36. *Rabbula Gospels* (586)	
	7-38. *Virgin and Child with Saints and Angels* (later 6th cent.)	
MIDDLE BYZANTINE 843–1204	7-49. *Archangel Michael* (late 10th/early 11th cent.)	14-17. *Utrecht Psalter* (c. 825–50), Netherlands
	7-51. *Joshua Roll* (c. 950)	11-1. **Byodo-in** (c. 1053), Japan
	7-50. *Paris Psalter* (mid-10th cent.)	12-13. *Chacmool* (9th–13th cent.), Mexico
	7-43. **Hosios Loukas** (early 11th cent.)	15-33. **Speyer Cathedral** (c. 1030–early 1100s), Germany
	7-40. **Santa Sophia** (c. 1017–37)	
	7-48. *Harbaville Triptych* (mid-11th cent.)	15-40. **Pisa Cathedral** (begun 1063), Italy
	7-39. **Cathedral of Saint Mark** (begun 1063)	15-32. *Bayeux Tapestry* (c. 1066–77), France
	7-44. *Christ Pantokrator* (c. 1080–1100)	9-28. *Shiva Nataraja* (12th cent.), India
		16-6. **Chartres Cathedral** (c. 1134–1220), France
		16-22. **Notre Dame, Paris** (begun 1163), France
		12-23. *Anasazi seed jar* (c. 1150), North America
	7-45. *Crucifixion* (late 11th cent.)	
	7-42. *Virgin of Vladimir* (12th cent.)	
	7-46. **Palatine Chapel** (mid-12th cent.)	
LATE BYZANTINE 1261–16TH CENTURY	7-52. **Church, Christ in Chora** (c. 1315–21)	13-4. **Ife head** (c. 1200–1300), Nigeria
	7-55. *The Old Testament Trinity (Three Angels Visiting Abraham)* (c. 1410–20)	13-10. **Great Friday Mosque** (13th cent.), Mali
		16-69. Giotto. *Virgin and Child* (1310), Italy

8-1. Page from Koran (*surah* 47:36) in kufic script, from Syria.
9th century. Ink, pigments, and gold on vellum, 9³/₈ x 13¹/₈"
(23.8 x 33.3 cm). The Metropolitan Museum of Art, New York
Rogers Fund, 1937 (37.99.2)

8
Islamic Art

During the holy month of Ramadan in 610 CE, a merchant named al-Amin ("the Trusted One") sought solitude in a cave on Mount Hira, a few miles north of Mecca, in Arabia. On that night, "The Night of Power and Excellence," the angel Gabriel is believed to have appeared to him and commanded him to recite revelations from God. In that moment, the merchant al-Amin became the Messenger of God, Muhammad. The revelations dictated by Gabriel at Mecca were the foundation of the religion called Islam ("submission to God's will"), whose adherents are referred to as Muslims ("those who have submitted to God"). Today, nearly a billion Muslims turn five times a day toward Mecca to pray.

The Word of God revealed to Muhammad was recorded in the book known as the Koran ("Recitation"). To transcribe these revelations, scribes adopted Arabic script wherever Islam spread, and the very act of transcribing the Koran became sacred. To accomplish this holy task, which is summarized in the ancient Arabic expression "Purity of writing is purity of the soul," scribes developed **calligraphy**, the art of writing, to an extraordinary degree (fig. 8-1). A prohibition against depicting representational images in religious art, as well as the naturally decorative nature of Arabic script, led to the use of calligraphic decoration on religious architecture, carpets, ceramics, and handwritten documents. Perhaps the foremost characteristic of Islamic religious art, wherever it is found in the world and among every race, is the presence of beautiful writing, used for reading, for prayer, and for decoration.

▲ c. 633–61 EARLY CALIPHS ▲ c. 750–1258 ABBASID DYNASTY ▲ c. 11th–14th CENTURY SELJUK OF RUM DYNASTY

▲ c. 661–750 UMAYYAD DYNASTY ▲ c. 909–1171 FATIMID DYNASTY

▲ c. 756–1031 SPANISH UMAYYAD DYNASTY ▲ c. 1037–1194 SELJUK DYNASTY

TIMELINE 8-1. The Islamic World. After the early Caliphs, rapid geographical expansion and internal rivalries led to the formation of powerful independent dynasties, some of which lasted for centuries.

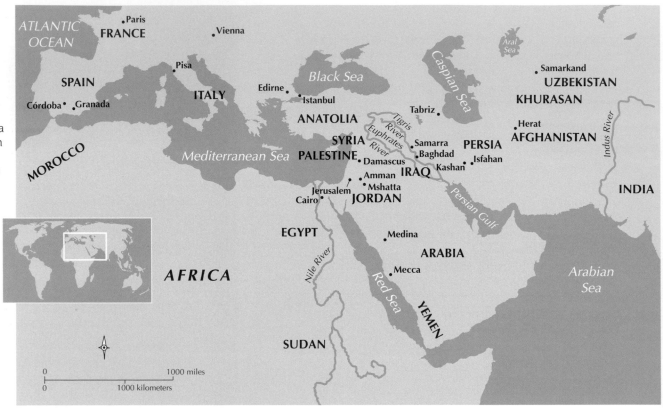

MAP 8-1.

The Islamic World. Within 200 years of its founding in 610 CE, the Islamic world expanded from Mecca to India in the east, to Spain in the northwest, and to Africa in the south.

ISLAM AND EARLY ISLAMIC SOCIETY

Islam spread rapidly after its founding, encompassing much of North Africa, the Middle East, and Southeast Asia. The art of this vast region draws its distinctive character both from Islam itself and from the diverse cultural traditions of the world's Muslims. Because Islam discouraged the use of figurative images, particularly in religious contexts—unlike Christian art—Islamic artists developed a rich vocabulary of **aniconic**, or nonfigural, ornament that is a hallmark of Islamic work. This vocabulary includes complex geometric patterns and the scrolling vines known outside the Islamic world as **arabesques**. Figural representation, to the extent it was permitted (which varied from time to time and place to place), first developed most prominently in regions with strong pre-Islamic figural traditions, such as those that had been under the control of the Roman and Byzantine empires. Stylized forms for representing animals and plants developed in the regions that had been under the control of the Sassanian dynasty of Persia (modern Iran), the heirs of the artistic traditions of the ancient Near East, who ruled from 226 to 641. Because the Arabian birthplace of Islam

had little art, these Persian and Roman-Byzantine influences shaped Islamic art in its formative centuries.

Much of Islamic art can be seen as an interplay between pure abstraction and organic form. For Muslims, abstraction helps free the mind from the contemplation of material form, opening it to the enormity of the divine presence. Islamic artists excelled in surface decoration, using repeated and expanding patterns to suggest timelessness and infinite extension. Shimmering surfaces created by dense, highly controlled patterning are characteristic of much later Islamic art, including architecture, carpet making, calligraphy, and book illustration.

Muslims date the beginning of their history to the flight of the Prophet Muhammad from Mecca to Medina—an exodus called in Arabic the *hijra*—in 622 (see "The Life of the Prophet Muhammad," pages 346–7). Over the next decade Muhammad succeeded in uniting the warring clans of Arabia under the banner of Islam. Following the Prophet's death in 632, four of his closest associates assumed the title of "caliph" ("successor"): Abu Bakr (ruled 633–34), Umar (ruled 634–44), Uthman (ruled 644–56), and finally Ali (ruled 656–61). According to tradition, during the time of Uthman, the Koran assumed its final form.

The accession of Ali provoked a power struggle that led to his assassination—and resulted in enduring divisions within Islam. Followers of Ali, known as Shiites, regard him as the Prophet's rightful successor and the first three caliphs as illegitimate. Sunni Muslims, in contrast, recognize all of the first four caliphs as "rightly guided." Ali was succeeded by his rival Muawiya (ruled 661–80), a close relative of Uthman and the founder of the Umayyad dynasty (661–750).

Beginning in the seventh century, Islam expanded dramatically. In just two decades, seemingly unstoppable Muslim armies conquered the Sassanian Persian Empire, Egypt, and the Byzantine provinces of Syria and Palestine. By the early eighth century, under the Umayyads, they had reached India, conquered all of North Africa and Spain, and penetrated France to within 100 miles of Paris before being turned back (Map 8-1). In Muslim-conquered lands, the circumstances of Christians and Jews who did not convert to Islam was neither uniform nor consistent. In general, as "People of the Book"—followers of a monotheistic religion based on a revealed scripture—they enjoyed a protected status. However, they were also subject to a special tax and restrictions on dress and employment.

Islam has proven a remarkably adaptable faith. Part of that adaptability is due to its emphasis on the believer's direct, personal relationship with God through prayer, along with a corresponding lack of ceremonial paraphernalia. Every Muslim must observe the Five Pillars, or duties, of faith. The most important of these is the statement of faith: "There is no god but God and Muhammad is his messenger." Next come ritual prayer five times a day, charity to the poor, fasting during the month of Ramadan, and a pilgrimage to Mecca—Muhammad's birthplace and the site of the Kaaba, Islam's holiest structure—once in a lifetime for those able to undertake it.

Muslims are expected to participate in congregational worship at a **mosque** (*masjid* in Arabic) on Fridays. When not at a mosque, the faithful simply kneel wherever they are to pray, facing the Kaaba in Mecca. The Prophet Muhammad himself lived simply and advised his companions not to waste their resources on elaborate architecture. Instead, he instructed and led them in prayer in a mud-brick structure, now known as the Mosque of the Prophet, adjacent to his home in Medina. This was a square enclosure with verandas supported by palm-tree trunks that framed a large courtyard. Muhammad spoke from a low platform on the south veranda. This simple arrangement—a walled courtyard with a separate space on one side housing a ***minbar*** (pulpit) for the *imam* (prayer leader)—became the model for the design of later mosques.

ART DURING THE EARLY CALIPHATES

The caliphs of the aggressively expansionist Umayyad dynasty ruled from their capital at Damascus (in modern Syria). They were essentially desert chieftains who had scant interest in fostering the arts except for architecture and poetry, which had been held in high esteem among Arabs since pre-Islamic times. The building of shrines and mosques throughout the empire in this period represented both the authority of the new rulers and the growing acceptance of Islam. The caliphs of the Abbasid dynasty, who replaced the Umayyads in 750 and ruled until 1258 (Timeline 8-1), governed in the grand manner of ancient Persian emperors from their capitals at Baghdad and Samarra (in modern Iraq). Their long and cosmopolitan reign saw achievements in medicine, mathematics, the natural sciences, philosophy, literature, music, and art. They were generally tolerant of the ethnically diverse populations in the territories they subjugated and admired the cultural traditions of Byzantium, Persia, India, and China. (The early art of India is discussed in Chapter 9 and that of China in Chapter 10.)

ARCHITECTURE

As Islam spread, architects adapted freely from Roman, Christian, and Persian models, which include the basilica, the *martyrium*, the peristyle house, and the palace audience hall. The Dome of the Rock in Jerusalem (figs. 8-2, 8-3, page 346), built about 687–91, is the oldest surviving Islamic sanctuary and is today the holiest site in Islam after Mecca and Medina. The building stands on the platform of the Temple Mount (Mount Moriah) and encloses a rock outcropping that has also long been sacred to the Jews, who identify it as the site on which Abraham prepared to sacrifice his son Isaac. Jews, Christians, and Muslims associate the site with the creation of Adam and the Temple built by Solomon. Muslims also identify it as the site from which Muhammad, led by the angel Gabriel, ascended to heaven in the Night Journey, passing through the spheres of heaven to the presence of God.

The Dome of the Rock was built by Syrian artisans trained in the Byzantine tradition, and its centralized plan—an octagon within an octagon—derived from both Early Christian and Byzantine architecture. Unlike its Byzantine models, however, with their plain exteriors, the Dome of the Rock, crowned with a golden dome that dominates the Jerusalem skyline, is opulently decorated with tiles outside and marble veneer and mosaics inside. A dome on a tall **drum** pierced with windows and supported by an **arcade** composed of alternating **piers** and **columns**—two columns to one pier in the outer ring, three to one in the inner—covers the central space

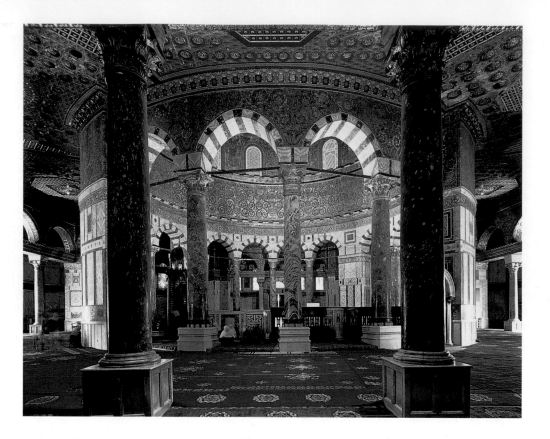

8-2. Dome of the Rock, Jerusalem, Israel. Interior. c. 687–91

The gilt wooden beams in the outer ambulatory are not visible. The carpets and ceiling are modern but probably reflect the original patrons' intention.

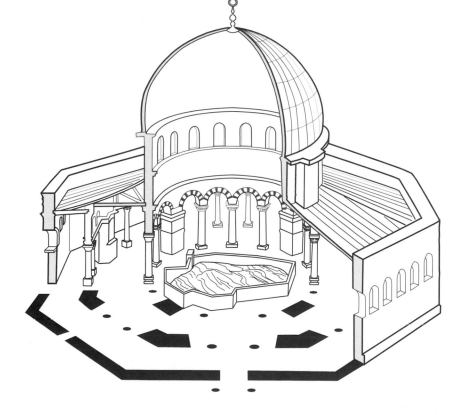

8-3. Cutaway drawing of the Dome of the Rock

containing the rock. Concentric **aisles (ambulatories)** permit the devout visitor to circumambulate the rock. Inscriptions from the Koran interspersed with passages from other texts and commentary, including information about the building, form a **frieze** around the inner wall. The pilgrim must walk around the central space first clockwise and then counterclockwise to read the inscriptions in gold mosaic on turquoise green ground. These texts are the first use of monumental Koranic inscriptions in architectural decoration. Below the frieze, the

walls are covered with pale marble, whose veining creates abstract symmetrical patterns, and columns with shafts of gray patterned marble and gilded capitals. Above the calligraphic frieze is another mosaic frieze depicting thick, symmetrical vine scrolls and trees in turquoise, blue, and green, embellished with imitation jewels, over a gold ground. The mosaics are thought to represent both the gardens of Paradise and trophies of Muslim victories offered to God. The focal point of the building, remarkably enough, is not the decorative program—or

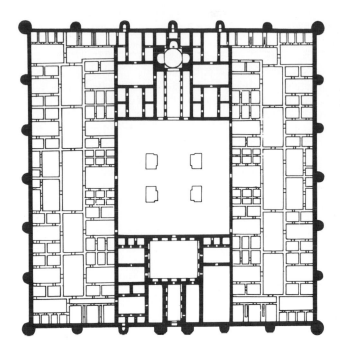

8-4. Plan of the palace, Mshatta, Jordan. Begun 740s

8-5. Frieze, detail of facade, palace, Mshatta. Stone. Staatliche Museen zu Berlin, Preussischer Kulturbesitz, Museum für Islamische Kunst

even something that can be seen. From the entrance one sees only pure light streaming down to the unseen rock, surrounded by color and pattern. After penetrating the space, the viewer/worshiper realizes that the light falls on the precious rock, and in a sense re-creates the passage of Muhammad to the heavens.

The Umayyad caliphs, disregarding the Prophet's advice about architectural austerity, built for themselves palatial hunting retreats on the edge of the desert. With profuse interior decoration depicting exotic human and animal subjects in stucco, mosaic, and paint, some had swimming pools, baths, and domed, private rooms. One of the later desert palaces was begun in the 740s at Mshatta (near present-day Amman, Jordan). Although never completed, this square, stone-walled complex is nevertheless impressively monumental (fig. 8-4). It measured about 470 feet on each side, and its outer walls and gates were guarded by towers and bastions reminiscent of a Roman fort. The space was divided roughly into thirds, with the center section containing a huge courtyard. The main spaces were a mosque and a domed, **basilica-plan** audience hall that was flanked by four private apartments, or *bayts*. *Bayts* grouped around small courtyards, for the use of the caliph's relatives and guests, occupied the remainder of the building.

Unique among surviving palaces, Mshatta was decorated with a frieze that extended in a band about 16 feet high across the base of its facade. This frieze was divided by a zigzag molding into triangular compartments, each punctuated by a large **rosette** carved in high relief (fig. 8-5). The compartments were filled with intricate carvings in low relief that included interlacing scrolls inhabited by birds and other animals (there were no animals on the mosque side of the building), urns, and candlesticks. Beneath one of the rosettes, two facing lions drink from an urn from which grows the Tree of Life, an ancient Persian motif.

The mosque was and is the Muslim place for communal worship, and its characteristic elements developed during the Umayyad period (see "Mosque Plans," page 351). The earliest mosques were very simple, modeled on Muhammad's house. The mosque's large rectangular enclosure is divided between a courtyard and a simple columnar hall (the prayer hall), laid out so that worshipers face Mecca when they pray. Designating the direction of Mecca are the **qibla** wall and its **mihrab** (a niche); the plan of identical repeated bays and aisles can easily be extended as congregations grow.

The origin and significance of the *mihrab* are debated, but the *mihrab* is within the tradition of niches that signifies a holy place—the shrine for the Torah scrolls in a synagogue, the frame for the sculpture of gods or ancestors in Roman architecture, the apse in a church. The **maqsura**, an enclosure in front of the *mihrab* for the ruler and other dignitaries, became a feature of the principal congregational mosque after an assassination attempt on the ruler. The **minbar**, or pulpit/throne, stands by the *mihrab* as the place for the prayer leader and a symbol of authority (for a fourteenth-century example, see fig. 8-14). **Minarets**, towers from which the *muezzins*, or criers, call the faithful to prayer, rise outside the mosque as a symbol of Islam's presence in a city.

When the Abbasids overthrew the Umayyads in 750, a survivor of the Umayyad dynasty, Abd ar-Rahman I

THE LIFE OF THE PROPHET MUHAMMAD

Muhammad, the prophet of Islam, was born about 570 in Mecca, a major pilgrimage center in west-central Arabia, to a prominent family that traced its ancestry to Ishmael, son of the biblical patriarch Abraham. Orphaned as a small child, Muhammad spent his early years among the Beduin, desert nomads. When he returned to Mecca, he became a trader's agent, accompanying caravans across the desert. At the age of twenty-five he married his employer, Khadija, a well-to-do, forty-year-old widow, and they had six children.

After Muhammad received revelations from God in 610, the first to accept him as Prophet was his wife. Other early converts included members of his clan and a few friends, among them the first four successors, or caliphs, who led the faithful after Muhammad's death. As the number of converts grew, Muhammad encountered increasing opposition from Mecca's ruling clans, including some leaders of his own clan. They objected to both his religious teachings and the threat his teachings posed to the trade that accompanied Mecca's status as a pilgrimage site. In 622 Muhammad and his companions fled Mecca and settled in the oasis town of Yathrib, which the Muslims renamed Medina, the Prophet's City. It is to this event, called the *hijra* ("emigration"), that Muslims date the beginning of their history. After years of fighting, Muhammad and his fol-lowers won control of Mecca in 630 with an army of 10,000, and its inhabitants converted to Islam. The Kaaba, a shrine in the courtyard of Mecca's Great Mosque, became the sacred center of Islam; it is toward this one-room, cube-shaped stone structure, traditionally thought to have been built as a sanctuary by Abraham and Ishmael on a foundation laid by Adam, that Muslims around the globe still turn to pray. Shortly after the conquest of Mecca, Islam spread throughout Arabia.

Muhammad married eleven times. (Muslim law allows men four coequal wives at once, although the Prophet was permitted more.) Some of these marriages were political and others were to provide for women in need—a social duty in a society in which clan feuds killed many men. Within the framework of Islam, women gained rights where they had had none before. Their degree of freedom depended greatly on the time and the place, and many were significant sponsors of architecture programs.

Muhammad is reputed to have been a vigorous, good-looking man for whom the world was a fragrant paradise. One of his wives, Aisha, provided much of the information available about his personal life. "People used to ask [Aisha] how the Prophet lived at home. Like an ordinary man, she answered. He would sweep the house, stitch his own clothes, mend his own sandals, water the camels, milk the goats, help the servants at their work, and eat his meals with them; and he would go fetch a thing we needed from the market" (cited in Glassé, page 281).

After making a farewell pilgrimage to Mecca, Muhammad died in Medina in 632. According to his wishes, he was buried in his house, in Aisha's room, where he breathed his last. His tomb is a major pilgrimage site. A generation after his death his revelations, which he continued to receive throughout his life, were assembled in 114 chapters, called *surahs*, organized from longest to shortest, each *surah* divided into verses. This is the sacred scripture of Islam, called the Koran ("Recitation"), which is the core of the faith. Another body of work, the Hadith ("Account"), compiled over the centuries, contains sayings of the Prophet, anecdotes about him, and additional revelations. The Koran and the Hadith are the foundation of Islamic law, guiding the lives of nearly a billion Muslims around the world today.

Muslims consider Muhammad to be the last in a succession of prophets, or messengers of God, that includes Adam, Abraham, Ishmael, Moses, and Jesus. Like Judaism and Christianity but unlike other religions prevalent in Arabia at the time, Islam is monotheistic, recognizing only a single, all-powerful deity. Muhammad's teaching emphasized the all-pervading immateriality of God and banned idol worship.

This painting shows Muhammad traveling by camel to a desert market fair to seek the support of a powerful

(ruled 756–88), fled across North Africa into southern Spain (known as al-Andalus in Arabic), where, with the support of Syrian Muslim settlers, he established himself as the provincial ruler, or *emir*. While the caliphs of the Abbasid dynasty ruled the eastern Islamic world from Baghdad for five centuries, the Umayyads continued their dynasty in Spain from their capital in Córdoba for the next three centuries (756–1031). The Umayyads were noted patrons of the arts, and one of the finest surviving examples of Umayyad architecture, the Great Mosque of Córdoba, thus is in Spain. (see figs. 8-6, 8-7)

In 785, the Umayyad conquerors began building the Córdoba mosque on the site of a Christian church. Later rulers expanded the building three times, and today the walls enclose an area about 620 by 460 feet, about a third of which is the courtyard, the Patio of the Orange Trees. Inside, the proliferation of pattern in the repeated columns and arches and the double flying arches is almost disorienting. The marble columns and capitals in the **hypostyle** prayer hall were recycled from the ruins of classical buildings in the region, which had been a wealthy Roman province (fig. 8-6, page 350). Two tiers of arches, one over the other, surmount these columns; the upper tier springs from rectangular posts that rise from the columns. This double-tiered design, which was widely imitated, effectively increases the height of the interior space and provides excellent air circulation. The distinctively shaped **horseshoe arches**—a form known from Roman times and favored by the Visigoths, Spain's pre-Islamic rulers—came to be closely associated with Islamic architecture in the West (see "Arches and *Muqarnas*," page 352). Another distinctive feature of these arches, also adopted from Roman and Byzantine precedents, is the alternation of pale stone and red brick **voussoirs** forming the curved arch.

uncle for his religious movement as well as to make converts among the fairgoers. He is accompanied by two close associates, the merchant Abu Bakr and the young warrior Ali. Abu Bakr, the first caliph, was the father of Muhammad's wife Aisha. Ali, husband of Muhammad's daughter Fatima, was the fourth caliph. The power struggle that ended in his death led to the rise of the Shiite sect. Although the faces of Abu Bakr and Ali are shown, that of Muhammad, in keeping with the Islamic injunction against idolatry and the making of idols, is not. The degree of representation permitted in Islamic art varied from place to place and from period to period depending in part on the strictness with which the injunction against idol making was interpreted and the purpose a work of art was to serve. This example suggests what the Ottoman court at the end of the sixteenth century considered acceptable for an illustration of its type.

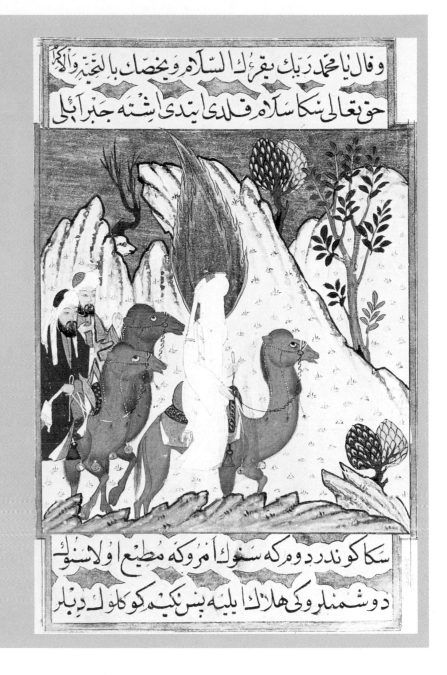

The Prophet Muhammad and His Companions Traveling to the Fair, from a copy of the 14th-century *Siyar-i Nabi* (*Life of the Prophet*) of al-Zarir, Istanbul, Turkey. 1594. Pigments and gold on paper, 10⅝ x 15" (27 x 38 cm). New York Public Library, New York Spencer Collection

In the final century of Umayyad rule, Córdoba emerged as a major commercial and intellectual hub and a flourishing center for the arts. It surpassed Christian European cities economically and in science, literature, and philosophy. Beginning with Abd ar-Rahman III (ruled 912–61), the Umayyads boldly claimed the title of "caliph." Al-Hakam II (ruled 961–76) made the Great Mosque a focus of his patronage, commissioning costly and luxurious renovations that disturbed many of his subjects. The caliph attempted to answer their objections to paying for such ostentation with an inscription giving thanks to God, who "helped him in the building of this eternal place, with the goal of making this mosque more spacious for his subjects, something which both he and they greatly wanted" (cited in Dodds, page 23). Among al-Hakam's renovations was a new *mihrab* with three bays in front of it. The melon-shaped, ribbed dome over one bay seems to float over a web of intersecting arches

that rise from polylobed, intersecting arches rather than supporting piers (fig. 8-7, page 350). Lushly patterned mosaics with inscriptions, geometric motifs, and stylized vegetation clothe the domes in brilliant color and gold.

CALLIGRAPHY

The Arabic language and script have held a unique position in Islamic society and art from the beginning. As the language of the Koran and Muslim liturgy, Arabic has been a powerful unifying force within Islam. Because reverence for the Koran as the Word of God extended also to the act of writing it, generations of extraordinary scribes made Arabic calligraphy one of the glories of Islam. Arabic script is written from right to left, and each of its letters takes one of three forms depending on its position in a word. With its rhythmic interplay between verticals and horizontals, the system lends itself to many variations.

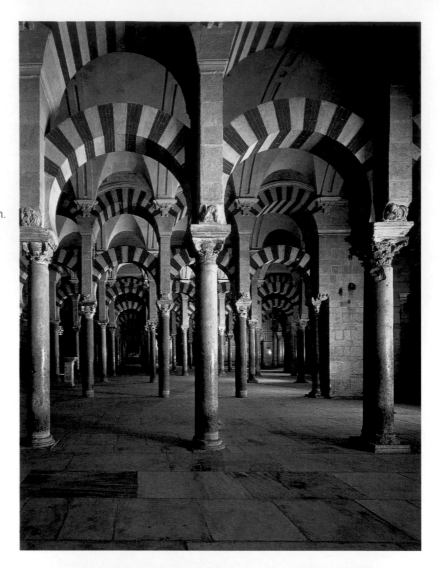

8-6. Prayer hall, Great Mosque, Córdoba, Spain. Begun 785–86, extension of 987

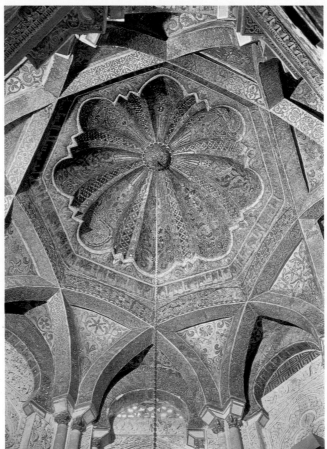

8-7. Dome in front of the *mihrab*, Great Mosque. 965

ELEMENTS OF ARCHITECTURE
Mosque Plans

The earliest mosques were pillared **hypostyle halls** such as the Great Mosque at Córdoba (see fig. 8-6). Approached through an open courtyard, the *sahn*, their interiors are divided by rows of columns leading, at the far end, to the **mihrab** niche of a **qibla** wall, which is oriented toward Mecca.

A second type, the **four-*iwan* mosque**, was originally associated with **madrasas** (schools for advanced study). The *iwans*—monumental barrel-vaulted halls with wide-open, arched entrances—faced each other across a central *sahn*; related structures spread out behind and around the *iwans*. Four-*iwan* mosques were most developed in Persia, in buildings like Isfahan's Masjid-i Jami (see fig. 8-12).

Central-plan mosques, such as the Selimiye Cami at Edirne (see fig. 8-15), were derived from Istanbul's Hagia Sophia (see fig. 7-22) and are typical of Ottoman Turkish architecture. Central-plan interiors are dominated by a large domed space uninterrupted by structural supports. Worship is directed, as in other mosques, toward a *qibla* wall and its *mihrab* opposite the entrance.

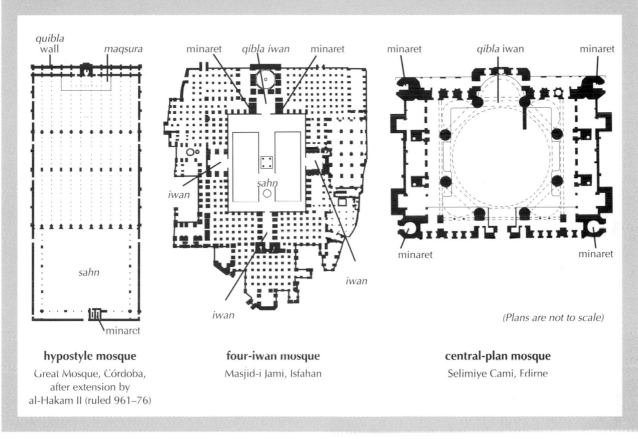

(Plans are not to scale)

hypostyle mosque
Great Mosque, Córdoba, after extension by al-Hakam II (ruled 961–76)

four-iwan mosque
Masjid-i Jami, Isfahan

central-plan mosque
Selimiye Cami, Edirne

Writing pervades Islamic art. In addition to manuscripts, decorative writing is prominent in architecture and on smaller-scale objects made of metal, glass, cloth, ceramic, and wood. The earliest scripts, called kufic (from the city of Kufa in modern Iraq), were angular and evolved from inscriptions on stone monuments. Kufic scripts were especially suitable for carved or woven inscriptions, as well as those on coins and other metalware; they are still used for Koran chapter headings. Most early Korans had only three to five lines per page and customarily had large letters because two readers shared one book (although they would have known the text by heart). A page from a ninth-century Syrian Koran exemplifies a style common from the eighth to the tenth century (see fig. 8-1). Red diacritical marks (pronunciation guides) accent the dark brown ink. Horizontals are elongated, and fat-bodied letters are also emphasized. The chapter heading is set against an ornate gold band that contrasts with the simplicity of the letters.

Because calligraphy was an honored occupation, calligraphers enjoyed the highest status of all artists in Islamic society. Included in their numbers were a few princes and women. Their training was long and arduous, and their work usually anonymous. Not until the later Islamic centuries did it become common for calligraphers to sign their work, and even then only the most accomplished were allowed this privilege. Apprentice scribes had to learn secret formulas for inks and paints, become skilled in the proper ways to sit, breathe, and manipulate their tools, and develop their individual specialties. They also had to absorb the complex literary traditions and number symbolism that had developed.

The Koran was usually written on **vellum**, very fine calfskin. Paper, a Chinese invention, was first imported into the Islamic realm in the mid-eighth century. Muslims subsequently learned how to make high-quality, rag-based paper and established their own paper mills. Among the most influential calligraphers in this process was a woman named Shuhda. By the tenth century, more than twenty cursive scripts had come into use. They were standardized by Ibn Muqla (d. 940), an Abbasid minister, who fixed the proportions of the letters in each and devised a method for teaching calligraphy that is still in use. By about 1000, paper had largely replaced vellum and parchment, encouraging

Islamic builders used a number of innovative structural devices. Among these were two arch forms, the horseshoe arch (see fig. 8-6) and the pointed arch (see fig. 8-13). There are many variations of each, some of which disguise their structural function beneath complex decoration.

Structurally, a **muqarna** is simply a **squinch** (see "Pendentives and Squinches," page 311). *Muqarnas* are used in multiples (see fig. 8-11) as interlocking, load-bearing, niche-shaped vaulting units. Over time they became increasingly ornamental and appear as intricately faceted surfaces. They are frequently used to vault *mihrabs* and, on a larger scale, to support and to form domes.

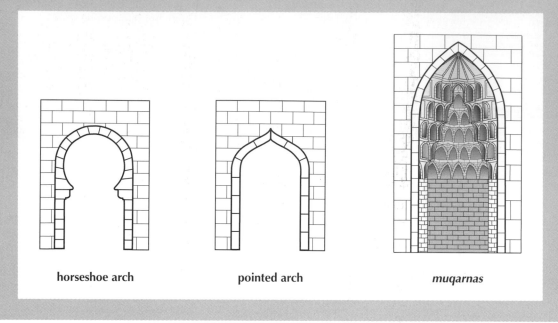

horseshoe arch pointed arch *muqarnas*

8-8. Bowl with kufic border, from Samarkand, Uzbekistan. 9th–10th century. Earthenware with slip, pigment, and lead glaze, diameter 14½" (37 cm). Musée du Louvre, Paris

The white ground of this piece imitated prized Chinese porcelains made of fine white kaolin clay. Both Samarkand and Khurasan were connected to the Silk Road (Chapter 10), the great caravan route to China, and were influenced by Chinese culture.

the proliferation of increasingly elaborate and decorative cursive scripts, which generally superseded kufic by the thirteenth century. The great calligrapher Yaqut al-Mustasim (d. 1299), the Turkish secretary of the last Abbasid caliph, codified six basic calligraphic styles, including *thuluth* (see fig. 8-19), *naskhi* (see the illustration in "The Life of the Prophet Muhammad," pages 348–9), and *muhaqqaq* (see fig. 8-13, outer frame). Al-Mustasim reputedly made more than 1,000 copies of the Koran.

CERAMIC AND TEXTILE ARTS

Kufic-style letters were used effectively as the only decoration on a type of white pottery made in the ninth and tenth centuries in and around Khurasan (a region also known as Nishapur, in modern northeastern Iran) and Samarkand (in modern Uzbekistan in Central Asia). Now known as Samarkand ware, it was the ancestor of a ware produced until fairly recently by Central Asian peasants. In the example here, a bowl of medium quality, clear lead glaze was applied over a black inscription on a white slip-painted ground (fig. 8-8). The letters have been elongated to fill the bowl's rim, stressing their vertical elements. The inscription translates: "Knowledge, the beginning of it is bitter to taste, but the end is sweeter than honey," an apt choice for tableware. Inscriptions on Samarkand ware provide a storehouse of such popular sayings.

A kufic inscription also appears on a tenth-century piece of silk from Khurasan (fig. 8-9): "Glory and happiness

8-9. Textile with elephants and camels, from Khurasan, Persia (Iran). c. 960. Dyed silk, largest fragment 20½ x 37" (94 x 52 cm). Musée du Louvre, Paris

Silk textiles were both sought-after luxury items and a medium of economic exchange. Government-controlled factories, known as *tiraz*, produced cloth for the court as well as for official gifts and payments. A number of fine Islamic fabrics have been preserved in the treasuries of medieval European churches, where they were used for priests' ceremonial robes, altar cloths, and covers for Christian saints' relics.

to the Commander Abu Mansur Bukhtakin, may God prolong his prosperity." Such good wishes were common in Islamic art, appearing as generic blessings on ordinary goods sold in the marketplace or, as here, personalized for the patron. Texts can sometimes help determine where and when a work was made, but they can also be frustratingly uninformative when little is known about the patron. Stylistic comparisons—in this case with other textiles, with the way similar subjects appear in other mediums, and with other kufic inscriptions—reveal more than the inscription alone.

This fragment shows two elephants with rich ornamental coverings facing each other on a dark red ground, each with a mythical griffin between its feet. A caravan of two-humped, Bactrian camels linked with rope moves up the left side, part of the elaborately patterned borders. The inscription at the bottom is upside-down, suggesting that the missing portion of the textile was the mirror image of the surviving fragment, with another pair of elephants joined back-to-back to this pair. The weavers used a complicated loom to produce repeated patterns. The technique and design derive from the sumptuous pattern-woven silks of Sassanian Persia. The Persian weavers had, in turn, adapted Chinese silk technology to the Sassanian taste for paired heraldic beasts and other Near Eastern imagery. This tradition, with modifications—the depiction of animals, for example, became less naturalistic—continued after the Islamic conquest of Persia.

LATER ISLAMIC SOCIETY AND ART

The Abbasid caliphate began its slow disintegration in the ninth century, and thereafter power in the Islamic world became fragmented among more or less independent regional rulers. During the eleventh century, the Seljuks, a Turkic people who had served as soldiers for the Abbasid caliphs and converted to Islam in the tenth century, became the virtual rulers of the Abbasid empire. The Seljuks united Persia and most of Mesopotamia, establishing a dynasty that endured from 1037/38 to 1194. A branch of the dynasty, the Seljuk of Rum, ruled much of Anatolia (Turkey) from the late eleventh to the beginning of the fourteenth century. In the early thirteenth century, the Mongols—non-Muslims led by Jenghiz Khan (ruled 1206–27) and his successors—swept out of central Asia, captured Baghdad in 1258, and encountered weak resistance until they reached Egypt. There the young Mamluk dynasty (1250–1517), founded by descendants of slave soldiers (*mamluk* means "slave"), firmly defeated them. In the west, Islamic control of Spain gradually succumbed to expanding Christian forces and ended altogether in 1492.

With the breakdown of Seljuk power in Anatolia at the end of the thirteenth century, another group of Muslim Turks seized power in the early fourteenth century in the northwestern part of that region, having migrated there from their homeland in central Asia. Known as the Ottomans, after an early leader named Osman, they

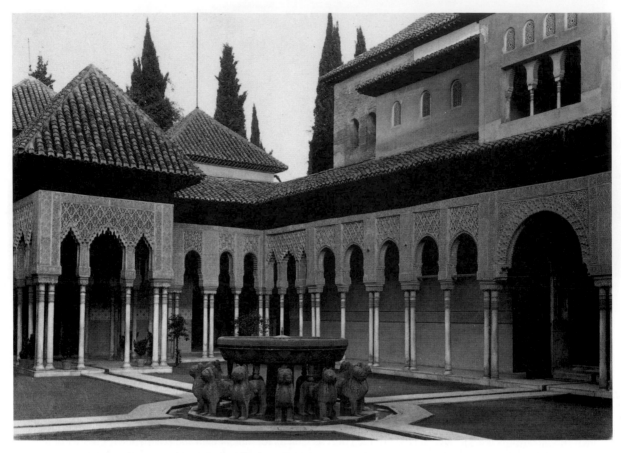

8-10. Court of the Lions, Palace of the Lions, Alhambra, Granada, Spain. Completed c. 1370–80

Granada, with its ample water supply, had long been known as a city of gardens. The twelve stone lions in the fountain in the center of this court were salvaged from the ruins of an earlier palatial complex on the Alhambra hill. Commentators of the time praised this complex, with its pools, fountains, and gardens.

pushed their territorial boundaries westward and, in spite of setbacks inflicted by the Mongols, ultimately created an empire that extended over Anatolia, western Persia, Iraq, Syria, Palestine, western Arabia (including Mecca and Medina), India, Southeast Asia, North Africa (including Egypt and the Sudan), and much of eastern Europe. In 1453, they captured Constantinople (renaming it Istanbul) and brought the Byzantine Empire to an end. The Ottoman Empire lasted until 1918. Another dynasty, the Safavids, established a Shiite state in Persia in the early years of the sixteenth century.

Although Islam remained a dominant and unifying force throughout these developments, the history of later Islamic society and art reflects largely regional phenomena. Only a few works have been selected to characterize the art of Islam, and they by no means provide a history of Islamic art.

ARCHITECTURE

For many people in the West, the Alhambra in Granada, Spain, typifies the beauty and luxury of Islamic palace architecture. To the conquering Christians at the end of the fifteenth century, the Alhambra represented the epitome of luxury. This fortified hilltop palace complex was the seat of the Nasrids (1232–1492), the last Spanish

Muslim dynasty, whose territory had shrunk to the region around Granada in southeastern Spain. The Alhambra remained fairly intact in part because it represented the defeat of Islam to the victorious Christian monarchs, who restored, maintained, and occupied it as much for its commemorative value as for its beauty.

The Alhambra exemplifies the growing regionalism in Islamic art. The founder of the Nasrid dynasty began the complex in 1238 on the site of a pre-Islamic fortress. Successive rulers expanded it, and it took its present form in the fourteenth century. Literally a small town extending for about half a mile along the crest of a high hill overlooking Granada, it included government buildings, royal residences, gates, mosques, baths, servants' quarters, barracks, stables, a mint, workshops, and gardens.

The Alhambra was a sophisticated pleasure palace, an attempt to create paradise on earth. Although the buildings offered views to the valley and mountains, the architecture of the Alhambra also turned inward toward its lush courtyard gardens—the Muslim vision of paradise as a well-watered, walled garden (the English word *paradise* comes from the Persian term for an enclosed park, *faradis*). The so-called Palace of the Lions in the Alhambra was a private retreat built by Muhammad V (ruled 1362–91) in the late fourteenth century. At its heart is the Court of the Lions, a rectangular courtyard named

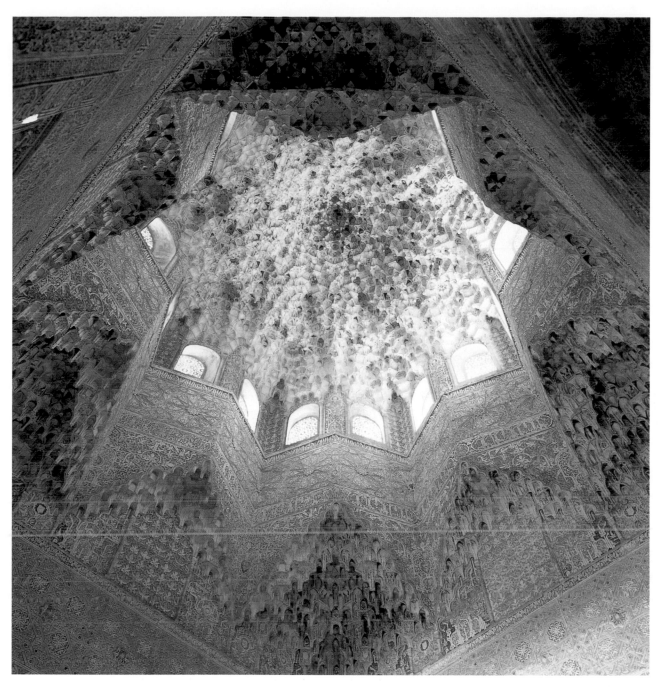

8-11. *Muqarnas* **dome, Hall of the Abencerrajes, Palace of the Lions, Alhambra**. c. 1370–80

for a marble fountain surrounded by stone lions (fig. 8-10). Although sanded today, the Court of the Lions was originally a garden, probably planted with aromatic shrubs, flowers, and small citrus trees between the water channels that radiate from the central Lion Fountain. Second-floor **miradors**—projecting rooms with windows on three sides—overlook the courtyard. One *mirador* looks out onto a large, lower garden and the plain below.

Four pavilions used for dining and performances of music, poetry, and dance open onto the Court of the Lions. One of these, the two-storied Hall of the Abencerrajes on the south side, was designed as a winter music room. Like the other pavilions (all of which had good acoustics), it is covered by a remarkable ceiling (fig. 8-11). The star-shaped vault is formed by a honeycomb of clustered **squinches** called **muqarnas** and also rests on *muqarnas* (see "Arches and *Muqarnas*," page 352). The effect is like architectural lace—material form made immaterial.

In the eastern Islamic world, the Seljuk rulers also proved themselves enlightened patrons of the arts. As builders of religious architecture, they introduced a new mosque plan, the **four-iwan mosque**. In this plan, *iwans*, which are large, rectangular, vaulted halls with monumental arched openings, face each other across a courtyard. Reflecting the influence of Sufism, a literary and philosophical movement that arose in the late tenth and early eleventh centuries, *iwans* may represent symbolic gateways between outside and inside, open and closed, the material and the spiritual.

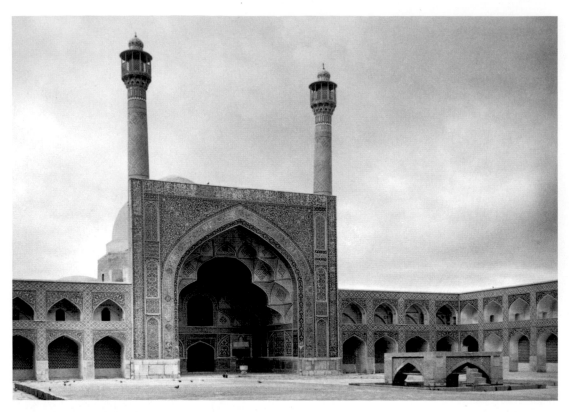

8-12. Courtyard, Masjid-i Jami (Great Mosque), Isfahan, Persia (Iran). 11th–18th century. View from the northeast

Iwans first appeared in **madrasas**, schools for advanced study that were the precursors of the modern university. Beginning in the eleventh century, Muslim rulers and wealthy individuals endowed hundreds of these institutions as acts of pious charity, and many are still in existence. The four-iwan mosque may have evolved from the need to provide separate quarters for four schools of thought within madrasas.

The Masjid-i Jami (Great Mosque) in the center of the Seljuk capital of Isfahan (in modern Iran) was originally a hypostyle mosque. In the late eleventh century, it was refurbished with two great brick domes, and in the twelfth century with four iwans and a monumental gate flanked by paired minarets (fig. 8-12). Construction continued sporadically on this mosque into the eighteenth century, but it retained its basic four-iwan layout, which became standard in Persia. The massive qibla iwan, on the southwest side, is a twelfth-century structure with fourteenth-century muqarnas and seventeenth-century exterior tilework and

8-13. Tile mosaic mihrab, from the Madrasa Imami, Isfahan, Persia (Iran). c. 1354 (restored). Glazed and painted ceramic, 11'3" x 7'6" (3.43 x 2.29 m). The Metropolitan Museum of Art, New York
Harris Brisbane Dick Fund (39.20)

One of the three Koranic inscriptions on this mihrab dates it to approximately 1354. Note the combination of decorated kufic (inner inscription) and cursive muhaqqaq (outer inscription) scripts. The outer inscription tells of the duties of believers and the heavenly rewards for the builders of mosques. The next (kufic) gives the Five Pillars of Islam. The center panel says: "The mosque is the house of every pious person."

8-14. *Qibla* **wall with** *mihrab* **and** *minbar*, main *iwan* (vaulted chamber) in a mosque, Sultan Hasan *madrasa-mausoleum-mosque*, Cairo, Egypt. 1356–63

minarets. The brick masonry on the interior of the *iwans* is unadorned; the facades, however, are sheathed in brilliant blue architectural tilework—a typically Islamic feature for which this monument is justly famous.

A fourteenth-century tile mosaic *mihrab* originally from a *madrasa* in Isfahan but now in the Metropolitan Museum of Art in New York is one of the finest examples of early architectural ceramic decoration in Islamic art (fig 8-13). More than 11 feet tall, it was made by painstakingly cutting each piece of tile individually, including the pieces making up the letters on the curving surface of the niche. The color scheme—white against turquoise and cobalt blue with accents of dark yellow and green—was typical of this type of decoration, as were the harmonious dense, contrasting patterns of organic and geometric forms.

A *madrasa*-mausoleum-mosque complex built in the mid-fourteenth century by the Mamluk sultan Hasan in Cairo, Egypt, shows Seljuk influence (fig. 8-14). The *iwans* in this structure functioned as classrooms, and students were housed in neighboring rooms. Hasan's

domed tomb lies beyond the *qibla* wall of the largest of the four *iwans*, which served as the mosque for the entire complex. The walls and vaulting inside this main *iwan* are unornamented except for a wide stucco frieze band. Originally painted, this band combines calligraphy and intricate carved scrollwork. The *qibla* wall has marble panels and a double-arched recessed *mihrab* with slender columns supporting pointed arches (see "Arches and *Muqarnas*," page 352). Marble inlays create blue, red, and white stripes on the *voussoirs*, a fanciful echo of the brick and stone *voussoirs* of Umayyad architecture (see fig. 8-6). Except for its elaborately carved door, the throne-like *minbar* at the right is made of carved stone instead of the usual wood.

Farther to the west, the rulers of the Ottoman Empire, after conquering Constantinople, converted the church of Hagia Sophia there into a mosque, framing it with two graceful Turkish-style minarets in the fifteenth century and two more in the sixteenth century. Calligraphic roundels with the names of Allah, Muhammad, and the early caliphs were added in the mid-nineteenth century to the

8-15. Sinan. Selimiye Cami (Mosque of Selim), Edirne, Turkey. 1570–74

The minarets that pierce the sky around the prayer hall of this mosque, their sleek, fluted walls and needle-nosed spires soaring to more than 295 feet, are only 12½ feet in diameter at the base, an impressive feat of engineering. Only royal mosques were permitted multiple minarets, and more than two was highly unusual.

interior (see figs. 7-22, 7-24). Inspired by this great Byzantine structure, Ottoman architects developed a domed, **central-plan** mosque. The finest example of this new form was the work of the architect Sinan (c. 1489–1588). Sinan began his career in the army and was chief engineer during the Ottoman campaign and siege of Vienna (1526–29). He rose through the ranks to become chief architect for Suleyman (known as "the Lawgiver" and "the Magnificent"), the tenth Ottoman sultan (ruled 1520–66). Suleyman, whose reign marked the height of Ottoman power, sponsored a building program on a scale not seen since the glory days of the Roman Empire. Sinan is credited with more than 300 imperial commissions, including palaces, *madrasas* and Koran schools, burial chapels, public kitchens and hospitals, caravansaries—way stations for caravans—treasure houses, baths, bridges, viaducts, and 124 large and small mosques.

Sinan's crowning accomplishment, completed when he was at least eighty, was a mosque he designed at the provincial capital of Edirne for Suleyman's son Selim II (ruled 1566–74) in the third quarter of the sixteenth century (fig. 8-15). The gigantic spherical dome that tops this structure is more than 102 feet in diameter, larger than the dome of Hagia Sophia. It crowns a building of great geometric complexity on the exterior and complete coherence

on the interior, a space at once soaring and serene. In addition to the mosque, the complex housed a *madrasa* and other educational buildings, a burial ground, a hospital, and charity kitchens, as well as the income-producing covered market and baths. Framed by the vertical lines of four minarets, the mosque shifts from square to octagon to circle as it moves upward and inward. Raised on a base at the city's edge, it dominates the skyline.

The interior seems superficially very much like Hagia Sophia's: an open expanse under a vast dome floating on a ring of light (fig. 8-16). The mosque, however, is a true central-plan structure and lacks Hagia Sophia's longitudinal pull from entrance to sanctuary. A small fountain covered by a *muezzin* platform emphasizes this centralization. The arches supporting the dome spring from eight enormous piers topped with *muqarnas*. Smaller half-domes between the piers define the corners of a square. Windows at every level flood the interior's cream-colored stone, restrained tile decoration, and softly glowing carpets with light.

PORTABLE ARTS

Islamic society was cosmopolitan, with considerable trade, pilgrimage, and other movement of people fostering

8-16. Selimiye Cami

8-17. Griffin, from the Islamic Mediterranean, probably
Fatimid Egypt. 11th century. Bronze, height 42¹/₈"
(107 cm). Museo dell'Opera del Duomo, Pisa

the circulation of goods. In this context, portable objects
such as textiles and books assumed greater cultural
importance than buildings, and decorated objects
were valued as much for the status they bestowed as for
their usefulness.

Metal. Islamic metalworkers inherited the techniques
of their Roman, Byzantine, and Sassanian predecessors,
applying them to new forms, such as incense burners
and water pitchers in the shape of birds. An example of
this delight in fanciful bronze work is an unusually large
and stylized griffin, perhaps originally a fountain spout
(fig. 8-17). Now in Pisa, Italy, it is probably Fatimid
(Egyptian) work, and it may have arrived as booty from
Pisan victories over the Egyptian fleet in 1087. The
Pisans displayed it atop their cathedral from about 1100
to 1828. Made of cast bronze, it is decorated with incised
feathers, scales, and silk trappings. The decoration on
the creature's thighs includes animals in medallions; the
bands across its chest and back are embellished with
kufic lettering and scale and circle patterns.

The Islamic world was administered by educated
leaders who often commissioned personalized contain-
ers—emblems of their class—for their pens, ink, and
blotting sand. One such container, an inlaid brass box,
was the possession of Majd al-Mulk al-Muzaffar, the
grand vizier, or chief minister, of Khurasan in the early
thirteenth century (fig. 8-18). An artist named Shazi

8-18. Shazi. Pen box, from Persia (Iran) or Afghanistan.
1210–11. Brass with silver and copper; height 2",
length 12⁵/₈", width 2¹/₂" (5 x 31.4 x 6.4 cm). Freer
Gallery of Art, Smithsonian Institution, Washington,
D.C. (36.7)

The inscriptions on this box include some twenty
honorific phrases extolling its owner, al-Mulk. The
inscription in *naskhi* script on the lid calls him the
"luminous star of Islam." The largest inscription,
written in animated *naskhi* (an animated script is one
with human or animal forms in it), asked twenty-four
blessings for him from God. Shazi, the designer of
the box, signed and dated it in animated kufic on the
side of the lid, making it one of the earliest signed
works in Islamic art. Al-Mulk enjoyed his box for only
ten years; he was killed by Mongol invaders in 1221.

8-19. Bottle, from Syria. Mid-14th century. Blown glass with enamel and gilding, 19½ x 9½" (49.7 x 24.8 cm). Freer Gallery of Art, Smithsonian Institution, Washington, D.C. (34.20)

cast, engraved, embossed, and inlaid the box with consummate skill. Scrolls, interlacing designs, and human and animal figures enliven its calligraphic inscriptions. All these elements, animate as well as inanimate, seem to be engaged in lively conversation. That a work of such quality was made of brass rather than a costlier metal may seem odd. A severe silver shortage in the mid-twelfth century had prompted the development of inlaid brass pieces like this one that used the more precious metal sparingly. Humbler brass ware would have been available in the marketplace to those of more modest means than the vizier.

Glass. Glass, according to the twelfth-century poet al-Hariri, is "congealed of air, condensed of sunbeam motes, molded of the light of the open plain, or peeled from a white pearl" (cited in Jenkins, page 3). Made with the most ordinary of ingredients—sand and ash—glass is the most ethereal of materials. It first appeared roughly 4,000 years ago, and the tools and techniques for making it have changed little in the past 2,000 years. Like their counterparts working in metal, Islamic glassmakers generally adapted earlier practices to new forms. They were particularly innovative in the application of enameled decoration in gold and various colors.

8-20. Ewer, from Kashan, Persia (Iran). Early 13th century. Glazed and painted fritware, height 11¹³⁄₁₆" (30 cm). The al-Sabah Collection, Kuwait

Fritware was used to make beads in ancient Egypt and may have been rediscovered there by Islamic potters searching for a substitute for Chinese porcelain. Its components were one part white clay, ten parts quartz, and one part quartz fused with soda, which produced a brittle, white ware when fired. The colors on this double-walled ewer and others like it were produced by applying mineral glazes over black painted detailing. The deep blue comes from cobalt and the turquoise from copper. Luster, a thin, transparent glaze with a metallic sheen, was applied over the colored glazes.

A tall, elegant enameled bottle from the mid-fourteenth century exemplifies their skill (fig. 8-19). One of several objects either given by Mamluk rulers to the Rasulid rulers of Yemen (southern Arabia) or ordered by the Rasulids from Mamluk workshops in Syria, it bears a large inscription naming and honoring a Rasulid sultan in *thuluth*—a popular Mamluk cursive script—and the Rasulid insignia, a five-petaled red rosette.

Ceramics. Ceramicists in the city of Kashan developed a distinctive pottery in the thirteenth century. Painted underglaze bowls and jugs were decorated with curling vines and leaves painted in black on white and then glazed with a shiny turquoise glaze. In this elaborate double-walled ewer (fig. 8-20), the artisan has pierced and painted the outer shell with a tangle of vines surrounding seated human figures. Glazes of translucent turquoise and luster (a metallic glaze that creates the appearance of precious metal) then cover the painting.

Textiles. The tradition of silk weaving that passed from Sassanian Persia to Islamic artisans in the early Islamic period (see fig. 8-9) was kept alive in Muslim Spain, where it was both economically and culturally important.

8-21. Banner of Las Navas de Tolosa, detail of center panel, from southern Spain. 1212–50. Silk tapestry-weave with gilt parchment, 10'9⅞" x 7'2⅝" (3.3 x 2.2 m). Museo de Telas Medievales, Monasterio de Santa Maria la Real de Las Huelgas, Burgos, Spain. Patrimonio Nacional

This banner was a trophy of King Ferdinand III, who gave it to Las Huelgas, the Cistercian convent outside Burgos, the capital city of Old Castile and the burial place of the royal family. This illustration shows only a detail of the center section of the textile. The calligraphic panels continue down the sides, and a second panel crosses the top. Eight lobes with gold crescents and white inscribed parchment medallions form the lower edge of the banner.

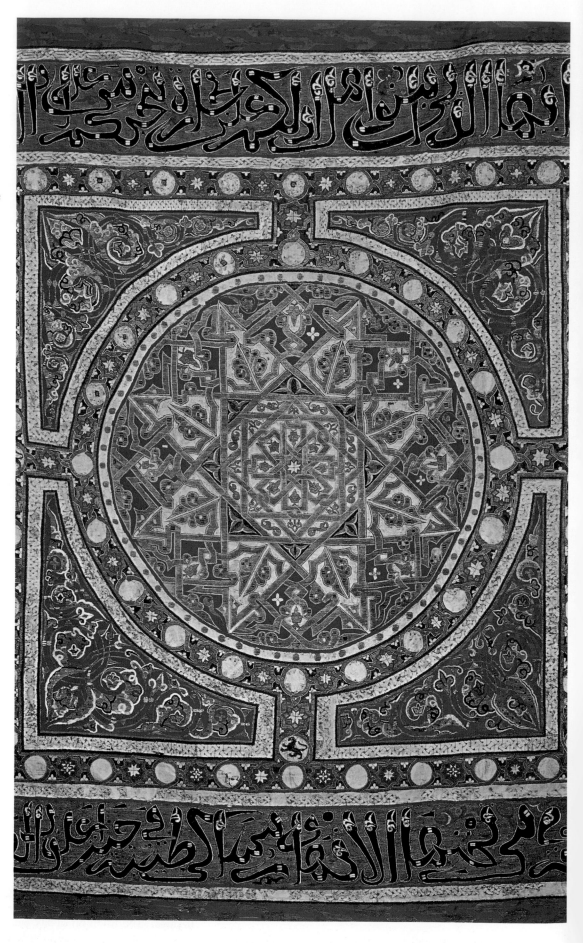

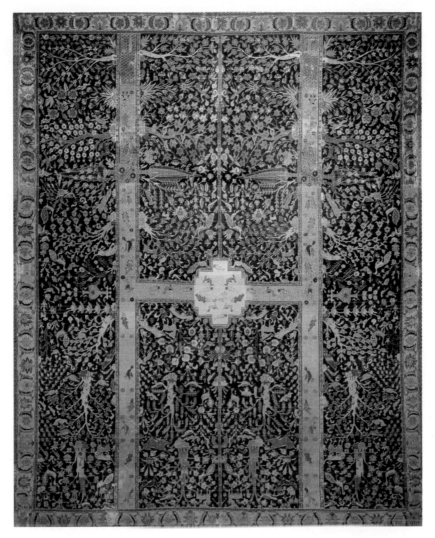

8-22. Garden carpet, from central Persia (Iran). Second half of 17th century. Woolen pile, cotton warps, cotton and wool wefts, 17'5" x 14'2" (5.31 x 4.32 m). The Burrell Collection, Glasgow Museums, Scotland

Spanish designs reflect a new aesthetic, with an emphasis beginning in the thirteenth century on architecture-like forms. An eight-pointed star forms the center of a magnificent silk and gold banner (fig. 8-21). The calligraphic panels continue down the sides and a second panel crosses the top. Eight lobes with gold crescents and white inscribed parchment medallions form the lower edge of the banner. In part, the text reads: "You shall believe in God and His Messenger. . . . He will forgive you your sins and admit you to gardens underneath which rivers flow, and to dwelling places goodly in Gardens of Eden; that is the mighty triumph."

Since the late Middle Ages, carpets have been the Islamic art form best known in Europe. Knotted rugs (see "Carpet Making," page 364) from Persia, Turkey, and elsewhere were so highly prized among Westerners that they were often displayed on tables rather than floors. Persian taste favored intricate, elegant designs that evoked the gardens of paradise. Written accounts indicate that such designs appeared on Persian carpets as early as the seventh century. In one fabled royal carpet,

garden paths were rendered in real gold, leaves were modeled with emeralds, and highlights on flowers, fruits, and birds were created from pearls and other jewels.

A typical garden carpet shows a bird's-eye view of an enclosed park. One such carpet from the second half of the seventeenth century depicts a garden irrigated by an H–shaped system of channels. In the middle is a basin filled with floating plants, fish, and birds (fig. 8-22). All kinds of animals and birds, some resting and others hunting, inhabit the dense forests of leafy trees and blooming shrubs represented in profile along the water channels, roots directed toward the water. The very finest carpets, like this, woven of cotton and wool or silk and wool in royal workshops, were status symbols in the Islamic world.

Rugs and mats have long been used for Muslim prayer, which involves repeated kneeling and touching of the forehead to the floor. Many mosques were literally "carpeted" with wool-pile rugs received as pious donations; wealthy patrons gave large prayer rugs (note, for example, the rugs on the floor of the Selimiye Cami in figure 8-16).

TECHNIQUE

CARPET MAKING

Because textiles, especially floor coverings, are destroyed through use, very few carpets from before the sixteenth century have survived. There are two basic types of carpets: flat-weaves and pile, or knotted. Both can be made on either vertical or horizontal frames. The best-known flat-weaves today are Turkish kilims, which are typically woven in wool with bold, geometric patterns and sometimes with embroidered details. Kilim weaving is done in the **tapestry** technique (see diagram, a).

Knotted carpets are an ancient invention. The oldest known example, excavated in Siberia and dating to the fourth or fifth century BCE, has designs evocative of Achaemenid Persian art, suggesting that the technique may have originated in ancient Persia. In knotted carpets, the pile—the plush, thickly tufted surface—is made by tying colored strands of yarn, usually wool but occasionally silk for deluxe carpets, onto the vertical elements (**warp**) of a yarn grid (b or c). These knotted loops are later trimmed and sheared to form the plush surface of the carpet. Rows of knots alternate with flat-woven rows (**weft**) that hold the carpet together. The weft is usually an undyed yarn and is hidden by the colored knots. Two common tying techniques are the symmetrical Turkish knot, which works well for straight-line designs (b), and the asymmetrical Persian knot, used for rendering curvilinear patterns (c). The greater the number of knots, the denser and more durable the pile. The finest carpets have a hundred knots per square inch, each one tied separately by hand.

Although royal workshops produced the most luxurious carpets (see fig. 8-22), most knotted rugs have traditionally been made in tents and homes. Carpets were woven by either women or men, depending on local custom. The photograph in this box shows two women, sisters in Ganakkale province in Turkey, weaving a large carpet in a typical Turkish pattern. The woman in the foreground pushes a row of knots tightly against the row below it with a wood comb called a beater. The other woman pulls a dark red weft yarn against the warp threads before tying a knot. Working between September and May, these women may weave five carpets, tying up to 5,000 knots a day. Generally, an older woman works with a young girl, who learns the art of carpet weaving at the loom and eventually passes it on to the next generation.

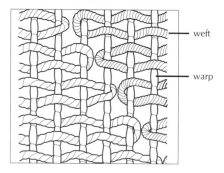

a. Kilim weaving pattern used in flat-weaving

b. Turkish knots, used typically in Anatolia (Turkey) to make pile, or knotted, carpets

c. Persian knots, favored by Persian carpet makers

MANUSCRIPT ILLUMINATION AND CALLIGRAPHY

The art of book production flourished in the later Islamic centuries. Islam's emphasis on the study of the Koran created a high level of literacy among both women and men in Muslim societies. Books on a wide range of secular as well as religious subjects were available, although even books modestly copied on paper were fairly costly. Libraries, often associated with *madrasas*, were endowed by members of the educated elite. Books made for royal patrons had luxurious bindings and highly embellished pages, the result of workshop collaboration between noted calligraphers and illustrators. New scripts were developed for new literary forms.

The **illuminators**, or manuscript illustrators, of Mamluk Egypt executed intricate nonfigural geometric designs for Korans. Geometric and botanical ornamentation achieved unprecedented sumptuousness and mathematical complexity. As in contemporary architectural decoration, strict underlying geometric organization combined with luxurious all-over patterning. In an impressive frontispiece originally paired with its mirror image on the facing left page, energy radiates from a sixteen-pointed starburst, filling the central square (fig. 8-23). The surrounding ovals and medallions are filled with interlacing foliage and stylized flowers that provide a backdrop for the Word of God. The page's resemblance to court carpets was not coincidental. Designers worked in more than one medium, leaving the execution of their efforts to specialized artisans.

In addition to religious works, scribes copied and recopied famous secular texts—scientific treatises, manuals of all kinds, fiction, and especially poetry. Painters supplied illustrations for these books, and they also created individual small-scale paintings—**miniatures**—that were collected by the wealthy and placed in albums. One of the great royal centers of miniature painting was at Herat in Khurasan (in modern Iran). A school of painting and calligraphy was founded there in the early fifteenth century under the cultured patronage of the Turkic Timurid dynasty (1370–1507). Prince Baysonghur held court in Herat. A great patron of painting and calligraphy, he commissioned superb illuminated manuscripts. The story of the Sassanian prince Bahram Gur, told in poems known as *Haft Paykar (Seven Portraits)* by the twelfth-century Persian mystic poet Nizami, was a favorite. The painting of Bahram Gur and the Indian Princess of the Black Pavilion illustrates the lyrical idealism that characterizes the Timurid style (fig. 8-24, page 366). The round, impassive faces of the amorous couple and their servants are part of this idealization.

Although the scene takes place at night (Bahram Gur married seven princesses, one for each night of the week), the colors are clear and bright without a trace of shadows. The night sky with stars and moon and the two tall candles in the pavilion signal the viewer that it is nighttime. The black pavilion is represented in shades of gray with an interior decorated with brilliant blue tiles. Through a central opening a garden in bloom can be seen, and in the foreground a stream of silver water

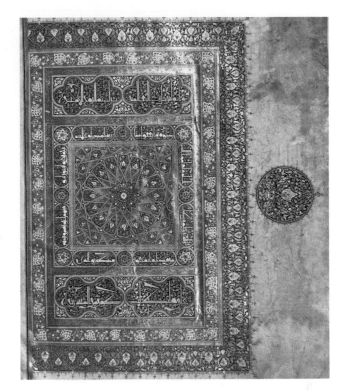

8-23. Koran frontispiece (right half of two-page spread), from Cairo, Egypt. c. 1368. Ink, pigments, and gold on paper, 24 x 18" (61 x 45.7 cm). National Library, Cairo. Ms. 7

The Koran to which this page belonged was donated in 1369 by Sultan Shaban to the *madrasa* established by his mother. Throughout the manuscript, as here, is evidence of close collaboration between illuminator and scribe.

runs into a silver pool (the silver has tarnished to black). The representation of setting, people, and objects from their most characteristic viewpoints is also typical of Timurid painting. The pavilion, tiled walls and step, huge pillow, and items on trays are seen straight on, while the floor, pool, platform, and bed are seen from a bird's-eye view. The viewpoint for the people and the things they carry, as well as the trays already in place, seems somewhere between the two extremes. Obviously, Timurid artists delighted in the representation of intricate decorative details; especially noteworthy are the representation of tiles and fabrics and the glimpse of the garden.

In the second half of the fifteenth century, the leader of the Herat school was Kamal al-Din Bihzad (c. 1440–1514). When the Safavids supplanted the Timurids and established their capital at Tabriz in northwestern Persia in 1506, Bihzad moved to Tabriz and briefly resumed his career there. Bihzad's paintings done around 1494 to illustrate the *Khamsa (Five Poems)*, also written by Nizami, demonstrate his ability to render human activity convincingly. He set his scenes within complex, stagelike architectural spaces that are stylized according to Timurid conventions, creating a visual balance between activity

8-24. *Bahram Gur Visiting One of His Wives, an Indian Princess*, from a copy of Nizami's 12th-century *Haft Paykar (Seven Portraits)*, Herat, Khurasan, Persia (Iran). late 1420s. Color and gilt on paper, height 8⅝", width 4⅝". The Metropolitan Museum of Art, New York

Gift of Alexander Smith Cochran, 1913 (13.228.13)

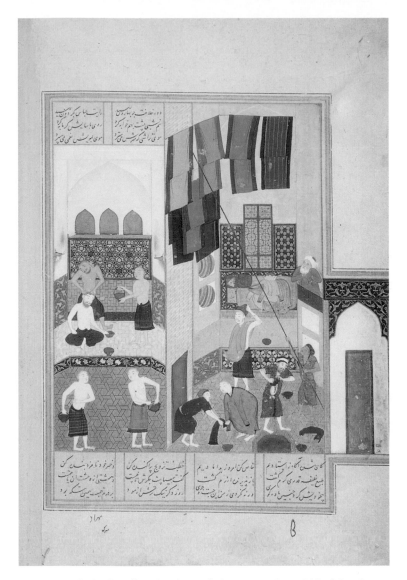

8-25. Kamal al-Din Bihzad. *The Caliph Harun al-Rashid Visits the Turkish Bath*, from a copy of the 12th-century *Khamsa (Five Poems)* of Nizami, Herat, Khurasan, Persia (Iran). c. 1494. Ink and pigments on paper, approx. 7 x 6" (17.8 x 15.3 cm). The British Library, London
Oriental and India Office Collections (Ms. Or. 6810, fol. 27v)

Despite early warnings against it as a place for the dangerous indulgence of the pleasures of the flesh, the bathhouse *(hammam)*, adapted from Roman and Hellenistic predecessors, became an important social center in much of the Islamic world. The remains of an eighth-century *hammam* are still standing in Jordan, and a twelfth-century *hammam* is still in use in Damascus. *Hammams* had a small entrance to keep in the heat, which was supplied by ducts running under the floors. The main room had pipes in the wall with steam vents. Unlike the Romans, who bathed and swam in pools of water, Muslims preferred to splash themselves from basins, and floors were slanted for drainage. A *hammam* was frequently located near a mosque, part of the commercial complex provided by the patron to generate income for the mosque's upkeep.

and architecture. In *The Caliph Harun al-Rashid Visits the Turkish Bath* (fig. 8-25), the bathhouse, its tiled entrance leading to a high-ceilinged dressing room with brick walls, provides the structuring element. Attendants wash long, blue towels and hang them to dry on overhead clotheslines. A worker reaches for one of the towels with a long pole, and a client prepares to wrap himself discreetly in a towel before removing his outer garments. The blue door on the left leads to a room where the caliph is being groomed by his barber while attendants bring buckets of water for his bath. The asymmetrical composition depends on a balanced placement of colors and architectural ornaments within each section.

This combination of abstract setting with realism in figures and details continued into the sixteenth century. The Ottoman Turks in Anatolia adopted the style for their miniatures, enhancing the decorative aspects with an intensity of religious feeling, as in the painting of

8-26. Illuminated *tugra* of Sultan Suleyman, from Istanbul,
Turkey. c. 1555–60. Ink, paint, and gold on paper, removed
from a *firman* and trimmed to 20¹/₂ x 25³/₈" (52 x 64.5 cm).
The Metropolitan Museum of Art, New York
Rogers Fund, 1938 (38.149.1)

Muhammad (see page 349) in which the Prophet appears
as a white wraithlike shadow riding a realistic camel
through a stylized landscape. At the Ottoman court of Sul-
tan Suleyman in Constantinople, the imperial workshops
also produced remarkable illuminated manuscripts. In
addition, following a practice begun by the Seljuks and
Mamluks, the Ottomans put calligraphy to another, political
use, developing the design of imperial emblems—*tugras*—
into a specialized art form. Ottoman *tugras* combined the
ruler's name with the title *khan* ("lord"), his father's name,
and the motto "Eternally Victorious" into an unvarying
monogram. *Tugras* symbolized the authority of the sultan
and of those select officials who were also granted an
emblem. They appeared on seals, coins, and buildings, as
well as on official documents called *firmans*, imperial
edicts supplementing Muslim law.

Suleyman issued hundreds of *firmans*. A high court
official affixed Suleyman's *tugra* to the top of official scrolls
and employed specialist calligraphers and illuminators
for documents, such as imperial grants to charitable
projects, that required particularly fancy *tugras*. The *tugra*
shown here (fig. 8-26) is from a document endowing an

institution in Jerusalem that had been established by
Suleyman's wife, Sultana Hurrem.

Tugras on paper were always outlined in black or
blue with three long, vertical strokes (*tug* means "horse-
tail") to the right of two horizontal teardrops, one inside
the other. Early *tugras* were purely calligraphic, but dec-
orative fill patterns became fashionable in the sixteenth
century. Fill decoration became more naturalistic by the
1550s and in later centuries spilled outside the emblems'
boundary lines. Figure 8-26 shows a rare, oversized *tugra*
that required more than the usual skill to execute. The
sweeping, fluid line had to be drawn with perfect control
according to set proportions, and a mistake meant start-
ing over. The color scheme of the delicate floral interlace
enclosed in the body of the *tugra* was inspired by Chinese
blue-and-white ceramics; similar designs appear on
Ottoman ceramics and textiles.

The Ottoman *tugra* is a sophisticated merging of
abstraction with naturalism, boldness with delicacy,
political power with informed patronage, and function—
both utilitarian and symbolic—with adornment. As such,
it is a fitting conclusion for this brief survey of Islamic art.

PARALLELS

PERIOD	ISLAMIC ART	ART IN OTHER CULTURES
EARLY CALIPHS 633–61		
UMAYYAD CALIPHS 661–750, 756–1031	**8-2. Dome of the Rock** (c. 687–91) **8-4. Mshatta palace** (c. 740) **8-6. Great Mosque**, Córdoba (begun 785 6)	
ABBASID, NASRID, SELJUK, MAMLUK, TIMRUD, CALIPHS 750–1570	**8-1. Koran page** (Abbasid, 9th cent.) **8-8. Kufic bowl**, Samarkand (Abbasid, 9th–10th cent.) **8-9. Textile**, Khurasan (Abbasid, c. 960) **8-17. Griffin** (Fatimid, 11th cent.) **8-18. Pen box**, Khurasan (Abbasid, 1210–11) **8-12. Masjid-i Jami** (Great Mosque,) Isfahan (Seljuk, 11th–18th cent.) **8-21. Banner of Las Navas de Tolosa**, Spain (Nasrid, 1212–50) **8-20. Ewer, Kashan** (Seljuk, early 13th cent.) **8-13. Mosaic** *mihrab*, Isfahan (Seljuk, c. 1354) **8-14.** *Qibla* **wall**, Cairo (Mamluk, 1356–63) **8-19. Bottle, Syria** (Mamluk, mid-14th cent.) **8-23. Koran frontispiece** (Mamluk, c. 1368) **8-10. Palace of the Lions**, Alhambra (Nasrid, c. 1370–80) **8-25.** *Khamsa* **page** (Timurid, c. 1494)	**7-51.** *Joshua Roll* (c. 950), Turkey **7-49.** *Archangel Michael* (late 10th / early 11th cent.), Italy **9-28.** *Shiva Nataraja* (c. 1000), India **7-39. Cathedral of Saint Mark** (begun 1063), Italy **15-32.** *Bayeux Tapestry* (c. 1066–77), France **7-42.** *Virgin of Vladimir* (12th cent.), Russia **12-23. Anasazi jar** (1100–1300), US **16-6. Chartres Cathedral** (c. 1134–1220), **16-69.** Giotto. *Virgin and Child* (1310), Italy **7-52.** *Christ in Chora* (c. 1315–21), Turkey **7-53.** *Anastasis* (c. 1315–21), Turkey
OTTOMAN EMPIRE 1290 1918	**8-26. Suleyman** *tugra*, Turkey (c. 1555–60) **8-15. Selimye Cami, Edirne** (Mosque of Selim) (1570–74) **8-22. Garden carpet**, Persia (second half 17th cent.)	**7-54. Cathedral of St. Basil the Blessed** (1555–61), Russia

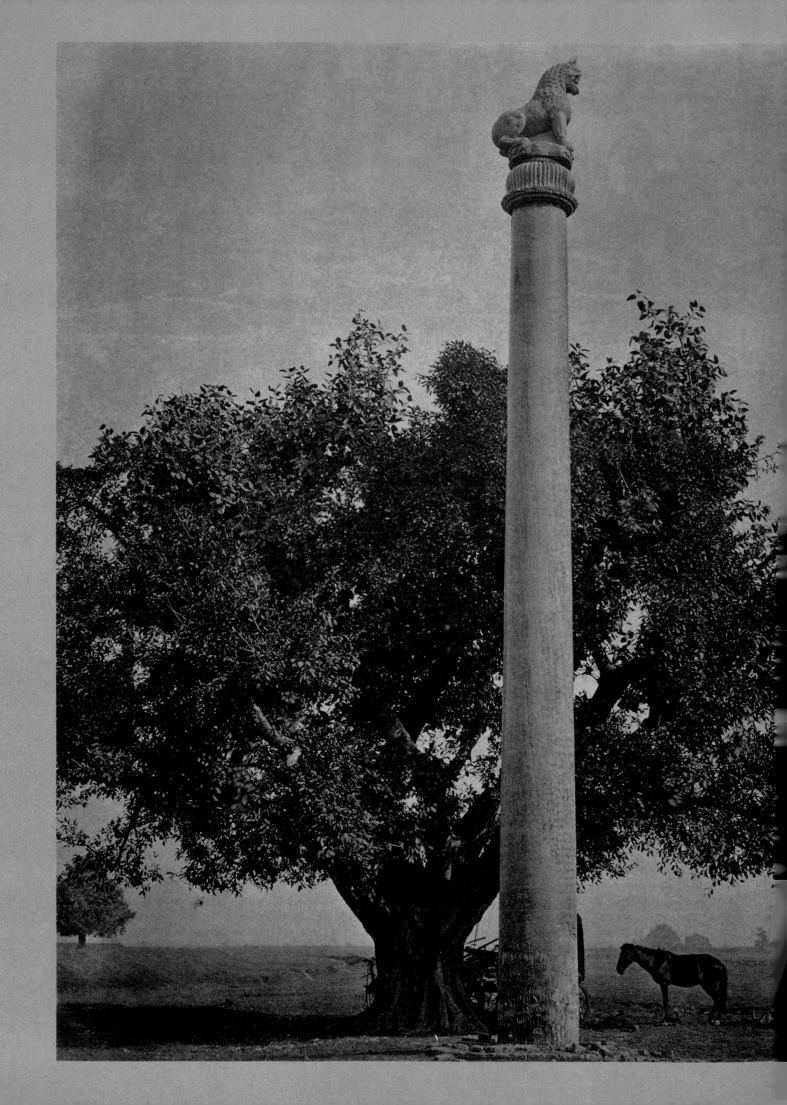

9-1. **Ashokan pillar**, Lauriya, Nandangarh. Maurya period, 246 BCE

9
Art of India before 1100

The ruler Ashoka was stunned by grief and remorse as he looked across the battlefield. In the custom of his dynasty, he had gone to war, expanding his empire until he had conquered many of the peoples of the Indian subcontinent. Now, in 261 BCE, after the final battle in his conquest of the northern states, he was suddenly—unexpectedly—shocked by the horror of the suffering he had caused. In the traditional account, it is said that only one form on the battlefield moved, the stooped figure of a Buddhist monk slowly making his way through the carnage. Watching this spectral figure, Ashoka abruptly turned the moment of triumph into one of renunciation. Decrying violence and warfare, he vowed to become a *chakravartin* ("world-conquering ruler"), not through the force of arms but through spreading the teachings of the Buddha and helping to establish Buddhism as a major religion of his realm. Although there is no absolute proof that Ashoka himself converted to Buddhism, from that moment on he set a noble example by living his belief in nonviolence and kindness to all beings.

In his impassioned propagation of Buddhism, Ashoka stimulated an intensely rich period of art. He erected and dedicated monuments to the Buddha throughout his empire—shrines, monasteries, sculpture, and the columns known as Ashokan pillars (fig. 9-1). In his missionary ardor, he sent delegates throughout the Indian subcontinent and to countries as distant as Syria, Egypt, and Greece.

TIMELINE 9-1. **Major Early Cultural Periods of the Indian Subcontinent.** A continuous Indian artistic tradition extended from the very early Indus Valley civilizations through the Early Medieval period.

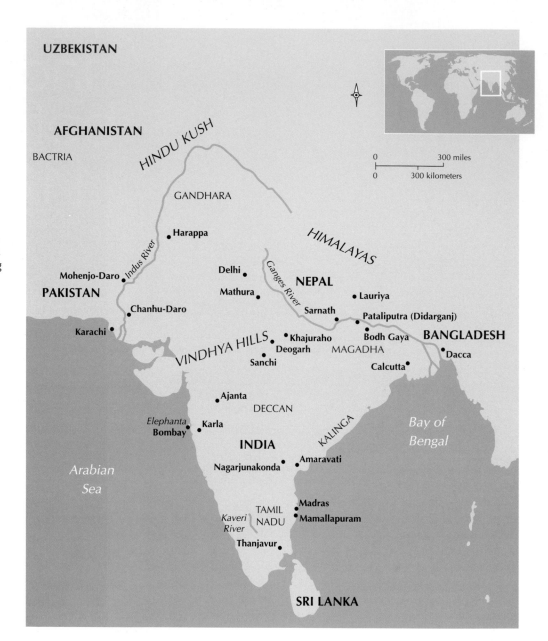

MAP 9-1. **The Indian Subcontinent.** The Vindhya Hills are a natural feature dividing North and South India.

THE INDIAN SUBCONTINENT

The South Asian subcontinent, or Indian subcontinent, as it is commonly called, is a peninsular region that includes the present-day countries of India, southeastern Afghanistan, Pakistan, Nepal, Bangladesh, and Sri Lanka (Map 9-1). From the beginning, these areas have been home to societies whose cultures are closely linked and remarkably constant. (South Asia is distinct from Southeast Asia, which includes Brunei, Burma [Myanmar], Cambodia [Kampuchea], Laos, Malaysia, the Philippines, Singapore, Thailand, and Vietnam.) Present-day India is approximately one-third the size of the United States. A

low mountain range, the Vindhya Hills, acts as a kind of natural division that demarcates North India and South India, which are of approximately equal size. On the northern border rises the protective barrier of the Himalayas, the world's tallest mountains. To the northwest are other mountains through whose passes came invasions and immigrations that profoundly affected the civilization of the subcontinent. Over these passes, too, wound the major trade routes that linked the Indian subcontinent by land to the rest of Asia and to Europe. Surrounded on the remaining sides by oceans, the subcontinent has also been connected to the world since ancient times by maritime trade, and during much of

200 BCE	200 CE	400 CE	600 CE	800 CE	1000 CE	1200 CE

▲ c. 322–185 BCE MAURYA ▲ c. 320–500 CE GUPTA
▲ c. 185 BCE–72 CE SHUNGA/EARLY ANDHRA ▲ c. 650–1200 CE EARLY MEDIEVAL
▲ c. 30–433 CE KUSHAN/LATER ANDHRA ▲ c. 500–650 CE POST-GUPTA

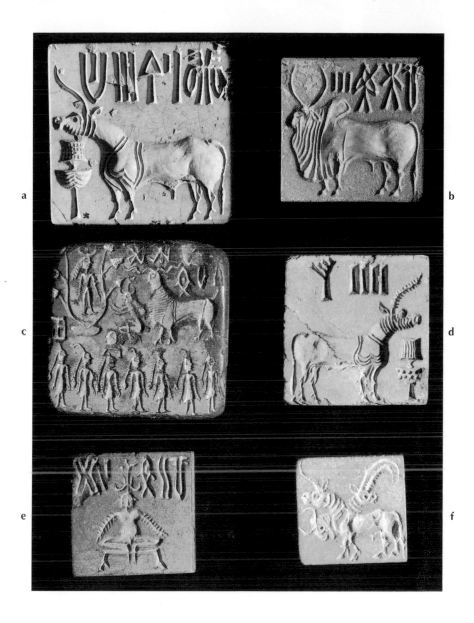

9-2. Seal impressions: a., d. horned animal; b. buffalo; c. sacrificial rite to a goddess (?); e. yogi; f. three-headed animal. Indus Valley civilization, c. 2500–1500 BCE. Seals: steatite, each approx. 1¼ x 1¼" (3.2 x 3.2 cm)

The more than 2,000 small seals and impressions that have been found offer an intriguing window on the Indus Valley civilization. Usually carved from steatite stone, the seals were coated with alkali and then fired to produce a lustrous, white surface. A perforated knob on the back of each may have been for suspending them. The most popular subjects are animals, most commonly a one-horned bovine standing before an altarlike object (a, d). Animals on Indus Valley seals are often portrayed with remarkable naturalism, their taut, well-modeled surfaces implying their underlying skeletons. The function of the seals, beyond sealing packets, remains enigmatic, and the pictographic script that is so prominent in the impressions has yet to be deciphered.

the period under discussion here it formed part of a coastal trading network that extended from eastern Africa to China.

Differences in language, climate, and terrain within India have fostered distinct regional and cultural characteristics and artistic traditions. However, despite such regional diversity, several overarching traits tend to unite Indian art. Most evident is a distinctive sense of beauty, with voluptuous forms and a profusion of ornament, texture, and color. Visual abundance is considered auspicious, and it reflects a belief in the generosity and favor of the gods. Another characteristic is the pervasive symbolism that enriches all Indian arts with intellectual and emotional layers. Third, and perhaps most important, is an emphasis on capturing the vibrant quality of a world seen as infused with the dynamics of the divine. Gods and humans, ideas and abstractions, are given tactile, sensuous forms, radiant with inner spirit.

INDUS VALLEY CIVILIZATION

The earliest civilization of South Asia was nurtured in the lower reaches of the Indus River, in present-day Pakistan and in northwestern India (Timeline 9-1). Known as the Indus Valley or Harappan civilization (after Harappa, the first-discovered site), it flourished from approximately 2700 to 1500 BCE, or during roughly the same time as the Old Kingdom period of Egypt, the Minoan civilization of the Aegean, and the dynasties of Ur and Babylon in Mesopotamia. Indeed, it is considered along with Egypt and Mesopotamia one of the world's earliest urban river-valley civilizations.

It was the chance discovery in the late nineteenth century of some small seals like those in figure 9-2 that provided the first clue that an ancient civilization had existed in this region. The seals appeared to be related to, but not the same as, seals known from ancient

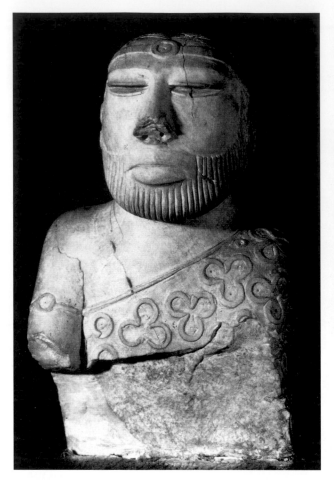

9-3. **Bust of a man**, from Mohenjo-Daro. Indus Valley civilization, c. 2000 BCE. Limestone, height 6⅞" (17.5 cm). National Museum of Pakistan, Karachi

9-4. **Torso**, from Harappa. Indus Valley civilization, c. 2000 BCE. Red sandstone, height 3¾" (9.5 cm). National Museum, New Delhi

Mesopotamia (see fig. 2-13). Excavations begun in the 1920s and continuing into the present subsequently uncovered a number of major urban areas at points along the lower Indus River, including Harappa, Mohenjo-Daro, and Chanhu-Daro.

The ancient cities of the Indus Valley resemble each other in design and construction, suggesting a coherent culture. At Mohenjo-Daro, the best preserved of the sites, archaeologists discovered an elevated **citadel** area, presumably containing important government structures, surrounded by a wall about 50 feet high. Among the buildings is the so-called Great Bath, a large, watertight pool that may have been used for ritual purposes. Stretching out below this elevated area was the city, arranged in a gridlike plan with wide avenues and narrower side streets. Its houses, often two stories high, were generally built around a central courtyard. Like other Indus Valley cities, Mohenjo-Daro was constructed of fired brick, in contrast to the less-durable sun-dried brick used in other cultures of the time. The city included a network of covered drainage systems that channeled away waste and rainwater. Clearly the technical and engineering skills of this civilization were highly advanced. At its peak, about 2500 to 2000 BCE, Mohenjo-Daro was approximately 6 to 7 square miles in size and had a population of about 20,000 to 50,000.

Although little is known about the Indus Valley civilization, motifs on the seals as well as the few art works that have been discovered strongly suggest continuities with later South Asian cultures. Seal (e) in figure 9-2, for example, depicts a man in the meditative posture associated in Indian culture with a yogi, one who seeks mental and physical purification and self-control, usually for spiritual purposes. In seal (c), persons with elaborate headgear in a row or procession observe a figure standing in a tree—possibly a goddess—and a kneeling worshiper. This scene may offer some insight into the religious or ritual customs of Indus Valley people, whose deities may have been ancient prototypes of later Indian gods and goddesses.

Numerous **terra-cotta** figurines and a few stone and bronze statuettes have been found in the Indus Valley. They reveal a confident maturity of artistic conception and technique. Two main styles appear: one is related to Mesopotamian art in its motifs and rather abstract rendering, while the other foreshadows the later Indian artistic tradition in its sensuous naturalism.

The bust of a man in figure 9-3 is an example of the Mesopotamian style. The man's garment is patterned with a **trefoil**, or three-lobed, motif also found in Mesopotamian art. Although the striated beard and the smooth, planar surfaces of the face resemble the

9-5. *Large Painted Jar with Border Containing Birds*, from Chanhu-Daro. Indus Valley civilization, c. 2400–2000 BCE. Reddish buff clay, height 9⅞" (25 cm). Museum of Fine Arts, Boston
Joint Expedition of the American School of Indic and Iranian Studies and the Museum of Fine Arts, Boston

Mesopotamian treatment of the head, distinctive physical traits emerge, including a low forehead, a broad nose, thick lips, and large, wide eyes. These traits may well record something of the appearance of the Indus Valley peoples. The depressions of the trefoil pattern were originally filled with red paste and the eyes inlaid with shell. The narrow band encircling the head falls in back into two long strands and may be an indication of rank. Certainly with its formal pose and simplified, geometric form the statue conveys a commanding human presence.

A nude male torso found at Harappa is an example of the contrasting naturalistic style (fig. 9-4). Less than 4 inches tall, it is one of the most extraordinary portrayals of the human form to survive from any early civilization. In contrast to the more athletic male ideal developed in ancient Greece, this sculpture emphasizes the soft texture of the human body and the subtle nuances of muscular form. The abdomen is relaxed in the manner of a yogi able to control his breath. With these characteristics the Harappa torso forecasts the essential aesthetic attributes of later Indian sculpture.

No wall paintings from the Indus Valley civilization have yet been found, but there are remains of handsome painted ceramic vessels (fig. 9-5). Formed on a potter's wheel and fired at high temperatures, the vessels are quite large and generally have a rounded bottom. They are typically decorated with several zones of bold, linear designs painted in black slip. Flower, leaf, bird, and fish motifs predominate. The elegant vessel here, for example, is decorated with peacocks poised gracefully among leafy branches in the upper zone and rows of leaves formed by a series of intersecting circles in the lower zone. Such geometric patterning is typical of Indus Valley decoration.

The reasons for the demise of this flourishing civilization are not yet understood. All we know is that apparently around 1500 BCE—possibly because of climate changes, a series of natural disasters, or invasions—the cities of the Indus Valley civilization declined, and over the next thousand years predominantly rural societies evolved.

THE VEDIC PERIOD

The centuries between the demise of the Indus Valley civilization and the rise of the first unified empire in the late fourth century BCE are generally referred to as the Vedic period. Named for the Vedas, a body of sacred writings that took shape over these centuries, the Vedic period witnessed profound changes in social structure and the formation of three of the four major enduring religions of India—Hinduism, Buddhism, and Jainism.

The period is marked by the dominance of Indo-European Aryans, a pastoral, seminomadic warrior people believed to have entered India sometime around 1500 BCE from the northwest. Gradually they supplanted the indigenous populations that had created the Indus Valley urban centers. The Aryans brought a language called Sanskrit, a hierarchical social order, and religious practices that centered on the propitiation of gods through fire sacrifice. The earliest of the Vedas, dating from the first centuries of Aryan presence, consist of hymns to such Aryan gods as the divine king Indra—the Vedic counterpart of the later Greek god Zeus. The importance of the fire sacrifice, overseen by a powerful priesthood, and religiously sanctioned social classes persisted through the Vedic period. At some point, the class structure became hereditary and immutable, with lasting consequences for Indian society.

During the latter part of this period, from about 800 BCE, the Upanishads were composed. These metaphysical texts examine the meanings of the earlier, more cryptic Vedic hymns. They focus on the relationship between the individual soul, or *atman*, and the universal soul, or Brahman, as well as on other concepts central to subsequent Indian philosophy. One is the assertion that the material world is illusory and that only Brahman is real and eternal. Another holds that our existence is cyclical and that beings are caught in *samsara*, a relentless cycle of birth, life, death, and rebirth. Believers aspire to attain liberation from *samsara* and to unite individual *atman* with the eternal universal Brahman.

The latter portion of the Vedic period also saw the flowering of India's epic literature, written in the melodious and complex Sanskrit language. By around 400 BCE, the eighteen-volume *Mahabharata*, the longest epic in world literature, and the *Ramayana*, the most popular and enduring religious epic in India and Southeast Asia, were taking shape. These texts, the cornerstones of Indian literature, relate histories of gods and humans that bring the philosophical ideas of the Vedas to a more accessible and popular level.

In this stimulating religious, philosophical, and literary climate numerous religious communities arose. The most influential teachers of these times were Shakyamuni Buddha and Mahavira. The Buddha, or "enlightened one," lived and taught in India around 500 BCE; his teachings form the basis of the Buddhist religion (see "Buddhism," below). Mahavira (c. 599–527 BCE), regarded as the last of twenty-four highly purified superbeings

BUDDHISM The Buddhist religion developed from the teachings of Shakyamuni Buddha, who lived from about 563 to 483 BCE in the present-day regions of Nepal and central India. At his birth, it is believed, seers foretold that the infant prince, named Siddhartha Gautama, would become either a *chakravartin*—a "world-conquering ruler"—or a *buddha*—a "fully enlightened being." Hoping for a ruler like himself, Siddhartha's father tried to surround his son with pleasure and shield him from pain. Yet the prince was eventually exposed to the sufferings of old age, sickness, and death—the inevitable fate of all mortal beings. Deeply troubled by the human condition, Siddhartha at age twenty-nine left the palace, his family, and his inheritance to live as an ascetic in the wilderness. After six years of meditation, he attained complete enlightenment near Bodh Gaya, India.

Following his enlightenment, the Buddha ("Enlightened One") gave his first teaching in the Deer Park at Sarnath. Here he expounded the Four Noble Truths, which are the foundation of Buddhism: (1) life is suffering; (2) this suffering has a cause, which is ignorance; (3) this ignorance can be overcome and extinguished; (4) the way to overcome this ignorance is by following the eightfold path of right view, right resolve, right speech, right action, right livelihood, right effort, right mindfulness, and right concentration. After the Buddha's death at the age of eighty, his many disciples developed his teachings and established the world's oldest monastic institutions.

A *buddha* is not a god but rather one who sees the ultimate nature of the world and is therefore no longer subject to *samsara*, the cycle of birth, death, and rebirth that otherwise holds us in its grip, whether we are born into the world of the gods, humans, animals, tortured spirits, or hell beings.

The early form of Buddhism, known as Theravada or Hinayana, stresses self-cultivation for the purpose of attaining *nirvana*, which is the extinction of *samsara* for oneself; Theravada Buddhism has continued mainly in southern India, Sri Lanka, and Southeast Asia. Within 500 years of the Buddha's death, another form of Buddhism, known as Mahayana, became popular mainly in northern India; it eventually flourished in China (as Chan), Korea, Japan (as Zen), and Tibet (as Vajrayana). Compassion for all beings is the foundation of Mahayana Buddhism, whose goal is not *nirvana* for oneself but buddhahood (enlightenment) for every being throughout the universe. Mahayana Buddhism recognizes *buddhas* other than Shakyamuni from the past, present, and future. One such is Maitreya, the next *buddha* to appear on earth. Another is Amitabha Buddha, the Buddha of Infinite Light and Infinite Life (that is, incorporating all space and time), who dwells in a paradise known as the Western Pure Land. Amitabha Buddha became particularly popular in East Asia. Mahayana Buddhism also developed the category of *bodhisattvas* ("those whose essence is wisdom"), saintly beings who are on the brink of achieving buddhahood but have vowed to help others achieve buddhahood before crossing over themselves.

In art, *bodhisattvas* and *buddhas* are most clearly distinguished by their clothing and adornments: *bodhisattvas* wear the princely garb of India, while *buddhas* wear monks' robes. In Hinduism a deity may dwell in its image, but in Buddhism portrayals of *buddhas* and *bodhisattvas* are recognized as purely symbolic, and no spirit is believed to reside within.

called pathfinders (*tirthankaras*), was the founder of the Jain religion. Both Shakyamuni Buddha and Mahavira espoused some basic Upanishadic tenets, such as the cyclical nature of existence and the need for liberation from the material world. However, they rejected the authority of the Vedas, and with it the legitimacy of the fire sacrifice and the hereditary class structure of Vedic society, with its powerful, exclusive priesthood. In contrast, Buddhism and Jainism were open to all, regardless of social position.

Buddhism became a vigorous force in South Asia and provided the impetus for much of the major art created between the third century BCE and the fifth century CE. The Vedic tradition, meanwhile, continued to evolve, emerging later as Hinduism, a loose term that encompasses the many religious forms that resulted from the mingling of Vedic culture with indigenous beliefs (see "Hinduism," page 378).

THE MAURYA PERIOD

After about 700 BCE, cities again began to appear on the subcontinent, especially in the north, where numerous kingdoms arose. For most of its subsequent history, India was a shifting mosaic of regional dynastic kingdoms. From time to time, however, a particularly powerful dynasty formed an empire. The first of these was the Maurya dynasty (c. 322–185 BCE), which extended its rule over all but the southernmost portion of the subcontinent.

The art of the Maurya period reflects an age of heroes and the rise to prominence of Buddhism, which became the official state religion under the greatest king of the dynasty, Ashoka (ruled c. 273–232 BCE). At this time emerged the ideal of upholding *dharma*, the divinely ordained moral law believed to keep the universe from falling into chaos. The authority of *dharma* seems fully embodied in a lifesize statue found at Didarganj, near the Maurya capital of Pataliputra (fig. 9-6). The statue probably represents a **yakshi**, a spirit associated with the productive forces of nature. With its large breasts and pelvis, the figure embodies the association of female beauty with procreative abundance, bounty, and auspiciousness—qualities that in turn reflect the generosity of the gods and the workings of *dharma* in the world.

Sculpted from fine-grained sandstone, the statue conveys the *yakshi*'s authority through the frontal rigor of her pose, the massive volumes of her form, and the strong, linear patterning of her ornaments and dress. Alleviating and counterbalancing this hierarchical formality are her soft, youthful face, the precise definition of prominent features such as the stomach muscles, and the polished sheen of her exposed flesh. This lustrous polish, the technique of which is a lost secret, is a special feature of Mauryan sculpture.

In addition to depictions of popular deities like the *yakshis* and their male counterparts, **yakshas**, the Maurya period is known for art associated with the imperial sponsorship of Buddhism. Emperor Ashoka, grandson of the dynasty's founder, is considered one of India's greatest rulers. Among the monuments he erected to Buddhism

9-6. *Yakshi Holding a Fly Whisk*, from Didarganj, Patna, Bihar, India. Maurya period, c. 250 BCE. Polished sandstone, height 5'4¼" (1.63 m). Patna Museum, Patna

Discovered near the ancient Maurya capital of Pataliputra, this sculpture has become one of the most famous works of Indian art. Holding a fly whisk in her raised right hand, the *yakshi* wears only a long shawl and a skirtlike cloth. The cloth rests low on her hips, held in place by a girdle. Subtly sculpted parallel creases indicate that it is gathered closely about her legs. The ends, drawn back up over the girdle, cascade down to her feet in a broad, central loop of flowing folds ending in a zigzag of hems. Draped low over her back, the shawl passes through the crook of her arm and then flows to the ground. (The missing left side of the shawl probably mirrored this motion.) The *yakshi*'s jewelry is prominent. A double strand of pearls hangs between her breasts, its shape echoing and emphasizing the voluptuous curves of her body. Another strand of pearls encircles her neck. She wears a simple tiara, plug earrings, and rows of bangles. The nubbled tubes about her ankles probably represent anklets made of beaten gold. Her hair is bound in a large bun in back, and a small bun sits on her forehead. This hairstyle appears again in Indian sculpture of the later Kushan period (c. second century CE).

throughout his empire were monolithic **pillars** set up primarily at sites related to events in the Buddha's life.

Pillars had been used as flag-bearing standards in India since earliest times. The creators of the Ashokan pillars seem to have adapted this already-ancient form to the symbolism of Indian creation myths and the new religion of Buddhism. The fully developed Ashokan pillar, a slightly tapered sandstone **shaft**, usually rested on a stone foundation slab sunk more than 10 feet into the ground and rose to a height of around 50 feet (see fig. 9-1). On it were carved inscriptions relating to rules of *dharma* that Vedic kings were enjoined to uphold but that many later Buddhists interpreted as also referring to Buddhist teachings or exhorting the Buddhist community to unity. At the top, carved from a separate block of sandstone, an elaborate **capital** bore animal sculpture. Both shaft and capital were given the characteristic Maurya polish. Scholars believe that the pillars symbolized the *axis mundi*, or "axis of the world," joining earth with the cosmos. It represented the vital link between the human and celestial realms, and through it the cosmic order was impressed onto the terrestrial world.

The capital in figure 9-7 originally crowned the pillar erected at Sarnath in northeast India, the site of the Buddha's first teaching. The lowest portion represents the down-turned petals of a lotus blossom. Because the lotus flower emerges from murky waters without any mud sticking to its petals, it symbolizes the presence of divine purity in the imperfect world. Above the lotus is an **abacus** (the slab forming the top of a capital) embellished with **low-relief** carvings of wheels, called *chakras*, alternating with four different animals: lion, horse, bull, and elephant. The animals may symbolize the four great rivers of the world, which are mentioned in Indian creation myths. Standing on this abacus are four back-to-back lions.

9-7. Lion capital, from an Ashokan pillar at Sarnath, Uttar Pradesh, India. Maurya period, c. 250 BCE. Polished sandstone, height 7' (2.13 m). Archaeological Museum, Sarnath

HINDUISM Hinduism is not one integral religion but many related sects. Each sect considers its particular deity supreme, and each deity is revealed and depicted in multiple ways. In Vaishnavism, for example, the supreme deity is Vishnu, who manifests himself in the world in ten major incarnations. In Shaivism it is Shiva, who has numerous, complex, and apparently contradictory aspects. In Shaktism, the Goddess, Devi—a deity worshiped under many different names and in various manifestations—has forms indicative of beauty, wealth, and auspiciousness, but also forms of wrath, pestilence, and power. Indeed, she can be more powerful than the male gods.

The Hindu sects all draw upon the texts of the Vedas, which are believed to be sacred revelation. Of critical importance is ritual sacrifice, in which offerings are placed into fire in the belief that they will carry to the gods prayers, most often seeking *moksha*, or liberation from *samsara*, the endless cycle of birth, death, and rebirth. As purity is deemed essential to effective sacrifice, priests (considered more pure than others) perform the ceremonies for other Hindus.

Hindus believe that every action has a purpose and consequences. Desire for the fruits of our actions keeps us trapped in *samsara*. But if our actions are offerings to a god, their fruits too will belong to the deity—meaning that we act not out of selfish desire, but for the god's sake. The most compelling expression of these beliefs occurs in the *Bhagavad Gita*, a section of the *Mahabharata*, where Krishna, an incarnation of Vishnu, reveals them as truths to the warrior Arjuna on the battlefield.

Hindu deities are believed to arise from a state of being called Brahman, or Formless One, into a Subtle Body stage. From the Subtle Body emanates our world of space-time and all that it contains. Into this world the deity then manifests itself in Gross Body form to help living beings. These three stages of a deity's emanation from One to the Many—Formless One, Subtle Body, and Gross Body—underlie much Hindu art and architecture.

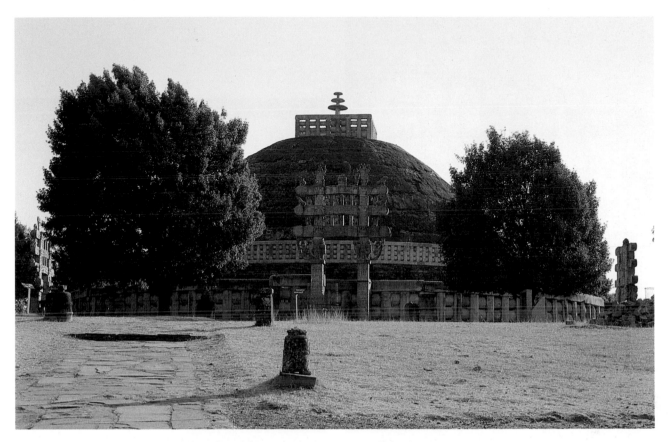

9-8. Great Stupa, Sanchi, Madhya Pradesh, India. Founded 3rd century BCE, enlarged c. 150–50 BCE

Facing the four cardinal directions, the lions may be emblematic of the universal nature of Buddhism. Their roar might be compared to the speech of the Buddha that spreads far and wide. The lions may also refer to the Buddha himself, who is known as "the lion of the Shakya clan" (the clan into which the Buddha was born as prince). The lions originally supported a great copper wheel, now lost. A universal Buddhist symbol, the wheel refers to Buddhist teaching, for with his sermon at Sarnath the Buddha "set the wheel of the doctrine [*dharma*] in motion."

Their formal, heraldic pose imbues the lions with something of the monumental quality evident in the statue of the *yakshi* of the same period. We also find the same strong patterning of realistic elements: Veins and tendons stand out on the legs; the claws are large and powerful; the mane is richly textured; and the jaws have a loose and fluttering edge.

THE PERIOD OF THE SHUNGAS AND EARLY ANDHRAS

With the demise of the Maurya Empire, India returned to local rule by regional dynasties. Between the second century BCE and the early first century CE, the most important of these dynasties were the Shunga in central India and the early Andhra in South India. During this period, Buddhism continued to be the main inspiration for art, and some of the most magnificent early Buddhist structures were created.

STUPAS

Probably no early Buddhist structure is more famous than the Great Stupa at Sanchi in central India (fig. 9-8). Originally built by King Ashoka in the Maurya period, the Great Stupa was part of a large monastery complex crowning a hill. During the mid-second century BCE the stupa was enlarged to its present size, and the surrounding stone railing was constructed. About 100 years later, elaborately carved stone gateways were added to the railing.

Stupas—religious monuments enclosing a relic chamber—are fundamental to Buddhism (see "Stupas and Temples," page 381). The first stupas were constructed to house the Buddha's remains after his cremation. At that time (c. 483 BCE), the relics were divided into eight portions and placed in eight **reliquaries**. Each reliquary was then encased in its own burial mound, called a stupa. In the mid-third century BCE King Ashoka opened the original eight stupas and divided their relics among many more stupas, probably including the one at Sanchi. Since the early stupas held actual remains of the Buddha, they were venerated as his body and, by extension, his enlightenment and attainment of *nirvana*—liberation from rebirth. The method of veneration was, and still is, to circumambulate, or walk around, the stupa in a clockwise direction, following the sun's path across the sky. Stupas are open to all for private worship.

A stupa may be small and plain or large and elaborate. Its form may vary from region to region, but its

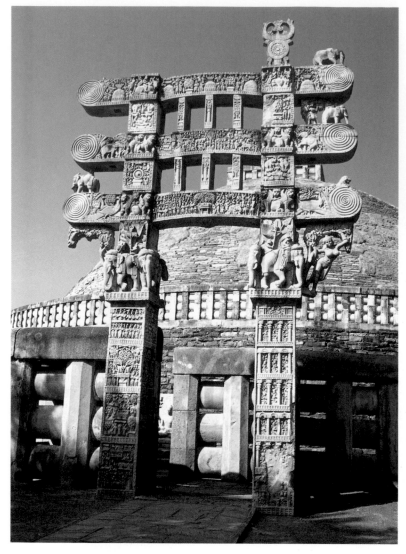

9-9. **East *torana* of the Great Stupa at Sanchi**. Early Andhra period, mid-1st century BCE. Stone, height 35' (10.66 m)

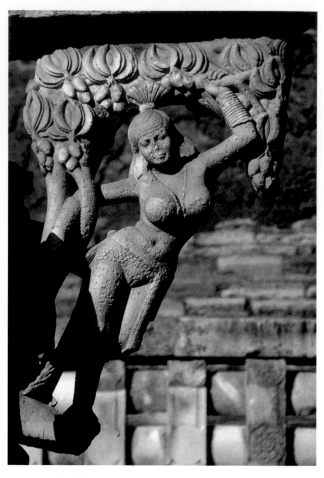

9-10. ***Yakshi* bracket figure**, on the east *torana* of the Great Stupa at Sanchi. Stone, height approx. 60" (152.4 cm)

symbolic meaning remains virtually the same, and its plan is a carefully calculated ***mandala***, or diagram of the cosmos as it is envisioned in Buddhism. The Great Stupa at Sanchi is a representative of the early central Indian type. Its solid, hemispherical **dome** was built up from rubble and dirt, faced with **dressed stone**, then covered with a shining white plaster made from lime and powdered seashells. The dome—echoing the arc of the sky—sits on a raised base. Around the perimeter is a walkway enclosed by a railing and approached by a pair of staircases. As is often true in religious architecture, the railing provides a physical and symbolic boundary between an inner, sacred area and the outer, profane world. On top of the dome, another stone railing, square in shape, defines the abode of the gods atop the cosmic mountain. It encloses the top of a mast bearing three stone disks, or "umbrellas," of decreasing size. These disks have been interpreted in various ways. They may refer to the Buddhist concept of the three realms of exis-

tence—desire, form, and formlessness. The mast itself is an *axis mundi*, connecting the cosmic waters below the earth with the celestial realm above it and anchoring everything in its proper place.

An 11-foot-tall stone railing rings the entire stupa, enclosing another, wider, circumambulatory path at ground level. Carved with octagonal uprights and lens-shaped crossbars, it probably simulates the wooden railings of the time. This design pervaded early Indian art, appearing in relief sculpture and as architectural ornament. Four stone gateways, or ***toranas***, punctuate the railing (fig. 9-9). Set at the four cardinal directions, the *toranas* symbolize the Buddhist cosmos. According to an inscription, they were sculpted by ivory carvers from the nearby town of Vidisha. The only elements of the Great Stupa at Sanchi to be ornamented with sculpture, the *toranas* rise to a height of 35 feet. Their square posts are carved with symbols and scenes drawn mostly from the Buddha's life and his past lives. Vines, lotuses,

geese, and mythical animals decorate the sides, while guardians sculpted on the lowest panel of each inner side protect the entrance. The "capitals" above the posts consist of four back-to-back elephants on the north and east gates, dwarfs on the south gate, and lions on the west gate. The capitals in turn support a three-tiered superstructure whose posts and crossbars are elaborately carved with still more symbols and scenes and studded with freestanding sculpture depicting such subjects as *yakshis* and *yakshas*, riders on real and mythical animals, and the Buddhist wheel. As in all known early Buddhist art, the Buddha himself is not shown in human form. Instead, he is represented by symbols such as his footprints, an empty "enlightenment" seat, or a stupa.

Forming a bracket between each capital and the lowest crossbar is a sculpture of a *yakshi* (fig. 9-10). These

yakshis are some of the finest female figures in Indian art, and they make an instructive comparison with the *yakshi* of the Maurya period (see fig. 9-6). The earlier figure was distinguished by a formal, somewhat rigid pose, an emphasis on realistic details, and a clear distinction between clothed and nude parts of the body. In contrast, the Sanchi *yakshi* leans daringly into space with casual abandon, supported by one leg as the other charmingly crosses behind. Her thin, diaphanous garment is noticeable only by its hems, and so she appears almost nude, which emphasizes her form. The band pulling gently at her abdomen accentuates the suppleness of her flesh. The swelling, arching curves of her body evoke this deity's procreative and bountiful essence. As the personification of the waters, she is the source of life. Here she symbolizes the sap of the tree, which flowers at her touch.

ELEMENTS OF ARCHITECTURE

Stupas and Temples

Buddhist architecture in South Asia consists mainly of stupas and temples, often at monastic complexes containing **viharas** (monks' cells and common areas). These monuments may be either structural—built up from the ground—or rock-cut—hewn out of a mountainside. Stupas derive from burial mounds and contain relics beneath a solid, dome-shaped core. A major stupa is surrounded by a railing that creates a sacred path for ritual circumambulation at ground level. This railing is punctuated by gateways called **toranas**, aligned with the cardinal points; access is through the eastern *torana*. The stupa sits on a round or square terrace; stairs lead to an upper circumambulatory path around the platform's edge. On top of the stupa's dome a railing defines a square, from the center of which rises a mast supporting tiers of disk-shaped "umbrellas."

Hindu architecture in South Asia consists mainly of temples, either structural or rock-cut, executed in a number of styles and dedicated to a vast range of deities. The two general Hindu temple types are the northern and southern styles—corresponding to North India and South India, respectively. Within these broad categories is great stylistic diversity, though all are raised on plinths and dominated by their superstructures, towers called **shikharas** in the North and **vimanas** in the South. *Shikharas* are crowned by **amalakas**, *vimanas* by large **capstones**. Inside, a series of **mandapas** (halls) leads to an inner sanctuary, the **garbhagriha**, which contains a sacred image. An *axis mundi* runs vertically up from the cosmic waters below the earth, through the *garbhagriha*'s image, and out through the top of the tower.

Jain architecture consists mainly of structural and rock-cut monasteries and temples that have much in common with their Buddhist and Hindu counterparts. Buddhist, Hindu, and Jain temples may share a site.

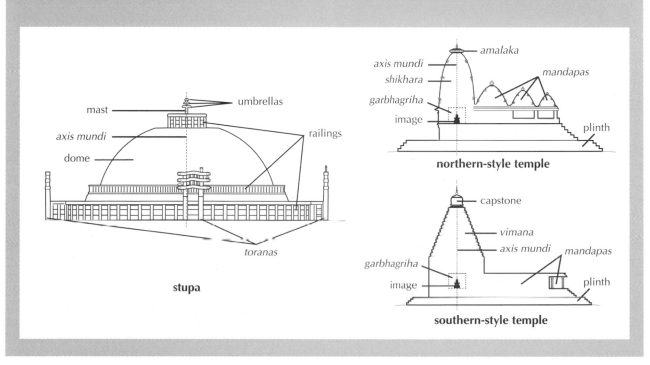

stupa

northern-style temple

southern-style temple

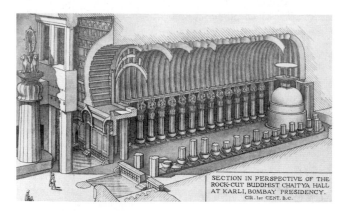

9-11. **Section of the** *chaitya* **hall at Karla**, Maharashtra, India. Early Andhra period, second half of 1st century BCE

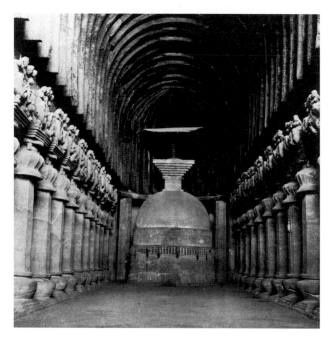

9-12. *Chaitya* **hall at Karla**

The profusion of designs, symbols, scenes, and figures carved on all sides of the gateways to the Great Stupa not only relates the history and lore of Buddhism but also represents the teeming life of the world and the gods.

BUDDHIST ROCK-CUT HALLS

From ancient times, caves have been considered hallowed places in India, for they were frequently the abode of holy ones and ascetics. Around the second century BCE, Buddhist monks began to hew caves for their own use out of the stone plateaus in the region of south-central India

known as the Deccan. The exteriors and interiors were carved from top to bottom like great pieces of sculpture, with all details completely finished in stone. To enter one of these remarkable halls is to feel transported to an otherworldly, sacred space. The energy of the living rock, the mysterious atmosphere created by the dark recess, the echo that magnifies the smallest sound—all combine to promote a state of heightened awareness.

The monastic community made two types of rock-cut halls. One was the **vihara**, used for the monks' living quarters, and the other was the **chaitya**, meaning "sacred," which usually enshrined a stupa. A *chaitya* hall at Karla, dating from around the latter half of the first century BCE, is the largest and most fully developed example of these early Buddhist works (figs. 9-11, 9-12). At the entrance, columns once supported a balcony, in front of which a pair of Ashokan-type pillars stood. The walls of the vestibule are carved in relief with rows of small balcony railings and arched windows, simulating the facade of a great multistoried palace. At the base of the side walls, enormous statues of elephants seem to be supporting the entire structure on their backs. Dominating the upper portion of the main facade is a large horseshoe-shaped opening called a sun window or *chaitya* window, which provides the hall's main source of light. The window was originally fitted with a carved wood screen, some of which remains, that filtered the light streaming inside.

Three entrances pierce the main facade. The two side entrances are each approached through a shallow pool of water, which symbolically purifies visitors as it washes their dusty feet. Flanking the entrances are sculpted panels of **mithuna** couples, amorous male and female figures that evoke the harmony and fertility of life. The interior hall, 123 feet long, has a 46-foot-high ceiling carved in the form of a **barrel vault** ornamented with arching wooden ribs. Both the interior and exterior of the hall were once brightly painted. A wide central aisle and two narrower side aisles lead to the stupa in the **apse** at the far end.

The closely spaced columns that separate the side aisles from the main aisle are unlike any known in the West, and they are important examples in the long and complex evolution of the many Indian styles. The base resembles a large pot set on a stepped pyramid of planks. From this potlike form rises a massive octagonal shaft. Crowning the shaft, a bell-shaped lotus capital supports an inverted pyramid of planks, which serves in turn as a platform for sculpture. The statues facing the main aisle depict pairs of kneeling elephants, each bearing a *mithuna* couple; those facing the side aisles depict pairs of horses also bearing couples. These figures, the only sculpture within this austere hall, represent the nobility coming to pay homage at the temple. The pillars around the apse are plain, and the stupa is simple. A railing motif ornaments the base; the dome was once topped with wooden "umbrella" disks, only one of which remains. Like nearly everything in the cave, the stupa is carved from the living rock. Although much less ornate than the stupa at Sanchi, its symbolism is the same.

THE KUSHAN AND LATER ANDHRA PERIODS

Around the first century CE the regions of present-day Afghanistan, Pakistan, and North India came under the control of the Kushans, a nomadic people from Central Asia. The beginning of the long reign of their most illustrious king, Kanishka, is variously dated from 78 to 143 CE. Kanishka's patronage supported the building of many stupas and Buddhist monasteries.

Buddhism during this period underwent a profound evolution that resulted in the form known as Mahayana, or Great Vehicle (see "Buddhism," page 376). This vital new movement, which was to sweep most of northern India and eastern Asia, probably inspired the first depictions of the Buddha himself in art. (Previously, as in the Great Stupa at Sanchi, the Buddha had been indicated solely by symbols.) The two earliest schools of representation arose in the Gandhara region in the northwest (present-day Pakistan and Afghanistan) and in the famous religious center of Mathura in central India. Both of these areas were ruled by the Kushans. Slightly later, a third school, known as the Amaravati school after its most famous site, developed to the south under the Andhra dynasty, which ruled much of southern and central India from the second century BCE through the second century CE.

While all three schools cultivated distinct styles, they shared a basic visual language, or **iconography**, in which the Buddha is readily recognized by certain characteristics. He wears a monk's robe called a **sanghati**, a long length of cloth draped over the left shoulder and around the body. The Buddha is said to have had thirty-two major distinguishing marks, called **lakshana**, some of which also passed into the iconography (see "Buddhist Symbols," page 432). These include a golden-colored body, long arms that reached to his knees, the impression of a wheel (*chakra*) on the palms of his hands and the soles of his feet, and the **urna**—a tuft of white hair between his eyebrows. Because he had been a prince in his youth and had worn the customary heavy earrings, his earlobes are usually shown elongated. The top of his head is said to have had a protuberance called an **ushnisha**, which in images often resembles a bun or topknot and symbolizes his enlightenment.

9-13. *Standing Buddha*, from Gandhara (Pakistan). Kushan period, c. 2nd–3rd century CE. Schist, height 7'6" (2.28 m). Lahore Museum, Lahore

THE GANDHARA SCHOOL

A typical image from the Gandhara school portrays the Buddha as a superhuman figure, more powerful and heroic than an ordinary human (fig. 9-13). This over-life-size Buddha dates to the fully developed stage of the Gandhara style around the third century CE. It is carved from schist, a fine-grained dark stone. The Buddha's body, revealed through the folds of the garment, is broad and massive, with heavy shoulders and limbs and a well-defined torso. His left knee bends gently, suggesting a slightly relaxed posture.

The treatment of the *sanghati* is especially characteristic of the Gandhara manner. Tight, riblike folds alternate with delicate creases, setting up a clear, rhythmic pattern of heavy and shallow lines. On the upper part of the figure, the folds break asymmetrically along the left arm; on the lower part, they drape in a symmetric **U** shape. The strong tension of the folds suggests life and power within the image. This complex fold pattern resembles the treatment of togas on certain Roman statues (see fig. 6-18), and it exerted a strong influence on portrayals of the Buddha in Central and East Asia. The Gandhara region's relations with the Hellenistic world may have led to this strongly Western style in its art. Pockets of Hellenistic culture had thrived in neighboring Bactria (present-day northern Afghanistan and southern Uzbekistan) since the fourth century BCE, when the Greeks under Alexander the Great reached the borders of India. Also, Gandhara's position near the

9-14. *Buddha and Attendants*, from Katra Keshavdev, Mathura, Madhya Pradesh, India. Kushan period, c. late 1st–early 2nd century CE. Red sandstone, height 27¼" (69.2 cm). Government Museum, Mathura

East-West trade routes appears to have stimulated contact with Roman culture in the Near East during the early centuries of the first millennium CE.

THE MATHURA SCHOOL

The second major school of Buddhist art in the Kushan period, that at Mathura, was not allied with the Hellenistic-Roman tradition. Instead, its style evolved from representations of *yakshas*, the indigenous male nature deities. Images produced at Mathura during the early days of the school may be the first representations of the Buddha to appear in art.

The **stele** in figure 9-14 is one of the finest of the early Mathura images. Carved in **high relief** from a block of red sandstone, it depicts a seated Buddha with two attendants. The Buddha sits in a yogic posture on a pedestal supported by lions. His right hand is raised in a symbolic gesture meaning "have no fear." Images of the Buddha rely on a repertoire of such gestures, called ***mudras***, to communicate certain ideas, such as teaching, meditation, or the attaining of enlightenment (see "Mudras," page 385). The Buddha's *urna*, his *ushnisha*, and the impressions of wheels on his palms and soles are all clearly visible in this figure. Behind his head is

a large, circular halo; the scallop points of its border represent radiating light. Behind the halo are branches of the pipal tree, the tree under which the Buddha was seated when he achieved enlightenment. Two celestial beings hover above.

As in the Gandhara school, the Mathura work gives a powerful impression of the Buddha. Yet this Buddha's riveting outward gaze and alert posture impart a more intense, concentrated energy. The robe is pulled tightly over the body, allowing the fleshy form to be seen as almost nude. Where the pleats of the *sanghati* appear, such as over the left arm and fanning out between the legs, they are depicted abstractly through compact parallel formations of ridges with an **incised** line in the center of each ridge. This characteristic Mathura tendency to abstraction also appears in the face, whose features take on geometric shapes, as in the rounded forms of the widely opened eyes. Nevertheless, the torso with its subtle and soft modeling is strongly naturalistic.

THE AMARAVATI SCHOOL

Events from the Buddha's life were popular subjects in the reliefs decorating stupas and Buddhist temples. One example from Nagarjunakonda, a site of the Amaravati

MUDRAS *Mudras* (Sanskrit word for "signs") are ancient symbolic hand gestures that are regarded as physical expressions of different states of being. In Buddhist art, they function iconographically. *Mudras* also are used during meditation to release these energies. Following are the most common *mudras* in Asian art.

Dharmachakra mudra

The gesture of teaching, setting the *chakra* (wheel) of the *dharma* (law, or doctrine) in motion. Hands are at chest level.

Dhyana mudra

A gesture of meditation and balance, symbolizing the path toward enlightenment. Hands are in the lap, the lower representing *maya*, the physical world of illusion, the upper representing *nirvana*, enlightenment and release from the world.

Vitarka mudra

This variant of *dharmachakra mudra* stands for intellectual debate. Each hand forms this gesture, the right at shoulder level, pointing downward, and the left at hip level, pointing upward.

Abhaya mudra

The gesture of reassurance, blessing, and protection, this *mudra* means "have no fear." The right hand is at shoulder level, palm outward.

Bhumisparsha mudra

This gesture calls upon the earth to witness Shakyamuni Buddha's enlightenment at Bodh Gaya. A seated figure's right hand reaches toward the ground, palm inward.

Varada mudra

The gesture of charity, symbolizing the fulfillment of all wishes. Alone, this *mudra* is made with the right hand; when combined with *abhaya mudra* in standing *buddha* figures, the left hand is shown in *varada mudra*.

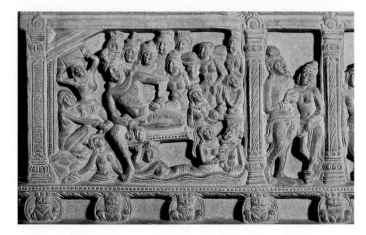

9-15. *Siddhartha in the Palace*, detail of a relief from Nagarjunakonda, Andhra Pradesh, India. Later Andhra period, c. 3rd century CE. Limestone. National Museum, New Delhi

In his *Buddhacharita*, a long poem about the life of the Buddha, the great Indian poet Ashvagosha (c. 100 CE) describes Prince Siddhartha's life in the palace: "The monarch [Siddhartha's father], reflecting that the prince must see nothing untoward that might agitate his mind, assigned him a dwelling in the upper storeys of the palace and did not allow him access to the ground. Then in the pavilions, white as the clouds of autumn, with apartments suited to each season and resembling heavenly mansions come down to earth, he passed the time with the noble music of singing-women." Later, during an outing, a series of unexpected encounters confronts Siddhartha with the nature of mortality. Deeply shaken, he cannot bring himself to respond to the perfumed entreaties of the women who greet him on his return: "For what rational being would stand or sit or lie at ease, still less laugh, when he knows of old age, disease and death?" In this relief, the prince, though surrounded by women in the pleasure garden, seems already to bear the sober demeanor of these thoughts, which were profoundly to affect not only his life, but the world.

(Translated by E. H. Johnston)

school in the south, depicts a scene from the Buddha's life when he was Prince Siddhartha, before his renunciation and subsequent quest for enlightenment (fig. 9-15). Carved in low relief, the panel reveals a scene of pleasure around a pool of water. Gathered around Siddhartha, the largest figure and the only male, are some of the palace women. One holds his foot, entreating him to come into the water; another sits with legs drawn up on the nearby rock; others lean over his shoulder or fix their hair; one comes into the scene with a box of jewels on her head. The panel is framed by decorated columns, crouching lions, and amorous *mithuna* couples. (One of these couples is visible at the right of the illustration.) The scene is skillfully orchestrated to revolve around the prince as the main focus of all eyes. Typical of the southern school, the figures are slighter than those of the Gandhara and Mathura schools. They are sinuous and mobile, even while at rest. The rhythmic nuances of the limbs and varied postures not only create interest in the activity of each individual but also engender a light and joyous effect.

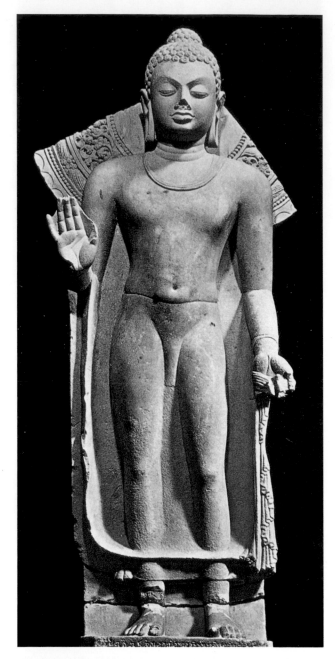

THE GUPTA PERIOD

The Guptas, who founded a dynasty in the eastern region of central India known as Magadha, expanded their territories during the fourth century to form an empire that encompassed northern and much of southern India. Although Gupta power prevailed for only about 130 years (c. 320–450 CE) before the dynasty's collapse around 500 CE, the influence of Gupta culture was felt for centuries.

The Gupta period is renowned for the flourishing artistic and literary culture that brought forth some of India's most widely admired sculpture and painting. During this time, Buddhism reached its greatest influence in India, although Hinduism, supported by the Gupta monarchs, began to rise in popularity.

BUDDHIST SCULPTURE

Two schools of Buddhist sculpture reached their artistic peak during the second half of the fifth century and dominated in northern India: the Mathura, one of the major schools of the earlier Kushan period, and the school at Sarnath.

The standing Buddha in figure 9-16 embodies the fully developed Sarnath Gupta style. Carved from fine-grained sandstone, the figure stands in a mildly relaxed pose, the body clearly visible through a clinging robe. This plain *sanghati*, portrayed with none of the creases and folds so prominent in the Kushan period images, is distinctive of the Sarnath school. Its effect is to concentrate attention on the perfected form of the body, which emerges in high relief. The body is graceful and slight, with broad shoulders and a well-proportioned torso. Only a few lines of the garment at the neck, waist, and hems interrupt the purity of its subtly shaped surfaces; the face, smooth and ovoid, has the same refined elegance. The downcast eyes suggest otherworldly introspection, yet the gentle, open posture maintains a human link. Behind the head are the remains of a large, circular halo. Carved in concentric circles of pearls and foliage, it would have contrasted dramatically with the plain surfaces of the figure.

The Sarnath Gupta style reveals the Buddha in perfection and equilibrium. He is not represented as a superhuman presence but as a being whose spiritual purity is evidenced by, and fused with, his physical purity, one whose nature blends that of the fully enlightened with that of the fully human.

9-16. *Standing Buddha*, from Sarnath, Uttar Pradesh, India. Gupta period, 474 CE. Chunar sandstone, height 6'4" (1.93 m). Archaeological Museum, Sarnath

PAINTING

The Gupta aesthetic also found expression in painting. Some of the finest surviving works are murals from the Buddhist rock-cut halls of Ajanta, in the western Deccan region of India (fig. 9-17). Under a local dynasty, many caves were carved around 475 CE, including Cave I, a large *vihara* hall with monks' chambers around the sides and a Buddha shrine chamber in the back. The walls of the central court were covered with murals painted in **fresco** technique, with mineral pigments on a prepared plaster surface. Some of these paintings depict episodes from the

During the first to third century CE, each of the three major schools of Buddhist art developed its own distinct idiom for expressing the complex imagery of Buddhism and depicting the image of the Buddha. The Gandhara and Amaravati schools declined over the ensuing centuries, mainly due to the demise of the major dynasties that had supported their Buddhist establishments. However, the schools of central India, including the school of Mathura, continued to develop, and from them came the next major development in Indian Buddhist art.

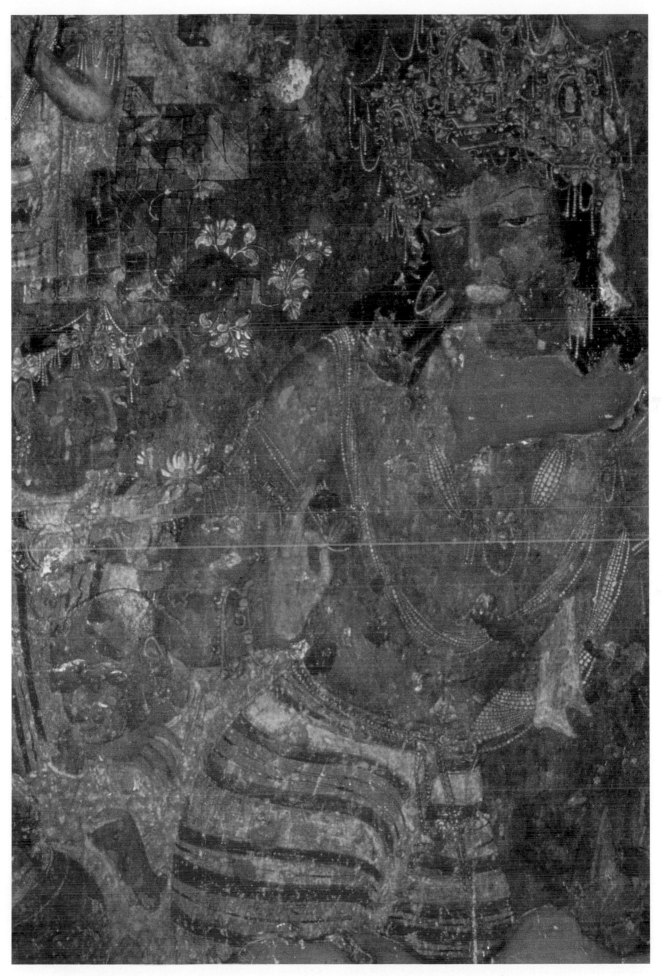

9-17. *Bodhisattva*, detail of a wall painting in Cave I, Ajanta, Maharashtra, India. Gupta period, c. 475 CE

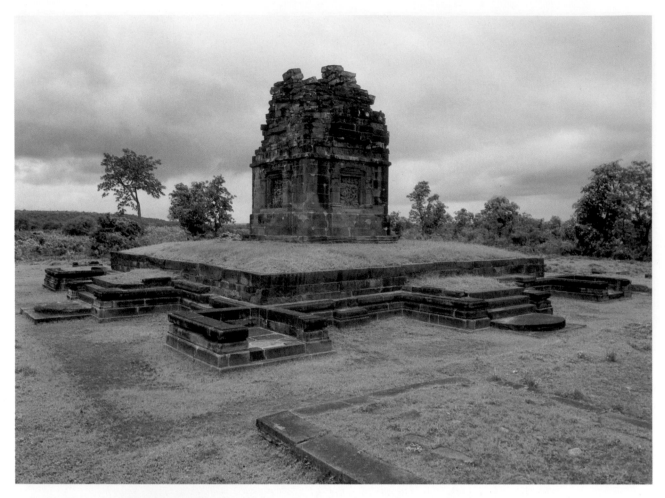

9-18. Vishnu Temple at Deogarh, Uttar Pradesh, India. Post-Gupta period, c. 530 CE

Buddha's past lives. Flanking the entrance to the shrine are two large *bodhisattvas*, one of which is seen in figure 9-17.

Bodhisattvas are enlightened beings who postpone *nirvana* and buddhahood to help others achieve enlightenment. They are distinguished from *buddhas* in art by their princely garments. The *bodhisattva* here is lavishly adorned with delicate ornaments. He wears a complicated crown with many tiny pearl festoons, large earrings, long necklaces of twisted pearl strands, armbands, and bracelets. A striped cloth covers his lower body. The graceful bending posture and serene gaze impart a sympathetic attitude. His spiritual power is suggested by his large size in comparison with the surrounding figures.

The naturalistic style balances outline and softly graded color tones. Outline drawing, always a major ingredient of Indian painting, clearly defines shapes; tonal gradations impart the illusion of three-dimensional form, with lighter tones used for protruding parts such as the nose, brows, shoulders, and chest muscles. Together with the details of the jewels, these highlighted areas resonate against the subdued tonality of the figure and the somber, flower-strewn background. Sophisticated, realistic detail is balanced, in typical Gupta fashion, by the languorous human form. In no other known examples of Indian painting do *bodhisattvas* appear so graciously divine yet at the same time so palpably human. This particular synthesis, evident also in the Sarnath statue, is the special Gupta artistic achievement.

THE POST-GUPTA PERIOD Although the Gupta dynasty came to an end around 500 CE, its influence—in both religion and the arts—lingered until the mid-seventh century. While Buddhism had flourished in India during the fifth century, Hinduism, sponsored by Gupta monarchs, began its ascent toward eventual domination of Indian religious life. Hindu temples and sculpture of the Hindu gods, though known earlier, increasingly appeared during the Gupta period and the post-Gupta era.

THE EARLY NORTHERN TEMPLE

The Hindu temple developed many different forms throughout India, but it can be classified broadly into two types, northern and southern. The northern type is chiefly distinguished by a superstructure called a **shikhara** (see "Stupas and Temples," page 381). The *shikhara* rises as a solid mass above the flat stone ceiling and windowless walls of the sanctum, or **garbhagriha**, which houses an image of the temple's deity. As it rises, it curves inward in a mathematically determined ratio. (In mathematical terms, the *shikhara* is a paraboloid.) Crowning the top is a circular, cushionlike element called an **amalaka**, which means "sunburst." From the *amalaka* a **finial** takes the eye to a point where the earthly world is thought to join the cosmic world. An imaginary *axis mundi* penetrates the

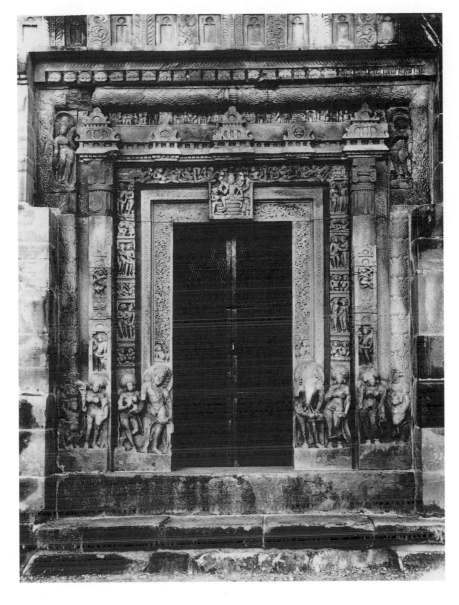

9-19. Doorway of the Vishnu Temple at Deogarh

entire temple, running from the point of the finial, through the exact center of the *amalaka* and *shikhara*, down through the center of the *garbhagriha* and its image, finally passing through the base of the temple and into the earth below. In this way the temple becomes a conduit between the celestial realms and the earth. This theme, familiar from Ashokan pillars and Buddhist stupas, is carried out with elaborate exactitude in Hindu temples, and it is one of the most important elements underlying their form and function (see "Meaning and Ritual in Hindu Temples and Images," page 390).

One of the earliest northern-style temples is the temple of Vishnu at Deogarh in central India, which dates from around 530 CE (fig. 9-18). Much of the *shikhara* has crumbled away, so we cannot determine its original shape with precision. Nevertheless, it was clearly a massive, solid structure built of large cut stones. It would have given the impression of a mountain, which is one of several metaphoric meanings of a Hindu temple. This early temple has only one chamber, the *garbhagriha*, which corresponds to the center of a sacred diagram called a *mandala* on which the entire temple site is patterned. As the deity's residence, the *garbhagriha* is likened to a sacred

cavern within the "cosmic mountain" of the temple.

The entrance to a Hindu temple is elaborate and meaningful. The doorway at Deogarh is well preserved and an excellent example (fig. 9-19). Because the entrance takes a worshiper from the mundane world into the sacred, stepping over a threshold is considered a purifying act. Two river goddesses, one on each upper corner of the **lintel**, symbolize the purifying waters flowing down over the entrance. These imaginary waters also provide symbolic nourishment for the vines and flowers decorating some of the vertical **jambs**. The innermost vines sprout from the navel of a dwarf, one of the popular motifs in Indian art. *Mithuna* couples and small replicas of the temple line other jambs. At the bottom, male and female guardians flank the doorway. Above the door, in the center, is a small image of the god Vishnu, to whom the temple is dedicated.

Large panels sculpted in relief with images of Vishnu appear as "windows" on the temple's exterior. These elaborately framed panels do not function literally to let light *into* the temple; they function symbolically to let the light of the deity *out* of the temple to be seen by those outside. The panels thus symbolize the third phase of Vishnu's threefold emanation from Brahman, the Formless One,

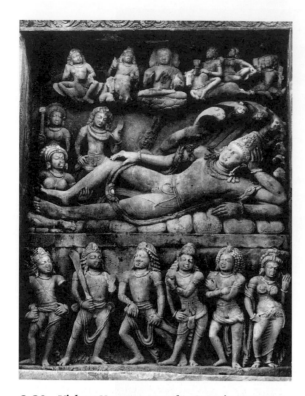

9-20. *Vishnu Narayana on the Cosmic Waters*,
relief panel in the Vishnu Temple at Deogarh.
Stone c. 530 CE

into our physical world. (For a discussion of the emanation of Hindu deities, see "Hinduism," page 378.)

One panel depicts Vishnu Lying on the Cosmic Waters at the beginning of creation (fig. 9-20). This vision represents the Subtle Body, or second, stage of the deity's emanation. Vishnu sleeps on the serpent of infinity, Ananta, whose body coils endlessly into space. Stirred by his female aspect (*shakti*, or female energy), personified here by the goddess Lakshmi, seen holding his foot, Vishnu dreams the universe into existence. From his navel springs a lotus (shown in this relief behind Vishnu), and the unfolding of space-time begins. The first being to be created is Brahma (not to be confused with Brahman), who appears here as the central, four-headed figure in the row of gods portrayed above the reclining Vishnu. Brahma turns himself into the universe of space and time by thinking, "May I become Many."

The sculptor has depicted Vishnu as a large, resplendent figure with four arms. His size and his many arms connote his omnipotence. He is lightly garbed but richly ornamented. The ideal of the Gupta style persists in the smooth, perfected shape of the body and in the lavishly detailed jewelry, including Vishnu's characteristic cylindrical crown. The four rightmost figures in the frieze below personify Vishnu's powers. They stand ready to fight the appearance of evil, represented at the left of the

MEANING AND RITUAL IN HINDU TEMPLES AND IMAGES

The Hindu temple is one of the most complex and meaningful architectural forms in Asian art. Age-old symbols and ritual functions are embedded not only in a structure's many parts but also in the process of construction itself. Patron, priest, and architect worked as a team to ensure the sanctity of the structure from start to finish. No artist or artisan was more highly revered in ancient Indian society than the architect, who could oversee the construction of an abode in which a deity would dwell.

For a god to take up residence, however, everything had to be done properly in exacting detail. By the sixth century CE, the necessary procedures had been recorded in texts called the *Silpa Shastra*. First, an auspicious site was chosen; a site near water was especially favored, for water makes the earth fruitful. Next, the ground was prepared in an elaborate process that took several years: spirits already inhabiting the site were invited to leave; the ground was planted and harvested through two seasons; then cows—sacred beasts since the Indus Valley civilization—were pastured there to lend their potency to the site. When construction began, each phase was accompanied by ritual to ensure its purity and sanctity.

All Hindu temples are built on a mystical plan known as a **mandala**, a schematic design of a sacred realm or space—specifically, the *mandala* of the Cosmic Man (Vastupurusha *mandala*), the primordial progenitor of the human species. His body, fallen on earth, is imagined as superimposed on the *mandala* design; together, they form the base on which the temple rises. The Vastupurusha *mandala* always takes the form of a square subdivided into a number of equal squares (usually sixty-four) surrounding a central square. The central square represents Brahman, the primordial, unmanifest Formless One. This square corresponds to the temple's sanctum, the windowless *garbhagriha*, or "womb chamber." The nature of Brahman is clear, pure light; that we perceive the *garbhagriha* as dark is considered a testament to our deluded nature. The surrounding squares belong to lesser deities, while the outermost compartments hold protector gods. These compartments are usually represented by the enclosing wall of a temple compound.

The *garbhagriha* houses the temple's main image—most commonly a stone, bronze, or wood statue of Vishnu, Shiva, or Devi. The image is made with the understanding that the god will inhabit it. To ensure perfection, its proportions follow a set canon, and rituals surround its making. When the image is completed, a priest recites *mantras*, or mystic syllables, that bring the deity into the image. The belief that a deity is literally present is not taken lightly. Even in India today, any image "under worship"—whether it be in a temple or a field, an ancient work or a modern piece—will be respected and not taken from the people who worship it.

A Hindu temple is a place for individual devotion, not congregational worship. It is the place where a devotee can make offerings to one or more deities and be in the presence of the god who is embodied in the image in the *garbhagriha*. Worship generally consists of prayers and offerings such as food and flowers or water and oil for the image, but it can also be much more elaborate, including dancing and ritual sacrifices.

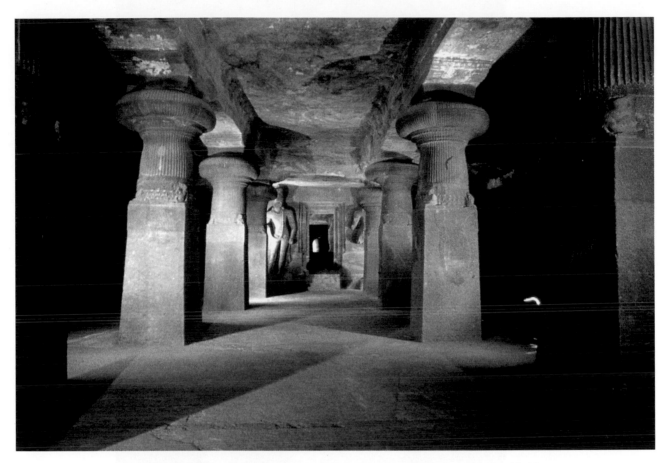

9-21. Cave-Temple of Shiva at Elephanta, Maharashtra, India. Post-Gupta period, mid-6th century CE.
View along the east-west axis to the *lingam* shrine

frieze by two demons who threaten to kill Brahma and jeopardize all creation.

The birth of the universe and the appearance of evil are thus portrayed here in three clearly organized **registers**. Typical of Indian religious and artistic expression, these momentous events are set before our eyes not in terms of abstract symbols but as a drama acted out by gods in superhuman form. The birth of the universe is imagined not as a "big bang" of infinitesimal particles from a supercondensed black hole but as a lotus unfolding from the navel of Vishnu.

MONUMENTAL NARRATIVE RELIEFS

Another major Hindu god, Shiva, was known in Vedic times as Rudra, "the howler." He was "the wild red hunter" who protected beasts and inhabited the forests. Shiva, which means "benign," exhibits a wide range of aspects or forms, both gentle and wild: he is the Great Yogi who dwells for vast periods of time in meditation in the Himalayas; he is also the Husband par excellence who makes love to the goddess Parvati for eons at a time; he is the Slayer of Demons; and he is the Cosmic Dancer who dances the destruction and re-creation of the world. Shiva assumes such seemingly contradictory natures purposely, to make us question reality.

Many of these forms of Shiva appear in the monu-mental relief panels adorning the Cave-Temple of Shiva carved in the mid-sixth century on the island of Elephanta off the coast of Bombay in western India. The cave-temple is complex in layout and conception, perhaps to reflect the nature of Shiva. While most temples have one entrance, this temple offers three—one facing north, one east, and one west. The interior, impressive in its size and grandeur, is designed along two main axes, one running north-south, the other east-west. The three entrances provide the only source of light, and the resulting cross- and back-lighting effects add to the sense of the cave as a place of mysterious, almost confusing complexity. A worshiper is thrown off-balance—fit preparation for a meeting with Shiva, the most unpredictable of the Hindu gods.

Along the east-west axis, large pillars cut from the living rock appear to support the low ceiling and its beams, although, as with all architectural elements in a cave-temple, they are not structural (fig. 9-21). The pillars form orderly rows, but the rows are hard to discern within the framework of the cave shape, which is neither square nor longitudinal, but overlapping *mandalas* that create a symmetric yet irregular space. The pillars are an important aesthetic component of the cave. Each has an unadorned, square base rising to nearly half its total height. Above is a circular column, which has a curved contour and a billowing "cushion" capital. Both column

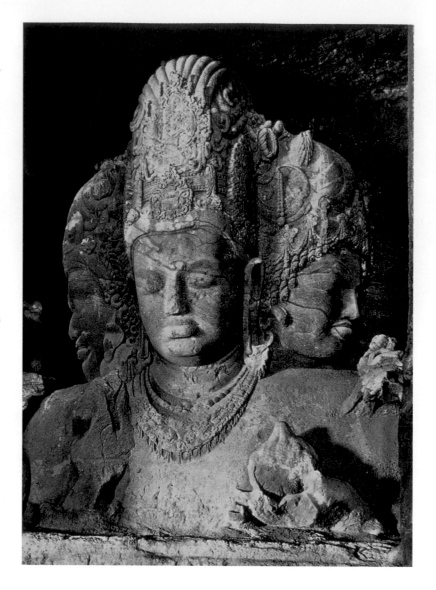

9-22. *Eternal Shiva*, rock-cut relief in the Cave-Temple of Shiva at Elephanta. Mid-6th century CE. Height approx. 11' (3.4 m)

and capital are delicately **fluted**, adding a surprising refinement to these otherwise sturdy forms. The focus of the east-west axis is a square **lingam shrine**, shown here at the center of the illustration. Each of its four entrances is flanked by a pair of colossal standing guardian figures. In the center of the shrine is the *lingam*, the phallic symbol of Shiva. The *lingam* represents the presence of Shiva as the unmanifest Formless One, or Brahman. It symbolizes both his erotic nature and his aspect as the Great Yogi who controls his seed. The *lingam* is synonymous with Shiva and is seen in nearly every Shiva temple and shrine.

The focus of the north-south axis, in contrast, is a relief on the south wall depicting Shiva in his Subtle Body, the second stage of the threefold emanation. A huge bust of the deity represents his Sadashiva, or Eternal Shiva, aspect (fig. 9-22). Three heads are shown resting upon the broad shoulders of the upper body, but five heads are implied: the fourth in back and the fifth, never depicted, on top. The heads summarize Shiva's fivefold nature as creator (back), protector (left shoulder), destroyer (right shoulder), obscurer (front), and releaser (top). The head in the front depicts Shiva deep in introspection. The massiveness of the broad head, the large eyes barely delineated, and the mouth with its

heavy lower lip suggest the god's serious depths. Lordly and majestic, he easily supports his huge crown, intricately carved with designs and jewels, and the matted, piled-up hair of a yogi. On his left shoulder, his protector nature is depicted as female, with curled hair and a pearl-festooned crown. On his right shoulder, his wrathful, destroyer nature wears a fierce expression, and snakes encircle his neck.

Like the relief panels at the temple to Vishnu in Deogarh (see fig. 9-20), the reliefs at Elephanta are early examples of the Hindu monumental narrative tradition. Measuring 11 feet in height, they are set in recessed niches, one on either side of each of the three entrances and three on the south wall. The panels portray the range of Shiva's powers and some of his different aspects, presented in the context of narratives that help devotees understand his nature. Taken as a whole, the reliefs represent the third stage of emanation, the Gross Body manifestation of Shiva in our world. Indian artists often convey the many aspects or essential nature of a deity through multiple heads or arms—which they do with such convincing naturalism that we readily accept the additions. Here, for example, the artist has united three heads onto a single body so skillfully that we still relate to the statue as an essentially human presence.

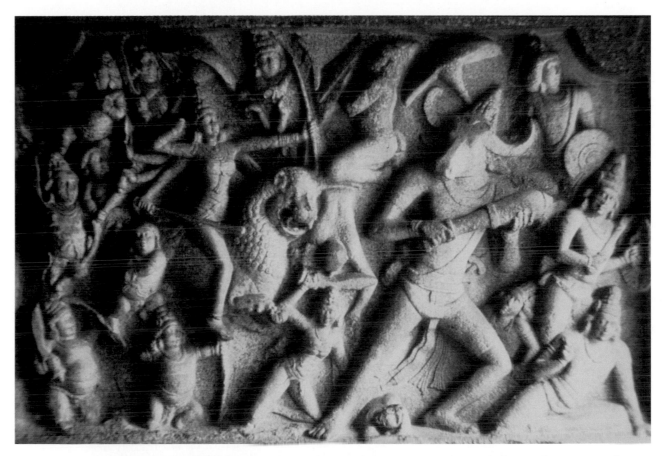

9-23. *Durga Mahishasura-mardini (Durga as Slayer of the Buffalo Demon)*, rock-cut relief, Mamallapuram, Tamil Nadu, India. Pallava period, c. mid 7th century CE. Granite, height approx. 9' (2.7 m)

The third great Hindu deity is Devi, a designation covering many deities who embody the feminine. In general, Devi represents the power of *shakti*, a divine energy understood as feminine. *Shakti* is needed to overcome the demons of our afflictions, such as ignorance and pride. Among the most widely worshiped goddesses are Lakshmi, goddess of wealth and beauty, and Durga, the warrior goddess.

Durga is the essence of the conquering powers of the gods. A large relief at Mamallapuram, near Madras, in southeastern India, depicts Durga in her popular form as the slayer of Mahishasura, the buffalo demon (fig. 9-23). Triumphantly riding her lion, a symbol of her *shakti*, the eight-armed Durga battles the demon. His huge figure with its human body and buffalo head is shown lunging to the right, fleeing her onslaught as his warriors fall to the ground. Accompanied by energetic, dwarfish warriors, victorious Durga, though small, sits erect and alert, flashing her weapons. The moods of victory and defeat are clearly distinguished between the left and right sides of the panel. The artist clarifies the drama by focusing our attention on the two principal actors. Surrounding figures play secondary roles that support the main action, adding visual interest and variety.

Stylistically, this and other panels at Mamallapuram represent the final flowering of the Indian monumental relief tradition. Here, as elsewhere, the reliefs portray stories of the gods and goddesses, whose heroic deeds unfold before our eyes. Executed under the dynasty of the Pallavas, which flourished in southern India from the seventh to ninth century CE, this panel illustrates the gentle, simplified figure style characteristic of Pallava sculpture. Figures tend to be slim and elegant with little ornament, and the rhythms of line and form have a graceful, unifying, and humanizing charm.

THE EARLY SOUTHERN TEMPLE

The coastal city of Mamallapuram was also a major temple site under the Pallavas. Along the shore are many large granite boulders and cliffs, and from these the Pallava stonecutters carved reliefs, halls, and temples. Among the most interesting Pallava creations is a group of temples known as the Five Rathas, which preserve a sequence of early architectural styles. As with other rock-cut temples, the Five Rathas were probably carved in the style of contemporary wood or brick structures that have long since disappeared.

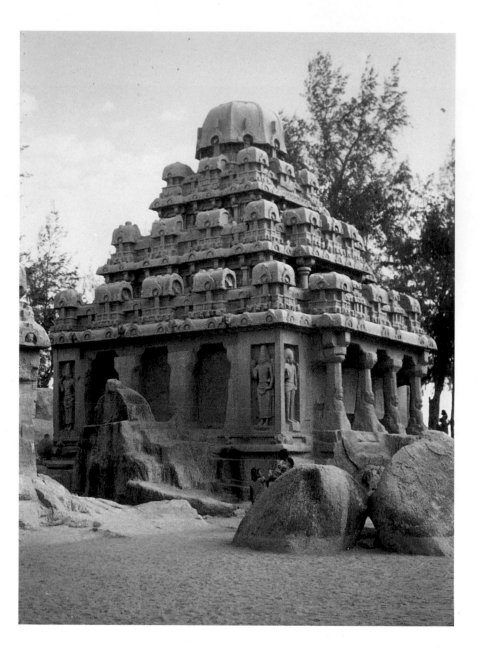

9-24. Dharmaraja Ratha, Mamallapuram, Tamil Nadu, India. Pallava period, c. mid-7th century CE

One of this group, the Dharmaraja Ratha, epitomizes the early southern-style temple (fig. 9-24). Though strikingly different in appearance from the northern style, it uses the same symbolism to link the heavens and earth and it, too, is based on a *mandala*. The temple, square in plan, remains unfinished, and the *garbhagriha* usually found inside was never hollowed out. On the lower portion, only the columns and niches have been carved. The use of a single deity in each niche forecasts the main trend in temple sculpture in the centuries ahead: the tradition of narrative reliefs began dying out, and the stories they told became concentrated in statues of individual deities, which conjure up entire mythological episodes through characteristic poses and a few symbolic objects.

Southern and northern temples are most clearly distinguished by their superstructures. The Dharmaraja Ratha does not culminate in the paraboloid of the northern *shikhara* but in a pyramidal tower called a **vimana**. Each story of the *vimana* is articulated by a **cornice** and carries a row of miniature shrines. Both shrines and cornices are decorated with a window motif from which faces peer. The shrines not only demarcate each story but also provide loftiness for this palace for a god. Crowning the *vimana* is a dome-shaped octagonal **capstone** quite different from the *amalaka* of the northern style.

During the centuries that followed, both northern- and southern-style temples developed into complex, monumental forms, but their basic structure and symbolism remained the same as those we have seen in these simple, early examples at Deogarh and Mamallapuram.

THE EARLY MEDIEVAL PERIOD During the Early Medieval period, which extends roughly from the mid-seventh through the eleventh century, many small kingdoms and dynasties flourished. Some were relatively long-lived, such as the Pallavas and Cholas in the south and the Palas in the northeast. Though Buddhism remained strong in a few areas—notably under the Palas—it generally declined, while the Hindu gods Vishnu,

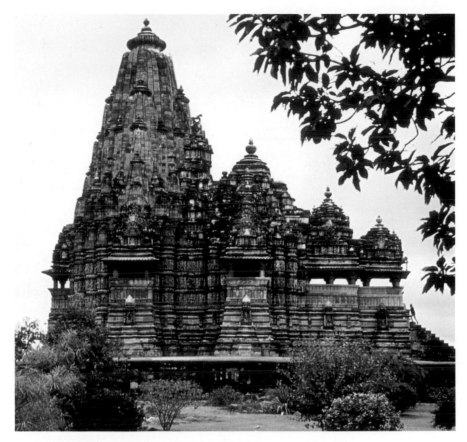

9-25. Kandariya Mahadeva temple, Khajuraho, Madhya Pradesh, India. Chandella dynasty, Early Medieval period, c. 1000 CE

Shiva, and the Goddess (mainly Durga) grew increasingly popular. Local kings rivaled each other in the building of temples to their favored deity, and many complicated and subtle variations of the Hindu temple emerged with astounding rapidity in different regions. By around 1000 CE the Hindu temple had reached unparalleled heights of grandeur and engineering.

THE MONUMENTAL NORTHERN TEMPLE

The Kandariya Mahadeva, a temple dedicated to Shiva at Khajuraho, in central India, was probably built by a ruler of the Chandella dynasty in the late tenth or early eleventh century (fig. 9-25). Khajuraho was the capital and main temple site for the Chandellas, who constructed more than eighty temples there, about twenty-five of which are well preserved. The Kandariya Mahadeva temple is in the northern style, with a *shikhara* rising over its *garbhagriha*. Larger, more extensively ornamented, and expanded through the addition of halls on the front and porches to the sides and back, the temple seems at first glance to have little in common with its precursor at Deogarh (see fig. 9-18). Actually, however, the basic elements and their symbolism remain unchanged.

As at Deogarh, the temple rests on a stone terrace that sets off a sacred space from the mundane world. A steep flight of stairs at the front (to the right in the illustration) leads to a series of three halls (distinguished on the outside by three pyramidal roofs) preceding the *garbhagriha*. Called **mandapas**, the halls symbolize the Subtle Body stage of the threefold emanation. They serve as spaces for ritual, such as dances performed for the deity, and for the presentation of offerings. The temple is built of stone blocks using only **post-and-lintel construction**. Because vault and arch techniques are not used, the interior spaces are not large.

The exterior has a strong sculptural presence, its massiveness suggesting a "cosmic mountain" composed of ornately carved stone. The *shikhara* rises more than 100 feet over the *garbhagriha* and is crowned by a small *amalaka*. The *shikhara* is bolstered by the many smaller *shikhara* motifs bundled around it. This decorative scheme adds a complex richness to the surface, but it also obscures the shape of the main *shikhara*, which is slender, with a swift and impetuous upward movement. The roofs of the *mandapas* contribute to the impression of rapid ascent by growing progressively taller as they near the *shikhara*.

Despite its apparent complexity, the temple has a clear structure and unified composition. The towers of the superstructure are separated from the lower portion by strong horizontal **moldings** and by the open spaces over the *mandapas* and porches. The moldings and rows of sculpture adorning the lower part of the temple create a horizontal emphasis that stabilizes the vertical thrust of the superstructure. Three rows of sculpture—some

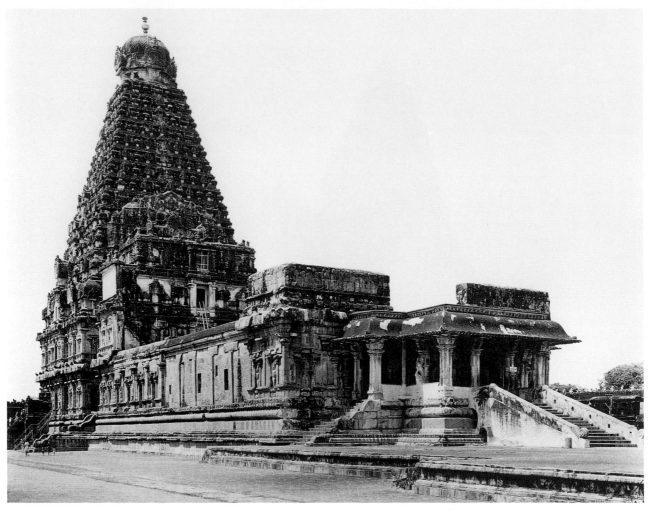

9-26. Rajarajeshvara Temple to Shiva, Thanjavur, Tamil Nadu, India. Chola dynasty, Early Medieval period, 1003–10 CE

600 figures—are integrated into the exterior walls. Approximately 3 feet tall and carved in high relief, the sculptures depict gods and goddesses, some in erotic postures. They are thought to express Shiva's divine bliss, the manifestation of his presence within, and the transformation of one to many.

In addition to its horizontal emphasis, the lower portion of the temple is characterized by a verticality created by protruding and receding elements. Their visual impact is similar to that of engaged columns and buttresses, and they account for much of the rich texture of the exterior. The porches, two on each side and one in the back, contribute to the complexity by outwardly expanding the ground plan, yet their curved bases also reinforce the sweeping vertical movements that unify the entire structure.

THE MONUMENTAL SOUTHERN TEMPLE

The Cholas, who superseded the Pallavas in the mid-ninth century, founded a dynasty that governed most of the far south well into the late thirteenth century. The Chola dynasty reached its peak during the reign of Rajaraja I (ruled 985–1014 CE). As an expression of gratitude for his many victories in battle, Rajaraja built the Rajarajeshvara Temple to Shiva in his capital, Thanjavur

(Tanjore). Known alternatively as the Brihadeshvara, this temple is the supreme achievement of the southern style of Hindu architecture (fig. 9-26). It stands within a huge, walled compound near the banks of the Kaveri River. Though smaller shrines dot the compound, the Rajarajeshvara dominates the area.

Clarity of design, a formal balance of parts, and refined decor contribute to the Rajarajeshvara's majesty. Rising to an astonishing height of 216 feet, this temple was probably the tallest structure in India in its time. Like the Kandariya Mahadeva temple at Khajuraho, the Rajarajeshvara has a longitudinal axis and greatly expanded dimensions, especially with regard to its superstructure. Typical of the southern style, the *mandapa* halls at the front of the Rajarajeshvara have flat roofs, as opposed to the pyramidal roofs of the northern style.

The base of the *vimana*, which houses the *garbhagriha*, rises for two stories, with each story emphatically articulated by a large cornice. The exterior walls are ornamented with niches, each of which holds a single statue, usually depicting a form of Shiva. The clear, regular, and wide spacing of the niches imparts a calm balance and formality to the lower portion of the temple, in marked contrast to the irregular, concave-convex rhythms of the northern style.

The *vimana* of the Rajarajeshvara is a four-sided, hollow pyramid that rises for thirteen stories. Each story is decorated with miniature shrines, window motifs, and robust dwarf figures who seem to be holding up the next story. Because these sculptural elements are not large in the overall scale of the *vimana*, they appear well integrated into the surface and do not obscure the thrusting shape. This is quite different from the effect of the small *shikhara* motifs on the *shikhara* of the Kandariya Mahadeva temple. Notice also that in the earlier southern style as embodied in the Dharmaraja Ratha (see fig. 9-24), the shrines on the *vimana* were much larger in proportion to the whole and thus each appeared to be nearly as prominent as the *vimana*'s overall shape.

Because the Rajarajeshvara *vimana* is not obscured by its decorative motifs, it forcefully ascends skyward. At the top is an octagonal dome-shaped capstone similar to the one that crowned the earlier southern-style temple. This huge capstone is exactly the same size as the *garbhagriha* housed thirteen stories directly below. It thus evokes the shrine a final time before the point separating the worldly from the cosmic sphere above.

THE BHAKTI MOVEMENT IN ART

Throughout the Early Medieval period two major religious movements were developing that affected Hindu practice and its art: the tantric, or esoteric, and the *bhakti*, or devotional. Although both movements evolved throughout India, the influence of tantric sects appeared during this period primarily in the art of the north, while the *bhakti* movements found artistic expression mostly in the south.

The *bhakti* devotional movement was based on ideas expressed in ancient texts, especially the *Bhagavad Gita*. *Bhakti* revolves around the ideal relationship between humans and deities. According to *bhakti*, it is the gods who create *maya*, or illusion, in which we are all trapped. They also reveal truth to those who truly love them and whose minds are open to them. Rather than focusing on ritual and the performance of *dharma* according to the Vedas, *bhakti* stresses an intimate, personal, and loving relation with god, and the complete devotion and surrender to god. Inspired and influenced by *bhakti*, southern artists produced some of India's greatest and most humanistic works, as revealed in the few remaining paintings and in the famous bronze works of sculpture.

Rajaraja's building of the Rajarajeshvara was in part a reflection of the fervent movement of Shiva *bhakti* that had reached its peak by that time. The corridors of the circumambulatory passages around its *garbhagriha* were originally adorned with frescoes. Overpainted later, they were only recently rediscovered. One painting apparently depicts the ruler Rajaraja himself, not as a warrior or majestic king on his throne, but as a simple mendicant humbly standing behind his religious teacher (fig. 9-27). With his white beard and dark skin, the aged teacher contrasts with the youthful, bronze-skinned king. The position of the two suggests that the king

9-27. *Rajaraja I and His Teacher*, detail of a wall painting in the Rajarajeshvara Temple to Shiva. Chola dynasty, Early Medieval period, c. 1010 CE

treats the saintly teacher, who in the devotee's or *bhakta*'s view is equated with god, with intimacy and respect. Both figures allude to their devotion to Shiva by holding a small flower as an offering, and both emulate Shiva in their appearance by wearing their hair in the "ascetic locks" of Shiva in his Great Yogi aspect.

The portrayal does not represent individuals so much as a contrast of types: the old and the youthful, the teacher and the devotee, the saint and the king—the highest religious and worldly models, respectively—united as followers of Shiva. Line is the essence of the painting. With strength and grace, the even, skillfully executed line defines the boldly simple forms and features. There is no excessive detail, very little shading, and no highlighting such as we saw in the Gupta paintings at Ajanta (see fig. 9-17). A cool, sedate calm infuses the monumental figures, but the power of line also invigorates them with a sense of strength and inner life.

Perhaps no sculpture is more representative of Chola bronzes than the statues of Shiva Nataraja, or Dancing Shiva. The dance of Shiva is a dance of cosmic proportions, signifying the universe's cycle of death and rebirth;

9-28. *Shiva Nataraja*, from Thanjavur, Tamil Nadu. Chola dynasty, 12th century CE. Bronze, 32" (81.25 cm). National Museum of India, New Delhi

The fervent religious devotion of the *bhakti* movement was fueled in no small part by the sublime writings of a series of poet-saints who lived in the south of India. One of them, Appar, who lived from the late sixth to mid-seventh century CE, wrote this tender, personal vision of the Shiva Nataraja. The ash the poem refers to is one of many symbols associated with the deity. In penance for having lopped off one of the five heads of Brahma, the first created being, Shiva smeared his body with ashes and went about as a beggar.

> If you could see
> the arch of his brow,
> the budding smile
> on lips red as the kovvai fruit,
> cool matted hair,
> the milk-white ash on coral skin,
> and the sweet golden foot
> raised up in dance,
> then even human birth on this wide earth
> would become a thing worth having.

(Translated by Indira Vishvanathan Peterson)

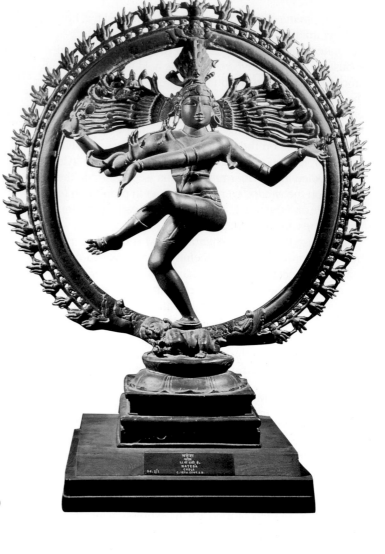

it is also a dance for each individual, signifying the liberation of the believer through Shiva's compassion. In the iconography of the Nataraja, perfected over the centuries, this sculpture shows Shiva with four arms dancing on the prostrate body of Apasmaru, a dwarf figure who symbolizes "becoming" and whom Shiva controls (fig. 9-28). Shiva's extended left hand holds a ball of fire; a circle of fire rings the god as well. The fire is emblematic of the destruction of *samsara* and the physical universe as well as the destruction of *maya* and our cgo-centered perceptions. Shiva's back right hand holds a drum; its beat represents the irrevocable rhythms of creation and destruction, birth and death. His front right arm gestures the "have no fear" mudra (see "Mudras," page 385). The front left arm, gracefully stretched across his body with the hand pointing to his raised foot, signifies the promise of liberation.

The artist has rendered the complex pose with great clarity. The central axis, which aligns the nose, navel, and insole of the weight-bearing foot, maintains the figure's equilibrium while the remaining limbs asymmetrically extend far to each side. Shiva wears a short loincloth, a ribbon tied above his waist, and delicately tooled ornaments. The scant clothing reveals his perfected form with its broad shoulders tapering to a supple waist. The jewelry is restrained and the detail does not detract from the beauty of the body.

The deity does not appear self-absorbed and introspective as he did in the Eternal Shiva relief at Elephanta (see fig. 9-22). He turns to face the viewer, appearing lordly and aloof yet fully aware of his benevolent role as he generously displays himself for the devotee. Like the Sarnath Gupta Buddha (see fig. 9-16), the Chola Nataraja Shiva presents a characteristically Indian synthesis of the godly and the human, this time expressing the *bhakti* belief in the importance of an intimate relationship with a lordly god through whose compassion one is saved. The earlier Hindu emphasis on ritual and the depiction of the heroic feats of the gods is subsumed into the all-encompassing, humanizing factor of grace.

The *bhakti* movement spread during the ensuing Late Medieval period into North India. However, during this period a new religious culture penetrated the subcontinent: Turkic, Persian, and Afghan invaders had been crossing the northwest passes into India since the tenth century, bringing with them Islam and its rich artistic tradition. New religious forms eventually evolved from Islam's long and complex interaction with the peoples of the subcontinent, and so too arose uniquely Indian forms of Islamic art, adding yet another dimension to India's artistic heritage.

PARALLELS

PERIOD	ART IN INDIA BEFORE 1100	ART IN OTHER CULTURES
INDUS VALLEY c. 2700–1500 BCE	**9-2. Seals** (c. 2500–1500) **9-5. Painted jar** (c. 2400–2000) **9-3. Mohenjo-Daro bust** (c. 2000) **9-4. Harappa torso** (c. 2000)	**2-13.** Sumerian cylinder seal (c. 2500 BCE), **3-13.** *Menkaura and a Queen* (c. 2500), Egypt **2-17.** *Stele of Hammurabi* (1792–1750 BCE), Babylonia **4-9.** *Woman or Goddess with Snakes* (c. 1600–1550), Knossos
VEDIC c. 1500–322 BCE		**2-27.** Lion Gate (c. 1400), Anatolia **3-38.** *Nefertiti* (c. 1352–1336), Egypt **5-39.** Parthenon (447–438), Greece
MAURYA c. 322–185 BCE	**9-6.** *Yakshi Holding a Fly Whisk* (c. 250) **9-7.** **Lion capital** (c. 250) **9-1.** Ashokan pillar (246)	**5-75.** *Dying Gallic Trumpeter* (c. 220), Greece
SHUNGA/ **EARLY ANDHRA** c. 185 BCE–72 CE	**9-8. Great Stupa, Sanchi** (3rd cent. CE, 150–50) **9-12.** *Chaitya* **hall, Karla** (Second half 1st cent. BCE)	**5-77.** Pergamon altar (c. 166–156 BCE), Greece **5-83.** *Aphrodite of Melos* (c. 150 BCE), Greece **6-63.** *Initiation Rites of the Cult of Bacchus* (c. 50 BCE), Italy **6-22.** *Ara Pacis* (13–9 BCE), Italy
KUSHAN/ **LATER ANDHRA** c. 30–433 CE	**9-13.** *Standing Buddha*, Gandhara (c. 2nd–3rd cent. CE) **9-15.** *Siddhartha in the Palace* (c. 3rd cent. CE)	**6-45.** Equestrian statue of Marcus Aurelius (c. 176 CE), Italy **7-5.** Dura-Europos synagogue (244–45 CE) **7-9.** Old Saint Peter's (c. 320–27 CE), Italy
GUPTA c. 320–500 CE	**9-16.** *Standing Buddha*, Sarnath (474) **9-17.** *Bodhisattva* (c. 475)	**7-17.** Mausoleum of Galla Placidia (c. 425–26 CE), Italy **7-18.** *Good Shepherd* (c. 425–26 CE), Italy
POST-GUPTA c. 500–650 CE	**9-20.** *Vishnu Narayana* (c. 530) **9-21. Shiva cave-temple, Elephanta** (mid-6th cent.)	**7-22.** Hagia Sophia (532–37 CE), Turkey **7-36.** *Rabbula Gospels* (586 CE), Syria **11-4.** *Haniwa* (c. 6th cent. CE), Japan
EARLY MEDIEVAL c. 650–1200 CE	**9-23.** *Durga Mahishasura-mardini* (*Durga as Slayer of the Buffalo Demon*) (mid-7th cent.) **9-25. Kandariya Mahadeva temple, Khajuraho** (c. 1000) **9-26. Rajarajeshvara temple to Shiva, Thanjavur** (1003–10) **9-27.** *Rajaraja I and His Teacher* (c. 1010) **9-28.** *Shiva Nataraja* (12th cent.)	**8-2.** Dome of the Rock (687–91 CE), Jerusalem **8-6.** Great Mosque, Córdoba (785–86 CE), Spain **14-12.** Charlemagne's chapel (792–805 CE), Germany **7-39.** Saint Mark's, Venice (begun 1063 CE), Italy **15-32.** *Bayeux Tapestry* (c. 1066–77 CE), France

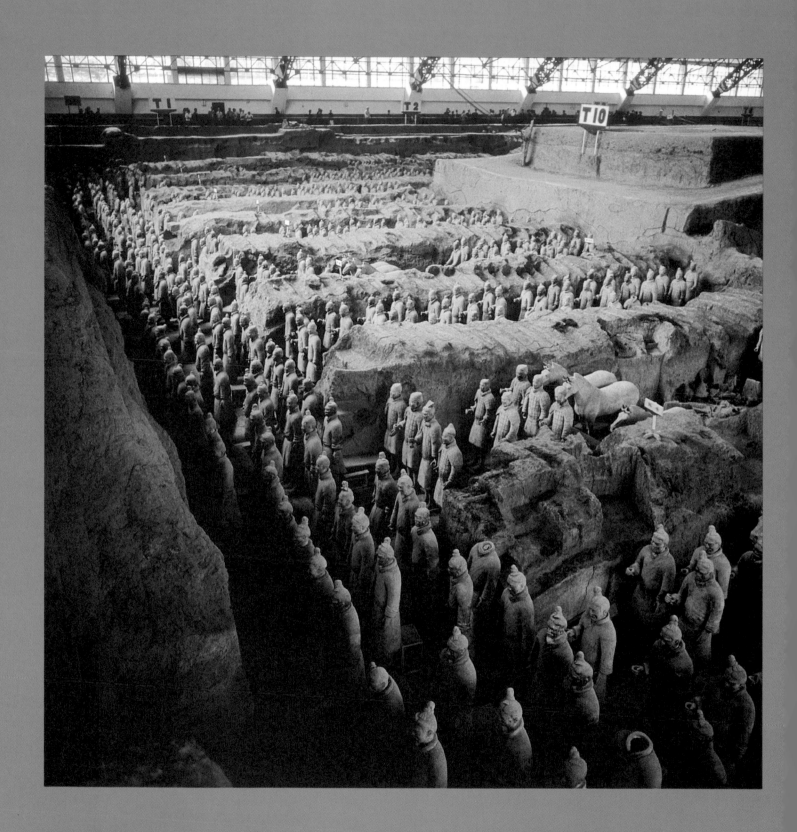

10 Chinese Art before 1280

10-1. **Soldiers**, from the mausoleum of Emperor Shihuangdi, Lintong, Shaanxi. Qin dynasty, c. 210 BCE. Earthenware, lifesize

As long as anyone could remember, the huge mound in China's Shaanxi province in northern China had been part of the landscape. No one dreamed that an astonishing treasure lay beneath the surface until one day in 1974 when peasants digging a well accidentally brought to light the first hint of the riches. When archaeologists began to excavate the mound, they were stunned by what they found: a vast underground army of more than 7,000 lifesize clay soldiers and horses standing in military formation, facing east, ready for battle (fig. 10-1). Originally painted in vivid colors, they emerged from the earth a ghostly gray. For more than 2,000 years, while the tumultuous history of China unfolded overhead, they had guarded the tomb of Emperor Shihuangdi, the ruthless ruler who first united the states of China into an empire, the Qin dynasty.

In 1990, a road-building crew in central China accidentally uncovered an even richer vault, containing perhaps tens of thousands of terra-cotta figures. Although excavations there are barely under way, the artifacts so far uncovered are exceptional both in artistic quality and in what they tell us about life—and death—during the Han dynasty, about 100 years later than the Qin find.

China has had a long-standing traditional interest in and respect for antiquity, but archaeology is a relatively young discipline there. Only since the 1920s have scholars methodically dug into the layers of history that lie buried at thousands of sites across the country. Yet in that short period so much has been unearthed that ancient Chinese history has been rewritten many times.

TIMELINE 10-1. **Major Periods in China before 1280.** The cultural history of China, though marked by changes of ruling dynasties, goes back unbroken some 8,000 years.

MAP 10-1. **China before 1280.** The heart of China is crossed by three great rivers—the Yellow, Yangzi, and Xi—and is divided into northern and southern regions by the Qinling Mountains.

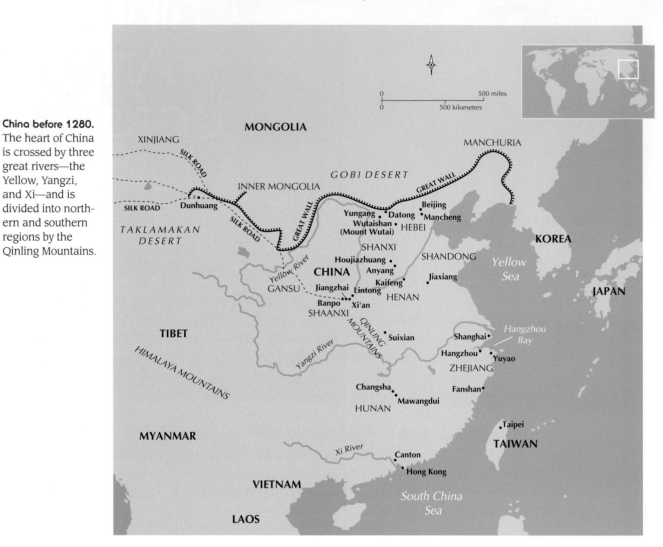

THE MIDDLE KINGDOM

Among the cultures of the world, China is distinguished by its long, uninterrupted development, now traced back some 8,000 years. From Qin, pronounced "chin," comes our name for the country the Chinese call the Middle Kingdom, the country in the center of the world. Modern China occupies a large landmass in the center of Asia, covering an area slightly larger than the continental United States. Within its borders lives one-fifth of the human race.

The historical and cultural heart of China—sometimes called Inner China—is the land watered by its three great rivers, the Yellow, the Yangzi, and the Xi (Map 10-1). The Qinling Mountains divide Inner China into north and south, regions with strikingly different climates, cultures, and historical fates. In the south, the Yangzi River flows through lush green hills to the fertile plains of the delta. Along the southern coastline, rich with natural harbors, arose China's port cities, the focus of a vast maritime trading network. The Yellow River, nicknamed "China's

Sorrow" because of its disastrous floods, winds through the north. The north country is a dry land of steppe and desert, hot in the summer and lashed by cold winds in the winter. Over its vast and vulnerable frontier have come the nomadic invaders that are a recurring theme in Chinese history, as well as caravans and emissaries from Central Asia, India, Persia, and, eventually, Europe.

NEOLITHIC CULTURES

Early archaeological evidence led scholars to believe that agriculture, the cornerstone technology of the Neolithic period, made its way to China from the ancient Near East. More recent findings, however, have shown that agriculture based on rice and millet arose independently in East Asia before 5000 BCE and that knowledge of Near Eastern grains followed some 2,000 years later. One of the clearest signs of Neolithic culture in China is the vigorous emergence of towns and cities (Timeline 10-1). At Jiangzhai, near modern Xi'an, for example, the foundations of more than

▲ c. 221–206 BCE QIN DYNASTY ▲ c. 589–617 SUI DYNASTY
▲ c. 206 BCE–220 CE HAN DYNASTY ▲ c. 618–907 TANG DYNASTY
▲ c. 220–579 SIX DYNASTIES ▲ c. 960–1279 SONG DYNASTY

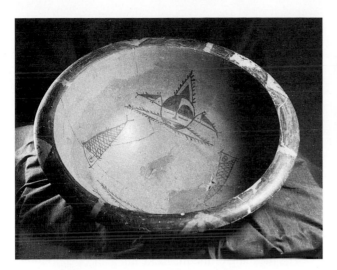

10-2. Bowl, from Banpo, near Xi'an, Shaanxi. Neolithic period, Yangshao culture, 5000–4000 BCE. Painted pottery, height 7" (17.8 cm). Banpo Museum

100 dwellings have been discovered surrounding the remains of a community center, a cemetery, and a kiln. Dated to about 4000 BCE, the ruins point to the existence of a highly developed early society. Elsewhere in China, the foundations of the earliest known palace have been uncovered and dated to about 2000 BCE.

PAINTED POTTERY CULTURES

In China, as in other places, distinctive forms of Neolithic pottery identify different cultures. One of the most interesting objects thus far recovered is a shallow red bowl with a turned-out rim (fig. 10-2). Found in the village of Banpo near the Yellow River, it was crafted sometime between 5000 and 4000 BCE. The bowl is an artifact of the Yangshao culture, one of the most important of the so-called Painted Pottery cultures of Neolithic China. Although the potter's wheel had not yet been developed, the bowl is perfectly round and its surfaces are highly polished, bearing witness to a distinctly advanced technology. The decorations are especially intriguing. The marks on the rim may be among the earliest evidence of the beginnings of writing in China, which had been fully developed by the time the first definitive examples appeared in the later Bronze Age.

Inside the bowl, a pair of stylized fish suggests that fishing was an important activity for the villagers. The image between the two fish represents a human face with four more fish, one on each side. Although there is no certain interpretation of the image, it probably served some magical purpose. Perhaps it is a depiction of an ancestral figure who could assure an abundant catch, for worship of ancestors and nature spirits was a fundamental element of later Chinese beliefs.

Schematic drawing of a *cong*

10-3. Image of a deity, detail from a *cong* recovered from Tomb 12, Fanshan, Yuyao, Zhejiang. Neolithic period, Liangzhu culture, before 3000 BCE. Jade, 3½ x 6⅞" (8.8 x 17.5 cm). Zhejiang Provincial Museum, Hangzhou

The *cong* is one of the most prevalent and mysterious of early Chinese jade shapes. Originating in the Neolithic era, it continued to play a prominent role in burials through the Shang and Zhou dynasties. Many scholars believe that the *cong* was connected with the practice of contacting the spirit world. They suggest that the circle symbolized heaven; the square, earth; and the hollow, the axis connecting these two realms. The animals found carved on many *cong* may have portrayed the priest's helpers or alter egos.

LIANGZHU CULTURE

Banpo lies near the great bend in the Yellow River, in the area traditionally regarded as the cradle of Chinese civilization—but archaeological finds have revealed that Neolithic cultures arose over a far broader area. Recent excavations in sites more than 800 miles away, near the Hangzhou Bay, in the southeastern coastal region, have turned up half-human, half-animal images more than 5,000 years old (fig. 10-3). Large, round eyes linked by a

TECHNIQUE

PIECE-MOLD CASTING

The early **piece-mold** technique for bronze casting is more complex than the **lost-wax** process developed in the ancient Mediterranean and Near East. Although we do not know the exact steps ancient Chinese artists followed, we can deduce the general procedure for casting a simple vessel.

First, a model of the bronze-to-be was made of clay and dried. To create the mold, damp clay was pressed onto the model; after the clay dried, it was cut away in pieces, which were keyed for later reassembly and then fired. The model itself was shaved down to serve as the core for the mold. The pieces of the mold were reassem-bled around the core and held in place by bronze spacers, which locked the core in position and ensured an even casting space. The reassembled mold was then covered with another layer of clay, and a spue, or pouring duct, was cut into the clay to receive the molten metal. A riser duct may also have been cut to allow the hot gases to escape. Molten bronze was then poured into the mold. When the metal had cooled, the mold was broken apart with a hammer. Finally, the vessel could be burnished—a long process that involved scouring the surface with increasingly fine abrasives.

bar like the frames of eyeglasses, a flat nose, and a rectangular mouth protrude slightly from the background pattern of wirelike lines. Above the forehead, a second, smaller face grimaces from under a huge headdress. The image is one of eight carved in **low relief** on the outside of a large jade *cong*, an object resembling a cylindrical tube encased in a rectangular block. This *cong* must have been an object of great importance, for it was found near the head of a person buried in a large tomb at the top of a mound that served as an altar. Hundreds of jade objects have been recovered from this mound, which measures about 66 feet square and rises in three levels.

The intricacy of the carving shows the technical sophistication of this jade-working culture, named the Liangzhu, which seems to have emerged around 4000 BCE. Jade, a stone cherished by the Chinese throughout their history, is extremely hard and is difficult to carve. Liangzhu artists must have used sand as an abrasive to slowly grind the stone down, but we can only wonder at how they produced such fine work.

The meaning of the masklike image is open to interpretation. Its combination of human and animal features seems to show how the ancient Chinese imagined supernatural beings, either deities or dead ancestors. Strikingly similar masks later formed the primary decorative motif of Bronze Age ritual objects. Still later, Chinese historians began referring to the ancient mask motif as **taotie**, but its original meaning had already been lost. The jade carving here seems to be a forerunner of this most central and mysterious image. It suggests that eventually the various Neolithic cultures of China merged to form a single culture, despite their separate origins thousands of miles apart.

CHINESE CHARACTERS

Each word in Chinese is represented by its own unique picture, called a character or **calligraph**. Some characters originated as **pictographs**, images that mean what they depict. Writing reforms over the centuries have often disguised the resemblance, but if we place modern characters next to their oracle-bone ancestors, the picture comes back into focus:

water horse moon child tree mountain

ancient 川 馬 月 子 米 山

modern 水 馬 月 子 木 山

Other characters are **ideographs**, pictures that represent abstract concepts or ideas:

sun + moon = bright

日 月 明

woman + child = good

女 子 好

Most characters were formed by combining a radical, which gives the field of meaning, with a phonetic, which originally hinted at pronunciation. For example, words that have to do with water have the character for "water" 水 abbreviated to three strokes 氵 as their radical. Thus "to bathe" 沐, pronounced *mu*, consists of the water radical and the phonetic 木, which by itself means "tree" and is also pronounced *mu*. Here are other "water" characters. Notice that the connection to water is not always literal.

river sea weep pure, clear extinguish, destroy

河 海 泣 清 滅

These phonetic borrowings took place centuries ago. Many words have shifted in pronunciation, and for this and other reasons there is no way to tell how a character is pronounced or what it means just by looking at it. While at first this may seem like a disadvantage, in the case of Chinese it is actually a strength. Spoken Chinese has many dialects. Some are so far apart in sound as to be virtually different languages. But while speakers of different dialects cannot understand each other, they can still communicate through writing, for no matter how they say a word, they write it with the same character. Writing has thus played an important role in maintaining the unity of Chinese civilization through the centuries.

10-4. *Fang ding*, from Tomb 1004, Houjiazhuang, Anyang, Henan. Shang dynasty, Anyang period, c. 12th century BCE. Bronze, height 24½" (62.2 cm). Academia Sinica, Taipei, Taiwan

BRONZE AGE CHINA

China entered its Bronze Age in the second millennium BCE. As with agriculture, scholars at first theorized that the technology had been imported from the Near East. It is now clear, however, that bronze casting using the **piece-mold casting** technique arose independently in China, where it attained an unparalleled level of excellence (see "Piece-Mold Casting," page 404).

SHANG DYNASTY

Traditional Chinese histories tell of three Bronze Age dynasties: the Xia, the Shang, and the Zhou. Modern scholars had tended to dismiss the Xia and Shang as legendary, but recent archaeological discoveries have now fully established the historical existence of the Shang (c. 1700–1100 BCE) and point strongly to the historical existence of the Xia as well.

Shang kings ruled from a succession of capitals in the Yellow River valley, where archaeologists have found walled cities, palaces, and vast royal tombs. Their state was surrounded by numerous other states—some rivals, others clients—and their culture spread widely. Society seems to have been highly stratified, with a ruling group that had the bronze technology needed to make weapons. They maintained their authority in part by claiming power as intermediaries between the supernatural and human realms. The chief Shang deity, Shangdi, may have been a sort of Great Ancestor. Nature and fertility spirits were also honored, and regular sacrifices were believed necessary to keep the spirits of dead ancestors alive so that they might help the living.

Shang priests communicated with the supernatural world through **oracle** bones. An animal bone or piece of tortoiseshell was inscribed with a question and heated until it cracked, then the crack was interpreted as an answer. Oracle bones, many of which have been recovered and deciphered, contain the earliest known form of Chinese writing, a script fully recognizable as the ancestor of the system still in use today (see "Chinese Characters," page 404).

Ritual Bronzes. Shang tombs reveal a warrior culture of great splendor and violence. Many humans and animals were sacrificed to accompany the deceased. In one tomb, for example, chariots were found with the skeletons of their horses and drivers; in another, dozens of human skeletons lined the approaches to the central burial chamber. Above all, the tombs contain thousands of jade, ivory, and lacquer objects, gold and silver ornaments, and bronze vessels. The enormous scale of Shang burials illustrates the great wealth of the civilization and the power of a ruling class able to consign such great quantities of treasure to the earth, as well as this culture's reverence for the dead.

Bronze vessels are the most admired and studied of Shang artifacts. Like oracle bones and jade objects, they were connected with shamanistic practices, serving as containers for ritual offerings of food and wine. A basic repertoire of about thirty shapes evolved. Some shapes clearly derive from earlier pottery forms, others seem to reproduce wooden containers, while still others are purely sculptural and take the form of fantastic composite animals.

The illustrated bronze *fang ding*, a square vessel with four legs, is one of hundreds of vessels recovered from the royal tombs near the last of the Shang capitals, Yin, present-day Anyang (fig. 10-4). Weighing more than 240 pounds, it is one of the largest Shang bronzes ever

10-5. **Set of sixty-five bells**, from the tomb of Marquis Yi of Zeng, Suixian, Hubei. Zhou dynasty, 433 BCE. Bronze, with bronze and timber frame, frame height 9' (2.74 m), length 25' (7.62 m). Hubei Provincial Museum, Wuhan

recovered. In typical Shang style, its surface is decorated with a complex array of images based on animal forms. The *taotie*, usually so prominent, does not appear. Instead, a large deer's head adorns the center of each side, and images of deer are repeated on all four legs. The rest of the surface is filled with images resembling birds, dragons, and other fantastic creatures. Such images seem to be related to the hunting life of the Shang, but their deeper significance is unknown. Sometimes strange, sometimes fearsome, Shang creatures seem always to have a sense of mystery, evoking the Shang attitude toward the supernatural world.

ZHOU DYNASTY

Around 1100 BCE, the Shang were conquered by the Zhou, from western China. During the Zhou dynasty (1100–221 BCE), a feudal society developed, with nobles related to the king ruling over numerous small states. (Zhou nobility are customarily ranked in English by such titles as duke and marquis.) The supreme deity became known as Tian, or Heaven, and the king ruled as the Son of Heaven. Heaven remained the personal cult of China's sovereigns until the end of imperial rule in the early twentieth century.

The first 300 years of this longest Chinese dynasty were generally stable and peaceful. In 771 BCE, however, the Zhou suffered defeat at the hands of a nomadic tribe in the west. Although they quickly established a new capital to the east, their authority had been crippled, and the later Eastern Zhou period was a troubled one. States grew increasingly independent, giving the Zhou kings merely nominal allegiance. Smaller states were swallowed up by their larger neighbors. During the time historians call the Spring and Autumn period (770–476 BCE), ten or twelve states, later reduced to seven, emerged as powers.

During the ensuing Warring States period (402–221 BCE), intrigue, treachery, and increasingly ruthless warfare became routine.

Against this background of constant social unrest, China's great philosophers arose—such thinkers as Confucius, Laozi, and Mozi. Traditional histories speak of China's "one hundred schools" of philosophy, indicating a shift of focus from the supernatural to the human world. Nevertheless, elaborate burials on an even larger scale than before reflected the continuation of traditional beliefs.

Ritual bronze objects continued to play an important role during the Zhou dynasty, and new forms developed. One of the most spectacular recent discoveries is a carillon of sixty-five bronze bells arranged in a formation 25 feet long (fig. 10-5), found in the tomb of Marquis Yi of the state of Zeng. Each bell is precisely calibrated to sound two tones—one when struck at the center, another when struck nearer the rim. The bells are arranged in scale patterns in a variety of registers, and several musicians would have moved around the carillon, striking the bells in the appointed order.

Music may well have played a part in rituals for communicating with the supernatural, for the *taotie* typically appears on the front and back of each bell. The image is now much more intricate and stylized, partly in response to the refinement available with the **lost-wax casting** process, which had replaced the older piece-mold technique. On the coffin of the marquis are painted guardian warriors with half-human, half-animal attributes. The marquis, who died in 433 BCE, must have been a great lover of music, for among the more than 15,000 objects recovered from his tomb were many musical instruments. Zeng was one of the smallest and shortest-lived states of the Eastern Zhou, but the contents of this tomb, in quantity and quality, attest to the high level of its culture.

10-6. Painted banner, from the tomb of the wife of the Marquis of Dai, Mawangdui, Changsha, Hunan. Han dynasty, c. 160 BCE. Colors on silk, height 6'8½" (2.05 m). Hunan Provincial Museum, Changsha

THE CHINESE EMPIRE: QIN DYNASTY

Toward the middle of the third century BCE, the state of Qin launched military campaigns that led to its triumph over the other states by 221 BCE. For the first time in its history, China was united under a single ruler. This first emperor of Qin, Shihuangdi, a man of exceptional ability, power, and ruthlessness, was fearful of both assassination and rebellion. Throughout his life, he sought ways to attain immortality. Even before uniting China, he began his own **mausoleum** at Lintong, in Shaanxi province. This project continued throughout his life and after his death, until rebellion abruptly ended the dynasty in 206 BCE. Since that time, the mound over the mausoleum has always been visible, but not until its accidental discovery in 1974 was the army of clay soldiers and horses even imagined (see fig. 10-1). Modeled from clay and then fired, the figures claim a prominent place in the great tradition of Chinese ceramic art. Individualized faces and meticulously rendered uniforms and armor demonstrate the sculptors' skill. Literary sources suggest that the tomb itself, which has not yet been opened, reproduces the world as it was known to the Qin, with stars overhead and rivers and mountains below. Thus did the tomb's architects try literally to ensure that the underworld—the world of souls and spirits—would match the human world.

Qin rule was harsh and repressive. Laws were based on a totalitarian philosophy called legalism, and all other philosophies were banned, their scholars executed, and their books burned. Yet the Qin also established the mechanisms of centralized bureaucracy that molded China both politically and culturally into a single entity. Under the Qin, the country was divided into provinces and prefectures, the writing system and coinage were standardized, roads were built to link different parts of the country with the capital, and battlements on the northern frontier were connected to form the Great Wall. China's rulers to the present day have followed the administrative framework first laid down by the Qin.

HAN DYNASTY

The commander who overthrew the Qin became the next emperor and founded the Han dynasty (206 BCE–220 CE). During this period the Chinese enjoyed a peaceful, prosperous, and stable life. Borders were extended and secured, and Chinese control over strategic stretches of Central Asia led to the opening of the Silk Road, a land route that linked China by trade all the way to Rome (see "The Silk Road," page 408).

The early Han dynasty marks the twilight of China's so-called mythocentric age, when people believed in a close relationship between the human and supernatural worlds, reflected in all the art we have looked at so far. From this time comes one of the most important works in Chinese art, a **T**-shaped silk banner that summarizes this early worldview (fig. 10-6). Found in the tomb of a noblewoman on the outskirts of present-day Changsha, the banner dates from the second century BCE and is

10-7. Incense burner, from the tomb of Prince Liu Sheng, Mancheng, Hebei. Han dynasty, 113 BCE. Bronze with gold inlay, height 10½" (26 cm). Hebei Provincial Museum, Shijiazhuang

THE SILK ROAD At its height, in the second century CE, the Silk Road was the longest road in the world, a 5,000-mile network of caravan routes from the Han capital of Luoyang on the Yellow River to Rome. The Western market for Chinese luxury goods such as silk and lacquer seemed limitless. For these goods, Westerners paid in gold and silver and sometimes exchanged their own commodities, including silver and gold vessels and glass wares, as well as transmitting ideas and religious objects, especially Buddhist icons.

The journey began at the Jade Gate (Yumen), at the westernmost end of the Great Wall, where Chinese merchants turned their goods over to Central Asian traders. Goods would change hands many more times before reaching the Mediterranean. Caravans headed first for the desert oasis of Dunhuang. Here northern and southern routes diverged to skirt the vast Taklamakan Desert. Farther west than the area shown in Map 10-1, at Khotan, in western China, travelers on the southern route could turn off toward a mountain pass into Kashmir, in northern India. Or they could continue on, meeting up with the northern route at Kashgar, on the western border of the Taklamakan, before proceeding over the Pamir Mountains into present-day Afghanistan. There, travelers could turn off into the Kushan Empire that stretched down into India, or they could continue on west through present-day Uzbekistan, Iran, and Iraq, arriving finally at Antioch, in Syria, on the coast of the Mediterranean. From there, land and sea routes led on to Rome.

Sections of the Silk Road were used throughout history by traders, travelers, conquerors, emissaries, pilgrims, missionaries, explorers, and adventurers. But only twice in history was the entire length of it open, with relatively safe passage likely from end to end. The first time was during the days of the Han dynasty and the Roman Empire. The second was during the thirteenth and fourteenth centuries, when the route lay within the borders of the vast Mongol Empire.

DAOISM Daoism is a kind of nature mysticism that brings together many ancient Chinese ideas regarding humankind and the universe. One of its first philosophers is said to have been a contemporary of Confucius (551–479 BCE) named Laozi, who is credited with writing a slim volume called the *Daodejing*, or *The Way and Its Power*. Later, a philosopher named Zhuangzi (369–286 BCE) took up many of the same ideas in a book that is known simply by his name, *Zhuangzi*. Together the two texts formed a body of ideas that crystallized into a school of thought during the Han period.

A *dao* is a way or path. The *Dao* is the Ultimate Way, the Way of the universe. The Way cannot be named or described, but it can be hinted at. It is like water. Nothing is more flexible and yielding, yet water can wear down the hardest stone. Water flows downward, seeking the lowest ground. Similarly, a Daoist sage seeks a quiet life, humble and hidden, unconcerned with worldly success. The Way is great precisely because it is small. In fact, it is nothing, yet nothing turns out to be essential (cited in Cleary, page 14):

When the potter's wheel makes a pot
the use of the pot
is precisely where there is nothing.

To recover the Way, we must unlearn. We must return to a state of nature. To follow the Way, we must practice *wu wei*, or nondoing. "Strive for nonstriving," advises the *Daodejing*.

All our attempts at asserting our egos, at making things happen, are like swimming against a current and thus ultimately futile, even harmful. If we let the current carry us, however, we will travel far. Similarly, a life that follows the Way will be a life of pure effectiveness, accomplishing much with little effort.

It is often said that the Chinese are Confucians in public and Daoists in private, and the two approaches do seem to balance each other. Confucianism is a rational political philosophy that emphasizes morality, conformity, duty, and self-discipline. Daoism is an intuitive philosophy that emphasizes individualism, nonconformity, and a return to nature. If a Confucian education molded scholars outwardly into responsible, ethical officials, Daoism provided some breathing room for the artist and poet inside.

painted with scenes representing the three levels of the universe: heaven, earth, and the underworld.

The heavenly realm is shown at the top, in the crossbar of the **T**. In the upper right corner is the sun, inhabited by a mythical crow; in the upper left, a mythical toad stands on a crescent moon. Between them is a primordial deity shown as a man with a long serpent's tail—a Han imagining of the Great Ancestor. Dragons and other celestial creatures swarm below.

A gate, indicated by two upside-down **T**s and guarded by two seated figures, stands where the horizontal of heaven meets the banner's long, vertical stem. Two intertwined dragons loop through a circular jade piece known as a **bi**, itself usually a symbol of heaven, dividing this vertical segment into two areas. The portion above the *bi* represents the earthly realm. Here, the deceased woman and her three attendants stand on a platform while two kneeling figures offer gifts. The lower portion represents the underworld. Silk draperies and a stone chime hanging from the *bi* form a canopy for the platform below. Like the bronze bells we saw earlier, stone chimes were ceremonial instruments dating from Zhou times. On the platform, ritual bronze vessels contain food and wine for the deceased, just as they did in Shang tombs. The squat, muscular man holding up the platform stands in turn on a pair of fish whose bodies form another *bi*. The fish and the other strange creatures in this section are inhabitants of the underworld.

PHILOSOPHY AND ART

The Han dynasty marked not only the end of the mythocentric age but also the beginning of a new age. During this dynasty, Daoism and Confucianism, two of the many philosophies formulated during the troubled times of the Eastern Zhou, became central in Chinese thought. Their influence since then has been continuous and fundamental.

Daoism and Nature. Daoism emphasizes the close relationship between humans and nature. It is concerned with bringing the individual life into harmony with the *Dao*, or Way, of the universe (see "Daoism," above). For some a secular, philosophical path, Daoism on a popular level developed into an organized religion, absorbing many traditional shamanistic folk practices and the search for immortality.

Immortality was as intriguing to Han rulers as it had been to the first emperor of Qin. Daoist adepts experimented endlessly with diet, physical exercise, and other techniques in the belief that immortal life could be achieved on earth. A popular Daoist legend told of the Isles of the Immortals in the Eastern Sea, depicted on a bronze incense burner from the tomb of Prince Liu Sheng, who died in 113 BCE (fig. 10-7). Around the bowl, gold inlay outlines the stylized waves of the sea. Above them rises the mountainous island, busy with birds, animals, and people who had discovered the secret of immortality. Technically, this exquisite piece represents the ultimate development of the long tradition of bronze casting in China.

Confucianism and the State. In contrast to the metaphysical focus of Daoism, Confucianism is concerned with the human world, and its goal is the attainment of peace. To this end, it proposes an ethical system based on correct relationships among people. Beginning with self-discipline in the individual, Confucianism goes on to achieve correct relationships with the family, including ancestors, then, in ever-widening circles, with friends

10-8. Detail from a rubbing of a stone relief in the Wu family shrine (Wuliangci), Jiaxiang, Shandong. Han dynasty, 151 CE., 27½ x 66½" (70 x 169 cm)

and others all the way up to the emperor (see "Confucius and Confucianism," below).

Emphasis on social order and respect for authority made Confucianism especially attractive to Han rulers, who were eager to distance themselves from the disastrous legalism of the Qin. The Han emperor Wu (ruled 141–87 BCE) made Confucianism the official imperial philosophy, and it remained the state ideology of China for more than 2,000 years, until the end of imperial rule in the twentieth century. Once institutionalized, Confucianism took on so many ritu-

als that it too eventually assumed the form and force of a religion. Han philosophers contributed to this process by infusing Confucianism with traditional Chinese cosmology. They emphasized the Zhou idea, taken up by Confucius, that the emperor ruled by the mandate of heaven. Heaven itself was reconceived more abstractly as the moral force underlying the universe. Thus the moral system of Confucian society became a reflection of the universal order.

Confucian subjects turn up frequently in Han art. Among the most famous examples are the reliefs from

CONFUCIUS AND CONFUCIANISM Confucius was born in 551 BCE in the state of Lu, roughly present-day Shandong province, into a declining aristocratic family. While still in his teens he set his heart on becoming a scholar; by his early twenties he had begun to teach.

By Confucius's lifetime, warfare for supremacy among the various states of China had begun, and the traditional social fabric seemed to be breaking down. Looking back to the early Zhou dynasty as a sort of golden age, Confucius thought about how a just and harmonious society could again emerge. For many years he sought a ruler who would put his ideas into effect, but to no avail. Frustrated, he spent his final years teaching. After his death in 479 BCE, his sayings were collected by his disciples and their followers into a

book known in English as the Analects, which is the only record of his words.

At the heart of Confucian thought is the concept of *ren*, or human-heartedness. *Ren* emphasizes morality and empathy as the basic standards for all human interaction. The virtue of *ren* is most fully realized in the Confucian ideal of the *junzi*, or gentleman. Originally indicating noble birth, the term was redirected to mean one who through education and self-cultivation had become a superior person, right-thinking and right-acting in all situations. A *junzi* is the opposite of a petty or small-minded person. His characteristics include moderation, inner integrity, self-control, loyalty, reciprocity, and altruism. His primary concern is justice.

Together with human-heartedness

and justice, Confucius emphasized *li*, or etiquette. *Li* includes scrupulous everyday manners as well as ritual, ceremony, protocol—all of the formalities of social interaction. Such forms, Confucius felt, choreographed life so that an entire society moved in harmony. *Ren* and *li* operate in the realm of the Five Constant Relationships that define Confucian society: parent and child, husband and wife, elder sibling and younger sibling, elder friend and younger friend, ruler and subject. Deference to age is clearly built into this view, as is the deference to authority that made Confucianism popular with emperors. Yet responsibilities flow the other way as well: the duty of a ruler is to earn the loyalty of subjects, of a husband to earn the respect of his wife, of age to guide youth wisely.

10-9. Tomb model of a house. Eastern Han dynasty, 1st century CE. Painted earthenware, 52 x 33½ x 27" (132.1 x 85.1 x 68.6 cm). The Nelson-Atkins Museum of Art, Kansas City, Missouri

Purchase, Nelson Trust (33–521)

the Wu family shrines built in 151 CE in Jiaxiang. Carved and engraved in low relief on stone slabs, the scenes were meant to teach such basic Confucian themes as respect for the emperor, filial piety, and wifely devotion. Daoist motifs also appear, as do figures from traditional myths and legends. Such mixed **iconography** is characteristic of Han art.

One relief shows a two-story building, with women in the upper floor and men in the lower (fig. 10-8). The central figures in both floors are receiving visitors, some of whom bear gifts. The scene seems to depict homage to the first emperor of the Han dynasty, indicated by his larger size. The birds and small figures on the roof may represent mythical creatures and immortals, while to the left the legendary archer Yi shoots at one of the sun-crows. (Myths tell how Yi shot all but one of the ten crows of the ten suns so that the earth would not dry out.) Across the lower register, a procession brings more dignitaries to the reception.

When compared to the Han dynasty banner (see fig. 10-6), this late Han relief clearly shows the change that took place in the Chinese worldview in the span of 300 years. The banner places equal emphasis on heaven, earth, and the underworld; human beings are dwarfed by a great swarming of supernatural creatures and divine

beings. In the Wu shrine, the focus is clearly on the human realm. The composition conveys the importance of the emperor as the holder of the mandate of heaven and illustrates the fundamental Confucian themes of social order and decorum.

ARCHITECTURE

Contemporary literary sources are eloquent on the wonders of the Han capital. Unfortunately, nothing of Han architecture remains except ceramic models. One model of a house found in a tomb, where it was provided for the dead to use in the afterlife, represents a typical Han dwelling (fig. 10-9). Its four stories are crowned with a watchtower and face a small walled courtyard. Pigs and oxen probably occupied the ground floor, while the family lived in the upper stories.

Aside from the multilevel construction, the most interesting feature of the house is the **bracketing** system supporting the rather broad eaves of its tiled roofs. Bracketing became a standard element of East Asian architecture, not only in private homes but more typically in palaces and temples. Another interesting aspect of the model is the elaborate painting on the exterior walls. Much of the painting is purely decorative, though some of it illustrates structural features such as posts and lintels. Still other images evoke the world outdoors: Notice the trees flanking the gateway with crows perched in their branches. Literary sources describe the walls of Han palaces as decorated with paint and lacquer and also inlaid with precious metals and stones.

SIX DYNASTIES With the fall of the Han dynasty in 220 CE, China splintered into three warring kingdoms. In 280 CE the empire was briefly reunited, but invasions by nomadic peoples from Central Asia, a source of trouble throughout Chinese history, soon forced the court to flee south. For the next three centuries, northern and southern China developed separately. In the north, sixteen kingdoms carved out by invaders rose and fell before giving way to a succession of largely foreign dynasties. Warfare was commonplace. Tens of thousands of Chinese fled south, where six short-lived dynasties succeeded each other in an age of almost constant turmoil broadly known as the Six Dynasties period or the period of the Southern and Northern dynasties (220–579 CE).

In such chaos, the Confucian system lost much influence. In the south especially, many intellectuals—the creators and custodians of China's high culture—turned to Daoism, which contained a strong escapist element. Educated to serve the government, they increasingly withdrew from public life. They wandered the landscape, drank, wrote poems, practiced calligraphy, and expressed their disdain for the world through willfully eccentric behavior.

The rarefied intellectual escape route of Daoism was available only to the educated elite. Far more people sought answers in the magic and superstitions of Daoism in its religious form. Though weak and disorganized,

10-10. Attributed to Gu Kaizhi. Detail of *Admonitions of the Imperial Instructress to Court Ladies*.
Six Dynasties period, c. 344–406 CE. Handscroll, ink and colors on silk, 9¹/₂" x 11'6" (24.8 cm x 3.5 m).
The British Museum, London

the southern courts continued to patronize traditional Chinese culture, and Confucianism remained the official doctrine. Yet ultimately it was a new influence, Buddhism, that brought the greatest comfort to the troubled China of the Six Dynasties.

PAINTING

Although few paintings survive from the Six Dynasties, abundant descriptions in literary sources make clear that the period was an important one for painting. Landscape, later a major theme of Chinese art, first appeared as a subject during this era. For Daoists, wandering through China's countryside was a source of spiritual refreshment. Painters and scholars of the Six Dynasties found that wandering in the mind's eye through a painted landscape could serve the same purpose. This new emphasis on the spiritual value of painting contrasted with the Confucian view, which had emphasized art's moral and didactic uses.

Reflections on the tradition of painting also inspired the first works on theory and aesthetics. One of the earliest and most succinct formulations of the ideals of Chinese painting are the six principles set out by the scholar Xie He (c. 500–c. 535). The first two principles in particular offer valuable insight to the spirit in which China's painters worked.

The first principle announces that "spirit consonance" imbues a painting with "life's movement." This "spirit" is the Daoist *qi*, the breath that animates all creation, the energy that flows through all things. When a painting has *qi*, it will be alive with inner essence, not merely outward resemblance. Artists must cultivate their own spirit so that this universal energy flows through them and infuses their work. The second principle recognizes that brushstrokes are the "bones" of a picture, its primary structural element. The Chinese judge a painting

above all by the quality of its brushwork. Each brushstroke is a vehicle of expression; it is through the vitality of a painter's brushwork that "spirit consonance" makes itself felt. We can sense this attitude already in the rapid, confident brushstrokes that outline the figures of the Han banner and again in the more controlled, rhythmical lines of one of the most important of the very few works surviving from this period, a painted scroll known as *Admonitions of the Imperial Instructress to Court Ladies*. Attributed to the painter Gu Kaizhi (c. 344–406 CE), it alternates illustrations and text to relate seven Confucian stories of wifely virtue from Chinese history.

The first illustration depicts the courage of Lady Feng (fig. 10-10). An escaped circus bear rushes toward her husband, a Han emperor, who is filled with fear. Behind his throne, two female servants have turned to run away. Before him, two male attendants, themselves on the verge of panic, try to fend off the bear with spears. Only Lady Feng is calm as she rushes forward to place herself between the beast and the emperor.

The style of the painting is typical of the fourth century. The figures are drawn with a brush in a thin, even-width line, and a few outlined areas are filled with color. Facial features, especially those of the men, are quite well depicted. Movement and emotion are shown through conventions such as the bands flowing from Lady Feng's dress, indicating that she is rushing forward, and the upturned strings on both sides of the emperor's head, suggesting his fear. There is no hint of a setting; instead, the artist relies on careful placement of the figures to create a sense of depth.

The painting is on silk, a Chinese material with origins in the remote past. Silk was typically woven in bands about 12 inches wide and up to 20 or 30 feet long. Early Chinese painters thus developed the format used here, the **handscroll**—a long, narrow, horizontal composition, compact enough to be held in the hands when

10-11. Wang Xizhi. Portion of a letter from the *Feng Ju* album. Six Dynasties period, mid-4th century CE. Ink on paper, 9½ x 18½" (24.7 x 46.8 cm). National Palace Museum, Taipei, Taiwan

The stamped calligraphs that appear on Chinese art works are seals—personal emblems. The use of seals dates from the Zhou dynasty, and to this day seals traditionally employ the archaic characters, known appropriately as "seal script," of the Zhou or Qin. Cut in stone, a seal may state a formal, given name, or it may state any of the numerous personal names that China's painters and writers adopted throughout their lives. A treasured work of art often bears not only the seal of its maker but also those of collectors and admirers through the centuries. In the Chinese view, these do not disfigure the work but add another layer of interest. This sample of Wang Xizhi's calligraphy, for example, bears the seals of two Song dynasty emperors, a Song official, a famous collector of the sixteenth century, and two emperors of the Qing dynasty of the eighteenth and nineteenth centuries.

rolled up. Handscrolls are intimate works, meant to be viewed by only two or three people at a time. They were not displayed completely unrolled as we commonly see them today in museums. Rather, viewers would open a scroll and savor it slowly from right to left, displaying only a foot or two at a time.

CALLIGRAPHY

The emphasis on the expressive quality and structural importance of brushstrokes finds its purest embodiment in **calligraphy**. The same brushes are used for both painting and calligraphy, and a relationship between them was recognized as early as Han times. In his teachings, Confucius had extolled the importance of the

pursuit of knowledge and the arts. Among the visual arts, painting was felt to reflect moral concerns, while calligraphy was believed to reveal the style and character of the writer.

Calligraphy is regarded as one of the highest forms of expression in China. For more than 2,000 years, China's literati ("educated"), all of them Confucian scholars, have enjoyed being connoisseurs and practitioners of this abstract art. During the fourth century, calligraphy came to full maturity. The most important practitioner of the day was Wang Xizhi (c. 303–61 CE), whose works have served as models of excellence for all subsequent generations. The example here comes from a letter, now somewhat damaged and mounted as part of an album, known as *Feng Ju* (fig. 10-11).

Feng Ju is an example of "walking" style, which is neither too formal nor too free but is done in a relaxed, easygoing manner. Brushstrokes vary in width and length, creating rhythmic vitality. Individual characters remain distinct, yet within each character the strokes are run together and simplified as the brush moves from one to the other without lifting off the page. The effect is fluid and graceful, yet still strong and dynamic. It was Wang Xizhi who first made this an officially accepted style, to be learned along with other styles.

BUDDHIST ART AND ARCHITECTURE

Buddhism originated in India during the fifth century BCE (Chapter 9), then gradually spread north into Central Asia. With the opening of the Silk Road during the Han dynasty, its influence reached China. To the Chinese of the Six Dynasties, beset by constant warfare and social devastation, Buddhism offered consolation in life and the promise of salvation after death. The faith spread throughout the country to all social levels, first in the north, where many of the invaders promoted it as the official religion, then slightly later in the south, where it found its first great patron in the emperor Liang Wu Di (ruled 502–49 CE). Thousands of temples and monasteries were built, and many people became monks and nuns.

Almost nothing remains in China of the Buddhist architecture of the Six Dynasties, but we can see what it must have looked like in the Japanese temple Horyu-ji (see fig. 11-6), which was based on Chinese models of this period. The slender forms and linear grace of Horyu-ji have much in common with the figures in Gu Kaizhi's handscroll, and they indicate the delicate, almost weightless style cultivated in southern China.

The most impressive works of Buddhist art surviving from the Six Dynasties are the hundreds of northern rock-cut caves that line the Silk Road between Xinjiang in Central Asia and the Yellow River valley. Both the caves and the sculpture that fill them were carved from the solid rock of the cliffs. Small caves high above the ground were retreats for monks and pilgrims, while larger caves at the base of the cliffs were wayside shrines and temples.

The caves at Yungang, in Shanxi province in central China, contain many examples of the earliest phase of

10-12. Seated Buddha, Cave 20, Yungang, Datong, Shanxi. Northern Wei dynasty, c. 460 CE. Stone, height 45' (13.7 m)

10-13. Altar to Amitabha Buddha. Sui dynasty, 593 CE. Bronze, height 30⅛" (76.5 cm). Museum of Fine Arts, Boston
Gift of Mrs. W. Scott Fitz (22.407) and Gift of Edward Holmes Jackson in memory of his mother, Mrs. W. Scott Fitz (47.1407–1412)

Buddhist sculpture in China, including the monumental seated Buddha in Cave 20 (fig. 10-12). The figure was carved in the latter part of the fifth century by imperial decree of a ruler of the Northern Wei dynasty (386–535 CE), the longest-lived and most stable of the northern kingdoms. Most Wei rulers were avid patrons of Buddhism, and under their rule the religion made its greatest advances in the north.

The front part of the cave has crumbled away, and the 45-foot statue, now exposed to the open air, is clearly visible from a distance. The elongated ears, protuberance on the head (*ushnisha*), and monk's robe (*sanghati*) are traditional attributes of the Buddha. The masklike face, full torso, massive shoulders, and shallow, stylized drapery indicate strong Central Asian influence. The overall effect of this colossus is remote and even austere, less human than the more sensuous expression of the early traditions in India. The image of the Buddha became increasingly formal and unearthly as it traveled east from its origins, reflecting a fundamental difference in the way the Chinese and the Indians visualize their deities.

SUI AND TANG DYNASTIES In 589 CE, a general from the last of the northern dynasties replaced a child emperor and established a dynasty of his own, the Sui. Defeating all opposition, he molded China into a centralized empire as it had been in Han times. The new emperor was a devout Buddhist, and his reunification of China coincided with a fusion of the several styles of Buddhist sculpture that had developed. This new style is seen in a bronze altar to Amitabha Buddha (fig. 10-13), one of the many buddhas espoused by Mahayana Buddhism. Amitabha dwelled in the Western Pure Land, a paradise into which his faithful followers were promised rebirth. With its comparatively simple message of salvation, the Pure Land sect eventually became the most popular form of Buddhism in China and one of the most popular in Japan (see fig. 11-1).

The altar depicts Amitabha in his paradise, seated on a lotus throne beneath a canopy of trees. Each leaf

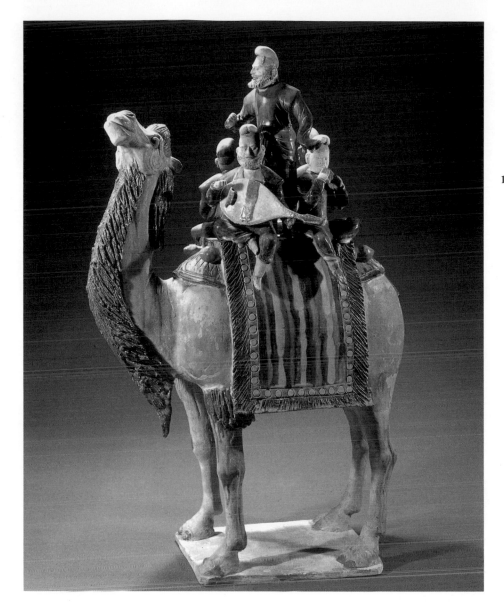

10-14. *Camel Carrying a Group of Musicians*, from a tomb near Xi'an, Shanxi. Tang dynasty, c. mid-8th century CE. Earthenware with three-color glaze, height 26⅛" (66.5 cm). Museum of Chinese History, Beijing

cluster is set with jewels. Seven celestial nymphs sit on the topmost clusters, and ropes of "pearls" hang from the tree trunks. Behind Amitabha's head is a halo of flames. To his left, the **bodhisattva** Guanyin holds a pomegranate; to his right, another *bodhisattva* clasps his hands in prayer. Behind are four disciples who first preached the teachings of the Buddha. On the lower level, an incense burner is flanked by seated dogs and two smaller *bodhisattvas*. Focusing on Amitabha's benign expression and filled with objects symbolizing his power, the altar combines the sensuality of Indian styles, the schematic abstraction of Central Asian art, and the Chinese emphasis on linear grace and rhythm into a harmonious new style.

The short-lived Sui dynasty fell in 617 CE, but in reunifying the empire it paved the way for one of the greatest dynasties in Chinese history, the Tang (618–907 CE). Even today many Chinese living abroad still call themselves "Tang people." To them, Tang implies that part of the Chinese character that is strong and vigorous (especially in military power), noble and idealistic, but also realistic and pragmatic.

Under a series of ambitious and forceful emperors, Chinese control again reached over Central Asia. As in

Han times, goods, ideas, and influence flowed across the Silk Road. In the South China Sea, Arab and Persian ships carried on a lively trade with coastal cities. Chinese cultural influence in East Asia was so important that Japan and Korea sent thousands of students to study Chinese civilization.

Cosmopolitan and tolerant, Tang China was confident in itself and curious about the world. Many foreigners came to the splendid new capital, Chang'an (present-day Xi'an), and they are often depicted in the art of the period. A ceramic statue of a camel carrying a troupe of musicians reflects the Tang fascination with the "exotic" Turkic cultures of Central Asia (fig. 10-14). The three bearded musicians (one with his back to us) are Central Asian, while the two smooth-shaven ones are Han Chinese. Two-humped Bactrian camels, themselves exotic Central Asian "visitors," were beasts of burden in the caravans that crisscrossed the Silk Road. The motif of musicians on camelback seems to have been popular in the Tang dynasty, for it also appears in some paintings.

Stylistically, the statue reveals a new interest in **naturalism**, an important trend in both painting and sculpture. Compared to the rigid, staring ceramic soldiers of the first emperor of Qin, the Tang group is alive

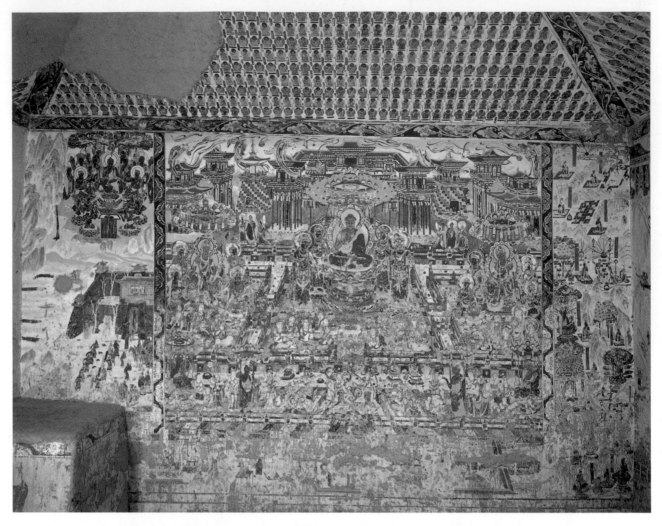

10-15. *The Western Paradise of Amitabha Buddha*, detail of a wall painting in Cave 217, Dunhuang, Gansu. Tang dynasty, c. 750 CE. 10'2" x 16' (3.1 x 4.86 m)

with gesture and expression. The majestic camel throws its head back; the musicians are vividly captured in mid-performance. Ceramic figurines such as this, produced by the thousands for Tang tombs, offer a glimpse into the gorgeous variety of Tang life. The statue's three-color **glaze** technique was a specialty of Tang ceramicists. The glazes—usually chosen from a restricted palette of amber, yellow, green, and white—were splashed freely and allowed to run over the surface during firing to convey a feeling of spontaneity. The technique seems symbolic of Tang culture itself in its robust, colorful, and cosmopolitan expressiveness.

BUDDHIST ART AND ARCHITECTURE

Buddhism reached its greatest development in China during the Tang dynasty. From emperors and empresses to common peasants, virtually the entire country adopted the Buddhist faith. A Tang vision of the most popular sect, Pure Land, was expressed in a wall painting from a cave in Dunhuang (fig. 10-15). A major stop along the Silk Road, Dunhuang has some 500 caves carved out of its sandy cliffs, all filled with painted clay sculpture and decorated with wall paintings from floor to ceiling. The site was worked on continuously from the fifth to the fourteenth century, a period of almost a thousand years. Rarely in art's history do we have the opportunity to study such an extended period of stylistic and iconographic evolution in one place.

In the detail shown here, Amitabha Buddha is seated in the center, surrounded by four *bodhisattvas*, who serve as his messengers to the world. Two other groups of *bodhisattvas* are clustered at the right and left. In the foreground, musicians and dancers create a heavenly atmosphere. In the background, great halls and towers rise. The artist has imagined the Western Paradise in terms of the grandeur of Tang palaces. Indeed, the lavish entertainment could just as easily be taking place at the imperial court. This worldly vision of paradise, recorded with great attention to naturalism in the architectural setting, contrasts tellingly with the simple portrayal in the earlier Sui altarpiece (see fig. 10-13), and it gives us our best visualization of the splendor of Tang civilization at a time when Chang'an was probably the greatest city in the world.

The early Tang emperors proclaimed a policy of religious tolerance, but during the ninth century a conservative reaction set in. Confucianism was reasserted and Buddhism was briefly persecuted as a "foreign" religion. Thousands of temples, shrines, and monasteries were destroyed and innumerable bronze statues melted down.

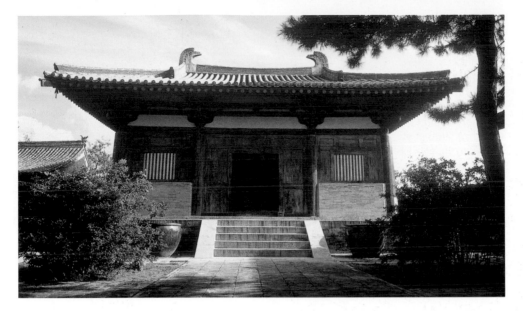

10-16. Nanchan Temple, Wutaishan, Shanxi. Tang dynasty, 782 CE

Nevertheless, several Buddhist structures survive from the Tang dynasty, one of which, the Nanchan Temple, is the earliest surviving example of important Chinese architecture.

Nanchan Temple. Of the few structures earlier than 1400 to have survived, the Nanchan Temple is the most significant, for it shows characteristics of both temples and palaces of the Tang dynasty (fig. 10-16). Located on Mount Wutai in the eastern part of Shanxi province, this small hall was constructed in 782 CE. The tiled roof, first seen in the Han tomb model (see fig. 10-9), has taken on a curved silhouette. Quite subtle here, this curve became increasingly pronounced in later centuries. The very broad overhanging eaves are supported by a correspondingly elaborate bracketing system.

Also typical is the **bay** system of construction, in which a cubic unit of space, a bay, is formed by four posts and their lintels. The bay functioned in Chinese architecture as a sort of module, a basic unit of construction. To create larger structures, an architect multiplied the number of bays. Thus the Nanchan Temple—modest in scope with three bays—gives an idea of the vast, multistoried palaces of the Tang depicted in such paintings as the one from Dunhuang.

Great Wild Goose Pagoda. Another important monument of Tang architecture is the Great Wild Goose Pagoda at the Ci'en Temple in Xi'an, the Tang capital (fig. 10-17). The temple was constructed in 645 CE for the famous monk Xuanzang on his return from a sixteen-year pilgrimage to India. At Ci'en Temple, Xuanzang taught and translated the materials he had brought back with him.

The **pagoda**, a typical East Asian Buddhist structure, originated in the Indian Buddhist **stupa**, the elaborated burial mound that housed relics of the Buddha (see "Pagodas," page 418). In India the stupa had developed a multistoried form in the Gandhara region under the Kushan dynasty (c. 50–250 CE). In China this form blended with a traditional Han watchtower to produce the pagoda. Built entirely in masonry, the Great Wild Goose Pagoda nevertheless imitates the wooden architecture of the time. The walls are decorated in low relief to resemble

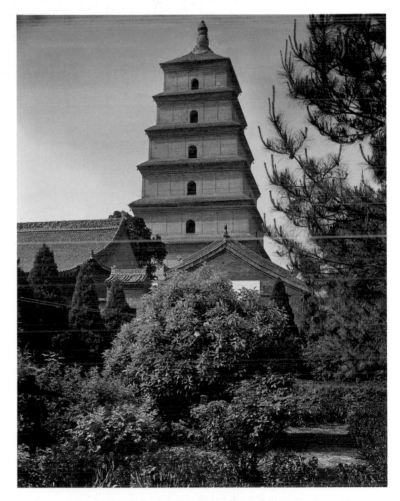

10-17. Great Wild Goose Pagoda at Ci'en Temple, Xi'an, Shanxi. Tang dynasty, first erected 645 CE; rebuilt mid-8th century CE

bays, and bracket systems are reproduced under the projecting roofs of each story. Although modified and repaired in later times (its seven stories were originally five, and a new **finial** has been added), the pagoda still preserves the essence of Tang architecture in its simplicity, symmetry, proportions, and grace.

ELEMENTS OF ARCHITECTURE
Pagodas

Pagodas are the most characteristic of East Asian architectural forms. Originally associated with Buddhism, **pagodas** developed from Indian **stupas** as Buddhism spread northeastward along the Silk Road. Stupas merged with the watchtowers of Han dynasty China in multistoried stone structures with projecting tiled roofs. This transformation culminated in wooden pagodas with upward-curving roofs supported by elaborate **bracketing** in China, Korea, and Japan. Buddhist pagodas retain the *axis mundi* masts of stupas. Like their South Asian prototypes, early East Asian pagodas were symbolic rather than enclosing structures; they were solid, with small devotional spaces hollowed out. Later examples often provided access to the ground floor and sometimes to upper levels. The layout and construction of pagodas, as well as the number and curve of their roofs, vary depending on the time and place.

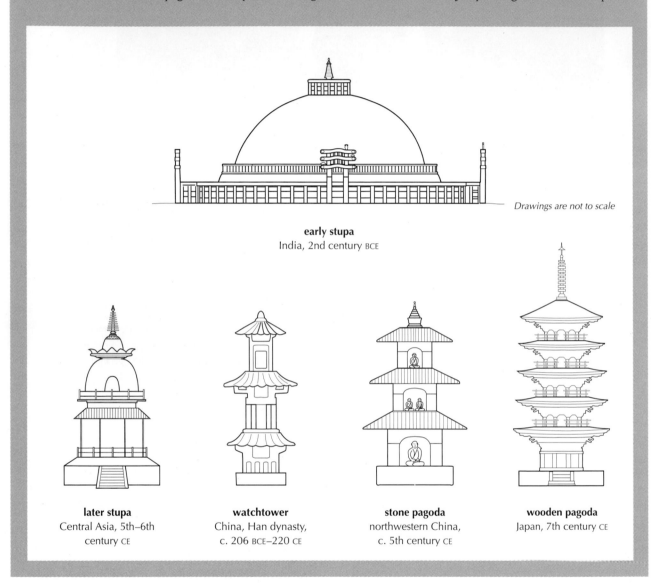

Drawings are not to scale

early stupa
India, 2nd century BCE

later stupa
Central Asia, 5th–6th century CE

watchtower
China, Han dynasty,
c. 206 BCE–220 CE

stone pagoda
northwestern China,
c. 5th century CE

wooden pagoda
Japan, 7th century CE

FIGURE PAINTING

Later artists looking back on their heritage recognized the Tang dynasty as China's great age of figure painting. Unfortunately, very few scroll paintings that can be definitely identified as Tang still exist. We can get some idea of the character of Tang figure painting from the wall paintings of Dunhuang (see fig. 10-15). Another way to savor the particular flavor of Tang painting is to look at copies made by later Song dynasty artists, which are far better preserved. An outstanding example of this practice is *Ladies Preparing Newly Woven Silk*, attributed to Huizong (ruled 1101–25 CE), the last emperor of the Northern Song dynasty (fig. 10-18). A long handscroll in several sections, it depicts the activities of court women as they weave and iron silk. An inscription on the scroll informs us that the painting is a copy of a famous work by Zhang Xuan, an eighth-century painter known for his depictions of women at the Tang court. The original no longer exists, so we cannot know how faithful the copy is. Still, its refined lines and bright colors seem to share not only the grace and simplicity of Tang sculpture and architecture but also the quiet beauty characteristic of Tang painting.

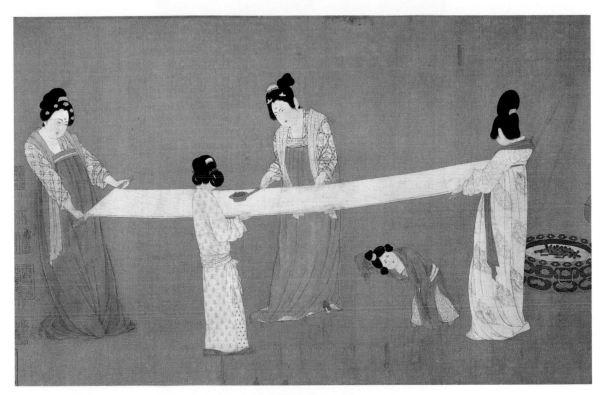

10-18. Attributed to Emperor Huizong. Detail of *Ladies Preparing Newly Woven Silk*, copy after a lost Tang dynasty painting by Zhang Xuan. Northern Song dynasty, early 12th century CE. Handscroll, ink and colors on silk, 14½ x 57½" (36.8 x 145.5 cm). Museum of Fine Arts, Boston

Chinese and Japanese Special Fund

Confucius said of himself, "I merely transmit, I do not create; I love and revere the ancients." In this spirit, Chinese painters regularly copied paintings of earlier masters. Painters made copies both to absorb the lessons of their great predecessors and to perpetuate the achievements of the past. In later centuries, painters took up the practice of regularly executing a work "in the manner of" some particularly revered ancient master. This was at once an act of homage, a declaration of artistic allegiance, and a way of reinforcing a personal connection with the past.

SONG DYNASTY

A brief period of disintegration followed the fall of the Tang dynasty before China was again united, this time under the Song dynasty (960–1279 CE), which established a new capital at Bianjing (present-day Kaifeng), near the Yellow River. In contrast to the outgoing confidence of the Tang, the mood during the Song was more introspective, a reflection of China's weakened military situation. In 1126 the Jurchen tribes of Manchuria invaded China, sacked the capital, and took possession of much of the northern part of the country. Song forces withdrew south and established a new capital at Hangzhou. From this point on, the dynasty is known as Southern Song (1127–1279 CE), with the first portion called in retrospect Northern Song (960–1126 CE).

Although China's territory had diminished, its wealth had increased because of advances in agriculture, commerce, and technology begun under the Tang. Patronage was plentiful, and the arts flourished. Song culture is noted for its highly refined taste and intellectual grandeur. Where the Tang had reveled in exoticism, eagerly absorbing influences from Persia, India, and Central Asia, Song culture was more self-consciously Chinese. Philosophy experienced its most creative era since the "one hundred schools" of the Zhou. Song scholarship was brilliant, especially in history, and its poetry is noted for its depth. But the finest expressions of the Song are in art, especially painting and ceramics.

PHILOSOPHY: NEO-CONFUCIANISM

Song philosophers continued the process, begun during the Tang, of restoring Confucianism to dominance. In strengthening Confucian thought, philosophers drew on Daoism and especially Buddhism, even as they openly rejected Buddhism itself as foreign. These innovations provided Confucianism with a metaphysical aspect it had previously lacked, allowing it to propose a more satisfying, all-embracing explanation of the universe. This new synthesis of China's three main paths of thought is called Neo-Confucianism.

Neo-Confucianism teaches that the universe consists of two interacting forces known as *li* (principle or idea) and *qi* (matter). All pine trees, for example, consist

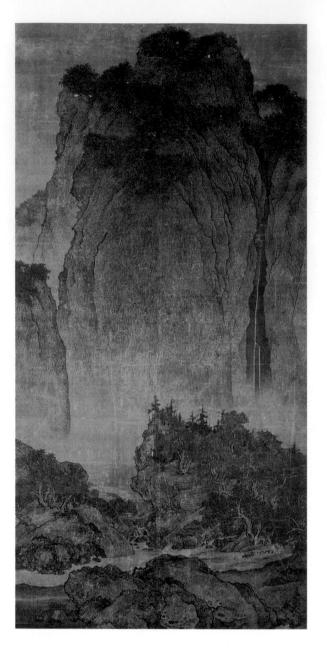

10-19. Fan Kuan. *Travelers among Mountains and Streams.* Northern Song dynasty, early 11th century CE. Hanging scroll, ink and colors on silk, height 6'9½" (2.06 m). National Palace Museum, Taipei, Taiwan

of an underlying *li* we might call "Pine Tree Idea" brought into the material world through *qi*. All the *li* of the universe, including humans, are but aspects of an eternal first principlc known as the Great Ultimate, which is completely present in every object. Our task as human beings is to rid our *qi* of impurities through education and self-cultivation so that our *li* may realize its oneness with the Great Ultimate. This lifelong process resembles the striving to attain buddhahood, and if we persist in our attempts, one day we will be enlightened—the term itself comes directly from Buddhism.

NORTHERN SONG PAINTING

The Neo-Confucian ideas found visual expression in art, especially in landscape, which became the most highly esteemed subject for painting. Northern Song artists studied nature closely to master its many appearances—the way each species of tree grew, the distinctive character of each rock formation, the changes of the

seasons, the myriad birds, blossoms, and insects. This passion for realistic detail was the artist's form of self-cultivation: Mastering outward forms showed an understanding of the principles behind them.

Yet despite the convincing accumulation of detail, the paintings do not record a specific site. The artist's goal was to paint the eternal essence of mountain-ness, for example, not to reproduce the appearance of a particular mountain. Painting a landscape required an artist to orchestrate his cumulative understanding of *li* in all its aspects—mountains and rocks, streams and waterfalls, trees and grasses, clouds and mist. A landscape painting thus expressed the desire for the spiritual communion with nature that was the key to enlightenment. As the tradition progressed, landscape also became a vehicle for conveying human emotions, even for speaking indirectly of one's own deepest feelings.

In the earliest times, art reflected the mythocentric worldview of the ancient Chinese. During the period when the three religions dominated people's lives, there

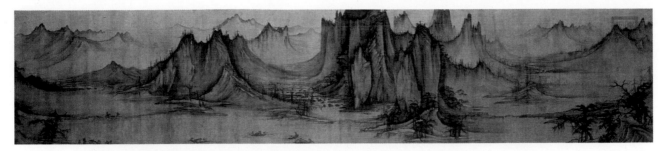

10-20. Xu Daoning. Detail of *Fishing in a Mountain Stream*. Northern Song dynasty, mid-11th century CE. Handscroll, ink on silk, 19" x 6'10" (48.9 cm x 2.09 m). The Nelson-Atkins Museum of Art, Kansas City, Missouri
Purchase, Nelson Trust (33–1559)

was a major shift in which religious images and human actions became the most important subjects. The choice of landscape as the chief means of expression, reflecting the general Chinese desire to avoid direct depiction of the human condition and to show things instead in a symbolic manner, was the second great shift in the focus of Chinese art. The major form of Chinese artistic expression thus moved from the mythical, through the religious and ethical, and finally to the philosophical and aesthetic.

One of the first great masters of Song landscape was the eleventh-century painter Fan Kuan (active c. 990–1030 CE), whose surviving major work, *Travelers among Mountains and Streams*, is generally regarded as one of the greatest monuments in the history of Chinese art (fig. 10-19). The work is physically large—almost 7 feet high—but the sense of monumentality also radiates from the composition itself, which makes its impression even when much reduced.

The composition unfolds in three stages, comparable to the three acts of a drama. At the bottom a large, low-lying group of rocks, taking up about one-eighth of the picture surface, establishes the extreme foreground. The rest of the landscape pushes back from this point. In anticipating the shape and substance of the mountains to come, the rocks introduce the main theme of the work, much as the first act of a drama introduces the principal characters. In the middle ground, travelers and their mules are coming from the right. They are somewhat startling, for we suddenly realize our human scale—how small we are, how vast nature is. This middle ground takes up twice as much picture surface as the foreground, and, like the second act of a play, shows variation and development. Instead of a solid mass, the rocks here are separated into two groups by a waterfall spanned by a bridge. In the hills to the right, the rooftops of a temple stand out above the trees.

Mist veils the transition to the background, with the result that the mountain looms suddenly. This background area, almost twice as large as the foreground and middle ground combined, is the climactic third act of the drama. As our eyes begin their ascent, the mountain solidifies. Its ponderous weight increases as it billows upward, finally bursting into the sprays of energetic brushstrokes that describe the scrubby growth on top. To the right, a slender waterfall plummets, not to balance the powerful upward thrust of the mountain but simply to enhance it by

contrast. The whole painting, then, conveys the feeling of climbing a high mountain, leaving the human world behind to come face to face with the Great Ultimate in a spiritual communion.

All the elements are depicted with precise detail and in proper scale. Jagged brushstrokes describe the contours of rocks and trees and express their rugged character. Layers of short, staccato strokes (called "raindrop texture" in Chinese) accurately mimic the texture of the rock surface. Spatial recession from foreground through middle ground to background is logically and convincingly handled, if not yet quite continuous.

Although it contains realistic details, the landscape represents no specific place. In its forms, the artist expresses the ideal forms behind appearances; in the rational, ordered composition, he expresses the intelligence of the universe. The arrangement of the mountains, with the central peak flanked by lesser peaks on each side, seems to reflect both the ancient Confucian notion of social hierarchy, with the emperor flanked by his ministers, and the Buddhist motif of the Buddha with *bodhisattvas* at his side. The landscape, a view of nature uncorrupted by human habitation, expresses a kind of Daoist ideal. Thus we find the three strains of Chinese thought united, much as they are in Neo-Confucianism itself.

The ability of Chinese landscape painters to take us out of ourselves and to let us wander freely through their sites is closely linked to the avoidance of perspective as it is understood in the West. Fifteenth-century European painters, searching for fidelity to appearances, developed a "scientific" system for recording exactly the view that could be seen from a single, fixed vantage point. The goal of Chinese painting is precisely to get away from such limits and show a totality beyond what we are normally given to see. If we can imagine the ideal for centuries of Western painters as a photograph, which shows only what can be seen from a fixed viewpoint, we can imagine the ideal for Chinese artists as a film camera aloft in a balloon: distant, all-seeing, and mobile.

The sense of shifting perspective is clearest in the handscroll, where our vantage point changes constantly as we move through the painting. One of the finest handscrolls to survive from the Northern Song is *Fishing in a Mountain Stream* (fig. 10-20), a 7-foot-long painting executed in the middle of the eleventh century by Xu Daoning

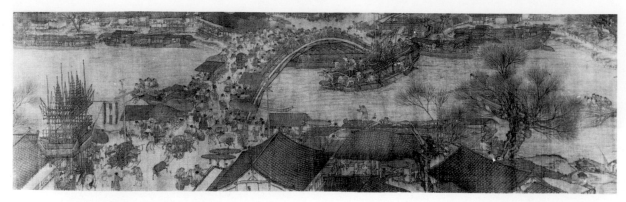

10-21. Zhang Zeduan. Detail of *Spring Festival on the River*. Northern Song dynasty, early 12th century CE. Handscroll, ink and colors on silk, 9½" x 7'4" (24.8 cm x 2.28 m). The Palace Museum, Beijing

(c. 970–c. 1052 CE). Starting from a thatched hut in the right foreground, we follow a path that leads to a broad, open view of a deep vista dissolving into distant mists and mountain peaks. (Remember that viewers observed only a small section of the scroll at a time. To mimic the effect, use two pieces of paper to frame a small viewing area, then move them slowly leftward.) Crossing over a small footbridge, we are brought back to the foreground with the beginning of a central group of high mountains that show extraordinary shapes. Again our path winds back along the bank, and we have a spectacular view of the highest peaks from another small footbridge the artist has placed for us. At the far side of the bridge, we find ourselves looking up into a deep valley, where a stream lures our eyes far into the distance. We can imagine ourselves resting for a moment in the small pavilion the artist offers us halfway up the valley on the right. Or perhaps we may spend some time with the fishers in their boats as the valley gives way to a second, smaller group of mountains, serving both as an echo of the spectacular central group and as a transition to the painting's finale, a broad, open vista. As we cross the bridge here, we meet travelers coming toward us, who will have our experience in reverse. Gazing out into the distance and reflecting on our journey, we again feel that sense of communion with nature that is the goal of Chinese artistic expression.

Such handscrolls have no counterpart in the Western visual arts and are often compared instead to the tradition of Western music, especially symphonic compositions. Both are generated from opening motifs that are developed and varied, both are revealed over time, and in both our sense of the overall structure relies on memory, for we do not see the scroll or hear the composition all at once.

The Northern Song fascination with precision extended to details within landscape. The emperor Huizong, whose copy of *Ladies Preparing Newly Woven Silk* was seen in figure 10-18, gathered around himself a group of court painters who shared his passion for quiet, exquisitely detailed, delicately colored paintings of birds and flowers. Other painters specialized in domestic and wild animals, still others in palaces and buildings. One of the most spectacular products of this passion for observation is *Spring Festival on the River*, a long handscroll painted in the first quarter of the twelfth century by Zhang Zeduan, an artist connected to the court (fig. 10-21).

10-22. Xia Gui. Detail of *Twelve Views from a Thatched Hut*. Southern Song dynasty, early 13th century CE. Handscroll, ink on silk, height 11" (28 cm), length of extant portion 7'7½" (2.31 m). The Nelson-Atkins Museum of Art, Kansas City, Missouri

Purchase, Nelson Trust (32-159/2)

Beyond its considerable visual delights, the painting is also an invaluable record of daily life in the Song capital.

The painting is set on the day of a festival, when local inhabitants and visitors from the countryside thronged the streets. One high point is the scene reproduced here, which takes place at the Rainbow Bridge. The large boat to the right is probably bringing goods from the southern part of China up the Grand Canal that ran through the city at that time. The sailors are preparing to pass beneath the bridge by lowering the sail and taking down the mast. Excited figures on ship and shore gesture wildly, shouting orders and advice, while a noisy crowd gathers at the bridge railing to watch. Stalls on the bridge are selling food and other merchandise; wine shops and eating places line the banks of the canal. Everyone is on the move. Some people are busy carrying goods, some are shopping, some are simply enjoying themselves. Each figure is splendidly animated and full of purpose; the buildings and boats are perfect in every detail—the artist's knowledge of this bustling world was indeed encyclopedic.

Little is known about the painter Zhang Zeduan other than that he was a member of the scholar-official class, the highly educated elite of imperial China. Interestingly, some of Zhang Zeduan's peers were already beginning to cultivate quite a different attitude toward painting as a form of artistic expression, one that placed overt skill at the lowest end of the scale of values. This emerging scholarly aesthetic later came to dominate Chinese thinking about art, with the result that only in the twentieth century has *Spring Festival* again found an audience willing to hold it in the highest esteem.

SOUTHERN SONG PAINTING AND CERAMICS

Landscape painting took a very different course after the fall of the north and the removal of the court to its new capital in the south, Hangzhou. This new sensibility is reflected in the extant portion of *Twelve Views from a Thatched Hut* (fig. 10-22) by Xia Gui (c. 1180–1230 CE), a member of the newly established Academy of Painters. In general, academy members continued to favor such subjects as birds and flowers in the highly refined, elegantly colored court style patronized earlier by Huizong. Xia Gui, however, was interested in landscape and cultivated his own style. Only the last four of the twelve views that originally made up this long handscroll have survived, but they are enough to illustrate the unique quality of his approach.

In sharp contrast to the majestic, austere landscapes of the Northern Song painters, Xia Gui presents an intimate and lyrical view of nature. Subtly modulated, perfectly controlled ink washes evoke a landscape veiled in mist, while a few deft brushstrokes suffice to indicate the details showing through—the grasses growing by the bank, the fishers at their work, the trees laden with moisture, the two bent-backed figures carrying their heavy load along the path that skirts the hill. Simplified forms, stark contrasts of light and dark, asymmetrical composition, and great expanses of blank space suggest a fleeting world that can be captured only in glimpses. The intangible is somehow more real than the tangible. By limiting himself to a few essential details, the painter evokes a deep feeling for what lies beyond.

This development in Song painting from the rational and intellectual to the emotional and intuitive, from the tangible to the intangible, had a parallel in philosophy. During the late twelfth century a new school of Neo-Confucianism called School of the Mind insisted that self-cultivation could be achieved through contemplation, which might lead to sudden enlightenment. The idea of sudden enlightenment may have come from Chan Buddhism, better known in the West by its Japanese name, Zen. Chan Buddhists rejected such formal paths to enlightenment as scripture, knowledge, and ritual in favor of meditation and techniques designed to "short-circuit" the rational mind. Xia Gui's painting seems also to follow this intuitive approach.

The subtle and sophisticated paintings of the Song were created for a highly cultivated audience equally discerning in other arts such as ceramics. Building on the considerable accomplishments of the Tang, Song potters achieved a technical and aesthetic perfection that has

10-23. Guan Ware vase. Southern Song dynasty, 13th century CE. Porcelaneous stoneware with crackled glaze, height 6⅝" (16.8 cm). Percival David Foundation of Chinese Art, London

made their wares models of excellence throughout the world. Like their painter contemporaries, Song potters turned away from the exuberance of Tang styles to create more quietly beautiful pieces.

The most highly prized of the many types of Song ceramics is Guan Ware, made mainly for imperial use (fig. 10-23). The everted lip, high neck, and rounded body of this simple vase show a strong sense of harmony. Aided by a lustrous white glaze, the form flows without break from base to lip. The piece has an introspective quality as eloquent as the blank spaces in Xia Gui's painting. The aesthetic of the Song is most evident in the crackle pattern that spreads over the surface. The crackle technique was probably discovered accidentally, but it came to be used deliberately in some of the finest Song

wares. In the play of irregular, spontaneous crackles over a perfectly regular, perfectly planned form we can sense the same spirit that hovers behind the self-effacing virtuosity and freely intuitive insights of Xia Gui's landscape.

In 1279 the Southern Song dynasty fell to the conquering forces of the Mongol leader Kublai Khan. China was subsumed into the vast Mongol Empire. Mongol rulers founded the Yuan dynasty (1279–1368 CE), setting up their capital in the northeast in what is now Beijing. Yet the cultural center of China remained in the south, in the cities that rose to prominence during the Song. This separation of political and cultural centers, coupled with a lasting resentment of "barbarian" rule, created the climate for later developments in the arts.

PERIOD	ART IN CHINA BEFORE 1280	ART IN OTHER CULTURES
NEOLITHIC c. 5000–2000 BCE	**10-2.** Yangshao bowl (5000–4000 BCE) **10-3.** Liangzhu *cong* (before 3000 BCE)	**2-25.** Susa beaker (c. 4000 BCE), Iran **3-4.** *Palette of Narmer* (c. 3000 BCE), Egypt **3-10.** Giza pyramids (c. 2613–2494 BCE), Egypt **9-4.** Harappa torso (c. 2000 BCE), India
BRONZE AGE c. 1700–221 BCE	**10-4.** *Fang ding* (c. 12th cent. BCE)	**5-39.** Parthenon (447–438 BCE), Greece **5-1.** *Discus Thrower* (c. 450 BCE), Greece
QIN DYNASTY c. 221–206 BCE	**10-1.** Qin soldiers (c. 210 BCE)	**5-74.** *Gallic Chieftain Killing His Wife and Himself* (c. 220 BCE), Greece
HAN DYNASTY c. 206 BCE–220 CE	**10-6.** Painted banner (c. 160 BCE) **10-8.** Wu shrine relief (151 CE) **10-9.** Model of Han house (1st cent. CE)	**6-22.** Ara Pacis (13–9 BCE), Italy **6-28.** Column of Trajan (113–16 or after 117 CE), Italy
SIX DYNASTIES c. 220–579 CE	**10-10.** Gu. *Admonitions of the Imperial Instructress to Court Ladies* (c. 344–406 CE) **10-11.** Wang. *Feng Ju* calligraphy (mid-4th cent. CE) **10-12.** Seated Buddha (c. 460 CE)	**7-5.** Dura-Europos synagogue (244–45 CE), Syria **9-17.** Ajanta *Bodhisattva* (c. 475 CE), India **7-22.** Hagia Sophia (532–37 CE), Turkey **11-4.** *Haniwa* (6th cent. CE), Japan
SUI DYNASTY c. 589–617 CE	**10-13.** Amitabha Buddha altar (593 CE)	
TANG DYNASTY c. 618–907 CE	**10-14.** *Camel Carrying a Group of Musicians* (c. mid-8th cent. CE) **10-15.** *The Western Paradise of Amitabha Buddha* (c. 750 CE) **10-16.** Nanchan Temple (782 CE) **10-17.** Great Wild Goose Pagoda (rebuilt mid-8th cent. CE)	**8-6.** Córdoba mosque (785–86 CE), Spain **14-12.** Charlemagne's chapel (792–805 CE), Germany **14-17.** *Utrecht Psalter* (c. 825–50 CE), Netherlands
SONG DYNASTY c. 960–1279 CE	**10-19.** Fan. *Travelers among Mountains and Streams* (early 11th cent. CE) **10-21.** Zhang. *Spring Festival on the River* (early 12th cent. CE) **10-22.** *Twelve Views from a Thatched Hut* (early 13th cent. CE) **10-23.** Guan Ware vase (13th cent. CE)	**7-39.** Cathedral of Saint Mark (begun 1063 CE), Italy **15-32.** *Bayeux Tapestry* (c. 1066–77 CE), France **9-28.** *Shiva Nataraja* (12th cent. CE), India **16-6.** Chartres Cathedral (c. 1134–1220 CE), France **12-23.** Anasazi seed jar (1150 CE), North America

11
Japanese Art before 1392

Rising militarism, political turbulence, and the excesses of the imperial court marked the beginning of the eleventh century in Japan. To many Japanese of the late Heian and Kamakura eras (Timeline 11-1), the unsettled times seemed to confirm the coming of *Mappo*, a long-prophesied dark age of spiritual degeneration. Japanese of all classes reacted by increasingly turning to the promise of simple salvation extended by Pure Land Buddhism, which had spread from China by way of Korea. The religion held that merely by chanting *Namu Amida Butsu*, hailing the Buddha Amida (the Japanese version of Amitabha Buddha), the faithful would be reborn into the Western Pure Land paradise over which he presided.

The practice had been spread throughout Japan by traveling monks such as the charismatic Kuya (903–72 CE), who encouraged people to chant by going through the countryside singing.

Believers would have immediately recognized Kuya in this thirteenth-century statue by Kosho (fig. 11-1): The traveling clothes, the small gong, the staff topped by deer horns (symbolic of his slaying a deer, whose death converted him to Buddhism), clearly identify the monk, whose sweetly intense expression gives this sculpture a radiant sense of faith. As for Kuya's chant, Kosho's solution to the challenge of putting words into sculptural form was simple but brilliant: He carved six small buddhas emerging from Kuya's mouth, one for each of the six syllables *Na-mu-A-mi-da-Buts(u)* (the final *u* is not articulated). Believers would have understood that these six small buddhas embodied the Pure Land chant.

In combining the realistic portrait of Kuya with the abstract representation of the chant, this statue reveals the tolerance of—even preference for—paradox in Japanese art.

11-1. Kosho. *Kuya Preaching*. Kamakura period, before 1207. Painted wood, height 46¹⁄₂" (117.5 cm). Rokuhara Mitsu-ji, Kyoto

TIMELINE 11-1. Japan before 1392. Prehistoric cultures gave way to a settled agricultural way of life. Beginning about 550 CE, Japan experienced several periods of intense cultural transformation: Asuka, Nara, Heian, and Kamakura.

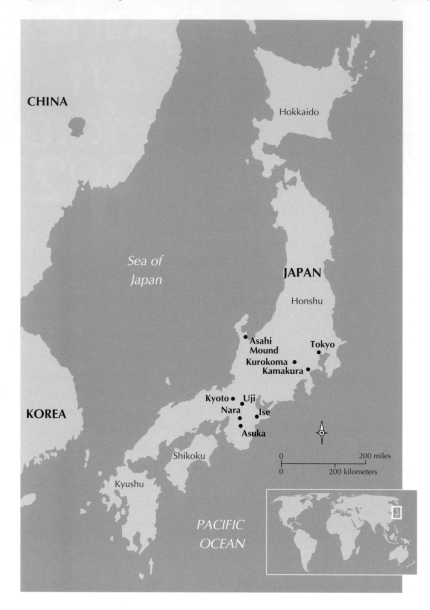

MAP 11-1. Japan before 1392. Melting glaciers at the end of the Ice Age in Japan 15,000 years ago raised the sea level and formed the four main islands of Japan: Hokkaido, Honshu, Shikoku, and Kyushu.

PREHISTORIC JAPAN

The earliest traces of human habitation in Japan are at least 30,000 years old. At that time the four islands that comprise the country today were still linked to the East Asian landmass, forming a ring from Siberia to Korea around the present-day Sea of Japan, which was then a lake. With the end of the last Ice Age there, some 15,000 years ago, melting glaciers caused the sea level to rise, gradually submerging the lowland links and creating the islands as we know them today (Map 11-1). Sometime after, Paleolithic peoples gave way to Neolithic hunter-gatherers, who crafted stone tools and gradually developed the ability to make and use ceramics. Recent scientific dating methods have shown some works of Japanese pottery to date earlier than 10,000 BCE, making them the oldest now known.

JOMON PERIOD

The Jomon period (c. 12,000–300 BCE) is named for the patterns on much of the pottery produced during this time, which were made by pressing cord onto damp clay (*jomon* means "cord markings"). Jomon people were able to develop an unusually sophisticated hunting-gathering culture in part because their island setting protected them from large-scale invasions and also because of their abundant food supply. Around 5000 BCE, agriculture emerged with the planting and harvesting of beans and gourds. Some 4,000 years later, the Jomon began to cultivate rice, but nevertheless remained primarily a hunting-gathering society that used stone tools and weapons. People lived in small communities, usually with fewer than ten or twelve dwellings, and

11-2. Vessel, from the Asahi Mound, Toyama Prefecture. Jomon period, c. 2000 BCE. Low-fired ceramic, height 14 3/4" (37.4 cm). Collection of Tokyo University

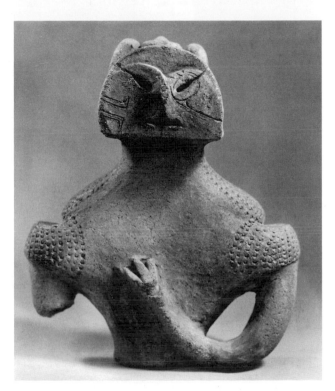

11-3. Dogu, from Kurokoma, Yamanashi Prefecture. Jomon period, c. 2000 BCE. Low-fired earthenware, height 10" (25.2 cm). Tokyo National Museum

seem to have enjoyed a peaceful life, giving them the opportunity to develop their artistry for even such practical endeavors as ceramics.

Jomon ceramics may have begun in imitation of reed baskets, as many early examples suggest. Other early Jomon pots have pointed bottoms. Judging from burn marks along the sides, they must have been planted firmly into soft earth or sand, then used for cooking. Applying fire to the sides rather than the bottom allowed the vessels to heat more fully and evenly. Still other early vessels were crafted with straight sides and flat bottoms, a shape that was useful for storage as well as cooking and eventually became the norm. Jomon usually crafted their vessels by building them up with coils of clay, then firing them in bonfires at relatively low temperatures. Researchers think that Jomon pottery was made by women, as was the practice in most early societies, especially before the use of the potter's wheel.

During the middle Jomon period (2500–1500 BCE), pottery reached a high degree of creativity. By this time communities were somewhat larger, and each family may have wanted its ceramic vessels to have a unique design. The basic form remained the straight-sided cooking or storage jar, but the rim now took on spectacular, flamboyant shapes, as seen in one example from the Asahi Mound (fig. 11-2). Middle Jomon potters

made full use of the tactile quality of clay, bending and twisting it as well as **incising** and applying designs. They favored asymmetrical shapes, although certain elements in the geometric patterns are repeated. Some designs may have had specific meanings, but the lavishly creative vessels also display a playful artistic spirit. Rather than working toward practical goals (such as better firing techniques or more useful shapes), Jomon potters seem to have been simply enjoying to the full their imaginative vision.

The people of the middle and late Jomon periods also used clay to fashion small humanoid figures. These figures were never fully realistic but rather were distorted into fascinating shapes. Called **dogu**, they tend to have large faces, small arms and hands, and compact bodies. Some of the later dogu seem to be wearing round goggles over their eyes. Others have heart-shaped faces. One of the finest, from Kurokoma, has a face remarkably like a cat's (fig. 11-3). The slit eyes and mouth have a haunting quality, as does the gesture of one hand touching the chest. The marks on the face, neck, and shoulders suggest tattooing and were probably incised with a bamboo stick. The raised area behind the face may indicate a Jomon hairstyle.

The purpose of Jomon dogu remains unknown, but most scholars believe that they were effigies, figures

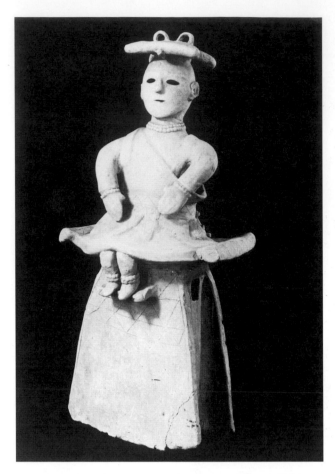

11-4. *Haniwa*, from Kyoto. Kofun period, 6th century CE. Earthenware, height 27" (68.5 cm). Tokyo National Museum

There have been many theories as to the function of *haniwa*. The figures seem to have served as some kind of link between the world of the dead, over which they were placed, and the world of the living, from which they could be viewed. This figure has been identified as a seated female shaman, wearing a robe, belt, and necklace and carrying a mirror at her waist. In early Japan, shamans acted as agents between the natural and the supernatural worlds, just as *haniwa* figures were links between the living and the dead.

representing the owner or someone else, and that they manifested a kind of sympathetic magic. Jomon people may have believed, for example, that they could transfer an illness or other unhappy experience to a *dogu*, then break it to destroy the misfortune. So many of these figures were deliberately broken and discarded that this theory has gained acceptance, but *dogu* may have had different functions at different times. Regardless of their purpose, the images still retain a powerful sense of magic thousands of years after their creation.

YAYOI AND KOFUN PERIODS

During the Yayoi (c. 300 BCE–300 CE) and Kofun (c. 300–552 CE) eras, several features of Japanese culture became firmly established. Most important of these was the transformation of Japan into an agricultural nation, with rice cultivation becoming widespread. This moment-ous change was stimulated by the arrival of immigrants from Korea, who brought with them more complex forms of society and government.

As it did elsewhere in the world, the shift from hunt-ing and gathering to agriculture brought profound social changes, including larger permanent settlements, the division of labor into agricultural and nonagricultural tasks, more hierarchical forms of social organization, and a more centralized government. The emergence of a class structure can be dated to the Yayoi period, as can the development of metal technology. Bronze was used to create weapons as well as ceremonial objects such as bells. Iron knives were developed later in this period, eventually replacing stone tools in everyday life.

Yayoi people lived in thatched houses with sunken floors and stored their food in raised granaries. The gran-ary architecture, with its use of natural wood and thatched roofs, reflects the Japanese appreciation of nat-ural materials, and the style of these raised granaries persisted in the architectural designs of shrines in later centuries (see fig. 11-5).

The trend toward centralization of government became more pronounced during the ensuing Kofun, or "old tombs," period, named for the large royal tombs that were built then. With the emergence of a more complex social order, the veneration of leaders grew into the beginnings of an imperial system. Still in existence today in Japan, this system eventually equated the emperor (or, very rarely, empress) with deities such as the sun goddess. When an emperor died, chamber tombs were constructed following Korean examples. Various grave goods were placed inside the tomb chambers, including large amounts of pottery, presumably to pacify the spir-its of the dead and to serve them in their next life. Many Korean potters came to Japan in the fifth century CE, bringing their knowledge of finishing techniques and improved kilns. Their new form of gray-green pottery was first used for ceremonial purposes in Japan and later entered daily life.

The Japanese government has never allowed the major sacred tombs to be excavated, but much is known about the mortuary practices of Kofun-era Japan. Some of the huge tombs of the fifth and sixth centuries CE were constructed in a shape resembling a large keyhole and surrounded by **moats** dug to preserve the sacred land from commoners. Tomb sites might extend over more than 400 acres, with artificial hills built over the tombs themselves. On the top of the hills were placed ceramic works of sculpture called **haniwa**.

The first *haniwa* were simple cylinders that may have held jars with ceremonial offerings. Gradually these cylinders came to be made in the shapes of ceremonial objects, houses, and boats. Still later, living creatures were added to the repertoire of *haniwa* subjects, including birds, deer, dogs, monkeys, cows, and horses. Finally, *haniwa* in human shapes were crafted, including males and females of all types, professions, and classes (fig. 11-4).

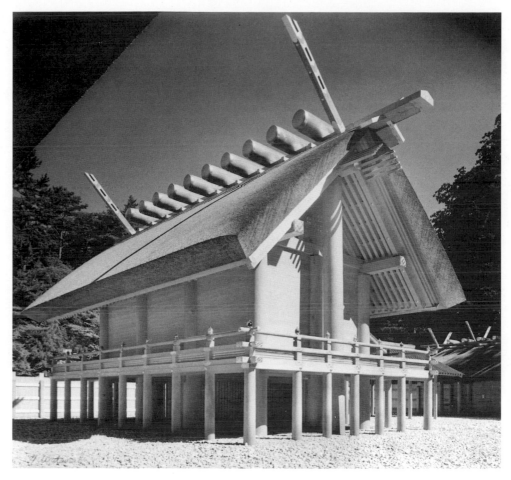

11-5. Inner shrine, Ise, Mie Prefecture. Yayoi period, early 1st century CE; last rebuilt 1993

Haniwa illustrate several enduring characteristics of Japanese aesthetic taste. Unlike Chinese tomb ceramics, which were often beautifully glazed, *haniwa* were left unglazed to reveal their clay bodies. Nor do *haniwa* show the interest in technical skill seen in Chinese ceramics. Instead, their makers explored the expressive potentials of simple and bold form. *Haniwa* shapes are never perfectly symmetrical; the slightly off-center placement of the eye slits, the irregular cylindrical bodies, and the unequal arms give them great life and individuality. No one knows what purpose *haniwa* served. The popular theory that they were intended as tomb guardians is weakened by their origin as cylinders and by the mundane subjects they portray. Indeed, they seem to represent every aspect of Kofun-period society. They may also reflect some of the beliefs of Shinto.

Shinto is often described as the indigenous religion of Japan, but whether it was originally a religion in the usual sense of the word is debatable. Perhaps Shinto is most accurately characterized as a loose confederation of beliefs in deities (*kami*). These *kami* were thought to inhabit many different aspects of nature, including particularly hoary and magnificent trees, rocks, waterfalls, and living creatures such as deer. Shinto also represents the ancient beliefs of the Japanese in purification through ritual use of water. Later, in response to the arrival of Buddhism in the sixth century CE, Shinto became somewhat more systematized, with shrines, a hierarchy of deities, and more strictly regulated ceremonies. Nevertheless, even today in many parts of Japan a **torii**, or wooden gateway, is the only sign that a place is sacred. Nature itself, not the gateway, is venerated.

One of the great Shinto monuments is the shrine at Ise, on the coast southwest of Tokyo (fig. 11-5), dedicated to the sun goddess, the legendary progenitor of Japan's imperial family. Visited by millions of pilgrims each year, this exquisitely proportioned shrine has been ritually rebuilt at twenty-year intervals for nearly 2,000 years (most recently in 1993) in exactly the same ancient Japanese style by expert carpenters who have been trained in this task since childhood. In this way, the temple preserves some features of Yayoi-era granaries and—like Japanese culture itself—is both ancient and endlessly new.

The Ise shrine has many aspects that are typical of Shinto architecture, including wooden piles raising the building off the ground, a thatched roof held in place by horizontal logs, the use of unpainted cypress wood, and the overall feeling of natural simplicity rather than overwhelming size or elaborate decoration. Only members of the imperial family and a few Shinto priests are

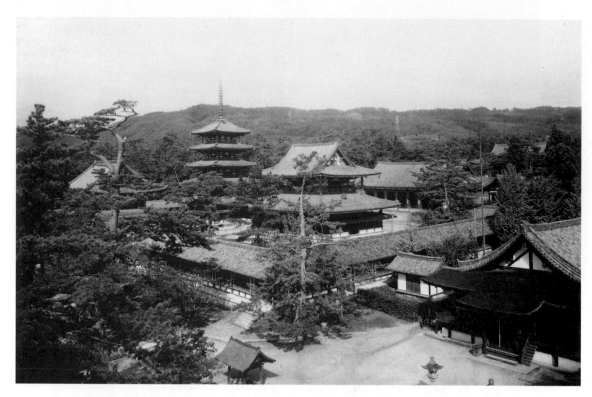

11-6. Main compound, Horyu-ji, Nara Prefecture. Asuka period, 7th century CE

allowed inside the fourfold enclosure housing the sacred shrine. The shrine in turn houses the three sacred symbols of Shinto—a sword, a mirror, and a jewel.

ASUKA PERIOD

Japan has experienced several periods of intense cultural transformation. Perhaps the greatest time of change was the Asuka period (552–646 CE). During a single century, new forms of philosophy, medicine, music, foods, clothing, agricultural methods, city planning, and arts and architecture were introduced into Japan from Korea and China. The three most significant introductions, however, were Buddhism, a centralized governmental structure, and a system of writing. Each was adopted and gradually modified to suit Japanese conditions, and each has had an enduring legacy.

Buddhism reached Japan in Mahayana form, with its many *buddhas* and *bodhisattvas* (see "Buddhism," page 376). After being accepted by the imperial family, it was soon adopted as a state religion. Buddhism represented not only different gods than Shinto but an entirely new concept of religion itself. Where Shinto had found deities in beautiful and imposing natural areas, Buddhist worship was focused in temples. At first this change must have seemed strange, for the Chinese-influenced architecture and elaborate iconography introduced by Buddhism (see "Buddhist Symbols," page 434) contrasted sharply with the simple and natural aesthetics of earlier Japan. Yet Buddhism offered a rich cosmology with profound teachings of meditation and enlighten-

ment. Moreover, the new religion was accompanied by many highly developed aspects of continental Asian culture, including new methods of painting and sculpture.

The most significant surviving early Japanese temple is Horyu-ji, located on Japan's central plains not far from Nara. The temple was founded in 607 CE by Prince Shotoku (574–622 CE), who ruled Japan as a regent and became the most influential early proponent of Buddhism. Rebuilt after a fire in 670, Horyu-ji is the oldest wooden temple in the world. It is so famous that visitors are often surprised at its modest size. Yet its just proportions and human scale, together with the artistic treasures it contains, make Horyu-ji an enduringly beautiful monument to the early Buddhist faith of Japan.

The main compound of Horyu-ji consists of a rectangular courtyard surrounded by covered corridors, one of which contains a gateway. Within the compound are only two buildings, the **kondo**, or golden hall, and a five-story **pagoda**. The simple layout of the compound is asymmetrical, yet the large *kondo* is perfectly balanced by the tall, slender pagoda (fig. 11-6). The *kondo* is filled with Buddhist images and is used for worship and ceremonies. The pagoda serves as a reliquary and is not entered. Other monastery buildings lie outside the main compound, including an outer gate, a lecture hall, a repository for sacred texts, a belfry, and dormitories for monks.

Among the many treasures still preserved in Horyu-ji is a miniature shrine decorated with paintings in lacquer. It is known as the Tamamushi Shrine after the

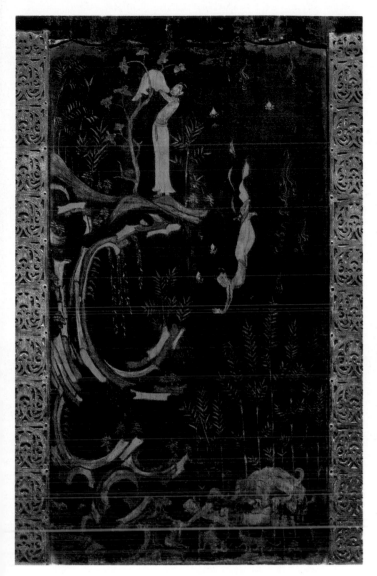

11-7. ***Hungry Tigress Jataka***, panel of the Tamamushi Shrine, Horyu-ji. Asuka period, c. 650 CE. Lacquer on wood, height of shrine 7'7½" (2.33 m). Horyu-ji Treasure House

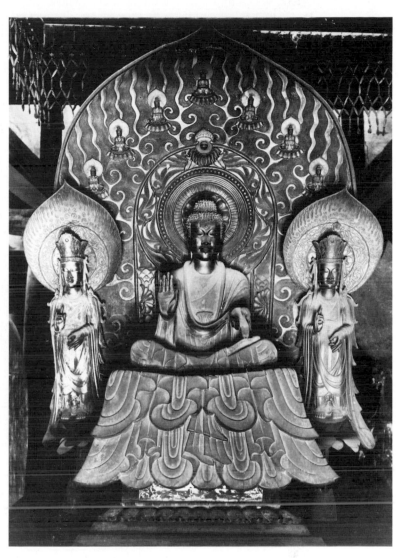

11-8. **Tori Busshi.** ***Shaka Triad***, in the *kondo*, Horyu-ji. Asuka period, c. 623 CE. Gilt bronze, height of seated figure 34½" (87.5 cm)

tamamushi beetle, whose iridescent wings were originally affixed to the shrine to make it glitter, much like mother-of-pearl. There has been some debate whether the shrine was made in Korea, in Japan, or perhaps by Korean artisans in Japan. The question of whether it is, in fact, a "Japanese" work of art misses the point that Buddhism was so international at that time that matters of nationality were irrelevant.

The Tamamushi Shrine is a replica of an even more ancient palace-form building, and its architectural details preserve a tradition predating Horyu-ji itself. Its paintings are among the few two-dimensional works of art to survive from the Asuka period. Most celebrated among them are two that illustrate *jataka* tales, stories about former lives of the Buddha. One depicts the future Buddha nobly sacrificing his life in order to feed his body to a starving tigress and her cubs (fig. 11-7). The tigers

are at first too weak to eat him, so he must jump off a cliff to break open his flesh. The anonymous artist has created a full narrative within a single frame. The graceful form of the Buddha appears three times, harmonized by the curves of the rocky cliff and tall sprigs of bamboo. First, he hangs his shirt on a tree, then he dives downward onto the rocks, and finally he is devoured by the starving animals. The elegantly slender renditions of the figure and the somewhat abstract treatment of the cliff, trees, and bamboo represent an international Buddhist style largely shared during this time by China, Korea, and Japan. These illustrations for the *jataka* tales helped spread Buddhism in Japan.

Another example of the international style of early Buddhist art at Horyu-ji is the sculpture called the *Shaka Triad*, by Tori Busshi (fig. 11-8). (Shaka is the Japanese name for Shakyamuni, the historical Buddha.) Tori

Busshi was a third-generation Japanese, whose grandfather had emigrated to Japan from China as part of an influx of craftspeople and artists. The *Shaka Triad* reflects the strong influence of Chinese art of the Northern Wei dynasty (see fig. 10-12). The frontal pose, the outsized face and hands, and the linear treatment of the drapery all suggest that Tori Busshi was well aware of earlier continental models, while the fine bronze casting of the figures shows his advanced technical skill. The *Shaka Triad* and the Tamamushi Shrine reveal how quickly Buddhist art became an important feature of Japanese culture. During an age when Japan was being unified under an imperial system, Buddhism introduced a form of compassionate idealism that is clearly expressed in its art.

NARA PERIOD

The Nara period (646–794 CE) is named for Japan's first permanent imperial capital. Previously, when an emperor died, his capital was considered tainted, and for reasons of purification (and perhaps also of politics) his successor usually selected a new site. With the emergence of a complex, Chinese-style government, however, this custom was no longer practical. By establishing a

BUDDHIST SYMBOLS A few of the most important Buddhist symbols, which have myriad variations, are described here in their most generalized forms.

Lotus flower: Usually shown as a white water lily, the lotus (Sanskrit, *padma*) symbolizes spiritual purity, the wholeness of creation, and cosmic harmony. The flower's stem is an *axis mundi*.

Lotus throne: Buddhas are frequently shown seated on an open lotus, either single or double, a representation of *nirvana*.

Chakra: An ancient sun symbol, the wheel (*chakra*) symbolizes both the various states of existence (the Wheel of Life) and the Buddhist doctrine (the Wheel of the Law). A *chakra*'s exact meaning depends on how many spokes it has.

Marks of a *buddha*: A buddha is distinguished by thirty-two physical attributes (*lakshanas*). Among them are a bulge on top of the head (*ush-nisha*), a tuft of hair between the eyebrows (*urna*), elongated earlobes, and thousand-spoked *chakras* on the soles of the feet.

Mandala: *Mandalas* are diagrams of cosmic realms, representing order and meaning within the spiritual universe. They may be simple or complex, three- or two-dimensional, in a wide array of forms—such as an Indian stupa (see fig. 9-8) or a Womb World *mandala* (see fig. 11-10), an early Japanese type.

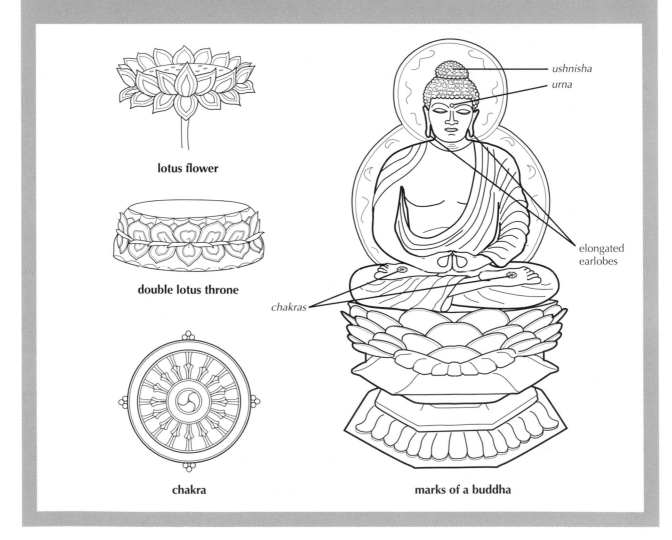

lotus flower

double lotus throne

chakra

chakras

ushnisha
urna

elongated earlobes

marks of a buddha

permanent capital in Nara, the Japanese were able to enter a new era of growth and consolidation. Nara swelled to a population of perhaps 200,000 people. During this period the imperial system solidified into an effective government that could withstand the powerful aristocratic families that had traditionally dominated the political world.

One positive result of strong central authority was the construction in Nara of magnificent Buddhist temples and monasteries that dwarfed those built previously. Even today a large area of Nara is a park where numerous temples preserve magnificent Nara-period art and architecture. The grandest of these temples, Todai-ji, is so large that the area surrounding only one of its pagodas could accommodate the entire main compound of Horyu-ji. When it was built, and for a thousand years thereafter, Todai-ji was the largest wooden structure in the world. Not all the monuments of Nara are Buddhist. There also are several Shinto shrines, and deer wander freely, reflecting Japan's Shinto heritage.

Buddhism and Shinto have coexisted quite comfortably in Japan over the ages. One seeks enlightenment, the other purification, and since these ideals did not clash, neither did the two forms of religion. Although there were occasional attempts to promote one over the other, more often they were seen as complementary, and to this day most Japanese see nothing inconsistent about having Shinto weddings and Buddhist funerals.

While Shinto became more formalized during the Nara period, Buddhism advanced to become the single most significant element in Japanese culture. One important method for transmitting Buddhism in Japan was through the copying of Buddhist sacred texts, the *sutras*. They were believed to be so beneficial and magical that occasionally a single word would be cut out from a *sutra* and worn as an amulet. Someone with hearing problems, for example, might use the word for "ear."

Copying the words of the Buddha was considered an effective act of worship by the nobility; it also enabled Japanese courtiers as well as clerics to become familiar with the Chinese system of writing—with both secular and religious results. During this period, the first histories of Japan were written, strongly modeled upon Chinese precedents, and the first collection of Japanese poetry, the *Manyoshu*, was compiled. The *Manyoshu* includes Buddhist verse, but the majority of the poems are secular, including many love songs in the five-line *tanka* form, such as this example by the late-seventh-century courtier Hitomaro (all translations from Japanese are by Stephen Addiss unless otherwise noted):

> Did those
> who lived in past ages
> lie sleepless
> as I do tonight
> longing for my beloved?

Unlike the poetry, most other art of the Nara period is sacred, with a robust splendor that testifies to the fervent belief and great energy of early Japanese Buddhists. Some of the finest Buddhist paintings of the late seventh

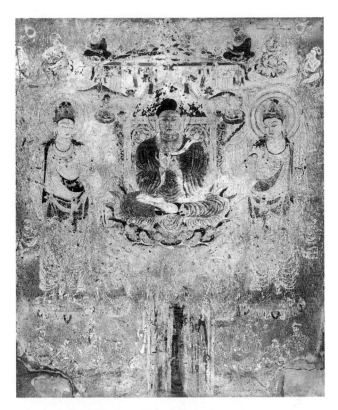

11-9. *Amida Buddha*, fresco in the *kondo*, Horyu-ji. Nara period, c. 700 CE. Ink and colors (now severely damaged), 10'3" x 8'6" (3.13 x 2.6 m)

century were preserved in Japan on the walls of the golden hall of Horyu-ji until a fire in 1949 defaced and partially destroyed them. Fortunately, they had been thoroughly documented before the fire in a series of color photographs. These murals represent what many scholars believe to be the golden age of Buddhist painting, an era that embraces the Tang dynasty in China (618–907 CE), the United Silla period in Korea (668–935 CE), and the Nara period in Japan.

One of the finest of the Horyu-ji murals is thought to represent Amida, the Buddha of the Western Paradise (fig. 11-9). Delineated in the thin, even brushstrokes known as iron-wire lines, Amida's body is rounded, his face is fully fleshed and serene, and his hands form the **dharmachakra** ("revealing the Buddhist law") *mudra* (see "Mudras," page 385). Instead of the somewhat abstract style of the Asuka period, there is now a greater emphasis on realistic detail and body weight in the figure. The parallel folds of drapery show the enduring influence of the Gandhara style current in India 500 years earlier (see fig. 9-13), but the face is fully East Asian in contour and spirit.

The Nara period was an age of great belief, and Buddhism permeated the upper levels of society. Indeed, one of the few empresses in Japanese history wanted to cede her throne to a Buddhist monk. Her advisers and other influential courtiers became extremely worried, and they finally decided to move the capital away from Nara, where they felt Buddhist influence had become overpowering. The move of the capital to Kyoto marked the end of the Nara period.

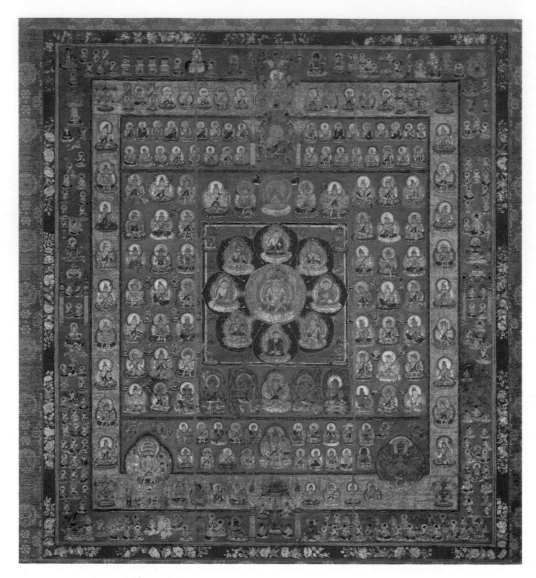

11-10. Womb World *mandala*, To-ji, Kyoto. Heian period, late 9th century CE. Hanging scroll, colors on silk, 6' x 5'1¹⁄₂" (1.83 x 1.54 m)

Mandalas are used not only in teaching but also as vehicles for practice. A monk, initiated into secret teachings, may meditate upon and assume the gestures of each deity depicted in the *mandala*, gradually working out from the center, so that he absorbs some of each deity's powers. The monk may also recite magical phrases called *mantras* as an aid to meditation. The goal is to achieve enlightenment through the powers of the different forms of the Buddha. *Mandalas* are created in sculptural and architectural forms as well as in paintings. Their integration of the two most basic shapes, the circle and the square, is an expression of the principles of ancient geomancy (divining by means of lines and figures) as well as Buddhist cosmology.

HEIAN PERIOD

The Japanese fully absorbed and transformed the influences from China and Korea during the Heian period (794–1185 CE). Generally peaceful conditions contributed to a new air of self-reliance on the part of the Japanese. The imperial government severed ties to China in the mid-ninth century and was sustained by support from aristocratic families. An efficient method of writing the Japanese language was developed, and the rise of vernacular literature generated such masterpieces as the world's first novel, Lady Murasaki's *Tale of Genji*. During these four centuries of splendor and refinement, two major religious sects emerged: first Esoteric Buddhism and later Pure Land Buddhism.

ESOTERIC BUDDHIST ART

With the removal of the capital to Kyoto, the older Nara temples lost their influence. Soon two new Esoteric sects of Buddhism, named Tendai and Shingon, grew to dominate Japanese religious life. Strongly influenced by polytheistic religions such as Hinduism, Esoteric Buddhism included a daunting number of deities, each with magical powers. The historical Buddha was no longer very important.

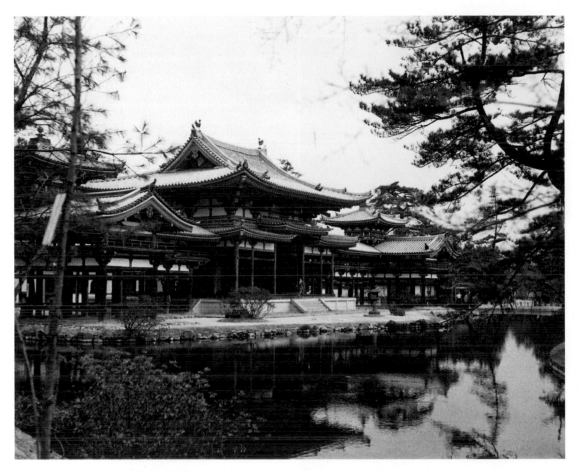

11-11. Byodo-in, Uji, Kyoto Prefecture. Heian period, c. 1053 CE

Instead, the universal Buddha (called Dainichi, "Great Sun," in Japanese) was believed to preside over the universe. He was accompanied by buddhas and *bodhisattvas*, as well as guardian deities who formed fierce counterparts to the more benign gods.

Esoteric Buddhism is hierarchical, and its deities have complex relationships to one another. Learning all the different gods and their interrelationships was assisted greatly by works of art, especially **mandalas**, cosmic diagrams of the universe that portray the deities in schematic order. The Womb World *mandala* from To-ji, for example, is entirely filled with depictions of gods. Dainichi is at the center, surrounded by buddhas of the four directions (fig. 11-10). Other deities, including some with multiple heads and limbs, branch out in diagrammatical order, each with a specific symbol of power. To believers, the *mandala* represents an ultimate reality beyond the visible world.

Perhaps the most striking attribute of many Esoteric Buddhist images is their sense of spiritual force and potency, especially in depictions of the wrathful deities, which are often surrounded by flames. Esoteric Buddhism, with its intricate theology and complex doctrines, was a religion for the educated aristocracy, not for the masses. Its network of deities, hierarchy, and ritual found a parallel in the elaborate social divisions of the Heian court.

PURE LAND BUDDHIST ART

During the latter half of the Heian period, a rising military class threatened the peace and tranquility of court life. The beginning of the eleventh century was also the time for which the decline of Buddhism (*Mappo*) had been prophesied. In these uncertain years, many Japanese were ready for another form of Buddhism that would offer a more direct means of salvation than the elaborate rituals of the Esoteric sects.

Pure Land Buddhism, although it had existed in Japan earlier, now came to prominence. It taught that the Western Paradise (the Pure Land) of the Amida Buddha could be reached through nothing more than faith. In its ultimate form, Pure Land Buddhism held that the mere chanting of a *mantra*—the phrase *Namu Amida Butsu* ("Hail to Amida Buddha")—would lead to rebirth in Amida's paradise. This doctrine soon swept throughout Japan. Spread by traveling monks who took the chant to all parts of the country (see fig. 11-1), it appealed to people of all levels of education and sophistication. Pure Land Buddhism has remained the most popular form of Buddhism in Japan ever since.

One of the most beautiful temples of Pure Land Buddhism is the Byodo-in, located in the Uji Mountains not far from Kyoto (fig. 11-11). The temple itself was originally

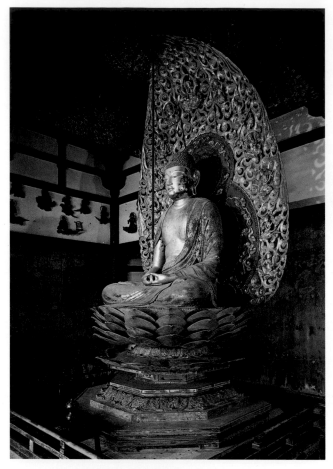

11-12. Jocho. *Amida Buddha*, Byodo-in. Heian period, c. 1053 CE. Gold leaf and lacquer on wood, height 9'8" (2.95 m)

allowed sculptors to create larger but lighter portrayals of buddhas and *bodhisattvas* for the many temples constructed and dedicated to the Pure Land faith. It also reaffirmed the Japanese love of wood, which during the Heian period became the major medium for sculpture.

Surrounding the Amida on the walls of the Byodo-in are smaller wooden figures of *bodhisattvas* and angels, some playing musical instruments. Everything about the Byodo-in was designed to suggest the paradise that awaits the believer after death. Its remarkable state of preservation after more than 900 years allows visitors to experience the late-Heian-period religious ideal at its most splendid.

POETRY AND CALLIGRAPHY

While Buddhism pervaded the Heian era, a refined secular culture also arose at court that has never been equaled in Japan. Gradually over the course of four centuries, the influence from China waned. Although court nobles continued to write many poems in Chinese, both men and women wrote in the new kana script of their native language (see "Writing, Language, and Culture," page 443). With its simple, flowing symbols interspersed with more complex Chinese characters, the new writing system allowed Japanese poets to create an asymmetrical calligraphy quite unlike that of China.

Refinement was greatly valued among the Heian-period aristocracy. A woman would be admired merely for the way she arranged the twelve layers of her robes by color, or a man for knowing which kind of incense was being burned. Much of court culture was centered upon the sophisticated expression of human love through the five-line *tanka*. A courtier leaving his beloved at dawn would send her a poem wrapped around a single flower still wet with dew. If his words or his calligraphy were less than stylish, however, he would not be welcome to visit her again. In turn, if she could not reply with equal elegance, he might not wish to repeat their amorous interlude. Society was ruled by taste, and pity any man or woman at court who was not accomplished in several forms of art.

During the later Heian period, the finest *tanka* were gathered in anthologies. The poems in one famous early anthology, the *Thirty-Six Immortal Poets*, are still known to educated Japanese today. This anthology was produced in sets of albums called the *Ishiyama-gire*. These albums consist of *tanka* written elegantly on high-quality papers decorated with painting, block printing, scattered gold and silver, and sometimes paper collage. The page shown here reproduces two *tanka* by the courtier Ki no Tsurayuki (fig. 11-13). Both poems express sadness for:

> Until yesterday
> I could meet her,
> But today she is gone—
> Like clouds over the mountain
> She has been wafted away.

a secular palace created to suggest the palace of Amida in the Western Paradise. It was built for a member of the powerful Fujiwara family who served as the leading counselor to the emperor. After the counselor's death in the year 1052, the palace was converted into a temple. The Byodo-in is often called Phoenix Hall, not only for the pair of phoenix images on its roof but also because the shape of the building itself suggests the mythical bird. The lightness of its thin columns gives the Byodo-in a sense of airiness, as though the entire temple could easily rise up through the sky to Amida's Western Paradise. The hall rests gently in front of an artificial pond created in the shape of the Sanskrit letter ***A***, the sacred symbol for Amida.

The Byodo-in's central image of Amida, carved by the master sculptor Jocho (d. 1057), exemplifies the serenity and compassion of the Buddha who welcomes the souls of all believers to his paradise (fig. 11-12). When reflected in the water of the pond before it, the Amida image seems to shimmer in its private mountain retreat. The figure was not carved from a single block of wood like earlier sculpture but from several blocks in Jocho's new **joined-wood** method of construction (see "Joined-Wood Sculpture," page 440). This technique

11-13. Album leaf from the _Ishiyama-gire_. Heian period, early 12th century CE. Ink with gold and silver on decorated and collaged paper, 8 x 6³/₈" (20.3 x 16.1 cm). Freer Gallery of Art, Smithsonian Institution, Washington, D.C. (F1969.4)

TECHNIQUE

JOINED-WOOD SCULPTURE

Wood is a temperamental medium, as sculptors who work with it quickly learn. Cut from a living, sap-filled tree, it takes many years to dry thoroughly. The outside dries first, then the inside gradually yields its moisture. As the core dries, however, the resulting shifts in tension can open up gaping cracks. A large statue carved from a single solid block thus runs the risk of splitting as it ages—especially if it has been painted or lacquered, which interferes with the wood's natural "breathing."

One strategy adopted by Japanese sculptors to prevent cracking was to split a completed statue into several pieces, hollow them out, then fit them back together. A more effective method was the **joined-wood** technique. Here the design for a statue was divided into sections, each of which was carved from a separate block. These sections were then hollowed out and assembled. By using multiple blocks, sculptors could produce larger images than they could from any single block. Moreover, statue sections could be created by teams of carvers, some of whom became specialists in certain parts, such as hands or crossed legs or lotus thrones. Through this cooperative approach, large statues could be produced with great efficiency to meet a growing demand.

The spiky, flowing calligraphy and the patterning of the papers, the rich use of gold, and the suggestions of natural imagery match the elegance of the poetry, epitomizing courtly Japanese taste.

Although the style of Japanese calligraphy such as that in the *Ishiyama-gire* was considered "women's hand," it is not known how much of the calligraphy of the time was actually written by women. It is certain, however, that women were a vital force in Heian society. Although the place of women in Japanese society was to decline in later periods, they contributed greatly to the art at the Heian court.

SECULAR PAINTING

Women were noted for both their poetry and their prose, including diaries, mythical tales, and courtly romances. Lady Murasaki transposed the life-style of the Heian court into fiction in the first known novel, *The Tale of Genji*, at the beginning of the eleventh century. She wrote in Japanese at a time when men still wrote prose primarily in Chinese, and her work remains one of Japan's—and the world's—great novels. Underlying the story of the love affairs of Prince Genji and his companions is the Japanese conception of fleeting pleasures and ultimate sadness in life, an echo of the Buddhist view of the vanity of earthly pleasures.

One of the earliest extant secular paintings from Japan is a series of scenes from *The Tale of Genji*, painted in the twelfth century by unknown artists in "women's hand" painting style. This style was characterized by delicate lines, strong if sometimes muted colors, and asymmetrical compositions usually viewed from above through invisible, "blown-away" roofs. The *Genji* paintings have a refined, subtle emotional impact. They generally show court figures in architectural settings, with the frequent addition of natural elements, such as sections of gardens, that help to represent the mood of the scene. Thus a blossoming cherry tree appears in a scene of happiness, while unkempt weeds appear in a depiction of loneliness. Such correspondence between nature and human emotion is an enduring feature of Japanese poetry and art.

The figures in *The Tale of Genji* paintings do not show their emotions directly on their faces, which are simply rendered with the fewest possible lines. Instead, their feelings are conveyed by colors, poses, and the total composition of the scenes. One evocative scene portrays a seemingly happy Prince Genji holding a baby boy borne by his wife, Nyosan. In fact, the baby was fathered by another court noble. Since Genji himself has not been faithful to Nyosan, who appears in profile below him, he cannot complain; meanwhile the true father of the child has died, unable to acknowledge his only son (fig. 11-14). The irony is even greater because Genji himself is the illegitimate son of an emperor. Thus what should be a joyful scene has undercurrents that lend it a sense of irony and sorrow.

One might expect a painting of such an emotional scene to focus on the people involved. Instead, they are rendered in rather small size, and the scene is dominated by a screen that effectively squeezes Genji and his wife into a corner. This composition deliberately represents how their positions in courtly society have forced them into this unfortunate situation. In typical Heian style, Genji expresses his emotion by murmuring a poem:

> How will he respond,
> The pine growing on the mountain peak,
> When he is asked who planted the seed?

The Tale of Genji scroll represents courtly life as interpreted through refined sensibilities and the "women's hand" style of painting. Heian painters also cultivated a contrasting "men's hand" style. Characterized by strong ink play and lively brushwork, it most often depicts subjects outside the court. One of the masterpieces of this style is *Frolicking Animals*, a set of scrolls satirizing the life of many different levels of society. Painted entirely in ink, the scrolls are attributed to Toba Sojo, the abbot of a Buddhist temple, and they represent the humor of Japanese art to the full.

In one scene, a frog is seated as a buddha upon an altar while a monkey dressed as a monk prays proudly to him; in other scenes frogs, donkeys, foxes, and rabbits are shown playing, swimming, and wrestling, with one frog boasting of his prowess when he flings a rabbit to the ground (fig. 11-15). Playful and irreverent though it may be, the quality of the painting is remarkable. Each line is

11-14. Scene from *The Tale of Genji*. Heian period, 12th century CE. Handscroll, ink and colors on paper, 8 5/8 x 18 7/8" (21.9 x 47.9 cm). Tokugawa Art Museum, Nagoya

Twenty chapters from *The Tale of Genji* have come down to us in illustrated scrolls such as this one. Scholars assume, however, that the entire novel of fifty-four chapters must have been written out and illustrated—a truly monumental project. Each scroll seems to have been produced by a team of artists. One was the calligrapher, most likely a member of the nobility. Another was the master painter, who outlined two or three illustrations per chapter in fine brushstrokes and indicated the color scheme. Next, colorists went to work, applying layer after layer of color to build up patterns and textures. After they had finished, the master painter returned to reinforce outlines and apply the finishing touches, among them the details of the faces.

11-15. Attributed to Toba Sojo. Detail of *Frolicking Animals*. Heian period, 12th century CE. Handscroll, ink on paper, height 12" (30.5 cm). Kozan-ji, Kyoto

11-16. Detail of *Night Attack on the Sanjo Palace*. Kamakura period, late 13th century CE. Handscroll, ink and colors on paper, height 16¼" (41.3 cm). Museum of Fine Arts, Boston
Fenollosa-Weld Collection

The battles between the Minamoto and Taira clans were fought primarily by mounted and armored warriors, who used both bows and arrows and the finest swords. In the year 1060, some 500 Minamoto rebels opposed to the retired emperor Go-Shirakawa carried out a daring raid on the Sanjo Palace. In a surprise attack in the middle of the night, they abducted the emperor. The scene was one of great carnage, much of it caused by the burning of the wooden palace. Despite the drama of the scene, this was not the decisive moment in the war. The Minamoto rebels would eventually lose more important battles to their Taira enemies. Yet Minamoto forces, heirs to those who carried out this raid, would eventually prove victorious, destroying the Taira clan in 1185.

brisk and lively, and there are no strokes of the brush other than those needed to depict each scene. Unlike the *Genji* scroll, there is no text to *Frolicking Animals*, and we must make our own interpretations of the people and events being satirized. Nevertheless, the visual humor is so lively and succinct that we can recognize not only the Japanese of the twelfth century, but perhaps also ourselves.

KAMAKURA PERIOD

The courtiers of the Heian era became so engrossed in their own refinement that they neglected their responsibilities for governing the country. Clans of warriors—samurai—from outside the capital grew increasingly strong. Drawn into the factional conflicts of the imperial court, samurai leaders soon became the real powers in Japan.

The two most powerful warrior clans were the Minamoto and the Taira, whose battles for domination became famous not only in medieval Japanese history but also in literature and art. One of the great painted handscrolls depicting these battles is *Night Attack on the Sanjo Palace* (fig. 11-16). Painted perhaps 200 years after the actual event, the scroll conveys a sense of eyewitness reporting even though the anonymous artist had to imagine the scene from verbal (and at best semifactual) descriptions. The style of the painting includes some of the brisk and lively linework of *Frolicking Animals* and

also traces of the more refined brushwork, use of color, and bird's-eye viewpoint of *The Tale of Genji* scroll. The main element, however, is the savage depiction of warfare (see "Arms and Armor," page 445). Unlike the *Genji* scroll, *Night Attack* is full of action: flames engulf the palace, horses charge, warriors behead their enemies, court ladies try to hide, and a sense of energy and violence is conveyed with great sweep and power. The era of poetic refinement was now over in Japan, and the new world of the samurai began to dominate the secular arts.

The Kamakura era (1185–1392 CE) began when Minamoto Yoritomo (1147–99) defeated his Taira rivals and assumed power as shogun (general-in-chief). To resist the softening effects of courtly life in Kyoto, he established his military capital in Kamakura. While paying respect to the emperor, Yoritomo kept both military and political power for himself. He thus began a tradition of rule by shogun that lasted in various forms until 1868.

PURE LAND BUDDHIST ART

During the early Kamakura period, Pure Land Buddhism remained the most influential form of religion and was expressed in sculpture such as *Kuya* by Kosho, a master of the new naturalistic style that evolved at this time (see fig. 11-1). Just as the *Night Attack* revealed the political turbulence of the period through its vivid colors and

WRITING, LANGUAGE, AND CULTURE

Chinese culture enjoyed great prestige in East Asia. Written Chinese served as an international language of scholarship and cultivation, much as Latin did in medieval Europe. Educated Koreans, for example, wrote almost exclusively in Chinese until the fifteenth century CE. In Japan, Chinese continued to be used for certain kinds of writing, such as philosophical and legal texts, into the nineteenth century.

When it came to writing their own language, the Japanese initially borrowed Chinese characters, or kanji. Differences between the Chinese and Japanese languages made this system extremely unwieldy, so during the ninth century CE two syllabaries, or kana, were developed from simplified Chinese characters. (A syllabary is a system in which each symbol stands for a syllable.) Katakana, now generally used for foreign words, consists of mostly angular symbols, while the more frequently used hiragana has graceful, cursive symbols.

Japanese written in kana was known as "women's hand," possibly because prestigious scholarly writing still emphasized Chinese, which women were rarely taught. Yet Japan had an ancient and highly valued poetic tradition of its own, and women as well as men were praised as poets from earliest times. So while women rarely became scholars, they were often authors During the Heian period kana were used to create a large body of literature, written either by women or sometimes for women by men.

A charming poem originated in Heian times to teach the new writing system. In two stanzas of four lines each, it uses almost all of the syllable sounds of spoken Japanese and thus almost every kana symbol. It was memorized as we would recite our ABCs. The first stanza translates as:

Although flowers glow with color
They are quickly fallen,
And who in this world of ours
Is free from change?
(Translation by Earl Miner)

Like Chinese, Japanese is written in columns from top to bottom and across the page from right to left. (Following this logic, Chinese and Japanese narrative paintings also read from right to left.) Below is the stanza written three ways. At the right, it appears in katakana glossed with the original phonetic value of each symbol. (Modern pronunciation has shifted slightly.) In the center, the stanza appears in flowing hiragana. To the left is the mixture of kanji and kana that eventually became standard. This alternating rhythm of simple kana symbols and more complex Chinese characters gives a special flavor to Japanese calligraphy.

色は匂へど
散りぬるを
我世誰ぞ
常ならむ

kanji and kana

いろはにほへと
ちりぬるを
わかよたれそ
つねならむ

hiragana

イ-Iro
ロ-ha
ハ-ni
ニ-ho
ホ-he
ヘ-to
ト

チ-Chi
リ-ri
ヌ-nu
ル-ru
ヲ-wo
ワ-Wa
カ-ka
ヨ-yo
タ-ta
レ-re
ソ-so

ツ-Tsu
ネ-ne
ナ-na
ラ-ra
ム-mu

katakana

forceful style, Kamakura-era portraiture saw a new emphasis on realism, including the use of crystal eyes in sculpture for the first time. Perhaps the warriors had a taste for realism, for many sculptors and painters of the Kamakura period became expert in depicting faces, forms, and drapery with great attention to naturalistic detail. As we have seen, Kosho took on the more difficult task of representing in three dimensions not only the person of the famous monk Kuya but also his chant.

Pure Land Buddhism taught that even one sincere invocation of the sacred chant could lead the most wicked sinner to the Western Paradise. Paintings called **raigo** (literally "welcoming approach") were created depicting the Amida Buddha, accompanied by *bodhi-sattvas*, coming down to earth to welcome the soul of the dying believer. Golden cords were often attached to

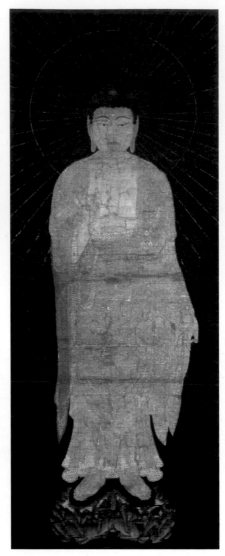
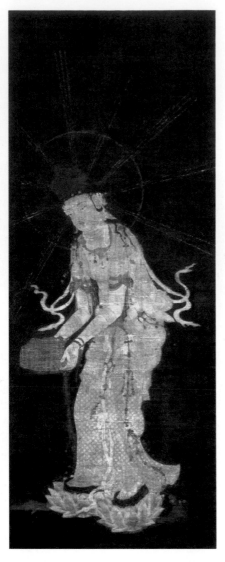

11-17. ***Descent of the Amida Trinity***, *raigo* triptych. Kamakura period, late 13th century CE. Ink and colors with cut gold on silk; each scroll 54 x 19 ½" (137.2 x 50.2 cm). The Art Institute of Chicago

Kate S. Buckingham Collection, 1929.855–1929.857

these paintings, which were taken to the homes of the dying. A person near death held on to these cords, hoping that Amida would escort the soul directly to paradise.

Raigo paintings are quite different in style from the complex *mandalas* and fierce guardian deities of Esoteric Buddhism. Like Jocho's sculpture of Amida at the Byodo-in, they radiate warmth and compassion. One magnificent *raigo*, a set of three paintings, portrays Amida Buddha and two *bodhisattvas* not only with gold paint but also with slivers of gold leaf cut in elaborate patterning to suggest the radiance of their draperies (fig. 11-17). The sparkle of the gold over the figures is heightened by the darkening of the silk behind them, so that the deities seem to come forth from the surface of the painting. In the flickering light of oil lamps and torches, *raigo* paintings would have glistened and gleamed in magical splendor in a temple or a dying person's home.

In every form of Buddhism paintings and sculpture became vitally important elements in religious teaching

and belief. In their own time they were not considered works of art but rather visible manifestations of faith.

ZEN BUDDHIST ART

Toward the latter part of the Kamakura period, Zen Buddhism, the last major form to reach Japan, appeared. Zen was already highly developed in China, where it was known as Chan, but it had been slow to reach Japan because of the interruption of relations between the two countries during the Heian period. But during the Kamakura era, both visiting Chinese and returning Japanese monks brought Zen to Japan. It would have a lasting impact on Japanese arts.

In some ways, Zen resembles the original teachings of the historical Buddha. It differed from both Esoteric and Pure Land Buddhism in emphasizing that individuals must reach their own enlightenment through meditation, without the help of deities or magical chants. It especially appealed to the self-disciplined spirit

ARMS AND ARMOR Battles such as the one depicted in *Night Attack on the Sanjo Palace* (see fig. 11-16) were fought largely by archers on horseback. Samurai archers charged the enemy at full gallop and loosed their arrows just before they wheeled away. The scroll clearly shows their distinctive bow, with its asymmetrically placed handgrip. The lower portion of the bow is shorter than the upper so it can clear the horse's neck. The samurai wear a long, curved sword at the waist.

By the tenth century, Japanese swordsmiths had perfected techniques for crafting their legendarily sharp swords. Sword makers face a fundamental difficulty: Steel hard enough to hold a razor-sharp edge is brittle and breaks easily, but steel resilient enough to withstand rough use is too soft to hold a keen edge. The Japanese ingeniously forged a blade from up to four strengths of steel, cradling a hard cutting edge in a less brittle support.

Samurai armor, illustrated here, was made of overlapping iron and lacquered leather scales, punched with holes and laced together with leather thongs and brightly colored silk braids. The principal piece wrapped around the chest, left side, and back. Padded shoulder straps hooked it back to front. A separate piece of armor was tied to the body to protect the right side. The upper legs were protected by a skirt of four panels attached to the body armor, while two large rectangular panels tied on with cords guarded the arms. The helmet was made of iron plates riveted together. From it hung a neckguard flared sharply outward to protect the face from arrows shot at close range as the samurai wheeled away from an attack.

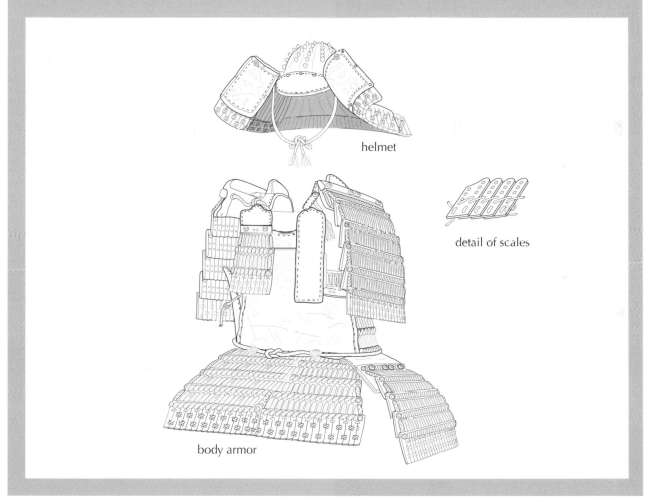

helmet

detail of scales

body armor

oof samurai warriors, who were not satisfied with the older forms of Buddhism connected with the Japanese court.

Zen temples were usually built in the mountains rather than in large cities. An abbot named Kao Ninga at an early Zen temple was a pioneer in the kind of rough and simple ink painting that so directly expresses the Zen spirit. We can see this style in a remarkable ink portrait of a monk sewing his robe (fig. 11-18, "The Object Speaks: Monk Sewing," page 446). Buddhist prelates of other sects undoubtedly had assistants to take care of such mundane tasks as repairing a robe, but in Zen Buddhism each monk, no matter how advanced, is expected to do all tasks for himself. Toward the end of the fourteenth century, Zen's spirit of self-reliance began to dominate many aspects of Japanese culture.

As the Kamakura era ended, the seeds of the future were planted: Control of rule by the warrior class and Zen values had become established as the leading forces in Japanese life and art.

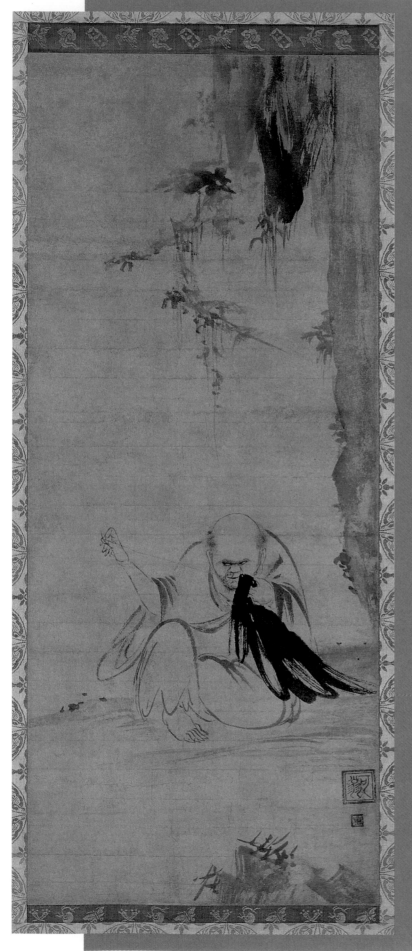

MONK SEWING

In the early thirteenth century CE, a statue such as Kosho's *Kuya Speaking* (see fig. 11-1) epitomized the faith expressed in Pure Land Buddhist art. At the very same time, Zen Buddhism was being introduced into Japan from China, and within a century its art communicated a far different message. Whereas Kuya had wandered the countryside, inviting the faithful to chant the name of Amida Buddha and relying on the generosity of believers to support him, Zen monks lived settled lives in monasteries—usually up in the mountains. They had no need of contributions from the court or from believers.

Then, as today, Japanese Zen monks grew and cooked their own food, cleaned their temples, and were as responsible for their daily lives as for their own enlightenment. In addition to formal meditation, they practiced *genjo koan*, taking an ordinary circumstance in their immediate world, such as mending a garment, as an object of meditation. Thus, a painting such as *Monk Sewing* (fig. 11-18), which bears the seals of the Buddhist priest-painter Kao Ninga (active mid-fourteenth century), would have spoken clearly to viewers of a commitment to a life of simplicity and responsibility for oneself. It was and is still so effective because it has the blunt style, strong sense of focus, and visual intensity of the finest Zen paintings. The almost humorous compression of the monk's face, coupled with the position of the darker robe, focuses our attention on his eyes, which then lead us out to his hand pulling the needle. We are drawn into the activity of the painting rather than merely sitting back and enjoying it as a work of art. This sense of intense activity within daily life, involving us directly with the painter and the subject, is a feature of the best Zen figure paintings.

11-18. Attributed to Kao Ninga. *Monk Sewing.* Kamakura period, early 14th century. Ink on paper, 32 7/8 x 13 1/2" (83.5 x 35.4 cm). The Cleveland Museum of Art
John L. Severance Fund (62.163)

PARALLELS

PERIOD	JAPANESE ART BEFORE 1392	ART IN OTHER CULTURES
JOMON c. 12,000–300 BCE	**11-2.** Asahi vessel (c. 2000 BCE) **11-3.** *Dogu* (c. 2000 BCE)	**9-5.** *Large Painted Jar with Border Containing Birds* (c. 2400–2000 BCE), India **4-6.** Kamares Ware (c. 2000–1900 BCE), Greece
YAYOI c. 300 BCE–300 CE	**11-5.** Inner shrine, Ise (early 1st cent. CE)	**6-14.** Portunas (?) temple (late 2nd cent. BCE), Italy
KOFUN c. 300–552 CE	**11-4.** *Haniwa* (6th cent. CE)	**9-17.** *Bodhisattva* (c. 475 CE), India **7-22.** Hagia Sophia (532–37 CE), Turkey
ASUKA c. 552–646 CE	**11-6.** Horyu-ji (7th cent. CE) **11-8.** Tori Busshi. *Shaka Triad* (c. 623 CE)	**7-36.** *Rabbula Gospels* (586 CE), Syria **10-13.** Amitabha altar (593 CE), China
NARA c. 646–794 CE	**11-9.** *Amida Buddha* (c. 700 CE)	**8-2.** Dome of the Rock (c. 687–91 CE), Jerusalem
HEIAN c. 794–1185 CE	**11-10.** Womb World *mandala* (late 9th cent. CE) **11-11.** Byodo-in, Uji (c. 1053 CE) **11-12.** Jocho. *Amida Buddha* (c. 1053 CE) **11-14.** *The Tale of Genji* (12th cent. CE)	**14-17.** *Utrecht Psalter* (c. 825–50 CE), Netherlands **7-39.** Cathedral of Saint Mark (begun 1063 CE), Italy **12-23.** Anasazi seed jar (c. 1150 CE), North America
KAMAKURA c. 1185–1392 CE	**11-1.** *Kuya Preaching* (before 1207 CE) **11-17.** *Descent of the Amida Trinity* (late 13th cent. CE) **11-18.** Kao. *Monk Sewing* (early 14th cent. CE)	**12-1.** Pueblo Bonito (c. 900–1230 CE), North America **16-6.** Chartres Cathedral (c. 1134–1220 CE), France **7-42.** *Virgin of Vladimir* (12th cent. CE), Russia

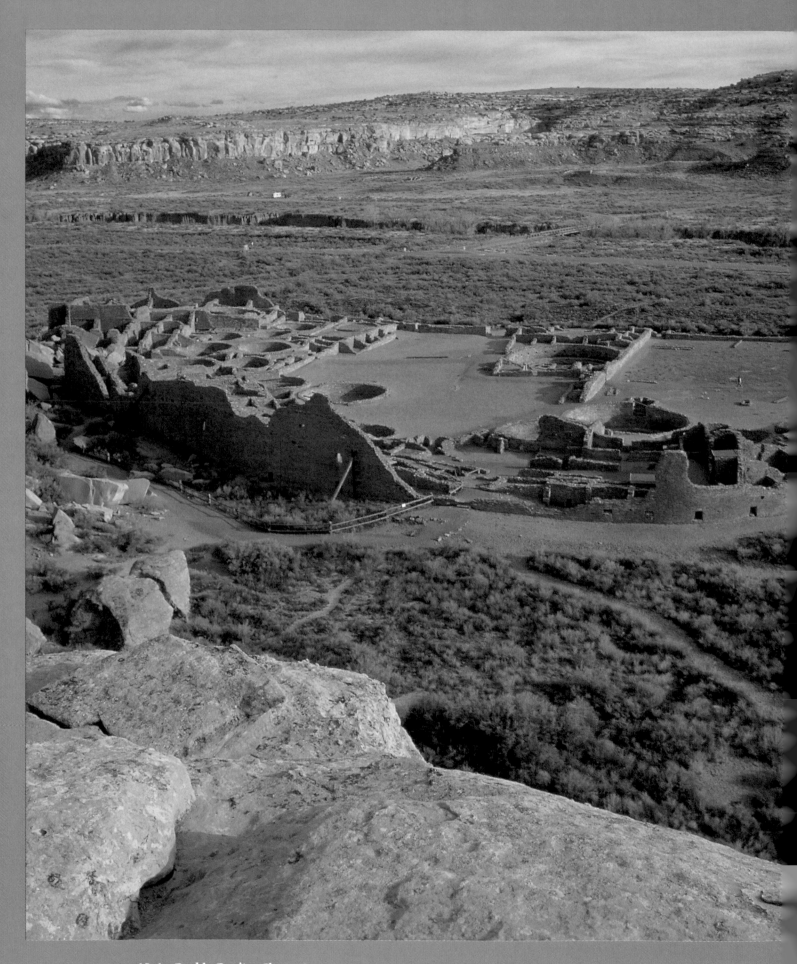

12-1. Pueblo Bonito, Chaco Canyon,
New Mexico. Anasazi culture, c. 900–1230 CE

12
Art of the Americas before 1300

We know—because there are written records—how Roman imperial architects planned cities such as Timgad in modern Algeria and apartment complexes such as the *insulae* in Ostia, Italy (Chapter 6). But the *pre*historic ruins in New Mexico's Chaco Canyon still only whisper hints of their secrets. As we look across the striking contours of Pueblo Bonito (fig. 12-1), we are seeing the high point of a culture that ended suddenly about 1400 CE for reasons that can only be guessed at.

We know much from archaeological research conducted during the past century: Pueblo Bonito and similar complexes known as great houses were built between about 900 and 1100 CE, dated by analyzing some of the 200,000 trees that were cut with stone axes or burned through, then transported at least 50 miles for use in roofs. Pueblo Bonito covered more than 3 acres, was four or five stories high, and had some 800 rooms, including 30 kivas (subterranean circular rooms used as ceremonial centers). Amazingly, all aspects of construction—including quarrying, timber cutting, and transport—were done without draft animals, wheeled vehicles, or metal tools. Pueblo Bonito stood at the center of a network of wide, straight roads, in some places with curbs and paving, that radiated more than 400 miles to some seventy other communities. The builders made no effort to avoid topographic obstacles; when they encountered cliffs, they ran stairs up them. Almost invisible today, the roads, most probably processional ways, were only recently discovered through aerial photography.

We also know that Chaco Canyon's inhabitants traded food, jewelry, turquoise, and black-and-white pottery known as Cibola. They buried their deceased with carved turquoise, shell, and bead jewelry. They were so sophisticated in astronomy that they built an accurate solar and lunar calendar known as the sun dagger and recorded in petrographs the activities of celestial objects, including what may have been a supernova in the Crab Nebula in 1054 and the passing in 1066 of what was later known as Halley's Comet.

But we don't know who *they* were—the Navajo, who came much later, called them Anasazi ("ancient ones")—or why their magnificent culture ended so suddenly.

| 1500 BCE | | 1000 BCE | | | |

▲ c. 1200–400 OLMEC

▲ c. 1000–200 CHAVIN

c. 350 BCE–900 CE MAYA ▲

c. 200 BCE–600 CE NAZCA ▲

▲ c. 1000 BCE–200 CE PARACAS

c. 200 BCE–600 CE MOCHE ▲

TIMELINE 12-1. **Mesoamerica, Central America, and the South American Andes before 1300.** In Mesoamerica, Olmec culture dominated during the Formative/Preclassic period (1500 BCE–300 CE); the Maya and Teotihuacan flourished during the Classic period (300–900 CE); and the Itza rose to prominence during the Postclassic period (900–1500 CE), about the same time that the Diquis culture thrived in Central America. In the Andes, the early Chavin and Paracas cultures were followed by the Nazca and Moche; the major Andean cultural periods before 1300 are categorized as Early Horizon (1000–200 BCE) and Middle Horizon (600–1000 CE).

MAP 12-1. **The Americas.** Between 15,000 and 17,000 years ago, Paleo-Indians moved across North America, then southward through Central America until they reached the Tierra del Fuego region of South America about 12,500 years ago.

THE NEW WORLD

During the last Ice Age, which began about 2.5 million years ago, glaciers periodically trapped enough of the world's water to lower the level of the oceans and expose land between Asia and North America. At its greatest extent, this land bridge was a vast, rolling plain a thousand miles wide, where grasses, sagebrush, sedge, and groves of scrub willow provided food and shelter for animals and birds.

Although most areas of present-day Alaska and Canada were covered by glaciers during the Ice Age, an ice-free corridor provided access from Asia to the south and east. Sometime before 12,000 years ago, perhaps as early as 20,000 to 30,000 years ago, Paleolithic hunter-gatherers emerged through this corridor and began to spread out into two vast, uninhabited continents (Map 12-1). Between 15,000 and 17,000 years ago, bands of hunters whose tool kits included sophisticated

fluted- and flaked-stone spearheads traveled across most of North America. The earliest uncontested evidence puts humans at the southern end of South America by 12,500 years ago. Although contact between Siberia and Alaska continued after the ice retreated and rising oceans again flooded the Bering Strait, the peoples of the Western Hemisphere, known as Paleo-Indians, were essentially cut off from the peoples of Africa and Eurasia.

In this isolation New World peoples experienced the same transformation from hunting to agriculture that followed the end of the Paleolithic era elsewhere. In many regions they cultivated corn, beans, and squash. Other plants first domesticated in the New World included potatoes, tobacco, cacao (chocolate), tomatoes, and avocados. New World peoples also domesticated many animals: turkeys, guinea pigs, llamas (and their camelid cousins, the alpacas, guanacos, and vicuñas), and, as did the peoples of the Old World, dogs.

As elsewhere, the shift to agriculture in the Americas was accompanied by population growth and, in some places, the rise of hierarchical societies, the appearance of ceremonial centers and towns with monumental architecture, and the development of sculpture, ceramics, and other arts. The peoples of Mesoamerica—the region that extends from central Mexico well into Central America—developed writing, astronomy, a complex and accurate calendar, and a sophisticated system of mathematics. Central and South American peoples had an advanced metallurgy and produced exquisite gold, silver, and copper pieces. The smiths of the Andes, the mountain range along the western coast of South America, began to produce metal weapons and agricultural implements in the first millennium CE, and people elsewhere in the Americas made tools and weapons from such other materials as bone, ivory, stone, wood, and, where it was available, obsidian, a volcanic glass capable of holding a cutting edge as fine as surgical steel. Basketry and, in the Andes, weaving (see "Andean Textiles," page 452) became major art forms.

Later civilizations such as the Aztec, Inka, and Pueblo of the North American Southwest are perhaps more familiar today, but before 1300 CE extraordinary artistic traditions already flourished in many regions in the Americas. This chapter explores the accomplishments of some of the cultures in five of those regions—Mesoamerica, Central America, the central Andes of South America, the southeastern woodlands and great river valleys of North America, and the North American Southwest.

MESO-AMERICA

Ancient Mesoamerica encompasses the area from north of the Valley of Mexico (the location of Mexico City) to modern Belize, Honduras, and western Nicaragua in Central America (see Map 12-1 inset). The region is one of great contrasts, ranging from tropical rain forest to semiarid mountains. Reflecting this physical diversity, the civilizations that arose in Mesoamerica varied, but they were linked by trade and displayed an overall cultural unity. Among their common features are a complex calendrical system based on interlocking 260-day and 365-day cycles, a ritual ball game (see "The Cosmic Ball Game," below), and aspects of the construction of monumental ceremonial centers. Mesoamerican society was sharply divided into elite and commoner classes.

The transition to farming began in Mesoamerica between 7000 and 6000 BCE, and by 3000–2000 BCE settled villages were widespread. Archaeologists traditionally have divided the region's subsequent history into three broad periods. Formative or Preclassic (1500 BCE–300 CE), Classic (300–900 CE), and Postclassic (900–1500 CE). This chronology derives primarily from the archaeology of the Maya—the people of Guatemala and the Yucatan peninsula. The Classic period brackets the time during which the Maya erected dated stone monuments. The term reflects the view of early Mayanists that it was a kind of golden age, the equivalent of the Classical period in ancient Greece. Although this view is no longer current

THE COSMIC BALL GAME

The ritual ball game was one of the defining characteristics of Mesoamerican society. The ball game was generally played on a long, rectangular court with a large, solid, heavy rubber ball. Using their elbows, knees, or hips—but not their hands—heavily padded players directed the ball toward a goal or marker. The rules, the size and shape of the court, the number of players on a team, and the nature of the goal varied. The largest surviving ball court, at Chichen Itza, was about the size of a modern football field. The goals of the Chichen Itza court were large stone rings set in the walls of the court about 25 feet above the field. The game had profound religious and political significance and was a common subject of Mesoamerican art. Players, complete with equipment, appear as figurines and on stone votive sculpture; the game and its attendant rituals were represented in relief sculpture. The movement of the ball represented celestial bodies—the sun, moon, or stars—held aloft and directed by the skill of the players. The ball game was sometimes associated with warfare. Captive warriors might have been made to play the game, and players might have been sacrificed when the stakes were high.

Textiles were of enormous importance in Andean life, serving significant functions in both private and public events. Specialized fabrics were developed for everything from ritual burial shrouds and shamans' costumes to rope bridges and knotted record-keeping devices. Clothing indicated ethnic group and social status and was customized for certain functions, the most rarefied being royal ceremonial garments made for specific occasions and worn only once. The creation of their textiles, among the most technically complex cloths ever made, consumed a major portion of ancient Andean societies' resources. Weavers and embroiderers used nearly every textile technique known, some of them unique inventions of these cultures. Dyeing technology, too, was an advanced art form in the ancient Andes, with some textiles containing dozens of colors.

Cotton was grown in Peru by 3500 BCE and was the most widely used plant fiber. From about 400 BCE on, animal fibers—superior in warmth and dye absorption—largely replaced cotton in the mountains, where cotton was hard to cultivate. The earliest Peruvian textiles were made by twining, knotting, wrapping, braiding, and looping fibers. Those techniques continued to be used even after the invention of weaving looms in the early second millennium BCE.

For weaving, early Andean peoples developed a simple, portable **backstrap loom** in which the undyed cotton **warp** (lengthwise thread) was looped and stretched between two poles. One pole was tied to a stationary object and the other to a strap circling the waist of the weaver. The weaver controlled the tension of the warp threads by leaning back and forth while threading a **bobbin**, or shuttle, through the warp to create the **weft** (crosswise threads) of camelid fiber, frequently vividly colored, that completely covered the warp.

Tapestry-weaving appeared in Peru around 900 BCE and was the main cloth-making technique for the next thousand or so years. In tapestry, a technique especially suited to representational textiles, the weft does not run the full width of the fabric; each colored section is woven as an independent unit (see illustration). Tapestry was followed by the introduction of **embroidery** on camelid fibers (llama, alpaca, or vicuña hair), the Andean equivalent of wool. (Embroidery on camelid fiber is seen in the Paracas mantle in figure 12-15.)

As much more complex techniques developed, the production of a single textile might involve a dozen processes requiring highly skilled workers. A tunic would have taken approximately 500 hours of work. Some of the most elaborate textiles were woven, unwoven, and rewoven to achieve special effects that were prized for their labor-intensiveness and difficulty of manufacture as well as their beauty. The most finely woven pieces contain a staggering 200 weft threads per square inch (fine European work uses 60–80 threads per inch).

Because of their complexity, deciphering how these textiles were made can be a challenge, and scholars rely on contemporary Andean weavers—inheritors of this tradition—for guidance. Then, as now, textile production was primarily in the hands of women.

Detail of tapestry-weave mantle, from Peru. c. 700–1100 CE. Wool and cotton. The Cleveland Museum of Art
Gift of William R. Carlisle, 56.84

Diagram of toothed tapestry-weaving technique, one of many sophisticated methods used in Andean textiles

12-2. **Great Pyramid and ball court, La Venta**, Mexico. Olmec culture, c. 900–600 BCE. Pyramid height approx. 100' (30 m)

and the periods are only roughly applicable to other cultures of Mesoamerica, the terminology has endured (Timeline 12-1).

THE OLMEC

The first major Mesoamerican art style, that of the Olmec, emerged during the Formative/Preclassic period. In dense vegetation along slow, meandering rivers of the modern Mexican states of Veracruz and Tabasco, the Olmec cleared farmland, drained fields, and raised earth mounds on which they constructed religious and political ceremonial centers. These centers probably housed an elite group of ruler-priests supported by a larger population of farmers who lived in villages of pole-and-thatch houses. The presence at Olmec sites of goods such as obsidian, iron ore, and jade that are not found in the Gulf of Mexico region but come from throughout Mesoamerica indicates that the Olmec participated in extensive long-distance trade. Olmec or Olmec-inspired art has been found as far away as Costa Rica and central Mexico.

The earliest Olmec ceremonial center, at San Lorenzo, flourished from about 1200 to 900 BCE and was abandoned

by 400 BCE. The archaeological findings there include a possible ball court, an architectural feature of other major Olmec sites. Another center, at La Venta, rose to prominence after San Lorenzo declined, thriving from about 900 to 400 BCE. La Venta was built on high ground between rivers. Its most prominent feature, an earth mound known as the Great Pyramid, still rises to a height of about 100 feet (fig. 12-2). This scalloped mound may have been intended to resemble a volcanic mountain, but its present form may simply be the result of erosion after thousands of years of the region's heavy rains. The Great Pyramid stands at the south end of a large, open court, possibly used as a playing field, arranged on a north-south axis and defined by long, low earth mounds. An elaborate drainage system of stone troughs may have been used as part of a ritual honoring a water deity. Many of the physical features of La Venta— including the symmetrical arrangement of earth mounds, platforms, and central open spaces along an axis that was probably determined by astronomical observations—are characteristic of later monumental and ceremonial architecture throughout Mesoamerica. Found buried within the site were carved jade, serpentine stone, and granite artifacts.

Although the Olmec developed no form of written language, their highly descriptive art enables scholars to gain an idea of their beliefs. The Olmec universe had three levels: sky, earth surface, and underworld. A bird monster ruled the sky. The earth surface itself was a female deity—apparently La Venta's principal deity—the repository of wisdom and overseer of surface water as well as land. The underworld—ruled by a fish monster—was a cosmic sea on which the earth surface, including its plants, floated. A vertical axis joining the three levels made a fourth element.

At the beginning, religion seems to have centered on shamanistic practices in which a shaman (a priest or healer) traveled in a trance state through the cosmos with the help of personal animal spirits, usually jaguars but also frogs and birds. Olmec sculpture and ceramics depict humans in the process of taking animal form. As society changed from a hunting base to an agricultural one and natural forces like sun and rain took on greater importance, a new priest class formed, in addition to the shamans, and created rituals to try to control these natural forces.

The Olmec produced an abundance of monumental basalt sculpture, including colossal heads, altars, and seated figures. The huge basalt blocks for the large works of sculpture were quarried at distant sites and transported to San Lorenzo, La Venta, and other centers. Colossal heads ranged in height from 5 to 12 feet and weighed from 5 to more than 20 tons. The heads are portraits of rulers, adult males wearing close-fitting caps with chin straps and large, round earplugs. The fleshy faces have almond-shaped eyes, flat broad noses, thick protruding lips, and downturned mouths. Each face is different, suggesting that they may represent specific individuals. Twelve heads were found at San Lorenzo. All had been mutilated and buried about 900 BCE, about the time the site went into decline. At La Venta, 102 basalt monuments were found (fig. 12-3).

The colossal heads and the subjects depicted on other monumental sculpture suggest that the Olmec elite, like their counterparts in later Mesoamerican civilizations, particularly the Maya, were preoccupied with the commemoration of rulers and historic events. This preoccupation was probably an important factor in the development of calendrical systems, which first appeared around 600 to 500 BCE in areas with strong Olmec influence.

Not long after 400 BCE, forests and swamps began to reclaim Olmec sites, but Olmec civilization had spread widely throughout Mesoamerica and was to have an enduring influence on its successors. As vegetation obscured the defunct Olmec centers of the Mesoamerican Gulf Coast, the Teotihuacan and Maya cultures began to rise. Their greatest achievements would flower during the Classic period, at Teotihuacan in the Valley of Mexico, at Monte Alban in the Valley of Oaxaca, and in the Maya regions of Guatemala and Palenque (Mexico).

TEOTIHUACAN

Teotihuacan is located some 30 miles northeast of present-day Mexico City. Early in the first millennium CE

12-3. Colossal head (no. 4), from La Venta, Mexico. Olmec culture, c. 900 BCE. Basalt, height 7'5" (2.26 m). La Venta Park, Villahermosa, Tabasco, Mexico

The naturalistic colossal heads found at La Venta and San Lorenzo are sculpture in the round that measure about 8 feet in diameter. They are carved from basalt boulders that were transported to the Gulf Coast from the Tuxtla Mountains, more than 60 miles inland.

it began a period of rapid growth, and by 200 it had emerged as a significant center of commerce and manufacturing, the first large city-state in the Americas. One reason for its wealth was its control of a source of high-quality obsidian. Goods made at Teotihuacan, including obsidian tools and pottery, were distributed widely throughout Mesoamerica in exchange for luxury items such as the brilliant green feathers of the quetzal bird, used for priestly headdresses, and the spotted fur of the jaguar, used for ceremonial garments. The city's farmers terraced hillsides and drained swamps, and on fertile, reclaimed land they grew the common Mesoamerican staple foods, including corn, squash, and beans. From the fruit of the spiky-leafed maguey plant they fermented pulque, a mildly alcoholic brew still consumed today.

At its height, between 350 and 650 CE, Teotihuacan covered nearly 9 square miles and had a population of about 200,000, making it the largest city in the Americas and one of the largest in the world at that time (figs. 12-4, 12-5). The people of Teotihuacan worshiped two primary

12-4. Ceremonial center of the city of Teotihuacan, Mexico. Teotihuacan culture, c. 500 CE

View from the Pyramid of the Moon toward the Ciudadela and the Temple of the Feathered Serpent. The Pyramid of the Sun is on the middle left.

gods: the goggle-eyed Storm God and the Great Goddess, an earth-surface and groundwater deity.

Sometime in the middle of the eighth century disaster struck Teotihuacan. The ceremonial center burned, and the city went into a permanent decline. Nevertheless, its influence continued as other centers throughout northern Mesoamerica borrowed and transformed its imagery over the next several centuries. The site was never entirely abandoned, however, because it remained a legendary pilgrimage center. The much later Aztec (c. 1300–1525 CE) revered the site, believing it to be the place where the gods created the sun and the moon. Its name, Teotihuacan, is an Aztec word meaning "The City [gathering place] of the Gods."

Teotihuacan's principal monuments include the Pyramid of the Sun and the Pyramid of the Moon. A broad thoroughfare laid out on a north-south axis, extending for more than 3 miles and in places as much as 150 feet wide, bisects the city. Much of the ceremonial center, in a pattern typical of Mesoamerica, is characterized by the symmetrical arrangement of structures around open courts or plazas. The Pyramid of the Sun is east of the main corridor.

The largest of Teotihuacan's architectural monuments, the Pyramid of the Sun is more than 210 feet high and measures about 720 feet on each side at its base, similar in size but not as tall as the largest Egyptian pyramid at Giza. It is built over a four-chambered cave with a spring that may have been the original focus of worship at the site and the source of its prestige. It rises in a series of sloping steps to a flat platform, where a two-room temple once stood. A monumental stone stairway led from level to level up the side of the pyramid to the temple platform. The exterior was faced with stone and stucco and was painted. The Pyramid of the Moon, not quite as large as the Pyramid of the Sun, stands at the

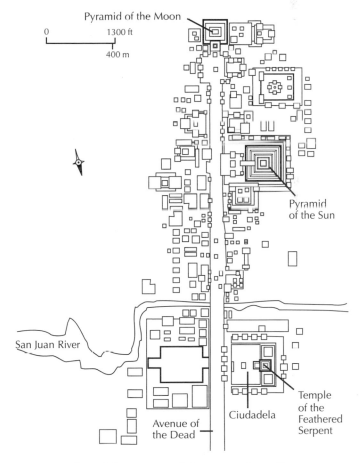

12-5. Plan of the ceremonial center of Teotihuacan

north end of the main avenue, facing a large plaza flanked by smaller, symmetrically placed platforms.

At the southern end of ceremonial center, and at the heart of the city, is the so-called Ciudadela, a vast sunken

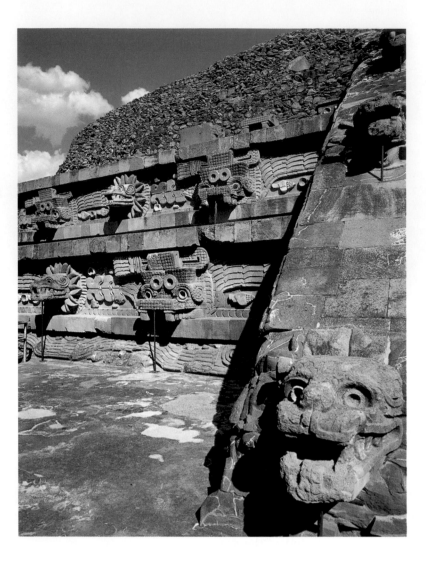

12-6. Temple of the Feathered Serpent, the Ciudadela, Teotihuacan, Mexico. Teotihuacan culture, after 350 CE

plaza surrounded by temple platforms. One of the city's principal religious and political centers—the plaza could accommodate more than 60,000 people—it had as its focal point the Temple of the Feathered Serpent. This structure exhibits the ***talud-tablero*** (slope-and-panel) construction that is a hallmark of the Teotihuacan architectural style. The sloping base, or *talud*, of each platform supports a *tablero*, or **entablature**, that rises vertically, is surrounded by a frame, and often was filled with sculptural decoration (fig. 12-6). The Temple of the Feathered Serpent was enlarged several times, and typical of Mesoamerican practice, each enlargement completely enclosed the previous structure.

Archaeological excavations of the temple's early-phase *tableros* and a stairway balustrade have revealed painted reliefs of the Feathered Serpent, the goggle-eyed Storm God, and aquatic shells and snails. Their flat, angular, abstract style is typical of Teotihuacan art and is a marked contrast to the three-dimensional, curvilinear Olmec style. The Storm God has a squarish, stylized head with protruding lips, huge round eyes originally inlaid with obsidian and surrounded by once-colored circles, and large, circular earspools. The fanged serpent heads emerge from an aureole of stylized feathers. The Storm God and the Feathered Serpent may represent alternating

wet and dry seasons or may be symbols of regeneration and cyclical renewal. Mass burials have been found here—in one case, eighty young men dressed as warriors. Archaeologists now suggest that male social groups had formed, with the Storm God and the Feathered Serpent as their patrons.

The residential sections of Teotihuacan fanned out from the city's center. The large palaces of the elite, with as many as forty-five rooms and seven patios, stood nearest the ceremonial center. Artisans, foreign traders, and peasants lived farther away, in simpler compounds. The palaces and more humble homes alike were rectangular one-story structures with high walls, thatched roofs, and suites of rooms arranged symmetrically around open courts. Walls were plastered and, in the homes of the elite, were covered with paintings.

Teotihuacan's artists worked in a true **fresco** technique, applying pigments directly on damp lime plaster. Their painting style, like that for sculpture, was flat, angular, and abstract. Their use of color is subtle—one work may include five shades of red with touches of ocher, green, and blue. A detached fragment of a wall painting, now in the Cleveland Museum of Art, depicts a bloodletting ritual in which an elaborately dressed man impersonating the Storm God enriches and revitalizes the earth (the

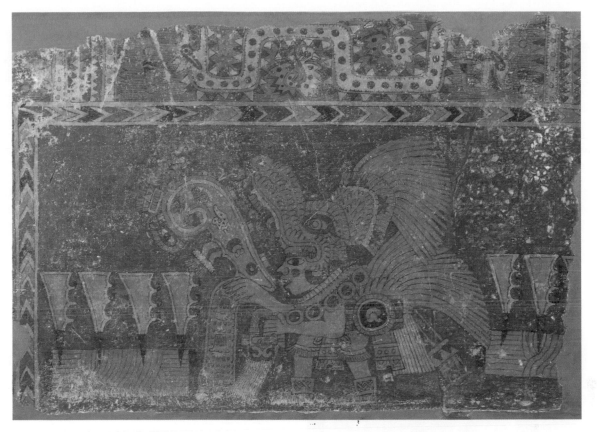

12-7. *Maguey Bloodletting Ritual*, fragment of a fresco from Teotihuacan, Mexico. Teotihuacan culture, 600–750 CE. Pigment on lime plaster, 32¼ x 45¼" (82 x 116.1 cm). The Cleveland Museum of Art
Purchase from the J. H. Wade Fund (63.252)

The maguey plant supplied the people of Teotihuacan with food; fiber for making clothing, rope, and paper; and the sacramental drink pulque. As this painting indicates, priestly officials used its spikes in rituals to draw their own blood as a sacrifice to the Great Goddess.

Great Goddess) with his own blood (fig. 12-7). The man's Feathered Serpent headdress, decorated with precious quetzal feathers, indicates his high rank. He stands between rectangular plots of earth planted with bloody maguey spines and scatters seeds or drops of blood from his right hand, as indicated by the panel with conventionalized symbols for blood, seeds, and flowers. The **speech scroll** emerging from his open mouth symbolizes his ritual chant. The visual weight accorded the headdress and speech scroll suggests that the man's priestly office and chanted words are essential elements of the ceremony. Such bloodletting rituals were not limited to Teotihuacan but were widespread in Mesoamerica.

THE MAYA

The Maya homeland in Mesoamerica includes Guatemala, the Yucatan peninsula, Belize, and the northwestern part of Honduras. The remarkable civilization created there endured to the time of the Spanish conquest in the early sixteenth century and is still reflected in present-day Maya culture. The ancient Maya are noted for a number of achievements, including finding ways to produce high agricultural yields in the seemingly inhospitable tropical rain forest of the Yucatan. In densely populated cities they built imposing pyramids, temples, palaces, and administrative structures. They developed the most advanced hieroglyphic writing in Mesoamerica and the most sophisticated version of the Mesoamerican calendrical system (see "Maya Record Keeping," page 458). With these tools they documented the accomplishments of their rulers in monumental commemorative **stelai**, in books, on ceramic vessels, and on wall paintings. (Scholars have determined the relationship between the Maya calendar and the European calendar, making it possible to date Maya artifacts with a precision unknown elsewhere in the Americas.) They studied astronomy and the natural cycles of plants and animals and developed the mathematical concepts of zero and place value before they were known in Europe.

An increasingly detailed picture of the Maya has been emerging from recent archaeological research and advances in deciphering their writing. That picture shows a society divided into competing centers, each with a hereditary ruler and an elite class of nobles and priests supported by a large group of farmer-commoners. Rulers established their legitimacy, maintained links with their divine ancestors, and sustained the gods through elaborate rituals, including ball games, bloodletting ceremonies, and human sacrifice. These rituals occurred in the pyramids, temples, and plazas that dominated Maya cities. Rulers commemorated such events and their

MAYA
RECORD
KEEPING

Since the rediscovery of the Classic-period Maya sites in the nineteenth century, scholars have puzzled over the meaning of the hieroglyphic writing that abounds in Maya art work. They soon realized that many of the glyphs were numeric notations in a complex calendrical system. In 1894, a German librarian, Ernst Forstermann, deciphered the numbering systems. By the early twentieth century, the calendrical system had been interpreted and approximately correlated with the European calendar. The Maya calendar counts time from a starting date now securely established as August 13, 3114 BCE.

Since the late 1950s scholars have made enormous progress in deciphering Maya writing. Previously, many prominent Mayanists argued that the inscriptions dealt with astronomical and astrological observations, not historical events. This interpretation was in accord with the prevailing view that the Classic-period Maya were a peaceful people ruled by a theocracy of learned priests. The results of the deciphering and archaeological research overturned the earlier view of Maya society and Maya writing. The inscriptions on Maya architecture and **stelai** are almost entirely devoted to historical events. They record the dates of royal marriages, births of heirs, alliances between cities, and great military victories, tying them to astronomical events and propitious periods in the Maya calendar.

Maya writing, like the Maya calendar, is the most advanced in ancient Mesoamerica. About 800 glyphs have been identified. The system combines logographs—symbols representing entire words—and symbols representing syllables in the Maya language.

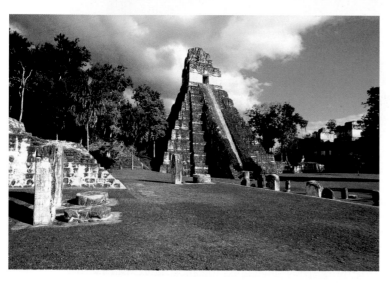

12-8. Base of North Acropolis (left) and Temple I, called the Temple of the Giant Jaguar (tomb of Ah Hasaw), Tikal, Guatemala. Maya culture. North Acropolis, 5th century CE; Temple I, c. 700 CE

military exploits on carved stelai. A complex pantheon of deities, many with several manifestations, presided over the Maya universe.

Olmec influence was widespread around 1000–300 BCE in what would come to be the Maya area. The earliest distinctively Maya centers emerged around 350 BCE–300 CE, and Maya civilization reached its peak in the southern lowlands of the Yucatan peninsula (Chiapas, northern Guatemala, Belize, and northwestern Honduras; see Map 12-1, page 450) during the Classic period (300–900 CE). Probably due to increased warfare and growing pressure on agricultural resources, the sites in the southern lowlands were abandoned at the end of the Classic period. The focus of Maya civilization then shifted to the northern Yucatan peninsula during the Postclassic period (900–1500 CE).

Classic-Period Architecture at Tikal and Palenque. The monumental buildings of Maya cities were masterly examples of the use of architecture for public display and propaganda. Seen from outside and afar, they would have impressed the common people with the power and authority of the elite and the gods they served.

Tikal, in what is now northern Guatemala, was the largest Classic-period Maya city, with a population of as many as 70,000 at its height. Like other Maya cities—and unlike Teotihuacan, with its grid plan—Tikal conformed to the uneven terrain of the rain forest. Plazas, pyramid-temples, ball courts, and other structures stood on high ground connected by elevated roads, or causeways. One major causeway, 80 feet wide, led from the center of the city to outlying residential areas.

Figure 12-8 shows part of the ceremonial core of Tikal. The structure whose base is visible on the left, known as the North Acropolis, dates to the early Classic period. It contained many royal tombs and covers earlier structures that date to the origin of the city, about 500 BCE. The tall pyramid in the center, known as Temple I or the Temple of the Giant Jaguar, faces a companion pyramid, Temple II, across a large plaza. Temple I covers the tomb of the ruler Ah Hasaw (682–c. 727 CE), who began an ambitious expansion of Tikal after a period in the sixth and early seventh centuries CE when there was little new construction at this or other major Maya sites. Under Ah Hasaw and his successors, Tikal's influence grew, with evidence of contacts that extended from highland Mexico to Costa Rica.

From Ah Hasaw's tomb in the limestone bedrock, Temple I rises above the forest canopy to a height of more than 140 feet. Its base has nine layers, probably reflecting the belief that the underworld had nine levels. Priests climbed the steep stone staircase on the exterior to the temple on top, which consists of two long, parallel rooms covered with a steep roof supported by **corbel vaults**. It is typical of Maya enclosed stone structures, which resemble the kind of pole-and-thatch houses the Maya still build in parts of the Yucatan today. The only entrance to the temple was on the long side, facing the plaza and the commemorative stelai erected there. The crest that rises over the roof of the temple, known as a

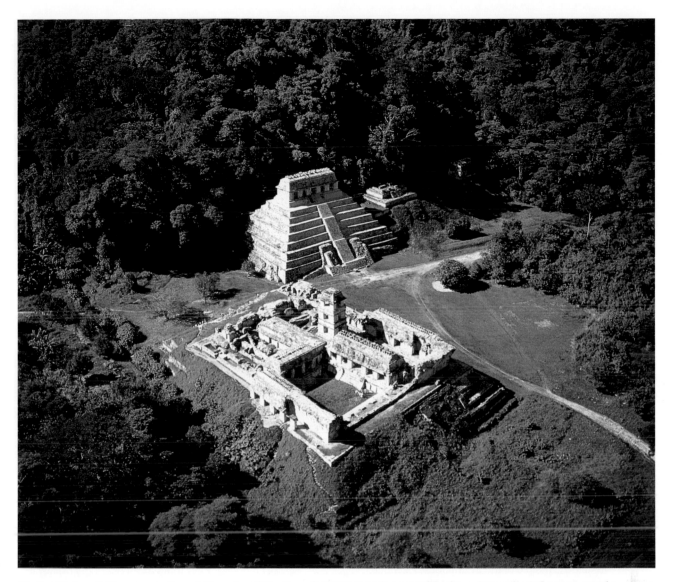

12-9. "Palace" (foreground) and Temple of the Inscriptions (tomb-pyramid of Lord Pacal), Palenque, Mexico. Maya culture, 7th century CE

roof comb, was originally covered with brightly painted sculpture. Archaeological evidence recently raised the possibility that the narrow platforms of the pyramids served as shallow stages for ritual reenactments of mythological narratives.

Palenque, in the Mexican state of Chiapas, rose to prominence in the late Classic period. Hieroglyphic inscriptions record the beginning of its royal dynasty in 431 CE, but the city had only limited regional importance until the ascension of a powerful ruler, Lord Pacal (Maya for "shield"), who ruled from 615 to 683 CE. He and the son who succeeded him commissioned most of the structures visible at Palenque today. As at Tikal, major buildings are grouped on high ground. A northern complex has five temples, two nearby adjacent temples, and a ball court. A central group includes the so-called Palace, the Temple of the Inscriptions, and two other temples (fig. 12-9). A third group of temples lies to the southeast.

The "palace" in the central group—a series of buildings on two levels around three open courts, all on a raised terrace—may have been an administrative rather than a residential complex. The Temple of the Inscriptions next to it is a pyramid that rises about 75 feet. Like Temple I at Tikal, it has nine levels. The shrine on the summit consisted of a portico with five entrances and a three-part, vaulted inner chamber surmounted by a tall roof comb. Its facade still retains much of its stucco sculpture. The inscriptions that give the building its name were carved on the back wall of the portico and the central inner chamber.

In 1952 an archaeologist studying the structure of the Temple of the Inscriptions discovered a corbel-vaulted stairway beneath the summit shrine. This stairway descended almost 80 feet to a small subterranean chamber that contained the undisturbed tomb of Lord Pacal himself, and in it were some remarkable examples of Classic-Period sculpture.

Classic-Period Sculpture. Lord Pacal lay in a monolithic sarcophagus with a lid carved in low relief that showed him balanced between the spirit world and the earth

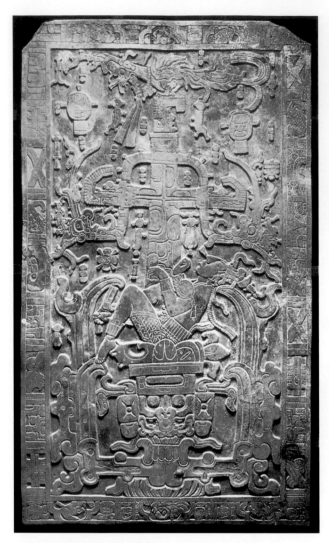

12-10. Sarcophagus lid, in the tomb of Lord Pacal (Shield 2), Temple of the Inscriptions, Palenque, Mexico. Maya culture, c. 683 CE. Limestone, approx. 12'6" x 7' (3.8 x 2.14 m)

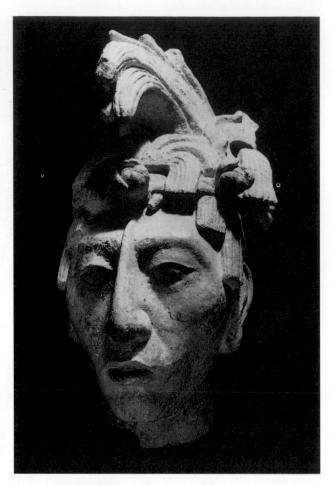

12-11. Portrait of Lord Pacal, from his tomb, Temple of the Inscriptions, Palenque, Mexico. Maya culture, mid-7th century CE. Stucco, height 16⁷/₈" (43 cm). Museo Nacional de Antropología, Mexico City

This portrait of the youthful Lord Pacal may have been placed in his tomb as an offering. Possibly it formed part of the original exterior decoration of the Temple of the Inscriptions.

(fig. 12-10). With knees bent, feet twisted, and face, hands, and torso upraised, he lies on the head of a creature that represents the setting sun. Together they are falling into the jaws of the underworld's monster. The image above him, which ends in the profile head of a god and a fantastic bird, represents the sacred tree of the Maya. Its roots are in the earth, its trunk is in the world, and its branches support the celestial bird in the heavens. The message is one of death and rebirth. Lord Pacal, like the setting sun, will rise again to join the gods after falling into the underworld. Lord Pacal's ancestors, carved on the side of his sarcophagus, witness his death and **apotheosis**. They wear elaborate headdresses and are shown only from the waist up, as though emerging from the earth. Among them are Lord Pacal's parents, Lady White Quetzal and Lord Yellow Jaguar-Parrot, supporting the contention of some scholars that both maternal and paternal lines transmitted royal power among the Maya.

Elite men and women, rather than gods, were the usual subjects of Maya sculpture, and most show rulers dressed as warriors performing religious rituals in elaborate costumes and headdresses. The Maya favored low-relief carving with sharp outlines on flat stone surfaces, but they also excelled at three-dimensional clay and stucco sculpture. A stucco portrait of Lord Pacal found with his sarcophagus shows him as a young man wearing a diadem of jade and flowers (fig. 12-11). His features—sloping forehead and elongated skull (babies' heads bound to produce this shape), large curved nose (enhanced by an ornamental bridge, perhaps of latex), full lips, and open mouth—are characteristic of the Maya ideal of beauty. His long narrow face and jaw are individual characteristics. Traces of pigment indicate that this portrait, like much Maya sculpture, was colorfully painted.

Classic-Period Painting. Artists had high status in Maya society, reflecting in part the great importance of record keeping to the Maya; they chronicled their history in carved and painted inscriptions on stelai, ceramic vessels, and walls and with hieroglyphic writing and illustrations in **codices**—books of folded paper made from the

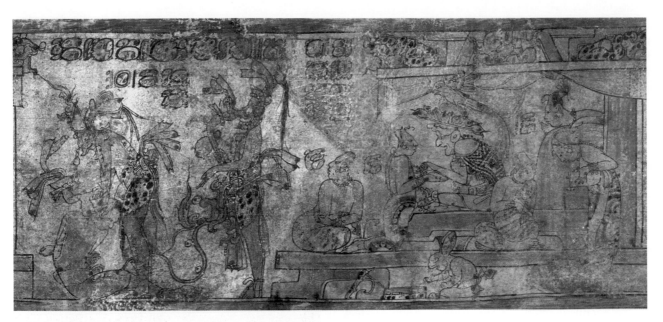

12-12. Cylindrical vessel (composite photograph in the form of a roll-out). Maya culture, 600–900 CE. Painted ceramic, diameter 6½" (16.6 cm); height 8⅜" (21.5 cm). The Art Museum, Princeton University, New Jersey

The clay vessel was first covered by a creamy white slip and then painted in light brown washes and dark brown or black lines. The painter may have used turkey feathers to apply the pigments.

maguey plant. Vase painters and scribes were often members of the ruling elite and perhaps included members of the royal family not in the direct line of succession.

Maya painting survives on ceramics and a few large murals; most of the illustrated books have perished, except for a few late examples with astronomical and divinatory information. However, the books' influence is reflected in vases painted in the so-called codex style, which often show a fluid line and elegance similar to that of the manuscripts.

The codex-style painting on a late Classic cylindrical vase (fig. 12-12) may illustrate an episode from the Book of Popol Vuh, the history of the creation of the world and the first people. The protagonists, the mythical Hero Twins, defeat the lords of Xibalba, the Maya underworld, and overcome death. The vessel shows one of the lords of Xibalba, an aged-looking being known to archaeologists as God L, sitting inside a temple on a raised platform. Five female deities attend him. The god ties a wrist cuff on the attendant kneeling before him. Another attendant, seated outside the temple, looks over her shoulder at a scene in which two men sacrifice a bound victim. A rabbit in the foreground writes in a manuscript, reminding us of the Maya obsession with historical records, as well as of the many books now lost. The two men may be the Hero Twins and the bound victim a bystander they sacrificed and then brought back to life to gain the confidence of the Xibalban lords. The inscriptions on the vessel have not been entirely translated. They include a calendar reference to the Death God and to the evening star, which the Maya associated with war and sacrifice.

Postclassic Art. A northern Maya group called the Itza rose to prominence when the focus of Maya civilization shifted northward in the Postclassic period. Their principal center, Chichen Itza, which means "at the mouth of the well of the Itza," grew from a village located near a sacred well. The city flourished from the ninth to the thirteenth century CE, eventually covering about 6 square miles.

One of Chichen Itza's most conspicuous structures is a massive pyramid in the center of a large plaza embellished with figures of the Feathered Serpent (fig. 12-13). A stairway on each side leads to a square, blocky temple on its summit. At the spring and fall equinoxes, the setting sun casts an undulating, serpentlike shadow on the stairway balustrades. Like earlier Maya pyramids, this one has nine levels, but many other features of Chichen Itza are markedly different from earlier sites. The pyramid,

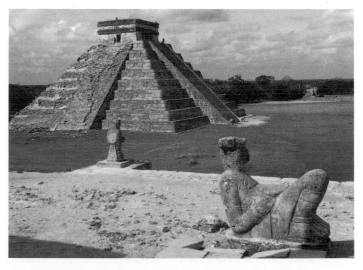

12-13. Pyramid with Chacmool in foreground, Chichen Itza, Yucatan, Mexico. Itza (northern Maya) culture, 9th–13th century CE; Chacmool, 800–1000 CE

for example, is lower and broader than the stepped pyramids of Tikal and Palenque, and Chichen Itza's buildings have wider rooms. Another prominent feature not found at earlier sites is the use of pillars and columns. Chichen Itza has broad, open galleries surrounding courtyards and inventive columns in the form of inverted, descending serpents. Brilliantly colored relief sculpture covered the buildings of Chichen Itza, and paintings of feathered serpents, jaguars, coyotes, eagles, and composite mythological creatures adorned its interior rooms. The surviving works show narrative scenes that emphasize the prowess of warriors and the skill of ritual ballplayers.

Sculpture at Chichen Itza, including the serpent columns and the half-reclining figures known as **Chacmools** (see fig. 12-13), has the sturdy forms, proportions, and angularity of architecture. It lacks the curving forms and subtlety of Classic Maya sculpture. The Chacmools probably represent fallen warriors and were used to receive sacrificial offerings. They were once, inaccurately, considered the archetypal Pre-Columbian sculpture.

After Chichen Itza's decline, Mayapan, on the north coast of the Yucatan, became the principal Maya center. But by the time the Spanish arrived in the early sixteenth century, Mayapan, too, had declined. The Maya people and much of their culture would survive the conquest despite the imposition of Hispanic customs and beliefs. The Maya continue to speak their own languages, to venerate traditional sacred places, and to follow traditional ways.

CENTRAL AMERICA

Unlike their neighbors in Mesoamerica, who lived in complex hierarchical societies, the people of Central America generally lived in extended family groups led by chiefs. A notable example of these small chiefdoms was the Diquis culture, which developed in present-day Costa Rica from about 700 CE to about 1500 CE.

The Diquis occupied fortified villages without monumental architecture or sculpture and seem to have engaged in constant warfare with one another. They nevertheless produced fine featherwork, ceramics, textiles, and gold objects. (The name Costa Rica, which means "rich coast" in Spanish, probably reflects the value the Spanish placed on the gold they found there.)

Metallurgy and the use of gold and copper-gold alloys were widespread in Central America. The technique of **lost-wax casting** probably first appeared in present-day Colombia between 500 and 300 BCE. From there it spread north to the Diquis. The small, exquisite pendant shown in figure 12-14 illustrates the sophisticated design and technical facility of Diquis goldwork. The pendant depicts a male figure wearing bracelets, anklets, and a belt with a snake-headed penis sheath. He plays a drum while holding the tail of a snake in his teeth and its head in his left hand. The wavy forms with serpent heads emerging from his scalp suggest an elaborate headdress, and the creatures emerging from his legs suggest some kind of reptile costume. The inverted triangles on the headdress probably represent birds' tails.

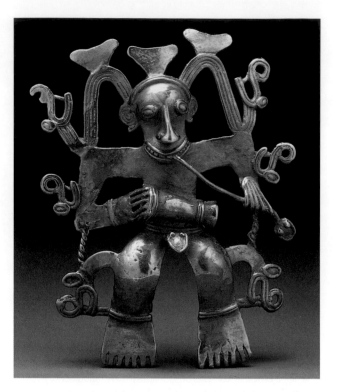

12-14. *Shaman with Drum and Snake*, from Costa Rica. Diquis culture, c. 1000 CE. Gold, 4¼ x 3¼" (10.8 x 8.2 cm). Museos del Banco Central de Costa Rica, San José, Costa Rica

In Diquis mythology serpents and crocodiles inhabited a lower world, humans and birds a higher one. Their art depicts animals and insects as fierce and dangerous. Perhaps the man in the pendant is a shaman transforming himself into a composite serpent-bird or performing a ritual snake dance surrounded by serpents or crocodiles. The scrolls on the sides of his head may represent the shaman's power to hear and understand the speech of animals. Whatever its specific meaning, the pendant evokes a ritual of mediation between earthly and cosmic powers involving music, dance, and costume.

Whether gold figures of this kind were protective amulets or signs of high status, they were certainly more than personal adornment. Shamans and warriors wore gold to inspire fear, perhaps because gold was thought to capture the energy and power of the sun. This energy was also thought to allow shamans to leave their bodies and travel into cosmic realms.

SOUTH AMERICA: THE CENTRAL ANDES

Like Mesoamerica, the central Andes of South America—primarily present-day Peru and Bolivia—saw the development of complex hierarchical societies with rich and varied artistic traditions. The area is one of dramatic contrasts. The narrow coastal plain, bordered by the Pacific Ocean on the west and the abruptly soaring Andes on the east, is one of the driest deserts in the world. Life here depends on the rich marine resources of the Pacific and the rivers that descend from the Andes, forming a series of valley oases from south to north. The Andes themselves are a

region of lofty snowcapped peaks, high grasslands, steep slopes, and deep, fertile river valleys. The high grasslands are home to the Andean camelids—llamas, alpacas, vicuñas, and guanacos—that have served for thousands of years as beasts of burden and a source of wool and meat. The lush eastern slopes of the Andes descend to the tropical rain forest of the Amazon basin.

The earliest evidence of monumental architecture in Peru dates to the third millennium BCE, contemporary with the earliest pyramids in Egypt. (There are no dated monuments; all dates are approximate.) On the coast, sites with ceremonial mounds and plazas were located near the sea. The inhabitants of these centers depended on marine and agricultural resources, farming the floodplains of nearby coastal rivers. Their chief crops were cotton, used to make fishing nets, and gourds, used for floats. Early centers in the highlands consisted of multi-roomed stone-walled structures with sunken central fire pits for burning ritual offerings.

In the second millennium BCE, herding and agriculture became prevalent in the highlands. On the coast, people became increasingly dependent on agriculture. They began to build canal irrigation systems, greatly expanding their food supply. Settlements were moved inland, and large, U-shaped ceremonial complexes with circular sunken plazas were built. These complexes were oriented toward the mountains, the direction of the rising sun and the source of the water that nourished their crops. The shift to irrigation agriculture also corresponded to the spread of pottery and ceramic technology in Peru.

Between about 1000 and 200 BCE an art style associated with the northern highland site of Chavin de Huantar spread through much of the Andes. In Andean chronology,

this era is known as the Early Horizon, the first of three so-called horizon periods marked by the widespread influence of a single style (see Timeline 12-1). The political and social forces behind the spread of the Chavin style are not known; many archaeologists suspect that they involved an influential religious cult.

The Chavin site was located on a major trade route between the coast and the Amazon basin, and Chavin art features images of many tropical forest animals. The period was one of artistic and technical innovation in ceramics, metallurgy, and textiles (ceramics, metalware, and textiles all were found in burial sites, reflecting the importance to the Chavin people of burial and the afterlife). These innovations were also expressed in the textiles of the Paracas culture on the south coast of Peru, the art of the Nazca culture there, and the ceramics and metalwork of the Moche culture on the north coast.

THE PARACAS AND NAZCA CULTURES

The Paracas culture of the Peruvian south coast flourished from about 1000 BCE to 200 CE, overlapping the Chavin period. It is best known for its stunning textiles, which were found in cemeteries wrapped in many layers around the dead. Some bodies were wrapped in as many as 200 pieces of cloth.

Weaving is of great antiquity in the central Andes and continues to be among the most prized arts in the region (see "Andean Textiles," page 452). Fine textiles were a source of prestige and wealth, and the production of textiles was an important factor in the domestication of both cotton and llamas. The designs on Paracas textiles include repeated **embroidered** (needlework) figures of warriors, dancers, and composite creatures such as

12-15. Mantle with bird impersonators, from the Paracas peninsula, Peru. Paracas culture, c. 50–100 CE. Camelid fiber, plain weave with stem-stitch embroidery, approx. 40" x 7'11" (101 cm x 2.41 m). Museum of Fine Arts, Boston

Denman Waldo Ross Collection

The stylized figures display the beautiful Paracas sense of color and pattern. The all-directional pattern is also characteristic of Paracas art.

TIMELINE 12-2. **North American Cultures before 1300.** The Adena, Hopewell, and Mississippian cultures settled the Mississippi, Missouri, Illinois, and Ohio river valleys. The Mogollon, Hohokam, and Anasazi cultures developed in the Southwest.

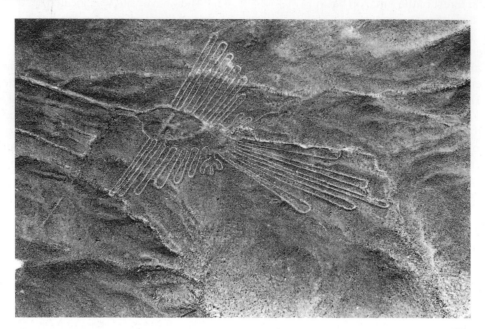

12-16. **Earth drawing of a hummingbird, Nazca Plain**, southwest Peru. Nazca culture, c. 200 BCE–200 CE. Length approx. 450' (138 m); wingspan approx. 200' (60.5 m)

bird-people (fig. 12-15). Embroiderers used tiny overlapping stitches to create colorful, curvilinear patterns, sometimes using as many as twenty-two different colors within a single figure. The effect of the clashing and contrasting colors and tumbling figures is dazzling.

The Nazca culture, which dominated the south coast of Peru from about 200 BCE to 600 CE, overlapped the Paracas culture. Nazca artisans continued to weave fine fabrics, but they also produced multicolored pottery with painted and modeled images reminiscent of those on Paracas textiles.

The Nazca are probably best known for their colossal earthworks, or **geoglyphs**, which dwarf even the most ambitious twentieth-century environmental sculpture. On great stretches of desert they literally drew in the earth. By removing dark, oxidized stones, they exposed the light underlying stones, then edged the resulting lines with more stones. In this way they created gigantic images—including a hummingbird, a killer whale, a monkey, a spider, a duck, and other birds—similar to those with which they decorated their pottery. They also made abstract patterns and groups of straight, parallel lines that extend for up to 12 miles. The beak of the hummingbird in figure 12-16 consists of two parallel lines, each 120 feet long. Each geoglyph was evidently maintained by a clan. At regular intervals the clans gathered on the plateau in a sort of fair where they traded goods and looked for marriage partners. How the glyphs functioned—perhaps as clan emblems or spirit patrons—is unknown, but the "lines" of stone are wide enough to have been ceremonial walkways.

THE MOCHE CULTURE

The Moche culture dominated the north coast of Peru from the Piura Valley to the Huarmey Valley—a distance of some 370 miles—between about 200 BCE and 600 CE. Moche lords ruled each valley in this region from a ceremonial-administrative center. The largest of these, in the Moche Valley (from which the culture takes its name), contained the so-called Pyramids of the Sun and the Moon. Both pyramids were built entirely of **adobe** bricks. The Pyramid of the Sun, the largest ancient structure in South America, was originally a cross-shaped structure 1,122 feet long by 522 feet wide that rose in a series of terraces to a height of 59 feet. This site had been thought to be the capital of the entire Moche realm, but evidence is accumulating that the Moche were not so centralized.

The Moche were exceptional potters and metalsmiths. They developed ceramic molds, which allowed them to mass-produce some forms. Vessels were made in the shape of naturalistically modeled human beings, animals, and architectural structures. They also created realistic portrait vessels and recorded mythological narratives and ritual scenes in intricate fine-line painting. Similar scenes were painted on the walls of temples and administrative buildings. Moche smiths, the most sophisticated in the central Andes, developed several innovative metal alloys.

The ceramic vessel in figure 12-17 shows a Moche lord sitting in a structure associated with high office. He wears an elaborate headdress and large earspools and

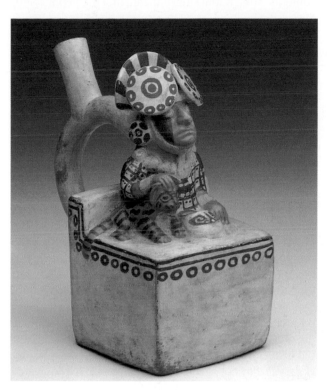

12-17. *Moche Lord with a Feline*, from Moche Valley, Peru. Moche culture, c. 100 BCE–500 CE. Painted ceramic, height 7½" (19 cm). Art Institute of Chicago Buckingham Fund, 1955-2281

Behind the figure is the distinctive stirrup-shaped handle and spout. Vessels of this kind, used in Moche rituals, were also treasured as special luxury items and were buried in large quantities with individuals of high status.

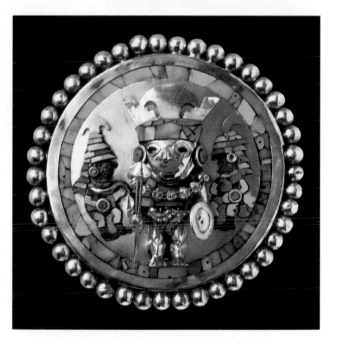

12-18. **Earspool**, from Sipan, Peru. Moche culture, c. 300 CE. Gold, turquoise, quartz, and shell, diameter approx. 5" (12.7 cm). Bruning Archaeological Museum, Lambayeque, Peru

strokes a cat or perhaps a jaguar cub. The so-called stirrup, or U-shaped spout, appears on many high-quality Moche vessels. Paintings indicate that vessels of this type were used in Moche rituals.

A central theme in Moche iconography is the sacrifice ceremony, in which prisoners captured in battle are sacrificed and several elaborately dressed figures drink their blood. Archaeologists have labeled the principal figure in the ceremony as the Warrior Priest and other important figures as the Bird Priest and the Priestess. The recent discovery of a number of spectacularly rich Moche tombs indicates that the sacrifice ceremony was an actual Moche ritual and that Moche lords assumed the roles of the principal figures. The occupant of a tomb at Sipan, on the northwest coast, was buried with the regalia of the Warrior Priest. In a tomb at the site of San José de Moro, just south of Sipan, an occupant was buried with the regalia of the Priestess.

Among the riches accompanying the Warrior Priest at Sipan was a pair of exquisite gold-and-turquoise earspools, each of which depicts three Moche warriors (fig. 12-18). The central figure is made of beaten gold and turquoise. He and his companions are adorned with tiny gold-and-turquoise earspools. They wear spectacular gold-and-turquoise headdresses topped with delicate sheets of gold that resemble the crescent-shaped knives used in sacrifices. The crests, like feathered fans of gold, would have swayed in the breeze as the wearer moved. The central figure has a crescent-shaped nose ornament and carries a gold club and shield. A necklace of owl's-head beads strung with gold thread hangs around his shoulders. Many of his anatomical features have been rendered in painstaking detail.

NORTH AMERICA Compared to the densely inhabited agricultural regions of Mesoamerica and South America, most of North America remained sparsely populated. People lived primarily by hunting, fishing, and gathering edible plants. In the Southeast and in the lands drained by the Mississippi and Missouri river system, a more settled way of life began to emerge, and by around 1000 BCE—in Louisiana as early as 2800 BCE, according to some anthropologists—nomadic hunting and gathering had given way to more settled communities (Timeline 12-2). People cultivated squash, sunflowers, and other plants to supplement their diet of game, fish, and berries. People in the American Southwest began to adopt a sedentary, agricultural life toward the end of the first millennium BCE.

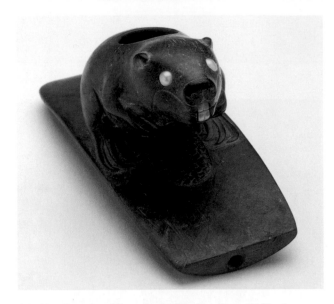

12-19. Beaver effigy platform pipe, from Bedford Mound, Pike County, Illinois. Hopewell culture, c. 100–200 CE. Pipestone, pearl, and bone, length 4¹/₂" (11.4 cm). Gilcrease Museum, Tulsa, Oklahoma

Pipes made by the Hopewell culture may have been used for smoking hallucinatory plants, perhaps during rituals involving the animal carved on the pipe bowl. The shining pearl eyes indicate association with the spirit world.

THE MOUND BUILDERS

Sometime before 1000 BCE, people living in the river valleys of the American East began building monumental earthworks, or mounds, and burying their leaders with valuable grave goods. The earliest of these earthworks, six concentric circles three-fourths of a mile across at Poverty Point in Louisiana, dates to about 1700 BCE. The contents of the burial sites indicate that the people of the Mississippi, Illinois, and Ohio river valleys traded widely with other regions. For example, the burial sites of two mound-building cultures—the Adena (c. 1100 BCE–200 CE) and the Hopewell (c. 100 BCE–500 CE)—contained elaborate and rich grave goods, including jewelry made with copper from Michigan's Upper Peninsula and silhouettes cut in sheets of mica from the Appalachian Mountains. Further evidence of extensive trade is that fine-grained pipestone and the pipes the Hopewell people created from it have been found from Lake Superior to the Gulf of Mexico. Among the items the Hopewell received in exchange for their pipestone and a flintlike stone used for toolmaking were turtle shells and sharks' teeth from Florida.

The Hopewell carved their pipes with realistic representations of forest animals and birds, sometimes with inlaid eyes and teeth of freshwater pearls and bone. In a combination of realism and aesthetic simplification that is exceptionally sophisticated, a beaver crouching on a platform forms the bowl of a pipe found in Illinois (fig. 12-19). As in a modern pipe, the bowl—a hole in the beaver's back—could be filled with dried leaves (the Hopewell may not have grown tobacco), the leaves lighted, and smoke drawn through the hole in the stem. A second way that these pipes were used was to blow smoke inhaled from another vessel through the pipe to envelop the animal carved on it.

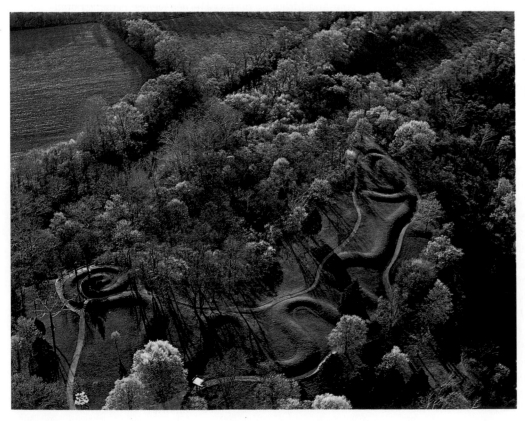

12-20. Great Serpent Mound, Adams County, Ohio. Mississippian culture, c. 1070 CE. Length approx. 1,254' (426.7 m)

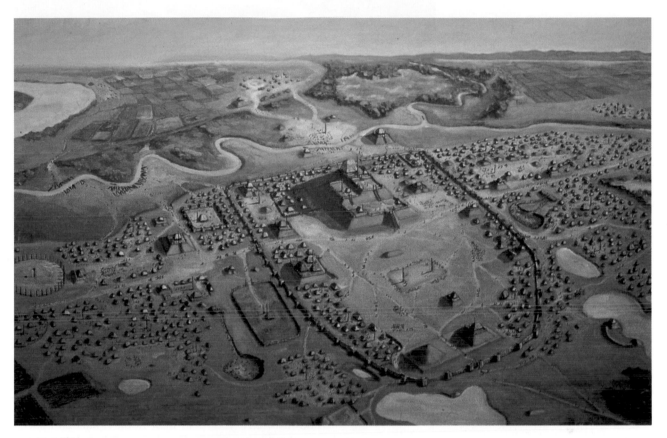

12-21. Reconstruction of central Cahokia, East St. Louis, Illinois. Mississippian culture, c. 1150 CE. East-west length approx. 3 miles (4.5 km), north-south length approx. 2¼ miles (3.6 km); base of great mound, 1,037 x 790' (316 x 241 m), height approx. 100' (30 m). Painting by William R. Iseminger

The people of the Mississippian culture (c. 900–1500 CE) continued the mound-building tradition begun by the earlier North American cultures. One of the most impressive mounds is the Great Serpent Mound in present-day Adams County, Ohio (fig. 12-20). A writhing earthen snake 1,254 feet long and 20 feet wide wriggles along the crest of a ridge overlooking a stream, with its head at the highest point. The serpent appears to open its jaws to swallow an enormous egg formed by a heap of stones. Researchers, using carbon-14 **radiometric dating**, have recently dated the mound at about 1070 CE. Perhaps the people who built it, like those who did the petroglyphs in Chaco Canyon (pages 448/449), were responding to mysterious lights in the sky, such as the Crab Nebula of 1054 or Halley's Comet in 1066.

One major site of Mississippian culture was Cahokia, 16 miles northeast of St. Louis near the juncture of the Illinois, Missouri, and Mississippi rivers (now East St. Louis, Illinois). It was an urban center of 6 square miles that at its height had a population of about 20,000 people, with another 10,000 in the surrounding countryside (figs. 12-21, 12-22). The site's most prominent feature is an enormous earth mound covering 15 acres. The location of the mound and the axis of the ceremonial center it dominated were established during the early part of the city's occupation (c. 900–1050 CE), but most construction occurred later, between about 1050 and 1200. A **stockade**, or fence, of upright wooden posts—a sign of increasing warfare—surrounded the 200-acre core. Within this barrier the principal mound rose in four stages to a height of about 100 feet. On its summit was a small, conical platform that supported a wood fence and a rectangular temple for the ancestor effigies that represented the soul of the people. In front of the principal mound lay a large, roughly rectangular plaza surrounded by smaller rectangular and conical mounds. In all, the walled enclosure contained more than 500 mounds, platforms, wooden enclosures, and houses. The various earthworks functioned as tombs and as bases for palaces and temples. A conical burial mound, for example, was located next to a platform that may have been used for sacrifices.

12-22. Cahokia

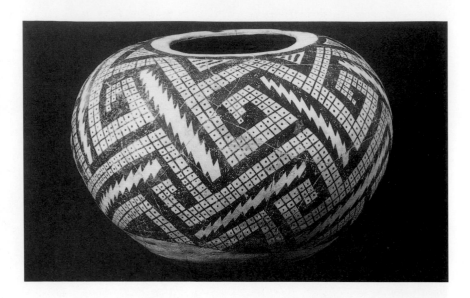

12-23. Seed jar. Anasazi culture, c. 1150 CE. Earthenware and black-and-white pigment, diameter 14¹/₂" (36.9 cm). The St. Louis Art Museum, St. Louis, Missouri

Purchase: Funds given by the Children's Art Festival 175:1981

Postholes indicate that wooden **henges** were a feature of Cahokia. The largest, with a diameter of about 420 feet (seen to the extreme left in figure 12-21), had forty-eight posts and was oriented to the cardinal points. Sight lines between a forty-ninth post set east of the center of the enclosure and points on the perimeter enabled native astronomers to determine solstices and equinoxes.

THE AMERICAN SOUTHWEST

The first farming culture emerged around 200 BCE in the arid southwestern region of what is now the United States, which became home to three major early cultures. The Mogollon culture, located in the mountains of west-central New Mexico and east-central Arizona, flourished from circa 200 CE to about 1250 CE. The Hohokam culture, concentrated in central and southern Arizona, emerged around 550 CE and endured until after about 1400 CE. The Hohokam built large-scale irrigation systems with canals that were deep and narrow to reduce evaporation and lined with clay to reduce seepage. The Hohokam shared a number of customs with their Mesoamerican neighbors to the south, including the ritual ball game.

The third southwestern culture, the Anasazi, emerged around 550 CE in the Four Corners region, where Colorado, Utah, Arizona, and New Mexico meet. The Anasazi adopted the irrigation technology of the Hohokam and began building "great houses," elaborate, multistoried, apartmentlike structures with many rooms for specialized purposes, including communal food storage. The largest known Anasazi center was in Chaco Canyon, a canyon of about 30 square miles with nine great houses. The Spanish called such communities *pueblos*, or "towns." (Descendants of the Anasazi, including the Hopi and Zuni Pueblo peoples, still occupy similar communities in the Four Corners area.)

The most extensive great house, Pueblo Bonito (see fig. 12-1), was built in stages between the tenth and mid-thirteenth centuries CE within a perimeter wall that was 1,300 feet long. Securing a steady food supply in the arid Southwest must have been a constant concern for the people of Chaco Canyon. At Pueblo Bonito the number of rooms far exceeds the evidence of human habitation, and many rooms were almost certainly devoted to food storage. It also has more than thirty **kivas**—including two that are more than 60 feet in diameter—attesting to the importance of ritual there. Kivas, with built-in platform seats around the perimeter, were a kind of ritual assembly hall where men performed important rites and instructed youths in their adult rituals and social responsibilities. The top of these circular, underground kivas became part of the floor of the communal plaza. Interlocking pine logs formed a shallow, domelike roof with a hole in the center through which only men entered the kiva by climbing down a ladder. Inside the kiva, in the floor directly under the entrance, a square hole—the "navel of the earth"—symbolized the place where the Anasazi ancestors had emerged from the earth in the mythic "first times."

Women were the potters in Anasazi society. In the eleventh century they perfected a functional, aesthetically pleasing, coil-built earthenware, or low-fired ceramic. This ceramic tradition continues today among the Pueblo peoples of the Southwest. One type of vessel, a wide-mouthed seed jar with a globular body and holes near the rim (fig. 12-23), would have been suspended from roof poles by thongs attached to the holes, out of reach of voracious rodents. The example shown here is decorated with black-and-white checkerboard and zigzag patterns. The patterns conform to the body of the jar, and in spite of their angularity, they enhance its curved shape. The intricate play of dark and light, positive and negative, suggests lightning flashing over a grid of irrigated fields.

Though no one knows for certain what happened to the Anasazi, the population of Chaco Canyon declined during severe drought in the twelfth century, and building at Pueblo Bonito ceased around 1230. Throughout the Americas for the next several hundred years, artistic traditions would continue to emerge, develop, and be transformed as the indigenous peoples of various regions interacted. The sudden incursions of Europeans, beginning in the late fifteenth century, would have dramatic and lasting impact on these civilizations and their art.

CULTURE	ART OF THE AMERICAS BEFORE 1300	ART IN OTHER CULTURES
OLMEC c. 1200–400 BCE	12-2. **Great Pyramid, La Venta** (c. 900–600 BCE) 12-3. **Colossal head** (c. 900 BCE)	5-4. *Centaur* (10th cent. BCE), Greece 2-1. *Lamassu* (883–859 BCE), Assyria
PARACAS c. 1000 BCE–200 CE	12-15. **Mantle** (c. 50–100 CE)	13-3. *Nok head* (c. 500 BCE–200 CE), Africa
NAZCA c. 200 BCE–600 CE	12-16. **Earth hummingbird** (c. 200 BCE–200 CE)	5-74. *Gallic Chieftain Killing His Wife and Himself* (c. 220 BCE), Greece 9-8. **Great Stupa**, Sanchi (3rd cent. BCE), India
MOCHE c. 200 BCE–600 CE	12-17. *Moche Lord with a Feline* (c. 100 BCE–500 CE) 12-18. **Earspool** (c. 300 CE)	7-3. *Good Shepherd Orants, and Story of Jonah* (4th cent. CE), Italy 9-17. **Bodhisattva**, Ajanta (c. 475 CE), India
HOPEWELL c. 100 BCE–500 CE	12-19. **Beaver effigy platform pipe** (c. 100–200 CE)	6-34. **Pantheon** (125–28 CE), Italy 7-9. **Old St. Peter's** (c. 320–27 CE), Italy
TEOTIHUACAN c. 1–750 CE	12-6. **Feathered Serpent temple** (after 350 CE) 12-4. **City of Teotihuacan** (c. 500 CE) 12-7. *Maguey Bloodletting Ritual* (600–750 CE)	6-49. **Timgad** (begun c. 100 CE), Algeria 11-4. *Haniwa* (6th cent. CE), Japan
MAYA c. 350 BCE–900 CE	12-12. **Cylindrical vessel** (600–900 CE) 12-10. **Lord Pacal sarcophagus** (c. 683 CE) 12-8. **Temple I, Tikal** (c. 700 CE)	7-22. **Hagia Sophia** (532–37 CE), Turkey 8-2. **Dome of the Rock** (687–91 CE), Jerusalem
ANASAZI c. 550–1400 CE	12-1. **Pueblo Bonito, Chaco Canyon** (c. 900–1230 CE) 12-23. **Seed jar** (c. 1150 CE)	8-6. **Córdoba mosque** (begun 785–86 CE), Spain 14-17. *Utrecht Psalter* (c. 825–50), Netherlands 8-8. **Kufic bowl** (9th–10th cent. CE), Uzbekistan
DIQUIS c. 700–1500 CE	12-14. *Shaman with Drum and Snake* (c. 1000 CE)	15-32. *Bayeux Tapestry* (c. 1066–77 CE), France
ITZA c. 9th–13th century CE	12-13. **Chichen Itza plaza** (9th–13th cent. CE)	10-19. Fan. *Travelers among Mountains and Streams* (early 11th cent.), China
MISSISSIPPIAN c. 900–1500 CE	12-20. **Great Serpent Mound, Adams County** (c. 1070 CE) 12-21. **Cahokia** (c. 1150 CE)	7-39. **Cathedral of St. Mark** (begun 1063 CE), Italy

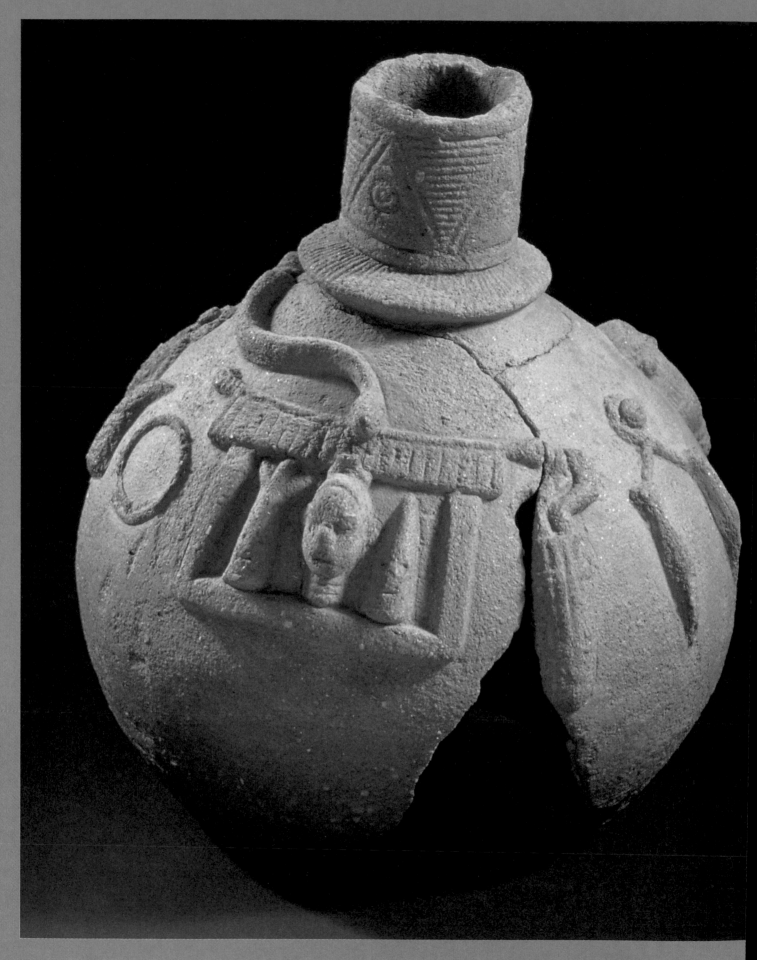

13-1. Ritual vessel, from Ife. Yoruba, 13–14th century. Terra-
cotta, height 9¹³/₁₆" (24.9 cm). University Art Museum,
Obafemi, Awolowo University, Ife, Nigeria

13
Art of Ancient Africa

The Yoruba people of southwestern Nigeria have traditionally regarded the city of Ife (also known as Ife-Ife) as the "navel of the world," the site of creation, the place where kingship originated when Ife's first ruler, the *oni* Oduduwa, came down from heaven to create earth and then to populate it. By the eleventh century CE, Ife was a lively metropolis and cultural center; today, every one of the many Yoruba cities claims "descent" from Ife.

Ancient Ife was essentially circular, with the *oni*'s palace at the center. Ringed by protective stone walls and moats, Ife was connected to other Yoruba cities by roads that radiated from the center and pierced the city walls at elaborate fortified gateways partially decorated with pavement mosaics created from stones and pottery shards. From these elaborately patterned pavement mosaics, which covered much of Ife's open spaces, came the name for Ife's most artistically cohesive centuries (c. 1000–1400 CE), the Pavement period.

Just as the *oni*'s palace was in a large courtyard in center of Ife, so too were ritual spaces elsewhere in Ife located in paved courtyards with altars. In the center of such a semicircular courtyard, outlined by half-rings of pavement mosaic, archaeologists excavated an exceptional terra-cotta vessel from Ife's Pavement period (fig. 13-1). The jar's bottom had been ritually broken before it was buried, so that liquid offerings (libations) poured into the neck opening would flow into the earth. The objects so elegantly depicted in high relief on the surface of the vessel include what looks like an altar table with three heads under it, the outer two quite abstract and the middle one **naturalistic** in the tradition of freestanding Yoruba portrait heads (see fig. 13-5). The abstraction of the two outside heads may well have been a way of honoring or blessing the central portrait, a practice that survives today among the Yoruba royalty.

TIMELINE 13-1. Art of Ancient Africa. Although most art created in impermanent materials such as wood has been lost, ancient African monuments in stone, terra-cotta, and brass can be found in existing cultural centers.

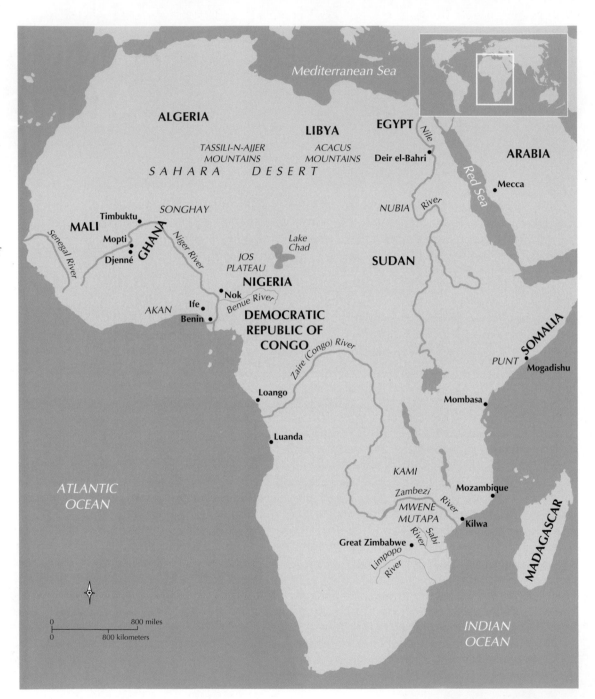

MAP 13-1.

Ancient Africa.
Nearly 5,000 miles from north to south, Africa is the second-largest continent and was the home of some of the earliest and most advanced cultures of the ancient world.

THE LURE OF ANCIENT AFRICA

"I descended [the Nile] with three hundred asses laden with incense, ebony, grain, panthers, ivory, and every good product." Thus the Egyptian envoy Harkhuf described his return from Nubia, the African land to the south of Egypt, in 2300 BCE. The riches of Africa attracted merchants and envoys in ancient times, and trade brought the continent in contact with the rest of the world. Egyptian relations with the rest of the African continent continued through the Hellenistic era and beyond. Phoenicians and Greeks founded dozens of settlements along the Mediterranean coast of North Africa between 1000 and 300 BCE to extend trade routes across the Sahara to the

| 500 BCE | 200 CE | 800 CE 1000 CE | 2000 CE |

▲ c. 500 BCE–200 CE NOK ▲ c. 200 CE–PRESENT DJENNÉ ▲ c. 1000–1500 CE GREAT ZIMBABWE
▲ c. 800 CE–PRESENT IFE
▲ c. 1170 CE–PRESENT BENIN

peoples of Lake Chad and the bend of the Niger River (Map 13-1). When the Romans took control of North Africa, they continued this lucrative trans-Saharan trade. In the seventh and eighth centuries CE, the expanding empire of Islam swept across North Africa, and thereafter Islamic merchants were regular visitors to Bilad al-Sudan, the Land of the Blacks (sub-Saharan Africa). Islamic scholars chronicled the great West African empires of Ghana, Mali, and Songhay, and West African gold financed the flowering of Islamic culture.

East Africa, meanwhile, had been drawn since at least the beginning of the Common Era into the maritime trade that ringed the Indian Ocean and extended east to Indonesia and the South China Sea. Arab, Indian, and Persian ships plied the coastline. A new language, Swahili, evolved from centuries of contact between Arabic-speaking merchants and Bantu-speaking Africans, and great port cities such as Mozambique, Kilwa, Mombasa, and Mogadishu arose.

In the fifteenth century, Europeans—whose hostile relations with Islam had cut them off from Africa for centuries—ventured by ship into the Atlantic Ocean and down the coast of Africa. Finally rediscovering the continent at first hand, they were often astonished by what they found (see "The Myth of 'Primitive' Art," below). "Dear King My Brother," wrote a fifteenth-century Portuguese king to his new trading partner, the king of Benin in West Africa. The Portuguese king's respect was well founded—Benin was vastly more powerful and more wealthy than the small European country that had just stumbled upon it.

As we saw in Chapter 3, Africa was home to one of the world's earliest great civilizations, that of ancient Egypt, and as we saw in Chapter 8, Egypt and the rest of North Africa contributed prominently to the development of Islamic art and culture. This chapter examines the artistic legacy of the rest of ancient Africa, beginning with the early peoples of the Sahara, then turning to other early civilizations (Timeline 13-1).

SAHARAN ROCK ART

Like the Paleolithic inhabitants of Europe, early Africans painted and inscribed an abundance of images on the walls of the caves and rock shelters in which they sought refuge. Rock art has been found all over Africa, in sites ranging from small, isolated shelters to great, cavernous formations. The mountains of the central Sahara—principally the Tassili-n-Ajjer range in the south of present-day Algeria and the Acacus Mountains in present-day Libya—contain images that span a period of thousands of years. They record not only the artistic and cultural development of the peoples who lived in the region, but also the transformation of the Sahara from the fertile grassland it once was to the vast desert we know today.

The earliest images of Saharan rock art are thought to date from at least 8000 BCE, during the transition into a geological period known as the Makalian Wet Phase. At that time the Sahara was a grassy plain, perhaps much like the game-park areas of modern East Africa. Vivid images of hippopotamus, elephant, giraffe, antelope, and other animals incised into rock surfaces testify to the abundant wildlife that roamed the region. Like the cave paintings in Altamira and Lascaux (Chapter 1), these images may have been intended to ensure plentiful game or a successful hunt, or they may have been symbolic of other life-enhancing activities, such as healing or rainmaking.

By 4000 BCE the climate had become more arid, and hunting had given way to herding as the primary life-sustaining activity of the Sahara's inhabitants. Among the most beautiful and complex examples of Saharan rock art created in this period are scenes of sheep, goats,

THE MYTH OF "PRIMITIVE" ART The word *primitive* was once used by Western art historians to categorize the art of Africa, the art of the Pacific islands, and the indigenous art of the Americas. The term itself means "early," and its very use implies that these civilizations are frozen at an early stage of development, rather than that their cultures have developed along different paths than those of Europe.

The origins of such a label, as well as many historical attitudes, lay with early Christian missionaries, who long described the peoples among whom they worked as "heathen," "barbaric," "ignorant," "tribal," "primitive," and other terms rooted in racism and colonialism. Such usages were extended to these peoples' creations, and "primitive art" became the dominant label for their cultural products.

Criteria that have been used to label a people "primitive" include the use of so-called Stone Age technology, the absence of written histories, and the failure to build great cities. Therefore, the accomplishments of the peoples of Africa, to take just one example, strongly belie this categorization: Africans south of the Sahara have smelted and forged iron since at least 500 BCE, and Africans in many areas made and used high-quality steel for weapons and tools. Many African peoples have recorded their histories in Arabic since at least the tenth century CE. The first European visitors to Africa admired the politically and socially sophisticated urban centers of Benin and Luanda, to name only two of the continent's great cities. Clearly, neither the cultures of ancient Africa nor the art works they produced were "primitive" at all.

13-2. *Cattle Being Tended*, section of rock-wall painting, Tassili-n-Ajjer, Algeria. c. 2500–1500 BCE

and cattle and of the daily lives of the people who tended them. One such scene, *Cattle Being Tended*, was found at Tassili-n-Ajjer and probably dates from late in the herding period, about 2500–1500 BCE (fig. 13-2). Men and women are gathered in front of their round, thatched houses, the men tending cattle, the women preparing a meal and caring for children. A large herd of cattle, many of them tethered to a long rope, has been driven in from pasture. The cattle shown are quite varied. Some are mottled, while others are white, red, or black. Some have short, thick horns, while others have graceful, lyreshaped horns. The overlapping forms and the confident placement of near figures low and distant figures high in the picture create a sense of depth and distance.

By 2500–2000 BCE the Sahara was drying and the great game had gone, but other animals were introduced that appear in the rock art. The horse was brought from Egypt by about 1500 BCE and is seen regularly in rock art over the ensuing millennia. The fifth-century BCE Greek historian Herodotus described a chariot-driving people called the Garamante, whose kingdom corresponded roughly to present-day Libya. Rock-art images of horse-drawn chariots bear out his account. Around 600 BCE the camel was introduced into the region from the east, and images of camels were painted on and incised into the rock.

The desiccation of the Sahara coincides with the rise of Egyptian civilization along the Nile Valley to the east.

Similarities have been noted between Egyptian and Saharan motifs, among them images of rams with what appear to be disks between their horns. These similarities have been viewed as evidence of Egyptian influence on the less-developed regions of the Sahara. Yet in light of the great age of Saharan rock art, it seems just as plausible that influence flowed the other way, carried by people who had migrated into the Nile Valley in search of arable land and pasture when the grasslands of the Sahara disappeared.

SUB-SAHARAN CIVILIZATIONS Saharan peoples presumably migrated southward as well, into the Sudan, the broad belt of grassland that stretches across Africa south of the Sahara desert. They brought with them knowledge of settled agriculture and animal husbandry. The earliest evidence of settled agriculture in the Sudan dates from about 3000 BCE. Toward the middle of the first millennium BCE, at the same time that iron technology was being developed elsewhere in Africa, knowledge of ironworking spread across the Sudan, enabling its inhabitants to create more efficient weapons and farming tools. In the wake of these developments, larger and more complex societies emerged, especially in the fertile basins of Lake Chad in the central Sudan and the Niger and Senegal rivers to the west.

13-3. Head. Nok,
c. 500 BCE–200 CE.
Terra-cotta, height
14³⁄₁₆" (36 cm).
National Museum,
Lagos, Nigeria

NOK

Some of the earliest evidence of iron technology in sub-Saharan Africa comes from the so-called Nok culture, which arose in the western Sudan, in present-day Nigeria, as early as 500 BCE. The Nok people were farmers who grew grain and oil-bearing seeds, but they were also smelters with the technology for refining ore. Slag and the remains of furnaces have been discovered, along with clay nozzles from the bellows used to fan the fires. The Nok people created the earliest known sculpture of sub-Saharan Africa, producing accomplished terra-cotta figures of human and animal subjects between about 500 BCE and 200 CE.

Nok sculpture was discovered in modern times by tin miners digging in the alluvial deposits on the Jos plateau north of the confluence of the Niger and Benue rivers. Presumably, floods from centuries past had removed the figures from their original contexts, dragged and rolled them along, then redeposited them. This rough treatment scratched and broke many, often leaving only the heads from what must have been complete human figures. Following archaeological convention, scholars gave the name of a nearby village, Nok, to the culture that created these works. Nok-style works of sculpture have since been found in numerous sites over a wide area.

The Nok head shown here (fig. 13-3), slightly larger than lifesize, probably formed part of a complete figure. The triangular or **D**-shaped eyes are characteristic of Nok style and appear also on sculpture of animals. Holes in the pupils, nostrils, and mouth allowed air to pass freely as the figure was fired. Each of the large buns of its elaborate hairstyle is pierced with a hole that may have held ornamental feathers. Other Nok figures boast large quantities of beads and other prestige ornaments. Nok sculpture may represent ordinary people dressed up for a special occasion or may portray people of high status, providing evidence of social stratification in this early farming culture. At the very least, the sculpture provides evidence of considerable technical accomplishment. The skill and artistry it reflects have led many scholars to speculate that Nok culture was built on the achievements of an earlier culture still to be discovered.

IFE

Following the disappearance of the Nok culture, the region of present-day Nigeria remained a vigorous cultural and artistic center. The naturalistic works of sculpture created by the artists of the city of Ife, which arose in the southern, forested part of that region by about 800 CE, are among the most remarkable in art history (see "Who Made African Art?," page 477).

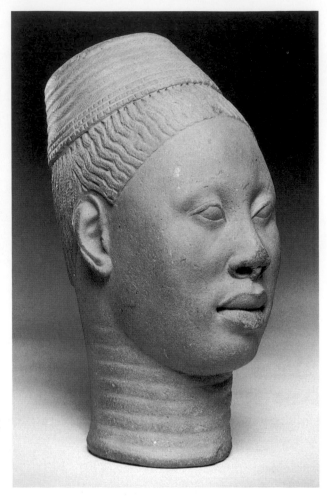

13-4. Head of a king, from Ife. Yoruba, c. 13th century CE. Zinc brass, height 11⁷/₁₆" (29 cm). Museum of Ife Antiquities, Ife, Nigeria

The naturalism of Ife sculpture contradicted everything Europeans thought they knew about African art. The German scholar who "discovered" Ife sculpture in 1910 suggested that it had been created not by Africans but by survivors from the legendary lost island of Atlantis. Later scholars speculated that influence from ancient Greece or Renaissance Europe must have reached Ife. Scientific dating methods, however, finally put such misleading comparisons and prejudices to rest. When naturalism flowered in Ife, the ancient Mediterranean world was long gone and the European Renaissance still to come. In addition, the proportions of the few known full figures are characteristically African, with the head comprising as much as one-quarter of the total height. These proportions probably reflect a belief in the head's importance as the abode of the spirit and the focus of individual identity.

Ife was, and remains, the sacred city of the Yoruba people. A tradition of naturalistic sculpture began there about 1050 CE and flourished for some four centuries. Although the line of Ife kings, or *oni*s, continues unbroken from that time to the present, the knowledge of how these works were used has been lost. When archaeologists showed the sculpture to members of the contemporary *oni*'s court, however, they identified symbols of kingship that had been worn within living memory, indicating that the figures represent rulers.

A lifesize head (fig. 13-4) shows the extraordinary artistry of ancient Ife. The modeling of the flesh is

13-5. Head said to represent the Usurper Lajuwa, from Ife. Yoruba, c. 1200–1300 CE. Terra-cotta, height 12¹⁵/₁₆" (32.8 cm). Museum of Ife Antiquities, Ife, Nigeria

supremely sensitive, especially the subtle transitions around the nose and mouth. The lips are full and delicate, and the eyes are strikingly similar in shape to those of some modern Yoruba. The face is covered with thin, parallel **scarification** patterns (decorations made by scarring). The head was cast of zinc brass using the **lost-wax** technique (see "Lost-Wax Casting," page TK).

Holes along the scalp apparently permitted a crown or perhaps a beaded veil to be attached. Large holes around the base of the neck may have allowed the head itself to be attached to a wooden mannequin for display during memorial services for a deceased *oni*. The mannequin was probably dressed in the *oni*'s robes; the head probably bore his crown. The head could also have been used to display a crown during annual purification and renewal rites.

The artists of ancient Ife also worked in terra-cotta. Unlike their brass counterparts, terra-cotta heads are not fitted for attachments. They were probably placed in shrines devoted to the memory of each dead king. Two of the most famous Ife sculptures were not found by archaeologists but had been preserved through the centuries in the *oni*'s palace. One, a terra-cotta head, is said to represent Lajuwa, a court retainer who usurped the throne by intrigue and impersonation (fig. 13-5). The other, a lifesize copper mask, is said to represent Obalufon, the ruler who introduced bronze casting.

Scholars continue to debate whether the Ife heads are true portraits. Their striking anatomical individuality strongly suggests that they are. The heads, however, all seem to represent men of the same age and seem to embody a similar concept of physical perfection, suggesting that they are **idealized** images. In the recent past, Africans did not produce naturalistic portraits, fearing that they could house malevolent spirits that would harm the soul of the subject. If the Ife heads are portraits, then perhaps the institution of kingship and the need to revere royal ancestors were strong enough to overcome such concerns.

BENIN

Ife was probably the artistic parent of the great city-state of Benin, which arose some 150 miles to the southeast. According to oral histories, the earliest kings of Benin belonged to the Ogiso, or Skyking, dynasty. After a long period of misrule, however, the people of Benin asked the *oni* of Ife for a new ruler. The *oni* sent Prince Oranmiyan, who founded a new dynasty in 1170 CE . Some two centuries later, the fourth king, or *oba*, of Benin decided to start a tradition of memorial sculpture like that of Ife, and he sent to Ife for a master metal caster named Iguegha. The tradition of casting memorial heads for the shrines of royal ancestors endures among the successors of Oranmiyan to this day (fig. 13-6).

Benin came into contact with Portugal in the late fifteenth century CE. The two kingdoms established cordial relations in 1485 and carried on an active trade, at first in ivory and other forest products but eventually in slaves. Benin flourished until 1897, when, in reprisal for the massacre of a party of trade negotiators, British troops sacked and burned the royal palace, sending the *oba* into an exile from which he did not return until 1914. The palace was later rebuilt, and the present-day *oba* continues the dynasty started by Oranmiyan.

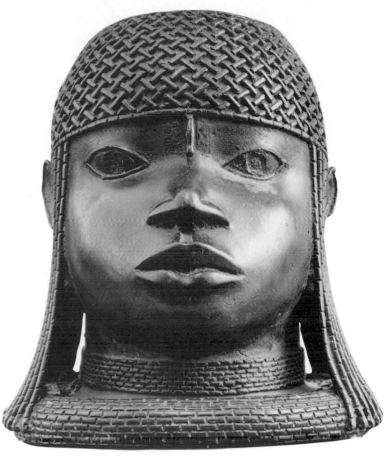

13-6. Memorial head Benin Early Period, c. 1400–1550 CE. Brass, height 9³/₈" (23.4 cm). The Metropolitan Museum of Art, New York

The Michael C. Rockefeller Memorial Collection, Bequest of Nelson A. Rockefeller, 1979 (1979.206.86)

WHO MADE AFRICAN ART? On label after label identifying African art works exhibited in museums, a standard piece of information is missing. Where are the artists' names? Who made this art?

Until quite recently, Westerners tended to see Africa as a single country and not as an immense continent of vastly diverse cultures. Moreover, they perceived artists working in Africa as obedient craftsworkers, bound to styles and images dictated by village elders and producing art that was anonymous and interchangeable.

Over the past several decades, however, these misconceptions have begun to crumble. One of the first non-Africans to understand that African art, as much as European art,

was the work of identifiable artists was the Belgian art historian Frans Olbrechts. During the 1930s, while assembling a group of objects from the present-day Democratic Republic of the Congo for an exhibition, Olbrechts noticed that as many as ten figures had been carved in a very distinctive style. A look at the labels revealed that two of the statues had been collected in the same town, Buli, in eastern Congo. Accordingly, Olbrechts named the unknown African artist the Master of Buli. In the late 1970s, the owners of an object in the style of the Master of Buli identified the artist as Ngongo ya Chintu, of Kateba village. Kateba villagers in turn remembered Ngongo ya Chintu as an artist of great skill.

The story of Ngongo ya Chintu showed clearly that African artists did not work anonymously and that Africans were fully aware of the names of their artists.

Art historians and anthropologists have now identified numerous African artists and compiled catalogs of their work. Certainly we will never know the names of the vast majority of African artists of the past, just as we do not know the names of the sculptors responsible for the portrait busts of ancient Rome or the monumental reliefs of the Hindu temples of South Asia. But, as elsewhere, the greatest artists in Africa were famous and sought after, while innumerable others labored honorably and not at all anonymously.

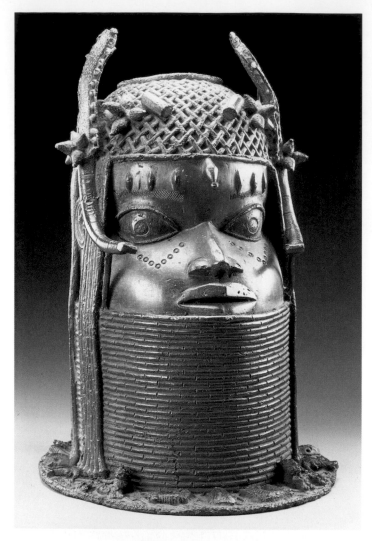

13-7. Head of an *oba* (king). Benin Late Period, c. 1700–1897 CE. Brass, height 17¼" (43.8 cm). Museum für Völkerkunde, Vienna/Musée Dapper, Paris

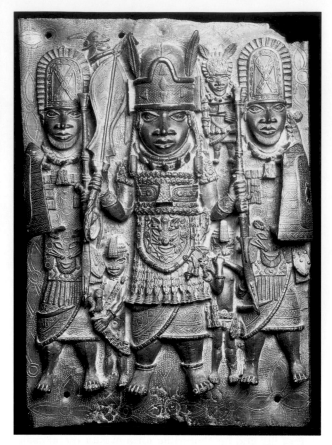

13-8. *General and Officers*. Benin Middle Period, c. 1550–1650 CE. Brass, height 21" (53.5 cm). National Museum, Lagos, Nigeria

The general wears an elaborate appliqué apron depicting the head of a leopard, and the flanking officers wear leopard pelts. Leopards were symbols of royalty in Benin. Live leopards were kept at the royal palace, where they were looked after by a special keeper. Water pitchers in the form of leopards were cast in bronze and placed on altars dedicated to ancestors. An engraving from a European travel book of the sixteenth century depicts a procession of courtiers in Benin led by a pair of magnificent leopards.

The British invaders discovered shrines to deceased *obas* filled with brass heads, bells, and figures. They also found wooden rattles and enormous ivory tusks carved with images of kings, court attendants, and sixteenth-century Portuguese soldiers. The British appropriated the treasure as war booty, making no effort to note which head came from which shrine, thus destroying evidence that would have helped establish the relative age of the heads and determine a chronology for the evolution of Benin style. Nevertheless, scholars have managed to piece together a chronology from other evidence.

Benin brass heads range from small, thinly cast, and naturalistic to large, thickly cast, and highly stylized. The heads that were being made at the time of the British invasion are of the latter variety, as are those being cast today. Many scholars have concluded that the smallest, most naturalistic heads were created during a so-called Early Period (1400–1550 CE), when Benin artists were still heavily influenced by Ife (see fig. 13-6). Heads grew increasingly stylized during the Middle Period (1550–1700 CE). Heads from the ensuing Late Period (1700–1897 CE) are very large and heavy, with angular, stylized features and an elaborate beaded crown (fig. 13-7). A similar crown is still worn by the present-day *oba*. One of the honorifics used for the king is "Great Head": The head leads the

body as the king leads the people. The Benin heads must be visualized on a semicircular platform—an altar to royal heads—surmounted by a large elephant tusk, another symbol of power.

All of the heads include representations of coral-bead necklaces, which formed part of the royal costume. Small and few in number on Early Period heads, the strands of beads increase in number until they conceal the chin during the Middle Period. During the Late Period, the necklaces form a tall, cylindrical mass that greatly increases the weight of the sculpture. Broad, horizontal flanges, or projecting edges, bearing small images cast in low relief ring the base of the Late Period statues, adding still more weight. The increase in size and weight of Benin memorial heads over time may reflect the growing power and wealth flowing to the *oba* from Benin's expanding trade with Europe.

The art of Benin is a royal art, for only the *oba* could commission works in brass. Artisans who served the court lived in a separate quarter of the city and were organized into guilds. Among the most remarkable visual records of

court life are the hundreds of brass plaques, each about 2 feet square, that once decorated the walls and columns of the royal palace. Produced during the Middle Period, the plaques are modeled in relief, sometimes in such high relief that the figures are almost freestanding. An exceptionally detailed plaque (fig. 13-8) shows a general in elaborate military dress holding a spear in one hand and a ceremonial sword in the other. Flanking the general, two officers, whose helmets indicate their rank, brandish spears and shields. Smaller figures appear between the three principal figures, one carrying a sword, another sounding a horn. Above the tip of the general's sword is a small figure of a Portuguese soldier.

Obas also commissioned important works in ivory. One example is a beautiful ornamental mask (fig. 13-9) that represents an *iyoba*, or queen mother. The woman who had borne the previous *oba*'s first male child (and thus the mother of the current *oba*), the *iyoba* ranked as the senior female member of the court. This mask may represent Idia, the first and best-known *iyoba*. Idia was the mother of Esigie, who ruled as *oba* from 1504 to 1550 CE. She is particularly remembered for raising an army and using her magical powers to help her son defeat his enemies.

The mask was carved as a belt ornament and was worn at the *oba*'s waist with an ivory leopard's head and several other plaques. Its pupils were originally inlaid with iron, as were the scarification patterns on the forehead. The necklace represents heads of Portuguese soldiers with beards and flowing hair. Like Idia, the Portuguese helped Esigie expand his kingdom. In the crown, more Portuguese heads alternate with figures of mudfish, which in Benin iconography symbolized Olokun, the Lord of the Great Waters. Mudfish live on the riverbank, mediating between water and land, just as the *oba*, who is viewed as semidivine, mediates between the human world and the supernatural world of Olokun.

<table>
<tr><td>OTHER
URBAN
CENTERS</td><td>Ife and Benin were but two of the many cities that arose in ancient Africa. The first European visitors to the West African coast at the end of the fifteenth</td></tr>
</table>

century were impressed not only by Benin, but also by the cities of Loango and Luanda near the mouth of the Zaire River. Exploring the East African coastline, European ships happened on cosmopolitan cities that had been busily carrying on long-distance trade across the Indian Ocean and as far away as China and Indonesia for hundreds of years.

Important centers also arose in the interior, especially across the central and western Sudan. There, cities and the states that developed around them grew wealthy from the trans-Saharan trade that had linked West Africa to the Mediterranean from at least the first millennium BCE. Indeed, the routes across the desert were probably as old as the desert itself. Among the most significant goods exchanged in this trade were salt from the north and gold from West Africa. Such fabled cities as Mopti, Timbuktu, and Djenné were great centers of commerce, where merchants from all over West Africa met caravans arriving from the Mediterranean.

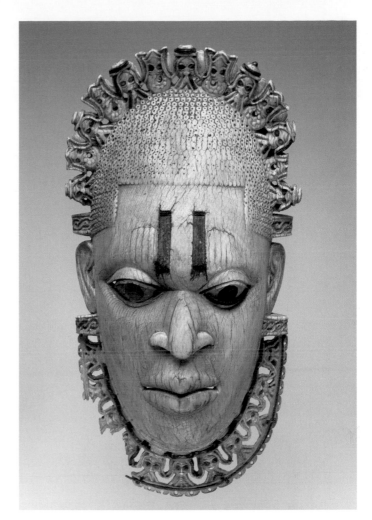

13-9. Mask representing an *iyoba* (queen mother). Benin Middle Period, c. 1550 CE. Ivory, iron, and copper, height 9³⁄₈" (23.4 cm). The Metropolitan Museum of Art, New York The Michael C. Rockefeller Memorial Collection, Gift of Nelson A. Rockefeller, 1972 (1978.412.323)

DJENNÉ

In 1655, the Islamic writer al-Sadi wrote this description of Djenné:

> This city is large, flourishing, and prosperous; it is rich, blessed, and favoured by the Almighty. . . . Jenne [Djenné] is one of the great markets of the Muslim world. There one meets the salt merchants from the mines of Teghaza and merchants carrying gold from the mines of Bitou. . . . Because of this blessed city, caravans flock to Timbuktu from all points of the horizon. . . . The area around Jenne is fertile and well populated; with numerous markets held there on all the days of the week. It is certain that it contains 7,077 villages very near to one another.
>
> (Translated by Graham Connah in Connah, page 97)

By the time al-Sadi wrote his account, Djenné, in present-day Mali, already had a long history. Archaeologists have determined that the city was established by the third century CE and that by the middle of the ninth century it had become a major urban center. Also by the ninth century,

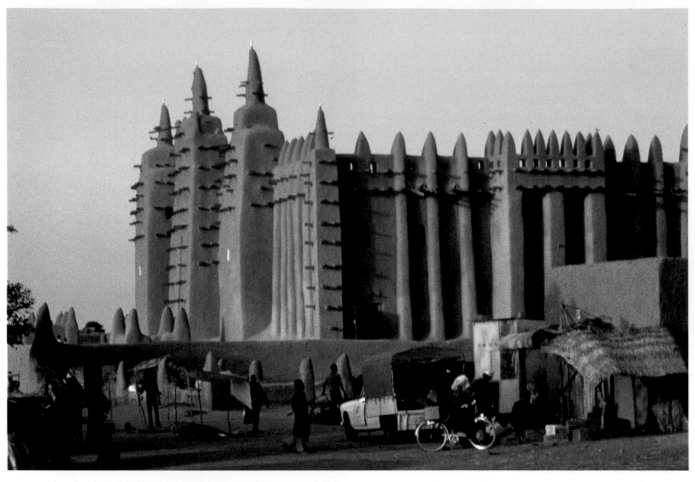

13-10. Great Friday Mosque, Djenné, Mali, showing the eastern and northern facades. Rebuilding of 1907, in the style of 13th-century original

The plan of the mosque is quite irregular. Instead of a rectangle, the building forms a parallelogram. Inside, nine long rows of heavy adobe columns some 33 feet tall run along the north-south axis, supporting a flat ceiling of palm logs. A pointed arch links each column to the next in its row, thereby forming nine east-west archways facing the *mihrab*, the niche that indicates the direction of Mecca. The mosque is augmented by an open courtyard for prayer on the west side, which is enclosed by a great double wall only slightly lower than the walls of the mosque itself.

Islam was becoming an economic and religious force in West Africa, North Africa and the northern terminals of the trans-Saharan trade routes having already been incorporated into the Islamic Empire. Much of what we know about African history from this time on is based on the accounts of Islamic scholars, geographers, and travelers.

When Koi Konboro, the twenty-sixth king of Djenné, converted to Islam in the thirteenth century, he transformed his palace into the first of three successive **mosques** in the city. Like the two that followed, the first mosque was built of **adobe** brick, a sun-dried mixture of clay and straw. With its great surrounding wall and tall towers, it was said to have been more beautiful and more lavishly decorated than the Kaaba, the central shrine of Islam, at Mecca. The mosque eventually attracted the attention of austere Muslim rulers, who objected to its sumptuous furnishings. Among these was the early-nineteenth-century ruler Sekou Amadou, who had it razed and a far more humble structure erected on a new site. This second mosque was in turn replaced by the current grand mosque, constructed between 1906 and 1907 on the ancient site and in the style of the original. The reconstruction was supervised by the architect Ismaila Traoré, the head of the Djenné guild of masons.

The mosque's eastern, or "marketplace," facade boasts three tall towers (fig. 13-10). The **finials**, or crowning ornaments, at the top of each tower bear ostrich eggs, symbols of fertility and purity. The facade and sides of the mosque are distinguished by tall, narrow, engaged columns, which act as buttresses. These columns are characteristic of West African mosque architecture, and their cumulative rhythmic effect is one of great verticality and grandeur. The most unusual features of West African mosques are the **torons**, wooden beams projecting from the walls. *Torons* provide permanent supports for the scaffolding erected each year so that the exterior of the mosque can be replastered.

GREAT ZIMBABWE

Thousands of miles from Djenné, in southeastern Africa, an extensive trade network developed along the Zambezi, Limpopo, and Sabi rivers. Its purpose was to funnel gold, ivory, and exotic skins to the coastal trading towns that had been built by Arabs and Swahili-speaking Africans. There, the gold and ivory were exchanged for prestige goods, including porcelain, beads, and other manufactured items. Between 1000 and 1500 CE, this trade was largely controlled from a site that was called Great Zimbabwe, home of the Shona people.

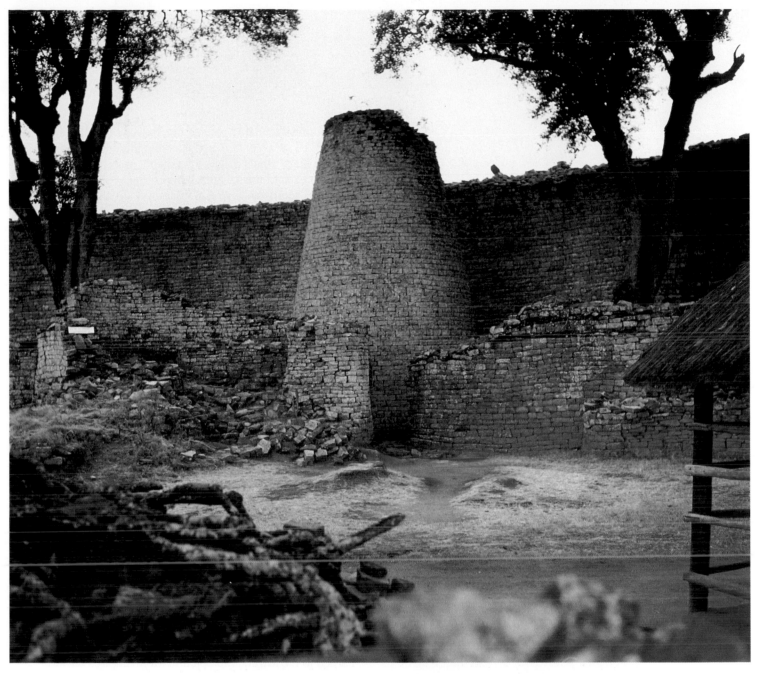

13-11. Conical Tower, Great Zimbabwe. c. 1350–1450 CE. Height of tower 30' (9.1 m)

The word *zimbabwe* derives from the Shona term for "venerated houses" or "houses of stone." Scholars agree that the stone buildings at Great Zimbabwe were constructed by ancestors of the present-day people in this region. The earliest construction at the site took advantage of the enormous boulders abundant in the vicinity. Masons incorporated the boulders and used the uniform granite blocks that split naturally from them to build a series of tall enclosing walls high on a hilltop. Each enclosure defined a family's living or ritual space and housed dwellings made of adobe with conical, thatched roofs.

The largest building complex at Great Zimbabwe is located in a broad valley below the hilltop enclosures. Known as Imba Huru, the Big House, the complex is ringed by a masonry wall more than 800 feet long, 32 feet tall, and 17 feet thick at the base. The buildings at Great Zimbabwe were built without mortar; for stability the walls are **battered**, or built so that they slope inward toward the top. Inside the great outer wall are numerous smaller stone enclosures and adobe foundations.

The complex seems to have evolved with very little planning. Additions and extensions were begun as labor and materials were available and need dictated. Over the centuries, the builders grew more skillful, and the later additions are distinguished by **dressed stones**, or smoothly finished stones, laid in fine, even, level **courses**. One of these later additions is a fascinating structure known simply as the Conical Tower (fig. 13-11). Some 18 feet in diameter and 30 feet tall, the tower was originally capped with three courses of ornamental stonework. It may have represented the good harvest and prosperity believed to result from allegiance to the ruler of Great Zimbabwe, for it resembles a present-day Shona granary built large.

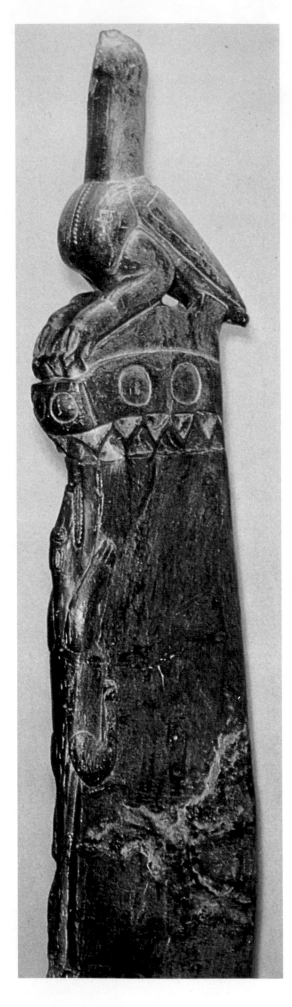

13-12. Bird, top part of a monolith, from Great Zimbabwe. c. 1200–1400 CE. Soapstone, height of bird 14¹⁄₂" (36.8 cm); height of monolith 5'4¹⁄₂" (1.64 m). Great Zimbabwe Site Museum, Zimbabwe

Among the many interesting finds at Great Zimbabwe is a series of carved soapstone birds (fig. 13-12). The carvings, which originally crowned tall **monoliths**, seem to depict birds of prey, perhaps eagles. They may, however, represent mythical creatures, for the species cannot be identified. Traditional Shona beliefs include an eagle called *shiri ye denga*, or "bird of heaven," who brings lightning, a metaphor for communication between the heavens and earth. These soapstone birds may have represented such messengers from the spirit world. Recently, the birds and the crocodiles also found decorating such monoliths have been identified as symbols of royalty, expressing the king's power to mediate between his subjects and the supernatural world of spirits.

Although some of the enclosures at Great Zimbabwe were built on hilltops, there is no evidence that they were constructed as fortresses. There are neither openings for weapons to be thrust through nor battlements for warriors to stand on. Instead, the walls and structures seem intended to reflect the wealth and power of the city's rulers. The Big House was probably a royal residence, or palace complex, and other structures housed members of the ruler's family and court. The complex formed the nucleus of a city that radiated for almost a mile in all directions. It is estimated that at the height of its power, in the fourteenth century CE, Great Zimbabwe and its surrounding city housed a population of more than 10,000 people. A large cache of goods containing items of such far-flung origin as Portuguese medallions, Persian pottery, and Chinese porcelain testify to the extent of its trade. Yet beginning in the mid-fifteenth century Great Zimbabwe was gradually abandoned. Its power and control of the lucrative southeast African trade network passed to the Mwene Mutapa and Kami empires a short distance away.

During the twentieth century, the sculpture of traditional African societies—wood carvings of astonishing formal inventiveness and power—have found admirers the world over, becoming virtually synonymous with "African art." Admiration for these art forms was evident in earlier periods as well. In the mid-seventeenth century, for example, a German merchant named Christopher Weickman collected a Yoruba divination board, textiles from the Congo, and swords with nubbly ray-skin sheaths from the Akan, all of which are now housed in a museum in Ulm, Germany. Wood decays rapidly, however, and little of African wood sculpture remains from before the nineteenth century. As a result, much of ancient Africa's artistic heritage has probably been as irretrievably lost as have, for example, the great monuments of wooden architecture of dynastic China. Yet the beauty of ancient African creations in such durable materials as terra-cotta, stone, and bronze bears eloquent witness to the skill of ancient African artists and the splendor of the civilizations in which they worked.

PARALLELS

CULTURE	ART IN ANCIENT AFRICA	ART IN OTHER CULTURES
SAHARA c. 8000–500 BCE	**13-2.** *Cattle Being Tended* (c. 2500–1500 BCE)	**9-4.** **Harappa torso** (c. 2000 BCF), India **5-74.** *Gallic Chieftain Killing His Wife and Himself* (c. 220 BCE), Greece
NOK c. 500 BCF–200 CE	**13-3.** **Head** (c. 500 BCE–200 CE)	**10-1.** **Qin soldiers** (c. 210 BCE), China
DJENNÉ c. 200 CE–PRESENT	**13-10.** **Great Friday Mosque** (13th cent. CE)	**8-12.** **Great Mosque**, Isfahan (11th–18th cent. CE), Iran
IFE c. 800 CE–PRESENT	**13-5.** **Head of Lajuwa** (c. 1200–1300 CE) **13-4.** **Head of a king** (c. 13th cent. CE) **13-1.** **Ritual vessel** (13–14th cent. CE)	**7-42.** *Virgin of Vladimir* (12th cent. CE), Russia
GREAT ZIMBABWE c. 1000–1500 CE	**13-12.** **Bird** (c. 1200–1400 CE) **13-11.** **Conical Tower** (c. 1350–1450 CE)	**9-28.** *Shiva Nataraja* (12th cent. CE), India **8-11.** **Palace of the Lions**, Alhambra (c. 1370-80 CE), Spain
BENIN c. 1170 CE–PRESENT	**13-6.** **Memorial head** (c. 1400–1550 CE) **13-9.** *Iyoba* **mask** (c. 1550 CE) **13-8.** *General and Officers* (c. 1550–1650 CE)	**8-15.** **Mosque of Selim**, Edirne (c. 1570–74 CE), Turkey

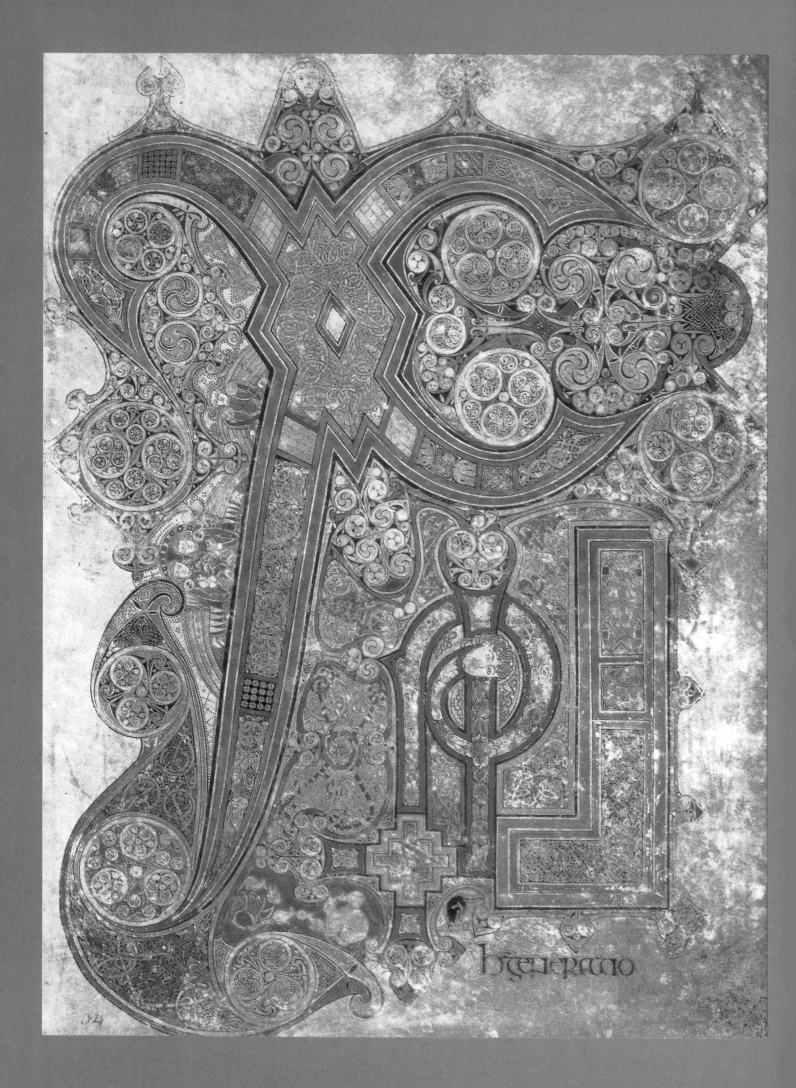

14 Early Medieval Art in Europe

According to legend, the Irish missionary Colum Cille (c. 521–97, later canonized as Saint Columba) copied a psalter without the permission of its owner, then refused to relinquish his copy. The two declared war over the book, and Colum fled to Iona, an island off the western coast of Scotland, where he established a monastery. Such remote Celtic monasteries stood "among craggy and distant mountains, which looked more like lurking places for robbers and retreats for wild beasts than habitation for men," as the eighth-century Anglo-Saxon historian Bede wrote. Nevertheless, they became seats of scholarship—and, as wealthy, isolated, and undefended sites, victims of Viking attacks beginning in 793 (Lindisfarne) and 795 (Iona).

Despite the repeated Viking attacks, Iona became the center of Celtic Christendom. Its monastery was as famous for its *scriptorium* (a room for producing manuscripts) as for its spirituality. In 806, monks fleeing raids on Iona established a refuge at Kells, on the Irish mainland, and brought with them the work now known as the *Book of Kells*, one of the most admired early medieval books, then and now—though no one knows how much was created at Iona, nor how much, if any, at Kells. To produce this illustrated version of the Book of Matthew entailed a lavish expenditure: Four scribes and three major illuminators worked on it (modern scribes take about a month to complete a comparable page), 185 calves were slaughtered to make the vellum, and the colors for the paintings came from as far away as Afghanistan.

The *Kells* style is especially brilliant in the monogram page (fig. 14-1). The artists have reaffirmed their Celtic heritage in the animal interlace and spirals with which they form the monogram of Christ (the three Greek letters *chi rho iota*) and the words *Christi autem generatio*, the first sentence of Matthew's Gospel. The illuminators outlined each letter, then subdivided the letters into panels filled with interlaced animals and snakes, as well as extraordinary spiral and knot motifs. The spaces between the letters form an equally complex ornamental field, dominated by spirals. In the midst of these abstractions, painters inserted pictorial observations and comments and symbolically referred to Christ many timess—including by his initials, the fish (see "Christian Symbols," page 294), moths (symbols of rebirth), the cross-inscribed wafer of the Eucharist and numerous chalices and goblets, and possibly in two human faces, one at the top of the page and one dotting the *i* of *iota* (in Ireland Jesus is depicted as a blond or redheaded youth). Three angels along the left edge of the *chi*'s stem are reminders that angels surrounded the Holy Family at the time of the Nativity, thus introducing Matthew's story while supporting the monogram of Christ.

In a particularly intriguing image, to the right of the *chi*'s tail two cats pounce on a pair of mice nibbling the Eucharistic wafer, and two more mice torment the vigilant cats. The vignette is a reference to the problem in medieval monasteries of keeping the monks' food and the sacred Host safe from rodents, as well as a metaphor for the struggle between good (cats) and evil (mice).

TIMELINE 14-1. Early Medieval Culture Centers in Europe. Art of the Early Middle Ages reflects the widely varying cultures in which it was created.

MAP 14-1. Europe of the Early Middle Ages. On this map, modern names have been used for medieval regions in northern and western Europe to make sites of cultural works easier to locate.

THE MIDDLE AGES

The roughly 1,000 years of European history between the collapse of the Western Roman Empire in the fifth century and the Renaissance in the fifteenth are known as the Middle Ages, or the medieval period. These terms reflect the view of early historians that this was a dark "middle" age of ignorance, decline, and barbarism between two golden ages. Although this view no longer prevails—the Middle Ages are now known to have been a period of great richness, complexity, and innovation that gave birth to modern Europe—the terms have endured. Art historians commonly divide the Middle Ages into three periods: early medieval (ending in the early eleventh century), Romanesque (eleventh and

twelfth centuries), and Gothic (extending from the mid-twelfth into the fifteenth century). The terms *Romanesque* and *Gothic* refer to distinctive artistic styles that were prevalent during the periods that bear their names and are discussed in Chapters 15 and 16; in this chapter we shall look at some early medieval art work that overlaps the Romanesque in time but not in style (Timeline 14-1). In this chapter, modern geographical names (Map 14-1) are used for convenience—for example, no such country as Germany or Italy existed before the nineteenth century.

As Roman authority crumbled at the outset of the Middle Ages, it was replaced by strong local leaders—including the leaders of the various tribes (among them the Germanic Franks, Visigoths, Ostrogoths, Saxons, and Norse, as well as the Celts) that had invaded or settled within much of the Roman Empire during the previous centuries. The Church, which remained centered in Rome, also gained influence at this time. The breakdown of central power, the fusion of Germanic, Celtic, and Roman culture, and the unifying influence of Christianity produced distinctive new political, social, and cultural forms. Relationships of patronage and dependence between the powerful—nobles and Church officials—and the less powerful became increasingly important, ultimately giving rise to a type of social organization known as feudalism. A system of mutual support developed between secular leaders and the Church, with secular leaders defending the claims of the Church and the Church validating their rule. The Church emerged as a repository of learning, and Church officials and the nobility became the principal patrons of the arts. The focus of their patronage was the church: its buildings and liturgical equipment, including altars, altar vessels,

crosses, candlesticks, and **reliquaries** (containers for holy relics), vestments, art portraying Christian figures and stories, and copies of sacred texts.

As Christianity spread north beyond the borders of what had been the Western Roman Empire, northern artistic traditions similarly worked their way south. Out of a tangled web of themes and styles originating from sources both northern and southern, eastern and western, pagan and Christian, and urban and rural, were born brilliant new artistic styles.

THE BRITISH ISLES AND SCANDINAVIA

When Roman armies first ventured into Britain in 55–54 BCE, it was a well-populated, thriving agricultural land of numerous small communities with close trading links to nearby regions of the European continent. Like the inhabitants of Ireland and much of Roman Gaul (modern France), the Britons were Celts, an ancient European people. (Welsh, Breton—the language of Brittany, in France—and the variants of Gaelic spoken in Ireland, Scotland, and Wales are all Celtic languages.) Following the Roman subjugation of the island in 43 CE, its fortunes rose and fell with those of the empire. Roman Britain experienced a final period of wealth and productivity from about 296 to about 370. Christianity flourished during this period and spread from Britain to Ireland, which was never under Roman control.

Scandinavia, which encompasses the modern countries of Denmark, Norway, and Sweden, was never part of the Roman Empire, either. In the fifth century CE it was a land of small independent agricultural and fishing communities. Most of its inhabitants spoke variants of a

THE NORTHERN DEITIES

Numerous gods, their descendants, mythical places, and attendant animals figured prominently in Pre-Christian legends in Scandinavia. The most well known include the following.

Odin, the supreme god, of wisdom, magic, law, justice, and war. Represented as one-eyed, riding on an eight-legged horse, accompanied by wolves and his two spying ravens. Presided over the Scandinavian world from his palace, Valhalla, in Aasgard, the realm of the gods. Taught people to write with runes and gave them folk wisdom and guides to conduct, such as "The generous and brave get the best out of life."

Frigg, goddess of the home and hearth and Odin's consort.

Thor, son of Odin, god of war and thunder. A huge, popular, boisterous god who protected people and the other gods from the giants. Rode across the heavens in his goat-cart, hurling his hammer and causing thunderstorms (followers wore gold or silver hammer-shaped amulets).

Frey and **Freya**, brother and sister, male and female fertility gods. Associated with boars, stallions, weather, and ships. Required human and animal sacrifices, so had carcasses hung in the trees around their temples.

Loki, fire god. A mischief-maker.

Balder, god of light and joy. Christian missionaries tried to identify him with Christ.

Valkyries, female messengers and ale-bearers of Odin. Descended from gods. Carried Viking warriors who died in battle to Valhalla, where they would enjoy themselves, fighting by day and drinking by night.

Yggdrasil, a great ash tree that supported the Viking universe.

Norns, fates that tended Yggdrasil and foretold the apocalyptic Ragnarok, a Twilight of the Gods when the world of men and gods would be destroyed and a new earth would arise (the basis for Richard Wagner's opera cycle *The Ring of the Neibelungen*).

14-2. Gummersmark brooch, Denmark. 6th century. Silver gilt, height 5¾" (14.6 cm). Nationalmuseet, Copenhagen

The faceted surface of this pin seethes with abstract human, animal, and grotesque forms such as the eye-and-beak motif that frames the headplate, the man compressed between dragons just below the bridge element, and the pair of crouching dogs with spiraling tongues that forms the tip of the footplate.

language called Norse and shared a rich mythology with other Germanic peoples. Among other deities, they worshiped Odin, chief of the gods, who protected the courageous in battle and rewarded the fallen by allowing them entrance into Valhalla, the great hall where warriors were received (see "The Northern Deities," page 487).

During the first millennium BCE, trade, warfare, and migration had brought a variety of jewelry, coins, textiles, and other portable objects into northern Europe. Scandinavian artists, who had exhibited a fondness for abstract patterning from early prehistoric times, incorporated the solar disks, spirals, and stylized animals on these objects into their already rich artistic vocabulary (see fig. 1-24). Beginning about 300 CE, Roman influences appeared in the art of Scandinavia. By the fifth century CE, the so-called **animal style** was prevalent there, displaying an impressive array of serpents, four-legged beasts, and squat human forms. Certain underlying principles govern works in this complex style: They are generally symmetrically composed, and they depict animals in their entirety from a variety of perspectives—in profile, from above, and sometimes with their ribs and spinal columns exposed as if they had been x-rayed.

The Gummersmark brooch (fig. 14-2), a large silver-gilt pin, probably one of a pair, was used to fasten a cloak around the wearer's shoulders (see Emperor Justinian's cohorts in fig. 7-29). Dating from the sixth century CE and made in Denmark, this elegant ornament consists of a large, rectangular headplate and a medallionlike, **openwork** footplate connected by an arched bow, which acts as a spring. The artist combines an intricate animal-style design with abstract, geometric motifs, including spirals and beaded bands. Bird heads, human figures, dogs, and

dragons form the footplate. The artist created a glittering surface by faceting the mold from which this piece was cast in a technique called **chip carving**. Earlier, Romans had developed chip carving as a cheap, fast way of decorating molded hardware for military uniforms. The northern artists who adopted the technique carefully crafted each item by hand, turning a process intended for fast production into an art form of great refinement.

The Roman army abandoned Britain in 406 to help defend Gaul against various Germanic peoples crossing the borders into the empire. The historical record for the subsequent period in Britain is sketchy, but it appears that the economy faltered, and large towns lost their commercial function and declined. Powerful Romanized British leaders took control of different areas, vying for dominance with the help of mercenary soldiers from the Continent. These mercenaries—Germanic Angles and Saxons, and Norse Jutes—soon began to operate independently, settling largely in the southeast part of Britain and gradually extending their control northwest across the island. Over the next 200 years, the people under their control adopted Germanic speech and customs, and this fusion of Romanized British and Germanic cultures produced a new Anglo-Saxon culture. By the beginning of the seventh century, rival Anglo-Saxon kingdoms had emerged in Britain, and the arts, which had suffered a serious decline, made a brilliant recovery. Celtic, Roman, Germanic, and Norse influences all contributed to vigorous new styles and techniques.

Anglo-Saxon literature is filled with references to splendid and costly jewelry and military equipment decorated with gold and silver. Leaders rewarded their followers and friends with gold rings and weapons. The

14-3. Purse cover, from the Sutton Hoo burial ship, Suffolk, England. c. 615–30. Cloisonné plaques of gold, garnet, and checked millefiore enamel, length 8" (20.3 cm). The British Museum, London

Only the decorations on this purse cover are original. The lid itself, of a light tan ivory or bone, deteriorated and disappeared centuries ago, and the white backing is a modern replacement. The purse was designed to hang at the waist. A leather pouch held thirty-seven coins, struck in France, the latest dated in the early 630s.

Anglo-Saxon epic *Beowulf*, composed perhaps as early as the seventh century, describes its hero's burial with a hoard of treasure in a grave mound near the sea. Such a burial site, located near the North Sea coast in Suffolk at a site called Sutton Hoo (*hoo* means "hill"), was discovered in 1938. The grave's occupant had been buried in a ship whose traces in the earth were recovered by the careful excavators. The wood—and the body—had disintegrated, and no inscriptions record his name.

The treasures buried with him confirm that he was, in any case, a wealthy and powerful man. His burial ship was 86 feet long. In it were weapons, armor, other equipment for the afterlife, and many luxury items, including a large purse filled with coins. Although the leather of the pouch and the bone or ivory of its lid have disintegrated, the gold and garnet fittings survive (fig. 14-3). The gold frame is set with garnets and blue checkered enamel, forming figures and rectilinear patterns. The upper ornaments, in the same materials, consist of polygons decorated with purely geometrical patterns flanking four animals with interlacing legs and jaws. Below, in the center, large, curved-beaked Swedish hawks attack ducks. Flanking the birds are images of men spread-eagled between two rampant beasts. The theme of a human attacked by or controlling a pair of animals is widespread in ancient Near Eastern art and in the Roman world. The hawks are Swedish, the interlacing animals Germanic, and the polychrome gem style eastern continental—a rich blend of motifs that heralds the complex Hiberno-Saxon style that flourished in England and Ireland (whose Roman name was Hibernia) during the seventh and eighth centuries.

Although the Anglo-Saxons who settled in Britain were pagans, Christianity endured through the fifth and sixth centuries in southwestern England and in Wales, Scotland, and Ireland. Monasteries began to appear in these regions in the late fifth century, and Irish Christians founded influential missions in Scotland and northern England. Some were located in inaccessible places, isolating their monks from the outside world. At many others, however, monks interacted with local Christian communities. The priests in the Christian communities spoke Celtic languages and had some familiarity with Latin. Cut off from Rome, they developed their own liturgical practices, church calendar, and distinctive artistic traditions. Then, in 597, Pope Gregory the Great (papacy 590–604), beginning a vigorous campaign of conversion in Britain, dispatched a mission from Rome to King Ethelbert of Kent, who had a Christian wife. The head of this mission, the monk Augustine (d. 604, canonized as Saint Augustine), became the archbishop of Canterbury in 601. The Roman Christian authorities and the Irish monasteries, although allied in the effort to Christianize the British Isles, came into conflict over their divergent practices. The Roman Church eventually triumphed in bringing British Christianity under its authority and in liturgical and calendrical matters. Local traditions, however, continued to dominate both secular and religious art.

Among the richest art works of the period were the beautifully written, illustrated, and bound manuscripts, especially the gospels, that rested on the altars of churches. They were produced by monks in local monastic workshops called *scriptoria* (see "The Medieval Scriptorium," page 490), which played a leading role in

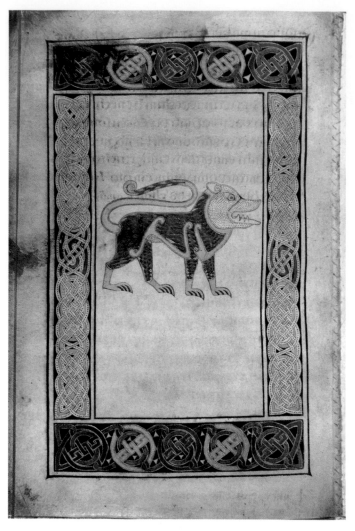

14-4. Page with *Lion*, Gospel of Saint John, *Gospel Book of Durrow*, probably made at Iona, Scotland. c. 675. Ink and tempera on parchment, 9⅝ x 5¹¹/₁₆" (24.5 x 14.5 cm). The Board of Trinity College, Dublin, MS 57 (TCD MS 57 fol. 191v)

diffusing artistic styles and themes. One of the many large, elaborately decorated Gospels of the period is the *Gospel Book of Durrow*, dating to about 675. This manuscript is named for the town in Ireland where it was kept in the late medieval period, but no one knows exactly where it was made. A likely possibility is the monastery founded on Iona by Colum Cille in the sixth century (see page 485). The format and text of the book reflect a knowledge of Roman Christian models, but its decoration is practically an encyclopedia of local design motifs, such as serpents and animals adopted from metalwork like the Sutton Hoo treasure (see fig. 14-3). Each of the four Gospels is introduced by a page with the symbol of the evangelist who wrote it, followed by a page of pure ornament (a carpet page), then decorated letters of the first words of the text (the incipit). In the *Gospel Book of Durrow*, the artist followed early Christian, pre-Vulgate tradition, using the lion, normally the symbol of Saint Mark, for Saint John (fig. 14-4) and Saint John's eagle for Saint Mark. The lion here is a ferocious beast with sharp claws, jagged teeth, curling tail, and wild eye. The stylization of the body is based on Pictish (Scottish) stone carving, rather than on a flesh-and-blood creature. Its eye, tail, and paws and the stylized muscles around hip and shoulder joints are painted yellow to suggest gold. Its head is decorated with a uniform stippled pattern, and the surface of its body is covered with diamond patterns similar to those found in cloisonné. Around the wide border are two types of **ribbon interlace**, a complex pattern of woven and knotted lines that may derive from similar border ornamentation in ancient Greek and Roman mosaics and is commonly found in medieval painting and metalwork. Here, a dotted pattern marks the vertical bands and shifting bright green, red, and yellow coloration adorns the horizontal bands.

Another Gospel book, the *Book of Kells*, described by an eleventh-century observer as "the chief relic [religious

THE MEDIEVAL SCRIPTORIUM Today books are made with the aid of computer software that can lay out pages, set type, and insert and prepare illustrations. Modern presses can produce hundreds of thousands of identical copies in full color. In Europe in the Middle Ages, however, before the invention there of printing from movable type in the mid-1400s, books were made by hand, one at a time, with ink, pen, brush, and paint. Each one was an important, time-consuming, and expensive undertaking.

Medieval books were usually made by monks and nuns in a workshop called a *scriptorium* (plural *scriptoria*) within the monastery. As

the demand for books increased, lay professionals joined the work, and great rulers set up palace workshops supervised by well-known scholars. Books were written on animal skin—either **vellum**, which was fine and soft, or **parchment**, which was heavier and shinier. (Paper did not come into common use in Europe until the early 1400s.) Skins for vellum were cleaned, stripped of hair, and scraped to create a smooth surface for the ink and water-based paints, which themselves required time and experience to prepare. Many pigments—particularly blues and greens—had to be imported and were as costly as semiprecious stones. In early manuscripts, bright yellow was used to suggest gold, but

later manuscripts were decorated with real gold leaf or gold paint.

Sometimes work on a book was divided between a scribe, who copied the text, and one or more artists, who did the illustrations, large initials, and other decorations. Although most books were produced anonymously, scribes and illustrators signed and dated their work on the last page, called the **colophon** (see fig. 14-7). One scribe even took the opportunity to warn the reader: "O reader, turn the leaves gently, and keep your fingers away from the letters, for, as the hailstorm ruins the harvest of the land, so does the injurious reader destroy the book and the writing" (cited in Dodwell, page 247).

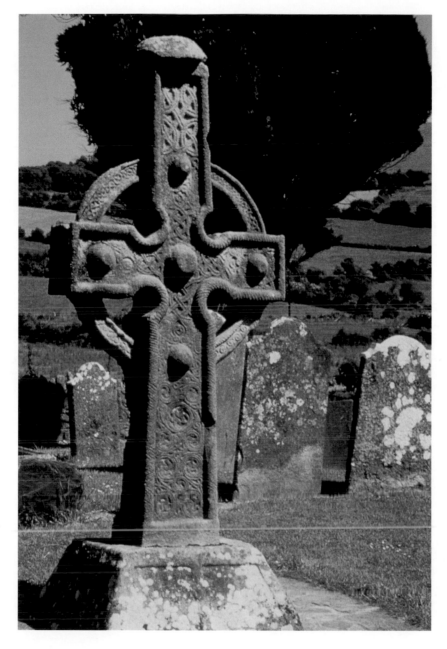

14-5. South Cross, Ahenny, County Tipperary, Ireland. 8th century. Stone

object] of the Western world," is one of the most beautiful, original, and inventive of the surviving Hiberno-Saxon Gospel books. It may have been begun or made at the monastery on Iona in the late eighth century and brought to the monastery at Kells, in Ireland, in the early ninth century.

In the twelfth century, a priest named Gerald of Wales, describing a Hiberno-Saxon Gospel book very much like the *Book of Kells*, wrote: "Fine craftsmanship is all about you, but you might not notice it. Look more keenly at it, and you will penetrate to the very shrine of art. You will make out intricacies, so delicate and subtle, so exact and compact, so full of knots and links, with colors so fresh and vivid, that you might say that all this was the work of an angel, and not of a man" (cited in Henderson, page 195). A close look at perhaps the most celebrated page in the *Book of Kells*—the one from the Book of Matthew (1:18–25) that begins the account of Jesus' birth—reveals what he means (see fig. 14-1). At first glance, the page seems completely abstract, but for

those who would "look more keenly," there is so much more—human and animal forms—in the dense thicket of spiral and interlace patterns derived from metalwork.

Metalwork's influence is seen not only in manuscript illumination, but also in the monumental stone crosses erected in Ireland in the eighth century. In the Irish "high crosses," so called because of their size, a circle encloses the arms of the cross. This Celtic ring has been interpreted as a halo or a glory (a ring of heavenly light), or as a purely practical support for the arms of the cross. The South Cross of Ahenny, in County Tipperary, is an especially well preserved example of this type (fig. 14-5). It seems to have been modeled on metal ceremonial or reliquary crosses, that is, cross-shaped containers for holy relics. It is outlined with **gadrooning** (ropelike, convex molding) and covered with spirals and interlace. The large **bosses** (broochlike projections), which form a cross within the cross, resemble the jewels that were similarly placed on metal crosses.

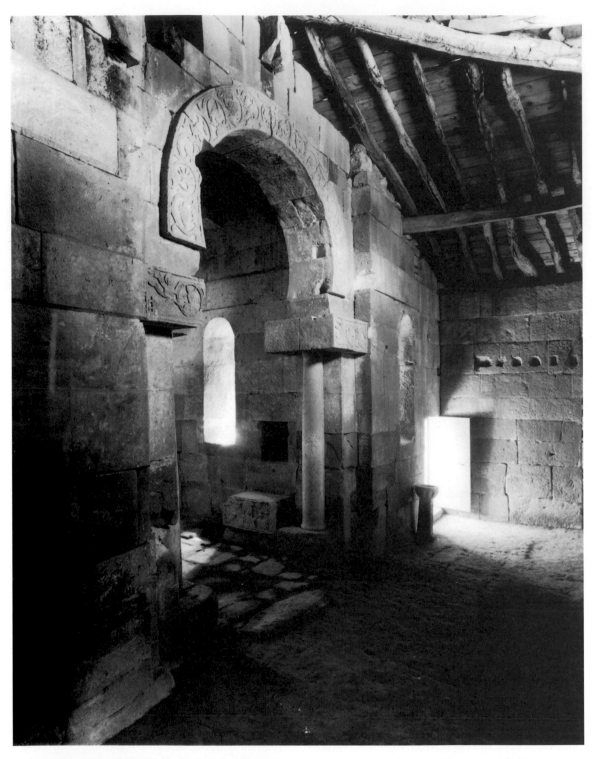

14-6. Church of Santa Maria de Quintanilla de las Viñas, Burgos, Spain. Late 7th century. View from the choir into the apse

CHRISTIAN SPAIN In the fourth and fifth centuries, as Roman control of western Europe deteriorated, a Germanic tribe known as the Visigoths converted to Arian Christianity (Chapter 7) and migrated across Europe and into Spain. By the sixth century the Visigoths had established themselves as an aristocratic elite ruling the indigenous population. They adopted Latin for writing and in 589 the Western Church's orthodox Christianity. Visigothic metalworkers, following the same late-Roman–Germanic tradition they shared with other Gothic peoples, created magnificent colorful jewelry.

The sixth- and seventh-century churches surviving in Spain are well-preserved examples of Visigothic stone architecture. The Church of Santa Maria de Quintanilla de las Viñas, located near Burgos, was built in the late seventh century. It was originally a **basilica** (see "Basilica-Plan and Central-Plan Churches," page 298)—the nave and two aisles no longer exist—and the aisles opened via narrow doorways into the **choir**. Like a **transept**, this

area, reserved for the clergy, extended the full width of the church. This marked partitioning of the nave from the choir and sanctuary, found in other Spanish churches of the same period, may reflect a change in liturgical practice in which the congregation no longer approached the altar to receive communion.

The Visigothic form of the **horseshoe arch** frames the entrance to the apse at Santa Maria de Quintanilla de las Viñas (fig. 14-6), refuting the popular belief that Islamic architects introduced this form in the eighth century (see the discussion of the Great Mosque of Córdoba in Chapter 8 and figure 8-6). The lowest *voussoirs* jut inward slightly into the apse entrance, supported on **piers** and freestanding columns and large **impost blocks**. The themes of the crisp bands of carving on the arch and impost blocks are found frequently in early Christian art. Above the arch is Christ between Angels. The sun and the moon are on the impost blocks. On the arch is a scrolling vine, the loops of which encircle birds and bunches of grapes, symbolic of the Eucharist. Like the carved decoration on the roughly contemporary South Cross at Ahenny, the style of these low-relief decorations is reminiscent of metalwork.

In 711, Islamic invaders conquered Spain, ending Visigothic rule. With some exceptions, Christians and Jews who did not convert to Islam but acknowledged the authority of the new rulers and paid the taxes required of non-Muslims were left free to follow their own religious practices. Christians in the Arab territories were called Mozarabs (from the Arabic *mustarib*, meaning "would-be Arab"). The conquest resulted in a rich exchange of artistic influences between the Islamic and Christian communities. Christian artists adapted many features of Islamic style to their traditional themes, creating a unique, colorful new style known as Mozarabic; when they migrated to the monasteries of northern Spain, which reverted to Christian rule not long after the initial Islamic invasion, they took this Mozarabic style with them.

In northern Spain, the antagonisms among Muslims, orthodox Christians, and the followers of various heretical Christian sects provided fertile material for writers to explore in religious commentaries. One of the most influential of these was the *Commentary on the Apocalypse* compiled in the eighth century by Beatus, abbot of the Monastery of San Martín at Liébana, in the north Spanish kingdom of Asturias. It is an analysis of the visions set down in the Apocalypse (the Book of Revelation), the book of the New Testament that vividly describes Christ's final, fiery triumph. Beatus's work, an impassioned justification of orthodox beliefs, appealed to Christians in their long struggle against the Muslims. The book was widely read, copied, and illustrated. Two copies from the late tenth century, illustrated in the Mozarabic style, were produced under the direction of the scribe-painter Emeterius, a monk in the workshop of the Monastery of San Salvador at Tábara in the kingdom of León.

The first of these copies was completed in 970 by Emeterius and a scribe-painter named Senior, who identified themselves in the manuscript. Unlike most monastic scribes at this time, Mozarabic scribes usually signed their

14-7. Emeterius and Senior. Colophon page, *Commentary on the Apocalypse* **by Beatus and** *Commentary on Daniel* **by Jerome**, made for the Monastery of San Salvador at Tábara, León, Spain. Completed July 27, 970. Tempera on parchment, 14¼ x 10⅛" (36.2 x 25.8 cm). Archivo Histórico Nacional, Madrid. MS 1079B f. 167.v

In medieval manuscripts the colophon page provided specific information about the production of a book. In addition to identifying himself and Senior on this colophon, Emeterius praised his teacher, "Magius, priest and monk, the worthy master painter," who had begun the manuscript prior to his death in 968. Emeterius also took the opportunity to comment on the profession of bookmaking: "Thou lofty tower of Tábara made of stone! There, over thy first roof, Emeterius sat for three months bowed down and racked in every limb by the copying. He finished the book on July 27th in the year 1008 (970, by modern dating) at the eighth hour" (cited in Dodwell, page 247).

work, sometimes showed themselves occupied with pen and brush, and occasionally offered the reader their own comments and asides (see "The Medieval Scriptorium," page 490). On the **colophon**, the page at the end of a manuscript or book that identifies its producers, is a picture of the five-story tower of the Tábara monastery and the two-story *scriptorium* attached to it, the earliest known depiction of a medieval *scriptorium* (fig. 14-7). The tower,

14-8. Emeterius and Ende, with the scribe Senior. Page with
Battle of the Bird and the Serpent, *Commentary on the*
Apocalypse by Beatus and *Commentary on Daniel* by Jerome,
made for Abbot Dominicus, probably at the Monastery of
San Salvador at Tábara, León, Spain. Completed July 6, 975.
Tempera on parchment, 15¾ x 10¼" (40 x 26 cm).
Cathedral Library, Gerona, Spain. MS 7[11], fol. 18v

with horseshoe-arched windows, and the workshop have been rendered in a cross section that reveals many details of the interior and exterior simultaneously. In the *scriptorium*, Emeterius on the right and Senior on the left, identified by inscriptions over their heads, are at work at the same small table. A helper in the next room cuts sheets of **parchment** or vellum for book pages. A monk standing inside (or perhaps outside) the ground floor of the tower pulls the ropes to the bell in the turret on the right. Three other men climb ladders between the floors, apparently on their way to the balconies on the top level. Brightly glazed tiles in geometric patterns, a common feature of Islamic architecture, cover what could be the tower's walls.

The other Beatus *Commentary* was produced five years later for a named patron, Abbot Dominicus. The colophon identifies Senior as the scribe for this project. Emeterius and a woman named Ende, who signed herself "painter and servant of God," shared the task of

illustration. A full-page painting from this book shows a peacock grasping a red and orange snake in its beak (fig. 14-8). With abstract shapes and colored enamel recalling Visigothic metalwork, Emeterius and Ende illustrate a metaphorical description of the triumph of Christ over Satan. A bird with a powerful beak and beautiful plumage (Christ) covers itself with mud to trick the snake (Satan). Just when the snake decides the bird is harmless, the creature swiftly attacks and kills it. "So Christ in his Incarnation clothed himself in the impurity of our [human] flesh that through a pious trick he might fool the evil deceiver. . . . [W]ith the word of his mouth [he] slew the venomous killer, the devil" (from the Beatus *Commentary*, cited in Williams, page 95). The Church often used such symbolic stories, or allegories, to translate abstract ideas into concrete events and images, making their implications accessible to almost anyone of any level of education.

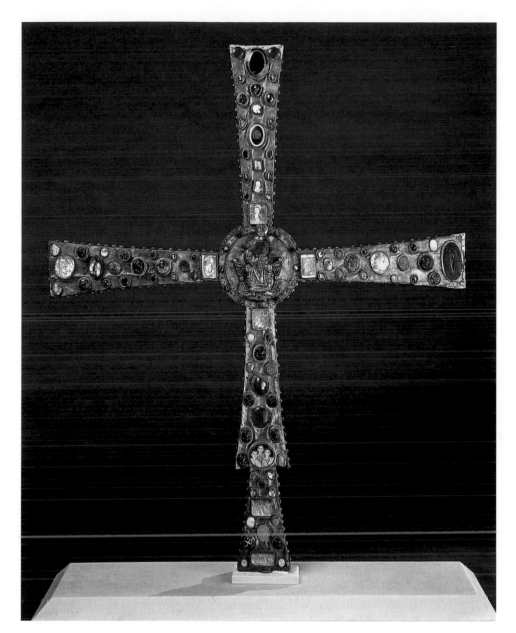

14-9. **Cross**, from the Church of Saint Giulia, Brescia, Italy. Late 7th–early 9th century. Gilded silver, wood, jewels, glass, cameos, and gold-glass medallion, 50 x 39" (126 x 99 cm). Museo di Santa Giulia, Brescia

LANGOBARD ITALY

The Western Empire did not recover after the disastrous but temporary conquest of Rome by the Visigoths in 410. Gradually the pope replaced the emperor as a temporal as well as spiritual ruler. At the same time, the Byzantines held the important port city of Ravenna and territory along the Adriatic coast against a succession of Germanic invaders. Among those who established short-lived kingdoms in Italy were the Visigoths, who captured Ravenna in 493–553) and established a short-lived kingdom, and the Langobards, who settled in northern and central Italy (568–774).

Most enduring was the Langobard kingdom. The Langobards had moved from their homeland in northern Germany to the Hungarian plain and then traveled west into Italy, where they became a constant threat to Rome. Like other migrating people, the Langobards excelled in fine metalwork and jewelry. A huge jeweled cross in Brescia (east of Milan) shows their love of bright colors and spectacular jewels (fig. 14-9). The cross has a Byzantine form—equal arms widening at the ends joined by a central disc. Gilded silver covers its wooden core. Christ enthroned in a silver jeweled **mandorla**, executed in relief, fills the central disk, and more than 200 jewels, pieces of glass, engraved gems, and antique **cameos** cover the arms. At the bottom of the lower vertical arm is a gold glass medallion inscribed "Bounneri Kerami," a fine example of Roman portraiture (see fig. 6-73). According to tradition, the last Langobard king, Desiderius (ruled 757–74), gave the cross to the Church of

14-10. Abbey Church of Saint Riquier, Monastery of Centula, France, dedicated 799. Engraving dated 1612, after an 11th-century drawing. Bibliothèque Nationale, Paris

church but having the form associated with the Byzantine East, and using engraved jewels and cameos from the ancient world, the cross achieves the effect of "barbarian" splendor.

The Langobards did not create a new integrated Roman-German style. For that we turn to the Carolingian dynasty founded by Charlemagne. King of the Franks, Charlemagne had married the Langobard princess as a diplomatic gesture in 770 but in 771 repudiated her and marched against her father, Desiderius, whom he vanquished in 774. Proclaiming himself king of the Langobards, Charlemagne incorporated the Langobardian kingdom into his growing realm.

CAROLINGIAN EUROPE

A new empire emerged in continental Europe during the second half of the eighth century, forged by the Carolingian dynasty (dynasty from 768, empire 800–77) that was created by Charlemagne, or Charles the Great (*Carolus* is Latin for "Charles"). The Carolingians were Franks, a Germanic people who had settled in northern Gaul by the end of the fifth century. Under Charlemagne (ruled 768–814; crowned emperor 800) the Carolingian realm reached its greatest extent, encompassing western Germany, France, the Langobard kingdom in Italy, and the Low Countries (modern Belgium and Holland). Charlemagne imposed Christianity, sometimes brutally, throughout this territory and promoted Church reform. In 800 Pope Leo III (papacy 795–816), in a ceremony in the Church of Saint Peter (later known as Old Saint Peter's) in Rome, crowned Charlemagne emperor, declaring him to be the rightful successor to Constantine, the first Christian emperor. This endorsement reinforced Charlemagne's authority over his diverse realm and strengthened the bonds between the papacy and secular government in the West.

Charlemagne sought to restore the Western Empire as a Christian state and to revive the arts. On his official seal, Charlemagne inscribed *renovatio Romani imperii* ("The revival of the Roman Empire"). He placed great emphasis on education, gathering around him the finest scholars of the time, and his court, in Aachen, Germany, became the leading intellectual center of

Saint Giulia in Brescia. Scholars cannot agree, and they date the cross variously to the late seventh, eighth, and even early ninth centuries.

The patron who gathered this rich collection of jewels and ordered the cross made intended to glorify it with glowing color—although nearly all the engraved gems (some of which are copies) have pagan subjects. The cross thus typifies this turbulent period in the western European history of art. Made for a Western Christian

THE WESTERN CHURCH'S DEFINITION OF ART In 787, when the iconoclastic controversy that had raged in the Eastern Empire temporarily ended with the reestablishment of the veneration of icons (discussed in Chapter 7), Charlemagne ordered his scholars to rebut the Eastern Church's position. In the *Caroline Books* (*Libri Carolini*), the Carolingians concluded that artists create visual fictions and that, contrary to pious Byzantine belief, icons are made by human beings. They rejected the supernatural powers attributed by the Eastern Church to icons.

The Western Church took the position that images are precious only if their material is precious (a gold image of Mary is more valuable than a wooden one, although both represent the Mother of God). In the case of ancient works, the value should be based on both the materials and the condition of the piece. Further, although images are not holy or products of divine inspiration, they do have an important educational function. Pope Gregory the Great (papacy 590–604) wrote in a letter: "What scripture is to the educated, images are to the ignorant." Therefore, artists should be well trained, work diligently, use good materials, and follow the best models. "Quality" should be determined by the artists' success in fulfilling their intentions and their patrons' commands.

western Europe. His architects, painters, and sculptors turned to Rome and Ravenna for inspiration, but what they created was a new, northern version of the Imperial Christian style (see "The Western Church's Definition of Art," opposite).

ARCHITECTURE

Charlemagne's biographer, Einhard, reported that the ruler, "beyond all sacred and venerable places . . . loved the church of the holy apostle Peter at Rome." Not surprisingly, Charlemagne's architects turned to Old Saint Peter's, a basilica-plan church with a long nave and side aisles ending in a transept and projecting apse (see fig. 7-9), as a model for his own churches. These churches, however, included purely northern features and were not simply imitations of Roman Christian structures. Among these northern features was a multistory **narthex**, or vestibule, flanked by attached stair towers. Because church entrances traditionally faced west, this type of narthex is called a **westwork**.

The Abbey Church of Saint Riquier, an ancient monastery at Centula in northern France was an example of the Carolingian reworking of the Roman basilica-plan church. Built when Angilbert, a Frankish scholar at Charlemagne's court, was abbot at Centula, it was completed about 799. Destroyed by Viking raids in 845 and 881 and rebuilt, it is known today from archaeological evidence and an engraved copy after a lost eleventh-century drawing of the abbey (fig. 14-10). For the abbey's more than 300 monks, the enclosure between the church and two freestanding chapels may have served as a **cloister**—cloisters are arcaded courtyards, with a well and sometimes with gardens, linking the church and the buildings for the monastic community. A second cloister has also been found. The small, barnlike chapel at the right in the drawing was dedicated to Saint Benedict. The more elaborate structure at the lower left, a basilica with a **rotunda** ringed with chapels, was dedicated to the Virgin and the Twelve Apostles. The interior would have had an altar of the Virgin in the center, an **ambulatory** passageway around it, and altars for each of the apostles against the perimeter walls.

The Church of Saint Riquier followed a basic basilica plan. Excavations have revealed a much longer nave than is indicated in the illustration. Giving equal weight to both ends of the nave are, at the left of the drawing, a multi-story westwork including paired towers, a **transept**, and a crossing tower, and, at the right (the east end of the church), a crossing tower that rises over the transept and an extended **chancel** (sanctuary) and apse. The westwork's liturgical function was so important that it served almost as a separate church. At the Church of Saint Riquier, the altar in the westwork was dedicated to Christ the Savior and used on great feast days. The boys' choir sang from its galleries, filling the church with angelic music, and its ground floor had altars with important relics. Later, the westwork held the chapel of the archangel Michael, instead of the Savior, whose altar was moved to the main body of the church. (During the

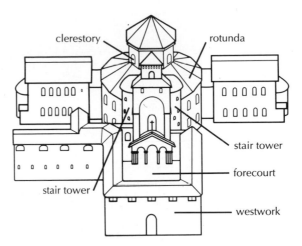

14-11. Reconstruction drawing of the Palace Chapel of Charlemagne, Aachen (Aix-la-Chapelle), Germany. 792–805

Romanesque and Gothic periods, the westwork element would evolve into a twin-towered facade.) The two tall towers, soaring from cylindrical bases through three arcaded levels to cross-topped spires, would have been the building's most striking feature, though their form has been debated. They were apparently made of timber, which, being lighter than masonry, posed fewer problems for tall construction. This vertical emphasis created by the many towers was a northern contribution to Christian architecture.

Remains of Charlemagne's palace complex provide another example of the Carolingian synthesis of Roman Christian and northern styles. Charlemagne, who enjoyed hunting and swimming, built his palace complex amid the forests and natural hot springs of Aachen (Aix-la-Chapelle in French), in the northern part of his empire. He installed his court there about 794, making it his capital. The complex included homes for his circle of advisers and his large family, administrative buildings, the palace school, and workshops supplying all the needs of church and state. An audience hall survives in part, and excavations have revealed the plan of the complex with a monumental gateway and judgment hall. Directly across from the royal audience hall on the north-south axis of the complex stood the Palace Chapel (fig. 14-11). This structure functioned as Charlemagne's private chapel, the church of his imperial court, a **martyrium** for certain precious relics of saints, and, after the emperor's death, the imperial **mausoleum**. To satisfy all these needs, the emperor's architects created a large, central-plan building similar to that of the Church of San Vitale in Ravenna (see fig. 7-26), but added a westwork with a tall, cylindrical stair tower on each side. The chapel originally had a very large, walled forecourt where crowds could assemble. Spiral stairs in the twin towers led to a throne room on the second level that opened onto the chapel rotunda, allowing the emperor to participate in the Mass. Relics were housed above the throne room on the third level.

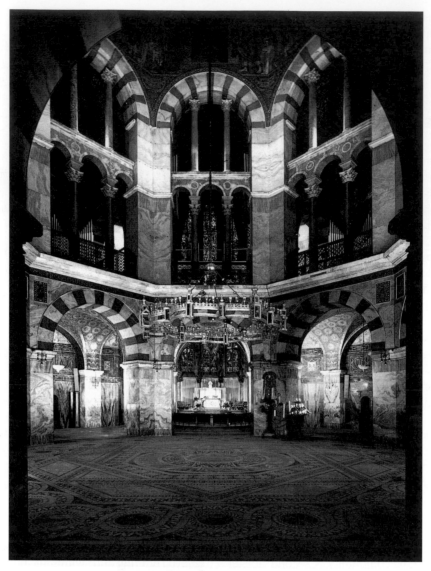

14-12. Palace Chapel of Charlemagne

Although this sturdily constructed chapel retains its original design and appearance, including the bronze railings, much of its decoration either has been restored or dates from later periods. The Gothic-style chapel seen through the center arches on the ground floor replaced the eighth-century sanctuary apse. The enormous "crown of light" chandelier suspended over the central space was presented to the church by Emperor Frederick Barbarossa in 1168. Extensive renovations took place in the nineteenth century, when the chapel was reconsecrated as the cathedral of Aachen, and in the twentieth century, after it was damaged in World War II.

The core of the chapel is an octagon that rises to a **clerestory** above the **gallery** level (fig. 14-12). An ambulatory aisle surrounds this central core to form a sixteen-sided outer wall. The gallery also opens on the central space through arched openings supported by two tiers of Corinthian columns. Compared to San Vitale, where the central space seems to flow outward from the dome into half domes and the **exedrae**, the Aachen chapel has a clarity created by flat walls and geometric forms. The columns and grilles on the gallery level lie flush with the opening overlooking the central area, screening it from the space beyond. The effect is to create

a powerful vertical visual pull from the floor of the central area to the top of the vault. Unlike San Vitale, which is covered by a smooth, round dome, the vault over the Palace Chapel rises from its octagonal base in eight curving masonry segments. Originally the vault had a mosaic depicting the twenty-four Elders of the Apocalypse. The clear division of the structure into parts and the vertical emphasis are both hallmarks of the new style that developed under Charlemagne.

Monastic communities had grown numerous by the early Middle Ages and had spread across Europe. In the early sixth century, Benedict of Nursia (c. 480–547) wrote

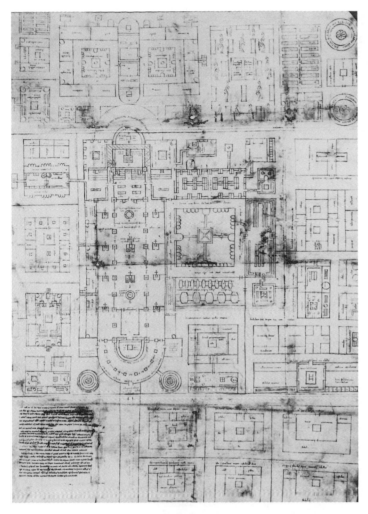

14-13. Plan of the Abbey of Saint Gall (redrawn) c. 817
Original in red ink on parchment, 28 x 44⅛" (71.1 x
112.1 cm). Stiftsbibliothek, St. Gallen, Switzerland.
Cod. Sang. 1092

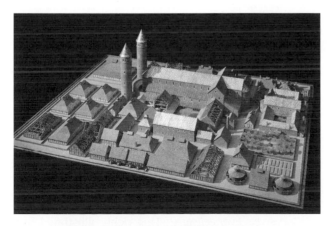

14-14. Model after the Saint Gall monastery plan
(see fig. 14-13), constructed by Walter Horn and
Ernst Born, 1965

his *Rule for Monasteries*, a set of guidelines for monastic
life. Benedictine monasticism quickly became dominant,
displacing earlier forms, including the Irish monasticism
that had developed in the British Isles. In the early ninth
century, Abbot Haito of Reichenau developed a general
plan for the construction of monasteries for his colleague

Abbot Gozbert of the Benedictine Abbey of Saint Gall
near Lake Constance (in modern Switzerland). The Saint
Gall plan (figs. 14-13, 14-14) was drawn on five pieces of
parchment sewn together.

This extremely functional plan was widely adopted
and can still be seen in many Benedictine monasteries.
Central to monastic life were the eight daily services in the
church (*Opus dei*, the *Work of God*). Monks entered from
the cloister or by stairs directly from their quarters. The
church had apses at both ends and a transept crossing the
nave at the eastern end. Most important was the devel-
opment of the cloister and complex of monastic buildings
surrounding it. The warming room and dormitory above
it stood on the east side of the cloister, the refectory (din-
ing hall) on the south, and the cellar (indicated by giant
barrels) on the west. Only a chapter house (the adminis-
trative center of the monastery where a chapter of the
Rule of Saint Benedict was read every day) is missing
from the plan; instead, the monks met in the north clois-
ter aisle, next to the church. The Saint Gall plan provides
beds for seventy-seven monks in the dormitory and space
for thirty-three more monks elsewhere, but only seven
seats are indicated in the main latrine. Six beds and refec-
tory seats were reserved for visiting monks. Members of
the lay community that inevitably developed outside the
walls of a large monastery used the main entryway. In the
surrounding buildings, monks pursued their individual
tasks. Scribes and painters, for example, spent much of
their day in the *scriptorium* studying and copying books,
and teachers staffed the monastery's schools and library.
Benedictine monasteries generally had two schools, one
inside the monastery proper for young monks and
novices (those hoping to take vows and become broth-
ers), and another outside for educating the sons of the
local nobility.

Saint Benedict had directed that monks extend hos-
pitality to all visitors, and the large building in the upper
left of the plan may be a hostel, or inn, for housing them.
A porter would have looked after visitors, supplying
them from the food produced by the monks. The plan
also included a hospice for the poor and an infirmary. A
monastery of this size had most of the features of a small
town and would have indirectly or directly affected many
hundreds of people. Essentially self-supporting, it would
have had livestock, barns, agricultural equipment, a bak-
ery and brewery, kitchen gardens (farm fields lay outside
the walls), and even a cemetery.

BOOKS

Books played a central role in the efforts of Carolingian
rulers to promote learning, propagate Christianity, and
standardize Church law and practice. As a result, much
of the artistic energy of the period found an outlet in the
empire's great *scriptoria*. One of the main tasks of these
workshops was to produce authoritative copies of key
religious texts, free of the errors that tired, distracted, or
confused scribes had introduced over the generations.
The scrupulously edited versions of ancient texts that
emerged are among the lasting achievements of the

14-15. Page with *Mark the Evangelist*, Book of Mark, *Godescalc Evangelistary*. 781–83. Ink and colors on vellum, 12½ x 8½" (32.1 x 21.8 cm). Bibliothèque Nationale, Paris. MS lat. 1203, fol. 16

Carolingian period. The Anglo-Saxon scholar Alcuin of York, whom Charlemagne called to his court, spent the last eight years of his life producing a corrected copy of the Latin Vulgate Bible. His revision served as the standard text of the Bible for the remainder of the medieval period.

Ordered by Charlemagne to create a simple, legible Latin script, the scribes and scholars developed uniform letters. Capitals (majuscules) based on ancient Roman inscriptions were used for very formal writing, titles and headings, and the finest manuscripts. Minuscules (now called lowercase letters, a modern term from printing) were used for more rapid writing and ordinary texts. This Caroline script is comparatively easy to read, although the scribes did not use punctuation marks or spaces between words.

One of the earliest surviving manuscripts in the new script, produced at Charlemagne's court between 781 and 783, was a collection of selections from the Gospels to be read at Mass, copied by the Frankish scribe Godescalc and known as the *Godescalc Gospel Lectionary* or *Godescalc Evangelistary*. This richly illustrated and sumptuously made book (featuring gold and silver letters and purple-dyed vellum pages) has a full-page portrait of the evangelist at the beginning of each Gospel section. The style of these illustrations suggests that Charlemagne's artists were familiar with the author portraits and illusionistic painting style of imperial Rome that had been preserved in Byzantine manuscripts.

In his portrait, Mark is in the act of writing at a lectern tilted up to display his work (fig. 14-15). He appears to be attending closely to the small haloed lion

14-16. Page with *Matthew the Evangelist*, Book of Matthew, *Ebbo Gospels.* c. 816–35. Ink, gold, and colors on vellum, 10¼ x 8¾" (26 x 22.2 cm). Bibliothèque Municipale, Epernay, France, MS 1, fol. 18v

In the upper left corner, the source of his inspiration and the iconographic symbol by which he is known. The artist has modeled Mark's arms, hips, and knees beneath his garment and rendered the bench and lectern to give a hint of three-dimensional space despite the flat, banded background. Mark's round-shouldered posture and sandaled feet, solidly planted on a platform decorated with a classical spiraling-vine motif, contribute an additional naturalistic touch, which is destroyed by the impossible position of the left knee. Stylized plants set the scene out of doors. Commissioned by Charlemagne and his wife Hildegarde, perhaps to commemorate the baptism of their sons in Rome, the *Godescalc Evangelistary* provided a model for later luxuriously decorated Gospel books.

Louis the Pious, Charlemagne's son and successor, appointed his childhood friend Ebbo as archbishop of Reims. Ebbo was archbishop from 816 to 835, was temporarily disgraced, then returned to rule from 840 to 845. A portrait of Matthew from a Gospel book made for Ebbo, begun after 816 at the Abbey of Hautevillers near Reims, illustrates the unique style that arose there, a medieval expressionism (fig. 14-16). Brilliant drawing in color creates a figure of Matthew that vibrates with intensity, and

the landscape in the background threatens to run off the page, contained only by the golden border. Even the acanthus leaves in the frame seem blown by a violent wind. The artist uses the brush like a pen, focusing attention less on the evangelist's physical appearance than on his inner, spiritual excitement as he hastens to transcribe the Word of God coming to him from the distant angel (Matthew's symbol) in the upper right corner. His head and neck jut out of hunched shoulders, and he grasps his pen and inkhorn. His twisted brow and prominent eyebrows lend his gaze an intense, theatrical quality. As if to echo Matthew's turbulent emotions, the desk, bench, and footstool tilt every which way and the top of the desk seems about to detach itself from the pedestal. Gold highlights the evangelist's hair and robe, the furniture, and the landscape. The accompanying text is written in magnificent golden capitals.

The most famous of all Carolingian manuscripts, the *Utrecht Psalter*, was made in the same *scriptorium*. This volume, which is illustrated with ink drawings, has the same linear vitality as the paintings in the Ebbo Gospel book. A psalter contains the Old Testament Book of Psalms, which does not tell a straightforward story and so is difficult to represent. The *Utrecht Psalter* solves this

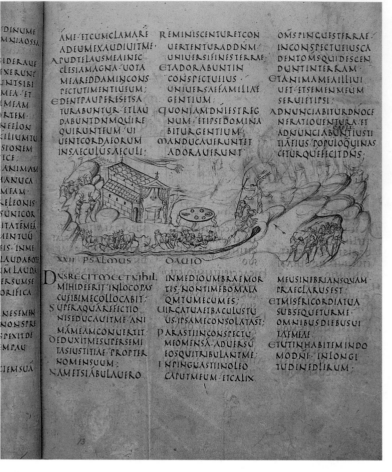

Left margin column:
DINUME
MNIAOSSA

IDERAVE
EXERUNT
JNTISIBI
MEA ET
IMIAM
IRTEM
NEELON
CILIUMTU
SIONEM
ICE
ANIMAM
IANUCA
MEAM
CELEONIS
SUNICOR
ITATEMEA
MENTUU
LIS INME
LAUDABOH
IM LAUDA
ERSUMSE
ORIFICA

NESEMEN
NONSPRE
SPEXITDE
MILAU

IEMSUA

Top columns:
AME ETCUMCLAMARE
ADEUMEXAUDIUITME
APUDTELAUSMEAINIC
CLESIAMAGNA UOTA
MEAREDDAMINCONS
PECTUTIMENTIUEUM
EDENTPAUPERESETSA
TURABUNTUR ETLAU
DABUNTDNMQUIRE
QUIRUNTUM UI
UENTCORDAIORUM
INSAECULUSAECULI

REMINISCENTURETCON
UERTENTURADDNM
UNIUERSIFINESTERRAE
ETADORABUNTIN
CONSPECTUEIUS
UNIUERSAEFAMILIAE
GENTIUM
QUONIAMDNIESTREG
NUM ETIPSEDOMINA
BITURGENTIUM
MANDUCAUERUNTET
ADORAUERUNT

OMSPINGUESTERRAE
INCONSPECTUEIUSCA
DENTOMSQUIDESCEN
DUNTINTERRAM
ETANIMAMEAILLIUI
UET ETSEMENMEUM
SERUIETIPSI
ADNUNCIABITURDNOCE
NERATIOUENTURA ET
ADNUNCIABUKTIUSTI
IIAEIUS POPULOQUINAS
CITURQUEFFECITDNS

XXII PSALMUS OAUO

DNSREGITMEETNIHIL
MIHIDEERIT INLOCOPAS
CUEIBIMECOLLOCABIT
SUPERAQUAREFECTIO
NISEDUCAUITME ANI
MAMEAMCONUERTIT
DEDUXITMESUPERSEMI
TASIUSTITIAE PROPTER
NOMENSUUM
NAMETSIABULAUERO

INMEDIOUMBRAEMOR
TIS NONTIMEBOMALA
QMTUMECUMES
UIRGATUAEIBACULUSTU
US IPSAMICONSOLATASI
PARASTIIANCONSPECTU
MEOMENSA ADUERSU
EOSQUITRIBULANTME
I NPINGUASTIINOLEO
CAPUTMEUM ETCALIX

MEUSINIBRIANSQUAM
PRAECLARUSEST
ETMISERICORDIATUA
SUBSEQUETURME
OMNIBUSDIEBUSUI
TAEMEAE
ETUTINHABITEMINDO
MODNI INLONGI
TUDINEDIERUM

14-17. Page with *Psalm 23*, *Utrecht Psalter*. from Benedictine Abbey at Hautvilliers, France. c. 820–835. Ink on vellum or parchment, 13 x 9⁷/₈" (33 x 25 cm). Universiteitsbibliotheek, Utrecht, Holland, MS 32, fol. 13r

problem by visually interpreting individual words and literary images. In figure 14-17, the words of the well-known Twenty-third Psalm are illustrated literally. "The Lord is my shepherd; I shall not want" (verse 1): The psalmist (traditionally King David) sits in front of a laden table holding a cup (verse 5). He is portrayed as a shepherd in a pasture filled with sheep, goats, and cattle, "beside the still water" (verse 2). Perhaps the stream flows through "the valley of the shadow of death" (verse 4). An angel supports the psalmist with a "rod and staff" and anoints his head (verses 4 and 5). "Thou preparest a table before me in the presence of mine enemies" (verse 5): The enemies gather at the lower right and shoot arrows, but the psalmist and angel ignore them and focus on the table and the House of the Lord, a basilica whose curtains are drawn back to reveal an altar and hanging votive crown: "I will dwell in the house of the Lord forever" (verse 6). Illustrations like this convey the characteristically close association between text and illustration in Carolingian art. The technique has been likened to a game of charades in which each word must be acted out.

The magnificent illustrated manuscripts of the medieval period represented an enormous investment in time, talent, and materials, so it is not surprising that they were often protected with equally magnificent covers. But because these covers were themselves made of valuable materials—ivory, enamelwork, precious metals, and jewels—they were frequently reused or stolen and broken up. The elaborate book cover of gold and jewels shown in figure 14-18 was probably made between 870 and 880 at one of the monastic workshops of Charles the Bald (ruled 840–77), who inherited the portion of Charlemagne's empire that corresponds roughly to modern France after the death of his father, Louis the Pious. It is not known what book it was made for, but sometime before the sixteenth century it became the cover of a Carolingian manuscript known as the *Lindau Gospels*, which was prepared at the Monastery of Saint Gall in the late ninth century.

The Cross and the Crucifixion were common themes for medieval book covers. The Crucifixion scene on the front cover of the *Lindau Gospels* is made of gold with figures in *repoussé* relief surrounded by heavily jeweled frames. Angels hover above the arms of the cross. Over Jesus' head, hiding their faces, are figures representing the sun and moon. The graceful, expressive poses of the mourners who float below the arms of the cross reflect the style of the *Utrecht Psalter* illustrations. Jesus has been modeled in a rounded, naturalistic style suggesting classical influence, but his stiff posture and stylized drapery counter the emotional expressiveness of the other figures. He stands straight and wide-eyed with outstretched arms, announcing his triumph over death and welcoming believers into the faith.

The Carolingian empire had been divided into three parts, ruled by three grandsons of Charlemagne, in 843. Although a few monasteries and secular courts continued to patronize the arts, intellectual and artistic activity slowed. Torn by internal strife and ravaged by Viking invaders, the Carolingian empire came to a bloody and inglorious end in the ninth century.

SCANDINAVIA: THE VIKINGS

Sometime in the late eighth century seafaring bands of Scandinavians known as Vikings (*Viken* originally meant "people from the coves" but came to be synonymous with "raiders" or "pirates") began descending on the rest of Europe. Setting off in flotillas of as many as 350 ships, they explored, plundered, traded with, and colonized a vast area and were an unsettling presence in Europe in the ninth and tenth centuries. Frequently, their targets were isolated, but wealthy, Christian monasteries. The earliest recorded Viking incursions were two devastating attacks: one in 793, on the religious community on Lindisfarne, an island off the northeast coast of England, and another, in 795, at Iona, off Scotland's west coast. In France they destroyed Centula and besieged Paris in 845 and harried the northern and western coasts of Europe for the rest of the century.

The Vikings raided and settled a vast territory, anywhere their ships could sail, stretching from Iceland and Greenland, where they settled in 870 and 985, respectively, to Ireland, England, Scotland, and France; the

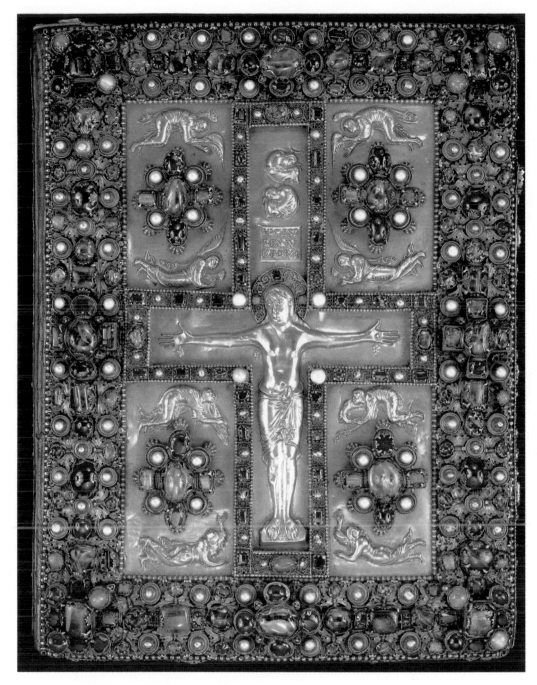

14-18. *Crucifixion with Angels and Mourning Figures*, outer cover, *Lindau Gospels*. c. 870–80. Gold, pearls, and gems, 13³/₄ x 10³/₈" (36.9 x 26.7 cm). The Pierpont Morgan Library, New York, MS 1

The jewels and pearls are arranged in a regular pattern in which pearls and smaller stones frame large jewels. All are raised from the metal plate so that they glow in the light. Gems were simply polished, not faceted, in the Middle Ages.

Viking explorer Leif Eriksson reached North America in 1000. In the early tenth century, the rulers of France bought off Scandinavian raiders (the Normans, or North men) with a large grant of land that became the duchy of Normandy. Some Viking groups also sailed down rivers to the Black Sea and Constantinople, while others, known as Rus, established settlements around Novgorod, one of the earliest cities in what would become Russia.

The Danish king Harold Bluetooth brought Christianity from Europe to Scandinavia in the middle of the ninth century. In Norway, Olaf Haraldsson (c. 995–1030, later canonized Saint Olaf) is credited with converting his people. Olaf accepted Christianity in Rouen, France, while on a Viking expedition. During the eleventh century the religion spread through the rest of the Scandinavian peninsula. Viking raids and the Viking era came to an end.

The Vikings erected large memorial stones both at home and abroad. Those covered mostly with inscriptions are called **rune stones**; those with figural decoration

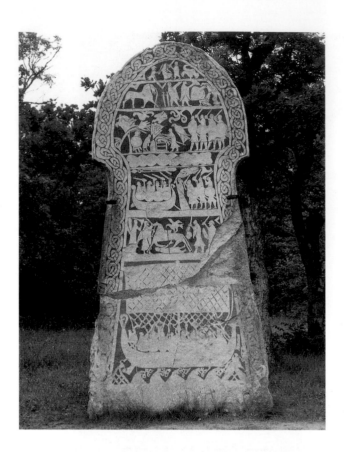

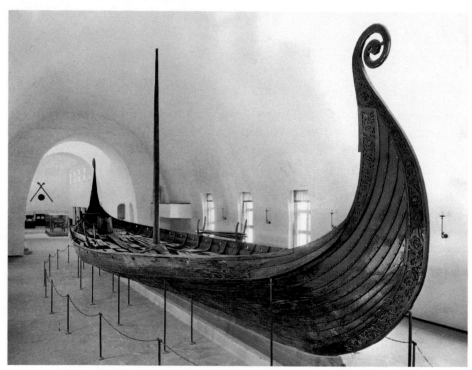

14-19. Memorial stone, Larbro Saint Hammers, Gotland, Sweden. 8th century

Much of what we know about Viking beliefs comes from later writings, especially the *Prose Edda*, compiled in the early thirteenth century by a wealthy Icelandic farmer-poet, Snorri Sturluson (1178–1241), as a guide to Norse religion and a manual for writing poetry. Among the stories he recounts is that of Gudrun and her brothers, Gunnar and Hogni, which may be the subject of the scene in the register just above the large ship on this stone. According to this legend, Gudrun was engaged to King Atli, who was interested in her only for the treasures her brothers had hidden. The scene on the stone—which shows men with raised swords on each side of a horse trampling a fallen victim and a woman with a sword boldly confronting the horse—may illustrate Gudrun and her brothers in battle against Atli. The brothers were captured in this battle and horribly murdered. Gudrun then made peace with Atli and married him, but later avenged her family's honor by serving him the hearts and blood of their children at a feast, following which she and a nephew killed Atli and burned his castle.

14-20. Burial ship, from Oseberg, Norway. Ship c. 815–20; burial 834. Wood, length 75'6" (23 m). Vikingskiphuset, Universitets Oldsaksamling, Oslo, Norway

This vessel, propelled by both sail and oars, was designed not for ocean voyages but for travel in the relatively calm waters of fjords, narrow coastal inlets. The shelter at the center of this ship was used as the burial chamber for two women, perhaps Queen Aase and a servant. A cart and four sleds, all made of wood with beautifully carved decorations, were stored on board. Fourteen horses, an ox, and three dogs had been sacrificed to accompany the women into the grave. It is also quite possible that one of the women was a willing sacrificial victim for the other, since Viking society believed that a courageous and honorable death was a guarantee of reward in the afterlife.

are called **picture stones**. Runes are twiglike letters of an early Germanic alphabet. Traces of pigments suggest that the memorial stones were originally painted in bright colors. Picture stones from Gotland, an island off the east coast of Sweden, share a common design and a common theme—heroic death in battle and the journey of the dead warriors to Valhalla (see "The Northern Deities," page 487). An eighth-century stone from Larbro Saint Hammers on Gotland has a characteristic "mushroom" shape (fig. 14-19). The scenes are organized into horizontal registers and surrounded by a band of ribbon interlace. In northern art such patterns probably were not merely decorative but carried some symbolic significance. Most of the registers show scenes of battle and scenes from Norse mythology, including rituals associated with the cult of Odin. The third register down, just above a horizontal band of interlace, depicts the ritual hanging of a willing victim in sacrifice to Odin. Directly in front of the hanged man is a burial mound, called the hall of Odin, and above it are symbols of Odin, the eagle and the triple knot.

The bottom panel shows a large Viking ship with a broad sail, intricate rigging, and a full crew sailing over foamy waves. Viking ships typically carried a 970-square-foot sail; the weaving of the sail by women took as long as the building of the ship by men. In good weather a ship could sail 200 miles in a day. In Viking iconography, ships symbolize the dead warrior's passage to Valhalla, and Viking chiefs were sometimes cremated in a ship in the belief that this hastened their ascent.

Women, too, might be honored by a seaworthy burial site. A 75-foot-long ship discovered in Oseberg, Norway, and dated 815–20 served as the vessel for two women on their journey to eternity (fig. 14-20). Although the burial chamber was long ago looted of jewelry and precious objects, the ship itself and the remaining artifacts attest to the wealth and prominence of the ship's owner (probably Queen Aase, since *Oseberg* means "Aase's mound") and have provided insight into the culture of Scandinavia in the early Middle Ages. The Vikings saw their ships as sleek sea serpents—they had represented them as such since prehistoric times—and the prow and stern of the Oseberg ship rise and coil accordingly, the spiraling prow ending with a tiny serpent head. The burial cabin contained empty chests that no doubt once held precious goods, as well as two looms, an indication of the skills of the women. The cabin walls had been covered with tapestries, fragments of which survived. Among the ship's artifacts are examples of wood carving, a major art form. Bands of animal interlace carved in low relief run along the ship's bow and stern. The animals are sturdy, broad-bodied creatures that grip each other with sharp claws.

Images of strange beasts adorned all sorts of Viking belongings—jewelry, houses, tent poles, beds, wagons, sleds—and, later, even churches. Traces of black, white, red, brown, and yellow indicate that the carved wood was painted. Found in the cabin of the Oseberg ship were several wooden animal-head posts about 3 feet long with handles, the purpose of which is unknown (fig. 14-21).

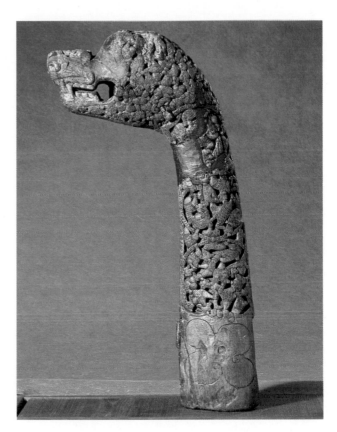

14-21. Post, from the Oseberg burial ship (see fig. 14-20). c. 815–20. Wood, length approx. 36" (92.3 cm). Vikingskiphuset, Universitets Oldsaksamling, Oslo, Norway

Although each is unique in style and design, all represent similar long-necked, grotesque, dog- or catlike creatures with bulging eyes, short muzzles, snarling mouths, and large teeth. These ferocious creatures are encrusted with a writhing mass of delicately carved beasts that clutch at each other with small, clawlike hands. This type of animal interlace, known as "gripping beasts," is a hallmark of Viking ornament. The beasts are organized into roughly circular, interlocking groups surrounded by decorated bands. The faceted cutting emphasizes the flicker of light over the densely carved surfaces. This vigorous style reinforced the tendency toward abstraction in medieval art.

OTTONIAN EUROPE

In the tenth century, a new dynasty arose in the eastern portion of the former Carolingian empire, which corresponded roughly to modern Germany and Austria. A dynasty of Saxon rulers founded by Henry the Fowler (919–36) but known as the Ottonians after its three principal figures, Otto I (ruled 936–73), Otto II (ruled 973–83), and Otto III (regency 983–96, ruled 996–1002). Henry the Fowler secured the territory by defeating the Vikings and the Magyars (Hungarians) in the 930s. Then Otto I gained control of northern Italy by marrying the Langobard queen in 951 and was crowned emperor by the pope in 962. Successors so dominated the papacy and appointments to other high Church offices that this union of Germany and Italy under a German ruler came to be known as the Holy Roman Empire.

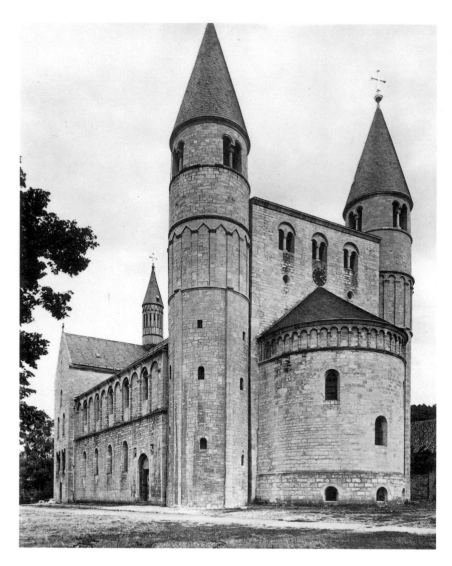

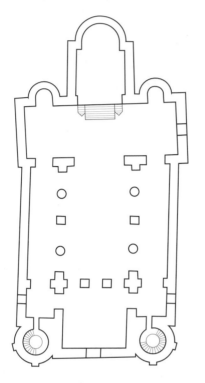

14-22. Church of Saint Cyriakus, Gernrode, Germany. Begun 961; consecrated 973

The apse seen here replaced the original westwork in the late 12th century.

14-23. Plan of the Church of Saint Cyriakus (after Broadley)

ARCHITECTURE

The Ottonian rulers, in keeping with their imperial status, sought to replicate the splendors of the Christian architecture of imperial Rome. The German court in Rome introduced northern architects to Roman architecture. Reinterpreting Roman buildings in their own local materials and time-tested techniques, the builders created a new Ottonian style. Some of their finest churches were also strongly influenced by Carolingian as well as Early Christian and Byzantine architecture.

Most of the great Ottonian buildings burned in their own time or were destroyed in later wars. One that survived was the Church of Saint Cyriakus at Gernrode, Germany (fig. 14-22). The margrave (provincial military governor) Gero founded the convent of Saint Cyriakus and commissioned the church in 961. Following the Ottonian policy of appointing relatives and close associates to important church offices, he made his widowed daughter-in-law the convent's first abbess. The church was designed as a basilica with a westwork (fig. 14-23). The choir and apse rose at the east end over the vaulted crypt. Two entrances on the south provided access to the church from the convent's cloister and dormitories. The towers and westwork that dominate the east and west ends of the church are reminiscent of similar features at Saint Riquier's. Windows, wall arcades, and **blind arcades** break the severity of the church's exterior.

The interior of Saint Cyriakus (fig. 14-24) has three levels: an arcade separating the nave from the side aisles, a gallery with groups of six arched openings, and a clerestory. The flat ceiling is made of wood and must have been painted. Galleries over aisles were used in Byzantine architecture but rarely in the West. Their function in Ottonian architecture is debated. They may have provided space for choirs as music became more elaborate in the tenth century. They may have held additional altars. They may have been simply a mark of status. The alternation of columns and rectangular piers in Saint Cyriakus creates a rhythmic effect more interesting than that of the uniform colonnades of earlier churches. Saint Cyriakus is also marked by vertical shifts in visual rhythm, with two arches on the nave level surmounted by six arches on the gallery level, surmounted in turn by three windows in the clerestory. This seemingly simple architectural aesthetic, with its rhythmic alternation of heavy and light supports, its balance of rectangular and round forms, and its combination of horizontal and vertical movement, was to inspire architects for the next 300 years, finding full expression in the Romanesque period.

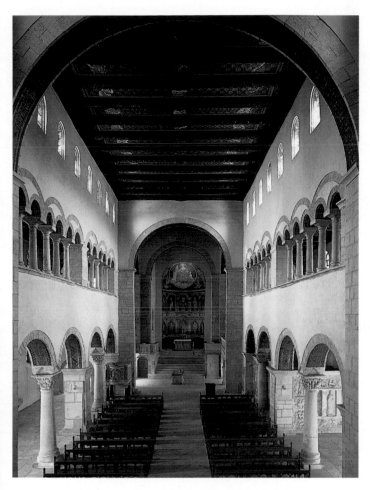

14-24. Nave, Church of Saint Cyriakus

SCULPTURE

Carved ivory panels for book covers and **diptychs** and **altarpieces** were among the products of both Carolingian and Ottonian bookmaking workshops. An Ottonian ivory plaque that shows Otto I presenting a model of the Magdeburg Cathedral to Christ may once have been part of the decoration of an altar or pulpit in the cathedral of Magdeburg, which was dedicated in 968 (fig. 14-25). Otto is the small figure holding the church on the left. Saint Maurice, the major saint in Magdeburg, wraps his arm protectively around him. Christ is seated on a wreath, which may represent the heavens, and his feet rest on an arc that may represent the earth. Saint Peter, patron of the church, faces Otto. The solemn dignity and intense concentration of the figures are characteristic of the Ottonian court style.

In the eleventh century under the last of the Ottonian rulers, Henry II and Queen Kunigunde (ruled 1002–24), Ottonian artists, drawing on Roman, Byzantine, and Carolingian models, created large sculpture in wood and bronze that would have a significant influence on later medieval art. An important patron of these sculptural works was Bishop Bernward of Hildesheim, who was himself an artist. His biographer, the monk Thangmar, described Bernward as a skillful goldsmith who closely supervised the artisans working for him. A pair of bronze doors made under his direction for the Abbey Church of

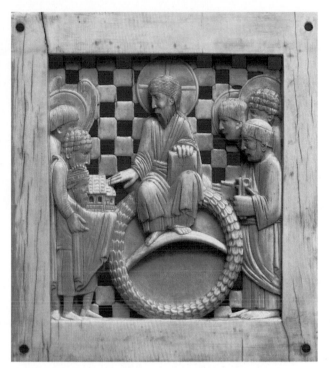

14-25. **Otto I Presenting Magdeburg Cathedral to Christ**, one of a series of 19 ivory plaques known as the *Magdeburg Ivories*. c. 962–73. Ivory, 5 x 4½" (12.7 x 11.4 cm). The Metropolitan Museum of Art, New York

Bequest of George Blumenthal, 1941 (41.100.157)

During the reign of Otto I, Magdeburg was on the edge of a buffer zone between the Ottonian empire and the pagan Slavs. In the 960s, Otto established a religious center there from which he aimed to convert the Slavs. One of the important saints of Magdeburg was Maurice, a Roman Christian commander of African troops who is said to have suffered martyrdom in the third century for refusing to worship in pagan rites. In later times, he was often represented as a dark-skinned African (see fig. 16-52). The warrior-saint appears here presenting both Otto and Magdeburg Cathedral to Christ.

Saint Michael represented the most ambitious and complex bronze-casting project since antiquity (figs. 14-26, 14-27, "The Object Speaks: The Doors of Bishop Bernward," pages 508–9). The bishop had lived for a while in Rome as tutor for Otto III and may have been inspired by the carved wooden doors of the fifth-century Church of Santa Sabina, located near Otto's palace there.

The doors' rectangular panels recall the framed miniatures in Carolingian Gospel books, and the style of the scenes within them is reminiscent of illustrations in works like the *Utrecht Psalter*. Small, extremely active figures populate spacious backgrounds. Architectural elements and features of the landscape are depicted in very low relief, forming little more than a shadowy stage for the actors in each scene. The figures stand out prominently, in varying degrees of relief, with their heads fully modeled in three dimensions. The result is lively and visually stimulating.

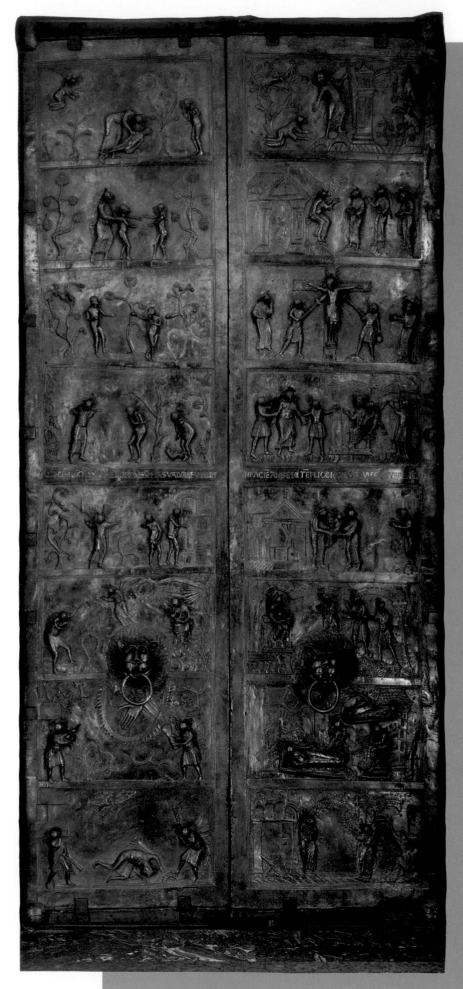

THE DOORS OF BISHOP BERNWARD

The design of the magnificent doors at Bishop Bernward's abbey church in Hildesheim, Germany, (fig. 14-26) anticipated by centuries the great sculptural programs that would decorate the exteriors of European churches in the Romanesque period. The awesome monumentality of the towering doors—nearly triple a person's height—is matched by the intellectual content of their iconography. The doors spoke eloquently to the viewers of the day and still speak to us through a combination of straightforward narrative history and subtle **typological** interrelationships, in which Old Testament themes, on the left, illuminate New Testament events, on the right (fig. 14-27). Bernward, both a scholar and a talented artist, must have designed the iconographical program himself, for only a scholar thoroughly familiar with Christian theology could have conceived it.

The Old Testament history begins in the upper left-hand panel with the Creation and continues downward to depict Adam and Eve's Expulsion from Paradise, their difficult and sorrowful life on earth, and, in the bottom panel, the tragic fratricidal story of their sons, Cain and Abel. The New Testament follows, beginning with the Annunciation at the lower right and reading upward through the early life of Jesus and his mother, Mary, through the Crucifixion to the Resurrection, symbolized by the Marys at the tomb and the meeting of Christ and Mary Magdalen in the garden.

The way the Old Testament prefigured the New in scenes paired across the doors is well illustrated, for example, by the third panels down. On the left, we see the Temptation and Fall of Adam and Eve in the Garden of Eden, believed to be the source of human sin, suffering, and death. This panel is paired on the right with the Crucifixion of Jesus, whose suffering and sacrifice redeemed humankind, atoned for Adam and Eve's Original Sin, and brought the promise of eternal life. Another example is the recurring pairing of "the two Eves": Eve, who caused humanity's Fall and Expulsion from Paradise and whose son Cain committed the first murder, and Mary, the "new Eve," through whose son, Jesus, salvation will be granted. In one of the clearest juxtapositions, in the sixth panel down, Eve and Mary are almost identical figures, each holding her first-born son; thus Cain and Jesus (evil and goodness) are also paired.

14-26. Doors of Bishop Bernward, made for the Abbey Church of Saint Michael, Hildesheim, Germany. 1015. Bronze, height 16'6" (5 m)

LEFT DOOR read down ↓ OLD TESTAMENT (Genesis)	THEMATIC COMPARISONS	RIGHT DOOR read up ↑ NEW TESTAMENT (Gospels)	
LIFE IN PARADISE Creation of Adam	PARADISE LOST VS. PARADISE GAINED	The Ascension	**PROMISE OF RETURN TO PARADISE**
Eve presented to Adam	GREETINGS	Women at the Tomb	
THE FALL Temptation and Fall	TREE OF KNOWLEDGE (SIN) VS. TREE OF LIFE (THE CROSS, SALVATION)	The Crucifixion	**THE PASSION**
Accusation and Judgment of Adam and Eve	JUDGMENT	Judgment of Christ by Pilate	
LIFE IN THE WORLD Expulsion from Paradise	SEPARATION FROM GOD VS. REUNION WITH GOD	Presentation of Jesus in Temple	**INFANCY OF JESUS**
Arduous life on earth	FIRSTBORN SONS OF EVE (CAIN) AND MARY (JESUS); POVERTY VS. WEALTH	Gifts of the Magi	
EVE'S CHILDREN Offerings by Cain (grain) and Abel (lamb)	ABEL'S SACRIFICAL LAMB VS. JESUS, LAMB OF GOD	The Nativity	**MARY'S CHILD**
Abel murdered by Cain	DESPAIR, SIN, MURDER VS. HOPE AND EVERLASTING LIFE	The Annunciation (Incarnation)	

14-27. Schematic diagram of the message of the Doors of Bishop Bernward

14-28. *Gero Crucifix*, from Cologne Cathedral, Germany. c. 970. Painted and gilded wood, height of figure 6'2" (1.87 m)

This lifesize sculpture is both a crucifix to be suspended over an altar and a special kind of reliquary. A cavity in the back of the head was made to hold a piece of the Host, or communion bread, already consecrated by the priest. Consequently, the figure not only represents the body of the dying Jesus but also contains within it the body of Christ obtained through the Eucharist.

Another treasure of Ottonian sculpture is the *Gero Crucifix*, one of the few large works of carved wood to survive from that period (fig. 14-28). Archbishop Gero of Cologne (served 969–76) commissioned the sculpture and presented it about 970 to his cathedral. The figure of Jesus is more than 6 feet tall and is made of painted and gilded oak. The focus here, following Byzantine models, is on Jesus' suffering. He is shown as a tortured martyr, not, as on the cover of the *Lindau Gospels* (see fig. 14-18), a triumphant hero. The intent is to inspire pity and awe in the viewer. Jesus' broken body sags on the cross and his head falls forward, eyes closed. The straight, linear fall of his golden drapery heightens the impact of his drawn face, emaciated arms and legs, sagging torso, and limp, bloodied hands. In this image of distilled anguish, the miracle and triumph of Resurrection seem distant indeed.

BOOKS

Great variation in style and approach is characteristic of book illustration in the Ottonian period. Artists worked in widely scattered centers, using different models or sources of inspiration. The *Liuthar* (or *Aachen*) *Gospels*, made for Otto III around 1000, is the work of the so-called Liuthar School, named for the scribe or patron responsible for the book. The center of this school was probably a monastic *scriptorium* in the vicinity of Reichenau or Trier. The dedication page of the *Liuthar Gospels* (fig. 14-29) is as much a work of imperial propaganda as the ancient Roman *Gemma Augustea* (see fig. 6-25). It establishes the divine underpinnings of Otto's authority and depicts him as a near-divine being himself. He is shown enthroned in heaven, surrounded by a

mandorla and symbols representing the evangelists. The Hand of God descends from above to place a crown on his head. Otto's arms are extended in an all-embracing gesture, and he holds the Orb of the World surmounted by a cross in his right hand. His throne, in a symbol of his worldly dominion, rests on the crouching Tellus, the personification of earth. In what may be a reference to the dedication on the facing page—"With this book, Otto Augustus, may God invest thy heart"—the evangelists represented by their symbols hold a white banner across the emperor's breast, dividing body, below, from soul (heart and head), above.

On each side of Otto is an emperor bowing his crowned head toward him. These may represent his Ottonian predecessors or subordinate rulers acknowledging his sovereignty. The bannered lances they hold may allude to the Ottonians' most precious relic, the Holy Lance, believed to be the one with which the Roman soldier Longinus pierced Jesus' side. In the lower register, two warriors face two bishops, symbolizing the union of secular and religious power under the emperor.

A second Gospel book made for Otto III in the same *scriptorium* illustrates the painters' narrative skill. In an episode recounted in Chapter 13 of the Gospel according to John (fig. 14-30), Jesus, on the night before his crucifixion, gathers his disciples together to wash their feet. Peter, feeling unworthy, at first protests. The painting shows Jesus in the center, larger than the other figures, extending an elongated arm and hand in blessing toward

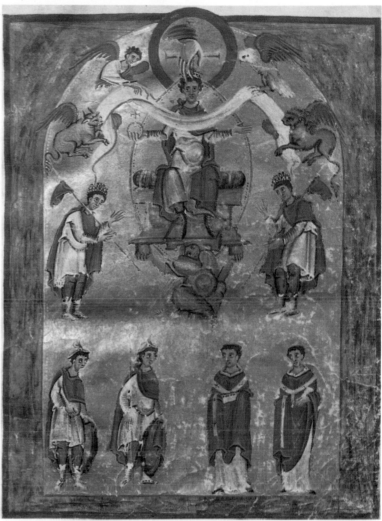

14-29. Page with *Otto III Enthroned*, *Liuthar Gospels (Aachen Gospels)*. c. 1000. Ink and colors on vellum, 10⁷/₈ x 8¹/₂" (27.9 x 21.8 cm). Cathedral Treasury, Aachen

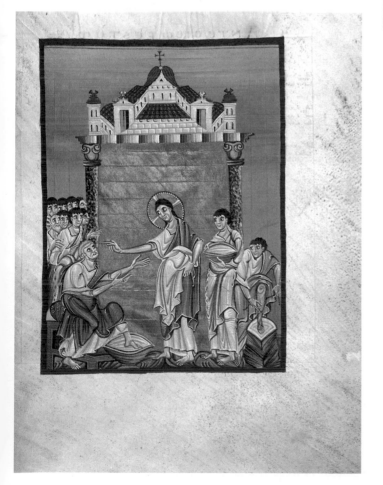

14-30. Page with *Christ Washing the Feet of His Disciples*, *Gospels of Otto III*. c. 1000. Ink and colors on vellum, approx. 8 x 6" (20.5 x 14.5 cm). Staatsbibliothek, Munich (CLM 4453)

The washing of the disciples' feet, as told in John 13, was a human gesture of hospitality, love, and humility as well as a symbolic transfer of spiritual power from Jesus to his "vicars," who would remain on earth after his departure to continue his work. At the time this manuscript was made, both the Byzantine emperor and the Roman pope practiced the ritual of foot-washing once a year, following the model provided by Jesus: "If I, therefore, the master and teacher, have washed your feet, you ought to wash one another's feet" (13:14). The pope still carries out this ritual, washing the feet of twelve priests every Maundy Thursday, the day before Good Friday.

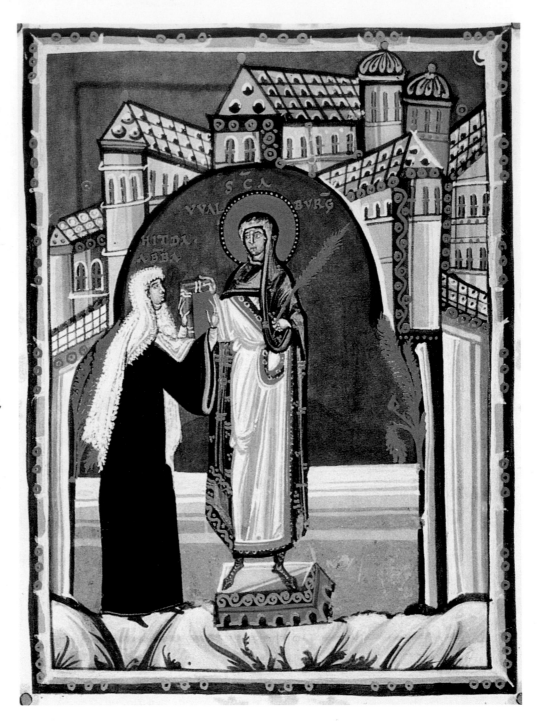

14-31. **Presentation page with *Abbess Hitda and Saint Walpurga*,** *Hitda Gospels.* Early 11th century. Ink and colors on vellum, 11³/₈ x 5⁵/₈" (29 x 14.2 cm). Hessische Landes- und-HochschulBibliothek, Darmstadt, Germany

the elderly apostle. Peter, his foot in a basin of water, reaches toward Jesus with similarly elongated arms. Gesture and gaze carry the meaning in Ottonian painting: The two figures fix each other with a wide-eyed stare. A disciple on the far right unbinds his sandals, and another, next to him, carries a basin of water. Eight other disciples look on from the left. The light behind Jesus has turned to gold, which is set off by buildings suggesting the Heavenly Jerusalem.

Elaborate architecture also provides the setting for a very different image, the presentation page of a Gospel book made for Hitda (d. 1041), the abbess of the convent at Meschede, near Cologne, in the early eleventh century. The abbess offers her book to Saint Walpurga, her convent's patron saint (fig. 14-31). The artist has arranged the architecture of the convent in the background to frame the figures and draw attention to their transaction. The size of the convent underscores the abbess's position of authority. The foreground setting—a rocky, uneven strip of ground—is meant to be understood as holy ground, separated from the rest of the world by the huge arch-shaped aura and golden trees that silhouette Saint Walpurga. The painter conveys a sense of spirituality and contained but deeply felt emotion, rather than the austere grandeur of the Ottonian court.

These manuscript paintings summarize the high intellectual and artistic qualities of Ottonian art. Ottonian artists drew inspiration from the past to create a monumental style for a Christian, German-Roman empire. From the groundwork laid during the early medieval period emerged the arts of the Romanesque and Gothic periods in western Europe.

PARALLELS

CULTURAL CENTER	EARLY MEDIEVAL ART IN EUROPE	ART IN OTHER CULTURES
BRITISH ISLES c. 500–1000	14-3. *Sutton Hoo purse cover* (c. 615–30) 14-4. *Gospel Book of Durrow* (c. 675) 14-5. **South Cross** (8th cent.) 14-1. *Book of Kells* (8th/9th cent.)	7-35. *Book of Genesis* (early 6th cent.), Syria 7-26. **Church of San Vitale** (526–47), Italy 7-22. **Hagia Sophia** (532–37), Turkey 9-21. **Shiva cave-temple** (mid-6th cent.), India 7-36. *Rabbula Gospels* (586), Syria 10-13. **Amitaba altar** (593), China 11-4. *Haniwa* (6th cent.), Japan 11-7. *Shaka Triad* (c. 623), Japan 12-11. **Lord Pacal sarcophagus** (mid-7th cent.), Mexico 8-2. **Dome of the Rock** (687–91), Jerusalem 10-14. *Camel Carrying a Group of Musicians* (c. mid-8th cent.), China 10-17. **Great Wild Goose Pagoda** (mid-8th cent.), China 8-6. **Córdoba mosque** (begun 785/6), Spain 12-13. **Chacmool** (9th–13th cent.), Mexico 11-10. *Mandala* (late 9th cent.), Japan 12-1. **Pueblo Bonito** (c. 900–1230) North America 7-51. *Joshua Roll* (c. 950), Turkey 10-19. Fan. *Travelers among Mountains and* *Streams* (early 11th cent.), China 8-17. **Griffin** (11th cent.), Islamic Mediterranean
SCANDINAVIA c. 500–1100	14-2. **Gummersmark brooch** (6th cent.) 14-19. **Memorial stone** (8th cent.) 14-20. **Burial ship** (c. 815–20)	
CHRISTIAN SPAIN c. 500–1000	14-6. **Church of Santa Maria de Quintanilla de las Viñas, Burgos** (late 7th cent.) 14-8. **Emeterius and Ende. Beatus and Jerome commentaries** (975)	
LANGOBARD ITALY c. 568–774	14-9. **Brescia cross** (late 7th–early 9th cent.)	
CAROLINGIAN EUROPE c. 768–877	14-15. *Godescalc Evangelistary* (781–83) 14-12. **Palace Chapel of Charlemagne, Aachen** (792–805) 14-10. **Abbey Church of St. Riquier** (799) 14-16. *Ebbo Gospels* (c. 816–35) 14-17. *Utrecht Psalter* (c. 816–35) 14-13. **Abbey of St. Gall** (c. 817) 14-18. *Lindau Gospels* (c. 870–80)	
OTTONIAN EUROPE c. 919–1002	14-22. **Church of Cyriakus, Gernrode** (begun 961) 14-25. *Magdeburg Ivories* (c. 962–73) 14-28. *Gero Crucifix* (c. 970) 14-29. *Liuthar Gospels* (c. 1000) 14-30. *Gospels of Otto III* (c. 1000) 14-26. **Doors of Bishop Bernward, Hildesheim** (1015) 14-31. *Hitda Gospels* (early 11th cent.)	

15-1. Reliquary statue of Saint Foy (Saint Faith), made in the Auvergne region, France, for the Abbey Church of Conques, Rouergue, France. Late 10th–11th century. Gold repoussé and gemstones over wood core (incorporating a Roman helmet and Roman cameos; later additions 12th–19th centuries), height 33" (85 cm). Cathedral Treasury, Conques, France

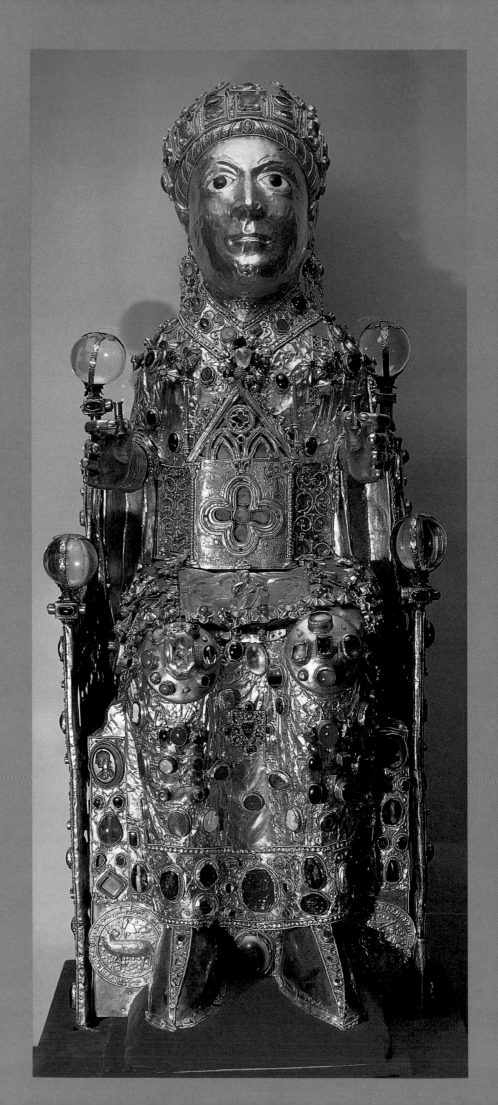

15 ROMANESQUE ART

During the late Middle Ages, people in western Europe once again began to travel in large numbers as traders, soldiers, and Christians on pilgrimages. Pilgrims throughout history have journeyed to holy sites—the ancient Greeks to Delphi, early Christians to Jerusalem and to Rome, Muslims to Mecca—but in the eleventh century, pilgrimages to the holy places of Christendom dramatically increased, despite the great financial and physical hardships they entailed (see "The Pilgrim's Journey," page 518).

As difficult and dangerous as these journeys were, rewards awaited the courageous travelers along the routes, even before they reached their destination. Pilgrims could stop along the way to venerate local saints through their relics and visit the places where miracles were believed to have taken place. Relics—bodies of saints, parts of bodies, or even things owned by saints—were thought to have miraculous powers, and they were kept in richly decorated reliquaries.

Having and displaying the relics of saints so enhanced the prestige and wealth of a community that people went to great lengths to acquire them, not only by purchase but also by theft. In the ninth century, for example, the monks of Conques stole the relics of the child martyr Saint Foy ("Saint Faith") from her shrine at Saint-Agens. Such a theft was called holy robbery, for the new owners insisted that the saint had encouraged them because she wanted to move. The monks of Conques encased their relic—the skull of Saint Foy—in a jewel-bedecked gold statue whose head was made from a Roman parade helmet (fig. 15-1).

To accommodate the faithful and instruct them in Church doctrine, many monasteries on the major pilgrimage routes built large new churches and filled them with sumptuous altars, crosses, and reliquaries. Sculpture and paintings on the walls illustrated important religious stories and doctrines and served to instruct as well as fascinate the faithful. These awe-inspiring works of art and architecture, like most of what has come down to us from the Romanesque period, had a Christian purpose. One monk wrote that by decorating the church "well and gracefully" the artist showed "the beholders something of the likeness of the paradise of God" (Theophilus, page 79).

▲ c. 1066 WILLIAM II OF NORMANDY INVADES ENGLAND c. 1095–99 FIRST CRUSADE ▲

▲ c. 1075 INVESTITURE CONTROVERSY 1098 CISTERCIAN ▲
ORDER FOUNDED

TIMELINE 15-1. The century between 1050 and 1150 in Europe is identified as the Romanesque period.

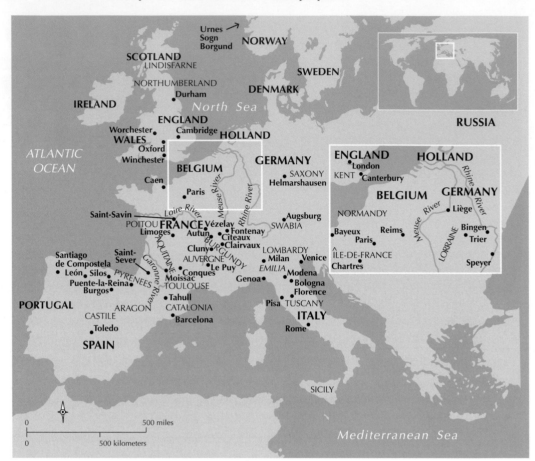

MAP 15-1. Romanesque Art. The term *Romanesque* is now applied to all the arts in Europe between the mid-eleventh and late-twelfth centuries.

ROMANESQUE CULTURE

Romanesque means "in the Roman manner," and the term applies specifically to an eleventh- and twelfth-century European style. The word was coined in the early nineteenth century to describe European church architecture of the eleventh and twelfth centuries, which displayed the solid masonry walls, rounded arches, and masonry vaults characteristic of imperial Roman buildings. Soon the term was applied to all the arts of the period from roughly the mid-eleventh to the late-twelfth century, even though the art reflects influences from many sources, including the Byzantine and Islamic empires and early medieval Europe, as well as imperial Rome.

At the beginning of the eleventh century, Europe was still divided into many small political and economic units ruled by powerful families. The nations we know today did not exist (Map 15-1). The king of France ruled only a small area around Paris. France had close linguistic and cultural ties to northern Spain. The duke of Normandy (a former Viking who controlled the northwest coast) and the duke of Burgundy paid the French king only token homage. By the end of the twelfth century, however, the lands in the Île-de-France region around Paris were beginning to emerge as the core of a

national state. After the Norman conquest of Anglo-Saxon Britain in 1066, the Norman duke became the English king, and England, too, became a nation. In Germany and northern Italy (collectively, the Holy Roman Empire), in contrast, the power of local rulers and towns ultimately prevailed against the attempts of the German emperor to impose a central authority. These regions remained politically fragmented until the nineteenth century. Sicily and southern Italy, previously in the hands of Byzantine and Islamic rulers, fell under the control of the Normans.

Europe remained an agricultural society, with land the primary source of wealth and power. In many regions the feudal system (at its simplest, an exchange of land for service) that had developed in the early Middle Ages governed social and political relations. In this system, a landowning lord granted some of his property to a subordinate, a vassal, offering the vassal protection and receiving in return the vassal's allegiance and promise of military service as an armed knight. Vassals, in turn, could grant part of their holdings to their own vassals.

The economic foundation for this political structure was the manor, an agricultural estate in which peasants worked in exchange for a place to live, food, military protection, and other services from the lord. Feudal estates,

community-based and almost entirely self sufficient, became hereditary over time. Economic and political power thus came to be distributed through a network of largely inherited but constantly shifting allegiances and obligations that defined relations among lords, vassals, and peasants. Women generally had a subordinate position in this hierarchical, military social system. When necessary, however, aristocratic women took responsibility for managing estates in their male relatives' frequent absences on military missions or pilgrimages. They could also achieve positions of authority and influence as the heads of religious communities. Among peasants and artisans, women and men often worked side by side.

In the early Middle Ages, church and state had forged an often fruitful alliance. Christian rulers helped assure the spread of Christianity throughout Europe and supported monastic communities and Church leaders, who were often their relatives, with grants of land. The Church, in return, provided rulers with crucial social and spiritual support, and it supplied them with educated officials. As a result, secular and religious authority became tightly intertwined. In the eleventh century, the papacy sought to make the Church independent of lay authority and so sparked a conflict known as the Investiture Controversy with secular rulers over the right to "invest" Church officials with the symbols of office.

In the eleventh and twelfth centuries, Christian Europe, previously on the defensive against the expanding forces of Islam, became the aggressor. In Spain the armies of the Christian north were increasingly successful against the Islamic south. In 1095, Pope Urban II, responding to a request for help from the Byzantine emperor, called for a Crusade to retake Jerusalem and the Holy Land (see "The Crusades," below). This First Crusade succeeded in establishing a short-lived Christian state in Palestine. Although subsequent Crusades were, for the most part, military failures, the crusading movement as a whole had far-reaching cultural and economic consequences. The West's direct encounters with the more sophisticated material culture of the Islamic world and the Byzantine Empire created a demand for goods from the East. This in turn helped stimulate trade,

and with it the rise of an increasingly urban society. An increase in trade during the eleventh and twelfth centuries promoted the growth of towns, cities, and an urban class of merchants and artisans.

Western scholars rediscovered many classical Greek and Roman texts that had been preserved for centuries in Islamic Spain and the eastern Mediterranean. The combination of intellectual ferment and increased financial resources enabled the arts to flourish. The first universities were established at Bologna (eleventh century) and Paris, Oxford, and Cambridge (twelfth century). This renewed intellectual and artistic activity has been called the twelfth-century "renaissance," a cultural "rebirth." Monastic communities continued to be powerful and influential in Romanesque Europe, as they had been in the early Middle Ages. Some monks and nuns were highly regarded for their religious devotion, for their learning, as well as for the valuable services they provided, including taking care of the sick and destitute, housing travelers, and educating the laity in monastic schools. Because monasteries were major landholders, they were part of the feudal power structure. The children of aristocratic families who joined religious orders also helped forge links between monastic communities and the ruling elite. As life in Benedictine communities grew increasingly comfortable, reform movements arose within the order itself. The first of these reform movements originated in the abbey of Cluny, founded in 910 in present-day east-central France. In the twelfth century, the Cistercians, another monastic order, provided spiritual reform.

FRANCE AND NORTHERN SPAIN

For most of the Romanesque period, power in France was divided among the nobility, the Church, and the kings of the Capetian dynasty, the successors in France to the Carolingians (Chapter 14). Centralized royal power was negligible in the eleventh century; the duchy of Burgundy was stronger than the Crown until the beginning of the twelfth century, when the Capetian kings began to consolidate their authority in the Île-de-France.

THE CRUSADES

Despite the schism within the Church (see "Rome, Constantinople, and Christianity," page 292), the emperor in Constantinople turned to the pope for help when his territories were besieged by conquering Turks, a Muslim people from Central Asia. The Western Church responded in 1095 by launching the Crusades, a series of military expeditions against Muslim powers.

This First Crusade, advocated by Pope Urban II (papacy 1088–99) and involving primarily the lesser nobility of France, was the only successful Crusade, concluding with the capture of Jerusalem in 1099. Eventually, in the Fourth Crusade (1202–4), Western Christian Crusaders turned against Eastern Christians as well, plundered Constantinople, and established their own rule there, which was not overturned until 1261.

THE PILGRIM'S JOURNEY

In Western Europe the eleventh and twelfth centuries saw an explosive growth in the popularity of religious pilgrimages. The rough roads that led to the most popular destinations—the Constantinian churches of Rome, the Church of the Holy Sepulchre in Jerusalem, and the Cathedral of Santiago de Compostela (Saint James at Compostela) in the northwest corner of Spain—were often crowded with pilgrims, who had to contend at times with bandits and dishonest innkeepers and merchants. Journeys could last a year or more.

The stars of the Milky Way, it was said, marked the way to Santiago de Compostela (see fig. 00, Introduction). Still, a guidebook helped, and in the twelfth century the priest Aymery Picaud wrote one for pilgrims on their way to the great shrine through what is now France. In Picaud's time, four main pilgrimage routes crossed France, merging into a single road in Spain at Puente-la-Reina and leading on from there through Burgos and León to Compostela. Conveniently spaced monasteries and churches offered food and lodging. Roads and bridges were maintained by a guild of bridge builders and guarded by the Knights of Santiago.

Picaud described the best-traveled routes and most important shrines to visit along the way. Chartres, for example, housed the tunic that the Virgin was said to have worn when she gave birth to Jesus. At Vézelay were the bones of Saint Mary Magdalen, and at Conques, those of Saint Foy (see fig. 15-1). Churches associated with miraculous cures—Autun, for example, which claimed to house the bones of Saint Lazarus, raised by Jesus from the dead—were filled with the sick and injured praying to be healed.

Like travel guides today, Picaud's book also provided shopping tips, advice on local customs, comments on food and the safety of drinking water, and pocket dictionaries of useful words in the languages the pilgrim would encounter en route. His warnings about the people who prey on travelers seem all too relevant today.

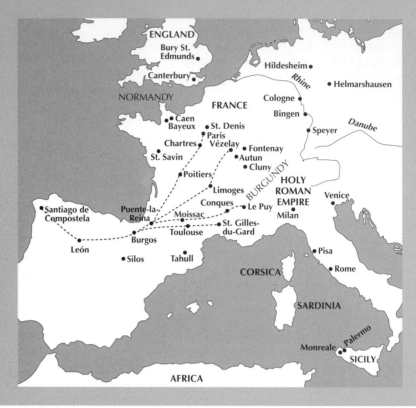

The Iberian peninsula (present-day Spain and Portugal) remained divided between Muslim rulers in the south and Christian rulers in the north. The power of the Christian rulers was growing, however. Their long struggle with the Muslims had heightened their religious fervor, and they joined forces to extend their territory southward throughout the eleventh and twelfth centuries. The Christians in 1085 reconquered the Muslim capital and stronghold Toledo, a center of Islamic and Jewish culture in the kingdom of Castile. Toledo would remain an oasis of concord between Christians, Muslims, and Jews until the early twelfth century. Its scholars played an important role in the transmission of classical writings to the rest of Europe, contributing to the cultural renaissance of the twelfth century.

ARCHITECTURE

The eleventh and twelfth centuries were a period of great building activity in Europe. Castles, manor houses, churches, and monasteries arose everywhere. As one eleventh-century monk noted, "Each people of Christendom rivaled with the other, to see which should worship in the finest buildings. The world shook herself, clothed everywhere in a white garment of churches" (Radulphus Glaber, cited in Holt, *A Documentary History of Art*, I, page 18). That labor and funds should have been committed on such a scale to monumental stone architecture at the same time as the Crusades and in a period of frequent domestic warfare seems extraordinary today. The buildings that still stand, despite the ravages of weather, vandalism, neglect, and war, testify to the power of religious faith and local pride.

In one sense, Romanesque churches were the result of master builders solving the problems associated with each individual project: its site, its purpose, the building materials and work force available, the builders' own knowledge and experience, and the wishes of the patrons providing the funding. The process was slow, often requiring several different masters and teams of masons over the years. The churches nevertheless exhibit an overall unity and coherence, in which each element is part of a geometrically organized, harmonious whole.

Like Carolingian churches, the basic form of the Romanesque church derives from earlier churches inspired by Early Christian **basilicas**. Romanesque builders made

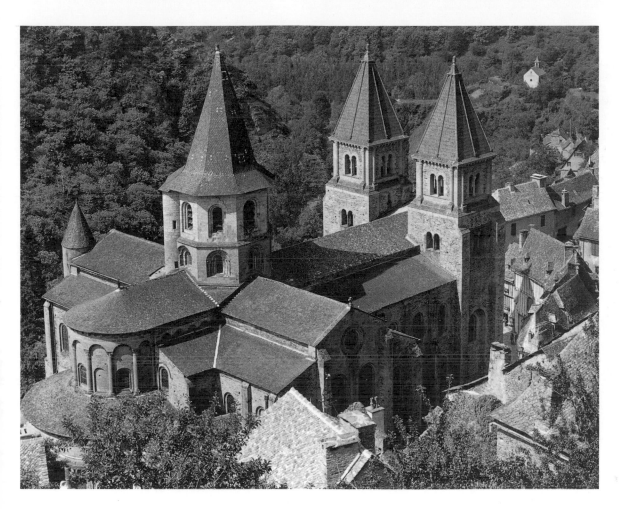

15-2. Abbey Church of Sainte-Foy, Conques, Rouergue, France. Mid-11th–12th century. Western towers rebuilt in the 19th century; crossing tower rib-vaulted in the 14th century, restored in the 19th century. View from the northeast

The contrast of nave and transepts, as well as the apse and lower ambulatory, are clearly seen in this exterior view, which supports a French scholar's characterization of Romanesque architecture as "additive."

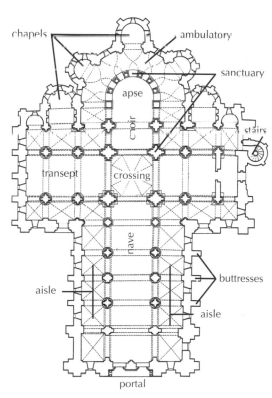

15-3. Plan of Abbey Church of Sainte-Foy

several key structural advances and changes in this form. Stone masonry **vaulting** replaced wooden roofs, increasing the protection from fire and improving the acoustics for music. The addition of **ribs**—curved and usually projecting stone members—as structural elements to both barrel

vaults and groin vaults permitted builders more flexibility in laying out interior space (see "Rib Vaulting," page 561). Masonry **buttresses** reinforced walls at critical points. The introduction of an **ambulatory** (walkway) around the apse allowed worshipers to reach additional, radiating chapels and to view relics displayed there. Builders of Romanesque churches emphasized the symbolic importance of towers, especially over the **crossing** and the west facade (the entrance to the church and, by extension, the gateway to paradise). This new form arose along the pilgrimage routes to the Cathedral of Saint James in Santiago de Compostela, in Spain (see "The Pilgrim's Journey, opposite). Pilgrims entering the north transept **portal** large doorway—(approach from the town was through the south transept portal) found themselves in a space as long as the nave. The builder laid out Saint James's to accommodate hordes of pilgrims, for besides the immense **transept** he created a two-story, barrel-vaulted nave with **galleries** over the side aisles and engaged half columns with foliate capitals inspired by ancient **Corinthian** capitals (see fig. 00, Introduction).

Another pilgrimage church, the Benedictine Abbey Church of Sainte-Foy, perches on a hillside at Conques in south-central France (fig. 15-2). Here pilgrims venerated the golden reliquary containing the remains of a child saint (see fig. 15-1). The original **cruciform** (cross-shaped) plan with a wide, projecting transept was typical of Romanesque pilgrimage churches (fig. 15-3). At the west a portal opens directly into the broad nave. The west portals of the largest churches, such as this, have three doors, the central one leading into the nave and the flanking

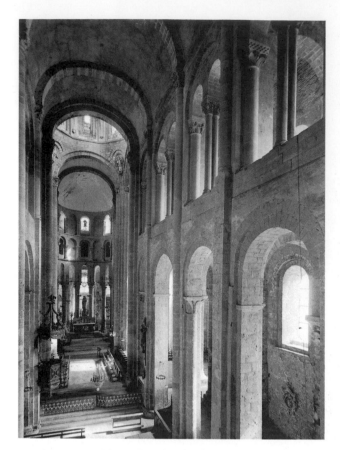

15-4. Nave, Abbey Church of Sainte-Foy. c. 1120

doors into the side aisles. The elongated **sanctuary** encompasses the **choir** and the **apse**, with its surrounding ambulatory and ring of chapels.

The building is made of local sandstone that has weathered to a golden color. Light enters indirectly through windows in the outer walls of the aisles and upper-level galleries (fig. 15-4). The galleries replace the **clerestory** along the side aisles and overlook the nave. Ribbed barrel vaults cover the nave, groin vaulting spans the side aisles, and half-barrel or quadrant vaulting, the arc of which is one-quarter of a circle, covers the galleries. The vaults over the galleries help strengthen the building by carrying the outward thrust of the nave vaults to the outer walls and buttresses.

The solid masonry piers that support the nave arcade have attached half columns on all four sides. This type of support, known as a **compound pier**, gives sculptural form to the interior and was a major contribution of Romanesque builders to architectural structure and aesthetics. Compound piers helped organize the architectural space by marking off the individual square, vaulted bays. Conques's square crossing is lit by an open, octagonal **lantern** tower resting on **squinches**. Light streaming in from the lantern and apse windows acted as a beacon, directing the worshipers' attention forward. During the Middle Ages the laity stood in the nave, separated from the priests and monks, who celebrated Mass in the choir.

Pilgrims arrived at Conques weary after many days of difficult travel through dense woods and mountains,

probably grateful to Saint Foy if they had been protected against bandits on the way. They no doubt paused in front of the west entrance to study its portal sculpture, a notable feature of Romanesque pilgrimage churches. Portal sculpture communicated the core doctrines of the Church to those who came to read its messages. At Conques, the Last Judgment in the **tympanum** (the **lunette** over the doorway) marked the passage from the secular world into the sacred world within the church. Inside, the walls resounded with the music of the plainsong, also called Gregorian chant after Pope Gregory I (papacy 590–604). The Benedictines spent eight-and-a-half to ten hours a day in religious services. Today they still spend two-and-a-half to three hours.

A different Romanesque architecture could be found at the Abbey Church of Cluny in Burgundy, founded in 909 as a reformed Benedictine monastery. Cluny had a special independent status, its abbot answering directly to the pope in Rome rather than to the local bishop and feudal lord. This unique freedom, jealously safeguarded by a series of long-lived and astute abbots, enabled Cluny to become influential and prosperous in the eleventh and early twelfth centuries. Cluniac reform spread to other monasteries within Burgundy, to the rest of France, Italy, Germany, and beyond. Cluny attracted the patronage of successive rulers, as well as the favor of the pope in Rome. By the second half of the eleventh century, there were some 300 monks in the abbey at Cluny alone. Cluny founded more than 200 priories (monasteries dependent on Cluny) in other locations—many along pilgrimage routes—and many more houses were loosely affiliated with it. At the height of its power, 1,450 monasteries answered to the strong central administration of the abbot of Cluny.

Cluniac monks and nuns dedicated themselves to the scholarly and artistic interests of their order. Most important was the celebration of the eight Hours of the Divine Office, including prayers, scripture readings, psalms and hymns, and the Mass, the symbolic rite of the Last Supper, celebrated after the third hour (*terce*). They depended for support on the labor of laymen and laywomen. Cluny's extensive landholdings, coupled with gifts of money and treasure, made it wealthy. Cluny and its affiliates were among the major patrons of art in Western Europe.

The great Hugh de Semur, abbot of Cluny for sixty years (1049–1109), began a new church at Cluny in 1088 with the help of financing from King Alfonso VI of León and Castile in northern Spain (ruled 1065–1109). Known to art historians as Cluny III (because it was the third building at the site), it was the largest church in Europe when it was completed in 1130 (fig. 15-5). Richly carved, painted, and furnished, it was described by a contemporary observer as the work of angels. Music and art were densely interwoven in Cluniac life, shaped by the Cluniac conception of the House of God. The proportions of Cluny III were based on harmonic relationships discussed in ancient Greek musical theory and mathematics. The towering barrel vaulting—98 feet high with a span of about 40 feet in a space more than 450 feet long from end

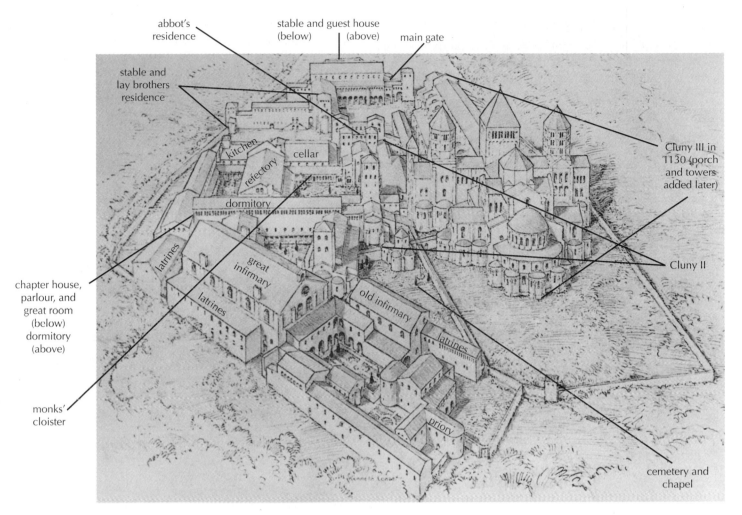

abbot's residence

stable and guest house (below) (above)

main gate

stable and lay brothers residence

kitchen

cellar

refectory

dormitory

Cluny III in 1130 (porch and towers added later)

latrines

great infirmary

chapter house, parlour, and great room (below) dormitory (above)

latrines

old infirmary

latrines

Cluny II

monks' cloister

priory

cemetery and chapel

15-5. Reconstruction drawing of the Abbey (Cluny III), Cluny, Burgundy, France. 1088–1130. View from the east (after Conant)

The Cluny complex expanded to accommodate its increasing responsibilities and number of monks until it was 6,351 feet long. In K. J. Conant's drawing of Cluny III, the abbey church (on the right) dominates the buildings, which are loosely organized around cloisters and courtyards. As at Saint Gall's (see fig. 14-13), the cloisters link buildings and provide private space for the monks; the two principal cloisters—for choir monks and for novices—are to the south (left of the church in the drawing). The abbot's residence, guesthouse, workrooms, and infirmary all have courtyards.

to end—enhanced the sound of the monks' chants. Sculpture, too, picked up the musical theme: Carvings on two surviving column capitals depict personifications of the eight modes of the plainsong. The hallmarks of Cluniac churches were functional design, skillful masonry technique, and the assimilation of elements from Roman and early medieval architecture and sculpture. Individual Cluniac monasteries, however, were free to follow regional traditions and styles; consequently Cluny III was widely influential, though not copied exactly.

Several new religious orders devoted to an austere spirituality arose in the late eleventh and early twelfth centuries. Among these were the Cistercians, another reform group within the Benedictine order. The Cistercians turned away from Cluny's elaborate liturgical practices and emphasis on the arts to a simpler monastic life. The order was founded in the late eleventh

century at Cîteaux (*Cistercium* in Latin, hence the order's name), also in Burgundy. Led by the commanding figure of Abbot Bernard of Clairvaux (abbacy 1115–54), the Cistercians thrived on strict mental and physical discipline. They settled and reclaimed vast tracts of wilderness. In time, their enterprises stretched from present-day Russia to Ireland, and by the end of the Middle Ages there were approximately 1,500 Cistercian abbeys, half of which were for women. Although their very success eventually undermined their austerity, they were able for a long time to sustain a way of life devoted to prayer and intellectual pursuits combined with shared manual labor. Like the Cluniacs, however, they depended on the assistance of laypersons.

Early Cistercian architecture reflects the ideals of the order. The Abbey Church of Notre-Dame at Fontenay, begun in 1139, is the oldest surviving Cistercian structure

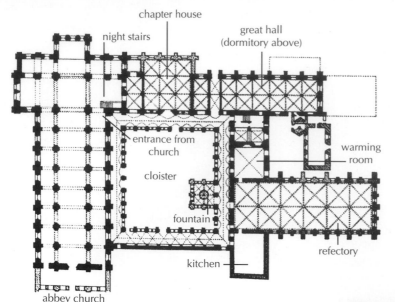

15-6. Plan of the Abbey of Notre-Dame, Fontenay, Burgundy, France. 1139–47

Always practical, the Cistercians made a significant change to the already very efficient monastery plan. They placed the refectory parallel to the dormitory and at a right angle to the cloister walk so that the two buildings could easily be extended should the community grow. The cloister fountain was moved from its usual central location to the side of the cloister directly in front of the refectory, conveniently located for washing.

15-7. Nave, Abbey Church of Notre-Dame, Fontenay. 1139–47

The pointed arch began to be used in northwestern Europe in the Romanesque period. It may have derived from Islamic buildings in southern Europe. Pointed arches are structurally more stable than round ones, directing more weight down into the floor instead of outward to the walls, and they can span greater distances at greater heights without collapsing. Pointed arches narrow the eye's focus and draw it upward, an effect intended to direct thoughts toward heaven.

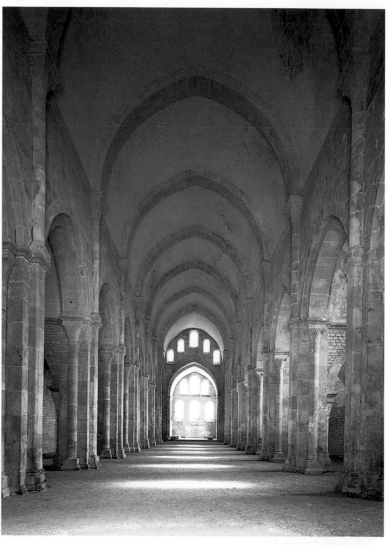

in Burgundy. The abbey has a simple geometric plan (fig. 15-6). The church has a long nave with rectangular chapels in the square-ended transept arms, and a shallow choir with a straight end wall. Lay brothers entered through the west doorway, monks from the attached cloister or upstairs dormitory by way of the "night stairs." Situated far from the distractions of the secular world, the building made few concessions to the popular taste for architectural adornment, either outside or inside. In other ways, however, Fontenay and other Cistercian monasteries fully reflect the architectural developments of their time in their masonry, vaulting, and proportions.

The Cistercians relied on harmonious proportions and fine stonework, not elaborate surface decoration, to achieve beauty in their architecture (fig. 15-7). A feature of Fontenay often found in Cistercian architecture is the use of pointed ribbed vaults over the nave and pointed arches in the nave arcade and side-aisle bays. Furnishings

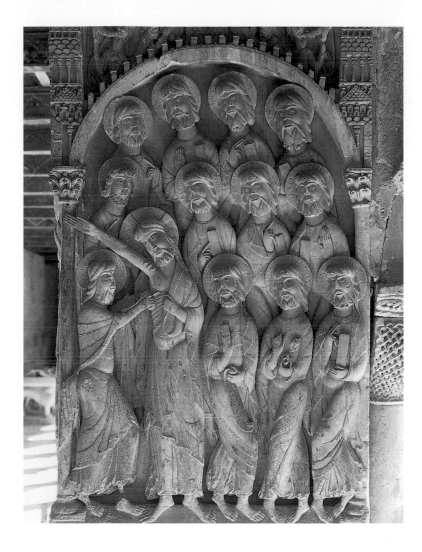

15-8. *Doubting Thomas*, pier in the cloister of the Abbey of Santo Domingo de Silos, Castile, Spain. c. 1100

included little else than altars and candles. The large windows in the end wall, rather than a clerestory, provided light. The sets of triple windows reminded the monks of the Trinity.

This simple architecture spread from the Cistercian homeland in Burgundy to become an international style. From Scotland and Germany to Spain and Italy, Cistercian designs and building techniques varied only slightly. The masonry vaults and harmonious proportions were to be influential in the development of the Gothic style later in the Middle Ages (Chapter 16).

ARCHITECTURAL SCULPTURE

Like Cluny and unlike the severe churches of the Cistercians, many Romanesque churches have a remarkable variety of painting and sculpture. Christ Enthroned in Majesty in heaven may be carved over the entrance or painted in the half-dome of the apse. Stories of Jesus among the people or images of the lives and the miracles of the saints cover the walls; the art also reflects the increasing importance accorded to the Virgin Mary. Depictions of the prophets, kings, and queens of the Old Testament symbolically foretell people and events in the New Testament, but also represented are contemporary bishops, abbots, other noble patrons, and even ordinary folk. A profusion of monsters, animals, plants, geometric ornament, allegorical figures such as Lust and Greed, and depictions of real and imagined buildings surround

the major works of sculpture. The Elect rejoice in heaven with the angels; the Damned suffer in hell, tormented by demons. Biblical and historical tales come alive, along with scenes of everyday life. All these events seem to take place in a contemporary medieval setting.

Superb reliefs embellish the corner piers in the cloister of the Abbey of Santo Domingo de Silos in Castile. One of these illustrates the story, recounted in the Gospel of John (Chapter 20), in which Christ, appearing to his apostles after the crucifixion, invites Thomas to touch his wounds to convince the doubting apostle of his resurrection (fig. 15-8). The composition is expert. Christ is shown larger than his disciples and placed off-center in the left foreground. His outstretched right arm forms a strong diagonal that bisects the space between his haloed head and that of Thomas in the lower left. Thomas's outstretched arm, reaching toward Christ's side, forms an opposing diagonal parallel to the slope between their heads, leading the eye back to Christ's face. The massed presence of the other apostles, bearing witness to the miracle, gives visual weight to the scene through the rhythmic repetition of form. The effect parallels the way the repetition of the nave bays in a Romanesque church culminates in the apse, its symbolic core. The arch that forms a canopy over the apostles' heads is crowned by a **crenellated** wall and towers plus musicians. The sculptors used these lively images from medieval life to frame the biblical story, just as medieval preachers used elements of daily life in their sermons to

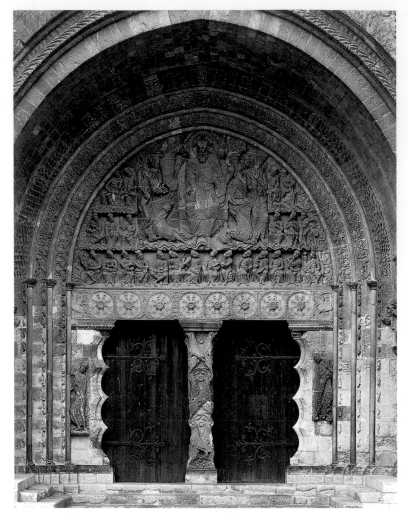

15-9. South portal and porch, Priory Church of Saint-Pierre, Moissac, Toulouse, France. c. 1115–30

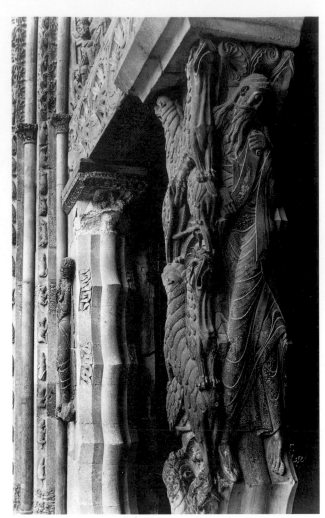

15-10. *Lions and Prophet Jeremiah (?)*, trumeau of the south portal, Priory Church of Saint-Pierre

In a letter to fellow cleric William of Saint-Thierry, Bernard of Clairvaux, leader of the Cistercian order (led 1125–53), objected to what he felt was excessive architectural decoration of Cluniac churches and cloisters. "So many and so marvellous are the varieties of diverse shapes on every hand," he wrote, "that we are more tempted to read in the marble than in our books, and to spend the whole day in wondering at these things rather than in meditating the law of God. For God's sake, if men are not ashamed of these follies, why at least do they not shrink from the expense?" (cited in Davis-Weyer, page 170).

provide a context for biblical messages. The art and literature of the period frequently combined "official" and "popular" themes in this way.

Carved portals are a significant innovation in Romanesque art. These complex works, which combine biblical narrative, legends, folklore, history, and Christian symbolism, represent the first attempt at large-scale architectural sculpture since the end of the Roman Empire. By the early twelfth century, sculpture depicting Christ in Majesty (the Second Coming), the Last Judgment, and the final triumph of good over evil at the Apocalypse could be seen on the portals of churches in northern Spain, southern France, and Burgundy. The churches of Conques and Cluny had carved portals; so did the churches of Saint-Pierre in Moissac in southern France, Saint-Lazare at Autun, and Sainte-Madeleine at Vézelay in Burgundy.

The Cluniac priory of Saint-Pierre at Moissac was a major pilgrimage stop and Cluniac administrative center on the route to Santiago de Compostela. The original shrine at the site was reputed to have existed in the Carolingian period. After joining the congregation of Cluny in 1047, the monastery prospered from the donations of pilgrims and the local nobility, as well as from its control of shipping on the nearby Garonne River. Moissac's monks launched an ambitious building campaign, and much of the sculpture from the cloister (c. 1100) and the church

(1115–30) has survived. The church was completed during the tenure of Abbot Roger (abbacy 1115–31), who commissioned the sculpture on the south portal and porch (fig. 15-9). This sculpture represents a genuine departure from earlier works in both the quantity and the quality of the carving. The sculpture covers the tympanum, the **archivolts** (the curved rows of ***voussoirs*** outlining the tympanum), and the lintel, door jambs and ***trumeau***, and porch walls (see "The Romanesque Church Portal," opposite). The stones still bear traces of the original paint.

The sculpture of Christ in Majesty dominates the huge tympanum. The scene combines images from the description of the Second Coming of Christ in Chapters 4 and 5 of the Apocalypse with others derived from Old Testament prophecies, all filtered through the early twelfth

The Romanesque Church Portal

Doorways of major Romanesque churches are often grand carved **portals**. Wood or metal doors are surrounded by elaborate stone sculpture arranged in zones to fit the architectural elements. The most important imagery is in the semicircular **tympanum** directly over the door lintel, which may be supported by a **pier** called the **trumeau**. **Archivolts**—curved moldings formed by the wedge-form stone **voussoirs** of which the arch is constructed—frame the tympanum. Romanesque archivolts are often decorated with carved geometric patterns or figures. **Spandrels** are the flat areas at the outside upper corners of the tympanum area. On both sides of the doors are **jambs**. These jambs form a shallow porch that leads into the church.

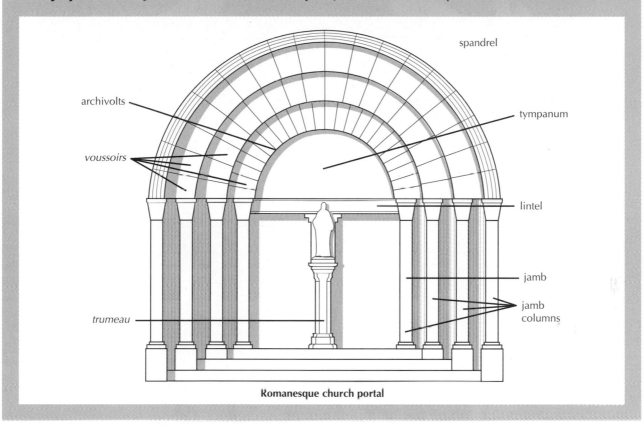

Romanesque church portal

century's view of scripture. A gigantic Christ, like an awe-inspiring Byzantine *Pantokrator* (see fig. 7 44), stares down at the viewer as he blesses and points to the book "sealed with seven seals" (Revelation 5:1). He is enclosed by a mandorla, and a cruciform halo rings his head. Four winged creatures symbolizing the evangelists—Matthew the Man (upper left), Mark the Lion (lower left), Luke the Ox (lower right), and John the Eagle (upper right)—frame Christ on either side, each holding a scroll or book representing his Gospel. Two elongated seraphim (angels) stand one on either side of the central group, each holding a scroll. A band beneath Christ's feet and another passing behind his throne represent the waves of the "sea of glass like crystal" (Revelation 4:6). These define three registers in which sit twenty-four elders with "gold crowns on their heads" in varied poses, each holding either a harp or a gold bowl of incense (Revelation 4:4 and 5:8). According to the medieval view, the elders were the kings and prophets of the Old Testament and, by extension, the ancestors and precursors of Christ.

The figures in the tympanum relief reflect a hierarchy of scale and location. Christ, the largest figure, sits at the top center, the spiritual heart of the scene, surrounded by smaller figures of the evangelists and angels. The elders, farthest from Christ, are roughly one-third his size. Despite this formality and the limitations forced on them by the tympanum's shape, the sculptors created a sense of action by turning and twisting the gesturing figures, shifting their poses off-center, and avoiding rigid symmetry or mirror images. Nonfigural motifs above and below Christ contribute to the dynamic play across the tympanum's surface. The sculptors carved the tympanum from twenty-eight stone blocks of different sizes. The elders were carved one or two per block, whereas the figures of the central group covered one or more blocks as needed. Paint would originally have disguised the join lines. The crowns and incense bowls—described as made of gold in Revelation—may have been gilded. Foliate and geometric ornament covers every surface. Monstrous heads in the lower corners of the tympanum spew ribbon scrolls that run up its periphery. Similar creatures, akin to the beasts seen in the Scandinavian **animal style** of the early Middle Ages (see fig. 14-2), appear at each end of the lintel, their tongues growing into ropes encircling a line of eight acanthus **rosettes**. A similar combination of animals, interlace, and rosettes can also be found in Islamic art. Heraldic beasts and rosettes appeared together on Byzantine and Islamic textiles. Processions of naturalistically depicted rats and rabbits climb the piers on either side of the doors (at the far left in figure 15-10). Halos, crowns, and Christ's throne in the tympanum are adorned with stylized foliage.

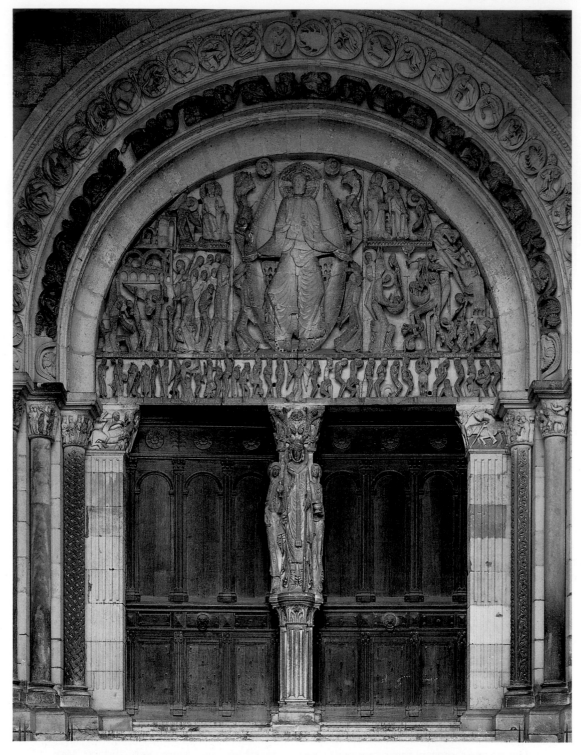

15-11. West portal, Cathedral (originally abbey church) of Saint-Lazare, Autun, Burgundy, France. c. 1120–35/40

Two side jambs and a central *trumeau* support the weight of the lintel and tympanum. Moissac's jambs and trumeau have scalloped profiles (see fig. 15-9). Saint Peter (holding his **attribute**, the key to the gates of heaven) is carved in high relief on the left jamb, the Old Testament prophet Isaiah on the right jamb. Saint Paul is carved on the left side of the *trumeau*, and another Old Testament prophet, usually identified as Jeremiah, is on the right. On the front face of the trumeau are pairs of lions crossing each other in **X**-patterns. The tall, thin prophet in figure 15-10 twists toward the viewer with his legs crossed. The sculptors placed him skillfully within the constraints of the scalloped trumeau, his head, pelvis, knees, and feet falling on the pointed cusps of the curved forms. On the front of the trumeau the lions' bodies also fit the cusps of the scalloped frame. Between each pair of lions are more rosettes. Such decorative scalloping resembles Islamic art. The sculpture at Moissac was created shortly after the First

Crusade and Europe's resulting encounter with the Islamic art and architecture of the Holy Land. Warriors from the region participated in the Crusade and presumably brought Eastern art objects and ideas home with them.

A very different pictorial style is seen in Burgundy. On the main portal of the Cathedral of Saint-Lazare at Autun (fig. 15-11), Christ has returned to judge the cowering, naked human souls at his feet. The damned writhe in torment at his left, while the saved enjoy serene bliss at his right hand. The inscribed message reads: "May this terror frighten those who are bound by worldly error. It will be true just as the horror of these images indicates" (trans. Petzold). Christ dominates the composition as he did at Moissac. The surrounding figures are thinner and taller than those at Moissac and are arranged in less regular compartmentalized tiers. The overall effect is less consciously balanced than the pattern-filled composition at Moissac. The stylized figures, stretched out and bent at sharp angles, are powerfully expressive, successfully conveying the terrifying urgency of the moment as they swarm around the magisterially detached Christ figure. Delicate weblike engraving on the robes may have derived from metalwork or manuscript illumination.

Angels trumpet the call to the Day of Judgment. Angels also help the departed souls to rise from their tombs and line up to await judgment. In the bottom register, two men at the left carry walking staffs and satchels bearing the cross and a scallop-shell badge, attributes identifying them as pilgrims to Jerusalem and Santiago de Compostela. A pair of giant, pincerlike hands descends at the far right to scoop up a soul (seen at the bottom center in the detail, fig. 15-12). Above these hands, in a scene reminiscent of Egyptian Books of the Dead (see fig. 3-43), the archangel Michael competes with devils as he weighs souls on the scale of good and evil. In the early decades of the twelfth century, Church doctrine came increasingly to stress the role of the Virgin Mary and the saints as intercessors who could plead for mercy on behalf of repentant sinners. The tympanum at Autun shows angels also acting as intercessors. The archangel Michael shelters some souls in the folds of his robe and may be jiggling the scales a bit. Another angel boosts a saved soul into heaven, bypassing the gate and Saint Peter. By far the most riveting players in the drama are the grotesquely decomposed, screaming demons grabbing at terrified souls and trying to cheat by pushing down souls and yanking the scales to favor evil.

A lengthy inscription in the band beneath Christ's feet identifies the Autun tympanum as the work of Gislebertus, who oversaw the sculpture and did much of the work himself. He may have carved a representation of the Magi asleep (fig. 15-13), one of the many capitals in the cathedral illustrating the Bible and the lives of the saints. The ingenious compression of instructive narrative scenes into the geometric confines of column capitals was an important Romanesque contribution to architectural decoration. The underlying form was usually that of the flaring Corinthian capital. Sculptors used undercutting, a technique known since ancient times, to sharpen contours and convey depth.

15-12. **Gislebertus.** ***Weighing of Souls***, detail of *Last Judgment* tympanum, Cathedral of Saint-Lazare, Autun

15-13. ***The Magi Asleep***, capital from the choir, Cathedral of Saint-Lazare. c. 1120–32. Musée Lapidaire, Autun

The lower half of the capital was carved with stylized acanthus leaves, probably inspired by Roman ruins in Autun.

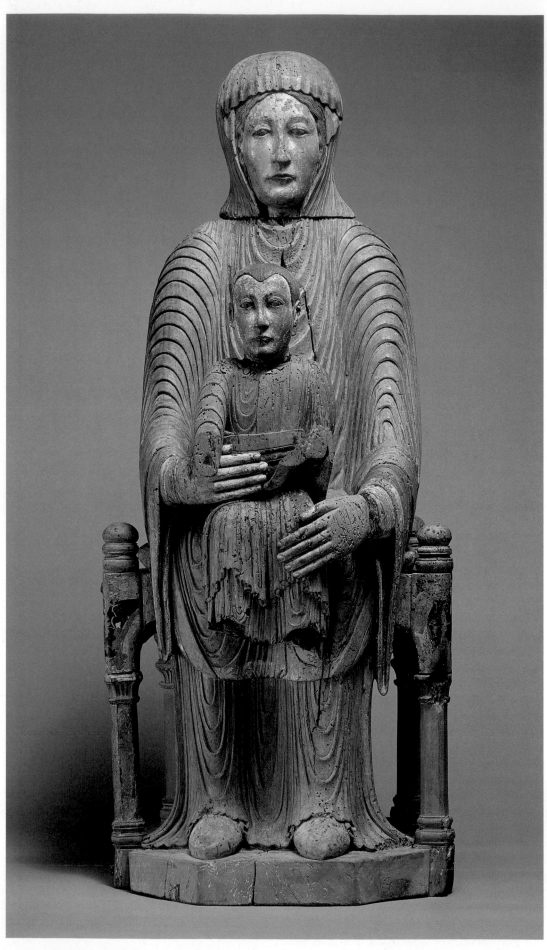

15-14. *Virgin and Child*, from the Auvergne region, France. c. 1150–1200. Oak with polychromy, height 31" (78.7 cm). The Metropolitan Museum of Art, New York

Gift of J. Pierpont Morgan, 1916 (16.32.194)

The Magi Asleep is one in a series of capitals depicting events surrounding the birth of Jesus. Medieval tradition identified the three Magi, or wise men—whom the Gospels say brought gold, frankincense, and myrrh to the newborn Jesus—as the kings Caspar, Melchior, and Balthasar. Caspar, the oldest, is shown bearded here; Melchior has a moustache; and Balthasar, the youngest, is clean-shaven. Later, he is often shown as a black African. The Magi, following heavenly signs, traveled from afar to acknowledge Jesus as King of the Jews. The position of the capital in the choir of the church suggests that it was meant to remind worshipers that they were embarking on a metaphorically parallel journey to find Christ. The slumbering Magi, wearing their identifying crowns, share a bed and blanket. An angel has arrived to hurry them on their way, awakening Melchior and pointing to the Star of Bethlehem, which will guide them. The sculptor's use of two vantage points simultaneously—the Magi and the head of their bed viewed from above, the angel and the foot of the bed seen from the side—communicates the key elements of the story with wonderful economy and clarity.

INDEPENDENT SCULPTURE

Reliquaries, altar frontals, crucifixes, devotional images, and other sculpture filled medieval churches. One form of devotional image that became increasingly popular during the later Romanesque period was that of the Virgin Mary holding the Christ Child on her lap, a type known as the Throne of Wisdom. A well-preserved example in painted wood dates from the second half of the twelfth century (fig. 15-14). Such images were a specialty of the Auvergne region of France, but are found throughout Europe. Mother and Child are frontally erect, as rigid as they are regal. Mary is seated on a thronelike bench symbolizing the lion throne of Solomon, the Old Testament king and symbol of wisdom. She supports Jesus with both hands. The small but adult Jesus holds a book—the Word of God—in his left hand and raises his (now missing) right hand in blessing. To the medieval believer, Christ represented the priesthood, humankind, and God. In Christ, the Wisdom of God became human; in the medieval scholar's language, he is the Word Incarnate. Mary represented the Church. And Mary, as earthly mother and God-bearer (*Theotokos*), gave Jesus his human nature and forms a throne on which he sits in majesty. As a fourteenth-century churchman wrote, "The throne of the true Solomon is the Most Blessed Virgin Mary, in which sat Jesus Christ, the true Wisdom" (trans: Forsyth, p. 27).

Earlier in the Middle Ages, small, individual works of art were generally made of costly materials for royal or aristocratic patrons (see the Brescia cross, fig. 14-9). In the twelfth century, however, when abbeys and local parish churches of more limited means began commissioning hundreds of statues, painted wood became an increasingly common medium. These devotional images were frequently carried in processions both inside and outside the churches. A statue of the Virgin and Child, like the one shown here, could also have played an important role in the liturgical drama performed at the

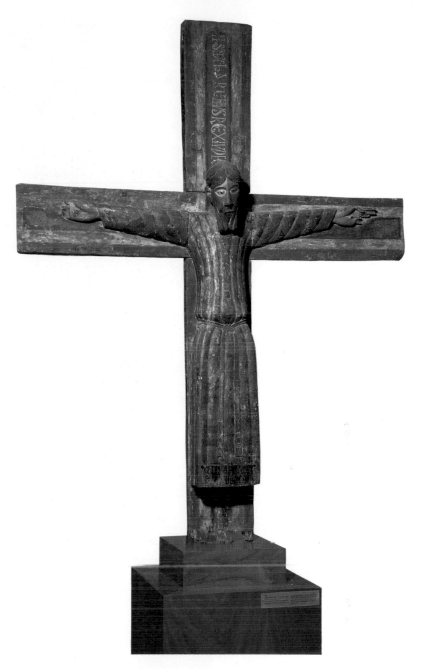

15-15. Batlló Crucifix, from the Olot region, Catalonia, Spain. Mid-12th century. Wood with polychromy, height approx. 36" (91 cm). Museu Nacional d'Art de Catalunya, Barcelona

This crucifix was modeled on a famous medieval sculpture called the *Volto Santo* (Holy Face) that had supposedly been brought from Palestine to Italy in the eighth century. Legend had it that the work had been made by Nicodemus, who helped Joseph of Arimathea bury Jesus. Many replicas of the *Volto Santo* still exist.

Feast of the Epiphany, which in the Western Church celebrates the arrival of the Magi to pay homage to the baby Jesus. Participants representing the Magi would act out their journey by searching through the church until they came to the statue. (Some scholars see this as the origin of western European drama.)

The Crucifixion continued to be a primary devotional theme in the Romanesque period. The image of Jesus in the mid-twelfth-century *Batlló Crucifix* from Catalonia (fig. 15-15) derives from Byzantine sources and is quite different from the nearly nude, tortured Jesus of the Ottonian-period *Gero Crucifix* (see fig. 14-28). Jesus'

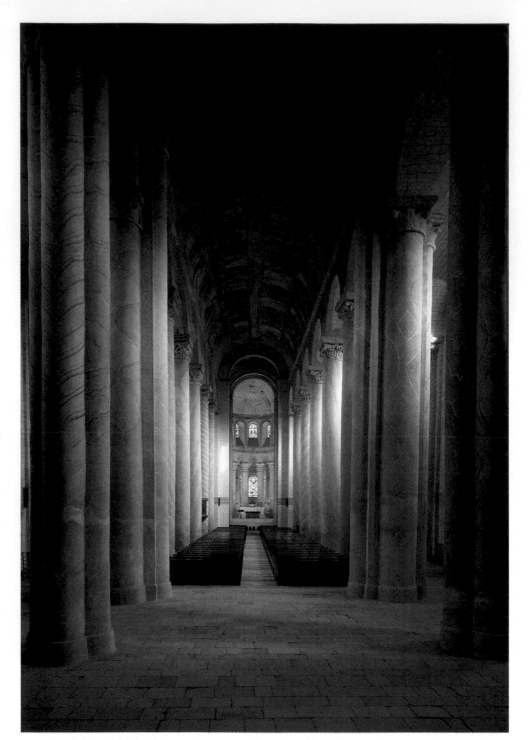

15-16. Nave, Abbey Church of Saint-Savin-sur-Gartempe, Poitou, France. c. 1100

The columns of Saint-Savin, painted to resemble veined marble, support an arcade and barrel vault without intermediate galleries or clerestory windows, a design known as a hall church.

bowed head, downturned mouth, and heavy-lidded eyes convey a sense of deep sadness or contemplation; however, he still wears royal robes that emphasize his kingship (see *Rabbula Gospels*, figs. 7-36, 7-37). He wears a long, medallion-patterned tunic with pseudo-kufic inscriptions—designs meant to resemble Arabic script—on the hem. The garment reflects how valuable silks from Islamic Spain were in Europe at this time. They were widely used as cloths of honor to designate royal and sacred places, appearing, for example, behind rulers' thrones, or as altar coverings and backdrops. Many wooden crucifixes such as this one have survived from the Romanesque period. They were displayed over church altars and, like other devotional statues, were carried in processions.

WALL PAINTING

Throughout Europe paintings on church walls glowed in flickering candlelight amid clouds of incense. Wall painting was subject to the same influences as the other visual arts: The painters were inspired by models available to them locally. Some must have seen examples of Byzantine art. Others had Carolingian or even Early Christian models from manuscripts. During the Romanesque period, painted decoration largely replaced mosaics on the walls of churches. This change occurred, at least partly, because the growing demand by the greater number of churches led to the use of less expensive materials and techniques.

15-17. *Tower of Babel*, detail of painted nave vaulting, Abbey Church of Saint-Savin-sur-Gartempe

One of the most extensive programs of Romanesque wall painting is at the Benedictine Abbey Church of Saint-Savin-sur-Gartempe in the Poitou region of western France. The tunnel-like barrel vault running the length of the nave and choir provides a surface ideally suited to painted decoration (fig. 15-16). The narthex, crypt, and chapels were also painted. Old Testament scenes can be seen in the nave; New Testament scenes and scenes from the lives of two local saints, Savin and Cyprian, appear in the transept, ambulatory, and chapels. The paintings were done about 1100 and may have been inspired primarily by manuscripts. The painters did not use the wet-plaster **fresco** technique favored in Italy for its long-lasting colors, but they did moisten the walls before painting, which allowed some absorption of pigments into the plaster, making them more permanent than paint applied to a dry surface. Consequently, the colors of the vault have a soft, powdery tone in contrast to the richer, more brilliant hues of Byzantine-inspired painting.

Several artists or teams of artists worked in different parts of Saint-Savin. The nave vault suggests the energy of Carolingian artists, like those working for Archbishop Ebbo, and the narrative drama of the Ottonian Hildesheim doors (see figs. 14-16, 14-26). The painters here seem to have immediately followed the masons and used the same scaffolding. Perhaps this intimate involvement with the building process accounts for the vividness with which they portrayed the biblical story of the Tower of Babel (fig. 15-17). According to the account in Genesis (11:1–9), God punished the prideful people who tried to build a tower to heaven by scattering them and making their languages mutually unintelligible. The tower in the painting is a medieval-looking structure, reflecting the practice of depicting legendary events in contemporary settings. Workers haul heavy stone blocks to the tower, lifting them to masons on the top with a hoist. The giant Nimrod, on the far right, simply hands over the blocks. On the far left, God confronts the people. He steps away

from them even as he turns back to chastise them. The scene's dramatic action, large figures, strong outlines, broad areas of color, and simplified modeling all help make it intelligible to a viewer looking up at it in dim light from far below.

Many Romanesque wall paintings survived in churches in the isolated mountain valleys of the Catalonian Pyrenees in northern Spain. In the twentieth century, the paintings were detached from the walls and placed in museums for security. The paintings from the Church of San Clemente in Tahull are now in Barcelona. A magnificently expressive Christ in Majesty filled the curve of the half-dome of the apse (fig. 15-18, page 532). Christ's powerful presence recalls the contemporary sculpture at Moissac and Autun (see figs. 15-9, 15-11), whose sculptors may have been inspired by monumental paintings such as this. The San Clemente Christ illustrates a Romanesque transformation of the Byzantine depiction of Christ *Pantokrator*, ruler and judge of the world (see fig. 7-44). The iconography is traditional. Christ sits within a mandorla; the symbols *alpha* and *omega* are on each side of his head. He holds the open Gospel inscribed "*ego sum lux mundi*" ("I am the light of the world," John 8:12). Four angels, each grasping an evangelist's symbol, float at his sides. At Christ's feet are six apostles, of whom Bartholomew and John are visible here, and the Virgin Mary holding a bowl. Flanking them are columns with stylized capitals and wavy lines indicating marble shafts. The intensity of the colors was created by building up many thin coats of paint, a technique called **glazing**.

The San Clemente Master, as the otherwise anonymous Tahull painter is known, was one of the finest Spanish painters of the Romanesque period. The elongated oval faces, large staring eyes, and long noses, as well as the placement of figures against flat colored bands and the use of heavy outlining, reflect Mozarabic influence (Chapter 14). The prevailing influence, however, was the Byzantine style, which the Tahull painter and other Western artists of the period adapted to their

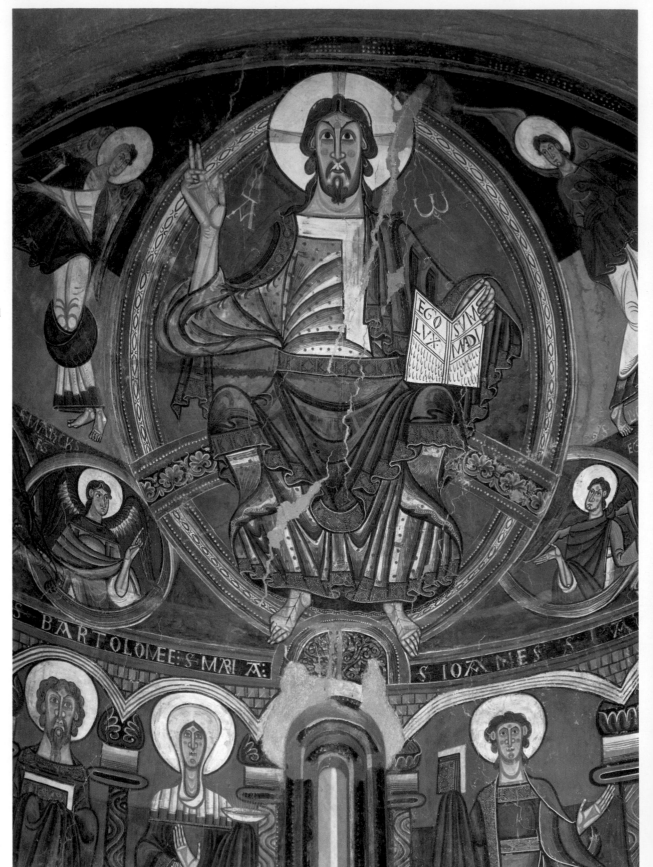

15-18. *Christ in Majesty*, detail of apse painting from the Church of San Clemente, Tahull, Lérida, Spain. c. 1123. Museu Nacional d'Art de Catalunya, Barcelona

own taste for geometric simplicity of form. Faces and figures are strictly frontal and symmetrical. Modeling from light to dark is accomplished through repeated colored lines of varying width in three shades—dark, medium, and light. Details of faces, hair, hands, and muscles are turned into elegant patterns.

BOOKS

As today, illustrated books played a key role in the transmission of artistic styles and other cultural information from one region to another. Like other arts, the output of books increased dramatically in the eleventh and twelfth

quodds suscepcoi e ci. Di eni erat
uerbu unigenciuf. gignera co
accnuf. Sed ut mediacoi darecur
nob. pineffabile gram uerbum
caro faccum e. & habicai innobif.
bLECTIO OCTAVA
axcloquucuffu uob uc
gaudiu mei inuob fic.
& gaudium urm impleacur.
Hoc e peccpcu mei uc diligacif in
uicc. sicuc dilexiuof. Audiftif ca
riffim drim dicerie difcipulif su
if. Hxcloquucuffu uob. uc gau
diu mei inuob fic. & gaudiu urm
impleacur. Quod e gaudiu xpi
innob. nifi quod dignae gaudere
de nob. & qd e gaudiu nrm qd
dicit implendu. nifi a habere con
forcu. Ipe qd beaco pecro dixe
rac. fi n lauerote non habebif par
te mecu. Gaudiu g cuf innobif.
gra e qua pftrat nob. ipfa e uciq
gaudiu nrm. Sed de hac ille eti
am exaccrnicace gaudebat.
quando nof elegte arce mundi
confticuaone. Nec recce poffu
muf dicere. quod gaudium cuf
plenu non erat. Non enim df in
pfecte Aliquando gaudebat.
fed illud ci gaudiu innob non
erat. quia. nec nof inquib. ce pof
fic iam eramuf. nec quando ce ce
pimuf cu illo ce cepimuf. In ipfo
auc fempcrat. qui nof suof futu
rof ceruffima suar pfcienua ueri
cate gaudebat. EVG. Hoc eft
pecptu mei. REd. IN NT. APtoxs.

cu euangtium legercur. drim di
cerie. Si diligitif me. mandata mea
feruace. Ec ego rogabo patrem
mei. & aluum paraclicu dabic
uob. uc maneac uobcu inaxernu.

VDI
VI
MVS
FRATRES

15-19. Page with *Pentecost*, Cluny Lectionary. Early 12th century. Ink and tempera on vellum, 9 x 5" (23 x 12.5 cm). Bibliothèque Nationale, Paris, MS lat. 2246, fol. 79v

centuries, despite the labor and materials required to make them. Monastic and convent *scriptoria* continued to be the centers of production, where monks and nuns copied books (see "The Medieval Scriptorium," page 490). The *scriptoria* sometimes also employed lay artisans who might be itinerant, traveling from place to place. Most books had religious subject matter, including scholarly commentaries, lives of saints, collections of letters, and even histories. Liturgical works were often large and lavish; other works were more modest, their embellishment confined to the initial letter of each section of text.

An illuminated **lectionary**, a work containing biblical excerpts arranged according to the Church calendar for reading during Mass, was made for the wealthy monastery of Cluny in the early 1100s. In the page at the beginning of the eighth reading (fig. 15-19), the framed scene illustrates the beginning of the second chapter of the Acts of the Apostles, which recounts how "tongues as of fire" from the Holy Spirit descended on each of the apostles while they were assembled, and they began to speak "in tongues." Christ appears at the top of the picture, and glowing red rays—tongues of fire—stream from the gold

banner draped over him to the heads of the Twelve Apostles below. Just under the picture is a beautifully interlaced *A*, the first letter of the word *audivimus* ("we have been hearing"). The subject—an unusual one for medieval art—may have been chosen as a symbolic reminder of Cluny's direct tie to the papacy. The picture may suggest that, just as the apostles received miraculous powers from Christ, so Cluny derived its power directly from the pope, the heir to the apostle Peter, the monastery's patron saint, who sits holding a gold-covered book in the center of the image. The image of Christ, like the Tahull *Christ in Majesty* (see fig. 15-18), is a reinterpretation of the Byzantine *Pantokrator* type. The faces of the figures have been delicately rendered with green and red highlighting. The drapery seems to fall over fleshy limbs. The illuminator deliberately deemphasized the drama of the supernatural event described in the text, conveying instead the psychological bond among the figures.

Despite their ascetic teachings and austere architecture, the Cistercians produced many elaborately illustrated books early in their history. A symbolic image known as the Tree of Jesse appears on a page from a copy of *Saint Jerome's Commentary on Isaiah* made in the *scriptorium* of the Cistercian mother house at Cîteaux about 1125 (fig. 15-20). Jesse was the father of King David, who was an ancestor of Mary and, through her, of Jesus. The Cistercians were particularly devoted to the Virgin and are credited with popularizing the Tree of Jesse as a device for showing her position as the last link in the genealogy connecting Jesus Christ to the house of David. In the manuscript illustration, *The Tree of Jesse* depicts Jesse asleep, a small tree trunk growing from his body. A monumental Mary, standing on the forking branches of the tree, dwarfs the sleeping patriarch. The Christ Child sits on her right arm, which is swathed in her veil. Following late Byzantine and Romanesque convention, he is portrayed as a miniature adult with his right hand raised in blessing. His cheek presses against Mary's, a display of affection similar to that shown in Byzantine icons like the *Virgin of Vladimir* (see fig. 7-42). Mary holds a flowering sprig from the tree, a symbol for Christ. The building held by the angel on the left refers to Mary as the Christian Church, and the crown held by the angel on the right refers to her as Queen of Heaven. The dove above her halo represents the Holy Spirit. The linear depiction of drapery in **V**-shaped folds and the jeweled hems of Mary's robes reflect Byzantine influence and her elevated status. The subdued colors are in keeping with Cistercian restraint.

15-20. Page with *The Tree of Jesse*, *Explanatio in Isaiam (Saint Jerome's Commentary on Isaiah)*, from the Abbey, Cîteaux, Burgundy, France. c. 1125. Ink and tempera on vellum, 15 x 4¾" (38 x 12 cm). Bibliothèque Municipale, Dijon, France. MS 129, fol. 4v

The Tree of Jesse, a pictorial representation of the genealogy of Jesus, was used to illustrate the Church's doctrine that Christ was both human and divine. The growing importance of devotion to Mary as the mother of God led to an emphasis on her place in this illustrious royal line.

THE NORTH SEA KINGDOMS

The North Sea became a Viking waterway in the ninth century (see Chapter 14), linking Norwegian and Danish mariners to the lands around it much as the Mediterranean Sea had served the Romans. Vikings saw the cold and turbulent water as the "whale way" for their ships, not as a barrier, and what began as exploration and raiding expeditions to the British Isles and Normandy soon turned to trade and colonization.

TIMBER CONSTRUCTION In northern Europe, the standard early building type made good use of the area's plentiful forests: It was typically framed in wood, using either **cruck** or **post-and-lintel** construction. Crucks are pairs of timbers made by cutting a tree trunk with a naturally forked branch to the correct length, then splitting it into a matching pair. Crucks are used as both wall and roof supports, and a series of crucks can be set up to make a long single-aisle building. The more technically advanced post-and-lintel frame consists of a series of paired upright timbers spanned at the top by a horizontal timber. That wooden skeleton supports a triangle of rafters, the sloping beams that form the roof. A post-and-lintel frame divides the inner area into three spaces (in church architecture, a nave and two side aisles), a configuration that eventually influenced masonry architecture. Sometimes the structure would be built on a stone foundation, which protected the wooden frame from rotting in the moist earth. Whichever construction method was used, the building would be finished with wattle-and-daub walls, composed of woven light branches (wattle) covered with clay, mud, or other substance (daub). The roof, made up of a ridgepole, rafters, and eave beams, was covered by shingles, turf, or thatch.

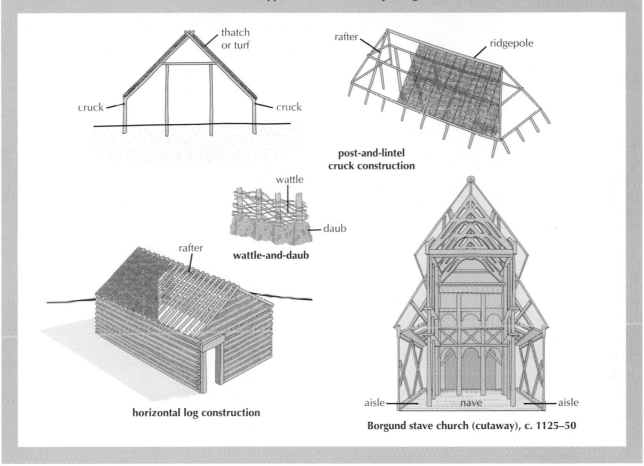

post-and-lintel
cruck construction

wattle-and-daub

horizontal log construction

Borgund stave church (cutaway), c. 1125–50

In the early tenth century, a band of Norse raiders seized the peninsula in northwest France that came to be known as Normandy. In 911, their leader, Rollo, gained recognition as duke of the region from the weak Carolingian king. Within little more than a century, Rollo's successors had transformed Normandy into one of Europe's most powerful feudal domains. The Norman dukes were astute and skillful administrators. They formed a close alliance with the Church, supporting it with grants of land and gaining in return the allegiance of abbots and bishops, many of whom also served as vassals of the duke. When in 1066 Duke William II of Normandy (1035–87) invaded England and, as William the Conqueror, became that country's new king, Norman nobles replaced the Anglo-Saxon nobility there, and England became politically and culturally allied to northern France.

TIMBER ARCHITECTURE AND SCULPTURE

The great forests of northern Europe provided the materials for timber buildings of all kinds. Two forms of timber construction evolved: one that stacked horizontal logs, notched at the ends, to form a rectangular building (the still-popular log cabin), and the vertical plank wall, with timbers set directly in the ground or into a sill (a horizontal beam). Typical buildings had rectangular plans, wattle-and-daub walls, and a turf or thatched roof that was supported in large halls by interior posts (see "Timber Construction," above).

The same basic structure was used for almost all building types—on a large scale for palaces, assembly halls, and churches, on a small scale for huts and family homes, which were shared with domestic animals, including horses and

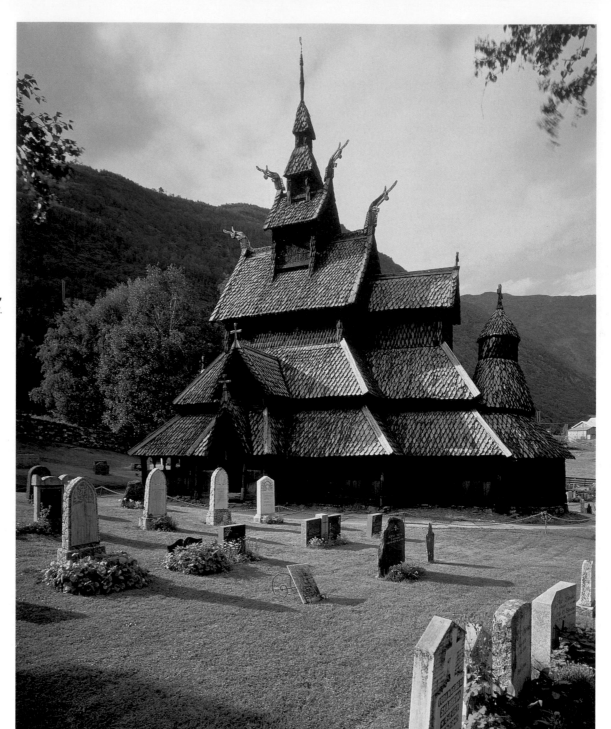

15-21. Borgund stave church, Sogn, Norway. c. 1125–50

cattle. The great hall had a central open hearth and an off-center door to prevent drafts. As defense, people created a kind of fort around residences and trading centers by building massive earthworks topped with palisades.

Subject to decay and fire, timber buildings of the period have largely disappeared, leaving only postholes and other traces in the soil. However, some timber churches—known as stave churches, from the four huge timbers (staves) that form the structural core of the building—survive in Norway. Borgund stave church, of about 1125–50, is one of the finest (fig. 15-21). Four corner staves support the central roof, and additional posts placed within or to the side of the space the corner staves define create the effect of a nave and side aisles, narthex, and choir. A rounded apse covered with a timber tower

is attached to the choir. Upright planks slotted into the sills form the walls. A steep-roofed gallery rings the entire building, and wooden shingles cover the roofs and some walls. Steeply pitched roofs protect the walls from the rain and snow. Openwork timber stages set on the roof ridge create a tower and an overall pyramidal shape. On all the gables—the triangular section at the upper part of the building's end—are crosses and dragons to protect the church and its congregation.

The penchant for carved relief decorations seen on the Oseberg ship (see figs. 14-20, 14-21) endured in the decoration of Scandinavia's earliest churches. The facades of these structures often teem with intricate animal interlace. A church at Urnes, Norway, entirely rebuilt in the twelfth century, still has some remnants of the original

15-22. **Doorway panels, Parish church, Urnes**, Norway. c. 1050–70. Carved wood

eleventh-century carving, including on its doorway (fig. 15-22). Although it did not originate with this church, the style of carvings like these is known as Urnes. The animal interlace in the Urnes style is composed of serpentine creatures snapping at each other, a fusion of the vicious little gripping beasts covering the surface of the Oseberg post and the interlace pattern of the Oseberg ship's bow and stern. The satin-smooth carving of rounded surfaces, the contrast of thick and very thin elements, and the organization of the interlace into harmoniously balanced figure-8 patterns are characteristic of the Urnes style. The effect is one of aesthetic and technical control rather than wild disarray. Works such as the Urnes doorway panels suggest the persistence of Scandinavia's mythological tradition even as Christianity took hold there and demonstrate its enriching influence on the vocabulary of Christian art. The great beast standing at the left of the door, fighting serpents and dragons, came to be associated with the Lion of Judah and with Christ, who fought Satan and the powers of darkness and paganism.

MASONRY ARCHITECTURE

When the British turned from timber architecture to stone and brick, they associated the masonry building—whether church, feasting hall, or castle—with the power and glory of ancient Rome, where those materials had been used. They also appreciated the greater strength and resistance to fire of masonry walls. Not surprisingly, they soon began to experiment with masonry vaults, as can be seen at Durham Castle and Cathedral in northeastern England.

Strategically located on England's northern frontier with Scotland, Durham grew after the Norman Conquest into a great fortified complex with a castle, a monastery, and a cathedral (fig. 15-23). Durham Castle is an excellent example of a Norman fortress. The only way in and out was over a drawbridge, which was controlled from a gatehouse

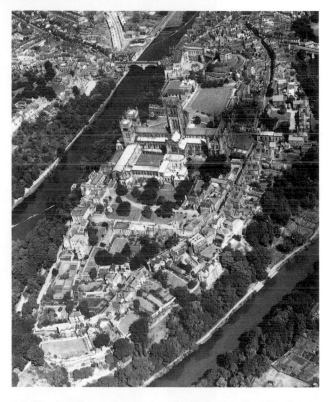

15-23. **Castle-monastery-cathedral complex, Durham**, Northumberland, England. c. 1075–1100s, plus later alterations and additions

Since 1837, the castle has housed the University of Durham (now joined with the University of Newcastle). The castle was added to and rebuilt over the centuries. The Norman portion extends to the left of the keep. The castle and cathedral share a parklike green. South of the cathedral (lower in the photograph), the cloister with chapterhouse, dormitory (now a library), and kitchens are clearly visible. Houses of the old city cluster around the buildings as they would have in earlier days. Trees, however, would not have been allowed to grow near the approaches to this fortified outpost against the Scots.

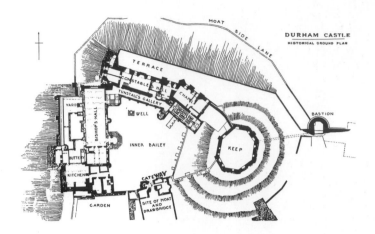

15-24. Plan of Durham Castle

In Norman times, the bishops of Durham lived in a three-story residence. An exterior staircase led from the courtyard (inner bailey) to a single undivided, multipurpose room on the middle floor occupied by the bishop and his principal servants (Constable's Hall and Tunstall's Gallery in the plan). Other people occupied humbler wood structures within the castle complex or outside its walls in the village that served it. The structures at the left date from Gothic times.

15-25. Nave of Durham Cathedral. Early 12th century. Original apses replaced by a Gothic choir, 1242–c. 1280. Vault height 73' (22.2 m). View from the west

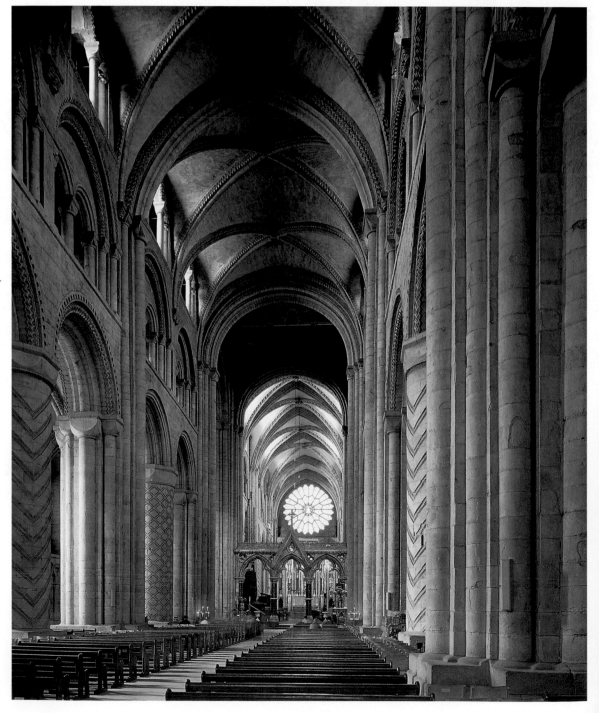

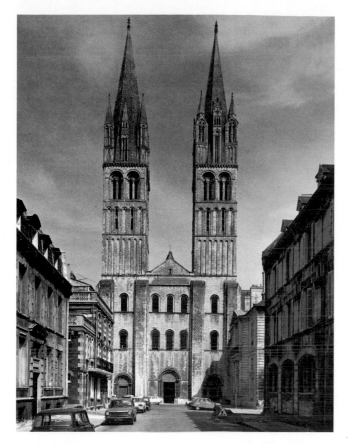

15-26. Church of Saint-Étienne, Caen, Normandy, France.
Begun 1064; facade late 11th century; spires 13th century

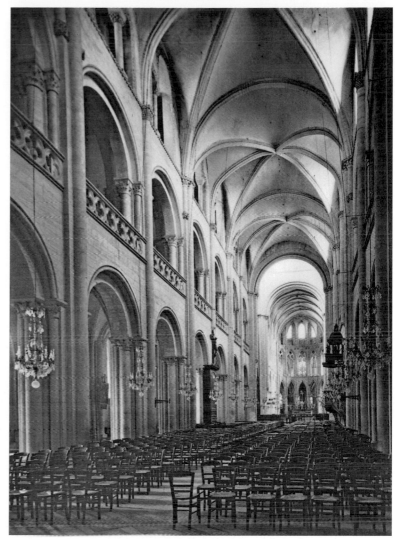

15-27. Nave, Church of Saint-Étienne, Caen

(fig. 15-24). Beyond the gatehouse was the **bailey**, or courtyard. In times of danger, the castle's defenders took up their battle positions in the **keep** (***donjon*** in French), the massive tower to the east of the bailey. At Durham, a stone keep replaced an earlier timber tower. Other buildings, including the great hall in which the bishops conducted their business, extended along the northern rampart overlooking a sheer cliff. The Norman chapel, located between the great hall and the keep, was built about 1075 and may have been the first stone structure in the compound. Medieval fortresses were often surrounded by a defensive water-filled ditch known as a **moat**. At Durham, the Wear River acted as a natural moat, looping around the high, rocky outcrop on which the complex was built.

Durham Cathedral and its adjoining monastery were built to the south of the castle (see fig. 15-23). The cathedral, begun in 1087 and vaulted beginning in 1093, is one of the most impressive medieval churches. Like most buildings that have been in continuous use, it has been altered several times. The visible parts of the towers, for example, are Gothic with eighteenth-century modifications. The cathedral's scale and decor are both ambitious (fig. 15-25). Enormous compound piers alternating with robust columns support the nave arcade. The columns are carved with **chevrons**, spiral fluting, and diamond patterns, and some have scalloped, cushion-shaped capitals. The arcades have round moldings and chevron ornaments. All this ornamentation was originally painted.

Above the cathedral's massive walls rise ribbed vaults. While most builders were still using timber roofs, the masons at Durham developed a new system of vaulting. The typical Romanesque ribbed groin vault (best

seen in Milan, fig. 15-34) used round arches that produced separate, domed spatial units. To create a more unified interior space, the Durham builders divided each bay with two pairs of crisscrossing ribs and so kept the crown of the vault at almost the same height as the keystone of the transverse arches. In the transept they experimented with rectangular rather than square bays, and the earliest quadrant vaults were built there. Between 1093 and 1133, when the project was essentially complete, they developed a system of vaulting that was carried to the Norman homeland in France, perfected in churches such as Saint-Étienne at Caen, in Normandy, then adopted by masons throughout France in the Gothic period (see "Rib Vaulting," page 561).

Saint-Étienne (fig. 15-26) was begun nearly a generation before Durham Cathedral, but work continued there through the century. William, duke of Normandy, had founded the monastery and begun construction of its church by the time of his conquest of England. His queen, Matilda, had already established an abbey for women in Caen. The two churches survived the devastation of Normandy in World War II, and their western towers still dominate the skyline. At Saint-Étienne, the nave wall has a three-part elevation with exceptionally wide arches in the nave arcade (fig. 15-27), which are repeated in the gallery above. At the clerestory level, a third arcade with

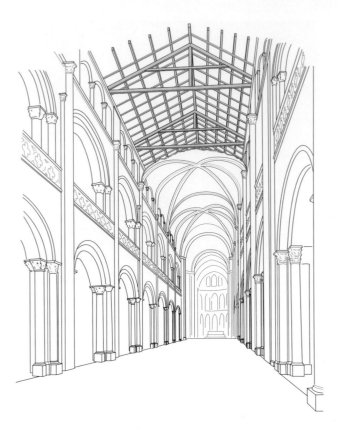

15-28. Diagram of roof and vaulting, Church of Saint-Étienne, Caen

four arches fronts the windows, creating a passageway. Alternating engaged columns and engaged columns backed by pilasters run the full height of the wall, emphasizing the nave's height and creating an interesting rhythmic pattern of heavy and light compound piers down the length of the nave. The side aisles are groin-vaulted. The building was dedicated in 1077.

Saint-Étienne's nave originally had a timber roof, which was replaced by a masonry vault sometime after 1120. The vault has been dated as late as 1130–35. A ribbed groined vault, divided by the addition of a second transverse rib, was raised over double bays (fig. 15-28). This design created square nave bays with six-part ribbed groin vaults—a system adopted by early Gothic builders in the Île-de-France. Soaring height was a Norman architectural goal, continuing the tradition of towers and verticality begun by Carolingian builders (see fig. 14-10). The west facade of Saint-Étienne was constructed at the end of the eleventh century, probably about 1096–1100. Wall buttresses divide the facade into three vertical sections, and small **stringcourses**, unbroken cornicelike moldings, at each window level suggest the three stories of the building's interior. This concept of reflecting in the design of the facade the plan and elevation of the church itself would be adopted by Gothic builders. Norman builders, with their brilliant technical innovations and sophisticated designs, in fact prepared the way for the architectural feats seen in Gothic cathedrals of the twelfth and thirteenth centuries.

BOOKS

The great Anglo-Saxon tradition of book illumination, which declined for a time in the wake of the Norman Conquest, revived after about 1130. The *Worcester Chronicle*

is the earliest known illustrated English history. This record of contemporary events by a monk named John was an addition to a work called *The Chronicle of England*, written by Florence, another monk. The pages shown here concern King Henry I (ruled 1100–35), the second of William the Conqueror's sons to sit on the English throne (fig. 15-29). The text relates a series of dreams the king had on consecutive nights in 1130 in which his subjects demanded tax relief. The illustrations depict the dreams with energetic directness. On the first night, angry farmers confront the sleeping king; on the second, armed knights; and on the third, monks, abbots, and bishops. In the fourth illustration, the king is in a storm at sea and saves himself by promising God to lower taxes for a period of seven years. The *Worcester Chronicle* assured its readers that this story came from a reliable source, the royal physician Grimbald, who appears in the margins next to most scenes.

More characteristic of Romanesque illumination are illustrated psalters. The so-called *Hellmouth* page from a psalter written in Latin and Norman French is one of the masterpieces of English Romanesque art (fig. 15-30). The psalter was produced at a renowned Anglo-Saxon monastic *scriptorium* in Winchester. The vigorous narrative style for which the *scriptorium* was famous had its roots in the style of the ninth-century workshop at Reims that produced the *Utrecht Psalter* (see fig. 14-17). The page depicts the gaping jaws of hell, a traditional Anglo-Saxon subject, one that inspired poetry and drama as well as the vivid descriptions of the terrors and torments of hell with which the clergy enlivened their sermons.

The inscription at the top of the page reads: "Here is hell and the angels who are locking the doors." The ornamental frame that fills the page represents the door to hell. An angel on the left turns the key to the door in the keyhole of the big red doorplate. The frenzy of the Last Judgment, as depicted on the tympanum at Autun (see fig. 15-11), has subsided. Inside the door, the last of the damned are crammed into the mouth of hell, the wide-open jaw of a grotesque double-headed monster. Sharp-beaked birds and fire-breathing dragons sprout from the monster's mane. Hairy, horned demons torment the lost souls, who tumble around in a dark void. Among them are kings and queens with golden crowns and monks with shaved heads, a daring reminder to the clergy of the vulnerability of their own souls.

THE BAYEUX TAPESTRY

The best-known work of Norman art is undoubtedly the *Bayeux Tapestry* (figs. 15-31, 15-32, "The Object Speaks," page 543). This narrative wall hanging, 230 feet long and 20 inches high, documents events surrounding the Norman Conquest of England in 1066. Despite its name, the work is **embroidery**, not tapestry. It was embroidered in eight colors of wool on eight lengths of undyed linen that were then stitched together (see "Embroidery Techniques," page 544). It was made for William the Conqueror's half brother Odo, who was bishop of Bayeux in Normandy and earl of Kent in southern England. Odo commissioned it for

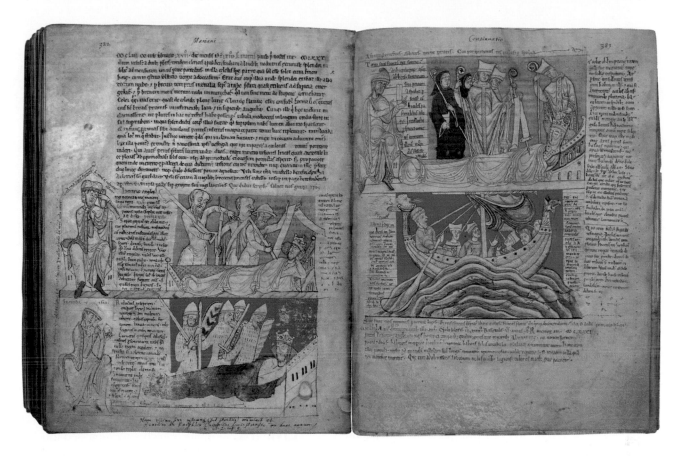

15-29. John of Worcester. Page with *Dream of Henry I*, *Worcester Chronicle*, from Worcester, England. c. 1140. Ink and tempera on vellum, each page 12¾ x 9⅜" (32.5 x 23.7 cm). Corpus Christi College, Oxford (CCC MS 157, pages 382–383)

One of the achievements of Henry's father, William the Conqueror, was a comprehensive census of English property owners, the *Domesday Book*. Compiled into two huge volumes, this document was used to assess taxes and settle property disputes. After Henry, too, raised taxes and encountered protests, a series of visions and a life-threatening storm at sea made him promise a seven-year delay in implementing the higher rate.

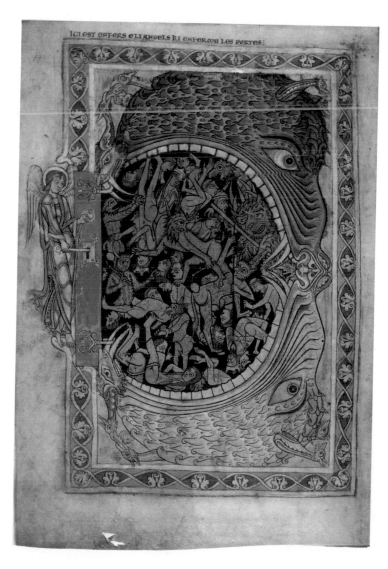

15-30. Page with *Hellmouth*, *Winchester Psalter*, from Winchester, England. c. 1150. Ink and tempera on vellum, 12¾ x 9⅛" (32.5 x 23 cm). The British Library, London

There are fascinating parallels between Hellmouth images and the liturgical dramas—known in England as mystery plays—that were performed throughout Europe from the tenth through the sixteenth century. Depictions of the Hellmouth in Romanesque English art were based on the large and expensive stage props used for the hell scenes in mystery plays. Carpenters made the infernal beast's head out of wood, papier-mâché, fabric, and glitter and placed it over a trapdoor onstage. The wide jaws of the most ambitious Hellmouths, operated by winches and cables, opened and closed on the actors. Smoke, flames, foul smells, and loud noises came from within, to the delight of the audience. Hell scenes, with their often scatological humor, were by far the most popular parts of the plays. Performances are still given today.

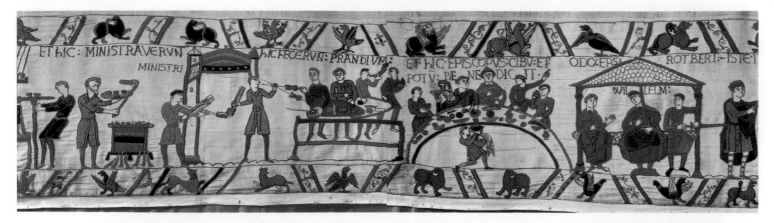

15-31. *Bishop Odo Blessing the Feast*, section 47–48 of the *Bayeux Tapestry*, Norman–Anglo-Saxon embroidery from Canterbury, Kent, England, or Bayeux, Normandy, France. c. 1066–82. Linen with wool, height 20" (50.8 cm). Centre Guillaume le Conquérant, Bayeux, France

Translation of text: ". . . and here the servants (*ministri*) perform their duty. /Here they prepare the meal /and here the bishop blesses the food and drink. Bishop Odo. William. Robert."

his Bayeux Cathedral, and it may have been completed in 1077, in time for the cathedral's consecration. According to an inventory made in 1476, it was "hung round the nave of the church on the Feast of relics" (Rud, page 9). Scholars disagree as to where it was made. Some argue for the famous embroidery workshops of Canterbury, in Kent, and others for Bayeux itself. A Norman probably directed the telling of the story and either an illuminator from a *scriptorium* or a specialist from an embroidery workshop provided drawings. Recent research suggests that the embroiderers were women.

The *Bayeux Tapestry* is a major political document, celebrating William's victory, validating his claim to the English throne, and promoting Odo's interests as a powerful leader himself. Today it is also a treasury of information about Norman and Anglo-Saxon society and technology, with depictions of everything from farming implements to table manners to warfare. The *Bayeux Tapestry* shows broadly gesturing actors on a narrow stage with the clarity and directness of English manuscript illustration. It is laid out in three registers. In the middle register, the central narrative, explained by Latin inscriptions, unfolds in a continuous scroll from left to right. Secondary subjects and decorative motifs adorn the top and bottom registers.

The section illustrated in figure 15-31 shows Odo and William, feasting on the eve of battle. Attendants provide roasted birds on skewers, placing them on a makeshift table of the knights' shields laid over trestles. The diners, summoned by the blowing of a horn, gather at a curved table laden with food and drink. Bishop Odo—seated at the center, head and shoulders above William to his right—blesses the meal while others eat. The kneeling servant in the middle proffers a basin and towel so that the diners may wash their hands. The man on Odo's left points impatiently to the next event, a council of war between William (now the central and tallest figure), Odo, and a third man labeled "Rotbert," probably Robert of Mortain, another of William's half brothers. These men held power after the conquest.

THE HOLY ROMAN EMPIRE

In the early eleventh century, the Salian dynasty replaced the Ottonians on the throne of the Holy Roman Empire, which encompassed much of Germany and Langobard Italy (Lombardy). The third Salian emperor, Henry IV (ruled 1056–1106), became embroiled in the dramatic conflict with the papacy known as the Investiture Controversy, which involved the right of lay rulers to "invest" high-ranking clergy with the symbols of their spiritual offices. In 1075, Pope Gregory VII (papacy 1073–85) declared that only the pope and his bishops could appoint bishops, abbots, and other important clergy—meaning that the clergy now depended on the pope, not the emperor. Many German nobles sided with the pope; some sided with the emperor. The controversy divided Germany into many small, competing states. The efforts of Holy Roman emperors of the late twelfth and early thirteenth centuries to reimpose imperial authority failed, and Germany remained divided until the late nineteenth century.

Italy too remained divided. The north, embroiled in the conflict between the papacy and the German emperors, experienced both economic growth and increasing political fragmentation. Toward the end of the eleventh century, towns such as Pisa and Genoa became self-governing municipal corporations known as communes, and by the middle of the twelfth century the major cities and towns of northern and central Italy were independent civic entities, feuding with one another incessantly in a pattern that continued for the next several hundred years. Port cities like Pisa, Genoa, and Venice maintained a thriving Mediterranean trade and also profited from their role in transporting Crusaders and pilgrims to the Holy Land. The great bishops of these urban centers were leading patrons of the arts in the building and furnishing of their cathedrals. In southern Italy and in Sicily, Norman adventurers displaced Islamic and Byzantine rulers in the late eleventh century, retaining control until the end of the twelfth.

Religious and political problems sapped energy and wasted financial resources. Nevertheless, building and the

THE OBJECT SPEAKS

THE BAYEUX TAPESTRY

Rarely has art spoken more vividly than in the *Bayeux Tapestry*, a strip of linen that tells the history of the Norman conquest of England. On October 14, 1066, William, duke of Normandy, after a hard day of fighting, became William the Conqueror, king of England. The story told in embroidery is a straightforward justification of the action, told with the intensity of an eyewitness account: The Anglo-Saxon noble Harold swears his feudal allegiance to William on the most sacred relics of Normandy—the saints of Bayeux and the blood of Christ himself. Betraying his feudal vows, Harold is crowned king of England but, unworthy to be king, he dies at the hands of the Normans.

At the beginning of the *Bayeux* story, Harold is a heroic figure, then events overtake him. After his coronation, cheering crowds celebrate—until a flaming star crosses the sky (fig. 15-32). (We know that it was Halley's Comet, which appeared shortly after Harold's coronation and reached astonishing brightness.) The Anglo-Saxons see it as a portent of disaster; the crowd cringes and gestures at the ball of fire with a flaming tail, and a man rushes to inform the new king. Harold slumps on his throne in the Palace of Westminster. He foresees what is to come: Below his feet is his vision of a ghostly fleet of Norman ships already riding the waves. The last great Viking flotilla has assembled on the Normandy coast.

The narrator was a skillful storyteller who used a staggering number of images. In the fifty surviving scenes are more than 600 human figures; 700 horses, dogs, and other creatures; and 2,000 inch-high letters. Perhaps he or she was assisted by William's half brother, Bishop Odo, who had fought beside William using a club, not a sword, to avoid spilling blood. The tragic drama would have spoken to audiences of Shakespeare's tragedy *Macbeth*—the story of a good man who is overcome by his lust for power and so betrays his king. But the images of this Norman invasion also spoke to people during the darkest days of World War II, when the Allies invaded Nazi-occupied Europe, taking the same route in reverse from England to beaches on the coast of Normandy. Harold or Hitler—the *Bayeux Tapestry* speaks to us of the folly of human greed and ambition and of two battles that changed the course of history.

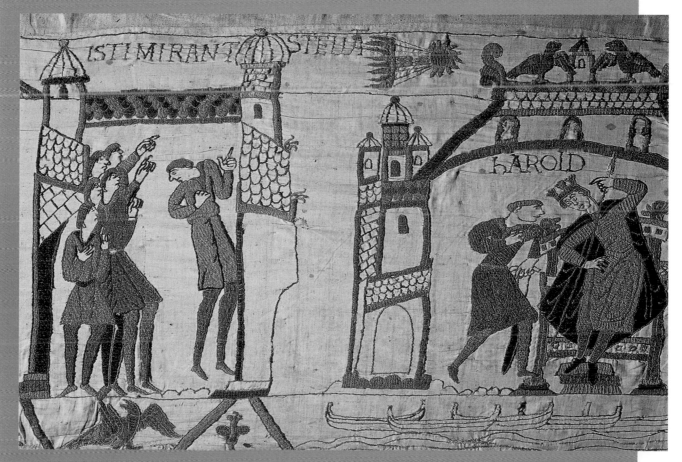

15-32. *Messengers Signal the Appearance of a Comet (Halley's Comet),* panel 32, section 20 of the *Bayeux Tapestry,* Norman–Anglo-Saxon embroidery from Canterbury, Kent, England, or Bayeux, Normandy, France. c. 1066–82. Linen with wool, height 20" (50.8 cm). Centre Guillaume le Conquérant, Bayeux, France

EMBROIDERY TECHNIQUES

The embroiderers of the *Bayeux Tapestry* probably followed drawings provided by a Norman, perhaps even an eyewitness to some of the events depicted. The style of the embroidery, however, is Anglo-Saxon, and the embroiderers were probably women. They worked in tightly twisted wool that was dyed in eight colors with dyes made from plants and minerals. They used only two stitches. The quick, overlapping, linear stem stitch produced a slightly jagged outline. The more time-consuming laid-and-couched work that was used to form blocks of color required three steps. The embroiderer first "laid" a series of long, parallel covering stitches, anchored them with a second layer of regularly spaced crosswise stitches, and finally tacked everything down with tiny "couching" stitches. Some of the tapestry's laid-and-couched work was done in contrasting colors for particular effects. Skin and other light-toned areas were represented by the bare linen cloth that formed the ground of this great work.

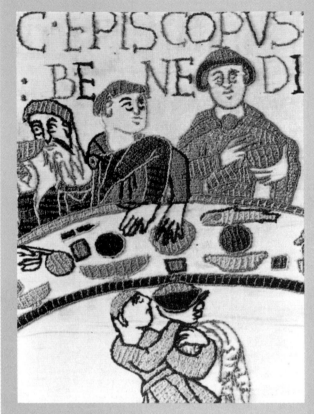

Laid-and-couched work and **stem-stitch techniques** are clearly visible in this detail of figure 15-31. Stem stitching outlines all the solid areas, is used to draw the facial features, and forms the letters of the inscription.

Centre Guillaume le Conquérant, Bayeux

stem stitching

crosswise stitches

laid threads

couching stitches

other arts continued. Carolingian and Ottonian cultural traditions persisted in the German lands during the eleventh and twelfth centuries. Ties between the northern Italian region of Lombardy and Germany also remained strong and provided a source of artistic exchange. Throughout Italy, moreover, artists looked to the still-standing remains of imperial Rome. All these influences shaped the character of the Romanesque style in the Holy Roman Empire.

ARCHITECTURE

The imperial cathedral at Speyer in the Rhine River valley of southwest Germany was a colossal structure that rivaled Cluny in size and magnificence. During the reign of Henry IV, beginning in the 1080s and finishing in 1106, the cathedral building was constructed on the foundations of an Ottonian imperial church. The emperor was fresh from recent successes against the papacy and a German rival, King Rudolf of Swabia, and the monumental rebuilding project was a testament to his power.

A nineteenth-century **lithograph** shows the interior of the Romanesque cathedral (fig. 15-33). Massive compound piers mark each nave bay and support the transverse ribs of the high vault. Lighter, simpler piers mark the aisle bays where two smaller bays cover the distance. This rhythmic alternation of heavy and light piers, first suggested for aesthetic reasons in Ottonian architecture, such as Saint Cyriakus at Gernrode (see fig. 14-24), is regularized in Speyer and became an important design element in Romanesque architecture. The ribbed groin vaults also relieve the stress on the side walls of the building, so that windows can be larger. The result is both a physical and a psychological lightening of the building.

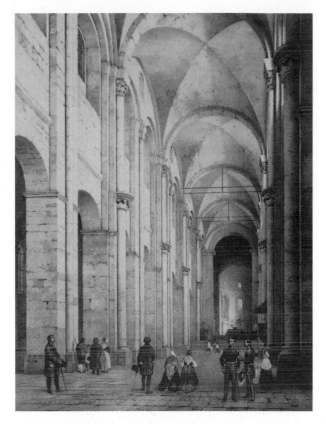

15-33. Interior, Speyer Cathedral, Speyer, Germany, as remodeled c. 1081–1106. Engraving of 1844 by von Bachelier. Kurpfälzisches Museum der Stadt Heidelberg

At roughly the same time, about 1080, construction began in Lombardy, in the city of Milan, on a new Church of Sant'Ambrogio (Saint Ambrose). Milan had been the capital of the Western Roman Empire for a brief period in the fourth century, and the city's first bishop, Ambrose (d. 397), was one of the fathers of the Christian Church. The new church replaced an often-renovated ninth-century church, and the builders reused much of the earlier structure, including the freestanding tenth-century "monks' tower." Lombard Romanesque architecture depended for its austere dignity on harmonious proportions and the restrained use of decorative motifs derived from architectural forms. The simple exterior architectural decoration of wall buttresses and a row of **corbels** (brackets) joined by arches and supporting a molding was carried to Germany, Normandy, and elsewhere by Lombard clerics and masons.

Following an earthquake in 1117, masons rebuilt the church using a technically advanced system of four-part rib vaulting (fig. 15-34). Compound piers support three domed, ribbed groin vaults over the nave, and smaller intermediate piers support the ribbed groin vaulting over the side-aisle bays. In addition to the vaulting system, the builders took other steps to assure the stability of the church. Sant'Ambrogio has a nave that was wider than that of Cluny III (with which it was roughly contemporary), but, at 60 feet, only a little more than half as high. Vaulted galleries buttress the nave, and there are windows only in the outer walls.

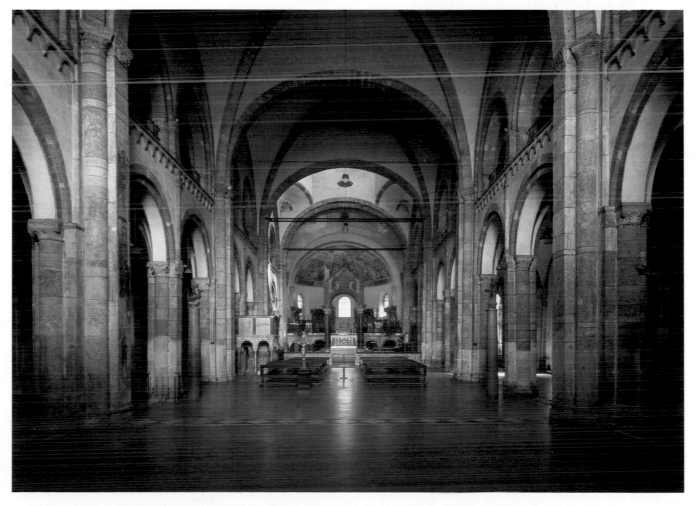

15-34. Nave, Church of Sant'Ambrogio, Milan, Lombardy, Italy. Church begun 1080; vaulting after 1117

15-35. Tomb cover with effigy of Rudolf of Swabia, from Saxony, Germany. After 1080. Bronze with niello, approx. 6'5¹/₂" x 2'2¹/₂" (1.97 x 0.68 m). Cathedral, Merseburg, Germany

METALWORK

For centuries, three centers in the West supplied much of the best metalwork for aristocratic and ecclesiastical patrons throughout Europe: German Saxony, the Meuse River valley region (in modern Belgium), and the lower Rhine River valley. The metalworkers in these areas drew on a variety of stylistic sources, including the work of contemporary Byzantine and Italian artists, as well as classical precedents as reinterpreted by their Carolingian forebears.

In the late eleventh century, Saxon metalworkers, already known for their large-scale bronze casting,

began making bronze **tomb effigies**, or portraits of the deceased. Thus began a tradition of funerary art that spread throughout Europe and persisted for hundreds of years. The oldest known bronze tomb effigy is that of King Rudolf of Swabia (fig. 15-35), who sided with the pope against Henry IV during the Investiture Controversy. The tomb effigy, made soon after Rudolf's death in battle in 1080, is the work of an artist originally from the Rhine region. Nearly lifesize, it has fine linear detailing in **niello**, an incised design filled with a black alloy. The king's head has been modeled in higher relief than his body. The spurs on his oversized feet identify him as a heroic warrior. In his hands he holds the scepter and cross-surmounted orb, emblems of Christian kingship.

Most work of the time is anonymous, but according to the account books of the Abbey of Helmarshausen in Saxony, an artist named Roger was paid on August 15, 1100, for a portable altar dedicated to Saints Kilian and Liborius. Found preserved in the treasury of the cathedral there, the foot-long, chestlike altar—made of gilt bronze, silver, gemstones, and niello—supports a beautiful altar stone (fig. 15-36). It rests on three-dimensionally modeled animal feet. On one end, in high relief, are two standing saints flanking Christ in Majesty, enthroned on the arc of the heavens. On the front are five apostles, each posed somewhat differently, executed in two-dimensional engraving and niello. Saint Peter sits in the center, holding his key. Roger adapted Byzantine figural conventions to his personal style, and he gave his subjects a sense of life despite their formal setting. He was clearly familiar with classical art, but his geometric treatment of natural forms, his use of decorative surface patterning, and the linear clarity of his composition are departures from the classical aesthetic.

Metalworkers in the Meuse and Rhine valleys excelled in a very different regional style. They were well known for sumptuous small pieces, such as the gilt bronze aquamanile shown here, which was made about 1130 (fig. 15-37). Aquamaniles (from the Latin *aqua*, "water," and *manus*, "hand") were introduced into western Europe from the Islamic East, probably by returning Crusaders. In their homelands, Muslims used aquamaniles for rinsing their hands at meals. In the West, they found their way to church altars, where priests purified themselves by pouring water over their hands. This griffin aquamanile recalls its Islamic prototypes (see fig. 8-17). In its liturgical context, however, the hybrid beast known as a griffin symbolized the dual nature of Christ: divine (half eagle) and human (half lion). Black niello sets off the gleaming gold and silver, and the circular handle echoes the curved forms of the rest of the vessel.

BOOKS

The great Carolingian and Ottoman manuscript tradition continued in the Romanesque period. A painting on an opening page from the earliest illustrated copy of the *Liber Scivias* by Hildegard of Bingen (1098–1179) shows the

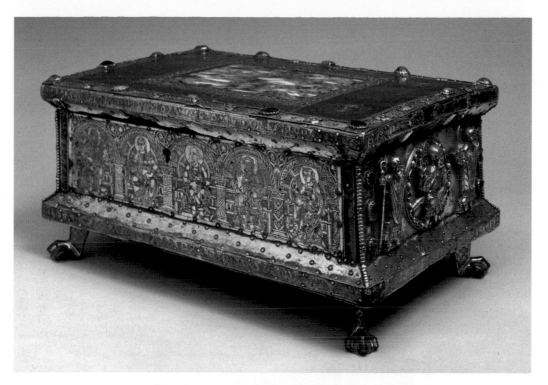

15-36. Roger of Helmarshausen. Portable altar of Saints Kilian and Liborius, from the Abbey, Helmarshausen, Saxony, Germany. c. 1100, with later additions. Silver and gilt bronze, with niello and gemstones, 6½ x 13⅝ x 8⅜" (16.5 x 34.5 x 21 cm). Erzbischöfliches Diözcsanmuseum und Domschatzkammer, Paderborn, Germany

Some scholars identify Roger, a monk, with "Theophilus," the pseudonym used by a monk who wrote an artist's handbook, *On Diverse Arts*, about 1100. The book gives detailed instructions for painting, glassmaking, and goldsmithing. In contrast to Abbot Bernard of Clairvaux, "Theophilus" assured artists that "God delights in embellishments" and that artists worked "under the direction and authority of the Holy Spirit." He wrote, "most beloved son, you should not doubt but should believe in full faith that the Spirit of God has filled your heart when you have embellished His house with such great beauty and variety of workmanship . . . Set a limit with pious consideration on what the work is to be, and for whom, as well as on the time, the amount, and the quality of work, and, lest the vice of greed or cupidity should steal in, on the amount of the recompense" (Theophilus, page 43). The last admonishment is a worldly reminder about fair pricing.

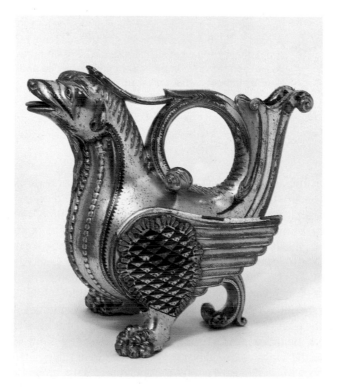

15-37. Griffin aquamanilc, in thc style of Mosan, Liège (?), Belgium. c. 1130. Gilt bronze, silver, and niello, height 7¼" (18.5 cm). Victoria and Albert Museum, London

15-38. Facsimile of page with *Hildegard's Vision*,
Liber Scivias. c. 1150–1200. Original manuscript
lost during World War II

The text that accompanies this picture of Hildegard of
Bingen reads: "In the year 1141 of the incarnation of
Jesus Christ the Son of God, when I was forty-two
years and seven months of age, a fiery light, flashing
intensely, came from the open vault of heaven and
poured through my whole brain. . . . And suddenly I
could understand what such books as the psalter, the
gospel and the other catholic volumes of the Old and
New Testament actually set forth" (*Scivias*, I, 1).

author at work (fig. 15-38). Born into an aristocratic German family, Hildegard transcended the barriers that limited most medieval women, and she became one of the towering figures of her age. Like many women of her class, she entered a convent as a child. Developing into a scholar and a capable administrator, Hildegard began serving as leader of the convent in 1136. In about 1147 she founded a new convent near Bingen. Since childhood she had been subject to what she interpreted as divine visions, and in her forties, with the assistance of the monk Volmar, she began to record them. Her book, *Scivias* (from the Latin *scite vias lucis*, "know the ways of the light"), records her visions. In addition to *Scivias*, Hildegard wrote

treatises on a variety of subjects, including medicine and natural science. Emerging as a major figure in the intellectual life of her time, she corresponded with emperors, popes, and the Cistercian abbot Bernard of Clairvaux.

The opening page of this copy of *Scivias* shows Hildegard receiving a flash of divine insight, represented by the tongues of flame encircling her head. She records the vision on a tablet while Volmar, her scribe, waits in the wings. Stylistic affinities suggest to some art historians that this copy of *Scivias* was made at the *scriptorium* of the Monastery of Saint Matthias in Trier, whose abbot was a friend of Hildegard. Others suggest it was made at Bingen under the direction of Hildegard herself.

15-39. **Page with self-portrait of the nun Guda,** *Book of Homilies.* Early 12th century. Ink on parchment. Stadt-und Universitäts-Bibliothek, Frankfurt, Germany. MS. Barth. 42, folio 110v

In the Romanesque period, as earlier in the Middle Ages, women were involved in the production of books as authors, scribes, painters, and patrons. Like Abbess Hitda (see fig. 14-31), the nun Guda, from Westphalia, was a scribe and painter. In a book of homilies, now in Frankfurt, she inserted her self-portrait into the letter *D* and signed "Guda, the sinful woman, wrote and illuminated this book" (fig. 15-39). A simple drawing with colors only in the background spaces, Guda's self-portrait is certainly not a major work of art. The importance of the drawing lies in its demonstration that women were far from anonymous workers in German *scriptoria*. Guda and other nuns played an important role in the production of books in the twelfth century, and this image is the earliest signed self-portrait by a woman in Western Europe.

ANCIENT ROME AND ROMANESQUE ITALY

The spirit of classical Rome reappeared in the Romanesque art of Pisa, Rome, Modena, and other centers in Italy. Pisa, on the west coast of Tuscany, was a great maritime power from the ninth through the thirteenth century. An expansionist republic, it competed with Muslim centers for control of trade in the western Mediterranean. In 1063, Pisa won a decisive victory over Muslim forces, and the jubilant city

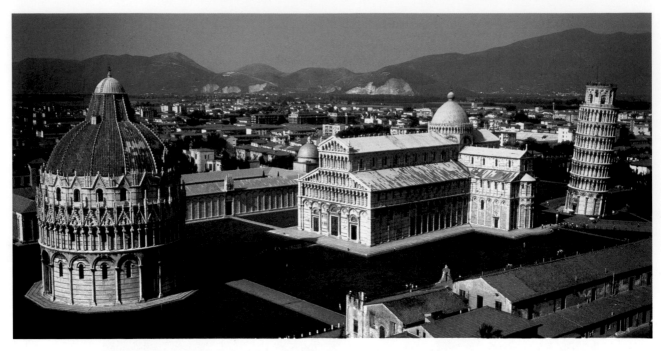

15-40. Cathedral complex, Pisa, Tuscany, Italy. Cathedral begun 1063; baptistry begun 1153; campanile begun 1174; Campo Santo 13th century

When finished in 1350, the Leaning Tower of Pisa stood 179 feet high. The campanile had begun to tilt while still under construction, and today it leans about 13 feet off the perpendicular. In the latest effort to keep it from toppling, engineers filled the base with tons of lead.

soon began constructing an imposing new cathedral dedicated to the Virgin Mary (fig. 15-40). The cathedral complex eventually included the cathedral itself; a **campanile**, or freestanding bell tower, a feature of Italian church architecture since the sixth century (this one now known for obvious reasons as the Leaning Tower); a baptistry; and the Campo Santo (Holy Field), a walled burial ground. The cathedral, designed by the master builder Busketos, was not completed until the late thirteenth century. Its plan is an adaptation on a grand scale of the cruciform basilica. It has a long nave with double side aisles crossed by a projecting transept each of which has aisles and an apse like the nave and main sanctuary. Three portals open onto the nave and side aisles, and a clerestory rises above the side aisles and second-story galleries. A dome covers the crossing. Pilasters, blind arcades, and narrow galleries adorn the five-story, pale-marble facade. An Islamic bronze griffin stood atop the building from about 1100 until 1828 (see fig. 8-17).

The Pisa baptistry, begun in 1153, has arcading and galleries on the lower levels of its exterior that match those on the cathedral (the baptistry's present exterior dome and ornate upper levels came later). The campanile was begun in 1174 by the master Bonanno Pisano. Built on inadequate foundations, it began to lean almost immediately. The cylindrical tower is encased in tier upon tier of marble arcades. This creative reuse of an ancient, classical theme is characteristic of Italian Romanesque art; artists and architects seem always to have been conscious of their Roman past.

Builders in Rome itself looked to revive the past when the city was destroyed in 1084. During the Investiture Controversy, Pope Gregory VII called on the Norman rulers of southern Italy for help when the forces of Emperor Henry IV threatened Rome. However, these erstwhile allies themselves looted and burned the city. Among the architectural victims was the eleventh-century Church of San Clemente. The Benedictines rebuilt the church between 1120 and 1130 as part of a program to restore Rome to its ancient splendor. The new church, built on top of the remains of a sanctuary of Mithras and the eleventh-century church, reflects a conscious effort to reclaim the artistic and spiritual legacy of the early Church (fig. 15-41). However, a number of features mark it as a Romanesque structure. A characteristic of early basilica churches, for example, was a strong horizontal movement down the nave to the sanctuary. In the new San Clemente, rectangular piers interrupt the line of Ionic columns, which had been assembled from ancient Roman buildings. In a configuration that came to be called the Benedictine plan, the nave and the side aisles each end in a semicircular apse. The different sizes of the apses, caused by the difference in the widths of the nave and the narrower side aisles, creates a stepped outline. The apse of the nave followed the outline of the apse of the older structure beneath and was too small to accommodate all the participants in the liturgy of the time. As a result, the choir, defined by the low barrier in the foreground of figure 15-41, was extended into the nave.

Mosaic was a rarely used medium in twelfth-century Europe because it required expensive materials and

15-41. Nave, Church of San Clemente, Rome. c. 1120–30

Ninth-century choir screens were reused from the earlier church on the site. The upper wall and ceiling decoration are eighteenth century. San Clemente contains one of the earliest surviving collections of church furniture: choir stalls, pulpit, lectern, candlestick, and also the twelfth-century inlaid floor pavement.

specialized artisans. The apse of San Clemente, however, is richly decorated with colored marble inlay and a gold mosaic apse half-dome, another reflection of its builders' desire to recapture the past. The style of the mosaics and the subject matter—a crucified Jesus, his mother, and Saint John, all placed against a vine scroll, and sheep representing the apostles and the Lamb of God—are likewise archaic. As in other Italian churches of the period, inlaid geometric patterns in marble embellish the floors of San Clemente. They are known as Cosmati work, after the family who perfected it. Ninth-century panels with relief sculptures, saved from

the earlier church, form the wall separating the choir from the nave. A **baldachin** (*baldacchino*), or canopy of honor symbolizing the Holy Sepulchre, covers the main altar in the apse.

The spirit of ancient Rome also pervades the sculpture of Romanesque Italy. Horizontal bands of relief on the west facade of Modena Cathedral, in north-central Italy, are among the earliest narrative portal sculpture in Italy (c. 1106–20). Wiligelmus, the sculptor, must have seen the sculpture of ancient sarcophagi and may also have looked at Ottonian carving. He took his subjects from the Old Testament Book of Genesis and included

15-42. Wiligelmus. *Creation and Fall*, on the west facade, Modena Cathedral, Emilia, Italy. 1106–20. Height approx. 3' (92 cm)

events from the Creation to the Flood. The panel in figure 15-42 shows the Creation and the Fall of Adam and Eve. On the far left is a half-length God with a cruciform halo, indicating two persons—father and son—framed by a mandorla supported by two angels. The scene to the right shows God bringing Adam to life. Next, he brings forth Eve from Adam's side. On the right, Adam and Eve cover their genitals in shame as they greedily eat the fruit of the forbidden tree, around which the serpent twists.

Wiligelmus's deft carving and undercutting give these low-relief figures a strong three-dimensionality. While most Romanesque sculpture seems controlled by a strong frame or architectural setting, Wiligelmus used the arcade to establish a stagelike setting. Rocks and a tree add to the impression that figures interact with stage props. Wiligelmus's figures, although not particularly graceful, have a sense of life and personality and effectively convey the emotional depth of the narrative. Bright

paint, now almost all lost, must have increased the impact of the sculpture.

An inscription reads: "Among sculptors, your work shines forth, Wiligelmo [Wiligelmus]." This self-confidence turned out to be justified. Wiligelmus's influence can be traced throughout Italy and as far away as the cathedral of Lincoln in England. Wiligelmus, Roger, Gislebertus, and many anonymous women and men of the eleventh and twelfth centuries created a new art that—although based on the Bible and the lives of the saints—focused on human beings, their stories, and their beliefs. The artists worked on a monumental scale in painting, sculpture, and even embroidery, and their art moved from the cloister to the public walls of churches. While they emphasized the spiritual and intellectual concerns of the Christian Church, they also began to observe and record what they saw around them. In so doing they laid the groundwork for the art of the Gothic period.

PARALLELS

REGION	ROMANESQUE ART	ART IN OTHER CULTURES
FRANCE/ NORTHERN SPAIN	15-1. *Saint Foy* (late 10th–11th cent) 15-2. **Abbey Church of Sainte-Foy, Conques** (mid-11th to 12th cent) 15-5. **Cluny III** (1088–1130) 15-8. *Doubting Thomas* (c. 1100) 15-17. *Tower of Babel* (c. 1100) 15-16. **Church of Saint-Savin-sur-Gartempe** (c. 1100) 15-19. *Cluny Lectionary* (early 12th cent.) 15-9. **Priory Church of Saint-Pierre, Moissac** (c. 1115/30) 15-10. *Lions and Prophet Jeremiah (?)* (c. 1115–30) 15-12. *Last Judgment* (c. 1120–35/40) 15-18. *Christ in Majesty* (c. 1123) 15-20. *The Tree of Jesse* (c. 1125) 15-6. **Abbey Church of Notre-Dame, Fontenay** (1139–47) 15-14. *Virgin and Child* (c. 1150–1200) 15-15. *Batlló Crucifix* (mid-12th cent.)	7-39. **Cathedral of Saint Mark** (begun 1063), Italy 12-20. **Great Serpent Mound** (c. 1070), North America 7-44. *Christ Pantokrator* (c. 1080–1100), Greece 7-42. *Virgin of Vladimir* (12th cent.), Russia 10-21. Zhang. *Spring Festival on the River* (early 12th cent.), China 12-23. **Anasazi seed jar** (c. 1150), North America 9-28. *Shiva Nataraja* (12th cent.), India 11-14. *The Tale of Genji* (12th cent.), Japan
NORTH SEA KINGDOMS	15-22. **Urnes panels** (c. 1050–70) 15-26. **Church of Saint-Étienne, Caen** (begun 1064) 15-31. *Bayeux Tapestry* (c. 1066–82) 15-23. **Durham castle-monastery-cathedral complex** (c. 1075–1100s) 15-29. *Worcester Chronicle* (c.1140) 15-30. *Winchester Psalter* (c. 1150) 15-21. **Borgund stave church, Sogn** (c. 1125–50)	
HOLY ROMAN EMPIRE	15-33. **Speyer Cathedral** (remodeled c. 1081–1106) 15-35. *Tomb cover with effigy of Rudolf of Swabia* (after 1080) 15-36. **Helmarshausen altar** (c. 1100) 15-34. **Church of Sant'Ambrogio, Milan** (after 1117) 15-37. **Griffin aquamanile** (c. 1130) 15-38. *Hildegard's Vision* (c. 1150–1200) 15-39. **Guda self-portrait** (early 12th cent.)	
ROME AND ROMANESQUE ITALY	15-40. **Pisa Cathedral complex** (begun 1063) 15-41. **Church of San Clemente, Rome** (c. 1120–30) 15-42. *Creation and Fall*, (1106–20)	

16 Gothic Art

16-1. Triforium wall of the nave,
Chartres Cathedral,
the Cathedral of Notre-Dame,
Chartres, France. c. 1194–1260

The twelfth-century Abbot Suger of Saint-Denis was, according to his biographer Wil-lelmus, "small of body and family, constrained by twofold smallness, [but] he refused, in his smallness, to be a small man" (cited in Panofsky, page 33). Educated at the monastery of Saint-Denis, near Paris, he rose from modest origins to become a powerful adviser to kings. And he built what many consider the first Gothic structure in Europe.

After Suger was elected abbot of Saint-Denis, he was determined to rebuild its church. Within it were housed the relics of Saint Denis—patron saint of France—and the remains of the kings of the Franks, whose burials had taken place there since the seventh century. Suger waged a successful campaign to gain both royal and popular support for his rebuilding plans. The current building, he pointed out, had become inad-equate. With a touch of exaggeration, he claimed that the crowds of worshipers had become so great that women were being crushed and monks sometimes had to flee with their relics by jumping through windows.

In carrying out his duties, the abbot had traveled widely—in France, the Rhineland, and Italy, including four trips to Rome—and so was familiar with the latest architecture and sculpture of Romanesque Europe. As he began planning the new church, he also turned for inspiration to Church writings, including the writings of a late fifth century Greek philosopher known as the Pseudo-Dionysius, who had identified radiant light with divinity. Seeing the name "Dionysius" (Denis), Suger thought he was reading the work of Saint Denis, so Suger not unreasonably adapted the concept of divine lumi-nosity into the redesign of the church dedicated to Saint Denis. Accordingly, when Suger began work on the choir after completing a magnificent Norman-inspired facade and narthex, he created "a circular string of chapels" so that the whole church "would shine with the wonderful and uninterrupted light of most luminous windows, pervad-ing the interior beauty" (cited in Panofsky, page 101).

Although Abbot Suger died before he was able to finish rebuilding Saint-Denis, his presence remained: The cleric had himself portrayed in a sculpture at Christ's feet in the central portal and in a stained-glass window in the apse. Suger is remembered not for these portraits, however, but for his inspired departure from traditional architecture in order to achieve radiant interior light. His innovation led to the widespread use of large stained-glass windows, such as those that bathe the inside walls of Chartres Cathedral with sublime washes of color (fig. 16-1).

TIMELINE 16-1. Gothic Art in Europe. In the two and a half centuries following 1150, known as the Gothic era, Europe underwent a gradual shift toward urbanization and experienced political, religious, and social change.

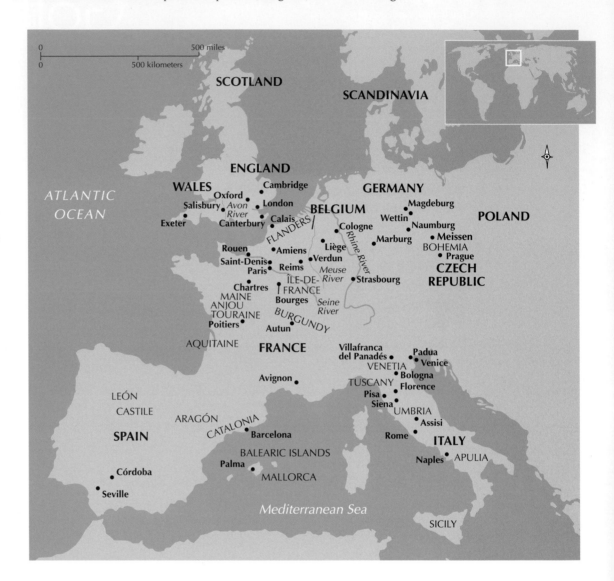

MAP 16-1. Gothic Art in Europe. Gothic art began in the Île-de-France in about 1140 and spread throughout Europe during the next 250 years.

THE GOTHIC STYLE

In the middle of the twelfth century, while builders throughout Europe were working in the Romanesque style, a distinctive new architecture known today as Gothic emerged in the Île-de-France, the French king's domain around Paris (Map 16-1). The appearance there of the new style and building technique coincided with the emergence of the monarchy as a powerful centralizing force in France. From that point, the Gothic style spread, and it prevailed in western European art until about 1400, then lingered for another century in some regions. The term *Gothic* was introduced in the sixteenth century by the Italian artist and historian Giorgio Vasari, who disparagingly attributed the style to the Goths, the Germanic invaders who had destroyed the classical civilization of the Roman Empire that he and his contemporaries so admired. In its own day the Gothic style was simply called modern style or the French style. As it spread from the Île-de-France, it gradually displaced Romanesque forms but took on regional characteristics inspired by those forms. England developed a distinctive national style, which also influenced architectural design in continental Europe. The Gothic style was slow to take hold in Germany but ultimately endured there well into the sixteenth century. Italy proved more resistant to French Gothic elements, and by 1400, Italian artists and builders there sought a return to classical traditions. In the late fourteenth century, the various regional styles of Europe coalesced into what is known as the International Gothic style.

16-2. Chartres Cathedral, the Cathedral of Notre-Dame, Chartres, France. West facade begun c. 1134; cathedral rebuilt after a fire in 1194 and building continued to 1260; north spire 1507–13. View from the southeast

Chartres was the site of a pre-Christian virgin-goddess cult and one of the oldest and most important Christian shrines in France. Its main treasure was a long piece of linen believed to have been worn by Mary—a gift from the Byzantine empress Irene to Charlemagne, which was donated to the cathedral by King Charles the Bald in 876—that was on display with other relics in a huge basement crypt. The healing powers attributed to this relic and its association with Mary made Chartres a major pilgrimage destination as the cult of the Virgin grew.

Gothic architecture's elegant, soaring buildings, the light, colors, and sense of transparency produced by great expanses of stained glass, and its linear qualities became more pronounced over time. The style was adapted to all types of structures—including town halls, meeting houses, market buildings, residences, and Jewish synagogues, as well as churches and palaces—and its influence extended beyond architecture and architectural sculpture to painting and other mediums.

The people of western Europe experienced both great achievements and great turmoil during the Gothic period. Although Europe remained rural, towns gained increasing prominence. By the late twelfth century, nearly all the major cities in western Europe today were sizable urban centers. The rise of towns stimulated intellectual life, and urban universities supplanted rural monastic schools as centers of learning. The first European university, at Bologna, Italy, was founded in the eleventh century, and important universities in Paris, Cambridge, and Oxford soon followed. The Gothic period saw the flowering of poetry and music as well as philosophy and theology.

As towns grew, they became increasingly important centers of artistic patronage. The production and sale of goods in many towns was controlled by guilds. Merchants and artisans of all types, from bakers to painters, formed these associations to advance their professional interests. Medieval guilds also played an important social role, safeguarding members' political interests, organizing religious celebrations, and looking after members and their families in times of trouble.

A town's walls enclosed streets, wells, market squares, shops, churches, and schools. Homes ranged from humble wood-and-thatch structures to imposing town houses of stone. Although wooden dwellings crowded together made fire an ever-present danger and hygiene was rudimentary at best, towns fostered an energetic civic life and a strong communal identity, reinforced by public projects and ceremonies.

Urban cathedrals, the seats of the ruling bishops, superseded rural monasteries as centers of religious patronage throughout western Europe during the Gothic period. So many of these churches were rebuilt between 1150 and 1400—usually after fires—that the period has been called the age of cathedrals. Cathedral precincts functioned almost as towns within towns. The great churches dominated their surroundings and were central fixtures of urban life (fig. 16-2). Their grandeur inspired

ROMANCE The ideal of romantic love arose in southern France in the early twelfth century during the cultural renaissance that followed the First Crusade. Unlike the noble marriages of the time, which were essentially business contracts based on political or financial exigencies, romantic love involved the passionate devotion of lover and loved one. The relationship was almost always illicit—the woman the wife of another, often a lord or patron—and its consummation was usually impossible. Dubbed "courtly love" in the nineteenth century, this movement transformed the social habits of western Europe's courts and has had an enduring influence on modern ideas of love. Images of gallant knights serving refined ladies, who bestowed tokens of affection on their chosen suitors or cruelly withheld their love on a whim, captured the popular imagination (see page 580).

Tales of romance were initially spread by the musician-poets known as troubadours, some of them professionals, some of them amateur nobles, and at least twenty of them women. They sang of love's joys and heartbreaks in daringly personalized terms, extolling the ennobling effects of the lovers' selfless devotion. Among the literature that emerged from this tradition was the story of the love of the knight Lancelot for Guinevere, the wife of King Arthur, recounted in the late twelfth century by Chrétien de Troyes, a French poet. Such works marked a major shift from the usually negative way in which women had previously been portrayed as sinful daughters of Eve. The following example, a stylized lovers' debate (the woman speaks first), is an example of courtly love poetry of southern France.

Friend, because of you I'm filled
 with grievous sorrow and
 despair,
but I doubt you feel a trace
 of my affliction.
Why did you become a lover,
since you leave the suffering
 to me?
Why don't we split it evenly?

Lady, such is love's nature
when it links two friends

together,
that whatever grief or joy they
 have
each feels according to his way.
The way I see it, and I don't
exaggerate, all the worst pain's
been on my end of the game.

Friend, I know well enough
 how skilled
you are in amorous affairs,
and I find you rather changed
from the chivalrous knight you
 used to be.
I might as well be clear,
for your mind seems quite
 distracted:
do you still find me attractive?

Lady, may sparrow-hawk not
 ride my wrist,
nor siren fly beside
me on the chase, if ever
since you gave me perfect joy
I possessed another woman;
I don't lie: out of envy
evil men insult my name.

(Attributed to the Countess of Dia and Raimbaut d'Orange, late twelfth century; cited in Bogin, pages 147, 149)

love and admiration; their great expense and the intrusive power of their bishops inspired resentment and fear. The twelfth century witnessed a growth of intense religiosity among the laity, particularly in Italy and France. The same devotional intensity gave rise in the early thirteenth century to two new religious orders, the Franciscans and the Dominicans, whose monks went out into the world to preach and minister to those in need, rather than confining themselves in monasteries.

The Crusades continued throughout the thirteenth century (see "The Crusades," page 517). In 1204, soldiers of the Fourth Crusade who had set out to conquer Egypt from the Muslims instead seized Constantinople—capital of the Byzantine Empire and the center of the Eastern Christian Church—and the city remained under Western control until 1261. The Crusades and the trade that followed from them brought western Europeans into contact with the Byzantine and Islamic worlds, and through them many literary works of classical antiquity, particularly those of Aristotle. These works posed a problem for medieval scholars because they promoted rational inquiry rather than faith as the path to truth, and their conclusions did not always fit comfortably with Church doctrine. A philosophical and theological movement called Scholasticism emerged to reconcile the two belief systems. The Dominican Thomas Aquinas (1225–74), the foremost Scholasticist, used reason to comprehend religion's supernatural aspects and in his writings convincingly integrated scientific rationalism with Christian faith. His work has endured as a basis of Catholic thought to this day.

The Scholastic thinkers applied their system of reasoned analysis to a vast range of subjects. Vincent de Beauvais, a thirteenth-century Parisian Dominican, organized his eighty-volume encyclopedia, *Speculum Maius* (*Greater Mirror*), to include categories of the Natural World, Doctrine, History, and Morality. This all-encompassing intellectual approach had a profound influence on the arts. Like the Scholastics, Gothic master builders saw divine order in geometric relationships and used these relationships as the underpinnings of architectural and sculptural programs. Sculptors and painters created naturalistic forms that reflected the combined idealism and analysis of Scholastic thought. Gothic religious imagery expanded to incorporate a wide range of subjects from the natural world, and like Romanesque imagery its purpose was to instruct and convince the viewer. In the Gothic cathedral, Scholastic logic intermingles with the mysticism of light and color to create for the worshiper the direct, emotional, ecstatic experience of the church as the embodiment of God's house, filled with divine light.

Yet beneath the achievements of the era lay the seeds of disaster. By the middle of the fourteenth century much of Europe was in crisis. Prosperity had fostered population growth, which by about 1300 began to

THE BLACK DEATH

In the early 1340s rumors began to circulate in Europe of a deadly plague spreading by land and sea from Asia. By 1348 the plague had reached Constantinople, Italy, and France; by the next winter it had struck the British Isles; and by 1350 it had swept across Germany, Poland, and Scandinavia. Successive waves struck again in 1362, 1374, 1383, 1389, and 1400, and new outbreaks continued sporadically over the next centuries, culminating in England's Great Plague of 1665. As much as half the urban population of Florence and Siena died in the summer of 1348, including many promising artists. England was similarly hard hit.

The plague, known as the Black Death, took two forms, both of which killed rapidly. The bubonic form was spread by fleas from rats, the pneumonic form through the air from the lungs of infected victims. To people of the time, ignorant of its causes and powerless to prevent it, the Black Death was a catastrophe. The fourteenth-century Italian writer Giovanni Boccaccio described how "the calamity had instilled such terror in the hearts of men and women that . . . fathers and mothers shunned their children, neither visiting them nor helping them" (cited in Herlihy, page 355). In their panic, some people turned to escapist pleasure seeking, others to religious fanaticism. Many, seeking a scapegoat, turned against Jews, who were massacred in several cities.

Francesco Traini. *Triumph of Death*, detail of a fresco in the Campo Santo, Pisa. 1325–50

exceed food production, and famines became increasingly common. Peasant revolts began as worsening conditions frustrated rising expectations. In 1337 a prolonged conflict known as the Hundred Years' War (1337–1453) erupted between France and England, devastating much of France. In the middle of the fourteenth century a lethal plague swept northward from Sicily, wiping out as much as 40 percent of Europe's population (see "The Black Death," above). By depleting the labor force, however, the plague gave surviving peasants increased leverage over their landlords and increased the wages of artisans. The Church, too, experienced great strain during the fourteenth century. In 1309 the papal court moved from Rome to Avignon, in southeastern France, where it remained until 1377. From 1378 to 1417, in what is known as the Great Schism, the papacy split, with two contending popes, one in Avignon and one in Rome, claiming legitimacy.

FRANCE

The birth and initial flowering of the Gothic style took place in France against the backdrop of the growing power of the French monarchy. Louis VI (ruled 1108–37) and Louis VII (ruled 1137–80) consolidated royal authority over the Île-de-France and began to exert control over powerful nobles in other regions. Before succeeding to the throne, Louis VII had married Eleanor (1122–1204), heir to the region of Aquitaine (southwestern France), the largest and most prosperous feudal domain in western Europe. Eleanor of Aquitaine was one of the great figures of her age. She accompanied Louis on the Second Crusade (1147–49), but the marriage was later annulled by papal decree. Taking her wealthy province with her, Eleanor then married Henry Plantagenet—the soon-to-be King Henry II of England. Henry and Eleanor together controlled more French territory than the French king, although he was technically their feudal overlord. The resulting tangle of conflicting claims eventually culminated in the Hundred Years' War.

The successors to Louis VII continued the consolidation of royal authority and nation building, increasing their domains and privileges at the expense of their vassals and the Church.

ARCHITECTURE AND ITS DECORATION

The political events of the twelfth and thirteenth centuries were accompanied by a burst of church building, often made necessary by the fires that swept through towns. It has been estimated that during the Middle Ages several million tons of stone were quarried to build some eighty cathedrals, 500 large churches, and tens of thousands of parish churches, and that within 100 years some 2,700 churches were built in the Île-de-France region alone. This explosion of cathedral building began at a historic abbey church on the outskirts of Paris.

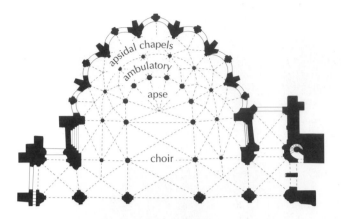

16-3. Plan of the sanctuary, Abbey Church of Saint-Denis, Saint-Denis, France. 1140–44

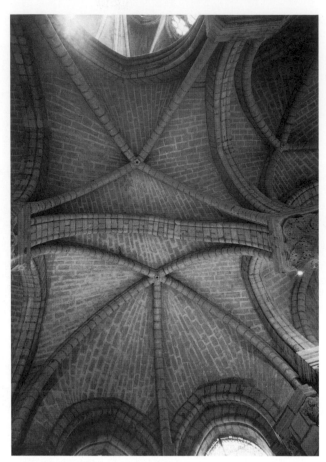

16-5. Ambulatory vaults, Abbey Church of Saint-Denis

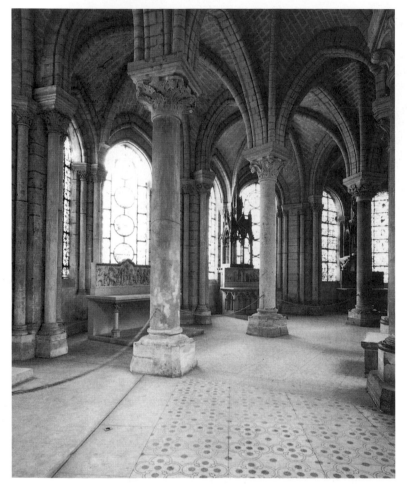

16-4. Ambulatory choir, Abbey Church of Saint-Denis

Abbey Church of Saint-Denis. The Benedictine monastery of Saint-Denis, a few miles north of central Paris, had great symbolic significance for the French monarchy. It housed the tombs of French kings, regalia of the French Crown, and the relics of Saint Denis, the patron saint of France, who, according to tradition, had been the first bishop of Paris. In the 1130s, under the inspiration of Abbot Suger, construction began on a new abbey church, which is arguably Europe's first Gothic structure.

Suger (1081–1151) was a trusted adviser to both Louis VI and Louis VII, and he governed France as regent when Louis VII and Eleanor of Aquitaine went on crusade.

Suger described his administration of the abbey and the building of the Abbey Church of Saint-Denis in three books. In contrast to the austerity advocated by the Cistercian Abbot Bernard of Clairvaux (Chapter 15), Suger prized magnificent architecture and art. The widely traveled cleric had seen the latest developments in church building, and his design combines elements from many sources. Because the Île-de-France had great Carolingian buildings and little monumental Romanesque architecture, Suger brought in masons and sculptors from other regions. Saint-Denis thus became a center of artistic interchange. Unfortunately for art historians today, Suger did not record the names of the masters he employed, nor information about them and the techniques they used, although he took an active part in the building. He found the huge trees and stone needed on the abbey's own lands. To generate income for the rebuilding, he instituted economic reforms, receiving substantial annual payments from the town's inhabitants and establishing free housing on abbey estates to attract peasants. For additional funds, he turned to the royal coffers and even to fellow clerics.

The first part of the new structure to be completed was the west facade and narthex (1135–40). Here Suger's masons combined Norman facade design like that at

ELEMENTS OF ARCHITECTURE

Rib Vaulting

Rib vaulting was one of the chief technical contributions of Romanesque and Gothic builders. Rib vaults are a form of **groin vault** (see "Arch, Vault, and Dome," page 228), in which the ridges (groins) formed by the intersecting vaults may rest on and be covered by curved moldings called ribs. These ribs were usually structural as well as decorative, and they strengthened the joins and helped channel the vaults' thrust outward and downward. The ribs were constructed first and supported the scaffolding of the vault. Ribs developed over time into an intricate masonry "skeleton" filled with an increasingly lightweight masonry "skin," the web of the vault, or webbing. Sophisticated variations on the basic rib vault created the soaring interiors for which Gothic churches are famous.

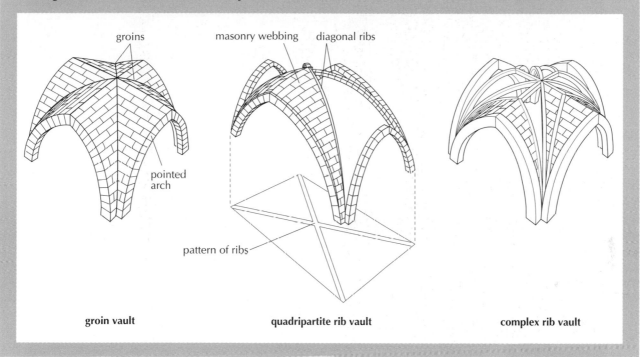

groins
masonry webbing
diagonal ribs
pointed arch
pattern of ribs

groin vault **quadripartite rib vault** **complex rib vault**

Caen (see fig. 15-26) with the richly sculptured portals of Burgundy, like those at Autun (see fig. 15-11). The east end represented a more stunning change. The choir was completed in three years and three months (1140–44), timing that Abbot Suger found auspicious. The plan of the choir (*chevet* in French) resembled that of a Romanesque pilgrimage church, with a semicircular sanctuary surrounded by an ambulatory from which radiated seven chapels of uniform size (fig. 16-3). All the architectural elements of the choir—ribbed groin vaults springing from round piers, pointed arches, wall buttresses to relieve stress on the walls, and window openings—had already appeared in Romanesque buildings. The dramatic achievement of Suger's master mason was to combine these features into a fully integrated architectural whole that emphasized the open, flowing space. Sanctuary, ambulatory, and chapels opened into one another; walls of stained glass replaced masonry, permitting the light to permeate the interior with color (fig. 16-4). To accomplish this effect, the masons relied on the systematic use of advanced vaulting techniques, the culmination of half a century of experiment and innovation (fig. 16-5; see "Rib Vaulting," above).

The apse of Saint-Denis represented the emergence of a new architectural aesthetic based on line and light. Citing early Christian writings, Suger saw light and color as a means of illuminating the soul and uniting it with

God, a belief he shared with medieval mystics such as Hildegard of Bingen (Chapter 15). For him, the colored lights of gemstones and stained-glass windows and the glint of golden church furnishings at Saint-Denis transformed the material world into the splendor of paradise.

Louis VII and Eleanor of Aquitaine attended the consecration of the new choir on June 14, 1144. Shortly thereafter the impending Second Crusade became the primary recipient of royal resources, leaving Suger without funds to replace the old nave and transept at Saint-Denis. The abbot died in 1151, and his church remained unfinished for another century. (Saint-Denis suffered extensive damage during the French Revolution in the late eighteenth century. Its current condition is the result of nineteenth- and twentieth-century restorations and cleaning.)

The Abbey Church of Saint-Denis became the prototype for a new architecture of space and light based on a highly adaptable skeletal framework constructed from buttressed perimeter walls and an interior vaulting system of pointed-arch masonry ribs. It initiated a period of competitive experimentation in the Île-de-France and surrounding regions that resulted in ever larger churches enclosing increasingly tall interior spaces walled with ever greater expanses of colored glass. These great churches, with their unabashed decorative richness, were part of Abbot Suger's legacy to France.

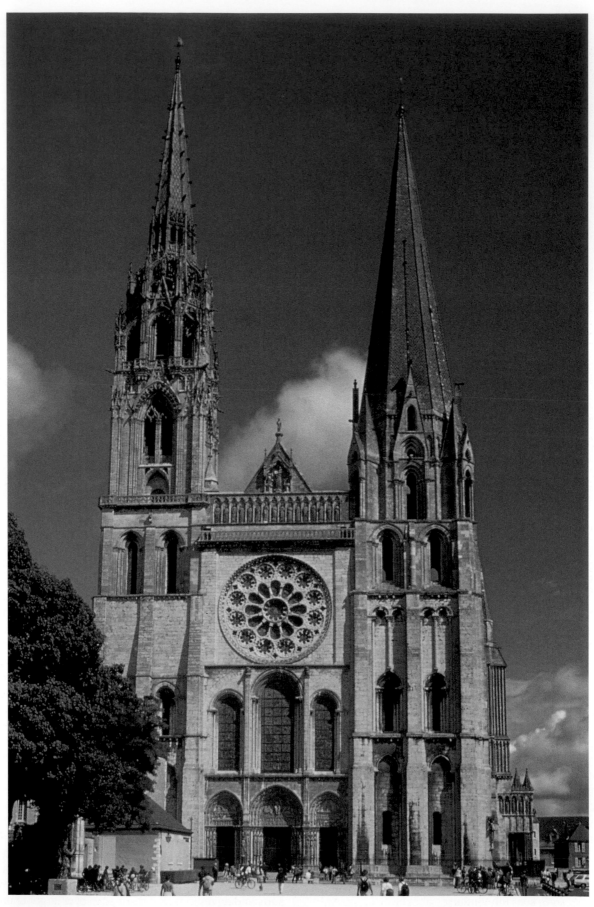

16-6. West facade, Chartres Cathedral, the Cathedral of Notre-Dame, Chartres, France. c. 1134–1220; south tower c. 1160; north tower 1507–13

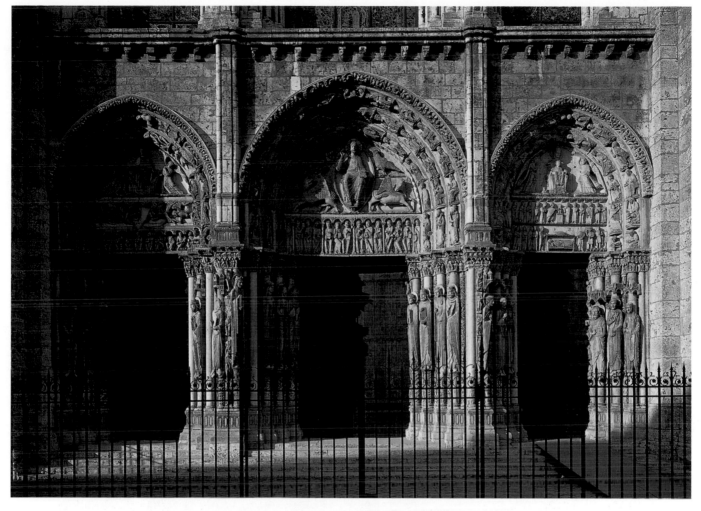

16-7. Royal Portal, west facade, Chartres Cathedral. c. 1145–55

Chartres Cathedral. The great Cathedral of Notre-Dame ("Our Lady," the Virgin Mary) dominates the town of Chartres, southwest of Paris (see fig. 16-2). For many people, Chartres Cathedral is a near-perfect embodiment of spirit in stone and glass. Constructed in several stages beginning in the mid-twelfth century and extending into the mid-thirteenth with later additions such as the north spire in the sixteenth century, the cathedral reflects the transition from an experimental twelfth-century phase to a mature thirteenth-century style. A fire in 1134 that damaged the western facade of an earlier cathedral on the site prompted the building of a new facade, influenced by the early Gothic style at Saint-Denis. After another fire in 1194 destroyed most of the rest of the original structure, a papal representative convinced reluctant local church officials to undertake a massive rebuilding project. He argued that the Virgin permitted the fire because she wanted a new and more beautiful church to be built in her honor (quoted in Von Simson, page 163). A new cathedral was built between approximately 1194 and 1260.

To erect such an enormous building required vast resources—money, raw materials, and skilled labor. Contrary to common perceptions, medieval people often opposed the building of cathedrals because of the burden of new taxes. Nevertheless, cathedral officials pledged all or part of their incomes for three to five years. The church's relics were sent on tour as far away as England to solicit contributions. As the new structure rose higher during the 1220s, the work grew more costly and funds dwindled. When the bishop and canons (cathedral clergy) tried to make up the deficit by raising feudal and commercial taxes, they were driven into exile for four years. The economic privileges claimed by the Church for the cathedral sparked intermittent riots by townspeople and the local nobility throughout the thirteenth century. Despite these tensions, the new cathedral emerged as a work of remarkable balance and harmony, still inspiring today, even to nonbelievers.

From a distance, the most striking features of the west facade are its prominent rose window—the huge circle of stained glass—and two towers and spires (fig. 16-6). The spire on the north tower (left) was added in the early sixteenth century; the spire on the south tower dates from the twelfth century. On closer inspection, the facade's three doorways—the so-called Royal Portal—capture the attention with their sculpture (fig. 16-7). Christ Enthroned in Royal Majesty dominates the central

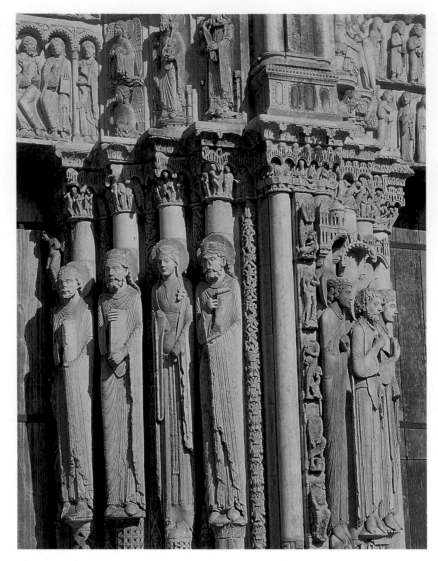

16-8. *Prophets and Ancestors of Christ*, right side, central portal, Royal Portal, Chartres Cathedral. c. 1145–55

tympanum. Flanking the doorways are monumental **column statues**, a form that originated at Saint-Denis. These column statues depict nineteen of the twenty-two Old Testament figures who were seen as precursors of Christ (fig. 16-8). In other biblical references, the builders of Gothic cathedrals identified themselves symbolically with Solomon, the builder of the Temple in Jerusalem, and the depiction of Old Testament kings and queens evokes the close ties between the Church and the French royal house. Because of this relationship, still potent after 600 years, most such figures at other churches were smashed during the French Revolution.

Earlier sculptors had achieved dramatic, dynamic effects by compressing, elongating, and bending figures to fit them into an architectural framework. At Chartres, in contrast, the sculptors sought to pose their high-relief figures naturally and comfortably in their architectural settings. The erect, frontal column statues, with their elongated proportions and vertical drapery, echo the cylindrical shafts from which they emerge. Their heads are finely rendered with idealized features.

Calm and order prevail in the imagery of the Royal Portal, in contrast to the somewhat more crowded imagery at many Romanesque churches, such as those at Moissac (see fig. 15-9) and Autun (see fig. 15-11). Christ in the central tympanum of the Royal Portal appears imposing but more benign and less terrifying than in earlier representations. The Twelve Apostles in the lintel below him and the twenty-four elders in the archivolts above him have been placed according to hierarchical scale—an arrangement by size and location to reflect their relative importance—with little narrative interaction between them. Even in narrative scenes, calm prevails, as in the Ascension of Christ in the tympanum of the left doorway and the enthroned Virgin and Child in the tympanum of the right doorway.

Column statues became standard elements of Gothic church portals, developing from shaftlike reliefs to fully three-dimensional figures that appear to interact with one another as well as with approaching worshipers. A comparison of the column statues of the Royal Portal with those of the south transept portal illustrates this

16-9. *Saint Stephen* (right, c. 1210–20) and ***Saint Theodore*** (left, c. 1230–35), left side, left portal, south transept entrance, Chartres Cathedral

16-10. Flying buttresses, Chartres Cathedral. c. 1200–20

transition. Figure 16-9 shows two column statues from the south transept portal. *Saint Stephen*, on the right, was made between 1210 and 1220; *Saint Theodore*, on the left, between 1230 and 1235. More lifelike than their predecessors, they seem to stand on projecting bases with carved brackets. The bases reinforce the illusion that the figures are free of the architecture to which they are attached. In another change, the dense geometric patterning and stylized foliage around the earlier statues have given way to plain stone.

Saint Stephen, still somewhat cylindrical, is more naturally proportioned than the earlier figures on the west facade. The sculptor has also created a variety of textures to differentiate cloth, embroidery, flesh, and other features. The later *Saint Theodore* reflects its sculptor's attempt to depict a convincingly "alive" figure. The saint is dressed as a contemporary crusader and stands, purposeful but contemplative, with his feet firmly planted and his hips thrust to the side (a pose often called the Gothic **S**-curve). The meticulous detailing of his expressive face and the textures of his chain mail and surcoat help create a strong sense of physical presence.

Many nearby churches built by local masons about the same time as Chartres Cathedral reflect an earlier style and are relatively dark and squat. Unlike them, Chartres was the work of artisans from areas north and northeast of the town who were accomplished practitioners of the Gothic style. In the new cathedral they brought together the hallmark Gothic structural devices for the first time: the pointed arch, ribbed groin vaulting, the **flying buttress**, and the ***triforium***, now designed as a mid-level passageway (see "The Gothic Church," page 568). The flying buttress, a gracefully arched, skeletal exterior support, counters the outward thrust of the vaulting over the nave and aisles (fig. 16-10). The Gothic *triforium* (which was a flat wall in the basilica church or a gallery in Byzantine and Romanesque architecture) overlooks the nave through an arcaded screen that contributes to the visual unity of the interior (fig. 16-11, page 566). Building on the concept pioneered at Saint-Denis of an elegant masonry shell enclosing a large open space, the masons at Chartres erected a structure with one of the widest naves in Europe and vaults that soar 118 feet above the floor. The enlarged sanctuary, another feature derived from Saint-Denis, occupies one-third of the building (fig. 16-12, page 567). The large and luminous clerestory is filled by pairs of tall, arched windows called **lancets** surmounted by circular windows, or *oculi*, and stained glass covers nearly half the clerestory surfaces. Whereas at a Romanesque pilgrimage church like Sainte-Foy (see fig. 15-4) the worshiper's gaze is drawn forward toward the apse, at Chartres it is drawn upward—to the clerestory windows and the soaring vaults overhead—as well as forward. Relatively little interior architectural decoration

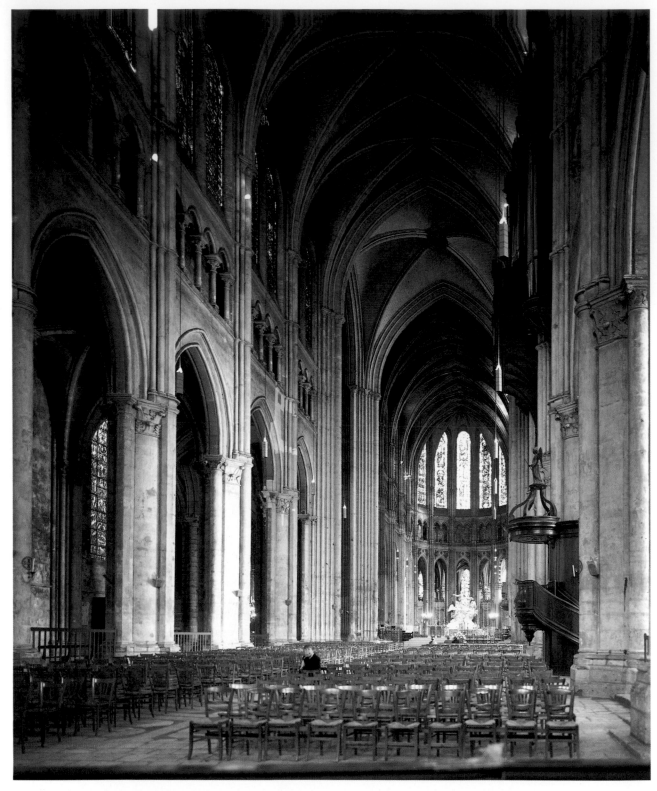

16-11. Nave, Chartres Cathedral. c. 1194–1260

Medieval churches did not have chairs or pews—the only seating was in the choir stalls. In this photograph, chairs have been turned away from the altar in preparation for a dramatic performance to be held in the narthex.

interrupts the visual rhythm of shafts and arches. Four-part vaulting has superseded more complex systems such as that at Durham Cathedral (see fig. 15-25), and the alternating heavy and light piers typical of Romanesque naves such as that at Speyer Cathedral (see fig. 15-33) have been eliminated.

At Chartres, architectural engineering incorporated numerical symbolism, reflecting Scholastic belief that the divine order of the natural world is expressed in its geometry. For example, the number 3, representing the Trinity, is reflected in the equilateral triangle that establishes the three points of the outer edges of the cathedral's buttresses and the keystone of the vault in the nave. Chartres's decorative program also encompasses number symbolism, for example, the number three represents the spiritual world of the Trinity, while the number 4

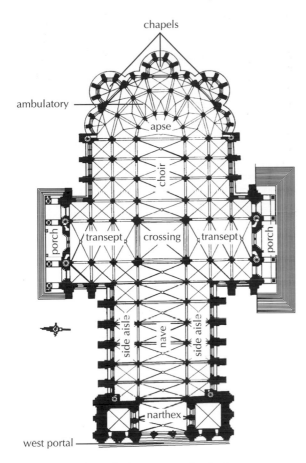

16-12. Plan of Chartres Cathedral. c. 1194–1220

represents the material world (the four winds, the four seasons, the four rivers of paradise). Combined, they form the perfect and all-inclusive number 7, expressed in the seven gifts of the Holy Spirit. References to the number seven recur throughout the church imagery. On the west facade, for example, the seven liberal arts surround the image of the Christ Child and Mary, that is, Notre Dame, to whom the church is dedicated. The imagery of Chartres, which emphasizes themes involving Mary, the Old Testament precursors of Christ, and the saints who came after the Incarnation, reflects the entire program of Scholastic thought.

Chartres is unique among French Gothic buildings in that most of its stained-glass windows have survived. The light from these windows changes constantly as sunlight varies with the time of day, the seasons, and the movement of clouds. Stained glass is an expensive and difficult medium, but its effect on the senses and emotions makes the effort worthwhile (see "Stained-Glass Windows," page 569). Chartres was famous for its glass-making workshops, which by 1260 had installed about 22,000 square feet of stained glass in 176 windows. Most of the glass dates between about 1210 and 1250, but a few earlier windows, from around 1150 to 1170, were preserved in the west facade. The iconography of the windows echoes that of the portal sculpture.

Among the twelfth-century works of stained glass in the west wall of the cathedral is the *Tree of Jesse* window

16-13. *Tree of Jesse*, west facade, Chartres Cathedral. c. 1150–70. Stained glass

(fig. 16-13). The monumental treatment of this subject, much more complex than its depiction in an early twelfth-century Cistercian manuscript (see fig. 15-20), was apparently inspired by a similar window at Saint-Denis. The body of Jesse lies at the base of the tree, and in the branches above him appear, first, four kings of Judaea, Christ's royal ancestors, then the Virgin Mary, and finally Christ himself. Seven doves, symbolizing the seven gifts of the Holy Spirit, encircle Christ, and fourteen prophets stand in the half-moons flanking the tree.

The glass in the *Tree of Jesse* is set within a rectilinear iron armature (visible as silhouetted black lines). In a later work, the *Charlemagne Window* (figs. 16-14, 16-15, page 569), the glass is set within an interlocking

Most large Gothic churches in western Europe were built on the **Latin-cross plan**, with a projecting **transept** marking the transition from **nave** to **sanctuary**. The main entrance **portal** was generally on the west, the **choir** and **apse** on the east. A **narthex** led to the nave and **side aisles**. An **ambulatory** with radiating chapels circled the apse and facilitated the movement of worshipers through the church. Above the nave were a *triforium* passageway and windowed **clerestory**. Narthex, side aisles, ambulatory, and nave usually had **rib vaults** in the Gothic period. Church walls were decorated inside and out with **arcades** of round and pointed arches,

engaged columns and **colonnettes**, and horizontal moldings called **stringcourses**. The roof was supported by a wooden framework. A spire or **crossing** tower above the junction of the transept and nave was usually planned, though often never finished. The **buttress piers** and **flying buttresses** that countered the outward thrusts of the interior vaults were visible on the outside. Portal facades were customarily marked by high, flanking towers or **gabled** porches ornamented with **pinnacles** and **finials**. Architectural sculpture generally covered each portal's **tympanum**, **archivolts**, and **jambs**. A magnificent stained-glass rose window typically formed the centerpiece of the facades. More stained glass filled the tall, pointed **lancet**-shaped aisle and clerestory windows.

Chartres Cathedral

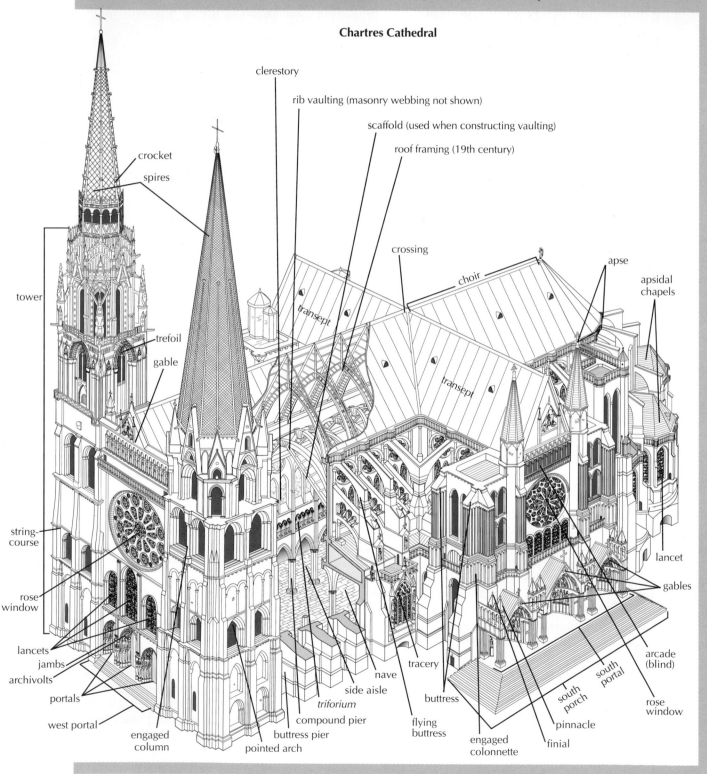

TECHNIQUE

STAINED-GLASS WINDOWS

The basic technique for making colored glass has been known since ancient Egypt. It involves the addition of metallic oxides—cobalt for blue, manganese for red and purple—to a basic formula of sand and ash or lime that is fused at high temperature. Such "stained" glass was used on a small scale in church windows during the Early Christian period and in Carolingian and Ottonian churches. Colored glass sometimes adorned Romanesque churches, but the art form reached a height of sophistication and popularity in the cathedrals and churches of the Gothic era.

Making a stained-glass image was a complex and costly process. A designer first drew a composition on a wood panel the same size as the opening of the window to be filled, noting the colors of each of the elements in it. Glassblowers produced sheets of colored glass, then artisans cut individual pieces from these large sheets and laid them out on the wood template. Painters added details with enamel emulsion, and the glass was reheated to fuse the enamel to it. Finally, the pieces were joined together with narrow lead strips, called **cames**. The assembled pieces were set into iron frames that had been made to fit the window opening.

The colors of twelfth-century glass—mainly reds and blues with touches of dark green, brown, and orange yellow—were so dark as to be nearly opaque, and early uncolored glass was full of impurities. But the demand for stained-glass windows stimulated technical experimentation to achieve new colors and greater purity and transparency. The Cistercians adorned their churches with **grisaille** windows, painting foliage and crosses onto a gray glass, and Gothic artisans developed a clearer material onto which elaborate narrative scenes could be drawn.

By the thirteenth century, many new colors were discovered, some accidentally, such as a sunny yellow produced by the addition of silver oxide. Flashing, in which a layer of one color was fused to a layer of another color, produced an almost infinite range of colors. Blue and yellow, for example, could be combined to make green. In the same way, clear glass could be fused to layers of colored glass in varying thicknesses to produce a range of hues from light to dark. The deep colors of early Gothic stained-glass windows give them a saturated and mysterious brilliance. The richness of some of these colors, particularly blue, has never been surpassed. Pale colors and large areas of *grisaille* glass became increasingly popular from the mid-thirteenth century on, making the windows of later Gothic churches bright and clear by comparison.

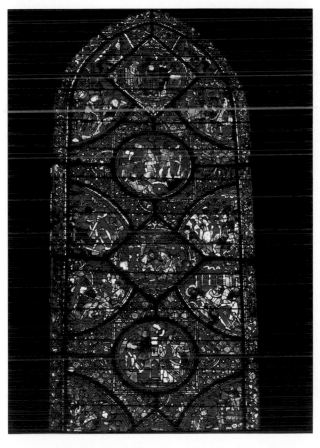

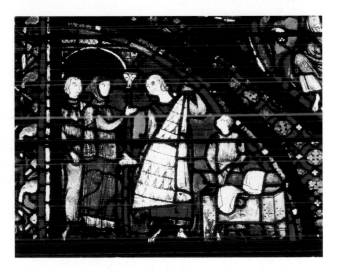

16-15. *Furrier's Shop*, detail of *Charlemagne Window*

This close-up shows how stained-glass artisans handled form and color. The figures have been reduced to simple shapes and their gestures kept broad to convey meaning from afar. The glass surfaces, however, are painted with fine lines that are invisible from the cathedral's floor. Forms stand out against a lustrous blue ground accented with red. Glowing clear glass serves as white, and violet-pink, green, and yellow complete the palette.

16-14. *Charlemagne Window*, ambulatory apse, Chartres Cathedral. c. 1210–36. Stained glass

This window depicts scenes from the *Song of Roland*, an epic based on events during the reign of Charlemagne that acquired its final form sometime around 1100. The hero, Roland, is portrayed as an ideal feudal knight, devoted to his lord, his fellow knights, and his faith. Roland was killed fighting Muslims in the Pyrenees Mountains, which lie between France and Spain.

16-16. Vaults, sanctuary, Amiens Cathedral, Cathedral of Notre-Dame, Amiens, France. Upper choir after 1258; vaulted by 1288

framework of medallions so that colored glass and **cames**, the lead strips that join the pieces of glass, work together to make the window imagery more decorative. The medallions contain narrative scenes, each surrounded by a field of stylized flowers, leaves, and geometric patterns. At the base of the *Charlemagne Window* is a scene of a customer buying a cloak in a furrier's shop. The furrier displays a large cloak made of small pelts (perhaps rabbit or squirrel) taken from the chest at the right. The potential buyer has removed one glove and reaches out, perhaps to feel the fur, perhaps to bargain. Several scenes at Chartres—and at other Gothic churches—

show tradespeople, including bakers, wheelwrights, weavers, goldsmiths, and carpenters. These scenes were once thought to have reflected pious donations by local guilds, but recent scholarship suggests that merchants and artisans had not yet been permitted to form guilds and contributed only through the taxes assessed on them by Church officials. The vignettes of tradespeople might thus be a form of Church propaganda, images of an ideal world in which the Church was the center of society and the focus of everyone's work.

Amiens and Reims Cathedrals. As it continued to evolve, Gothic taste favored increasingly sculptural, ornate facades and intricate window **tracery** (geometric decorative patterns molded in stone or wood). Builders across northern France refined the geometry of church plans and elevations and found ways to engineer ever stronger masonry skeletons to support ever larger expanses of stained glass.

The Cathedral of Notre-Dame at Amiens, an important trading and textile-manufacturing center north of Paris, burned in 1218, and as at Chartres, church officials devoted their resources to making its replacement as splendid as possible. Their funding came mainly from the cathedral's rural estates and from important trade fairs. Construction began in 1220 and continued for some seventy years. The result is the supreme architectural statement of elegant Gothic verticality. The nave, only 48 feet wide, soars upward 144 feet. Not only is the nave exceptionally tall, its narrow proportions create an exaggerated sense of height (figs. 16-16, 16-18).

A labyrinth, now destroyed, recorded the names of the master builders at Amiens on the inlaid floor of the nave (see "Master Builders," page 586). This practice honored the mythical Greek hero Daedalus, master builder of the first labyrinth at the palace of King Minos in Crete. The labyrinth identifies Robert de Luzarches (d. 1236) as the builder who established the overall design for the Amiens Cathedral. He was succeeded by Thomas de Cormont, who was followed by his son Renaud. The lower portions of the church were probably substantially complete by around 1240.

The plan of the cathedral of Amiens derived from that of Chartres, with some simple but critical adjustments (fig. 16-17). The narthex was eliminated, while the transept and sanctuary were expanded and the crossing brought forward. The result is a plan that is balanced east and west around the crossing. The elevation of the nave is similarly balanced and compact (fig. 16-18). Chapels of the same size and shape enhance the clarity and regularity of the design. Tracery and **colonnettes** (small columns) unite the *triforium* and the clerestory, which makes up nearly half the height of the nave. Evenly spaced piers with engaged half columns topped by foliage capitals support the arcades. An ornate floral stringcourse below the *triforium* level and a simpler one below the clerestory both run uninterrupted across the otherwise plain wall surfaces and colonnettes, providing a horizontal counterpoint. The vaulting and the light-filled choir date to the second phase of construction,

16-17. Robert de Luzarches, Thomas de Cormont, and Renaud de Cormont. Plan of Amiens Cathedral. 1220–88

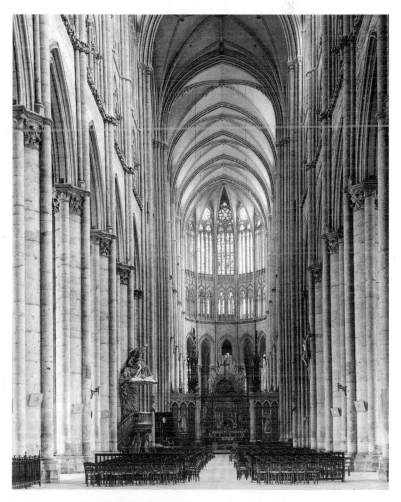

16-18. Nave, Amiens Cathedral. 1220–88; upper choir reworked after 1258

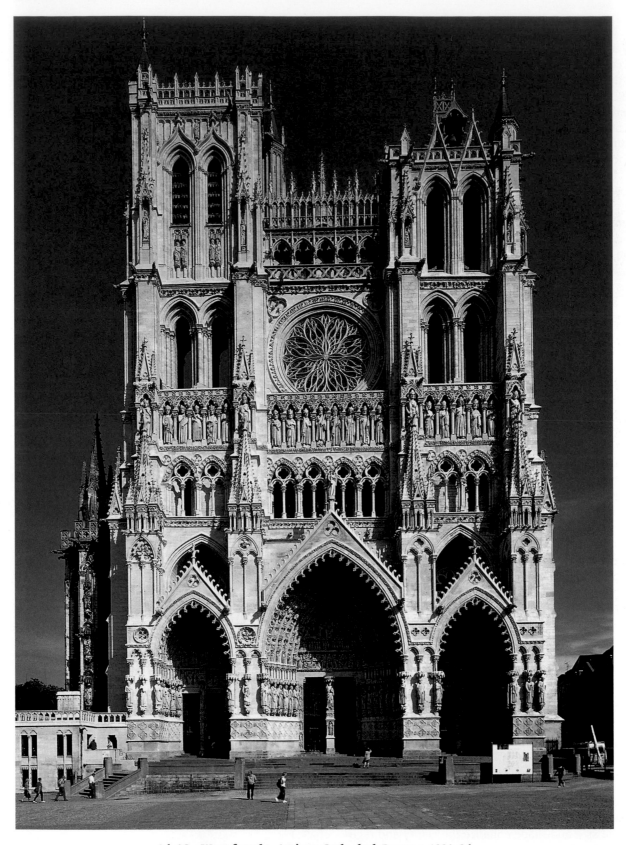

16-19. West facade, Amiens Cathedral. Begun c. 1220–36

directed by Thomas de Cormont, probably after a fire in 1258. The choir is illuminated by large windows subdivided by tracery into slender lancets crowned by **trefoils** (three-lobed designs) and circular windows.

The west front of Amiens reflects several stages of construction (fig. 16-19). The lower levels, designed by Robert de Luzarches, are the earliest, dating to about 1220–40, but building continued over the centuries. The towers date to the fourteenth and fifteenth centuries, and the tracery in the rose window is also from this later date. Consequently, the facade has a somewhat disjointed appearance, and all its elements do not correspond to the

16-20. *Virtues and Vices*, central portal, west entrance, Amiens Cathedral. c. 1220–36

Quatrefoils appeared here as a framing device for the first time and soon became one of the most widespread decorative motifs in Gothic art. In the top row are the Virtues, personified as seated figures. Each holds a shield with an animal on it that symbolizes a particular virtue: the lion for Courage, the cow for Patience, and the lamb for Meekness. Below the Virtues are figures that represent the Vices that correspond to each of the Virtues: a knight dropping his sword and turning to run when a rabbit pops up (Cowardice); a woman on the verge of plunging a sword through a man (Discord); and a woman delivering a swift kick to her servant (Impatience or Injustice).

interior spaces behind them. Design had begun to be detached from structural logic, an indication of the loosening of the traditional ties between architectural planning and the actual building process. This trend led to the elevation of architectural design—as opposed to structural engineering and construction—to a high status by the fifteenth century.

The sculptural program of the west portals of Amiens presents an almost overwhelming array of images. The sculpture was produced rapidly by a large workshop in only fifteen years or so (1220–c. 1236), making it stylistically more uniform than that of the cathedrals of Chartres or Reims. In the mid-thirteenth century, Amiens-trained sculptors carried their style to other parts of Europe, especially Castile (Spain) and Italy.

Worshipers approaching the main entrance encountered figures of apostles and saints lined up along the door jambs and projecting buttresses, as were seen at Chartres. At Amiens something new captures the attention. On the base below the figures, at eye-level, are **quatrefoils** (four-lobed medallions) containing relief sculpture illustrating Good and Evil in daily life (fig. 16-20), the seasons and labors of the months, the lives of the saints, and biblical stories. High above, in the tympanum and archivolts of the central portal, the history of humanity ends in the Last Judgment. The left portal sculpture illustrates the life of Saint Firmin, an early bishop of Amiens and the town's patron saint; those on

16-21. *Beau Dieu*, trumeau, central portal, west facade, Amiens Cathedral. c. 1220–36

the right portal are dedicated to Mary and her coronation as Queen of Heaven.

A sculpture of Christ as the *Beau Dieu* ("Noble" or "Beautiful" "God"), the kindly teacher-priest bestowing his blessing on the faithful (fig. 16-21), adorns the **trumeau** of the central portal. This exceptionally fine sculpture may have been the work of the master of the Amiens workshop himself. The broad contours of the heavy drapery wrapped around Christ's right hip and bunched over his left arm lead the eye up to the Gospel book he holds and past it to his face, which is that of a young king. He stands on a lion and a dragonlike creature

THE OBJECT SPEAKS

NOTRE-DAME OF PARIS

Think of Gothic architecture. Chances are, the image that springs to mind is the Cathedral of Notre-Dame of Paris. Just as this structure rivals the Eiffel Tower as the symbol of Paris itself, Notre-Dame is the vision of what a Gothic cathedral should look like. In fact, the Notre-Dame we see today began as an early Gothic building that bridged the period between Abbot Suger's rebuilding of the Abbey Church of Saint-Denis and the thirteenth-century Chartres Cathedral. On this site—a small island in the Seine River called the Île de la Cité, where the Parisii people who gave the city its name first settled— Pope Alexander III set the building cornerstone in 1163. Construction was far enough along for the altar to be consecrated twenty years later. The nave, rising to 115 feet, dates to 1180–1200. The west facade, whose tympana (like that of the north portal) are dedicated to Mary (*Notre Dame*) dates to 1200–50. By this time, the massive walls and buttresses and six-part vaults, adopted from Norman Romanesque architecture, must have seemed very old-fashioned. After 1225, new masters modernized and lightened the building by reworking the clerestory into the large double-lancet and rose windows

we see today. Notre-Dame had the first true flying buttresses, although those seen at the right of the photograph, rising dramatically to support the high vault of the choir, result from later Gothic remodeling. (The 290-foot spire over the crossing is the work of the nineteenth-century architect Eugène-Emmanuel Viollet-le-Duc.)

Throughout its history, Notre-Dame has spoken so powerfully that people in each age have embraced it as a symbol of their most passionate beliefs. For example, French revolutionaries decapitated the statues associated with deposed nobility and transformed the cathedral into the secular Temple of Reason (1793–95). Soon afterward, Notre-Dame returned to Christian use, and in 1804 Napoleon crowned himself emperor at its altar. Notre-Dame was also where Paris celebrated its liberation from the Nazis in August 1944. Today, boats filled with tourists drift under the bridges spanning the Seine and circle the Île de la Cité to admire the beautiful cathedral. Notre-Dame so resonates with life and history that it has become more than a house of worship and work of art; it expresses so many aspirations of Western culture even as it inspires affection and awe at a universal level.

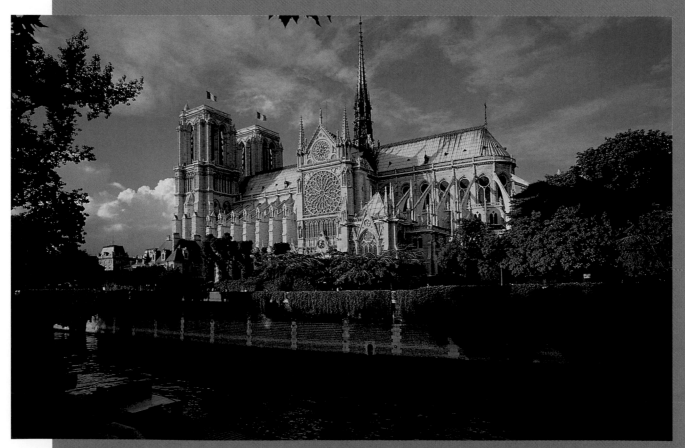

16-22. **Cathedral of Notre-Dame, Paris.** Begun 1163; choir chapels 1270s; spire 19th-century replacement. View from the south

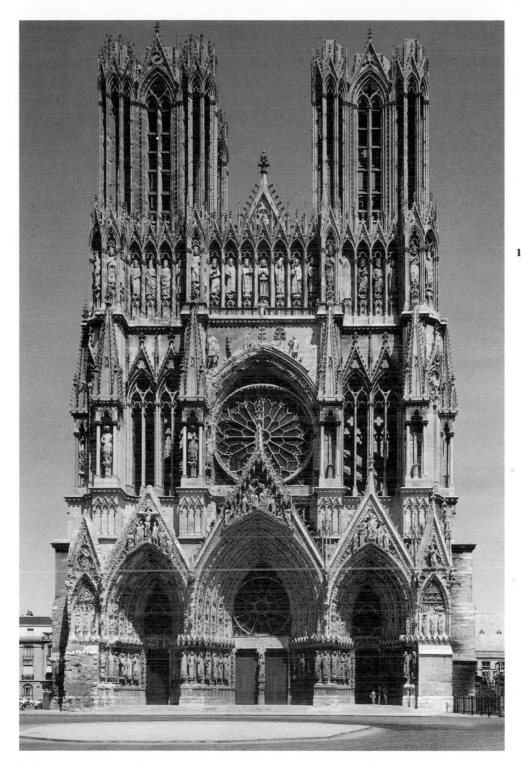

16-23. West facade, Reims Cathedral, Cathedral of Notre-Dame, Reims, France. Rebuilding begun c. 1211 after fire in 1210; facade 1230s was largely unfinished by 1287; towers left unfinished in 1311; additional work 1406–28

The cathedral was restored in the sixteenth century and again in the nineteenth and twentieth centuries. During World War I it withstood bombardment by some 3,000 shells, an eloquent testimony to the skills of its builders. It was recently cleaned.

called a basilisk, symbolizing his kingship and his triumph over evil and death. With its clear, solid forms, elegantly cascading robes, and interplay of close observation with idealization, the *Beau Dieu* embodies the Amiens style and the Gothic spirit.

In the Church hierarchy, the bishop of Amiens was subordinate to the archbishop of Reims, a town northeast of Paris. Politically the archbishop also had great power, for the French kings were crowned in his cathedral, though they were buried at Saint-Denis. Reims, like Saint-Denis, had been a cultural and educational center since Carolingian times. As at Chartres and Amiens, the community at Reims, led by the clerics responsible for the building, began to erect a new cathedral after a fire destroyed an earlier church. And as at Chartres, the expense of the project

sparked local opposition, with revolts in the 1230s twice driving the archbishop and canons into exile. Construction of the cathedrals of Chartres, Amiens, and Reims overlapped, and the artisans at each site borrowed ideas from and influenced one another.

Many believe the Cathedral of Notre-Dame at Reims to be the most beautiful of all Gothic cathedrals, surpassing even Chartres and Notre-Dame of Paris (fig. 16-22, "The Object Speaks: Notre-Dame of Paris"). The cornerstone at Reims was laid in 1211 and work continued on it throughout the century. Its master builders, their names recorded in the cathedral labyrinth, were Jean d'Orbais, Jean le Loup, Gaucher de Reims, and Bernard de Soissons.

The magnificent west facade at Reims was built from 1254 through 1287 and left unfinished in 1311 (fig. 16-23).

16-24. **Annunciation** (left pair: Mary [right] c. 1245, angel [left] c. 1255) and **Visitation** (right pair: Mary [left] and Elizabeth [right] c. 1230), right side, central portal, west facade, Reims Cathedral

16-25. **Saint Joseph**, left side, central portal, west facade, Reims Cathedral. c. 1255

Scratched onto the column behind Joseph's head are a crescent and four lines. These masons' marks, called setting marks, were used to position a piece of sculpture during installation. A crescent mark indicates the left side of the central doorway, and four lines indicate the fourth in a series. The work site for such an enormous project would have been filled with dressed and undressed stone blocks, carved slabs in various stages of completion, and work crews hauling and hoisting the finished pieces into place.

Its massive gabled portals project forward, rising higher than those at Amiens. Their soaring peaks, the middle one reaching to the center of the rose window, help to unify the facade. Large windows fill the portal tympana, displacing the sculpture usually found there. The deep porches are encrusted with sculpture that reflects changes in plan, iconography, and sculpture workshops. In a departure from tradition, Mary rather than Christ dominates the central portal, a reflection of the growing popularity of her cult. The enormous rose window, the focal point of the facade, fills the entire clerestory level. The towers were later additions, as was the row of carved figures that runs from the base of one tower to the other above the rose window. This "gallery of kings" is the only strictly horizontal element of the facade. Its subject matter is appropriate for a coronation church.

Different workshops and individuals worked at Reims over a period of several decades. Further complicating matters, a number of the works of sculpture have been moved from their original locations, creating sometimes abrupt stylistic shifts. A group of four figures on the right jamb of the central portal of the western front illustrates three of the Reims styles (fig. 16-24).

The pair on the right is the work of the "Classical Shop," which was active beginning in about the 1230s and most of whose work is at the east and north sides of the building. The subject of the pair is the Visitation, in which Mary (left), pregnant with Jesus, visits her older cousin Elizabeth (right), who is pregnant with John the Baptist. The sculptors drew on classical sources, to which they had perhaps been exposed indirectly through earlier Mosan metalwork (see fig. 16-50) or directly in the form of local examples of ancient works (Reims had been an important Roman center). The heavy figures have the same solidity seen in Roman portrayals of noblewomen, and Mary's full face, gently waving hair, and heavy mantle recall imperial portrait statuary. The contrast between the features of the young Mary and the older Elizabeth is also reminiscent of the contrast between two Flavian portrait heads, one of a young woman and the other of a middle-aged woman (see figs. 6-42, 6-43). The Reims sculptors used deftly modeled drapery not only to provide volumetric substance that stresses the theme of pregnancy but also to create a stance in which a weight shift with one bent knee allows the figures to seem to turn toward each other. The new freedom, movement, and sense of relationship implied in the sculpture inspired later Gothic artists toward ever greater realism.

The pair on the left of figure 16-24 illustrates the Annunciation; the archangel Gabriel (left) announces to Mary (right) that she will bear Jesus. The Mary in this pair, quiet and graceful, with a slender body, restrained gestures, and refined features, contrasts markedly with the bold tangibility of the Visitation Mary to the right. The drapery style and certain other details resemble those of Amiens, suggesting that those who made this pair—and much of the other sculpture of the west entrance—may also have worked at Amiens.

The figure of the angel Gabriel illustrates yet a third style, the work of a sculptor known today as the Joseph Master or the Master of the Smiling Angels. This artist created tall, gracefully swaying figures that suggest the fashionable refinement associated with the Parisian court in the 1250s (see fig. 16-33). The facial features of Gabriel—and of Saint Joseph, on the opposite side of the doorway (fig. 16-25)—are typical: a small, almost triangular head with a broad brow and pointed chin has short, wavy hair; long, puffy, almond-shaped eyes under arching brows; a well-shaped nose; and thin lips curving into a slight smile. Voluminous drapery drawn into elegant folds by the movement and gestures of the figures adds to the impression of aristocratic grace. This engaging style was imitated from Paris to Prague, as elegance and refinement became a guiding force in later Gothic sculpture and painting.

The architectural plan of Reims (fig. 16-26), like that of Amiens, was adapted from Chartres. The nave is longer in proportion to the choir, so the building lacks the perfect balance of Amiens. The three-part elevation and ribbed vault are familiar, too (fig. 16-27). The carvings on the capitals in the nave are notable for their variety, naturalism, and quality. Unlike the idealized foliage of

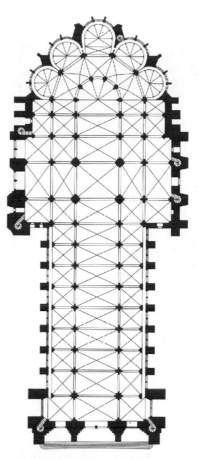

16-26. Plan of Reims Cathedral. 1211–60

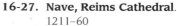

16-27. Nave, Reims Cathedral. 1211–60

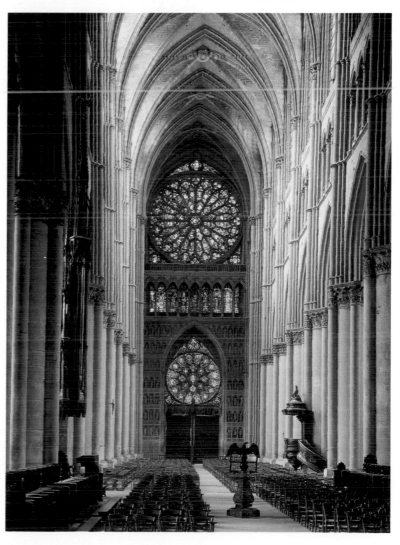

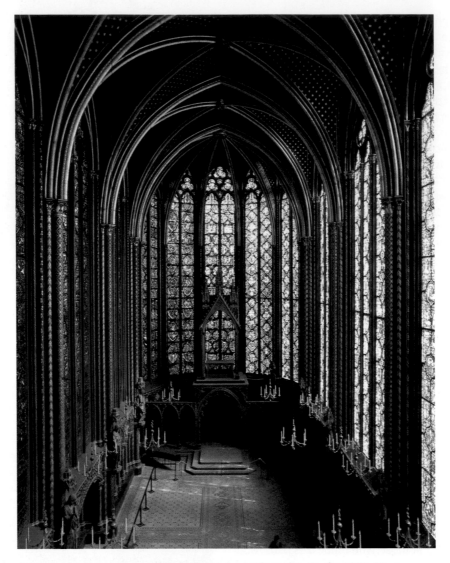

16-28. Interior, upper chapel, the Sainte-Chapelle, Paris. 1243–48

Louis IX avidly collected relics of the Passion, some of which became available in the aftermath of the Crusaders' sack of Constantinople. Those that Louis acquired were supposedly the crown of thorns that had been placed on Jesus' head before the Crucifixion, a bit of the metal lance tip that pierced his side, the vinegar-soaked sponge offered to wet his lips, a nail used in the Crucifixion, and a fragment of the True Cross. The king is depicted in the Sainte-Chapelle's stained glass walking out barefoot to demonstrate his piety and humility when his treasures arrived in Paris.

Amiens, the Reims carvings depict recognizable plants and figures. The remarkable sculpture and stained glass of the west wall complement the clerestory and choir. A great rose window in the clerestory, a row of lancets at the *triforium* level, and windows over the portals replace the stone of wall and tympana. Visually the wall "dissolves" in colored light. This great expanse of glass was made possible by **bar tracery**, a technique perfected at Reims, in which thin stone strips, called **mullions**, form a lacy matrix for the glass, replacing the older practice in which glass was inserted directly into window openings. Reims's wall of glass is anchored visually by a masonry screen around the doorway. Here ranks of carved Old Testament prophets and ancestors serve as moral guides for the newly crowned monarchs who faced them after coronation ceremonies.

The Sainte-Chapelle in Paris. In 1243 construction began on a new palace chapel in Paris to house Louis IX's prized collection of relics from Christ's Passion. The Sainte-Chapelle was finished in 1248, and soon thereafter Louis (ruled 1226–70) departed for Egypt on the Seventh Crusade. This exquisite structure epitomizes a new Gothic style known as Rayonnant ("radiant" or "radiating" in French) because of its radiating bar tracery, like that at Reims; it is also known as the Court style because of its association with Paris and the royal court. The hallmarks of the style include daring engineering, the proliferation of bar tracery, exquisite sculpture and painting, and vast expanses of stained glass.

Originally part of the king's palace, the Sainte-Chapelle is located in the present-day administrative complex in the center of Paris. Intended to house precious

relics, it resembles a giant reliquary itself, one made of stone and glass instead of gold and gems. It was built in two stories, with a ground-level chapel accessible from a courtyard and a private upper chapel entered from the royal residence. The ground-level chapel has narrow side aisles, but the upper level is a single room with a western porch and a rounded east wall. Entering the upper level after climbing up the narrow spiral stairs from the lower level is like emerging into a kaleidoscopic jewel box (fig. 16-28). The ratio of glass to stone is higher here than in any other Gothic structure, for the walls have been reduced to clusters of slender painted colonnettes framing tall windows filled with brilliant color. Bar tracery in the windows is echoed in the blind arcading and tracery of the **dado**, the decoration on the lower walls at floor level. The dado's surfaces are richly patterned in red, blue, and gilt so that stone and glass seem to merge in the multicolored light. Painted statues of the Twelve Apostles stand between window sections, linking the dado and the stained glass. The windows contain narrative and symbolic scenes. Those in the curve of the sanctuary behind the altar and relics, for example, illustrate the Nativity and Passion of Christ, the Tree of Jesse, and the life of Saint John the Baptist. The story of Louis's acquisition of his relics is told in one of the bays, and the Last Judgment appeared in the original rose window on the west.

Later Gothic Architecture. Beginning in the late thirteenth century, France began to suffer from overpopulation and economic decline, followed in the fourteenth century by the devastation of the Hundred Years' War and the plague (see "The Black Death," page 559). Large-scale construction gradually ceased, ending the great age of cathedral building. The Gothic style continued to develop, however, in smaller churches, municipal and commercial buildings, and private residences. Many of these later buildings were covered with elaborate decoration in the new Flamboyant ("flaming" in French) style, named for the repeated flamelike patterns of its tracery. Flamboyant may have reflected an English architectural style known as Decorated (see fig. 16-39). New window tracery was added to many earlier churches in this period, as at Amiens (see fig. 16-19), and a Flamboyant north spire, built between 1507 and 1513, was even added to the west facade of Chartres (see fig. 16-6).

INDEPENDENT SCULPTURE

Gothic sculptors found a lucrative new outlet for their work in the growing demand among wealthy patrons for small religious statues intended for homes and personal chapels or as donations to favorite churches. Busy urban workshops produced large quantities of statuettes and reliefs in wood, ivory, and precious metals, often decorated with enamel and gemstones. Much of this art was related to the cult of the Virgin Mary.

Among the treasures of the Abbey Church of Saint-Denis is a silver-gilt image, slightly over 2 feet tall, of a standing Virgin and Child (fig. 16-29), an excellent

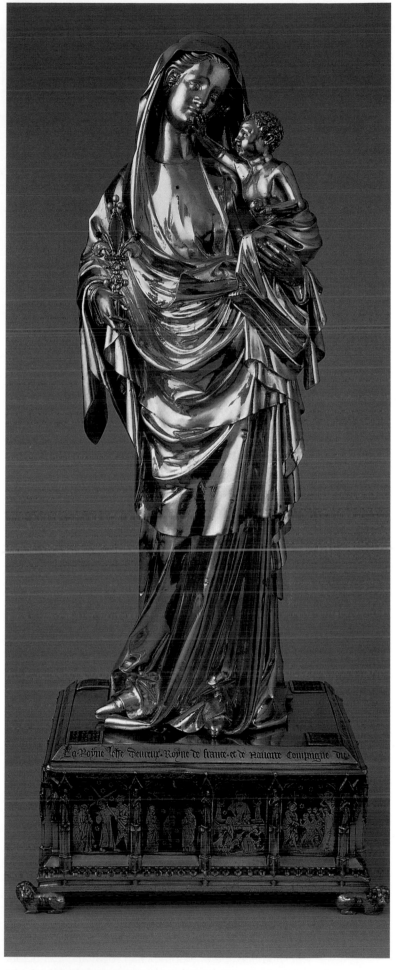

16-29. *Virgin and Child*, from the Abbey Church of Saint-Denis. c. 1339. Silver gilt and enamel, height 27⅛" (69 cm). Musée du Louvre, Paris

16-30. *Attack on the Castle of Love*, lid of a jewelry box, from Paris. c. 1330–50. Ivory casket with iron mounts, panel 4¹/₂ x 9¹¹/₁₆" (11.5 x 24.6 cm). Walters Art Gallery, Baltimore

The god of love (upper left) shoots his arrows; knights and ladies throw flowers as missiles and joust with flowers (right).

example of such works. An inscription on the base bears the date 1339 and the name of Queen Jeanne d'Evreux, wife of Charles IV of France (ruled 1322–28). The Virgin holds her son in her left arm, her weight on her left leg, creating the graceful S-curve pose that was a stylistic signature of the period. Fluid drapery with the consistency of heavy silk covers her body. She holds a scepter topped with a large enameled and jeweled *fleur-de-lis,* the heraldic symbol of French royalty, and she originally wore a crown. The scepter served as a reliquary for hairs said to be from Mary's head. Despite this figure's clear association with royalty, Mary's simple clothing and sweet, youthful face anticipate a type of imagery that emerged in the later fourteenth and fifteenth centuries in northern France, Flanders, and Germany: the ideally beautiful mother. The Christ Child, clutching an apple in one hand and reaching with the other to touch his mother's lips, is more babylike in his proportions and gestures than in earlier depictions. Still, prophets and scenes of Christ's Passion in enamel cover the statue's simple rectangular base, a reminder of the suffering to come.

In addition to devotional or moralizing subjects, there was a strong market for objects with secular subjects taken from popular literature. Themes drawn from the poetry of the troubadours (see "Romance," page 558) decorated women's jewelry boxes, combs, and mirror cases. A casket for jewelry made in a Paris workshop around 1330–50 provides a delightful example of such a work (fig. 16-30). Its ivory panels depict scenes of love, including vignettes from the King Arthur legend. The central sections of the lid shown here depict a tournament. Such mock battles, designed to keep knights fit for war, had become one of the chief royal and aristocratic entertainments of the day. In the scene on the lid, women of the court, accompanied by their hunting falcons,

watch with great interest as two jousting knights, visors down and lances set, charge to the blare of trumpets played by young boys. In the scene on the left, ardent knights assault the Castle of Love, firing roses from crossbows and a catapult. Love, in the form of a winged boy, aids the women defenders, aiming a giant "Cupid's arrow" at the attackers. The action concludes in the scene on the right, where the tournament's victor and his lady love meet in a playful joust of their own.

BOOK ARTS

France gained renown in the thirteenth and fourteenth centuries not only for its new architectural style but also for its book arts. These works ranged from lodge books, practical manuals for artisans, to elaborate devotional works illustrated with exquisite miniatures.

Lodge books were an important tool of the master mason and his workshop, or lodge. Compiled by heads of workshops, lodge books provided visual instruction and inspiration for apprentices and assistants. Since the drawings received hard use, few have survived. One of the most famous architect's collections is the early-thirteenth-century sketchbook of Villard de Honnecourt, a well-traveled master mason who recorded a variety of images and architectural techniques. A section labeled "help in drawing figures according to the lessons taught by the art of geometry" (fig. 16-31) illustrates the use of geometric shapes to form images and how to copy and enlarge images by superimposing geometric shapes over them as guides.

The production of high-quality manuscripts flourished in Paris during the reign of Louis IX, whose royal library was renowned. Queen Blanche of Castile, Louis's mother and granddaughter of Eleanor of Aquitaine,

16-31. **Villard de Honnecourt. Sheet of drawings with geometric figures and ornaments**, from Paris. 1220–35. Ink on vellum, 9¼ x 6" (23.5 x 15.2 cm). Bibliothèque Nationale, Paris

served as regent of France (1226–34) until he came of age. She and the teenage king appear on the dedication page (fig. 16-32) of a Moralized Bible—one in which selected passages of the Old and New Testaments are paired to give an allegorical, or moralized, interpretation. The royal pair sits against a solid gold background under trilobed arches. Below them a scholar-monk dictates to a scribe. The ornate thrones of Louis and his mother and the buildings atop the arches suggest that the figures are inside a royal palace, and in fact it would not have been unusual for the queen to have housed scholar, scribe, and illuminator while they were executing her commission during her regency. Interestingly, only the slightly oversized heads of the queen and king preserve a sense of hierarchical scale. The scribe, in the lower right, is working on a page with a column of

16-32. **Page with *Louis IX and Queen Blanche of Castile***, Moralized Bible, from Paris. 1226–34. Ink, tempera, and gold leaf on vellum, 15 x 10½" (38 x 26.6 cm). The Pierpont Morgan Library, New York M.240, f.8

Thin sheets of gold leaf were painstakingly attached to the vellum and then polished to a high sheen with a tool called a burnisher. Gold was applied to paintings before pigments.

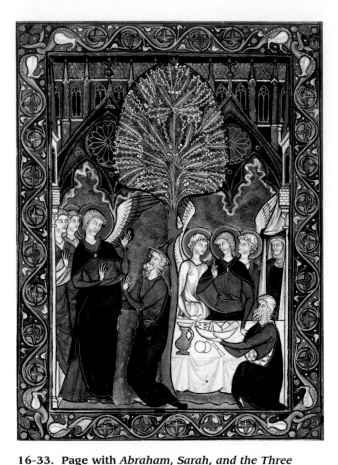

16-33. Page with *Abraham, Sarah, and the Three Strangers*, *Psalter of Saint Louis,* from Paris. 1253–70. Ink, tempera, and gold leaf on vellum, 5 x 3¹⁄₂" (13.6 x 8.7 cm). Bibliothèque Nationale, Paris

The Court style had enormous influence throughout northern Europe, spread by illuminators who flocked to Paris from other regions. There they joined workshops affiliated with the Confrérie de Saint-Jean ("Guild of Saint John"), supervised by university officials who controlled the production and distribution of manuscripts.

rest. On the right, he offers the men a meal prepared by his wife, Sarah, who stands in the entryway of their tent on the far right. God says that Sarah will soon bear a child, and she laughs because she and Abraham are old. But God replies, "Is anything too marvelous for the Lord to do?" (18:14). She later gives birth to Isaac, whose name comes from the Hebrew word for "laughter." Christians in the Middle Ages viewed the three strangers in this story as symbols of the Trinity and believed that God's promise to Sarah was a precursor of the Annunciation to Mary.

The architectural background in this painting establishes a narrow stage space in which the story unfolds. Wavy clouds float within the arches under the gables. The imaginatively rendered oak tree establishes the location of the story and separates the two scenes. The gesture of the central haloed figure in the scene on the right and Sarah's presence in the entry of the tent indicate that we are viewing the moment of divine promise. This new spatial sense, as well as the depiction of a tree with oak leaves and acorns, reflects a tentative move toward the representation of the natural world that will gain momentum in the following centuries.

By the late thirteenth century, literacy had begun to spread among laypeople. Private prayer books became popular among those who could afford them. Because such books contained special prayers to be recited at the eight canonical "hours" between morning and night, these books came to be called Books of Hours. The material in them was excerpted from a larger liturgical book called a breviary, which contained all the canonical offices (Psalms, readings, and prayers) used by priests in celebrating Mass. Books of Hours were usually devoted to the Virgin, but they could be personalized for particular patrons with prayers to other saints, a calendar of saints' feast days and other Church events, and even other offices, such as that said for the dead. During the fourteenth century a richly decorated Book of Hours, like jewelry, would have been among a noble person's most important portable possessions.

A tiny, exquisite Book of Hours given by Charles IV to his queen, Jeanne d'Evreux, shortly after their marriage in 1325 is the work of an illuminator named Jean Pucelle (fig. 16-34). Instead of the intense colors used by earlier illuminators, Pucelle worked in a technique called ***grisaille***—monochromatic painting in shades of gray with faint touches of color (see also "Stained-Glass Windows," page 569)—that emphasized his accomplished drawing. The book combines two narrative cycles. One, the Hours of the Virgin, juxtaposes scenes from the Infancy and Passion of Christ, a form known as the Joys and Sorrows of the Virgin. The other is a collection of scenes from the life of Saint Louis (King Louis IX), whose new cult was understandably popular at court. In the pages shown here, the joy of the *Annunciation* on the right is paired with the sorrow of the *Betrayal and Arrest of Christ* on the left. Queen Jeanne appears in the initial below the *Annunciation,* kneeling before a lectern and reading from her Book of Hours. This inclusion of the patron in prayer within a scene, a practice that continued in monumental painting and sculpture

roundels for illustrations. This format of manuscript illustration—used on the pages that follow the Bible's dedication page—derives from stained-glass lancets, with their columns of images in medallions (see fig. 16-28). The illuminators also show their debt to stained-glass in their use of glowing red and blue and reflective gold surfaces.

The *Psalter of Saint Louis* (the king was canonized in 1297) defines the Court style in manuscript illumination. The book, containing seventy-eight full-page illuminations, was created for Louis IX's private devotions sometime between 1253 and 1270. The illustrations fall at the back of the book, preceded by Psalms and other readings unrelated to them. Intricate scrolled borders and a background of Rayonnant architectural features modeled on the Sainte-Chapelle frame the narratives. Figures are rendered in an elongated, linear style. One page (fig. 16-33) illustrates two scenes from the Old Testament story of Abraham, Sarah, and the Three Strangers (Genesis 18). On the left, Abraham greets God, who has appeared to him as three strangers, and invites him to

16-34. Jean Pucelle. Pages with *Betrayal and Arrest of Christ*, folio 15v. (left), and *Annunciation*, folio 16r. (right), *Book of Hours of Jeanne d'Evreux*, from Paris. c. 1325–28. *Grisaille* and color on vellum, each page 3½ x 2¼" (8.2 cm x 5.6 cm). The Metropolitan Museum of Art, New York

The Cloisters Collection, 1954 (54.1.2)

This book was precious to the queen, who mentioned it in her will; she named its illuminator, an unusual tribute.

in the fifteenth century, conveyed the idea that the scenes were visions inspired by meditation rather than records of historical events. In this case, the young queen would presumably have identified with Mary's joy at Gabriel's message.

In the *Annunciation* Mary is shown receiving the archangel Gabriel in her Gothic-style home as rejoicing angels look on from windows under the eaves. The group of romping children at the bottom of the page (known as the *bas-de-page* in French) at first glance seems to echo the joy of the angels. Scholars have determined, however, that the children are playing "froggy in the middle," a game in which one child was tagged by the others (a symbolic reference to the Mocking of Christ). The game thus evokes a darker mood, foreshadowing Jesus' death even as his life is beginning. In the Betrayal scene on the left page, the disciple Judas Iscariot embraces Jesus, thus identifying him to the soldiers who have come to seize him and setting in motion the events that lead to the Crucifixion. Peter, on the left, realizing the danger, draws his sword to defend Jesus and slices off the ear of one of the soldiers. The *bas-de-page* on this side shows "knights" riding goats and jousting at a barrel stuck on a pole, a spoof of military training that is perhaps a comment on the valor of the soldiers assaulting Jesus.

Pucelle's work represents a sophisticated synthesis of French, English, and Italian painting traditions. From English illuminators he borrowed the merging of Christian narrative with allegory, the use of foliate borders filled with real and grotesque creatures (instead of the standard French vine scrolls), and his lively *bas-de-page* illustrations. His presentation of space, with figures placed within coherent architectural settings, apparently reflects his firsthand knowledge of developments in painting in Siena, Italy (for a slightly later example, see fig. 16-65). Pucelle also adapted to manuscript illumination the Parisian Court style in sculpture, with its softly modeled, voluminous draperies gathered around tall, elegantly curved figures with curly hair and broad foreheads. For instance, Jesus on the left page in figure 16-34 and Mary on the right stand in the swaying S-curve pose typical of Court-style works in other mediums, such as the Virgin and Child from Saint-Denis (see fig. 16-29). Similarly, the earnest face of the Annunciation archangel resembles that of the smiling Annunciation archangel at Reims (see fig. 16-24).

The thirteenth and fourteenth centuries saw the growing use of book margins for fresh and unusual images. Often drawn by illustrators who specialized in this kind of work, marginal imagery was a world of its own, interacting in unexpected ways with the main images and

16-35. Page with *Fox Seizing a Rooster*, *Book of Hours of Jeanne d'Evreux*. The Metropolitan Museum of Art, New York

The Cloisters Collection, 1954 (54.1.2 f. 46)

"The Fox," according to a medieval bestiary, "never runs straight but goes on his way with tortuous windings. He is a fraudulent and ingenious animal. When he is hungry and nothing turns up for him to devour, he rolls himself in red mud so that he looks as if he were stained with blood. Then he throws himself on the ground and holds his breath. The birds, seeing that he is not breathing, think he is dead and come down to sit on him. As you can guess, he grabs them and gobbles them up. The Devil has this same nature" (cited in Schrader, page 24). Bestiaries, an English specialty, were popular compilations of animal lore that were sometimes, as here, made into Christian moral tales. Some of these fables or their characterizations survive in present-day folklore, such as this familiar view of the fox as a cunning trickster.

text, and often deliberately obscure or ambiguous. Visual puns on the main image or text abound. There are also humorous corrections of scribes' errors, pictures of hybrid monsters, erotic and scatological scenes, and charming depictions of ordinary activities and folklore that may or may not have functioned as ironic commentaries on what was going on elsewhere on the page. In addition to the *bas-de-page* scenes, the *Book of Hours of Jeanne d'Evreux* contains other minute but vivid marginalia, such as a fox capturing a rooster (fig. 16-35).

ENGLAND

The Plantagenet dynasty, founded by Henry II and Eleanor of Aquitaine in 1154, ruled England until 1485. Under Plantagenet rule, the thirteenth century was marked by conflicts between the king and England's feudal barons over their respective rights. In 1215, King John (ruled 1199–1216), under compulsion from powerful barons, set his seal to the draft of the Magna Carta (Latin for "Great Charter"), which laid out feudal rights and dues and became an important document in the eventual development of British common law. The thirteenth century also saw the annexation of the western territory of Wales and the settlement of long-standing border disputes with Scotland. In the mid-fourteenth century, the Black Death ravaged England as it did the rest of Europe. During the Hundred

Years' War (1337–1453), English kings claimed the French throne and by 1429 controlled most of France, but after a number of reversals they were driven from all their holdings in France except Calais.

Late medieval England was characterized by rural villages and bustling market towns, all dominated by the great city of London. England's two universities, Oxford and Cambridge, dominated intellectual life. A rich store of Middle English literature survives, including the brilliant social commentary of the *Canterbury Tales*, by Geoffrey Chaucer (c. 1342–1400). Many of the Plantagenet kings, especially Henry III (ruled 1216–72), were great patrons of the arts.

ARCHITECTURE

Gothic architecture in England was strongly influenced by Cistercian and Norman Romanesque architecture as well as by French master builders like William of Sens, who directed the rebuilding of Canterbury Cathedral, in southeastern England, between 1174 and 1178 (see "Master Builders," page 586). English cathedral builders were less concerned with height than their French counterparts, and they constructed long, broad naves, Romanesque-type galleries, and clerestory-level passageways. Walls retained a Romanesque solidity.

Salisbury Cathedral, because it was built in a relatively short period of time, has a consistency of style that makes it an ideal representative of English Gothic architecture (fig. 16-36). The cathedral, in southern England, was begun in 1220 and nearly finished by 1258, an unusually short period for such an undertaking. The west facade was completed by 1265. The huge crossing tower and its 400-foot spire are fourteenth-century additions, as are the flying buttresses that were added to stabilize the tower. Typically English is the parklike setting (the cathedral close) and attached cloister and chapter house for the cathedral clergy. The thirteenth-century structure seems to hug the earth, more akin to Fontenay (see fig. 15-7), built a century earlier, than to the contemporary Amiens Cathedral in France.

In contrast to French cathedral facades, which suggest the entrance to paradise with their mighty towers flanking deep portals, English facades like the one at Salisbury suggest the jeweled wall of paradise itself. The small flanking towers of the west front project beyond the side walls and buttresses, giving the facade an increased width that was underscored by tier upon tier of blind tracery and arcaded niches. Lancet windows grouped in twos, threes, and fives introduce a vertical element.

Typical of English cathedrals, Salisbury has wide projecting transepts (double transepts, in this case), a square apse, and a spacious sanctuary (fig. 16-37). The interior reflects enduring Norman traditions, with its heavy walls and tall nave arcade surmounted by a short gallery and a clerestory with simple lancet windows (fig. 16-38). The emphasis on the horizontal movement of the arcades, unbroken by colonnettes in the unusually restrained nave, directs worshipers' attention forward to

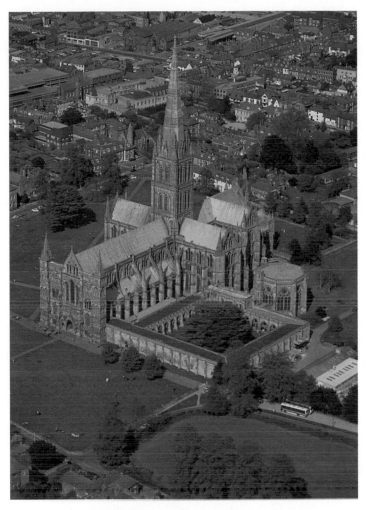

16-36. Salisbury Cathedral, Salisbury, Wiltshire, England. 1220–58; west facade 1265; spire c. 1320–30; cloister and chapter house 1263–84

The original cathedral had been built within the hilltop castle complex of a Norman lord. In 1217, Bishop Richard Poore petitioned the pope to relocate the church, claiming the wind howled so loudly there that the clergy could not hear themselves say Mass. A more pressing concern was probably his desire to escape the lord's control; Pope Innocent III (papacy 1198–1216) had only recently lifted a six-year ban on church services throughout England and Wales after King John (ruled 1199–1216) agreed to acknowledge the Church's sovereignty. The bishop himself laid out the town of Salisbury (from the Saxon *Searisbyrig*, meaning "Caesar's burg," or town) after the cathedral was under way. Material carted down from the old church was used in the cathedral, along with dark, fossil-filled Purbeck stone from quarries in southern England and stone from Caen. The building was abandoned and vandalized during the Protestant Reformation in England initiated by King Henry VIII (ruled 1509–47). In the eighteenth century, the English architect James Wyatt, called the Destroyer, subjected it to radical renovations, during which the remaining stained glass and figure sculpture were removed or rearranged. Similar campaigns to refurbish medieval churches were common at the time. The motives of the restorers were complex and their results far from our notions of historical authenticity today.

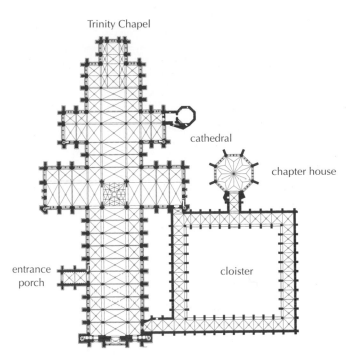

16-37. Plan of Salisbury Cathedral

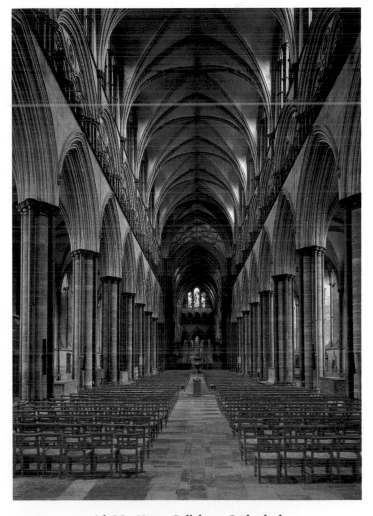

16-38. Nave, Salisbury Cathedral

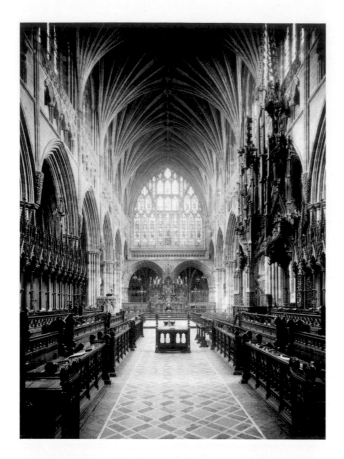

the altar, rather than upward into the vaults. Reminiscent of Romanesque interiors is the use of color in the stonework: The shafts supporting the four-part rib vaults are made of a darker stone that contrasts with the lighter stone of the rest of the interior. The stonework was originally painted and gilded as well as carved.

Just as the Rayonnant style was emerging in France at mid-century, English designers were developing a new Gothic style of their own that has come to be known as the Decorated style (a nineteenth-century term). At Salisbury the tall, elegant spire and the octagonal chapter house with huge traceried windows were built in the Decorated style. This change in taste has been credited to King Henry III's ambition to surpass his brother-in-law, Louis IX of France, as a royal patron of the arts.

A splendid example of this new style is Exeter Cathedral, in southwest England. After the Norman Conquest in 1066, a Norman church replaced an earlier structure, and it, in

16-39. Sanctuary, Exeter Cathedral, Exeter, Devon, England. c. 1270–1366

The Gothic choir stalls and bishop's throne illustrate the skill of the English wood carvers and carpenters. Exeter has some of the finest surviving medieval furniture.

MASTER BUILDERS

"At the beginning of the fifth year [of the rebuilding of England's Canterbury Cathedral], suddenly by the collapse of beams beneath his feet, [master William of Sens] fell to the ground amid a shower of falling masonry and timber from . . . fifty feet or more. . . . On the master craftsman alone fell the wrath of God—or the machinations of the Devil" (Brother Gervase, Canterbury, twelfth century, cited in Andrews, page 20).

Master masons oversaw all aspects of church construction in the Middle Ages, from design and structural engineering to decoration. The job presented formidable logistical challenges, especially at great cathedral sites. The master mason at Chartres coordinated the work of roughly 400 people scattered, with their equipment and supplies, at many locations, from distant stone quarries to high scaffolding. This workforce set in place some 200 blocks of stone each day.

Master masons gained in prestige during the thirteenth century as they increasingly differentiated themselves from the laborers working under them. In the words of Nicolas de Biard, a thirteenth-century Dominican preacher, "The master masons, holding measuring rod and gloves in their hands, say to others: 'Cut here,' and they do not work; nevertheless they receive the greater fees" (cited in Frisch, page 55). By the standards of their time they were well read; they traveled widely. They knew both aristocrats and high Church officials, and they earned as much as knights. From the thirteenth century on, in what was then an exceptional honor, masters were buried, along with patrons and bishops, in the cathedrals they built. The tomb sculpture of a master mason named Hugues Libergier in the Reims Cathedral portrays him, attended by angels, as a well-dressed figure with his tools and a model of the cathedral. The names of more than 3,000 master masons are known today. In some cases their names were prominently inscribed in the labyrinths on cathedral floors.

The illustration here shows a master—right-angle and compass in hand—conferring with his royal patron while workers carve a capital, hoist stones with a winch, cut a block, level a course of masonry using a plumb rule (a board with a line and a weight), and lay dressed stones in place. Masters and their crews moved constantly from site to site, and several masters contributed to a single building. A master's training was rigorous but not standardized, so close study of subtle differences in construction techniques can reveal the hand of specific individuals. Fewer than 100 master builders are estimated to have been responsible for all the major architectural projects around Paris during the century-long building boom there, some of them working on parts of as many as forty churches. Funding shortages and technical delays, such as the need to let mortar harden for three to six months, made construction sporadic.

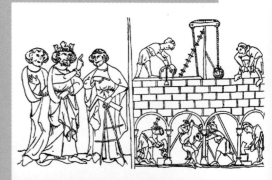

Page with *King Henry III Supervising the Works*, copy of an illustration from a 13th-century English manuscript; original in The British Library, London

A typical Gothic castle was a defensible, enclosed structure that combined fortifications and living quarters for the lord, his family, and those defending them. It was built on raised ground and sometimes included a **moat** (ditch), filled with water and crossed by a bridge; **ramparts** (heavy walls), which were freestanding or built against earth embankments; **parapets**, walls into which towers were set; a **keep**, or *donjon*, a tower that was the most secure place within the compound; and a great hall where the rulers and their closest associates lived. The **bailey**, a large open courtyard in the center, contained wooden structures such as living quarters and stables, as well as a

stone chapel. The castle complex was defended by a wooden **stockade**, or fence, outside the moat; inside the stockade lay **lists**, areas where knightly combats were staged. The main entrance was approached by a wide bridge, which passed through moat gateways called **barbicans**, ending in a drawbridge and then an iron **portcullis**, a grating set into the doorway that could be lowered as defense. Elsewhere, small doors called **posterns** provided secret access for the castle's inhabitants. Ramparts and walls were topped by stone **battlements** designed to screen defenders standing on the **parapet walks** while they aimed weapons through notched **crenellations**. Covered parapet walks and miniature towers called **turrets** lay along the castle's more secure perimeter walls.

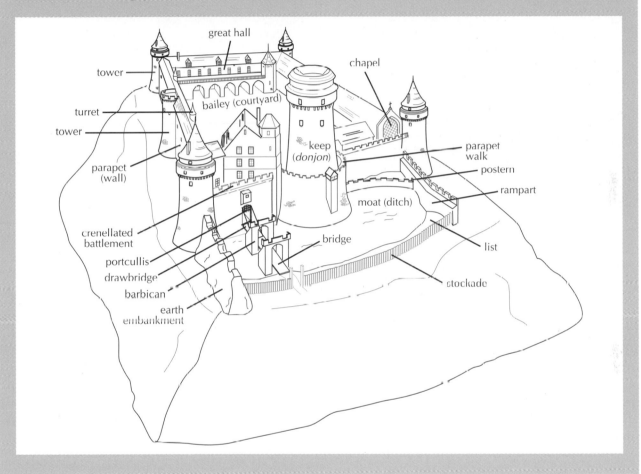

turn, was rebuilt beginning about 1270. When the cathedral was redesigned and vaulted in the first half of the fourteenth century, its interior was turned into a dazzling stone forest of arch moldings and vault ribs (fig. 16-39). From diamond-shaped piers (partly hidden by Gothic choir stalls in the illustration), covered with colonnettes, rise massed moldings that make the arcade seem to ripple. Bundled colonnettes spring from ornate **corbels** between the arches to support conical clusters of thirteen ribs that meet at the summit of the vault, a modest 69 feet above the floor. The basic structure here is the four-part vault with intersecting cross-ribs, but the designer added purely decorative ribs, called **tiercerons**, between the supporting ribs to create a richer linear pattern. Elaborately carved knobs known as **bosses** punctuate the

intersections where ribs meet. Large clerestory lancets with bar-tracery mullions illuminate the 300-foot-long nave. Unpolished gray marble shafts, yellow sandstone arches, and a white French stone used in the upper walls add color to the many-rayed space.

Although Gothic architectural style is most studied in cathedrals and other church buildings, it also is seen in such secular structures as castles, which during the turbulent Middle Ages were necessary fortress-residences. Castles evolved during the Romanesque and Gothic periods from enclosed and fortified strongholds to elaborate defended residential complexes from which aristocrats ruled their domains. Usually sited on a promontory or similar defensive height, British castles had many elements in common with continental ones (see "The Gothic Castle," above).

16-40. Page with *Psalm 1 (Beatus Vir)*, *Windmill Psalter*, from London. c. 1270–80. Ink, pigments, and gold on vellum, each page 12¾ x 8¾" (32.3 x 22.2 cm). The Pierpont Morgan Library, New York
M.102, f. lv-2

BOOK ARTS

In France book production had become centralized in the professional **scriptoria** of Paris, and its main patrons were the universities and the court. In thirteenth-century England, by contrast, the traditional centers of production—far-flung rural monasteries that had produced such twelfth-century work as the beautiful *Winchester Psalter* (see fig. 15-30)—continued to dominate the book arts. Toward the close of the thirteenth century, however, secular workshops became increasingly active, reflecting a demand for books from newly literate landowners, townspeople, and students. These people read books, both in English and in Latin, for entertainment and general knowledge as well as for prayer. The fourteenth century was a golden age of manuscript production in England, as the thirteenth century had been in France. Among the delights of English Gothic manuscripts are their imaginative marginalia (pictures in margins of pages).

The dazzling artistry and delight in ambiguities that had marked earlier Anglo-Saxon manuscript illumination reappeared in the *Windmill Psalter* (c. 1270–80), so-called because of a windmill at the top of the initial *E* at the beginning of Psalm 1 (fig. 16-40). The Psalm begins

with the words *"Beatus vir qui non abiit"* ("Happy those who do not follow the counsel [of the wicked]," Psalm 1:1). The letter *B*, the first letter of the Psalm, fills the left page, and an *E*, the second letter, occupies the top of the right page. The rest of the opening words appear on a banner carried by an angel at the bottom of the *E*. The *B* outlines a densely interlaced Tree of Jesse. The *E* is formed from large tendrils that escape from delicate background vegetation to support characters in the story of the Judgment of Solomon. The story, seen as a prefiguration of the Last Judgment, relates how two women (at the right) claiming the same baby came before King Solomon (on the crossbar) to settle their dispute. He ordered a guard to slice the baby in half with his sword and give each woman her share. This trick exposed the real mother, who hastened to give up her claim in order to save the baby's life.

Charming images appear among the pages' foliage, many of them visual puns on the text. For example, the large windmill at the top of the initial *E* illustrates the statement in the Psalm that the wicked would not survive the Judgment but would be "like chaff driven by the wind" (Psalm 1:4). Imagery such as this would have stimulated contemplation of the inner meanings of the text's familiar messages.

16-41. *Life of the Virgin*, back of the Chichester-Constable chasuble, from a set of vestments embroidered in *opus anglicanum*, from southern England. 1330–50. Red velvet with silk and metallic thread and seed pearls; length 5'6" (164 cm), width 30" (76 cm). The Metropolitan Museum of Art, New York

Fletcher Fund, 1927 (2.7 162.1)

OPUS ANGLICANUM

Since Anglo-Saxon times, the English were famous for their embroidery. From the thirteenth through the sixteenth centuries the pictorial needlework in colored silk and gold thread of English embroiderers, both men and women, gained such renown that it came to be referred to by the Latin term *opus anglicanum* ("English work"). Among the collectors of this luxurious textile art was the pope in Rome, who had more than 100 pieces. The names of several prominent embroiderers are known, such as Mabel of Bury Saint Edmunds, who worked for Henry III in the thirteenth century, but few can be connected to specific works.

Opus anglicanum was employed for banners, court dress, and other secular uses, as well as for the vestments worn by the clergy during Mass. A mid-fourteenth-century vestment known as the Chichester-Constable chasuble

(fig. 16-41) is embroidered with scenes from the Life of the Virgin—from the bottom, the Annunciation, the Adoration of the Magi, and the Coronation of the Virgin—arranged in three registers on its back. Cusped, crocketed S-shaped arches, twisting branches sprouting oak leaves, seed-pearl acorns, and animal faces define each register. The star and crescent moon in the Coronation of the Virgin scene, heraldic emblems of the royal family, suggest that the chasuble may have been made under the patronage of Edward III (ruled 1327–77). The embroidery was done in split stitch with fine gradations of colored silk forming the images as subtly as painting (see "Embroidery Techniques," page 544). Where gold threads were laid and couched, the effect is like the burnished gold-leaf backgrounds of manuscript illuminations. During the celebration of the Mass, garments of *opus anglicanum* would have glinted in the candlelight amid the other treasures of the altar. So heavy did such gold and bejeweled garments become, however, that their wearers often needed help to move.

SPAIN The Christian Reconquest of Muslim Spain gained momentum in the thirteenth century, first under Ferdinand III (ruled 1217-52), then under Alfonso X "the Wise" (ruled 1252–84), king of the newly unified northern realm of León and Castile. In the east, the union of Aragón with Catalonia created a prosperous realm that benefited from expanding Mediterranean trade. Christian rulers were initially tolerant of the Muslim and Jewish populations that came under their control, but this tolerance would give way in the late fifteenth century to a drive toward religious conformity. Like other European lands in the fourteenth century, Spain was ravaged by rebellion, war, and plague.

From the twelfth century on, the art of Christian Spain reflects the growing influence of foreign styles, particularly those of France and Italy. Patrons often brought in master masons, sculptors, and painters from these regions to direct or execute important projects. Local artisans adapted the new influences and combined them with local traditions to create a recognizably Spanish Gothic style.

ARCHITECTURE

While most of the great thirteenth-century churches of Castile and León were inspired by French Gothic architecture—and some even had French masons working on their structure and sculpture—to the east, Catalonia and the Balearic Islands developed their own distinctive Catalán Gothic style. Mallorca, the largest of the Balearic Islands and a major center of Mediterranean trade, had been captured from the Muslims in 1229 by James I of Aragón (ruled 1214–76); he converted the mosque at its capital, Palma, into a church. His son initiated the construction of a new cathedral in 1306. The structure has an imposing, fortresslike exterior dominated by closely packed wall buttresses at the continuous line of chapels along the outer aisles. The tall nave, supported by flying buttresses (every third buttress on the exterior), soars to

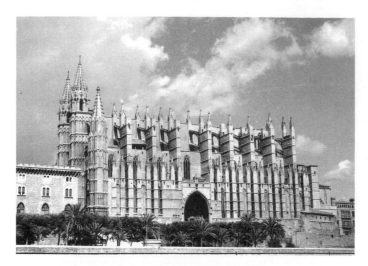

16-42. Cathedral of Palma, Mallorca, Balearic Islands, Spain. Begun 1306. View from the south

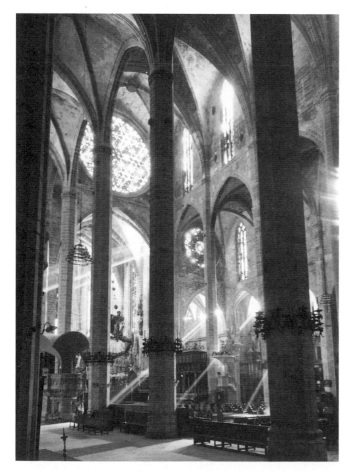

16-43. Nave and side aisle, Palma Cathedral

16-44. Page with *Alfonso the Wise*, *Cantigas de Santa María*, from Castile, Spain. Mid- to late-13th century. Ink, pigments, and gold on vellum. El Escorial, Real Biblioteca de San Lorenzo, Madrid

BOOK ARTS

King Alfonso X of Castile was known as a patron of the arts who maintained a brilliant court of poets, scholars, artists, and musicians during the mid-thirteenth century. He promoted the use of local vernacular languages instead of Latin in his realm for everything from religious literature and history to legal codes and translations of important Arabic scientific texts. He was a poet and musician himself, compiling and setting to music a collection of poems, some of them his own, devoted to the Virgin Mary. An illustration from this manuscript, the *Cantigas de Santa María (Songs of Saint Mary)*, shows Alfonso as poet-musician above one of his own songs (fig. 16-44). Like Queen Blanche and King Louis in the French Court–style Moralized Bible seen earlier (see fig. 16-32), Alfonso is shown seated in a Gothic building. He holds a copy of his poetry, which he presents to admiring courtiers.

PAINTED ALTARPIECES

Large-scale paintings on or just behind church altars, called **altarpieces**, began to appear in the thirteenth century and came into use throughout Europe thereafter. While manuscript illumination and stained glass, and to some extent the fiber arts of embroidery and tapestry,

the amazing height of 143 feet; the side-aisle vaults rise to more than 94 feet (figs. 16-42, 16-43). These tall side aisles, combined with slender polygonal piers in the nave arcade, create a unified interior space. Large windows in the clerestory and both eastern and western nave walls flood the interior with light.

16-45. Luis Borrassá. *Virgin and Saint George*, altarpiece in Church of San Francisco, Villafranca del Panadés, Barcelona. c. 1399. Tempera on wood panel

The contract for another of Borrassá's altarpieces, dated 1402, specifies its subject matter in detail as well as its dimensions and shape. The contract requires the use of high-quality materials and calls for delivery in six months, with payment at specified stages upon inspection of work in progress. It holds the painter responsible for all stages of production "according to what is customary in other beautiful [altarpieces]" (cited in Binski, page 52).

remained the most important forms of two-dimensional art, altarpieces, murals, and smaller paintings on wood panels became increasingly important in the thirteenth century. Professional painters worked for both individual and institutional patrons. Many were members of painting dynasties that lasted for generations, and some had wide-ranging responsibilities at court.

One of the major figures in late medieval Spanish painting was Luis Borrassá (1360–1426). From a Catalán family of painters, he worked for the court of Aragón early in his career, probably in the style favored by the French-born queen. Sometime during the 1380s he set up a workshop in the Catalán capital of Barcelona.

Among the altarpieces attributed to him is the *Virgin and Saint George* made for the Church of San Francisco at Villafranca del Panadés (fig. 16-45). This work is a distinctively Spanish-type altarpiece called a **retablo**, which consists of an enormous wooden framework—taking up the whole wall behind an altar—that is filled with either painted or carved narrative scenes. The depiction of space and the lively narrative scenes in the panels of the *Virgin and Saint George* reflect the influence of the painting style that had developed in Tuscany, in northern Italy, but the realistic details, elegant drawing, and rich colors are characteristically Catalán. Borrassá's synthesis of foreign artistic influences reflects the development of the

16-46. Luis Borrassá. *Education of the Virgin*, detail
from *Virgin and Saint George* altarpiece

A new type of church, the **hall church**, developed in thirteenth-century Germany in response to the increasing importance of sermons in church services. The hall church featured a nave and side aisles with vaults of the same height, creating a spacious and open interior that could accommodate the large crowds drawn by charismatic preachers. The flexible design of these great halls was also widely adopted for civic and residential buildings.

The Church of Saint Elizabeth at Marburg, near Cologne in Germany, built between 1233 and 1283, was popular as a pilgrimage site and as a funerary chapel for the local nobility. The earliest example of a hall church in Germany, Saint Elizabeth's has a beautiful simplicity and purity of line. Light from two stories of tall windows fills the interior, unimpeded by nave arcades, galleries, or *triforia* (fig. 16-47). The exterior has a similar verticality and geometric clarity.

The Gothic style was also adopted for Jewish religious structures. The oldest functioning synagogue in Europe, Prague's Altneuschul ("Old-New Synagogue"), replaced a synagogue of 1230–40 in the third quarter of the thirteenth century (fig. 16-48). One of two principal synagogues serving the Jews of Prague, it reflects the geometric clarity and regularity of Gothic architecture and

courtly International Gothic style that emerged in much of Europe about the beginning of the fourteenth century.

The panel depicting the *Education of the Virgin* (fig. 16-46) shows Mary among a group of fourteenth-century Spanish girls presenting their embroidery for a teacher's approval. All except Mary have produced the assigned floral design. Mary instead has stitched the enclosed garden of Paradise where five golden-winged angels flutter around the Fountain of Life. Embroidery is such an important art that even the child Mary has learned to do it.

GERMANY AND THE HOLY ROMAN EMPIRE

In contrast to England and France, which were becoming strong national states, by about the middle of the thirteenth century Germany had developed into a decentralized conglomeration of independent principalities, bishoprics, and even independent cities. The Holy Roman Empire, weakened by prolonged struggle with the papacy and with German princes, had ceased to be a significant power. Its Italian holdings had established their independence, and Holy Roman emperors—now elected by German princes—had only nominal authority over a loose union of Germanic states. Each emperor in turn held court from his own state. Charles IV (ruled 1355–78), for example, who was also king of Bohemia, ruled from the Bohemian city of Prague, which he helped develop into a great city. Indeed, the emperors exhibited their greatest powers as patrons of the arts, promoting local traditions as well as the spread of the French Court style and the International Gothic style that followed it.

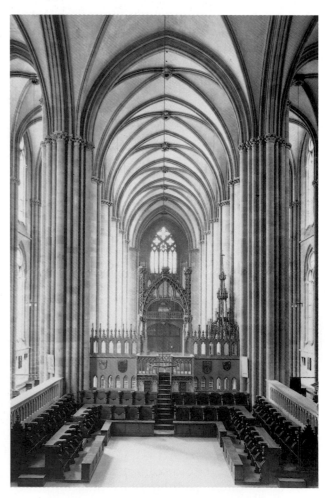

16-47. Nave, Church of Saint Elizabeth, Marburg,
Germany. 1233–83

16-48. Interior, Altneuschul, Prague, Bohemia (Czech Republic). c. late 13th century; *bimah* after 1483; later additions and alterations. Engraving from *Das Historisches Prag in 25 Stahlstichen*, 1864

16-49. Plan of Altneuschul

demonstrates the adaptability of the Gothic hall-church design for non-Christian use (fig. 16-49). Like a hall church, the vaults of the synagogue are all the same height. Unlike a church, with its nave and side aisles, the Altneuschul has two aisles with three bays each. The bays have four-part vaulting with a decorative fifth rib.

Because of sporadic repression, Jewish communities in the cities of northern Europe tended to be small throughout the Middle Ages. Towns often imposed restrictions on the building of synagogues, requiring, for example, that they be lower than churches. Since local guilds controlled the building trades in most towns, Christian workers usually worked on Jewish construction projects. Franciscans may have built the Altneuschul for the Jewish community.

The medieval synagogue was both a place of prayer and a communal center of learning and inspiration where men gathered to read and discuss the Torah. The synagogue had two focal points, the *aron*, or shrine for the Torah scrolls, and a raised reading platform called the *bimah*. Worshipers faced the *aron*, which was located on the east wall, in the direction of Jerusalem. The *bimah* stood in the center of the hall. The pedimented *aron* of the Altneuschul can be seen in figure 16-48, partially obscured by a fifteenth-century openwork partition around the *bimah*, which straddled the two center bays. The synagogue's single entrance was placed off-center in a corner bay at the west end. Candles along the walls and in overhead chandeliers supplemented natural light from twelve large windows. The interior was also originally adorned with murals (the large, richly decorated Torah case shown on the *bimah* table was made later). Men worshiped and studied in the principal space; women were sequestered in annexes on the north and west sides.

SCULPTURE

One of the creative centers of Europe since the eleventh century had been the region known as the Mosan (from the Meuse River, in today's Belgium), with centers in Liège and Verdun, and the closely related Rhine River valley. Nicholas of Verdun, a pivotal figure in the early development of Gothic sculpture, influenced both French and German art through his work well into the thirteenth century. Born in the Meuse River valley between Flanders and Germany, he was heir to the great Mosan metalworking tradition (see fig. 15-37). Nicholas worked for a number of important German patrons, including the archbishop of Cologne, for whom he created a magnificent reliquary (c. 1190–1205/10) to hold what were believed to be relics of the Three Magi (fig. 16-50, page 594). Called the *Shrine of the Three Kings*, the reliquary resembles a basilica, a traditional reliquary form that evolved to reflect changes in church architecture. It is made of gilded bronze and silver with gemstones and dark blue enamel that accentuate its architectonic details. Mosan classicism reached new heights in this work. Figures are fully and naturalistically modeled in bronze **repoussé**. The Magi and Virgin are on the front end, and figures of prophets and the apostles fill the

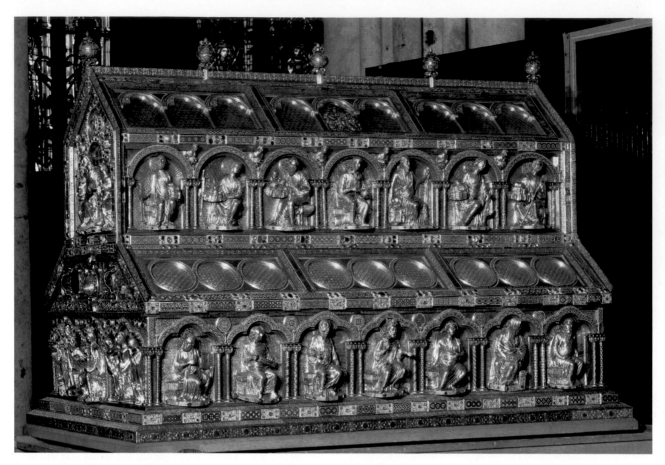

16-50. **Nicholas of Verdun and workshop.** *Shrine of the Three Kings*. c. 1190–c. 1205/10. Silver and gilded bronze with enamel and gemstones, 5'8" x 6' x 3'8" (1.73 x 1.83 x 1.12 m). Cathedral Treasury, Cologne, Germany

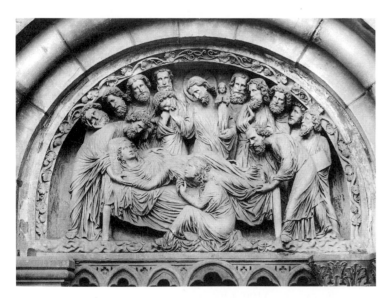

16-51. *Dormition of the Virgin*, south transept portal tympanum, Strasbourg Cathedral, Strasbourg, France. c. 1230

niches in the two levels of arcading on the sides. The work combines robust, expressively mobile sculptural forms with a jeweler's exquisite ornamental detailing to create an opulent, monumental setting for its precious contents.

Nicholas and his fellow goldsmiths inspired a new classicizing style in architectural sculpture, seen, for example, in the works by the "Classical Shop" at Reims (see fig. 16-24) and the sculpture in the south transept facade at the cathedral in Strasbourg (a border city variously claimed by France and Germany over the centuries). Although the works on the Strasbourg facade reflect this classicizing style, they also have an emotional expressiveness that is characteristic of much German medieval sculpture. A relief depicting the death and assumption of Mary, a subject known as the Dormition (Sleep) of the Virgin, fills the tympanum of the south transept portal (fig. 16-51). Mary lies on her deathbed, but Christ has received her soul, the doll-like figure in his arms, and will carry it directly to heaven, where she will be enthroned next to him. The scene is filled with dynamically expressive figures with large heads and short bodies clothed in fluid drapery that envelops their rounded limbs. Deeply undercut, the large figures stand out dramatically in the crowded scene, their grief vividly rendered.

In addition to such emotional expressionism, a powerful current of naturalism ran through German Gothic sculpture. Some works—among them a famous statue of Saint Maurice, produced about 1240–50, from Magdeburg Cathedral—may even have been based on living models instead of idealized types (fig. 16-52). Magdeburg Cathedral, in north-central Germany, had been built on the site of an earlier church dedicated to Saint Maurice, and his relics were preserved there. Maurice, the leader of a

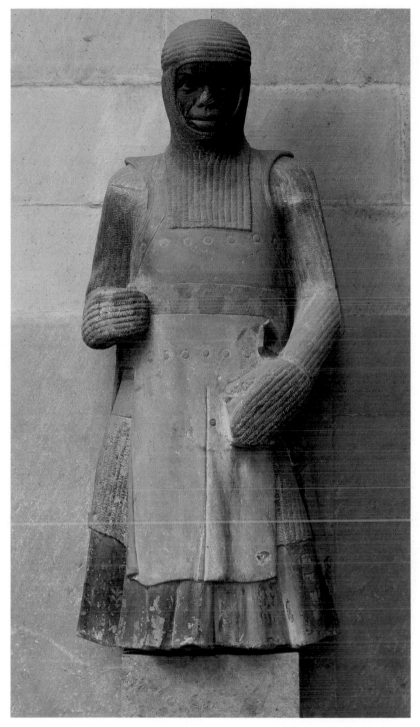

16-52. *Saint Maurice*, Magdeburg Cathedral, Magdeburg, Germany.
c. 1240–50. Dark sandstone with traces of polychromy

group of Egyptian Christians in the Roman army in Gaul, was martyred together with his troops in 286. The crusading knights of the Middle Ages viewed him and other warrior-saints as models of the crusading spirit, and he was a favorite saint of military aristocrats. Because he came from Egypt, Maurice was commonly portrayed with black African features. Dressed in a full suit of chain mail covered by a sleeveless coat of leather, this Saint Maurice represents a distinctly different ideal of warriorship and manhood than does the *Saint Theodore* from

Chartres (see fig. 16-9), which is nearly contemporary.

Another exceptional sculptor worked in a naturalistic style for the bishop of Wettin, Dietrich II, on the decoration of a new chapel-sanctuary built at the west end of Naumburg Cathedral about 1245–60. Dietrich, a member of the ruling family of Naumburg, had lifesize statues of twelve ancestors who were patrons of the church placed on pedestals around the chapel—in effect, securing their perpetual attendance at Mass. Among them are representations of Ekkehard of Meissen and his Polish-born

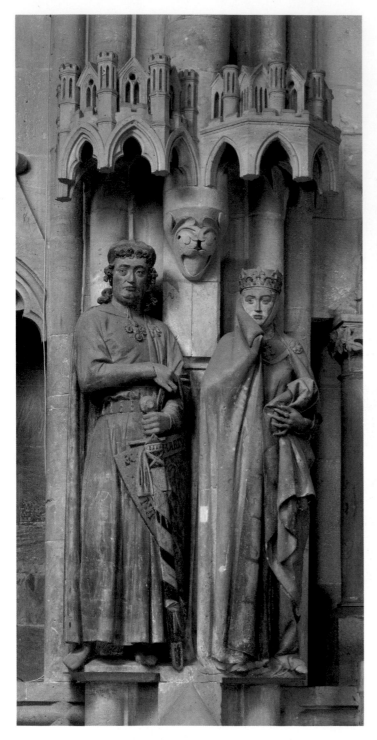

16-53. Ekkehard and Uta, west chapel sanctuary, Naumburg Cathedral, Naumburg, Germany. c. 1245–60. Stone, originally polychromed, approx. 6'2" (1.88 m)

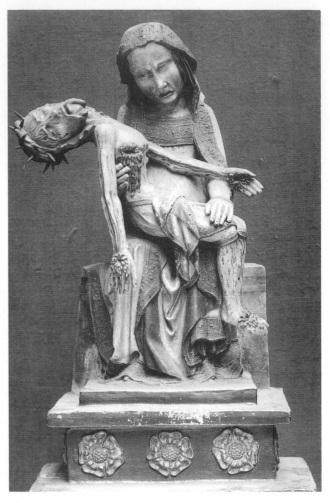

16-54. Vesperbild, from Middle Rhine region, Germany. c. 1330. Wood, height 34½" (88.4 cm). Landesmuseum, Bonn, Germany

wife, Uta (fig. 16-53). Although long dead when these statues were carved, they seem extraordinarily lifelike and individualized. Ekkehard appears as a proud warrior and no-nonsense administrator, while Uta, coolly elegant, artfully draws her cloak to her cheek. Traces of pigment indicate that the figures were originally painted.

The ordeals of the fourteenth century—famines, wars, and plagues—helped inspire a mystical religiosity that emphasized both ecstatic joy and extreme suffering.

The joys and sorrows of Mary became important themes, represented expressionistically in German Gothic art with almost cloying sweetness in Nativity depictions and excruciatingly graphic physical suffering in portrayals of the Crucifixion and the Lamentation. Devotional images, known as *Andachtsbilder* in German, inspired the worshiper to contemplate Jesus' first and last hours, especially during evening prayers, vespers (giving rise to the term *Vesperbild* for the image of Mary mourning her son). Through such religious exercises, worshipers hoped to achieve understanding of the divine and union with God. In the well-known example shown here (fig. 16-54), blood gushes from the hideous rosettes that are the wounds of an emaciated Jesus. The Virgin's face conveys the intensity of her ordeal, mingling horror, shock, pity, and grief. Such images had a profound impact on later art, both within Germany and beyond.

ITALY The thirteenth century was a period of political division and economic expansion for the Italian peninsula and its neighboring islands. With the death of Holy Roman Emperor Frederick II (ruled 1220–50), Germany and the empire ceased to be an important factor in Italian politics and culture, and France and Spain began to vie for control of Sicily and southern Italy. In northern and central Italy, the prolonged conflict between the papacy and the empire had created two political factions: the pro-papacy Guelphs and the pro-imperial Ghibellines. Northern Italy was dominated by several independent and wealthy city-states controlled by a few powerful families. These cities were subject to chronic internal factional strife as well as conflict with one another.

The papacy had emerged from its conflict with the Holy Roman Empire as a significant international force. But its temporal success weakened its spiritual authority and brought it into conflict with the growing power of the kings of France and England. In 1309, after the election of a French pope, the papal court moved from Rome to Avignon, in southern France. During the Great Schism of 1378 to 1417, there were two rival lines of popes, one in Rome and one in Avignon, each claiming legitimacy.

Great wealth and a growing individualism promoted arts patronage in northern Italy. It was here that artisans began to emerge as artists in the modern sense, both in their own eyes and the eyes of patrons. Although their methods and working conditions remained largely unchanged, artisans in Italy now belonged to powerful urban guilds and contracted freely with wealthy townspeople and nobles and with civic and religious bodies. Their ambitious, self-aware art reflects their economic and social freedom.

ARCHITECTURE

Italian Gothic architecture developed from earlier Italian Romanesque architecture in a way that only marginally reflects the influence of the French Gothic style. Rather than the complex narrative sculptural programs typical of French Gothic facades, the decorative focus is on the doors themselves and, inside, on furnishings such as pulpits, tomb monuments, and baptismal fonts.

Florence erected a colossal cathedral (*duomo*) in the fourteenth century (fig. 16-55, page 598). The building has a long and complex history. The original plan, by Arnolfo di Cambio (c. 1245–1302), was approved in 1294, but political unrest brought construction to a halt until 1357. Several modifications of the design were made, and Florence Cathedral assumed much of its present appearance between 1357 and 1378. The west facade was rebuilt again in the sixteenth century. The facade was given its veneer of white and green marble in the nineteenth century to coordinate with that of the nearby Romanesque Baptistry of San Giovanni.

The cathedral's spacious, square-bayed nave (fig. 16-56, page 598) is approximately as tall as the nave at Amiens (see fig. 16-18) but is three times as wide, giving it a radically different appearance. Here, well-proportioned

form is more important than light. The tall nave arcade, harkening back to single-storied imperial Christian designs, has a short clerestory with a single oculus in each bay and no triforium. The regular procession of four-part ribbed vaults springing from composite piers, however, clearly reflects northern Gothic influence. When the vaults began to crack under their own weight in 1366, unsightly iron tie bars had to be installed to hold them together. Builders in northern Europe solved this problem with exterior buttressing.

Sculptors and painters rather than masons were often responsible for designing Italian architecture, and as the plan of Florence Cathedral reflects, they tended to be more concerned with pure design than with engineering (fig. 16-57, page 598). The long nave ends in an octagonal domed crossing, as wide as the nave and side aisles, from which the apse and transept arms extend. In basic architectural terms, this is a central-plan church grafted onto a basilica-plan church. It symbolically creates a Dome of Heaven over the crossing, where the main altar is located, and separates it from the worldly realm of the congregation in the nave. The great ribbed dome, so fundamental to this abstract conception, could not be built when it was planned in 1365. Not until 1420 did Filippo Brunelleschi solve the engineering problems involved in constructing it.

SCULPTURE

In the first half of the thirteenth century, Holy Roman Emperor Frederick II fostered a classical revival at his court in southern Italy that is often compared to Charlemagne's undertakings in the early ninth century. The revival stimulated a trend toward greater naturalism in Italian Gothic sculpture that paralleled a similar trend in the north. A leading early exemplar of the trend was Nicola Pisano (active c. 1258–78), who came from the southern town of Apulia, where imperial patronage was still strong. An inscription on a freestanding marble pulpit (fig. 16-58, page 599) in the Pisa Baptistry (see fig. 15-40) identifies it as Nicola's earliest work in northern Italy. The inscription reads: "In the year 1260 Nicola Pisano carved this noble work. May so gifted a hand be praised as it deserves." The six-sided structure is open on one side for a stairway. It is supported by columns topped with leafy Corinthian capitals and standing figures flanking Gothic trefoil arches. A center column stands on a high base carved with crouching figures and domestic animals. Every second outer column rests on the back of a shaggy-maned lion guarding its prey. The format, style, and technique of Roman sarcophagus reliefs—readily accessible in the burial ground near the cathedral—may have inspired the carving on the pulpit's upper panels. The panels illustrate New Testament subjects, each treated as an independent composition unrelated to the others.

The Nativity cycle panel (fig. 16-59, page 599) illustrates three scenes—the Annunciation, the Nativity, and the Adoration of the Shepherds—within a shallow space. The reclining Virgin dominates the middle of the

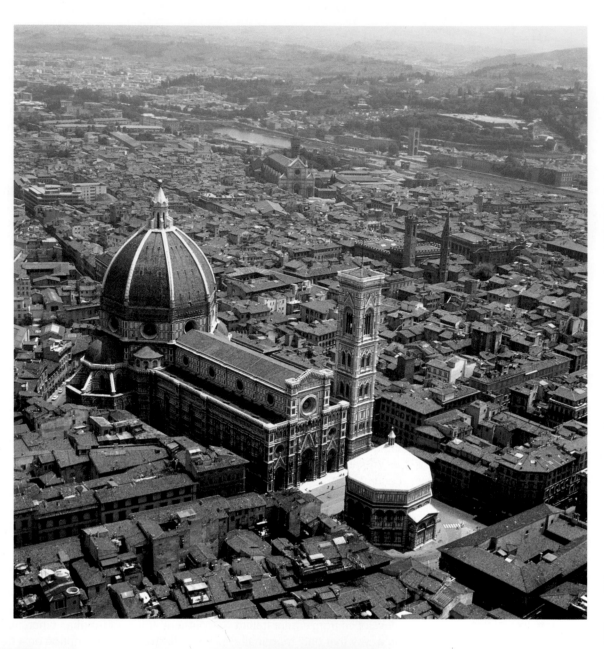

16-55. Arnolfo di Cambio, Francesco Talenti, Andrea Orcagna, and others. Florence Cathedral, Florence. Begun 1296; redesigned 1357 and 1366; drum and dome by Brunelleschi, 1420–36; campanile by Giotto, Andrea Pisano, and Francesco Talenti, c.1334–50.

The Romanesque Baptistry of San Giovanni stands in front of the *duomo*. In the distance, near the Arno River, is the Church of Santa Croce.

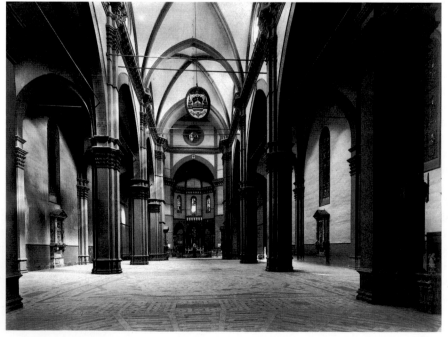

16-56. Nave, Florence Cathedral. 1357–78

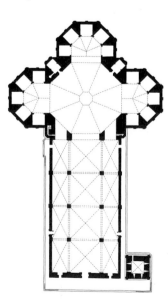

16-57. Plan of Florence Cathedral. 1357–78

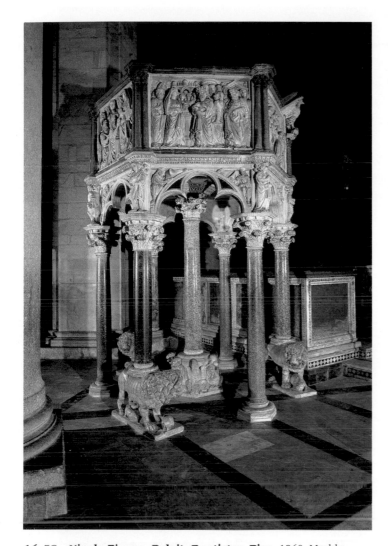

16-58. Nicola Pisano. Pulpit, Baptistry, Pisa. 1260. Marble; height approx. 15' (4.6 m)

The scene of the Presentation is clearly visible on the pulpit.

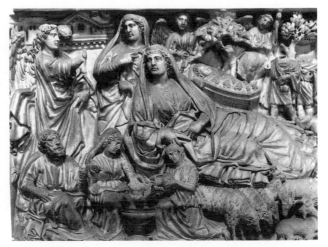

16-59. Nicola Pisano. *Nativity*, detail of pulpit, Baptistry, Pisa. Marble, 33½ x 44½" (85 x 113 cm)

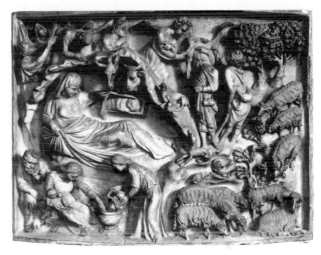

16-60. Giovanni Pisano. *Nativity*, detail of pulpit, Pisa Cathedral, Pisa. 1302 10. Marble, 34⅜ x 43" (87.2 x 109.2 cm)

composition. In the foreground, midwives wash the infant Jesus as Joseph looks on. In the upper left is the Annunciation, with the archangel Gabriel and the Virgin. The scene in the upper right combines the Adoration with the Annunciation to the Shepherds. The composition leads the eye from group to group back to the focal point in the center, the reclining and regally detached Mother of God. The sculptural treatment of the deeply cut, full-bodied forms is quite classical, as are their heavy, placid faces; the congested layout and the use of hierarchical scale are not.

Nicola's son Giovanni (active in Italy c. 1265–1314; he may also have worked or studied in France) assisted his father in his later projects and emerged as a versatile artist in his own right near the end of the thirteenth century. Between 1302 and 1310, Giovanni created a pulpit for Pisa Cathedral that is similar to his father's in conception and general approach but is significantly different in style and execution. Giovanni's graceful, animated Nativity figures inhabit an uptilted, deeply carved space (fig. 16-60). In place of Nicola's impassive Roman matron, Giovanni depicts a slender young Virgin, sheltered by a shell-like cave, gazing delightedly at her baby. Below her, a midwife who doubted the virgin birth has her withered hand restored by dipping it into the baby Jesus' bath water. Angelic onlookers in the upper left have replaced the Annunciation. Sheep, shepherds, and angels spiral up from the landscape with trees and sheep at the right. Dynamic where Nicola's was static, the scene pulses with energy.

Another Italian sculptor called Pisano but unrelated to Giovanni and Nicola, Andrea Pisano (active c. 1320s–48), in 1330 was awarded the prestigious commission for a pair of gilded bronze doors for the Florentine Baptistry of San Giovanni. Completed within six years, the doors are decorated with twenty-eight scenes from the life of John the Baptist (San Giovanni) set in quatrefoils (fig. 16-61, page 600). Surrounding the doors are lush vine scrolls filled with flowers, fruits, and birds, cast in bronze and applied to the doorway's lintel and jambs. The figures within the quatrefoils are in the monumental classicizing style then current in Florentine painting. The individual scenes are elegantly natural, and the

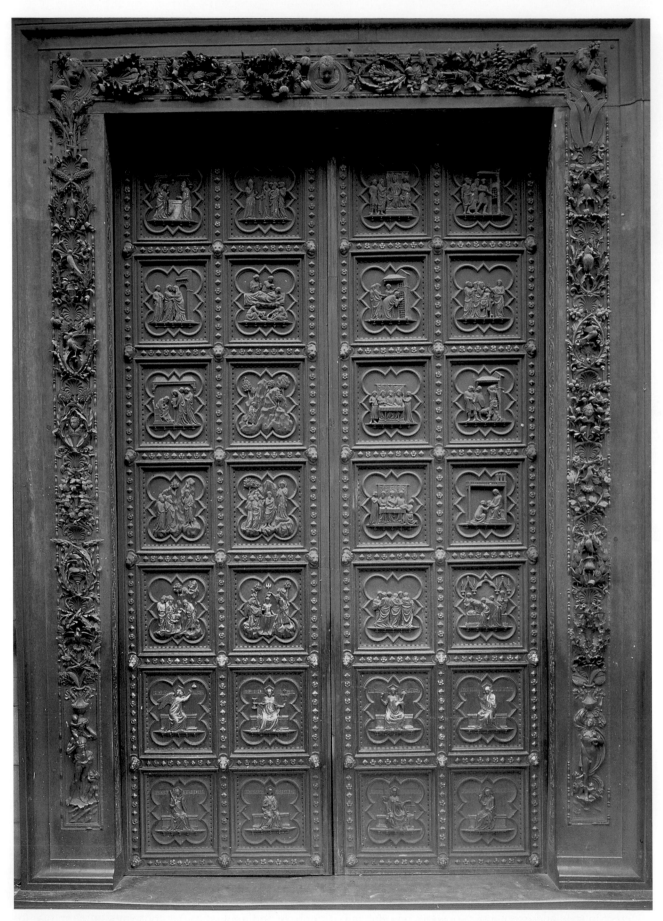

16-61. Andrea Pisano. *Life of John the Baptist*, south doors, Baptistry of San Giovanni, Florence. 1330–36. Gilded bronze

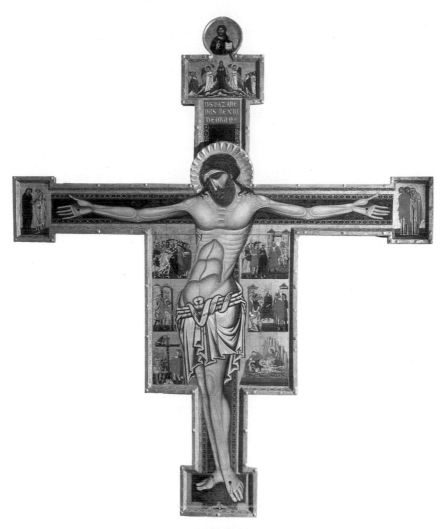

16-62. Coppo di Marcovaldo. *Crucifix*, from Tuscany, Italy.
c. 1250–1300. Tempera and gold on wood panel, 9'7³/₈" x
8'1¹/₄" (2.93 x 2.47 m). Pinacoteca, San Gimignano, Italy

figures' placement and modeling create a remarkable illusion of three-dimensionality, but the overall effect of the repeated barbed quatrefoils is two-dimensional and decorative.

PAINTING

Wall painting, common elsewhere in Europe, became a preeminent art form in Italy. Painting on wood panels also surged in popularity (see "Cennini on Panel Painting," page 602). Altarpieces were commissioned not just for the main altars of cathedrals but for secondary altars, parish churches, and private chapels as well. This growing demand reflected the new sources of patronage created by Italy's burgeoning urban society. Art proclaimed a patron's status as much as it did his or her piety.

The capture of Constantinople by Crusaders in 1204 had brought an influx of Byzantine art and artists to Italy, influencing Italian painters of the thirteenth and fourteenth centuries to varying degrees. This influence appears strongly in the emotionalism of a large wooden crucifix attributed to the Florentine painter Coppo di Marcovaldo and dated about 1250–1300 (fig. 16-62). Instead of the *Christus triumphans* type common in earlier Italo-Byzantine painting, Coppo has represented the *Christus patiens*, or suffering Christ, with closed eyes and bleeding, slumped body (see figs. 7-45, 14-28). The six scenes at the sides of Christ's body tell the Passion story. Such historiated crucifixes were mounted on the **rood screens** (partitions holding the rood, or cross) that hid sanctuary rituals from worshipers (as depicted in figure 16-70). Some were painted on the back, too, suggesting that they were carried in religious processions.

Two very important schools of Italian Gothic painting emerged in Siena and Florence, rivals in this as in everything else. Siena's foremost painter was Duccio di Buoninsegna (active 1278–1318), whose synthesis of Byzantine and northern Gothic influences transformed the tradition in which he worked. Duccio and his studio painted the grand *Maestà* ("Majesty") *Altarpiece* for the

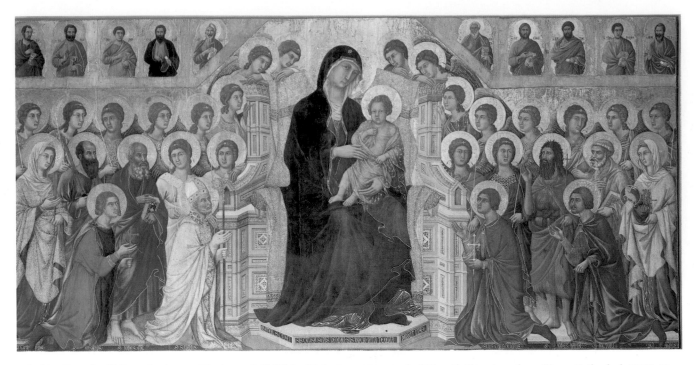

16-63. Duccio di Buoninsegna. *Virgin and Child in Majesty*, main panel of *Maestà Altarpiece*, from Siena Cathedral. 1308–11. Tempera and gold on wood panel, 7' x 13'6¼" (2.13 x 3.96 m). Museo dell'Opera del Duomo, Siena

"On the day that it was carried to the [cathedral] the shops were shut, and the bishop conducted a great and devout company of priests and friars in solemn procession, accompanied by . . . all the officers of the commune, and all the people, and one after another the worthiest with lighted candles in their hands took places near the picture, and behind came the women and children with great devotion. And they accompanied the said picture up to the [cathedral], making the procession around the Campo [square], as is the custom, all the bells ringing joyously, out of reverence for so noble a picture as is this" (Holt, page 69).

TECHNIQUE

CENNINI ON PANEL PAINTING

Cennino Cennini's *Il Libro dell' Arte* (*The Handbook of the Crafts*), a compendium of early fifteenth-century Florentine artistic techniques, includes step-by-step instructions for making panel paintings: The wood for these paintings, he specified, should be fine-grained, free of blemishes, and thoroughly seasoned by slow drying. The first step in preparing a panel for painting is to cover its surface with clean white linen strips soaked in a **gesso** made from gypsum, a task best done on a dry, windy day. Gesso provides a ground, or surface, on which to paint. Cennini specified that at least nine layers should be applied, with a minimum of two-and-a-half days' drying time between layers, depending on the weather. The gessoed surface should then be burnished until it resembles ivory. The artist can now sketch the composition of the work with charcoal made from burned willow twigs. At this point, advised the author, "When you have finished drawing your figure, especially if it is in a very valuable [altarpiece], so that you are counting on profit and reputation from it, leave it alone for a few days, going back to it now and then to look it over and improve it wherever it still needs something . . . (and bear in mind that you may copy and examine things done by other good masters; that it is no shame to you)" (cited in Thompson, page 75). The final version of the design should be inked in with a fine squirrel-hair brush, and the charcoal brushed off with a feather. Gold leaf should be affixed on a humid day over a reddish clay ground called bole, the tissue-thin sheets carefully glued down with a mixture of fine powdered clay and egg white, and burnished with a gemstone or the tooth of a carnivorous animal. Punched and incised patterning should be added to the gold leaf later.

Italian painters at this time worked in a type of paint known as **tempera**, powdered pigments mixed most often with egg yolk, a little water, and an occasional touch of glue. Apprentices were kept busy grinding and mixing paints according to their masters' recipes, setting them out for more senior painters in wooden bowls or shell dishes.

Cennini specified a detailed and highly formulaic painting process. Faces, for example, were always to be done last, with flesh tones applied over two coats of a light greenish pigment and highlighted with touches of red and white. The finished painting was to be given a layer of varnish to protect it and enhance its colors. Reflecting the increasing specialization that developed in the thirteenth century, Cennini assumed that an elaborate frame would have been produced by someone else according to the painter's specifications and brought fully assembled to the studio.

Cennini claimed that panel painting was a gentleman's job, but given its laborious complexity, that was wishful thinking. The claim does, however, reflect the rising social status of painters.

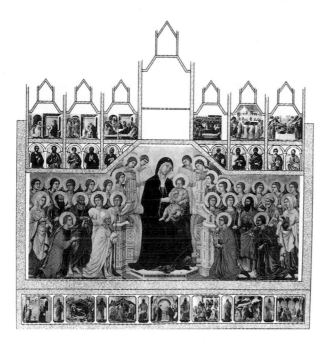

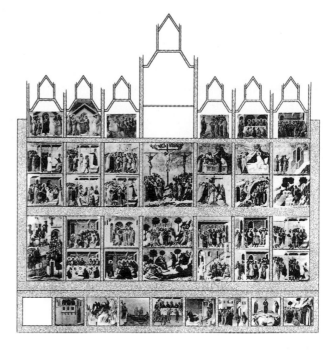

16-64. Plan of front and back of *Maestà Altarpiece*

Duccio's *Maestà Altarpiece* was removed from the cathedral's main altar in 1505. In 1771, the altarpiece was cut up to make it salable. Over the years, sections were dispersed, appearing later at auctions or in museums and private collections. The value of the panels remaining in Siena was finally recognized, and they were placed in the cathedral museum there in 1878.

main altar of Siena Cathedral—dedicated, like the town itself, to the Virgin—between 1308 and 1311 (fig. 16-63). Creating this altarpiece was an arduous undertaking. The work was large—the central panel alone was 7 by 13 feet—and it had to be painted on both sides because the main altar stood in the center of the sanctuary.

Because the *Maestà* was broken up in the eighteenth century, the power and beauty of Duccio's original work must be imagined today from its scattered parts (fig. 16-64). The main scene, depicting the *Virgin and Child in Majesty*, was once accompanied above and below by narrative scenes from the Life of the Virgin and the Infancy of Christ. On the back were scenes from the Life and Passion of Christ. The brilliant palette and ornate **punchwork**—tooled designs in gold leaf—are characteristically Sienese. Duccio has combined a softened Italo-Byzantine figure style with the linear grace and the easy relationship between figures and their settings characteristic of the later northern Gothic style. This subtle blending of northern and southern elements can be seen in the haloed ranks around Mary's architectonic throne (which represents both the Church and its specific embodiment, Siena Cathedral). The central, most holy figures retain an iconic Byzantine solemnity and immobility, but those adoring them reflect a more naturalistic, courtly style that became the hallmark of the Sienese school for years to come.

Simone Martini, a practitioner (active 1315–44) of the style pioneered by Duccio, may have been among Duccio's assistants on the *Maestà*. In 1333, Martini painted an outstanding altarpiece depicting the Annunciation (fig. 16-65) for Siena Cathedral. This exquisite work, with its lavish punchwork, reflects a love of ornamental detail. The elegant figures, robed in fluttering

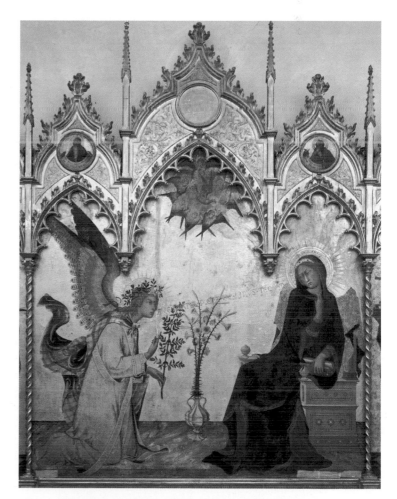

16-65. **Simone Martini.** *Annunciation*, center panel of altarpiece from Siena Cathedral. 1333. Tempera and gold on wood panel; 19th-century frame, 10' x 8'9" (3.05 x 2.67 m). Galleria degli Uffizi, Florence

The altarpiece's side panels depict saints and prophets. They were done by Lippo Memmi, Simone's brother-in-law and assistant.

Buon ("true") **fresco** ("fresh") wall painting on wet plaster was an Italian specialty, derived from Byzantine techniques and distinguished from **fresco secco** ("dry" fresco). The two methods were commonly used together in Italy.

The advantage of *buon fresco* was its durability. A chemical reaction occurred as the painted plaster dried that bonded the pigments into the wall surface. *Fresco secco*, in contrast, tended to flake off over time. The chief disadvantage of *buon fresco* was that it had to be done quickly and in sections. The painter plastered and painted only as much as could be completed in a day. Each section was thus known as a **giornata**, or day's work. The size of a *giornata* varied according to the complexity of the painting within it. A face, for instance, could occupy an entire day, whereas large areas of sky could be painted quite rapidly. A wall to be frescoed was first prepared with a rough, thick undercoat of plaster (*arriccio*). When this was dry, assistants copied the artist's composition onto it with sticks of charcoal, with the artist making any necessary adjustments. These drawings, known as **sinopia**, were often beautifully executed. Painting proceeded in irregularly shaped sections conforming to the contours of major figures and objects, with painters working from the top down so that drips fell on unfinished portions. Assistants covered one section at a time with a fresh, thin coat of very fine plaster, called *intonaco*, over the *sinopia*, and when this was "set" but not dry, pigments mixed with water were painted on. Blue areas, as well as details, were usually painted afterward in tempera using the *fresco secco* method.

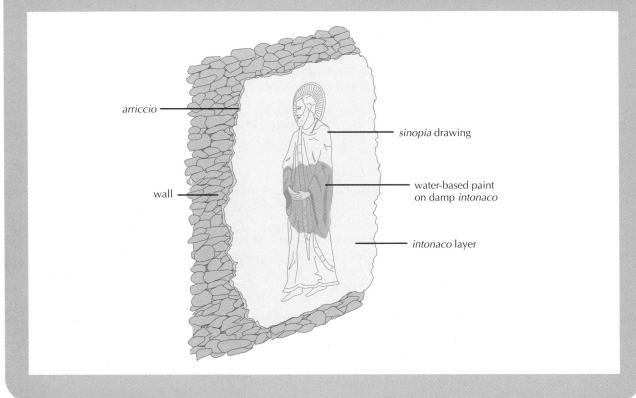

arriccio

sinopia drawing

wall

water-based paint on damp *intonaco*

intonaco layer

draperies and silhouetted against a flat gold ground, seem weightless. Reflecting the Marian literature of his day, the painter focused on the psychological impact of the Annunciation on a young and very human Mary. Gabriel has just appeared, his plaid-lined cloak swirling about him as he kneels in front of the Virgin. The words of his salutation—"Hail, favored one! The Lord is with you"—run from his mouth to her ear. Interrupted while reading the Bible in her room, Mary recoils in shock and fear from this gorgeous apparition. Only essential elements occupy the emotionally charged space. In addition to the two figures, these include Gabriel's olive-branch crown and scepter (emblems of triumph and peace), Mary's thronelike seat (an allusion to her future status as Queen of Heaven), the vase of white lilies (a symbol of her purity), and the dove of the Holy Spirit surrounded by cherubim. Mary's face harks back to Byzantine conventions, but the stylized elegance of her body, seen in the deft curve of her recoiling form, the folds of her rich robe, and her upraised right hand, are characteristic of the Italian Gothic court style. Soon after finishing the *Annunciation*, Simone Martini was summoned to southern France to head a workshop at the papal court in Avignon (he had worked earlier for the French king of Sicily and Naples). His Sienese reformulation of the French Gothic style would contribute to the development of the International Gothic style at the turn of the century.

The Lorenzetti brothers, Pietro (active c. 1306–45) and Ambrogio (active c. 1319–47), worked in a more robust style that dominated Sienese painting during the second quarter of the fourteenth century. One of Pietro's outstanding works was a **triptych**, the *Birth of the Virgin* (fig. 16-66), painted in 1335–42 for one of the cathedral's

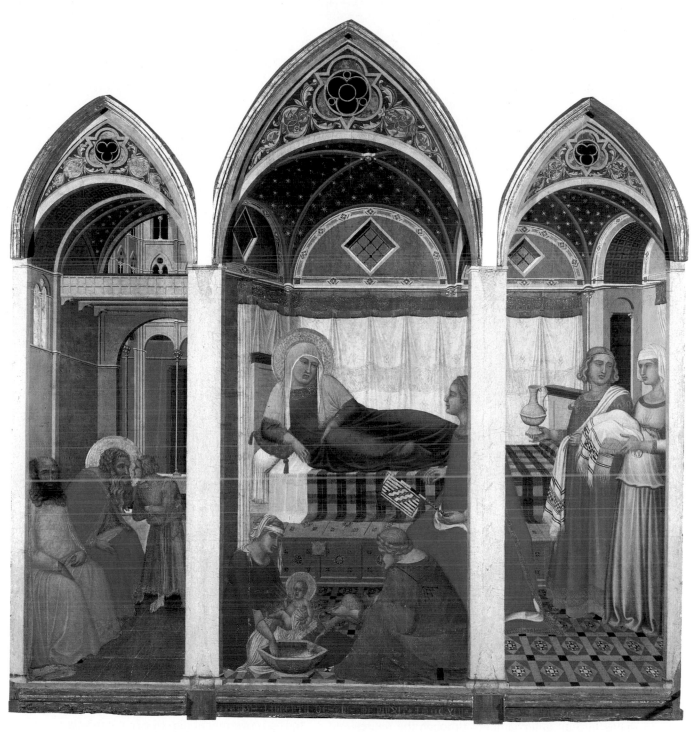

16-66. Pietro Lorenzetti. _Birth of the Virgin_, from Siena Cathedral. c. 1335–42. Tempera and gold on wood panel; frame partially replaced; 6'1¹/₂" x 5'11¹/₂" (1.88 x 1.82 m). Museo dell'Opera del Duomo, Siena

The illusion of space would have been greater in the original altarpiece. Columns supporting the arches would have emphasized the sense of looking through a window into two rooms.

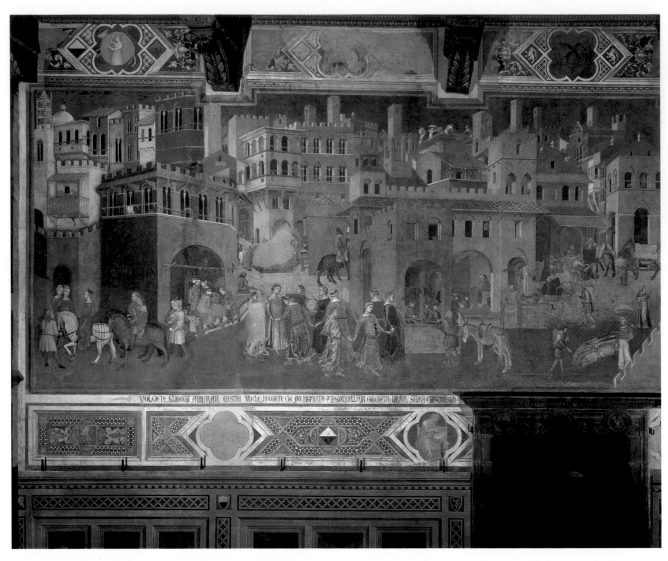

16-67. **Ambrogio Lorenzetti.** *Allegory of Good Government in the City* and *Allegory of Good Government in the Country*, frescoes in the Sala della Pace, Palazzo Pubblico, Siena. 1338–40

secondary altars. In striking contrast to Simone Martini's *Annunciation*, Pietro's ample figures people a well-furnished scene. The only supernatural elements here are the gold halos identifying the baby Mary and her parents, Anna and Joachim. The painter has attempted to create the illusion of an interior space seen through the "windows" of a triple-arched frame. The center and right windows open into a single room, and the left window opens into an antechamber. Although the figures and the architecture are on different scales, Pietro has conveyed a convincing sense of space through an intuitive system of perspective. The lines of floor tiles, the chest, and the plaid bedcover, for example, appear to converge as they recede. Thematically, the Virgin's birth is depicted as a forerunner of the birth of Jesus, with elements that echo those of Nativity scenes: the mother reclines on a bed, midwives bathe the newborn, the elderly father sits off to one side, and three people bearing gifts appear at the right. The gift-bearers are local women with simple offerings of bread and wine (an allusion to the Eucharist) instead of kings bearing treasures. Anna wears the royal color purple, and gold-starred vaulting forms a heavenly canopy.

A few years earlier, in 1338, the Siena city council commissioned Pietro's brother Ambrogio to paint in fresco (see "*Buon Fresco*," page 604) a room called the Sala della Pace ("Chamber of Peace") in the Palazzo Pubblico (city hall). The allegorical theme chosen for the walls was the contrast between the effects on people's lives of good and bad government (fig. 16-67). For the *Allegory of Good Government in the City*, and in tribute to his patrons, Ambrogio created an idealized but recognizable portrait of Siena and its immediate environs. The cathedral dome and the distinctive striped **campanile** are visible in the upper left-hand corner. Above the gateway dividing city from country is perched the statue of the wolf suckling Romulus and Remus, the legendary founders of Rome, identifying it as Siena's Porta Romana. Hovering outside the gate is an allegory of Security as a woman clad only in a wisp of transparent drapery, a scroll in one hand and a miniature gallows complete with a hanged man in the other. The scroll bids those entering the city to come in

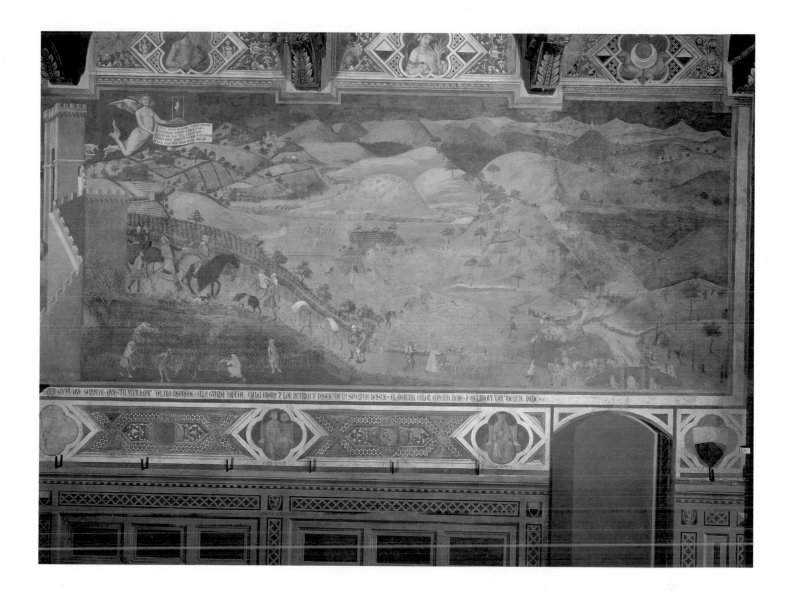

peace, and the gallows is a reminder of the consequences of not doing so.

Ambrogio's achievement in this fresco was twofold. First, he maintained an overall visual coherence despite the shifts in vantage point and scale, helping to keep all parts of the flowing composition intelligible. Second, he created a feeling of natural scale in the relationship between figures and environment. From the women dancing to a tambourine outside a shoemaker's shop to the contented peasants tending fertile fields and lush vineyards, the work conveys a powerful vision of an orderly society, of peace and plenty at this particular time and place. Sadly, famine, poverty, and disease overcame Siena just a few years after this work was completed.

In Florence, the transformation of the Italo-Byzantine style began somewhat earlier than in Siena. Duccio's Florentine counterpart was an older painter named Cenni di Pepi (active c. 1272–1302), better known by his nickname, Cimabue. He is believed to have painted the *Virgin and Child Enthroned* (fig. 16-68, page 608) in about 1280 for the main altar of the Church of Santa Trinità ("Holy Trinity") in Florence. At almost 12 feet high, this enormous panel painting seems to have set a precedent for monumental altarpieces. In it, Cimabue follows the Byzantine iconography of the Virgin Pointing the Way. The Virgin sits surrounded by saints, angels, and Old Testament prophets. She holds the infant Jesus in her lap and points to him as the path to salvation.

Cimabue employed Byzantine formulas in determining the proportions of his figures, the placement of their features, and even the tilts of their haloed heads. Mary's huge throne, painted to resemble gilded bronze with inset enamels and gems, provides an architectural framework for the figures. To render her drapery and that of the infant Jesus, Cimabue used the Italo-Byzantine technique of highlighting drapery with thin lines of gold to indicate divinity, as in Mary's blue cloak. The vantage point suspends the viewer in space in front of the image, simultaneously looking down on the projecting elements of the throne and Mary's lap while looking straight on at the prophets at the base of the throne and the splendid angels at each side. These interesting spatial ambiguities, the subtle asymmetries throughout the composition, the Virgin's thoughtful, engaging gaze, and the well-observed faces of the old men are all departures from tradition that enliven the picture. Cimabue's concern for spatial

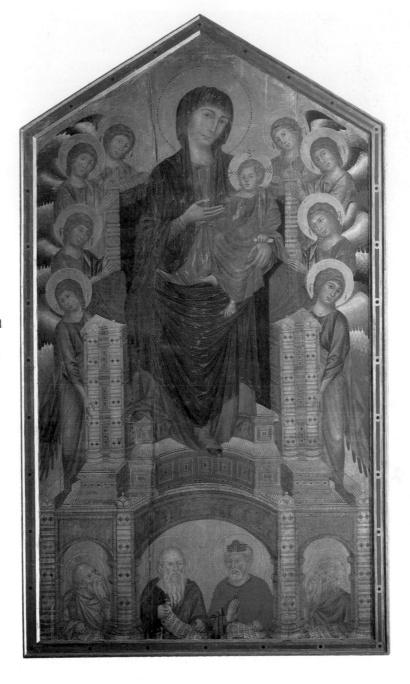

16-68. Cimabue. *Virgin and Child Enthroned*, from the Church of Santa Trinità, Florence. c. 1280. Tempera and gold on wood panel, 11'7½" x 7'4" (3.53 x 2.2 m). Galleria degli Uffizi, Florence

volumes, solid forms, and warmly naturalistic human figures contributed to the course of later Italian painting.

According to the sixteenth-century chronicler Vasari, Cimabue discovered a talented shepherd boy, Giotto di Bondone, and taught him how to paint. Then, "Giotto obscured the fame of Cimabue, as a great light outshines a lesser." Vasari also credited Giotto (active c. 1300–37) with "setting art upon the path that may be called the true one [for he] learned to draw accurately from life and thus put an end to the crude Greek [i.e., Italo-Byzantine] manner" (trans. J. C. and P. Bondanella). The painter and commentator Cennino Cennini (c. 1370–1440), writing in the late fourteenth century, was struck by the accessibility and modernity of Giotto's art, which, though it retained traces of the "Greek manner," was moving toward the depiction of a humanized world anchored in three-dimensional form.

Compared to Cimabue's *Virgin and Child Enthroned*, Giotto's painting of the same subject (fig. 16-69), done about 1310 for the Church of the Ognissanti ("All Saints") in Florence, exhibits a groundbreaking spatial consistency and sculptural solidity while retaining certain of Cimabue's conventions. The central and largely symmetrical composition, the rendering of the angels' wings, and Mary's Byzantine facial type all reflect Cimabue's influence. Gone, however, are her modestly inclined head and delicate gold-lined drapery. This colossal and mountainlike Mary seems to burst forth from her slender Gothic **baldachin**. Giotto has imbued the picture with an unprecedented physical immediacy, despite his retention of hierarchical scale, the formal, enthroned image type, and a flat, gold ground. By rendering the play of light and shadow across their substantial forms, he has created the sense that his figures are fully three-dimensional beings inhabiting real space.

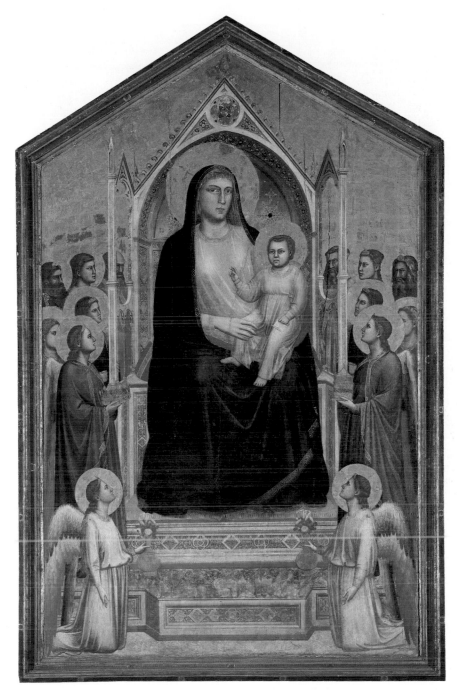

16-69. Giotto di Bondone. *Virgin and Child Enthroned*, from the Church of the Ognissanti, Florence. c. 1310. Tempera and gold on wood panel, 10'8" x 6'8¼" (3.53 x 2.05 m). Galleria degli Uffizi, Florence

Giotto may have collaborated on murals at the prestigious Church of San Francesco in Assisi, the home of Saint Francis (c. 1181–1226), founder of the Franciscan order. Saint Francis's message of simple, humble devotion, direct experience of God, and love for all creatures was gaining followers throughout western Europe and had a powerful impact on thirteenth-century Italian literature and art. The Church of San Francesco, the Franciscans' mother church, was consecrated by the pope in 1253, and the Franciscans commissioned many works to adorn it. Among those who worked there were Simone Martini, Pietro Lorenzetti, Cimabue, and perhaps some unidentified artists from Rome.

The *Life of Saint Francis*, in the upper church at San Francesco, was apparently among the last of the fresco cycles to be completed there. Scholars differ on whether they were painted by the young Giotto as early as

1295–1301 or by his followers as late as 1330; many have adopted the neutral designation of the artist as the Saint Francis Master; others see in these paintings the influence of Roman masters such as Pietro Cavallini (c. 1240/50–1330s). One scene, the *Miracle of the Crib at Greccio*, depicts the legendary story of Saint Francis making the first crèche, a Christmas tableau representing the birth of Jesus, in the church at Greccio. The artist of this scene has made great strides in depicting a convincing space with freely moving solid figures. The fresco documents the way the sanctuary of an early Franciscan church looked and the observances that took place within it. A large wooden historiated crucifix similar to the one by Coppo di Marcovaldo (see fig. 16-62) has been suspended from a stand on top of the rood screen. It has been reinforced by cross-bracing on the back and tilted forward to hover over worshipers in the nave. A high pulpit

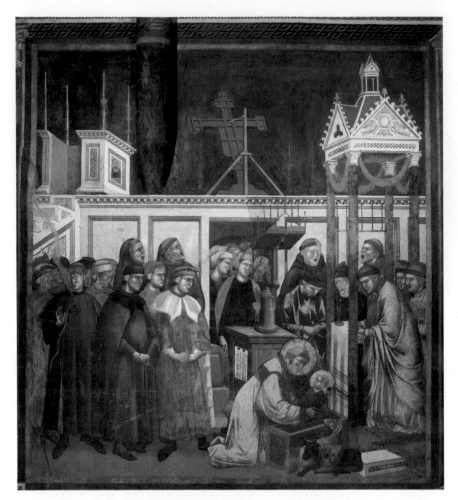

16-70. Saint Francis Master. *Miracle of the Crib at Greccio*, fresco in upper church of San Francesco, Assisi, Italy. c. 1295–1301/30

Saint Francis, born Giovanni Bernadone (c. 1181–1226), was the educated son of a rich cloth merchant. After an early career as a soldier, he dedicated himself to God. Embracing poverty, he lived as a wandering preacher. Contemporaries described him as an innocent eccentric. The Franciscan order began after he and his followers gained the recognition of the pope. Two years before his death, he experienced the stigmata, wounds in his hands and feet like those of the crucified Christ. This panel, on a lower nave wall, survived the disastrous earthquake that wracked Assisi on September 26, 1997.

with candlesticks at its corners rises over the screen at the left. Other small but telling touches include a seasonal liturgical calendar posted on the lectern, foliage swags decorating a Gothic baldachin, and the singing monks. Saint Francis, in the foreground, reverently places a statue of the Holy Infant in a plain, boxlike crib next to representations of various animals that might have been present at his birth (fig. 16-70). Richly dressed people—presumably patrons of the church—stand at the left, while women—normally excluded from the sanctuary—look on through an opening in the screen.

Giotto's masterpiece is the frescoed interior of another church, the Arena Chapel, for the Scrovegni family in Padua (fig. 16-71), painted about 1305. While working at the Church of Saint Anthony in Padua, Giotto was approached by a local merchant, Enrico Scrovegni, to decorate a new family chapel. The chapel, named for a nearby ancient Roman arena, is a simple, barrel-vaulted room.

Giotto covered the entrance wall with a scene of the Last Judgment. He subdivided the side walls with a dado of allegorical *grisaille* paintings of the Virtues and Vices, from which rise vertical bands containing quatrefoil portrait medallions. The medallions are set within a framework painted to resemble marble inlay and carved relief. The central band of medallions spans the vault, crossing a brilliant lapis blue, star-spangled sky in which large portrait disks float like glowing moons. Set into this framework are rectangular narrative scenes juxtaposing the life of the Virgin with that of Jesus. Both the individual scenes and the overall program display Giotto's genius for distilling a complex narrative into a coherent visual experience. Among Giotto's achievements was his ability to model form with color. He rendered his bulky figures as pure color masses, painting the deepest shadows with the most intense hues and highlighting shapes with lighter shades mixed with white. These sculpturally

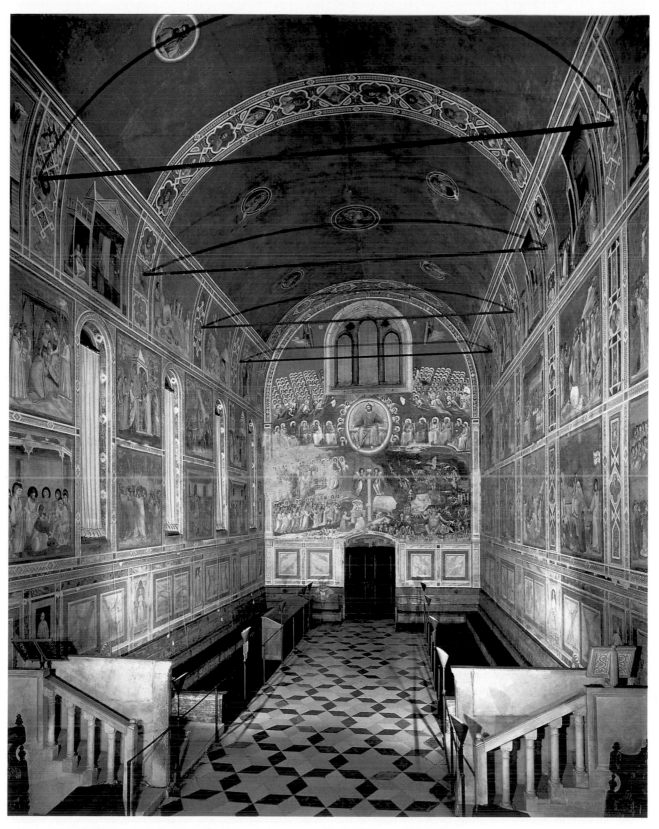

16-71. Giotto di Bondone. *Last Judgment* on west wall, *Life of Christ and the Virgin* on north and south walls, Arena (Scrovegni) Chapel, Padua. 1305–6

16-72. Giotto di Bondone. *The Lamentation*. 1305–6. Fresco in the Arena (Scrovegni) Chapel

modeled figures enabled Giotto to convey a sense of depth in landscape settings without relying on the traditional convention of an architectural framework, although he did make use of that convention.

In the moving work *The Lamentation* (fig. 16-72), in the lowest register of the Arena Chapel, Giotto focused the composition for maximum emotional effect off-center, on the faces of Mary and the dead Jesus. A great downward-swooping ridge—its barrenness emphasized by a single dry tree, a medieval symbol of death—carries the psychological weight of the scene to its expressive core. Mourning angels hovering overhead mirror the anguish of Jesus' followers. The stricken Virgin communes with her dead son with mute intensity, while John the Evangelist flings his arms back in convulsive despair and other figures hunch over the corpse. Instead of symbolic sorrow, Giotto conveys real human suffering, drawing the viewer into the circle of personal grief. The

direct, emotional appeal of his art, as well as its deliberate plainness, embodies Franciscan values.

While Sienese painting was a key contributor to the development of the International Gothic style, Florentine painting in the style originated by Giotto and kept alive by his pupils and their followers was fundamental to the development over the next two centuries of Italian Renaissance art. Before these movements, however, came the disastrous last sixty years of the fourteenth century, during which the world of the Italian city-states—which had seemed so full of promise in Ambrogio Lorenzetti's *Good Government* frescoes—was transformed into uncertainty and desolation by epidemics of the plague. Yet as dark as those days must have seemed to the men and women living through them, beneath the surface profound, unstoppable changes were taking place. In a relatively short span of time, the European Middle Ages gave way to what is known as the Renaissance.

REGION	GOTHIC ART	ART OF OTHER CULTURES
FRANCE	16-3. **Abbey Church of Saint-Denis** (1140–44) 16-22. **Notre-Dame, Paris** (begun 1163) 16-1. **Chartres Cathedral** (c. 1194–1260) 16-14. *Charlemagne Window* (c. 1210–36) 16-16. **Cathedral of Notre-Dame, Amiens** (1220–88) 16-20. *Virtues and Vices* (c. 1220–36) 16-23. **Cathedral of Notre-Dame, Reims** (begun 1230s) 16-24. *Annunciation* and *Visitation* (begun c. 1230) 16-28. **Sainte-Chapelle, Paris** (1243–48) 16-33. *Psalter of Saint Louis* (1253–70) 16-34. Pucelle. *Book of Hours* (c. 1325–28) 16-29. *Virgin and Child*, **Saint-Denis** (c. 1339)	7-42. *Virgin of Vladimir* (12th cent.), Russia 9-28. *Shiva Nataraja* (12th cent.), India 11-14. *The Tale of Genji* (12th cent.), Japan 10-21. Zhang. *Spring Festival on the River* (early 12th cent.), China 12-23. **Anasazi seed jar** (c. 1150), North America 12-21. **Cahokia** (c. 1150), North America 8-18. **Abbasid pen box** (1210–11), Khurasan 13-4. **Head of king** (c. 13th cent.), Ife 10-23. **Guan Ware vase** (13th cent.), China 11-17. *Raigo* triptych (13th cent.) Japan 13-11. **Conical tower** (1350–1450), Great Zimbabwe 8-14. **Mamluk** *qibla* **wall** (1356–63), Egypt
ENGLAND	16-36. **Salisbury Cathedral** (1220–58) 16-39. **Exeter Cathedral** (c. 1270–1366) 16-40. *Windmill Psalter* (c. 1270–80) 16-41. **Chichester-Constable chasuble** (1330–50)	
SPAIN	16-44. *Cantigas de Santa María* (mid- to late-13th cent.) 16-42. **Cathedral of Palma, Mallorca** (begun 1306) 16-45. Borrassá. *Virgin and Saint George* **altarpiece** (c. 1399)	
GERMANY, HOLY ROMAN EMPIRE	16-50. Nicholas of Verdun and workshop. *Shrine of the Three Kings* (c. 1190–c. 1205/10) 16-51. *Dormition of the Virgin* (c. 1230) 16-47. **Church of Saint Elizabeth, Marburg** (1233–83) 16-53. *Ekkehard and Uta* (c. 1245–60) 16-54. *Vesperbild* (c. 1330)	
ITALY	16-58. N. Pisano, Pulpit, **Pisa Baptistry** (1260) 16-68. Cimabue. *Virgin and Child Enthroned* (c. 1280) 16-55. **Florence Cathedral** (begun 1296) 16-60. G. Pisano. **Nativity pulpit, Pisa Cathedral** (1302–10) 16-71. Giotto. **Arena (Scrovegni) Chapel frescoes** (1305–6) 16-63. Duccio. *Maestà Altarpiece* (1308–11) 16-69. Giotto. *Virgin and Child Enthroned* (c. 1310) 16-61. A. Pisano. **Baptistry doors, Florence** (1330–36) 16-65. Martini. *Annunciation* (1333) 16-66. P. Lorenzetti. *Birth of the Virgin* (c. 1335–42) 16-67. A. Lorenzetti. *Allegory of Good Government* (1338–40)	

Glossary

abacus The flat slab at the top of a **capital**, directly under the **entablature**.

absolute dating A method of assigning a precise historical date to periods and objects based on known and recorded events in the region as well as technically extracted physical evidence (such as carbon-14 disintegration). *See also* **radiometric dating, relative dating**.

abstract, abstraction Any art that does not represent observable aspects of nature or transforms visible **forms** into a pattern resembling the original model. Also: the formal qualities of this process.

academic art *See* **academy, academician**.

academy, academician An institution established to train artists. Most academies date from the Renaissance and later; they became powerful state-run institutions in the seventeenth and eighteenth centuries. Academies replaced **guilds** as the venue where students learned both the craft and the theory of art. Academies held exhibitions and awarded prizes; helped artists be seen as trained specialists, rather than craftspeople; and promoted the change in the social status of the artist. An academician is an official academy-trained artist whose work establishes the accepted style of the day.

acanthus A leafy plant whose foliage inspired architectural ornamentation, used in the **Corinthian** and **Composite orders** and in the relief scroll known as the *rinceau*.

acropolis The **citadel** of an ancient Greek city, located at its highest point and housing temples, a **treasury**, and sometimes a royal palace. The most famous is the Acropolis in Athens.

acroterion An ornament at the corner or peak of a roof.

acrylic A fast-drying synthetic paint popular since the 1950s.

adobe Sun-baked blocks made of clay mixed with straw. Also: the buildings made with this material.

adyton The back room of a Greek temple. At Delphi, the place where the **oracles** were delivered. More generally, a very private space or room.

aedicula (aediculae) A type of decorative architectural frame, usually found around a niche, door, or window. An *aedicula* is made up of a **pediment** and **entablature** supported by **columns** or **pilasters**.

aerial perspective. *See* **perspective**.

aesthetics The philosophy of beauty.

agora An open space in a Greek town used as a central gathering place or market. *See also* **forum**.

aisle Passage or open corridor of a church, hall, or other building that parallels the main space, usually on both sides, and is delineated by a row, or **arcade**, of **columns** or **piers**. Called side aisles when they flank the **nave** of a church.

album A book consisting of blank pages (leaves) on which typically an artist may sketch, draw, or paint.

alignment An arrangement of stones (**menhirs**) in straight rows.

allegory In a work of art, an image (or images) that illustrates an **abstract** concept, idea, or story, often suggesting a deeper meaning.

altar A tablelike structure where religious rites are performed. In Christian churches, the **altar** contains a consecrated slab of stone, the **mensa**, supported by the **stipes**.

altarpiece A painted or carved panel or **winged** structure placed at the back of or behind and above. The religious imagery is often specific to the place of worship for which it was made. *See also* **reredos; retablo**.

amalaka In Hindu architecture, the circular or square-shaped element on top of a spire *(shikhara)*, often crowned with a **finial**, symbolizing the cosmos.

ambulatory The passage (walkway) around the **apse** in a **basilican** church or around the central space in a **central-plan** building.

amphiprostyle Term describing a building, usually a temple, with **porticoes** at each end but without **columns** along the other two sides.

amphitheater An oval arena for athletic events and spectacles developed by ancient Roman architects from the idea of two theaters placed facing each other, with ascending tiers of seats for the audience.

amphora An ancient Greek jar for storing oil or wine, with an egg-shaped body and two curved handles.

Anastasis In the Byzantine Church, Christ's descent into hell to release and resurrect the worthy dead.

Andachtsbild (Andachtsbilder) German for "devotional image." A painting or sculpture that depicts themes of Christian grief and suffering, such as the *pietà*, intended to encourage meditation.

aniconic A symbolic representation without images of human figures, very often found in Islamic art.

animal interlace Decoration of interwoven animals or serpents, often found in Celtic and northern European art in the early medieval period.

animal style A type of imagery used in Europe and western Asia during the ancient and medieval periods, characterized by stylized, animal-like shapes arranged in intricate patterns or in combats.

ankh A looped cross signifying life, used by ancient Egyptians.

anta (antae) A rectangular **pilaster** found at the ends of the framing walls of a recessed **portico**.

antependium (antependia) The front panel of a **mensa** or **altar** table.

anticlassical A term designating any image, idea, or **style** that opposes the **classical** norm.

apotheosis Deification of an individual. In art, often shown as an ascent to Heaven, borne by angels, *putti*, or an eagle.

appliqué A piece of any material applied to another.

apprentice A student artist or craftsperson in training. In a system of artistic training established under the **guilds** and still in use today, master artists took on apprentices (who usually lived with the master's family) for several years. The apprentice was taught every aspect of the artist's craft, and he or she participated in the master's workshop or **atelier**.

appropriation An artist's practice of taking ideas or objects from another source for a new work of art. In previous centuries artists often copied one another's figures, **motifs**, or **compositions**, while in modern times the sources for appropriation extend from material culture to works of art.

apse, apsidal A large semicircular or polygonal (and usually **vaulted**) **niche**. In the Christian church, it contains the **altar**. *Apsidal* is an adjective describing the condition of having such a space.

aquamanile A vessel holding water used for washing hands, whether during the celebration of the Catholic Mass or before eating at a secular table. An aquamanile may have the form of a human figure or a grotesque animal.

aquatint A type of **intaglio** printmaking developed in the eighteenth century that produces an area of even **tone** without laborious **cross-hatching**. Basically similar in technique to an **etching**, the aquatint is made through use of a porous resin coating of a metal plate, which when immersed in acid allows an even, all-over biting of the plate. When printed, the end result has a granular, textural effect.

aqueduct A trough to carry water through gravity, if necessary supported by **arches**.

arabesque A type of **linear** surface decoration based on foliage and **calligraphic forms**, usually characterized by flowing lines and swirling shapes.

arcade A series of **arches**, carried by **columns** or **piers** and supporting a common wall or **lintel**. In a blind arcade, the **arches** and supports are engaged (attached to the wall) and have a decorative function.

arch In architecture, a curved structural element that spans an open space. Built from wedge-shaped stone blocks called *voussoirs*, which, when placed together and held at the top by a trapezoidal **keystone**, form an effective space-spanning and weight-bearing unit. Requires **buttresses** at each side to counter the outward thrust caused by the weight of the structure. **Corbel arch**: arch or vault formed by **courses** of stones, each of which projects beyond the lower course until the space is closed, usually with a **capstone**. **Horseshoe arch**: an arch with more than a half-circle shape; typical of western Islamic architecture. **Ogival arch**: a pointed arch created by **S** curves. **Relieving arch**: an arch built into a heavy wall just above a **post-and-lintel** structure (such as a gate, door, or window) to help support the wall above by transferring the load to the side walls.

Archaic smile The curved lips of an ancient Greek statue, usually interpreted as an attempt to animate the features.

architectonic Resembling or relating to the spatial or structural aspects of architecture.

architrave The bottom element in an **entablature**, beneath the **frieze** and the **cornice**.

Archivolt Curved moldings formed by the **voussoirs** making up an **arch**.

ashlar A highly finished, precisely cut block of stone. When laid with others in even **courses**, ashlar masonry creates a uniform face with fine joints. Often used as a facing on the visible exterior of a building, especially as a **veneer** for the **facade**. Also called dressed stone.

assemblage Artwork created by gathering and manipulating two and/or three-dimensional found objects.

astragal A thin convex decorative **molding**, often found on **Classical entablatures**, and usually decorated with a continuous row of beadlike circles.

atelier The studio or workshop of a master artist or craftsperson, usually consisting of junior associates and **apprentices**.

atmospheric perspective Variations in color and clarity caused by distance. *See also* **perspective**.

atrial cross The cross placed in the **atrium** of a church. In Colonial America, used to mark a gathering and teaching place.

atrium An unroofed interior courtyard or room in a Roman house, sometimes having a pool or garden, sometimes surrounded by columns. Also: the open courtyard in front of a Christian church; or an entrance area in modern architecture.

attic story The top story of a building. In **classical** architecture often decorated or carrying an inscription.

attribute The symbolic object or objects that identify a particular deity, saint, or personification in art.

automatism A technique whereby the usual intellectual control of the artist over his or her brush or pencil is forgone. The artist's aim is to allow the subconscious to create the artwork without rational interference. Also called automatic writing.

avant-garde In art, *avant-garde* (derived from the French military word meaning "before the group," or "vanguard") denotes those artists or concepts of a strikingly new, experimental, or radical nature for the time.

axial Term used to describe a **plan** or design that is based on a symmetrical, **linear** arrangement of elements along a central axis. Bilateral symmetry.

axis Imaginary central line.

axis mundi A concept of an "axis of the world," which denotes a link between the human and celestial realms.

background Within the depicted space of an artwork, the area of the image at the greatest distance from the **picture plane**.

bailey The outermost walled courtyard of a castle.

baldachin A canopy (whether suspended from the ceiling, projecting from a wall, or supported by **columns**) placed over an honorific or sacred space such as a throne or **altar**.

balustrade A low barrier consisting of a series of short circular posts (called balusters), with a rail on top.

baptismal font A large open vessel or tank, usually of stone, containing water for the Christian ritual of baptism.

baptistry A building used for the Christian ritual of baptism, traditionally having a **central plan**.

bar tracery *See* **tracery**.

barbican An exterior defensive fortification of a gate or portal.

barrel vault *See* **vault**.

base Masonry supporting a statue or the **shaft** of a **column**.

basilica A large rectangular building. Often built with a **clerestory**, side **aisles** separated from the center **nave** by **colonnades**, and an **apse** at one or both ends. Roman centers for administration, later adapted to Christian church use. Constantine's architects added a transverse aisle at the end of the nave called a **transept**.

basilica plan A plan consisting of **nave** and side **aisles**, often with a **transept** and usually with an **apse**.

bas-relief Low-relief sculpture. *See also* **relief sculpture**.

battered A wall that slopes inward at the top for stability.

battlement The uppermost, fortified sections of a building or wall, usually including **crenellations** and other defensive structures.

bay A unit of space defined by architectural elements such as **columns, piers**, and walls.

beadwork Any decoration created with or resembling beads.

beehive tomb A corbel-vaulted tomb, conical in shape like a beehive, and covered by an earthen mound.

Benday dots In modern printing and typesetting, the individual dots that, together with many others, make up lettering and images. Often machine- or computer-generated, the dots are very small and closely spaced to give the effect of density and richness of **tone**.

bestiary A book describing characteristics, uses, and meaning illustrated by moralizing tales about real and imaginary animals, especially popular during the Middle Ages in western Europe. *See also* **herbal**.

bevel, beveling A cut made at any angle except a right angle. Also: the technique of cutting at a slant.

bi A jade disk with a hole in the center used in China for the ritual worship of the sky. Also: a badge indicating noble rank.

biomorphic Term used to describe forms that resemble or suggest shapes found in nature.

bird's-eye view A view from above.

black-figure A **style** or technique of ancient Greek pottery in which black figures are painted on a red clay ground.

blackware A ceramic technique that produces pottery with a primarily black surface. Blackware has both **matte** and glossy patterns on the surface of the wares.

blind Decorative elements attached to the surface of a wall, with no openings, used decoratively.

block printing A printed image, such as a **woodcut** or wood **engraving**, made from a carved woodblock.

bobbin A cylindrical reel around which a material such as yarn or thread is wound when spinning, sewing, or weaving.

bodhisattva A being who is far advanced in the journey of becoming a Buddha. The *bodhisattva* defers personal enlightenment to help all living beings emancipate themselves from the cycle of suffering.

boiserie Decoratively carved and/or painted wood paneling or wainscotting, usually applied to seventeenth- and eighteenth-century French interiors.

Book of Hours. A private prayer book, having a calendar, services for the canonical hours, and sometimes special prayers.

boss A decorative knoblike element. Bosses can be found in many places, such as at the intersection of a Gothic **vault rib**. Also button-like projections in decorations and metalwork.

bracket, bracketing An architectural element that projects from a wall to support a horizontal part of a building, such as beams or the eaves of a roof.

broken pediment *See* **pediment**.

bronze A metal made from copper alloy, usually mixed with tin or zinc. Also: any sculpture or object made from this substance.

buon fresco *See* **fresco**.

burin A metal instrument used in the making of **engravings** to cut lines into the metal plate.

bust A portrait depicting only the head and shoulders of the subject.

buttress, buttressing A type of architectural support. Usually consists of massive masonry with a wide **base** built against an exterior wall to brace the wall and strengthen the **vaults**. Acts by transferring the weight of the building from a higher point to the ground. **Flying buttress.** An **arch** built on the exterior of a building that transfers the thrust of the roof vaults at important stress points to a detached buttress **pier** leading to the wall buttress.

cairn A pile of stones or earth and stones that served as a prehistoric burial site and as a marker of underground tombs.

calligraphy A form of writing with pictures, as in the Chinese language.

calotype The first photographic process utilizing negatives and paper positives, invented by William Henry Fox Talbot in the late 1830s.

calyx krater *See* **krater**.

came A lead strip, H-shape in **section**, used in the making of leaded or **stained-glass** windows. Separate pieces of glass are fitted into the grooves on the sides to hold the design together.

cameo Gemstone, clay, glass, or shell having layers of color, carved in **low relief** to create an image and ground of different colors.

camera obscura An early cameralike device. A dark box (or room) with a hole in one side (sometimes fitted with a lens), the camera obscura operates when bright light shines through the hole, casting an upside-down image of an object outside onto the inside wall of the box. This image then can be traced.

campanile The Italian term for a freestanding bell tower.

canon Established rules or standards.

canon of proportions A set of ideal mathematical ratios in art based on measurements of the human body.

cantilever A beam or structure that is anchored at one end and projects horizontally beyond its vertical support, such as a wall or **column**. It can carry loads throughout the rest of its unsupported length. Or a bracket used to carry the **cornice** or extend the eaves of a building.

capital The sculpted top of a **column** forming a transition between the vertical **shaft** and the horizontal **lintel** or **entablature**. According to the conventions of the **orders**, capitals include different decorative elements. A historiated capital has narrative figures. *See also* **order**.

capriccio A painting or print of a fantastic, imaginary landscape, usually with architecture.

capstone The final, topmost stone in a **corbel arch** or **vault**, which joins the sides and completes the structure.

caricature An artwork that exaggerates individual peculiarities, usually with humorous or satirical intent.

cartoon A full-scale drawing used to transfer the outline of a design onto a surface (such as a wall, canvas, panel, or tapestry) to be painted or woven.

cartouche A frame for a **hieroglyphic** inscription formed by a rope design surrounding an oval space. Used to signify a sacred or honored name. Also: in architecture, a decorative device or plaque, usually with a plain center used for inscriptions or epitaphs.

caryatid A sculpture of a draped female figure acting as a **column** supporting an **entablature**.

casemate A vaulted chamber within the thickness of a fortified wall that provides storage space, usually for weapons or military equipment.

casement A window sash that opens on hinges at the side, swinging open the entire length.

catacomb An underground burial ground consisting of tunnels on different levels, having niches for urns and *sarcophagi* and often incorporating rooms (*cubiculae*).

cathedral the principal Christian church in a diocese, built in the bishop's administrative center and housing his throne (*cathedra*).

cella The principal interior room at the center of a Greek or Roman temple within which the cult statue was usually housed. Also called the **naos**.

cenotaph A funerary monument commemorating an individual or group buried elsewhere.

centaur In Greek mythology, a creature with the head, arms, and torso of a man and the legs and hind quarters of a horse.

centering A temporary structure that supports a masonry **arch** and **vault** or **dome** during construction until the mortar is fully dried and the masonry is self-sustaining.

central-plan building Any structure designed with a primary central space; may be surrounded by radiating elements as in the **Greek-cross** (equal-armed cross) **plan**.

ceramics A general term covering all types of **wares** made from fired clay, including **porcelain** and **terra-cotta**.

Chacmool In Mayan sculpture, a half-reclining figure, probably representing an offering bearer.

chaitya A type of Buddhist temple found in India. Built in the **form** of a hall or **basilica**, a *chaitya* hall is highly decorated with sculpture and usually is carved from a cave or natural rock location. It houses a sacred shrine or **stupa** for worship.

chakra Sanskrit term for "wheel"; (see *dharmachakra*)

chamfer The slanted surface produced when an angle is trimmed or **beveled**, common in building and metalwork.

champlevé An enamel technique in which the cells gouged out of the metal plate hold colored glass. *See also* **cloisonné**.

chancel The end of the church containing the **choir**, **ambulatory**, and radiating chapels. Also called **chevet**.

chasing Ornamentation made on metal by indenting the surface with a hammer.

château (châteaux) A French country house or castle. A château fort or military castle incorporates defensive fortifications such as **moats** and towers.

chattri (chattris) A decorative pavilion with an umbrella-shaped **dome** in Indian architecture.

cherub (cherubim) The second highest order of angels (*see* **seraph**). Popularly, an idealized small child, usually depicted naked and with wings.

chevet A French term for the area of a church beyond the **crossing** and including the **apse**, **ambulatory**, and radiating chapels.

chevron A decorative or heraldic **motif** of repeated **V**s; a zigzag pattern.

chiaroscuro An Italian word designating the contrast of dark and light in a painting, drawing, or print. Spatial depth and **volumetric forms** through slight gradations in the intensity of light and shadow are used to indicate three dimensions.

chinoiserie The decorative imitation of Chinese art and **style** common in the eighteenth century.

chip carving A type of decorative incision on wood, usually made with a knife or chisel, characterized by small triangular or square patterns.

chiton A thin sleeveless garment, fastened at waist and shoulders, worn by men and women in ancient Greece.

choir The section of a Christian church reserved for the clergy or the religious, either between the **crossing** and the **apse** or in the **nave** just before the crossing, screened or walled and fitted with stalls (seats). In convents, funeral chapels, and later Protestant churches, the choir may be raised above the nave over the entrance. Also: an area reserved for singers.

chromolithography A type of **lithographic** process utilizing color. A new stone is made for each color, and all are printed onto the same piece of paper to create a single, colorful lithographic image.

ciborium A canopy over the **altar** in Christian churches, usually consisting of a domed roof supported by **columns**. Also: the receptacle for the Eucharist in the Catholic Mass. *See also* **baldachin**.

circus A circular or oval arena built by ancient Romans and usually enclosed by raised seats for spectators.

citadel A fortress or defended city, if possible placed in a high, commanding location.

clapboard Horizontal planks used as protective siding for buildings, particularly houses in North America.

Classical When capitalized, a term referring to the culture, art, and architecture of the Classical period of ancient Greece, from about 480 BCE to about 320 BCE. *See also* **classical**.

Classical orders *See* **order**.

classical, classicism Any aspect of later art or architecture following the rules, canons, and examples of the art of ancient Greece and Rome. Also: in general, any art aspiring to the qualities of restraint, balance, and rational order exemplified by the ancient Greeks and Romans.

clerestory The topmost zone of a wall with windows in a **basilica** (secular or church), extending above the roofs of the **aisles**. Provides direct light into the central interior space, the **nave**.

cloisonné An enamel technique in which metal strips are affixed to the surface to form the design. The resulting areas (cloisons) are filled with colored glass.

cloister An open space, part of a monastery, surrounded by an **arcaded** or **colonnaded** walkway, often having a fountain and garden, and dedicated to nonliturgical activities and the secular life of the religious. Members of a cloistered order do not leave the monastery or interact with outsiders.

cloth of honor A piece of fabric, usually rich and highly decorated, hung behind a person of great rank on ceremonial occasions. Signifying the exalted status of the space before them, cloths of honor may be found behind thrones, **altars**, or representations of holy figures.

codex (codices) A book, or a group of **manuscript** pages (a gathering of folios), held together by stitching or other binding on one side.

coffer A recessed decorative panel that, repeated, is used to decorate ceilings or **vaults**. The use of coffers is called coffering.

coiling A technique in basketry. Coiled baskets are made from a spiraling structure held or sewn in place by another material.

collage A technique in which cutout forms of paper (including newsprint), cloth, or found materials are pasted onto another surface. Also: an image created using this technique.

colonnade A row of **columns**, supporting a straight **lintel** (as in a **porch** or **portico**) or a series of **arches** (an **arcade**).

colonnette A small **column**, usually found attached to a **pier** or wall. Colonnettes are decorative features that may reach into the **vaulted** sections of the building, contributing to the vertical effect.

colophon The data placed at the end of a book listing the book's author, publisher, illuminator, and other information related to its production.

colossal order *See* order.

column An architectural element used for support and/or decoration. Consists of a rounded or polygonal vertical **shaft** placed on a **base** topped by a larger, usually decorative **capital**. In classical architecture, built in accordance with the rules of one of the architectural **orders**. Columns can be freestanding or attached to a background wall (**engaged**).

column statue A **column** carved to depict a human figure.

complementary color The primary and secondary colors across from each other on the color wheel (red and green, blue and orange, yellow and purple). When juxtaposed, the intensity of both colors increases. When mixed together, they negate each other to make a neutral gray-brown.

Composite order *See* order.

composition The arrangement of elements in an artwork.

compound pier A **pier** or large **column** with shafts, pilasters, or **colonnettes** attached to it on one or more sides.

conch *See* half dome.

concrete A building material developed by the Romans, which is easily poured or molded when wet and hardens into a strong and durable stonelike substance. Made primarily from lime, sand, cement, and rubble mixed with water.

cone mosaic An early type of surface decoration created by pressing colored cones of baked clay into prepared wet plaster; associated with Sumerian architecture.

cong A square or octagonal jade tube with a cylindrical hole in the center. A symbol of the earth, it was used for ritual worship and astronomical observations in ancient China.

connoisseurship A term derived from the French word *connoisseur*, meaning "an expert," and signifying the study and evaluation of art based primarily on formal, visual, and stylistic analysis. A connoisseur studies the **style** and technique of an object to deduce its relative quality and possible maker. This is done through visual association with other, similar objects and styles the connoisseur has seen in his or her study. *See also* contextualism; formalism.

content When discussing a work of art, the term can include all of the following: its **subject matter**; the ideas contained in the work; the artist's intention; and even its meaning for the beholder.

contextualism A methodological approach in art history that focuses on the culture surrounding an art object. Unlike **connoisseurship**, contextualism utilizes the literature, history, economics, and social developments (among other things) of a period, as well as the object itself, to explain the meaning of an artwork. *See also* **connoisseurship**.

contrapposto A way of representing the human body so that its weight appears to be borne on one leg. Also: a twisting body position. *Contrapposto* first appears in sculpture from the ancient Greece.

corbel arch *See* arch.

corbel vault *See* vault.

corbel, corbeling An early roofing and **arching** technique in which each **course** of stone projects slightly beyond the previous layer (a corbel) until the uppermost corbels meet. Results in a high, almost pointed **arch** or **vault**. A corbel table is a ledge supported by corbels.

Corinthian order *See* order.

cornice The uppermost section of a **Classical entablature**. More generally, any horizontally projecting element of a building, usually found at the top of a wall. A **raking cornice** is formed by the junction of two slanted cornices, supporting or following the line of the roof.

course A horizontal layer of stone used in building.

cove A concave **molding**, or the area of ceiling where a wall and ceiling converge. A **cove ceiling** incorporates such moldings on all sides.

crenellation Alternating high and low sections of a wall, giving a notched appearance and creating permanent defensive shields in the walls of fortified buildings.

crockets Stylized leaves used in Gothic decoration.

cromlech In prehistoric architecture, a circular arrangement of upright stones (**menhirs**).

cross vault *See* groin vault.

cross-hatching A technique primarily used in printmaking and drawing in which parallel lines (hatching) are drawn across a previous set, but from a different angle. Cross-hatching gives a great density of **tone** and allows the artist to create the illusion of shadows.

crossing The part of a cross-shaped church where the **nave** and the **transept** meet, often marked on the exterior by a tower or **dome**.

cruciform A term describing anything that is cross-shaped, as in the cruciform **plan** of a church.

cruck One of a pair of curved timbers forming a principal support of a roof or wall.

crypt The **vaulted** underground space beneath the floor of a church, usually under the sanctuary, which may contain tombs and relics.

cubiculum (cubiculae) A private chamber for burial in the **catacombs**. The *sarcophagi* of the affluent were housed there in arched wall **niches**.

cuneiform An early form of writing with wedge-shaped marks impressed into wet clay with a **stylus**, primarily used by ancient Mesopotamians.

curtain wall A wall in a building that does not support any of the weight of the structure. Also: the freestanding outer wall of a castle.

cycle A series of images depicting a single story or theme intended to be displayed together.

cyclopean construction or **masonry** A method of building using huge blocks of rough-hewn stone. Any large-scale, **monumental** building project that impresses by sheer size. Named after the Cyclops, one-eyed giants of legendary strength in Greek myths.

cylinder seal A small cylindrical stone decorated with **incised** patterns. When rolled across soft clay or wax, a raised pattern or design (**relief**) is made, which served in Mesopotamian and Indus Valley cultures as an identifying signature.

dado (dadoes) The lower part of a wall, differentiated in some way (by a **molding** or different coloring or paneling) from the upper section.

daguerreotype An early photographic process that makes a positive print on a light-sensitized copperplate; invented and marketed in 1839 by Louis-Jacques-Mandé Daguerre.

Day-Glo A trademark name for fluorescent painted materials.

Deesis In Byzantine art, the representation of Christ flanked by the Virgin Mary and Saint John the Baptist.

demotic writing An informal **script** developed by the ancient Greeks in about the eighth century BCE and used exclusively for non-sacred texts.

dentil Small, toothlike blocks arranged in a continuous band to decorate a **Classical entablature**.

dharmachakra Sanskrit for "wheel" (*chakra*) and "law" or "doctrine" (*dharma*); often used in Buddhist iconography to signify the "wheel of the law."

di sotto in su Seen from below (worm's eye view), in Italian.

diorama A large painting made to create an environment, giving the viewer an impression of being at the site depicted. Usually hung on several walls of a room and specially lit, the diorama was a popular attraction in the nineteenth century and was sometimes exhibited with sculpted figures.

dipteral A building that is surrounded by two rows of **columns** (a double **peristyle**).

diptych Two panels of equal size (usually decorated with paintings or reliefs) hinged together.

dogu Small human figurines made in Japan during the Jomon period. Shaped from clay with exaggerated expressions and in contorted poses, *dogu* were probably used in religious rituals.

dolmen A prehistoric structure made up of two or more large upright stones supporting a large, flat, horizontal slab or slabs (called **capstones**).

dome A curved masonry **vault** theoretically consisting of an **arch** rotated on its **axis**. May be crowned by an open space (**oculus**) and/or an exterior **lantern** and may rest on a vertical wall (**drum**). When a dome is built over a square space, an intermediate element (a **pendentive** or a **squinch**) is required to make the transition to a circular drum or dome. A dome on pendentives incorporates arched, sloping intermediate sections of wall (spherical triangles) that carry the weight and thrust of the dome to heavily **buttressed** supporting **piers**. A dome on squinches uses an four beams supported by an arch built into the wall (**squinch**) in the upper corners of the space, converting the square plan to an octagon to carry the weight of the dome across the corners of the square space below.

donjon *See* keep.

Doric order *See* order.

dormer A vertical window built into a sloping roof. A dormer window has its own roof and side walls that adjoin to the body of the roof proper.

dressed stone *See* ashlar.

drillwork The technique of using a drill for the creation of shadows in sculpture.

drum The wall that supports a **dome**. Also: a segment of the circular **shaft** of a **column**.

drypoint An **intaglio** printmaking process by which a metal (usually copper) plate is directly inscribed with a pointed instrument (**stylus**). The resulting design of scratched lines is inked, wiped, and printed. Also: the print made by this process.

earthworks Artwork and/or sculpture, usually on a large scale, created by manipulating the natural environment. Also: the earth walls of a fort.

easel painting Any painting of small to intermediate size that can be executed on an artist's easel.

echinus A cushionlike circular element found below the **abacus** of a **Doric capital**. Also: a similarly shaped **molding** (usually with **egg-and-dart motifs**) between the **volutes** of an **Ionic capital**.

edition A single printing of a book or print. An edition can have a different number but includes only what is printed at a particular time by the same press by the same publisher or artist.

egg-and-dart A decorative **molding** made up of an alternating pattern of round (egg) and downward-pointing, tapered (dart) elements.

electron spin resonance techniques Method that uses magnetic field and microwave irradiation to date material such as tooth enamel and it surrounding soil.

elevation The arrangement, proportions, and details of any vertical side or face of a building. Also: an architectural drawing showing an exterior or interior wall of a building. A building's main elevation is usually its **facade**.

emblema (emblemata) In a mosaic, the elaborate central **motif** on a floor, usually a self-contained unit done in a more refined manner, with smaller *tesserae* of both marble and semi-precious stones.

embossing The technique of working metal by hammering from the back to produce a **relief**. *See also repoussé.*

embroidery The technique in needlework of decorating fabric by stitching designs and figures of colored threads of fine material (such as silk) into another material (such as cotton, linen, or wool). Also: the material produced by this technique.

enamel Glass bonded to a metal surface by heat. After firing, the glass forms an opaque or translucent substance that is fixed to the metal background in a decorative or narrative design. Also: an object created with enamel technique. *See also* **champlevé; cloisonné**.

encaustic A painting technique using pigments mixed with hot wax as a **medium**. Popular in Egypt, Greece, and Rome.

engaged column A **column** attached to a wall. *See also* **column**.

engraving An **intaglio** printmaking process of inscribing an image, design, or letters onto a metal or wood surface from which a print is made. An engraving is usually drawn with a sharp implement (**burin**) directly onto the surface of the plate. Also: the print made from this process.

entablature In the **Classical orders**, the horizontal elements above the **columns** and **capitals**. The entablature consists of, from bottom to top, an **architrave**, a **frieze**, and a **cornice**.

entasis A slight bulge built into the shaft of a Greek **column**. The optical illusion of entasis makes the **column** appear to be straight.

etching An **intaglio** printmaking process, in which a metal plate is coated with acid-resistant resin and then inscribed with a **stylus** in a design, revealing the plate below. The plate is then immersed in acid, which eats away the exposed metal. The resin is removed, leaving the design etched permanently into the metal and the plate ready to be inked, wiped, and printed.

Eucharist The central rite of the Christian church, from the Greek word "thanksgiving." Also known as the Mass or Holy Communion, the ritual was inspired by the Last Supper. According to traditional Catholic Christian belief, consecrated bread and wine become the body and blood of Christ; in Protestant belief, bread and wine symbolize body and blood.

exedra (exedrae) In architecture, a semicircular **niche**. On a small scale, often used as decoration, whereas larger *exedrae* can form interior spaces (such as an **apse**).

expressive When used in describing art, **form** that seems to convey the feelings of the artist and to elicit an emotional response in the viewer.

expressionism, expressionistic Terms describing a work of art in which **forms** are created primarily to evoke subjective emotions rather than to portray objective reality.

extrados The upper, curving surface of a **vault** or **arch**. *See also intrados*.

facade The face or front wall of a building.

faience Glazed **ceramic** that, upon firing, acquires a lustrous, smooth, impermeable texture.

faktura An idea current among Russian Constructivist artists and other Russian artists of the early twentieth century that referred to the inherent **forms** and colors suitable to different materials. Used primarily in their mixed-**medium** constructions of a **nonrepresentational** type.

fang ding A square or rectangular bronze vessel with four legs. The *fang ding* was used for ritual offerings in ancient China during the Shang dynasty.

fête galante A subject in painting depicting well-dressed people at leisure in a park or country setting, often associated with eighteenth-century French painting.

filigree Delicate, lacelike ornamental work.

fillet The flat surface between the carved out flutes of a **column shaft**. *See also* **fluting**.

finial A knoblike architectural or furniture decoration found at the top point of a spire, **pinnacle**, canopy, or **gable**.

flower piece Any painting with flowers as the primary subject. **Still lifes** of flowers became particularly popular in the seventeenth century in the Netherlands and Flanders.

fluting In architecture, evenly spaced parallel vertical grooves **incised** on **shafts** of **columns** or columnar elements (such as **pilasters**).

flying buttress *See* **buttress**.

folio A page or leaf in a **manuscript** or book. Also: a large sheet of paper or parchment, which, when folded twice and cut, produces four separate sheets; more generally, any large book.

foreground Within the depicted space of an artwork, the area that is closest to the **picture plane**.

foreshortening The illusion created on a flat painted or drawn surface in which figures and objects appear to recede or project sharply into space. Accomplished according to the rules of **linear perspective**.

form In speaking of a work of art or architecture, the term refers to purely visual components: line, color, shape, texture, mass, spatial qualities, and **composition**—all of which are called formal elements.

formal elements *See* **form**.

formalism, formalist An approach to the understanding, appreciation, and valuation of art based almost solely on considerations of **form**. This approach tends to regard an artwork as independent of its time and place of making. *See also* **connoisseurship**.

formline In Native American works of art, a line that defines and creates a space or **form**.

forum A Roman town center; site of temples and administrative buildings and used as a market or gathering area for the citizens.

four-iwan mosque *See* **iwan** *and* **mosque**.

freestanding An independent column or sculpture.

fresco A painting technique in which water-based pigments are applied to a surface of wet plaster (called *buon fresco*). The color is absorbed by the plaster, becoming a permanent part of the wall. *Fresco secco* is created by painting on dried plaster, and the color my flake off. **Murals** made by both these techniques are called frescoes.

frieze The middle element layer of an **entablature**, between the **architrave** and the **cornice**. Usually decorated with sculpture, painting, or **moldings**. Also: any continuous flat band with **relief sculpture** or painted decorations.

fritware A type of pottery made from a mix of white clay, quartz, and other chemicals that, when fired, produces a highly brittle substance.

frontispiece An illustration opposite or preceding the title page of a book. Also: the primary **facade** or main entrance **bay** of a building.

frottage A design produced by laying a piece of paper over a **relief** or **incised** pattern and rubbing with charcoal or other soft **medium**.

fusuma Sliding doors covered with paper, used in Japanese construction. *Fusuma* are often highly decorated with paintings and colored backgrounds.

gable The triangular wall space found on the end wall of a building between the two sides of a pitched roof. Also: a triangular decorative panel that has a gablelike shape.

gadrooning A form of decoration on architecture and in metalwork characterized by sequential convex **moldings** that curve around a circular surface; the opposite of **fluting**.

galleria In church architecture, the story found above the side **aisles** of a church, usually open to and overlooking the **nave**. Also: in secular architecture, a long room, usually above the ground floor in a private house or a public building used for entertaining, exhibiting pictures, or promenading. Also called **gallery**.

gallery A place where art is exhibited, specifically an art gallery. A gallery may be commercial, that is, a place where art is sold, or public or private, where it is not for sale. *See also galleria.*

garbhagriha From the Sanskrit word meaning "womb chamber," a small room or shrine in a Hindu temple containing a holy image.

genre A type or category of artistic form, subject, technique, **style**, or **medium**. *See also* genre painting.

genre painting A term used to loosely categorize paintings depicting scenes of everyday life, including (among others) domestic interiors, party scenes, inn scenes, and street scenes.

geoglyphs Earthen designs on a colossal scale, often created in a landscape as if to be seen from the air.

Geometric A period in Greek art from about 1100 BCE to 600 BCE. The pottery is characterized by patterns of rectangles, squares, and other **abstract** shapes. Also: lower-cased, any style or art using primarily these shapes.

gesso A ground made from glue, gypsum, and/or chalk forming the ground of a wood panel or the priming layer of a canvas that provides a smooth surface for painting.

gesturalism Painting and drawing in which the brushwork or line visibly records the artist's physical gesture at the moment the paint was applied or the lines laid down. Associated especially with expressive styles, such as Zen painting and Abstract Expressionism.

gilding The application of paper-thin **gold leaf** or gold pigment to an object made from another **medium** (for example, a sculpture or painting). Usually used as a decorative finishing detail.

giornata Adopted from the Italian term meaning "a day's work," a *giornata* is the section of a **fresco** that is plastered and painted in a single day.

glaze *See* glazing.

glazing In **ceramics**, a method of treating earthenwares with an outermost layer of vitreous liquid (glaze) that, upon firing, renders a waterproof and decorative surface. In painting, a technique particularly used with oil **mediums** in which a transparent layer of paint (glaze) is laid over another, usually lighter, painted or glazed area.

gloss A type of clay **slip** used in **ceramics** by ancient Greeks and Romans that, when fired, imparts a colorful sheen to the surface.

gold leaf Paper-thin sheets of hammered gold that are used in **gilding**. In some cases (such as Byzantine **icons**), also used as a ground for paintings.

golden section A line that when divided into two, the smaller part is the same proportion to the larger as the larger is to the whole. Said to be the ideal proportion, it was supposedly discovered by the ancient Greeks

Good Shepherd A man carrying a sheep or calf or with a sheep or calf at his side. In **classical** art, the god Hermes carrying a calf; in Christian art, Jesus Christ with a sheep (an image inspired by the Old Testament Twenty-third Psalm or the New Testament parable of the Good Shepherd).

gopura The towering gateway to an Indian Hindu **temple complex**. A temple complex can have several different *gopuras*.

gouache Opaque **watercolor** having a chalky effect.

graffiti Usually drawings and/or text of an obscene, political, or violent nature by anonymous persons; found in all periods and all **mediums**.

Grand Manner An elevated **style** of painting popular in the Neoclassical period of the eighteenth century in which an artist looked to the ancients and to the Renaissance for inspiration; for portraits as well as history painting, the artist would adopt the poses, **compositions**, and attitudes of Renaissance and antique models.

granulation A technique for decorating gold in which tiny balls of the precious metal are fused to the main surface.

graphic arts A term referring to art, whether drawn or printed, that utilizes paper as primary support.

graphic artist *See* graphic arts, graphic design.

graphic design A concern in the visual arts for shape, line, and two-dimensional patterning, often especially apparent in works including typography and lettering.

graphic designer *See* graphic arts, graphic design.

grattage A pattern created by scraping off layers of paint from a canvas laid over a textured surface. *See also frottage.*

Greek-cross plan *See* central-plan building.

Greek-key pattern A continuous rectangular scroll often used as a decorative border. Also called a meander pattern.

grid A system of regularly spaced horizontally and vertically crossed lines that gives regularity to an architectural **plan**. Also: in painting, a grid enables designs to be enlarged or transferred easily.

griffin An imaginary creature with the head, wings, and claws of an eagle and the body and hind legs of a lion.

grisaille A painting executed primarily in shades of gray.

groin vault *See* vault.

groundline The solid baseline that indicates the ground plane on which the figure stands. In ancient representations, such as those of the Egyptian, the figures and the objects are placed on a series of groundlines to indicate depth (space in **registers**).

grout A soft cement placed between the *tesserae* of a **mosaic** or of tiles to hold the pieces together.

guild An association of craftspeople. The medieval guild had great economic power, as it controlled the selling and marketing of its members' products, and it set standards and provided economic protection, group solidarity, and training in the craft to its members.

half dome Semicircular dome that expands outward from a central dome, in Byzantine architecture to cover the **narthex** on one side and the **sanctuary apse** on the other. Also called conch.

half-timber construction A method of building, particularly in heavily timbered northern European areas, for vernacular structures. Beginning with a timber framework built in the **post-and-lintel** manner, the builder constructed walls between the timbers with bricks, mud, or **wattle**. The exterior could then be faced with plaster or other material.

hall church A church with a **nave** and **aisles** of the same height, giving the impression of a large, open hall.

halo The representation of a circle of light surrounding the head of deities, saints, or other holy beings. *See also* **mandorla**.

halos An outdoor pavement used by ancient Greeks for ceremonial dancing.

hammered gold Created by indenting a gold surface with a hammer.

handscroll A long, narrow, horizontal painting and/or text, common in ancient Roman, Chinese, and Japanese art, of a size intended for individual use. A handscroll is stored wrapped tightly around a wooden pin and is unrolled for viewing or reading.

hanging scroll In Chinese and Japanese art, a vertical painting or text mounted on sections of silk. At the top is a semicircular rod; at the bottom is a round dowel. Hanging scrolls are kept rolled and tied except for special occasions, when they are hung for display, contemplation, or commemoration

haniwa Pottery forms, including cylinders, buildings, and human figures, that were placed on top of Japanese tombs or burial mounds.

Happening A type of art form incorporating performance and visual images developed in the 1950s. A Happening was organized without a specific narrative or intent; with audience participation, the event proceeded according to chance and individual improvisation.

header In building, a brick laid so that its end, rather than its side, faces out.

heliograph A type of early photograph created by the exposure to sunlight of a plate coated with light-sensitive asphalt.

hemicycle A semicircular interior space or structure.

henge A circular area enclosed by stones or wood posts set up by Neolithic peoples. It was usually bounded by a ditch and raised embankment.

herbal A book describing the characteristics, uses, and meaning of plants. *See also* **bestiary**.

herm A statue that has the head and torso of a human but the lower part of which is a plain, tapering pillar of rectangular shape. Used primarily for architectural decoration.

hieratic In painting and sculpture, a formalized **style** for representing rulers or sacred or priestly figures.

hieratic scale The use of different sizes for significant or holy figures and those of the everyday world to indicate importance. The larger the figure, the greater the importance.

hieroglyphs Picture writing; words and ideas rendered in the form of pictorial symbols.

high relief Relief sculpture in which the image projects strongly from the background. *See also* relief sculpture.

himation In ancient Greece, a long loose outer garment.

historiated Bearing images or a narrative, as a historiated capital or initial.

historicism A nineteenth-century consciousness of and attention to the newly available and accurate knowledge of the past, made accessible by historical research, textual study, and archaeology.

history painting The term used to denote those paintings that include figures in any kind of historical, mythological, or biblical narrative. Considered from the Renaissance until the twentieth century as the noblest form of art, history paintings generally convey a high moral or intellectual idea and often are painted in a grand pictorial style.

hollow-casting *See* lost-wax casting.

horizon line A horizontal "line" formed by the implied meeting point of earth and sky. In linear perspective, the vanishing point or points are located on this line.

horseshoe arch *See* arch.

house-church A private home used as a Christian church.

house-synagogue A Jewish place of worship located in a private home.

hue Pure color. The saturation or intensity of the hue depends on the purity of the color. Its value depends in its lightness or darkness.

hydria A large ancient Greek and Roman jar with three handles (horizontal ones at both sides and one vertical at the back), used for storing water.

hypostyle hall Marked by numerous rows of tall, closely spaced columns. In ancient Egyptian architecture, a large interior room of a temple complex preceding the sanctuary.

icon An image in any material representing a sacred figure or event in the Byzantine, and later the Orthodox, Church. Icons were venerated by the faithful, who believed them to have miraculous powers to transmit messages to God.

iconoclasm The banning or destruction of images, especially icons and religious art. Iconoclasm in eighth- and ninth-century Byzantium and sixteenth- and seventeenth-century Protestant territories arose from differing beliefs about the power, meaning, function, and purpose of imagery in religion.

iconographic *See* iconography.

iconography The study of the significance and interpretation of the subject matter of art.

iconostasis The partition screen in a Byzantine Orthodox church between the sanctuary (where the Mass is performed) and the body of the church (where the congregation assembles). The iconostasis displays icons.

idealism *See* idealization.

idealization A process in art through which artists strive to make their forms and figures attain perfection, based on pervading cultural values and their own mental image of beauty.

ideograph A motif or written character that expresses an idea or symbolizes an action in the world. It is distinct from a pictograph, which symbolizes or represents an actual object, person, or thing. Egyptian hieroglyphs and Chinese calligraphs are examples of writing that consist of both ideographs and pictographs.

ignudi Heroic figures of nude young men.

illumination A painting on paper or parchment used as illustration and/or decoration for manuscripts or albums. Usually done in rich colors, often supplemented by gold and other precious materials. The illustrators are referred to as illuminators. Also: the technique of decorating manuscripts with such paintings.

illusionism, illusionistic An appearance of reality in art created by the use of certain pictorial means, such as perspective and foreshortening. Also: the quality of having this type of appearance.

impasto Thick applications of pigment that give a painting a palpable surface texture.

impost, impost block A block, serving to concentrate the weight above, imposed between the capital of a column and the lowest block (*voussoir*) of an arch above.

impression Any single printing of a print (woodcut, engraving, drypoint, or etching). Each and every impression of a print is by nature different, given the possibilities for variation inherent in the printing process, which requires the plate to be inked and wiped between every impression.

in antis Term used to describe the position of columns set between two walls, as in a portico or a cella.

incising A technique in which a design or inscription is cut into a hard surface with a sharp instrument.

ink painting A style of painting developed in China using only monochrome colors, usually black ink with gray washes. Ink painting was often used by artists of the literati painting tradition and is connected with Zen Buddhism.

inlay A decorative process in which pieces of one material (usually wood or metal) are set into the surface of an object fashioned from a different material.

installation *See* installation art.

installation art Artworks created for a specific site, especially a gallery or outdoor area, that create a total environment.

intaglio A technique in which the design is cut into the surface of an object, such as an engraved seal stone. In the graphic arts, intaglio includes engraving, etching, and drypoint—all processes in which ink transfers to paper from incised, ink-filled lines cut into a metal plate.

intarsia The decoration of wood surfaces with inlaid designs created of contrasting materials such as metal, shell, and ivory.

interlace A type of linear decoration particularly popular in ancient and early medieval art, in which ribbonlike serpents, vines, or animals or ribbons are interwoven.

interlacing *See* interlace.

intrados The curving inside surface of an arch or vault. *See also extrados*.

intuitive perspective *See* perspective.

Ionic order *See* order.

isometric projection A building diagram that represents graphically the parts of a building. Isometric projections have all planes of the building parallel to two established vertical and horizontal axes. The vertical axis is true, while the horizontal is drawn at an angle to show the effect of recession. All dimensions in an isometric drawing are proportionally correct. *See also* plan, section.

iwan A large, vaulted chamber in a mosque with a monumental arched opening on one side.

jamb In architecture, the vertical element found on both sides of an opening in a wall, such as a door or window.

japonisme A style in French and American nineteenth-century art that was highly influenced by Japanese art, especially prints.

joined-wood sculpture A method of constructing large-scale wooden sculpture developed in Japan. The entire work is constructed from smaller hollow blocks, each individually carved, and assembled when complete. The joined-wood technique allowed the production of larger sculpture, as the multiple joints alleviate the problems of drying and cracking found with sculpture carved from a single block.

ka The name given by ancient Egyptians to the human life force, or spirit.

kantharos A type of Greek vase or goblet with two large handles and a wide mouth.

keep The most heavily fortified defensive structure in a castle; a tower located at the heart of the castle complex.

kente A woven silk cloth made by the Ashanti peoples (men) of Africa. *Kente* cloth is woven in long, narrow pieces in complex and colorful patterns, which are then sewn together.

key block A key block is the master block in the production of a colored woodcut, which requires different blocks for each color. The key block is a flat piece of wood with the entire design carved or drawn on its surface. From this, other blocks with partial drawings are made for printing the areas of different colors.

keystone The topmost *voussoir* at the center of an arch—the last block to be placed. The pressure of this block holds the arch together. Sometimes of a larger size and/or highly decorated.

kiln An oven designed to produce enough heat for the baking, or firing, of clay.

kinetic Artwork that contains parts that can be moved either by hand, air, or motor.

kiva A structure in a Native American pueblo used for community gatherings and rituals.

kondo The main hall inside a Japanese Buddhist temple where the images of Buddha are housed.

kore (korai) An Archaic Greek statue of a young woman.

kouros (kouroi) An Archaic Greek statue of a young man or boy.

krater An ancient Greek vessel for mixing wine and water, with many subtypes that each

have a distinctive shape. **Calyx krater:** a bell-shaped vessel with handles near the base that resemble a flower calyx. **Volute krater:** a type of krater with handles shaped like scrolls.

kufic An ornamental, angular Arabic script.

kylix A shallow Greek vessel or cup, used for drinking, with a wide mouth and small handles near the rim.

lacquer A type of hard, glossy surface varnish used on objects in East Asian cultures, made from the sap of the Asian sumac or from shellac, a resinous secretion from the lac insect. Lacquer can be layered and manipulated or combined with pigments and other materials for various decorative effects.

lakshana Term used to designate the thirty-two marks of the historical Buddha. The *lakshana* include, among others, the Buddha's golden body, his long arms, the wheel impressed on his palms and the soles of his feet, and his elongated earlobes.

lamassu Supernatural guardian-protector of ancient Near Eastern palaces and throne rooms, often represented architecturally as a combination of the bearded head of a man, powerful body of a lion or bull, wings of an eagle, and the horned headdress of a god, and usually possessing five legs.

lancet A lancelike or blade shape. Also: a tall narrow window crowned by a sharply pointed **arch**, typically found in Gothic architecture.

landscape architecture, landscape gardening The creation of artificial landforms, lakes, and contrived planting to produce an ideal nature.

landscape painting A painting in which a natural outdoor scene or vista is the primary subject.

lantern A turretlike structure situated on top of a dome, with windows that allow light into the space below.

Latin-cross plan A cross-shaped building plan, incorporating a long **nave** and shorter **transept** arms.

lectionary A book containing readings from Christian scripture arranged according to the Church calendar from which the officiant reads to the congregation during holy services.

lekythos (lekythoi) A slim Greek oil vase with one handle and a narrow mouth.

limner An artist, particularly a portrait painter, in England during the sixteenth and seventeenth centuries and in New England during the eighteenth and nineteenth centuries.

linear perspective *See* **perspective.**

linear, linearity A descriptive term indicating an emphasis on line, as opposed to mass or color, in art.

lingam **shrine** A place of worship centered on an object or representation in the form of a phallus (the *lingam*), which symbolizes the power of the Hindu god Shiva.

lintel A horizontal element of any material carried by two or more vertical supports to form an opening.

literati painting A **style** of painting that reflects the taste of the educated class of East Asian intellectuals and scholars. Aspects include an appreciation for the antique, smaller

scale, and an intimate connection between maker and audience.

lithograph A print made from a design drawn on a flat stone block with greasy crayon. Ink is applied to the wet stone, and when printed, adheres only to the open areas of the design. *See also* **chromolithography.**

lithograph *See* lithography.

loculus (loculi) A **niche** in a tomb or **catacomb** in which a *sarcophagus* was placed.

loggia Italian term for a covered open-air gallery.

lost-wax casting A method of casting metal, such as **bronze**, by a process in which a wax mold is covered with clay and plaster, then fired, melting the wax and leaving a hollow **form**. Molten metal is then poured into the hollow space and slowly cooled. When the hardened clay and plaster exterior shell is removed, a solid metal form remains to be smoothed and polished.

low relief Relief sculpture whose figures project slightly from the background. *See also* **relief sculpture.**

lozenge A decorative **motif** in the shape of a diamond.

lunette A semicircular shape; on a wall, often framed by an **arch** over a door or window.

lusterware Ceramic pottery decorated with metallic **glazes.**

madrasa An Islamic institution of higher learning, where teaching is focused on theology and law.

maenad In ancient Greece, a female devotee of the wine god Dionysos who participated in orgiastic rituals. She is often depicted with swirling drapery to indicate wild movement or dance. (Also called a Bacchante, after Bacchus, the Roman name of Dionysos.)

majolica Tin-**glazed** pottery.

maki-e In Japanese art, the effect achieved by sprinkling gold or silver powder on successive layers of **lacquer** before each layer dries.

mandala An image of the cosmos represented by an arrangement of circles or concentric geometric shapes containing diagrams or images. Used for meditation and contemplation by Buddhists.

mandapa In a Hindu temple, an open hall dedicated to ritual worship.

mandorla Light encircling, or emanating from, the entire figure of a sacred person. *See also* **halo.**

manifesto A written declaration of an individual's or group's ideas, purposes, and intentions.

manuscript A handwritten book or document.

maqsura A separate enclosure in a Muslim **mosque,** near the **mihrab,** designated for dignitaries.

martyrium (martyria) In Christian architecture, a church, chapel, or shrine built over the grave of a martyr or the site of a great miracle.

mastaba A flat-topped, one-story structure with slanted walls over an ancient Egyptian underground tomb.

mathematical perspective *See* **perspective.**

matte A smooth surface that is without shine or luster.

mausoleum A monumental building used as a tomb. Named after the tomb of Mausolos erected at Halikarnassos around 350 BCE.

meander *See* **Greek-key pattern.**

medallion Any round ornament or decoration. Also: a large medal.

medium, mediums, media In general, the material(s) from which any given object is made. In painting, the liquid substance in which pigments are suspended.

megaron The main hall of a Mycenaean palace or grand house, having a columnar porch and a room with a central fireplace surrounded by four **columns.**

memento mori From Latin terms meaning "reminder of death." An object, such as a skull or extinguished candle, typically found in a *vanitas* image, symbolizing the transience of life.

memory image An image that relies on the generic shapes and relationships that readily spring to mind at the mention of an object.

menhir A **megalithic** stone block, placed by prehistoric peoples in an upright position.

menorah A lamp stand with seven or nine branches; the nine-branched menorah is used during the celebration of Hanukkah. Representations of the seven-branched menorah, once used in the Temple of Jerusalem, are a symbol of Judaism.

mensa The consecrated stone of the **altar** in a Christian church.

metope The carved or painted rectangular panel between the **triglyphs** of a **Doric frieze.**

mezzanine The low intermediate story of a building inserted between two stories of regular size.

middle ground Within the depicted space of an artwork, the area that takes up the middle distance of the image. *See also* **foreground.**

mihrab A recess or **niche** that distinguishes the wall oriented toward Mecca (*qibla*) in a **mosque.**

minaret A tall tower next to a **mosque** from which believers are called to prayer.

minbar A high platform or pulpit in a **mosque.**

miniature Anything small. In painting, miniatures may be illustrations within **albums** or **manuscripts** or intimate portraits.

minuscule *See* **script.**

mirador In Spanish and Islamic palace architecture, a room with windows and sometimes balconies on three sides overlooking gardens and courtyards.

mithuna The amorous male and female couples in Buddhist sculpture, usually found at the entrance to a sacred building. The *mithuna* symbolize the harmony and fertility of life.

moat A large ditch or canal dug around a castle or fortress for military defense. When filled with water, the moat protects the walls of the building from direct attack.

mobile A sculpture made with parts suspended in such a way that they move in a current of air.

modeling In painting, the process of creating the illusion of three-dimensionality on a two-dimensional surface by use of light and

shade. In sculpture, the process of molding a three-dimensional form out of a malleable substance.

module A segment or portion of a repeated design.

molding A shaped or sculpted strip with varying contours and patterns. Used as decoration on architecture, furniture, frames, and other objects.

monastery The buildings housing a community of men (monks) or women (nuns) living under religious vows.

monolith A single stone, often very large.

Monophysitism The Christian doctrine stating that Jesus Christ has only one nature, both divine and human. Declared a heresy in the fifth century.

monoprint A single print pulled from a hard surface (such as a blank plate or stone) that has been prepared with a painted design. Each print is an individual artwork, as the original design is a transient one, lost in the printing process.

monstrance A liturgical vessel displaying a relic or the consecrated Host during the **Eucharist** rite.

monumental A term used to designate a project or object that, whatever its physical size, gives an impression of grandeur.

mortise-and-tenon joint A method of joining two elements. A projecting pin (tenon) on one element fits snugly into a hole designed for it (mortise) on the other. Such joints are very strong and flexible.

mosaic Images formed by small colored stone or glass pieces (*tesserae*), affixed to a hard, stable surface.

mosque An edifice used for communal Muslim prayers.

motif Any recurring element of a design or **composition**. Also: a recurring theme or subject.

movable-type printing A method of printing text in which the individual letters, cast on small pieces of metal (die), are assembled into words on a mechanical press. When each **edition** was complete, the type could be reused for the next project.

mudra A symbolic hand gesture in Buddhist art that denotes certain behaviors, actions, or feelings.

mullion A slender vertical element or **colonnette** that divides a window into subsidiary sections.

multiculturalism Recognition of all cultures and ethnicities in a society or civilization.

multiple-point perspective *See* perspective.

muqarna The complex **squinches** used in Islamic architecture to achieve the transition between walls and **vaults** or flat and rounded surfaces.

mural Wall-like. A large painting or decoration, done either directly on a wall or separately and affixed to it.

naos The principal room in a temple or church. In ancient architecture, the **cella**. In a Byzantine church, the **nave** and **sanctuary**.

narthex The vestibule or entrance **porch** of a church.

naturalism, naturalistic A **style** of depiction in which the physical appearance of the rendered image in nature is the primary inspiration. A naturalistic work appears to record the visible world.

nave The central aisle of a **basilica**, two or three stories high and flanked by **aisles**.

nave arcade *See* nave *and* arcade.

nave colonnade *See* nave *and* colonnade.

necking The **molding** at the top of the **shaft** of the **column**.

necropolis A large cemetery or burial area; literally a "city of the dead."

negative space Empty or open space within or bounded by the forms of a painting, sculpture, or architectural design.

niche A hollow or recess in a wall or other solid architectural element. Niches can be of varying size and shape and may be intended for many different uses, from display of objects to housing of a tomb.

niello A metal technique in which a black sulfur alloy is rubbed into fine lines engraved into a metal (usually gold or silver). When heated, the alloy becomes fused with the surrounded metal and provides contrasting detail.

nimbus A **halo**.

nishiki-e A multicolored and ornate Japanese print.

nocturne A night scene in painting, usually lit by artificial illumination.

nonobjective *See* nonrepresentational.

nonrepresentational **Abstract** art that does not attempt to reproduce the appearance of objects, figures, or scenes in the natural world. Also called **nonobjective art**.

obelisk A tall, four-sided stone **shaft**, hewn from a single block, that tapers at the top and is completed by a **pyramidion**. A sun symbol erected by the ancient Egyptians in ceremonial spaces (such as entrances to **temple complexes**). Today used as a commemorative monument.

oblique perspective *See* perspective.

oculus (oculi) In architecture, a circular opening. Oculi are usually found either as windows or at the apex of a **dome**. When at the top of a dome, an oculus is either open to the sky or covered by a decorative exterior **lantern**.

odalisque From the Turkish term for a woman in a harem. Usually represented as a reclining female nude shown among the accouterments of an exotic, luxurious environment by nineteenth- and twentieth-century artists.

ogival arch *See* arch.

oil painting Any painting executed with the pigments floating in a **medium** of oil. Oil paint has particular properties that allow for greater ease of working (among others, a slow drying time, which allows for corrections, and a great range of relative opaqueness of paint layers, which permits a high degree of detail and luminescence).

oil sketch An **oil painting**, usually on a small scale, intended as a preliminary stage for the production of a larger work. Oil sketches are often very **painterly** in technique.

oinoche A Greek wine jug with a round mouth and a curved handle.

olpe Any Greek vase or jug without a spout.

one-point perspective *See* perspective.

onion dome A bulbous, unvaulted and therefore nonstructural dome found in Russia and Eastern Europe, usually in church architecture.

openwork Decoration, such as **tracery**, with open spaces incorporated into the pattern.

oracle A person, usually a priest or priestess, who acts as a conduit for divine information. Also: the information itself or the place at which this information is communicated.

orant A standing figure praying with outstretched arms and upraised hands.

order A system of proportions in **Classical** architecture. **Doric**: the **column shaft** of the Doric order can be **fluted** or smooth-surfaced and has no **base**. The Doric **capital** consists of an undecorated **echinus** and **abacus**. The Doric **entablature** has a plain **architrave**, a **frieze** with **metopes** and **triglyphs**, and a simple **cornice**. **Tuscan**: a variation of Doric characterized by a smooth-surfaced column shaft with a base, a plain architrave, and an undecorated frieze. **Ionic**: the column of the Ionic order has a base, a fluted shaft and a capital decorated with **volutes**. The Ionic entablature consists of an architrave of three panels, a frieze usually containing carved **relief** ornament, and a cornice with **dentils** and **moldings**. **Corinthian**: the most ornate of the orders, the Corinthian column includes a base, a fluted shaft with a bell-shaped capital elaborately decorated with **acanthus** leaf carvings. Its entablature consists of an architrave decorated with moldings, a frieze often containing sculptured reliefs, and a cornice with dentils. **Composite**: a combination of the Ionic and the Corinthian orders. The capital combines acanthus leaves with volute scrolls. A **colossal** order is any of the above built on a large scale, rising through several stories in height and often raised from the ground by a **pedestal**.

orthogonal Any line running back into the represented space of a picture perpendicular to the imagined **picture plane**. In **linear perspective**, all orthogonals converge at a single **vanishing point** in the picture and are the basis for a **grid** that maps out the internal space of the image. An orthogonal plan is any plan for a building or city that is based exclusively on right angles, such as the grid plan of many modern cities.

orthogonal plan *See* orthogonal.

overpainting A final layer of paint applied over a dry underlayer.

ovoid An adjective describing a rounded oval object or shape. Also: a characteristic **form** in Native American art, consisting of a rectangle with bent sides and rounded corners.

pagoda An East Asian temple in the form of a tower built with successively smaller, repeated stories. Each story is usually marked by an elaborate projecting roof.

painterly A **style** of painting, that emphasizes the techniques and surface effects of brushwork (also light and **shade**).

palace complex A group of buildings used for living and governing by a ruler and his supporters, usually fortified.

palette A handheld support used by artists for the storage and mixing of paint during the

process of painting. Also: the choice of a range of colors made by an artist in a particular work or typical of his or her **style**.

palisade A stake fence that forms a defensive barrier.

Palladian An adjective describing a style of architecture, or an architectural detail, reminiscent of the classicizing work of the sixteenth-century Italian architect Andrea Palladio.

palmette A fan-shaped ornament with radiating leaves.

panel painting Any painting executed on a wood support. The wood is usually planed to provide a smooth surface. A panel can consist of several boards joined together, normally covered with **gesso**.

Pantokrator Christ Almighty, represented holding a book and giving a blessing.

papyrus A native Egyptian river plant; a writing paper made from the stems; a popular decorative element in Egyptian architecture.

parapet A low wall at the edge of a balcony, bridge, roof, or other place from which there is a steep drop, built for the safety of onlookers. A parapet walk is the passageway, usually open, immediately behind the uppermost exterior wall or battlement of a fortified building.

parchment A writing surface made from treated skins of animals and used during antiquity and the Middle Ages.

Paris Salon The annual display of art by French artists in Paris during the eighteenth and nineteenth centuries. Established in the seventeenth century as a venue to show the work of members of the French **Academy**, the Salon and its judges established the accepted official **style** of the time. *See also* **salon**.

parterre An ornamental, highly regimented flowerbed. An element of the ornate gardens of seventeenth-century palaces and **châteaux**.

passage In painting, *passage* refers to any particular area within a work, often those where painterly brushwork or color changes exist. Also: a term used to describe Paul Cézanne's technique of blending adjacent shapes.

passage grave A prehistoric tomb under a **cairn**, reached by a long, narrow, slab-lined access passageway.

pastel Dry pigment, chalk, and gum in stick or crayon form.

pedestal A platform or base supporting a sculpture or other monument.

pediment A triangular **gable** found over the narrow ends of buildings. In the **Classical** Greek temple, formed by an **entablature** and the sloping roof or a **raking cornice**. The form may be used decoratively above a door or window, sometimes with a curved upper **molding**. A **broken pediment** has an open space at the center of the topmost angle and/or the horizontal **cornice**.

pendentive The concave triangular section of a wall that forms the transition between a square or polygonal space and the circular base of a **dome**.

pendentive dome *See* **dome**.

peplos A loose outer garment worn by women of ancient Greece. A cloth rectangle fastened on the shoulders and belted below the bust or at the waist.

performance art An artwork based on a live, sometimes theatrical performance by the artist.

peripteral A term used to describe any building (or room) that is surrounded by a single row of **columns**. When such columns are engaged instead of freestanding, called pseudo-peripteral.

peristyle A surrounding **colonnade** in Greek architecture. A peristyle building is surrounded on the exterior by a colonnade. Also: a peristyle court is an open colonnaded courtyard, often having a pool and garden.

perspective A system for representing three-dimensional space on a flat surface. **Atmospheric perspective**: A method of rendering the effect of spatial distance on a two-dimensional plane by subtle variations in color and clarity of representation. **One-point** and **multiple-point perspective** (also called **linear**, scientific, or **mathematical perspective**): A method of creating the illusion of three-dimensional space on a two-dimensional surface by delineating a **horizon line** and multiple **orthogonal** lines. These recede to meet at one or more points on the horizon (called **vanishing points**), giving the appearance of spatial depth. Called scientific or mathematical because its use requires some knowledge of geometry and mathematics, as well as optics. **Intuitive perspective**: A method of representing three-dimensional space on a two-dimensional surface by the use of **formal elements** that act to give the impression of recession. This impression, however, is achieved by visual instinct, not by the use of an overall system or program involving scientific principles or mathematics for depicting the appearance of spatial depth. **Oblique perspective**: An intuitive spatial system used in painting, in which a building or room is placed with one corner in the **picture plane**, and the other parts of the structure all recede to an imaginary **vanishing point** on its other side. Oblique perspective is not a comprehensive, mathematical system. **Reverse perspective**: A Byzantine perspective theory in which the orthogonals or rays of sight do not converge on a vanishing point in the picture, but are thought to originate in the viewer's eye in front of the picture. Thus, in reverse perspective the image is constructed with orthogonals that diverge, giving a slightly tipped aspect to objects.

petrograph A prehistoric drawing or painting on rock. Also called petroglyph.

photomontage A photographic work created from many smaller photographs arranged (and often overlapping) in a **composition**.

piazza The Italian word for an open city square.

pictograph A highly stylized depiction serving as a symbol for a person or object. Also: a type of writing utilizing such symbols.

picture plane The theoretical spatial plane corresponding with the actual surface of a painting.

picture stone A stone used in medieval northern Europe as a commemorative monument, which is carved or inscribed with ancient writing and representations of human figures, gods, ships, and serpents. *See also* **rune stone**.

picturesque A term describing the taste for the familiar, the pleasant, and the pretty, popular in the eighteenth and nineteenth centuries in Europe. When contrasted with the

sublime, the picturesque stood for all that was ordinary but pleasant.

piece-mold casting A casting technique in which the mold consists of several sections that are connected during the pouring of molten metal, usually **bronze**. After the cast form has hardened, the pieces of the mold are then disassembled, leaving the completed object. Because it is made in pieces, the mold can be reused.

pier A masonry support made up of many stones, or rubble and **concrete** (in contrast to a **column shaft** which is formed a single stone or a series of drums), often square or rectangular in **plan**, and capable of carrying very heavy architectural loads. *See also* **compound pier**.

pietà Italian for "pity." A devotional subject in Christian religious art. After the Crucifixion, the body of Jesus was laid across the lap of his grieving mother, Mary. When others are present the subject is called the Lamentation.

pietra dura Italian for "hard stone." Semi-precious stones selected for color variation and cut in shapes to form ornamental designs such as flowers or fruit.

pietra serena A gray Tuscan limestone used in Florence.

pigment A substance that gives color to a material.

pilaster A rectangular, **engaged** columnar element that is used for decoration in architecture.

pillar In architecture, any large, freestanding vertical element. Usually functions as an important weight-bearing unit in buildings.

pinnacle In Gothic architecture, a steep pyramid decorating the top of another element such as a **buttress**.

plaiting The technique of weaving strips of fabric or other flexible substances under and over each other. Used in basketry.

plan A graphic convention for representing the arrangement of the parts of a building.

plasticity The three-dimensional quality of an object, or the degree to which any object can be modeled, shaped, or altered.

plinth The slablike **base** or **pedestal** of a **column**, statue, wall, building, or piece of furniture.

pluralism A social structure or goal that allows members of diverse ethnic, racial, or other groups to exist peacefully within the society while continuing to practice the customs of their own divergent cultures. Also: an adjective describing the state of having many valid contemporary **styles** available at the same time to artists.

podium A raised platform that acts as the foundation for a building. Most often used for Etruscan, Greek, and Roman temples.

polychrome *See* polychromy.

polychromy The multicolored painted decoration applied to any part of a building, sculpture, or piece of furniture.

polyptych An **altarpiece** constructed from multiple panels, sometimes with hinges to allow for movable **wings**.

popular culture The elements of culture (arts) that are recognized by the general public. Popular culture has the associations of something cheap, fleeting, and accessible to all.

porcelain A type of extremely hard and fine **ceramic** made from a mixture of kaolin and other minerals. Porcelain is fired at a very high heat, and the final product has a translucent surface.

porch The covered entrance on the exterior of a building. With a row of **columns** or **colonnade**, also called a **portico**.

portal A grand entrance, door, or gate, usually to an important public building, and often decorated with sculpture.

portcullis A fortified gate, constructed to move vertically and often made of metal bars, used for the defense of a city or castle.

portico In architecture, a projecting roof or **porch** supported by **columns**, often marking an entrance. *See also* **porch.**

post-and-lintel construction An architectural system of construction with two or more vertical elements (posts) supporting a horizontal element (**lintel**).

postern A side or back (often secret) exit from a fortified city or castle.

potassium-argon dating Technique used to measure the decay of a radioactive potassium isotope into a stable isotope of argon, an inert gas**.**

potsherd A broken piece of **ceramic ware**.

Prairie Style A type of domestic architecture, named after a design by Frank Lloyd Wright, popular in the Midwestern United States from 1900 to 1920**.** Prairie Style buildings are characterized by low-pitched roofs with wide overhanging eaves that emphasize the horizontality of the structure, large hearths, and the use of traditional materials.

predella The lower zone, or **base**, of an **altarpiece**, decorated with painting or sculpture related to the main **iconographic** theme of the altarpiece.

primary colors Blue, red, and yellow—the three colors from which all others are derived.

primitivism The borrowing of subjects or forms usually from non-Western or prehistoric sources by Western artists. Originally practiced by Western artists as an attempt to infuse their work with the naturalistic and expressive qualities attributed to other cultures, especially colonized cultures, primitivism also borrowed from the art of children and the insane.

Prix de Rome A prestigious scholarship offered by the French **Academy** at the time of the establishment of its Roman branch in 1666. The scholarship allowed the winner of the prize to study in Rome for three to five years at the expense of the state. Originally intended only for painters and sculptors, the prize was later expanded to include printmakers, architects, and musicians.

pronaos The enclosed vestibule of a Greek or Roman temple, found in front of the **cella** and marked by a row of **columns** at the entrance.

propylon (propylaia) A large, often elaborate gateway to a temple or other important building.

proscenium The stage of an ancient Greek or Roman theater. In modern theater, the area of the stage in front of the curtain. Also: the framing **arch** that separates a stage from the audience.

prostyle A term used to describe a **classical** temple with a **colonnade** placed across the entrance.

provenance The history of ownership of a work of art from the time of its creation to the present.

psalter In Jewish and Christian scripture, a book containing the songs attributed to King David.

pseudo-kufic Designs intended to resemble the script of the Arabic language.

pseudo-peripteral *See* **peripteral.**

punchwork Decorative designs that are stamped onto a surface, such as metal or leather, using a punch (a handheld metal implement).

putto (putti) A plump, naked little boy. Cupid in **classical** art; a **cherub** or baby angel in Christian art.

pylon A massive gateway formed by a pair of tapering walls of oblong shape. Erected by ancient Egyptians to mark the entrance to a **temple complex.**

pyramidion A pyramid-shaped block set as the finishing element atop an **obelisk.**

qibla The **mosque** wall indicating the direction of Mecca; includes the *mihrab.*

quadrant vault *See* **vault.**

quatrefoil A four-lobed decorative pattern common in Gothic art and architecture.

quillwork A Native American decorative craft. The quills of porcupines and bird feathers are dyed and attached to fabric, birch bark, or other material in patterns.

quincunx A building in which five **domed bays** are arranged within a square, with a central unit and four corner units. (When the central unit has similar units extending from each side, the form becomes a **Greek cross.**)

quoin A stone, often extra large or decorated for emphasis, forming the corner of two walls.

radiometric dating A method of dating prehistoric works of art made from organic materials, based on the rate of degeneration of radiocarbons in these materials. *See also* **relative dating, absolute dating.**

radiometry *See* **radiometric dating.**

raigo A painted image that depicts the Amida Buddha and other Buddhist deities guiding the soul of a dying worshiper to paradise.

raking cornice *See* **cornice.**

raku A type of **ceramic** pottery made by hand, coated with a thick, dark **glaze**, and fired at a low heat. The resulting vessels are irregularly shaped and glazed, and are highly prized. *Raku* **ware** is used in the Japanese tea ceremony.

rampart The raised walls or embankments used as primary protection in the fortification of a city or castle.

readymade An object from popular or material culture presented without further manipulation as an artwork by the artist.

realism In art, a term first used in Europe around 1850 to designate a kind of **naturalism** with a social or political message, which soon lost its didactic import and became synonymous with naturalism.

realistic Describes a style in which an artist attempts to depict objects as they are in actual, visible reality.

recto The right-hand page in the opening of a book or **manuscript**. Also: the principal or front side of a leaf of paper or parchment, as in the case of a drawing. The **verso** is the reverse side.

red-figure A **style** and technique of ancient Greek vase painting characterized by red clay-colored figures on a black background. (The figures are reversed against a painted ground and details are drawn, not engraved, as in **black-figure**.) *See also* **black-figure.**

refectory The dining hall for monks or nuns in a monastery or convent.

register A device used in systems of spatial definition. In painting and sculpture, a register indicates the use of differing **groundlines**, self-contained bands in a vertical arrangement, to differentiate distance within an image. In printmaking, the marks at the edges used to align the print correctly on the page, especially in multiple-block color printing; also called **registration marks**.

reintegration The process of adaptation and transformation of European techniques and styles by artists in colonial areas.

relative chronology A practice of dating objects in relation to each other when the **absolute dating** of those objects cannot be or has not been established. Also known as relative dating.

relative dating *See also* **absolute dating; relative chronology; radiometric dating.**

relief sculpture A three-dimensional image or design whose flat background surface is carved away to a certain depth, setting off the figure. Called **high** or **low** (bas) **relief** depending upon the extent of projection of the image from the background. Called **sunken relief** when the image is modeled below the original surface of the background, which is not cut away.

relieving arch *See* **arch.**

reliquary A container, often made of precious materials, used as a repository to protect and display sacred relics. *See also* **monstrance.**

replica A very close copy of a painting or sculpture, sometimes done by the same artist who created the original.

repoussé A technique of hammering metal from the back to create a protruding image. Elaborate reliefs are created with **wooden forms** against which the metal sheets are pressed and hammered.

repoussoir French for "something that pushes back." An object or figure placed in the immediate **foreground** of a **composition**, usually the left or right edge, whose purpose is to direct the viewer's eye into the background and suggest recession into depth.

representational Any art that attempts to depict an aspect of the external, natural world in a visually understandable way.

reredos A decorated wall or screen behind the **altar** of a church. *See also* *retablo.*

retablo Spanish for "altarpiece." The screen placed behind an **altar**. Often very a large scale, having many painted or carved panels.

reverse perspective *See* **perspective.**

revetment A covering of cut stone, fine brick, or other solid facing material over a wall built of coarser materials. Also: surface covering used to reinforce a retaining wall, such as an embankment.

revivalism The practice of using older **styles** and modes of expression in a conscious manner. Revivalism does not usually entail the same academic and historical interest as **historicism**.

rhyton A vessel in the shape of a figure or an animal, used for drinking or pouring liquids on special occasions.

rib Projecting band at the juncture of the curved surfaces, or cells, of a **vault** that is sometimes structural and sometimes purely decorative.

rib vault *See* vault.

ribbon interlace A **linear** decoration made up of interwoven bands, often found in Celtic and northern European art of the medieval period.

ridge rib A rib running the length of the **vault**.

ridgepole A longitudinal timber at the apex of a roof that supports the upper ends of the rafters.

rinceau A decorative foliage scroll, usually **acanthus**.

ring wall Any wall surrounding a building, town, or fortification, intended to separate and protect the enclosed area.

rock-cut tomb Ancient Egyptian multichambered burial site, hewn from solid rock and often hidden.

rood A crucifix.

rood screen In a church, a screen that separates the public **nave** from the private and sacred area of the **choir**. The screen supports a **rood** (crucifix).

roof comb In a Mayan building, a masonry wall along the apex of a roof that is built above the level of the roof proper and often highly decorated false **facades**.

rose window A round window, often filled with **stained glass**, with **tracery** patterns in the form of wheel spokes. Large, elaborate, and finely crafted, rose windows are usually a central element of the **facade** of French Gothic cathedrals.

rosette A round or oval ornament resembling a rose.

rotulus (rotuli) A scroll or **manuscripts** rolled in a tubular form.

rotunda Any building (or part thereof) constructed in a circular (or sometimes polygonal) shape, usually producing a large open space crowned by a **dome**.

round arch *See* arch.

roundel Any element with a circular format, often placed as a decoration on the exterior of architecture.

rune stone A stone used in early medieval northern Europe as a commemorative monument, which is carved or inscribed with runes, ancient German or Scandinavian writing.

running spirals A decorative **motif** based on the shape formed by a line making a continuous spiral.

rustication In building, the rough, irregular, and unfinished effect deliberately given to the exterior facing of a stone edifice. Rusticated stones are often large and used for decorative emphasis around doors or windows, or across the entire lower floors of a building, probably deriving from fortifications.

sacristy In a Christian church, the room in which the priest's robes and the sacred vessels are housed. Sacristies are usually located close to the sanctuary and often have a place for ritual washing as well as a private door to the exterior.

sahn The central courtyard of a Muslim **mosque**.

salon A large room, often used for intellectual gatherings and the exhibition of works of art. *See* **Paris Salon**.

sanctuary A sacred or holy enclosure used for worship. In Greece, includes one or more temples and an **altar**. In Christian buildings, the space around the altar in a church, usually at the east end (also called the chancel or presbytery).

sand painting Ephemeral religious art created with different colored sands by Native Americans of North America, Australian Aborigines, and other peoples in Japan and Tibet.

sanghati The robe worn by a Buddhist monk. Draped over the left shoulder, the robe is made from a single piece of cloth wrapped around the body.

sarcophagus (sarcophagi) A rectangular stone coffin. Often decorated with **relief sculpture**.

scarification Ornamental marks, scars, or scratches made on the human body.

school of artists An art historical term describing a group of artists, usually working at the same time and sharing similar **styles**, influences, and ideals. The artists in a particular school may not necessarily be directly associated with one another, unlike those in a workshop or atelier.

scientific perspective *See* perspective.

script Handwriting. Includes minuscule (as in lower-case type) and minuscule (capital letters). *See also* **calligraphy**.

scriptorium (scriptoria) A room in a monastery for writing or copying **manuscripts**.

scroll painting A painting executed on a rolled support. Rollers at each end permit the horizontal scroll to be unrolled as it is studied or the vertical scroll to be hung for contemplation or decoration.

sculpture in the round Three-dimensional sculpture that is carved free of any attaching background or block.

section A method of representing the three-dimensional arrangement of a building in a graphic manner. A section is produced when an imaginary vertical plane intersects with a building, laying bare all the elements that make up the (cross section of the) structure at that point. Also: a view of an element of an object as if sliced through. *See also* **elevation**.

segmental pediment A **pediment** formed when the upper **molding** is a shallow arc.

sepia An ink **medium** often used in drawing that has an extremely rich, dark brownish **tone**.

seraph (seraphim) An angel of the highest rank in the Christian hierarchy.

serdab In Egyptian tombs, the small room in which the *ka* statue was placed.

sfumato Italian term meaning "smoky," soft, and mellow. In painting, the effect of haze in an image. Resembling the color of the atmosphere at dusk, *sfumato* gives a smoky effect.

shade Any area of an artwork that is shown through various technical means to be in shadow. Also: the technique of making such an effect.

shaft The main vertical section of a **column** between the **capital** and the **base**, usually circular in cross section.

shater A type of roof used in Russia and the Near East with a steep pitch and tentlike shape.

shikhara In the architecture of northern India, a conical (or pyramidal) spire found atop a Hindu temple and often crowned with an *amalaka*.

shoin The architecture of the aristocracy and upper classes in Japan, built in traditional asymmetrical fashion and incorporating the traditional elements of residences, such as the *tokonoma* and *shoji* screens.

shoji A standing Japanese screen covered in translucent rice paper and used in interiors.

side aisle *See* aisle.

silversmith An artisan who makes silver wares.

sinopia The preparatory design or underdrawing of a **fresco**. Also: a reddish chalklike earth pigment.

site-specific sculpture A sculpture commissioned and designed for a particular spot.

slip A mixture of clay and water applied to a **ceramic** object as a final decorative coat. Also: a solution that binds different parts of a vessel together, such as the handle and the main body.

spandrel The area of wall adjoining the exterior curve of an **arch** between its springing and the **keystone**, or the area between two arches, as in an **arcade**.

speech scroll A scroll painted with words indicating the speech or song of a depicted figure.

springing The point at which the curve of an **arch** or **vault** meets with and rises from its support.

squinch An **arch** or **lintel** built across the upper corners of a square space, allowing a circular or polygonal **dome** to be more securely set above the walls.

stadium In ancient Greece, a race track with tiers of seats for spectators.

stained glass A decorative process in glassmaking by which glass is given a color (whether intrinsic in the material or painted onto the surface). To fill windows, small pieces of differently colored glass are precisely cut and assembled into a design, held together by **cames**. Details of images may be painted on the colored glass to create symbols and narratives.

stele (stelai) A stone slab placed vertically and decorated with inscriptions or reliefs. Used as a grave marker or memorial.

stepped pyramid A pyramid consisting of successive levels of **mastaba** forms appearing to rise in staggered "steps" rather than in sloping triangular faces.

stereobate A foundation upon which a **Classical** temple stands.

stigmata The wounds of Christ; said to appear on the bodies of certain holy persons.

still life A type of painting that has as its subject inanimate objects (such as food, dishes, fruit, or flowers).

stipes The support structure of an **altar** which holds up the **mensa**, or top surface.

stoa In Greek architecture, a **portico** or promenade with long rows of **columns** used as a meeting place.

stockade A defensive fencelike wood fortification built around a village, house, or other enclosed area.

stretcher The wooden framework on which an artist's canvas is attached, usually with tacks, nails, or staples. Also: a reinforcing horizontal brace between the legs of a piece of furniture, such as a chair. Also: in building, a brick laid so that its longer edge is parallel to the wall.

stringcourse A continuous horizontal band, such as a **molding**, decorating the face of a wall.

stucco A mixture of lime, sand, and other ingredients into a material that can be easily molded or modeled. When dry, produces a very durable surface used for covering walls or for architectural sculpture and decoration.

stupa In Buddhist architecture, a bell-shaped or pyramidal religious monument, made of piled earth or stone, and containing sacred relics.

style A particular manner, **form**, or character of representation, construction, or expression typical of an individual artist or of a certain school or period.

stylization, stylized A manner of representation that conforms to an intellectual or artistic idea rather than to **naturalistic** appearances.

stylobate In **Classical** architecture, the stone foundation on which a temple **colonnade** stands.

stylus An instrument with a pointed end (used for writing and printmaking), which makes a delicate line or scratch. Also: a special writing tool for **cuneiform** writing with one pointed end and one triangular wedge end.

subject matter *See* **content**.

sublime A concept, thing, or state of exceptional and awe-inspiring beauty and moral or intellectual expression. The sublime was a goal to which many nineteenth-century artists aspired in their artworks.

sunken relief *See* **relief sculpture**.

swag A decorative device in architecture or interior ornament (and in paintings), in which a loosely hanging garland is made to look as if constructed of flowers or gathered cloth.

syncretism In religion or philosophy, the union of different ideas or principles.

tablinum A large reception room for family records and hereditary statues in an ancient Roman house, connected to the **atrium**.

talud-tablero A design characteristic of architecture at Teotihuacan in which a sloping *talud* at the base of a building supports a wall-like *tablero*, where ornamental painting and sculpture are usually placed.

taotie A mask with a dragon or animal-like face common as a decorative **motif** in Chinese art.

tapa A cloth made in Polynesia by pounding the bark of a tree, such as the paper mulberry. It is also known as bark cloth.

tapestry Multicolored pictorial or decorative weaving meant to be hung on a wall or placed on furniture.

tatami Mats of woven straw used in Japanese houses as a floor covering.

temenos A sacred enclosure. In **Classical** architecture, includes temples, treasuries, **altars**, and other buildings and spaces for ritual activities.

tempera A painting **medium** made by blending egg yolks with water, pigments, and occasionally other materials, such as glue. The technique was often used during the fourteenth and fifteenth centuries to paint **murals** and **panel paintings**.

temple complex A group of buildings dedicated to a religious purpose, usually located close to one another in a **sanctuary**.

tenebrism A term signifying the use of strong **chiaroscuro** and artificially illuminated areas to create a dramatic contrast of light and dark in a painting.

tepee A portable dwelling constructed from hides stretched on a structure of poles set at the base in a circle and leaning against one another at the top. Tepees were typically found among the nomadic Native Americans of the North American Plains.

terminal Any element of sculpture or architecture that functions as decorative closure. Terminals are usually placed in pairs at either end of an object (such as furniture) or **facade** (as on a building) to help frame the **composition**.

terra-cotta A **medium** made from clay fired over a low heat and sometimes left unglazed. Also: the orange-brown color typical of this medium.

tessera (tesserae) The small cube of stone, glass, or other object that is pieced together with many others to create a **mosaic**.

Theotokos In Byzantine art, the Virgin Mary as mother or "bearer" of God.

thermoluminescence dating A technique that measures the irradiation of the crystal structure of materials such as flint or pottery and the soil in which it is found, determined by luminescence produced when a sample is heated.

tholos A small, round building. Sometimes built underground, as in a Mycenaean tomb.

tierceron In **vault** construction, a secondary rib that arcs from a **springing** point to the rib that runs lengthwise through the **vault**, called the **ridge rib**.

tint The dominant color in an object, image, or pigment.

tokonoma A **niche** for the display of an art object (such as a scroll or flower arrangement) in a Japanese tearoom.

tomb effigy A carved portraitlike image of the deceased on a tomb or *sarcophagus*.

tondo A circular painting or relief.

tone The overall degree of brightness or darkness in an artwork. Also: saturation, intensity, or value of color and its effect.

torana In Indian architecture, an ornamented gateway **arch** in a temple, usually leading to the **stupa**.

torii The ceremonial entrance gate to a Japanese Shinto temple.

toron In West African **mosque** architecture, the wooden beams that project from the walls. Torons are used as support for the scaffolding erected annually for the replastering of the building.

torque A neckpiece, especially favored by the Celts, fashioned as a twisted metal ring.

tracery The thin stone or wooden bars in a Gothic window, screen, or panel, which create an elaborate decorative pattern while supporting the structure.

transept The arm of a **cruciform** church, perpendicular to the **nave**. The point where the nave and transept cross is called the **crossing**. Beyond the crossing lies the **sanctuary**.

travertine A mineral building material similar to limestone, typically found in central Italy.

treasury A building or room, for keeping valuable (and often holy) objects.

trefoil An ornamental design made up of three rounded lobes placed adjacent to one another.

triforium The element of the interior **elevation** of a church, found between the **nave arcade** or **colonnade** and the **clerestory**, covers the blind area created by the sloping roof over the aisles. The triforium can be made up of openings from a passageway or gallery, or can be wall supporting paintings or **mosaics**.

triglyph Rectangular blocks between the **metopes** of a **Doric frieze**. Identified by the three carved vertical grooves, which approximate the appearance of the ends of wooden beams.

trilithon Prehistoric structure composed of two upright **monoliths** supporting a third one laid horizontally.

triptych An artwork made up of three panels. The panels are often hinged together so the side segments (**wings**) fold over and protect the central area.

triumph In Roman times, a celebration of a particular military victory, usually granted to the commanding general upon his return to Rome. Also: in later times, any depiction of a victory.

triumphal arch A freestanding, massive stone gateway with a large central **arch**, built as urban ornament to celebrate military victories (as by the Romans).

trompe l'oeil A manner of representation in which the appearance of natural space and objects is re-created with the express intention of fooling the eye of the viewer, who may be convinced that the subject actually exists as three-dimensional reality.

trophy Captured military objects such as armor and weapons that Romans displayed in an upheld pole or tree to celebrate victory. Also: a similar grouping that recalls the Roman custom of displaying the looted armor of a defeated opponent.

trumeau A **column**, **pier**, or post found at the center of a large **portal** or doorway, supporting the **lintel**.

tug (tugra) The calligraphic imperial monograms used in Ottoman courts.

tunnel vault *See* **vault**.

turret A tall and slender tower.

Tuscan order *See* **order**.

twining A basketry technique in which short rods are sewn together vertically. The panels are then joined together to form a vessel.

tympanum In **classical** architecture, the vertical panel of the **pediment**. In medieval and later architecture, the area over a door enclosed by an **arch** and a **lintel**, often decorated with **sculpture** or **mosaic**.

types In theology, figures or examples of biblical events. *See also* **typology**.

typological See typology.

typology In Christian iconography, a system of matching Old Testament figures and events and even some classical and other secular sources to New Testament counterparts to which they were seen as prefigurements.

ukiyo-e A Japanese term for a type of popular art that was favored from the sixteenth century, particularly in the **form** of color **woodblock** prints. *Ukiyo-e* prints often depicted the world of the common people in Japan, such as courtesans and actors, as well as landscapes and myths.

undercutting A technique in sculpture by which the material is cut back under the edges so that the remaining **form** projects strongly forward, casting deep shadows.

underdrawing The original drawing, obscured by application of paint.

underglaze Color or decoration applied to a ceramic piece before **glazing**.

urna In Buddhist art, the curl of hair on the forehead that is a characteristic mark of a *buddha*. The *urna* is a symbol of divine wisdom.

ushnisha In Asian art, a round turban or tiara symbolizing royalty and, when worn by a *buddha*, enlightenment.

value The darkness or lightness of a color (**hue**).

vanishing point In a **perspective** system, the point on the **horizon line** at which **orthogonals** meet. A complex system can have multiple vanishing points.

vanitas An image, especially popular in Europe during the seventeenth century, in which all the objects symbolize the transience of life. *Vanitas* paintings are usually of **still lifes** or **genre** subjects.

vault An **arched** masonry structure that spans an interior space. **Barrel** or **tunnel vault**: an elongated or continuous vault, shaped like half a cylinder. **Quadrant vault**: a half barrel vault. **Groin** or **cross vault**: a vault created by the intersection of two barrel vaults of equal size. **Rib vault**: ribs (extra masonry) demark the junctions of a groin vault. Ribs may function to reinforce the groins or may be purely decorative. **Corbel vault**: a vault made by projecting **courses** of stone. *See also* **corbeling**.

vaulting A system of space spanning using vaults.

veduta (vedute) Italian for "vista" or "view." Paintings, drawings, or prints often of expansive city scenes or of harbors.

vellum A fine animal skin prepared for writing and painting. *See also* **parchment**.

veneer In architecture, the exterior facing of a building, often in decorative patterns of fine stone or brick. In decorative arts, a thin exterior layer for decoration laid over wooden objects or furniture. Made of fine materials such as rare wood, ivory, metal, and semiprecious stones.

verism A **style** in which artists concern themselves with capturing the exterior likeness of an object or person, usually by rendering its visible details in a finely executed, meticulous manner.

verso The (reverse) left-hand page of the opening of a book or **manuscript**. Also: the subordinate or back side of a leaf of paper, as in the case of drawings.

vignette A small **motif** or scene that has no established border.

vihara From the Sanskrit term meaning "for wanderers." A *vihara* is, in general, a Buddhist monastery in India. It also signifies monks' cells and gathering places in such a monastery.

villa A country house.

vimana The main element of a Southern Indian Hindu temple, usually in the shape of a pyramidal or tapering tower raised on a **plinth**.

volumetric A term indicating the concern for rendering the impression of three-dimensional volumes in painting, usually achieved through **modeling** and the manipulation of light and shadow (**chiaroscuro**).

volute A spiral scroll, most often decoration on an Ionic **capital**.

volute krater *See* **krater**.

votive figure An image created as a devotional offering to a god or other deity.

voussoirs The oblong, wedge-shaped stone blocks used to build an **arch**. The topmost center *voussoir* is called a **keystone**.

wall painting *See* **mural**.

ware A general term designating pottery produced and decorated by the same technique.

warp The vertical threads in a weaver's loom. Warp threads make up a fixed framework that provides the structure for the cloth and are thus often stronger than **weft** threads. *See also* **weft**.

wash A diluted **watercolor**. Often washes are applied to drawings or prints to add **tone** or touches of color.

watercolor A type of painting using water-soluble pigments that are floated in a water **medium** to make a transparent paint. The technique of watercolor is most suited to a paper support.

wattle-and-daub A wall construction method combining upright branches, woven with twigs (wattles) and plastered or filled with clay or mud (daub).

weft The horizontal threads in a woven piece of cloth. Weft threads are woven at right angles to and through the **warp** threads to make up the bulk of the decorative pattern. In carpets, the weft is often completely covered or formed by the rows of trimmed knots that form the carpet's soft surface.

westwork The **monumental**, west-facing entrance section of a Carolingian, Ottonian, or Romanesque church. The exterior consists of multiple stories between two towers; the interior includes an entrance vestibule, a chapel, and a gallery overlooking the **nave**.

white-ground A type of ancient Greek pottery in which the background color of the object is painted with a **slip** that turns white in the firing process. Figures and details were added by painting on or incising into this slip. White-ground **wares** were popular in the **Classical** period as funerary objects.

wing A side panel of a **triptych** or **polyptych** (usually found in pairs), which was hinged to fold over the central panel. Wings often held the depiction of the donors and/or subsidiary scenes relating to the central image.

woodblock print A print made from a block of wood that is carved in **relief** or incised. *See also* **woodcut**.

woodcut A type of print made by carving a design into a wooden block. The ink is applied to the plate with a roller. As the ink remains only on the raised areas between the carved-away lines, these carved-away areas and lines provide the white areas of the print. Also: the process by which the woodcut is made.

x-ray style In Australian aboriginal art, a manner of representation in which the artist depicts a figure or animal by drawing its essential internal organs and bones, as well as its outline.

yaksha, yakshi The male (*yaksha*) and female (*yakshi*) nature spirits that act as agents of the Hindu gods. Their sculpted images are often found on Hindu temples and other sacred places, particularly at the entrances.

zeitgeist German for "spirit of the time," meaning the cultural and intellectual aspects of a period that pervade human experience and are expressed in all creative and social endeavors.

ziggurat In Mesopotamia, an artificial (human-made) mountain; a tall stepped tower of earthen materials, often supporting a shrine.

Bibliography

Susan Craig

This bibliography is composed of books in English that are appropriate "further reading" titles. Most items on this list are available in good libraries, whether college, university, or public institutions. I have emphasized recently published works so that the research information would be current. There are three classifications of listings: general surveys and art history reference tools, including journals and Internet directories; surveys of large periods (ancient art in the Western tradition, European medieval art, European Renaissance through eighteenth-century art, modern art in the West, Asian art, and African and Oceanic art and art of the Americas); and books for individual chapters 1 through 29.

General Art History Surveys and Reference Tools

Adams, Laurie Schneider. *Art across Time*. New York: McGraw-Hill, 1999.

Andrews, Malcolm. *Landscape and Western Art*. Oxford History of Art. Oxford: Oxford Univ. Press, 1999.

Barral I Altet, Xavier. *Sculpture From Antiquity to the Present*. 4 vols. London: Taschen, 1996.

Bazin, Germain. *A Concise History of World Sculpture*. London: David & Charles, 1981.

Brownston, David M., and Ilene Franck. *Timelines of the Arts and Literature*. New York: HarperCollins, 1994.

Chadwick, Whitney. *Women, Art, and Society*. 2nd ed, Rev. & exp. New York: Thames and Hudson, 1997.

Cole, Bruce, and Adelheid Gealt. *Art of the Western World: From Ancient Greece to Post-Modernism*. New York: Summit, 1989.

Crofton, Ian, comp. *A Dictionary of Art Quotations*. New York: Schirmer, 1989.

Dictionary of Art, The. 34 vols. New York: Grove's Dictionaries, 1996.

Encyclopedia of World Art. 16 vols. New York: McGraw-Hill, 1972–83.

Fleming, John, Hugh Honour, and Nikolaus Pevsner. *The Penguin Dictionary of Architecture and Landscape Architecture*. 5th ed. New York: Penguin, 1998.

Fletcher, Banister. *Sir Banister Fletcher's A History of Architecture*. 20th ed. Ed. Dan Cruickshank. Oxford: Architectural Press, 1996.

Gardner, Helen. *Gardner's Art through the Ages*. 10th ed. Ed. Richard G. Tansey and Fred S. Kleiner. Fort Worth: Harcourt Brace College, 1996.

Griffiths, Antony. *Prints and Printmaking: An Introduction to the History and Techniques*. 2nd ed. London: British Museum Press, 1996.

Hall, James. *Dictionary of Subjects and Symbols in Art*. Rev. ed. New York: Harper & Row, 1979.

Hartt, Frederick. *Art: A History of Painting, Sculpture, Architecture*. 4th ed. New York: Abrams, 1993.

Havercamp Begemann, Egbert, and Carolyn Logan. *Creative Copies: Interpretative Drawings from Michaelangelo to Picasso*. London: Sotheby's, 1988.

Heller, Nancy G. *Women Artists: An Illustrated History*. 3rd ed. New York: Abbeville, 1997.

Holt, Elizabeth Gilmore, ed. *A Documentary History of Art*. 3 vols. New Haven: Yale Univ. Press, 1986.

Honour, Hugh, and John Fleming. *The Visual Arts: A History*. 5th ed. New York: Abrams, 1999.

Hornblower, Simon, and Antony Spawforth. *The Oxford Classical Dictionary*. 3rd ed. Oxford: Oxford Univ. Press, 1996.

Hults, Linda C. *The Print in the Western World: An Introductory History*. Madison: Univ. of Wisconsin Press, 1996.

Janson, H. W., and Anthony F. Janson. *History of Art*. 6th ed. Rev. and Exp. New York: Abrams, 2000.

Jervis, Simon. *The Penguin Dictionary of Design and Designers*. London: Lane, 1984.

Jones, Lois Swan. *Art Information and the Internet: How to Find It, How to Use It*. Phoenix: Oryx Press, 1999.

Kemp, Martin. *The Oxford History of Western Art*. Oxford: Oxford Univ. Press, 2000.

Kostof, Spiro. *A History of Architecture: Settings and Rituals*. 2nd ed. Rev. Greg Castillo. New York: Oxford Univ. Press, 1995.

Livingstone, E. A. *The Concise Oxford Dictionary of the Christian Church*. Oxford: Oxford Univ. Press, 2000.

Mackenzie, Lynn. *Non-Western Art: A Brief Guide*. Upper Saddle River, NJ: Prentice Hall, 1995.

Mair, Roslin. *Key Dates in Art History: From 600 BC to the Present*. Oxford: Phaidon, 1979.

McConkey, Wilfred J. *Klee as in Clay: A Pronunciation Guide*. 3rd ed. Lanham, MD.: Madison Books, 1992.

Preble, Duane, Sarah Preble, and Patrick Frank. *Artforms: An Introduction to the Visual Arts*. 6th ed. New York: Longman, 1999.

Roberts, Helene, ed. *Encyclopedia of Comparative Iconography: Themes Depicted in Works of Art*. 2 vols. Chicago: Fitzroy Dearborn, 1998.

Rotberg, Robert I., Theodore K. Rabb, and Jonathan Brown eds. *Art and History: Images and Their Meaning*. Cambridge: Cambridge Univ. Press, 1988.

Sed-Rajna, Gabrielle. *Jewish Art*. Trans. Sara Friedman and Mira Reich. New York: Abrams, 1997.

Slatkin, Wendy. *Women Artists in History: From Antiquity to the Present*. 3rd ed. Upper Saddle River, NJ: Prentice Hall, 1997.G

Stangos, Nikos, ed. *The Thames and Hudson Dictionary of Art and Artists*. Rev. exp. & updated ed. World of Art. New York: Thames and Hudson, 1994.

Steer, John, and Antony White. *Atlas of Western Art History: Artists, Sites and Movements from Ancient Greece to the Modern Age*. New York: Facts on File, 1994.

Sutton, Ian. *Western Architecture: From Ancient Greece to the Present*. World of Art. New York: Thames and Hudson, 1999.

Thacker, Christopher. *The History of Gardens*. Berkeley: Univ. of California Press, 1979.

Trachtenberg, Marvin, and Isabelle Hyman. *Architecture: From Prehistory to Postmodernity*. Upper Saddle River, NJ: Prentice Hall, 2001.

Walker, John A. *Design History and the History of Design*. London: Pluto, 1989.

West, Shearer, ed. *The Bulfinch Guide to Art History: A Comprehensive Survey and Dictionary of Western Art and Architecture*. Boston: Little, Brown and Co., 1996.

Wilkins, David G., Bernard Schultz, and Katheryn M. Linduff. *Art Past/Art Present*. 4th ed. Upper Saddle River, NJ: Prentice Hall, 2000.

Art History Journals: A Selected List

African Arts. Quarterly. Los Angeles
American Art. 3/year. Washington, D.C.
American Journal of Archaeology. Quarterly. Boston
Antiquity. Quarterly. Cambridge
Apollo. Monthly. London
Architectural History. Annually. Farnham, Surrey, Eng.
Archives of American Art Journal. Quarterly. Washington, D.C.
Archives of Asian Art. Annually. New York
Ars Orientalis. Annual. Ann Arbor, MI.
Art Bulletin. Quarterly. New York
Artforum. Monthly. New York
Art History. 11/year. New York
Art in America. Monthly. New York
Art Journal. Quarterly. New York
Art News. Quarterly. Mumbai, India
Arts and the Islamic World. Annually. London
Asian Art and Culture. Triannually. Washington, D.C.
Burlington Magazine. Monthly. London
Flash Art International. Bimonthly. Milan
Gesta. Semiannually. New York
History of Photography. Quarterly. London
Journal of Design History. Quarterly. Oxford
Journal of Egyptian Archaeology Annually. London
Journal of Hellenic Studies. Annually. London
Journal of Roman Archaeology. Annually. Portsmouth, RI
Journal of the Society of Architectural Historians. Quarterly. Chicago
Journal of the Warburg and Courtauld Institutes. Annually. London
Marg. Quarterly. 5/year. Mumbai, India
Master Drawings. Quarterly. New York
Oriental Art. Quarterly. Singapore
Oxford Art Journal. Semiannually. Oxford
Print Quarterly. Quarterly. London
Simiolus. Quarterly. Utrecht, Netherlands
Woman's Art Journal. Semiannually. Laverock, PA

Internet Directories for Art History Information

THE ART HISTORY RESEARCH CENTRE
http://www-fofa.concordia.ca/arth/ARHC/splash.html

Sponsored by Concordia University in Montreal, this directory includes the following divisions: search engines, newsgroups, mailing lists, library catalogues and bookstores, article indexes, universities, collections, other resources, and citing sources. There is also a link to an article by Leif Harmsen, "The Internet as a Research Medium for Art Historians."

ART HISTORY RESOURCES ON THE WEB
http://witcombe.sbc.edu/ARTHLinks.html

Authored by Christopher L. C. E. Witcombe of Sweet Briar College in Virgina, the site includes an impressive number of links for various art historical eras as well as links to research resources, museums, and galleries.

ART IMAGES FOR COLLEGE TEACHING (AICT)
http://www.mcad.edu/AICT/html

These images are the property of art historian and photographer Allan T. Kohl who offers them for nonprofit use. The images are organized into the following groupings: ancient, medieval era, Renaissance and Baroque, 18th–20th century, non-Western.

ART IN FLUX: A DIRECTORY OF RESOURCES FOR RESEARCH IN CONTEMPORARY ART
http://www.art.uidaho.edu/artnet/bsu/contemporary/artinflux/intro.html

Cheryl K. Shutleff of Boise State University in Montana has authored this directory, which includes sites selected according to their relevance to the study of national or international contemporary art and artists.

MOTHER OF ALL ART HISTORY LINKS PAGES
http://www.umich.edu/~hartspc/histart/mother/index.html

Maintained by the Department of the History of Art at the University of Michigan, this directory includes useful annotations and the URLs for each site included.

VOICE OF THE SHUTTLE: ART AND ART HISTORY PAGE
http://vos.ucsb.edu/shuttle/art.html

Sponsored by University of California, Santa Barbara, this is part of the larger directory which includes all areas of humanities. A very extensive list of links including general resources, museums, institutes and centers, galleries and exhibitions, auctions, artists and works by chronology, cartography, art theory and politics, cartography, design, architectural historical preservation, art and technology, image, slide and clip-art resources, image copyright and intellectual property issues, journals and zines, studio art depts. and programs, art history depts. and programs, conferences, calls for papers, deadlines, course syllabi and teaching resources.

YAHOO! ARTS>ART HISTORY
http://dir.yahoo.com/Arts/Art_History/

Another extensive directory of art links. Each listing includes the name of the site as well as a few words of explanation.

WORLD WIDE ARTS RESOURCES
http://www.wwar.com

Interactive arts gateway offering access to artists, museums, galleries, art, art history, education, and more.

ART MUSEUM NETWORK
http://www.amn.org

The official website of the world's leading art museums, the Art Museum Network offers links to the websites of countless museums worldwide, as well as links to the Art Museum Image Corsortium (AMICO) (www.amico.org), an illustrated search engine of more than 50,000 works of art available by subscription and ExCalendar (www.excalendar.net), the official exhibition calendar of the world's leading art museums, among other websites.

ARTMUSEUM.NET
http://www.artmuseum.net

ArtMuseum.net provides a forum for internet-based museum exhibitions around the country.

Ancient Art in the Western Tradition, General

Adam, Robert. *Classical Architecture: A Comprehensive Handbook to the Tradition of Classical Style*. New York: Abrams, 1991.

Amiet, Pierre. *Art in the Ancient World: A Handbook of Styles and Forms*. New York: Rizzoli, 1981.

Becatti, Giovanni. *The Art of Ancient Greece and Rome, from the Rise of Greece to the Fall of Rome*. New York: Abrams, 1967.

Dunabin, Katherine M.D. *Mosaics of the Greek and Roman World*. Cambridge: Cambridge Univ. Press, 1999.

Ehrich, Robert W., ed. *Chronologies in Old World Archaeology*. 3rd ed. Chicago: Univ. of Chicago Press, 1992.

Groenewegen-Frankfort, H. A., and Bernard Ashmole. *Art of the Ancient World: Painting, Pottery, Sculpture, Architecture from Egypt, Mesopotamia, Crete, Greece, and Rome.* Library of Art History. Upper Saddle River, NJ: Prentice Hall, 1972.

Huyghe, René. *Larousse Encyclopedia of Prehistoric and Ancient Art.* Rev. ed. Art and Mankind. New York: Prometheus, 1966.

Laing, Lloyd Robert, and Jennifer Laing. *Ancient Art: The Challenge to Modern Thought.* Dublin: Irish Academic, 1993.

Lloyd, Seton, and Hans Wolfgang Muller. *Ancient Architecture.* New York: Rizzoli, 1986.

Oliphant, Margaret. *The Atlas of the Ancient World: Charting the Great Civilizations of the Past.* New York: Simon & Schuster, 1992.

Powell, Ann. *Origins of Western Art.* London: Thames and Hudson, 1973.

Saggs, H. W. F. *Civilization before Greece and Rome.* New Haven: Yale Univ. Press, 1989.

Scranton, Robert L. *Aesthetic Aspects of Ancient Art.* Chicago: Univ. of Chicago Press, 1964.

Smith, William Stevenson. *Interconnections in the Ancient Near East: A Study of the Relationships between the Arts of Egypt, the Aegean, and Western Asia.* New Haven: Yale Univ. Press, 1965.

Stillwell, Richard, ed. *Princeton Encyclopedia of Classical Sites.* Princeton: Princeton Univ. Press, 1976.

European Medieval Art, General

Binski, Paul. *Painters. Medieval Craftsmen.* London: British Museum Press, 1992.

Brown, Michelle P. *Understanding Illuminated Manuscripts: A Guide to Technical Terms.* London: J. Paul Getty Museum, 1994.

Brown, Sarah, and David O'Connor. *Glass-painters. Medieval Craftsmen.* London: British Museum Press, 1992.

Calkins, Robert G. *Medieval Architecture in Western Europe: From A.D. 300 to 1500.* 1v. + laser optical disc. New York: Oxford Univ. Press, 1998.

———. *Monuments of Medieval Art.* New York: Dutton, 1979.

Camille, Michael. *The Gothic Idol: Ideology and Image-Making in Medieval Art.* Cambridge New Art History and Criticism. Cambridge: Cambridge Univ. Press, 1989.

———. *The Medieval Art of Love: Objects and Subjects of Desire.* New York: Abrams, 1998.

Cherry, John F. *Goldsmiths. Medieval Craftsmen.* London: British Museum Press, 1992.

Coldstream, *Masons and Sculptors. Medieval Craftsmen* London: British Museum Press, 1991.

Conant, Kenneth John. *Carolingian and Romanesque Architecture, 800–1200.* 3rd ed. Pelican History of Art. Harmondsworth, Eng.: Penguin, 1973.

De Hamel, Christopher. *Scribes and Illuminators. Medieval Craftsmen.* London: British Museum Press, 1992.

Duby, Georges. *Sculpture: The Great Art of the Middle Ages from the Fifth to the Fifteenth Century.* New York: Skira/Rizzoli, 1990.

Eames, Elizabeth S. *English Tilers. Medieval Craftsmen.* London: British Museum Press, 1992.

Fossier, Robert, ed. *The Cambridge Illustrated History of the Middle Ages.* 3 vols. Trans. Janet Sondheimer and Sarah Hanbury Tenison. Cambridge: Cambridge Univ. Press, 1986–97.

Hurlimann, Martin, and Jean Bony. *French Cathedrals.* Rev. & enl. London: Thames and Hudson, 1967.

Kenyon, John. *Medieval Fortifications.* Leicester: Leicester Univ. Press, 1990.

Labarge, Margaret Wade. *A Small Sound of the Trumpet: Women in Medieval Life.* London: Hamilton, 1990.

Larousse Encyclopedia of Byzantine and Medieval Art. London: Hamlyn, 1963.

Mâle, Emile. *Religious Art in France: The Late Middle Ages: A Study of Medieval Iconography and Its Sources.* Princeton: Princeton Univ. Press, 1986.

Pfaffenbichler, Matthias. *Armourers. Medieval Craftsmen.* London: British Museum Press, 1992.

Snyder, James. *Medieval Art: Painting-Sculpture-Architecture, 4th–14th Century.* New York: Abrams, 1989

Staniland, Kay. *Embroiderers. Medieval Craftsmen.* London: British Museum Press 1991

Stoddard, Whitney. *Art and Architecture in Medieval France: Medieval Architecture, Sculpture, Stained Glass, Manuscripts. The Art of the Church Treasuries.* New York: Harper & Row, 1972.

Stokstad, Marilyn. *Medieval Art.* 2nd ed. New York: Westview, 2001.

Wieck, Roger S. *Painted Prayers: The Book of Hours in Medieval and Renaissance Art.* New York: Braziller, 1997.

Zarnecki, George. *The Art of the Medieval World: Architecture, Sculpture, Painting, the Sacred Arts.* New York: Abrams, 1975.

European Renaissance through Eighteenth-Century Art, General

Black, C. F., et al. *Cultural Atlas of the Renaissance.* New York: Prentice Hall, 1993.

Blunt, Anthony. *Art and Architecture in France, 1500-1700.* 5th ed. Rev. Richard Beresford. Pelican History of Art. New Haven: Yale Univ. Press, 1999.

Brown, Jonathan. *Painting in Spain: 1500-1700.* Pelican History of Art. New Haven: Yale Univ. Press, 1998.

Circa 1492: Art in the Age of Exploration. Washington, D.C.: National Gallery of Art, 1991.

Cole, Bruce. *Italian Art, 1250–1550: The Relation of Renaissance Art to Life and Society.* New York: Harper & Row, 1987.

Craske, Matthew. *Art in Europe, 1700-1830: A History of the Visual Arts in an Era of Unprecedented Urban Economic Growth.* Oxford History of Art. Oxford: Oxford Univ. Press, 1997.

Cuttler, Charles D. *Northern Painting from Pucelle to Bruegel: Fourteenth, Fifteenth and Sixteenth Centuries.* New York: Holt, Rinehart and Winston, 1973.

Graham-Dixon, Andrew. *Renaissance.* Berkeley: Univ. of California Press, 1999.

Harbison, Craig. *The Mirror of the Artist: Northern Renaissance Art in Its Historical Context.* Perspectives. New York: Abrams, 1995.

Hartt, Frederick. *History of Italian Renaissance Art: Painting, Sculpture, Architecture.* 4th ed. Rev. David C. Wilkins. New York: Abrams, 1994.

Huyghe, René. *Larousse Encyclopedia of Renaissance and Baroque Art.* Art and Mankind. New York: Prometheus, 1964.

Kubler, George, and Martin Soria. *Art and Architecture in Spain and Portugal and Their American Dominions, 1500 1800.* Pelican History of Art. Harmondsworth, Eng.: Penguin, 1959.

McCorquodale, Charles. *The Renaissance: European Painting, 1400–1600.* London: Studio Editions, 1994.

Minor, Vernon Hyde. *Baroque & Rococo: Art & Culture.* New York: Abrams, 1999.

Murray, Peter. *Renaissance Architecture.* History of World Architecture. Milan: Electa, 1985.

Roettgen, Steffi. *Italian Frescoes.* 2 vols. Trans. Russell Stockman. New York: Abbeville, 1996.

Stechow, Wolfgang. *Northern Renaissance, 1400–1600: Sources and Documents.* Upper Saddle River, NJ: Prentice Hall, 1966.

Summerson, John. *Architecture in Britain: 1530-1830.* 7th ed. Pelican History of Art. Harmondsworth, Eng.: Penguin, 1983.

Turner, Richard. *Renaissance Florence: The Invention of a New Art.* Perspectives. New York: Abrams, 1997.

Waterhouse, Ellis K. *Painting in Britain, 1530 to 1790.* 5th ed. Yale Univ. Press Pelican History of Art. New Haven: Yale Univ. Press, 1994.

Whinney, Margaret Dickens. *Sculpture in Britain: 1530–1830.* 2nd ed. Rev. by John Physick. Pelican History of Art. London: Penguin, 1988.

Modern Art in the West, General

Arnason, H. Harvard. *History of Modern Art: Painting, Sculpture, Architecture, Photography.* 4th ed. Rev. Marla Prather. New York: Abrams, 1998.

Baigell, Matthew. *A Concise History of American Painting and Sculpture.* Rev. ed. New York: Icon Editions, 1996.

Bjelajac, David. *American Art: A Cultural History.* Upper Saddle River, NJ: Prentice Hall, 2000.

Bowness, Alan. *Modern European Art.* World of Art. New York: Thames and Hudson, 1995.

Brettell, Richard R. *Modern Art, 1851–1929: Capitalism and Representation.* Oxford History of Art. Oxford: Oxford Univ. Press, 1999.

Brown, Milton W. *American Art: Painting, Sculpture, Architecture, Decorative Arts, Photography.* New York: Abrams, 1979.

Burnett, David G. *Masterpieces of Canadian Art from the National Gallery of Canada.* Edmonton, AB: Hurtig, 1990.

Chipp, Herschel Browning. *Theories of Modern Art: A Source Book by Artists and Critics.* California Studies in the History of Art. Berkeley: Univ. of California Press, 1984.

Clarke, Graham. *The Photograph.* Oxford History of Art. Oxford: Oxford Univ. Press, 1997.

Craven, Wayne. *American Art: History and Culture.* New York: Abrams, 1994.

———. *Sculpture in America.* An American Art Journal/Kennedy Galleries Book. Newark: Univ. of Delaware Press, 1984.

Eitner, Lorenz. *Neoclassicism and Romanticism, 1750-1850: An Anthology of Sources and Documents.* New York: Harper & Row, 1989.

Ferebee, Ann. *A History of Design from the Victorian Era to the Present.* New York: Van Nostrand Reinhold, 1980.

Frampton, Kenneth. *Modern Architecture: A Critical History.* 3rd ed. Rev. & enl. World of Art. New York: Thames and Hudson, 1992.

Greenough, Sarah, et al. *On the Art of Fixing a Shadow: One Hundred and Fifty Years of Photography.* Washington, D.C.: National Gallery of Art, 1989.

Hamilton, George Heard. *Painting and Sculpture in Europe, 1880-1940.* 6th ed. Pelican History of Art. New Haven: Yale Univ. Press, 1993.

Hammacher, A. M. *Modern Sculpture: Tradition and Innovation.* Enlg. ed. New York: Abrams, 1988.

Handlin, David P. *American Architecture.* World of Art. London: Thames and Hudson, 1985.

Harris, Ann Sutherland, and Linda Nochlin. *Women Artists: 1550–1950.* Los Angeles: Los Angeles County Museum of Art, 1976.

Harrison, Charles, and Paul Wood, eds. *Art in Theory, 1900–1990: An Anthology of Changing Ideas.* Cambridge: Blackwell, 1992.

Hitchcock, Henry Russell. *Architecture: Nineteenth and Twentieth Centuries.* 4th ed. Pelican History of Art. Harmondsworth, Eng.: Penguin, 1977.

Hughes, Robert. *The Shock of the New.* Rev. ed. New York: Knopf, 1991.

Hunter, Sam, and John Jacobus. *American Art of the 20th Century: Painting, Sculpture, Architecture.* New York: Abrams, 1973.

———, and Daniel Wheeler. *Modern Art: Painting, Sculpture, Architecture.* 3rd Rev. ed. New York: Abrams, 2000.

Kroeber, Karl. *British Romantic Art.* Berkeley: Univ. of California Press, 1986.

Lewis, Samella S. *African American Art and Artists.* Rev. ed. Berkeley: Univ. of California Press, 1994.

Lindsay, Jack. *Death of the Hero: French Painting from David to Delacroix.* London: Studio, 1960.

Lynton, Norbert. *The Story of Modern Art.* 2nd ed. Oxford: Phaidon, 1989.

McCoubrey, John W. *American Art, 1700–1960: Sources and Documents.* Upper Saddle River, NJ: Prentice Hall, 1965.

Mellen, Peter. *Landmarks of Canadian Art.* Toronto: McClelland and Stewart, 1978.

Middleton, Robin, and David Watkin. *Neoclassical and 19th Century Architecture.* 2 vols. History of World Architecture. New York: Electa/Rizzoli, 1987.

Murray, Joan. *Canadian Art in the Twentieth Century.* Toronto: Dundurn, 1999.

Newhall, Beaumont. *The History of Photography: From 1839 to the Present.* 5th ed. Rev. New York: Museum of Modern Art, 1997.

Patton, Sharon F. *African American Art.* Oxford History of Art. Oxford: Oxford Univ. Press, 1998.

Powell, Richard J. *Black Art and Culture in the 20th Century.* World of Art. New York: Thames and Hudson, 1997.

Rosenblum, Naomi. *A World History of Photography.* 3rd ed. New York: Abbeville, 1997.

Roth, Leland. *A Concise History of American Architecture.* Icon Editions. New York: Harper & Row, 1979.

Russell, John. *The Meanings of Modern Art.* New York: Museum of Modern Art, 1991.

Schapiro, Meyer. *Modern Art: 19th and 20th Centuries.* New York: Braziller, 1978.

Sparke, Penny. *Introduction of Design and Culture in the Twentieth Century.* New York: Harper & Row, 1986.

Stangos, Nikos, ed. *Concepts of Modern Art: From Fauvism to Postmodernism.* 3rd ed. Exp. & updated. World of Art. New York: Thames and Hudson, 1994.

Stiles, Kristine, and Peter Howard Selz. *Theories and Documents of Contemporary Art: A Sourcebook of Artists' Writings.* California Studies in the History of Art; 35. Berkeley: Univ. of California Press, 1996.

Tafuri, Mantredo. *Modern Architecture.* 2 vols. History of World Architecture. New York: Electa/Rizzoli, 1986.

Tuchman, Maurice. *The Spiritual in Art: Abstract Painting 1890-1985.* Los Angeles: Los Angeles County Museum of Art, 1986.

Upton, Dell. *Architecture in the United States.* Oxford History of Art. Oxford: Oxford Univ. Press, 1998.

Weaver, Mike, ed. *The Art of Photography, 1939-1989.* New Haven: Yale Univ. Press, 1989.

Wilmerding, John. *American Art.* Pelican History of Art. Harmondsworth, Eng.: Penguin, 1976.

Woodham, Jonathan M. *Twentieth Century Design.* Oxford History of Art. Oxford: Oxford Univ. Press, 1997.

Asian Art, General

Barnhart, Richard M. *Three Thousand Years of Chinese Painting.* New Haven: Yale Univ. Press, 1997.

Blunden, Caroline, and Mark Elvin. *Cultural Atlas of China.* 2nd ed. New York: Checkmark Books, 1998.

Bussagli, Mario. *Oriental Architecture.* 2 vols. History of World Architecture. New York: Electa/Rizzoli, 1989.

Chang, Leon Long-Yien, and Peter Miller. *Four Thousand Years of Chinese Calligraphy*. Chicago: Univ. of Chicago Press, 1990.

Clunas, Craig. *Art in China*. Oxford History of Art. Oxford: Oxford Univ. Press, 1997.

Collcutt, Martin, Marius Jansen, and Isao Kumakura. *Cultural Atlas of Japan*. New York: Facts on File, 1988.

Craven, Roy C. *Indian Art: A Concise History*. Rev. ed. World of Art. New York: Thames and Hudson, 1997.

Dehejia, Vidya. *Indian Art*. Art & Ideas. London: Phaidon Press, 1997.

Ebrey, Patricia Buckley. *The Cambridge Illustrated History of China*. Cambridge Illustrated History. Cambridge: Cambridge Univ. Press, 1996.

Elisseeff, Danielle, and Vadime Elisseeff. *Art of Japan*. Trans. I. Mark Paris. New York: Abrams, 1985.

Fisher, Robert E. *Buddhist Art and Architecture*. World of Art. New York: Thames and Hudson, 1993.

Harle, James C. *The Art and Architecture of the Indian Subcontinent*. 2nd ed. Pelican History of Art. New Haven: Yale Univ. Press, 1994.

Heibonsha Survey of Japanese Art. 31 vols. New York: Weatherhill, 1972–80.

Japanese Arts Library. 15 vols. New York: Kodansha International, 1977–87.

Kramrisch, Stella. *The Art of India: Traditions of Indian Sculpture, Painting, and Architecture*. 3rd ed. London: Phaidon Press, 1965.

Lee, Sherman E. *A History of Far Eastern Art*. 5th ed. Ed. Naomi Noble Richards. New York: Abrams, 1994.

———. *China, 5000 Years: Innovation and Transformation in the Arts*. New York: Solomon R. Guggenheim Museum, 1998.

Loehr, Max. *The Great Painters of China*. New York: Harper & Row, 1980.

Louis-Frederic. *Buddhism*. Flammarion Iconographic Guides. Trans. Nissim Marshall. Paris: Flammarion, 1995.

Martynov, Anatolii Ivanovich. *Ancient Art of Northern Asia*. Urbana: Univ. of Illinois Press, 1991.

Mason, Penelope. *History of Japanese Art*. New York: Abrams, 1993.

Medley, Margaret. *Chinese Potter: A Practical History of Chinese Ceramics*. 3rd ed. Oxford: Phaidon, 1989.

Michell, George. *The Penguin Guide to the Monuments of India*. 2 vols. New York: Viking, 1989.

Paine, Robert Treat, and Alexander Soper. *Art and Architecture of Japan*. 3rd ed. Pelican History of Art. Harmondsworth, Eng.: Penguin, 1981.

Rowland, Benjamin. *Art and Architecture of India: Buddhist, Hindu, Jain*. Pelican History of Art. Harmondsworth, Eng.: Penguin, 1977.

Seckel, Dietrich. *Art of Buddhism*. Rev. ed. Art of the World. New York: Greystone Press, 1968.

Sickman, Lawrence, and Alexander Soper. *Art and Architecture of China*. Int. ed. Pelican History of Art. New Haven: Yale Univ. Press, 1992.

Stanley-Baker, Joan. *Japanese Art*. Rev. & exp. ed. World of Art. New York: Thames and Hudson, 2000.

Stutley, Margaret. *Harper's Dictionary of Hinduism: Its Mythology, Folklore, Philosophy, Literature and History*. New York: Harper & Row, 1977.

Sullivan, Michael. *The Arts of China*. 4th ed., Exp. & rev. Berkeley: Univ. of California Press, 1999.

Tadgell, Christopher. *The History of Architecture in India: From the Dawn of Civilization to the End of the Raj*. London: Architecture, Design, and Technology Press, 1990.

Thorp, Robert L., and Richard Ellis Vinograd. *Chinese Art & Culture*. New York: Abrams, 2001.

Tregear, Mary. *Chinese Art*. Rev. ed. World of Art. New York: Thames and Hudson, 1997.

Vainker, S. J. *Chinese Pottery and Porcelain: From Prehistory to the Present*. London: British Museum, 1991.

Varley, H. Paul. *Japanese Culture*. 4th ed., Updated & exp. Honolulu: Univ. of Hawaii Press, 2000.

African and Oceanic Art and Art of the Americas, General

Anderson, Richard L. *Art in Small-Scale Societies*. 2nd ed. Upper Saddle River, NJ: Prentice Hall, 1989.

Berlo, Janet Catherine, and Lee Ann Wilson. *Arts of Africa, Oceania, and the Americas: Selected Readings*. Upper Saddle River, NJ: Prentice Hall, 1993.

Blocker, H. Gene. *The Aesthetics of Primitive Art*. Lantham, MD: Univ. Press of America, 1994.

Coote, Jeremy, and Anthony Shelton, eds. *Anthropology, Art, and Aesthetics*. New York: Oxford Univ. Press, 1992.

D'Azevedao, Warren L. *The Traditional Artist in African Societies*. Bloomington: Indiana Univ. Press, 1989.

Drewal, Henry, and John Pemberton III. *Yoruba: Nine Centuries of African Art and Thought*. New York: Center for African Art, 1989.

Guidoni, Enrico. *Primitive Architecture*. Trans. Robert Eric Wolf. History of World Architecture. New York: Rizzoli, 1987.

Hiller, Susan, ed. & comp. *The Myth of Primitivism: Perspectives on Art*. London: Routledge, 1991.

Leiris, Michel, and Jacqueline Delange. *African Art*. Arts of Mankind. London: Thames and Hudson, 1968.

Leuzinger, Elsy. *The Art of Black Africa*. Trans. Ann Keep. New York: Rizzoli, 1976.

Mexico: Splendors of Thirty Centuries. New York: Metropolitan Museum of Art, 1990.

Murray, Jocelyn, ed. *Cultural Atlas of Africa*. Rev. ed. New York: Facts on File, 1998.

Phillips, Tom. *Africa: The Art of a Continent*. London: Prestel, 1996.

Price, Sally. *Primitive Art in Civilized Places*. Chicago: Univ. of Chicago Press, 1989.

Schuster, Carl, and Edmund Carpenter. *Patterns that Connect: Social Symbolism in Ancient & Tribal Art*. New York: Abrams, 1996.

Visonà, Monica Blackmun et al., *A History of Art in Africa*. New York: Abrams, 2000.

Willett, Frank. *African Art: An Introduction*. Rev ed. World of Art. New York: Thames and Hudson, 1993.

CHAPTER 1 Prehistory and Prehistoric Art in Europe

Anati, Emmanuel, and Tiziana Cittadini. *Valcomonica Rock Art: A New History for Europe*. English version ed. Thomas King and Jason Clairborne. Capo di Ponte, Italy: Edizioni del Centro, 1994.

Bahn, Paul G. *The Cambridge Illustrated History of Prehistoric Art*. Cambridge Illustrated History. Cambridge: Cambridge Univ. Press, 1998.

Bandi, Hans-Georg, et al. *Art of the Stone Age: Forty Thousand Years of Rock Art*. 2nd ed. Trans. Ann E. Keep. Art of the World. London: Methuen, 1970.

Beltrán Martinez, Antonio. *Rock Art of the Spanish Levant*. Trans. Margaret Brown. Cambridge: Cambridge Univ. Press, 1982.

Castleden, Rodney. *The Making of Stonehenge*. London: Routledge, 1993.

Chauvet, Jean-Marie, Eliette Brunel Deschamps, and Christian Hillaire. *Dawn of Art: The Chauvet Cave: The Oldest Known Paintings in the World*. Trans. Paul G. Bahn. New York: Abrams, 1996.

Chippindale, Christopher. *Stonehenge Complete*. New York: Thames and Hudson, 1994.

Forte, Maurizio, and Alberto Siliotti. *Virtual Archaeology: Re-Creating Ancient Worlds*. New York: Abrams, 1997.

Freeman, Leslie G. *Altamira Revisited and Other Essays on Early Art*. Chicago: Institute for Prehistoric Investigation, 1987.

Gowlett, John A. J. *Ascent to Civilization: The Archaeology of Early Humans*. 2nd ed. New York: McGraw-Hill, 1993.

Graziosi, Paolo. *Paleolithic Art*. New York: McGraw-Hill, 1960.

Laing, Lloyd. *Art of the Celts*. World of Art. New York: Thames and Hudson, 1992.

Leakey, Richard E. and Roger Lewin. *Origins Reconsidered: In Search of What Makes Us Human*. New York: Doubleday, 1992.

Leroi-Gourhan, André. *The Dawn of European Art: An Introduction to Paleolithic Cave Painting*. Trans. Sara Champion. Cambridge: Cambridge Univ. Press, 1982.

Lhote, Henri. *The Search for the Tassili Frescoes: The Story of the Prehistoric Rock-Paintings of the Sahara*. 2nd ed. Trans. Alan Houghton Brodrick. London: Hutchinson, 1973.

Marshack, Alexander. *The Roots of Civilization: The Cognitive Beginnings of Man's First Art, Symbol, and Notation*. New York: McGraw-Hill, 1971.

Megaw, Ruth, and Vincent Megaw. *Celtic Art: From Its Beginnings to the Book of Kells*. New York: Thames and Hudson, 1989.

O'Kelly, Michael J. *Newgrange: Archaeology, Art, and Legend*. New Aspects of Antiquity. London: Thames and Hudson, 1982.

Powell, T. G. E. *Prehistoric Art*. World of Art. New York: Oxford Univ. Press, 1966.

Price, T. Douglas, and Gray M. Feinman. *Images of the Past*. 3rd ed. Mountain View, CA: Mayfield, 2000.

Renfrew, Colin, ed. *The Megalithic Monuments of Western Europe*. London: Thames and Hudson, 1983.

Ruspoli, Mario. *The Cave of Lascaux: The Final Photographs*. New York: Abrams, 1987.

Sandars, N. K. *Prehistoric Art in Europe*. 2nd ed. Pelican History of Art. New Haven: Yale Univ. Press, 1995.

Sura Ramos, Pedro A. *The Cave of Altamira*. Gen. Ed. Antonio Beltran. New York: Abrams, 1999.

Sieveking, Ann. *The Cave Artists*. Ancient People and Places, vol. 93. London: Thames and Hudson, 1979.

Soffer, Olga. *The Upper Paleolithic of the Central Russian Plain*. Studies in Archaeology. Orlando, Fla.: Academic, 1985.

Torbrugge, Walter. *Prehistoric European Art*. Trans. Norbert Guterman. Panorama of World Art. New York: Abrams, 1968.

Ucko, Peter J., and Andree Rosenfeld. *Paleolithic Cave Art*. New York: McGraw-Hill, 1967.

CHAPTER 2 Art of the Ancient Near East

Akurgal, Ekrem. *The Art of the Hittites*. Trans. Constance McNab. New York: Abrams, 1962.

Amiet, Pierre. *Art of the Ancient Near East*. Trans. John Shepley and Claude Choquet. New York: Abrams, 1980.

Bienkowski, Piotr, and Alan Millard, eds. *Dictionary of the Ancient Near East*. Philadelphia: Univ. of Pennsylvania Press, 2000.

Bottero, Jean. *Mesopotamia: Writing, Reasoning, and the Gods*. Trans. Zainab Bahrani and Marc Van De Mieroop. Chicago: Univ. of Chicago Press, 1992.

Collon, Dominque. *Ancient Near Eastern Art*. Berkeley: Univ. Of California Press, 1995.

———. *First Impressions: Cylinder Seals in the Ancient Near East*. Chicago: Univ. of Chicago Press, 1987.

Downey, Susan B. *Mesopotamian Religious Architecture: Alexander through the Parthians*. Princeton: Princeton Univ. Press, 1988.

Ferrier, R. W., ed. *Arts of Persia*. New Haven: Yale Univ. Press, 1989.

Frankfort, Henri. *The Art and Architecture of the Ancient Orient*. 5th ed. Pelican History of Art. New Haven: Yale Univ. Press, 1996.

Ghirshman, Roman. *The Arts of Ancient Iran from Its Origins to the Time of Alexander the Great*. Trans. Stuart Gilbert and James Emmons. Arts of Mankind. New York: Golden, 1964.

Harper, Prudence, Joan Arz, and Françoise Tallon, eds. *The Royal City of Susa: Ancient Near Eastern Treasures in the Louvre*. New York: The Metropolitan Museum of Art, 1992.

Haywood, John. *Ancient Civilizations of the Near East and Mediterranean*. London: Cassell, 1997.

Kramer, Samual Noah. *History Begins at Sumer: Thirty-Nine Firsts in Man's Recorded History*. 3rd rev. ed. Philadelphia: Univ. of Pennsylvania Press, 1956.

———. *The Sumerians, Their History, Culture, and Character*. Chicago: Univ. of Chicago Press, 1963.

Lloyd, Seton. *Ancient Turkey: A Traveller's History of Anatolia*. Berkeley: Univ. of California Press, 1989.

Maisels, Charles Keith. *The Near East: Archaeology in the "Cradle of Civilization"*. The Experience of Archaeology. London: Routledge, 1993.

Oppenheim, A. Leo. *Ancient Mesopotamia: Portrait of a Dead Civilization*. Rev. ed. completed by Erica Reiner. Chicago: Univ. of Chicago Press, 1977.

Parrot, André. *The Arts of Assyria*. Trans. Stuart Gilbert and James Emmons. Arts of Mankind. New York: Golden, 1961.

———. *Sumer: The Dawn of Art*. Trans. Stuart Gilbert and James Emmons. Arts of Mankind. New York: Golden, 1961.

Porada, Edith. *The Art of Ancient Iran: Pre-Islamic Cultures*. Art of the World. New York: Crown, 1965.

Roaf, Michael. *Cultural Atlas of Mesopotamia and the Ancient Near East*. New York: Facts on File, 1990.

Roux, Georges. *Ancient Iraq*. 3rd ed. London: Penguin, 1992.

Russell, John Malcolm. *Sennacherib's Palace without Rival at Nineveh*. Chicago: Univ. of Chicago Press, 1991.

Saggs, H. W. F. *Everyday Life in Babylonia and Assyria*. New York: Dorset, 1987.

———. *Civilization before Greece and Rome*. New Haven: Yale Univ. Press, 1989.

Woolley, Leonard. *The Art of the Middle East including Persia, Mesopotamia and Palestine*. Trans. Ann E. Keep. Art of the World. New York: Crown, 1961.

CHAPTER 3 Art of Ancient Egypt

Aldred, Cyril. *Egyptian Art in the Days of the Pharaohs, 3100–320 B.C.* World of Art. London: Thames and Hudson, 1980.

Arnold, Dieter. *Temples of the Last Pharaohs*. New York: Oxford Univ. Press, 1999.

Baines, John, and Jaromír Málek. *Atlas of Ancient Egypt*. Rev. ed. New York: Facts on File, 2000.

Breasted, James Henry. *A History of Egypt from the Earliest Times to the Persian Conquest*. 2nd ed. Rev. London: Hodder & Stroughton, 1920.

Brier, Bob. *Egyptian Mummies: Unraveling the Secrets of an Ancient Art*. New York: Morrow, 1994.

David, A. Rosalie. *The Pyramid Builders of Ancient Egypt: A Modern Investigation of Pharaoh's Workforce*. London: Routledge, 1986.

Egyptian Art in the Age of the Pyramids. New York: Metropolitan Museum of Art, 1999.

The Egyptian Book of the Dead: The Book of Going Forth by Day: Being the Papyrus of Ani (Royal Scribe of the Divine Offerings). Trans. Raymond O. Faulkner. 2nd Rev. ed. San Francisco: Chronicle, 1998.

Grimal, Nicolas-Christophe. *A History of Ancient Egypt.* Trans. Ian Hall. Oxford: Blackwell, 1992.

Kozloff, Arielle P., and Betsy M. Bryan. *Egypt's Dazzling Sun: Amenhotep III and His World.* Cleveland: Cleveland Museum of Art, 1992.

Lehner, Mark. *The Complete Pyramids.* New York: Thames and Hudson, 1997.

Malek, Jaromir. *Egyptian Art.* Art & Ideas. London: Phaidon, 1999.

Manniche, Lise. *City of the Dead: Thebes in Egypt.* Chicago: Univ. of Chicago Press, 1987.

Martin, Geoffrey Thorndike. *The Hidden Tombs of Memphis: New Discoveries from the Time of Tutankhamun and Ramesses the Great.* London: Thames and Hudson, 1991.

Menu, Bernadette. *Ramesses II, Greatest of the Pharoahs.* Discoveries. New York: Abrams, 1999.

Montet, Pierre. *Everyday Life in Egypt in the Days of Ramesses the Great.* Trans. A. R. Maxwell-Hysop and Margaret S. Drower. Philadelphia: Univ. of Pennsylvania Press, 1981.

Pemberton, Delia. *Ancient Egypt.* Architectural Guides for Travelers. San Francisco: Chronicle, 1992.

Reeves, C. N. *The Complete Tutankhamun. The King, the Tomb, the Royal Treasure.* London: Thames and Hudson, 1990.

Robins, Gay. *The Art of Ancient Egypt.* Cambridge: Harvard Univ. Press, 1997.

Russmann, Edna R. *Egyptian Sculpture: Cairo and Luxor.* Austin: Univ. of Texas Press, 1989.

Smith, W. Stevenson. *The Art and Architecture of Ancient Egypt.* 3rd ed. Rev. William Kelly Simpson. Pelican History of Art. New Haven: Yale Univ. Press, 1998.

Strouhal, Eugen. *Life of the Ancient Egyptians.* Norman: Univ. of Oklahoma Press, 1992.

Tiradritti, Francesco, and Araldo De Luca. *Egyptian Treasures from the Egyptian Museum in Cairo.* New York: Abrams, 1999.

Wilkinson, Richard H. *Reading Egyptian Art: A Hieroglyphic Guide to Ancient Egyptian Painting and Sculpture.* London: Thames and Hudson, 1992.

Winstone, H. V. F. *Howard Carter and the Discovery of the Tomb of Tutankhamun.* London: Constable, 1991.

CHAPTER 4 Aegean Art

Barber, R. L. N. *The Cyclades in the Bronze Age.* Iowa City: Univ. of Iowa Press, 1987.

Castleden, Rodney. *The Knossos Labyrinth: A New View of the "Palace of Minos" at Knossos.* London: Routledge, 1990.

Demargne, Pierre. *The Birth of Greek Art.* Trans. Stuart Gilbert and James Emmons. Arts of Mankind. New York: Golden, 1964.

Dickinson, Oliver. *The Aegean Bronze Age.* Cambridge World Archaeology. Cambridge: Cambridge Univ. Press, 1994.

Doumas, Christos. *The Wall-Paintings of Thera.* 2nd ed. Trans. Alex Doumas. Athens: Kapon Editions, 1999.

Fitton, J. Lesley. *Cycladic Art.* 2nd ed. London: British Museum, 1999.

Higgins, Reynold. *Minoan and Mycenean Art.* Rev. ed. World of Art. New York: Thames and Hudson, 1997.

Immerwahr, Sara Anderson. *Aegean Painting in the Bronze Age.* University Park: Pennsylvania State Univ. Press, 1994.

Marinatos, Nanno. *Art and Religion in Thera: Reconstructing a Bronze Age Society.* Athens: Mathioulakis, 1984.

Marinatos, Spyridon, and Max Hirmer. *Crete and Mycenae.* New York: Abrams, 1960.

Matz, Friedrich. *The Art of Crete and Early Greece: Prelude to Greek Art.* Trans. Ann E. Keep. Art of the World. New York: Crown, 1962.

Morgan, Lyvia. *The Miniature Wall Paintings of Thera: A Study in Aegean Culture and Iconography.* Cambridge: Cambridge Univ. Press, 1988.

Preziosi, Donald, and Louise Hitchcock. *Aegean Art and Architecture.* Oxford History of Art. Oxford: Oxford Univ. Press, 1999.

Pellegrino, Charles R. *Unearthing Atlantis: An Archaeological Survey.* New York: Random House, 1991.

CHAPTER 5 Art of Ancient Greece

Akurgal, Ekrem. *The Art of Greece: Its Origins in the Mediterranean and Near East.* Trans. Wayne Dynes. Art of the World. New York: Crown, 1968.

Arias, Paolo. *A History of 1000 Years of Greek Vase Painting.* New York: Abrams, 1962.

Ashmole, Bernard. *Architect and Sculptor in Classical Greece.* Wrightsman Lectures. New York: New York Univ. Press, 1972.

Berve, Helmut, and Gottfried Gruben. *Greek Temples, Theatres, and Shrines.* New York: Abrams, 1963.

Biers, William. *The Archaeology of Greece: An Introduction.* 2nd ed. Ithaca: Cornell Univ. Press, 1996.

Blumel, Carl. *Greek Sculptors at Work.* 2nd ed. Trans. Lydia Holland. London: Phaidon, 1969.

Boardman, John. *Early Greek Vase Painting: 11th-6th Centuries B.C.: A Handbook.* World of Art. London: Thames and Hudson, 1998.

———. *Greek Art.* 4th ed., Rev. & exp. World of Art. London: Thames and Hudson, 1997.

———. *Greek Sculpture: The Archaic Period: A Handbook.* World of Art. New York: Oxford Univ. Press, 1991.

———. *Greek Sculpture: The Classical Period: A Handbook.* London: Thames and Hudson, 1985.

———. *Greek Sculpture: The Late Classical Period and Sculpture in Colonies and Overseas.* World of Art. New York: Thames and Hudson, 1995.

———. *Oxford History of Classical Art.* Oxford: Oxford Univ. Press, 1993.

———. *The Parthenon and Its Sculptures.* Austin: Univ. of Texas Press, 1985.

Buitron-Oliver, Diana, and Nicholas Gage. *The Greek Miracle: Classical Sculpture from the Dawn of Democracy: The Fifth Century B.C.* Washington, D.C.: National Gallery of Art, 1992.

Camp, John M. *The Athenian Agora: Excavations in the Heart of Classical Athens.* New York: Thames and Hudson, 1986.

Carpenter, Thomas H. *Art and Myth in Ancient Greece: A Handbook.* World of Art. London: Thames and Hudson, 1991.

Cartledge, Paul, ed. *The Cambridge Illustrated History of Ancient Greece.* Cambridge Illustrated History. Cambridge: Cambridge Univ. Press, 1998.

Charbonneaux, Jean, Robert Martin, and François Villard. *Archaic Greek Art (620–480 B.C.).* Trans. James Emmons and Robert Allen. Arts of Mankind. New York: Braziller, 1971.

———. *Classical Greek Art (480–330 B.C.).* Trans. James Emmons. Arts of Mankind. New York: Braziller, 1972.

———. *Hellenistic Art (330–50 B.C.).* Trans. Peter Green. Arts of Mankind. New York: Braziller, 1973.

Durando, Furio. *Splendours of Ancient Greece.* Trans. Ann Ghitinghelli. London: Thames and Hudson, 1997.

Francis, E. D. *Image and Idea in Fifth-Century Greece: Art and Literature after the Persian Wars.* London: Routledge, 1990.

Fullerton, Mark D. *Greek Art.* Cambridge: Cambridge Univ. Press, 2000.

Havelock, Christine Mitchell. *Hellenistic Art: The Art of the Classical World from the Death of Alexander the Great to the Battle of Actium.* 2nd ed. New York: Norton, 1981.

Homann-Wedeking, Ernst. *The Art of Archaic Greece.* Trans. J. R. Foster. Art of the World. New York: Crown, 1968.

Hood, Sinclair. *Arts in Prehistoric Greece.* Pelican History of Art. Harmondsworth, Eng.: Penguin, 1978.

Human Figure in Early Greek Art, The. Washington, D.C.: National Gallery of Art, 1988.

Hurwit, Jeffrey M. *The Art and Culture of Early Greece 1100–480 B.C.* Ithaca: Cornell Univ. Press, 1985.

———. *The Athenian Acropolis: History, Mythology, and Archaeology from the Neolithic Era to the Present.* Cambridge: Cambridge Univ. Press, 1999.

Jenkins, Ian. *The Parthenon Frieze.* Austin: Univ. of Texas Press, 1994.

Lagerlof, Margaretha Rossholm. *The Sculptures of the Parthenon: Aesthetics and Interpretation.* New Haven: Yale Univ. Press, 2000.

Lawrence, A. W. *Greek Architecture.* 5th ed. Rev. R. A. Tomlinson. Pelican History of Art. New Haven: Yale Univ. Press, 1996.

Lullies, Reinhart, and Max Hirmer. *Greek Sculpture.* Rev. & enl. ed. Trans. Michael Bullock. New York: Abrams, 1960.

Martin, Roland. *Greek Architecture: Architecture of Crete, Greece, and the Greek World.* History of World Architecture. New York: Electa/Rizzoli, 1988.

Onians, John. *Art and Thought in the Hellenistic Age: The Greek World View 350–50 B.C.* London: Thames and Hudson, 1979.

Osborne, Robin. *Archaic and Classical Greek Art.* Oxford History of Art. Oxford: Oxford Univ. Press, 1998.

Papaioannou, Kostas. *The Art of Greece.* Trans. I. Mark Paris. New York: Abrams, 1989.

Pedley, John Griffiths. *Greek Art and Archaeology.* 2nd ed. New York: Abrams, 1998.

Pollitt, J. J. *Art and Experience in Classical Greece.* London: Cambridge Univ. Press, 1972.

———. *Art in the Hellenistic Age.* Cambridge: Cambridge Univ. Press, 1986.

———. *The Art of Ancient Greece: Sources and Documents.* Cambridge: Cambridge Univ. Press, 1990.

Powell, Anton, ed. *The Greek World.* London: Routledge, 1995.

Ridgway, Brunilde Sismondo. *The Archaic Style in Greek Sculpture.* 2nd ed. Chicago: Ares, 1993.

———. *Fifth Century Styles in Greek Sculpture.* Princeton: Princeton Univ. Press, 1981.

———. *Fourth Century Styles in Greek Sculpture.* Wisconsin Studies in Classics. Madison: Univ. of Wisconsin Press, 1997.

———. *Hellenistic Sculpture I: The Styles of ca. 331–200 B.C.* Wisconsin Studies in Classics. Madison: Univ. of Wisconsin Press, 1990.

Robertson, Martin. *Greek Painting: The Great Centuries of Painting.* Geneva: Skira, 1959.

Roes, Anna. *Greek Geometric Art: Its Symbolism and Its Origin.* London: Oxford Univ. Press, 1933.

Sacks, David, and Oswyn Murray. *Encyclopedia of the Ancient Greek World.* New York: Facts on File, 1995.

Schefold, Karl. *Classical Greece.* Trans. J. R. Foster. Art of the World. London: Methuen, 1967.

Scully, Vincent. *The Earth, the Temple, and the Gods: Greek Sacred Architecture.* Rev. ed. New Haven: Yale Univ. Press, 1979.

Smith, R. R. R. *Hellenistic Sculpture: A Handbook.* World of Art. New York: Thames and Hudson, 1991.

Spivey, Nigel. *Greek Art.* Art & Ideas. London: Phaidon Press, 1997.

Stewart, Andrew F. *Greek Sculpture: An Exploration.* 2 vols. New Haven: Yale Univ. Press, 1990.

Webster, T. B. L. *The Art of Greece: The Age of Hellenism.* Art of the World. New York: Crown, 1966.

CHAPTER 6 Etruscan Art and Roman Art

Andreae, Bernard. *The Art of Rome.* Trans. Robert Erich Wolf. New York: Abrams, 1977.

Bianchi Bandinelli, Ranuccio. *Rome: The Centre of Power: Roman Art to A.D. 200.* Trans. Peter Green. Arts of Mankind. London: Thames and Hudson, 1970.

———. *Rome: The Late Empire: Roman Art A.D. 200–400.* Trans. Peter Green. Arts of Mankind. New York: Braziller, 1971.

Bloch, Raymond. *Etruscan Art.* Greenwich, CT: New York Graphic Society, 1965.

Boethius, Axel, and J. B. Ward-Perkins. *Etruscan and Early Roman Architecture.* 2nd ed. Pelican History of Art. Harmondsworth, Eng.: Penguin, 1978.

Breeze, David John. *Hadrian's Wall.* 4th ed. London: Penguin, 2000.

Brendel, Otto J. *Etruscan Art.* 2nd ed. Pelican History of Art. New Haven: Yale Univ. Press, 1995.

Brilliant, Richard. *Roman Art: From the Republic to Constantine.* London: Phaidon, 1974.

Buranelli, Francesco. *The Etruscans: Legacy of a Lost Civilization from the Vatican Museums.* Memphis: Lithograph, 1992.

Christ, Karl. *The Romans: An Introduction to Their History and Civilization.* Berkeley: Univ. of California Press, 1984.

Cornell, Tim, and John Matthews. *Atlas of the Roman World.* New York: Facts on File, 1982.

D'Ambra, Eve. *Roman Art.* Cambridge: Cambridge Univ. Press, 1998.

Elsner, Ja's. *Imperial Rome and Christian Triumph: The Art of the Roman Empire A.D. 100–450.* Oxford History of Art. Oxford: Oxford Univ. Press, 1998.

Grant, Michael. *Art in the Roman Empire.* London: Routledge, 1995.

Guillaud, Jacqueline, and Maurice Guillaud. *Frescoes in the Time of Pompeii.* New York: Potter, 1990.

Heintze, Helga von. *Roman Art.* New York: Universe, 1990.

Henig, Martin, ed. *A Handbook of Roman Art: A Comprehensive Survey of All the Arts of the Roman World.* Ithaca: Cornell Univ. Press, 1983.

Kahler, Heinz. *The Art of Rome and Her Empire.* Trans. J. R. Foster. Art of the World. New York: Crown, 1963.

Ling, Roger. *Roman Painting.* Cambridge: Cambridge Univ. Press, 1991.

L'Orange, Hans Peter. *The Roman Empire: Art Forms and Civic Life.* New York: Rizzoli, 1985.

MacDonald, William L. *The Architecture of the Roman Empire: An Introductory Study.* Rev. ed. 2 vols. Yale Publications in the History of Art. New Haven: Yale Univ. Press, 1982.

———. *The Pantheon: Design, Meaning, and Progeny.* Cambridge: Harvard Univ. Press, 1976.

———, and John A. Pinto. *Hadrian's Villa and Its Legacy.* New Haven: Yale Univ. Press, 1995.

Mansuelli, G. A. *The Art of Etruria and Early Rome.* Art of the World. New York: Crown, 1965.

Packer, James E., and Kevin Lee Sarring. *The Forum of Trajan in Rome: A Study of the Monuments.* 2 vols., portfolio and microfiche. California Studies in the History of Art; 31. Berkeley: Univ. of California Press, 1997.

Pollitt, J. J. *The Art of Rome, c. 753 B.C.–337 A.D.:* Sources and Documents. Upper Saddle River, NJ: Prentice Hall, 1966.

Quennell, Peter. *The Colosseum*. New York: Newsweek, 1971.

Ramage, Nancy H., and Andrew Ramage. *The Cambridge Illustrated History of Roman Art*. Cambridge: Cambridge Univ. Press, 1991.

———. *Roman Art: Romulus to Constantine*. 2nd ed. Upper Saddle River, NJ: Prentice Hall, 1996.

Rediscovering Pompeii. 4th ed. Rome: L'Erma di Bretschneider, 1992.

Spivey, Nigel. *Etrusan Art*. World of Art. New York: Thames and Hudson, 1997.

Sprenger, Maja, and Bartolini, Gilda. *The Etruscans: Their History, Art, and Architecture*. New York: Abrams, 1983.

Strong, Donald. *Roman Art*. 2nd ed. Rev. & annotated. Ed. Roger Ling. Pelican History of Art. New Haven: Yale Univ. Press, 1995.

Vitruvius Pollio. *Ten Books on Architecture*. Trans. Ingrid D. Rowland; Commentary Thomas Noble Howe, Ingrid D. Rowland, Michael J. Dewar. Cambridge: Cambridge Univ. Press, 1999.

Ward-Perkins, J. B. *Roman Architecture*. History of World Architecture. New York: Electa/Rizzoli, 1988.

———. *Roman Imperial Architecture*. Pelican History of Art. New Haven: Yale Univ. Press, 1981.

Wheeler, Robert Eric Mortimer, Sir. *Roman Art and Architecture*. World of Art. New York: Oxford Univ. Press, 1964.

CHAPTER 7 Early Christian, Jewish, and Byzantine Art

Age of Spirituality: Late Antique and Early Christian Art, Third to Seventh Century. New York: Metropolitan Museum of Art, 1979.

Beckwith, John. *The Art of Constantinople: An Introduction to Byzantine Art 330–1453*. 2nd ed. London: Phaidon, 1968.

———. *Early Christian and Byzantine Art*. 2nd ed. Pelican History of Art. Harmondsworth, Eng.: Penguin, 1979.

Boyd, Susan A. *Byzantine Art*. Chicago: Univ. of Chicago Press, 1979.

Buckton, David, ed. *The Treasury of San Marco, Venice*. Milan: Olivetti, 1985.

Carr, Annemarie Weyl. *Byzantine Illumination, 1150–1250: The Study of a Provincial Tradition*. Chicago: Univ. of Chicago Press, 1987.

Christe, Yves. *Art of the Christian World, A.D. 200–1500: A Handbook of Styles and Forms*. New York: Rizzoli, 1982.

Cutler, Anthony. *The Hand of the Master: Craftsmanship, Ivory, and Society in Byzantium (9th–11th Centuries)*. Princeton: Princeton Univ. Press, 1994.

Demus, Otto. *Byzantine Art and the West*. Wrightsman Lectures. New York: New York Univ. Press, 1970.

———. *Byzantine Mosaic Decoration: Aspects of Monumental Art in Byzantium*. New Rochelle: Caratzas, 1976.

———. *The Church of San Marco in Venice: History, Architecture, Sculpture*. Washington, D.C.: Dumbarton Oaks, 1960.

Evans, Helen C., and William D. Wixom, eds. *The Glory of Byzantium*. New York: Abrams, 1997.

Ferguson, George Wells. *Signs and Symbols in Christian Art*. New York: Oxford Univ. Press, 1967.

Gough, Michael. *Origins of Christian Art*. World of Art. London: Thames and Hudson, 1973.

Grabar, André. *The Art of the Byzantine Empire: Byzantine Art in the Middle Ages*. Trans. Betty Forster. *Art of the World*. New York: Crown, 1966.

———. *Byzantine Painting: Historical and Critical Study*. Trans. Stuart Gilbert. New York: Rizzoli, 1979.

———. *Early Christian Art: From the Rise of Christianity to the Death of Theodosius*. Trans. Stuart Gilbert and James Emmons. Arts of Mankind. New York: Odyssey, 1969.

———. *The Golden Age of Justinian from the Death of Theodosius to the Rise of Islam*. Trans. Stuart Gilbert and James Emmons. Arts of Mankind. New York: Odyssey, 1967.

Hubert, Jean, Jean Porcher, and W. F. Volbach. *Europe of the Invasions*. Trans. Stuart Gilbert and James Emmons. Arts of Mankind. New York: Braziller, 1969.

Kitzinger, Ernst. *Byzantine Art in the Making: Main Lines of Stylistic Development in Mediterranean Art, 3rd–7th Century*. Cambridge: Harvard Univ. Press, 1977.

Krautheimer, Richard. *Early Christian and Byzantine Architecture*. 4th ed. Pelican History of Art. Harmondsworth, Eng: Penguin, 1986.

———. *Rome, Profile of a City, 312-1308*. Princeton: Princeton Univ. Press, 1980.

Mainstone, R. J. *Hagia Sophia: Architecture, Structure and Liturgy of Justinian's Great Church*. London: Thames and Hudson, 1988.

Lowden, John. *Early Christian and Byzantine Art. Art & Ideas*. London: Phaidon, 1997.

Mango, Cyril. *Art of the Byzantine Empire, 312–1453: Sources and Documents*. Upper Saddle River, NJ: Prentice Hall, 1972.

———. *Byzantine Architecture*. History of World Architecture. New York: Rizzoli, 1985.

Manincelli, Fabrizio. *Catacombs and Basilicas: The Early Christians in Rome*. Florence: Scala, 1981.

Mathew, Gervase. *Byzantine Aesthetics*. London: J. Murray, 1963.

Mathews, Thomas P. *Byzantium: From Antiquity to the Renaissance*. Perspectives. New York: Abrams, 1998.

Milburn, R. L. P. *Early Christian Art and Architecture*. Berkeley: Univ. of California Press, 1988.

Oakshott, Walter Fraser. *The Mosaics of Rome: From the Third to the Fourteenth Centuries*. London: Thames and Hudson, 1967.

Rice, David Talbot. *Art of the Byzantine Era*. New York: Praeger, 1963.

———. *Byzantine Art*. Harmondsworth, Eng.: Penguin, 1968.

Rodley, Lyn. *Byzantine Art and Architecture: An Introduction*. Cambridge: Cambridge Univ. Press, 1993.

Schapiro, Meyer. *Late Antique, Early Christian, and Mediaeval Art*. New York: Braziller, 1979.

Simson, Otto Georg von. *Sacred Fortress: Byzantine Art and Statecraft in Ravenna*. Chicago: Univ. of Chicago Press, 1948.

Stevenson, James. *The Catacombs: Rediscovered Monuments of Early Christianity*. Ancient Peoples and Places. London: Thames and Hudson, 1978.

Weitzmann, Kurt. *Late Antique and Early Christian Book Illumination*. New York: Braziller, 1977.

———. *Place of Book Illumination in Byzantine Art*. Princeton: Art Museum, Princeton Univ., 1975.

Wharton, Annabel Jane. *Art of Empire: Painting and Architecture of the Byzantine Periphery: A Comparative Study of Four Provinces*. University Park: Pennsylvania State Univ. Press, 1988.

CHAPTER 8 Islamic Art

Akurgal, Ekrem, ed. *The Art and Architecture of Turkey*. New York: Rizzoli, 1980.

Al-Faruqi, Ismail R, and Lois Lamya'al Faruqi. *Cultural Atlas of Islam*. New York: Macmillan, 1986.

Aslanapa, Oktay. *Turkish Art and Architecture*. London: Faber, 1971.

Atasoy, Nurhan. *Splendors of the Ottoman Sultans*. Ed. and Trans. Tulay Artan. Memphis, TN: Lithograph, 1992.

Atil, Esin. *The Age of Sultan Suleyman the Magnificent*. Washington, D.C.: National Gallery of Art, 1987.

———. *Art of the Arab World*. Washington, D.C.: Smithsonian Institution, 1975.

———. *Islamic Art and Patronage: Treasures from Kuwait*. New York: Rizzoli, 1990.

———. *Renaissance of Islam: Art of the Mamluks*. Washington, D.C.: Smithsonian Institution, 1981.

Blair, Sheila S., and Jonathan Bloom. *The Art and Architecture of Islam 1250–1800*. Pelican History of Art. New Haven: Yale Univ. Press, 1994.

Brend, Barbara. *Islamic Art*. Cambridge: Harvard Univ. Press, 1991.

Dodds, Jerrilynn D., ed. *al-Andalus: The Art of Islamic Spain*. New York: Metropolitan Museum of Art, 1992.

Ettinghausen, Richard, and Oleg Grabar. *The Art and Architecture of Islam: 650–1250*. Pelican History of Art. New Haven: Yale Univ. Press, 1994.

Falk, Toby, ed. *Treasures of Islam*. London: Sotheby's, 1985.

Frishman, Martin, and Hasan-Uddin Khan. *The Mosque: History, Architectural Development and Regional Diversity*. London: Thames and Hudson, 1994.

Glasse, Cyril. *The Concise Encyclopedia of Islam*. San Francisco: Harper & Row, 1989.

Grabar, Oleg. *The Alhambra*. Cambridge: Harvard Univ. Press, 1978.

———. *The Formation of Islamic Art*. Rev. ed. New Haven: Yale Univ. Press, 1987.

———. *The Great Mosque of Isfahan*. New York: New York Univ. Press, 1990.

———. *The Mediation of Ornament*. A. W. Mellon Lectures in the Fine Arts. Princeton: Princeton Univ. Press, 1992.

———, Mohammad al-Asad, Abeer Audeh, and Said Nuseibeh. *The Shape of the Holy; Early Islamic Jerusalem*. Princeton: Princeton Univ. Press, 1996.

Grube, Ernest J. *Architecture of the Islamic World: Its History and Social Meaning*. Ed. George Mitchell. New York: Morrow, 1978.

Hillenbrand, Robert. *Islamic Art and Architecture*. World of Art. London: Thames and Hudson, 1999.

Hoag, John D. *Islamic Architecture*. History of World Architecture. New York: Abrams, 1977.

Irwin, Robert. *Islamic Art in Context: Art, Architecture, and the Literary World*. Perspectives. New York: Abrams, 1997.

Jones, Dalu, and George Mitchell, eds. *The Arts of Islam*. London: Arts Council of Great Britain, 1976.

Khatibi, Abdelkebir, and Mohammed Sijelmassi. *The Splendour of Islamic Calligraphy*. Rev. and exp. ed. New York: Thames and Hudson, 1996.

Lentz, Thomas W., and Glenn D. Lowry. *Timur and the Princely Vision: Persian Art and Culture in the Fifteenth Century*. Los Angeles: Los Angeles County Museum of Art, 1989.

Papadopoulo, Alexandre. *Islam and Muslim Art*. Trans. Robert Erich Wolf. New York: Abrams, 1979.

Petsopoulos, Yanni, ed. *Tulips, Arabesques and Turbans: Decorative Arts from the Ottoman Empire*. New York: Abbeville, 1982.

Raby, Julian, ed. *The Art of Syria and the Jazira, 1100–1250*. Oxford Studies in Islamic Art. Oxford: Oxford Univ. Press, 1985.

Rice, David Talbot. *Islamic Art*. World of Art. New York: Thames and Hudson, 1965.

Robinson, Francis, ed. *The Cambridge Illustrated History of the Islamic World*. Cambridge Univ. Press, 1996.

Schimmel, Annemarie. *Calligraphy and Islamic Culture*. New York: New York Univ. Press, 1983.

Ward, R. M. *Islamic Metalwork*. New York: Thames and Hudson, 1993.

Welch, Anthony. *Calligraphy in the Arts of the Muslim World*. Austin: Univ. of Texas Press, 1979.

CHAPTER 9 Art of India before 1100

Allchin, Bridget, and Raymond Allchin. *The Rise of Civilization in India and Pakistan*. Cambridge World Archaeology. Cambridge: Cambridge Univ. Press, 1982.

Behl, Benoy K. *The Ajanta Caves: Artistic Wonder of Ancient Buddhist India*. New York: Abrams, 1998.

Berkson, Carmel. *Elephanta: The Cave of Shiva*. Princeton: Princeton Univ. Press, 1983.

Brooks, Robert R.R. , and Vishnu S. Wakakar. *Stone Age Painting in India*. New Haven: Yale Univ. Press, 1976.

Chandra, Pramod. *The Sculpture of India, 3000 B.C.–1300 A.D.* Washington, D.C.: National Gallery of Art, 1985.

Czuma, Stanisław J. *Kushan Sculpture: Images from Early India*. Cleveland: Cleveland Museum of Art, 1985.

Dehejia, Vidya. *Art of the Imperial Cholas*. New York: Columbia Univ. Press, 1990.

———. *Early Buddhist Rock Temples*. Ithaca: Cornell Univ. Press, 1972.

Dessai, Vishakha N., and Darielle Mason, eds. *Gods, Guardians, and Lovers: Temple Sculptures from North India, A.D. 700–1200*. New York: Asia Society Galleries, 1993.

Dimmitt, Cornelia. *Classical Hindu Mythology*. Philadelphia: Temple Univ. Press, 1978.

Eck, Diana L. *Darsan. Seeing the Divine Image in India*. 3rd. ed. Chambersburg, PA: Anima, 1998.

Gupta, S. P. *The Roots of Indian Art: A Detailed Study of the Formative Period of Indian Art and Architecture, Third and Second Centuries B.C., Mauryan and Late Mauryan*. Delhi: B. T. Pub. Corp., 1980.

Harle, J. C. *Gupta Sculpture*. Oxford: Clarendon, 1974.

Huntington, Susan L. *The Arts of Ancient India: Buddhist, Hindu, Jain*. New York: Weatherhill, 1985.

———. *Leaves from the Bodhi Tree: The Art of Pala India (8th–12th Centuries) and Its International Legacy*. Dayton, OH: Dayton Art Institute, 1990.

Hutt, Michael. *Nepal. A Guide to the Art and Architecture of the Kathmandu Valley*. Boston: Shambala, 1995.

Knox, Robert. *Amaravati: Buddhist Sculpture from the Great Stupa*. London: British Museum, 1992.

Kramrisch, Stella. *The Art of Nepal*. New York: Abrams, 1964.

———. *Presence of Siva*. Princeton: Princeton Univ. Press, 1981.

Meister, Michael, ed. *Discourses on Siva: On the Nature of Religious Imagery*. Philadelphia: Univ. of Pennsylvania Press, 1984.

———. *Encyclopedia of Indian Temple Architecture*. 2 vols. in 7. Philadelphia: Univ. of Pennsylvania Press, 1983.

Flaherty, Wendy. *Hindu Myths*. Harmondsworth, Eng.: Penguin, 1975.

Pal, Pratapaditya, ed. Aspects of Indian Art. Leiden: Brill, 1972.

———. *The Ideal Image: The Gupta Sculptural Tradition and Its Influence*. New York: Asia Society, 1978.

Possehl, Gregory, ed. *Ancient Cities of the Indus*. Durham, NC: Carolina Academic, 1979.

———. *Harappan Civilization: A Recent Perspective*. 2nd ed. New Delhi: American Institute of Indian Studies, 1993.

Poster, Amy G. *From Indian Earth: 4,000 Years of Terracotta Art*. Brooklyn: Brooklyn Museum, 1986.

Rosenfield, John M. *The Dynastic Arts of the Kushans.* California Studies in the History of Art. Berkeley: Univ. of California Press, 1967.

Sankalia, H. D. *Prehistoric Art in India.* Durham, N.C.: Carolina Academic Press, 1978.

Shearer, Alistair. *Upanishads.* New York: Harper & Row, 1978.

Skelton, Robert, and Mark Francis. *Arts of Bengal: The Heritage of Bangladesh and Eastern India.* London: Whitechapel Gallery, 1979.

Thapar, Romila. *Asoka and the Decline of the Mauryas.* Rev. ed. Delhi: Oxford, 1997.

———, and Percival Spear. *History of India.* London: Penguin, 1990.

Weiner, Sheila L. *Ajanta: Its Place in Buddhist Art.* Berkeley: Univ. of California Press, 1977.

Williams, Joanna G. *Art of Gupta India, Empire and Province.* Princeton: Princeton Univ. Press, 1982.

CHAPTER 10 Chinese Art before 1280

The Art Treasures of Dunhuang. Hong Kong: Joint, 1981.

Barnhart, Richard. *Along the Border of Heaven: Sung and Yuan Painting from the C. C. Wang Family Collection.* New York: Metropolitan Museum of Art, 1983.

Billeter, Jean François. *The Chinese Art of Writing.* New York: Skira/Rizzoli, 1990.

Cahill, James. *Art of Southern Sung China.* New York: Asia Society, 1962.

———. *Index of Early Chinese Painters and Paintings: T'ang, Sung, and Yuan.* Berkeley: Univ. of California Press, 1980.

De Silva, Anil. *The Art of Chinese Landscape Painting: In the Caves of Tun-huang.* Art of the World. New York: Crown, 1967.

Fong, Wen, ed. *Beyond Representation: Chinese Painting and Calligraphy, 8th–14th Century.* Princeton Monographs in Art and Archaeology. New York: Metropolitan Museum of Art, 1992.

———. *The Great Bronze Age of China: An Exhibition from the People's Republic of China.* New York: Metropolitan Museum of Art, 1980.

Fong, Wen, and Marilyn Fu. *Sung and Yuan Paintings.* New York: New York Graphic Society, 1973.

Gridley, Marilyn Leidig. *Chinese Buddhist Sculpture under the Liao: Free Standing Works in Situ and Selected Examples from Public Collections.* New Delhi: International Academy of Indian Culture, 1993.

Ho, Wai-kam, et al. *Eight Dynasties of Chinese Painting: The Collections of the Nelson Gallery-Atkins Museum, Kansas City, and the Cleveland Museum of Art.* Cleveland: Cleveland Museum of Art, 1980.

James, Jean M. *A Guide to the Tomb and Shrine Art of the Han Dynasty 206 B.C.– A.D. 220.* Chinese Studies; 2. Lewiston: E. Mellen Press, 1996.

Juliano, Annette L. *Art of the Six Dynasties: Centuries of Change and Innovation.* New York: China House Gallery, 1975.

Karetzky, Patricia Eichenbaum. *Court Art of the Tang.* Lantham: Univ. Press of America, 1996.

Lawton, Thomas. *Chinese Art of the Warring States Period: Change and Continuity, 480–222 B.C.* Washington, D.C.: Freer Gallery of Art, Smithsonian Institution, 1982.

———. *Chinese Figure Painting.* Washington, D.C.: Smithsonian Institution, 1973.

Lim, Lucy. *Stories from China's Past: Han Dynasty Pictorial Tomb Reliefs and Archaeological Objects from Sichuan Province, People's Republic of China.* San Francisco: Chinese Culture Foundation, 1987.

Ma, Ch'eng-yuan. *Ancient Chinese Bronzes.* Ed. Hsio-Yen Shih. Hong Kong: Oxford Univ. Press, 1986.

Munakata, Kiyohiko. *Sacred Mountains in Chinese Art.* Champaign: Krannert Art Museum, Univ. of Illinois, 1991.

Paludan, Ann. *Chinese Spirit Road: The Classical Tradition of Stone Tomb Sculpture.* New Haven: Yale Univ. Press, 1991.

———. *Chinese Tomb Figurines.* Hong Kong: Oxford Univ. Press, 1994.

Powers, Martin J. *Art and Political Expression in Early China.* New Haven: Yale Univ. Press, 1991.

Rawson, Jessica. *Ancient China: Art and Archaeology.* London: British Museum, 1980.

———. *Mysteries of Ancient China: New Discoveries from the Early Dynasties.* London: British Museum Press, 1996.

Rhie, Marylin M. *Early Buddhist Art of China and Central Asia.* Handbuch der Orientalistik. Vierte Abteinlung. China; 12. Leiden: Brill, 1999-.

Watson, William. *Ancient Chinese Bronzes.* 2nd ed. The Arts of the East. London: Faber and Faber, 1977.

———. *The Arts of China to AD 900.* Pelican History of Art. New Haven: Yale Univ. Press, 1995.

Weidner, Marsha, ed. *Latter Days of the Law: Images of Chinese Buddhism, 850–1850.* Lawrence: Spencer Museum of Art, Univ. of Kansas, 1994.

Whitfield, Roderick, and Anne Farrer. *Caves of the Thousand Buddhas: Chinese Art from the Silk Route.* London: British Museum, 1990.

Wu Hung. *Monumentality in Early Chinese Art and Architecture.* Stanford: Stanford Univ. Press, 1995.

CHAPTER 11 Japanese Art before 1392

Cunningham, Michael R. *Buddhist Treasures from Nara.* Cleveland: Cleveland Museum of Art, 1998.

Kidder, J. Edward. *Early Buddhist Japan.* Ancient People and Places. New York: Praeger, 1972.

———. *Early Japanese Art: The Great Tombs and Treasures.* Princeton: Van Nostrand, 1964.

———. *Japanese Temples: Sculpture, Paintings, Gardens, and Architecture.* London: Thames and Hudson, 1964.

———. *Prehistoric Japanese Arts: Jomon Pottery.* Tokyo: Kodansha International, 1968.

Kurata, Bunsaku. *Horyu-ji, Temple of the Exalted Law: Early Buddhist Art from Japan.* New York: Japan Society, 1981.

LaMarre, Thomas. *Uncovering Heian Japan: An Archaeology of Sensation and Inscription.* Asia-Pacific. Durham, NC: Duke Univ. Press, 2000.

Miki, Fumio. *Haniwa.* Trans. and adapted by Gino Lee Barnes. Arts of Japan, 8. New York: Weatherhill, 1974.

Mino, Yutaka. *The Great Eastern Temple: Treasures of Japanese Buddhist Art from Todai ji.* Chicago: Art Institute of Chicago, 1986.

Murase, Miyeko. *Iconography of the Tale of Genji: Genji Monogatari Ekotoba.* New York: Weatherhill, 1983.

Nishiwara, Kyotaro, and Emily J. Sano. *The Great Age of Japanese Buddhist Sculpture, A.D. 60–1300.* Fort Worth, TX: Kimbell Art Museum, 1982.

Okudaira, Hideo. *Narrative Picture Scrolls.* Trans. Elizabeth ten Grutenhuis. Arts of Japan, 5. New York: Weatherhill, 1973.

Pearson, Richard J. *Ancient Japan.* Washington, D.C.: Sackler Gallery, 1992.

Rosenfield, John M., Fumiko E. Cranston, and Edwin A. Cranston. *The Courtly Tradition in Japanese Art and Literature: Selections from the Hofer and Hyde Collections.* Cambridge: Fogg Art Museum, Harvard Univ., 1973.

———. *Japanese Arts of the Heian Period: 794–1185.* New York: Asia Society, 1967.

Soper, Alexander Coburn. *Evolution of Buddhist Architecture in Japan.* Princeton Monographs in Art and Archaeology, no. 22. New York: Hacker Art, 1978.

Swann, Peter. *The Art of Japan: From the Jomon to the Tokugawa Period.* Art of the World. New York: Crown, 1966.

CHAPTER 12 Art of the Americas before 1300

Abel-Vidor, Suzanne. *Between Continents/Between Seas: Precolumbian Art of Costa Rica.* New York: Abrams, 1981.

Abrams, Elliot Marc. *How the Maya Built Their World: Energetics and Ancient Architecture.* Austin: Univ. of Texas Press, 1994.

Alcina Franch, José. *Pre-Columbian Art.* Trans. I. Mark Paris. New York: Abrams, 1983.

Anton, Ferdinand. *Art of the Maya.* Trans. Mary Whitall. London: Thames and Hudson, 1970.

Benson, Elizabeth P., and Beatriz de la Fuente. *Olmec Art of Ancient Mexico.* Washington, D.C.: National Gallery of Art, 1996.

Berrin, Kathleen, ed. *Feathered Serpents and Flowering Trees: Reconstructing the Murals of Teotihuacan.* San Francisco: Fine Arts Museums of San Francisco, 1988.

———, and Esther Pasztory. *Teotihuacan: Art from the City of the Gods.* New York: Thames and Hudson, 1993.

Brody, J. J. *The Anasazi: Ancient Indian People of the American Southwest.* New York: Rizzoli, 1990.

———. *Anasazi and Pueblo Painting.* Albuquerque: Univ. of New Mexico Press, 1991.

Coe, Michael D. *The Jacquar's Children: Pre-Classical Central Mexico.* New York: Museum of Primitive Art, 1965.

Coe, Ralph T. *Sacred Circles: Two Thousand Years of North American Indian Art.* London: Arts Council of Great Britain, 1976.

Donnan, Christopher B. *Ceramics of Ancient Peru.* Los Angeles: Fowler Museum of Cultural History, Univ. of California, 1992.

———. *Moche Art of Peru: Pre-Columbian Symbolic Communication.* Rev. ed. Los Angeles: Fowler Museum of Cultural History, Univ. of California, 1978.

Fash, William Leonard. *Scribes, Warriors, and Kings: The City of Copan and the Ancient Maya.* London: Thames and Hudson, 1991.

Fewkes, Jesse Walter. *The Mimbres: Art and Archaeology.* Albuquerque: Avanyu, 1989.

Frazier, Kendrick. *People of Chaco: A Canyon and Its Culture.* Rev. & updated ed. New York: Norton, 1999.

Herreman, Frank. *Power of the Sun: The Gold of Colombia.* Antwerp: City of Antwerp, 1993.

Heyden, Doris, and Paul Gendrop. *Pre-Columbian Architecture of Mesoamerica.* Trans. Judith Stanton. History of World Architecture. New York: Electa/Rizzoli, 1988.

Korp, Maureen. *The Sacred Geography of the American Mound Builders.* Native American Studies. Lewiston, NY: Mellen, 1990.

Kubler, George. *The Art and Architecture of Ancient America: The Mexican, Maya, and Andean Peoples.* 3rd ed. Pelican History of Art. New Haven: Yale Univ. Press, 1990.

———. *Esthetic Recognition of Ancient Amerindian Art.* Yale Publications in the History of Art. New Haven: Yale Univ. Press, 1991.

Longhena, Maria. *Ancient Mexico: The History and Culture of the Maya, Aztecs, and Other Pre-Columbian Peoples.* Trans. Neil Frazer Davenport. New York: Stewart, Tabori & Chang, 1998.

Miller, Mary Ellen. *The Art of Mesoamerica: From Olmec to Aztec.* Rev. ed. World of Art. New York: Thames and Hudson, 1996.

———. *Maya Art and Architecture.* World of Art. London: Thames and Hudson, 1999.

———, and Karl Taube. *The Gods and Symbols of Ancient Mexico and the Maya: An Illustrated Dictionary of Mesoamerican Religion.* New York: Thames and Hudson, 1993.

Moseley, Michael. *The Incas and Their Ancestors: The Archaeology of Peru.* London: Thames and Hudson, 1992.

Pang, Hildegard Delgado. *Pre-Columbian Art: Investigations and Insights.* Norman: Univ. of Oklahoma Press, 1992.

Pasztory, Esther. *Pre-Columbian Art.* Cambridge: Cambridge Univ. Press, 1998.

Paul, Anne. *Paracas Art and Architecture: Object and Context in South Coastal Peru.* Iowa City: Univ. of Iowa Press, 1991.

Schele, Linda, and David Freidel. *A Forest of Kings: The Untold Story of the Ancient Maya.* New York: Morrow, 1990.

Schele, Linda, and Mary Ellen Miller. *The Blood of Kings: Dynasty and Ritual in Maya Art.* New York: Braziller, 1986.

Stone-Miller, Rebecca. *Art of the Andes: From Chavin to Inca.* World of Art. New York: Thames and Hudson, 1996.

———. *To Weave for the Sun: Andean Textiles in the Museum of Fine Arts, Boston.* Boston: Museum of Fine Arts, 1992.

Townsend, Richard, ed. *The Ancient Americas: Art from Sacred Landscapes.* Chicago: Art Institute of Chicago, 1992.

———. *The Aztecs.* 2nd rev. ed. Ancient Peoples and Places. London: Thames and Hudson, 2000.

Wuthenau, Alexander von. *The Art of Terracotta Pottery in Pre-Columbian Central and South America.* Art of the World. New York: Crown, 1970.

CHAPTER 13 Art of Ancient Africa

Bassani, Ezio, and William Fagg. *Africa and the Renaissance: Art in Ivory.* New York: Center for African Art, 1988.

Ben-Amos, Paula. *The Art of Benin.* Rev. ed. Washington, D.C.: Smithsonian Institution Press, 1995.

———, and Arnold Rubin. *The Art of Power, the Power of Art: Studies in Benin Iconography.* Monograph Series, no. 19. Los Angeles: Fowler Museum of Cultural History, Univ. of California, 1983.

Cole, Herbert M. *Igbo Arts: Community and Cosmos.* Los Angeles: Fowler Museum of Cultural History, Univ. of California, 1984.

Connah, Graham. *African Civilizations: Precolonial Cities and States in Africa: An Archaeological Perspective.* Cambridge: Cambridge Univ. Press, 1987.

Eyo, Ekpo, and Frank Willett. *Treasures of Ancient Nigeria.* Ed. Rollyn O. Kirchbaum. New York: Knopf, 1980.

Ezra, Kate. *Royal Art of Benin: The Perls Collection in the Metropolitan Museum of Art.* New York: Metropolitan Museum of Art, 1992.

Fagg, Bernard. *Nok Terracottas.* Lagos: Ethnographica, 1977.

Garlake, Peter S. *Great Zimbabwe.* London: Thames and Hudson, 1973.

———. *The Hunter's Vision: The Prehistoric Art of Zimbabwe.* Seattle: Univ. of Washington Press, 1995.

Huffman, Thomas N. *Symbols in Stone: Unravelling the Mystery of Great Zimbabwe.* Johannesburg: Witwatersrand Univ. Press, 1987.

Lhote, Henri. *The Search for the Tassili Frescoes: The Story of the Prehistoric Rock-Paintings of the Sahara.* 2nd ed. Trans. Alan Houghton Brodrick. London: Hutchinson, 1973.

Shaw, Thurstan. *Unearthing Igbo-Ukwu: Archaeological Discoveries in Eastern Nigeria.* New York: Oxford Univ. Press, 1977.

Willcox, A. R. *The Rock Art of Africa.* London: Croon Helm, 1984.

Willett, Frank. *Ife in the History of West African Sculpture.* New York: McGraw-Hill, 1967.

CHAPTER 14 Early Medieval Art in Europe

Alexander, J. J. G. *Medieval Illuminators and Their Methods of Work.* New Haven: Yale Univ. Press, 1992.

Art of Medieval Spain, A.D. 500-1200, The. New York: Metropolitan Museum of Art, 1993.

Backes, Magnus, and Regine Dolling. *Art of the Dark Ages.* Trans. Francisca Garvie. *Panorama of World Art.* New York: Abrams, 1971.

Backhouse, Janet, D. H. Turner, and Leslie Webster. *The Golden Age of Anglo-Saxon Art, 966-1066.* Bloomington: Indiana Univ. Press, 1984.

Beckwith, John. *Early Medieval Art: Carolingian, Ottonian, Romanesque.* World of Art. New York: Oxford Univ. Press, 1974.

Cahn, Walter. *Romanesque Bible Illumination.* Ithaca: Cornell Univ. Press, 1982.

———. *Romaesque Manuscripts: The Twelfth Century.* 2 vols. A Survey of Manuscripts Illuminated in France. London: H. Miller, 1996.

Calkins, Robert G. *Illuminated Books of the Medieval Ages.* Ithaca: Cornell Univ. Press, 1983.

Davis-Weyer, Caecilia. *Early Medieval Art, 300-1150: Sources and Documents.* Upper Saddle River, NJ: Prentice Hall, 1971.

Dodds, Jerrilynn D. *Architecture and Ideology in Early Medieval Spain.* University Park: Pennsylvania State Univ. Press, 1990.

Dodwell, C. R. *Pictorial Art of the West 800-1200.* Yale Univ. Press Pelican History of Art. New Haven: Yale Univ. Press, 1993.

Eco, Umberto. *Art and Beauty in the Middle Ages.* Trans. Hugh Bredin. New Haven: Yale Univ. Press, 1986.

Evans, Angela Care. *The Sutton Hoo Ship Burial.* Rev. ed. London: British Museum, 1994.

Farr, Carol. *The Book of Kells: Its Function and Audience.* London: British Library, 1997.

Fergusson, Peter. *Architecture of Solitude: Cistercian Abbeys in Twelfth-Century England.* Princeton: Princeton Univ. Press, 1984.

Fernie, E. C. *The Architecture of the Anglo-Saxons.* London: Batsford, 1983.

Fitzhugh, William W. , and Elisabeth I. Ward, eds. *Vikings: The North Atlantic Saga.* Washington, D.C.: Smithsonian Institution Press, 2000.

Harbison, Peter. *The Golden Age of Irish Art: The Medieval Achievement, 600-1200.* London: Thames and Hudson, 1998.

Henderson, George. *Early Medieval.* Style and Civilization. Harmondsworth, Eng.: Penguin, 1972.

———. *From Durrow to Kells: The Insular Gospel-Books, 650-800.* London: Thames and Hudson, 1987.

Horn, Walter W., and Ernest Born. *Plan of Saint Gall: A Study of the Architecture and Economy of and Life in a Paradigmatic Carolingian Monastery.* 3 vols. California Studies in the History of Art. Berkeley: Univ. of California Press, 1979.

Hubert, Jean, Jean Porcher, and W. F. Volbach. *Carolingian Renaissance.* Arts of Mankind. New York: Braziller, 1970.

———. *Europe of the Invasions.* Trans. Stuart Gilbert and James Emmons. Arts of Mankind. New York: Braziller, 1969.

Lasko, Peter. *Ars Sacra, 800-1200.* 2nd ed. Pelican History of Art. New Haven: Yale Univ. Press, 1994.

Mayr-Harting, Henry. *Ottonian Book Illumination: An Historical Study.* 2 vols. 2nd rev. ed. London: Harvey Miller, 1999.

Nordenfalk, Carl Adam Johan. *Early Medieval Book Illumination.* New York: Rizzoli, 1988.

Palol, Pedro de, and Max Hirmer. *Early Medieval Art in Spain.* Trans. Alisa Jaffa. London: Thames and Hudson, 1967.

Richardson, Hilary, and John Scarry. *An Introduction to Irish High Crosses.* Dublin: Mercier, 1990.

Stalley, R.A. *Early Medieval Architecture.* Oxford History of Art. Oxford: Oxford Univ. Press, 1999.

Tschan, Francis Joseph. *Saint Bernward of Hildesheim.* 3 vols. Notre Dame, IN: The Univ. of Notre Dame, 1942.

Verzone, Paola. *The Art of Europe: The Dark Ages from Theodoric to Charlemagne.* Art of the World. New York: Crown, 1968.

Williams, John. *Early Spanish Manuscript Illumination.* New York: Braziller, 1977.

Wilson, David M. *Anglo-Saxon Art: From the Seventh Century to the Norman Conquest.* London: Thames and Hudson, 1984.

———, and Ole Klindt-Jensen. *Viking Art.* 2nd ed. Minneapolis: Univ. of Minnesota Press, 1980.

CHAPTER 15 Romanesque Art

Armi, C. Edson. *Masons and Sculptors in Romanesque Burgundy: The New Aesthetics of Cluny III.* 2 vols. University Park: Pennsylvania State Univ. Press, 1983.

Barral I Altet, Xavier. *The Romanesque: Towns, Cathedrals and Monasteries.* Taschen's World Architecture. New York: Taschen, 1998.

Braunfels, Wolfgang. *Monasteries of Western Europe: The Architecture of the Orders.* Trans. Alastair Laing. New York: Thames and Hudson, 1993.

Busch, Harald, and Bernd Lohse. *Romanesque Sculpture.* London: Batsford, 1962.

Cahn, Walter. *Romanesque Bible Illumination.* Ithaca: Cornell Univ. Press, 1982.

Evans, Joan. *Cluniac Art of the Romanesque Period.* Cambridge: Cambridge Univ. Press, 1950.

Focillon, Henri. *The Art of the West in the Middle Ages.* 2 vols. Ed. Jean Bony. Trans. Donald King. London: Phaidon, 1963.

Forsyth, Ilene H. *The Throne of Wisdom: Wood Sculptures of the Madonna in Romanesque France.* Princeton: Princeton Univ. Press, 1972.

Gantner, Joseph, and Marvel Pobe. *Romanesque Art in France.* London: Thames and Hudson, 1956.

Grape, Wolfgang. *The Bayeux Tapestry: Monument to a Norman Triumph.* New York: Prestel, 1994.

Hearn, M. F. *Romanesque Sculpture: The Revival of Monumental Stone Sculptures in the Eleventh and Twelfth Centuries.* Ithaca: Cornell Univ. Press, 1981.

Jacobs, Michael. *Northern Spain: The Road to Santiago de Compostela.* Architectural Guides for Travelers. San Francisco: Chronicle, 1991.

Kennedy, Hugh. *Crusader Castles.* Cambridge: Cambridge Univ. Press, 1994.

Kubach, Hans Erich. *Romanesque Architecture.* History of World Architecture. New York: Electa/Rizzoli, 1988.

Kuhnel, Biana. *Crusader Art of the Twelfth Century: A Geographical, and Historical, or an Art Historical Notion?* Berlin: Gebr. Mann, 1994.

Kunstler, Gustav. *Romanesque Art in Europe.* Greenwich, CT: New York Graphic Society, 1969.

Little, Bryan D. G. *Architecture in Norman Britain.* London: Batsford, 1985.

Mâle, Emile. *Religious Art in France, the Twelfth Century: A Study of the Origins of Medieval Iconography.* Bollingen Series. Princeton: Princeton Univ. Press, 1978.

Nebosine, George A. *Journey into Romanesque: A Traveller's Guide to Romanesque Monuments in Europe.* Ed. Robyn Cooper. London: Weidenfeld and Nicolson, 1969.

Norton, Christopher, and David Park. *Cistercian Art and Architecture in the British Isles.* Cambridge: Cambridge Univ. Press, 1986.

Petzold, Andreas. *Romanesque Art.* Perspectives. New York: Abrams, 1995.

Radding, Charles M., and William W. Clark. *Medieval Architecture, Medieval Learning: Builders and Masters in the Age of Romanesque and Gothic.* New Haven: Yale Univ. Press, 1992.

Schapiro, Meyer. *Romanesque Art.* New York: Braziller, 1977.

———. *The Romanesque Sculpture of Moissac.* New York: Braziller, 1985.

Stones, Alison, and Jeanne Krochalis, Paula Gerson, and Annie Shaver-Crandell. *The Pilgrim's Guide: A Critical Edition.* 2 vols. London: Harvey Miller, 1998.

Swarzenski, Hanns. *Monuments of Romanesque Art: The Art of Church Treasures of North-Western Europe.* 2nd ed. Chicago: Univ. of Chicago Press, 1967.

Tate, Robert Brian, and Marcus Tate. *The Pilgrim Route to Santiago.* Oxford: Phaidon, 1987.

Wilson, David M. *The Bayeux Tapestry: The Complete Tapestry in Color.* New York: Random House, 1985.

The Year 1200. 2 vols. New York: Metropolitan Museum of Art, 1970.

Zarnecki, George. *Romanesque Art.* New York: Universe, 1971.

———, Janet Holt, and Tristam Holland. *English Romanesque Art, 1066-1200.* London: Weidenfeld and Nicolson, 1984.

CHAPTER 16 Gothic Art

Alexander, Jonathan, and Paul Binski, eds. *Age of Chivalry: Art in Plantagenet England, 1200-1400.* London: Royal Academy of Arts, 1987.

Andrews, Francis B. *The Mediaeval Builder and His Methods.* New York: Barnes & Noble, 1993.

Armi, C. Edson. *The "Headmaster" of Chartres and the Origins of "Gothic" Sculpture.* University Park: Pennsylvania State Univ. Press, 1994.

Aubert, Marcel. *The Art of the High Gothic Era.* Rev. ed. Art of the World. New York: Greystone, 1966.

Binski, Paul. *Medieval Craftsmen: Painters.* London: British Museum, 1991.

Bony, Jean. *French Gothic Architecture of the 12th and 13th Centuries.* California Studies in the History of Art. Berkeley: Univ. of California Press, 1983.

Borsook, Eve, and Fiorella Superbi Gioffredi. *Italian Altarpieces, 1250-1550: Function and Design.* Oxford: Clarendon, 1994.

Branner, Robert. *Manuscript Painting in Paris during the Reign of Saint Louis: A Study of Styles.* California Studies in the History of Art. Berkeley: Univ. of California Press, 1977.

Camille, Michael. *Gothic Art: Glorious Visions.* Perspectives. New York: Abrams, 1996.

Coe, Brian. *Stained Glass in England, 1150-1550.* London: Allen, 1981.

Crosby, Sumner McKnight. *The Royal Abbey of Saint-Denis from Its Beginnings to the Death of Suger, 475-1151.* Yale Publications in the History of Art. New Haven: Yale Univ. Press, 1987.

Erlande-Brandenburg, Alain. *Gothic Art.* Trans. I. Mark Paris. New York: Abrams, 1989.

———. *Notre-Dame de Paris.* New York: Abrams, 1998.

Favier, Jean. *The World of Chartres.* Trans. Francisca Garvie. New York: Abrams, 1990.

Franklin, J. W. *Cathedrals of Italy.* London: Batsford, 1958.

Frisch, Teresa G. *Gothic Art, 1140-c. 1450: Sources and Documents.* Upper Saddle River, NJ: Prentice Hall, 1971.

Grodecki, Louis. *Gothic Architecture.* Trans. I. Mark Paris. History of World Architecture. New York: Electa/Rizzoli, 1985.

———, and Catherine Brisac. *Gothic Stained Glass, 1200-1300.* Ithaca: Cornell Univ. Press, 1985.

Mâle, Emile. *Religious Art in France, the Thirteenth Century: A Study of Medieval Iconography and Its Sources.* Princeton: Princeton Univ. Press, 1984.

Martindale, Andrew. *Gothic Art.* World of Art. London: Thames and Hudson, 1967.

McIntyre, Anthony. *Medieval Tuscany and Umbria.* Architectural Guides for Travellers. San Francisco: Chronicle, 1992.

Metropolitan Museum of Art, The. *The Secular Spirit: Life and Art at the End of the Middle Ages.* New York: Dutton, 1975.

O'Neill, John Philip, ed. *Enamels of Limoges: 1100-1350.* Trans. Sophie Hawkes, Joachim Neugroschel, and Patricia Stirneman. New York: Metropolitan Museum of Art, 1996.

Panofsky, Erwin. *Abbot Suger on the Abbey Church of St.-Denis and Its Art Treasures.* 2nd ed. Ed. Gerda Panofsky-Soergel. Princeton: Princeton Univ. Press, 1979.

———. *Gothic Architecture and Scholasticism.* Latrobe, PA: Archabbey, 1951.

Pevsner, Nikolas, and Priscilla Metcalf. *The Cathedrals of England.* 2 vols. Harmondsworth, Eng.: Viking, 1985.

Pope-Hennessy, John. *Italian Gothic Sculpture.* 3rd ed. Oxford: Phaidon, 1986.

Sauerlander, Willibald. *Gothic Sculpture in France, 1140-1270.* Trans. Janet Sandheimer. London: Thames and Hudson, 1972.

Scott, Kathleen L. *Later Gothic Manuscripts, 1390-1490.* 2 vols. A Survey of Manuscripts Illuminated in the British Isles; 6. London: H. Miller, 1996.

Simson, Otto Georg von. *The Gothic Cathedral: Origins of Gothic Architecture and the Medieval Concept of Order.* 3rd ed. Bollingen Series. Princeton: Princeton Univ. Press, 1988.

Smart, Alastair. *The Dawn of Italian Painting, 1250-1400.* Ithaca: Cornell Univ. Press, 1978.

White, John. *Art and Architecture in Italy, 1250 to 1400.* 3rd ed. Pelican History of Art. Harmondsworth, Eng.: Penguin, 1993.

Wieck, Roger S. *Time Sanctified: The Book of Hours in Medieval Art and Life.* New York: Braziller, 1988.

Williamson, Paul. *Gothic Sculpture 1140-1300.* Pelican History of Art. New Haven: Yale Univ. Press, 1995.

Wilson, Christopher. *The Gothic Cathedral: The Architecture of the Great Church, 1130-1530.* New York: Thames and Hudson, 1990.

CHAPTER 17 Early Renaissance Art in Europe

Alexander, J.J.G. *The Painted Page: Italian Renaissance Book Illumination, 1450-1550.* Munich: Prestel, 1994.

Ames-Lewis, Francis. *Drawing in Early Renaissance Italy.* New Haven: Yale Univ. Press, 2000.

———. *The Intellectual Life of the Early Renaissance Artist.* New Haven: Yale Univ. Press, 2000.

Baxandall, Michael. *Painting and Experience in Fifteenth-Century Italy: A Primer in the Social History of Pictorial Style.* Oxford: Clarendon, 1972.

Blum, Shirley. *Early Netherlandish Triptychs: A Study in Patronage.* California Studies in the History of Art. Berkeley: Univ. of California Press, 1969.

Campbell, Lorne. *Renaissance Portraits: European Portrait-Painting in the 14th, 15th, and 16th Centuries.* New Haven: Yale Univ. Press, 1990.

Cavallo, Adolph S. *The Unicorn Tapestries at the Metropolitan Museum of Art.* New York: The Museum, 1998.

Chastel, André. *The Flowering of the Italian Renaissance.* Trans. Jonathan Griffin. Arts of Mankind. New York: Odyssey, 1965.

——. *French Art: The Renaissance, 1430-1620.* Paris: Flammarion, 1995.

——. *Studios and Styles of the Italian Renaissance.* Trans. Jonathan Griffin. Arts of Mankind. New York: Odyssey, 1966.

Christianity and the Renaissance: Image and Religious Imagination in the Quattrocento. Syracuse, NY: Syracuse Univ. Press, 1990.

Christiansen, Keith, Laurence B. Kanter, and Carl Brandon Strehlke. *Painting in Renaissance Siena, 1420-1500.* New York: Metropolitan Museum of Art, 1988.

Christine, de Pisan. *The Book of the City of Ladies.* Trans. Rosalind Brown-Grant. London: Penguin Books, 1999.

Flanders in the Fifteenth Century: Art and Civilization. Detroit: Detroit Institute of Arts, 1960.

Gilbert, Creighton, ed. *Italian Art, 1400-1500: Sources and Documents.* Evanston: Northwestern Univ. Press, 1992.

Heydenreich, Ludwig Heinrich. *Architecture in Italy 1400-1500.* Rev. Paul Davies. Pelican History of Art. New Haven: Yale Univ. Press, 1996.

Hind, Arthur M. *An Introduction to a History of Woodcut.* New York: Dover, 1963.

Huizinga, Johan. *The Autumn of the Middle Ages.* Trans. Rodney J. Payton and Ulrich Mammitzsch. Chicago: Univ. of Chicago Press, 1996.

Lane, Barbara G. *The Altar and the Altarpiece: Sacramental Themes in Early Netherlandish Painting.* New York: Harper & Row, 1984.

Levey, Michael. *Early Renaissance.* Harmondsworth, Eng.: Penguin, 1967.

Meiss, Millard. *French Painting in the Time of Jean de Berry: Muller, Theodor. Sculpture in the Netherlands, Germany, France, and Spain: 1400-1500.* Trans. Elaine and William Robson Scott. Pelican History of Art. Harmondsworth, Eng.: Penguin, 1966.

Pacht, Otto. *Early Netherlandish Painting: From Rogier van der Weyden to Gerard David.* Ed. Monika Rosenauer. Tran. David Britt. London: Harvey Miller, 1997.

Panofsky, Erwin. *Early Netherlandish Painting: Its Origins and Character.* 2 vols. Cambridge: Harvard Univ. Press, 1966.

Plummer, John. *The Last Flowering: French Painting in Manuscripts, 1420-1530, from American Collections.* New York: Pierpont Morgan Library, 1982.

Seymour, Charles. *Sculpture in Italy, 1400-1500.* Pelican History of Art. Harmondsworth, Eng.: Penguin, 1966.

Snyder, James. *Northern Renaissance Art: Painting, Sculpture, the Graphic Arts from 1350 to 1575.* New York: Abrams, 1985.

Welch, Evelyn S. *Art and Society in Italy, 1350-1500.* Oxford History of Art. Oxford: Oxford Univ. Press, 1997.

CHAPTER 18 Renaissance Art in Sixteenth-Century Europe

Baxandall, Michael. *The Limewood Sculptors of Renaissance Germany.* New Haven: Yale Univ. Press, 1980.

Bosquet, Jacques. *Mannerism: The Painting and Style of the Late Renaissance.* Trans. Simon Watson Taylor. New York: Braziller, 1964.

Chastel, André. *The Age of Humanism: Europe, 1480-1530.* Trans. Katherine M. Delavenay and E. M. Gwyer. London: Thames and Hudson, 1963.

Chelazzi Dini, Giulietta, Alessandro Angelini, and Bernardina Sani. *Sienese Painting: From Duccio to the Birth of the Baroque.* New York: Abrams, 1998.

Cole, Alison. *Virtue and Magnificence: Art of the Italian Renaissance Courts.* Perspectives. New York: Abrams, 1995.

Farmer, John David. *The Virtuoso Craftsman: Northern European Design in the Sixteenth Century.* Worcester, MA: Worcester Art Museum, 1969.

Freedberg, S. J. *Painting in Italy, 1500 to 1600.* 3rd ed. Pelican History of Art. New Haven: Yale Univ. Press, 1993.

Hayum, André. *The Isenheim Altarpiece: God's Medicine and the Painter's Vision.* Princeton Essays on the Arts. Princeton: Princeton Univ. Press, 1989.

Hollingsworth, Mary. *Patronage in Sixteenth Century Italy.* London: Murray, 1996.

Huse, Norbert, and Wolfgang Wolters. *Art of Renaissance Venice: Architecture, Sculpture and Painting, 1460-1590.* Trans. Edmund Jephcott. Chicago: Univ. of Chicago Press, 1990.

Klein, Robert, and Henri Zerner. *Italian Art, 1500-1600: Sources and Documents.* Upper Saddle River, NJ: Prentice Hall, 1966.

Kubler, George. *Building the Escorial.* Princeton: Princeton Univ. Press, 1982.

Landau, David, and Peter Parshall. *The Renaissance Print: 1470-1550.* New Haven: Yale Univ. Press, 1994.

Lazzaro, Claudia. *The Italian Renaissance Garden: From the Conventions of Planting, Design, and Ornament to the Grand Gardens of Sixteenth-Century Central Italy.* New Haven: Yale Univ. Press, 1990.

Lieberman, Ralph. *Renaissance Architecture in Venice, 1450-1540.* New York: Abbeville, 1982.

Lotz, Wolfgang. *Architecture in Italy, 1500-1600.* Pelican History of Art. Rev. Deborah Howard. New Haven: Yale Univ. Press, 1995.

Mann, Nicholas, and Luke Syson, eds. *The Image of the Individual: Portraits in the Renaissance.* London: British Museum Press, 1998.

Martineau, Jane, and Charles Hope. *The Genius of Venice, 1500-1600.* New York: Abrams, 1984.

Murray, Linda. *The High Renaissance and Mannerism: Italy, the North and Spain, 1500-1600.* World of Art. London: Thames and Hudson, 1995.

Olson, Roberta J. M. *Italian Renaissance Sculpture.* World of Art. New York: Thames and Hudson, 1992.

Osten, Gert von der, and Horst Vey. *Painting and Sculpture in Germany and the Netherlands, 1500-1600.* Pelican History of Art. Harmondsworth, Eng.: Penguin, 1969.

Paoletti, John T, and Gary M. Radke. *Art in Renaissance Italy,* 2nd ed. Upper Saddle River, NJ: Prentice Hall, 2001.

Pietrangeli, Carlo, et al. *The Sistine Chapel: The Art, the History, and the Restoration.* New York: Harmony, 1986.

Pope Hennessy, Sir John. *Italian High Renaissance and Baroque Sculpture.* 3rd ed. Oxford: Phaidon, 1986.

——. *Italian Renaissance Sculpture.* 3rd ed. Oxford: Phaidon, 1986.

Rosand, David. *Painting in Cinquecento Venice: Titian, Veronese, Tintoretto.* Rev. ed. Cambridge: Cambridge Univ. Press, 1997.

Rowland, Ingrid D. *The Culture of the High Renaissance: Ancients and Moderns in Sixteenth Century Rome.* Cambridge. Cambridge Univ. Press, 1998.

Shearman, John. *Mannerism.* Harmondsworth, Eng.: Penguin, 1967.

Smith, Jeffrey Chipps. *Nuremberg, a Renaissance City, 1500-1618.* Austin: Huntington Art Gallery, Univ. of Texas, 1983.

Strong, Roy C. *Artists of the Tudor Court: The Portrait Miniature Rediscovered, 1520-1620.* London: Victoria and Albert Museum, 1983.

Vasari, Giorgio. *The Lives of the Artists.* Trans. Julia Conaway Bondanella and Peter Bondanella. New York: Oxford Univ. Press, 1991.

Verheyen, Egon. *The Paintings in the Studiolo of Isabella d'Este at Mantua.* Monographs on Archaeology and Fine Arts. New York: New York Univ. Press, 1971.

Williams, Robert. *Art, Theory, and Culture in Sixteenth-Century Italy: From Techne to Metateche.* Cambridge: Cambridge Univ. Press, 1997.

CHAPTER 19 Baroque Art in Europe and North America

Ackley, Clifford S. *Printmaking in the Age of Rembrandt.* Boston: Museum of Fine Arts, 1981.

Bazin, Germain. *Baroque and Rococo.* Trans. Jonathan Griffin. World of Art. New York: Praeger, 1964.

Berger, Robert W. *The Palace of the Sun: The Louvre of Louis XIV.* University Park: Pennsylvania State Univ. Press, 1993.

——. *Versailles: The Chateau of Louis XIV.* Monographs on the Fine Arts. University Park: Pennsylvania State Univ. Press, 1985.

Blunt, Anthony, et al. *Baroque and Rococo Architecture and Decoration.* New York: Harper & Row, 1982.

Boucher, Bruce. *Italian Baroque Sculpture.* World of Art. New York: Thames and Hudson, 1998.

Brown, Christopher. *Scenes of Everyday Life: Dutch Genre Painting of the Seventeenth Century.* London: Faber & Faber, 1984.

Enggass, Robert, and Jonathan Brown. *Italy and Spain 1600-1750: Sources and Documents.* Upper Saddle River, NJ: Prentice Hall, 1970.

Fuchs, R. H. *Dutch Painting.* World of Art. New York: Oxford Univ. Press, 1978.

Gerson, Horst, and E. H. ter Kuile. *Art and Architecture in Belgium, 1600-1800.* Pelican History of Art. Baltimore: Penguin, 1960.

Haak, Bob. *The Golden Age: Dutch Painters of the Seventeenth Century.* Trans. and ed. Elizabeth Willems-Treeman. New York: Abrams, 1984.

Held, Julius Samuel, and Donald Posner. *17th and 18th Century Art: Baroque Painting, Sculpture, Architecture.* Library of Art History. New York: Abrams, 1971.

Hempel, Eberhard. *Baroque Art and Architecture in Central Europe: Germany, Austria, Switzerland, Hungary, Czechoslovakia, Poland. Painting and Sculpture: 17th and 18th Centuries. Architecture: 16th to 18th Centuries.* Trans. Elisabeth Hempel and Marguerite Kay. Pelican History of Art. Harmondsworth, Eng.: Penguin, 1965.

Lagerlof, Margaretha Rossholm. *Ideal Landscape: Annibale Caracci, Nicolas Poussin, and Claude Lorrain.* New Haven: Yale Univ. Press, 1990.

Montagu, Jennifer. *Roman Baroque Sculpture: The Industry of Art.* New Haven: Yale Univ. Press, 1989.

Norberg-Schulz, Christian. *Baroque Architecture.* New York: Rizzoli, 1986.

——. *Late Baroque and Rococo Architecture.* History of World Architecture. New York: Rizzoli, 1985.

Rosenberg, Jakob, Seymour Slive, and E.H. Ter Kuile. *Dutch Art and Architecture 1600 to 1800.* Pelican History of Art. New Haven: Yale Univ. Press, 1977.

Slive, Seymour. *Dutch Painting 1600-1800.* Pelican History of Art. New Haven: Yale Univ. Press, 1995.

Stechow, Wolfgang. *Dutch Landscape Painting of the Seventeenth Century.* 3rd ed. Oxford: Phaidon, 1981.

Temple, R. C., ed. *The Travels of Peter Mundy in Europe and Asia, 1608-1667.* London: n.p., 1925.

Vlieghe, Hans. *Flemish Art and Architecture, 1585-1700.* Pelican History of Art. New Haven: Yale Univ. Press, 1998.

Wittkower, Rudolf. *Art and Architecture in Italy, 1600 to 1750.* 3 vols. 6th ed. Rev. Joseph Connors and Jennifer Montagu. Pelican History of Art. New Haven: Yale Univ. Press, 1999.

CHAPTER 20 Art of India after 1100

Asher, Catherine B. *Architecture of Mughal India.* New York: Cambridge Univ. Press, 1992.

Beach, Milo Cleveland. *Grand Mogul: Imperial Painting in India, 1600-1660.* Williamstown: Sterling and Francine Clark Art Institute, 1978.

——. *Imperial Image, Paintings for the Mughal Court.* Washington, D.C.: Freer Gallery of Art, Smithsonian Institution, 1981.

——. *Mughal and Rajput Painting.* New York: Cambridge Univ. Press, 1992.

Blurton, T. Richard. *Hindu Art.* Cambridge: Harvard Univ. Press, 1993.

Davies, Philip. *Splendours of the Raj: British Architecture in India, 1660 to 1947.* London: Murray, 1985.

Desai, Vishakha N. *Life at Court: Art for India's Rulers, 16th-19th Centuries.* Boston: Museum of Fine Arts, 1985.

Guy, John, and Deborah Swallow, eds. *Arts of India, 1550-1900.* London: Victoria and Albert Museum, 1990.

Khanna, Balraj, and Aziz Kurtha. *Art of Modern India.* London: Thames and Hudson, 1998.

Losty, Jeremiah P. *The Art of the Book in India.* London: British Library, 1982.

Miller, Barbara Stoller. *Love Song of the Dark Lord: Jayadeva's Gitagovinda.* New York: Columbia Univ. Press, 1977.

Mitchell, George. *The Royal Palaces of India.* London: Thames and Hudson, 1994.

Nou, Jean-Louis. *Taj Mahal.* Text by Amina Okada and M. C. Joshi. New York: Abbeville, 1993.

Pal, Pratapaditya. *Court Paintings of India, 16th-19th Centuries.* New York: Navin Kumar, 1983.

——, et al. *Romance of the Taj Mahal.* Los Angeles: Los Angeles County Museum of Art, 1989.

Tillotson, G. H. R. *Mughal India.* Architectural Guides for Travelers. San Francisco: Chronicle, 1990.

——. *The Rajput Palaces: The Development of an Architectural Style, 1450-1750.* New York: Oxford Univ. Press, 1999.

——. *The Tradition of Indian Architecture: Continuity, Controversy and Change since 1850.* New Haven: Yale Univ. Press, 1989.

Welch, Stuart Cary. *The Emperors' Album: Images of Mughal India.* New York: Metropolitan Museum of Art, 1987.

——. *India. Art and Culture 1300-1900.* New York: Metropolitan Museum of Art, 1985.

CHAPTER 21 Chinese Art after 1280

Andrews, Julia Frances. *Painters and Politics in the People's Republic of China, 1949-1979.* Berkeley: Univ. of California Press, 1994.

Barnhart, Richard M. *Painters of the Great Ming: The Imperial Court and the Zhe School.* Dallas: Dallas Museum of Art, 1993.

——. *Peach Blossom Spring: Gardens and Flowers in Chinese Painting*. New York: Metropolitan Museum of Art, 1983.

——, et al. *The Jade Studio: Masterpieces of Ming and Qing Painting and Calligraphy from the Wong Nan-p'ing Collection*. New Haven: Yale Univ. Art Gallery, 1994.

Beurdeley, Michael. *Chinese Furniture*. Trans. Katherine Watson. Tokyo: Kodansha International, 1979.

Billeter, Jean François. *The Chinese Art of Writing*. New York: Skira/Rizzoli, 1990.

Bush, Susan, and Hsui-yen Shih, eds. *Early Chinese Texts on Painting*. Cambridge: Harvard Univ. Press, 1985.

Cahill, James. *The Compelling Image: Nature and Style in Seventeenth-Century Chinese Painting*. Charles Norton Lectures 1978–79. Cambridge: Harvard Univ. Press, 1982.

——. *The Distant Mountains: Chinese Painting in the Late Ming Dynasty, 1580–1644*. New York: Weatherhill, 1982.

——. *Hills beyond a River: Chinese Painting of the Y'uan Dynasty, 1279–1368*. New York: Weatherhill, 1976.

——. *Parting at the Shore: Chinese Painting of the Early and Middle Ming Dynasty, 1368–1580*. New York: Weatherhill, 1978.

Chan, Charis. *Imperial China*. Architectural Guides for Travelers. San Francisco: Chronicle, 1992.

Clunas, Craig. *Pictures and Visualities in Early Modern China*. Princeton: Princeton Univ. Press, 1997.

Fang, Jing Pei. *Treasures of the Chinese Scholar: Form, Function and Symbolism*. Ed. J. May Lee Barrett. New York: Weatherhill, 1997.

Fong, Wen C., and James C. Y. Watt. *Possessing the Past: Treasures from the National Palace Museum, Taipei*. New York: Metropolitan Museum of Art, 1996.

In Pursuit of the Dragon: Traditions and Transitions in Ming Ceramics: An Exhibition from the Idemitsu Museum of Arts. Seattle: Seattle Art Museum, 1988.

Jenyns, Soame. *Later Chinese Porcelain: The Ch'ing Dynasty, 1644–1912*. 4th ed. London: Faber & Faber, 1971.

Keswick, Maggie. *The Chinese Garden: History, Art and Architecture*. New York: Rizzoli, 1978.

Knapp, Ronald G. *China's Vernacular Architecture: House Form and Culture*. Honolulu: Univ. of Hawaii Press, 1989.

Lee, Sherman, and Wai-Kam Ho. *Chinese Art under the Mongols: The Y'uan Dynasty, 1279–1368*. Cleveland: Cleveland Museum of Art, 1968.

Lim, Lucy. *Contemporary Chinese Painting: An Exhibition from the People's Republic of China*. San Francisco: Chinese Culture Foundation of San Francisco, 1983.

——, ed. *Wu Guanzhong: A Contemporary Chinese Artist*. San Francisco: Chinese Culture Foundation, 1989.

Liu, Laurence G. *Chinese Architecture*. New York: Rizzoli, 1989.

Ng, So Kam. *Brushstrokes: Styles and Techniques of Chinese Painting*. San Francisco: Asian Art Museum of San Francisco, 1993.

Polo, Marco. *The Travels of Marco Polo*. Trans. Teresa Waugh and Maria Bellonci. New York: Facts on File, 1984.

Shih-t'ao. *Returning Home: Tao-chi's Album of Landscapes and Flowers*. Commentary by Wen Fong. New York: Braziller, 1976.

Sullivan, Michael. *Art and Artists of Twentieth-Century China*. Berkeley: Univ. of California Press, 1996.

——. *Symbols of Eternity: The Art of Landscape Painting in China*. Stanford: Stanford Univ. Press, 1979.

Tsu, Frances Ya-sing. *Landscape Design in Chinese Gardens*. New York: McGraw-Hill, 1988.

Vainker, S. J. *Chinese Pottery and Porcelain: From Prehistory to the Present*. London: British Museum, 1991.

Walters, Derek. *Feng Shui: The Chinese Art of Designing a Harmonious Environment*. New York: Simon & Schuster, 1988.

Watson, William. *The Arts of China 900–1620*. Pelican History of Art. New Haven: Yale Univ. Press, 2000.

Weidner, Marsha Smith. *Views from Jade Terrace: Chinese Women Artists, 1300–1912*. Indianapolis, IN: Indianapolis Museum of Art, 1988.

Yu Zhuoyun, comp. *Palaces of the Forbidden City*. Trans. Ng Mau-Sang, Chan Sinwai, and Puwen Lee. New York: Viking, 1984.

CHAPTER 22 Japanese Art after 1392

Addiss, Stephen. *The Art of Zen: Painting and Calligraphy by Japanese Monks, 1600–1925*. New York: Abrams, 1989.

——. *Zenga and Nanga: Paintings by Japanese Monks and Scholars, Selections from the Kurt and Millie Gitter Collection*. New Orleans: New Orleans Museum of Art, 1976.

Baekeland, Frederick, and Robert Moes. *Modern Japanese Ceramics in American Collections*. New York: Japan Society, 1993.

Guth, Christine. *Art of Edo Japan: The Artist and the City 1615–1868*. Perspectives. New York: Abrams, 1996.

Hickman, Money L. *Japan's Golden Age: Momoyama*. New Haven: Yale Univ. Press, 1996.

Hiesinger, Kathryn B., and Felice Fischer. *Japanese Design: A Survey Since 1950*. Philadelphia: Philadelphia Museum of Art, 1994.

Meech-Pekarik, Julia. *The World of the Meiji Print: Impressions of a New Civilization*. New York: Weatherhill, 1986.

Merritt, Helen. *Modern Japanese Woodblock Prints: The Early Years*. Honolulu: Univ. of Hawaii Press, 1990.

——, and Nanako Yamada. *Guide to Modern Japanese Woodblock Prints: 1900–1975*. Honolulu: Univ. of Hawaii Press, 1995.

Michener, James A. *The Floating World*. New York: Random House, 1954.

Munroe, Alexandra. *Japanese Art after 1945: Scream Against the Sky*. New York: Abrams, 1994.

Murase, Miyeko. *Emaki, Narrative Scrolls from Japan*. New York: Asia Society, 1983.

——. *Masterpieces of Japanese Screen Painting: The American Collections*. New York: Braziller, 1990.

——. *Tales of Japan: Scrolls and Prints from the New York Public Library*. Oxford: Oxford Univ. Press, 1986.

Okakura, Kakuzo. *The Book of Tea*. Ed. Everett F. Bleiler. New York: Dover, 1964.

Okyo and the Maruyama-Shijo School of Japanese Painting. Trans. Miyeko Murase and Sarah Thompson. St. Louis: St. Louis Art Museum, 1980.

Seo, Aubrey Yoshiko. *The Art of Twentieth-Century Zen: Paintings and Calligraphy by Japanese Masters*. Boston: Shambala, 1998.

Singer, Robert T., with John T. Carpenter. *Edo, Art in Japan 1615–1868*. Washington, D.C.: National Gallery of Art, 1998.

Takeuchi, Melinda. *Taiga's True Views: The Language of Landscape Painting in Eighteenth-Century Japan*. Stanford: Stanford Univ. Press, 1992.

Thompson, Sarah E., and H. D. Harpptunian. *Undercurrents in the Floating World: Censorship and Japanese Prints*. New York: Asia Society Gallery, 1992.

Till, Barry. *The Arts of Meiji Japan, 1868–1912: Changing Aesthetics*. Victoria, BC: Art Gallery of Victoria, 1995.

CHAPTER 23 Art of the Americas after 1300

Archuleta, Margaret, and Rennard Strickland. *Shared Visions: Native American Painters and Sculptors in the Twentieth Century*. Phoenix: Heard Museum, 1991.

Baquedano, Elizabeth. *Aztec Sculpture*. London: British Museum, 1984.

Berdan, Frances F. *The Aztecs of Central Mexico: An Imperial Society*. New York: Holt, 1982.

Berlo, Janet Catherine, and Ruth B. Phillips. *Native North American Art*. Oxford History of Art. Oxford: Oxford Univ. Pres, 1998.

Bringhurst, Robert. *The Black Canoe: Bill Reid and the Spirit of Haida Gwaii*. Seattle: Univ. of Washington Press, 1991.

Broder, Patricia Janis. *American Indian Painting and Sculpture*. New York: Abbeville, 1981.

——. *Earth Songs, Moon Dreams: Paintings by American Indian Women*. New York: St. Martin's Press, 1999.

Coe, Ralph. *Lost and Found Traditions: Native American Art 1965–1985*. Ed. Irene Gordon. Seattle: Univ. of Washington Press, 1986.

Conn, Richard. *Circles of the World: Traditional Art of the Plains Indians*. Denver: Denver Art Museum, 1982.

Crandall, Richard C. *Inuit Art: A History*. Jefferson, NC: McFarland, 2000.

Dockstader, Frederick J. *The Way of the Loom: New Traditions in Navajo Weaving*. New York: Hudson Hills, 1987.

Feest, Christian F. *Native Arts of North America*. Updated ed. World of Art. New York: Thames and Hudson, 1992.

Haberland, Wolfgang. *Art of North America*. Rev. ed. Art of the World. New York: Greystone, 1968.

Hawthorn, Audrey. *Art of the Kwakiutl Indians and Other Northwest Coast Tribes*. Vancouver: Univ. of British Columbia Press, 1967.

Hemming, John. *Monuments of the Incas*. Boston: Little, Brown, and Co., 1982.

Highwater, Jamake. *The Sweet Grass Lives On: Fifty Contemporary North American Indian Artists*. New York: Lippincott and Crowell, 1980.

Jonaitis, Aldona. *Art of the Northern Tlingit*. Seattle: Univ. of Washington Press, 1986.

——, ed. *Chiefly Feasts: The Enduring Kwakiutl Potlatch*. Seattle: Univ. of Washington Press, 1991.

Kahlenberg, Mary Hunt, and Anthony Berlant. *The Navajo Blanket*. New York: Praeger, 1972.

Levi-Strauss, Claude. *Way of the Masks*. Trans. Sylvia Modelski. Seattle: Univ. of Washington Press, 1982.

MacDonald, George F. *Haida Art*. Seattle: Univ. of Washington Press, 1996.

Maurer, Evan M. *Visions of the People: A Pictorial History of Plains Indian Life*. Minneapolis: Minneapolis Institute of Arts, 1992.

McNair, Peter L., Alan L. Hoover, and Kevin Neary. *Legacy: Tradition and Innovation in Northwest Coast Indian Art*. Vancouver: Douglas and McIntyre, 1984.

Nicholson, H. B., and Eloise Quinones Keber. *Art of Aztec Mexico: Treasures of Tenochtitlan*. Washington, D.C.: National Gallery of Art, 1983.

Parezo, Nancy J. *Navajo Sandpainting: From Religious Act to Commercial Art*. Tucson: Univ. of Arizona Press, 1983

Pasztory, Esther. *Aztec Art*. New York: Abrams, 1983.

Penney, David. *Art of the American Indian Frontier: The Chandler-Pohrt Collection*. Detroit: Detroit Institute of Arts, 1992.

Peterson, Susan. *The Living Tradition of Maria Martinéz*. Tokyo: Kodansha International, 1977.

Smith, Jaune Quick-to-See, and Harmony Hammond. *Women of Sweetgrass: Cedar and Sage*. New York: American Indian Center, 1984.

Stewart, Hilary. *Totem Poles*. Seattle: Univ. of Washington Press, 1990.

Stierlin, Henri. *Art of the Aztecs and Its Origins*. New York: Rizzoli, 1982.

——. *Art of the Incas and Its Origins*. New York: Rizzoli, 1984.

Trimble, Stephen. *Talking with the Clay: The Art of Pueblo Pottery*. Santa Fe: School of American Research Press, 1987.

Wade, Edwin, and Carol Haralson, eds. *The Arts of the North American Indian: Native Traditions in Evolution*. New York: Hudson Hills, 1986.

Walters, Anna Lee. *Spirit of Native America: Beauty and Mysticism in American Indian Art*. San Francisco: Chronicle, 1989.

Wood, Nancy C. *Taos Pueblo*. New York: Knopf, 1989.

CHAPTER 24 Art of Pacific Cultures

Allen, Louis A. *Time before Morning: Art and Myth of the Australian Aborigines*. New York: Crowell, 1975.

Barrow, Terrence. *The Art of Tahiti and the Neighbouring Society, Austral and Cook Islands*. New York: Thames and Hudson, 1979.

——. *An Illustrated Guide to Maori Art*. Honolulu: Univ. of Hawaii Press, 1984.

Buhler, Alfred, Terry Barrow, and Charles P. Montford. *The Art of the South Sea Islands, including Australia and New Zealand*. Art of the World. New York: Crown, 1962.

Caruana, Wally. *Aboriginal Art*. World of Art. New York: Thames and Hudson, 1996.

Craig, Robert D. *Dictionary of Polynesian Mythology*. New York: Greenwood, 1989.

D'Alleva, Anne. *Arts of the Pacific Islands*. Perspectives. New York: Abrams, 1998.

Gell, Alfred. *Wrapping in Images: Tattooing in Polynesia*. Oxford Studies in Social and Cultural Anthropology. New York: Oxford Univ. Press, 1993.

Greub, Suzanne, ed. *Art of Northwest New Guinea: From Geelvink Bay, Humboldt Bay, and Lake Sentani*. New York: Rizzoli, 1992.

Guiart, Jean. *The Arts of the South Pacific*. Trans. Anthony Christie. Arts of Mankind. New York: Golden, 1963.

Hammond, Joyce D. *Tifaifai and Quilts of Polynesia*. Honolulu: Univ. of Hawaii Press, 1986.

Hanson, Allan, and Louise Hanson. *Art and Identity in Oceania*. Honolulu: Univ. of Hawaii Press, 1990.

Heyerdahl, Thor. *The Art of Easter Island*. Garden City, NY: Doubleday, 1975.

Jones, Stella M. *Hawaiian Quilts*. Rev. 2nd ed. Honolulu: Daughters of Hawaii, 1973.

Kaeppler, Adrienne Lois, Christian Kaufmann, and Douglas Newton. *Oceanic Art*. Trans. Nora Scott and Sabine Bouladon. New York: Abrams, 1997.

Layton, Robert. *Australian Rock Art: A New Synthesis*. New York: Cambridge Univ. Press, 1992.

Leonard, Anne, and John Terrell. *Patterns of Paradise: The Style and Significance of Bark Cloth around the World*. Chicago: Field Museum of Natural History, 1980.

Mead, Sydney Moko, ed. *Te Maori: Maori Art from New Zealand Collections*. New York: Abrams, 1984.

Morphy, Howard. *Ancestral Connections: Art and an Aboriginal System of Knowledge*. Chicago: Univ. of Chicago Press, 1991.

People of the River, People of the Trees: Change and Continuity in Sepik and Asmat Art. St. Paul: Minnesota Museum of Art, 1989.

Rabineau, Phyllis. *Feather Arts: Beauty, Wealth, and Spirit from Five Continents*. Chicago: Field Museum of Natural History, 1979.

Scutt, R. W. B., and Christopher Gotch. *Art, Sex, and Symbol: The Mystery of Tattooing*. 2nd ed. New York: Cornell Univ. Press, 1986.

Serra, Eudaldo, and Alberto Folch. *The Art of Papua and New Guinea*. New York: Rizzoli, 1977.

Sutton, Peter, ed. *Dreamings, the Art of Aboriginal Australia*. New York: Braziller, 1988.

Thomas, Nicholas. *Oceanic Art*. World of Art. New York: Thames and Hudson, 1995.

Wardwell, Allen. *Island Ancestors: Oceania Art from the Masco Collection*. Seattle: Univ. of Washington Press, 1994.

CHAPTER 25 Art of Africa in the Modern Era

Abiodun, Rowland, Henry J. Drewal, and John Pemberton III, eds. *The Yoruba Artist: New Theoretical Perspectives on African Arts*. Washington, D.C.: Smithsonian Institution, 1994.

Adler, Peter, and Nicholas Barnard. *African Majesty: The Textile Art of the Ashanti and Ewe*. New York: Thames and Hudson, 1992.

Astonishment and Power. Washington, D.C.: National Museum of African Art, Smithsonian Institution, 1993.

Bacquart, Jean-Baptiste. *The Tribal Arts of Africa*. New York: Thames and Hudson, 1998.

Barley, Nigel. *Foreheads of the Dead: An Anthropological View of Kalabari Ancestral Screens*. Washington, D.C.: National Museum of African Art, Smithsonian Institution, 1988.

———. *Smashing Pots: Feats of Clay from Africa*. London: British Museum, 1994.

Biebuyck, Daniel P. *Lega Culture: Art, Initiation, and Moral Philosophy among a Central African People*. Berkeley: Univ. of California Press, 1973.

Brincard, Marie-Therese, ed. *The Art of Metal in Africa*. Trans. Evelyn Fischel. New York: African-American Institute, 1984.

Cole, Herbert M., ed. *I Am Not Myself: The Art of African Masquerade*. Los Angeles: Fowler Museum of Cultural History, Univ. of California, 1985.

———. *Icons: Ideals and Power in the Art of Africa*. Washington, D.C.: National Museum of African Art, Smithsonian Institution, 1989.

———. *Mbari, Art and Life among the Owerri Igbo*. Bloomington: Indiana Univ. Press, 1982.

Drewal, Henry John. *African Artistry: Technique and Aesthetics in Yoruba Sculpture*. Atlanta: High Museum of Art, 1980.

———, and Margaret Thompson Drewal. *Gelede: Art and Female Power among the Yoruba*. Bloomington: Indiana Univ. Press, 1983.

Fagg, William Buller, and John Pemberton III. *Yoruba Sculpture of West Africa*. Ed. Bryce Holcombe. New York: Knopf, 1982.

Gilfoy, Peggy S. *Patterns of Life: West African Strip-Weaving Traditions*. Washington, D.C.: National Museum of African Art, Smithsonian Institution, 1992.

Glaze, Anita. *Art and Death in a Senufo Village*. Bloomington: Indiana Univ. Press, 1981.

Heathcote, David. *The Arts of the Hausa*. Chicago: Univ. of Chicago Press, 1976.

Kasfir, Sidney Littlefield. *Contemporary African Art*. World of Art. London: Thames and Hudson, 2000.

Kennedy, Jean. *New Currents, Ancient Rivers: Contemporary Artists in a Generation of Change*. Washington, D.C.: Smithsonian Institution, 1992.

Laude, Jean. *African Art of the Dogon: The Myths of the Cliff Dwellers*. Trans. Joachim Neugroschell. New York: Brooklyn Museum, 1973.

Martin, Phyllis, and Patrick O'Meara, eds. *Africa*. 3rd ed. Bloomington: Indiana Univ. Press, 1995.

McEvilley, Thomas. *Fusion: West African Artists at the Venice Biennale*. New York: Museum for African Art, 1993.

McNaughton, Patrick R. *The Mande Blacksmiths: Knowledge, Power and Art in West Africa*. Bloomington: Indiana Univ. Press, 1988.

Neyt, François. *Luba: To the Sources of the Zaire*. Trans. Murray Wyllie. Paris: Editions Dapper, 1994.

Perrois, Louis, and Marta Sierra Delage. *The Art of Equatorial Guinea: The Fang Tribes*. New York: Rizzoli, 1990.

Picon, John, and John Mack. *African Textiles*. New York: Harper & Row, 1989.

Roy, Christopher D. *Art of the Upper Volta Rivers*. Meudon, France: Chaffin, 1987.

Schildkrout, Enid, and Curtis A. Keim. *African Reflections: Art from Northeastern Zaire*. Seattle: Univ. of Washington Press, 1990.

Sieber, Roy. *African Furniture and Household Objects*. Bloomington: Indiana Univ. Press, 1980.

———. *African Textiles and Decorative Arts*. New York: Museum of Modern Art, 1972.

———, and Roslyn Adele Walker. *African Art in the Cycle of Life*. Washington, D.C.: National Museum of African Art, Smithsonian Institution, 1987.

Thompson, Robert Farris, and Joseph Cornet. *The Four Moments of the Sun: Kongo Art in Two Worlds*. Washington, D.C.: National Gallery of Art, 1981.

Vogel, Susan. *Africa Explores: 20th Century African Art*. New York: Center for African Art, 1991.

CHAPTER 26 Eighteenth-Century Art in Europe and North America

(see the bibliography for Chapter 19 for additional information on Rococo art)

Age of Neoclassicism. London: Arts Council of Great Britain, 1972.

Boime, Albert. *Art in an Age of Revolution, 1750–1800*. Chicago: Univ. of Chicago Press, 1987.

Braham, Allan. *The Architecture of the French Enlightenment*. Berkeley: Univ. of California Press, 1980.

Clark, Kenneth. *The Romantic Rebellion: Romantic versus Classic Art*. New York: Harper & Row, 1973.

Crow, Thomas E. *Painters and Public Life in Eighteenth-Century Paris*. New Haven: Yale Univ. Press, 1985.

Denvir, Bernard. *The Eighteenth Century: Art, Design, and Society, 1689–1789*. London: Longman, 1983.

Fried, Michael. *Absorption and Theaticality: Painting and Beholder in the Age of Diderot*. Berkeley: Univ. of California Press, 1980.

Honour, Hugh. *Neo-Classicism*. Harmondsworth, Eng.: Penguin, 1968.

Kalnein, Wend von. *Architecture in France in the Eighteenth Century*. Trans. David Britt. Pelican History of Art. New Haven: Yale Univ. Press, 1990.

Levey, Michael. *Painting and Sculpture in France, 1700–1789*. Pelican History of Art. New Haven: Yale Univ. Press, 1993.

Montgomery, Charles F., and Patricia E. Kane, eds. *American Art, 1750–1800: Towards Independence*. Boston: New York Graphics Society, 1976.

Rosenblum, Robert. *Transformations in Late Eighteenth-Century Art*. Princeton, NJ: Princeton Univ. Press, 1967.

Summerson, John. *Architecture of the Eighteenth Century*. World of Art. New York: Thames and Hudson, 1986.

CHAPTER 27 Nineteenth-Century Art in Europe and North America

Adams, Steven. *The Barbizon School and the Origins of Impressionism*. London: Phaidon, 1994.

Art of the July Monarchy: France, 1830 to 1848. Columbia: Univ. of Missouri Press, 1989.

Barger, M. Susan, and William B. White. *The Daguerreotype: Nineteenth-Century Technology and Modern Science*. Washington, D.C.: Smithsonian Institution, 1991.

Baudelaire, Charles. *The Painter of Modern Life, and Other Essays*. 2nd ed. Trans. and ed. Jonathan Mayne. London: Phaidon, 1995.

Berger, Klaus. *Japonisme in Western Painting from Whistler to Matisse*. Trans. David Britt. Cambridge Studies in the History of Art. Cambridge: Cambridge Univ. Press, 1992.

Boime, Albert. *Art in an Age of Bonapartism, 1800–1815*. Chicago: Univ. of Chicago Press, 1990.

Brion, Marcel. *Art of the Romantic Era: Romanticism, Classicism, Realism*. World of Art. New York: Praeger, 1966.

Clark, T. J. *The Absolute Bourgeois: Artists and Politics in France, 1848–1851*. Berkeley: Univ. of California Press, 1999.

———. *Image of the People: Gustave Courbet and the 1848 Revolution*. Berkeley: Univ. of California Press, 1999.

———. *The Painting of Modern Life: Paris in the Art of Manet and His Followers*. Rev. ed. Princeton, NJ: Princeton Univ. Press, 1999.

Cooper, Wendy A. *Classical Taste in America 1800–1840*. Baltimore: Baltimore Museum of Art, 1993.

Cumming, Elizabeth, and Wendy Caplan. *Arts and Crafts Movement*. World of Art. New York: Thames and Hudson, 1991.

Denis, Rafael Cardoso, and Colin Trodd. *Art and the Academy in the Nineteenth Century*. New Brunswick, NJ: Rutgers Univ. Press, 2000.

Denvir, Bernard. *Post-Impressionism*. World of Art. New York: Thames and Hudson, 1992.

———. *The Thames and Hudson Encyclopedia of Impressionism*. World of Art. New York: Thames and Hudson, 1990.

Duncan, Alastair. *Art Nouveau*. World of Art. New York: Thames and Hudson, 1994.

Eisenman, Stephen. *Nineteenth Century Art: A Critical History*. London: Thames and Hudson, 1994.

Eitner, Lorenz. *An Outline of Nineteenth Century European Painting: From David to Cezanne*. 2 vols. New York: Harper & Row, 1987.

Gerdts, William H. *American Impressionism*. New York: Abbeville, 1984.

Goldwater, Robert John. *Symbolism*. Icon Editions. New York: Harper & Row, 1979.

Hemingway, Andrew, and William Vaughan. *Art in Bourgeois Society, 1790–1850*. Cambridge: Cambridge Univ. Press, 1998.

Herbert, Robert L. *Impressionism: Art, Leisure, and Parisian Society*. New Haven: Yale Univ. Press, 1988.

Hilton, Timothy. *Pre-Raphaelites*. World of Art. London: Thames and Hudson, 1970.

Holt, Elizabeth Gilmore, ed. *The Expanding World of Art, 1874–1902*. New Haven: Yale Univ. Press, 1988.

Honour, Hugh. *Romanticism*. London: Allen Lane, 1979.

Needham, Gerald. *19th-Century Realist Art*. New York: Harper & Row, 1988.

Nochlin, Linda. *Impressionism and Post-Impressionism, 1874–1904: Sources and Documents*. Upper Saddle River, NJ: Prentice Hall, 1966.

———. *Realism and Tradition in Art, 1848–1900: Sources and Documents*. Upper Saddle River, NJ: Prentice Hall, 1966.

Novotny, Fritz. *Painting and Sculpture in Europe, 1780–1880*. 2nd ed. Pelican History of Art. New Haven: Yale Univ. Press, 1995.

Pool, Phoebe. *Impressionism*. World of Art. New York: Praeger, 1967.

Post-Impressionism: Cross-currents in European and American Painting, 1880–1906. Washington, D.C.: National Gallery of Art, 1980.

Rewald, John. *The History of Impressionism*. 4th rev. ed. New York: Museum of Modern Art, 1973.

———. *Post-impressionism: From Van Gogh to Gauguin*. 3rd ed. New York: Museum of Modern Art, 1978.

Rosenblum, Robert, and H.W. Janson. *19th Century Art*. New York: Abrams, 1984.

Stansky, Peter. *Redesigning the World: William Morris, the 1880s, and the Arts and Crafts*. Princeton: Princeton Univ. Press, 1985.

Sutter, Jean, ed. *The Neo-Impressionists*. Greenwich, CT: New York Graphic Society, 1970.

Triumph of Realism. Brooklyn: Brooklyn Museum, 1967.

Vaughan, William, and Francoise Cachin. *Arts of the 19th Century*. 2 vols. New York: Abrams, 1998.

Vaughan, William. *Romanticism and Art*. World of Art. New York: Thames and Hudson, 1994.

Weisberg, Gabriel P. *The European Realist Tradition*. Bloomington: Indiana Univ. Press, 1982.

CHAPTER 28 The Rise of Modernism in Europe and America

Ades, Dawn. *Photomontage*. Rev ed. World of Art. New York: Thames and Hudson, 1986.

Art into Life: Russian Constructivism, 1914–32. New York: Rizzoli, 1990.

Baigell, Matthew. *The American Scene: American Painting of the 1930's*. New York: Praeger, 1974.

Banham, Reyner. *Theory and Design in the First Machine Age*. 2nd ed. Cambridge: MIT Press, 1980.

Barr, Alfred H., Jr. *Cubism and Abstract Art: Painting, Sculpture, Constructions, Photography, Architecture, Industrial Arts, Theatre, Films, Posters, Typography*. Cambridge, MA: Belknap, 1986.

Barron, Stephanie, ed. *Degenerate Art: The Fate of the Avant Garde in Nazi Germany*. Los Angeles: Los Angeles County Museum of Art, 1991.

Bayer, Herbert, Walter Gropius, and Ise Gropius. *Bauhaus 1919–1928*. New York: Museum of Modern Art, 1975.

Brown, Milton. *Story of the Armory Show: The 1913 Exhibition That Changed American Art*. 2nd ed. New York: Abbeville, 1988.

Corn, Wanda. *The Great American Thing: Modern Art and National Identity, 1915–1935*. Berkeley: Univ. of California Press, 1999.

Curtis, James. *Mind's Eye, Mind's Truth: FSA Photography Reconsidered*. Philadelphia: Temple Univ. Press, 1989.

Curtis, Penelope. *Sculpture 1900–1945: After Rodin*. Oxford History of Art. Oxford: Oxford Univ. Press, 1999.

Dachy, Marc. *The Dada Movement, 1915–1923*. New York: Skira/Rizzoli, 1990.

Davidson, Abraham A. *Early American Modernist Painting, 1910–1935*. New York: Harper & Row, 1981.

Dube, Wolf Dieter. *Expressionists*. Trans. Mary Whittall. World of Art. New York: Thames and Hudson, 1998.

Freeman, Judi. *The Fauve Landscape*. Los Angeles: Los Angeles County Museum of Art, 1990.

Fry, Edward. *Cubism*. New York: McGraw-Hill, 1966.

Golding, John. *Cubism: A History and an Analysis, 1907–1914*. Cambridge, MA: Belknap, 1988.

Gordon, Donald E. *Expressionism: Art and Idea*. New Haven: Yale Univ. Press, 1987.

Gray, Camilla. *Russian Experiment in Art, 1863–1922*. New York: Abrams, 1970.

Green, Christopher. *Art in France: 1900–1940*. Pelican History of Art. New Haven: Yale Univ. Press, 2000.

Haiko, Peter, ed. *Architecture of the Early XX Century*. Trans. Gordon Clough. New York: Rizzoli, 1989.

Harrison, Charles, Francis Frascina, and Gill Perry. *Primitivism, Cubism, Abstraction: The Early Twentieth Century*. New Haven: Yale Univ. Press, 1993.

Haskell, Barbara. *The American Century: Art & Culture, 1900–1950*. New York: Whitney Museum of American Art, 1999.

Herbert, James D. *Fauve Painting: The Making of Cultural Politics*. New Haven: Yale Univ. Press, 1992.

Hulten, Pontus. *Futurism and Futurisms*. New York: Abbeville, 1986.

Jaffe, Hans L. C. *De Stijl, 1917–1931: The Dutch Contribution to Modern Art*. Cambridge, MA: Belknap, 1986.

Lane, John R., and Susan C. Larsen. *Abstract Painting and Sculpture in America 1927–1944*. Pittsburgh: Museum of Art, Carnegie Institute, 1984.

Lloyd, Jill. *German Expressionism: Primitivism and Modernity*. New Haven: Yale Univ. Press, 1991.

Overy, Paul. *De Stijl*. World of Art. New York: Thames and Hudson, 1991.

Picon, Gaetan. *Surrealists and Surrealism, 1919–1939*. Trans. James Emmons. New York: Rizzoli, 1977.

Rickey, George. *Constructivism: Origins and Evolution*. Rev. ed. New York: G. Braziller, 1995.

Rosenblum, Robert. *Cubism and Twentieth-Century Art*. Rev. ed. New York: Abrams, 1984.

Spate, Virginia. *Orphism: The Evolution of Non-Figurative Painting in Paris, 1910–1914*. Oxford Studies in the History of Art and Architecture. Oxford: Clarendon, 1979.

Stich, Sidra. *Anxious Visions: Surrealist Art*. New York: Abbeville, 1990.

Tisdall, Caroline, and Angelo Bozzolla. *Futurism*. World of Art. New York: Oxford Univ. Press, 1978.

Weiss, Jeffrey S. *The Popular Culture of Modern Art: Picasso, Duchamp, and Avant-Gardism*. New Haven: Yale Univ. Press, 1994.

Whitfield, Sarah. *Fauvism*. World of Art. New York: Thames and Hudson, 1996.

Whitford, Frank. *Bauhaus*. World of Art. London: Thames and Hudson, 1984.

Zurier, Rebecca, Robert W. Snyder, and Virginia M. Mecklenburg. *Metropolitan Lives: The Ashcan Artists and Their New York*. Washington, D.C.: National Museum of American Art, 1995.

CHAPTER 29 The International Avant-Garde since 1945

Alberro, Alexander, and Blake Stimson, eds. *Conceptual Art: A Critical Anthology*. Cambridge: MIT Press, 1999.

Andersen, Wayne. *American Sculpture in Process, 1930–1970*. Boston: New York Graphic Society, 1975.

Anfam, David. *Abstract Expressionism*. World of Art. New York: Thames and Hudson, 1996.

Archer, Michael. *Art Since 1960*. World of Art. London: Thames and Hudson, 1997.

Ashton, Dore. *American Art since 1945*. New York: Oxford Univ. Press, 1982.

———. *The New York School: A Cultural Reckoning*. Harmondsworth, Eng.: Penguin, 1979.

Atkins, Robert. *Artspeak: A Guide to Contemporary Ideas, Movements, and Buzzwords*. 2nd ed. New York: Abbeville, 1997.

Baker, Kenneth. *Minimalism: Art of Circumstance*. New York: Abbeville, 1988.

Battcock, Gregory. *Idea Art: A Critical Anthology*. New York: Dutton, 1973.

———. *Minimal Art: A Critical Anthology*. Berkeley: Univ. of California Press, 1995.

———, and Robert Nickas. *The Art of Performance: A Critical Anthology*. New York: Dutton, 1984.

Beardsley, John. *Earthworks and Beyond: Contemporary Art in the Landscape*. 3rd ed. New York: Abbeville, 1998.

Blake, Peter. *No Place Like Utopia: Modern Architecture and the Company We Kept*. New York: Knopf, 1993.

Bolton, Richard, ed. *Culture Wars: Documents from the Recent Controversies in the Arts*. New York: New, 1992.

Broude, Norma, and Mary D. Garrard. *The Power of Feminist Art: The American Movement of the 1970s, History and Impact*. New York: Abrams, 1994.

Castleman, Riva, ed. *Art of the Forties*. New York: Museum of Modern Art, 1991.

Chase, Linda. *Hyperrealism*. New York: Rizzoli, 1975.

Causey, Andrew. *Sculpture since 1945*. Oxford History of Art. Oxford: Oxford Univ. Press, 1998.

Collins, Michael, and Andreas Papadakis. *Post-Modern Design*. New York: Rizzoli, 1989.

Crow, Thomas. *The Rise of the Sixties: American and European Art in the Era of Dissent*. Perspectives. New York: Abrams, 1996.

De Oliveira, Nicolas, Nicola Oxley, and Michael Petry. *Installation Art*. Washington, D.C.: Smithsonian Institution Press, 1994.

Dormer, Peter. *Design since 1945*. World of Art. New York: Thames and Hudson, 1993.

Endgame: Reference and Simulation in Recent Painting and Sculpture. Boston: Institute of Contemporary Art, 1986.

Ferguson, Russell, ed. *Discourses: Conversations in Postmodern Art and Culture*. Documentary Sources in Contemporary Art. Cambridge: MIT Press, 1990.

———. *Out There: Marginalization and Contemporary Cultures*. Documentary Sources in Contemporary Art; 4. New York: New Museum of Contemporary Art, 1990.

Fineberg, Jonathan David. *Art Since 1940: Strategies of Being*. 2nd ed. New York: Abrams, 2000.

Ghirardo, Diane. *Architecture after Modernism*. World of Art. New York: Thames and Hudson, 1996.

Godfrey, Tony. *Conceptual Art*. Art & Ideas. London: Phaidon, 1998.

Goldberg, RoseLee. *Performance: Live Art Since 1960*. New York: Abrams, 1998.

Green, Jonathan. *American Photography: A Critical History since 1945 to the Present*. New York: Abrams, 1984.

Grundberg, Andy. *Photography and Art: Interactions since 1945*. New York: Abbeville, 1987.

Hays, K. Michael, and Carol Burns, eds. *Thinking the Present: Recent American Architecture*. New York: Princeton Architectural, 1990.

Henri, Adrian. *Total Art: Environments, Happenings, and Performance*. World of Art. New York: Oxford Univ. Press, 1974.

Hertz, Richard. *Theories of Contemporary Art*. 2nd ed. Upper Saddle River, NJ: Prentice Hall, 1993.

Hobbs, Robert Carleton, and Gail Levin. *Abstract Expressionism: The Formative Years*. Ithaca: Cornell Univ. Press, 1981

Hoffman, Katherine. *Explorations: The Visual Arts since 1945*. New York: HarperCollins, 1991.

Jencks, Charles. *Architecture Today*. 2nd ed. London: Academy, 1993.

———. *The New Moderns from Late to Neo-Modernism*. New York: Rizzoli, 1990.

———. *What Is Post-Modernism?* 4th rev., enl. ed. London: Academy Editions, 1996.

Joachimedes, Christos M., Norman Rosenthal, and Nicholas Serota, eds. *New Spirit in Painting*. London: Royal Academy of Arts, 1981.

Johnson, Ellen H., ed. *American Artists on Art from 1940 to 1980*. New York: Harper & Row, 1982.

Kaprow, Allan. *Assemblage, Environments & Happenings*. New York: Abrams, 1965.

Kingsley, April. *The Turning Point: The Abstract Expressionists and the Transformation of American Art*. New York: Simon & Schuster, 1992.

Kramer, Hilton. *The Age of the Avant-Garde: An Art Chronicle of 1956–1972*. New York: Farrar, Straus & Giroux, 1973.

Land and Environment Art. Ed. Jeffrey Kastner. Survey Brian Wallis. Themes and Movements. London: Phaidon Press, 1998.

Lippard, Lucy. *Pop Art*. World of Art. New York: Praeger, 1966.

Livingstone, Marco. *Pop Art: A Continuing History*. New York: Abrams, 1990.

Lucie-Smith, Edward. *Art in the Eighties*. Oxford: Phaidon, 1990.

———. *Art in the Seventies*. Ithaca: Cornell Univ. Press, 1980.

———. *Artoday*. London: Phaidon, 1995.

———. *Movements in Art since 1945: Issues and Concepts*. 3rd rev. & exp. ed. World of Art. London: Thames and Hudson, 1995.

———. *Sculpture since 1945*. Oxford: Phaidon, 1987.

———. *Super Realism*. Oxford: Phaidon, 1979.

Manhart, Marcia, and Tom Manhart, eds. *The Eloquent Object: The Evolution of American Art in Craft Media since 1945*. Tulsa: Philbrook Museum of Art, 1987.

Meisel, Louis K. *Photo-Realism*. New York: Abrams, 1989.

Meyer, James, ed. *Minimalism*. Themes and Movements. London: Phaidon, 2000. Phillips, Lisa. *The American Century: Art and Culture, 1950-2000*. New York: Whitney Museum of American Art, 1999.

Polcari, Stephen. *Abstract Expressionism and the Modern Experience*. Cambridge: Cambridge Univ. Press, 1991.

Risatti, Howard, ed. *Postmodern Perspectives: Issues in Contemporary Art*. 2nd ed. Upper Saddle River, NJ: Prentice Hall , 1998.

Rosen, Randy, and Catherine C. Brawer, comps. *Making Their Mark: Women Artists Move into the Mainstream, 1970–85*. New York: Abbeville, 1989.

Rush, Michael. *New Media in Late 20th-Century Art*. World of Art. London: Thames and Hudson, 1999.

Russell, John. *Pop Art Redefined*. New York: Praeger, 1969.

Sandler, Irving. *American Art of the 1960's*. New York: Harper & Row, 1988.

———. *Art of the Postmodern Era: From the Late 1960s to the Early 1990s*. New York: Icon Editions, 1996.

———. *The New York School: The Painters and Sculptors of the Fifties*. New York: Harper & Row, 1978.

———. *The Triumph of American Painting: A History of Abstract Expressionism*. New York: Harper & Row, 1976.

Sayre, Henry M. *The Object of Performance: The American Avant-Garde since 1970*. Chicago: Univ. of Chicago Press, 1989.

Shapiro, David, and Cecile Shapiro. *Abstract Expressionism: A Critical Record*. New York: Cambridge Univ. Press, 1990.

Shohat, Ella. *Talking Visions: Multicultural Feminism in a Transnational Age*. Documentary Sources in Contemporary Art; 5. New York: New Museum of Contemporary Art, 1998.

Skilled Work: American Craft in the Renwick Gallery, National Museum of American Art, Smithsonian Institution. Washington, D.C.: Smithsonian Institution Press, 1998.

Smith, Paul J., and Edward Lucie-Smith. *Craft Today: Poetry of the Physical*. New York: American Craft Museum, 1986.

Stich, Sidra. *Made in USA: An Americanization in Modern Art, the '50s & '60s*. Berkeley: Univ. of California Press, 1987.

Taylor, Brandon. *Avant-Garde and After: Rethinking Art Now*. Perspectives. New York: Abrams, 1995.

Taylor, Paul, ed. *Post-Pop Art*. Cambridge: MIT Press, 1989.

Waldman, Diane. *Collage, Assemblage, and the Found Object*. New York: Abrams, 1992.

———. *Transformations in Sculpture: Four Decades of American and European Art*. New York: Solomon R. Guggenheim Foundation, 1985.

Wallis, Brian, ed. *Art after Modernism: Rethinking Representation*. Documentary Sources in Contemporary Art; 1. New York: New Museum of Contemporary Art, 1984.

———. *Blasted Allegories: An Anthology of Writings by Contemporary Artists*. Documentary Sources in Contemporary Art; 2. New York: New Museum of Contemporary Art, 1987.

Wheeler, Daniel. *Art since Mid-Century: 1945 to the Present*. Upper Saddle River, NJ: Prentice Hall, 1991.

Wood, Paul. *Modernism in Dispute: Art Since the Forties*. New Haven: Yale Univ. Press, 1993.

Word as Image: American Art, 1960–1990. Milwaukee: Milwaukee Art Museum, 1990.

Zolberg, Vera L., and Joni Maya Cherbo, eds. *Outsider Art: Contesting Boundaries in Contemporary Culture*. Cambridge Cultural Social Studies. Cambridge: Cambridge Univ. Press, 1997.

Index

men's hand (Japanese), 440
Mentuhotep II, 108
Mercury, 158
Merye-ankhnes, Queen, 106
Mesoamerica: ancient, 451–62; art, chronology of, 451–53
Mesopotamia (modern Iraq), 68–69, 353
Messengers Signal the Appearance of a Comet (Halley's Comet), Bayeux Tapestry, Norman-Anglo-Saxon, 540–42, 543, *543*
metalwork: Aegean, 136, 137; Africa, 474–75; Ancient Near East, 74; Byzantine, 334; Celtic, 491; early European, 63; German, 492, 593–94; Greek, 160, 177; Islamic, 359–60; Mesoamerican, 462; Minoan, 135; Mycenaean, 150; nomadic, 495; Peruvian, 464; Romanesque, 546
Metochites, Theodore, 337
metopes, 163, 164
Meuse Valley (Mosan), 546, 593; metalwork, 577
Michael, Archangel, 334
Michelangelo Buonarroti, 39
Middle-Aged Flavian Woman, bust, Roman, 257, 258, *258*, 577
Middle Ages, 486–87
Middle Kingdom (China), 402
Mieris, Frans van, 25–26
mihrab, 347, 351
Milan, Italy, 302, 545; Santa Maria delle Grazie, 34–35, *35*; Sant'Ambrogio church, 539, 545, *545*
Miletos, Asia Minor (modern Turkey), 199; Market Gate, 249–50, *250*; plan of, 199, *199*
Mills, Robert, 189
mimesis (imitation), 25, 229
minaret, 347
minbar, 345, 347
Minerva, 158
miniatures, 304; Islamic, 365
Minoan civilization, 133–42, 149; art, 148–49, 175; dating of, 131; Late Period, 141–42; Old Palace Period, 135–37; Second Palace Period, 137–41
Minos, king of Crete, 133, 134, 139, 149, 158
Minotaur, 134, 139
Miracle of the Crib at Greccio (Saint Francis Master), 601, 609–10, *610*
mirador, 355
mirror, Etruscan, 232, *233*
Mississippian culture (North America), 467
Mithras, 236, 282
mithuna couples, 382, 389
Mnesikles, 193
moat, 430, 539, *587*
Moche culture (Peru), 464–65
Moche Lord with a Feline, ceramic, Peru, 464–65, *465*
modeling, 52, 208
model of a house, China, Han dynasty, 411, *411*, 417
model of a house and garden, Egyptian, 109, *109*
Modena, Italy, Cathedral, 551, 552, *552*
Mogollon culture (American Southwest), 468
Mohenjo-Daro, India, 374; *Bust of a Man*, 374, *374*
Moissac, Toulouse, France, Saint-Pierre priory church, 524; south portal, 524–27, *524*, *525*, 531, 564
molding, 245, 395
Monastery of Hosios Loukas, Stiris, Greece, Katholikon, 328–30, *329*
Monastery of Saint Catherine, Mount Sinai, Egypt, 313–14, *313*, 322–23, *323*
monastic communities, 309, 498–99, 517
Mongols, 353, 354, 408, 424
monks, Buddhist, 446
Monk Sewing (Kao Ninga, attributed to), 445, 446, *446*
monograms (Christian symbols), 294
monolith, 482
Monophysitism, 304–5
monotheism, 290
Montagnac, France, menhir statue of a woman, 60, *60*
monumental narrative relief, 391–93

monumental sculpture, 78, 161
monumental tombs, Greek, 200–201
Mora, Paolo and Laura, 124
Moralized Bible, French Gothic, page, *Louis IX and Queen Blanche of Castile*, 581, *581*, 590
mortise-and-tenon joint, 59
mosaic: Byzantine, 313–14, 328; Greek, 207–8; Imperial Christian, 299–300; Jewish, 296; Mesopotamian, 70; Roman, 267–69; Romanesque, 550–51
mosaic synagogue floor, Maon (Menois), France, 296, *296*
Mosan region. *See* Meuse Valley
Moscow, Russia, Saint Basil the Blessed, 324, *324*, 338, *339*
Moses, 291, 296
mosque, 345, 347, 480
mound builders, North America, 466–68
Mount Olympos, 156, 158
Mount Sinai, Egypt, Monastery of Saint Catherine, 313–14, *313*, 322–23, *323*
Mount Vesuvius, 229
Mozarabic art, 493, 531
Mshatta, Jordan, palace, 347, *347*; facade of, 347, *347*
mudra, 384, *385*, 435
Muhammad, the Prophet, 290, 343, 344, 345; life of, 348–49
al-Mulk, pen box of (Shazi), 359, *359*
al-Mulk al-Muzaffar, Majd, 359
mullions, 578
mummies, 92, 99
mummy wrapping of a young boy, Hawara, Egypt, 126, *126*
muqarna, 311, 352, 355
murals. *See* wall painting
Murasaki, Lady, *Tale of Genji*, 436, 440; scroll, Japanese, 440, *441*
museums, 36–37, 193
music, Chinese, 406
Musicians and Dancers, wall painting, Tomb of the Lionesses, Tarquinia, Italy, 231, *232*
Muslims. *See* Islam
al-Mustasim, Yaqut, 352
Mut, 96, 114
Mycenae, Greece, 141–42, 145, 149; citadel, 142–46, *143*; Lion Gate, 144, *144*, 149; "Mask of Agamemnon" (funerary mask), 136, 144, *145*, 149, 150; *tholos* ('Treasury of Atreus'), 146, *146*, 199; *Two Women with a Child*, figurine, 149, *149*; *Warrior Vase*, 150, *150*
Mycenaean civilization, 142–51
Myron, 182–83; *Discus Thrower (Diskobolos)*, *152*, 153, 182–83, 190, 268
mystery plays (liturgical dramas), 541
mystery religions, 206, 236, 271–72, 289
mythocentric age, China, 407

N

Nanchan Temple, Wutaishan, Shanxi, China, 417, *417*
Nanna Ziggurat, Ur (modern Muqaiyir, Iraq), 72–73, *72*
naos, 160, 163, 298, 311
Nara, Japan, 434–35; Todai-ji temple, 435
Nara period (Japan), 434–35
Narmer, 96
narrative art, Indian, 391–93
narthex, 296, 298, 497, *568*
Nashville, Tennessee, Parthenon, 189
Nasrid dynasty, 354
National Endowment for the Arts (NEA), 35
Nativity, pulpit (Giovanni Pisano), 599, *599*
Nativity, pulpit (Nicola Pisano), 597–99, *599*
Nativity, the (in Christian art), 306
naturalism, 25–26, 218, 476; Chinese, 415–16; Gothic, 594; Indian, 384
Naumburg, Germany, Cathedral, 595–96, *596*
nave, 247, 296, 298, *568*
nave arcade, 299
nave colonnade, 298
Naxos, Greek island, 132
Nazca culture (Peru), 463–64

Nazca lines, Peru, 464, *464*
Near East, ancient, 67–91; map, *68*
Nebuchadnezzar II, King, 83, 291
necking, 164
necropolis, 100, 239
Nefertari, 117; tomb of, 123–25
Nefertiti, 120–21, 131
Nefertiti, head, Egyptian, *121*
negative spaces, 160
Neo-Babylonia, 83–85
Neo-Confucianism, 419–20, 423
Neolithic period, 53–63; cities, 69–70; Japan, 428–30
Nephthys, 96
Neptune, 158
Nero, 234, 246, 250
Nerva, 246
Newgrange, Ireland, tomb interior, 57, *57*, 146
New Testament, 291
New York, N.Y.: Pennsylvania Railroad Station, waiting room, interior, 276, *277*; Solomon R. Guggenheim Museum, 36, *37*
New York Kouros, kouros statue, Greek, 168, *168*
Ngongo ya Chintu, 477
Nicholas of Verdun, 593; *Shrine of the Three Kings*, reliquary, 577, 593–94, *594*
niello, 136, 546
Nigeria, 475; head, Nok culture, 475, *475*
Night Attack on the Sanjo Palace, scroll, Japan, Kamakura period, 442–43, *442*, 445
Nike, 158, 214
Nike (Victory) Adjusting Her Sandal, relief sculpture, Temple of Athena Nike, Acropolis, Athens, Greece, 194–96, *195*, 203, 218
Nike (Victory) of Samothrace, Samothrace, Macedonia, 216–17, *216*
Nile River, 94, 96
Nîmes, France: Maison Carrée, 238–39, *238*; Pont du Gard, 235, *235*
Nimrud, Iraq, 67, 80; Palace of Assurnasirpal II, *66*, 67, 80, *81*, 291; tomb of Queen Yabay, 82, *82*, 137
Nineveh (modern Kuyunjik, Iraq), 71, 82; *Assurbanipal and His Queen in the Garden*, 82, *82*
Nizami, 365
Nok culture (Nigeria), 475
Noli Me Tangere ("Do Not Touch Me") (in Christian art), 307
nonrepresentational (nonobjective) art, 27
Normandy, France, 503, 516
Norman Palace, Palermo, Sicily, Chamber of King Roger, 333, *333*
Normans, 331, 503, 542
Norns, 487
Norse, 487
North America: Pre-European, 465–68; Vikings in, 503
North Sea, 534–35
Notre-Dame cathedral, Amiens, Île-de-France, France, *570*, 571–75, *571*, *572*, *573*, 579, 597
Notre-Dame cathedral, Chartres, Île-de-France, France, 554, 555, 557, *557*, 562, 563–70, *564*, *565*, *566*, *567*, *569*, 579, 586, 595; Royal Portal, 563–64, *563*
Notre-Dame cathedral, Paris, France, 574, *574*, 575
Notre-Dame cathedral, Reims, Île-de-France, France, 575–77, *575*, *576*, *577*, 583, 586, 594
Nubia, Egypt, 125, 472; Temple T, Kawa, 125, *125*
nude, in art, 168–69, 202, 203–5
Nut (sky), 96

O

obelisks, 115
observation of nature, 177, 218
Octopus Flask, Palaikastro, Crete, 139, *139*
oculus, 228, 253, 311
Odin, 487, 505
Odysseus, 144, 158, 175
Odyssey, 149
O'Keeffe, Georgia, 27, 41; *Red Canna*, *26*, 27

veneer, 99, 236, 237

Venice, Italy, 323, 325–26, 542; Palazzo Ducale, Council Chamber, 32, *32*, 35; San Marco cathedral, 302, *324*, 325–26, *325*

Venus, 158

"Venus figures," 47

Verdun, 593

Vergina, Macedonia, Greece: *Abduction of Persephone*, wall painting, 170, *206*, 207; Tomb II, so-called Tomb of Philip, *206*, 207

verism, 239, 258

Veronese (Paolo Caliari), 32; *The Triumph of Venice*, fresco, Council Chamber, Palazzo Ducale, Venice, Italy, 32, *32*, 35

Vespasian, 234

Vesperbild, Bonn museum, 596, *596*

Vesperbild (Christian art form), 307, 596

vessel, Japan, Jomon period, 429, *429*

vessel, painted, Mayan, 461, *461*

vessels: Neolithic, 60–63; standard shapes, Greek, 172, *172*

Vesta, 158

Vézelay, Burgundy, France, Sainte-Madeleine church, 518, 524

vignette, 321

vihara, 381, 382

Vikings, 485, 502–5, 534–35

Villa Farnesina, Rome, Italy, 271, *271*, 293

village plan, Skara Brae, Orkney Islands, Scotland, 56–57, *56*

Villa of Livia, Primaporta, Italy, 266, 270, *270*, 293

Villa of the Mysteries, Pompeii, Italy, 271–72, *271*

Villard de Honnecourt, sketchbook, page, 580, *581*

Villa Torlonia, Rome, Italy, 293, *293*

vimana, 381, 394

Violet Persian Set with Red Lip Wraps (Dale Chihuly), 33, *33*, 35

Viollet-le-Duc, Eugène-Emmanuel, 574

Virgil, 144, 229, 233

Virgin and Child, sculpture, abbey church, Saint- Denis, Ile-de-France, France, 579–80, *579*, 583

Virgin and Child, sculpture, French Romanesque, *528*, 529

Virgin and Child Enthroned (Cimabue), 607, *608*

Virgin and Child Enthroned (Giotto di Bondone), 608, *609*

Virgin and Child in Majesty panel, *Maestà Altarpiece* (Duccio di Buoninsegna), 602–3, *602*

Virgin and Child with Saints and Angels, icon, Monastery of Saint Catherine, Mount Sinai, Egypt, 322–23, *323*

Virgin and Saint George, altarpiece (Luis Borrassá), 591–92, *591*; *Education of the Virgin*, 592, *592*

Virgin Mary, 291, 299–300, 322–23, 527, 534

Virgin of Vladimir, icon, Christian, 328, *328*, 534

Virtues and Vices, relief, Nôtre-Dame cathedral, Amiens, Ile-de-France, France, 573, *573*

Visgoths, 492

Vishnu, 378, 389–91

Vishnu Narayana on the Cosmic Waters, relief, Vishnu Temple, Deogarh, Uttar Pradesh, India, 390, *390*, 392

Vishnu Temple, Deogarh, Uttar Pradesh, India, *388*, 389, *389*, 390, *390*, 392, 395

Visigoths, 348, 487, 495

Visitation, the (in Christian art), 306

Vitruvius, Marcus Pollio, 226; *Ten Books of Architecture*, 229, 235

Vladimir, Grand Prince, 326–27

Volto Santo medieval sculpture, 529

volute, 164

volute krater, 172

votive figures, 73–74, 133, 226

votive statue of Gudea, Lagash (modern Telloh, Iraq), 78, *78*, 80

votive statues, Eshnunna (modern Tell Asmar, Iraq), 73–74, *73*

voussoir, 226, 228, 348, 524, 525, *525*

Vulca (artist), 227

Vulcan, 158

W

wall painting: Ancient Near East, 78–80; Gothic, 591; Greek, 207–8; Mesoamerican, 456; Minoan, 139–41; Roman, 269–173; Romanesque, 530–32

wall painting, House of M. Lucretius Fronto, Pompeii, Italy, 272–73, *273*

Wall with horses, Cosquer cave, Cap Morgiou, France, *42–43*, 48

Wang Xizhi, 413; calligraphy sample, 413, *413*

wares (ceramic), 60, 85

warp, 364, 452

Warring States period (China), 406

Warrior Vase, Mycenae, Greece, 150, *150*

watchtower, China, 418

wattle and daub construction, 55–56, *535*

wedjat (Egyptian symbol), 96

weft, 364, 452

Weickman, Christopher, 482

Weighing of Souls, *Last Judgment*, relief, Gislebertus, Saint-Lazare cathedral, Autun, Burgundy, France, 524, 527, *527*

Western Empire. *See* Roman Empire

Western Paradise of Amitabha Buddha, The, wall painting, Dunhuang, Gansu, China, 416, *416*, 418

Western Pure Land, 376, 414, 427, 437

West House, Akrotiri, Thera, Greek island, *128*, 129, 140

Weston, Edward, 26; *Succulent*, 26, *26*

westwork, 497

Whistler, James Abbott McNeill, 36; *Harmony in Blue and Gold*, Peacock Room, Frederick Leyland house, London, England, 36, *36*; *The Princess from the Land of Porcelain*, 36

white-ground vase painting, 173, 197

Wild Blackberry, *De Materia Medica*, manuscript (Pedanius Dioscorides), *320*, 321

Wiligelmus, 551–52; *Creation and Fall*, relief, Cathedral, Modena, Italy, 552, *552*

William of Sens, 584, 586

William the Conqueror, 535, 539, 541, 543

Winchester Psalter, *Hellmouth*, manuscript, English, 540, *541*, 588

Windmill Psalter, English, *Psalm 1 (Beatus Vir)*, 588, *588*

Woman and Maid, vase (style of Achilles Painter), 198, *198*

Woman at the Height of Her Beauty (Kitagawa Utamaro), 29, *29*, 33

Woman from Brassempouy, figurine, France, paleolithic, 46, 47, *47*

Woman from Ostrava Petrkovice, figurine, Czech Republic, paleolithic, 46, *46*

Woman from Willendorf, figurine, Austria, paleolithic, 46, *46*, 47

Woman or Goddess with Snakes, Knossos, Crete, 137–38, *138*

Woman Spinning, Susa (modern Shush, Iran), 86, *87*

Womb World mandala, Japan, Heian period, 434, *436*, 437

women
in art, depiction of, 28–29
artists, medieval, 549
in cultures: Greek, 197; Japanese, 440; Muslim, 348; Roman, 263, 274

Women at a Fountain House, vase ("A.D." Painter), 175, *175*, 186

women figurines, Cyclades, Greek islands, 132, *132*

women's hand (Japanese), 440

wood, sculpture, 438, 440

woodblock prints, 28; Japanese, 40

Worcester Chronicle (John of Worcester), *Dream of Henry I* page, 540, *541*

workshop, artists', 33

Wright, Frank Lloyd, Solomon R. Guggenheim Museum, New York, N.Y., 36, *37*

writing: Chinese, 403, 404, 405, 435; Egyptian, 111; Japanese, 435, 436, 438–40; Mayan, 458; medieval script, 500; Mesopotamia, 70–71; Minoan, 134

Wu, Chinese emperor, 410

Wu family shrine, Jiaxiang, Shandong, China, 410–11, *410*

Wutaishan, Shanxi, China, Nanchan Temple, 417, *417*

Wyatt, James, the Destroyer, 585

X

Xerxes I, 89

Xia dynasty (China), 405

Xia Gui, 423, 424; *Twelve Views from a Thatched Hut*, 422–23, *423*

Xi'an, Shanxi, China, Ci'en Temple, Great Wild Goose Pagoda, 417, *417*

Xie He, 412

Xi River, 402

Xuanzang, 417

Xu Daoning, 421–22; *Fishing in a Mountain Stream*, 421–22, *421*

Y

Yabay, Queen, tomb of, Nimrud, Iraq, 82, *82*, 137

yaksha, 377, 384

yakshi, 377

Yakshi Holding a Fly Whisk, India, Maurya period, 377, *377*, 381

Yangshao culture, 403

Yangzi River, 402

Yayoi period (Japan), 430–31

Yellow River, 402

Yggdrasil, 487

Yoritomo, Minamoto Yoritomo, 442

Yoruba Ife, Nigeria, 471, 476

Yoruba people, 31

Young, Thomas, 111

Young Flavian Woman, bust, Roman, 257–58, *257*, 577

Young Girl Gathering Crocus Flowers, wall painting, House Xeste 3, Akrotiri, Thera, Greek island, 140–41, *140*

Young Woman Writing, wall painting, Pompeii, Italy, 272, *272*

Yuan dynasty (China), 424

Yungang, Shanxi, China, *Seated Buddha*, sculpture, 414, *414*

Z

al-Zarir, *Life of the Prophet*, manuscript, *Prophet Muhammad and His Companions Traveling to the Fair* page, *349*, 368

Zen Buddhism, 423, 444–45

Zeus, 156, 158

Zeuxis, 25

Zhang Xuan, 418

Zhang Zeduan, 422; *Spring Festival on the River*, 422–23, *422*

Zhou dynasty (China), 406, 410

ziggurats, 70, 101

Zimrilim, 78

Zuni, 468

Credits

Credits and Copyrights

Adros Studio, Rome: 7-15, 15-16, 15-17, 16-38; Aerofilms, UK: 16-36; (c) 1981 Mark Horton/Aga Khan Program Visual Archives, MIT: 13-10; (c) Hervé Champollion/Agence Top: 3-35, 16-6; AKG London/Schütze/Rodeman, 5-2; AKG London/John Hios, 5-31; AKG London/Hilbrich, 6-78; Alexandria Press, London: 8-23; American Institute of Indian Studies: 9-6, 9-19, 9-26; Alison Frantz Collection, American School of Classical Studies, Athens: 4-10, 5-47, 5-49; ANSA, Rome Italy: p.183; Archeological Survey of India: 9-20; (c) 1981 Center for Creative Photography, Arizona Board of Regents: 3; Photograph (c) 2001 The Art Institute of Chicago, All Rights Reserved: 2; Photograph (c) 1994 The Art Institute of Chicago, All Rights Reserved: 11-17, 12-17; Art Resource, NY: 12, 14-15, 16-31, 16-33; Alinari/Art Resource, NY: 5-51, 5-67, 6-41, 6-42, 6-43, 6-69, 6-72, 6-75, 6-76, 16-56, 16-60, 16-71; Bibliothèque Nationale, Paris/Art Resource, NY: 14-16; Bildarchiv Foto Marburg/Art Resource, NY: 14-22, 16-51, 16-47; Egyptian Museum, Cairo/Art Resource, NY: 3-5; Photo by Kurt Lange, Oberstdorf/Allgäu /Egyptian Museum, Cairo/Art Resource, NY: 3-4; Giraudon/Art Resource, NY: 26, 2-18; Erich Lessing/Art Resource, NY: 1-4, 1-22, 1-22, 6-9, 6-1, 6-30, 7-21, 15-21, 15-32, 16-39; New York Public Library, Spencer Collection/Art Resource, NY: p.349; Nimatallah/Art Resource, NY: 4-1, 4-26, 5-52, 5-61; Pierpont Morgan Library, NY/Art Resource, NY: 14-18, 16-32, 16-40; Réunion des Musées Nationaux, Paris/Art Resource, NY: 1-13, 2-15, 2-16, 2-25, 2-26, 3-15, 5-25, 5-46, 5-80, 6-19, 7-48, 7-50, 8-8, 8-9, 14-10; Photo by D. Arnaudet, J. Schurmans/Réunion des Musées Nationaux, Paris/Art Resource, NY: 5-83; Scala/Art Resource, NY: 7, 14, 5-35, 5-84, 6-7, 6-44, 6-61, 6-64, 6-66, 6-74, 7-27, 7-29, 7-30, 7-32, 7-42, 16-67, 16-70; Tate Gallery, London/Art Resource, NY: 5; Gian Berto Vanni/Art Resource, NY: 5-12, 16-8; Victoria &Albert Museum, London/Art Resource, NY: 15-37; Werner Forman Archive, London/Art Resource, NY: p. 108; M. Babey/Arthephot: 3-16; Bapier/Artephot: 6-36; Robert Estall/Lajoux/Artephot: 13-2; R. Percueron/Artephot: 7-5; Asanuma Photo Studios, Kyoto, Japan: 11-1; Griffith Institute, Ashmolean Museum, Oxford: 3-1; James Austin, Cambridge, England: 15-2, 15-26, 16-23; Avery Architecture and Fine Arts Library, Columbia University: 5-41, 16-48; (c) 1980 Dirk Bakker: 13-3, 13-4, 13-5, 13-8; Bayerische Staatsbibliothek, Munich (CLM 4453): 14-30; Bernard Beaujard, Martignargues, France: 16-2; (c) Achim Bednorz, Köln: 10, 14-24, 15-7; Photograph by Benoy K. Behl, Bombay: 9-17; Raffaello Bencini, Florence: 8-7; Benrido, Tokyo: 11-7, 11-9, 11-10; Jean Bernard, Aix-en-Provence, France: 16-1, 16-13, 16-28; Constantin Beyer, Weimar, Germany: 15-35, 16-52; Biblioteca Apostolica Vaticana (Cod Palat. grec. 431): 7-51; Erwin Böhm, Mainz, Germany: 2-6; Bildarchiv Preussischer Kulturbesitz, Berlin: 5-19, 5-29, 5-77, 5-78, 6-30, 6-57, 6-67; Montserrat Blanc, Arte Gotico en Espagñe, Barcelona, 1972, cover: 16-46; (c) Lee Boltin/Boltin Picture Library: 1-25, 5-70; The Board of Trinity College/Dublin Bridgeman Art Library International: 14-1; Photo courtesy of The British Library, London: 9-1, 14-3, 2.5 (lower), 2-21, 3-39, 3-43, 5-8, 5-45, 5-57, 5-58, 6-83, 6-85, 7-33, 10-10; Photo by Graham Harrison/(c) The British Museum Press 2000: 3-20; Architectural plan by Percy Brown, reproduced from Indian Architecture, Vol. I, Bombay: 9-11; (c) Dr. Brian Byrd, University of California, San Diego: 2-2; Cahokia Mounds State Historic Site: 12-22; Helga Schmidt-Glassner, Callwey Verlag, Munich: 6-16; Cambridge University Collection of Air Photographs: 15-23; Canali Photobank, Capriolo, Italy: 5-24, 6-5, 6-14, 6-18, 6-32, 6-34, 6-45, 6-56, 7-2, 7-12, 7-17, 7-18, p. 304, 7-19, 15-34, p. 599, 16-58, 16-62, 16-63, 16-65, 16-66, 16-72; Carrieri Fotografo, Milan: 7-49, 8-17; Casement Collection Photo Library: 13-11; (c) Centre des Monuments Nationaux, Paris: 15-4, 15-10, 16-9, 16-20; François Lauginie/(c) Centre des Monuments Nationaux, Paris: 16-7, Patrick Muller/(c) Centre des Monuments Nationaux, Paris: 16-19, Mario Ruspoli/(c) Centre des Monuments Nationaux, Paris: 1-11; Centre Guillaume le Conquerant, Bayeux, France: p. 544; China Pictorial Publications, Beijing: 10-1; Peter Clayton: 3-31; (c) 2001 The Cleveland Museum of Art: 7-4, 11-18; Georg Gerster/Comstock, Inc.: 12-3, 12-16; (c) G. E. Kidder Smith/CORBIS: 7-22, Roger Wood/CORBIS: 1; The Conway Library, Courtauld Institute of Art, London: 4-21; Cultural Relics Publishing House, Beijing: 10-3, 10-6, 10-7, 10-8, 10-14, 10-15, 10-16, 10-17; (c) G. Dagli Orti: 3-34; Walter Hege, Die Akropolis; Deutscher Kunstverlag, Berlin, 1930: 5-22; Deutsches Archaeologisches Institut, Athens: 4-18, 5-73, 5-11, 6-10, 6-21, 6-55, 6-82; C. M. Dixon: 4-21; (c) Domkapitel Aachen (Foto Münchow), Aachen, Germany: 14-29; Dúchas The Heritage Service: 1-17; Fotocielo, Rome: 7-31; Fototeca Unione, American Academy, Rome: 6-13, 6-23, 6-24, 6-26, 6-29, 6-49, 6-80; Photo by Susan Einstein/Fowler Museum of Cultural History, UCLA: 12-18; Gabinetto Fotografico, Pisa: 16-59; Gayle Garrett, Washington, D.C.: p. 364 ; Photographer Guillermo Aldana/(c) The J. Paul Getty Trust, 2001, All rights reserved: 3-42, p. 124; The J. Paul Getty Museum, Los Angeles, California: 17; (c) Wim Swaan/Getty Research Library: 2-2, 3-9, 3-29, 7-24, 12-6, 7-53, 12-13, 16-10, 16-14, 16-15, 16-24, 16-27; Oleg Grabar, The Formation of Islamic Art, New Haven and London: 8-4; The Human Figure in Early Greek Art, 1988, Greek Ministry: 5-4; The Green Studio Limited: 14-4; Photo by David Heald, 1993/(c) The Solomon R. Guggenheim Foundation, NY: 22; Gulf International (U.K.) Ltd, London: 8-20; Sonia Halliday Photographs, Weston Turville, Bucks, UK: 8-15; (c) David Harris, Jerusalem: 7-7; Photo Hassia: 4-9; Hellenic Ministry of Culture/Archaeological Receipts Fund/TAP Service, Athens, Greece: 4-11, 4-14, 5-50; Hellenic Ministry of Culture/Archaeological Receipts Fund/ TAP Service, Athens, Greece/courtesy of Dumbarton Oaks, Washington, D.C.: 7-44, 7-45; Archaeological Museum, Epidaurus/Hellenic Ministry of Culture/Archaeological Receipts Fund/ TAP Service, Athens, Greece: 6; Gennadius Library, American School of Classical Studies, Athens/Hellenic Ministry of Culture/Archaeological Receipts Fund/ TAP Service, Athens, Greece: 5-40; Ekdotike Athenon/Hellenic Ministry of Culture/Archaeological Receipts Fund/TAP Service, Athens, Greece: 5-65; Hessische Landesbibliothek Wiesbaden: 15-38; Brian Brake, John Hillelson Agency, London: 6-48; Hirmer Fotoarchiv, Munich: 25, 4-6, 4-8, 5-7, 5-14, 5-32, 5-33, 5-43, 5-44, 5-48, 5-60, 5-63, 5-64, 6-8, 7-16, 7-20, 7-28, 16-21, 16-50; Colliva Giuliano/The Image Bank, NY: 3-8; Guido Alberto/The Image Bank, NY: 3-33; Imperial Embassy of Iran, Washington, D.C.: 8-12; Araldo de Luca/INDEX, Firenze: 3-12, 3-41, 5-74, 5-75, 6-46, 6-51, 6-79; (c) Archivio Electa, Milano/INDEX, Firenze: 6-62; Foto Vasari/INDEX, Firenze: 5-1, 6-20, 6-22, 6-33, 6-40, 15-41; Metropolitan Museum of Art Excavations, (1915-1916)/Photo by Araldo de Luca/INDEX, Firenze: 3-21; Nimatallah/INDEX, Firenze: 7-10, 7-11; Luciano Pedicini/Archivo Dell'Arte/INDEX, Firenze: 6-53, 6-63, 6-64; (c) Pontifcia Commissione de Archeologia Sacra, Rome/Index, Firenze: 7-1; Publifoto/INDEX, Firenze: 7-46, 7-47; Rapuzzi/ INDEX, Firenze: 14-9; Ghigo Roli/INDEX, Firenze: 15-42; A. Vasari/INDEX, Firenze: 6-37; Tosi/INDEX, Firenze: 16-61; Instituto Amaltier d=Art Hispanic, Barcelona: 8-10, 8-21, 1-14, 16-42, 16-43, 16-44; Japan National Tourist Organization, NY: 11-11, (c) Wolfgang Kaehler, Bellevue, WA: 10-12; Justin Kerr: 12-8; A.F. Kersting, London: 8-16, 15-25; (c) Kodansha Ltd, Tokyo: 3-2; Achim Bednorz/(c) Könemann Verlagsgesellschaft mbH, Köln: 15-8, 15-9, 15-11, 15-12; (c) Studio Kontos, Athens: 4-2, 4-7, 4-12, 4-15, 4-16, 4-17, 4-25, 4-27, 5-18, 5-20, 5-21, 5-34, 5-66; Nikos Kontos, courtesy of Ekdotike Athenon, Athens: 7-25; Laboratoire Photographique Blow Up: 15-20; Laboratoires Photographiques: 5-26; Liaison Agency: 12-1; Michael Lorblanchet, France: 1-7; (c) Tony Luck: 12-20; Sakamoto Manschichi Photo Research Library, Tokyo: 11-15; Gene Markowski: 9-9; Mr. Junkichi Mayuyama, Tokyo: 11-6; Courtesy McRae Books, Florence: 4-5; Photo by Kenneth John Conant/(c) The Medieval Academy of America, 1968/ Les Eglises el la Maison du Chef d'Ordre, Cluny: 15-5; Photograph (c) The Metropolitan Museum of Art, NY. 3-22 (1979), 2-1, 16-41 (1981), 8-13 (1982), 3-24 (1983), 8-26, 14-25 (1986), 12-9 (1990),

16-34 (1991), 3-18 (1992), 5-69 (1993), 8-1, 8-24, 12-2, 14-7 (1994), 13-9 (1995), 6-60, 4-4, 5-5, 5-6 (1996), 3-23, 5-17 (1997), 5-28, 15-14 (1999); Photo by Schecter Lee (c) 1986 The Metropolitan Museum of Art, NY: 6-59; Photo by Bruce White (c) 1997 The Metropolitan Museum of Art, NY: 7-39, 7-43, 7-41; Midlothian, VA, Rome: 7-14; Photo by A. Chene-Centre Camille Jullian-CNRS/Ministere de la Culture, France: 1-1; Photo by Calveras, Mérida, Sagristà/MNAC Photographic Service: 15-18; Monumenti Musei e Gallerie Pontificie, Vatican City (Rome): 24, 5-62, 5-79, 6-11. 6-58; Roger Moss, Cornwall, England: 16-11 Foto Ann Münchow, Aachen, Germany: 14-12; Courtesy, Museum of Fine Arts, Boston. Reproduced with permission. (c) 2001 Museum of Fine Arts, Boston. All Rights Reserved: 5-27, 5-36, 5-53, 9-5, 10-13, 10-18, 11-16, 12-15; (c) 2001 Board of Trustees, National Gallery of Art, Washington, D.C.: 11; Clarence Ward Photographic Archive/National Gallery, Washington, D.C.: 15-27; Sisse Brimberg/National Geographic Society Image Collection: 1-10, 1-6, 1-8; (c) The Nelson Gallery Foundation: 9, 15, 10-9, 10-20, 10-22; (c) McKim, Mead & White Collection/(c) Collection of The New-York Historical Society: 6-71; Ch. Doumas, The Wall Paintings of Thera, Idryma Theras-Petros M. Nomicos, Athens, 1992: 4-13; Jean-Louis Nou: 9-3, 9-4, 9-7, 9-18; (c) 1992 Saïd Nuseibeh Photography, San Francisco: 8-2; Oroñoz-Nieto, Madrid: 14-8, 16-45; Courtesy Dr. James E. Packer: 6-27; Yann Arthus-Bertrand/Altitude/Photo Researchers, Inc: 1-18; Photohaus Zumbühl, St. Gallen, Switzerland: 14-13; Donato Pineider, Florence: 7-36, 7-37; Foto Pontificia Commissione di Archeologia Sacra: 7-3; Photo by Justin Kerr/(c) 2001 Trustees of Princeton University. May not be reproduced without permission in writing from The Art Museum, Princeton University, Princeton, NJ/Museum purchase, gift of the Hans A. Widenmann, Class of 1918, and Dorothy Widenmann Foundation: 12-12; Studio Mario Quattrone, Florence: 6-6, 15-40, 16-55, 16-68, 16-69; Serge De Sazo/Rapho: 16-22; Fotostudio Rapuzzi, Brescia: 6-73; Reconstruction drawing by J. V. Schaubild, Der heilige Bezirk von Delphi: 5-3; Rheinisches Bildarchiv: 14-28, 16-54; Hervé Lewandowsk/Réunion des Musées Nationaux, Paris: 2-17; M. Beck-Coppola/Réunion des Musées Nationaux, Paris: 16-29; Merle Greene Robertson (c) 1976: 12-10; (c) Elizabeth Barlow Rogers: 12-4; Photo by Peter Dorrell and Stuart Laidlaw/Courtesy University of London, Institute of Archaeology, (c) Dr. Gary Rollefson: 2-3; Jean Roubier, Paris: 15-13, 16-18; Sakamoto Manschichi Photo Research Library, Tokyo: 11-12; Peter Sanders Photography, Chesham, Bucks, UK: 8-1; Seitz-Gray Foto: 15-39; Photo by Carl Andrews/ (c) President and Fellows of Harvard College for the Semitic Museum: 3-11; Ronald Sheridan's Ancient Art & Architecture Collection, London: 8-14; (c) Franko Khoury/National Museum of African Art, Smithsonian Institution, Washington D.C.: 13; Soprintendenza Archeologica all'Etruria Meridionale: 6-9; Sovfoto/Eastfoto: 7-55; Spectrum Colour Library, London: 4-23; William Bridges Thayer Memorial Spencer Museum of Art: 8; Staatliche Antikensammlungen/Diana Buitron-Oliver, The Greek Miracle, Classical Sculpture from the Dawn of Democracy, The Fifth Century B.C., Washington, D.C.: 5-15; (c) Henri & Anne Stierlin: 9-28; Dr. Franz Stoedtner, Dusseldorf: 5-13; Photograph courtesy of Marilyn Stokstad: 14-5; John Bigelow Taylor, NY: 12-14; (c) Jerry L. Thompson: 13-1; Barry Iverson, Time Magazine/Time Picture Syndication, NY: 2-22; Richard Todd: 9-8, 9-13, 9-15; Marvin Trachtenberg: 5-71, 16-4, 16-5; Courtesy The Oriental Institute, The University of Chicago: 2-9, 2-20, 2-23, 2-29, 2-30; Universitets Oldsaksamling, Oslo, Norway: 14-21, 14-20; University of Cincinnati Department of Classics, reproduced by permission: 4-24; Asian Art Archives, University of Michigan: 9-10, 9-12, 9-16, 9-21, 9-23, 9-24, 9-25; Jean Vertut Archive, Issy-les-Moulineaux: 3-19, 3-28; Museum fur Völkerkunde, Vienna: 13-7; Gemeinnützige Stiftung/ (c) Leonard von Matt, Buochs, Switzerland: 6-2, 6-65, 15-1; Clarence Ward, Oberlin, OH: 16-16; Yoshio Watanabe, Tokyo: 11-5; Kit Weiss, Copenhagen, Denmark: 14-2; From John White, Duccio, published by Thames and Hudson Ltd, London, 1979. Photo courtesy of Thames and Hudson Ltd.: 16-64 ; Robert Frerck/ Woodfin Camp and Associates: 6-28; D & J Heaton/ Leo de Wys, Inc.: 3-10, Arthur Hustwitt/Leo de Wys, Inc.: 7-40; Siegfried Tauquer/Leo de Wys, Inc.: 6-39; Photo YAN (Jean Dieuzaide), Toulouse: 1-12; (formerly) Yugoslav State Tourist Office: 6-77; Zefa Pictures, Dusseldorf: 5-55; Photo Zodiaque: 14-6, 15-22.

Artist Copyrights

(c) 2001 The Georgia O'Keeffe Foundation/Artists Rights Society (ARS), NY: 4.

Illustration Copyrights

Blaser/Hannaford (eds.), *Drawings of Great Buildings*, Birkhäuser Verlag AG, Basel 1993: 16-57, 16-17, 16-37, 16-12, 16-26.

Text Copyrights

Reprinted from Magda Bogin, *The Women Troubadours*, New York, W. W. Norton & Company, Inc., 1980. Copyright (c) Magda Bogin: Page 558; Selected excerpt from *The Essential Tao: An Initiation into the heart of Taoism through the Authentic Tao Te Ching and the Inner Teachings of Chuang Tzu*, translated by Thomas Cleary. Copyright (c) 1991 by Thomas Cleary. Reprinted by permission of HarperCollins Publishers, Inc.: page 409; Reprinted from *Eight Dynasties of Chinese Painting: The Collections of the Nelson Gallery-Atkins Museum, Kansas City and Cleveland Museum of Art*, Cleveland Museum of Art & Indiana University Press, 1980: page 849; From *Love Song of the Dark Lord* by Barbara Stoller Miller. Copyright (c) 1977 by Columbia University Press. Reprinted by permission of the publisher: page 834; Scripture selections are taken from the *New American Bible* (c) 1991, 1986, 1970 Confraternity of Christian Doctrine, Washington, D.C. Used with permission: pages 309, 331, 531, 558; *Buddhacharita, or Acts of the Buddha*, translated by E. H Johnston, published by permission of Munshiram Manoharlal Publishers Pvt. Ltd., New Delhi: page 385; From *Life of the Ancient Egyptians*, by Eugen Strouhal. Copyright (c) 1992 by Opus Publishing Limited. Text (c) 1989, 1992 by Eugen Strouhal. Reprinted with permission of Opus Publishing Limited and University of Oklahoma Press: page 106; Earl Miner, Hiroko Odagiri, and Robert E. Morrell, *The Princeton Companion to Classical Japanese Literature*. Copyright (c) 1989 by Princeton University Press. Reprinted by permission of Princeton University Press: page 443; Indira Vishvanathan Peterson, translator, *Poems to Shiva: The Hymns of the Tamil Saints*, copyright (c) 1989 by Princeton University Press. Reprinted by permission of Princeton University Press: 398; Miriam Lichtheim, *Ancient Egyptian Literature*, Vol. 1, copyright (c) 1973 The Regents of the University of California by arrangement with the University of California Press, Berkeley: page 124.

N
5300
S923

CARROLL COMMUNITY COLLEGE LMTS

Art history.

00000009323213